BLAKE RECORDS

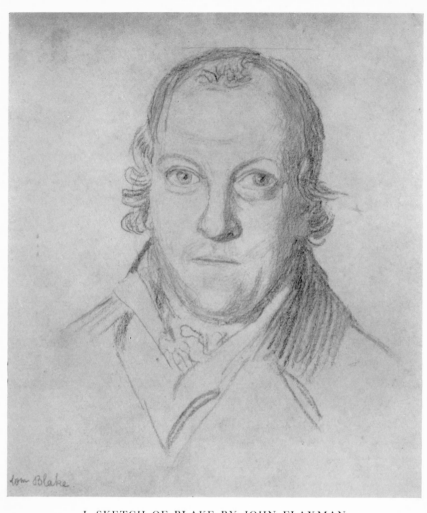

I. SKETCH OF BLAKE BY JOHN FLAXMAN

Blake Records

G. E. BENTLEY, Jr.

OXFORD

AT THE CLARENDON PRESS

1969

Oxford University Press, Ely House, London W. 1

GLASGOW NEW YORK TORONTO MELBOURNE WELLINGTON
CAPE TOWN SALISBURY IBADAN NAIROBI LUSAKA ADDIS ABABA
BOMBAY CALCUTTA MADRAS KARACHI LAHORE DACCA
KUALA LUMPUR SINGAPORE HONG KONG TOKYO

TO
E. B.

ACKNOWLEDGEMENTS

THE *Blake Records* began in 1955 with what I thought was just an article, and then a series of articles, on contemporary references to the poet. During the past twelve years, I have received generous assistance for these *Records* from every Blake student and collector with whom I have been able to get in touch. Of the former I should especially single out for thanks Martin Butlin, D. V. Erdman, and Sir Geoffrey Keynes; of the latter, Miss Joan Linnell Ivimy, Mr. Paul Mellon, Mr. Lessing Rosenwald, the Bodleian Library, and the British Museum. Collections of unique materials used here are listed on pp. ix–xi, but I must isolate in that list Miss Ivimy in particular, who very generously permitted me to spend much of the summer of 1959 sifting through the thousands of letters and miscellaneous documents in her possession. Blake students will participate in my gratitude to her for allowing the Blake references in these papers to be published. The world of Blake scholars and collectors has proved a generous fraternity to me; I have drawn as much in friendship as in knowledge from my brothers.

Research for the book has been supported by Fellowships from the Guggenheim Foundation (1958–9) and the Canada Council (1963–4), and by grants from the University of Chicago, from the Huntington Library, and, annually, from the University of Toronto. For this timely assistance I am deeply grateful.

The book was measurably improved by anonymous suggestions from press readers. The most tactful and cherished assistance I received, however, was from my mother. She would have liked to have seen it in print.

I have enjoyed writing this book; I hope it may give some pleasure, as well as information, to others.

<div align="right">G. E. B.</div>

DUTCH BOYS LANDING
MEARS, MICHIGAN *June* 1967

OWNERS AND REPOSITORIES OF UNIQUE MATERIALS

━━━

I AM deeply indebted to the owners and custodians of the unique materials cited in the *Blake Records*, who have shown me uniform kindness.

Public Collections

Art Institute of Chicago
Berg Collection, New York Public Library
Bermondsey County Council, London
*Bodleian Library, Oxford
*British Museum, London
Cornell University Library, Ithaca, N.Y.
Cowper Museum, Olney, Buckinghamshire
Dove Cottage, Grasmere
Drapers' Hall, London
*Fitzwilliam Museum, Cambridge, England
Greater London Record Office
Guildhall Library, London
Harvard Libraries, Cambridge, Massachusetts
Haverford College Library, Haverford, Pennsylvania
Huntington Library, San Marino, California
Lambeth Palace Library, London
Library of Congress
Liverpool Public Library
London County Council
London Library
Manchester City Art Galleries
Middlesex County Record Office, London
Pierpont Morgan Library, New York
National Buildings Record, London

National Gallery of Victoria, Melbourne, Australia
National Portrait Gallery, London
New Church College, Woodford Green, Essex
Oxford University Press, Oxford
Pennsylvania Historical Society, Philadelphia
Carl H. Pforzheimer Library, New York
Princeton University Library
Rosenwald Collection, Alverthorpe Gallery, Jenkintown, Pennsylvania (Library of Congress and National Gallery)
Royal Academy of Arts, London
St. George's Church, Hanover Square, London
St. James's Church, Piccadilly, London
St. Mary's Church, Battersea
St. Marylebone Public Library, London
Society of Antiquaries, Burlington House, London
Somerset House, London
Stationers' Hall, London
Sussex County Record Office, Chichester
Swedenborg Society Inc., London
Tate Central Library, Brixton
Tate Gallery, London
Trinity College Library, Hartford, Connecticut
University of Chicago Library
Westminster Public Library, Buckingham Palace Road, London
Whitworth Art Gallery, Manchester
Dr. Williams's Library, London
Yale University Library, New Haven, Connecticut

Private Collections

Roger W. Barrett, Chicago
G. E. Bentley Jr., Toronto
David Bindman, London
Sir Anthony Blunt, London
Mrs. Robert D. Chellis, Weston, Massachusetts
Mr. Claytonn-Stamm
Edward Croft Murray, London
H.M. Queen Elizabeth, Royal Library, Windsor

Mrs. George Galt, Toronto
Joseph Holland, Los Angeles
*Miss Joan Linnell Ivimy
Miss Mary Barham Johnson, Norwich
Miss Johnstone, Trewithen, Cornwall
Sir Geoffrey Keynes, Brinkley, Newmarket
John S. Linnell, Hindon, Salisbury, Wilts.
Longmans, Green & Co. Ltd., London
Mrs. Mary E. Malone, Park Forest, Illinois
Miss Ruth Marshall, Rickmansworth, Hertfordshire
H. Bradley Martin, New York
Gwen Lady Melchett, London
Paul Mellon, Upperville, Virginia
James M. Osborn, Yale University
The late Kenneth Povey, London
Kerrison Preston, Merstham, Surrey
Antonia Lady Radcliffe, London
Stanbury Thompson, Stapleford, Nottinghamshire
Mrs. Landon K. Thorne, New York
Mrs. William F. Tonner, Philadelphia

CONTENTS

ACKNOWLEDGEMENTS *page* vii

OWNERS AND REPOSITORIES OF UNIQUE MATERIALS ix

LIST OF ILLUSTRATIONS xv

ABBREVIATIONS xxi

INTRODUCTION xxiii

NEW REFERENCES TO BLAKE xxvii

PRELUDE 1737–1757 Family and Milieu 1

PART I 1757–1779 The Visionary Apprentice 5

PART II 1779–1799 From Artisan to Artist 15

PART III 1800–1805 Patronage and Dependence 62

PART IV 1806–1818 Independence and Obscurity 175

PART V 1818–1827 The Ancients and the Interpreter 256

PART VI 1827–1831 A Fading Shadow 348

POSTSCRIPT: 1831–1833 'God protect me from my
friends' 413

APPENDIX

Section I: Early Essays on Blake
 A. B. H. Malkin, *A Father's Memoirs of His Child* (1806) 421
 B. H. C. Robinson, *Vaterländisches Museum* (1811) 432
 English translation 448

Contents

C. J. T. Smith, *Nollekens and his Times* (1828) 455

D. Allan Cunningham, *Lives of . . . British Painters . . .* (1830) 476

E. Frederick Tatham, MS. 'Life of Blake' (?1833) 507

F. H. C. Robinson, 'Reminiscences' (1852) 535

Section II: Blake Residences 550

Section III: Blake Accounts 569

 A. Separate Accounts 569

 B. Linnell's General Account Books 584

 C. Linnell's *Job* Accounts 598

 D. Linnell's Payments to Mrs. Blake 605

 Summaries of Accounts 606

Section IV: Engravings by and after Blake 609

ADDENDA 621

INDEX 628

LIST OF ILLUSTRATIONS

N.B. No attempt has been made to reproduce the plates the sizes of the originals.

Works distinguished below by an asterisk (*) have apparently not been reproduced before. In some cases (Plates XX, XXI, XXIV, XXVI–XXXI, XLV–XLVI, LIII, LV–LIX, and LXa) it is only this state of the work which has not been reproduced before.

*I. Sketch of Blake by John Flaxman. By permission of the Syndics of the Fitzwilliam Museum, Cambridge — *Frontispiece*

*II. Sketch of James Parker by John Flaxman. By permission of the Syndics of the Fitzwilliam Museum, Cambridge — *facing p.* 12

III. Self portrait by John Flaxman. By permission of the Art Institution of Chicago — „ 19

IV. Sketch of A. S. Mathew by John Flaxman. By permission of Mrs. I. A. Williams — „ 25

V. Sketch of Harriet Mathew by John Flaxman. By permission of Mr. Edward Croft Murray — „ 26

*VI. Copies of three Blake drawings by Flaxman (1792). By permission of Mr. David Bindman — „ 47

*VII. a. Blake's drawing for Young's *Night Thoughts* (1796). By permission of the Trustees of the British Museum

b. Blake's engraving for Young's *Night Thoughts* (1797), p. 23. By permission of the Trustees of the British Museum — „ 52

VIII. Frontispiece to Burger's *Leonora* (1796) designed by Blake. By permission of the Trustees of the British Museum — „ 55

IX. Young's *Night Thoughts* (1797), p. 46, and Butts engraving. By permission of the Trustees of the British Museum and *The Connoisseur* — „ 57

x. *a.* Blake's Malevolence (1799). By permission of Mrs. William F. Tonner

 b. Night Thoughts (1797), p. 15, and *Europe* (1794), pl. 4. By permission of the Syndics of the Fitzwilliam Museum, Cambridge, and the Trustees of the British Museum *facing p.* 60

xi. Blake's engraving of Thomas Hayley for Hayley's *Essay on Sculpture* (1800). By permission of the Trustees of the British Museum ,, 65

xii. Blake's water-colour portrait of Thomas Hayley (1800). By permission of the Manchester City Art Galleries ,, 69

xiii. Decorations for Hayley's 'Little Tom the Sailor' (1800). By permission of the Trustees of the British Museum ,, 74

*xiv. Miniature of John Johnson by Blake (1802). By permission of Miss Mary Barham Johnson ,, 88

xv. Engraving for 'The Elephant', Hayley's first *Ballad* (1802). By permission of the Trustees of the British Museum ,, 102

xvi. Engraving for 'The Eagle', Hayley's second *Ballad* (1802). By permission of the Trustees of the British Museum ,, 104

xvii. Engraving for 'The Horse' in Hayley's *Ballads* (1805). By permission of the Trustees of the British Museum ,, 162

xviii. 'A Widow Embracing her Husband's Grave' (1805) by Blake for Blair's *Grave*. By permission of Gwen Lady Melchett ,, 166

*xix. Sketch of R. H. Cromek by Flaxman. By permission of the Syndics of the Fitzwilliam Museum, Cambridge ,, 168

*xx. 'Death of The Good Old Man' for *Blair's Grave* (1808). By permission of the Huntington Library, San Marino, California ,, 172

*xxi. 'Death of the Strong Wicked Man' for Blair's *Grave* (1808). By permission of the Huntington Library, San Marino, California ,, 174

XXII. 'The Dog' for Hayley's *Ballads* (1805). By permission of the Trustees of the British Museum — *facing p.* 177

XXIII. Frontispiece to Malkin's *Memoirs of His Child* (1806). By permission of the Trustees of the British Museum — „ 181

XXIV. Phillips's Portrait of Blake Etched for Blair's *Grave* (1808). By permission of the Huntington Library, San Marino, California — „ 183

XXV. Vignette Sketch (1807) for Blair's *Grave*. By permission of the Trustees of the British Museum — „ 184

*XXVI. 'Christ Descending into the Grave' for Blair's *Grave* (1808). By permission of the Huntington Library, San Marino, California — „ 192

*XXVII. 'The meeting of a Family in Heaven' for Blair's *Grave* (1808). By permission of the Huntington Library, San Marino, California — „ 197

*XXVIII. 'The Soul hovering over the Body' for Blair's *Grave* (1808). By permission of the Huntington Library, San Marino, California — „ 199

*XXIX. 'The descent of Man into the Vale of Death' for Blair's *Grave* (1808). By permission of the Huntington Library, San Marino, California — „ 203

*XXX. 'The King, Councellor, Warrior, Mother and Child in the Tomb' for Blair's *Grave* (1808). By permission of the Huntington Library, San Marino, California — „ 206

*XXXI. 'The Day of Judgment' for Blair's *Grave* (1808). By permission of the Huntington Library, San Marino, California — „ 214

XXXII. *a.* Stothard's painting of 'Chaucer's Procession to Canterbury'. By permission of the Tate Gallery, London

b. Blake's Engraving of 'Chaucer's Canterbury Pilgrims' (1810). By permission of the National Gallery of Art, Rosenwald Collection — „ 217

XXXIII. Sketch of Catherine Blake, by Blake (after 1802). By permission of the Tate Gallery, London — „ 237

XXXIV. Etched title-page for Blair's *Grave* (1808). By permission of the Huntington Library, San Marino, California *facing p.* 246

*XXXV. 'Holy Thursday' (1789) from *Songs of Innocence and of Experience.* By permission of Sir Anthony Blunt ,, 252

XXXVI. Engraving for 'Holy Thursday' in *City Scenes* (1818). By permission of the Toronto Public Library ,, 253

*XXXVII. *a.* Visionary head of Richard I (1819). By permission of Mr. F. Bailey Vanderhoef, Jr.

b. Visionary head, subject unknown. By permission of G. E. Bentley, Jr. ,, 259

XXXVIII. Visionary head of Edward I (1819). By permission of the National Gallery of Art, Rosenwald Collection ,, 261

XXXIX. Visionary Heads of William Wallace and Edward I (1819). By permission of Mr. F. Bailey Vanderhoef, Jr. ,, 262

XL. Three Blake woodcuts for Virgil's *Pastorals* (1821). By permission of the Trustees of the British Museum ,, 267

XLI. Three Blake designs anonymously re-engraved for Virgil's *Pastorals* (1821). By permission of the Trustees of the British Museum ,, 268

XLII. Deville's life mask of Blake (1823). By permission of the National Portrait Gallery, London ,, 278

XLIII. Dante Design No. 90 (*c.* 1824). By permission of the National Gallery of Victoria, Melbourne, Australia ,, 290

XLIV. Blake's third *Job* engraving (1826). By permission of the Trustees of the British Museum ,, 300

*XLV. 'The Reunion of the Soul & the Body' for Blair's *Grave* (1808). By permission of the Huntington Library, San Marino, California ,, 326

*XLVI. 'La Caverna' for Mora's *Meditaciones Poeticas* (1826). By permission of the University of Liverpool Library ,, 334

XLVII. Blake's second engraving for Dante (1827). By permission of the National Gallery of Art, Rosenwald Collection *facing p.* 347

XLVIII. Blake's 'Ghost of a Flea' in Varley's *Zodiacal Physiognomy* (1828). By permission of the Trustees of the British Museum „ 373

*XLIX. Blake's apprentice drawing of Edward III (*c.* 1778). By permission of the Bodleian Library „ 422

*L. Blake's apprentice drawing of Richard II (*c.* 1778). By permission of the Bodleian Library „ 423

LI. *America* (1793) pl. 10. By permission of the Syndics of the Fitzwilliam Museum, Cambridge „ 446

LII. 'The Ancient of Days' (1794). By permission of the Whitworth Art Gallery, University of Manchester „ 471

*LIII. 'Death's Door' for Blair's *Grave* (1808). By permission of the Huntington Library, San Marino, California „ 491

LIV. *Jerusalem* (?1820) pl. 46. By permission of the Syndics of the Fitzwilliam Museum, Cambridge „ 520

*LV. Photograph of 28 Broad Street. By permission of the National Buildings Record, London „ 553

*LVI. Sketch of 13 Hercules Buildings. By permission of the Greater London Record Office „ 560

*LVII. *a.* Photograph of Blake's Felpham cottage. By permission of Kenneth Gravett, New Malden, Surrey

b. Milton (?1808) pl. 36. By permission of the Trustees of the British Museum „ 561

*LVIII. *a.* Photograph of 17 South Molton Street. By permission of R. B. Fleming & Co. Ltd., London

b. Photograph of 3 Fountain Court. From *Art Journal*, iv (1858) „ 563

*LIX Horwood's *Plan* (1792–99) showing part of Westminster. By courtesy of the Archives Department of the Westminster City Library *between pp.* 564–5

*LX Horwood's *Plan* (1792–99) showing part of Lambeth. By courtesy of the Archives Department of the Westminster City Library *between pp.* 566–7

ABBREVIATIONS

BM	British Museum, London.
BM Add. MSS.	British Museum Additional Manuscripts.
Bodley	The Bodleian Library, Oxford.
Fitzwilliam	The Fitzwilliam Museum, Cambridge, England.
Gilchrist, 1942, 1863	Alexander Gilchrist, *Life of William Blake*, ed. Ruthven Todd, London and N.Y., 1942; *Life of William Blake*, '*Pictor Ignotus*', London and Cambridge, 1863.
HCR	Henry Crabb Robinson; the nature of his Diaries and Reminiscences is described on p. 223 n. 1.
Ivimy MSS.	The voluminous Linnell family records in the possession of Miss Joan Linnell Ivimy.
Keynes and Wolf	Geoffrey Keynes and Edwin Wolf 2nd, *William Blake's Illuminated Books: A Census*, N.Y., 1953.
Linnell Journal	A. H. Palmer's transcript in the Ivimy MS. of Linnell's untraced Journal; see p. 256 n. 2.
N & Q	*Notes and Queries.*
TLS	*Times Literary Supplement*, London.

INTRODUCTION

Acts themselves alone are history Tell me the
Acts, O historian, and leave me to reason upon them as
I please; away with your reasoning and your rubbish!
All that is not action is not worth reading.

Descriptive Catalogue

Purpose

THE purpose of the *Blake Records* is to collect and publish as
many as possible of the references to Blake made by his con-
temporaries. The book is not designed to present newly dis-
covered material, though naturally a number of new facts
turned up. Only a very small percentage of what follows
appears in print for the first time.[1] In almost every case the
facts have been previously published elsewhere, and my chief
task has been to locate these published references, to verify
them, if possible by finding manuscript sources for them, and
to set them in a full enough context to make them meaningful
to students of Blake.

There appears to be a consistent financial and legal bias in
these *Records* which is the product rather of the kinds of
information that survive than of the character of the subject or
the interests of the collector. Apprenticeship and marriage
records, wills, and rate-books are preserved primarily because
they have significance in law and commerce and are likely to
survive long after other kinds of information have disappeared.
Further, his early friends were anxious about, and his late
friends admired, his cavalier attitude towards his worldly
prospects. These *Records* give a very one-sided picture of
Blake—the picture of Blake as seen by his contemporaries and
as chance and the legal and economic forces of history have
preserved the documents. For as complete a picture as possible,
the student must absorb as well Blake's writings and designs.

[1] The few documents which, so far as I know, are published here for the first
time in connexion with Blake will be found tabulated on pp. xxvii–xxviii.

Scope

The book ranges in time from the earliest reference to Blake's known family (1737) to the last (1833). The records dealt with range from official documents such as marriage allegations to casual references to Blake in the letters of his contemporaries. The most important groups of material used are the very extensive manuscripts of Blake's intimate friends George Cumberland, John Flaxman, William Hayley, and John Linnell.

Blake and his wife had twenty brothers and sisters, but not one of them is known to have had children, and both family lines were probably extinct by 1840. Extraordinarily little is known about either family except for the poet and his wife. Consequently, though I have tried to gather information about any relation of Blake at any time, very little will be found in the book which does not relate directly to the poet himself.

Method of Organization

The body of the text presents in chronological order every surviving record known to me concerning the poet and his relatives. Information about Blake's life is divided into six sections, with a Prelude and a Postscript covering the years just before his birth and just after his death. *Part I, 1757–79,* covers the period from Blake's birth to the end of his apprenticeship, about which very little is known. *Part II, 1779–99,* is the time of Blake's young manhood, when he lived chiefly by engraving and designing for the London booksellers. During this period he was writing almost all his lyric poetry, all his short Prophecies and one long one, printing his own works, making hundreds of designs—it was by a considerable margin his most prolific and financially successful period.

Part III, 1800–5, deals with the years when Blake was almost entirely committed to the patronage of William Hayley, and the materials for this period are especially rich. *Part IV, 1806–18,* dips back into obscurity. Up to about 1810 there are frequent public comments on Blake's designs, but thereafter he seems to have lost contact with both the public and his old friends.

Part V, 1818–27, takes us from Blake's meeting with John Linnell to his death. Because Linnell and a group of long-lived

disciples were devoted to Blake and helped to support him, we have a very great deal of information about this period. In some ways it was the happiest and most fruitful era of Blake's life. *Part VI, 1827–31*, covers the years from Blake's death to the death of his wife, with a *Postscript*, dealing with the disputes over the disposition of Blake's pathetically small property.

A number of significant references to Blake do not fall strictly within the scope of the plan outlined above. I have assumed that the testimony about Blake of anyone who knew him is worth considering, and therefore that such of Blake's friends as survived to write or talk about him even after 1831 may appropriately be quoted in this collection of *Blake Records*. The most important such authorities are Samuel Palmer, Edward Calvert, George Richmond, Seymour Kirkup, and John Linnell, whose testimony will be found scattered through the book.

A rather difficult case in this respect is presented by Alexander Gilchrist, who did not know Blake but who knew people who did and who often quoted them without recording his sources. When I have been able to trace Gilchrist's footsteps I have found that he is highly reliable, and I have therefore taken on trust those parts of his testimony that my own research into prior sources does not duplicate or controvert.

The inevitable danger of such a rigidly factual and chronological arrangement is that the disparate pieces may not coalesce and present a unified and coherent picture. Occasionally the chronological units neatly complement each other, as with the letters of Hayley, Johnny Johnson, and Lady Hesketh, and at such times the records achieve something of the flow of a biography. I have tried to encourage this flow as systematically and unobtrusively as possible, but sometimes the obstacles have proved insuperable to me.

Appendix

The evidence which does not fit conveniently into the chronological arrangement has been gathered together in the Appendix in Sections dealing with: I, 'Early Essays on Blake' by Malkin, Crabb Robinson, J. T. Smith, Cunningham, and Tatham; II, 'Blake Residences'; III, 'Blake Accounts'; and IV, a table of 'Engravings by and after Blake'. The Sections in the Appendix

are carefully cross-referenced to the main chronological sequence, but in most respects each Section of the Appendix is self-sufficient. A section of Addenda collects references to Blake which have come to my attention in the four or five years during which the book has been in the printer's hands.

References

Biographical data about peripheral figures are silently taken from *The Dictionary of National Biography*. *Blake's Letters* are cited merely by date from the manuscript, the locations of which are given in *A Blake Bibliography* (1964), and his other writings are also quoted from the originals. Throughout the body of the *Records*, cross-references are given by date alone, but it should be noticed that when the cross-reference is to an Account or to an Engraving the relevant information will be found in the Appendix.

NEW REFERENCES TO BLAKE

THE dates in this table are a rough guide to the references to Blake in these *Blake Records* which do not appear to have been printed since 1831. The modern works in which contemporary references have been printed may be located from the Bentley and Nurmi *Blake Bibliography*.

1737 July 14
1769–72
1779 Oct. 8
1780 May 27
1782 April 2, Aug. 13, 18
1783 April 28
1791 Jan., summer, Sept. 1
1792 Jan.–June
1796 June 18–20, Nov.
1801 Feb. 3, July 25, 30, Sept. 5, 9, 15
1802 Jan. 28, April 10, Aug. 6, Sept. 1, Oct. 17, Nov. 2
1803 Jan. 15, 29, Dec. 25
1804 Feb. 4
1805 Feb. 28, March 28, July 31
1806 July 16
1807 Summer
1808 Feb. 9, June 5, Aug. 28, 31, Nov., Nov. 30, Dec., Dec. 1, 4, 12
1810 April 19, 20, 21, 23, 28, May 7, 24, 25, June 11, 25, July 1, Aug. 20–27, Nov. 1
1813 April 12
1814 June 3
1815 April 21, April
1818 June
1820 May 11, Dec.
1822 July 1
1823 Nov.
1824 March 24, May 9, 14, 16, 24, June 17, 21, Aug. 2, 4, Sept., Oct. 21–22, autumn
1825 April 5, 25, Aug. 6, Oct. 13, 15, 18, 20, Dec. 5
1826 Jan. 3, 31, Feb. 9, March, March 28, 29, April 10, 11, 22, 24, May, May 2, late July, Nov. 4, 20, Dec.
1827 Jan. 5, Feb., Feb. 22, Aug. 14, 15, 18, Sept. 1, 4, Oct. 10, 23, Nov., Nov. 3, 12, Nov., Nov. 25, 27, Dec. 3, 11, 26
1828 Jan. 11, 15, 17, Jan., Jan., Jan. 20, 23, 27, 31, Feb. 1, March 11, Aug. 29, Sept., Oct., Oct. 11, Nov.
1829 Jan. 21

1830 Jan., Feb. 6, 8, 12, March 8, 11, Aug. 13
1831 March 9, 16, 18, April, May 11, Oct. 18

RESIDENCES

Rotherhithe	29 Broad Street
Glasshouse Street	South Molton Street
28 Broad Street	Cirencester Place
Hog Lane	Charlton Street

ACCOUNTS

1795 Oct.	1822 Nov. 2
1796–7	1826 Jan. 18, March 9
1799 Oct. 5–12	1828 Jan. 16
1806 Nov. 22	1831 March 31
1810 Dec. 27	General Accounts
1814	Cash Paid to Mrs. Blake

ADDENDA

1780 Sept.	1819
1809	1828 Nov. 19, Dec.
1812 Sept.	1830 Feb.

PRELUDE

FAMILY AND MILIEU

1737–1757

I give you the end of a golden string,
Only wind it into a ball:
It will lead you in at Heavens gate,
Built in Jerusalems wall.[1]

T H E father of William Blake led such an ordinary existence
that even his son's tardy fame has not illuminated his life and
character. The first occasion on which he moves from the
shadows for us was when, as a boy of perhaps fourteen, he and
his father went to the great hall of the Company of Drapers and
agreed to the following form of apprentice indenture: 'James
Blake, Son of James Blake of Rotherhithe[2] in the County of
Surrey Gentleman [*was bound as a draper's apprentice*] to
Francis Smith—for Seven Years [*from July 14th, 1737*]— *July 14th, 1737*
Cons[*ideratio*]ⁿ. 60 £', and a fee of 1*s*. 2*d*.[3] It seems likely that

[1] *Jerusalem*, p. 77.

[2] According to the present Rector of Rotherhithe, the Revd. R. A. Shute,
there is no record of a James Blake in the Rotherhithe christening records for
1704–30, which are still in the church. Symons (*William Blake*, London, 1907,
p. 27) found no baptismal record for James Blake in St. James's Parish Church
(where all James's children were baptized), but according to H. M. Margoliouth
('William Blake's Family', *N & Q*, cxciii [1948], 296–8), a James, son of James
and Susanna Blake, was born Aug. 26th and baptized on Aug. 31st, 1721 in the
neighbouring parish of St. Anne's, Soho. In the same parish register for 1724 is
recorded the birth (Oct. 12th) and baptism (Nov. 1st) of James, the son of John
and Mary Blake. The former couple had no more children baptized at St. Anne's
(1717–40), but John and Mary appear in the parish register as the parents of
Richard (1723), Richard (1726), William (1728), and George (1735). Neither
of these James Blakes fits with the other scattered facts we have about the poet's
father quite so well as the James Blake of Rotherhithe, though neither can be
ruled out.

[3] The Register of Bindings for the Drapers' Company is now in Drapers' Hall,
London.

the James Blake here mentioned is the father of the poet William Blake, for his apprenticeship was up exactly when William's father, a hosier, moved into Glasshouse Street—see 'Blake Residences' (p. *551*).

Fifteen years later, and eight years after the apprenticeship was completed, 'James Blake and Catherine Harmitage of S.^t James', Westminster' were married in St. George's Chapel, *October* just off Hanover Square, on Sunday, October 15th, 1752.[1] St.
15th, George's Chapel did a land office business in hasty, informal
1752 weddings—fifteen took place the day the Blakes were married—until they were forbidden by Act of Parliament from March 25th, 1754, just a year and a half after the Blakes were married.

Catherine Harmitage Blake was about thirty when she was married (see September 9th, 1792), and her husband, if we calculate that he was fourteen when he was apprenticed in 1737, must have been about twenty-nine. The young couple spent their first year of married life in a house in Glasshouse Street and then moved into the bride's family home in Broad Street, Golden Square, Westminster.[2]

Almost exactly nine months after their marriage 'James
July Blake, Son of James & Catherine, [*was born*] July 10', 1753,
10th, and he was baptized on Sunday the 15th in the parish church of
1753 St. James, Piccadilly.[3] Young James grew up to be a cautious shopkeeper like his father, and was the only one of the children who achieved any moderate conventional success. He had, however, startling qualities that he shared with his younger brother. 'James—for the most part an humble matter-of-fact man—had his spiritual and visionary side too; would at times *talk Swedenborg*, talking of seeing Abraham and Moses, and to outsiders seem like his gifted brother "a bit mad"—a mild madman instead of a wild and stormy.'[4] Nevertheless, his

[1] The marriage registers, now in the parish church of St. George, Hanover Square (the chapel no longer exists), were very shoddily kept, and the usual data about the officiating clergyman, witnesses, signatures of the principals, etc., were omitted. There is a '+' in front of the entry, an unusual distinction, but I do not know what it signifies. It does not appear to indicate that the marriage was by licence, as no record of it is preserved with other licences for the area and time in Lambeth Palace Library. The cost of fees and certificates was one guinea.

[2] See Residences, pp. 551–2.

[3] The baptismal registers for St. James's, Piccadilly, in which this and other births in the Blake family are recorded, are still kept in the church.

[4] Gilchrist, 1942, p. 48; 1863, p. 55. The picture of James's conventionality

virtues and his sympathies seem on the whole to have been very unlike his brother's. Gilchrist wrote of him:

This James Blake is characterised, by those who remember him, as an honest, unpretending shopkeeper in an old-world style, ill calculated for great prosperity in the hosiery, or any other line. In his dress he is described to me as adhering to knee-breeches, worsted stockings, and buckles. As primitive as his brother he was, though very unlike: his head not in the clouds amid radiant visions, but bent downwards, and studying the pence of this world—how to get them, which he found no easy task, and how to keep. He looked upon his erratic brother with pity and blame, as a wilful, misguided man, wholly in a wrong track; while the latter despised him for his grovelling, worldly mind,—as he reckoned it. Time widened the breach. In after years, when James had retired on a scanty independence [*in 1812*] and lived in Cirencester Street, becoming a near neighbour of Mr. Linnell, at whose house Blake was then a frequent visitor, they did not even speak. At James's shop, ladies yet living, friend's of Blake's, remember to have made their little purchases of gloves and haberdashery.[1]

At Cirencester Place he lived in cautious gentility for some fifteen years, dying there just a few months before his brother.

The birth of the Blakes' second son was carelessly recorded in the same church register: 'John Blake, Son of John & Catherine [*was born on*] May 12' and baptized on Sunday June 1st, 1755, in St. James's, Piccadilly.[2]

The information about the poet's family that survives for the years before he was born is unusually meagre—a boy bound

May 12th, 1755

comes from Tatham (p. 509); there is no other evidence besides Gilchrist's for his vision-seeing. James Blake, like his brother William, almost certainly did not 'talk Swedenborg' until after about 1787.

[1] Gilchrist, 1942, p. 243; 1863, p. 227. Blake's relations with his brother were certainly fairly amicable up to 1812, when James exhibited Blake's Chaucer engraving. Gilchrist's informants (Linnell, Tatham, Palmer) had not known Blake and his relations with his brother until after 1818.

[2] The 'John' listed for the father is almost certainly a clerical error for 'James'; certainly no other 'John & Catherine' Blake entries appear in these records during the years when the young Blakes were being baptized. It is clear, from the fact that James and Catherine Blake also named their fourth son John, that the present John died young, but there is no record of his burial in the records of St. James's, Piccadilly, or of the Bunhill Fields burying ground, where both his parents were buried. It is possible that this John Blake was not in London when he died.

apprentice, a marriage, a few entries in the rate books, and the baptism of two children. The fact which this obscurity re-emphasizes is that there was nothing very remarkable about William Blake's family; the only distinction in the family belongs to the poet.

PART I

THE VISIONARY APPRENTICE—
A CITY OF GOLD

1757–1779

———

Two years after John Blake was baptized the parish clerk registered the birth of the Blakes' third son: 'William Blake, Son of James & Catherine, [*was born*] Nov. 28', 1757, and was *November* baptized on Sunday, December 11th, 1757 in St. James's Church, *28th,* Piccadilly. *1757*

The Blakes' next child, 'John Blake, Son of James & *March* Catherine, [*was born*] Mar. 20' and baptized Monday, March *20th,* 31st, 1760 in St. James's Piccadilly.[1] *1760*

The girl who later married William Blake, 'Catherine Sophia Da^r of William & Mary Boucher [*born April*] 25', was *April* christened in the parish church of St. Mary, Battersea, on *25th,* Sunday, May 16th, 1762.[2] Except for Catherine Sophia, their *1762* last child, 'William & Mary Boucher' (always so spelled in the church records) had children regularly every second year for eighteen years: *Sarah*, christened January 8th, 1743 (buried September 22nd, 1751); *Martha*, christened September 15th, 1745; *Elizabeth*, christened October 4th, 1747 (born September 17th, 1747, buried September 12th, 1791, age '43'); *William*, christened August 13th, 1749 (born August 4th); *Hester*, christened April 21st, 1751; *John Hillesdon*, christened March 14th, 1753; *Jane*, christened May 11th, 1755; *Sarah*, christened February 6th, 1757; '*Charlott & Julett*', born August 18th, christened August 19th, buried September 11th and 14th 1759; and *Richard & James*, born January 3rd and christened the 11th 1761 (Richard, age nine, was buried July 15th, 1770).

[1] No burial record of this John Blake has been found in the Bunhill Fields burial registers, but it is likely that he died abroad; see Tatham, p. 509.

[2] Quoted from the parish records still in the church.

It is difficult to trace the family confidently because the orthography of the name seems to have varied with the fancy of the writer—see, for example, Catherine's marriage register, August 18th, 1782. There were numbers of Boucher-Butchers in the same parish who may have been relatives,[1] but the name is not uncommon elsewhere. However, Catherine's family does not seem to have been firmly planted in the neighbourhood, for William and Mary Boucher were not married there (between 1730 and 1743); William was not christened there (between 1710 and 1725); their children did not marry there, nor, if there were any Boucher grandchildren, were they christened there. Presumably William and Mary Boucher moved about 1743 to Battersea, at the time James Blake moved to Glasshouse Street in Westminster. If Catherine's mother was buried at St. Mary's, she must be the Mrs. Butcher, poor, who was interred on September 2nd, 1782, just fifteen days after Catherine and William Blake were married. Catherine's father is probably the 'W.ᵐ Boucher Aged 80 years Poor' who was buried at St. Mary's on September 16th, 1794.

According to the rate books[2] William Boucher (or Butcher, Bouchier, Boutchor) first occupied rateable property (£3) in 1751, and he paid taxes steadily until 1763, when the rates could not be extracted from him because he was 'p[oo]r'. Tatham (p. 517) says that William 'Boutcher' was a 'respectable and industrious' 'market Gardener', and there is some evidence[2] that he had at one time some eighteen acres of land which he presumably farmed. However, all the records suggest that throughout Catherine's life the large family was declining in fortune, if not actually becoming poverty-stricken.

June 19th, 1762 The only known reference to the poet's youngest baptized brother is that 'Richard Blake, Son of James & Catherine, [*born*] June 19', was christened on Sunday, July 11th, 1762 in

[1] *John Butcher's wife Elizabeth* was buried Feb. 12th, 1758 at St. Mary's, Battersea, and another wife of John Butcher, *Margaret*, age 70, was buried Aug. 20th, 1765. Four months later, on Dec. 9th, 1765, John Butcher married *Ann* Marshall. Their children, *Ann and Mary*, were christened Oct. 12th, 1766 and Sept. 10th, 1769; the first was buried on Sept. 9th, 1770; the second on June 7th, 1771; and the father was buried, poor, on March 31st, 1783. On May 10th, 1764 *Mary Boucher* married Robert Moody, and one of the witnesses was 'William Butcher', who may have been Catherine Sophia's father.

[2] Cf. P. Miner, 'William Blake's London Residences', *Bulletin of the New York Public Library*, lxii (1958), 548.

the family church of St. James's, Piccadilly. Apparently he died while still an infant.[1]

The poet's only sister, 'Catherine Elizabeth Blake, Da.ʳ of James & Catherine, [*was born*] Jan. 7', 1764 and was christened *January* three weeks later on Saturday the 28th in St. James's, Pic- *7th,* cadilly.[2] *1764*

William Blake was, then, one of a large family, living in ordinary lower-middle-class circumstances over the draper's shop in Westminster. We know of nothing remarkable about his surroundings or situation, but the visions began to come to him while he was still very young.

On Peckham Rye (by Dulwich Hill) it is, as he will in after years relate, that while quite a child, of eight or ten perhaps, he has his *1765–7* first vision. Sauntering along, the boy looks up, and sees a tree filled with angels, bright angelic wings bespangling every bough like stars. Returned home he relates the incident, and only through his mother's intercession escapes a thrashing from his honest father, for telling a lie. Another time, one summer morn, he sees the hay-makers at work, and amid them angelic figures walking.[3]

Already the world of the imagination was all-important to him.

One day, a traveller was telling bright wonders of some foreign city. 'Do you call *that* splendid?' broke in young Blake; 'I should call a city splendid in which the houses were of gold, the pavement of silver, the gates ornamented with precious stones.' At which outburst, hearers were already disposed to shake the head and pronounce the speaker crazed. . . .[4]

Blake's favourite brother Robert was born on August 4th, *August* 1767 (see the entry for April 2nd, 1782), but he was not *4th,* baptized in the family church of St. James's, Piccadilly. *1767*

Robert Blake's father may have joined the Baptist Church about 1769. According to 'A List of Subscribers To support the Ministry who are Members' of the Grafton Street Baptist

[1] Not even a death record has been discovered for this brother. Heretofore it has always been assumed that 'Richard' was simply a clerical slip for Blake's favourite brother 'Robert' who died in 1787; but see April 2nd, 1782.

[2] No burial record has been found for Catherine, but she is said to have survived all her known relations, and to have died, therefore, after 1831; see Postscript, 1833.

[3] Gilchrist, 1942, p. 6; 1863, p. 7. Cf. Tatham, p. 519.

[4] Gilchrist, 1942, p. 6; 1863, p. 7.

Church (1766–72) '— Blake' (no Christian name is ever
1769–72 given) contributed regularly from 1769 to 1772, and perhaps
beyond.[1]

If about 1769 the senior Blake joined a Baptist church, this
would answer a few puzzling questions. The poet's early bio-
graphers agree that his father was a dissenter, but none took the
trouble to specify what kind of dissenter. The suggestion that
for a time he was a Baptist identifies the kind of dissenter and
explains their reticence—evidently the senior Blake was not
indissolubly bound to one church. Further, the suggestion
explains why Robert, born in 1767, was not baptized in the
parish church, though all his brothers and sisters had been,
his sister Catherine only four years previously. Finally, we can
with this suggestion understand why James Blake, his wife, his
sons William, Robert, and probably James were all buried in
Bunhill Fields, the dissenters' burying ground, though they
had all been brought up in the forms of the State Church.
Unfortunately the evidence is so tenuous that it can be nothing
better than a suggestion, but it seems to be a profitable one,
contradicting nothing that we know and helping us to put in
place several loose strands in Blake's life.[2]

By the summer of 1772 the time had come when a decision
had to be made as to what trade or profession Blake was to
follow. For Blake there was probably very little hesitation; he

[1] This green vellum notebook is now with the Ivimy MSS. The 'Blake' occurs
regularly: Michaelmas Quarter 1769, 2s. 6d; Midsummer 1770 'Blake 2 qrs' 10s.
6d.; 'Crismus Qr' 1770, 10s. 6d.; Lady Day, Midsummer, Michaelmas, and Christ-
mas 1771, Lady Day, Midsummer, and Michaelmas 1772, 5s. 3d. each.

[2] A good deal of information is available about this and other Baptist groups at
the time in: (1) W. Wilson, *The History and Antiquities of Dissenting Churches
and Meeting Houses*, London, 1814, vol. iv, p. 25; (2) the registers in Somerset
House, London (vol. 106), of the names (not baptisms) of children born to members
of the Baptist groups from 1787 to 1837, including seven children of Thomas
Chevalier, five children of Thomas Palmer (Linnell's father-in-law), and one of
C. H. Tatham; and (3) the Autobiography of John Linnell (in the possession of
Mr. John S. Linnell) giving lengthy accounts of his relations and experiences with
the Grafton Street Baptists. It is clear from the two last sources particularly that
if Blake himself did not belong to this Baptist Church, many of his best friends of
later years did.

The church migrated from Glasshouse Street to Grafton Street in 1750, and
thence to Keppell Street, under the Revd. John Martin, about 1795. In 1959 Mr.
L. S. Hill, Hon. Sec. of the Metropolitan Association of Strict Baptist Churches,
wrote to me that though the congregation flourished in Keppell Street up to 1902,
in that year it moved to Bassett Street, Kentish Town, and in fairly recent years
expired. The church records of this roving congregation have not been traced.

would have liked to be an artist, but his father could only afford to make him an engraver.[1] Their choice fell upon James Basire, a member of a family of engravers and, at that time, the most distinguished topographical and antiquarian engraver in London. In the presence of the gowned officers of the Court of Assistants of Stationers' Hall, early on the morning of Tuesday, August 4th, 1772,[2] James Blake and Basire exchanged indentures which probably read as follows:

This Indenture Witnesseth, That

[*William Blake*][3] the Son of [*James of Broad Street Carnaby Market Hosier*] doth put himself Apprentice to [*James Basire of Great Queen Street Lincolns Inn ffields Engraver*] Citizen and STATIONER[4] of *London*, to learn his Art; and with him (after the manner of an Apprentice) to serve from the day of the Date of these Presents, until the full End and Term of Years from thence next following, to be fully compleat and ended. During which Term the said Apprentice his said Master faithfully shall serve, his Secrets keep, his

[1] See Tatham, pp. 510–11, for some of the circumstances affecting this decision.

[2] They were due at 9.30, and there was a fine if they were later than 10.00 a.m. (C. Blagden, 'The Stationers' Company in the Eighteenth Century', *Guildhall Miscellany*, no. 10 [1959], p. 37). The Court of Stationers' Hall met on the first Tuesday of each month to transact business, such as binding apprentices (E. Howe, *A List of London Bookbinders 1648–1815*, London, 1950, p. x).

[3] Blake's form of indenture itself has not survived, so I have taken the ordinary printed form of the time (see below, p. 10, note 2) and entered on it [*in italics and within square brackets*] the relevant information taken from the Stationers' Hall documents. Since the printed forms for all apprentices of the same Company were presumably identical, the clerk who was recording the information for official purposes merely transcribed the portions which had been entered in MS. First he made a rough notation for his own information, and later he transcribed this note in a copperplate hand into a formal apprentice register. Both these transcripts of the significant portions of Blake's indenture are among the records of Stationers' Hall, London. The copperplate copy reads: 'William Blake Son of James of Broad Street Carnaby Market to James Basire of Great Queen Street Lincolns Inn ffields Engraver seven years Cons[*ideratio*]ⁿ £52. 10.— paid by his ffather[.]' The *rough* note (reproduced in facsimile in G. Keynes, *Blake Studies*, London, 1949) differs from it only in abbreviations. Besides the £52. 10s. 0d. there was a Stationers' Hall fee of 9s. 6d. Because the indenture was a bond for which money was paid, the document had to be stamped and registered with the government. This register (now in the Public Record Office, London, pressmark INL 1/27, f. 133) reads: 'James Basire Citizen and Stationer [*took*] William Blake [*to be trained in*] Ind[*ustry, i.e., not in a profession, on*] 4 August 1772 [*for*] 7 [*years*] from date [*for a Consideration of £*]52 10 [*the duty of* 1s. *per pound on which comes to £*] 2 12 6[.]'

[4] James Basire himself had been apprenticed at Stationers' Hall on Sept. 3rd, 1745 and was made free on Dec. 5th, 1752.

lawful Commandments every where gladly do. He shall do no Damage to his said Master, nor see to be done of others, but that he to his power shall lett, or forthwith give warning to his said Master of the same. He shall not waste the Goods of his said Master, nor lend them unlawfully to any. He shall not commit Fornication, nor contract Matrimony within the said Term. He shall not play at Cards, Dice, Tables, or any other unlawful Games, whereby his said Master may have any loss. With his own Goods or others, during the said Term, without License of his said Master he shall neither buy nor sell. He shall not haunt Taverns, or Play houses, nor absent himself from his said Master's Service Day nor Night unlawfully: But in all things as a faithful Apprentice, he shall behave himself towards his said Master, and all his, during the said Term. And the said Master (for and in Consideration of the Sum of [*Fifty Guineas*]¹ of lawful Money of *Great-Britain* to him in Hand paid, by [*James Blake aforesaid*] at and before the ensealing and Delivery of these Presents, the Receit whereof is hereby acknowledged) his said Apprentice in the same Art and Mystery which he useth, by the best Means that he can, shall teach and instruct, or cause to be taught and instructed, finding unto his said Apprentice, Meat, Drink, Apparel, Lodging, and all other Necessaries, according to the Custom of *London*, during the said Term. And to the true performance of all and every the said Convenants and Agreements either of the said Parties binds himself unto the other by these Presents. In witness whereof, the Parties above named to these Indentures have put their Hands and Seals the [*Fourth*] day of [*August*] in the [*thirteenth*] Year of the Reign of our Sovereign Lord King GEORGE, of *Great Britain*, &c. *Anno Dom.* 17[*72*]

August 4th, 1772

　　Presentat. die Dat. Supra dict. Coram　　　　　　[　　　　]
　　Deb. Regis, Prius Impress.　　　　　　　　　　*Magistro*
[*James Basire*
James Blake]²

¹ Sometimes the fee was regarded as caution money instead of as payment for instruction and board-and-room. The publisher Bowyer, for instance, advertized that he would return £30 out of a £50 apprenticeship fee if the boy behaved himself (C. Blagden, 'The Stationers' Company in the Eighteenth Century', *Guildhall Miscellany*, no. 10 [1959], p. 40). In the absence of Blake's indenture, however, we can only assume that no such extraordinary conditions were attached to it.

² Blagden, op. cit., pp. 51–52. The late Mr. Blagden told me that he knew of no other extant indenture for Stationers' Hall. This exemplar dates from the 1720s (the printer dated it '172 '), but it is extremely unlikely that the form changed very significantly during the next fifty years. For one thing, the same 'Form of usual printed Indenture' for all apprentices is given, with only trifling changes, by J. Chitty in *A Practical Treatise on the Law relative to Apprentices and Journeymen, and to Exercising Trades*, London, 1812, pp. 145–6. For another, the most

At the same ceremony at which Blake was apprenticed, according to the Stationers' Hall registers, other boys were bound to a haberdasher and a stationer for £100 each; to a bookbinder for £40; to a goldbeater for £5; and for no payment to a printseller, a stationer, a printer (3), a mathematical instrument maker, and an ironmonger.[1]

The most important clause of the indenture so far as the apprentice was concerned, the heart of the apprenticeship system surviving from medieval times, was the sentence specifying that the master 'shall teach and instruct, or cause to be taught and instructed, finding unto his said Apprentice, Meat, Drink, Apparel,[2] Lodging, and all other Necessaries, according to the Custom of *London*, during the said Term'. From time to time, as the eighteenth century progressed, there were attempts to change the apprentices from novices being initiated into a mystery to mere hired labourers.[3] Consequently regulations were made to enforce the living-in clause, and, almost exactly a year after young William Blake was apprenticed, the Court of the Stationers' Company decreed that an apprentice who left his master's house and worked for wages, or who accepted a weekly allowance instead of the regulation board and lodging, was to be refused the Freedom of the Company.[4] Except in unusual circumstances, then, the boys lived at the homes of their masters, who stood *in loco parentis* to them.

It is very likely, therefore, that Blake lived with Basire's family at 31 Great Queen Street, Lincoln's Inn Fields, from 1772 to 1779, only going home occasionally in the evenings

important clauses in the indenture—requiring the master to find all necessaries for his apprentices—were quoted in exactly the same words in an indignant letter of May 1807 from the Compositors of London to the Master Printers (*The London Compositor*, ed. E. Howe, London, 1947, p. 128). From about 1710 on, the standard term was seven years. One copy of the indenture was kept by the master and the other by the boy's father or guardian.

[1] These proportions are not unrepresentative for the century; see Blagden, op. cit., pp. 36–37, and E. Howe, *The London Compositor*, London, 1947, p. 39.

[2] Some fathers agreed in a sub-contract to provide clothing, medicine, washing, and 'physical advice' in lieu of the master, or to pay a £100 fine, but this seems to have been always a rather unusual arrangement (Blagden, op cit., p. 38).

[3] In 1737 the Court of the Stationers' Company permitted masters to pay 3s. weekly in lieu of board for the first half of an apprenticeship (Blagden, op. cit. p. 38), but the printers made more and more strenuous efforts to prevent this kind of perversion of the system.

[4] Blagden, op. cit., p. 37.

after his long day, or perhaps on Sundays.[1] One of the few
things we know about Blake during these years is that he
acquired a copy of Abbé Winckelmann's *Reflections on the
Painting and Sculpture of the Greeks*, 1765, in which he wrote
with a swagger: 'William Blake, Lincoln's Inn', as if he were
a member of the Inns of Court, not just a neighbour. We can
also be confident that most of the *Poetical Sketches*, composed
between 1770 and 1778, were written while he was with
Basire.

He would clearly have been intimate with the whole Basire
family, and he would have known the twelve other boys who
were apprenticed to James Basire between 1764 and 1792:
Thomas Ryder (1746–1810), son of Thos. of Paternoster Row,
bookbinder, apprenticed on August 16th, 1765, for £52. 10s. 0d;
John Ward, son of John of Red Lyon Street, Clerkenwell,
broker, on March 6th, 1770 for £47. 5s. 0d.; *James Parker*[2]
(1750–1805), son of Paul of St. Mary le Strand, cornchandler,
on August 3rd, 1773, for £52. 10s. 0d.; *John Dawson*, son of
Richard of Bagnio Court, Newgate Street, engraver, for
£52. 10s. 0d. on June 1st, 1779; *Isaac James Basire*, September
4th, 1781; *George Phillips*, son of John, late of the County of
Gloucester, Gentleman, deceased, for £63 paid by his guardian
John Scott, Esquire, on November 4th, 1783: *James Basire*
(1769–1832), apprenticed free to his father February 3rd, 1784;
John Roffe, son of Joseph of Littlefield Street, Soho, school-
master, on February 1st, 1785, for £21; *Philip Lautenshlager*,
son of Adam of Tower Street, St. Giles, baker, on July 5th,
1785 for £63; *Richard Woollett Basire*, May 1st, 1787; and
William Poole, bound February 7th, 1792. Of these boys, all
apparently finished their apprenticeship except John Ward,
who was 'turned over by Consent of proper parties [*on April
7th, 1772*] to Samuel Sonsby of White Cross Street Citizen and
Joiner for the Remainder of his Term'. Blake was apprenticed
within two weeks of the end of the term of Basire's only other
apprentice of the time, Thomas Ryder (August 16th, 1772).
From 1765 to 1770 Basire had only one apprentice; from 1770
to 1783 (Blake's period) he had two; and from then on, with

[1] In the absence of any contemporary witness about where Blake slept as an
apprentice, we must assume (with Gilchrist, 1942, p. 18; 1863, p. 21) that Blake
followed the normal practice of his time. [2] See Plate II.

PLATE II

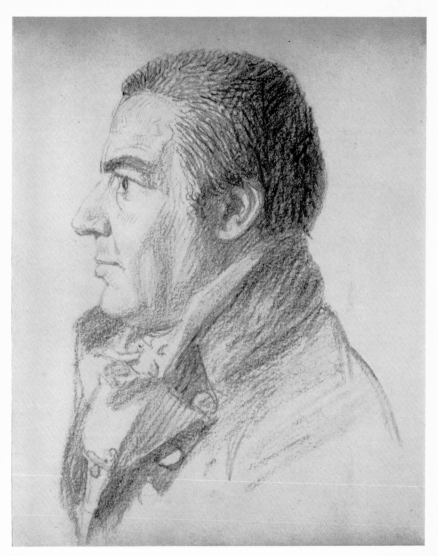

SKETCH BY JOHN FLAXMAN OF JAMES PARKER, Blake's fellow apprentice and later his partner in a print shop (see pp. 12, 29)

the infusion of his sons, he had from three to six, except for the last few years of the century.[1]

Life in the engraver's shop must have opened up many kinds of vistas to the young apprentice, with its direct contact with the literary and artistic worlds: 'One day, by the way (as Blake ever remembered), Goldsmith walked into Basire's. It must have been during the very last years of the poet's life: he died *1772–4* in 1774. The boy—as afterwards the artist was fond of telling— mightily admired the great author's finely marked head as he gazed up at it, and thought to himself how much *he* should like to have such a head when he grew to be a man.'[2]

From 1774 on[3] Blake was sent regularly by Basire to sketch from the tombs in Westminster Abbey in preparation for the engravings the Basire manufactory was making for Gough and the Society of Antiquaries. 'It was when he was one day thus secluded in the dim vaulted solitude of Westminster Abbey that he saw, as he afterwards records, one of his visions. The aisles *1774–9* and galleries of the old building (or sanctuary) suddenly filled with a great procession of monks and priests, choristers and censer-bearers, and his entranced ear heard the chant of plain-song and chorale, while the vaulted roof trembled to the sound of organ music.'[4] Gilchrist was told that 'Shut up alone with these solemn memorials of far off centuries—for, during service and in the intervals of visits from strangers, the vergers turned the key on him,—the Spirit of the past became his familiar companion. Sometimes his dreaming eye saw more palpable shapes from the past: once a vision of "Christ and the Apostles," as he used to tell'[5]

The impression the Abbey made upon Blake was profound, and was communicated enthusiastically to his young disciples fifty years later. Samuel Palmer wrote: 'In Westminster Abbey were his earliest and most sacred recollections. I asked him how

[1] The *DNB* adds that William Skelton (1763–1848) also 'was a pupil first [*c.* 1777?] of Basire . . . and later of William Sharp'.

[2] Gilchrist, 1942, pp. 12–13; 1863, p. 15.

[3] See Malkin, p. 422.

[4] This is Oswald Crawfurd's paraphrase ('William Blake: Artist, Poet, and Mystic', *New Quarterly Magazine*, ii [1874], 475) of 'a letter addressed apparently to Mr. Butts, which was purchased with others, at a sale in 1861 by a friend of the present writer'. The letter also contained accounts 'of several [*more*] of Blake's earlier visions'.

[5] Gilchrist, 1942, p. 15; 1863, p. 81.

he would like to paint on glass, for the great west window, his "Sons of God shouting for Joy," from his designs in the *Job*. He said, after a pause, "I could do it!" kindling at the thought.'[1]

Blake was presumably free of his indentures in August 1779, seven years from the beginning of his apprenticeship, and perhaps the occasion was observed by a gift of money from Basire, or by the even older custom of giving the erstwhile apprentice a double suit of apparel and the tools of his trade.[2] During the last quarter of the eighteenth century about half the boys apprenticed to Stationers went on after finishing their terms to become Freemen of their Guild, the prerequisite technically necessary to setting up in business for themselves or taking apprentices of their own.[3] However, neither William Blake nor James Parker took up the Freedom open to them, even when they set up an abortive business partnership a few years later.

[1] Gilchrist, 1942, p. 303; 1863, p. 303 from a letter dated August 23rd, 1855. When this passage is quoted in *Anne Gilchrist: Her Life and Writings*, ed. H. H. Gilchrist, London, 1887, p. 262, it is inexplicably dated '1861'.

[2] O. J. Dunlop & R. D. Denman, *English Apprenticeship & Child Labour*, London & Leipsic, 1912, p. 170.

[3] The figures for the century are given in C. Blagden, *The Stationers' Company*, London, 1960, p. 289. Cf. E. Howe, *A List of London Bookbinders 1684–1815*, London, 1950, p. xv.

PART II

FROM ARTISAN TO ARTIST

1779–1799

W HEN he had completed his apprenticeship, Blake probably wanted to exercise his talents in painting, poetry, and music, but first he had to earn a living as a journeyman engraver. For the next twenty years he gradually became better known and better paid as a competent engraver who had a flair for designing, but his success was limited partly by the restricted nature of his training.

Blake's ambition beyond the mechanic skills is indicated by his application for admission to the ten-year-old Royal Academy of Arts. First, in July 1779, he must have submitted a drawing and a testimonial from a respected artist to George Michael Moser, the Keeper of the Royal Academy.[1] When these credits proved satisfactory, the regulations allowed him to work for three months as a probationer in the Antique School of the Academy, making an elaborate outline drawing at least two feet high of an anatomical figure, with lists of the muscles and tendons.

At the end of the three months he submitted his drawing and applied for permission to be a full student at the Academy. According to the Minutes of the Council, on Friday, October 8th, 1779

The Keeper presented several Drawings done from Casts in the Royal Academy. The following were admitted Students Viz —

[1] These and many of the following regulations of the Royal Academy were not formally adopted until 1814 (Sidney C. Hutchison, 'The Royal Academy Schools, 1768–1830', *Walpole Society*, xxxviii [1962], 130), but they were probably already standard practice by the time they were codified. The probationary drawing and the dates of submission (Jan. and July) are taken from an article on the laws of the Royal Academy in the *Library of the Fine Arts*, iii (1832), 436. Mr. Hutchison tells me that none of the testimonials or the probationary or later qualifying drawings has survived in the Royal Academy.

Tho:̊ Goss [*14, painter*]———Peter Holland [*22, painter*]———Jos.

October Toomer [*19, painter*] John Wᵐ Edy [*19, painter*]———John Smyth
8th, Cranfield [*21, sculptor*]———Will:̇ᵐ Blake———J. Cappe————
1779 Order'd / That Admission Tickets be given to them

J Reynolds Pres.

F M. Newton, Sec

And in the book he was entered on that day as 'Blake William— [*age*] 21 Y ʳˢ [*on the*] 28ᵗʰ [*of*] last Novʳ. [*to study as an*] Eng[*rave*]ʳ'.[1] As a token of his admission, Blake was probably given an ivory ticket, which entitled him to draw in the galleries of the Royal Academy and to attend lectures and exhibitions for six years.[2]

Besides the regular schools of the Plaster and Living Models, there are four active Professorships in the Royal Academy, viz. of Painting, Anatomy, Architecture, and Perspective. The Professors are charged to deliver six lectures every year, in their respective provinces. In the . . . last they have been wholly omitted, and private tuition has been substituted . . . [*There is no*] provision in the Academy for instruction in Engraving[3]

As a later critic complained, the young artists were traditionally a high-spirited lot, 'playing at leap frog, knocking off the hand of Michalangiolo's beautiful Fawn, spouting water, breaking

[1] The Minute Book (vol. i, p. 274) and the register of 'Students admitted in the Royal Academy from MDCCLXIX' are both in the Royal Academy Library. According to the admission register, in 1779 the students were admitted in two groups, the first on March 25th, when Blake was still an apprentice. The choices of study were painting, sculpture, architecture, and engraving.

[2] *The Library of the Fine Arts*, iii (1832), 436. Hutchison says (op. cit.) that up to 1792 students were admitted for six years. The Living Academy, where students over twenty-one sketched from the nude model, began at 4 p.m. in summer and at 6 in winter. The terms were May 26–Aug. 31, Sept. 29 (Michaelmas)–April 9, with a holiday from Christmas Eve to Epiphany.

According to *The Library of the Fine Arts*, iii (1832), 443, 444, 437, students were required to present a drawing of a figure or a group, and another of a hand or foot, life-size, to be allowed to progress to the Living Academy. Lists of current students were annually laid before the Council of the Academy, with a report of the Keeper on their individual attendance, and students who neglected their opportunities were liable to expulsion. Mr. Hutchison tells me that the Keeper's reports have not survived. Apparently the only extant early student attendance records are those for the Plaister Academy, 1790–8, the Life Academy, 1790–9, and the Library, 1799–1807.

[3] P. Hoare, *An Inquiry into the Requisite Cultivation and Present State of the Arts ¹Design in England*, London, 1806, pp. 127–8 fn., 125 fn.

the fingers of the Apollo, pelting one another with modeller's clay and crusts of bread, roasting potatoes in the stove, teizing the Keeper by imitating cats . . .'.[1]

Blake also was capable of teasing the Keeper, though in his own way. Many years later he recalled indignantly:

I was once looking over the Prints from Rafael & Michael Angelo in the Library of the Royal Academy[.] Moser came to me & said[:] ['']You should not Study these old Hard Stiff & Dry Unfinishd Works of Art. Stay a little & I will shew you what you should Study[.''] He then went & took down Le Bruns & Rubens's Galleries[.] How I did secretly rage. I also spoke my Mind I said to Moser, ['']These things that you call Finishd are not Even Begun[;] how can they then, be Finishd? The Man who does not know The Beginning, never can know the End of Art[.'']²

At the same time as he was making his qualifying drawings at the Royal Academy, Blake was working on a picture described in the catalogue of *The Exhibition of the Royal Academy, M.DCC.LXXX, The Twelfth*, as entry no. '315 Death of Earl Goodwin *W. Blake*', and the meticulous index listed 'W. BLAKE, No. 28, the Corner of Broad-street, Carnaby-market'. *May 1780*

In *The Morning Chronicle and London Advertiser* for Saturday, May 27th, 1780 appeared the fourth and last section of a survey by Blake's friend, George Cumberland, of the Royal Academy Exhibition for that year, in which Cumberland wrote: 'On looking once again over the Exhibition there are a few more [*pictures*] which claim our attention: . . . [*Last is*] No. 315, the death of Earl Goodwin, by Mr. Blake; in which, though there is nothing to be said of the colouring, may be discovered a good design, and much character.'³ *May 27th, 1780*

During June of 1780 the Lord George Gordon no-Popery

¹ J. Elmes, *Annals of the Fine Arts*, ii (1818), 359. Linnell's MS. Autobiography, p. 19, gives a similar account.

² Quoted from Blake's marginalia to Reynolds's *Works* in the British Museum (vol. i, p. xlvii). The anecdote dates from Blake's student days, for Moser died in Jan. 1783.

³ These survey articles (May 4th, 20th, 22nd, 27th) are signed 'Candid', and in a letter to his brother of May 6th, 1780 (BM Add. MSS. 36492, ff. 338–41) George said he was enclosing two articles on the exhibition, signed 'Candid', in which he had taken care to praise three of his friends, including Shelly and Collins. Further evidence of Blake's early friendship with Cumberland may be found in the obituary of Flaxman under Jan. 1828.

rioters swept over London, burning and looting. On Wednesday, June 7th George Cumberland wrote that he stood

near the greatest part of Sunday night [*June 4th*] on a wall near the Romish Chapel in Moor fields witnessing scenes wh made my heart bleed, without being able to prevent them[.]——it was the most singular and unhappy sight in the world——the Mob encouraged by *Magistrates* and protected by *troops*——with the most *orderly injustice* destroying the property of inocent individuals——Next to L̤ᵈ Gordon, for whom no punishment can be too great [,] the magistrates of this City deserve an ample share of vengeance from a basely deserted people . . . grown bold by sufferance they yesterday burnt S̤ʳ G. Saville and a Chandlers who had taken one of them [*prisoner,*] besides 2s chools and many private Masses—— to day they burnt L̤ᵈ Peters Furniture Mr Hydes &c and armed with clubs to the amount as I am informed of 5000 are at this instant going to the D. of Richmonds Ld Shelburns &c [;] they have broke open Newgate and [*set*] the prisoners at large and at this moment it is in flames . . . the soldiers its said laid down their arms to day on being ordered to fire[1]

Blake's sentiments were probably similar, though his experiences were more direct and more terrifying.

June 6th, 1780 In this outburst of anarchy, Blake long remembered an involuntary participation of his own. On the third day, Tuesday, 6th of June, 'the Mass-houses' having already been demolished——one, in Blake's near neighbourhood, Warwick Street, Golden Square——and various private houses also; the rioters, flushed with gin and victory, were turning their attention to grander schemes of devastation. That evening, the artist happened to be walking in a route chosen by one of the mobs at large, whose course lay from Justice Hyde's house near Leicester Fields, for the destruction of which less than an hour had sufficed, through Long Acre, past the quiet house of Blake's old master, engraver Basire, in Great Queen Street, Lincoln's Inn Fields, and down Holborn, bound for Newgate. Suddenly, he encountered the advancing wave of triumphant Blackguardism, and was forced (for from such a great surging mob there is no disentanglement) to go along in the very front rank, and witness the storm and burning of the fortress-like prison, and release of its three hundred inmates.[2]

During his early manhood, Blake probably spent a good deal of time with a small group of active young artists, including

[1] BM. Add. MSS. 36492, ff. 350–1.
[2] Gilchrist, 1942, p. 30; 1863, p. 35.

PLATE III

SELF-PORTRAIT OF JOHN FLAXMAN, the sculptor, Blake's most loyal and
distinguished friend

John Flaxman,[1] a young sculptor supporting himself by designing for Wedgwood; George Cumberland, a painter and etcher who worked for an insurance company; and Thomas Stothard, a painter who already by 1780 was making an important name for himself as a prolific inventor of charming vignettes for the booksellers. Stothard, Cumberland, and their friends often went on sailing trips.[2] Some seventy years later Stothard's daughter-in-law described an expedition, which may have taken place about September 1780:[3]

Stothard would occasionally spend a few days with his friends in sailing up the Medway, landing and sketching as they pleased. In one of these he was accompanied by his old friend Mr. Ogleby,[4] *September?* and Blake, that amiable, eccentric and greatly gifted artist, who *1780?* produced so many works indicative of a high order of genius, and sometimes no less of an unsound mind. Whilst the trio were one day engaged with the pencil on the shore, they were suddenly surprised by the appearance of some soldiers, who very unceremoniously made them prisoners, under the suspicion of their being spies for the French government; as this country was then at war with France. In vain did they plead that they were only there sketching for their own amusement; it was insisted upon that they could be doing nothing less than surveying for purposes inimical to the safety of

[1] See Plate III.

[2] C. R. Leslie, *Autobiographical Recollections*, ed. T. Taylor, Boston, 1860, p. 88 (an undated account); letter from Stothard to Cumberland of about 1781 (BM Add. MSS. 36198, f. 88); Cumberland letter of Dec. 15th, 1783 (BM Add. MSS. 36494, ff. 214–15).

[3] The quotation below begins 'In the early times of which I am now speaking', and alludes to Stothard's student days at the Royal Academy. Stothard was admitted to the Royal Academy on Dec. 31, 1777, but Blake was not free of his apprenticeship for such expeditions until the summer of 1779, so the earliest likely date is 1779. The termination of the war with France gives 1783 as the latest possible year. The young men seem to enjoy bachelor freedom, and since Blake was married in Aug. 1782 and Stothard in 1783, the most probable years are 1780 and 1781; September, when the Academy was closed, seems the most likely month.

[4] With one of the two known prints from the engraving of this incident (now in the Rosenwald Collection) is the following puzzling note in an unknown nineteenth-century hand, which seems to identify the third man on the expedition as James Parker instead of Ogleby: 'This print is an etching of T. Blake's, from a memorandum designed by T. Stothard, of the tent he & Parkes [*i.e. Parker?*] were confined in, or took refuge in, when taken as Spies whilst sailing a Boat on the Coast of France.—This is M⸢r⸣ᵉ Blakes account of it[.]' This story is almost impossible to reconcile with the one told by Stothard's daughter-in-law, and only the mysterious last sentence makes it worth considering. The orthographic and diction difficulties of the anonymous account (T. Blake? memorandum?) make one place greater credence in the longer, more circumstantial, account by Mrs. Bray.

Old England. Their provisions were brought on shore, and a tent formed for them of their sails, suspended over the boat-hook and oars, placed as uprights in the ground. There were they detained, with a sentinel placed over them, until intelligence could be received from certain members of the Royal Academy, to whom they appealed, to certify they were really peaceable subjects of his Majesty King George, and not spies for France.

Stothard made a very spirited pen and ink drawing of this scene,[1] whilst under detention. On their liberation, they spent a merry hour with the commanding officer, to whom the artist remarked, that an opportunity had been given him for making a sketch he had not anticipated; whilst Ogleby declared that once being taken prisoner was enough for him; he would go out no more on such perilous expeditions.[2]

During these years Blake was probably spending much time *April* teaching his brother Robert and on Tuesday 'April 2ᵈ [*1782*] *2nd,* Blake Robert [*aged*] 14 Yʳˢ last 4ᵗʰ Augˢᵗ [*was admitted to* *1782* *the Royal Academy to study as an*] Eng[*rave*]ʳ'. This is the only record of the birthdate of Blake's favourite brother, but there seems to be no good reason to challenge its accuracy.[3]

As his *Poetical Sketches* testify, Blake was one who

> love[*d*] the jocund dance,
> The softly-breathing song,
> Where innocent eyes do glance,
> And where lisps the maiden's tongue.

His thoughts were not exclusively absorbed in the task-work of engraving or the inspiration of art.

These were days of Courtship, too. And the course of Blake's love did not open smoothly. 'A lively little girl' in his own, or perhaps a humbler station, the object of his first sighs readily allowed him, as

[1] Mrs. Bray reproduced the sketch and explained in a footnote that 'In the British Museum . . . Print Room, an etching from this drawing may be seen, called A Boating Excursion. The etching is there stated to be by Blake; but Alfred Stothard says it was by his father.'

Sir Geoffrey Keynes owns a print of a river scene with figures inscribed on the back 'By Blake (Mr Stothard)', which may mean that the information, the design, or the print itself came from Stothard. Sir Geoffrey also owns an etching by George Cumberland of a man sitting by a river bank, who, Sir Geoffrey thinks, may be Blake.

[2] Mrs. [A. E.] Bray, *Life of Thomas Stothard, R.A.*, London, 1851, pp. 20–21.

[3] For a discussion of the issues, see 1769–72. It is possible but unlikely that this Robert Blake is not related to the poet.

girls in a humbler class will, meaning neither marriage nor harm, to 'keep company' with her; to pay his court, take mutual walks, and be as lovesick as he chose; but nowise encouraged the idea of a wedding. In addition to the pangs of fruitless love, attacks of jealousy had stoically to be borne. When he complained that the favour of her company in a stroll had been extended to another admirer, 'Are you a fool?' was the brusque reply—with a scornful glance. 'That cured me of jealousy,' Blake used naïvely to relate.[1]

However, Blake soon found a wife under suitably romantic circumstances, as Tatham evidently reported to all Blake's biographers (see pp. 517–18). In the summer of 1782 he made out a formal Marriage Allegation as follows:

[Tuesday] 13.*th* *August 1782* August
13th,
1782

Faculty ⎱
Office ⎰

Appeared personally *William Blake* and made Oath, that he is of *the Parish of Battersea in the County of Surry a Batchelor upwards of twenty One Years of Age* and intendeth to marry with *Catharine Butcher of the same Parish a Spinster upwards of twenty One Years of Age* and that he knoweth of no lawful Impediment, by Reason of any Pre-contract, Consanguinity, Affinity, or any other lawful Means whatso-ever, to hinder the said intended Marriage and prayed a Licence to solemnize the same in *the Parish Church of Battersea aforesaid* and further made Oath that the usual Place of Abode of *him this Appearer* hath been in the said Parish of *Battersea* for the Space of four weeks last past

William Blake [in his own hand]

Sworn before me

And: Coltee Ducaret
Surrogate[2]

Blake was, of course, not normally a resident of the Parish of Battersea, but it is possible that he was staying with relatives. Gilchrist 'trace[d] relatives of Blake's father to have been then living' in Battersea,[3] and at least in the earlier part of the

[1] Gilchrist, 1942, pp. 31–32; 1863, p. 37. This may be an amplification of a reference by Tatham; see p. 517.
[2] The Allegation is in the Lambeth Palace Library. In this and the next forms, *italics* indicate the parts of the printed form which were filled in by hand.
[3] Gilchrist, 1942, p. 33; 1863, p. 39. Gilchrist does not hint as to how he knew the Battersea Blakes were related to James Blake.

century there were hosts of Blakes in the neighbourhood, some of them in fairly humble circumstances.[1]

Blake's Marriage Bond, made the same day as his allegation, reads:

Know all Men by these Presents, That We *William Blake of the Parish of Battersea in the County of Surry Gentleman and John Thomas* are holden and firmly bound to the most Reverend Father in God *Frederick* by Divine Providence, Lord Archbishop of CANTERBURY, Primate of all ENGLAND, and Metropolitan, in the Sum of Two Hundred Pounds of good and lawful Money of GREAT BRITAIN, to be paid to the said most Reverend Father, or his certain Attorney, Successors or Assigns: To which Payment well and truly to be made, we bind ourselves, and each of us by himself for the whole, our Heirs, Executors and Administrators, firmly by these Presents, Sealed *August* with our Seals, Dated the *thirteenth* Day of *August* in the *twenty* *13th,* *second* Year of the Reign of our Sovereign Lord *George the Third* by *1782* the Grace of God of Great Britain, France, and Ireland, King, Defender of the Faith, and in the Year of our Lord One Thousand Seven Hundred and Eighty *two*.

The Condition of this Obligation is such, that if hereafter there shall not appear any lawful Let or Impediment, by Reason of any Pre-Contract entered into before the Twenty-fifth Day of March, One Thousand Seven Hundred and Fifty-four, Consanguinity, Affinity, or any other lawful Means whatsoever, but that the above bounden *William Blake a Batchelor and Catharine Butcher a Spinster* may lawfully solemnize Marriage together, and in the same afterwards lawfully remain and continue for Man and Wife, according to

[1] (1) *Henry Blake* (wife not named) had five children who were christened in St. Mary's, Battersea: *Mary*, Nov. 6th, 1709; *Elizabeth*, Jan. 15th, 1711/12; *Henry*, Sept. 2nd, 1714; *Christopher*, Oct. 1st, 1717; and *Catherine*, Aug. 15th, 1719. *Henry Blake* (presumably Senior) was buried Dec. 16th, 1746. (2) *William Blake* (wife also anonymous) was even more prolific: his children were *Philip*, christened Oct. 15th, 1711; *Henry*, July 13th, 1713; *John*, Feb. 11th, 1714/15; *Rebecca*, May 3rd, 1716; *Jane*, Sept. 22nd, 1717; *Joseph*, July 11th, 1719; and *William*, April 4th, 1721. (3) To *Thomas and Elizabeth Blake* were born: *Thomas*, christened Dec. 31st, 1731; *John*, Sept. 15th, 1734; *Samuel*, Feb. 2nd, 1742/3 (buried Jan. 23rd, 1750/51); and *Elizabeth*, who was born in the workhouse April 8th, 1751, christened Dec. 25th, 1752, died in the workhouse, and was buried Oct. 8th, 1758. Other miscellaneous Blakes found in the church records are: (4) *Caesar*, son of *Francis*, christened March 26th, 1712; (5) *Thomas Blake and Sarah* Phillips, married Jan. 12th, 1722/3, and their son *Thomas*, christened Dec. 16th, 1744; and (6) *Elizabeth* (buried July 8th, 1740), (7) *Daniel* (Nov. 13th, 1741), (8) *Thomas*, a child (Sept. 24th, 1744), (9) *Mary*, aged 83, a widow (April 29th, 1770), and *Mary*, a child (Feb. 7th, 1770).

the Laws in that Behalf provided: And moreover if there be not at this present Time any Action, Suit, Plaint, Quarrel, or Demand moved or depending before any Judge Ecclesiastical or Temporal, for or concerning any such lawful Impediment between the said Parties: Nor that either of them be of any other Parish, or of better Estate or Degree than to the Judge at granting of the Licence is suggested, and by *him* sworn to [*here a blank in the form for other conditions is left empty:*] And lastly, if the said Marriage shall be openly solemnized in the Church or Chapel in the Licence specified between the Hours appointed in Constitutions Ecclesiastical, confirmed and according to the Form of the Book of Common-Prayer, now by law established, and if the above bounden *William Blake* do save harmless the above-mentioned Most Reverend Father, his Commissary of the Faculties, his Surrogates and all other his Officers whatsoever, by Reason of the Premises; then this Obligation to be void or else to remain in full Force and Virtue.

<div align="right">William Blake [in his own hand]</div>

Sealed and delivered in the Presence of
<div align="center">John Rodd[1]</div>

John Thomas was presumably a bondsman and perhaps a family friend. I do not know why Blake should have described himself as a 'Gentleman', a title ordinarily reserved for men of leisure or members of the legal profession, unless it were because his grandfather had also been of 'the County of Surrey Gentleman' (see July 14th, 1737).

The marriage took place in the recently rebuilt church of St. Mary, Battersea, and was recorded in the church register as:

N° 281 *William Blake* of *the* Parish *of* Battersea Batchelor and *Catherine Butcher* of *the same* Parish *Spinster* were Married in this *Church* by *License* this *Eighteenth* Day of *August* in the Year One Thousand Seven Hundred and *Eighty two* by me *J Gardnor Vicar* *August 18th, 1782*

This Marriage was
solemnized between Us

In the Presence of *Thomas Monger*[2]
<div align="center">Jas Blake
Rob. Munday Parish Clerk[3]</div>

<div align="right">William Blake
The Mark of
x Catherine
Butcher</div>

[1] The Marriage Bond is in the Lambeth Palace Library, endorsed on the back '13.ᵗʰ Aug.ᵗ 1782 Blake & Butcher', and with a 2s. 6d. seal affixed. John Rodd was presumably a clerk, though I found no other signatures of his on adjacent marriage bonds.

[2] No other connexion of a Monger with the Blakes or Bouchers is known, but

[*Footnotes 2 and 3 continued overleaf*

Signing with an X, as Catherine Boucher did here, was by no means uncommon at the time, particularly among women, and did not necessarily denote illiteracy. Of the thirty-four people married in the church in 1782, fourteen signed only with a mark. For some of these fourteen, writing was perhaps a difficult and precarious skill which it was thought best not to attempt in moments of emotional stress.

It is impossible to be certain whether the third witness was William's father or brother. The father is unreliably reported to have opposed the marriage,[1] and therefore may not have attended. On the other hand, if this James Blake is the bridegroom's brother, we might have expected him to sign with a 'Jun.' John Flaxman, who was also named after his father, scrupulously signed his name 'Jun' while his father was alive. The chances are that the witness 'James Blake' was the poet's father.

When they were married, Catherine was a blooming, vivacious girl, but over the years the drudgery of poverty took its toll of her: 'A "brunette" and "very pretty" are terms I have picked up as conveying something regarding her appearance in more youthful days. Blake himself would boast what a pretty wife he had. She lost her beauty as the seasons sped,—"never saw a woman so much altered" was the impression of one on meeting her again after a lapse of but seven years; a life of hard work and privation having told heavily upon her in the interim.'[2]

June 18th, [1783] John Flaxman, who was becoming more and more involved in finding patrons for Blake, wrote to his wife Nancy on Wednesday June 18th, 1783 about a young man their own age: 'M.ʳ Hawkins paid me a visit & at my desire has employed Blake to make him a capital drawing for whose advantage in consideration of his great talents he seems desirous to employ his utmost interest[.]'[3]

there is evidence (P. Miner, *Bulletin of the New York Public Library*, lxii [1958], 539, 548) that Thomas was born in Aug. 1749, that he had a daughter in June 1777, and that he paid the rates for a fairly substantial property (£32).

[3] The marriage register is still in St. Mary's, Battersea. The parish clerk witnessed all marriages as a matter of course in St. Mary's.

[1] Cunningham, p. 482, Gilchrist, 1942, p. 37; 1863, p. 43; these two somewhat remote authorities are suspiciously unsupported by the far more trustworthy J. T. Smith or Tatham.

[2] Gilchrist, 1942, pp. 98–99; 1863, p. 118. Flaxman, who was in Italy from 1787 to 1794, may have reported this 'impression' to Maria Denman, another of Gilchrist's informants.

[3] BM Add. MSS. 39780, f. 29. Flaxman omitted the year from his date, but a

PLATE IV

SKETCH BY JOHN FLAXMAN OF ANTHONY STEPHEN MATHEW,
the sponsor of Blake's *Poetical Sketches* (1783) (see pp. 25–27)

Nancy replied: "I rejoice for Blake".[1] Unhappily Blake's [*June 20th, 1783*] "capital drawing" for Hawkins can be neither traced nor identified today.

Flaxman had been employing his persuasive talents to assist Blake in other ways as well. Between 1771 and 1777, chiefly while he was an apprentice to Basire, Blake had been writing poetry. These poems he read or sang to his friends, who were sufficiently impressed to have them printed for Blake. Chiefly responsible for this printing were John Flaxman and a patroness of his, Mrs. Harriet Mathew, the wife of the Revd. A. S. Mathew.[2] Eleven quarto sheets were printed with a reticent title-page reading: "Poetical Sketches. By W. B. London: Printed in the Year M DCC LXXXIII." The only explanatory matter was a brief and rather deprecatory "Advertisement", apparently by the Revd. A. S. Mathew:

The following sketches were the production of untutored youth, commenced in his twelfth, and occasionally resumed by the author *1783* till his twentieth year; since which time, his talents having been wholly directed to the attainment of excellence in his profession, he has been deprived of the leisure requisite to such a revisal of these sheets, as might have rendered them less unfit to meet the public eye.

Conscious of the irregularities and defects to be found in almost every page, his friends have still believed that they possessed a poetic originality, which merited some respite from oblivion. These their opinions remain, however, to be now reproved or confirmed by a less partial public.

Blake's patrons gave him the sheets of his *Poetical Sketches*, uncut and unsewn, apparently in the expectation that he would make some effort to sell them to a bookseller, or at least to

contemporary hand has added the year in pencil to this and many others of these letters, particularly those from Nancy. The Flaxmans, who were married June 3rd, 1782 (as Nancy said in a letter, BM. Add MSS. 39780, f. 304), were surely not separated within two weeks, so that the most likely year, 1783, agrees with the pencilled additions. John Hawkins (1758?–1841) was an antiquary and dilettante who built up 'a valuable collection of pictures by the Dutch, Flemish and English masters', centring on Potter, Ruysdael, Teniers, Canaletto, Gainsborough, Lely, and Hogarth (James Dallaway, *The Parochial Topography of the Rape of Arundel, in the Western Division of the County of Sussex*, ed. E. Cartwright, London, 1832, p. 249, which is vol. ii, part i of Dallaway's *History of the Western Division of the County of Sussex*).

[1] BM Add. MSS 39780, f. 157. The letter is undated, but it clearly replies to the foregoing, as Nancy was 'charm'd with your noble account of Miss Younge' which John had sent in the letter of June 18th. The pencil date is June 20th, 1783.

[2] See J. T. Smith, p. 456, and Plates IV, V.

disperse them as widely as he could. Blake, however, never seems to have shown much interest in the little volume.

For several years Blake, with his friend Flaxman, had been attending the literary evenings of Mrs. Mathew, and many years later John Thomas Smith wrote:

> This year [*1784*] Mr. Flaxman, who then lived in Wardour Street, introduced me to one of his early patrons, the Rev. Henry Mathew, of Percy Chapel, Charlotte Street, which was built for him; he was also afternoon preacher at Saint-Martin's-in-the-Fields. At that gentleman's house, in Rathbone Place, I became acquainted with Mrs. Mathew and her son.* At that lady's most agreeable convers-aziones I first met William Blake, the artist, to whom she and Mr. Flaxman had been truly kind.[2] There I have often heard him read and sing several of his poems. He was listened to by the company with profound silence, and allowed by most of the visitors to possess original and extraordinary merit.†
>
> Mrs. Mathew was not only a great encourager of musical com-posers, particularly the Italians, but truly kind to young artists. She patronised Oram, Loutherbourg's assistant. . . .
>
> Mr. Flaxman, in return for the favours he had received from the Mathew family, decorated the back parlour of their house, which was their library, with models, (I think they were in putty and sand,) of figures in niches, in the Gothic manner; and Oram painted the window in imitation of stained-glass; the bookcases, tables, and

1784

* The late John Hunter's favourite pupil. With that gentleman in his youthful days I had many an innocent frolic. I was obliged to him in several instances, and can safely say no one could excel him as an amiable friend, a dutiful son, or excellent husband. [*Smith's note.*][1]

† A time will come when the numerous, though now very rare works of Blake, (in consequence of his taking very few impressions from the plates before they were rubbed out to enable him to use them for other subjects,) will be sought after with the most intense avidity. He was considered by Stothard and Flaxman (and will be by those of congenial minds, if we can reasonably expect such again,) with the highest admiration. These artists allowed him their utmost unqualified praise, and were ever anxious to recommend him and his productions to the patrons of the Arts; but, alas! they were not so sufficiently appreciated as to en-able Blake, as every one could wish, to provide an independence for his surviving partner Kate, who adored his memory. [*Smith's note.*]

[1] For evidence that W. H. Mathew may not always have been 'an amiable friend' or 'John Hunter's favourite pupil', and that in fact he may have caused Hunter's death, see 'A. S. Mathew, Patron of Blake and Flaxman', *N & Q*, cciii (1958), 168–78. 'Henry Mathew' is a mistake for 'A. S. Mathew'.

[2] This statement probably refers to their sponsorship of Blake's *Poetical Sketches*.

PLATE V

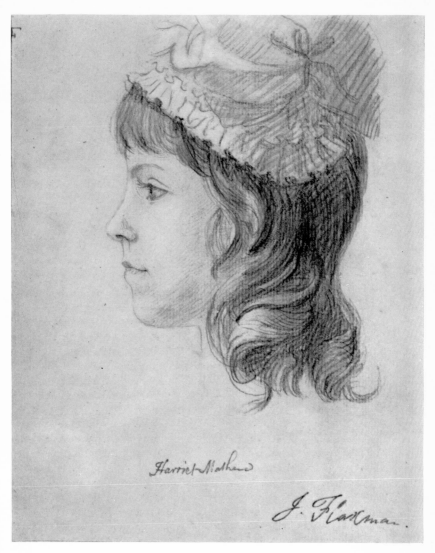

Harriet Mathew

J. Flaxman.

SKETCH BY JOHN FLAXMAN OF HARRIET MATHEW, the blue-stocking wife of Blake's patron, and sponsor of 'agreeable conversaziones' at which Blake sometimes sang his poems (see p. 26)

chairs, were also ornamented to accord with the appearance of those of antiquity.[1]

Other evidence of the patronage of Blake may be found in a letter which John Flaxman wrote to his new friend, the very popular poet William Hayley,[2] on Monday, April 26th, 1784.[3]

Sir

I return many thanks for the present of your last publication & I have the pleasure to inform you (exclusive of the satisfaction I felt in perusing such genuine & new productions of genius) I have conversed with many persons of considerable abilities, who with one consent praise the Noble purity & Pathos of the Tragedies, & the novelty, Wit, & originality of the Comedies— I have particularly met with one Gentleman whose admiration of yourself & productions is absolute Enthusiasm, D⸢r⸣ James Fordyce, whose delight was so great in reading your Poetical Epistle &c that he could not forbear, immediately sending an Anonymous congratulatory Letter to you— I have left a *Pamphlet of Poems* with M⸢r⸣ Long[4] which he will transmit to Eartham;[5] they are the writings of a M⸢R⸣ BLAKE you have heard me mention, his education will plead sufficient excuse to your Liberal mind for the defects of his work & there are few so able to distinguish & set a right value on the beauties as yourself, I have beforementioned that M⸢r⸣ Romney thinks his historical drawings rank with those of M⸢r⸣ Angelo; he is at present employed as an engraver, in which his encouragement is not extraordinary—M⸢r⸣ Hawkins a Cornish

April 26th [1784]

[1] J. T. Smith, *A Book for a Rainy Day*, London, 1845, pp. 81–83.

[2] In his autobiography (*Memoirs of the Life and Writings of William Hayley, Esq.*, ed. J. Johnson, London, 1823, vol. i, pp. 319–20), Hayley erroneously dates his friendship with Flaxman from May 1784, but in a letter dated Oct. 20th, 1783 (Morgan Library) Flaxman expresses his gratitude to Romney for having introduced him to Hayley.

[3] There is no year in the date of the letter, the paper is not watermarked except for chain lines, and the postmark is merely 'Ap 28', but the letter almost certainly belongs to 1784. It does not belong to 1783 (1) because Flaxman evidently did not know Hayley in the spring of 1783, and (2) because the letter says that Hawkins was leaving England on May 10th, and on June 18th, 1783 Flaxman told his wife that Hawkins had just 'paid me a visit'. The 'last publication' mentioned in the April 26th letter is clearly Hayley's *Plays of Three Acts*, which was entered at Stationers' Hall on March 17th, 1784. The 'Poetical Epistle' which Dr. Fordyce admired is evidently the rhymed dedication to the 'Dutchess of Devonshire'.

[4] Long himself was also given a copy, for his volume, inscribed 'To M⸢r⸣ Long from J Flaxman' is in the collection of Mr. H. Bradley Martin.

[5] Hayley's copy, now in the Huntington Library, is inscribed 'To William Hale[*y*] from John [*Flaxman*]'. It did not appear in the catalogue of Hayley's library, which was auctioned by Evans 13–27 Feb. 1821. Hayley probably gave it promptly to the Duchess of Devonshire, whose husband had it bound with his crest.

Gentleman has shewn his taste & liberality in ordering Blake to make several drawings for him, & is so convinced of his uncommon talents that he is now endeavouring to raise a subscription to send him to finish [*his*] studies in Rome [;] if this can be done at all it will he determined on before the 10th of May next at which time Mr Hawkins is going out of England—his generosity is such he would bear the whole charge of Blakes travels—but he is only a younger brother, & can therefore only bear a large proportion of the expence [.] with best & most respectful wishes to Mrs Haley & yourself

	I have the honor to be
April 26th	Sir
Wardour Street	Your much Obliged servant
Soho	J Flaxman[1]

The '*Pamphlet of Poems*' which Flaxman enclosed was *Poetical Sketches*, but the subscription never materialized, and Blake never left England.

May 1784 At the Exhibition of the Royal Academy which opened in May 1784 were two drawings catalogued as '400 A breach in a city, the morning after a battle *W. Blake*' and '427 War unchained by an angel, Fire, Pestilence, and Famine following *W. Blake*'.[2]

May 15th, 1784 The Flaxmans seem to have been very busy spreading Blake's poetic reputation in the spring of 1784. One copy of the *Poetical Sketches* was inscribed '[present *del*] from Mrs Flaxman May 15, 1784', and was made the more valuable by Blake's transcription of three pastoral 'Songs' that have not survived in this form elsewhere.[3]

July 4th, 1784 In July Blake's father died, and on Sunday the 4th he was buried in Bunhill Fields, according to the Bunhill Fields Burial Register: 'Mr James Blake [*was brought from*] Soho Square [*and buried*] in a Grave [*i.e., not in a vault*]' for a standard fee of 13s. 6d.[4]

At his father's death, Blake probably inherited a modest sum

[1] Quoted from the MS. in the Pierpont Morgan Library.

[2] *The Exhibition of the Royal Academy, M.DCC.LXXXIV.* The Sixteenth, London [1784]. '*W. Blake*, No. 23, Green-street, Leicester-fields—400 427' appears in the index.

[3] Quoted from a microfilm of the original in the Turnbull Library, Wellington, New Zealand.

[4] The burial register is in Somerset House, London. James Blake was probably buried from his brother John's house in Hog Lane; see Residences, pp. 556-7.

of money, perhaps as much as £100.[1] If so, one of the first ways to invest it that may have occurred to him was to put it into a shop to sell prints, since 'Printsellers are very often Engravers', and since to set up in business 'will require from 100 to 1000 l. according to the figure he would make in trade'.[2] Whatever their immediate motives and resources, not long after James Blake's death Basire's old apprentices James Parker and William Blake formed a print-selling business between them. Some time during 1784 the Blakes moved with their old friend Parker and his wife into the house beside Blake's birthplace in Broad Street.

As his share of the investment Blake may have bought a copperplate press so that the firm could print off the plates they engraved or commissioned.[3] This was a rather unusual step, for 'very few of the Engravers keep Copper-plate presses in their houses',[4] but only about £50 was necessary to set up in business as a copperplate printer, including £40 for Blake's press itself,[5] and the printing business could bring in a very satisfactory income, as Catherine Blake found in 1802.

Blake engraved the only two plates that are known to have been published by the partners (December 17th, 1784), but the chief business was probably selling prints by others, both new and second-hand. It is a good guess that 'Mrs Blake helped in the shop; the poet busied himself with his graver and pencil still'.[6] The business was not a marked success, at a period when, as Blake said (July 2nd, 1800), 'a Print shop was a rare bird in London', and Blake may have had more leisure than he relished. He was teaching his youngest brother at the time, a task which he must have found above all others delightful, and it is even possible that Robert lived with the Blakes.[7] Their domestic

[1] Since no will was filed in the Prerogative Court of Canterbury in James Blake's name, this is pure speculation, justified only by the apparent affluence of William Blake which it explains.

[2] J. Collyer, *The Parent's and Guardian's Directory*, London, 1761, pp. 231, 232.

[3] Blake certainly owned a press by 1800, for on Nov. 26th of that year he wrote of Catherine's printing 'Little Tom the Sailor'; see also June 10th, 1802. It seems very likely that Blake would have acquired the press at the time of his print-selling business. When the business broke up, Blake probably kept the press, while Parker kept the stock of prints and the shop. [4] J. Collyer, op. cit., p. 117.

[5] J. Collyer, op. cit., p. 118, and Linnell's note to J. T. Smith on p. 463 n. 1.

[6] Gilchrist (1942, p. 48; 1863, p. 56) gives no source.

[7] Gilchrist says (1942, p. 50; 1863, p. 58): 'With Blake and his wife, at the print-shop in Broad Street, Robert for two happy years and a half lived in seldom disturbed accord.' The two and a half years is almost certainly wrong (see Residences,

happiness was, however, occasionally disrupted by violent opinions on all sides.

One day, a dispute arose between Robert and Mrs. Blake. She, in the heat of discussion, used words to him, his brother (though a husband too) thought unwarrantable. A silent witness thus far, he could now bear it no longer, but with characteristic impetuosity—

1784–5 when stirred—rose and said to her: 'Kneel down and beg Robert's pardon directly, or you never see my face again!' A heavy threat, uttered in tones which, from Blake, unmistakably showed it was *meant*. She, poor thing! 'thought it very hard,' as she would afterwards tell, to beg her brother-in-law's pardon when she was not in fault! But being a duteous, devoted wife, though by nature nowise tame or dull of spirit, she *did* kneel down and meekly murmur: '*Robert, I beg your pardon, I am in the wrong.*' 'Young woman, you lie!' abruptly retorted he: '*I* am in the wrong!'[1]

Though Blake continued to publish some of his own plates all his life, the partnership with Parker was short-lived, even with help from Mrs. Mathew,[2] and by Christmas 1785 the Blakes had moved to Poland Street, leaving the Parkers at 27 Broad Street.[3] (See Plate II.)

In the Royal Academy exhibition which opened on April 27th, 1785 '*W. Blake*' exhibited four drawings: '449 Joseph making himself known to his brethren'; '455 Joseph's brethren bowing before him'; '462 Joseph ordering Simeon to be bound';

April 28th, 1785 and '607 The Bard, from Gray'. The next day, on Thursday the 28th, an anonymous critic in the *Morning Chronicle and Daily Advertiser* mentioned 'Blake 'in a selective list of artists who had contributed drawings.[4]

It may have been on some such occasion as the great dinner which inaugurated the Royal Academy exhibition of 1785 that

pp. 557–9), and it seems a little unlikely that Robert should have *lived* with William, Catherine, and the two Parkers, when his birthplace next door was housing only his brother James, his mother Catherine, and his sister Catherine.

[1] Gilchrist, 1942, pp. 50–51; 1863, pp. 58–59. This story was almost certainly told to Gilchrist by Tatham.

[2] See J. T. Smith, p. 457 n. 2.

[3] See Residences, p. 558.

[4] In the index of *The Exhibition of the Royal Academy*, M.DCC.LXXXV, the Seventeenth, is '*W. Blake*, No. 27, Broad-street, Golden-square—449, 455, 462, 607'. The untitled article in the *Morning Chronicle* was not by 'Candid', the usual reviewer of the R.A. exhibitions, because George Cumberland was on the Continent at the time.

Blake had a conversation with the Academy's perennial President:

Blake used to tell of an interview he had once had with Reynolds, in which our neglected enthusiast found the originator of a sect in art to which his own was so hostile, very pleasant personally, as most found him. 'Well, Mr Blake,' blandly remarked the president, who, doubtless, had heard strange accounts of his interlocutor's sayings and doings, 'I hear you despise our art of oil painting.' 'No, Sir Joshua, I don't despise it; but I like fresco better.'[1]

Other meetings with Reynolds, however, were not so amicable:

'Once I remember his talking to me of Reynolds,' writes a surviving friend: 'he became furious at what the latter had dared to say of his early works. When a very young man he had called on Reynolds to show him some designs, and had been recommended to work with less extravagance and more simplicity, and to correct his drawing. This Blake seemed to regard as an affront never to be forgotten. He was very indignant when he spoke of it.'[2]

It may have been about 1786 that Blake showed, on one occasion, the impulsive fearlessness of which he was capable.

Seeing once, somewhere about St. Giles's, a wife knocked about by some husband or other violent person, in the open street, a bystander saw this also—that a small swift figure coming up in full swing of passion fell with such counter violence of reckless and raging *1786?* rebuke upon the poor ruffian, that he recoiled and collapsed, with ineffectual cudgel; persuaded, as the bystander was told on calling afterwards, that the very devil himself had flown upon him in defence of the woman; such Tartarean overflow of execration and objurgation had issued from the mouth of her champion. It was the fluent tongue of Blake which had proved too strong for this fellow's arm[3]

In the winter of his nineteenth year Robert Blake became fatally ill.

Blake affectionately tended him in his illness, and during the last fortnight of it watched continuously day and night by his bedside,

[1] Gilchrist, 1942, pp. 82–83; 1863, p. 96.

[2] Gilchrist, 1942, p. 275; 1863, p. 267. This story probably dates from Blake's first years as a student at the Royal Academy, when, in a sense, all the Academicians were his masters.

[3] A. C. Swinburne, *William Blake*, London, 1868, p. 79. I cannot guess the identity of the bystander or the source of the story, and the best I can do for a date is to associate St. Giles with Blake's residences in the neighbourhood up to 1790.

without sleep. When all claim had ceased with that brother's last breath, his own exhaustion showed itself in an unbroken sleep of three days' and nights' duration. The mean room of sickness had *February 1787* been to the spiritual man, as to him most scenes were, a place of vision and of revelation; for Heaven lay about him still, in manhood, as in infancy it 'lies about us' all. At the last solemn moment, the visionary eyes beheld the released spirit ascend heavenward through the matter-of-fact ceiling, 'clapping its hands for joy'—a truly Blake-like detail. No wonder he could paint such scenes! With him they were work'y-day experiences.[1]

Because of his exhausted sleep of 'three days and nights', Blake was probably not present at the funeral on Sunday *February* February 11th, 1787, when 'Mᵣ Robert Blake [*was brought*] *11th, 1787* from Golden Square [*and buried in Bunhill Fields*] in a Grave'.

In the 1780s there was much interest in stereotype printing in France and Britain, with inventions in 1784 and 1785 by Franz Ignaz Joseph Hoffmann, Alexander Tilloch, and George Cumberland. Blake probably learned something of these experiments from his friend Cumberland, but there is a tradition that Blake's own process of relief etching and printing was revealed to him in a vision from his brother.

After intently thinking by day and dreaming by night, during long weeks and months, of his cherished object, the image of the *1787?* vanished pupil and brother at last blended with it. In a vision of the night, the form of Robert stood before him, and revealed the wished-for secret, directing him to the technical mode by which could be produced a fac-simile of song and design.[2] On his rising in the morning, Mrs. Blake went out with half a crown, all the money they had in the world,[3] and of that laid out *1s. 10d.* on the simple materials necessary for setting in practice the new revelation. Upon that investment of *1s. 10d.* he started what was to prove a principal

[1] Gilchrist, 1942, p. 51; 1863, p. 59. This story, apparently with verbal elaboration, came from Linnell; see p. 459 n. 2.

[2] The technical mode of Blake's process was not ordinary etching, like Cumberland's process, but relief etching. Edwin Wolf 2nd points out to me that this process is described in the first chapter of *Valuable Secrets concerning Arts and Trades* ([1758], 1775, 1778, 1795, 1798, 1809, 1810) which gives highly detailed directions about how '*To engrave with* aquafortis, *so that the work may appear like a* basso relievo'. Blake's chief addition to this part of the process seems to have been the invention of an 'ink' impervious to acid with which he wrote on the copper. The vision could have occurred before Robert's death in 1787.

[3] Tatham says (p. 525) that Catherine always secretly kept a guinea by her. The process was probably not significantly cheaper than ordinary commercial printing.

means of support through his future life,[1]—the series of poems and writings illustrated by coloured plates[2]

There were other visions which supplied other parts of his art.

He ground and mixed his water-colours himself on a piece of statuary marble, after a method of his own, with common carpenter's glue diluted, which he had found out, as the early Italians had done before him, to be a good binder. Joseph, the sacred carpenter, had appeared in vision and revealed *that* secret to him. The colours he used were few and simple: indigo, cobalt, gamboge, vermilion, Frankfort-black freely, ultramarine rarely, chrome not at all. These he applied with a camel's-hair brush, not with a sable, which he disliked. . . . the poet and his wife did everything in making the book, —writing, designing, printing, engraving,—everything except manufacturing the paper: the very ink, or colour rather, they did make.[3]

Another invention of this time or a few years later was his process for printing pictures in oil. Tatham told Gilchrist that

Blake, when he wanted to make his prints in oil . . . took a common thick millboard, and drew in some strong ink or colour his design upon it strong and thick. He then painted upon that in such oil colours and in such a state of fusion that they would blur well. He painted roughly and quickly, so that no colour would have time to dry. He then took a print of that on paper, and this impression he coloured up in water-colours, re-painting his outline on the mill-board when he wanted to take another print. This plan he had recourse to, because he could vary slightly each impression; and each having

[1] I very much doubt that the Illuminated Works were ever 'a principal means of support'. If he sold three hundred copies in his lifetime (122 more than have survived) for about £2 apiece (in 1793 the average price of seven works offered was 5s. 11d.), he earned £600 with them, not counting expenses—perhaps six years' income for thirty-eight years' work.

[2] Gilchrist, 1942, pp. 59–60; 1863, p. 69.

[3] Gilchrist, 1942, pp. 60, 61; 1863, pp. 69–70. Linnell (Ivimy MSS.) reported that Blake was pleased to find his process described in Ceninni's *Trattato* (1821). He also told Gilchrist (1942, p. 359; 1863, pp. 368–9) that Blake 'evidently founded his claim to the name *fresco* on the material he used, which was water-colour on a plaster ground (literally glue and whiting); but he always called it either fresco, gesso, or plaster. And he certainly laid this ground on too much like plaster on a wall. When so laid on to canvas or linen, it was sure to crack and, in some cases, for want of care and protection from damp, would go to ruin. Some of his pictures in this material on board have been preserved in good condition, and so have a few even on cloth. They come nearer to *tempera* in process than to anything else, inasmuch as white was laid on and mixed with the colours which were tempered with common carpenter's glue.' See also J. T. Smith, p. 472.

a sort of accidental look, he could branch out so as to make each one different. The accidental look they had was very enticing.[1]

The first known printed reference to *Poetical Sketches* appeared in John Egerton's dramatic chronicle in 1788: 'W. BLAKE. "King Edward the Third." Drama. 8vo. 1783. Printed in a Pamphlet, called, "Poetical Sketches." '[2] It set something of a fashion, for not only are the bulk of the contemporary references to *Poetical Sketches* concerned exclusively with its unfinished dramas, but the Duke of Devonshire bound his copy (now in the Huntington Library) with other works with a label 'PLAYS VOL. 30' and a MS Table of Contents beginning: '1783. [*Blake*] K. Edward 3. [*Steele*] School of Action[, *Blake*] Prologue to Edward 4[, *Blake*] Prologue to King John[, *Addison*] The Gentleman'

By the winter of 1788–9 Blake had become deeply interested in the New Jerusalem Church promised by Emanuel Swedenborg. He had bought copies of Swedenborg's *Heaven and Hell*

[1] Gilchrist, 1942, p. 366; 1863, p. 376. Most of the colour prints are from about 1795, but the process may have been invented earlier. Elsewhere (*Rossetti Papers 1862 to 1870*, ed. W. M. Rossetti, London, 1903, p. 16) Tatham wrote that the colour prints 'were printed in a loose press from an outline sketched on pasteboard; the oil colour was blotted on, which gave the sort of impression you will get by taking the impression of anything *wet*.' Linnell, however, protested that 'Tatham's account of the oil-printing process is inaccurate' (*Anne Gilchrist: Her Life and Writings*, ed. H. H. Gilchrist, London, 1887, pp. 134–5). Anne Gilchrist wrote (*Rossetti Papers 1862 to 1870*, p. 21): 'Tatham always uses the word "millboard," and says he has some of them, or had, still by him. I am afraid we must give up all hope of getting at the rights of the oil-printing process. Linnell would hardly speak so positively of the inaccuracy of Tatham's account (as he does not know *who* wrote it) unless he had good grounds for doing so; but he says it would "take too much time to set it right." I believe the honest truth to be he does not himself thoroughly understand it, but knows, as an artist, Tatham's process to be an impossible one.'

[2] [J. Egerton] *The Theatrical Remembrancer*, containing a Complete List of All the Dramatic Performances in the English Language, London, 1788, p. 258. This information was combined with the next entry in Egerton's *Remembrancer* (John Murdock's *Double Disguise*, 12mo, 1783) and reprinted in [J.] *Barker's Continuation of Egerton's Theatrical Remembrancer* . . . arranged &c. by Walley Chamberlain Oulton (1801) and *Barker's Complete List of Plays* (1803) as '[*King*] Edward III. D[*rama*]. 12mo. 1783. *Murdock*'; it was corrected in *The Drama Recorded*; or, Barker's List of Plays, London, 1814, p. 48: '— [*Edward III.*] Dr[*ama*]. Poet. Sk[*etch, an abbreviation for an unfinished play, not the title of the book*].—1783 Blake'. It was copied under Blake ('— [W. . . .] King Edward the third. Drama. 1783') in Jer. Dav. Reuss, *Alphabetical Register of All the Authors actually living in Great-Britain, Ireland and in the United Provinces of North-America*, with a Catalogue of their Publications From the Year 1770 to the Year 1790, Berlin and Stettin, 1791, p. 40. No Blakes at all are mentioned in the 1804 edition of Reuss. See also p. 245.

(1784) and *Divine Love and Divine Wisdom* (1788), and as a consequence he probably received 'a general Invitation by Circular Letters, [*which was sent on December 7th, 1788*] to all the Readers of the Theological Works of the Hon. *Emanuel Swedenborg*, who are desirous of rejecting, and separating themselves from the Old Church, or the present established Churches, together with all their Sectaries, through Christendom, and of fully embracing the Heavenly Doctrines of the New Jerusalem'.[1]

At the first session of the general conference of the New Church on April 13th, 1789 sixty or seventy readers of Swedenborg's writings met at a public house, and the first thing they did, as a prerequisite to attendance, was to sign the following paper: 'We whose Names are hereunto subscribed, do each of us approve of the Theological Writings of Emanuel Swedenborg, believing that the Doctrines contained therein are genuine Truths, revealed from Heaven, and that the New Jerusalem Church ought to be established, distinct and separate from the Old Church.' Among the signatures to this manifesto were those of 'W. Blake' and his wife 'C. Blake'.[2]

April 13th, 1789

The first meeting, unlike those that followed it, was conducted with great authority and efficiency, not to say highhandedness. A total of thirty-two resolutions were adopted unanimously. These resolutions, which Catherine and William Blake must have supported, may be summarized as follows:

1. Swedenborg had a Divine Revelation.

[1] *Minutes of a General Conference of the Members of the New Church Signified by the New Jerusalem in the Revelation* [April 13–17, 1789], London, 1789, p. 1. Apparently invitations went to those on the subscription lists of Robert Hindmarsh, who printed both Swedenborg's works and the pamphlet above, but a determined search has located no such list, nor do various Swedenborgian societies seem to know anything about it.

Five hundred copies of the circular letter were sent out, at a cost of three guineas, but it seems to have lured in only some twenty new prospects. In the manuscript minutes of the meeting cited below, there are only twenty names in the list of 'Persons who subscribed [*to the conditions of admission*], besides yᵉ 77. who signed yᵉ circular letter—'.

[2] The signatures and document are copied in the 'Minute Book of the Society for Promoting the Heavenly Doctrines of the New Jerusalem Church. Eastcheap. London. 7. May 1787. to 7. Nov. 1791', which is preserved at the New Church College, Woodford Green, Essex. The volume itself is a fat brown book in an eighteenth-century binding and written in an eighteenth-century hand, but it is clearly a copy of the original, for it unaccountably skips from May 4th, 1789 to April 11th, 1790, though no pages are missing.

2. These revealed 'Doctrines he was enabled by the Lord alone to draw from the Holy Word'.

3. Propositions 1 and 2 in the circular letter are consistent with the Bible and are true. [There were forty-two propositions attached to the circular letter, the first two of which were that Jehovah God, creator of Heaven and Earth, is the Trinity, and that he 'came down himself to remove Hell from Man'.]

4. The Old Church, which means *all* other churches, is dead.

5. The Old Church believes in three gods; that is, it believes that nature is God, or that there is no god.

6. The Old Church faith should be abolished.

7. While the Old Church lasts, Heaven cannot come to man.

8. Any worship not addressed to the Divine Humanity, Jesus Christ, is lamentable.

9. The idea of a three-person Trinity is dangerous.

10. Believers have a duty to train their children in the New Jerusalem Church alone, the essential propositions for which are nos. 1, 23, and 42. [The 23rd and 42nd propositions were that repentance is the foundation of the Church, and that the New Church is the crown of all churches because it worships one invisible God.]

11. A committee should be appointed to make a catechism.

12. Swedenborgians must separate from the Old Church.

13. They should have no connexion with other churches.

14. But the separation must be gradual.

15. The establishment of the New Church is good.

16. The eleventh proposition has been proved. [The eleventh proposition was that 'the Word of the Lord is Holy' and contains 'a three-fold Sense, namely, Celestial, Spiritual, and Natural, which are united by Correspondences'.]

17. The books of the twelfth proposition should be received as the canon of the Bible. [The twelfth proposition was 'That the Books of the Word are all those which have the internal Sense, which are as follows, viz. in the Old Testament, . . . Genesis, Exodus, Leviticus, Numbers, and Deuteronomy; . . . Joshua, . . . Judges, the two Books of Samuel, the two Books of Kings, the Psalms of David, the Prophets Isaiah, Jeremiah, Lamentations, Ezechiel, Daniel, Hosea, Joel, Amos, Obadiah, Jonah, Micah, Nahum, Habakkuk, Zephaniah, Haggai, Zechariah, Malachi; and in the New Testament, . . . Matthew, Mark, Luke, John, and the Revelation. And that other Books, not having the internal Sense, are not the Word'.][1]

[1] This list excludes thirty-two books and about a fourth of the bulk of the Protestant canon, including Job, Proverbs, and the Song of Solomon. Acceptance of these

18 and 19. The 13th, 14th, 17th, 30th, 33rd, 36th, and 37th proposi-
 tions are good. [These propositions were: (13) that all things
 were created by the spiritual sun, which gives heat (love) and
 light (wisdom); (14) that death is only a continuation of life,
 but that the body is never reassumed—instead on death the
 spiritual body becomes perfect; (17) that all life is communicated
 by God; (30) that the Lord does good, and Hell is responsible
 for evil; (33) that it is now possible to know the mysteries of
 faith; (36) that God's kingdom is one of uses;[1] and (37) that
 good conjugal love is better than any other.]
20. Miracles do not occur.
21. All kinds of religious services are acceptable.
22. There must be a new baptism in the New Church.
23. The Holy Supper is good, but not as celebrated in the Old Church.
24. True conjugal married love is good.
25. The Second Coming, which has begun, involves the destruction
 of the Old Church and the formation of the New.
26. True Christianity exists only in the New Church.
27. All can be saved, even the heathen, if they live charitable lives.
28. The New Jerusalem Church knows most about God's Word.
29. Swedenborgians must exhibit charity toward the Old Church.
30. They must recommend Swedenborg.
31. They must recommend the New Church.
32. And they must have another meeting on April 5th, 1790.[2]

Though Blake must have agreed to these resolutions, he
began to have second thoughts very soon after. Even in his
appreciative notes to Swedenborg's *Wisdom of Angels, con-
cerning Divine Love and Divine Wisdom,* 1788 (p. 429), he
observes that what Swedenborg says contradicts what 'was
asserted in the society'.[3] He soon became actively hostile to

works became a credo of the New Church enforced upon all new members. In
Jerusalem (plate 48) 'the Divine Lord' created exactly the same books of the
Bible as the first session of the New Church had accepted.

[1] Cf. Blake's note to Swedenborg's *Wisdom of Angels, concerning Divine Love and
Divine Wisdom* (p. 181) 'The Whole of the New Church is in the Active Life &
not in Ceremonies at all'.

[2] *Minutes of a General Conference of the Members of the New Church Signified by
the New Jerusalem in the Revelation,* London, 1789.

[3] G. Trowbridge, 'Blake and Swedenborg', *Morning Light,* xxvi (1903), 119,
reported that he had seen a Blake sketch at the Burlington Fine Arts Club Exhibi-
tion some years previously (in 1876?) with a 'list of works to be studied' on it,
headed by Swedenborg's *Worship and Love of God,* but there is no evidence that
Blake read this work.

both Swedenborg and Swedenborgians. His notes to Sweden-
borg's *Wisdom of Angels, concerning the Divine Providence*, 1790
(p. 434), assert with some relish Swedenborg's 'Cursed Folly',
and in *The Marriage of Heaven and Hell*, partly written in 1790,
he enthusiastically damned Swedenborg and his followers as
arrogant spiritual predestinarians. It seems likely, however,
that his attitude was always somewhat ambivalent. According
to a Swedenborgian report of a century later, Blake told his
friend C. A. Tulk 'that he had two different states; one in which
he liked Swedenborg's writings, and one in which he disliked
them. The second was a state of pride in himself, and then
they were distasteful to him, but afterwards he knew that
he had not been wise and sane. The first was a state of
humility, in which he received and accepted Swedenborg.'[1]
Blake never joined the New Church,[2] and one early friend
reported that from this time on he never attended any church of
any kind.[3]

 While Blake was in the midst of his engravings for Salzmann's
Elements of Morality, he received some very cheering encourage-
January, ment in a review: 'The [*anonymous*] prints are far superior,
1791 both with respect to design and engraving, to any we have ever
seen in books designed for children; and that prints, judiciously
introduced, are particularly calculated to enforce a moral tale,

 [1] Quoted from a letter from Garth Wilkinson in J. Spilling, 'Blake the Vision-
ary', *The New Church Magazine*, vi (1887), 210. The last two sentences read
suspiciously like a New Church rationalization of Blake's extremely vocal mockery
of Swedenborg in *The Marriage of Heaven and Hell*.

 [2] A determined search has revealed no further connexion of Blake or his friends
with organized Swedenborgianism, in particular in the baptismal registers of the
New Church which were deposited in Somerset House, London: (1) [Black]
Friar Street, Doctor's Commons (formerly Great East Cheap), 1788–1837
(Manoah Sibly); (2) Store Street, Tottenham Court Road, 1792; (3) Red Cross
Street, Barbican, 1795; (4) Cross Street, Hatton Garden, 1797, moved to York
Street, St. James's Square, 1799, moved to Lisle Street, Leicester Square, 1813,
moved to Hanover Street, Long Acre, 1823, moved to Cross Street again 1827
(Samuel Noble); (5) Brownlow Street, Holborn, and Dudley Court, St. Giles,
Middlesex, 1805–14 (James Hodson); (6) Fryars Street, 1803 ff.; (7) Leather
Lane, Holborn, 1813–30; (8) St George's Fields, 1816–34.

 It should be noted that, particularly in the early years, the majority of those
baptized were adults, and that the earliest recorded baptism (in the Eastcheap
register) is for Robert Hindmarsh and four others 'at Mr Wright's Poultry London'
on July 21st, 1787.

 [3] J. T. Smith's statement (p. 458) covers the last forty years of Blake's life,
1787–1827.

must be obvious to every one who has had any experience in education.'[1]

Blake had been engraving plates for the publisher Joseph Johnson since 1780, but it was not, apparently, until 1787, when 'Flaxman was taken to Italy [*and*] Fuseli was given to me for a season',[2] that Blake came to know Johnson's good friend Fuseli very well. In 1788 he had engraved a plate after Fuseli for the latter's translation of Lavater's *Aphorisms*, which Johnson published, and thereafter he had a very close relationship with Fuseli. Blake made copious enthusiastic annotations on his own copy of the *Aphorisms*, which he showed 'to Fuseli; who said one could assuredly read their writer's character in *them*'.[3] '[*Both*] Fuseli and Flaxman . . . were in the habit of declaring with unwonted emphasis, that "the time would come" when the finest [*of Blake's designs*] "would be as much sought after and treasured in the portfolios" of men discerning in art, "as those of Michael Angelo now." "And ah! sir," Flaxman would sometimes add, to an admirer of the designs, "his poems are as grand as his pictures." '[4] Blake and Fuseli got on famously despite their notorious tempers, and each learned a great deal from the other. As 'Fuseli, with characteristic candour, used to declare, *"Blake is d——d good to steal from!"* '[5] George Richmond repeated the same story when he was asked if

Fuseli was a close friend of Blake?

'Yes, Fuseli admired Blake very much. The former when Blake showed him a design, said—"Blake, I shall invent that myself." '

It was Stothard who first gave a nickname to Blake?

[1] Anon., 'Art. XLII. *Elements of Morality* . . ., Vol. i. . . . Price 3s. sewed. Johnson. 1791', *The Analytical Review*, ix (Jan. 1791), 102. Volumes ii and iii of Salzmann were reviewed in Oct. 1791. It is merely a probable speculation that Blake engraved some of the plates for Salzmann.

[2] Letter of Sept. 12th, 1800.

[3] Gilchrist, 1942, p. 54; 1863, p. 62.

[4] Gilchrist, 1942, p. 1; 1863, p. 2. These comments probably derive from Palmer, who told Gilchrist (1942, p. 303; 1863, pp. 303–304): 'His poems were variously estimated. They tested rather severely the imaginative capacity of their readers. Flaxman said they were as grand as his designs, and Wordsworth delighted in his *Songs of Innocence* [*this must have been reported by Crabb Robinson*]. To the multitude they were unintelligible . . . we must regret that he should sometimes have suffered fancy to trespass within sacred precincts.' Gilchrist repeated this elsewhere (1942, p. 101; 1863, p. 120), and added: 'Blake himself thought his poems finer than his designs.'

[5] Gilchrist, 1942, p. 45; 1863, p. 52.

'Oh, I do not know that; Blake would say outrageous things to people—answering a fool according to his folly, to those who did not and never would understand either him or his work.'[1]

Perhaps the nickname was 'the Visionary'.[2]

Through Fuseli, Blake probably came to know Johnson well, for Fuseli was a member of the inner circle of Godwin, Paine, Mary Wollstonecraft, Priestley, and most of the effective radicals of the day, to all of whom Johnson was a generous publisher and a kind friend.

To Blake, also, Johnson was friendly, and tried to help him, as far as he could help so unmarketable a talent.

In Johnson's shop—for booksellers' shops were places of resort then with the literary—Blake was, at this date, in the habit of meeting a remarkable coterie. The bookseller gave, moreover, plain but hospitable weekly dinners at his house, No. 72, St Paul's Churchyard, in a little quaintly shaped upstairs room, with walls not at right angles, where his guests must have been somewhat straitened for space. Hither came Drs. Price and Priestley; and occasionally Blake . . . Fuseli . . . [*and*] Godwin. . . . Him, the author of the *Songs of Innocence* got on ill with, and liked worse. . . . Here, too, he met . . . Holcroft, . . . Tom Paine, . . . [*and*] Mary Wollstonecraft

Blake was himself an ardent member of the New School, a vehement republican and sympathiser with the Revolution, hater and contemner of kings and king-craft. . . . Down to his latest days Blake always avowed himself a 'Liberty Boy,' a faithful 'Son of Liberty'; and would jokingly urge in self-defence that the shape of his forehead made him a republican. 'I can't help being one,' he would assure Tory friends, 'any more than you can help being a Tory: your forehead is larger above; mine, on the contrary, over the eyes.' . . . He courageously donned the famous symbol of liberty and equality— the *bonnet rouge*—in open day, and philosophically walked the streets with the same on his head. He is said to have been the only one of the set who had the courage to make that public profession of faith.[3] . . .

[1] *Anne Gilchrist: Her Life and Writings*, ed. H. H. Gilchrist, London, 1887, p. 26.

[2] According to Anon., 'Hôpital des fous à Londres', *Revue Britannique*, iii S., iv (July 1833), 183, Blake was 'surnommé le *Voyant*'.

[3] Gilchrist got the colour wrong, and Blake was not alone among his friends in his defiance of English orthodoxy. George Cumberland was bitterly antiministerial, and referred to the time 'when I wore the white hat' of liberty (BM Add. MSS. 36507, f. 276, March 5th, 1820). On Jan. 6th, 1795, when he was working with Blake on the *Thoughts on Outline*, Cumberland wrote to his son arranging family affairs, for 'we are likely soon to live under an absolute [*English*] Government or to be plunged into a Civil-war' (BM Add. MSS. 36498, ff. 1–2).

When the painter heard of these September doings [*the massacres in Paris of* 1792] he tore off his white cockade, and assuredly never wore the red cap again.[1]

Godwin's diary, the only consistent record of the Johnson circle, gives no conclusive evidence that Blake was *ever* a member of the group,[2] and Godwin himself did not own any of Blake's writings.[3] It is clear from other evidence, however, that Blake was at least on the periphery of the Johnson circle. The 'help' which Gilchrist says Johnson gave Blake presumably refers to Blake's poem called *The French Revolution*, which got no further than the proofs of the first of seven books under Johnson's aegis in 1791; it was neither registered at Stationers' Hall nor announced in Johnson's *Analytical Review*.

Blake must have made a strange figure in these radical gatherings at Johnson's, for, though he was as intent on political freedom as Paine, Godwin, and the rest, it was spiritual freedom that was closest to his heart. Samuel Palmer wrote: 'He was fond of the works of St. Theresa, and often quoted them with other writers on the interior life.[4] Among his eccentricities will,

[1] Gilchrist, 1942, pp. 79–81; 1863, pp. 92–94. Palmer told Gilchrist (1942, p. 303; 1863, p. 304) that Blake 'rebuked the profanity of Paine, and was no disciple of Priestley'. No other direct evidence indicates whether Gilchrist's account of Blake in Johnson's radical circle was factual or merely hypothetical.

[2] See D. V. Erdman, '"Blake" Entries in Godwin's Diary', *N & Q*, cxcviii (1953), 354–6.

[3] The only significant work of Blake's sold with Godwin's library at Sotheby's on June 18th, 1836 was the 1797 Young's *Night Thoughts* (Lot 912).

[4] Frederick Tatham wrote to Francis Harvey, a book dealer of 30 Cockspur Street Charing Cross:

Odessa Road, Forest Gate, Essex E.
June 8, 1864.

Dear Sir,

The MS you purchased of me [*the Pickering MS.*] was part of the possessions into which I came by legacy [*but see March 1st, 1833*] from Mrs. Blake, the widow of that extraordinary and excellent man, William Blake, Visionary, Poet and Painter, who also had a most consummate knowledge of all the great writers in all languages. To prove that, I may say that I have possessed books well thumbed and dirtied by his graving hands, in Latin, Greek, Hebrew, French, and Italian, besides a large collection of works of the mystical writers, Jacob Behmen, Swedenborg, and others. His knowledge was immense, his industry beyond parallel, and his life innocent and simple and laborious, far beyond that of most other men. Childlike, impetuous, fiery, indomitable, proud, and humble, he carried out a sort of purpose in his life which seemed only to produce what was invisible to the natural eye, to the despising of the things which are seen; he therefore became wild and his theories wanted solidity; but he was the most delightful and interesting man that ever an intellectual lover of art could spend a day with; and he died as he lived. He was

no doubt, be numbered his preference for ecclesiastical governments. He used to ask how it was that we heard so much of priestcraft, and so little of soldiercraft and lawyercraft. The Bible, he said, was the book of liberty and Christianity the sole regenerator of nations.'[1]

Gilchrist gives other accounts of Blake's ideas and arguments in debate.

Once, in later years, a disputant got up and left his company. 'Ah,' said Blake, 'we could not get on at all: he wanted to teach me, and I to teach him.' . . . he would often hazard wild assertions about the Sacred Person. Yet he would consider that a believer only in the historical character of Christ in reality denied Christ. . . . He had a sentimental liking for the Romish Church, and, among other paradoxes, would often try to make out that priestly despotism was better than kingly. 'He believed no subjects of monarchies were so happy as the Pope's'. . . . Blake's friend may well add: 'I fancy this was one of his *wilful* sayings, and meant that he believed priests to be more favourable to liberty than kings: which he certainly did. He loved liberty, and had no affection for statecraft or standing armies, yet no man less resembled the vulgar radical. His sympathies were with Milton, Harrington, and Marvel—not with Milton as to his puritanism, but his love of a grand ideal scheme of republicanism; though I never remember him speaking of the American institutions: I suppose Blake's republic would always have been ideal.' We must assuredly number among his more 'wilful' assertions the curious hypothesis, 'that the Bonaparte of Italy was killed, and that another was somehow substituted from the exigent want of the name, who was the Bonaparte of the Empire! He referred to the different physiognomies (as he thought) in the earlier and later portraits. But, stranger still, he gave me the (forgotten) name of some public man much associated with many of the great men of the age in which he lived, and was meek and companionable with them. These things are to be deduced, and the great interest which the public have taken in him, by the several Biographies that have been published of him since his death—to which the reader and yourself had better be referred.

<div style="text-align:right">

Believe me, dear Sir
Very faithfully yours
FREDERICK TATHAM

</div>

Mr. Frederick Harvey.

This letter was printed by Harvey in his sale catalogue of about 1865, a fragment of which is in the Anderdon Papers in the British Museum Print Room.

[1] Gilchrist, 1942, p. 303; 1863, p. 303. Palmer goes on: 'In politics a Platonist, he put no trust in demagogues. His ideal home was with Fra Angelico: a little later he might have been a reformer, but after the fashion of Savanarola.'

—ambassador, or something of the sort—who assured him such was the case; and a very plausible story he made of it,' says the same friend.[1]

Such assertions by Blake astonished strangers, but his friends learned to take them with a grain of salt.

'Often,'—to this effect writes Mr. Linnell,—'he said things on purpose to puzzle and provoke those who teased him in order to bring out his strongest peculiarities. With the froward he showed himself froward, but with the gentle, he was as amiable as a child. . . . His eccentricities have been enlarged upon beyond the truth. He was so far from being so absurd in his opinions, or so nearly mad as has been represented, that he always defended Christian truth against the attacks of infidels, and its abuse by the superstitious. . . . It must be confessed, however, he uttered occasionally sentiments sadly at variance with sound doctrine.'[2]

Samuel Palmer concurred: 'He had great powers of argument, and on general subjects was a very patient and good-tempered disputant; but materialism was his abhorrence: and if some unhappy man called in question the world of spirits, he would answer him "according to his folly," by putting forth his own views in their most extravagant and startling aspect. This might amuse those who were in the secret, but it left his opponent angry and bewildered.'[3]

During the early 1790s Johnson was employing Blake on more and more important engraving work. For instance, he wrote to Erasmus Darwin about his plan to have Wedgwood's replica of the Portland Vase engraved for Darwin's *Botanic Garden*:

London, [*Saturday*] *July* 23, 1791

Dear Sir,

It is not the expence of *purchasing* Bartolozzi's plates that is any object; they *cannot be copied* without Hamilton's consent, being protected by act of parlt. [*under copyright law.*] *July*

Blake is certainly capable of making an exact copy of the vase, I *23rd,*
believe more so than Mr. B., if the vase were lent him for that *1791*

[1] Gilchrist, 1942, pp. 326–7; 1863, pp. 329–31.

[2] Gilchrist, 1942, pp. 324–5; 1863, pp. 327–8; the ellipses appear in Gilchrist. It seems likely that Linnell is the author of Gilchrist's further untraced quotations as well.

[3] Gilchrist, 1942, p. 304, 1863, p. 304.

purpose, & I see no other way of its being done, for the drawing he had was very imperfect—this you will determine on consulting Mr. Wedgwood, & also whether it should be copied as before, or reduced & brought into a folding plate.

I have no wish in this case but to do what you desire. It is not advisable to publish before the winter, yet I will do it as soon as the work is ready if you desire it. . . .

I could wish for particular instructions for the engraver.[1]

On "SEPT. I." Joseph Johnson and R. Edwards issued

September 1st, 1791

PROPOSALS FOR ENGRAVING AND PUBLISHING BY SUBSCRIPTION THIRTY CAPITAL PLATES [16 *inches by 23*], FROM SUBJECTS IN MILTON; TO BE PAINTED PRINCIPALLY, IF NOT ENTIRELY, BY HENRY FUSELI, R.A. AND FOR COPYING THEM IN A REDUCED SIZE TO ACCOMPANY A CORRECT AND MAGNICENT EDITION, EMBELLISHED ALSO WITH FORTY-FIVE ELEGANT VIGNETTES, OF HIS POETICAL WORKS, WITH NOTES, ILLUSTRATIONS, AND TRANSLATIONS OF THE ITALIAN AND LATIN POEMS. By W. COWPER Messieurs Bartolozzi, Sharp, Holloway, Blake, and other eminent Engravers have promised their Assistance in the Execution of the Plates.[2]

Six weeks later Blake was invited to contribute to one of the greatest scholarly works of the eighteenth century, Stuart and Revett's *Antiquities of Athens*, which had been in progress for some thirty years. The editor of the third volume of the work wrote:

October 18th, [1791]

Mr Reveley's Comptts to Mr Blake[;] if he wishes to engrave any of Mr Pars's drawings for the Antiquities of Athens, & can do them by the end of January Mr Reveley will be glad to [*send*] some to him.

Great Titchfield St.
[*Tuesday*] Oct 18[3]

In his reply Blake said that 'tho full of work he is glad to embrace

[1] G. Keynes, *Blake Studies*, London, 1949, pp. 68–69.

[2] This proposal is in the John Johnson Collection in the Oxford University Press. Details from this proposal and Fuseli's letter below (see May 29th, 1792) are summarized by J. Knowles, *The Life and Writings of Henry Fuseli, Esq. M.A. R.A.*, London, 1831, vol. i, p. 172. Another proposal in the Johnson Collection announcing Cowper's translation of Homer for the spring of 1791 lists 'W. Blake, Esq' among the subscribers.

[3] Quoted from the MS. in the Huntington Library. The commission evidently came through George Cumberland (see May 1808), but it may have been connected with the fact that Blake had received his formal instruction in art from the designer's brother.

the offer of engraving such beautiful things and will do what he can by the end of January'. Apparently they were not finished as soon as he had hoped, for they are dated April 3rd, 1792.

Blake seems to have been a dilatory correspondent all his life—he was tardy in writing even to his best friends, and John Flaxman's wife Nancy wrote from Rome to her sister-in-law Maria in London on Monday, November 21st: 'pray call on M^r Blake & beg of him to answer your Brother's Letter directly'.[1] Blake is not known to have replied even to such a simple request as this.

November 21st, 1791

One of Blake's earliest important commissions was for engravings after the author's designs for the *Narrative, of a five years' expedition, against the Revolted Negroes of Surinam, in Guiana, on the Wild Coast of South America* which Joseph Johnson published for Captain John Gabriel Stedman. The author was a retired soldier-of-fortune, poet, painter, and engraver, who was often taken to be 'mad', as he confessed in his Journal, 'owing entirely to my studying to be singular, in as much as can be'.[2] The work was years in passing through the press; in his Journal for Thursday, December 1st, 1791, Stedman wrote:

About this time I re[*ceive*]^d above 40 Engravings from London, Some well Some very ill I wrote to the Engraver *B*lake to thank him twice for his excellent work but never received any answer[.]

December 1st, 1791

Stedman's sympathetic attitude toward Negro slaves may have

[1] BM Add. MSS. 39780, f. 56.

[2] *The Journal of John Gabriel Stedman 1744–1797*, ed. Stanbury Thompson, London, 1962, p. 269. There are references to Blake in Stedman's Journal under Dec. 1, 1791; June 21, Oct., Nov. 1794; June, 2, 5, 9, 24, Aug., Sept., Dec. 18, 1795; Jan.–Feb., May, July 16, 1796 (printed by Thompson on pp. 336, 352, 360, 363, 381–5, 387, 389–92), all but the last two of which I quote, with the editor-owner's permission, from a photocopy of the MS. which he generously permitted me to examine.

Stedman's Journal appears to be an exceedingly heterogeneous mass of manuscripts. For the years with which we are concerned (1791–6), it is written on blank, unnumbered leaves in a manner that becomes progressively less systematic. The hand-writing is often quite difficult, the spelling eccentric ('quarl' for 'quarrel'. 'Bartholozy' for 'Bartolozzi'), and the connexion between phrases is sometimes exceedingly obscure. Thus under June 9th, 1795, Mr. Thompson reads 'cruse' where I read (hesitantly) 'cup'. Oddities of context are clearest in the quotations for Aug. and Sept. 1795.

influenced Blake's attack on slavery in his *Visions of the Daughters of Albion* of 1793.[1]

In 'JANUARY, 1792' the publisher Bowyer issued a prospectus for a splendid edition of Hume's *History of England*, with a continuation by David Williams, 'in Sixty Numbers; making FIVE magificent Volumes'. 'SIXTY PICTURES' plus many vignettes commissioned from the first artists such as Barry, Cosway, Fuseli, Romney, Stothard, and West were to 'form *January–* an Exhibition' 'at Mr. BOWYERS' and to be put into 'the hands *June,* of the most eminent Engravers', including 'BARTOLOZZI . . . *1792* W. BLAKE . . . FITTLER [*and*] . . W. SHARP' 'under the direction of Mr. BOWYER . . . in conjunction with Mr. FITTLER'. According to another prospectus, evidently issued in February, these 'Gentlemen are actually engaged' for the engravings.[2] However, Blake signed none of the 195 plates issued between 1793 and 1806, and he was probably thinking of this neglect when he wrote on December 11th, 1805 that he 'was known by them [*Boydell, Macklin, and Bowyer*] & was lookd upon by them as Incapable of Employment'.

Fuseli reported the progress of his Miltonic undertaking to his friend and patron William Roscoe of Liverpool on Tuesday May 29th:

Sharpe has had his picture (the picture itself, not a Copy) nearly these two months and is busy in the aquafortis part of both plates. *May* we have contrived a roller for him from the design of Mr Paine who *29th,* is a Mechanic as well as a Demogorgon, to enable him to place it, *1792* for it is 13 feet high by a width of 10; & though his house is larger than those of most Engravers it was too high to enter any of his rooms.[3] . . . Of the Second Number Adam & Eve observed by Satan;

[1] See D. V. Erdman, 'Blake's Vision of Slavery', *Journal of the Warburg and Courtauld Institutes*, xv (1952), 242–52.

[2] All the prospectuses for Hume's *History* I have seen are in the John Johnson Collection in the Bodleian Library. One, in folio, dated Jan. 1792, is almost identical with another, undated, in octavo. A third, also undated but probably of February, refers to the previous 'Prospectus . . . given at large with this publication of last month'. The fourth is dated June 21st, 1792 and includes as publishers Murray and 'Mr. EDWARDS, PALL MALL'. When completed the work did not include the continuation of Williams, and had only a kind of half-title: *The History of England*, from the Invasion of Julius Caesar to the Revolution in 1688. By David Hume Esq. [*5 vols. in 9.*]

[3] According to Flaxman (Nov. 7th, 1804), William Sharp lived at 50 Upper Litchfield Street, Oxford Market. The Demogorgon is of course Tom Paine, the

PLATE VI

COPIES BY 'J. FLAXMAN FROM MEMORY OF THREE DRAWINGS OF BLAKE
JUNE 1792'. I cannot identify these Blake drawings. Flaxman had not seen Blake for five years when
he made these copies

and Satan taking his flight upwards from chaos which is of the same dimensions with Sharp's and intended for Blake, are much advanced; and upon the whole Sketches of a number of Subjects are ready and wait for execution on Canvas.[1]

However, Cowper was not well, Alderman Boydell opposed the book because it might hurt the sale of his own illustrated edition of Milton, and the plan for the Cowper–Fuseli edition was therefore abandoned. Consequently Fuseli was free to use his paintings in his 'Milton Gallery', which had been in preparation at least since 1790, and Blake engraved neither plate.

While he was in Italy, Flaxman made three outline sketches on a sheet of paper, at the bottom of which he wrote 'J. Flaxman from memory of three drawings of Blake June 1792'.[2] The vividness of Flaxman's memory may perhaps lend some credit to Blake's assertion of many years later that 'Flaxman cannot deny that one of the very first Monuments he did I gratuitously designd for him'.[3] *June, 1792*

In the summer of 1792 the health of Blake's mother apparently declined, and about September 7th she died. At 4:30 on Sunday the 9th 'Catherine Blake [aged] 70 [was brought from] St James Westminster [and buried in a grave in Bunhill Fields] 9 feet [deep, located E. and W.] 16 [N. and S.] 42,,43 [for a fee of £0.] 19. 0'.[4] Blake seems to have been a dutiful son to his parents, and he was no doubt grieved by their deaths, but his brother was the most important member of the family as far as *September 9th, 1792*

revolutionary, who was about to be prosecuted for writing the second part of *The Rights of Man*.

[1] Transcribed from a microfilm of the MS. in the Liverpool Public Library.

[2] Quoted from a photostat of the sketches now in the possession of Mr. David Bindman; see Plate VI.

[3] *Notebook*, p. 53. The rest of the passage reveals that the date Blake had in mind was about 1784.

[4] This burial register is now kept in Somerset House, filed as Bunhill Fields Register, vol. xv, p. 83. According to the Order Book (now in Guildhall Library) the preliminary arrangements were made Sept. '7th Catherine Blake 70 St James's Westminster 9 ft [duty] 3 [shillings,] [Minister] 3/- [fee £]1.2.3. [E. and W.] 16 [N. and S.] 42.43 [to be buried] On Sunday at 1/2 past 4'. (This Order Book does not cover the years before 1791.) This document adds the minister's fee, the duty, the time of burial, and gives a different burial fee (unless the difference of 3s. 3d. means that she had no minister); blanks in the form indicate that she had no stone or screen, and was not buried in a vault. The identification of this Catherine Blake with the poet's mother is a sound hypothesis based on the coincidence of names and the burial of her husband (1784) and three sons (1787, 1827, 1827) in the same graveyard.

the poet was concerned. 'Blake's associates in later years re-member to have heard him speak but rarely of either father or mother, amid the frequent allusions to his brother Robert.'[1]

In the winter of 1793 appeared an advertisement announcing: 'A Splendid Edition of Barlow's Aesop's Fables . . . [is] In the Press, and Speedily will be Published, . . . embellished with ONE HUNDRED and FOURTEEN beautiful Copper Plates, from Barlow's Designs, and engraved by Hall, Mazell, Eastgate, Grainger, Wilson, Audinet, Medland, Skelton, Cromeck, *February* Blake, Leney, Corner, Lovegrove, &c. &c. . . . Printed for *2nd,* JOHN STOCKDALE, Piccadilly. . . . Feb. 2, 1793.'[2] The list of *1793* engravers was not notably accurate, however, for almost a third of those specified, including Blake, did not sign engravings in that edition of *Aesop's Fables.*

Evidently Nancy Flaxman's plea of November, 1791 for a letter from Blake had little effect, for she wrote somewhat *November* plaintively to her sister-in-law Maria Flaxman in London on *20th,* Wednesday, November 20th, 'know you anything of Stothard *1793* or Blake[?]'[3]

Blake's last ten plates for Stedman's *Narrative* were dated December 2nd, 1793, and the author was evidently sufficiently impressed by them to make the acquaintance of his engraver. For the next two years there are frequent references to Blake in Stedman's Journal, and for a time at least Blake was clearly Stedman's most trusted friend in London. The first personal contact between the two men recorded in Stedman's Journal is *June* that for Saturday, June '21 [1794] Call on M.[r] Johnson & Blake'. *21st,* His list of letters written in October 1794 includes 'Johnson son *October,* [sic] Blake', and in November 1794 he reported in his Journal: *November,* *1794* 'I wrote—to . . . Bartholozy—/Johnson—/Blake—/'.

Six months later Stedman came from his country house in Tiverton, Devon, to London, probably to see the last parts of *June* his *Narrative* through the press. In his Journal he wrote: '[Tues-*2nd,* day, June] 2 [1795]—wrote M.[rs] Stedman—/ and I trip [sic] to *1795* M.[r] & M.[rs] Blake'. He was having great difficulties with

[1] Gilchrist, 1942, p. 82; 1863, p. 96.

[2] This advertisement is found in some copies of the edition of Gay's *Fables* (1793) for which Blake engraved plates.

[3] BM Add. MSS. 39780, f. 61, n.d. Another hand has written November 30th, 1793 on the MS. This date seems credible, for the death of John's stepmother (who died early in 1793) may be inferred from the letter.

Johnson and the proofs of his book, and Blake may have been trying to mediate between Stedman and Johnson. On June 5th Stedman wrote: 'I force Bartholozy to return my plates—and Brute Gregory to run away altogether—then take home My Spoilt M. Script and repair all plates[.]' A few days later, after June '9 . . . [*I*] gave a blue Sugar cup to Mʳˢ Blake . . . dined *P*almer—Blake—Johnsons—*R*igaud—Bartholozy[.]' The conversation probably concerned Stedman's *Narrative*, for Blake and John Francis Rigaud, R.A., subscribed to the book, as did Thomas and William Palmer. Stedman's troubles, however, were only beginning. On June 24th he wrote: 'on Mid Summer day receive the 1ᵗ vol. of My book quite mard[,] oaths and Sermons inserted &c[.]' Under the same date, but perhaps some days later, he wrote: 'Gave oil portrait to Mʳ Blake— . . . dined at Blakes My book mard intirely[;] am put to the most extreme trouble and expence I reconcile Johnson and cansel best part of first volume[.]' Some weeks later, apparently in August, 'I visit Mʳ Blake for 3 days who undertakes to do busness for me when I am not in London— I leave him all my papers— . . . d—n Bartholoz. . . . *A*vershaw [*Louis Jeremiah Abershaw*] &c hangd [*for highway robbery on August 3rd, 1795*], 8—Saw a Mermaid— . . . two days at *B*lakes[.]' These unsorted notes continue perplexingly: 'Septemb. . . . / all knaves and fools—/and cruel to the excess—/ *B*lake was mob'd and robbd[.]' The connexion of the first sentence with the second is obscure, and nothing further is known of the second reference, unless it be connected with Tatham's account of how Blake's house in Lambeth was robbed of £100 when the Blakes were out (see Tatham, p. 522).

The next reference from Stedman's Journal is at least quite clear: 'being come home on [*Friday*] the 18 Dec I . . . Send a goose to Johnson and one to Blake Johnson Sends me a blur'd index—Such as the book good for nothing[.]'

The fashionable miniaturist Richard Cosway wrote to George Cumberland on Saturday, December 27th, 1795:

I have contemplated with pleasure the Outline you was so good as to leave with Mʳˢ C of the Picture of Leonard*o*, & do not hesitate to pronounce it one of the most beautiful Compositions I ever beheld of that Great Man. I hope it will not be long before I shall be able to request a sight of the Picture, why do you not get Blake to make

June 5th, 1795

After June 9th, 1795

June 24th, 1795

August, 1795

September, 1795

December 18th, 1795

December 27th, 1795

an engraving of it? I shou'd think he wou'd be delighted to undertake such a Work & it wou'd certainly *pay him very well* for whatever time & pains he may bestow upon such a Plate, as we have so *very few* of Leonardo's Works well engrav'd & the composition of this Picture is so very graceful & pleasing I am convinc'd he might put allmost any Price on the Print & assure himself of a very extensive Sale.[1]

There is no evidence that Blake ever undertook such a work, unless one or more of the six unidentified plates mentioned in his letter to Cumberland of December 23rd, 1796, is the Leonardo.

February 19th, 1796

A few months later the sociable painter Joseph Farington noted in his Diary for Friday, February 19th, 1796: 'West, Cosway & Humphry spoke warmly in favour of the designs of Blake the Engraver, as works of extraordinary genius and imagination.—Smirke differed in opinion, from what He had seen, so do I.'[2] Probably the designs spoken of in this conversation were those Blake was making to illustrate Young's *Night Thoughts*. The work had been commissioned by Richard Edwards, a prosperous bookseller of Pall Mall who specialized in books of prints. By 1796 Blake had apparently been at work for about a year, for many years later Richard Edwards's brother wrote that 'the Artist was employed for more than two years' upon the 'Work'[3] before it was published in 1797.

About this time Stedman recorded in his Journal:

January– February, 1796

During these last 2 months of January and February [1796] I write to . . . [*about* 20 *people, including*] to Johnson 3 times—do [*i.e. London*] to Blake—3 times—d⁰ I sent besides to London Hansard [*the printer, all the preliminaries for the book, index, etc.*] I charged *H*ansard not to trust the above papers with Johnson[,] who I would now not Save from the gallows[,] with only one of them

[1] BM Add. MSS. 36498, f. 53. In 1808 Cumberland confidently 'valued the Leonardo d vinci [*at*] £1000' (BM Add. MSS. 36519H, f. 355), but some years later he was not so sure and reduced his estimate to £300, 'as it may be a Luino copy' (BM Add. MSS. 36514, f. 265, n.d.).

[2] All extracts from the Farington Diary are quoted from the original in the Windsor Castle Library.

[3] See May 10th, 1826, and 1821, where the time is said to have been 'nearly two years'. I take the 'more than' or 'nearly two years' to refer primarily to the drawings.

Professor Edwards, of 43 Cumnor Hill, Cumnor, Berkshire, a great-grandson of James Edwards (brother of Richard), informed me in Sept. 1959 that he knew of no old family papers, and thought it probable that none had survived.

so cruelly was I treated—and I declare him a Scound[r]ell without he gives me Satisfaction[.]

This tactic was only partially successful, for in May Stedman wrote:

Mr Hansard, the printer, writes me that all, all, all is well, and printed to my mind and wishes. I am pleased, but Johnson, the demon of hell, again torments me by altering the dedication to the Prince of Wales &c., &c., he being a d-mn'd eternal [*infernal?*] Jacobin scoundrel.

Correspondence.

May, 1796

I wrote lately to Hansard the printer. I [*wrote*] 12 letters to Blake, 2 to Will Robertson, to Wright, printer, London . . . to Simpkins, engraver, . . . to Johnson, 2, and damn him in them

The whole or most of my publication, of which I send away, the last cancels so late as the middle of May 1796, having been in hand no less than 7 or 8 long years.

Blake was apparently also engaged to make sketches for other friends. On Saturday, June 18th, Thomas Hayley, William Hayley's sixteen-year-old illegitimate son, who was apprenticed to Flaxman as a sculptor, wrote to his father:

I have not yet seen anything of Blake or his drawings[.] I have written this on Saturday eve that I may if possible take a walk to his house tomorrow morning. Till then adieu[.] I will add a line to tell you how I succeed. ... Monday morning[.] I have not been able to call on Blake yesterday as I intended but I will lay hold on the first opportunity. You know it is a great distance from us. Nevertheless I hope to be able to see him very soon.[1]

[*June 18th– 20th, 1796*]

In his Diary for Friday, June 24th, the artist Joseph Farington wrote:

Fuseli called on me last night & sat till 12 oClock. He mentioned Blake, the Engraver, whose genius & invention have been much

June 24th, 1796

[1] Quoted from the MS. in the Sussex County Record Office, Chichester. The letter is dated Saturday, June 19th, without a year, but June 19th did not fall on a Saturday between 1794, when Flaxman returned from Italy, and 1800, when Thomas died, so we must assume Tom used the wrong date. However, in this letter Tom says Romney had just taken him to see his new house in Hampstead, and Romney bought the house in the late spring of 1796. Since June 19th was a Sunday in 1796, Tom's letter was probably written on June 18th and June 20th. According to Hayley (*Memoirs of the Life and Writings of William Hayley, Esq.*, ed. J. Johnson, London, 1823, vol. ii, p. 133) Tom wrote in his diary for July 7th, 1795 that he 'drank tea on the other side of the river', perhaps with Blake.

spoken of. Fuseli has known him several years, and thinks He has a great deal of invention, but that 'fancy is the end, and not a means in his designs'. He does not employ it to give novelty and decoration to regular conceptions; but the whole of his aim is to produce singular shapes & odd combinations.

He is ab! 38 or 40 years of age, and married a maid servant, who has imbibed something of his singularity. They live together with! a servant at a very small expence.

Blake has undertaken to make designs to encircle the letter press of each page of 'Youngs night thoughts.['] Edwards the Bookseller, of Bond S!ʳ employs him, and has had the letter press of each page laid down on a large half sheet of paper. There are ab! 900 pages.— Blake asked 100 guineas for the whole. Edwards said He could not afford to give more than 20 guineas for which Blake agreed.—Fuseli understands that Edwards proposes to select ab! 200 from the whole and to have that number engraved as decorations for a new edition.—

Fuseli says, Blake has something of madness ab! him. He acknowledges the superiority of Fuseli: but thinks himself more able than Stothard.—

Fuseli's is the only known suggestion that Catherine was a 'maid servant' before she was married, but the extremely humble situation of her family makes it seem possible that she had been in service. On the subject of their own servants, Tatham (p. 522) says that when the Blakes moved into Hercules Buildings (in 1790) they 'at first kept a servant, but finding (as Mrs. Blake declared, and as everyone else knows) the more service the more inconvenience', they gave her up.

Farington's account of the *Night Thoughts* commission is rather ambiguous. Probably Fuseli meant that Edwards supplied some 900 sheets of paper for Blake's designs and proofs. The context strongly suggests as well that the £21 was to pay for the drawings alone, at a rate of somewhat less than 9½d. for each of the 537 finished watercolours, each measuring some sixteen inches by twelve. J. T. Smith, who concluded that it was 'a despicably low' sum,[1] was not far off the mark. We do not know whether Blake was paid at all for the engravings.

Blake and Fuseli obviously got on well, as Blake's admission of 'the superiority of Fuseli' suggests. Blake's other close friend of the time, the pious John Flaxman, was a very different kind

[1] See p. 461 and Plates VII, IX, X, Smith did not mention the size of the sum.

PLATE VII

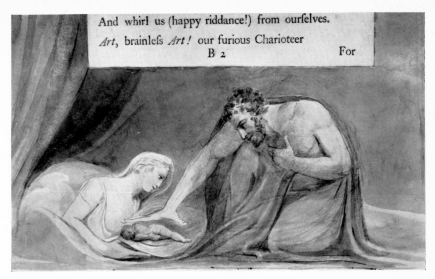

And whirl us (happy riddance!) from ourselves.

Art, brainlefs *Art!* our furious Charioteer

B 2 For

BLAKE'S DRAWING FOR YOUNG'S *NIGHT THOUGHTS* (1796), the en-
graving from which Bulwer Lytton found 'literal to ridicule' (see pp. 402, 52–60)

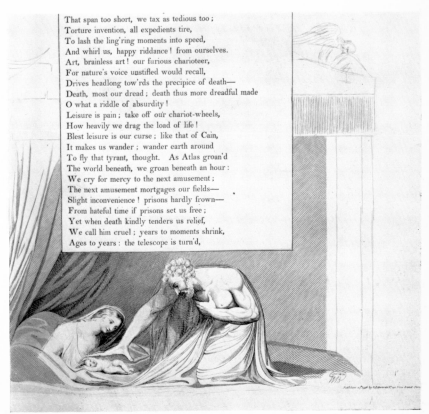

That span too short, we tax as tedious too ;
Torture invention, all expedients tire,
To lash the ling'ring moments into speed,
And whirl us, happy riddance ! from ourselves.
Art, brainless art ! our furious charioteer,
For nature's voice unstifled would recall,
Drives headlong tow'rds the precipice of death—
Death, most our dread ; death thus more dreadful made
O what a riddle of absurdity !
Leisure is pain ; take off our chariot-wheels,
How heavily we drag the load of life !
Blest leisure is our curse ; like that of Cain,
It makes us wander ; wander earth around
To fly that tyrant, thought. As Atlas groan'd
The world beneath, we groan beneath an hour :
We cry for mercy to the next amusement ;
The next amusement mortgages our fields—
Slight inconvenience ! prisons hardly frown—
From hateful time if prisons set us free ;
Yet when death kindly tenders us relief,
We call him cruel ; years to moments shrink,
Ages to years : the telescope is turn'd,

BLAKE'S ENGRAVING FOR YOUNG'S *NIGHT THOUGHTS* (1797), p. 23

of man as is illustrated by a story George Richmond used to tell:

> *Flaxman:* 'How do you get on with Fuseli? I can't stand his foul-mouthed swearing. Does he swear at you?'
>
> *Blake:* 'He does.'
>
> *Flaxman:* 'And what do you do?'
>
> *Blake:* 'What do I do? Why—I swear again! and he says astonished, *"vy, Blake, you are svaring!"* but he leaves off himself !'[1]

The vigour of Fuseli's speech was widely known. In his manuscript Autobiography (pp. 18, 19) Linnell wrote that

Fuseli used strong language even to cursing & swearing before And at the porters. He is said to have boasted that he could swear in nine languages [Blake told me that *del*] I was told that when Fuseli's wife was vexed one day he said to her['']Why don't you swear my dear[?] it would ease your mind.['] And that once when Fuseli introduced Nolekens & Merchant to some eminent foreigner he said—'M^r Knowlekens & M^r Merchant two of the gretest sculptors in the Vorld but in everyting else they are two old daddie's['.]

If even Fuseli was willing to admit there was 'something of madness' about Blake, it is easy to imagine the regularity with which eccentric stories attached themselves to his name. 'One—which I believe Leigh Hunt used to tell—bears internal evidence, to those who understand Blake, of having been a fabrication. Once, it is said, the visionary man was walking down Cheapside with a friend. Suddenly he took off his hat and bowed low. "What did you do that for?" "Oh! that was the Apostle Paul." '[2] This is the kind of story which is cherished for its own sake and not because of the name to which it is attached. 'Sir Henry Taylor, in his copy of Gilchrist's "Blake," makes the following note [*on it*]: "This was told to me by Southey not of Blake, but of Swedenborg." '[3]

Another anecdote seems to have appeared first toward the middle of the nineteenth century.

One story in particular he [*Butts*] was fond of telling, which has

[1] G. & W. B. Richmond, *The Richmond Papers*, ed. A. M. W. Stirling, London, 1926, p. 8. A rather less dramatic version of the anecdote told by Richmond is given by A. H. Palmer, *The Life and Letters of Samuel Palmer*, London, 1892, 24 fn.

[2] Gilchrist, 1942, p. 319; 1863, p. 321.

[3] Gilchrist, ed. W. G. Robertson, 1907, p. 339 fn. Taylor (1800–86) knew Southey from 1823 on, when he came to London.

been since pretty extensively retailed about town. At the end of the little garden in Hercules Buildings there was a summer-house. Mr. Butts calling one day found Mr. and Mrs. Blake sitting in this summer-house, freed from 'those troublesome disguises' which have prevailed since the Fall. *'Come in!'* cried Blake; *'it's only Adam and Eve, you know!'* Husband and wife had been reciting passages from *Paradise Lost*, in character, and the garden of Hercules Buildings had to represent the Garden of Eden: a little to the scandal of wondering neighbours, on more than one occasion.[1]

The story persisted despite outraged denials by Blake's disciples, headed by Palmer and Linnell, and it was only finally discredited when 'the late Captain Butts said that he distinctly remembers hearing his grandfather declare that there was no truth in it'.[2]

Sometimes Blake's visions were all too real for comfort. J. T. Smith (p. 470) says Blake saw a vision of the 'Ancient of Days' at the top of his staircase in Hercules Buildings.

On that same staircase it was Blake, for the only time in his life, *saw a ghost*. When talking on the subject of ghosts, he was wont to say they did not appear much to imaginative men, but only to common minds, who did not see the finer spirits. A ghost was a thing seen by the gross bodily eye, a vision, by the mental. 'Did you ever see a ghost?' asked a friend. 'Never but once,' was the reply. And it befel thus. Standing one evening at his garden-door in Lambeth, and chancing to look up, he saw a horrible grim figure, 'scaly, speckled, very awful,' stalking downstairs towards him. More frightened than ever before or after, he took to his heels, and ran out of the house.[3]

In the September issue of *The British Critic*, an anonymous reviewer criticized the four translations of Burger's *Leonora* that had appeared that year, and specifically praised the illustrations of one edition; they form, he said,

a most striking contrast to the distorted, absurd, and impossible monsters, exhibited in the frontispiece [*designed by Blake*] to Mr. Stanley's last edition. Nor can we pass by this opportunity of execrating that detestable taste, founded on the depraved fancy of one man

[1] Gilchrist, 1942, pp. 96–97; 1863, p. 115. Gilchrist maintained that Blake believed with 'the Gymnosophists of India, the ancient Britons, and others of whom history tells' in the essential virtue of nudity, but this sounds very much like Gilchrist's rationalization after the fact.

[2] A. E. Briggs, 'Mr. Butts, the Friend and Patron of Blake', *Connoisseur*, xix (1907), 95.

[3] Gilchrist, 1942, pp. 106–7; 1863, p. 128.

PLATE VIII

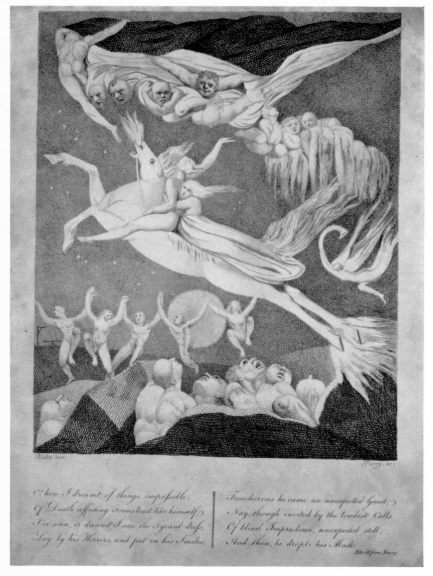

THE FRONTISPIECE TO BURGER'S *LEONORA* (1796), engraved by Perry after Blake. The design is full of echoes from *Visions of the Daughters of Albion, America,* and *Vala*

of genius, which substitutes deformity and extravagance for force and expression, and draws men and women without skins, with their joints all dislocated; or imaginary beings, which neither can nor ought to exist.[1] *September, 1796*

There is nothing resembling 'men and women without skins' in these engravings, nor can I imagine what they could be, unless skeletons or, more probably, flayed bodies with the muscles exposed.

Apparently few people liked Blake's *Leonora* designs, for they were also condemned in Joseph Johnson's *Analytical Review* for November: 'This edition is embellished with a frontis- piece, in which the painter has endeavoured to exhibit to the eye the wild conceptions of the poet, but with so little success, as to produce an effect perfectly ludicrous, instead of terrific.'[2] *November, 1796*

George Cumberland's *Thoughts on Outline* apparently came out in early August 1796, and the author gave away bound copies to nineteen friends, including Lucas, Fox, Sheridan, Parrs, G. Wakefield, Banks, Cosway, Barry, Hastings, Stothard, and 'Mr Blake'.[3] By September he had begun to receive thanks from the recipients, though Blake did not reply until December 23rd, with apologies.

The book had evidently been published for a couple of months before Cumberland entered it at Stationers' Hall on Tuesday, November 22nd. It appeared with eight plates by Blake and a most respectful acknowledgment of indebtedness to him:

one thing may be asserted of this work, which can be said of few others that have passed the hands of an engraver, which is, that *Mr.* *November 22nd, 1796*

[1] Anon., 'Translations of Burger's Leonora', *The British Critic*, viii (Sept., 1796), 277. See Plate VIII.

[2] Anon., 'Art. XI. *Leonora*. . . . A new Edition. 4to. 16 pages, with a Frontis- piece and two Vignettes, by Blake. Price 7s. 6d. sewed. Miller. 1796', *Analytical Review*, xxiv (Nov. 1796), 472.

[3] BM Add. MSS. 36518, f. 60, an undated notebook memorandum. I have found another such list, which, however, I cannot satisfactorily date. It is on the back of a print (BM Add. MSS. 36519E, f. 203) pasted in a notebook of 1804–5, and reads: 'works. to [*Charles*] Lucas, Buchan, [*Samuel*] Townly, Shelly. Collings [*i.e. Richard Collins, always so spelled by Cumberland*], [*Thomas*] Stothard, Long[, *Charles*] Irvine Mʳ C. Mr Timbril Townleys friend old[?] Decd. Cha. Town[*ly*] Blake, Bishop. T. Price'. I know of no work by Cumberland between 1798 and 1810; the most likely candidate seems to be his *Original Tales* of the latter year.

There are other references to the *Thoughts on Outline* in BM Add. MSS. 36498, ff. 5–6, 74, 108–10, 120, 123; 36501, ff. 79–83; 36503, f. 68; 36505, ff. 63–65, 73; 36514, ff. 97, 255; 36519 f. 185; 36520B, f. 69.

Blake has condescended to take upon him the laborious office of making them, I may say, fac-similes of my originals:[1] a compliment, from a man of his extraordinary genius and abilities, the highest, I believe, I shall ever receive:—and I am indebted to his generous partiality for the instruction which encouraged me to execute a great part of the plates myself; enabling me thereby to reduce considerably the price of the book.[2]

The book sold very slowly.

On almost the same day that Blake was writing to thank Cumberland for sending him a copy of the *Thoughts on Outline*, Richard Edwards wrote a revealing introduction for the ambitious illustrated edition of Young's *Night Thoughts* that he and Blake were preparing:

ADVERTISEMENT.

In an age like the present of literature and of taste, in which the arts, fostered by the general patronage, have attained to growth beyond the experience of former times, no apology can be necessary for offering to the publick an embellished edition of an english classick; or for giving to the great work of Young some of those advantages of dress and ornament which have lately distinguished the immortal productions of Shakspeare and of Milton.[3]

But it was not solely to increase the honours of the british press, or to add a splendid volume to the collections of the wealthy, that the editor was induced to adventure on the present undertaking. Not uninfluenced by professional, he acted also under the impulse of higher motives; and when he selected the *Night Thoughts* for the subject of his projected decoration, he wished to make the arts, in their most honourable agency, subservient to the purposes of religion; and by their allurements to solicit the attention of the great for an enforcement of religious and moral truth, which can be ineffectual only as it may not be read.

December 22nd, 1796 From its first appearance in the world, this poem has united the suffrages of the criticks in the acknowledgement of its superior merit. . . .

The principal charges which have been urged against this poem,

[1] Thomas Dodd wrote (about 1835) :'some few of the accompanying pieces are etch'd by *W. Blake,* which are decidedly more correct than those produced by the author' (BM Add. MSS. 33397, f. 257 ʳ).

[2] G. Cumberland, *Thoughts on Outline, Sculpture and the System that Guided the Ancient Artists in Composing their Figures and Groupes,* London, 1796, pp. 47–48.

[3] This clearly refers to the Boydells' magnificent illustrated editions of Milton and Shakespeare.

PLATE IX

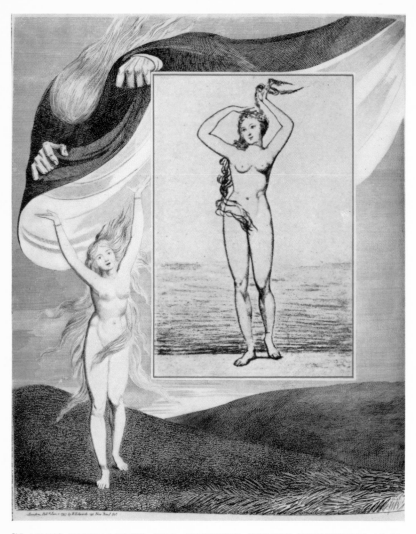

BLAKE'S ENGRAVING FOR YOUNG'S *NIGHT THOUGHTS* (1797),
p. 46. For the printed text of Young's poem in the middle of the design is substituted
the apprentice engraving of Thomas Butts (*c.* 1805) to indicate how he was copying Blake
(see pp. 52–60, 176, 402)

and which in some degree may have affected its popularity, are the dark tints of its painting; and the obscurities which occasionally occur in it to retard the progress of the reader. . . .

On the immediate subject of the present edition of this valuable work the editor has only to say that he has shrunk from no expence in the preparing of it; and that to make it as worthy in every respect as possible of the public favour has been the object of his particular and solicitous attention. It has been regarded by him, indeed, not as a speculation of advantage, but as an indulgence of inclination;—as an undertaking in which fondness and partiality would not permit him to be curiously accurate in adjusting the estimate of profit and loss. If this edition, therefore, of the *Night Thoughts* be found deficient in any essential requisite to its perfection, the circumstance must be imputed to some other cause, than to the oeconomy or the negligence of the editor.

Of the merit of Mr. Blake in those designs which form not only the ornament of the page, but, in many instances, the illustration of the poem, the editor conceives it to be unnecessary to speak. To the eyes of the discerning it need not be pointed out; and while a taste for the arts of design shall continue to exist, the original conception, and the bold and masterly execution of this artist cannot be unnoticed or unadmired. Dec. 22d. 1796.[1]

This is a strange piece of puffing. Edwards can say no more than that the editor is not to blame for any flaws in the work, and that Blake's designs 'cannot be unnoticed or unadmired'. With such unenthusiastic backing, it is perhaps not surprising that when the work came to be published in June of 1797 it was a failure.

The artistic sensation of the winter of 1797 was the alleged discovery, from an old manuscript, of Titian's secret of colouring. The process was submitted to the inspection of a committee of the Royal Academy consisting of Farington, Hoppner, Stothard, Rigaud, and Opie. On January 12th, 1797 they met on this business at Wright's Coffee House, but, according to Farington's diary, their attention was not devoted exclusively to their official purpose.

We supped together and had laughable conversation. Blakes eccentric designs were mentioned. Stothard supported his claims to Genius, but allowed He had been misled to extravagance in his

[1] E. Young, *The Complaint, and The Consolation; or, Night Thoughts*, London, 1797, pp. iii–viii.

art, & He knew by whom.—Hoppner ridiculed the absurdity of his designs, and said nothing could be more easy than to produce such.—
January 12th, 1797
They were like the conceits of a drunken fellow or a madman. 'Represent a man sitting on the moon, and pissing the Sun out—that would be a whim of as much merit.'—Stothard was angry mistaking the laughter caused by Hoppners description.—

Flaxman was mentioned, who Hoppner [equally *del*] spoke of with contempt as a draughtsman.— 'I cannot draw, but I can draw better than Flaxman can, and his thoughts are all borrowed & purloined from a variety of things which He has seen. He has nothing original abᵗ him.—['] Stothard defended Flaxmans claims but thought him overrated.— Hoppners description of Flaxmans figures was equally ridiculous as that of Blakes fancies.

Stothard's dark reference to Blake's seducer was probably meant for Fuseli, for, as Fuseli said on June 24th, 1796, Blake 'acknowledges the superiority of Fuseli'.

In the spring of 1797 Blake was one of nineteen engravers who signed a testimonial for a device invented by Alexander Tilloch to prevent banknote forgeries:

London, 5th April, 1797.

Mr. Alexander Tilloch, of Cary-street, London, having submitted to our inspection a Specimen of an Art invented by him, for the purpose of producing checks to prevent the forgery of Bank Notes, Bills of Exchange, Drafts, &c. &c. &c. we have examined the same
April 5th, 1797
with care and attention, and we DECLARE each of us for ourselves, that we could not make a copy of it, nor do we believe that it can be copied by any of the known arts of engraving. It therefore appears to us to be highly deserving of the notice of the Bank of England and private Bankers, as an Art of great merit and ingenuity, calculated, not merely to DETECT, but to PREVENT the possibility of forging Bank and other circulating Bills.

JAMES BASIRE, Engraver to the Royal Society and to the Society of Antiquarians. . . .

WILLIAM SHARP. . . .

W. S. BLAKE, (Writing Engraver). . . .

WILLIAM BLAKE. . . .[1]

The following prospectus was probably issued in the early spring of 1797:

[1] After the poet's name 'The Visionary Artist' is written in the copy of this printed testimonial in the possession of Mrs. George Galt, whose late husband was a descendant of Tilloch.

EDWARDS's
MAGNIFICENT EDITION
OF
YOUNG's NIGHT THOUGHTS.

EARLY in JUNE will be published, by subscription, part of the first of a splendid edition of this favorite work, elegantly printed, and illustrated with forty [*eventually forty-three*] very spirited engravings from original drawings by BLAKE.

These engravings are in a perfectly new style of decoration, surrounding the text which they are designed to elucidate. [*Spring? 1797*]

The work is printed in atlas-sized quarto, and the subscription for the whole, making four parts, with one hundred and fifty engravings, is five guineas;—one to be paid at the time of subscribing, and one on the delivery of each part.—The price will be considerably advanced to non-subscribers.

Specimens may be seen at EDWARDS's, No 142, *New Bond-Street*; at Mr. EDWARDS's, *Pall-Mall*; and at the HISTORIC GALLERY, *Pall-Mall*; where subscriptions are received.[1]

The *Night Thoughts* appeared at a most unfortunate juncture, because of the banking crash of the time and 'the abject and almost expiring state to which the fine arts had been reduced'.[2] Only four of the nine Nights were published, and most readers were not as enthusiastic as Bulwer Lytton, who many years later called them 'at once so grotesque, so sublime—now [*illustrated*] by so literal an interpretation, now by so vague and disconnected a train of invention, that the whole makes one of the most astonishing and curious productions which ever balanced between the conception of genius and the raving of insanity'.[3]

In the Royal Academy exhibition of May 1799 '*W. Blake*' exhibited no. '154 The last supper[:] "Verily I say unto you, that one of you shall betray me."—Matt. chap. 26. ver. 21'.[4] *May, 1799*

[1] The only copy I know of this very small flier (14·4 × 11·1 cm.) is in the John Johnson Collection in the Bodleian Library. Richard Edwards, who published the *Night Thoughts*, had a shop at 142 New Bond Street, and his brother James had one in Pall Mall.

[2] *Memoirs and Recollections of the Late Abraham Raimbach, Esq. Engraver*, ed. M. T. S. Raimbach, London, 1843, p. 22. About 1796 'Everything connected with them [*the arts*], was, of course, at the lowest ebb'.

[3] See Dec. 1830 and Plates VII, IX, X.

[4] In the index of *The Exhibition of the Royal Academy, M, DCC, XCIX*, The Thirty-First, London [1799], is 'W. Blake, 13, Hercules Buildings, Walworth—154'.

In the summer of this year George Cumberland apparently introduced Blake to a friend and neighbour of his, the Revd. Dr. Trusler.[1] Trusler gave Blake a commission to paint a picture representing 'Malevolence', and evidently included fairly strict instructions as to what he had in mind. On August 16th Blake wrote to Trusler:

I attempted every morning for a fortnight together to follow your Dictate, but when I found my attempts were in vain, resolvd to shew an independence I could not do otherwise, it was out of my power! I know I begged of you to give me your Ideas & promised to build on them[;] here I counted without my host [*my Genius or Angel*] . . . And tho I call them [*my Designs*] Mine, I know that they are not mine being of the same opinion with Milton when he says That the Muse visits his Slumbers & awakes & governs his Song when Morn purples the East.

The inspiration of the 'Malevolence' design[2] was somewhat second-hand, however, for it is clearly derived from *Europe* plate 3 and from the fifth plate illustrating Young's *Night Thoughts* of two years before.

Blake felt that the 'Drawing [*was*] in my best manner', but Trusler nevertheless 'sent it back [*at once*] with a Letter full of Criticisms in which he says It accords not with his Intentions which are to Reject all Fancy from his Work'.

August 18th– 22nd, 1799 *Your Fancy [said Trusler]* from what I have seen of it, & I have seen variety at M^r Cumberlands seems to be in the other world or the World of Spirits, which accords not with my Intentions, which whilst living in This World Wish to follow *the Nature of it*.[3]

Blake replied promptly on August 23rd:

I really am sorry that you are falln out with the Spiritual World

[1] Blake's letter of Aug. 23rd, 1799 is addressed to 'Rev^d D^r Trusler Englefield Green Egham Surrey' (BM Add. MSS. 36498, f. 328), and Thomas Taylor's letter to Cumberland of Oct. 7th, 1798 (now in the collection of The Historical Society of Pennsylvania) is addressed to Cumberland at 'Bishops Gate, near Egham Surry', so Cumberland and Trusler were neighbours. Blake wrote to Cumberland on Aug. 26th, 1799 'to thank you for your recommendation to D^r Trusler'.

[2] See Plate X.

[3] Trusler's letter must have been written between Aug. 17th, when he received Blake's first letter, and Aug. 23rd, when Blake replied to Trusler's strictures. Blake quotes Trusler's letter in his own letter to Cumberland of Aug. 26th. Trusler seems to have been thinking of using Blake's design in illustration of a book he was writing, perhaps in a similar vein to his *Luxury not Political Evil* or *The Way to be Rich and Respectable*.

PLATE X

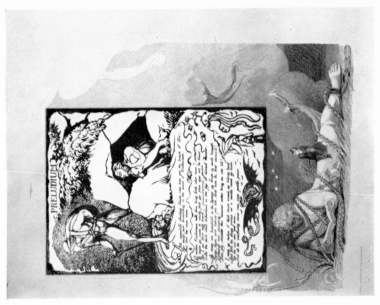

BLAKE'S ENGRAVING FOR *YOUNG'S NIGHT THOUGHTS* (1797), p. 15, with *Europe* (copy M), pl. 4 re-produced in place of Young's text to show its relationship to 'Malevolence'. The sizes here are much reduced

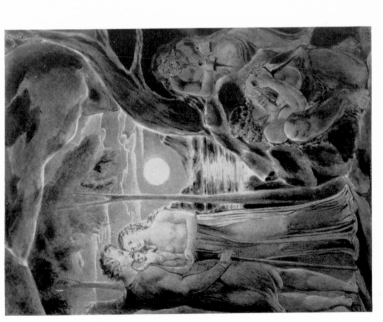

BLAKE'S 'MALEVOLENCE' (1799) which Dr. Trusler refused to buy (see pp. 60–61)

Especially if I should have to answer for it That which can be made Explicit to the Idiot is not worth my care. . . . I know that This World Is a World of Imagination & Vision[.] I see Every thing I paint In This Worl*d*, but Every body does not see alike. To the Eyes of a Miser a Guinea is more beautiful than the Sun To Me This World is all One continued Vision of Fancy or Imagination

Generous and righteous though Blake's indignation is, it is not perhaps surprising that Trusler considered the correspondence closed on receipt of this letter, docketed it 'Blake Dimd with Superstition', and gave it to Cumberland, with whose papers it is preserved.

One evidence of the friendships Blake was successfully making at this time is the inscription on the frontispiece of copy B of *America*: 'From the author to C H Tatham [*Monday*] Oct.ʳ 7 1799'. Tatham is not known to have owned any of Blake's other works in Illuminated Printing. It seems likely that the gift was not unconnected with Tatham's *Etchings, Representing the Best Examples of Ancient Ornamental Architecture*, 1799 [–1800], in the subscription list to which appears the name of 'Mr. William Blake'. *October 7th, 1799*

Such friendships were probably especially important to Blake at this time, when commissions for both designs and engravings were hard to come by. As the mother of Leigh and Robert Hunt wrote on June 18th, 1799: 'The engraving of Pictures is at present but a dull business. The war occasions a scarcity of cash, people in general find it difficult to obtain the necessary comforts of life, and have not a surplus of money for elegancies.'[1] Blake never again made as prosperous a living from his graver as he had from 1785 to 1795, nor was his poetic imagination as fertile and inventive again as it had been during those years. When the connoisseurs could not afford the elegancies of life, Blake often had to forgo some of his necessary comforts, and to throw himself more and more upon the patronage of a few men.

[1] L. A. Brewer, *My Leigh Hunt Library: The Autograph Letters*, Iowa City, 1938, p. 5.

PART III

PATRONAGE AND DEPENDENCE
'The Visions were angry with me'
1800–1805

———

When the commercial publishers failed him, Blake turned to Flaxman's friend William Hayley, an art connoisseur and popular poet with an independent mind and fortune. From 1800 onwards the interests of Blake and Hayley were extraordinarily intertwined.

At the end of 1799 Hayley was hurrying to finish his *Essay on Sculpture* in a Series of Epistles to John Flaxman, partly in order to please his illegitimate son Tom, who was dying of a spinal disease. On Saturday, December 21st he wrote to Flaxman:

For my first Edition I wish to have *only the two following Decorations*, if you approve the*m*—a Frontispiece & a vignette at the close—the 1st from poor Toms outline of Demosthenes at the base of Neptunes Statue (a scene described expressly for this purpose in the poem) & a neat small Head, as a closing vignette, from your medallion of the dear disciple, whose character I have sketch'd in the closing Epistle—You I know will have the Goodness to retouch for Him his Demosthenes in such a manner, that it may form an engrav'd outline, & yet still remain very fairly his own design—& you will have the goodness to desire our Friend Howard to make for me such a drawing from your medallion of the dear disciple, as may furnish us with a proper siz'd ornament for a quarto page to appear under the closing Lines of the Poem[.]—[1]

Samuel Rose was asked to help, and on Thursday, January 2nd, 1800 Hayley reported to him 'that our excellent Flaxman

[1] Vol. ix of the Hayley Correspondence in the Fitzwilliam Museum. Henry Howard (1769–1847) was a portrait and historical painter whom Flaxman had met in Rome about 1791. Hayley wrote in similar terms to Samuel Rose on the same day (vol. iii of the Hayley Correspondence in the Fitzwilliam).

approves, & Kindly promises to promote my plan for decorating the intended Publication in such a manner, as may most gratify my dear Invalide'.[1]

Flaxman had recommended Blake to do the engravings, and on Wednesday, January 29th, he wrote to report to Hayley on their progress: 'I have delivered the Drawing of Demosthenes to M⟨r⟩ Blake with the right orthography of the Dedication to Neptune, I have also consulted M⟨r⟩ Howard concerning the portrait of Friend Thomas for the Vignette, he prefers the Medallion to the Picture . . .'.[2] On February 18th Hayley told Rose 'I am vexed by a delay of our Friend Howards in regard to his medallion',[3] and he asked Rose to do what he could to hurry Howard along. Within a few days he had heard that the reason for Howard's delay was an inflammation of the eyes, and on Tuesday, February 25th he told Rose that the engraving of Demosthenes had arrived, '& the sight of it has been a real Gratification to his [*Tom's*] affectionate Spirit—. . . .—I yet hope the dear departing angel will see his own engraved portrait arrive before his own departure[.]'[4] *January 29th, 1800* *February 25th, 1800*

About this time Hayley's spirits were raised by an apparently successful operation on Tom, and in his letter to Rose of Friday, March 7th, he suggested that his friend Davies should enlarge his work by a volume on Greek poets, illustrated 'by works of Grecian & Etruscan art' engraved after outlines by Tom; '—it is a subject that deserves *mature deliberation*: with the aid of Flaxman, Howard, & that worthy ingenious Engraver Blake (who has done the outline of dear Toms Demosthenes delightfully) we might produce a Book that would do Credit to our Country[.]—'[5] *March 7th, 1800*

Tom's operation, however, proved to be another failure,

[1] Vol. iii of the Fitzwilliam Hayley Correspondence. Samuel Rose (1767–1804), a lawyer, was the intimate friend of Hayley and Cowper.

[2] No. 18 of a group of fifty-six Flaxman–Hayley letters in a green book in the Fitzwilliam. Sir Geoffrey Keynes owns this sketch, with 'the right [*Greek*] orthography' presumably supplied by Flaxman.

[3] Vol. iii of the Fitzwilliam Hayley Correspondence.

[4] Vol. iii of the Fitzwilliam Hayley Correspondence. Rose had also helped to expedite the Demosthenes engraving, which Blake had sent, 'approved by M⟨r⟩ Flaxman', on Feb. 18th.

[5] Vol. iii of the Fitzwilliam Hayley Correspondence. In his letter of March 12th (in the same collection) Hayley said that 'Davies approved our Suggestion for his Intended Book'. Davies may be Edward Davies, the Welsh antiquary and British Israelite, or William Davies, Hayley's publisher.

March 14th, 1800 as Hayley told Rose a week later, on March 14th: 'My beloved Cripple is sinking gradually in all probability—yet I felt or fancied his pulse much better yesterday—no news yet of the *Medallion*—I hope He will yet see it engraved[.]'[1]

March 23rd, 1800 By the 23rd Hayley was becoming quite anxious: 'What can have happend to our Friend Howard—Here is the last sheet of the poem, & no Medallion, & no Tidings of it[.]'[1] He complained gently to Flaxman about the delay, and on Wednesday, March 26th, Flaxman replied:

March 26th, 1800 It is equally Surprizing & unaccountable that you have had no farther news of the Engravings, for M[r] Howard finished a beautiful drawing from the Medallion of my Friend Thomas I think four weeks ago, since which time it has been in the hands of M[r] Blake & the copper plate from it is most likely done by this time, as well as that of the head of Pericles[;] but perhaps You are not acquainted with M[r] Blake's direction? it is N[o] 13 Hercules Buildings near the Asylum, Surry Side of Westminster Bridge[.][2]

All this anxiety finally had its desired effect, and on April 1st Blake wrote to Hayley:

With all possible expedition I send you a proof of my attempt to express your & our Much Beloveds Countenance. M[r] Flaxman has seen it & approved of my now sending it to you for your remarks.

Its arrival did not, however, soothe Hayley, who wrote to Rose on Wednesday the 2nd:

April 2nd, 1800 if the mild endurance of very long & encreasing Calamities is true Heroism [*Tom*] is assuredly one of the most heroic beings that ever existed—Here is the long-expected medallion arrived today from the Engraver Blake—& I must endeavour to be a Hero in another way & bear a most mortifying disappointment with serenity[,] for mortifying you will allow it to be when I tell you the portrait instead of representing the dear juvenile pleasant Face of yr Friend exhibits a heavy sullen sulky Head which I can never present to the public Eye as the Image of a Being so tenderly & so justly beloved. I believe I must have a fresh outline & a mere outline instead of it—but I shall consult the dear artist himself on his own Head to-morrow— . . .

[*Next day Hayley continued:*] I rode to consult the dear cripple

[1] Vol. iii of the Fitzwilliam Hayley Correspondence.
[2] No. 19 of the Flaxman letters in the green book in the Fitzwilliam.

PLATE XI

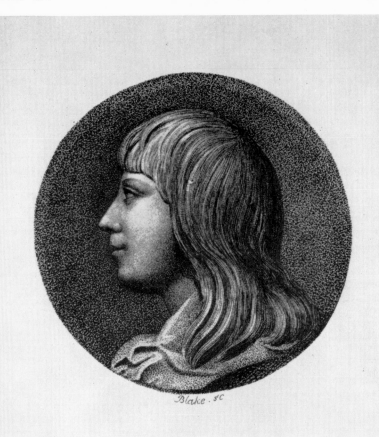

Blake . sc

THOMAS HAYLEY,

the Disciple of

John Flaxman.

from a Medallion.

BLAKE'S ENGRAVING OF FLAXMAN'S MEDALLION OF THOMAS
HAYLEY for Hayley's *Essay on Sculpture* (1800), altered, as Hayley requested, to give the
impression of 'gay juvenility' (see pp. 65–66)

on this unfortunate Head of Himself & He agrees with me that the drawing is all wrong[.]—[1]

Blake was asked to improve the plate, and apparently about ten days later he sent Hayley a proof of the reworked engraving (see Plate XI). The only letter from Hayley that Blake is known to have kept is his reply:

Thursday April 17 1800

My Dear Blake,

You are very good to take such pains to produce a Resemblance of our dear disabled artist—you have improved yr first plate a little, & I believe with a little more alteration it may be more like than the second outline.

April 17th, 1800

The great & radical defect I conceive to be this—the engraving is a Head 3 years older than the medallion—the Features by being made *longer & more sedate* have lost the *lively sensibility* of 16—our dear Flaxman's medallion is *very faithful* to that *time of Life*, & certainly *like* tho I cannot say I ever thought it a *very very strong* similitude of the *Individual*.

Truth, precision, & Force of character is that exquisite & subtle essence of art, which is so apt to escape from the finest & ablest Hand in the formation of Portraits, of whatever materials they are formed.

Romney, who was so marvellously happy in *several*, yet has failed egregiously in *many*; & so, I apprehend has *every* modern artist from the Revival of the Art to the present Hour—perhaps we should think so also of the antients if we saw all their portraits & the originals, altho yr great Connoisseurs presume to say, These said antients were far superior to the moderns in seizing this subtle Truth of character, particularly on their Gems & Medals.

But to speak of still farther alterations in yr first plate—would it not give a little younger appearance to shorten the space between the nose & the upper lip a little more by representing the mouth rather more open, in the act of speaking which appears to me the Expression of the medallion? I submit the part to you & our dear Flaxman with *proper deference* to yr *superior judgment*; as I do the following Question whether the making the Dot at the corner of the mouth a little deeper, & adding a darker Touch also at the

[1] Vol. iii of the Fitzwilliam Hayley Correspondence. Hayley was living at Eartham, and Tom was a few miles away in the Marine Turret which his father had built for him in Felpham. It appears from the last few words as if Tom were blaming Howard and not Blake.

Bottom of the Eye would add a little gay juvenility to the Features
without producing (what I by all means wish to avoid) a *Grin* or
a *Smirk*—In short I wish the character of the engraving to *harmonise
a little more*, than *it does at present*, with the following verses towards
the conclusion of the Poem, which as *you* are a *kind-hearted Brother
of Parnassus*, you will forgive my inserting in this letter to *explain
my meaning to you*—

> 'That youth of fairest Promise, fair as May,
> Pensively tender, and benignly gay,
> On thy Medallion still retains a Form
> In Health exulting, & with pleasure warm.
> Teach Thou my Hand, with mutual love, to trace
> His Mind, as perfect, as thy Lines his Face!
> For Nature in that Mind' &c

You will have the goodness not to shew these verses to any one,
except to our dear Flaxman, who will, I know, kindly assist you in
yr endeavours to catch the exact cast of character, that I wish you
to seize—I have to thank Heaven (as I do with my whole Heart)
for having been able to *gratify this dear departing angel* with a sight
of his *own Portrait united* to the *completion* of a *long*, & *severely
interrupted work*; which *He* most tenderly pressed me to *complete* &
which nothing I believe but *his wishes* could have enabled my wounded
spirit to pursue under the Heart-rending affliction of seeing a
child so justly beloved *perishing by slow Tortures*. His Life may
probably not last many days—accept our united Benedictions &
believe me dear Blake

<div align="right">

your very sincere Friend
W.H.[1]

</div>

May, A couple of weeks later the spring exhibition of the Royal
1800 Academy opened, showing as entry no. '685 The loaves and
fishes—*W. Blake*, H[*onorary*]'.[2]

[1] *Letters of William Blake*, ed. G. Keynes, London, 1956. The MS., which is
owned by Keynes, is endorsed on the back: 'Letter from Hayley the Poet to
Blake, found among the papers of the latter. F. Tatham.' The lines quoted appeared
unchanged on p. 160 (ll. 97–103) of Hayley's *Essay on Sculpture*, London, 1800.

[2] *The Exhibition of the Royal Academy*, M.DCCC. The Thirty-Second. Blake
was demoted to 'Honorary' because of the reforms undertaken by the Royal
Academy in 1799, when 'those students of ten years standing, who had not obtained
a medal, were excluded altogether' (*Memoirs and Recollections of the Late Abraham
Raimbach, Esq. Engraver*, ed. M. T. S. Raimbach, London, 1843, p. 27). Blake
had not been 'Honorary' in 1780, 1784, 1785, and 1799, nor was he again in
1808.

Thomas Hayley died on May 2nd, and Blake wrote four days later:

Dear Sir

I am very sorry for your immense loss, which is a repetition of what all feel in this valley of misery & happiness mixed. I send the Shadow of the departed Angel, hope the likeness is improved, the lip I have again lessened as you advised & done a good many other softenings to the whole—I know that our deceased friends are more really with us than when they were apparent to our mortal part. Thirteen years ago I lost a brother & with his spirit I converse daily & hourly in the Spirit & See him in my remembrance in the regions of my Imagination. I hear his advice & even now write from his Dictate. Forgive me for Expressing to you my Enthusiasm which I wish all to partake of Since it is to me a Source of Immortal Joy[:] even in this world by it I am the companion of Angels. May you continue to be so more & more & to be more & more perswaded, that every Mortal loss is an Immortal Gain. The Ruins of Time builds Mansions in Eternity.—I have also sent A Proof of Pericles for your remarks thanking you for the Kindness with which you Express them & feeling heartily your Grief with a brother's Sympathy[.]

For some years Blake had been a close friend of Thomas Butts, a clerk in the office of the Commissary General of Musters, who bought books and drawings from Blake at a rate that must have strained his known income. The Blakes and Buttses met regularly on Tuesday evenings, and one of their meetings was briefly recorded by twelve-year-old Tommy Butts in his diary for Tuesday, May 13th: 'Mr. and Mrs. Blake and Mr. T. Jones drank tea with mama'.[1]

May 13th, 1800

[1] The diary quotation is given by M. Wilson, *The Life of William Blake*, London, 1948, p. 84, with another of Sept. 13th. Two quite separate references from this diary are given by A. E. Briggs, 'Mr. Butts, the Friend and Patron of Blake', *Connoisseur*, xix (1907), 92–96, for Sept. 10th and 16th, 1800. It seems likely that the diary was in the Butts family, for Ada Briggs was the sister-in-law of Captain Frederick Butts, the only surviving grandson of Blake's patron, and Miss Wilson (pp. xii–xiii) gives thanks for information about the Butts family to her friend Mrs. Colville-Hyde, the remarried widow of Captain Butts. Inquiries about the diary through the family have proved fruitless; it may have been lost with other family treasures put in storage during World War II and destroyed by Nazi bombs.

The known facts about Butts, chiefly financial, are collected in 'Thomas Butts, White Collar Maecenas', *PMLA*, lxxi (1956), 1052–66. In his letter of Sept. 23rd, 1800 Blake told Butts: 'I shall wish for you on tuesday Evening as usual.' Briggs gives Tommy's dates as 1788–1862.

Hayley invited Blake to come down to his little hamlet by the sea, apparently so that Blake could work on a drawing and his engraving of Thomas Alphonso for a few days under Hayley's eyes.

On Saturday, July 5th Flaxman wrote to thank Hayley for his admirable *Essay on Sculpture*, and he went on: 'when Mͬ Hawkins left town he desired me to send You a Bas-relief of Paris & Helen framed, which I had no opportunity of doing without making the packing & carriage expensive, untill Mͬ Blake's departure who is so kind as to take charge of it together with a Roll (I believe of prints) which Mͬ Townley sent for You'. And in a P.S. Nancy asked 'for a Pocket volume from the dear Boy's Library—as a Keep Sake—for *Remembrancer* I need none'.[1]

During the last two weeks of July Hayley was polishing a poem to encourage Blake with his drawing of Thomas Alphonso.

<div align="right">M[*arine*] T[*urret*] July 12</div>

<div align="center">Sonnet</div>

Blake whose pure Thoughts the patient Graver guide
Kindly attentive to affection's Prayer
Let willing art exert her fondest Care
Well to portray in Nature's blooming pride
a youth as dear to both as ever died[;]

For in his morn of Life[,] a morn how fair[,]
In his expanding Talents rich & rare
all that announced perfection they descried[.]

 Laborious artist of a liberal Heart
atone for Errors of a skillful Hand
That failed the due Resemblance to impart
To that dear Form which prompts my tear to start[.]
As truth herself let his new portrait stand
Correctly beautiful & mildly grand[!]

<div align="center">July |15| 29[2]</div>

[1] Quoted from a microfilm of the MS. in the Library of the Historical Society of Pennsylvania.

[2] Quoted from the MS. in the possession of Mr. James Osborn of New Haven. The dates presumably signify that the poem was revised on the 15th and 29th. A fair copy (Vol. iv, no. 4) in a collection of Hayley's poems in the Cornell University Library (reproduced for me on microfilm) makes no significant changes.

PLATE XII

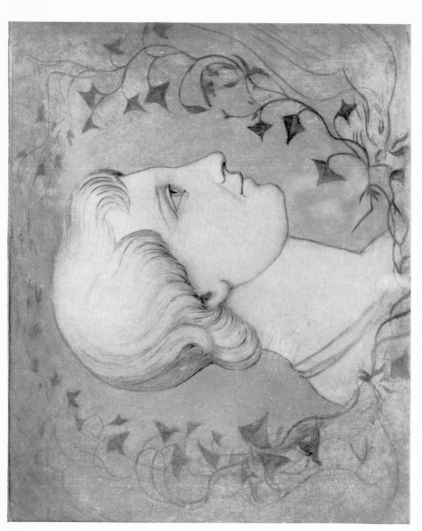

BLAKE'S WATER-COLOUR COPY (1800) OF THOMAS HAYLEY'S SELF-PORTRAIT
for Hayley's Library in Felpham, in which Blake made up for the engraved portrait (Plate XI) over which
Hayley suffered such 'mortification' (see pp. 69-71)

The portrait referred to in the poem above is the drawing by Blake after a self-portrait by Tom (see Hayley's letter of July 22nd, 1800). This may well have been the first step in Blake's portrait of Thomas, which was later placed among the worthies of literature in Hayley's Library.

The building of Hayley's Marine Turret had begun in 1797, and it seems probable that all along Hayley had planned to decorate it with portraits of great authors. An undated plan of the library that has been preserved[1] exhibits a long narrow room with a fireplace at one end, eight portraits on each long wall, and two on the wall facing the fireplace. These, numbered in clockwise order from the fireplace, represent (1) 'Cowp[er]', (2) 'Spen[ser]', (3) 'Cowley', (4) 'Cic[ero]', (5) 'Voltaire', (6) 'Shakespeare', (7) 'Dryden', (8) 'Sapph[o]',(9) 'Tass[o]', (10) 'Cam[oens]', (11) 'Anac[reon]' replaced in pencil by 'Ercilla', (12) 'Pope', (13) 'Euripides', (14) 'Ariosto', (15) 'Dem[osthenes]', (16) 'Homer' replaced by an illegible word, (17) 'Liv[y]' replaced by 'Horace', and (18) 'Gib[bon]'. In the eighteen portraits that Blake eventually made (the order of which is not known), nos. 3, 8, 13, 14, and 16–18 above were replaced by Chaucer, Milton, Otway, Dante, Homer, Klopstock, and Thomas Alphonso Hayley.[2] Those of Demosthenes, Shakespeare, Tasso, and Klopstock derive from designs by Tom. The plan underwent further changes between the manuscript quoted above and the final portraits, for on November 26th, 1800 Blake says he has been 'Absorbed by the poets Milton, Homer, Camoens, Ercilla, Ariosto, and Spenser, whose physiognomies have been my delightful study'. Blake's partial list includes two poets from the original list who were finally included (Camoens and Spenser); two who were not on the

Another undated sonnet on Tom's death (Vol. iv, no. 8) may perhaps refer to Blake's drawing after Tom's self-portrait. The sestet reads:

Young Artist in whose Works my Eyes rejoice[,]
Thy own just Portrait I most fondly bless[,]
For there I still a living son possess[,]
My Bosom Friend by nature and by choice[;]
But all the arts combin'd could neer express
How mild thy manners were[,] how sweet thy voice[.]

(The same poem, unchanged, is to be found in the Osborn MSS.)

[1] In a box marked 'Hayley' among the Osborn MSS.

[2] K. Povey ('Blake's "Heads of the Poets"', *N & Q*, cli [1926], 57–58) identifies the portraits. See Plate XII.

original list as emended (Homer and Milton); one who is only on the emended list (Ercilla); and one who appeared on the original list but who was eventually eliminated (Ariosto). On September 11th, 1801 Blake told Butts 'Mʳ Hayleys Library . . . is still unfinishd but is in a finishing way & looks well'.

After Blake had been at Felpham some time Hayley replied to Flaxman's letter of the 5th.

July 16th, 1800 My very dear Flaxman

 as I find our good enthusiastic Friend Blake will (in his Zeal to render the Portraits of our beloved scholar more worthy of Him) extend the time of his Residence in the south a little longer than we at first proposed, I shall not wait to transmit my Thanks to you for a Letter of infinite Kindness by the worthy Engraver on his Return.— . . .

 The good Blake is taking great pains to render all the Justice in his Power to Romneys exquisite Portrait of Him, & I hope the two next prints will atone for all the defects of the engraved Medallion—¹

 It will please you to hear that, as a Tribute to the Genius of our poor disabled Romney we have preserv'd, & I think improv'd, in a Copy of considerable size, the Miltonic design of our old Friend, that you remember on the Boards of Demogorgons Hall,² as we us'd to call his p[*ainting*] apartment—But I [*shall le*]ave the good Blake to [*carry*] on with a History of what He h[*as*] done in the South on his Return, & only add at present his kind Remembrance to you & yr dear Nancy with the cordial Benediction

<div align="right">of yr ever
affectionate & afflicted
Hermit</div>

The Turrett

[*Wednesday*] July 16 1800

pray assure Nancy with my Love to her, that such a little Book as she desires shall travel to Her by the Favor of Blake— I was highly gratified by the Kind presents from Messieurs Hawkins & Townley which you were so good as to send me under his friendly Care— adieu[.]—³

¹ Blake seems to have been engraving after a portrait of Tom by Romney, but no copy of this print has survived. Romney's group portrait of Meyer, Hayley, and Tom, engraved by Caroline Watson, forms the frontispiece to Vol. ii of Hayley's *Memoirs*, 1823.

² This may mean that Paine had helped to fit up Romney's studio—see May 29th, 1792 and Tatham, p. 530.

³ Vol. ix of the Hayley Correspondence in the Fitzwilliam Museum.

For some time Hayley had been courteously fencing with Lady Hesketh, Cowper's cousin, over who should actually write the life of their late friend,[1] and on the 22nd he wrote to her saying that her biography should be published as a series of letters to Earl Cowper.

I shall have a pleasure in furnishing yr Book with an Engraving of his expressive countenance from the exquisite portrait by Romney, which now adorns the Library of my marine Turret, & which I could not bear to send away from my daily contemplation of it— but a very happy Incident will render that *unnecessary* for a most worthy, enthusiastic Engraver, who has within these few days finished for me a small drawing (from a most wonderful portrait, as large as Life, which my dear crippled child contrived to execute of Himself in crayons) has attached himself so much to me, that He has taken a cottage in this little marine village to pursue his art in its various Branches under my auspices, & as He has infinite Genius with a most engaging simplicity of character I hope He will execute many admirable things in this sequestered scene, with the aid of an excellent Wife, to whom he has been married 17 years, & who shares his Labours and his Talents—

July 22nd, 1800

He has already made me most agreable amends for the mortification I suffered in seeing that *very unfaithful* representation of my dear child, which appears in the volume I had the Honour to send you—a portrait drawn from the medallion by an excellent artist, but in a most unfavorable season, when he [*Howard*] was suffering from enflamed Eyes & too great a Pressure of business!—[2]

The move was one that promised great benefits to Blake, and 'his friend, Mr Butts, rejoiced aloud, deeming his protégé's fortune made'.[3]

Three weeks later Hayley was still as enthusiastic about his new friend. On Monday, August 11th, he wrote to Blake's old patron John Hawkins to thank him belatedly for 'the Cast of your admirable Bronze!' which Blake had delivered, and to describe a lady who spoke of Klopstock, the 'Milton of Germany',

[1] Cf. 'Blake, Hayley, and Lady Hesketh', *Review of English Studies*, N.S., vii (1956), 264–8. Caroline Bowles commented unkindly but aptly to Southey after Hayley's death: 'Hayley wrote epitaphs upon his dearest friends before their eyes were well closed—a sort of poetical carrion crow!' (*The Correspondence of Robert Southey with Caroline Bowles*, ed. E. Dowden, London & Dublin, 1881, vol. ii, p. 64.) [2] BM Add. MSS. 30803A. See Plate XII.

[3] Gilchrist, 1942, p. 124; 1863, p. 147.

with a mixture of modesty, affection, & Enthusiasm—

I cannot write the word Enthusiasm without recollecting that worthy Enthusiast, the ingenious Blake, who appeared the happiest of human Beings on his prospect of inhabiting a marine Cottage in this pleasant village: yet happy as He was, He thought one Circumstance would encrease his Felicity:—you are too modest to guess, what this Circumstance may be:—I will therefore tell you—but alas! I must tell it with a Sigh, because we despair of seeing it realized. Are you yet aware, that I allude to his wish of seeing *you also* settled *in Sussex*?[1] a wish, that I should share with Him most ardently, if I discerned any probability of its being crowned with success![2]

August 11th, 1800

Flaxman's first reference to Blake's move appears in a letter of Tuesday, August 19th, in which he told Hayley:

August 19th, 1800

You may naturally suppose that I am highly pleased with the exertion of Your usual Benevolence in favour of my friend Blake & as such an occasion offers you will perhaps be more satisfied in having the portraits engraved under your own eye, than at a distance, indeed I hope that Blake's residence at Felpham will be a Mutual Comfort to you & him, & I see no reason why he should not make as good a livelihood there as in London, if he engraves & teaches drawing, by which he may gain considerably as also by making neat drawings of different kinds but if he places any dependence on painting large pictures, for which he is not qualified, either by habit or study, he will be miserably decieved[.]—[3]

Johnson and Fuseli also urged Blake to concentrate more upon his own monetary interests. On January 10th, 1802 Blake wrote from Felpham to his patron Butts: 'I find on all hands great objections to my doing any thing but the meer drudgery of business & intimations that if I do not confine myself to this I shall not live This from Johnson & Fuseli brought me down here & this from Mr H will bring me back again, for that I cannot live without doing my duty to lay up treasures in heaven is Certain & Determined . . . '.

In September, despite the bustle of uprooting themselves for

[1] Hawkins finally bought Bignor Park, only a few miles from Eartham and Felpham, in 1806, three years after Blake left Sussex.

[2] Quoted from a reproduction of the MS. which has been placed on deposit in the Sussex County Record Office along with other voluminous Hawkins family papers by Miss Johnstone of Trewithen, Cornwall.

[3] No. 21 of a group of Flaxman–Hayley letters in a green book in the Fitzwilliam.

the move to Felpham, the Blakes were busy seeing old friends in anticipation of the long parting. In his diary for the autumn of 1800, young Tommy Butts wrote: '[*Wednesday*] September 10th, Mr. and Mrs. Blake, his brother, and Mr. Birch came to tea'.[1] Catherine may have brought with her on this occasion her drawing inscribed 'Agnes / from the Novel of the Monk / Designed & Painted by Catherine Blake / & Presented by her in Gratitude & Friendship to Mrs. Butts'.[2]

September 10th, 1800

These teas may have been rather elegant occasions, for the Butts family long preserved a 'George III Tea Pot and Stand' and a 'George III silver Mug' 'traditionally stated [*in the family*] to be used by BLAKE'.[3]

Three days later, on Saturday the 13th, Tommy again noted in his diary: 'Mr. Blake breakfasted with Mama.'[4]

September 13th, 1800

Though he had undertaken the biography of Cowper, Hayley told Lady Hesketh on that same day: 'I am at present finishing a work devoted to the memory of my dear child, which I mean to print in November, with two engraved portraits of Him more faithful to his expressive Countenance, than the miserably unjust Medallion in the Essay on Sculpture[.]'[5]

The Blakes had intended to set out for Felpham on Tuesday, September 16th, but on that day Blake had to write to Hayley saying they would be delayed: 'My Dear & too careful & over joyous Woman has Exhausted her strength to such a degree with expectation & gladness added to labour in our removal that I fear it will be Thursday before we can get away from this —— City.... My fingers Emit sparks of fire with Expectation of my future labours[.]'[6] Instead he took time to go round

[1] For the source and complexities of this quotation, see the note to May 13th, 1800. The brother was James. John Birch (1745?–1815) was a surgeon of St. Thomas's Hospital, London, and an enthusiastic advocate of the use of electricity in medicine. There are frequent references to him in Blake's letters: e.g. (Dec. 18th, 1804), 'My wife continues well, thanks to Mr. Birch's Electrical Magic'.

[2] G. Keynes, *Bibliotheca Bibliographici*, London, 1964, no. 469.

[3] Dec. 19th, 1932, Sotheby sale of the property of (among others) Anthony Bacon Drury Butts, great-grandson of Thomas Butts, Lots 122 and 123, hallmarked 1792, 1794, and 1796. [4] See the note to May 13th, 1800.

[5] BM Add. MSS. 30803A. When Hayley's biography of his son appeared in 1823 it had no plates by Blake.

[6] Coleridge reports a similar phenomenon occurring in himself about 1801 or 1802 (*Collected Letters of Samuel Taylor Coleridge*, ed. E. L. Griggs, Oxford, 1959, vol. iv, p. 731): 'I have myself once seen (i.e. appeared to see) my own body under the bed cloaths flashing silver Light from whatever part I prest it—and the

September
16th,
1800
to see Mrs. Butts, as her small son noted in his diary: 'September 16th, Mr. Blake had breakfast with mama'.[1]

Blake and his wife and sister did in fact set off that Thursday between six and seven o'clock on a glorious morning, and after a cheerful but wearing trip they arrived in Felpham at 11.30 that night, having had to shift their sixteen boxes and portfolios to seven different chaises during the course of the trip. Blake immediately set to work next day, and found, as he told Flaxman on the 21st, that 'Felpham is a sweet place for Study, because it is more Spiritual than London[.] Heaven opens here on all sides her golden Gates' To their delight 'Mr Hayley recievd us with his usual brotherly affection'. After he and Catherine had had a chance to settle 'the sticks & feathers of [their] nest', Blake wrote to Butts:

Dear Friend of My Angels

We are safe arrived at our Cottage Please to tell Mrs Butts that we have dedicated a Chamber [to h]er Service My Wife & Sister are both very well & courting Neptune for an Embrace Meat is cheaper than in London but the sweet air & the voices of winds trees & birds & the odours of the happy ground makes it a dwelling for immortals. Work will go on here with God speed—A roller & two harrows lie before my window. I met a plow on my first going out at my gate the first morning after my arrival & the Plowboy said to the Plowman 'Father The Gate is Open[.]'

Four days after their arrival,

September
22nd,
1800
On [*Monday*] the 22d of September He [*Hayley*] wrote a[n interesting del] Ballad, entitled Little Tom the Sailor. It was printed with two designs by Mr Blake the Engraver, who had now settled himself in a Cottage near the poet, to execute various works of art, & particularly the prints, with which He hoped to decorate the projected Life of Cowper. The Ballad was successfully devoted to relieve the necessities of a meritorious poor Woman on the Kentish Coast, whose misfortunes Mrs. Rose had imparted to Hayley, & whose heroic sea Boy was the Hero of the Ballad.—[2]

same proceed from the tips of my fingers. I have thus written, as it were, my name, Greek words, cyphers &c on my Thigh: and instantly seen them together with the Thigh in brilliant Letters of silver Light.'

[1] See the note to the entry of May 13th, 1800 for the complex source of this quotation.

[2] Quoted from a microfilm of the MS. (vol. vi, pp. 44–45) in the Yale University Library corresponding to Hayley's published *Memoirs*, vol. ii, pp. 22–23— see June 1823. See also Plate XIII.

PLATE XIII

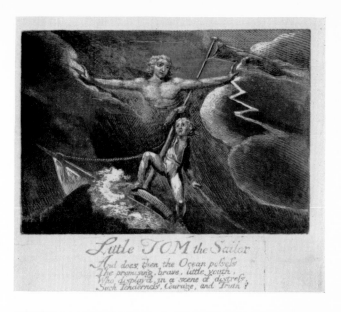

BLAKE'S DECORATIONS FOR HAYLEY'S 'LITTLE
TOM THE SAILOR' (1800) (see p. 74), with the ten central
stanzas of the broadsheet omitted

Butts replied to Blake's letter within a few days:

Marlborough Street

Dear Sir

I cannot immediately determine whether or no I am dignified by the Title you have graciously conferred on me—you cannot but recollect the difficulties that have unceasingly arisen to prevent my discerning clearly whether your Angels are black white or grey and that on the whole I have rather inclined to the former opinion and considered you more immediately under the protection of the black- *September* guard[;] however at any rate I should thank you for an introduction [*26th?*] to his Highness["]s Court that when refused admittance into other *1800* Mansions I may not be received as a stranger in His[.]

I am well pleased with your pleasures feeling no small interest in your Happiness and it cannot fail to be highly gratifying to me and my affectionate Partner to know that a Corner of your Mansion of Peace is asylumd to Her & when invalided & rendered unfit for service who shall say she may not be quarterd on your Cot—but for the present she is for active Duty and satisfied with requesting that if there is a Snug Berth unoccupied in any Chamber of your warm Heart that her Portrait may be [suspended *del*] ther*e*, at the same time well aware that you like me prefer the Original to the Copy— Your good Wife will permit & I hope may benefit from the Embraces of Neptune but she will presently distinguish betwixt the warmth of his Embraces & yours, & court the former with caution[.][1] I suppose you do not admit of a third in that concern or I would offer her mine even at this distance[.] Allow me before I draw a Veil over this interesting Subject to lament the frailty of the fairest Sex for who alass! of us my good Friend could have thought that

> So Virtuous a Woman would ever have fled,
> From Hercules' Buildings to Neptunes Bed[?][2]

Whether you will be a better Painter or a better Poet from your change of ways & means I know not; but this I predict; that you will be a better Man—excuse me, as you have been accustomed from friendship to do, but certain opinions imbibed [from indulgence *del*] from reading, [rivitted *del*] nourishd by indulgence, and rivitted by a confined Conversation, and which have been equally prejudicial to your Interest & Happiness, will [gradually *del*] now I trust,

[1] An earlier draft of this sentence read 'but they [*the Embraces of Neptune*] must be courted with far more caution than yours . . . recollecting that what may be taken by all must be prejudicial to some'.

[2] This couplet was first expressed as prose: 'that so [good *del*] virtuous a Woman would ever have [bartered *del*] exchanged the Buildings of Hercules for the Bed of Neptune?'

disperse as a Day-break Vapour, and you will henceforth become a Member of that Community of which you are at present, in the opinion of the Archbishop of Canterbury, but a Sign to mark the residence of dim incredulity, haggard suspicion, & bloated philosophy[1]—whatever can be effected by sterling [good *del*] Sense by opinions which harmonize [with *del*] society & beautify creation, will, in future be exemplified in you & the time I trust is not distant and that because I truly regard you when you will be a more valorous Champion of Revelation & Humiliation than any of those who now wield the Sword of the Spirit[;] with your natural & acquired Powers nothing is wanting but a proper direction of them & altho the way is both straight & narrow I know you too well to fear your want of resolution to persevere & to pursue it—you have the Plough & the Harrow in full view & the Gate you have been prophetically told is Open[;] can you then hesitate joyfully to enter into it[?]

I have much to congratulate you on—Meat cheap, Music for nothing[,] a command of the Sea and brotherly affection fluttering [at your Window *del*] around ye— The Arts have promised to be propitious and the Graces will courtesy to your wishes—

Happy, happy, happy Pair,[2]
On Earth, in Sea, or eke in Air,
In morn, at noon, & [een all *del*] thro' the Night
From Visions fair receiving light
Long may ye live your Guardians Care,
And when ye die may not a Hair
Fall to the lot of Demons black
Be singed by Fire or heard to crack
But may your [friendly *del*] faithful Spirit[s *del*] upward bear
Your gentle Souls to him whose care
Is ever sure and ever nigh
Those who on Providence rely
And in his Paradise above
Where all is Beauty Truth & Love
O May ye be allowed to chuse
For your firm Friend [the fairest *del*] a Heaven born Muse
From purest Fountains sip delight
Be cloathed in Glory burning bright,
For ever blest for ever free
The [fairest *del*] loveliest Blossoms on Lifes Tree[.]

[1] 'in the opinion of the Archbishop of Canterbury' was added as an afterthought and therefore scarcely implies that John Moore (Archbishop of Canterbury 1783–1805) spoke directly about Blake.

[2] This line appears in Dryden's 'Alexander's Feast', which was frequently sung at musical festivals.

I have no more Nonsense for you just now but must assure you that I shall always sincerely devote myself to your service when my humble endeavours may be useful— Mrs Butts greets your Wife & charming Sister with a holy Kiss and I with old Neptune bestow my Embraces there also—for myself I commend you to the protection of your Guard & am

<div align="center">

Dear Sir
yours most Cordially
& faithfully[1]

</div>

Blake replied with unusual promptness and deference on October 2nd:

Friend of Religion and Order
 . . . Your prediction will I hope be fulfilled in m*e*, & in future I am the determined advocate of Religion & Humility the two bands of Society.

In November Hayley seems to have left Felpham for a time, and to have written asking for more copies of the Ballad of 'Little Tom the Sailor', and on the 26th Blake replied that because of

my wife's illness not being quite gone off she has not printed any more since you went to London. But we can muster a few in colours and some in black which I hope will be no less favour'd tho' they are rough like rough sailors. We mean to begin printing again to-morrow. Time flies very fast and very merrily. I sometimes try to be miserable that I may do more work, but find it is a foolish experiment. Happinesses have wings and wheels; miseries are leaden legged, and their whole employment is to clip the wings and to take off the wheels of our chariots. We determine, therefore, to be happy and do all that we can, tho' not all that we would.

He must have printed and sent more copies to Hayley promptly, for on Thursday, December 4th Hayley wrote to his old friend *December* George Romney: 'I send you a Ballad which I have recently *4th,* written for a charitable purpose with decorations by our good *[1800]*

[1] The undated draft of this letter in the collection of Kerrison Preston begins in a beautiful, clerkly copperplate hand and degenerates, through many deletions which I have ignored, to hasty pencil at the end ('From purest Fountains sip delight'), later darkened in ink. It may be given an approximate date with some confidence because it answers Blake's letter of Sept. 22nd and in turn was answered by Blake on Oct. 2nd, 1800.

enthusiastic Blake, who is happily settled in that Cottage in Felpham which you used to admire[.]—'[1]

On Sunday, January 25th, 1801 Lady Hesketh's sister Theodora wrote to protest about the proposal to include the engraved portrait after Romney in Hayley's biography of Cowper: 'His having mention'd the *Artist* whom he has employ'd in the Engravings so intended for the present work induces me to say *January* that I have it very much at heart to obtain some alteration at *25th,* least in the Print w.ch in my opinion will have a very contrary *1801* effect. Surely it is an Unjust and most unfavorable representation of the Dear Departed!'[2]

Hayley, however, was enthusiastic about Blake's abilities, and on Tuesday, February 3rd, he wrote to the failing Romney:

It may interest you perhaps to hear that I am very busy at present in writing a Life of our beloved Cowper, & the good Enthusiastic *February* Blake, who is most happily settled in the Cottage, that you used so *3rd,* much to admire in this Marine Village, is also at work on the same *1801* subject, I have taught him he says to paint in Miniature, & in Truth he has made a very creditable copy from your admirable Portrait of the dear departed Bard, from which he will also make an engraving[.] How often in our social Labours have I wish'd that the Caro Pittore was also at work by our side![3]

On Wednesday, February 25th, he wrote to Lady Hesketh:

pray, my dear Lady, have you the little picture of his Mother.—I *February* think the Life should contain an engraving of that Portrait, as well *25th,* as of her Son, & I have an excellent enthusiastic Creature, a Friend *1801* of Flaxmans, under my own Eye residing in this village; He is by profession an Engraver, but He says I have taught Him to paint in miniature & in Truth He has improved his excellent versatile Talents very much in this retired scene, where He has constant access to several very fine works of art by my Friend Romney, & by that very wonderful young artist, my dear departed child!—I intend that this

[1] Vol. ix of the Hayley Fitzwilliam Correspondence. The letter is addressed only to 'Carissimo Pittore', but it is preserved with Hayley's letters to Romney and his son, and it sends love from Lady Hamilton, Romney's beloved model. The date is merely Thursday, Dec. 4th, but in 1800 Dec. 4th fell on a Thursday.

[2] BM Add. MSS. 30803A. The year is missing from the date of the letter, but such protests were very much in the air early in 1801. The letter was evidently meant to be enclosed by Lady Hesketh to Hayley.

[3] Quoted from Hayley's 'copy' of his letter in the Princeton University Library. The salutation is merely 'Carissimo Pittore', as usual in Hayley's letters to Romney.

very amiable Man shall execute, under my own Inspection, all the plates for the Work; & I am persuaded He will produce a Head of Cowper, that will surprise & delight you; & assuredly it will be executed *con amore*, as he idolizes the Poet, & will have as fine a portrait to work from, as ever pencil produced.—[1]

Cowper's young cousin Johnny Johnson, who had recently been to Felpham, wrote gaily to Hayley on Tuesday, March 17th: 'P.S. Remember me most kindly to our dear friend Blake, and the Duck to whom he is a Drake!—Also to the incomparable inhabitant of the Peerless Villa of Lavant.—One of these days I hope to see you all again.'[2] *March 17th, 1800*

Hayley sent Lady Hesketh Blake's miniature after Romney's portrait of Cowper, and on Thursday, March 19th she wrote fiercely:

[*On one subject*] I am *determin'd—absolutely determind!*—I mean the subject of the picture, which I have *this moment* receiv'd and for which I do indeed thank you; tho.' the Sight of it has in *real truth* inspired me with a degree of horror, which I shall not recover from in haste! . . . I cannot restrain my Pen from declaring that I think it *dreadful! Shocking!* and that I intreat you on my Knees not to suffer so horrible a representation of our angelic friend to be presented to the publick and to disgrace and disfigure a work I long so much to see[.] I give you my word that I opend the elegant Case you sent me without y^e smallest spark of *prejudice*, not having heard a Sylable about this picture from anybody *but yourself*, and tho.' I thought perhaps that it wou'd be difficult for *any* resemblance of our friend to please me so well as that of my Lawrence, yet I still hoped, and *expected* to be *pleased* with any picture which He had sat for;—but Alas! how am I disappointed? . . . I cannot bear to have it in my possession nor wou'd I for worlds, shew it to *any one* I must observe that I have no doubt that the *Original* from which this fatal Miniature is taken is a very fine *Picture*, considered *as a Picture*, & I even believe the miniature is very well executed . . . [*but I must intreat*] that you will not be so cruel as to multiply this fatal resemblance, by having the picture *engrav'd*[!]][3] *March 19th, 1801*

[1] BM Add. MSS. 30803A. The picture of Cowper's mother by D. Heins was eventually engraved by Blake for vol. i of the Life. In his letters to Lady Hesketh of Jan. 12th and 15th, 1801 Hayley had mentioned work done by 'my secretary' and 'by a sick secretary', and these references may have been to Blake.

[2] Bodleian Library, MSS. Eng. misc. d. 134, no. 66. The lady of Lavant was Henrietta Poole, to whose house Hayley, and with him Blake, often went for gossip and the mail. [3] BM Add. MSS. 30803A.

Lady Hesketh's objection to Blake's miniature was clearly based upon the faint hint in Romney's portrait of the sitter's madness.

March 20th, 1801 To this outburst Hayley replied discreetly but evasively the next day: 'I am more concerned than surprised at the Impression which the picture made on yr Fancy—you may be confident that I shall endeavour not to wound yr affectionate Feelings on this Subject—The experiment I have already made has convinced me that no Engraving from the work of Romney would satisfy yr Imagination[.]'[1] Hayley was equally determined to include the Romney portrait, and evidently work on it went forward without a pause.

All this time Blake seems to have been busy making miniatures as well as engravings, for two months later Hayley sent a picture of his dead wife to David Parker Coke, with the following letter:

[*Wednesday*] May 13

My dear Sir

May 13th, 1801 I hope the inclosed little portrait may prove an agreable surprize to you—I have long wished to send you such a memorial of a wonderful Being, equally entitled to our admiration & our pity—a Being to whom your Friendship was an Honour & a delight.—

My dear Tom intended to execute for you such a Resemblance of Mrs H— His own calamitous Illness & Death precluded Him from that pleasure— I have recently formed a new artist for this purpose by teaching a worthy creature (by profession an Engraver) who lives in a little Cottage very near me to paint in miniature—accept this little specimen of his Talent as a mark of Kind Remembrance from

yr sincere & affectionate Friend

W Hayley[2]

At this time (May 10th) Blake was telling Butts 'M^r Hayley acts like a Prince. I am at complete Ease Miniature is become a Goddess in my Eyes & my Friends in Sussex say that I Excell in the pursuit. I have a great many orders & they Multiply. . . . Sussex is certainly a happy place & Felpham in particular is the sweetest spot on Earth[.]'

June 17th, 1801 Johnny Johnson closed a letter to Hayley about Cowper's genealogy on Wednesday, June 17th with a request: 'Remember

[1] BM Add. MSS. 30803A.

[2] Quoted from the MS. in the possession of Sir Geoffrey Keynes. The postmark gives the date.

me kindly to M^rs Lambert and to the good enthusiastic Blake.'[1]

Hayley told Joseph Cooper Walker on Saturday, July 25th:

—I have an amiable artist now working by my side on the plates, with which we hope to decorate the Life. He is at this moment engraving that portrait of the poets mother, to which He [*Cowper*] address'd a little poem of exquisite Beauty & pathos— I hope by Xmas the united Labours of the Engraver & the Biographer will be completed for the press; but they cannot be so, unless we in some measure neglect almost all other objects of our attention, so forgive me for an abrupt adieu![2]

July 25th, 1801

Hayley's old friend John Carr made a visit to Felpham in the summer of 1801, bringing with him some sketches he had made on his travels. After his departure he wrote to his host, on Thursday, July 30th: 'Many thanks to the ingenious Artist of Felpham for his remembrance of me, & to both of you for your favourable opinion of my rude untutord delineations of Nature.'[3]

July 30th, 1801

Early next month, on Thursday, August 13th, Johnny wrote again to Hayley about his progress with the editing of Cowper's translation of Homer: 'P.S. The Iliad is finished—and the Odyssey just begun. Johnson shall send you down the first two volumes directly Kind remembrances to the Blakes.'[4]

August 13th, 1801

Some three weeks later Hayley squeezed a few last words down the inside margin of his letter to Johnny of Thursday, September 3rd: 'The good Blake is finishing very happily the plate of the poet's mother[.] He salutes you affectionately—'.[5] And two days later, on Saturday the 5th, Hayley wrote after the signature of his letter to John Carr: 'Blake who is engraving at my side salutes you affection[*ately;*] we frequently talk of yr very original & masterly manner of sketching Land-

September 3rd, 1801

September 5th, 1801

[1] Bodley MSS. Eng. misc. d. 134, no. 76.

[2] Vol. xv of the Fitzwilliam Hayley MSS. J. C. Walker is probably the Irish antiquarian of that name, with whom Godwin and others corresponded.

[3] This MS., like the rest of the letters from Carr to Hayley quoted below (Sept. 9th, 15th, 1801, April 10th, Aug. 6th, Oct. 17th, 1802, Jan. 29th, 1803, Feb. 4th, 1804, March 11th, 28th, 1805), came to the Princeton University Library from the Collection of Professor Neilson C. Hannay.

[4] Bodley MSS. Eng. misc. d. 134, no. 78. The Johnson mentioned is Joseph, the London bookseller who published the translation.

[5] Quoted from the MS. in the volume of Hayley–Johnson Correspondence in the Fitzwilliam.

scape—adieu[.]'[1] In his reply on Wednesday the 9th Carr
said: 'Pray remember me warmly to M.ʳ Chetwynd. he is a noble
Youth—You & Blake have made a Coxcomb of a wretched
untutored Artist[.]' This suggests that Hayley and Blake had
been teaching, or at least praising, Mr. Chetwynd, whom Blake
later (September 28th, 1804) described as 'a Giant in body
mild & polite in Soul as I have in general found great bodies
to be'.

In his letter to Hayley of Tuesday the 15th Carr wrote: 'I
beg also to be remembered to M.ʳ Blake, whose modesty is the
Companion of much merit. I shall long to see his Head of
Cowper[.]' This is useful testimony as to the impression Blake
made on Hayley and his friends at this time. Within just two
years Hayley began to think that Blake claimed considerably
more merit than modesty or truth would justify.

On the first of the next month Hayley wrote to Johnny:

October you see is arriv'd & you my dear Johnny *will arrive* I
trust before half this pleasant Month shall pass away; for we want
you as a faithful Coadjutor in the Turret more than I can express.

I say *we*; for the warmhearted indefatigable Blake works daily
by my side, on the intended decorations of our Biography.—Engrav-
ing, of all human Works, appears to require the largest Portion of
patience,[2] & He happily possesses more of that inestimable Virtue,
than I ever saw united before to an Imagination so lively & so prolific!

Come, & criticize what we have done!—Come & assist us to do
more! . . . Blake joins me in wishing you a speedy & pleasant Journey
to the Turret[.][3]

At the end of his letter of Wednesday, October 7th to Hayley,
Flaxman added a note: 'I shall beg your perm[i]ssion to

[1] Quoted from Hayley's 'Copy' of his letter in the Princeton University Library.

[2] In a letter to Lady Hesketh of Jan. 10th, 1802 (now in Princeton), Hayley
wrote: 'When you want to teach any of yr Friends *patience* my dear Lady, persuade
them to be either a biographer or an Engraver—& if they do not acquire the virtue
in those two instructive occupations, you may safely tell them they have *no Talents*
for *it*[.]—'

[3] Quoted from the MS. in the volume of Hayley–Johnson Correspondence in
the Fitzwilliam. Many of these letters were printed in Hayley's *Memoirs*, 1823,
which Johnny edited, and when he was preparing them for the press Johnny deleted
many sentences, such as the last one above, which Hayley wrote sideways as an
afterthought.

address the other Side to Mr: Blake', and on the other side he
wrote:

Dear Blake,

I rejoice in Your happiness & contentment under the kind & affec-
tionate auspices of our Friend. M�r̄s Flaxman & myself would feel
no small gratification in a visit of participation in the domestic
Innocence & satisfaction of your rural retreat; but the same Provi- *October*
dence that has given retirement to you, has placed me in a great City *7th,*
where my employments continually exact an attention neither to be *1801*
remitted or delayed, & thus the All besto[*wing*] Hand deals out
happiness to his creatures when they are sensible of His Goodness;
the little commissions I troubled you with in my last are such as
one friend offers unwillingly to another on account of the Scanty
recompence, but I know you relieve yourself from more tedious
labours by Composition & Design, when they are done let me have
them & I will take care to get the money for you, My Wife unites
in love to you & M�r̄s Blake.

with your affectionate
J Flaxman[1]

Between September 10th and November 20th, Hayley
wrote a poem to his dead son asking his spiritual guidance for
Blake:

<div style="text-align:center">

My Angel Artist in the skies[,] [*October?*]
Thou mayst inspirit & controul *1801*
a Failing[2] Brother's Hand & Eyes
or temper his eccentric Soul.

Now to the feeling Blake attend[,]
His Copies of dear Cowper view
And make his Portraits of our Friend
Perfect in Truth as Thou art true[.][3]

</div>

[1] Quoted from a group of Flaxman–Hayley letters in an orange folder in the
Fitzwilliam Museum. Hayley's part of the letter is given in T. Wright, *The Life
of William Blake*, Olney, 1929, vol. ii, p. 184, and Blake's part is reproduced in
facsimile in A. N. L. Munby, 'Letters of British Artists of the XVIIIth and XIXth
Centuries—Part I', *The Connoisseur*, cxviii (1946), 26–28.

[2] Written 'Foiling'.

[3] This is the 58th poem in the volume in the Cornell University Library en-
titled 'A Collection of brief devotional Poems composed on the Pillow before the
Dawn of Day 1801 . . . volume the first[.] This transcript was begun Sunday noon
Sept 27 1801 & this 1st volume finished Dec: 17'. The dates to a number of the poems
indicate that they were transcribed in chronological order. The 57th is dated Sept.
10th and the 63rd Nov. 20th.

October 13th, 1801 Johnny Johnson ended his letter of Tuesday, October 13th to Hayley with 'Kind remembrance to the unwearied engraver by your side, & to all whom I know near you.'[1]

Next Sunday Hayley replied to Flaxman's letter of October 7th:

Oct 18 1801

My very dear Flaxman

October 18th, 1801 It affords a lively Gratification to your two warm-hearted Friends, the Hermit & the artist of Felpham, to find, that you remember us both so Kindly, in the midst of your grand Occupations.—

Be assured, we both take a most friendly Interest in the happy Progress of all your noble Works!—we are both following your excellent Example in point of Industry; & shall rejoice, if we make any near approaches to you in the Merit, & Felicity of our Labours.— With all of these you will in Time be made acquainted, since however deficient they may be, they will not fail to interest, in some Measure, a Friend, whose Feelings are so benevolently warm.—it is with great delight I assure you, that our good Blake grows more & more attach'd to this pleasant marine village, & seems to gain in it a perpetual Increase of improving Talents, & settled Comfort.— . . .
[*Hayley encloses an epitaph on his wife which was composed at dawn:*]

> If lovely Features, & a lofty Mind,
> Tender as Charity, as Bounty Kind,
> If these were Blessings, that to Life could give
> a Lot, which makes it Happiness to live;
> Thou, fair Eliza! had'st been blest on Earth:
> But Seraphs in Compassion wept thy Birth:
> For thy deep nervous Woes, of wondrous Weight,
> Love could not heal, nor Sympathy relate:
> Yet Pity trusts, with hallow'd Truth serene,
> Thy God o'er-pays them in a purer Scene.
> Peace to thy Ashes! to thy Memory, Love!
> and to thy spirit, in the Realms above,
> all, that from blameless sufferings below
> Mortality can hope, or Angels Know!

If this should happen to strike you, as it does Blake & me, I shall wish, at *your Leisure*, to have a most simple marble monument [*designed for her.*] . . .
adio! carissimo Principe dei Scolptori!—I leave the next page for

[1] Bodley MSS. Eng. misc. d. 134.

Blake to fill—with Kind remembrance to Nancy & our united Bene-
diction to you both

<div align="center">ever your most sincere & affectionate

Hermit[1]</div>

On the next page Blake replied with rejoicing for the peace
negotiations with France.

On the same day that he wrote to Flaxman, Hayley told
Johnny Johnson: 'It is worth riding from Dereham to the
Turret to see the Engravings, that our good Blake is making
to decorate the Book—'.[2] *October 18th, 1801*

Johnny replied to Hayley on Wednesday, October 21st,
urging him to visit Norfolk, and in his margin he scribbled
enthusiastically: 'My kind rem̃brance to the Blake & his agree-
able partner in the cottage—Tell them I count upon their second-
ing my motion for the moving scheme. The incomparable
Pauline will, in her goodness, do the same, I doubt not.'[3] To
his answer of Sunday, October 25th Hayley added a postscript:
'The good Blake advancing happily in his most important En-
graving salutes you affectionately—adieu!'[4] *October 21st, 1801* *October 25th, 1801*

Hayley wrote to Lady Hesketh on Sunday, November 1st:

I have desired our dear Rose to persuade you to indulge the warm-
hearted artist, who is preparing the decorations for Cowpers Life,
with the privilege of having the *original drawings of Lawrence* for a
few weeks at Felpham, as He is confident, that He shall by that means
provide a *more satisfactory Engraving*—He is already far advanced
in two other portraits for the Book in question & I think they will
be excellent—I am sure they must be so, if they prove equal to the
industry & the affectionate Zeal of the artist[.]—[5] *November 1st, 1801*

The next day Johnny Johnson was writing cheerfully to
Hayley '—Remember me kindly to your patient and peaceful
fellow Labourer, & believe me ever'[6] *November 2nd, 1801*

On the following Sunday Hayley sent Johnny an epitaph on
Cowper's friend Mary Unwin:

<div align="center">Trusting in God, with all her Heart & Mind,

This Woman prov'd magnanimously Kind;</div>

[1] Vol. ix of the Hayley Fitzwilliam Correspondence.
[2] Hayley–Johnson letters in the Fitzwilliam; this sentence was deleted by Johnny.
[3] Bodley MSS. Eng. misc. d. 134.
[4] Hayley–Johnson letters in the Fitzwilliam; this sentence also was deleted.
[5] BM Add. MSS. 30803A. [6] Bodley MSS. Eng. misc. d. 134.

Endur'd affliction's desolating Hail,
And watch'd a Poet thro' Misfortune's vale:
Her spotless Dust angelic Guards defend;
It is the Dust of Unwin, Cowper's Friend!
That single Title in itself is Fame,
For all, who read his verse, revere her name.

If it pleases you my dear Johnny, as I hope it may from the applause
it has receiv'd from the accomplish'd Lady of Lavant, from our good
enthusiastic Blake, & two or three more very delicate Critics, let us
have it inscribed on a neat little Tablet of the plain grey marble,
which the *masons call Dove-Colour*, & which I presume your Town
of Dereham can produce— . . .

& now let me congratulate you on having travell'd so well thro
the odyssey!—Blake & I read every Evening that Copy of the Iliad,
which yr namesake of St pauls was so good as to send me, comparing
it with the 1st Edition & with the Greek as we proceed.—we shall
be glad to see the odyssey also, as *soon as it is visible*—& with it the
pages of the Iliad, that were not dispatch'd from the press, when
our Copy arriv'd, they contain the close of the 12th Book— . . . The
good Blake still advancing happily in his engravings joins with me
in fervent Benediction to you[.]—[1]

About a week later, on Saturday, November 14th, Johnny
remarked to Hayley: 'It is a curious circumstance that our
beloved Poet should have derived, by the mother, from a
Sussex Fair one! It is a fact, that the G. mother's mother of the
interesting Lady whose picture our good Blake is engraving,
was the daughter of John Pellet Esqr of *Bolney in Sussex*. But
where Bolney is I know not[.]'[2]

In the meantime Lady Hesketh had given permission for
Blake to make an engraving from her Lawrence portrait, and on

the same day Hayley wrote to her: 'I hasten to thank you, my
dear Lady Hesketh, for the gracious alacrity, with which you
promise to indulge the laudable wishes of the worthy artist
(who devotes his Hand & all his Faculties most fervently to
our dear Cowper) with the original sketch of Lawrence.'[3]

Hayley was in fine spirits when he wrote on Wednesday,
November 18th to Johnny:

[1] Hayley–Johnson Fitzwilliam letters. All the prose except the second paragraph
to '*as it is visible*' was deleted by Johnson.
[2] Bodley MSS. Eng. misc. d. 134.
[3] BM Add. MSS. 30803A.

Your warm-hearted Letter (that has met me this instant in the apartments of our benevolent Paulina, at Lavant,) has delighted us all so much—(by *all*, I mean Paulina, Blake & myself) that I seize a pen, while the Coffee is coming to the Table, to tell you with what cordial pleasure we shall expect you & yr interesting Pupil— If my Epitaph delighted you, believe me your affectionate reception of it has afforded me equal delight.—I have been a great Scribbler of Epitaphs in the last month, & as you are so kindly partial to my monumental verses, I will transcribe for you, even in the bustle of this morning, a recent Epitaph on yr humble old Friend my good William, who closed his length of chearful & affectionate existence (near 80) this day Fortnight, in the great House at Eartham where Blake & I had the mournful Gratification of attending Him (by accident) in the few last Hours of his Life— ... providence conducted his dissolution in a manner most merciful to his own Feelings & those of his affectionate Master— . . . Paulina & Blake send you their kindest Remembrances & best wishes—adieu![1]

<div style="text-align:right">*November 18th, 1801*</div>

Hayley wrote triumphantly to Johnny, on Sunday, November 22nd: 'Did I tell you that our excellent Blake has wished to have Lawrence's original Drawing to copy in his second engraving, & that our good Lady H is so gracious as to send it?'[2] He was not quite so confident as this note might suggest, however, for on the same day he wrote to Lady Hesketh: 'Fear not for your celestial drawing:—it shall not be taken out of the Frame, if it arrives to gratify my worthy artist who works constantly in my study, as our respective Labours never clash & I have great pleasure in promoting his success—for He is in Truth an excellent Creature with admirable Talents[.]'[3]

<div style="text-align:right">*November 22nd, 1801*</div>

<div style="text-align:right">*November 22nd, 1801*</div>

When Lawrence's portrait arrived, Hayley wrote promptly to Lady Hesketh, on Monday, December 7th, to announce that it was safe, and to say that he did not think Bartolozzi's engraving had done it justice: 'Well! Heaven grant to the kind enthusiastic engraver at my side ability to be more delicately faithful to the proper Expression of this invaluable portrait . . .'.[4]

<div style="text-align:right">*December 7th, 1801*</div>

[1] Hayley–Johnson Fitzwilliam letters. Metcalf did not die 'this day Fortnight' (Nov. 4th), for no. 50 in the Cornell 'Collection of brief devotional Poems' is an 'Epitaph on William Metcalfe born deceas'd Oct 27 1801'.
[2] Hayley–Johnson Fitzwilliam letters.
[3] BM Add. MSS. 30803A.
[4] BM Add. MSS. 30803A.

In his autobiography Hayley recalled that amidst all his biographical activity,

He yet found time to compose various little pieces of Poetry towards the end of the year 1801 particularly several of the Ballads founded on anecdotes relating to animals, which He printed for the emolument of the interesting artist, who had settled in a Cottage, as the Poets Neighbour, to execute the Engravings for the Quarto Edition of Cowpers Life.—That singularly industrious man applied himself *January* to various Branches of art—He had wonderful Talents for original *1802* design—& at Hayleys suggestion, He executed some portraits in miniature very happily, particularly a portrait of Cowpers beloved Relation, the Revd Dr Johnson, who arrived at Felpham on a kind visit to the Biographer in January 1802[.][1]

At an unspecified time Blake also painted 'Winter', 'Evening', and 'Olney Bridge' for Johnny, the last of which has disappeared.[2]

January By mid-January Johnny was back home, and on Monday,
18th, January 18th Hayley wrote to him, exulting over 'one of the
1802 kindest penetentiary Letters you can imagine' from Lady Hesketh, and concluding 'The excellent Blake joins me in all Kind wishes to you'.[3]

January On the same day that Hayley wrote Johnny (January 18th),
18th, he wrote Flaxman; in a postscript, he says that 'our worthy
1802 Friend Blake joins me in every kind wish to you & yr dear Nancy. He allows me to inclose one of his *unfinish'd* Engravings, that we think you may wish to see for the purpose of forming a medallion—Be kind enough to keep it in *friendly privacy* & tell us your *frank opinion* of it, in its *present unfinish'd state*: we shall *both* thank you heartily for *any suggestions that may improve it*[.][4]

January A week later, on Monday the 25th, Flaxman replied most
25th, satisfactorily: 'In the Engraving of Cowper I think my friend
1802 Blake has kept the spirit of the likeness most perfectly[;] the eyes are exceedingly well, & in the finishing I presume the

[1] Quoted from a microfilm of the MS. (vol. vi. p. 69), corresponding to Hayley's *Memoirs*, vol. ii, pp. 31–32—see June 1823. In 1955 the miniature of Johnson (see Plate XIV) was discovered in the possession of Miss Mary Barham Johnson.

[2] Gilchrist, 1942, p. 379.

[3] Quoted from the MS. in the possession of Miss Mary Barham Johnson of Norwich. The year of the letter is supplied by the postmark.

[4] Vol. ix of the Fitzwilliam Hayley Correspondence.

PLATE XIV

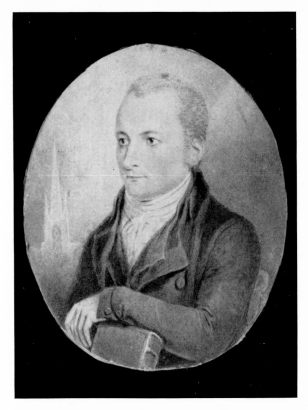

MINIATURE OF JOHNNY JOHNSON (January 1802)
which Hayley thought Blake had executed 'very happily' (p. 88)

extremities of the nose & mouth will be softened which at present appear rather harsh, with kindest wishes & remembrance from Mrs Flaxman to Yourself & Mr & Mrs Blake I have the honour to remain'[1]

Hayley replied to Flaxman, probably with characteristic promptness, sending five epitaphs including those on William Metcalfe, Cowper, and Mrs. Unwin, and commenting:

These insinuating verses have engrossed so much of my paper, that I have hardly left room to tell you how happy you have made our good Blake by yr approbation of his Engraving. we shall receive with delight *any of yr monumental sketches* & the more so, as we are both so attached to this little marine village that we have neither of us any thoughts of visiting your great Babel—I print my extensive work in my neighbouring native City, that I may not be drawn, by literary business, away from my favorite Cell, where I hope, in some propitious autumn, we may tempt you to visit

[January 28th? 1802]

> your most sincere
> & affectionate Hermit

Blake at my side unites in Benediction to you & Nancy—adio[.][2]

On Saturday, January 30th Johnny Johnson replied enthusiastically to Hayley's letter of the 18th, and in closing asked him to 'Remember me most kindly and respectfully at the peerless Villa, where you will probably receive this; also to the admirable Blake.'[3]

January 30th, 1802

At the conclusion of his letter to Flaxman of Sunday, January 31st Hayley wrote: 'Here I will only add, that the zealous indefatigable Blake desires to join in every good wish to you & Nancy with your sincere & affectionate Hermit'.[4] And three days later to Johnny: 'Here is instantaneously a Title page for Thee, & a Greek motto, which I & *Blake* who is just become *a Grecian* & literally learning the Language consider as a *happy Hit!*' Up the centre of his letter he scribbled 'The new Grecian greets you affectionately—'.[5] On Wednesday, February 17th

January 31st, 1802

February 3rd, 1802

[1] Quoted from one of a group of Flaxman–Hayley letters loose in a folder in the Fitzwilliam Museum.

[2] Quoted from the undated MS. in the Princeton University Library. The letter is roughly datable from Flaxman's approbation of Blake's engraving sent in his letter of Jan. 25th. [3] Bodley MSS. Eng. misc. d. 134.

[4] Vol. ix of the Fitzwilliam Hayley Correspondence.

[5] Hayley–Johnson Fitzwilliam letters. The 'Title-page' with its 'Greek motto'

February
17th,
1802 Johnny replied most enthusiastically about the motto, and up-
side down over the salutation he sent 'Love to the Blake'.[1]

A few days later Hayley was involved with a 'presumptuous
. . . attempt . . . to *out-design* my dear Flaxman Himself' for a
monument to Cowper, and on Sunday, February 21st he wrote
to Lady Hesketh:

February
21st,
1802 I have been *bold enough* to *try* my own Powers for *monumental
Invention*, & have made a Device, of which I send you a neat Copy
(on the other side of this paper) from the kind Hand of the friendly
Zealous Engraver, who daily works by my side, & who flatters me
so far as to say, that He never saw any monumental design more
modestly appropriate to the *honoured dead.* . . . I will be frank enough
to own, the design *pleases myself*—I have sent it to Flaxman, desiring
his sincere opinion, & to know for what Sum He could accomplish
it[.]—[2]

On Thursday the 25th Hayley complained to Johnny about

February
25th,
1802 all the preposterous prejudices of our good Lady H against *simple* &
graceful ornaments for the Tomb of our beloved Bard I form'd there-
fore a Device of *the Bible upright* supporting '*the Task*' with a Laurel
Wreath & *Palms*, such as I send you neatly copied by our Kind Blake.
. . . If her Ladyship & Flaxman are as much pleasd with my Idea,
as the good Blake & Pauline of Lavant *are*, all our difficulties on this
grand monumental Contention will *end most happily.* tell me how *you*,
my dear Johnny, like my device!—to enable you to *judge fairly*, even
against myself, I desird the kind Blake to *add for you* under the copy
of my design a copy of Flaxman's also with the Lyre whose shape
displeases me[.]—[3]

In his letter of the same day, begging Flaxman's more
authoritative support, Hayley wrote: 'The Truth is, Lady H.
is so idly prejudic'd *against ornament*, that I fear'd she would

was published as: *The Odyssey of Homer*, translated into English Blank Verse by
the late William Cowper, Esq. The Second Edition, With copious Alterations and
Notes, prepared for the press by the translator, and now published with a preface
by his kinsman, J. Johnson, LL.B. chaplain to the Bishop of Peterborough. τάδε
δ'ἀεὶ πάρεσθ' ὅμοια, διὰ δὲ τῶν αὐτῶν ἀεί.—Epicharmus. [2 vols.] London:
printed for J. Johnson, St. Paul's Church Yard, by Bunney and Gold, Shoe Lane.
1802. [1] Bodley MSS. Eng. misc. d. 134, no. 94.
 [2] The letter is in the Harvard University Library, and a draft is in BM Add.
MSS. 30803B. This draft, which does not differ from the final copy as far as the
references to Blake are concerned, was published in 'Blake, Hayley, and Lady
Hesketh,' *Review of English Studies*, N.S., vii (1956), 270.
 [3] Hayley–Johnson Fitzwilliam letters.

object to *the Lyre* in your design for the Dereham monument, & I therefore tried to *hit her particular Fancy* by a device, that struck me as very modestly suited to *her wishes.*—our Friend Blake was so Kind as to make me some neat Copies of my design[.]'[1]

February 25th, 1802

In his reply on February 25th to Hayley's letter of the 21st, Flaxman wrote that having 'examined Mͬ Blake's drawing for the Monument, repeatedly, I am of opinion, that altho' the emblems are very proper, they would not produce a good effect if executed in that manner I have troubled you with another Sketch, the books & bays of intire relief, the length 4 feet, the price 40 Guineas exclusive of affixing, with Love to Mͬ Mͬˢ Blake in which Nancy unites to them & Yourself'[2]

February 25th, 1802

Hayley's February 21st letter to Lady Hesketh seems to have gone astray, and on Sunday, March 7th he wrote again: 'you will judge of my disappointment, when I add, that the *device was litterally a design* of *my own*, copied for you by the neat pencil of that friendly & zealous artist, who labours every day in my presence, with admirable Industry.'[3]

March 7th, 1802

By now two weeks had gone by without a reply from Johnny Johnson, and in his letter to him of Thursday, March 11th Hayley supposed him dead. In the margin of his letter he wrote: 'The kind indefatigable Blake salutes you cordially, and begs a little fresh news from the spiritual world.'[4]

March 11th, 1802

A few days later, on Saturday the 13th, Hayley wrote to Lady Hesketh yet again about the design of the monument: 'I enclose for yr choice a *new device of my own*, which my in- dustrious Friend Blake the Engraver, & I prefer *to my first design*[,]' and a sketch of this design was also sent to Flaxman. In the same letter to Lady Hesketh Hayley sent yet another poem intended to inspire Blake with his engraving work.

March 13th, 1802

[1] Vol. ix. of the Fitzwilliam Hayley Correspondence. Hayley went on about his biography of Cowper: 'I imagin'd I had just finish'd; when behold! a large unex- pected supply of new materials will oblige me to take parts of my *fairly copied* work *to pieces*, & *put them together again*[.]—'

[2] Quoted from the MS. in the Berg Collection of the New York Public Library.

[3] BM Add. MSS. 30803ʙ. He enclosed sketches of Flaxman's two designs and his own.

[4] This letter, in the Fitzwilliam, was bound so that the words from the second to the ninth were covered, and I have therefore transcribed them from *Memoirs of the Life and Writings of William Hayley, Esq.*, ed. J. Johnson, London, 1823, vol. ii, p. 200 fn.

Good Angels guide the Graver's Hand
 With perfect skill to trace
Those Looks, that could the Heart command,
 The Light of Cowper's Face!

Shew Character, surpass'd by none!
 Wit, modest as a child!
and spirits like a vernal Sun,
 Tho penetrating, mild!

So shall his portrait with regard,
 And with his Verse contend;
Displaying all, that made the Bard
 Affection's favorite Friend![1]

During the early spring, much of Hayley's energies were devoted to his memoir of his dead son, but, as he wrote in his *March* autobiography, it was not his only literary project: 'This new *1802* Biography, which seemed to engage so much of the author's Heart and soul did not preclude Him from the Composition of several brief poems, particularly Epitaphs, & the Ballads already mentioned of which he formed a series for the Emolument of Mr Blake the artist.—In March He wrote a preface to these Ballads, which were first published in quarto numbers, with two Engravings to each number . . . '.[2]

In the Preface to the collection of ballads, called *Designs to a Series of Ballads*, Hayley wrote very much in his own way of his aims and motives:

BOOKS of a pleasing and useful tendency have sometimes owed their existence to accident or sport: I hope the Book for which I am *March* anxious to conciliate favour, may be included in this description— *1802* at all events, it is more the offspring of chance, than of labour, and that a Reader may not expect from it either too much, or too little, I wish to prefix to it an ingenuous history of its origin.

Having been, for some time, engaged in a Work that required much sedentary and serious attention, I wished to indulge occasion-

[1] BM Add. MSS 30803B.

[2] Quoted from the MS. (vol. vi, p. 77) in Yale University Library, which corresponds to Hayley's *Memoirs*, vol. ii, pp. 37–38—see June 1823. The passage continues: 'but as this mode of circulating them was thought too costly, it was soon discontinued & they afterwards [*1805*] appeared in a neat Pocket volume with several engravings published by Phillips, who divided the profits equally with the Engraver.'

ally in such literary relaxation, as might relieve my own mind, and still more amuse a friendly fellow-labourer, whose assiduous occupation gives him a better claim to such indulgence:—I mean my friend, Mr. Blake, the Artist, who has devoted himself, with indefatigable spirit, to engrave the plates intended to decorate the volumes, in which I hope to render affectionate justice to the memory of COWPER.—There is hardly any kind of ingenious employment in which the mind requires more to be cheared and diverted, than the slow, and sometimes very irksome, progress of engraving; especially, when that art is exercised by a person of varied talents, and of a creative imagination.—To amuse the Artist in his patient labour, and to furnish his fancy with a few slight subjects for an inventive pencil, that might afford some variety to his incessant application, without too far interrupting his more serious business, I chanced to compose, in hours of exercise and leisure, a few Ballads, upon anecdotes relating to animals, that happened to interest my fancy. They succeeded perfectly as an amusement to my Friend; and led him to execute a few rapid sketches, that several judges of his talent are desirous of converting to his honour and emolument. The favour that two or three Ballads obtained, in a private circle, inclined us to enlarge the number; and to try their success in the world as a periodical publication.—It is proposed to publish every month, a Number, containing three Engravings, with one Ballad, at the price of Half-a-crown; and to complete the whole series in fifteen Numbers, so that the purchaser will ultimately obtain a quarto Volume, containing forty-five Engravings, not to mention the Ballads, which indeed I wish to be considered as vehicles contrived to exhibit the diversified talents of my Friend for original design, and delicate engraving.— Since friendship induced this meritorious Artist to leave London (the great lucrative theatre of talents!) for the sake of settling near me, it seems to be a duty incumbent on me to use every liberal method, in my power, to obtain for his industrious ingenuity, the notice and favour of my Countrymen. . . . The little unavoidable impediments, that arise to obstruct the rapid progress of a long biographical compilation, may sometimes suspend the exercise of a provincial Press: To counteract, therefore in part, a disadvantage arising to the Printer from such suspence, I am induced to print these Ballads at a time that might be imagined unseasonable. . . . They are very unequal in their length; but we have judged it right to commence the publication with the shortest; especially as the animal it records, is entitled to precedence.—Let me add, that I am indebted to a Sussex Lady, for a lively account of the real fact, on which it is founded! Instead of endeavouring to recommend these

productions of my Friend's pencil to the express patronage of any
individual, I here presume to INSCRIBE them to the

INHABITANTS OF CHICHESTER.

The 'several judges' to whom the work was privately cir-
culated in manuscript probably included the printer Seagrave,
Miss Poole, Mr. Weller the carver, and Mr. Guy the doctor.

That other judges would have agreed with the plan of this
series may be suggested by Charles Lamb's letter[1] to Southey
of about this date concerning Southey's poem called a 'Spider':
'I would persuade you, if I could (I am in earnest), to com-
mence a series of these animal poems, which [*if*] . . . accom-
panied with plates . . . would take excessively. I will willingly
enter into a partnership in the plan with you . . . '.

March 23rd, 1802 On Tuesday, March 23rd, Hayley expressed his pleasure
at Lady Hesketh's approval of the epitaphs of Cowper which
he had sent earlier: 'I have this instant been trying to make *the
first Epitaph* (which I meant for Dereham [*where Cowper was
buried*]) in perfect Harmony (according to my own Ideas) with
the sculptural design—The friendly artist by my side tells me
I have succeeded, but I want your opinion, before I give him full
credit.'[2]

March 23rd, 802 On the same day Johnny sent '—A thousand thanks to you
for your kind letters, and to yᵉ admirable Blake for his most wel-
come sketch.'[2] Next day, March 24th, Hayley wrote Flaxman:

March 24th, 1802 I hope Blake's drawing express'd my Idea, that the Books are to
appear as *whole* Books, & not like a *sham Library in Wood*—. . . The
Kind industrious Blake by my side unites in this Benediction & in
every good wish to you & Nancy

<div align="right">with yr

most affectionate
Hermit[4]</div>

March 25th, 1802 The following day, Thursday the 25th, Hayley sent to Joseph
Cooper Walker the poem about Blake which he had sent to

[1] *The Letters of Charles and Mary Lamb*, ed. E. V. Lucas, London, 1935, vol.
i, 153, March 20th, 1799.

[2] BM Add. MSS. 30803B.

[3] Quoted from a microfilm of the MS. in the Liverpool Public Library. Blake's
sketch had been sent on Feb. 25th.

[4] Vol. ix of the Fitzwilliam Hayley Correspondence.

Lady Hesketh some two weeks previously, commenting that it was 'a few stanzas to encourage the friendly artist, who works by my side, with great zeal, in engraving two portraits of our favourite Bard—'.[1]

In his diary for March 26th and 27th Hayley wrote: 'read the death of Klopstock in the newspaper of the day, and looked into his Messiah, both the original, & the Translation.—read Klopstock into English to Blake; & translated the opening of his third Canto, where he speaks of his own death[.]'[2]

March 26th–27th, 1802

A few days later, on Wednesday, March 31st, Johnny Johnson wrote upside down over the salution of his letter from Dereham: 'Remember me to the good Blake and tell him that I long to see his last touches of my Aunt Cowper's picture & of our dear Bard by Romney. Has he begun Lawrence?'[3]

March 31st, 1802

On Saturday, April 10th, Johnny wrote again about the monument: 'the sketch of our dear Blake has exceedingly gratified us— . . . I shall look for *a world of grace* in that most *capable* and *pregnant* curve that our dear Blake has thrown over the Books. . . . Kind love and a thousand thanks to the most industrious of all Blakes.'[4] In his letter of the same day, John Carr asked Hayley to 'remember me to the Artist of Felpham'.

April 10th, 1802

April 10th, 1802

On Sunday, May 16th Hayley wrote to Johnny: 'you will feel anxious when I tell you, that both my good Blakes have been confin'd to their Bed a week by a severe Fever—Thank Heaven they are both revived, & He is at this moment by my side, representing on Copper an adam, of his own, surrounded [by] animals, as a Frontispiece to the projected Ballads.— . . . accept our united Benedictions[.]'[5] Practically by return of post, on Thursday, May 20th, Johnny replied, 'remember me kindly . . . to the poor dear Blakes, who, I hope have lost their fever—'.[6]

May 16th, 1802

May 20th, 1802

[1] Vol. xv of the Fitzwilliam Hayley Correspondence.

[2] Quoted from the MS. (vol. vi, p. 86) in the Yale University Library corresponding to Hayley's *Memoirs*, vol. ii, p. 42—see June 1823. The passage is introduced as follows: 'His diary on the 26th & 27th of March has the following words.' Perhaps the first sentence is for the 26th and the second for the 27th.

[3] Bodley MSS. Eng. misc. d. 134, no. 98.

[4] Bodley MSS. Eng. misc. d. 134, no. 71.

[5] Hayley–Johnson Fitzwilliam letters. There is no year in the date, but the context clearly indicates 1802, as did Johnny when he included the letter in Hayley's *Memoirs*.

[6] Bodley MSS. Eng. misc. d. 134, no. 100.

At the beginning of the next week, on Monday the 24th, Hayley wrote to Lady Hesketh:

May 24th, 1802 Do not be surprised if you receive in about a Fortnight a Bundle of Ballads, for I have a wicked project of turning your Ladyship into a Ballad Monger for the sake of serving the excellent friendly artist, who has been working long & patiently by my side on our portraits of Cowper.—He has drawn & engraved some very ingenious designs of his own to a series of singular Ballads, one of which He proposes to publish every Month with three prints annexed to it.—for the moderate price of half a crown—His first number will be ready in a week or two, delicately printed on a fine quarto paper, & if I send you one dozen to dispose of among yr friends I know you will not think yrself overloaded by

your sincere &
affectionate Hermit[1]

Lady Hesketh replied on Friday the 28th:

May 28th, 1802 I shall be happy to assist *any* friend of *yours*, but am afraid, at this time, of year, *Bath* will be a bad place to attempt to circulate any thing new, as there will be hardly a human Being left in it but myself in a week's time![2] . . . but to return to yr Ingenious friend & Artist, and to say how glad I shall be if you can put me in a way to do him the smallest service: but indeed you must chalk out the method, and make the way plain, and *very* plain, before me, for I am more stupid *even* than *you ever knew me* a *bold* Assertion, but a true one, and I can form to myself no idea of the purport or design of a *ballad* to be publish'd once a Month! tho.' (as I think, without being a Witch, I can guess the *Author*) I have no doubt *said* ballads will be very delightful: but I repeat, that you must both spell and put together, for you will be greatly mistaken if you think you may venture to leave anything to my ingenuity; tell me therefore, & tell me in the plainest Terms, what I can do to serve your friend? *and conclude it Done !*[3]

Hayley wrote on about June 6th to forewarn Johnny of the advent of his first consignment of Ballads:

A score of Elephants will begin their March to you tomorrow,

[1] BM Add. MSS. 30803B.

[2] Cf. *Jane Austen's Letters*, ed. R. W. Chapman, Oxford, 1952, vol. i, p. 125, May 5, 1801: 'Bath is getting so very empty that I am not afraid of doing too little.'

[3] BM Add. MSS. 30803B.

calling on the dear Barrister in their Journey, to beg He will teach them their best road to Norfolk.—[1] *[June 6th, 1802]*

As the Norfolcienses may love dumplins better than Elephants, that are not for the Kitchen, you may not find it so easy as we could wish to metamorphose this Tribe of animals into Half Crowns for our benevolent Artist—do all for Him among yr Friends, that you can do *with pleasure*, but be not *surpriz'd* or *vex'd*, if you find yr countrymen not so well dispos'd towards a worthy Elephantmaker as you are yrself[.]—[2]

On Thursday the 10th Hayley wrote to Lady Hesketh:

—If our Sussex Elephants have reached you, as I trust They have by the Guidance of our Friend Rose, you will require no commendation from me to give you a good opinion of our provincial printer— apropos of the Elephants! you receive a *smaller number*, than I led you to expect; not from an apprehension that you might find it difficult to metamorphose them into Half Crowns for the ingenious Artist, at a Time, when Bath is deserted, but in Truth, because the busy artist had not Time to furnish a larger number of these interesting animals for his distant friends *immediately*—He & his excellent Wife (a true Helpmate!) pass the plates thro' a rolling press in their own cottage together; & of course it is a work of some Time to collect a Number of Impressions.—But if you find, that you are likely to have *many Customers* in *your new Trade of Ballad Monger*, He will take care that you shall not want *a stock in Hand*, & He expresses himself highly gratified by the Honour you do Him in condescending to circulate his production— . . . I shall rejoice to hear that the Elephant has amused you—with repeated Thanks for all yr Kindness to my Friend, whose profitable servant I hope He may prove, & with a hearty wish that his whole Collection of Animals may be regarded by you as amusing Visitors, I am my dear Lady[3] *June 10th, 1802*

The next day, Friday the 11th, Johnny wrote to 'perhaps the best friend he has in the world':

I am *all eye* for the Blakian Elephants—you gave me reason to expect them this week but here's friday come, and no trunks—Well, come when they will, they'll be sure of a welcome, and you shall *June 11th, 1802*

[1] i.e. Hayley sent the Ballads to Rose in London to be forwarded to Johnny in Dereham.

[2] Quoted from the MS. in the possession Mary Barham Johnson. The letter is undated, and only a '6' is discernible in the postmark. Someone has written on the back Sept[?] 16 1802, but June 6th is the more probable date, for the Ballad was published on June 1st, and Johnny expected to receive it by June 11th.

[3] BM Add. MSS. 30803B.

hear of their arrival by the very next Post— . . . [*The stonecutter says that the inscription on the monument should be in gold on jet marble.*] Was there ever such a Goth? Write immediately to insist upon the *Dove marble*, & get our kindhearted Blake to sketch your idea in a letter to me, which I will carry to him, or else I fear he will make a poor hand of it.[1]

Lady Hesketh reported to Hayley on Wednesday, June 16th:

June 16th, 1802 I should not Dear Sir worry you again so *very* soon, was I not extremely impatient to inform you of the Arrival of that powerful but gentle beast the Elephant, and likewise of my admiration of it! I am ill qualified to speak of the Merits either of the Engravings or the ballad, but to me I confess they seem very worthy of each other, and I cannot tell how much I honor you for this fresh proof of the active part you take so readily whenever an opp.[y] offers of Serving your friends! your Zeal I well know dear Sir never loiters, but on the contrary is always foremost when any thing useful, or pleasing is to be done for the good of others: M.[r] Blake I have not the pleasure of knowing, but have no doubt that His Merits, and Talents will equally Justify the kind, and *very agreable* Method you have taken to bring that Merit, and those Talents into Notice I have done all I cou'd to second your kind intentions, having laid one in the most conspicuous part of Three of the most Conspicuous & best frequented Librarys which this City affords, having tacked to the same a few names together with my own as Sub.[rs] to this very agreable and elegant Work. I have likewise sent one to Lord & Lady Harcourt by a very sensible amiable friend of mine who goes this day to pass some time at Nuneham. few people have more *taste* than L.[d] & L.[y] H: and as they are adorers of *Cowper*, they will be almost as well pleased as I am with the sweet delightful manner in which you have taken notice of the friendly labor you are engaged in! . . . I know she [*Lady Harcourt*] will be charmed with *the Elephant*, and so will her Lord, and you may depend upon their doing all in their power to Circulate the work in question. D.[r] Randolph was with me at the moment that your letter from Felpham, and the Pacquet from London arrived together and consider'd himself as not a little fortunate in having call'd on me at that Juncture;—he *read to me* both the preface and the ballad and instantly set his Name down —he dined yes.[y] with Lord Spencer, & I gave him one to shew Him, as I shall not see him myself, tho' he is here with his Lady[.][2]

[1] Bodley MSS Eng. misc. d. 134, no. 102. In later letters Johnny expressed approval of Hayley's idea of putting a gold inscription on metal.

[2] BM Add. MSS. 30803B.

Flaxman also reported cheeringly on his success as a Ballad-monger on Sunday June 27th:

Mᵣ Hawkins has taken two copies, Mᵣ Long one, Mᵣ Rogers one, I enclose my subscription for the whole of my copy which I must beg of you to give to my friend Blake, & do me the favor to tell him that I will send the other Subscriptions as soon as I get them— I think the Etchings have Spirit & Sentiment, & calling the attention of man to the virtues of the brute creation & making this the vehicle of Service to the worthy artist & printer at the same time, is a part of that tissue of Benevolence which forms the Good Bard's character with Love to Mʳ & Mʳˢ Blake in which Mʳˢ Flaxman unites as well as to the Bard I have the honour to remain[1]

June 27th, 1802

Hayley replied on Monday the 28th to Lady Hesketh's letter:

your extreme Kindness, my dear Lady, to the Group of Elephants, that lately had the Honour of waiting upon you has so endeared you to the Tribes of the noble animals, that five imperial Eagles (who are preparing to take wing, as the immediate successors to the train of Elephants) hope in the course of next Week to have the pleasure of perching in your presence.—Indeed they are so eager to express their regard to you, that they meditate a Flight across the country, to reach you by a road more expeditious than that of the Elephants, & they please themselves with an idea of paying their respects to you, before any of their Tribe can be visible in the Metropolis.— In sober Truth I am heartily pleased that the Ballad & its decorations found such Favour in your sight: & both the Engraver & the Hermit feel most agreably obliged to you for your Kindness on this Occasion.— . . . If we are pleasd in finding the Elephant a Favorite with the Fair, we please ourselves yet more in fancying, that the Eagle may soar to a greater Height in the sunshine of their Favour. . . . —you will rejoice to hear that the good Blake & his Elephants are in triumphant spirits[.][2]

June 28th, 1802

On the same day there was further good news from Charlotte Collins, who had recently been to Felpham:

suffer me to . . . shew you that I am willing to discover your kindness by my attention to the Interests of Mʳ Blake[.] I have the pleasure to inform you that I have dispos'd of seven Elephants already, in

June 28th, 1802

[1] One of a group of Flaxman-Hayley letters loose in a folder in the Fitzwilliam Museum. The written year is 1801, but the postmark is clearly June 28th, 1802. Flaxman was conspicuously more successful than most of Hayley's outlying agents; for example, on January 30th, 1803 Blake sent '5 Copies of N4 of the Ballads for Mʳˢ Flaxman'. [2] BM Add. MSS. 30803ʙ.

my little Circle—and am ready to take as many Eagles—by the way, you must send me two more Elephants—as the one you brought to Lavington, is I think a little injured—I believe I told you that there was a new Family settled at Midhurst by the name of *Spilsbury*—the Gentleman has devoted his Time to the study of animals, and he has lately made a drawing of M^rs Poyntz's *Prize Bull*[1]—which he has some thoughts of having engraved— I believe that he would be glad to engage M^r Blake on the occasion—at least, he express'd a strong desire to be introduced to him as a brother-artist: and was so well pleas'd with the Engravings of the Ballad that he beg'd to become a purchaser immediately— I have sent a little sketch taken from some deer in Cowdray Park, not as being the best, but the most portable— M^r Spilsbury would rather have sent the Cowdray Bull, or the Burton Ox—but they were too bulky for my pacquet— Can you tell me how these Knights of the Brush, & the Burin, are to meet? it is so long a ride, that I cannot find in my Heart to wish that you would undertake it— altho' I am always highly gratified by your Visits, I do not desire to put you to the slightest inconvenience on my account—settle the matter and let me know—. . . . Remember me also to Mess^rs Meyer & Blake & believe me as ever[2]

Nothing more is known of this prospective commission, but it is likely that Blake at least met the genteel bull-painter, for in his letter of March 21st, 1803, Flaxman refers to Mr. Spilsbury as if he were at Felpham.

Also on the 28th Hayley wrote to Johnny of Norfolk:

June our alert Blake is preparing, con spirito, to launch his Eagle with a
28th–29th, lively hope of seeing Him superior to the Elephant, &
1802

'sailing with supreme dominion
Thro the azure deep of air.'

our good Lady Hesketh has received & patronized his Elephant with the most obliging Benignity & we hope soon to hear, that the gentle & noble Beast arrived safe at Dereham & finds Favour with the good

[1] William Stephen Poyntz (1770–1840), later M.P. for Chichester, obtained the Cowdray Park estate at Midhurst, about seven miles north of Felpham (J. Hawkins, *I am, my dear Sir* . . ., ed. F. W. Steer, [*Chichester*] 1959, pp. 9, 35).

[2] Vol. xv of the Hayley letters in the Fitzwilliam Museum. Meyer was William, the artist son of Jeremiah Meyer (1735–89), Hayley's old friend the miniaturist. It seems likely that Hayley's close friendship with the senior Meyer influenced him to urge Blake to take up miniature painting. Young William seems to have been at Felpham pretty regularly with his sister and mother, for 'E. G.' Marsh sent remembrances to them and Blake on Nov. 6th, 1802, and Blake refers to them in his letters.

Folks of yr County—The ingenious Maker of Elephants & Eagles, who is working at this instant on the latter, salutes you with Kindest Remembrance

[*Next day Hayley continued*:] Blake & his Elephant are marching triumphantly on the road of prosperity & salute you on their March— elated by the applause of Flaxman—Bravo![1]

These triumphant spirits were, however, premature, for on Saturday, July 3rd Lady Hesketh wrote dismally from Bath:

Dear Sir—

From my Heart I hope that London & Chichester make ample amends to yr ingenious Artist, for the deficiencies of Bath; which I have reason to fear is still more empty and deserted than I thought it possible it should be; even at *this* season of the year! too certain however it is that it is abandond by all those of Genius and Taste or the Elephants must have attracted more company: sorry I am to say that not more than half a dozen Names are yet to be found, so low are the Arts fallen in this sweet City of Bath. I flatter myself however that your bookseller in Pall Mall will have a long list of *Cowpers*, who I trust will gladly endeavour to attone for the deficiencies of other people. I have sent them word that I shall expect to see *all* their Names, and to have *all their Interest* exerted towards the work in hand;—and now dear Sir, may I be *forgiven* if I say, *to you* that *some* among the *very few* now here, who have any pretensions to Taste, find many defects in your friends engravings?—I know you would be much better pleased that they shou'd find fault with *You* than with Him whom you patronize, *yet*,—if Mr B: is but New in the world, may it be not *in reality kinder* to point out his failings, than to suffer him to think his performances faultless.—surely it may, as it may stimulate his endeavours after Perfection!—it wou'd be wrong to *name* those who have dared to Criticize what I own pleased *me* very much: but I will try if I can put under the Seal—(for I would not make you pay for a double letter[2]) the opinion of one who I believe to have as much *Taste* as he has goodness, Learning, Knowledge of all kinds, both in the *polite* arts, and all others! he has likewise great knowledge of the *world*, having always liv'd in the very first Circles—He is *to be sure 82 !*[3]—and you

July 3rd, 1802

[1] Hayley–Johnson Fitzwilliam letters. The quotation in this letter is from Gray's 'Progress of Poesy'.

[2] Letters were paid for by the sheet. The enclosure is not now with her letters to Hayley.

[3] Blake's critic may have been the fashionable and accomplished Richard Hurd (1720–1808), Bishop of Worcester, who was '*to be sure 82 !*' at the time of this letter, and the 'woman of Quality' further on was perhaps Princess Elizabeth whose enthusiasm for design was widely known.

may therefore suppose Him to be *Superannuated*;—but *indeed he is not*, & cou'd you see his little Billets to Ladys, and see the grace & even gallantry with w.<u>ch</u> he presides at our little Suppers & the Spirits he is in at Eleven at *Night* you wou'd be inclined to allow some degree of Credit to his opinion—be this as it may I will not *transcribe*, but give you that part of his note that relates to the Elephant in question, because as that is in his own hand, you will think I am sure that it would be no discredit to a man of five & Thirty! there was also a *certain Lady*, of whose skill in painting &c: you and all the world have I know a high opinion;—I dont visit her, but she was lately here, & when D.<u>r</u> Randolph shew'd her this (perhaps with all the enthusiastic warmth which makes his manner)—She too I know (She is a woman of Quality) made objections, chiefly I believe to the design[;] the Elephant not being seen in the back ground in the same piece where the man is struggling at the windows,[1] *she* consider'd as a defect, since no one cou'd tell how he came there? the window too shou'd have appeard in Light as a motive to influence the motions of the Elephant & all this I heard,—whether I am wrong, or not to *tell* it to *You* Time only can discover! one thing I am sure of, that I wou'd not willingly give you Pain—there, where I know you are most Vulnerable. I mean in the person of your Friends, but I cannot help fancying that some hints from you very *gently applied*, as I know you will apply them, may be *useful* to your protegéé—and if they shou'd induce Improvement, I shall applaud myself for the liberty I have taken & for having had the *courage* to tell you, what perhaps *nobody else* will!—and now let me say that tho.' the Eagles have taken Wing they have not yet arrived here; when they do I shall endeavour to receive them with all the honors due to these birds of Jo[*ve*] and all English as they are, shall think no Roman ones could exceed them[,] but pray dear Sir do not trouble yourself in future to send them here, as both myself, and the few Sub.<u>rs</u> I have got, have given orders to our booksellers to send them down and I received two more Elephants last night. . . . Examine *yourself* dear Sir who have so much taste[;] is there not something Strikingly disproportionate in the Figure of the Horse & of some of those in the *first* Piece? *even to Me that* is not agreable at all.[2]

Blake's reaction may be imagined. In another context and at a later date he wrote: 'The Enquiry in England is not whether a Man has talent*s*. & Geniu*s*. But whether he is Passive &

[1] The story of the Ballad is that a 'singularly mild' elephant, 'fresh and gay', with a 'blythe proboscis', rescues a friendly vegetable-monger from an unsuspected tiger by putting his friend out of harm's way through an upper-story window, see Plate XV.

[2] BM Add. MSS. 30803B.

PLATE XV

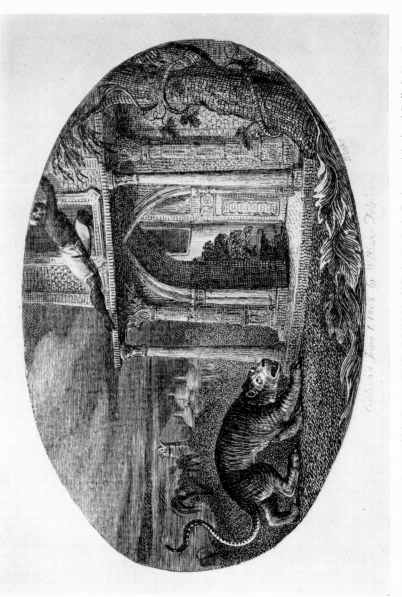

BLAKE'S ENGRAVING FOR 'THE ELEPHANT' in Hayley's *Design to A Series of Ballads* (1802). Princess Elizabeth thought the elephant should be shown to explain the drama of the scene (p. 102)

Polite & a Virtuous Ass: & obedient to Noblemens Opinions in Art & Science. If he is; he is a Good Man: If Not he must be Starved.'[1]

Hayley replied promptly and generously from Lavant on Tuesday the 6th:

I cannot let a single post escape me without thanking you, my dear *July* Lady, for your very kind Letter—sincerety is to my Feelings the Es- *6th,* sence of Kindness, and I take all that you so benevolently say of my *1802* worthy artist exactly as you would wish me to take it—

Alas! I grieve to add that altho it is his constant custom to attend me to the House of the benevolent & accomplishd Lady in whose appartment I scrawl these hasty Lines, yet today sickness detained Him in Bed—But I trust He will speedily revive under the care of perhaps the very best Wife that ever mortal possessed, at least one, that most admirably illustrates that expressive appellation *a Helpmate*.

He has packed off his Eagles to Kiss yr Hand, & I would not mortify him in his sickness by desiring Him to try & get them to take a longer road to you, as I believe they will set forth by the mail coach of this day directly for Bath. When I have a little Leisure I will talk to you of my good artist & his Wife, for both of whom you will feel a benevolent increasing Interest when I can delineate their Merits for yr Inspection.— . . . [*Our troubles in obtaining paper for the biography of Cowper might have been less if we had arranged*] (as Blake has done for his Ballads) to deal with his own stationer in London, & send it down as He thought proper you will Kindly sympathise with my vexation, & by a Kind report of the Eagles safe arrival at Bath console

<div align="right">

your troubled & affectionate
Hermit[2]

</div>

Fortunately Johnny Johnson sent better news the next day:

<div align="right">

E. Dereham. July 7. 1802 *July*
Wednesday *7th,*
 1802

</div>

My dear Sir

The Elephant arrived in perfect safety—and delighted us beyond measure. By *Us* you are to understand the four personages that follow—Peggy, my Cousin Castres and Me—*Three prime Virgins*—and my sister Catherine, *an especial Wife*. In the opinion of the first

[1] Reynolds marginalia, p. 5.

[2] BM Add. MSS. 30803B. Hayley also mentioned that he regularly went to Lavant on Tuesdays and Fridays for proof sheets, as it was only two miles from there to his printer. According to John *Cary's New and Correct English Atlas*, London, 1793, p. 6, letters posted in London (for sixpence) arrived sixty-three miles away in Chichester next day at 11 a.m., and the outgoing mail left Chichester at 4 p.m.

Maiden, They were *exceedingly pretty*—in that of the second (to whom, as he is a Cantab, I wish I may not have ascribed more honour than he deserves) they were *interesting and novel in the extreme*—and in the judgement of the Last (who,

> Were HE-*maidens* crown'd, wou'd *out-mitre* THE POPE,)

They were—*what were they not?*—

We anticipate with pleasure the arrival of the Eagle. My Cousin Castres, who is ripening into a Poet, as fast as he is ripening into a Man, would meet him *in the Sky's middle*, had he *Garnerin's Balloon*;

> 'sailing with supreme dominion
> Thrõ the azure Deep of air.'

These lines are for ever in his mouth, and almost as often in mine— I have already disposed of several copies of the Elephant, and hope shortly to send you a good account of my further progress. Remember me most kindly to Blake, the dear sculptor, and clap him on the back for me *seven* times—If the '*Ram's horn*' should 'sound', you may comfort him with this reflection, that you are thumping his *back* and not his *head*.

Our Ladies are at present on a journey to a distant part, or they would desire me to thank both the *pen* and the *graver* for their high gratification.[1]

Unhappily Lady Hesketh again had gloomier news to report when she wrote on Saturday, July 10th:

July 10th, 1802 Dear Sir, I lose as little time as possible to acquaint you of the Arrival of those Imperial birds the Eagles, who arrived safe, and alighted at my door the day before yesterday.—I dare give no opinion of them in regard to the Engravings, as I certainly place no dependence on *my own* Judgment in these matters, and have not yet been able to consult that of others—to me I own they appear more perfect than the Elephants, but that may be fancy— I have however one objection to make.—I'm afraid you will say 'tis a very *feminine one!* but will you not at the same time Join with me in opinion that yr ingenious friend pays little Respect to the 'Human Face Divine' for certainly the Countenance of his women and Children are nothing less than pleasing [*sic*]:—the *figure* of the woman hovering over her child is fine, but her *Countenance* is to me rather unpleasant, and that of the child extremely so, without any of those Infantine Graces which few babies are without, and which are to me so delightful[2]—in short the faces of

<hr>

[1] Bodley MSS. Eng. misc. d. 134. Blake twice refers to himself as a 'Ram hornd with gold' in a letter to Butts of Oct. 2nd, 1800. Jacques Garnerin was a balloonist and parachutist.

[2] See Plate XVI.

PLATE XVI

BLAKE'S ENGRAVING FOR 'THE EAGLE' in Hayley's *Designs to A Series of Ballads* (1802). Lady Hesketh found the baby lamentably lacking in 'Infantine Graces' (p. 104)

his babies are *not young*, and this I cannot pardon! may I be allow'd after all this to say the ballad is delightful, ye Story *true* I conclude, astonishing & miraculous as it certainly appears? . . . I really wish to thank you dear Sir a thousand times, for the Justice you do to *my intentions*, and for the Kindness with which you have receiv'd the Criticisms I was Impudent enough to send you and which I really mention'd not without some Scruples of conscience, and some anxiety of Mind, but when you say 'you take my animadversions as I meant you shou'd' I feel quite easy and nothing remains but to be grateful. I sincerely hope that before you receive this all *your* anxieties, respecting the health of this amiable friend of yours, will be at an end;— you must have many anxious moments I am sure in respect to your biographical troubles & torments: & need not the additional pain of trembling for the health of those you love. . . . & now let me observe that I think you mistook my meaning in regard to the not troubling yourself to send the ballads. I only meant that as my bookseller has orderd the bookseller in Pall Mall to send down the numbers as they come out, I thot it needless to trouble you any further. tho.' I do certainly feel rather proud of being possessed of my Eagles before [*any*] of the Londoners have had a Glympse at their feathers[.][1]

Hayley's pacific letter to Lady Hesketh of July 6th had been written before he conveyed her news to Blake, but his next, on Thursday, July 15th, was clearly written after extensive mutual consultation:

Pray suffer no Mortal, my dear Lady, however you may give them *July credit for refined Taste in art*, to *prejudice you* against the works of that *15th*, too feeling artist, whose designs met with *so little Mercy* from your *1802 octogenaire admirable*! I allow the *aimable Veillard* to be as severe as He pleases, as we happily counteract his Censure with the applause of *a more competent* but *also nameless Judge*,[2] who has said, I think with *more Truth*, that there is great spirit & sentiment in the engravings, of my Friend.— To this variety of opinions I apply the lively words of the goodhumoured Goldoni on a similar subject—'Ciascuno ha la sua maniera d'operari: gli uni trovano buono, quel che altri han trovato cattivo, e ne risulta piu bene che male.'—Whatever the Merits or the Failings of my diligent & grateful artist may be, I know I shall interest your Heart & Soul in *his Favour*, when I tell you, that He resembles our beloved Bard in the Tenderness of his Heart, & in the perilous powers of an Imagination utterly unfit to take due Care of

[1] BM Add. MSS. 30803B. Clearly, Blake and Hayley wanted if possible to supply the Ballads directly so that only a minimum of the profits would be siphoned off by middlemen. [2] Flaxman, June 27th, 1802.

Himself.— with admirable Faculties, his sensibility is so *dangerously acute*, that the common rough Treatment which true genius often receives from *ordinary Minds* in the commerce of the World, might not only wound Him *more than it should do*, but really reduce Him to the Incapacity of an Ideot without the consolatory support of a considerate Friend.— From these excesses of Feeling, & of irregular Health (forever connected with such excess) His productions must ever perhaps be *unequal*, but in all he does, however wild or hasty, a penetrating eye will discover true Genius, & if it were possible to Keep his too apprehensive Spirit for a Length of Time *unruffled*, He would produce Works of the pencil, almost as excellent & original, as those works of the pen, which flowed from the dear poet, of whom he often reminds me by little Touches of *nervous Infirmity*, when his mind is darkend with any unpleasant apprehension.—He reminds me of him also by being a most fervent admirer of the Bible, & intimately acquainted with all its Beauties—I wish our beloved Bard had been as happy in *a Wife*, for Heaven has bestowed on this extraordinary mortal perhaps the only female on Earth, who could have suited Him *exactly*. They have been married more than 17 years[1] & are as fond of each other, as if their Honey Moon were still shining— They live in a neat little cottage, which they both regard as the most delightful residence ever inhabited by a mortal; they have no servant:—the good woman not only does all the work of the House, but she even makes the greatest part of her Husbands dress, & assists him in *his art*—she draws, she engraves, & sings delightfully & is so truly the Half of her good Man, that they seem animated by one Soul, & that a soul of indefatigable Industry & Benevolence—it sometimes hurries them both to labour *rather too much*, & I had some time ago the pain of seeing both confined to their Bed.— I endeavour to be as kind as I can to two creatures so very interesting & meritorious, & indeed I consider it as a point of devotion to the *two dear departed angels* (Cowper & Tom!) to be so, for I am confident I could gratify their Spirits in nothing so much, as in befriending two wonderful Beings, whom they both, were they still on Earth, & possest of Health, would peculiarly delight to befriend.—[2]

[1] Catherine and William Blake had been married seventeen years in Sept. 1800 when first they came to Felpham. Hayley's conviction of the mutual devotion of the Blakes may have been the result of personal experiment; certainly some time later Blake wrote (Notebook, p. 35) that Hayley tried but 'could not act upon my wife'. Hayley's impression of their contentedness with Felpham was out of date, for on Jan. 10th, 1802 Blake had complained bitterly of his situation, particularly of the mechanical drudgery to which he was confined. The 'irregular Health', which Hayley thought 'forever connected' with '*dangerously acute*' faculties, Blake attributed in the same letter to 'the unhealthiness of the place'—and indeed he and his wife seem to have been far healthier in London.

[2] BM Add. MSS. 30803B. Hayley's association of the spirit of Cowper with

This is a truly extraordinary letter. Eloquent though it is of the Blakes' virtues, it was scarcely diplomatic to allude pointedly to the *'ordinary Minds'* of Blake's critics. Hayley was particularly tactless to identify Blake with Cowper both in genius and in 'little Touches of *nervous Infirmity'*, for Lady Hesketh was clearly horrified by any reference to the madness of her cousin.

Under the date of his letter of Thursday, July 22nd Johnny *July* wrote: 'Where is the Eagle?' And upside down above the salu- *22nd,* tation he sent 'Kindest remembr⁵ to all especially to "sweet *1802* William".'[1] On the same day Lady Hesketh wrote again:

The account you have so kindly sent me dear Sir of your amiable *July* Protegéés, was not necessary to Impress me with a favorable opinion *22nd,* of their Merit.—I could have no doubt of the good qualities both of *1802* heart and head of those who are so distinguished by your friendship, and the affectionate Interest you take in them—it was only respecting the Gentlemans Skill as an Engraver that I took the Impertinent liberty of hinting my doubts [, *in*] which I say, with *Regret* that I have been but too well authorized; and indeed I hope you do not think I obtruded my own Opinion in this Subject, in which I am perfectly Incompetent to give any, except the idle one I hazarded in my last, as to the *'human face Divine'* which I really think should always be made as handsome as possible, (those of women & children particu- larly) unless where there is a reason for making them otherwise; I must however beg leave to observe, that this, *my only Criticism*, does not in the least impeach your friends character either as a painter or as an Engraver, for Hogarth who excell'd so much, & whose fame will never dye, made all his children frightful! . . . and now dear Sir as I have assur'd you with great truth that I have never presum'd to offer any opinion of my own on the Subject of your amiable Friends per- formances; and have only Ecchoed those of others, and others who I knew were *Judges*, I must likewise assure you that nothing should have tempted me to have made so unpleasant a confidence, *even to you,* but that I know M⁵ B: is to furnish some Engravings for a work where (not I alone, but) all the world will grieve should the pencil prove only a Foil to the Pen:—the *General Wish* is that they should be

the living Blake is particularly interesting in the light of a comment Blake made years later (Spurzheim marginalia): 'Cowper came to me and said, "Oh! that I were insane, always. I will never rest. Cannot you make me truly insane? I will never rest till I am so. Oh! that in the bosom of God I was hid. You retain health and yet are as mad as any of us all—over us all—mad as a refuge from unbelief— from Bacon, Newton and Locke." '

[1] Bodley MSS. Eng. misc. d. 134, no. 106.

worthy of each other! . . . *[I agree with Goldini that tastes differ, but]* it does however *sometimes* happen (however rarely) that the same performance meets the general approbation, and this I shou'd wish might be the case with those engravings which are to be honor'd with a place in your interesting Work—and now I can't help lamenting the resemblance which you imagine Subsists between your friend and Him who will ever live in our remembrance! from my Heart I pity all those who are under the Dominion of such acute and delicate feelings I must now say that I am grieved you are again suffering in the persons of your friends. large Connections whatever pleasure they may at times procure us, are the Cause of much Sorrow, as they make us vulnerable in so many Quarters from all those Sorrows *[from which]* the Selfish heart, feeling for itself alone seems Secure, but I don't believe that idea will engage you to circumscribe your feelings into that Confined Circle. I shall therefore content myself with sincerely wishing recover'd health to your friends for Your Sake as well as their own*[.]*[1]

July 28th, 1802 To this Hayley replied on Wednesday, July 28th: 'I have been alarmed again for the Health of my interesting Artist, but He also is reviving, & I hope a Lion, that He is eagerly preparing as a successor to his Eagle, will have the Honor of Kissing yr Hand in the Course of next week*[.]*'[2]

Two days later Samuel Greatheed also made a discouraging report about the success of the Ballads:

Newport Pagnel, 30 July, 1802

My dear Friend,

July 30th, 1802 I have delayed replying to your last kind letter in the hope of giving you a good account of the Menagerie which you announced in it, and which arrived safely and peaceably at my recess. As collections of that kind are generally exhibited, I committed them for that purpose to the care of my neighbour whose name closes the preceding page. He assures me that he has missed no opportunity of inviting gentlemen and ladies to see—the elephants; but although their anxiety has led them to survey those wondrous animals, I find with regret that nobody has discovered an inclination to keep them. It is I think a severe reflexion on the taste of my fellow pagnelians, as well as of their want of love toward the noblest of the Brute Creation. I heartily wish that they may act so as to vindicate themselves from these imputations, and to

[1] BM Add. MSS. 30803B.
[2] BM Add. MSS. 30803B. 'The Lion' apparently was not sent directly from Felpham to Bath—see Lady Hesketh's letter of Oct. 15th, 1802.

encourage the importation of the rest of your beautiful and respectable menagerie. I hope to hear better tidings from the Southern coasts than I am able to send you from the central part of our island.[1]

The appearance of these Ballads caused very little comment,[2] though Coleridge may have intended to review them, for he wrote enigmatically to Southey on August 9th, 1802: 'I believe that I can execute the Criticisms with no Offence to Hayley'.[3]

On Friday, August 6th, Hayley wrote to Johnny:

our good Blake is actually *in Labour with a young Lion*.— The new born Cub will probably kiss yr Hands in a week or two— The Lion is his 3d Ballad, & we hope his Plate to it will surpass its 2 predecessors— *August 6th, [1802]*

Apropos of this good warm-hearted Artist He has a great wish that you should prevail on Cowper's dear Rose to send her portrait of the beloved Bard by Abbot to Felpham, that Blake may engrave it for the Milton we meditate which we devote (you know) to the Sublime purpose of raising a monument, suited to the dignity of the dear Bard in the Metropolis, if the public shows proper Spirit (as I am persuaded it will) on that occasion—a point that we shall put to the end in publishing the Life [*of Cowper.*]—[4]

Six months later, on January 30th, 1803, Blake still had

a head full of botheration about . . . a work now Proposed . . . which will very likely be of great consequence[;] it is Cowpers Milton the

[1] Vol. i of the Fitzwilliam Hayley Correspondence. There is no 'preceding page', but the letter is only half the normal size, and perhaps the other half was torn off. It seems strange that Hayley apparently sent no Ballads to Greatheed until mid-July 1802.

[2] The only published notice of the 1802 Ballads I know is, Anon. 'Designs to a Series of Ballads, written by William Hayley, Esq. and founded on Anecdotes relating to Animals. 4to. Three Numbers. pp. 39', *The Poetical Register* for 1802 (London, 1803), p. 440: 'These ballads are written in a style of elegance and simplicity. They are three [*actually four*] in number, and the subjects are the Elephant, the Lion, and the Eagle. It is intended to continue the publication to the extent of a quarto volume. The work is inscribed by Mr. Hayley to the inhabitants of Chichester.' The complete absence of reference to Blake demonstrates the failure of the venture's intention to provide poems merely as vehicles for his designs and profit.

[3] *Collected Letters of Samuel Taylor Coleridge*, ed. E. L. Griggs, Oxford, 1956, vol. ii, p. 847. Coleridge may be referring to an early announcement of Hayley's life of Cowper.

[4] Hayley–Johnson Fitzwilliam letters. There is no year in the date of this letter, and Johnny placed it with those of 1801 in Hayley's *Memoirs*, but the context quite clearly indicates 1802. The labour for 'The Lion' was presumably printing, as the plates are dated Aug. 5th.

same that Fuselis Milton Gallery was painted for, & if we succeed in our intentions the prints to this work will be very profitable to me & not only profitable but honourable at any rate[.] The Project pleases Lord Cowpers family, & I am now labouring in my thoughts Designs for this & other works equally creditable[.]

August 6th, 1802

On Friday, August 6th John Carr wrote to Hayley about his trip to Paris, and he concluded: 'Pray also remember me to the Artist of Felpham, & tell him I have made about 30 little sketches which I mean to have bound up with the Journal of my little Tour,[1] which should an opportunity ever offer I shall with pleasure shew him.' In his letter of Saturday, August 14th,

August 14th, 1802

just before he left for Paris, Flaxman asked Hayley to give his 'love to Mͬ Mͬˢ Blake & Yourself in which Mͬˢ F unites'.[2]

September 1st, 1802

Samuel Greatheed wrote to Johnny Johnson on Wednesday, September 1st: 'Our kind friend Mͬ Hayley sent me half a dozen of his first Ballad, and I am ashamed of a flagrant deficiency of taste among my neighbours, betrayed by their inattention to this conjunction of the Muses and the Arts. I am above all surprised that a Copy sent by the Bookseller to Mͬ Courteney's should have been returned unpurchased. I hardly know how to inform our friend of this circumstance which I fear will grieve him.'[3]

Hayley evidently wrote that he was dispatching more of his zoological poetry, for on Friday, September 3rd, Greatheed wrote cautiously:

September 3rd, 1802

I much wish for the arrival of the Royal Animals from your Menagerie. Being apprehensive I may not speedily find a conveyance more suited to their dignity, I shall be obliged to you when sending to Mͬ Blake if you will desire him to leave them for me at Conder's in Bucklesbury. I find that my active bookseller here, had sent a copy of the Elephant to Mͬˢ Throckmorton before yours arrived. As I have not the honor of her acquaintance will it not be best for you to inclose to me a note for her, which I will send with a copy of each ballad, when the others arrive, to ensure her patronage?[4]

[1] The book is '*The Stranger in France:* or, A Tour from Devonshire to Paris. Illustrated by Engravings in Aqua Tinta of Sketches Taken on the Spot, by John Carr, Esq. . . . J. Johnson . . . 1803'. Carr was working on the book about the time he wrote this letter, for his Preface is dated Aug. 1802.

[2] One of a group of Flaxman–Hayley letters loose in a folder in the Fitzwilliam Museum.

[3] Quoted from the MS. in the possession of Miss Mary Barham Johnson.

[4] Volume i of the Fitzwilliam Hayley Correspondence. 'Royal Animals' suggests

Six weeks later, on Friday, October 15th, Lady Hesketh wrote apologizing for her long delay in writing to Hayley, and continuing:

one other proof equally Shameful with the former of my Loss of *memory* and of my having left my Recollection, as well as my Gratitude at Bath, appears in my totally forgetting 'till Just now my debts to your Ingenious friend M⸢r⸣ Blake, who honored me more than I appear to have deserv'd by the two packets of ballads he was so good to send me;—I think I had ten from Felpham, five of each of the two first;—the rest my bookseller at Bath has regularly from London, as well as those I take in for my Sist⸢r⸣ and some other friends,—but for the above mentiond I am still deb⸢tr⸣ to M⸢r⸣ Blake and shall this day send a draft to our good friend M⸢r⸣ Rose for Five guineas which trifling Sum I flatter myself Mr Blake will have the goodness to accept as I have desired our worthy Barrister will forward it with this Letter[.]—[1]

October 15th, 1802

This was extremely generous, for, according to her own figures, she owed Blake only twenty-five shillings.

In his letter to Hayley of Sunday, October 17th, John Carr wrote: 'I beg to be always rememberd to the amiable Artist of Felpham', and as an afterthought to his letter of Tuesday, November 2nd, to Hayley, Flaxman said: 'Pray give our love to M⸢r⸣ & M⸢rs⸣ Blake'.[2]

October 17th, 1802

November 2nd, 1802

On Saturday, November 6th, 'E.G.', probably Hayley's young friend Edward Garrard Marsh, sent Hayley a poetical epistle which concluded with a

Postscript
You'll let the Meyers and M⸢r⸣ Blake
My kind remembrances partake[.][3]

November 6th, 1802

Apparently Hayley had ceased to mention Blake in his letters to his friends, for on Friday, December 3rd, Johnny Johnson wrote: 'By the bye is our dear Blake *dead?* You are as silent about him as the *grave!*'[4]

December 3rd, 1802

the third Ballad, 'The Lion', so presumably Hayley had also sent the second Ballad, The Eagle'.

[1] BM Add. MSS. 30803B. [2] BM Add. MSS. 37538, f. 4.

[3] Quoted from a microfilm of the MS. in Harvard University Library. Clearly 'E.G.' had recently been to Felpham. The facts that the initials match those of E. G. Marsh, and that the letter was dated from Oxford, where Marsh was an undergraduate at Wadham, seem to clinch the identification.

[4] Bodley MSS. Eng. misc. d. 134, no. 118.

December 10th, 1802 At the end of her letter of Friday, December 10th, in which she described 'our late Excursion to France', Nancy Flaxman asked Hayley to 'give our love to the good Cottagers—'.[1] On *December 16th, 1802* Wednesday, December 16th, Hayley added a P.S. to his letter to Nancy: 'poor Mrs Blake has suffer'd most severely from Rheumatism but she is reviving—They return yr good wishes—'.[2]

On Monday, December 20th Hayley wrote to Lady Hesketh to prepare her for the long delayed arrival of his biography of Cowper:

December 20th, 1802 my Friend the anxious, enthusiastic Engraver says, that all the Demons, who tormented our dear Cowper when living, are now labouring to impede the publication of his Life.— To which I reply that it may be so, but if it is, I am confident my two dear Angels the Bard & the Sculptor will assist us in *our Conflict* with *the powers* of *darkness*, & enable us to triumph over all *their Machinations*. . . . I know your tender Humanity will spare my good zealous Coadjutor the Engraver, if you think He has failed in one Portrait, as I am confident you must think he has succeeded delightfully in the second—His plate from Romney has not all the merit of *his own drawing in India* Ink whence He copied it, but his print from Lawrence is infinitely superior to Bartolozzi's in *tender fidelity to the Character of the original*[.][3]

December 23rd, 1802 Lady Hesketh replied most cordially on Thursday, December 23rd that she had not yet received the biography, but that she wished the Romney portrait had been omitted: 'well, and now dear Sir I must say (and *you will I hope forgive me if I say*) that however your friend may have faild in copying Mr Romneys picture I forgive him from my heart beforehand if Mr Blake has succeeded happily in that of Lawrence he will have answer'd all *my* wishes, for as to the other he cannot possibly have done it *Injustice!*'[4] Within the week the biography had arrived, and in a postscript to her letter of Wednesday, December 29th

[1] Quoted from the MS. in the Art Institute of Chicago. There is no year on the letter but the Flaxman's trip to France took place in the brief peace of the autumn of 1802. Mrs. Flaxman also refers to the recent death of Romney, who died on Nov. 15th, 1802.

[2] Vol. ix of the Fitzwilliam Hayley Correspondence. In his letter of Jan. 30th, 1803 Blake wrote to his brother James: 'My Wife has had Agues & Rheumatisms almost ever since she has been here'. [3] BM Add. MSS. 30803B.

[4] BM. Add. MSS 30803B. Hayley complained that 'some persons and ladies in particular . . . have supposed Romney's portrait of him [*Cowper*] to border on extravagance of expression' (*The Life of George Romney, Esq.*, London, 1809, p. 178).

Lady Hesketh wrote: 'I must tell you that I admire Romneys
head of all things! now it is *Softened*[;] of the engraving I
pretend not to Judge, but I like it[.]'[1] The relief to Blake must
have been enormous. A month later, on January 30th of the new
year, he wrote in exultation to his brother James: 'My Heads
of Cowper for M^r H's life of Cowper have pleasd his Relations
exceedingly & in Particular Lady Hesketh & Lord Cowper[;]
to please Lady H was a doubtful chance who almost adord her
Cousin the poet & thought him all perfection & she writes
that she is quite satisfied with the portraits & charmd by the
great Head in particular tho she never could bear the original
Picture[.]'

Lady Hesketh began collecting and cataloguing the reactions
of her relatives, and on Monday, January 10th she wrote to
Hayley: 'the only thing my Sister has particularized is the
print from Romney which she dislikes as much as ever, but to
which I am perfectly reconciled, as a Print I mean for my
abhorrence of the Miniature is in its full force but this Engraving
has an effect totally different from that[.]'[2] By Saturday,
January 15th, a few days later, she could report that she now
positively liked the Romney portrait: 'the print softens it
extremely & it has not that distracted and distracting look which
prevails in the miniature[.]'[3]

On the same day Hayley sent Mrs. Bodham a copy of the life
of Cowper and thanked her for the loan of her portrait of
Cowper's mother, which Blake had engraved: 'The Picture shall
travel home to you very carefully—but first let me request the
favour of another Portrait!—you will see by the close of the 2d
volume, that I have farther Projects in honour of our beloved
Bard.—To decorate his Milton, I wish to have a print engraved,
by my Friend M^r Blake, from your picture of the poet by Abbot,
if you will have the kindness to let it travel to Felpham for that
purpose[.]'[4]

A fortnight later, on Saturday, January 29th, John Carr wrote
in his letter to Hayley: 'I beg to be remembered to the philo-
sophical & ingenious owner of the little white-faced Cottage

[1] BM Add. MSS. 30803B.
[2] BM Add. MSS. 30803B. [3] BM Add. MSS. 30803B.
[4] Quoted from the MS. in the Princeton University Library. Blake did not
engrave Abbot's portrait, nor did it appear in Cowper's *Milton*.

on the sea shore[.]'[1] On Thursday, March 3rd Anna Seward
told Hayley 'I take in your Ballads, & have received the first
3 numbers',[2] but though she commented on the verse '(I per-
ceive . . . that you write them for the Multitude') she said
nothing about the engravings. Flaxman wrote to Hayley on
March Monday, March 21st to say: '—I am sorry for M͞r Spilsbury's
21st, illness[.] I hope he is better & I hope you & your Household
1803 with M͞r & M͞rs Blake have escaped the Influenza[.]'[3]

On Sunday, April 3rd Hayley wrote to R. H. Evans, the
bookseller of Pall Mall:

My dear Evans
April Can you tell me what is become of our Friend Sockett?—He wrote
3rd, to me from London on receiving the Life of Cowper, & I replied
1803 *immediately* to his Letter, giving Him some commissions *relating to
you*, of which I have *not heard a syllable*: first I begged Him to convey
to me your Bill, secondly I desired Him to send me your full & frank
opinion concerning the adventure of my worthy Friend Blake, in the
Ballads, that I gave him in a sanguine Hope of putting a little Money
in his pocket.— He suspended their publication, that He might pro-
ceed, without any Interruption, in his plates for the Life of Cowper,
which have engrossed much of his time even to this Hour, as He and
his good industrious Wife together take all the Impressions from the
various Engravings in their own domestic Press—
Do you think it will answer to Him to resume the series of the
Ballads?—all the number mentioned in the preface [*fifteen*] are *written*,
but his *designs are not prepared* for them, & I am very desirous of not
leading Him into *an unprofitable adventure*— He has paid a Bill of 30 £
for paper & the copies He has disposed of in the country have not
produced more than half that sum to reimburse Him— What Cash
have you for Him?— He is an excellent creature, but not very fit to
manage pecuniary Concerns to his own advantage. should you like
(as you have by this Time probably been able to judge whether his
publication is likely to prosper or not) to take the charge of it allowing
Him any settled conditional sum?—perhaps Ballads in *Quarto may not
be [as] suited* for *general Sale*, as the same work might prove on a

[1] The words '& ingenious' are added over a caret.
[2] Transcribed for me from the MS. in the Carl H. Pforzheimer Library, N.Y.,
by Charles Ryskamp. Clearly the fourth Ballad was not published through the
ordinary channels, for it should have been delivered before this time.
[3] BM Add. MSS. 37583, f. 5. This Mr. Spilsbury, presumably of Midhurst
(see Charlotte Collins's letter of June 28th, 1802), does not seem to be the profes-
sional artist to whom Blake refers familiarly in his letter to Hayley of Sept. 28th,
1804.

smaller Scale—my Idea for Him was to go thro the series in quarto, & afterwards to make a little Book of the whole like the small Triumphs of Temper, with no[?] other plates to it, than *a single animal to each Ballad* like the *small Elephant* at the close of the first—[1] Favour me with all your Ideas on this subject! & assist me, as far as you properly can, in my cordial wish to serve a very ingenius worthy Man, who is devoted to a life of Industry & Retirement!—[2]

Hayley's remarks about Blake's financial competence were not consonant with Blake's own ideas at the time. On January 30th he wrote to his brother James:

now it is in my power to stay or return or remove to any other place that I choose because I am getting before hand in money matters[.] The Profits arising from Publications are immense[3] & I now have it in my power to commence publication with many very formidable works, which I have finishd & ready[.] A Book price half a guinea may be got out at the Expense of Ten pounds & its almost certain profits are 500 G. I am only sorry that I did not know the methods of publishing years ago & this is one of the numerous benefits I have obtain by coming here for I should never have known the nature of Publication unless I had known H & his connexions & his method of managing. It now would be folly not to venture publishing. . . . I am now so full of work that I have had no time to go on with the Ballads, & my prospects of more & more work continually are certain. . . .[4] in short I have Got every thing so under my thumb that it is more profitable that things

[1] Blake did not finish any more designs for the 1802 series of Ballads; the Ballads issued in 1805 were the size of the small *Triumphs of Temper* but there were only five plates for the sixteen Ballads, and the designs were much more ambitious than the copy of the medallion-elephant in the 1802 Ballads.

[2] Quoted from a microfilm of the MS. in the Library of Harvard University. Hayley's reference to Blake's life of 'Retirement' is curious, because three weeks later Blake wrote of his decision to 'return to London with the full approbation of M[r] Hayley'. Presumably Hayley meant a quiet life rather than life necessarily in the country.

[3] Rumour had it, at least in 1853 when Thomas Rees wrote his *Reminiscences of Literary London from 1779 to 1853*, N.Y., 1896, p. 78, that Johnson 'paid as much as £10,000 for Hayley's "Life of Cowper" '.

[4] These prospects were probably for: (1) retouching his quarto plates to Cowper for a new edition; (2) engraving new plates for an octavo edition of Cowper; (3) designing some of and engraving all the plates for Cowper's translation of Milton's Latin and Italian poems (see Blake's letter of July 6th, 1803); (4) engraving the twelve plates for Hayley's life of Romney; (5) engraving more Ballads plates; (6) engraving the plates to Hayley's *Triumphs of Temper*. All these commissions were more or less firmly promised to Blake by Hayley, but only the last two materialized, and partly as a consequence Blake largely gave up engraving work from 1805 to 1814.

should be as they are than any other way. . . . These Ballads are likely
to be Profitable for we have Sold all that we have had time to print.
Evans the Bookseller in Pallmall says they go off very well & why
should we repent of having done them[?] it is doing Nothing that is to
be repented of & not doing such things as these[.]

And three weeks after Hayley had written to Evans, Blake told
Butts confidently on April 25th: 'The Reason the Ballads
have been suspended is the pressure of other business but they
will go on again Soon.' These estimates and ambitions proved
illusory.

The affair of the Ballads may serve as an example of Blake's
methods and success as a private publisher, for we can account
for most of the copies 'disposed of in the country'. Greatheed
had six copies of the first Ballad, and presumably six also of the
second and third (£2. 5s. 0d.). Lady Hesketh had ten copies for
which she paid £5. 5s. 0d. Johnny Johnson was sent a few less
than twenty of the Elephant, and presumably a few at least of
the Eagle, say twenty in all (£2. 10s. 0d.). Charlotte Collins
sold seven of the first Ballad, and probably received, as she re-
quested, seven of the second as well (£1. 15s. 0d.). Flaxman
paid for a subscription for himself, sold four others of the first
Ballad,[1] and received at least five of the last (according to
Blake's letter of January 30th, 1803)—it seems reasonable to
suppose that he took five sets of each number (£2. 10s. 0d.).
Mrs. Chetwynd took two copies of the fourth Ballad from James
Blake (January 30th, 1803), and probably had the preceding
numbers as well, eight in all (£1. 0s. 0d.). Thomas Butts had
fourteen numbers but did not pay for them until 1805 (see
Accounts for March 3rd, 1806). On April 25th, 1803 Blake
sent 'the 4 Numbers for Mr Birch', three of which went to Butts
according to the same debtor-creditor account; presumably
Birch took in all a complete set of four Ballads (10s.). Hayley
owned 'Hayley's Ballads, with Blake's Designs, 4 Numbers
1802', and 'Another set, 3 Numbers, 1802', seven Ballads in all,[2]
for which he probably paid nothing. The total of £15. 15s. 0d.

[1] One of Flaxman's customers was probably Blake's old partner James Parker.
On the blue cover of the first of the four Ballads in original wrappers in the
Rosenwald Collection 'J Parker' is written in old brown ink.

[2] 'A *Catalogue of the very Valuable and Extensive Library of the late William
Hayley, Esq.* which will be Sold by Auction, by Mr Evans On Tuesday February
13th, and Twelve following Days [London], 1821.'

by 1803 for 115 copies is close enough to Hayley's estimate of half £30 from country sales (i.e., not through booksellers) to give us some confidence in the accuracy of these totals.

Probably there were even smaller returns from the booksellers. Of the three booksellers, the most likely to be successful was R. H. Evans in London, but on October 26th, 1803 Evans had sold less than £2 worth of Ballads, and the other booksellers presumably had even smaller sales to report. Probably Blake had to meet part of the expenses for Seagrave's printing bill and the £30 for paper out of his own pocket.[1] The Ballads must have been a clear loss to Blake, not even counting his wages for designing, engraving, and printing the engravings.

The last that we hear of this curious and unsuccessful way of selling Ballads, chiefly through friends rather than through booksellers, is in Blake's letter to Hayley of October 26th, 1803:

> I called on Mr. Evans, who gives small hopes of our ballads; he says he has sold but fifteen numbers at the most, and that going on would be a certain loss of almost all the expenses. I then proposed to him to take a part with me in publishing them on a smaller scale, which he declined on account of its being out of his line of business to publish, and a line in which he is determined never to engage He advises that some publisher should be spoken to who would purchase the copyright: and, as far as I can judge of the nature of publication, no chance is left to one out of the trade. Thus the case stands at present. God send better times.

About the same time he was negotiating with Evans, Hayley apparently wrote to Lady Hesketh asking if she would allow a young (unnamed) painter who was a friend of his to paint her portrait, and in her reply of Wednesday, April 20th she naturally assumed that he had referred to Blake:

> you thought that I did not see thro.' your ingenious intention, of making work for Mr B: at ye expense of your Humble Servant . . . [*but*] I was fully aware of your illicit intentions from the moment I read your first letter upon the Subject. . . and indeed was I ever so desirous of exhibiting my Wrinkles to the Publick I shou'd be very sorry to add to the

April 20th, 1803

[1] According to Blake's letter of Dec. 28th, 1804, Hayley had lent him twelve guineas so that he could pay Seagrave £30 'in part of his Account'. On Dec. 11th, 1805 he was still writing of 'the Generous Seagrave, In whose debt I have been too long but percieve that I shall be able to Settle with him Soon what is between us.'

Criticisms I have already heard on the Subject of some certain en-
gravings which I am sorry to say are not thought *quite* worthy of the
work and I have been told more than once that (however *difficult* it
might have been to find) M^r Hayley shou'd have endeavor'd after a
pencil more nearly allied to his admirable Pen. . . . [*I don't want my
picture painted, but*] if your *protegee*, will accept of 5 Guineas at my
hands, they shall be at his Service, and I shall receive a very real
pleasure from making this little offering, *because he is your* protegée[.]¹

April Next day, April 21st, Johnny Johnson asked Hayley to 'Re-
21st, member me also to the Blakes and the incomparable Lady of
1803 Lavant.'² He also sent regards to Greatheed, who was in
Felpham and who may have taken this opportunity to settle
accounts with Blake about the Ballads.

April On Monday, April 25th Hayley wrote to Lady Hesketh that
25th, he had merely 'wished to befriend the artist' and obtain her
1803 picture for himself. 'Yr refusal however may be productive of
some Good—It will assuredly preserve you from the Trouble
of ever receiving subsequent requests from the sufficiently
mortified Hermit Whenever I make that Liberality [*her
proposed gift*] known to Him I must contrive to do it with the
utmost caution as I know his honest pride would be otherwise
hurt by the Idea[.]'³ Poor Lady Hesketh still had no way of
knowing which artistic protégé Hayley was referring to.

May Sometime in May 1803 George Cumberland made a note to
1803 himself to remember—or to look for?—the 'Plate engraved by
Blake for 12 good rules—'.⁴ No such work is known, and there
is no hint from Cumberland's notebook as to what it was.
Perhaps the plate is related to the popular broadside of 'King

¹ BM Add. MSS. 30803B. Hayley's protégé in this instance was not Blake but
an artist named Dudman, who committed suicide in September.
² Bodley MSS. Eng. misc. d. 134, no. 134,
³ Quoted from the MS. in the Princeton University Library. The year is missing
from the date, but the context makes it clear that the letter answers Lady Hesketh's
of April 20th.
⁴ BM Add. MSS. 36519D, f. 165. The entry occurs just after the date May 1803
in a notebook filled in roughly chronological order. Confusion as to date arises
occasionally when entries are simply transcribed from earlier notebooks. This
entry, for instance, was copied in the notebooks *for 1804–1805* (BM Add. MSS.
36519E, f. 209): 'Q[*uer*]y Plate engraved by Blake of 12 good rules—where—[?]';
for 1805–1806 (F, f. 251): 'Qy Plate of 12 good rules Blake where [?]'; *for*
1807 (G, f. 303): 'Qy Plate of 12 rules where?'; *for 1807–1808* (H, f. 335): 'Qy
who has Plate of 12 good rules [?]'; and *for 1808* (I, f. 385): 'Qy who has Plate of
the 12 good Rules by Blake lost [?]' Thereafter the reference disappears.

Charles' "Twelve Good Rules"' whose ubiquity is celebrated by Goldsmith in *The Deserted Village*, by Crabbe in *The Parish Register*, and by Thomas Bewick, who remembered seeing it 'when I was a boy in every cottage and farm house throughout the country'.[1] The rules themselves were sententious, simpleminded, and redundant,[2] but they were admirably adapted to a country audience such as Blake had at hand in Felpham, and this plate may have been one of the 'formidable works' which were 'finishd & ready' and whose 'certain profits' Blake calculated to be 'immense' in January 1803.[3]

Probably in the spring of 1803, Hayley wrote to the Countess of Portarlington:

*A*s Mᴿ H: has taken the Liberty to recommend and the Countess of Portarlington has had the goodness to permit Mᴿ Blake to wait on her Ladyship to shew some of his designs, Mᴿ H: conceives it cannot be improper to signify to her Ladyship, that the drawings wᶜʰ Mᴿ Blake will bring are the sole & exclusive property of a private Gentleman who has purchas'd them for his own amusement and Instruction—

Spring?
1803

Mᴿ B. is an artist of great original powers and of uncommon Merit in his Inventions, in wᶜʰ Line he is perhaps unequal'd among the Br[*itish*]. Artists[.]

Mᴿ B. is a married man but without a Family & his wife is a virtuous, & singularly amiable woman, & they have passed their lives together with so scanty an Income as scarcely to have afford[*ed*] them the means of subsistence—

Mᴿ H:[*'s*] sole motive for wishing to make him known to Lady Portarlington, was to introduce to her Ladyship Mᴿ Blakes neglected merits and almost unexampled difficulties & perseverence with a hope that among L.P: extensive and powerful friend[*s*], some may be found who will be sensible of his Merit, and who will be willing to assist in supporting and encouraging so extraordinary a Man[.] It

[1] *A Memoir of Thomas Bewick*, ed. A. Dobson, London, 1887, p. 261.

[2] Dobson gives them as: 1 Urge no healths; 2 Profane no divine ordinances; 3 Touch no state matters; 4 Reveal no secrets; 5 Pick no quarrels; 6 Make no comparisons; 7 Maintain no ill opinions; 8 Keep no bad company; 9 Encourage no vice; 10 Make no long meals; 11 Repeat no grievances; 12 Lay no wagers.

[3] To save money and trouble Blake may have engraved the rules on pewter, a process which he described in his Notebook (p. 10) and recommended to Cumberland (see April 12th, 1813). It is possible that the 'Twelve Good Rules' can be connected with the 'Illustrations by W. Blake—pewter-types 13' that were sold at Christie's with the collection of Mrs. Steel on Feb. 7th, 1893. Certainly no other plates of Blake's are known which might answer this description of 1893.

may perhaps not be unnecessary to add that M⸢r⸣ B. has at present a number of Commissions, that afford him a sustenance, to [*live*] upon the narrowest state[.]—[1]

By this time Flaxman had heard of the Blakes' plans to move,
May and in his letter to Hayley of Saturday, May 28th, he indicated
28th, where his sympathies lay: 'your account of M⸢r⸣ & M⸢rs⸣ Blake's
1803 having suffered so much from a damp Situation concerns me, I earnestly hope what they propose is for the best, you have allways acted with the same bounty & Kindness by them as you do by all.'[2] Blake had told his brother (January 30th, 1803) that Hayley 'is very afraid of losing me & also very afraid that my Friends in London should have a bad opinion of the reception he has given to me'. Hayley seems to have told Flaxman that the bad climate of Felpham was the chief reason for Blake's intended move.

Though Hayley zealously continued to urge Blake's merits as an engraver and his virtues as a man to possible patrons, misunderstanding and strain between the two had been growing for some months. As early as January 10th, 1802 Blake had complained to Butts of his situation, and by July 6th, 1803 he was 'determind to be no longer Pesterd with his [*Hayley's*] Genteel Ignorance & Polite Disapprobation'. He was, in short, asserting his independence in a way which Hayley was sure would hurt Blake's material fortunes. Blake's differences with Hayley had a disrupting effect upon his poetry and his spiritual state as well. ' "The Visions were angry with me at Felpham["], he would afterwards say.'[3]

A project on which Blake had long been anxiously working came to a disappointing fruition in the summer of 1803. On January 10th, 1802 he had told Butts that he was 'engaged in Engraving 6 small plates for a New Edition of M⸢r⸣ Hayleys

[1] The MS. in the Yale University Library (associated with *America* copy K) has no written or watermark date. The Countess of Portarlington (married 1778, died 1813) was born Lady Caroline Stuart, daughter of the third earl of Bute. Her elder brother, the Marquis of Bute, may have acquired *Songs of Innocence* copy M (watermarked 1804). The 'private gentleman' who owned the Blake drawings was presumably either Thomas Butts (who held, however, a public position as clerk in the Muster Master General's Office) or the Revd. Mr. Thomas, for whom, according to his letter to Flaxman of Oct. 19th 1801, Blake was making designs for *Comus*.

[2] Quoted from a microfilm of the MS. in the Yale University Library.

[3] Gilchrist, 1942, p. 161; 1880, p. 184—not in 1863

Triumphs of Temper, from drawings by Maria Flaxman sister
to my friend the Sculptor and it seems that other things will
follow in course if I do but Copy these well[.]' Blake had pro-
bably been given the commission for engraving these designs not
long after Miss Flaxman exhibited them at the Royal Academy
in May 1800. By May 1803 the plates were finished enough to
be dated, and Hayley sent one of the earliest copies to Lady
Hesketh. In her letter of Friday, July 1st thanking him for the
volume she said succinctly: 'I am disappointed in the Prints'.[1]

July 1st, 1803

On Sunday, August 7th Hayley wrote to Flaxman about their
reception:

the Engravings were made from the drawings in the State I found
them except the omission of one Figure (the tall *Minerva*) that Blake
& I thought it would be better to omit[?]— I am sorry to say that
the Ladies (& it is a Ladys Book) find Fault with the Engravings—
our poor industrious Blake has received sixty Guineas for them from
my Bookseller & I believe both the artist & the paymaster are dissatis-
fied on the occasion— The Engravings of Cowper have been also
heavily censur'd but I think in the Portrait from Lawrence very un-
justly for Blake was certainly more faithful than Bartolozzi to the
original drawing— I wish our Friend may be more fortunate in the two
engravings that He is now beginning[,] to decorate a Life of our
lost Romney— . . .

August 7th, 1803

Blake has made two excellent drawings of Romney one from his own
large picture the other from our dear disciples Medallion—I thought
of having both engraved for a single quarto volume of his Life—but
Blake surprised me a little in saying (after we had settled the price of
30 Guineas for the first the price which He had for the Cowper) that
Romneys head would require much Labor & he must have 40 for it—
startled as I was I replied I will not stint you in behalf of Romney—
you shall have 40—but soon after while we were looking at the smaller
& slighter drawing of the Medallion He astonished me by saying I
must have 30G for this— I then replied—of this point I must consider
because you will observe Romneys Life can hardly [sell *del*] circulate
like Cowpers & I shall perhaps print it entirely at my own risk— So
the matter rests between us at present—yet I certainly wish to have
both the portraits engraved[.]—[2]

[1] BM Add. MSS. 30803B.

[2] Quoted from the MS. of the rough draft in the possession of Sir Geoffrey Keynes.
Blake eventually engraved only one plate for the Romney, a fact which made him
most indignant, as his epigrams in his Notebook show. There is further debate
about prices in Blake's letter to Hayley of June 22nd, 1804, though Blake there
seems to have modified his demands somewhat.

Blake's new commercial righteousness was part of a deliberate policy, for on July 6th, 1803 he had written of

my late Firmness [*by which*] I have brought down his [*Hayley's*] affected Loftiness & he begins to think I have some Genius, as if Genius & Assurance were the same thing, but his imbecile attempts to depress Me only deserve laughter. . . . [*I have now been*] set at liberty to remonstrate against former conduct & to demand Justice & Truth which I have done in so effectual a manner that my antagonist is silencd completely & I have compelld [*him to give*] what should have been [*given*] of freedom[,] My Just Right as an Artist & as a Man.

Such disputes and attitudes were soon forgotten, however. On Friday, August 12th Blake was involved in an incident which, as Blake told Butts on the 16th, began when a soldier named Scolfield

was invited [*into my garden*] as an assistant by a Gardener at work therein, without my knowledge that he was so invited. I desired him as politely as was possible to go out of the Garden, he made me an impertinent answer[.] I insisted on his leaving the Garden[;] he refused[.] I still persisted in desiring his departure[;] he then threatend to knock out my Eyes with many abominable imprecations & with some contempt for my Person[;] it affronted my foolish Pride[.] I therefore took him by the Elbows & pushed him before me till I had got him out, there I intended to have left him but he turning about put himself into a Posture of Defiance threatening & swearing at me. I perhaps foolishly & perhaps not, stepped out at the Gate & putting aside his blows took him again by the Elbows & keeping his back to me pushed him forwards down the road about fifty yards[,][1] he all the while endeavouring to turn round & strike me & raging & cursing which drew out several neighbours, at length when I had got him to where he was Quarterd, which was very quickly done, we were met at the Gate by the Master of the house, The Fox Inn,[2] (who is the proprietor of my Cottage) & his wife & Daughter, & the Mans Comrade & several other people[.] My Landlord compelld the Soldiers to go in doors after many abusive threats against me & my wife from the two Soldiers but not one word of threat on account of Sedition was utterd at that time. This method of Revenge [*a charge*

[1] The distance from Blake's cottage (which still stands) to the Fox Inn where the soldiers were quartered is fifty paces.

[2] The original Fox Inn, which was named after a ship, burned in 1946 and was replaced in 1949 by another pub of the same name and on the same site. A photograph of the old building is reproduced in T. Wright, *The Life of William Blake*, Olney, 1929, vol. i, p. 156.

of sedition] was Plannd between them after they had got together into the Stable. This is the whole outline.

On comparing this letter with Blake's 'Memorandum' below (August 15th) it becomes clear that those present at the inn besides Blake and John Scolfield the soldier were: (1) Mr. Grinder, the landlord of the Fox; (2) his wife; (3) his daughter; (4) Mrs. Haynes, who was (according to Hayley's letter of August 3rd, 1805) the wife of the miller's servant and whose garden adjoined Blake's; (5) Mrs. Haynes's daughter; (6) Private Cock, Scolfield's comrade; (7) Hayley's gardener, who may be the Mr. Hosier who was willing to testify about what he heard Scolfield say next day (the 13th); (8) Mr. Cosens, owner of the mill at Felpham. Not far away were William, who was the hostler at the Fox and Blake's gardener, and an old man named Jones who stayed in the taproom. Apparently the fracas was noisy enough to turn out a good part of the village.

Much of Blake's case lay in the fact that none of the independent witnesses gathered at the door of the Fox heard any accusations of sedition there. No one had overheard the conversation between Blake and Scolfield in Blake's garden, and Blake could not be convicted on Scolfield's unsupported testimony. So far as the sedition charge was concerned, therefore, Blake had to have damned the king when he was in the presence of both Scolfield and Cock, and the three men were only together in front of the Fox where there were other witnesses, all of whom seem to have testified for Blake. As Blake told Butts, it is clear 'that the whole accusation is a wilful Perjury'. On the other hand, Blake may have damned the king in the garden, and he is known to have harboured sentiments sufficiently seditious to convict him before any provincial jury of his time, but he clearly did not express them before two witnesses on August 12th.

The soldier, John Scolfield, deposed against Blake before a magistrate on Monday, August 15th, 1803,[1] as follows:

[1] There is some confusion as to date (see below), but we can reasonably expect that the deposition was made on the 15th, which was a Monday, and was presumably the first day after the incident of Friday the 12th on which the Justice of the Peace could muster a clerk to take evidence such as Scolfield's 'Information'. It was also the day before the principals in the case were required to enter into recognizances, and the day before Blake wrote to Butts about what was said to him by 'the Lawyer who wrote down the Accusation'.

Sussex—The Information and Complaint of John Scofield a private Soldier in His Majesty's first Regiment of Dragoons taken upon his oath this 25.ᵗʰ Day of august 1803[1] before me one of His Majesty's Justices of the peace in and for the County aforesaid

August 15th, 1803

Who saith that on the twelfth day of this instant august at the parish of Felpham in the County aforesaid one Blake a Miniature painter & now residing in the said Parish of Felpham did utter the following seditious expressions viz.ᵗ That we (meaning the people of England) were like a parcel of Children, that they wo.ᵈ play with themselves 'till they wo.ᵈ get scalded and burnt[,] that the French knew our strength very well and if Buonapart sho.ᵈ come he wo.ᵈ be master of Europe in an hour's time, that England might depend upon it that when he sat his Foot on English Ground that every Englishman wo.ᵈ be put to his choice whether to have his throat cut or to join the French & that he was a strong Man and wo.ᵈ certainly begin to cut throats and the strongest Man must conquer—that he Damned the King of England—his Country and his Subjects—that his soldiers were all bound for Slaves & all the poor people in general—that his Wife then came up & said to him this is nothing to you at present but that the King of England wo.ᵈ run himself so far into the Fire that he might get himself out again & altho she was but a Woman she wo.ᵈ fight as long as she had a Drop of Blood in her—to which the said Blake said, my Dear you wo.ᵈ not fight against France—she replied, no, I wo.ᵈ fight for Buonaparte as long as I am able—that the said Blake then addressing himself to this Informant, said, tho' you are one of the King's Subjects I have told what I have said before greater people than you— and that this Informant was sent by his Captain on Esquire Hayley to hear what he had to say and to go and tell them—that his wife then told her said Husband to turn this Informant out of the Garden—that

<hr/>

[1] There is a contemporary transcript of this 'Information', headed '/Copy/', in the Library of Trinity College, Hartford, Connecticut, and on the same sheet and in the same hand (not Blake's) is written 'Blake's Memorandum'.

The transcript of the 'Information' is mechanically somewhat more orthodox than the original document, and has very minor differences, such as 'Deponant' for 'Informant' and the omission of the footnote and Quantock's signature. The most important variant is the date, which is given as the 15th in the 'Copy', but as the 25th in the original. For arguments supporting the reliability of the 15th, see p. 123, n. 1.

In the same collection is Rose's speech of Jan. 11th, 1804. All three documents— the statements by Blake and Scolfield and Rose's speech—were preserved with Hayley's papers, and the last two were Lot 34 in the Sotheby sale of Hayley's MSS., May 20th, 1878. Presumably Blake's lawyer had the statements of Blake and Scolfield copied at the same time.

this Informant thereupon turned round to go peacefully out when the said Blake pushed this Informant out of the Garden into the Road, down which he followed this Informant & twice took this Informant by the Collar without this Informant's making any resistance and at the same time said Blake* *damned the King & said the*——*Soldiers were all Slaves*—
Sworn before me
 John Quantock John Scholfield

 * this can be proved by another Soldier[1]

Despite the plausibility of some of the sentiments attributed to Blake, the accusation is filled with the most patent inventions, many of which are pointed out in

—Blake's Memorandum in Refutation of the Information and Complaint of John Scholfield, a private Soldier, &c[.]

The Soldier has been heard to Say repeatedly, that he did not know how the Quarrel began, which he would not Say if Such seditious words were Spoken.—

Mrs. Haynes Evidences, that she saw me turn him down the Road, & all the while we were at the Stable Door, and that not one word of charge against me was uttered, either relating to Sedition or any thing else; all he did was Swearing and threatening.—

Mr. Hosier heard him Say that he would be revenged, and would have me hanged if he could. He spoke this the Day after my turning him out of the Garden. Hosier says he is ready to give Evidence of this if necessary.—

The Soldier's Comrade Swore before the Magistrates,[2] while I was present, that he heard me utter Seditious words, at the Stable Door, and in particular Said, that he heard me D—n the K—g. Now I have all the Persons who were present at the Stable Door to witness that no Word relating to Seditious Subjects was uttered, either by one Party or the other, and they are ready, on their Oaths, to Say that I did not utter Such Words.—[3]

 [1] Quoted from the MS. in the Sussex County Record Office, pressmark QR w. 643, f. 78. On the back of the document is written: 'Information of Jn Scofield ag.ᵗ Blake—'. The two signatures at the bottom are written in the same hand, but not in the hand that wrote the indictment itself.

 [2] No deposition by Private Cock is known, nor has the evidence given by Blake's witnesses survived.

 [3] Blake told Butts on Aug. 16th: 'The Landlord of the Inn & His Wife & daughter will Evidence the Same & will evidently prove the Comrade perjurd who swore that he heard me while at the Gate utter Seditious words & D—— the K——

Mrs. Haynes says very sensibly, that she never heard People quarrel, but they always charged each other with the Offence, and repeated it to those around, therefore as the Soldier charged not me with Seditious Words at that Time, neither did his Comrade, the whole Charge must have been fabricated in the Stable afterwards.—

If we prove the Comrade perjured who swore that he heard me D—n the K—g, I believe the whole Charge falls to the Ground.

Mr. Cosens, owner of the Mill at Felpham, was passing by in the Road, and Saw me and the Soldier and William standing near each other; he heard nothing, but Says we certainly were not quarrelling.—

The whole Distance that William could be at any Time of the Conversation between me and the Soldier (Supposing Such Conversation to have existed) is only 12 Yards, & W—— Says that he was backwards and forwards in the Garden. It was a still Day, there was no Wind stirring.

William says on his Oath, that the first Words that he heard me Speak to the Soldier were ordering him out of the Garden;[1] the truth is, I did not Speak to the Soldier till then, & my ordering him out of the Garden was occasioned by his Saying something that I thought insulting.

The Time that I & the Soldier were together in the Garden, was not Sufficient for me to have uttered the Things that he alledged.

The Soldier Said to Mrs. Grinder, that it would be right to have my House Searched, as I might have plans of the Country which I intended to Send to the Enemy; he called me a Military Painter; I suppose mistaking the Words Miniature Painter, which he might have heard me called. I think that this proves, his having come into the Garden, with Some bad Intention, or at least with a prejudiced Mind.[2]

It is necessary to learn the Names of all that were present at the Stable Door, that we may not have any Witnesses brought against us, that were not there.

All the Persons present at the Stable Door were, Mrs. Grinder and her Daughter, all the Time; Mrs. Haynes & her Daughter all the Time; Mr Grinder, part of the Time; Mr Hayley's Gardener part of the Time.—Mrs. Haynes was present from my turning him out at my without which perjury I could not have been committed & I had no witness with me before the Justices who could combat his assertion as the Gardener remain in my Garden all the while & he was the only person I thought necessary to take with me [*to the Bench of Justices*].'

[1] The Aug. 16th letter says: 'The Gardener who is Hostler at the Fox . . . Evidences that to his knowledge no word of the remotest tendency to Government or Sedition was utterd[.]'

[2] At the trial Rose prudently ignored Blake's allegation of predisposed malignity in Private Scolfield.

Gate, all the rest of the Time—What passed in the Garden, there is no person but William & the soldier, & myself can know.—

There was not any body in Grinder's Tap-room, but an Old Man, named Jones, who (Mrs. Grinder Says) did not come out—He is the Same Man who lately hurt his Hand, & wears it in a sling—

The Soldier after he and his Comrade came together into the Tap-room, threatened to knock William's Eyes out (this was his often re-peated Threat to me and to my Wife) because W—— refused to go with him to Chichester, and Swear against me. William Said that he would not take a false Oath, for that he heard me Say nothing of the Kind (i.e. Sedition)[.] Mrs. Grinder then reproved the Soldier for threatening William, and Mr. Grinder Said, that W—— should not go, because of those Threats, especially as he was Sure that no Sedi-tious Words were Spoken.—

William's timidity in giving his Evidence before the Magistrates, and his fear of uttering a Falsehood upon Oath, proves him to be an honest Man, & is to me an host of Strength. I am certain that if I had not turned the Soldier out of my Garden I never should have been free from his Impertinence & Intrusion.

Mr. Hayley's Gardener came past at the time of the Contention at the Stable Door, & going to the Comrade Said to him, Is your Comrade drunk?—a Proof that he thought the Soldier abusive, & in an Intoxication of Mind.

If Such a Perjury as this can take effect, any Villain in future may come & drag me and my Wife out of our Home, & beat us in the Garden, or use us as he pleases, or is able, & afterwards go and Swear our Lives away.

Is it not in the Power of any Thief who enters a Man's Dwelling, & robs him, or misuses his Wife or Children, to go & Swear as this Man has Sworn.—[1]

On the morning of Tuesday the 16th, bonds were taken for the appearance at the Quarter Sessions of Blake, the soldier named Scolfield, his accomplice John Cock, and their lieutenant, who was responsible for preferring the charge.

Sussex To wit. Be it remembered, that on the *Sixteenth* Day of *August* in the Year of our Lord One Thousand *Eight* Hundred and *Three William Blake of the Parish of Felpham in the County aforesaid Designer and En-* *August 16th, 1803*

[1] Transcribed from a photostat of the MS., on paper watermarked '1802', in the Library of Trinity College, Hartford, Connecticut. Clearly the 'Memo-randum' provided only defensive heads to jog the memory, and was not a considered outline of what happened.

(No. 11.)

graver[,] William Hayley of the same parish Esquire and Joseph Seagrave of the City of Chichester in the County aforesaid printer personally came before me one of his Majesty's Justices of the Peace for the said *County* and acknowledged *themselves* to be indebted to our Sovereign Lord the King *as follows (to wit) the said William Blake in the Sum of One Hundred Pounds and the said William Hayley and Joseph Seagrave in the Sum of Fifty Pounds each* Upon Condition, that if *the above bound William Blake* shall personally appear at the next General Quarter Sessions of the Peace to be holden in and for the said *County then and there to answer to such Bill or Bills of Indictment as shall be preferred against him by George Hulton a Lieutenant in* Taken and *the First Regiment of Dragoons for a Misdemeanor and* acknowledged *do not depart the Court without Licence* then this Recog-
before me nizance to be void.

John Quantock[1]

Blake was deeply grateful for the friends who stood by him. On this same day, August 16th, he explained to Butts that he had

been before a Bench of Justices at Chichester this morning, but they as the Lawyer [*Ellis?*] who wrote down the Accusations told me in private are compelld by the Military to suffer a prosecution to be enterd into altho they must know & it is manifest that the whole is a Fabricated Perjury. I have been forced to find Bail. M^r Hayley was kind enough to come forwards & M^r Seagrave Printer at Chichester, M^r H. in 100£ & M^r S. in 50£ & myself am bound in 100£ for my appearance at the Quarter Sessions which is after Michaelmass.

The error about Hayley's bond may perhaps be explained by supposing that Hayley lent Blake £50.

Scolfield and Cock too had to put up £50 apiece:

August 16th, 1803

Sussex. To Wit. Be it remembered, that on the *sixteenth* Day of *August* in the Year of our Lord One Thousand *Eight* Hundred and *Three John Scolfield and John Cock private Soldiers in the First Regiment of Dragoons* came before me one of his Majesty's Justices of the Peace for the said *County and severally* acknowledged *themselves to be* indebted to our Sovereign

[1] Sussex County Record Office (Pressmark QR w. 643, f. 92). Words in italics above appear in MS. on the printed form.

Lord the King in the Sum of *Fifty pounds each* Upon Condition that if the above bound *John Scolfield and John Cock do severally* personally appear at the next General *Quarter* Session of the Peace to be holden in and for the said *County* and give Evidence on his Majesty's Behalf, upon a Bill of Indictment to be then and there exhibited by *George Hulton a Lieutenant in the said Regiment* to the Grand Jury against *William Blake* for *a Misdemeanor*[.] And in Case the said Bill be found a true Bill: Then if the said *John Scolfield and John Cock do also Severally* give Evidence to the Jurors who shall pass upon the Trial of the said *William Blake* for the same *Then this Recognizance to be void.*

Taken and acknowledged the Day and Year above written, before me

John Quantock

[on a Misdemeanor]¹

And the lieutenant himself had to put up a bond:

Sussex. To Wit. Be it remembered, that on the *sixteenth* Day of *August* in the Year of our Lord One Thousand Eight Hundred and *Three George Hulton a Lieutenant in the First Regiment of Dragoons* personally came (No. 11.) before me one of his Majesty's Justices of the Peace for the said *County* and acknowledged *himself* to be indebted to our Sovereign Lord the King *in the Sum of Fifty pounds*—Upon Condition, that if *the said George Hulton* shall personally appear at the next General Quarter Sessions of the Peace to be holden in and for the said *County and then and there prefer one or more Bill or Bills of Indictment against William*

August 16th, 1803

¹ Sussex County Record Office (QR w. 643, f. 91). Since this was an official document, and taken in the presence of their lieutenant, it may be presumed that this spelling of the soldiers' names is correct, though a bewildering variety of orthography has been put forward. The depth of Blake's outrage may be indicated by the facts that 'Scofield' appears in the text of the contemporary *Milton*, p. 17, *Jerusalem*, pp. 5, 7, 11, 19, 43, 51, 60; 'Schofield' in *Jerusalem*, p. 7: 'Scofeld' in *Jerusalem*, p. 43; 'Skofield' in *Jerusalem*, pp. 17, 22, 58, 68; and 'Skofeld' in *Jerusalem*, pp. 8, 15, 32, 36, 67, 71, and 90.

John Quantock (1740–1820), the justice of the peace, appears in *Jerusalem* as Gwantock (p. 36), Gwantok (p. 32) Gwantoke (p. 71), Guantock (p. 19) and Kwantok (p. 5).

Taken and *Blake late of the parish of Felpham in the County*
acknowledged *aforesaid Designer and Engraver for a Misdemeanor*
before me then this Recognizance to be void.
 John Quantock[1]

Almost two weeks after this incident Flaxman answered Hayley's letter of August 7th, and indicated by his silence that he had as yet heard nothing of the charges against Blake. In his letter of Wednesday the 24th, he apologized for his tardiness in writing, and went on:

August 24th, 1803 a word or two concerning the prints both for the Triumphs of Temper & the projected life of Romney. there certainly was a drawing of Serena veiwing herself in the Glass when dressed for the Masquerade whilst her Maid adjusts her train, & this was by far the prettiest of the set, it was so great a favorite with us that Nancy & myself prevailed on my Sister to make its fellow for our private Collection, you will therefore naturally imagine we were surprized when we greedily examined our Friend's present, to find that our favorite had either been overlooked, or discarded from the Suite of decorations[.] I have not Yet shewn the kind passage in Your letter on this occasion to my Sister, because I feel some uneasiness for all parties concerned but I shall communicate what you have written as soon as I can have a little conversation with her alone—I hope You will excuse my partiality when I say the Sentiment of my Sister's drawings allways appeared to me, just & delicate, altho I must acknowledge there is room for amendment in the effects & drawing of her figures, these corrections might be done in the engraving but I confess the prints for Serena seem in these respects to be worse than the drawings. I am sorry for it because now there is no remedy; since I wrote so far, my sister has told [*me*] that the drawing in question was sent to You, but returned for some reason & is the same now in M.ʳˢ Flaxman's folio, but as we are on the Subject of engraving, permit me to offer an opinion concerning the medallion, you may remember how much you was disappointed in the engraving from our Dear Thomas's portrait, & consider whether there is not a possibility that You may be as little pleased with the prints from Romney's Medallion? if this should be the case you will pay an additional sum to make the Your book less acceptable [*sic*] . . .—I am heartily grieved for Blake's irritability, & your consequent trouble[.]—[2]

[1] Sussex County Record Office (QR w. 643, f. 90). Blake's indignation was also directed against Hulton, but he seems to have misheard the name, for 'Hutton' appears in *Jerusalem*, pp. 5, 19, 36; 'Huttn' in *Jerusalem*, pp. 32, 71; and 'Hut'n' in *Jerusalem*, p. 7.

[2] Quoted from a microfilm of the MS. in the Pierpon Morgan Library.

In September Blake moved back to London, away from Hayley's protection and interference, though the two men continued to work in each other's interests. Hayley wrote to the Revd. John Johnson about Blake's contretemps, and in his letter of Thursday, September 22nd Johnny made it quite clear on which side his sympathies lay: 'Remember me kindly to poor Blake, who, I hope, will soon be out of his uncomfortable scrape. What a villain of a soldier to interfere with the most peaceable of creatures!'[1]

September 22nd, 1803

The Michaelmas Quarter Sessions were held at Petworth on Tuesday, October 4th before John Sargent, Charles Duke of Richmond, George Obrien Earl of Egremont, Sir George Thomas, Baronet, Lieutenant-General John Whyte, John Peachey, William Mitford, William Battini, John Napper, Richard Hollist, William Stephen Poyntz, Nathaniel Trederoft, William Brereton, and John Leach, Justices of the Peace, with William Ellis Gentleman Clerk of the Peace attending. The case against Blake was presented to the jury, who returned the following True Bill:[2]

[*Rex v Blake*] *WILLIAM BLAKE late of the Parish of Felpham in the Indictmt County of Sussex came here in Court in his own proper person and desired to hear the Indictment of Record against him read which is in the words following (that is to say)*] *T*he Jurors for our Lord the King upon their Oath present *T*hat on the *t*welfth *D*ay of *a*ugust in the Year of our Lord *o*ne thousand *e*ight hundred and three *w*ar was carrying

October 4th, 1803

[1] Bodley MSS. Eng. misc. d. 134, No. 146.

[2] The document as printed below has two sources. The primary source is in the Sussex County Record Office (QR w. 643, f. 63). On the back of the document is written: 'John Scholfield John Cock Sworn in Court True Bill'. The secondary document, which amplifies the primary one and which may be the transcript Blake's lawyer applied for on December 25th, 1803 (q.v.), was transcribed, from an original I have not traced, by Herbert Jenkins in a typescript (now in my possession) and printed in his 'The Trial of William Blake for High Treason', *Nineteenth Century*, lxvii (1910), 853–5, and *William Blake*, London, 1925. The Jenkins typescript has a few words at the beginning and end not in the Sussex County Record Office version, which I give here in brackets and in italics; the body of the text is almost identical in substance in both versions; differences in capitalization I have indicated by italicizing the letters in the Sussex County Record Office document which are given in a different case in the Jenkins typescript. The very slight differences in punctuation I have ignored, giving only the Record Office punctuation. The marginal notation in the Record Office version is absorbed in the text in the Jenkins transcript. The last six words of the Record Office document do not appear in the Jenkins typescript.

on between the persons exercising the powers of government
in France and our said Lord the King towit at the *p*arish of
Felpham in the said County of Sussex and That W*illiam* B*lake*
late of the said Parish of Felpham in the said County of
Sussex being a Wicked Seditious and *e*vil disposed person
and greatly disaffected to our said Lord the King and
*w*ickedly and *s*editiously intending to bring our said Lord
the King into great *h*atred contempt and *S*candal with all his
liege and faithful Subjects of this Realm and the Soldiers of
our said Lord the King to Scandalize and *v*ilify and intending
to withdraw the fidelity and allegiance of his said Majesty's
Subjects from his said Majesty and to encourage and incite
[*in*v*ite*] as far as in him lay the Enemies of our said Lord the
King to *i*nvade this *R*ealm and *u*nlawfully and *w*ickedly
to seduce and encourage his Majesty's Subjects to resist and
oppose our said Lord the King—on the said twelfth *D*ay of
August in the *Y*ear of our Lord *o*ne thousand eight hundred
and three with force and arms at the parish aforesaid in the
County aforesaid in the presence and hearing of divers liege
Subjects of our said Lord the King with whom the said
William Blake then and there was conversing of and con-
cerning our said Lord the King and his Soldiers and of and
concerning an Invasion of this Realm by the Enemies of our
said Lord the King maliciously unlawfully wickedly and sedi-
tiously did pronounce utter and declare The English words
following[:] 'The English (meaning the Subjects of our said
Lord the King residing in this Realm) know within themselves
that Buonaparte (meaning the Chief Consul of the French
Republic and one of the persons exercising the powers of
*g*overnment in France) could [*would*] take possession of
England in an *H*our's time and then it would be put to every
Englishman's choice for to either fight for the French or to
have his Throat cut[.] I (meaning himself the said William
Blake) think that I (meaning himself the said William Blake)
am as strong a *M*an as most and it shall be throat cut for
throat cut and the strongest *M*an will be the *C*onqueror[;]
*y*ou meaning one of the said liege *S*ubjects of our said Lord
the King with whom he was then and there conversing) would
not fight against the French; *D*amn the King (meaning our
said Lord the King) and Country (meaning this Realm) and
all his Subjects (meaning the Subjects of our said Lord the
King)[.] I (meaning himself the said William Blake) have
told this before to greater *P*eople than you (meaning one of

the liege Subjects of our said Lord the King with whom he
was then and there conversing)[.] Damn the King (meaning
our said Lord the King) and his Country (meaning this
Realm)[;] his Subjects (meaning the Subjects of our said
Lord the King) and all you Soldiers (meaning the Soldiers of
our said Lord the King) are sold for Slaves'[,] to the great
Scandal of our said Lord the King and his Soldiers[;] in
Contempt of our said Lord the King and his Laws[;] to the
evil and pernicious example of all others in the like case
offending and against the peace of our said Lord the King his
Crown and Dignity—And the Jurors aforesaid upon their
oath aforesaid further present that the said William Blake
being such Person as aforesaid and again wickedly and
seditiously intending to bring our said Lord the King into
great hatred contempt and scandal with all his liege Subjects
and the Subjects and Soldiers of our said Lord the King to
scandalize and vilify afterwards to wit on the same Day and
Year above mentioned with force and arms at the Parish
aforesaid in the County aforesaid wickedly maliciously and
seditiously in the presence and hearing of divers other liege
Subjects of our said Lord the King did pronounce utter and
declare the English words following[:] ['']Damn the King
(meaning our said Lord the King) and Country (meaning
this Realm)[;] his Subjects (meaning the Subjects of our said
Lord the King) and all you Soldiers (meaning the Soldiers of
our said Lord the King) are sold for Slaves' to the great
Scandall of our said Lord the King and his Subjects and
Soldiers, in contempt of our said Lord the King and his Laws,
to the evil example of all others in the like case offending, and
against the peace of our said Lord the King his Crown and
Dignity and the Jurors aforesaid upon their Oath aforesaid
further present That the said William Blake being such
Person as aforesaid and again wickedly and seditiously intend-
ing to bring our said Lord the King into great hatred con-
tempt and scandal with all his liege Subjects with force and
arms afterwards to wit on the same Day and Year above-
mentioned in [at] the Parish aforesaid in the County afore-
said wickedly seditiously and maliciously in the presence and
hearing of divers other liege Subjects of our said Lord the
King did pronounce utter and declare the following English
words 'Damn the King' (meaning our said Lord the King)
to the great Scandal of our said Lord the King in contempt of
our said Lord the King and his Laws to the evil example of

all others in the like Case offending and against the peace of
our said Lord the King his Crown and Dignity
> For the King
>
> Ellis
> Trav^d

*[And having heard the same Read says and pleads that he is
thereof not Guilty and for his Trial puts himself upon the
Country and William Ellis Gentleman Clerk of the Peace for the
said County who for our Sovereign Lord the King in this behalf
prosecute &c. doth so likewise therefore the Sheriff of the
said County is commanded &c to raise to come a Jury &c.
To try &c.*
AND the said William Blake—Ackw. 100 £

Recogn. *AND WILLIAM HAYLEY of Felpham* ⎫
to *aforesaid Esquire and Joseph* ⎪
pros^e *Seagrave of Chichester in the* ⎬ 50 £ each
 said County Printer Ackwd ⎭
*UPON CONDITION for the said William Blake to appear at
the next Sessions and try his Traverse with Effect &c. Then
&c. Otherwise &c.]*

A separate True Bill concerning Blake's 'Assault' on Scol-
field was also returned:

October Sussex. The Jurors for our Lord the King upon their Oath present,
4th, that *William Blake late of the parish of Felpham in the County
1803* *of Sussex Designer and Engraver* on the *twelfth* Day of *August*
 in the *forty third* Year of the Reign of our Sovereign Lord
 GEORGE the Third, of the United Kingdom of Great
 Britain and Ireland, now King, with Force and Arms, at
 Assault the Parish of *Felpham aforesaid* in the County aforesaid, in
 and upon one *John Scholfield* in the Peace of God and of our
 said Lord the King, then and there being, did make an
 Assault and *him* the said *John Scholfield* then and there did
 beat, wound, and ill treat, so that *his* Life was greatly des-
 paired of, and other Wrongs to the said *John Scholfield* then
 and there did, to the great Damage of the said *John Scholfield*
 and against the Peace of our said Lord the King, his Crown
 and Dignity.
 For the King
 Trav^d Ellis.[1]

[1] Sussex County Record Office (QR w. 643, f. 64); on the back is 'John Schol-
field John Cock Sworn in Court True Bill'. It should be noticed that the violence
of this statement ('*his* Life was greatly despaired of') is in the printed part of the

This result was reported in the *Sussex Weekly Advertiser* for Monday, October 10th: 'A bill of indictment was preferred against a man named Blake for sedition, and returned by the Grand Jury, a true bill. He entered into a recognizance, himself in one thousand pounds, and two sureties in the like sum for his appearance to answer the charge, at the next Quarter Sessions.'[1] The temper of the times is illustrated by the very next item in the paper: 'A bill of indictment was also found against ten men at Little-Hampton, for creating a riot and rescuing a man from the custody of a pressgang.'

October 10th, 1803

On Sunday, November 27th, Lady Hesketh wrote to Hayley:

November 27th, 1803

By the way I have never taken up the Subject you mention'd to me concerning Mr Blake, and this, because I had at the time great reason to fear that your kind unsuspecting Friendship was drawing you into a Scrape, for one who did not merit that you shou'd incur blame on his account;—if I mistook this affair I am sorry for it, and ask his pardon as well as yours, but to own the truth, He appeard to me much to blame, even upon his own representation of the matter, but if I may give credit to some reports which reachd me at that time, Mr B: was more *Seriously* to blame than you were at all aware of I believe—but I will only add on this Subject—that—*if he was*, I sincerely hope that you are no Stranger to it![2]

document, and is merely a matter of form. According to T. E. Tomlin, *The Law Dictionary*, London, 1810, to traverse is to deny an indictment.

A copy (which I have not traced) of this indictment is also transcribed in the Jenkins typescripts in my possession (see the note above). The typescript begins: 'THE SAID WILLIAM BLAKE late of the Parish . . . Engraver came here in Court in his own proper person and desired to hear the Indictment of Record against him Read why he on the Twelfth day' After the closing words ('Crown and Dignity') it continues with the form concluding the former indictment ('And having heard . . . Otherwise &c.'), differing from the former only here and there in capitalization.

According to the pricked list of possible jurors (Sussex County Record Office QR w. 643, f. 2), the jury consisted of Robert Palmer, Robert Upperton, George Combes, Matthew Halladay, Benjamin Challen, George Pratt, James Goldring, John Wait, Thomas Hews, John Colebrook, William Hoffley, and William Boxall.

[1] These sums seem very large, for Blake's previous bail was £100, and Hayley and Seagrave, his two sureties, had each put up £50.

[2] BM Add. MSS. 30803B. It is hard to know who might have pretended to better information than Hayley. The most likely candidate is her friend Samuel Rose, who was probably engaged as early as this as Blake's advocate. Of course, it would take very little to excite the fears of such an arch-royalist and conservative as Lady Hesketh.

Blake's friends in London, however, continued to look out for his interests. Prince Hoare, the Secretary for Foreign Correspondence of the Royal Academy, evidently wrote to Flaxman about a newly found bust of Ceres which he thought the President of the Academy at Vienna would be interested in, and Flaxman replied with a description and a sketch.[1] Apparently Hoare was so pleased with the sketch that he asked to have it engraved, and Flaxman agreed, recommending Blake. On Christmas Day of 1803 he wrote again to Hoare:

[*Sunday*] Dec.ʳ 25. 1803
Buckingham Street
Fitzroy Square

December
25th,
1803

Dear Sir

As I forgot to give you M.ʳ *Blake's* address in writing, he will take the liberty of presenting this note, & in case you should not be at home, he lives at N.º *17 South Molton Street*, Oxford Street opposite Stratford Place; as I observed to you he etched & engraved some of the fine Basso Relievos in the 3.ᵈ Vol of Stuart's Athens in a very masterly manner & I think he will do the bust of Ceres exactly in the manner You wish for—.

I remain with great respect
Dear Sir
Your friend & Servant
John Flaxman[2]

Flaxman's recommendation was successful, for Blake not only engraved Flaxman's outline of the statue of Ceres for Hoare's *Academic Correspondence, 1803*, but Hoare was pleased enough with his work to commission him to engrave the only plate for his *Inquiry into the Requisite Cultivation and Present State of the Arts of Design in England* in 1806.

On the same day R. Dally, evidently a Chichester solicitor, wrote to 'Mr Ellis Clerk of the peace Horsham':

December,
25th,
1803

Sir,

I shall be obliged to you to send as early this week as possible a Copy of the Indictment agst Mʳ Blake, for uttering seditious words & for an assault, preferred at the last Sessions at Petworth.

[1] P. Cunningham, 'New Materials for the Life of John Flaxman, R.A.', *The Builder*, xxi (1863), 38. The salutation is 'Dear Sir' and the date given is merely '[London, 1803.]'

[2] Quoted from the MS. in the Library of the University of Chicago. Because Blake delivered the note in person, there is no address or addressee.

Your cl[*er*]k can probably copy both these indictments on *one* Draft
Sheet by writing close & thereby save me postage.

I am, Sir,
Your H[*umble*] Serv
R. Dally

Chichester 25 Dec.ʳ
1803[1]

Mr. Dally must have performed fairly extensive services for
Blake, for on April 2nd, 1804 Blake wrote to Hayley: 'I am
uneasy at not hearing from Mr. Dally, to whom I enclosed £15
in a letter a fortnight ago, by his desire. I write to him by this
post to inquire about it. Money in these times is not to be
trifled with.'

On Saturday, January 1st, 1804 Hayley wrote to Johnny: *January*
'When will you reach the Turret? in Time I hope to hear our *1st,*
beloved Rose eloquently & successfully defend our interesting *1804*
Artist, whose Trial is to take place on Tuesday the 10th of this
month[.]' And he concluded with a P.S., written next day:
'a new stout & tall Horse fell suddenly in his Canter & had I
not luckily had on a new strong Hat my skull would have been
smashed by a Flint—as it is I have a little Cut on the Fore-
head[.]'[2]

Hayley also wrote to Flaxman about an engraving of Cowper's
tomb, and the sculptor replied:

Janʸ 2ᵈ 1804
Buckingham Street
Fitzroy Square

Dear and Kind Friend

Mᵣ Blake's opinion that the drawing sent from Norfolk may be ad- *January*
vantageously engraved for the ensuing volume of Cowper's life as *2nd,*
1804

[1] Sussex County Record Office (QR w. 644, f. 70). At the bottom of the page in
another hand is written:

<pre>
 S D
Copy both Indᵗˢ fo: 17 —5. 8
 post 7
 6 – 3
</pre>

Apparently these figures mean that there were four pages or sheets ($4 \times 17d.$ =
5s. 8d.). For transcripts of these copied indictments see the footnotes to October
4th, 1803.

[2] Hayley–Johnson Fitzwilliam letters. Blake's trial was scheduled for the 10th,
but it was postponed to January 11th.

an agreable perspective of the Situation, seems very just, whilst the
Monument itself may be represented on a larger Scale in a Vignette,
and for the materials on this subject he will be at no loss—I sincerely
wish with You that the Tryal was over, that our poor friend's peace of
mind might be restored, altho' I have no doubt from what I have heard
of the Soldier's character and the merits of the case that the bill will
at least be thrown out by the Court as groundless & vexatious—
Blake's irritability as well as the Association & arrangement of his
ideas do not seem likely to be Soothed or more advantageously dis-
posed by any power inferior to That by which man is originally endowed
with his faculties—I wish all our defects were fewer, certainly my own
among the rest—but if we really are desirous this should come to pass,
we are told to Whom & by what means we should apply.

I wonder my Good Friend as You admired the Genius of Romney
so much that You do not remember the whole Catalogue of his Chalk
Cartoons as I think it was Your opinion in common with other Suffi-
cient judges that they were the noblest of his Studies, besides they
were but few in number, the following were the Subjects—A Lapland
Witch raising a Storm—Charity & her Children—Pliny & his Mother
flying from the eruption of Vesuvius—the following from Æschylus—
Raising the Ghost of Darius—Atossa's Dream—The Furies— I hope
they exist in a perfect State, & if they do, they are all well worth etch-
ing in a bold manner which I think Blake is likely to do with great
success & perhaps at an expence that will not be burthensome—but
at any rate give him one to do first for a tryal, the exhibition of a
painter's noblest Sentiments & grandest thoughts must certainly be-
come as Striking & interesting in his life, as their Several poems in the
lives of Milton, Homer or Virgil . . . —I have troubled You by Mʳ
Blake with a Short tract written for Dʳ Rees's Cyclopedia, on Basso
Relievo, with one of the prints [*by Parker*] referred to at the end of the
article, the rest are not yet engraven[.] I do no[*t*] send it from the
vanity of giving information to You, because I dare say You are well
acquainted with all it contains, but because I would not publish any-
thing of this kind without sending a Copy even tho' it should not be
worth Your notice ;—A happy release from his afflictions to poor Blake,
& to you my Dear Friend many happy years unclouded by misfortune
or Sorrow[.]

> I have the honor to remain
> Your ever affectionate
> & much obliged
> John Flaxman[1]

[1] Quoted from a microfilm of the MS. in the Pierpont Morgan Library.

Flaxman also sent his article to Prince Hoare, who wrote to thank him on Wednesday, January 4th: 'Dear Sir, Being disappointed of a proper copy of my pamphlet & proof of Mʳ Blake's Etching which I hoped to have sent you today, I will not longer delay thanking you for your dissertation on Bas relief, which I have read with very great admiration.'[1] Blake's plate for Prince Hoare's *Academic Correspondence, 1803*, is not dated, but Blake sent Hayley a copy of the work on February 23rd, 1804.

January 4th, 1804

Blake had become Hayley's London agent for the biography of Romney, and part of his job was to discover where his paintings were. On October 26th, 1803 Blake reported to Hayley 'I have been with Mr. Saunders', perhaps the most important of Romney's dealers, and on December 13th he went on: 'Mʳ Saunders will shortly write to you giving you every information in his power with notices of where Mʳ Romneys best pictures now are & other articles collected from every Fountain he can visit[.]' On January 5th William Saunders wrote to Hayley:

Sʳ

Mʳ Blake calld on me some time ago, saying it was your wish that I should collect the names of as many of Mʳ Romneys most Capital paintings as I possibly could, & in Whose possession they were, I should have done so much sooner, but have been ill about a Month, I have enclosed a list of what I can recollect & if I can find out any more you may depend on it I will send you an Account of them[.] Mʳ Blake mentiond a Christ preaching in the Wilderness which I cannot find nor recollect[.][2]

January 5th, 1804

At the end of his letter to Hayley of January 6th, Johnny Johnson sent his good wishes to Blake's advocate: 'Success to the Rose Amen.'[3]

January 6th, 1804

Blake probably went to Felpham a few days before his trial, and he almost certainly stayed with Hayley. When he arrived he was carrying with him Flaxman's article on Basso Relievo and a copy of his own engraving after Fuseli for an edition of Shakespeare as presents for Hayley.[4]

[1] BM Add. MSS. 39781, f. 41.

[2] Quoted from the MS. in my possession. The letter is written from No. 10 Great Castle Street, Cavendish Square, and goes on to list twenty-seven pictures and their present locations. After this time Blake's letters have constant references to Mr Saunders.

[3] Bodley MSS. Eng. misc. d. 134.

[4] See Flaxman's letter of Jan. 2nd above, and Blake's letter to Hayley of Dec.

The trial took place on Wednesday, January 11th, 1804, in the ancient Guildhall in Chichester. The magistrates were the Duke of Richmond, John Peechey, John Napper, John Quantock, W. S. Poyntz, J. H. Gobbe, and Geo. White Thomas.[1] Blake seems to have felt that two of the magistrates were predisposed against him, for in addition to the references in *Jerusalem* to Quantock who had registered the indictment, 'Peachey' appears on pp. 5, 19, 32, 36, and 71 of *Jerusalem*. On the other hand, one of the judges may have been his friend. On June 28th, 1802 there had been a proposal that he should engrave a drawing for W. S. Poyntz.

The verdict was summarized in a document probably drawn up later from official records for Blake's lawyer:

January 11th, 1804

CAME as well the said William Ellis as the aforesaid William Blake and the Jury by the Sheriff of the County aforesaid impanelled (to wit) William Bayley[,] Alexander Fogden[,] Thomas Millyard[,] Thomas Smith[,] Richard Piercey[,] Charles Newland[,] John Chitty[,] George Collins[,] George Harding[,] Joshua Jelliff[,] James Guy and John Grove who being Chosen and Sworn to Enquire

Not Guilty per Country

into the Truth of the premises do upon their Oath say That the said William Blake is not Guilty of the Sedition aforesaid as in the said Indictment is alleged against him[,] Therefore he goes without day.

CAME as well the said William Ellis as the aforesaid William Blake and the Jury by the Sheriff of the County aforesaid

Not Guilty per Country

(to wit) [*as above*] . . . [*who*] say That the said William Blake is not Guilty of the Assualt [*sic*] aforesaid as in the said Indictment is alleged against him Therefore he goes without day.[2]

Notes of the defence were 'taken in short Hand by the Revd Mr Jowatt':

28th, 1804, in which he says 'when I left Felpham last' 'I left a good impression' of 'the Print of Romeo & the Apothecary'. The plate must have been post-dated, for it was 'Publish'd . . . Jan 14, 1804', the day Blake got *back* from Felpham. It is unlikely that Blake ever returned to Felpham after Jan. 1804.

[1] Sussex County Record Office (QR 2. 644, f. 1).

[2] This summary of the verdicts on the two charges I have found only in the transcripts of Herbert Jenkins (see Oct. 4th, 1803). There is no record of the verdict with the other trial documents in the Sussex County Record Office.

[3] Though the speech is said to have been 'taken in short Hand', the transcript itself is in longhand.

The Speech of Counsellor Rose
In Defence of Blake the Artist
at the Chichester Sessions Jan 11 1804

Gentlemen of the Jury—
 I perfectly agree with my learned friend, with regard to the atrocity
& malignity of the charge now laid before you. I am also much obliged
to him, for having given me the credit, that no justification, or ex-
tenuation of such a charge would have been attempted by me, supposing
the charge could have been proved to your satisfaction;—& I must be
permitted to say, that it is a credit which I deserve.—If there be a man,
who can be found guilty of such a transgression, he must apply to
some other person to defend him, if a palliation of such an offence be-
comes part of the duty of his counsel.—I certainly think that such an
offence is incapable of extenuation— My task is to shew that my client
is not guilty of the words imputed to him.— It is not to shew that they
are capable of any mitigated sense.— We stand here not merely in
form, but in sincerety & truth, to declare that we are *not guilty*. I am
instructed to say, that M^r Blake is as loyal a subject as any man in this
court:—that he feels as much indignation at the idea of exposing to
contempt or injury the sacred person of his sovereign as any man:—
that his indignation is equal to that, which I doubt not every one of
you felt, when the charge was first stated to you.— Gentlemen this is
a very uncommon accusation—it is foreign to our natures & opposite
to our habits.— Do you not hear every day, from the mouths of thou-
sands in the streets the exclamation of God save the King:—it is the
language of every Englishman's lip—it is the effusion of every English-
man's heart.— The charge therefore laid in the indictment, is an offence
of so extraordinary a nature, that evidence of the most clear, positive,
& unobjectionable kind is necessary to induce you to believe it.—
Extraordinary vices, Gentlemen are very rare, as well as extraordinary
virtues; indeed the term extraordinary implies as much.— There is
no doubt that the crime which is laid to the charge of my client, is a
crime of most extraordinary malignity— I choose the term malignity
purposely—for if the offence be clearly proved I am willing to allow,
that [guilt of *del*] public malignity, [that *del*] and indelible disgrace
are fixed upon my client— If on the other hand when you have heard
the witnesses which I shall call, you should be led to believe that it is a
fabrication for the purpose of answering some scheme of revenge you
will have little difficulty in deciding that it is still greater malignity on
the part of the witness Scholfield—
Gentlemen the greater the offence charged the greater the improba-
bility of its being true.— I will state to you the situation of M^r Blake

& it will be for you to judge whether it is probable he should be guilty of the crime alledged.—He is an artist, who tho' not a native here, has lived in your part of the country for 2 or 3 years.— He is an engraver.— He was brought into this country by Mr Hayley, a gentleman well known to you, & whose patriotism & loyalty have never been impeached.— Blake was previously known to Mr Hayley.— I think I need not state that Mr Hayley would never have brought Mr Blake into this part of the country, & given him encouragement, if he conceived it possible that he could have uttered these sentiments. Mr Hayley from his previous knowledge of him was certain that he was not the seditious character here represented.

Gentlemen, the story is very improbable, if we farther consider Mr Blake's situation.— Mr Blake is engaged as an engraver— He has a wife [& family *del*] to support:—that wife & himself he has supported by his art—an art, which has a tendency, like all the other fine arts, to soften every asperity of feeling & of character, & to secure the bosom from the influence of those tumultuous & discordant passions, which destroy the happiness of mankind.— If any men are likely to be exempt from angry passions it is such an one as Mr Blake.— He had resided in this vill[*a*]ge for some time, when you have heard one day the witness Scholfield came into his garden for the purpose of delivering a message to the ostler, there he continues for some time without any apparent reason—But I will just make this observation, in addition to what I have said of the great incredibility, of so infamous a crime being committed by such an individual—the proof adduced ought to be uniform, consistent & clear, so much as to leave no doubts of the [truth *del*] veracity of those persons who come forward—not only so—it should proceed from characters of unimpeachable credit—those who have acted in such a way, that you can be morally certain, no temptation whatever will induce them to speak what is not true— The first witness is in a different situation from what he has been—he was once in a superior [rank—he *del*] but now appears in an inferior rank.— Now Gentlemen, merit always promotes a man—misconduct degrades him—misconduct not only degrades him in his situation, but in the consideration of all men, who know the circumstances— This Man was once a Serjeant,—he is now a private— He says he was degraded on account of drunkenness— He is degraded, be it from what cause it may—& he certainly does not stand before you under the most favourable circumstances, nor is he entitled to that credit which you would have given him, if by his good conduct he had continued in his former situation, or raised himself to a higher— He tells you a story, which to be sure requires a great deal [I even rejoice to say *del*] of faith in order to believe it—because it is an unaccountable story— He was

in Blake's garden talking to the ostler—he came to tell him that he could not do the job he was to do, for he was order'd to march to Chichester—that he had but few words to say, & no time to spare, yet we find him lounging about leaning against the garden wall— That M^r Blake came out, & without any provocation, without one word being spoken on either side, began to utter these expressions— (the words in the Indictment)— These expressions divide themselves into 2 classes— Some of them deserve the reprobation, which my learned friend has bestowed upon them—others are so absurd & unintelligible, that he with all his ingenuity has not attempted to explain them—as cut throat for cut throat—It does not appear what can be meant,—If you are able to understand them, I honestly confess, that after no small pains bestowed on the point I cannot— The witness at one time asserted, that these words were spoken to him, then he was doubting whether they were addressed to M^rs Blake—at last he asserts again that they were spoken to him—Gentlemen you will take notice that the Ostler was all this time working in the Garden—this Garden I shall be able to prove to you did not contain above 10 yards square— no words consequently could have been uttered, without every person in the Garden hearing them, especially when Scholfield acknowledged that they were talking rather high—The Ostler is allowed to have been in the Garden, he was in a situation to hear all that passed—& he will prove to you by & bye that he heard no such expressions uttered by M^r Blake—Here then Gentlemen is a charge, attended with circumstances of the most extraordinary nature. A man comes out of his house for the purpose of addressing a malignant & unintelligible discourse to those who are most likely to injure him for it—A person exerting such an art, tending to render him indifferent to the factions & disputes of the world, uttering this discourse without any inducement whatsoever [so to do *del*] & stated by the witness to have been uttered in the presence of one, who will [state to you *del*] presently tell you that no such words were uttered—All this as to the words which are represented to have been spoken to the soldier, & you will not forget that the man who has given you this testimony, is a man who so far from being thought worthy of reward has been degraded— The second witness states, that there was a noise in the Street, he was at work, in the stable, & came out in consequence of the noise, he saw M^r Blake and Scholfield, in the act of collering each other, and M^rs Grinder separated them—that M^rs G—— was as near to Blake as Cock was, [because she was the person who separated them *del*]—he states that without any farther provocation or hearing any words from Scholfield or Blake, Blake uttered these words, damn the king, damn the country, you soldiers are all slaves—M^rs G—— I shall call to you &

she will state that she was as near M^r Blake as Cock was, & heard no such words— I would observe, in order to shew that there is a small difference between the testimony of Cock & Scholfield—that when Scholfield was asked if any thing had been utterd beside the words which were spoken in the garden, he [denied it *del*] replied no.— Scholfield confines himself to the words in the Garden—the other says they were utterd before the public house— If they were spoken in the Garden the Ostler must have heard them—If they were utterd before the public-house M^{rs} G must have heard them too. I will call these witnesses & you shall hear their account—you will then agree with me that they totally overthrow the testimony of these Soldiers[.]—[1]

Apparently at this point Rose broke down and could not continue his speech, as Hayley explained later.

The story of the trial is summarized by Hayley in his autobiography as a kind of sequel to the story of his fall from his horse, when he was attended by 'his intimate medical Friend Mr Guy':

The poet said to Him very cheerfully, 'my dear *Machaon*, you must patch me up very speedily, for living or dying, I must make a public appearance within a few days at the Trial of our Friend Blake, in your City'— Hayley alluded to a Business that pressed not a little at this time on his Mind & Heart. The friendly Engraver, who had settled himself in a Cottage at Felpham, that He might work under the Inspection of the Biographer, was unluckily involved in a squabble with an insolent soldier, in the last August. Blake, who had great personal strength & courage, had forcibly and justly thrust the abusive Intruder from his Cottage Garden. The vindictive soldier engaged one of his comrades to join him in swearing that his antagonist in their Scuffle uttered many seditious expressions.

On this charge the accused was brought to his Trial at the Quarter Sessions in Chichester on Wednesday the eleventh of January 1804. Hayley had engaged his [intimate *del*] zealous Friend Samuel Rose as Counsel for the accused, yet He made a point of appearing in Court himself as He imagined it might be incumbent on Him to speak in favor of a new Inhabitant of Sussex, with whose Habits of Life He was particularly acquainted.— The young admirable Barrister in his examination of the accuser most happily exposed the falsehood and

[1] Quoted from a photostat of the MS. in the Library of Trinity College, Hartford, Connecticut. The MS. consists of two sheets (which I call A and B), folded so as to give four leaves in the following order: A1, B1, B2, A2. I have found no material relating to Blake's trial among the legal documents in the Public Record Office.

malignity of the charge. He spoke also very eloquently for his Client, but in the midst of his defence a sudden illness siez'd Him, & altho' he maintained his station, He ended his Speech with apparent Infirmity.— but he had gained his Cause.— The verdict of the Jury was in favour of his calumniated client. The exultation of Hayley was great;[1] & the greater because He had observed, with concern & Indignation, that the chairman of the Sessions, the old Duke of Richmond was bitterly prejudiced against Blake; & had made some unwarrantable observations in the course of the trial, that might have excited prejudice in the Jury.— as soon therefore as their verdict was given, Hayley approached the duke, & said 'I congratulate your Grace, that after having been wearied with the condemnation of sorry Vagrants, you have at last had the gratification of seeing an honest man honorably delivered from an infamous persecution. Mr Blake is a pacific, industrious, & deserving artist.' —The duke replied rather impolitely— 'I Know nothing of Him.' ["]True, my Lord,["] rejoined the Poet, ['] your Grace can Know nothing of Him; & I have therefore given you this Information: I wish your Grace a good Night.'—[1] It was late in the Evening, & Hayley was eager to present the delivered artist to their very Kind & anxious Friend, the Lady of Lavant— Great was his exultation, & that of all who regarded Him on the issue of this vexatious affair:—but altho' this anxious day concluded with the purest Joy, it proved, in its remote consequences, a source of the deepest heartfelt affliction to Hayley.—a most severe cold, that attacked his Friend Rose, on the very day of the Trial, laid the foundation of that cureless malady, which [killed him.][2]

The trial must have been a cause for great local excitement, with its gathering of notable local figures. 'An old man at Chichester, but lately dead, who was present, as a stripling, at the trial, attracted thither by his desire to see Hayley, "the great man" of the neighbourhood, said, when questioned, that the only thing he remembered of it was Blake's flashing eye.'[3] Poor

[1] The passage between these footnote numbers was strangely omitted from the text when it was later printed. This is the only evidence of the Duke's prejudice against Blake, and places in a more credible light Blake's later suspicion that Scolfield had been an *agent provocateur* in a government plot.

[2] Quoted from a microfilm of the MS. (vol. vi, pp. 95–97) in the Yale University Library which corresponds to Hayley's *Memoirs*, vol. ii, pp. 46–47; see June 1823. In a section about Rose added to the 1806 edition of *The Life and Posthumous Writings of William Cowper, Esq.*, vol. iii, pp. 439–58, Hayley says only: 'Attending the Sussex sessions in January 1804, where he appeared again as the eloquent and successful advocate of innocence, he caught a cold so severe, that it produced a rheumatic fever in the head' from which he died late in the year.

[3] Gilchrist, 1942, pp. 172–3; 1880, p. 197. Since this passage does not appear in 1863, the 'lately' must refer to 1880.

Catherine had stayed behind when Blake went to stand his trial, and on his return Blake wrote to Hayley on January 14th: 'My poor wife has been near the Gate of Death . . . but my arrival has dispelld the formidable malady'. Blake recounted to her the details of the trial so vividly that she almost felt she had been there. 'Mrs Blake used afterward to tell how, in the middle of the trial, when the soldier invented something to support his case, her husband called out *"False!"* with characteristic vehemence, and in a tone which electrified the whole court and carried conviction with it.'[1]

As time went by, Blake became more and more convinced that the trial was not an isolated accident, but an event of national or cosmic significance; he 'used to declare the Government, or some high person, knowing him to have been of the Paine set, "sent the soldier to entrap him"; which we must take the liberty of regarding as a purely visionary notion.'[2]

January 13th, 1804 On Friday, January 13th Johnny Johnson wrote to Hayley that they must treat Lady Hesketh with delicacy to 'keep our two selves in two whole skins. Apropos of skins how is the outside of your forehead? And how is poor Blake? in a whole one, or *on the other hand*?' And down the centre of his double page he wrote: 'I am very anxious to hear of poor Blake. Therefore write to me directly and tell me how it is?'[3]

The *Sussex Weekly Advertiser* reported the outcome of Blake's trial on Monday, January 16th:

January 16th, 1804 Charles[4] Blake, an engraver, at Felpham, was tried on a charge exhibited against him by two soldiers, for having uttered seditious and treasonable expressions, such as 'D—n the King, d—n all his subjects, d—n his soldiery, they are all slaves; when Bonaparte comes, it will be cut throat for cut throat, and the weakest must go to the wall; I will help him, &c. &c.' After a very long and patient hearing he was by the Jury acquitted, which so gratified the auditory, that the court was, in defiance of all decency, thrown into an uproar by their noisy exultations.

[1] Gilchrist, 1942, p. 172; 1863, p. 175.
[2] Gilchrist, 1942, p. 174; 1863, p. 177.
[3] Bodley MSS. Eng. misc. d. 134, no. 158.
[4] The confusion over the Christian name of the accused may perhaps be explained by the fact that one of the ten labourers indicted at the same Session for riotously releasing an impressed seaman was a Charles Blake (Sussex County Record Office, QR w. 644, f. 124).

The business of the aforegoing Sessions, owing to the great length
of time taken up by the above trials, was extended to a late hour on
the second day, a circumstance that but rarely happens in the Western
Division. The Duke of Richmond presided, and sat the first day from
ten in the morning till eight at night, without quitting the court, or
taking any refreshment.

On the same day as this newspaper report, Hayley took up
in a letter to Romney's son John the problem that Flaxman
had raised two weeks before:

pray what is the destiny of his *[George Romney's]* large Cartoons of *January*
black Chalk—several of these were from subjects that I suggested to *16th,*
Him & He had promised to give me half a dozen of them in narrow *1804*
Frames—a promise that I never claimd & mean not to claim now but
as Flaxman thinks that two of these might be engraved in a rapid
free & bold manner to decorate his Life as pleasing specimens of his
Talent for original design I wish you would allow Mr Blake to copy
two of them if they are still in London—particularly the Lapland Witch
raising a Storm a design that our Friend Meyer used to call equal to
any Figure of Michael Angelos—& Pliny the younger with his Mother
in the scene of the Earthquake—If these two designs are with you in
the North & you will be so obliging as to lend them to Blake I will
readily pay the expence of their Carriage to London & back to you
again[.] I wish you also to let Blake make a drawing from a sketch in
oil now I hear at Saunders' of the man & Horse rescuing females from
the perils of Shipwreck[.]—[1]

This letter Hayley evidently enclosed to Blake for Flaxman's
approval, for on January 27th Blake replied:

I shewd your Letter to Mr John Romney to Mr Flaxman who was
perfectly Satisfied with it. I seald & sent it immediately as directed
by Mr Sa[u]nders to Kendall, Westmoreland. Mr Sa[u]nders expects
Mr Romney in town soon. Note, Your Letter to Mr J Romney I sent
off the morning after I recievd it from you[.]

On Wednesday, January 18th, Hayley wrote to Johnny;
the latter had evidently sent a drawing of the chapel in which
Cowper's monument appeared:

your amiable Archi.ect has not done full justice to my design I
shall obviate the disadvantage that might arise to the design of the

[1] Vol. xv of the Fitzwilliam Hayley MSS. This is a draft. The first two drawings
were among those suggested to Hayley by Flaxman, but only the third was in-
cluded in the biography of Romney, and it was engraved by Blake.

Monument from this Circumstance—1st by desiring our good Blake to *make out* the parts more carefully in his Engraving, & secondly to introduce a second plate in our third volume with the Monument & the Epitaph by themselves— . . . & now let me tell you a Letter met me yesterday at Lavant from our good Blake so full of the most cordial Gratitude & Felicity on his safe return to his anxious Wife, that no feeling Mortal can read it without Tears[.][1]

January 18th, 1804

The letter which moved Hayley so was the one dated January 14th, in which Blake said that 'Gratitude is Heaven itself[;] there could be no heaven without Gratitude[.] I feel it & I know it[.] I thank God & Man for it & above all You My dear friend & benefactor in the Lord'.

January? 1804

It was probably at the same time that Hayley wrote to Lady Hesketh that he would offset the failure of 'Johnny's architect, who has so murdered the elegance of my design . . . by introducing a second plate of the monument itself, without the chapel. Blake assures me the plaister model of the monument, now in Flaxman's study, is universally admired for its elegant simplicity.'[2]

January 27th, 1804

On January 27th Johnny Johnson wrote to Hayley: 'A thousand thanks and huzzas, for yᵣ lettᵣ about poor dear Blake, in whose felicity I rejoice most copiously.'[3] Samuel Greatheed wrote on the same day about Hayley's fall from his horse:

January 27th, 1804

I have never forgotten the affectionate anxiety of our friend Blake, when the return of Hidalgo (without his occasional rider) excited his apprehension that a fate, somewhat similar to that which has fallen the poetical Hermit of Felpham, had occurred to the Theological pilgrim of Newport. Gratitude, and my deference for Genius in every situation, excited therefore my sincere concern at what I learned from a Newspaper of the trial at Chichester. This was, merely, that he had been tried, and had been acquitted; with the very unsatisfactory explanation, that some Soldiers had sworn to his having used seditious lan-

[1] Hayley–Johnson Fitzwilliam letters.

[2] *The Works of William Cowper, Esq.*, ed. R. Southey, London, 1836, vol. iii, p. 238. The letter is introduced merely as 'an unpublished letter to Lady Hesketh, written while his [*Hayley's*] third and supplementary volume of the Life of Cowper was in the press'. Blake's assurance about the universal admiration for Flaxman's model must have been given while he was in Chichester for his trial, for it does not appear in any surviving letters.

[3] Bodley MSS. Eng. misc. d. 134, no. 160. This is the last letter in the Hayley–Johnson Correspondence in which Blake is mentioned.

guage. I knew our friend's eccentricity, and understood, that, during the crisis of the French Revolution, he had been one of its earnest partisans: but of everything else I remain ignorant; and shall be obliged to you for information.[1]

On February 1st Lady Hesketh wrote on the last available space on her paper: 'Sincerely do I congratulate you on the acquittal of your friend & on the kindness & Eloquence of our good Rose. You are so Staunch and Jealous in your friendships once made that you cannot be too careful in your choice.'[2]
February 1st, 1804

On Saturday, February 4th Carr wrote that he was 'severely shocked' by Hayley's narrative of 'the dreadful disaster', apparently his fall from his horse: 'I am still under heavy anxiety on your account, particularly from the postscript of your letter. For God's sake take care of yourself. Your benevolent enthusiasm in the cause of oppressed Innocence, will I fear for some time augment your sufferings. Remember how dear you are to your Country & to your Friends, & do not by hurrying your spirits hazard a life so truly & eminently precious to both.'
February 4th, 1804

On February 5th Hayley wrote to Lord Glenbervie that he was sorry to say

my highly valued Friend Rose is still a disabled Invalide[.] His spirit carried him beyond his strength in professional exertions at our last sessions when He made a very eloquent & successful defence for the interesting artist who came to reside a long time in this village to engrave the Portraits of Cowper[.] Being a man of resolution as well as ingenuity He last summer thrust a lounging intrusive soldier out of his Cottage Garden—The vindictive Fellow basely conspired with his Comrade to fabricate a charge of uttering seditious expressions against the artist—who might have suffered as a victim to this villainy had not Heaven & his Innocence with the testimony of some honest rustic neighbours enforced by our dear eloquent Rose preserved him from the snare[.]—[3]
February 5th, 1804

During this time Blake was being harried about the two Cowper plates. On February 23rd he promised Hayley 'you

[1] Vol. i of the Fitzwilliam Hayley Correspondence. Hidalgo was a spirited horse of Hayley's, the poetical Hermit of Felpham was Hayley, and the Theological Pilgrim of Newport was Greatheed.

[2] Quoted from the MS. in the Cowper Museum, Olney, Buckinghamshire,

[3] A draft of the letter is in vol. xi of the Fitzwilliam Hayley Correspondence. Douglas Sylvester (1743–1823), Lord Glenbervie, a very influential politician and lawyer, had probably known Hayley from the time when he was M.P. for Midhurst in 1796.

shall have Proofs in another week'; on March 12th they were 'almost finishd'; on March 16th he sent proofs, though he said 'they have not [*had*] the last touches'; on March 21st he sent two proofs of each plate 'which I hope will please. Should have sent the twelve of each if I had not wishd to improve them still more, & because I had not enough paper in proper order for printing: beg pardon[.]' Hayley became anxious, because the book was all printed, and he had promised copies to his friends. He rushed a letter to Blake asking for the prints by Tuesday, March 27th, but it was not until Saturday the 31st that Blake wrote:

I did not recieve your Letter till Monday of course could not have got them Printed to send by tuesdays Coach But there is a real reason equally good why I have not yet sent. I hope you will believe me when I say that my solicitude to bring them to perfection has caused this delay as also not being quite sure that you had Copies ready [*printed*] for them. I could not think of delivering the 12 Copies without giving the last touches which are always the best. I have now I hope given them & we directly go to Printing. Consequently it will be by Tuesdays Coach that you will recieve 12 of Each.

Before Hayley actually received Blake's not-very-penitent letter he had begun a rather plaintive explanation to Rose on April 1st:

April 1st, 1804 The Copy prepar'd for the tender Theodora reach'd you, I hope, on Wednesday Evening, & I hope you took an affectionately Eager Survey of *several Pages at least* for Heaven only knows, when you may see *another complete Copy*;—not within the Time when I led you to expect it, for that Time is *past*, & the fresh Engravings we expected from Blake by the Coach of Tuesday were not arriv'd when Seagrave met me at the Cottage on *Friday*—our mutual Consternation was *extreme*, for the bitter consequence of this disappointment is, that we can not raise a Copy for *one* of the particular Friends, whom we wish'd to supply with the *utmost Celerity*— We have however (thank Heaven) provided for our excellent coadjutor Paulina, & the two tender Cousins of the dear Bard,[1] & for this I shall be thankful indeed, if I should find (no improbable Supposition) that the plates were de-

[1] Cowper's two cousins were Lady Hesketh and her sister Theodora, and Paulina was Miss Poole of Lavant. Hayley intended to have Seagrave insert the engravings in twelve copies, to be sent to his friends directly from Chichester, instead of having Johnson of St. Paul's Churchyard send them from London.

stroy'd in that cruel Fire, which I observ'd in the Newspaper, & which is said to have destroy'd many valuable Plates of that excellent Engraver Sharp— Blake told me He had found an excellent Copperplate Printer not far from Him[1] & perhaps He had confided his Work to the very person so unfortunate in regard to the Engravings of Sharp— yet in *that case I* think our Friend would have given me a Line by the Post to *relate the mischance*—perhaps his little parcel is only loitering at the Coach office in London— I am weary of Conjectures & I hope my courier of today may happily end them by bringing me Intelligence from Seagrave, that these tardy plates arriv'd *last Night*—my zealous printer informd me on *Friday*, that his Cargo of large paper copies are gone to St Pauls[;] you will be kind enough therefore (if Blake has not fail'd in supplying Johnson with plates) to accelerate the delivery of presentation Copies

Huzza!—Here is my Courier with Letters from the dear Counsellor,[2] from Blake, & my pleasant Cousin Charles Godfrey—The plates *are safe*—Blake apologizes for delay, assuring me it arose only from *his Zeal* to improve them & not *understanding* they were so eagerly wanted—Patienza!—they will arrive here on Tuesday & at St Pauls the plates may be worked with expedition—. . . . I write to Blake— He will probably send the plates to Johnson *Tomorrow Evening* so pray get Books for yrself from St Pauls with the utmost Celerity[.][3]

Apparently the prints arrived as promised (Blake said he had sent them on April 2nd), and the books were dispatched. On Monday, April 30th Greatheed praised his copy, which had just arrived, thoughtfully including a kind word for Blake at the end of his appreciation: 'Again, Thank You for giving Cowper's friends a repeated peep at his rural monument, without taking a journey to Dereham for the purpose. Friend Blake has well executed his business respecting it.'[4] *April 30th, 1804*

On the receipt of his copy Flaxman wrote on May 1st:

You will readily believe how much I was delighted with your friendship equally generous & magnanimous to poor Blake under the most threatening circumstances, & indeed I rejoiced no less in the event— . . . —M[r] Blake is to have from 5 to 6 Guineas each from *May 1st, 1804*

[1] Blake's letter about his copperplate printer has not survived, but why was he not printing them himself, as he had those for the first two volumes? (See Blake's letter of Jan. 30th, 1803.)

[2] The 'dear Counsellor' is Samuel Rose.

[3] Quoted from the MS. in the possession of the late Kenneth Povey, who gen - rously sent it to me to allow me to transcribe it.

[4] Vol. i of the Fitzwilliam Hayley Correspondence.

Messʳˢ Longman & Rees for the plates of the Homer according to the
labor, but what the proper recompense for more finished engraving
might be I cannot tell, but this might be learned from the Booksellers,
Mʳ Davis is better qualified than almost any one to inform you of the
current prices; it might perhaps be advantageous to Romney's life,
to adorn the book with two or three bold etchings shadowed on a
small scale, in which Blake has succeeded admirably sometimes & to
engrave some of the other compositions in outline only for head &
tail pieces to the Chapters or divisions of the work[1]

Hayley evidently wrote to Blake immediately on receipt of
this letter, repeating Flaxman's proposals or enclosing his
letter, for on the 4th Blake replied: 'Mr. Flaxman agrees with
me that somewhat more than outline is necessary to the execu-
tion of Romney's designs, because his merit is eminent in the
art of massing his lights and shades. I should propose to etch
them in a rapid but firm manner, somewhat, perhaps, as I did
the *Head of Euler*;[2] the price I receive for engraving Flaxman's
outlines of *Homer* is five guineas each.'

*May
5th,
1804*
In a letter postmarked the next day, Saturday, May 5th,
Samuel Rose wrote to his father-in-law Dr. Farr: 'Mʳˢ R. will
probably have told you I was highly complimented by the Duke
of Richmond for my Defense of Blake, and magnificently
remunerated by Hayley[.]—'[3] Probably Blake himself delivered
to Rose a cheque from Hayley enclosed in a complimentary
sonnet which Blake had copied in his best copperplate hand,
for on January 27th, 1804 Blake assured Hayley 'I have taken
your noble present to Mʳ Rose & left it with charge to the
Servant of Great Care[;] the Writing looks very pretty[.]
I was fortunate in doing it myself & hit it off excellently[.]'

Because of Blake's suddenly startling prices, Hayley tried
to enlist Flaxman's help in finding other engravers for his bio-
graphy of Romney. Flaxman replied cautiously on Friday, June
8th:

*June
8th,
1804*
before I spoke to Caroline Watson concerning the engraving I was
willing to know the probable expence by consulting a friend who is a
very great Artist in that way, he told me that the abovementioned

[1] BM Add. MSS. 36540, f. 50. Mr. Davis is presumably Hayley's publisher in
the firm of Cadell & Davies.

[2] The head of Euler appeared in Euler's *Elements of Algebra*, 1797.

[3] BM Add. MSS. 37060, f. 79.

lady engraves in the dotted manner only, which is not fit for the decoration of Books, & that the lowest expence of such a plate will be 35 Guineas, you will decide on the price & manner, & then let me know your determination—. . . . I beg you will countermand your desire that Blake should buy the additional plates to the Homer when published for I shall send them to beg your acceptance sufficiently ashamed that they are no return for the many presents you have sent to me of a kind so much more valuable[.]—[1]

On Saturday, June 16th Saunders wrote to Hayley about *June* Romney's son: 'I am now Writing to him [*and*] will ask him *16th,* for a list of pictures from his Book with two or three questions *1804* Mr Blake mentioned [*P.S.*] Since I wrote my Letter Mr Blake calld on me & I have sent him—the three pictures, one the Oil picture, & the two drawings he chose—deliverd them at his house in South Molton St[.]'[2] On June 22nd Blake himself told Hayley the same news: 'I have got the three Sublime Designs of Romney now in my Lodgings'. He identified them as 'The Shipwreck', 'Hecate', and 'Pliny', and estimated that it would cost thirty guineas to engrave 'The Shipwreck' properly, and fifteen guineas for the smaller drawings.

On Saturday the 16th Flaxman wrote:

Notwithstanding Your apparent determination & reasons given for *June* having the drawing engraved by the Lady you have mentioned I *16th,* cannot communicate that commission untill I have given my reasons *1804* for delay, I, like You, delight in paying a large portion of respect & preference to Female Talent but if I am to execute a commission for a Friend it ought to be done faithfully with a view to his satisfaction & advantage, at least not to his hurt, & really I have seen two children's heads with the abovementioned lady's name lately copied from pictures by Sr Wm Beechey, but so miserably executed that similar engraving instead of being a decoration, would be a blemish in your Book[.] I am very sure the fault could not be in the pictures, for the Painter is a man of great merit[.] if after this information you still continue in the same resolution as at first I will deliver Your Commission but there my interference must cease & all further communication must be between the Engraver & Yourself, because I foresee that

[1] Quoted from the MS. in a volume entitled *William Blake Letters by Several Hands* in the Library of Congress.
[2] Quoted from the MS. in my possession.

the conclusion of such an engagement must be unsatisfactory to all parties concerned[.][1]

Hayley was reminded by Flaxman's letter of what Blake had told him on May 28th: 'if you suffer yourself to be persuaded to print in London you will be cheated every way in London every calumny and falsehood utter'd against another of the same trade is thought fair play. Engravers, Painters, Statuaries, Printers, Poets, we are not in a field of battle, but in a City of Assassinations.' Probably on the day he received Flaxman's letter, Hayley replied through a semi-literate amanuensis:

[*Monday*] June 18 1804

June My very Dear Flaxman
18th, If I interpreted litrally an expression in a Letter, of our so lively
1804 Friend Blake, who says 'London among authors & artists of every kind, is a city of assassinations, where every thing is reckond fair in destroying those [*we*] happen to dislike', I should apprehend, that even my Dear magnanimos sculpter had struck with a Varberous stiletto, the Reputation of Caroline The Engraver but as I hold it to be an uter impossibility, that you can act or speak unjustly on so tender a point as that of professional merit, I must suppose that the Eyes or Hand of that ingenious Woman have been injur'd by Time or chance, & no longer possess the Talent for which i gave her full Credit.— at all Events I held it my duty to Romneys Pupil (who generously declines all pecuniary reward for his drawing) to our Dear Painter Himself, & to his promising poetical namesake, to sacrifice my predilection for the female Engraver, & confided the execution of the plate from this very delicate & pathetic Drawing to your kind care & direction.— I will only add therefore it is my wish to have it executed with all possible parfection & I shall think the sum you mentiond 25 Guinas a very reasonable price— I should like to employ your Freand Cromak on the Ship wreck you menion, but as I learn by a Letter from Saunders which arriv'd with your last, that Blake has just got in his own apartments the three designs of Romney; given to me by his Son, I should be sorry to risque wounding the Feelings of our quick-spirited Freand by sending the oil sketch from his possassion to the House of any other Engraver[.][2]

[1] Quoted from no. 22 of a group of 56 Flaxman–Hayley letters in the Fitzwilliam. Flaxman went on to recommend Cromek for the Romney engravings. 'M^r Cromak is a man of independent Spirit & is very handsomely employed as he well deserves—.'

[2] Quoted from the MS. in the possession of Sir Geoffrey Keynes. Hayley con-

Flaxman replied tardily on Thursday, August 2nd, recommend- *August 2nd, 1804*
ing which Romney pictures should be engraved for the life and
saying that Cromek 'is abundantly employed & sought after':
'with respect to Blake's remark upon "Assassinations" I
suppose he may have been acquainted with wretches capable of
such practices, but I desire it may be understood that I am not
one of them, & 'tho I do not deal in "barbarous Stilettos" my-
self I am willing to acknowledge the benevolence & soundness
of Blake's general observation as well as the point & keenness
with which it was applied; but this was only a poetic jeu d'esprit
which neither did nor intended harm[.]'¹ Flaxman's comment
seems to indicate that he consulted Blake himself about his
poetic meaning in this case.

In the event Caroline Watson engraved seven plates, and
Blake's only engraving was the one called 'The Shipwreck'.
Hayley appears to have had some twinges of conscience, as we
may deduce from the letter Flaxman wrote to him four months
later, on Wednesday, November 7th:

You can have little need to dwell on your friend's [*Rose's*] illness *November 7th, 1804*
as an apology for not having been liberal to the artists employed in
Romney's life, because in truth your bounty exceeds the expectations
& frequently the wishes of all those who do anything for you; as to
Mr Sharpe's leisure to engage in this work, I can say nothing certain
about it, for his pursuits & mine for some years past have been so
different that we never meet notwithstanding I shall always respect
him as a great artist & a benevolent man, I have understood that there
is great difficulty in prevailing on him to finish his works, but if You
choose to write to him the direction is No 50 Upper Litchfield Street
Oxford Market London, there is another Engraver of distinguished
merit who is a punctual honest Man[,] Mr Parker a fellow Student
of Blake,² by whom You have a beautiful small print of David playing
on the harp before Saul, he lives at, Spring Place Kentish Town, near
London, You may besides see specimens of the best Engravers of the
present time in Bowyer's History of England & other popular works

cludes by asking Flaxman to pick out pictures by Romney 'for your favourite
Engraver' Cromek to engrave for the biography. The Flaxman letters of this time
are full of references to Cromek; see especially Maria Flaxman's letters of 1804
and 1805, BM Add. MSS. 39783

¹ No. 23 of a group of Flaxman letters in a green book in the Fitzwilliam.
² By 'fellow Student' Flaxman meant that Parker and Blake were apprentices
together under Basire.

now or lately published, which will enable you to select the Man[?] that pleases you most with more satisfaction than can arise from any inter-ference of mine as I have no intimacy among them & have no know-ledge whatever of their several prices & conditions of undertaking work[1]

Blake would have agreed heartily with Flaxman's sympathy for Rose. When he died six weeks later, Blake wrote to Hayley (on December 28th): 'Farewell Sweet Rose thou hast got be-fore me into the Celestial City. I also have but a few more Mountains to pass for I hear the bells ring & the trumpets sound to welcome thy arrival among Cowpers Glorified Band of Spirits of Just Men made Perfect[.]'[2]

On November 14th Lady Hesketh asked 'that no inferior or midling artists, may ever more be suffered to lay their insuffi-cient Hands on any future work of yours! . . . [*I am*] ardent in my wishes that the ingenious Catherine [*Watson*] shou'd have the Glory of embellishing your Work[.]'[3] Indeed, she went on to say that she had already written to Miss Watson to tell her that the commission was hers.

About this time Blake was becoming involved with another of Hayley's projects, the first account of which was given by Blake in his letter of April 7th, 1804: 'M[r] Phillips . . . [*whose*] connections throughout England & indeed Europe & America enable him to Circulate Publications to an immense Extent . . . [*proposes that you edit a periodical which*] may be calld a Defence of Literature against those pests of the Press & a bulwark for Genius . . .'. Phillips wrote on April 20th to tell Hayley, 'it is in your power more than that of any other person to effect this most desirable purpose',[4] and on the 23rd of April Hayley answered that Phillips overvalued his services: 'You must think *me* therefore *entirely out of the question*'. Early in the next

[1] Quoted from a microfilm of the MS. in the Pierpont Morgan Library.

[2] Rose does not seem to have been a patron to Blake, for at the sale of his library by Leigh & Sotheby on May 1–3, 1805 there were no works by Blake except commercial engravings.

[3] Quoted from the MS. in Olney.

[4] All the Phillips–Hayley Correspondence quoted here (except the letter of Feb. 28th, 1805) is taken from the original MSS. preserved in a large green box in the Fitzwilliam Museum. Because Hayley's letters are rough drafts, dating them is occasionally difficult. In this letter Phillips said he was prepared to spend £1500 a year on the periodical, £400 for Hayley and the rest for eight to twelve co-adjutors.

year Hayley suggested that Phillips should buy his literary copyrights, including those for unwritten works, the whole of which could be published in a series of one elegant volume a year. On January 19th, 1805 Blake reported that he had just been to see Phillips,

& he has in the most open & explicit manner offerd his service to you Expressing his desire that I will repeat to you his regret that your last beautiful Poem [The Triumph of Music, *printed by Seagrave*] was not Publishd in the Extensive way (I speak his own words) that a Poem of Confessedly the first Poet of England ought to be given to the Public [*He said, I hope that*] if M^r H has no Engagement with any London Book-Seller I may myself be appointed by him in so honourable a concern as the Publication of his Labours. He then Proceeded to find fault with the Printing of our friend the Chichester Printer. Here I considerd it my duty to interfere. I expressd my own respect for our Good Seagrave & said I knew your chief intentions in Employing him were 1^st to Encourage a Worthy Man & 2^d For the Honour of Chichester. M^r P immediately replied, If M^r Hayley should think fit to employ me as his Publisher I should have no objection but a pleasure in employing his Printer & have no doubt I could be of service to him in many ways but I feel for the Honour of London Booksellers & consider them as losing a great deal of Honour in Losing the first Publication of any work of M^r Hayleys & the Public likewise are deprived of the advantage of so extensive a diffusal as would be promoted by the methods which they use to Publish & disperse Copies into all parts to a very great amount[.] He then said, If M^r Hayley is willing to dispose of this his New Poem I will Purchase it & at his own Price or any other of his Works I thought it best to keep Silent as to any thing like a hint of a proposal relating to Edw^d 1^st or the Ballads having come from you accordingly I did not say that I knew of any Poem but left all to you intirely

Pray might I not Shew Phillips the four Numbers of Ballads? or will you write to him? or will you think it best to commission me to answer him? whatever you command I will zealously perform—& Depend upon it I will neither do nor say but as you Direct[.]

Hayley must have written to Phillips about the Ballads immediately, for on January 22nd Blake hastened to express to Hayley his

thanks for your generous manner of proposing the *Ballads* to him on my account, and inform you of his advice concerning them; and he thinks that they should be published *all together* in a volume the size

of the small edition of the *Triumphs of Temper*, with six or seven plates. That one thousand copies should be the first edition, and if we choose, we might add to the number of plates in a second edition. And he will go equal shares with me in the expense and the profits, and that Seagrave is to be the printer. That we must consider all that has been printed as lost, and begin anew, unless we can apply some of the plates to the new edition. I consider myself as only put in trust with this work, and that the copyright is for ever yours. I, therefore, beg that you will not suffer it to be injured by my ignorance, or that it should in any way be separated from the grand bulk of your literary property. Truly proud I am to be in possession of this beautiful little estate; for that it will be highly productive, I have no doubt, in the way now proposed; and I shall consider myself a robber to retain more than you at any time please to grant. In short, I am tenant at will

Evidently Phillips committed himself to rather more in conversation than he was willing to do in writing, for many of the conditions Blake mentions here as agreed upon were haggled over for several months. Phillips seems to have begun by objecting to using a provincial printer like Seagrave of Chichester, but about January 25th Hayley stated firmly that he had

January 25th, 1805 an unalterable attachment to my intelligent alert liberal goodhearted printer Seagrave & living or dying I shall ever desire that my publications may be printed by my worthy Countyman— I have desired our zealous Friend Blake to speak to you on some poetry of mine that I composed expressly for his Benefit & that I wish you to render as beneficial to Him as possible— I only wish to reserve to myself a right of inserting them, (without the ornaments annex'd) in a Collection of my works[.][1]

February 11th, 1805 On Monday, February 11th Phillips apologized for his tardiness in writing: 'This day is in fact the first on which I could write to you with effect, having in the course of it agreed with M^r Blake about the publication of your Ballads I am ready to participate in promoting your Scheme of benevolence. What are your wishes?—I shall endeavour on a twofold account to meet them.' In the same month Phillips evidently wrote to Seagrave trying to arrange special printing terms with him, and Seagrave replied that his prices were the

[1] The draft is undated, but the date of it can be determined by Phillips's reply of Feb. 11th, in which he apologized for his delay in answering Hayley's 'Letter of the 25th Ult.'

same as those of the London printers.[1] This alarmed Phillips,
who had counted on being able to get preferential rates; on
February 13th he wrote to Hayley that he could not do business
on Hayley's terms because Seagrave's rates were so high as to
endanger his (Phillips's) independence. Hayley was astonished
at this turn of affairs and on the 17th wrote to conciliate Phillips;
on the 21st Phillips wrote to Seagrave stating his position
somewhat curtly, and on Friday, February 22nd he wrote to *February*
Hayley again: 'Dear Sir, At the instance of M.ʳ Blake & in *22nd,*
accordance with my own feelings I have written again to M.ʳ *1805*
Seagrave, & if his answer is in any degree Satisfactory, I shall
have pleasure in communicating the result to you.'

Seagrave was distressed at these letters, and on Thursday,
February 28th Hayley wrote to Phillips:

Dr Sir *February*
Be not surprized, that you receive no Reply from my honest Sea- *28th,*
grave!—as He Kindly came, *on Sunday,* to shew me what had passed *1805*
between you, I voluntarily undertook to answer your last Letter to
Him. . . .

It seems to me, that you must have been *in haste* when you failed to
understand Seagraves last Letter. It appears to me as plain & civil a
Letter, as you could wish— . . .

Now, my good Mr Phillips, as I cannot perceive you have any
important Ground for differing with my worthy Seagrave, let me en-
treat you to be *perfectly frank*; & . . . if you discover *any probable Sources*
of *such discontent not visible to me,* I advise you, very candidly, *not to
form the connection—*

To guard against the chances of disagreement your rule is a good
one, to be *as explicit* as *possible* in the *outset of Business.*—If you pub-
lish the Ballads, I have no wish concerning them, but that they may
be well executed by my own Printer, for the joint advantage of my
Friend Blake, & yrself—I shall only expect to receive 30 Copies to
present to my particular Friends, reserving also the right to reprint
them in a collection of my Works.[2]

On Tuesday, March 5th Phillips wrote to Hayley agreeing to *March*
Hayley's terms of compromise, and calling Hayley 'a minster *5th,*
of Peace!' 'I am chiefly concerned for Poor Blake who has been *1805*
sadly tortured by these untoward circumstances. I shall now

[1] This information is summarized from a number of undated letters from Sea-
grave to Hayley and Phillips in vol. xi of the Fitzwilliam Hayley Correspon-
dence.

[2] Quoted from the MS. in the Osborn Collection.

direct him to proceed with his designs & engravings.' To this
letter Hayley replied brusquely on Saturday, March 9th that
the terms Phillips had agreed to were not the ones he had
proposed, and that his terms must be met. 'I am sorry the
Impediments in our business have vexed Mr Blake but I must
not permit my eagerness to serve one Friend to render me
unjust to another[.]'

In a letter postmarked Monday, March 11th Phillips acceded
to Hayley's further terms. He was probably influenced in his
willingness to deal with Seagrave by the current turmoil in the
London printing industry. By March 9th some 250 pressmen
had left their jobs, 'thereby [*according to the Master Printers*]
leaving, on their part, all public and private Business nearly at
a stand'.[1] Phillips was very shrewd to farm out some of his
printing to the country while the London printing industry was
at a standstill, or at best moving forward fitfully. Blake was
probably aware of these issues at the time, for on March 22nd he
told Hayley: 'The Journeyman Printers throughout London are
at War with their Masters & are likely to get the better[.]
Each Party meet to consult against the other, nothing can be
greater than the Violence on both sides[.] Printing is suspended
in London Except at private Presses. I hope this will become a
source of Advantage to our Friend Seagrave[.]'

In his letter of compromise Phillips went on: 'Notwithstand-
ing my numerous interviews with *Blake*, I have never been in
possession of his address, I wish therefore that you would do
me & him the favour to apprize him that we are all agreed &
"ready for the fight."' It was not, however, until eleven days later,
on Thursday, March 22nd, that Blake could write: 'This Morning
I have been with M^r Phillips & have intirely settled with him
the plan of Engraving for the new Edition of the Ballads
I am making little high finishd Pictures the Size the Engravings
are to be, & am hard at it to accomplish in time what I intend.
M^r P says he will send M^r Seagrave the Paper directly[.]'

At the same time Hayley was negotiating for a new engraver
to undertake the plates for the new edition of the life of Cowper,
and he commissioned John Carr to help him. On March 11th
Carr reported: 'I was not able to see Miss Watson, [*but my*

[1] *The London Compositor*, ed. E. Howe, London, 1947, pp. 103, 104; cf. also
pp. 84–104 and J. Johnson, *Typographia*, London, 1824, vol. i, p. 579.

publisher] Phillips says, that she will execute what you wish in 6 weeks, her price 25 Guineas—he paid her this sum for each of the portraits which she engraved for him, & she is now a little in want of employ, so that you could not have applied in a better time—Phillips will be happy to speak to her if you wish it, or I will with equal pleasure[.]' Hayley apparently replied that he would like Carr to speak to Miss Watson, for on Thursday, March 28th Carr wrote:

I yesterday called upon M[r] Blake before I received your last letter, *March* with respect to Caroline Watson's engraving, he observed that his *28th,* feelings were not wounded, & that he was completely satisfied with your *1805* wishes—I then proceeded to C. W. who lives at N[o] 10 Furnivals Inn Court Holborn with the drawing. I found her a very interesting, diffident woman, she shewed me some of her recent engravings which are very beautiful indeed, she will reduce the Engraving in the way you mentioned, & she hopes to be ready in a Month's time—Her reputation is so high, & her powers of art so delightful, that I rejoice you have employed her—I think entre nous, a little money in advance would be acceptable, not that she expressed the slightest wish upon the subject, but upon my entering her room, she appeared much agitated, & I saw tears in her eyes, in the course of our conversation she apologized for the negligence of her Apartment, which however I thought neat, & was adorned with some exquisite specimens of her talents . . . [*She used to live with her brother, but left abruptly when he was*] obliged to abscond[.]

A week before, on March 22nd, Blake had written: 'The Idea of Seeing an Engraving of Cowper by the hand of Caroline Watson is I assure you a pleasing one to me[;] it will be highly gratifying to see another Copy by another hand & not only gratifying but Improving which is better[.]'

On Thursday, April 25th Phillips wrote to Hayley:

The Paper for the Ballads has been sent to M[r] Seagrave & M[r] Blake *April* is forewarding [*i.e., going forward with*] the Plates. Before M[r] S. *25th,* puts any sheet to press I should like to see a proof that certain little *1805* features of his printing may be corrected to give it a metropolitan & fashionable Air.[1] I would recommend M[r] Roger[s]'s pleasures of Memory, Campbell's Pleasures of Hope, or the Poems by [*Mason*] the

[1] On Jan. 19th, 1805 Blake had written to Hayley: 'P's chief objection to the manner in which the Triumphs of Music are printed—were the strong Metal Rules at the Ends of the Canto's—but he confessd to me that the first Page of the Poem was beautifully executed & could not be better done[.]'

Author of the Heroic Epistle as the most worthy of M^r Seagrave's imitation in this affair of the Ballads.—

Blake had promised in his March 22nd letter to have the plates finished by May 28th, and in fact they are dated only three weeks after that, on June 18th. Within a month they were published, for on Thursday, July 18th Hayley wrote to Lady Hesketh to say that he was sending her not just a letter but a 'pacquet':

July 18th, 1805 I say *pacquet* because my Billet is to travel to you with a little Book, *a respectful offering* of *gratitude to you* from a very *industrious* tho not a very *prosperous* artist—smile on his gratitude, tho you will frown on some productions of his pencil, particularly *the last*, in the little volume, which He thinks his *best!*[1]—so little can artists & authors judge of their own *recent* Composition[.] as to *the Failings* of the Ballads themselves, they perhaps may be allowed to *find shelter* in the *Mantle of Charity* so famous for *covering sins of all sorts*, at least they will meet with *that indulgence* from *your GoodNature*, my dear Lady, as I will whisper in *your Ear*, that I printed them *only*, that they may prove more beneficial in their *pocket size* to the diligent artist, who laboured in the Cause of dear Cowper with *more Zeal*, than *Success*—but as Addison tells us in his Cato

'Tis not in Mortals to *command* success'

& even your lovely princess, like your zealous Hermit, must lament, I think, that the *Hand* of an industrious artist did not *perfectly record* the wishes of her *Heart*[.][2]

In the last sentence Hayley evidently means that Princess Elizabeth must lament, as Hayley did, that she had no more realized 'the wishes of her *Heart*' in the book of designs she had published in 1804 than Blake had in his engravings.

On Saturday, July 27th Lady Hesketh protested to Hayley:

Surely my dear Sir you are gifted with *more* true Charity, than falls to the lot of most mortals, (or that perhaps one wou'd wish there

[1] The last plate in the volume was 'The Horse', which Blake 'consider[ed] as one of my best' (June 4th, 1805). Rossetti wrote (*Letters of Dante Gabriel Rossetti to William Allingham 1854–1870*, ed. G. B. Hill, London, 1897, p. 158): 'Ruskin's favourite (who has just been looking at it) is the *Horse*; but I can't myself quite get over the intensity of comic decorum in the brute's face. He seems absolutely snuffling with propriety.' See Plate XVII.

[2] Quoted from the MS. in Olney. On Nov. 10th, 1804 Hayley had written of the 'endearing kindness' which Lady Hesketh received from Princess Elizabeth (*Memoirs of the Life and Writings of William Hayley, Esq.*, ed. J. Johnson, London, 1823, vol. ii, p. 150).

PLATE XVII

The Horse

BLAKE'S ENGRAVING FOR 'THE HORSE' for Hayley's *Ballads*
(1805), which Lady Hesketht hought 'a little extra!' D. G. Rossetti claimed
the horse was 'absolutely snuffling with propriety' (see pp. 162–3)

should) if you can not only forgive but continue to *protect*, and cherish, one, (whom, for y^r sake, I ever *tremble* to think of, and whom certainly I will *not name*) and now let me, before I say another word, return you a thousand thanks for your sweet little work of which I did not at all know that the whole were come out, and was rather surpris'd when a Lady of my acquaintance told me that her bookseller had sent her *Hayley's ballads* I apprehended the work had been laid aside, the rather as I knew you had undertaken it with a benevolent intention which I imagind you had not Judg'd necessary to carry thro.'[*It*] has given me much Entertainment. . . . I confess I think with you that the Horse is a little extra! to say nothing of the extreme composure of the Lady, but I was never formd to Criticize any of the Sister arts, and shall leave to abler Judges to decide on the merits of the Engravings I wish I cou'd say which of these ballads pleases most, but 'tis difficult[.]^1

<div style="text-align: right">*July 27th, 1805*</div>

She was, however, more outspoken than ever in her letter to Johnny Johnson of July 31st: 'My hair stands on end to think that Hayley & Blake are as dear friends as ever! He talks of him as if he was an Angel! How can you Johnny suffer our poor friend to be thus impos'd upon?—I don't doubt he will poison him in his Turret or set fire to all his papers, & poor Hayley will consume in his own Fires.'^2

<div style="text-align: right">*July 31st, 1805*</div>

On Monday, August 1st Hayley wrote to Joseph Cooper Walker saying that he was 'sending you a trifling little volume of *Ballads*, which I printed merely in the Hope of serving the very industrious, but not very prosperous artist, whose designs & engravings make a part of the Book[.]'^3 Another copy went to 'Mr. Weller, / With grateful Remembranc[e] / from / William Blake'.^4

<div style="text-align: right">*August 1st, 1805*</div>

On Wednesday, August 3rd Hayley defended Blake to Lady Hesketh again:

I am glad the Ballads amused you— . . .

Now let me say, you made me smile, my dear Lady, by your supposition, that *your Hermit* has a *super-abundance of Christian charity*,
 'Whose heavenly spirit sanctifies Excess'—

<div style="text-align: right">*August 3rd, 1805*</div>

^1 Quoted from the MS. in Olney.
^2 Quoted from a transcript of the letter sent me by its owner, Miss Mary Barham Johnson.
^3 Quoted from vol. xv of the Fitzwilliam Hayley Correspondence. On Aug. 21st and Aug. 28th Jane Moody wrote to thank Hayley for sending 'Your interesting Ballads' to Richard Vernon Sadleir (vol. x of the Fitzwilliam Hayley Correspondence). ^4 The book is in the possession of Mrs. Landon K. Thorne.

I perceive by your striking Intimation, that you have heard some extra-ordinary Incidents relating to poor Blake, incorrectly, if not malevo-lently, reported.—you wonder, that I should continue to befriend Him; but I must be a despicable mortal in my own opinion, if I utterly renounced a *very industrious*, tho not a very *successful* artist, who, while his *Zeal* in my service induced him to work peaceably in this village, was involved (by residing here) in as vexatious, & unjust a persecution, as an innocent, well-meaning Creature could possibly fall into!—The Fact simply was that a brutal quarrelsome soldier (a degraded sargent) intruded into the garden of Blake's Cottage, & refused to quit it— Blake who has courage, agility, & strength, seized the abusive In-truder, & pushed Him (over several paces of ground) to the door of *his Quarters*. The vindictive soldier, provoked to Frenzy, swore He would *have the artist hanged*, & actually engaged a comrade to swear also, in league with Himself, that Blake had uttered the most horrible seditious Expressions.—our dear Rose made an Eloquent speech in the Cause of the poor artist entangled in the snare of these perjured Wretches; but it was *not the Eloquence* of *an advocate*, that saved the innocent man on his trial, & Heaven seemed to show, in a striking manner, that He was to *owe his security* to *different defenders*: for our beloved Barrister, who had caught his fatal Cold in the Evening of the preceding day, felt the Faculties of his admirable Head *desert him*, before *He concluded*; & failed to reply, (as He otherwise would have done,) to the art and malevolence of the opposite Counsel—yet *his client* was *safe*—for Providence had graciously raised Him a little host of honest & friendly rustic Witnesses, particularly one benevolent, clear-headed woman, (the wife of a millers servant) whose garden adjoined to Blakes, & who, by her shrewd Remarks, clearly proved *several impos-sibilities* in the *false accusation*.

In truth this diligent & quiet artist was cordially regarded by his rustic neighbours; & the citizens of Chichester (as I probably told you at the time) were loud in the honest exultation of their joy in his acquittal.—I of course rejoiced most cordially in the public testimony of his Innocence; & shall ever be glad to do Him all the little good in my power, & for extraordinary reasons, (*that may make you smile*) *because* He is *very apt* to *fail in his art*:—a species of failing peculiarly entitled to pity *in Him*, since it arises from nervous Irritation, & a *too vehement desire to excell*.—I have also every wish to befriend Him from *a motive*, that, I know, our dear angelic Cowper *would approve*, because this poor man with an admirable quickness of apprehension & with uncommon powers of mind, has *often appeared to me on the verge of Insanity*:—But Heaven, who has graciously assigned to Him, as an invaluable Helpmate, perhaps the only woman on Earth, who could

have perfectly suited Him as a wife, will continue, I hope, to watch over this singularly Endangered mortal, unfit in truth to take care of Himself in a world like this!—[1]

On Monday, August 12th Flaxman wrote to Hayley:

concerning the Edward the first,[2] I have seen two or three noble Sketches by Blake which might be drawn in outline by him in a manner highly creditable to your book & I would overlook them so far as to see that they should be Suitable to the other designs— . . . the day after I recieved your last letter, Blake brought a present of two Copies of the Songs, it is a beautiful work, Nancy and I are equally thankful for this present and equally delighted with your bounty to the Poet-Artist[.][3]

August 12th, 1805

Almost a month after Hayley's defence of Blake, Lady Hesketh replied on Sunday, September 1st:

In regard to a certain *Artist* I will remember the Story of the Soldier, & of the pains our poor Rose took in that affair, but it was not to that I alluded when I ventur'd to testify my Surprise at the *obstinacy* of y.r Friendship after the *very* strong and proper Cause you had to withdraw it, but I must allow you to have the merits of this affair better than I can do ⁴ so will say no more about it except to say that it is my concern you may not be a Sufferer from your goodness and unbounded Confidence.[5]

September 1st, 1805

When he had been at Felpham, Blake had written to Flaxman, on October 19th, 1801, thanking him for recommending a new patron: 'M.r Thomas your friend to whom you was so kind as to make honourable mention of me—has been at Felpham & did me the favor to call on me. I have promisd him to send my

¹ Quoted from the MS. in Olney.

² The reference to Edward I here and in Blake's letter of January 19th, 1805 is explained by Lot 181 in Sotheby's May 20th–22nd, 1878, sale of Hayley's papers, which listed the MS. of 'Edward the First, a Tragedy,' 1 vol.

³ Quoted from no. 26 of a number of Flaxman–Hayley letters in the Fitzwilliam. The reference to 'the Poet-Artist' suggests *Songs of Innocence* copy D or *Innocence and Experience* copy O which the Flaxmans owned (Christie catalogue of April 26th, 1876, Lots 4–6), but the fact that Hayley was sending his own poems to his friends at this time makes the *Ballads* the more likely gift.

⁴ At this point the old lady's pen ran dry, but her eyes had become so bad that she did not notice she needed to dip it for three words, leaving this small gap. Just above, the words 'proper Cause' are a doubtful reading, and, below, 'concern' is also doubtful.

⁵ Quoted from the MS. in Olney. The letter contains the last reference to Blake in the Hayley–Hesketh Correspondence.

Designs for Comus when I have done them directed to you'.
Flaxman's friend, the 'Rev. Joseph Thomas, Rector of Epsom',
who subscribed to the 1808 edition of Blair's *Grave* with Blake's
designs, proved a steady and generous patron to Blake, paying
high prices for a variety of works. Gilchrist says, 'Flaxman
recommended more than one friend to take copies [*of the* SONGS
OF INNOCENCE AND OF EXPERIENCE], a Mr Thomas among them,
who, wishing to give the artist a present, made the price ten
guineas. For such a sum Blake could hardly do enough, finishing
the plates like miniatures.'[1] Blake also made six drawings
(1806, 1809, and n.d.) of the thirty-seven used to ornament
Thomas's 1632 Shakespeare folio (now in the British Museum).
A further commission can be seen in a letter which Nancy Flax-
man wrote one Sunday in September 1805. She told her hus-
band that their friend 'Mr T' had been near death, but

September is now slowly recovering[,] wishes much to see us at Epsom[,] ex-
1805 presses a great & sincere regard for us both & wishes as a great favor
the loan of *Blake's Gray* to amuse himself with promising that it shall
not go from his chamber or be wantonly shewn to anybody[.] he
wishes to make a few copies from it—to keep with his Youngs Nights
Thoughts & some other works he has of Blakes[.] he wishes to collect
all B— has done, & I have a little commission to give to Blake for him—
respecting the Loan, I shall take [care] to consider of it[.]—[2]

This is the first known explicit and datable reference to Blake's
Gray designs. Perhaps they were a recent commission, pre-
sented on Nancy's birthday, July 6th, 1805.

On Friday, October 18th Flaxman told Hayley:

October M.ʳ Cromak has employed Blake to make a set of 40 drawings
18th, from Blair's poem of the Grave 20 of which he proposes [to] have
1805 engraved by the Designer and to publish them with the hope of
rendering Service to the Artist, several members of the Royal Aca-
demy have been highly pleased with the specimens and mean to en-
courage the work, I have seen several compositions, the most Striking
are, The Gambols of Ghosts according with their affections previous to
the final Judgment—A widow embracing the turf which covers her

[1] Gilchrist, 1942, p. 104; 1863, p. 124. Thomas was B.A. (1789) and M.A.
Cantab. (A. Venn, *Alumni Cantabrigienses*, Cambridge, 1954, part ii, vol. vi, p. 154),
and died in 1811. Mr. Leslie Parris has traced to Thomas designs for Shakespeare,
Comus, Paradise Lost, and perhaps *Songs* (Q) and the 'Nativity Ode'.

[2] BM Add. MSS. 39780, f. 263. 'Mr T' is not further described in the letter,
but his location makes him easy to identify with the Rev. Joseph Thomas.

PLATE XVIII

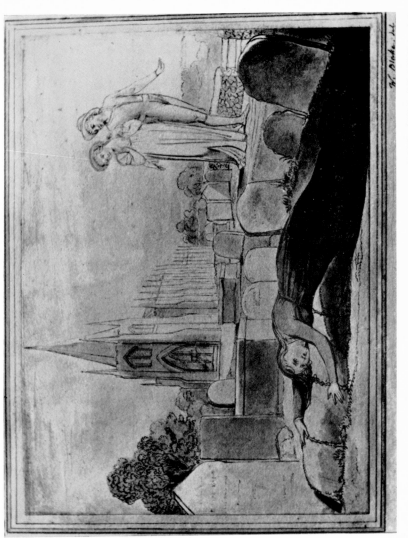

W. Blake. del.

'A WIDOW EMBRACING THE TURF WHICH COVERS HER HUSBANDS GRAVE' (1805), an unused design for Blair's *Grave*, which Flaxman found one of 'the most Striking' of the set (see pp. 166–7)

husband's grave—Wicked Strong man dying—the good old man's
Soul recieved by Angels[.]—[1]

The points of particular importance in this letter are: (1) that
Cromek initiated the project; (2) that Blake was to make
forty drawings; (3) that there were to be *twenty* engravings;
and (4) that *Blake* was specifically named as the engraver.
Cromek was an engraver who was just venturing forth as an
entrepreneur and promoter. According to the anonymous
'Biographical Sketch of Robert Hartley Cromek' in the 1813
edition of *The Grave*, 'The first instance in which he [*Cromek*]
displayed an union of his literary with his professional taste, was
in the first edition of the present work, with designs of that artist
of singular genius, William Blake, etched by his [*Cromek's?*]
friend, the celebrated Louis Schiavonetti'

Apparently Cromek had first called on Blake with his pro-
posal in late September, for on November 27th Blake said
'our Progress . . . is but of about two Months Date'.

Four weeks after his previous letter Flaxman reported to
Hayley, on Thursday, November 14th, about the progress that
Caroline Watson was making with the engravings for the new
edition of the life of Cowper, and he continued: 'on the Subject
of Engravers you will be glad to hear that Blake has his hands
full of work for a considerable time to come and if he will only
condescend to give that attention to his worldly concerns which
every one does that prefers living to Starving, he is now in a
way to do well[.]'[2] *November 14th, 1805*

On Thursday, November 21st Samuel Greatheed wrote to
Hayley: 'Your pretty little volume of Ballads followed your
letter, haud passibus aquis, some weeks behind. It has given
me, and several others hereabout much pleasure, and I hope will
do good both to my friend Blake, and to many of my junior
friends to whose pleasure and benefit I think it exceedingly well
adapted. Accept my hearty thanks for the gratification it has
afforded me.'[3] *November 21st, 1805*

Six weeks after Flaxman's announcement of the grand new

[1] Quoted from a microfilm of the MS. in the Pierpont Morgan Library. Only
the last two drawings were engraved, and there is no other evidence that Blake
ever made as many as forty designs for *The Grave*. See Plates XVIII–XXI.

[2] Quoted from a microfilm of the MS. in the Pierpont Morgan Library.

[3] Vol. i of the Fitzwilliam Hayley Correspondence.

project to Hayley, Blake himself wrote (November 27th) to Hayley explaining the progress of the negotiations:

Mr Cromek the Engraver came to me desiring to have some of my Designs, he namd his Price & wishd me to Produce him Illustrations of The Grave A Poem by Robert Blair, in consequence of this I produced about twenty Designs which pleasd so well that he with the same liberality with which he set me about the drawings, has now set me to Engrave them. He means to Publish them by Subscription with the Poem as you will see in the Prospectus which he sends you in the same Pacquet with the Letter. You will I know feel as you always do on such occasions, not only warm wishes to promote the Spirited Exertions of my Friend Cromek. You will be pleased to see that the Royal Academy have Sanctioned the Style of work. I now have reason more than ever to lament your Distance from London as that alone has prevented our Consulting you in our Progress, which is but of about two Months Date[.]

This summary of the negotiations accords remarkably well with the account given by Flaxman in October. The forty designs have been reduced to about twenty—unless Blake means that of the forty produced there were 'twenty Designs which pleasd' Cromek well enough to have them engraved—but Blake is still clearly and explicitly to be the engraver. Blake evidently gave this letter to Cromek to forward with the prospectus. That is, Blake did not send the prospectus; Cromek did. Had he known the contents of the prospectus he would have written in very different terms to Hayley.

The prospectus which Cromek enclosed was a single sheet boldly printed.

Prospectus / of / A New and Elegant Edition / of / Blair's Grave, / illustrated with / Twelve[1] Very Spirited Engravings / by / Louis

[1] According to J. Knowles (*The Life and Writings of Henry Fuseli, Esq. M.A. R.A.*, London, 1831, vol. i, pp. 290–3), 'Mr. Blake, who was not only a celebrated engraver, but known also for his original designs, distributed this year (1805) a prospectus for publishing an edition of the poem of "The Grave" of William [*i.e., Robert*] Blair, to be illustrated with fifteen [*sic*] plates designed and engraved by himself [*sic*]'. Though Knowles knew Fuseli, and therefore perhaps Blake, from 1805, his description here is clearly highly inaccurate. The prospectus announced twelve plates, not fifteen, and said Schiavonetti was to be the engraver. Further, the other actions Knowles attributes to Blake—submission of the drawings to the Royal Academicians for praise and solicitation of Fuseli's encomium—should rather be ascribed to Cromek. There is no significant likelihood that Knowles was referring to another, previous, prospectus; for this one quoted above, dated

PLATE XIX

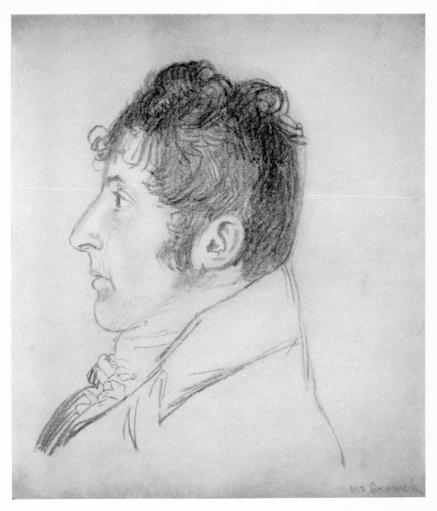

SKETCH OF THOMAS HARTLEY CROMEK BY FLAXMAN. Cromek was a
special friend of the Flaxmans at the time he was dealing so deviously with Blake

Schiavonetti, / from Designs Invented / by ∫ William Blake; / with a Preface / containing an explanation of the artist's view in the designs, / and / a critique on the poem. / [*Rule*] / The Work has been honoured with the Subscriptions and Patronage of the following Gentlemen: / Benjamin West, Esq. President of the Royal Academy.

Sir William Beechey, R.A.	James Northcote, Esq. R.A.[1]
Richard Cosway, Esq, R.A.	John Opie, Esq. Pr. in Painting.
Henry Fuseli, Esq. R.A.	Thomas Stothard, Esq. R.A.
John Flaxman, Esq. R.A.	Martin Archer Shee, Esq. R.A.
Thomas Lawrence, Esq. R.A.	Henry Thomson, Esq. R.A. and
Joseph Nollekens, Esq. R.A.	Henry Tresham, Esq. R.A.

Thomas Hope, Esq. and William Locke, Jun. Esq.[2] / [*Rule*] / The Preface will be contributed by Benjamin Heath Malkin, Esq. M.A. F.S.A. / [*Double rule*] /

The Proprietor of the present Work, diffident of his own Judgment *November* in general, and more particularly so in a Case, where private Friend- *1805* ship and personal Interests might be suspected of undue Influence, was afraid to venture on ushering this Prospectus into the World, merely on his own Opinion. That he might know how far he was warranted in calling the Attention of the Connoisseurs to what he himself imagined to be a high and original Effort of Genius, he submitted the Series of Drawings to Mr. West, and Mr. Fuseli, whose Character and Authority in the highest Department of the Art are unquestionable. The latter Gentleman has favoured the Proprietor with some Observations from his elegant and classical Pen, with Permission to make them public: they are decisive in their Testimony, and as they preclude the Possibility of any additional Remarks, they are here subjoined in the Author's own Words.

'Nov. 1805', was clearly printed about the time of Blake's letter of Nov. 27th; if there had been another one in the few previous weeks during which the project had been under way, the November prospectus would surely have had to refer directly to and refute the earlier one.

Another apparent reference to an unknown prospectus appeared in the *Literary Gazette* obituary of Blake (Aug. 18th, 1827), which said the *Grave* 'was borne forth into the world on the warmest praises of all our prominent artists', and listed not only those whose names appear in this prospectus but five more as well (Hoppner, Phillips, Rossi, Soane, and Westmacott). Clearly, however, the *Gazette* writer merely went through the 1808 subscription list looking for Royal Academicians, for he has omitted only two (R. A. Daniell and O. Humphry) whose names are in the 1808 list, and of these one was minor and the other blind in 1808.

1 Northcote's name does not appear in the subscription list or the list of recommenders printed in 1808 (see July). All the others except Hope subscribed.

2 When this list of patrons was reprinted in the 1808 *Grave*, Fuseli, Northcote, Opie, Hope, and Locke were dropped and William Owen was added.

'The Moral Series here submitted to the Public, from its Object 'and Method of Execution, has a double Claim on general attention.

'In an Age of equal Refinement and Corruption of Manners, when 'Systems of Education and Seduction go hand in hand; when Religion 'itself compounds with Fashion; when in the Pursuit of present En- 'joyment, all Consideration of Futurity vanishes, and the real Object 'of Life is lost—in such an Age, every Exertion confers a Benefit on 'Society which tends to impress Man with his Destiny, to hold the 'Mirror up to Life, less indeed to discriminate its Characters, than 'those Situations which shew what all are born for, what all ought to 'act for, and what all must inevitably come to.

'The Importance of this Object has been so well understood at 'every Period of Time, from the earliest and most innocent, to the 'latest and most depraved, that Reason and Fancy have exhausted 'their Stores of Argument and Imagery, to impress it on the Mind: 'animate and inanimate Nature, the Seasons, the Forest and the Field, 'the Bee and Ant, the Larva, Chrysalis and Moth, have lent their 'real or supposed Analogies with the Origin, Pursuits, and End of 'the Human Race, so often to emblematic Purposes, that Instruction 'is become stale, and Attention callous. The Serpent with its Tail in 'its Mouth, from a Type of Eternity, is become an Infant's Bauble; 'even the nobler Idea of Hercules pausing between Virtue and Vice, 'or the varied Imagery of Death leading his Patients to the Grave, owe 'their Effect upon us more to technic Excellence than allegoric Utility.

'Aware of this, but conscious that Affectation of Originality and 'trite Repetition would equally impede his Success, the Author of the 'Moral Series before us, has endeavoured to wake Sensibility by 'touching our Sympathies with nearer, less ambiguous, and less 'ludicrous Imagery, than what Mythology, Gothic Superstition, or 'Symbols as far-fetched as inadequate could supply. His Invention has 'been chiefly employed to spread a familiar and domestic Atmosphere 'round the most Important of all Subjects, to connect the visible and 'the invisible World, without provoking Probability, and to lead the 'Eye from the milder Light of Time to the Radiations of Eternity.

'Such is the Plan and the Moral Part of the Author's Invention; the 'technic Part, and the Execution of the Artist, though to be examined 'by other Principles, and addressed to a narrower Circle, equally 'claim Approbation, sometimes excite our Wonder, and not Seldom 'our Fears, when we see him play on the very Verge of legitimate In- 'vention; but Wildness so picturesque in itself, so often redeemed by 'Taste, Simplicity, and Elegance, what Child of Fancy, what Artist 'would wish to discharge? The Groups and single Figures on their 'own Basis, abstracted from the general Composition, and considered

'without Attention to the Plan, frequently exhibit those genuine and
'unaffected Attitudes, those simple Graces which Nature and the Heart
'alone can dictate, and only an Eye inspired by both, discover. Every
'Class of Artists, in every Stage of their Progress or Attainments,
'from the Student to the finished Master, and from the Contriver of
'Ornament, to the Painter of History, will find here Materials of Art
'and Hints of Improvement!' [*Double rule*]

The Work will be printed by T. Bensley, in Imperial Quarto.[1]

The Price to Subscribers will be Two Guineas;[2] one Guinea to be
paid at the Time of subscribing, and the Remainder on Delivery of
the Work.— The Price will be considerably advanced to Non-
Subscribers.

Subscriptions are received by J. Johnson, St. Paul's Church Yard;
T. Payne, Mews' Gate; J. White, Fleet Street; Longman, Hurst,
Rees, and Orme, Paternoster Row; Cadell and Davies, Strand;
W. Miller, Albemarle Street; and Mr. Cromek, No. 23, Warren
Street, Fitzroy Square, where Specimens may be seen.[3]

London, Nov. 1805.

<div align="right">

T. Bensley, Printer,
Bolt-court, Fleet-street, London.[4]

</div>

Hayley may well have wondered about Blake's sanity when
Blake wrote on November 27th that Cromek 'has now set me
to Engrave' the 'twenty Designs' 'as you will see in the
Prospectus', while that same bold prospectus said quite plainly
that there were to be only 'Twelve . . . Engravings by Louis
Schiavonetti'. It is little wonder then that Blake, crippled for
the moment in both pocket and pride, reacted with violence.
His notebook erupted with little pustules of irritated verse:

> A petty Sneaking Knave I knew
> O Mr Cr——, how do ye do[?]

> Cr—— loves artists as he loves his Meat
> He loves the Art but tis the Art to Cheat[.][5]

It may be useful to try to reconstruct what happened.

[1] In both 1808 and 1813 there were separate printings of Blake's *Grave* designs in
both quarto and folio.

[2] Subscribers' copies later cost two and a half guineas, non-subscribers paid
four guineas, and large paper copies were five guineas.

[3] All these booksellers appeared on the 1808 title-page, with the addition of
Murray, and Constable and Co.

[4] Quoted from a microfilm of BM Add. MSS. 33403, f. 153, part of the volumi-
nous papers of Thomas Dodd. [5] Notebook, p. 29.

Blake had presumably begun with his usual energy to etch the plates himself, starting with 'Death's Door'. Perhaps Flaxman saw this plate and was thinking of its lack of smoothness and finish when in his November 14th letter he lamented Blake's lack of 'attention to his worldly concerns'. Years later Stothard's son wrote: 'I have heard it stated by my father that Cromek got Blake to make for him a series of drawings from Blair's "Grave." Cromek found, and explained to my father, that he had etched one of the subjects, but so indifferently and so carelessly—(see Cumberland's "Thoughts on Outline," as an instance in that particular branch of art of his (Blake's) carelessness as an engraver)—that he employed Schrovenetti [*sic*] to engrave them.'[1]

November 30th, 1805 Joseph Farington noted in his Diary for Saturday, November 30th: 'Cromek, engraver, called and brought designs by *Blake* to illustrate "Blair's grave."—' By the next day Flaxman apparently knew the gist of the prospectus, for he hastened to assure Hayley that Blake's prospects did not rest entirely with the Blair commissions. On Sunday, December 1st he wrote: *December 1st, 1805* 'Blake is going on gallantly with his drawings from the Grave, which are patronized by a formidable list of R.A's and other distinguished persons— I mentioned before that he has [all *del*] good employment besides, but still I very much fear his abstracted habits are so much at variance with the usual modes of human life, that he will not derive all the advantage to be wished from the present favourable appearances[.]'[2]

On the same day Greatheed's review of the 1805 *Ballads* was published in *The Eclectic Review*:

December 1st, 1805 we think that Mr. Hayley's well-known benevolence has been wisely directed, and usefully employed, in the small volume which he has now published. . . . If Esop's lion were the reviewer of this book, he would doubtless charge the Engraver, as well as the Poet, with partiality; for having represented one of his fraternity transfixed to a tree, by the poisoned arrow of a negress. The plates, of which there are five, mark the genius, if not the taste, of an artist to whom the public are indebted for an excellent likeness of Cowper, from a sketch by Lawrence, in-

[1] Robert T. Stothard, 'Stothard and Blake', *The Athenaeum*, no. 1886 (19th Dec., 1863), 838. R. T. Stothard's judgement and logic are suspect, but his facts are probably reliable. It seems significant that Schiavonetti's first plate, 'Death's Door', was completed only two months later, on Feb. 1st, 1806.

[2] BM Add. MSS. 39780, f. 92.

PLATE XX

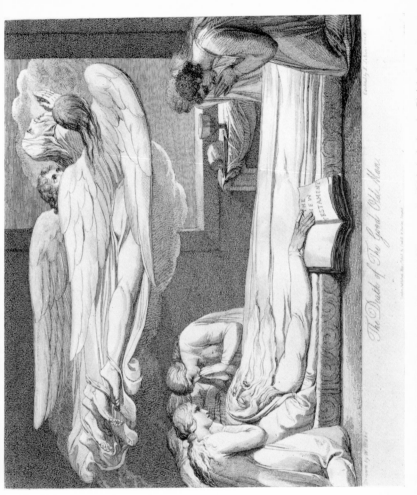

The Death of The Good Old Man.

'THE DEATH OF THE GOOD OLD MAN', a proof of Blake's design for Blair's *Grave* (1808).
The Antijacobin Review admired the figures but objected to the symbolism (see p. 205)

serted in Mr. Hayley's biography of his friend. The correctness of its resemblance as much exceeds that of an engraving by Bartolozzi, which we have seen, from the same drawing, as the latter excels in delicacy of execution. We recollect, also, to have met some of the engravings of these Ballads, on a larger scale; and we think it would be likely to impress the minds of young people more strongly with the subjects if a plate by the same artist were prefixed to each tale, in any future edition.[1]

Hayley replied generously to Blake's letter about the *Grave* designs, and on December 11th Blake wrote: 'I cannot omit to Return you my Sincere & Grateful Acknowledgments, for the kind Reception you have given my New Projected Work.[2] It bids fair to set me above the difficulties I have hitherto encounterd. But my Fate has been so uncommon that I expect Nothing[.]'

In his letter to Hayley of Tuesday, December 17th, Flaxman asked: 'When You have occasion to write to M.ͬ Blake pray inquire if he has sufficient time to spare from his present undertaking to engrave, my drawings of Hero & Leander,[3] & the orphan family, if he has not I shall look out for another engraver, I would rather this question should be proposed by you then me because I would not have either his good nature or convenience strained to work after my designs[.]'[4]

December 17th, 1805

In the autumn of 1805 Blake was riding the crest of a wave of prosperity which began to break under him in December and January. His 'Dearest Friend' Flaxman harboured doubts as to his talents as an historical painter and as an engraver of finished plates, and lamented Blake's 'abstracted habits [*which*] are so

[1] Anon., 'Art. VIII. *Ballads*; by William Hayley, Esq. founded on Anecdotes relating to Animals, with Prints designed and engraved by William Blake. Small 8vo. pp. 216. Price 10s. 6d. Phillips. 1805', *The Eclectic Review*, i (Dec. 1805), 923. The article is unsigned but circumstantial evidence points to Greatheed: (1) He had recently acknowledged receipt of the 1805 *Ballads* (21st Nov., 1805); (2) The article writer was, with Greatheed, one of the very few persons who had seen the 1802 Ballads; (3) Greatheed was an editor of *The Eclectic Review* at the time

[2] This 'kind Reception' was probably in the form of subscriptions to the *Grave* for William Hayley, Esq.; Mrs. Harriet Poole, Levant [*sic*], near Chichester; W. S. Poyntz, Esq.; Mr. Seagrave, Printer, Chichester; and Richard Vernon Sadleir.

[3] In his letter of Oct. 18th, 1805 Flaxman had written 'we have read your Hero & Leander and are much pleased with the beauty and elegance of the Translation'. When the MS. was sold (Sotheby, May 21st, 1878, Lot 184), the catalogue specified that Hayley had translated 'The Poem of Musaeus on Hero and Leander'. Blake made none of these engravings. [4] BM Add. MSS. 39780, ff. 94–95.

much at variance with the usual modes of human life'. Hayley, to whom Blake owed particular gratitude, was in the process of diverting from Blake the commissions for Cowper, Milton, Romney, and other works. B. H. Malkin, who praised Blake so emphatically in print (see pp. 421–31), may about this time (just before February 1806) have taken the commission to engrave the frontispiece to his *Memoirs* from Blake and given it to Cromek. And Cromek was busy reducing the number of designs he had agreed to pay for, and giving to Schiavonetti the contract for engraving the Blair designs, which he had promised to Blake.

Probably all these betrayals became obvious to Blake in the winter of 1805–6. Blake apparently broke with Hayley, Flaxman, Malkin, and Cromek, in December 1805 and January 1806. Thereafter, for almost ten years, he made no more commercial engravings.

PLATE XXI

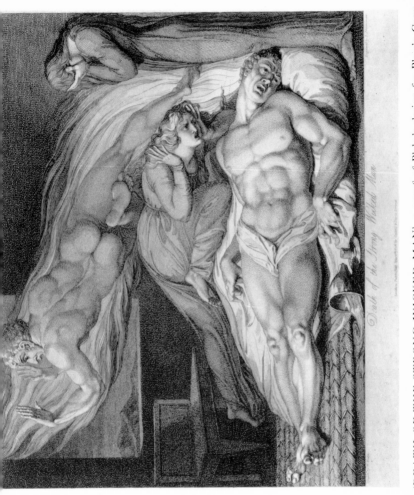

Death of the Strong Wicked Man

'DEATH OF THE STRONG WICKED MAN', a proof of Blake's design for Blair's *Grave* (1808). *The Antijacobin Review* admired the dying figure but was 'shocked' at the '*corporeal* representation' of the departing soul above (see p. 204)

PART IV

INDEPENDENCE AND OBSCURITY—
'YOU ARE MAD AS A REFUGE FROM UNBELIEF'[1]
1806–1818

———

In the winter of 1805–6 Blake took a new direction in his work. As Hayley, Cromek, Malkin, and Flaxman seemed to fail him, and as his commissions for engravings faded away, Blake turned more and more to one infallible patron, Thomas Butts. For five years Butts supported Blake almost single-handed, paying his protégé over £400 during that time and filling his house to overflowing with pictures and books. The consequence was that Blake was independent of the approval of other men and that, except as the author of *The Grave* designs, he increasingly disappeared from public awareness.

The new relationship between Butts and Blake was made apparent in a receipt of March 3rd, 1806 (see Accounts) which showed payment not only for goods delivered, paintings and books, as in the past, but for services as well. The new agreement that Blake was to give engraving lessons to young Tommy Butts ensured him a steady but small income, no matter how few pictures he painted. There was 'a family tradition that the father profited more than the son from these lessons',[2] and it is difficult to distinguish the work of the patron from that of the student. The evidence of these lessons is contained in a few surviving works:

Engravings:
 1. A classical figure playing a lyre;
 2. An aged couple;

[1] Spurzheim marginalia.
[2] M. Wilson, *The Life of William Blake*, London, 1948, p. 83. The 'TB' or 'T Butts' signed to some of the work may signify either the younger or the elder Thomas Butts.

3. A head of St Jerome(?), engraved on the back of a cancelled plate of *America*;
4. Venus Anadyomene [copied from Blake's design for *Night Thoughts*, p. 46; see Plate IX];
5. The bust and heavy wings of an angel;
6. A tiny circular print of a satyr and dancing figures;
7. A centaur with a lapith on his back (and the drawing for the engraving);
8. Christ trampling upon Urizen, probably partly engraved by Blake (see Table of Engravings, p. 617);

Drawings:

9. Insects, a frog, and a grasshopper in the centre;
10. A seated market woman, with a cow and a goat in the background;
11. A reclining nude male;
12. Details copied from Blake's *Night Thoughts* designs;

Needlework Panel:

13. Two hares in long grass, embroidered by Mrs Butts, perhaps after a design by Blake.[1]

It was perhaps in the first enthusiasm of receiving such a lucrative teaching commission that Blake gave Butts an elaborate mahogany 'Apothecary's Cabinet' 'to hold his engraving materials and tools'.[2]

After he returned from Felpham to London in 1803 Blake apparently met Benjamin Heath Malkin, a London schoolmaster and an enthusiastic devotee of picturesque scenery. The two

[1] In this list, nos. 1–4 are reproduced in A. E. Briggs, 'Mr. Butts, the Friend and Patron of Blake', *Connoisseur*, xix (1907), 92–96; nos. 1–3, 5–7, 11–13 are described in G. Keynes, *Bibliotheca Bibliographici*, London, 1964, entries 775–83, 497; nos. 9–10, 13 are listed in the Dec. 19th, 1932 Sotheby sale of Anthony Bacon Drury Butts, Lot 118. Five proofs of no. 2 and the copperplate of no. 3 are in the Rosenwald Collection (acquired from W. A. White), and six other proofs of nos. 1–4 were sold with the W. E. Moss Collection at Sotheby's, March 2–9, 1937, Lot 278. Nos. 2, 3, and 8 are signed 'Drawn and engraved by WB', conventionally acknowledging, as Blake had in his plates for Basire, the apprentice's indebtedness to his master.

[2] Lot 284 in the 1937 Moss sale, 'believed to have been given him [*Thomas Butts*] by Blake At the time of its recovery it contained [*in a hidden compartment*] several plates engraved by Butts', including no. 3 above. The cabinet was 18½ in. × 16⅛ in. × 7½ in., and it is probably a fair assumption that Blake had one like it.

PLATE XXII

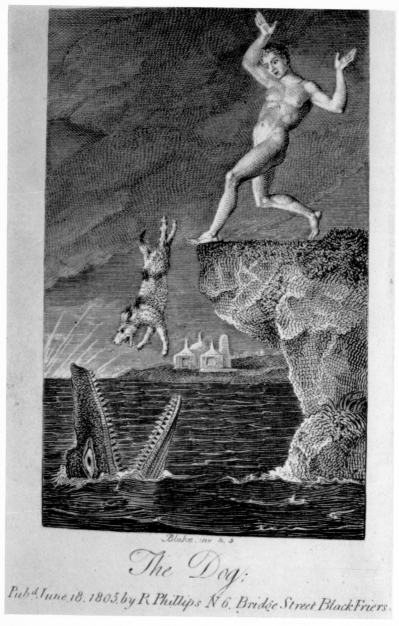

The Dog;

Pub.d June 18. 1805. by R Phillips N 6. Bridge Street Black Friers.

BLAKE'S ENGRAVING OF 'THE DOG' for Hayley's Ballads (1805), repre-
senting, as Southey remarked, 'Edward starting back, fido *volant*, and the crocadile
rampant' (see p. 177)

men may well have come in contact through their shared
interest in art and radical politics.[1] Malkin subscribed to *The
Grave* and offered to write a preface for it, and he bought a
copy of *Songs of Innocence* (P), which he inscribed to '[Mr.
Johnes] the gift of Mr. Malkin—1805'.[2] At the same time he was
writing a memoir of his child, who had died in 1802 at the age
of six, and Blake provided for the memoir a design for the frontis-
piece and an appreciation of the artistic talents of the dead boy.
In return, Malkin included a long prefatory note on Blake
(see pp. 421-31) dated Saturday, January 4th, 1806.

January 4th, 1806

Robert Southey reviewed the 1805 *Ballads* in *The Annual Review*:

MEDIOCRITY, as all the world knows, is forbidden to poets and
to punsters; but the punster has a privilege peculiar to himself,—the
exceeding badness of his puns is imputed as a merit. This privilege
may fairly be extended to Mr. Hayley: his present volume is so in-
comparably absurd that no merit within his reach could have amused
us half so much.[*Here intervene stanzas from 'The Dog', Plate XXII.*]...
Edward, when he was in India, used, it seems, frequently to take a
fearless swim, as Mr. Hayley poetically expresses himself, not being
aware that there was a crocadile in the water. His custom was to leap
from a high bank. One day when he was undressing, Fido did all he
could to prevent him; his master, not understanding the meaning of
this interruption, scolded, and at last beat him; but the dog finding all
his efforts vain, and seeing Edward about to plunge in, ran before him,
and leapt—into the crocadile's mouth. The poet has had the singular
good fortune to meet with a painter capable of doing full justice to his
conceptions; and, in fact, when we look at the delectable frontispiece
to this volume which represents Edward starting back, fido *volant*,
and the crocadile *rampant*, with a mouth open like a boot-jack to
receive him, we know not whether most to admire the genius of Mr.
William Blake or of Mr. William Hayley.[3]

January? 1806

[1] Godwin reported meeting Malkin at dinner at Horne Tooke's on Oct. 30th,
1796 and Dec. 24th, 1797, and at Fuseli's Milton Gallery on May 17th, 1800 with,
among others, Fuseli, Flaxman, Hoare, Johnson, and [J. T. ?] Smith.

[2] The only Blake lot in Evans's *Catalogue of the Valuable Library of Benjamin
Heath Malkin*, March 22nd-29th, 1828, is no. 37, *The Grave*, 1808.

In 1809 and 1810 George Cumberland wrote the addresses of Blake and Malkin
together in his notebook (see Residences, p. 560), though he does not elsewhere
refer to Malkin.

[3] Anon., '*Art. XVII*. Ballads. By *William Hayley, Esq.* Founded on Anecdotes
relating to Animals, with Prints, designed and engraved by *William Blake*.
8vo. pp. 212', *The Annual Review* for 1805, iv (1806), 575. According to *The Poetical*

Blake evidently asked his friend the fashionable miniaturist
Ozias Humphry for assistance in applying for permission to
dedicate his *Grave* designs to the Queen. Humphry apparently
drafted a proposal to be submitted to the proper authorities,
which Blake transcribed and revised and returned for Humphry's
advice. On Sunday, June 15th Humphry replied:

June D? William
15th, I learn with great concern from M? Watson[1] that your Complaint is
1806 the Erisipilas, but it is in no respect dangerous, & as you are improv-
ing, a few days will probably restore you altogether—
You talked of calling on me Thursday next but as I am going into
Kent for five or Six days I wou'd recommend you not to call till sunday
Morning next when I shall hope for the pleasure of seeing you at
Breakfast at ten oClock—Lord Melvilles tryal has terminated as I
hoped and in some degree foretold—[2]
I must not conclude this without acquainting you, that, to day I
read for the first time your Copy of my Statement, & like it so much,
that if you have not time to write a more accurate, or rather, a more
stately one, before my return from Kent I shall without hesitation
submit this to the perusal of the Queen & all the Royal Family.—Till
Sunday Morning I bid you farewell—

 Ozias Humphry

 Prince of Wales's Hotel
 June 15th 1806—

I called on Saturday & saw your Companion at the Institution &
like him very much, as well as the progress you have made in the
Arrangement of the Bar[*d ?.*][3]

Register for 1805 (London, 1807): 'These ballads are designed for young persons,
into whose hands they may certainly be put with the hope of advantage, as they
tend to promote a spirit of humanity towards the animal creation. The verse,
though sometimes careless, is sufficiently flowing. A part of these ballads was
published in quarto form three years ago.'
 [1] Mr. Watson may be George Watson (1767–1837), a fashionable portrait
painter who apparently lived in Edinburgh but exhibited regularly at the Royal
Academy and the British Institution, and who may have come down to see the
spring exhibitions, particularly the one at the British Institution, which is apparently
referred to below.
 [2] Henry Dundas (1742–1811), first Viscount Melville, was impeached of high
crimes and misdemeanours (peculation in the Navy Office) and acquitted in the
House of Lords by a narrow margin on June 12th, 1806.
 [3] Quoted from the MS. of Mr. Roger W. Barrett. The addressee is identified and
the second and third paragraphs quoted in Catalogue No. 501 of Maggs Bros.,
London. The last word runs into the right-hand margin, and I transcribe it as it
appears, in some puzzlement.

The petition was successful, for the volume was dedicated to the Queen in a poem by Blake.

The postscript seems to suggest that Humphry had met Blake with a friend at the first spring exhibition of the British Institution. The friend may have been a Blake collector, for the enigmatic reference to 'the Arrangement of the Bar[*d?*]' appears to indicate a picture by Blake which Humphry saw when he 'called' at the home of Blake's 'Companion'.[1]

There had apparently been some hope of publishing *The Grave* in the spring of 1806 (see the Table of Engravings, pp. 616–17), but that summer Cromek was still soliciting subscriptions, armed with introductions such as the one Fuseli wrote on Wednesday, July 16th to his friend and patron William Roscoe in Liverpool: *July 16th, 1806* 'The bearer of this M? Cromeck an ingenious Engraver will shew You the prospectus & Several Specimens of a Work of which he is the Editor; if You shall find that the Latter prove what the former asserts, You will of course grant Your patronage to the undertaking.'[2] Mr. Roscoe was persuaded, for his name appeared in the subscription list when it was finally published.

Since Blake had been denied the engraving work for the Blair, he had been progressing vigorously with his plan for an engraving from Chaucer. At the same time Stothard began an almost identical project to be published by Cromek, and Blake soon became convinced of the complicity of both men in stealing his idea for the picture. Stothard may have been ignorant

of the fact that a subscription paper for an engraving of *The Canterbury Pilgrims* had been circulated by Blake's friends.[3]

This was in 1806, two years before publication of *The Grave*. . . . [*Probably the best conclusion about Stothard's guilt is*] Flaxman's

[1] The companion might be Butts, or perhaps the Earl of Egremont, whose wife commissioned Blake to paint 'Satan calling up his Legions' for her, and for whom, through Humphry's recommendation, Blake painted a picture of the Last Judgement (letter of Jan. 18th, 1808). The picture Humphry saw may be 'The Bard, from Gray' listed in Blake's 1809 *Descriptive Catalogue*.

[2] Quoted from a microfilm of the MS. in the Liverpool Public Library. The prospectus was, of course, largely by Fuseli (see Nov. 1805). The 'Specimens' were presumably the plates dated Feb. 1st and June 1st 1806.

[3] The only subscription paper for Blake's Chaucer now known is dated May 15th, 1809. If such a subscription prospectus was in fact circulated about 1806, it is difficult to believe that in the tight little artistic world of his time Stothard would not have known of it.

opinion, viz., that Stothard's act was not a wilful one, in being made a party to an engraving of a picture by himself, on a subject previously taken by Blake.[1]

This was certainly the point of view of Stothard and his family. Stothard's son wrote: 'my father . . . had no time for going about, and seeing what other artists were employed upon or engaged in, and therefore his seeing Blake's design of the "Pilgrimage to Canterbury" is doubtful'[2]

From this point onward the bitterness engendered by the treatment he had received from Cromek and Stothard over Chaucer drove Blake steadily deeper into obscurity and isolation, from which he emerged at times to defy fiercely the worlds of commerce and probability. The only period in his life when Blake does not seem to have a firmer grasp than ordinary of the nature and limits of reality is just before and after his 1809 exhibition. Between 1807 and 1812 he sometimes seems to have thought of the spiritual world as supplanting rather than supplementing the ordinary world of causality. More and more frequently the spirits seem to have been controlling Blake rather than merely advising him. For instance,

The completion of the [*Canterbury*] *Pilgrimage* was attended by adverse influences of the supernatural kind—as Blake construed them. He had hung his original design over a door in his sitting-room, where, for a year perhaps it remained. When, on the appearance of Stothard's picture, he went to take down his drawing, he found it nearly effaced: the result of some malignant spell of Stothard's, he would, in telling the story, assure his friends. But as one of them (Flaxman) mildly expostulated, 'Why! my dear sir! as if, after having left a pencil drawing so long exposed to air and dust, you could have expected

[1] Gilchrist, 1942, pp. 220–1; 1863, p. 204. This summary is based not so much on facts as on Stothard's generally good character.

[2] R. T. Stothard, 'Stothard and Blake', *Athenaeum*, no. 1886 (Dec. 19th, 1863), p. 838. Stothard says that Cromek's commission came 'soon after he had completed the Burleigh staircase commission for the Marquis of Exeter. Whether Cromek had seen it or not, dates will prove: this of which I am speaking was in 1804–5.' R. T. Stothard's cloudy meaning appears to be that the Burleigh commission was completed in 1804–5; that Stothard painted his Chaucer picture in 1805; and that this probably means that Stothard's picture was painted before Blake's, thus exonerating Stothard. However, since we do not know when Blake's picture was painted, and since R. T. Stothard's dating of his father's painting is unreliable (among other things, the Burleigh staircase seems to have been completed about 1803), this account is very nearly worthless as evidence. At best it is based upon rather dubious possibilities.

PLATE XXIII

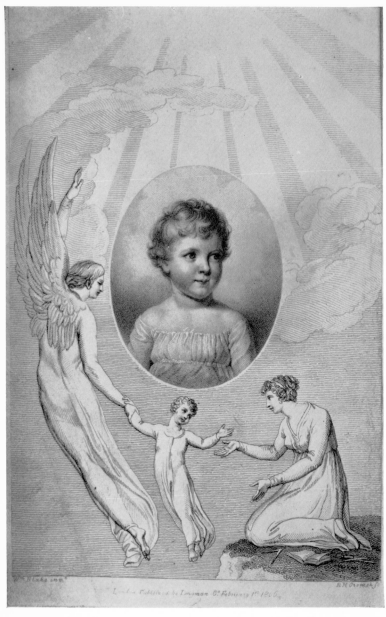

FRONTISPIECE TO MALKIN'S *MEMOIRS OF HIS CHILD* (1806),
designed by Blake and engraved by Cromek. *The British Critic* thought it demon-
strated that Blake mistook 'extravagance for genius' (see p. 181)

otherwise!' The *fresco* was ultimately bought by a customer who seldom failed—Mr Butts[1]

One mark of the depth of Blake's feelings was the publicity with which he avowed them: 'Blake was at no pains, throughout this business or afterwards, to conceal his feelings towards Stothard. To the end of his life he would, to strangers, abuse the popular favourite, with a vehemence to them unaccountable. With friends and sympathizers, he was silent on the topic.'[2]

A review of Malkin's memoir of his prodigious son in *The British Critic* of September said the book

is one of the most idle and superfluous works that we have ever seen

<div style="text-align: right">September
1806</div>

In a very long and elaborate address to a valuable friend, by way of dedication, another supposed prodigy is celebrated, the designer of the frontispiece to the book. He is celebrated both as an artist and as a poet; but so little judgment is shown, in our opinion, with regard to the proofs of these talents, that we much doubt whether the encomium will be at all useful to the person praised. As an artist, he seems to be one of those who mistake extravagance for genius; as is testified even by his angel in the frontispiece, though the kneeling figure is elegant, and that of the child is passable. As a poet, he seems chiefly inspired by that,

<div style="text-align: center">——Nurse of the didactic muse,
Divine Nonsensia.——
Loves of Triangles.[3]</div>

The *Monthly Review* commented upon Malkin's book next month: 'In the long dedication to Mr. Johnes of Hafod, a biographical notice is inserted of Mr. William Blake the artist, with some selections from his poems, which are highly extolled: but if Watts seldom rose above the level of a mere versifier, in what class must we place Mr. Blake, who is certainly very inferior to Dr. Watts?'[4]

<div style="text-align: right">October
1806</div>

[1] Gilchrist, 1942, p. 241; 1863, p. 225.

[2] Gilchrist, 1942, p. 247; 1863, p. 232.

[3] Anon., 'Art. 40. *A Father's Memoirs of his Child. By Benjamin Heath Malkin, Esq. M.A. F.A.S.* Royal 8vo. 172 pp. 10s. 6d. Longman and Co. 1806', *The British Critic*, xxviii (Sept. 1806), 339. Sir Geoffrey Keynes thoughtfully pointed out this reference to me. 'The Loves of the Triangles. A Mathematical and Philosophical Poem. Inscribed [*in mockery*] to Dr. Darwin' was published with these lines [by John Hookham Frere] in *The Antijacobin*, iii (April 16th, 1798), 170.

[4] [Christopher Lake Moody], 'Art. 37. *A Father's Memoirs . . .*', *Monthly*

Blake's gratitude to Fuseli was probably particularly stimulated by the recommendation Fuseli had written in 1805 for Blake's illustrations to Blair's *Grave*, and by his assistance in finding subscribers to the book. In thankfulness he evidently gave Fuseli a copy of his *For Children: The Gates of Paradise*, which Fuseli in turn passed on: 'To Harriet Jane Moore from her friend Henry Fuseli Novʳ 22ⁿᵈ 1806'.[1]

November 22nd, 1806

The last review of Malkin to mention Blake, *The Monthly Magazine* of January 25th, 1807, concluded laconically: 'The poetry of Mr. Blake, inserted in the dedication, does not rise above mediocrity; as an artist he appears to more advantage.'[2]

January 25th, 1807

It was perhaps in the winter of 1807 that Blake went to the home of the Royal Academician Thomas Phillips at 8 George Street, Hanover Square, to have his portrait painted. Phillips was something of a raconteur, and afterwards he used to tell this story of the sittings:

[Winter? 1807?]

Blake, who always saw in fancy every form he drew, believed that angels descended to painters of old, and sat for their portraits. When he himself sat to Phillips for that fine portrait so beautifully engraved by Schiavonetti, the painter, in order to obtain the most unaffected attitude, and the most poetic expression, engaged his sitter in a conversation concerning the sublime in art. 'We hear much,' said Phillips, 'of the grandeur of Michael Angelo; from the engravings, I should say he has been over-rated; he could not paint an angel so well as Raphael.' 'He has not been over-rated, Sir,' said Blake, 'and he could paint an angel better than Raphael.' 'Well, but' said the other, 'you never saw any of the paintings of Michael Angelo; and perhaps speak from the opinions of others; your friends may have deceived you.' 'I never saw

Review, N.S., li (Oct. 1806), 217. The authorship of the review is given by B. C. Nangle (*The Monthly Review Second Series 1790–1815*, Oxford, 1955, p. 259) on the basis of the editor's marked copy (now in Bodley) in which this piece is attributed to 'Mo[od]y'. The reference to Watts is from Malkin, p. 427. See Plate XXIII.

[1] When this book (now in the possession of Paul Mellon) was sold at Sotheby's on April 14th, 1949, Lot 75D, the catalogue description said that at the time of the gift Harriet Jane Moore, a niece of Sir John Moore of Corunna, was 'a child of five'. The only other important works by Blake which Fuseli is known to have owned are the 'Illustrations of Blair's Grave, after *Blake*, by *Schiavonetti*; and one by *Blake, rare, proofs* 8' and Blake's 'Canterbury Pilgrimage', which were sold, respectively, to Shirley for 9*s.* 6*d.* and (with Stothard's 'Canterbury Pilgrimage') to Wainewright for £1. 10*s.* 0*d.* in the Sotheby sale *of the small and very select Classical Library of the late Henry Fuseli*, July 25th, 1825.

[2] Anon., 'Half-Yearly Retrospect of Domestic Literature', *The Monthly Magazine*, Supplementary Number, xxii (Jan. 25th, 1807), 633.

PLATE XXIV

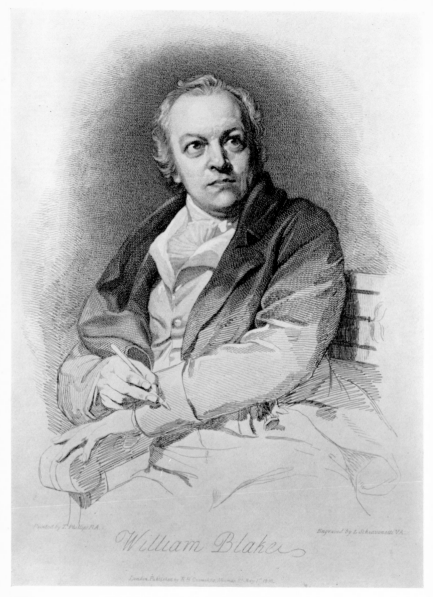

THOMAS PHILLIPS'S PORTRAIT OF BLAKE (1807), proof etched by Schiavonetti as the frontispiece to Blair's *Grave* (1808). The *Monthly Magazine* and *The Antijacobin Review* hailed this as a masterpiece of the portrait painter's and the etcher's arts (see pp. 208, 210)

any of the paintings of Michael Angelo,' replied Blake, 'but I speak
from the opinion of a friend who could not be mistaken.' 'A valuable
friend truly,' said Phillips, 'and who may he be I pray?' 'The arch-
angel Gabriel, Sir,' answered Blake. 'A good authority surely, but
you know evil spirits love to assume the looks of good ones; and this
may have been done to mislead you.' 'Well now, Sir,' said Blake,
'this is really singular; such were my own suspicions; but they were
soon removed—I will tell you how. I was one day reading Young's
Night Thoughts,[1] and when I came to that passage which asks "who
can paint an angel," I closed the book and cried, "Aye! who can paint
an angel?" A voice in the room answered, "Michael Angelo could."
"And how do *you* know," I said, looking round me, but I saw nothing
save a greater light than usual. "I *know*," said the voice, "for I sat to
him: I am the arch-angel Gabriel." "Oho!" I answered, "you are, are
you: I must have better assurance than that of a wandering voice; you may
be an evil spirit—there are such in the land." "You shall have good
assurance," said the voice, "can an evil spirit do this?" I looked whence
the voice came, and was then aware of a shining shape, with bright
wings, who diffused much light. As I looked, the shape dilated more
and more: he waved his hands; the roof of my study opened; he
ascended into heaven; he stood in the sun, and beckoning to me, moved
the universe. An angel of evil could not have *done that*—it was the
arch-angel Gabriel.' The painter marvelled much at this wild story;
but he caught from Blake's looks, as he related it, that rapt poetic
expression which has rendered his portrait one of the finest of the
English school.[2]

The terminal date for the anecdote is supplied by the fact *May*
that in the 'Anti-Room' of *The Exhibition of the Royal Academy*, *1807*
[*May*] *M.DCCCVII* was hung number '274 Portrait of Mr.
Blake—[*by*] T. Phillips, A[*ssociate Royal Academician*]', and
presumably it had been painted in the preceding winter.
According to the *Antijacobin* review of Blair's *Grave* in
November 1808, Phillips gave this portrait to Cromek, who
had it engraved for *The Grave*, and eventually it found its way
to the National Portrait Gallery (see Plate XXIV.)

[1] The reference to reading Young's *Night Thoughts* suggests that the incident
Blake is describing took place about 1795, when he was making his hundreds of
drawings for the poem. He is also more likely to have had a 'study' at this time
than at any other.

[2] Allan Cunningham, *The Cabinet Gallery of Pictures*, London, 1833, vol. i,
pp. 11–13. The language of the story sounds Blakean enough, though it is likely
that Cunningham heightened it for effect.

Meanwhile Blake was still making designs for *The Grave* (see Plate XXV), and Cromek wrote:

> 64, *Newman Street*
> *May*, 1807

Mr. BLAKE,—Sir, I recd, not witht great surprise, your letter, demanding 4 guineas for the *sketched vignette*, dedn to the Queen. I have returned the drawing wh this note, and I will briefly state my reasons for so doing. In the first place I do not think it merits the price you affix to it, *under any circumstances*. In the next place I never had the remotest suspicion that you cd for a moment entertain the idea of writing *me* to supply money to create an honour in wh I cannot possibly participate. The Queen allowed *you*, not *me*, to dedicate the work to *her!* The honour wd have been yours exclusy,[1] but that you might not be deprived of any advantage likely to contribute to your reputation, I was willing to pay Mr. Schiavonetti *ten* guineas for etching a plate from the drawing in question.

Another reason for returning the sketch is that *I can do without it*, having already engaged to give a greater number of etchings[2] than the price of the book will warrant;[3] and I neither have nor ever had any encouragement from *you* to place you before the public in a more favourable point of view than that which I have already chosen. You charge me wh *imposing upon you.* Upon my honour I have no recollection of anything of the kind. If the world and I were to settle accounts to-morrow, I do assure you the balance wd be considerably in my favour. In this respect '*I am more sinned against than sinning.*' But, if I cannot

[1] The question of honour here is largely irrelevant. The Queen's name on the title-page and at the head of the subscription list could be expected to increase sales enormously, the profits of which went exclusively to Cromek.

[2] Cromek clearly implies that he had been generous in buying twelve designs from Blake, whereas he had engaged to publish twenty, or perhaps as many as forty designs.

[3] The price of the book (£2. 12s. 6d.) might warrant a profit of about £1. 6s. 0d. per copy or about £900 for a printing of 700 (680 were subscribed for). By analogy with Flaxman's 1805 *Iliad* (see G. E. Bentley, Jr, *The Early Engravings of Flaxman's Classical Designs*, N.Y., 1964, p. 35), the expenses of printing *The Grave* may be estimated as follows: composition of text £30; 12 designs (frontispiece free) £21; 13 copperplates £6. 10s. 0d.; engraving 13 plates £260 (the outlines for the *Iliad* had been only £5. 5s. 0d. apiece); writing to 13 plates at 13s. per plate £8. 9s. 0d.; paper for plates (£40 at £4. 8s. 0d. per ream) and text (£20) £60; printing plates (£27. 6s. 0d. at 6s. per hundred pulls) and text (£5) £32. 6s. 0d.; labels at 2s. 6d. per hundred 17s. 6d.; hotpressing £5; binding at about 2s. each £70: total £491. 12s. 6s. or 14s. per copy. If the costs of advertising and selling are taken at a flat 12s. 6d. (as they were for Flaxman's *Hesiod* also published at £2. 12s. 6d.), the publication costs are about £1. 6s. 6d., leaving a profit per copy of about £1. 6s. 0d.

PLATE XXV

VIGNETTE SKETCH (1807) FOR BLAIR'S *GRAVE* which Cromek refused to pay for (see pp. 184–7)

recollect any instances wherein I have imposed upon *you*, several present themselves in wh I have imposed upon *myself*. Take two or three that press upon me.

When I first called on you I found you without reputation; I *imposed* on myself the labour, and an Herculean one it has been, to create and establish a reputation for you. I say the labour was Herculean, because I had not only the public to contend with, but I had to battle with a man who had predetermined not to be served. What public reputation you have, the reputation of eccentricity excepted, I have acquired for you, and I can honestly and conscientiously assert that if you had laboured thro' life for yourself as zealously and as earnestly as I have done for you your reputation as an artist wd not only have been enviable but it would have placed you on an eminence that wd have put it out of the power of an individual, as obscure as myself, either to add to it or take from it. *I also imposed on myself* when I believed what you so often have told me, that your works were equal, nay superior, to a Raphael or to a Michael Angelo! Unfortunately for me as a publisher the public awoke me from this state of stupor, this mental delusion. That public is willing to give you credit for what real talent is to be found in your productions, *and for no more*.[1]

May 1807

I have imposed on myself yet more grossly in believing you to be one altogether abstracted from this world, holding converse wh the world of spirits!—simple, unoffending, a combination of the *serpent* and the *dove*. I really blush when I reflect how I have been cheated in this respect.[2] The most effectual way of benefiting a designer whose aim is general patronage is to bring his designs before the public through the medium of engraving. Your drawings have had the *good fortune* to be engraved by one of the first artists in Europe, and the specimens already shown have already produced you orders that I verily believe you otherwise wd not have recd.[3] Herein I have been gratified, for I was determined to bring you food as well as reputation, tho' from your late conduct I have some reason to embrace your wild opinion, that to manage genius, and to cause it to produce good things, it is absolutely necessary to starve it;[4] indeed, this opinion is considerably heightened by the recollection that your best work, the

[1] This was an argument close to Blake's heart, and he made repeated and confident 'appeals to the Public' (*Descriptive Catalogue*).

[2] It will be noticed that Cromek presents no evidence in support of this point.

[3] On the contrary, Blake appears to have received fewer commissions and to have become poorer during the next fifteen years.

[4] So far is this from being Blake's known opinion that he often protested against it loudly, particularly in his marginalia to Reynolds of about 1808.

illustrations of 'The Grave,' was produced when you and Mrs. Blake were reduced so low as to be obliged to live on half-a-guinea a week![1]

Before I conclude this letter, it will be necessary to remark, when I gave you the order for the drawings from the poem of 'The Grave,' I paid you for them more than I could then afford, more in proportion than you were in the habit of receiving,[2] and what you were perfectly satisfied with, though I must do you the justice to confess much less than I think is their real value. Perhaps you have friends and admirers who can appreciate their merit and worth as much as I do. I am decidedly of opinion that the 12 for 'The Grave' should sell at least for 60 guineas. If you can meet with any gentleman who will give you this sum for them, I will deliver them into his hands on the publication of the poem.[3] I will deduct the 20 guineas I have paid you from that sum, and the remainder 40 do shall be at your disposal.

I will not detain you more than one minute. Why shd you so *furiously rage* at the success of the little picture of 'The Pilgrimage?' 3,000 people have now *seen it and have approved of it.* Believe me, yours is *'the voice of one crying in the wilderness!'*

You say the subject is *low,* and *contemptibly treated.*[4] For his excellent mode of treating the subject the poet has been admired for the last 400 years! The poor painter has not yet the advantage of antiquity on his side, therefore wh some people an apology may be necessary for him.[5] The conclusion of one of Squire Simkin's letters to his

[1] From Jan. to Oct. 1805 Blake's known receipts were four times this sum (£98 or £2. 3s. 0d a week): £15. 15s. 0d., for three plates to Homer in 1805 (see Accounts); £29. 15s. 0d. from Butts on Jan. 12th, July 12th, and Oct. 5th (see Accounts under Dec. 25th. 1805); and £52. 10s. 0d. from Phillips for Blake's five plates for Hayley's *Ballads* (see Blake's letter of April 25th, 1805).
As an indication of what might have been anticipated in the way of income and expense for Blake, we may note that 'a journeyman [*engraver*], who is esteemed a tolerable hand may earn 30s. a week; and some, who are extraordinary workmen, earn half a guinea a day' (J. Collyer, *The Parent's and Guardian's Directory,* London, 1761, pp. 133–4). On Jan. 11th, 1810 the journeymen compositors in London estimated the 'economical weekly expence of a man, his wife, and two children' at £2. 7s. ¾d. (E. Howe, ed., *The London Compositor,* London, 1947, p. 159).
[2] Cromek's guinea-a-design is the same as Blake was paid for the fifty *small* pictures he was commissioned to paint in 1799 (see Blake's letter of Aug. 26th).
[3] The only value to Cromek of Blake's designs lay in the copyright which would be secured to him as soon as they were published, and it will be noticed that he offers to deliver the designs to a purchaser found by Blake only 'on the publication of the poem'. Had Blake accepted this proposal, the effect would have been to give Cromek the copyright for nothing.
[4] Blake said exactly the opposite, that *Stothard's treatment* was low and comtemptible. He demonstrated in his own engraving and the description of it in his *Descriptive Catalogue* that Chaucer's subject is elevated.
[5] Stothard's picture had been attacked by unnamed critics as appearing too modern, and was defended by Hoppner on lines very similar to Cromek's here in

mother in the Bath Guide will afford one. He speaks greatly to the
purpose:

> ——I very well know,
> Both my subject and verse is exceedingly low;
> But if any *great critic* finds fault with my letter,
> *He has nothing to do but to send you a better*.[1]

With much respect for your talents
> I remain, sir,
> Your real friend and well-wisher,
>
> R. H. CROMEK.[2]

Cumberland apparently came to London in the early summer *Summer*
of 1807 and called on Blake, for in his notebook some time after *1807*
June 6th he made a series of notes about his friend:

Blake made 130 drawg[s] for Flaxman for 10.10—[3]

Blake has eng[d] 60 Plates of a new Prophecy![4]

Intends to publish his new method through means[?] of stopping lights.

I am to prepare my new Plan for really encouraging the arts by buy-
ing pictures—[.][5]

The last two references in the list were evidently thought of
as being somehow connected, for they appear together else-
where in Cumberland's notebook. Next year, before May 1808,

a letter published in *The Artist* for June 6th, 1807. Naturally Blake did not criticize
Stothard for not being antique.
 According to [A. E.] Bray, *Life of Thomas Stothard, R.A.*, London, 1851, pp.
142–3, despite his vast profits Cromek paid Stothard only £60 of the £100 they
had agreed on.
 [1] Cromek's quotation is taken accurately (except for the italics) from *The New
Bath Guide*, London, 1804 [first published 1766], pp. 38–39.
 [2] Cromek's letter was supplied by Allan Cunningham's son Peter for an anony-
mous review of 'The Life and Works of Thomas Stothard, R.A. [*by Mrs. Bray*]',
Gentleman's Magazine, N.S., xxxvii (1852), 149–50.
 [3] These may be the 116 drawings illustrating Gray's poems Blake made for
Flaxman. The price, about 1s. 10d. per drawing, is clearly the price of friendship
rather than of commerce. The drawings may have been completed fairly recently;
see Sept. 1805.
 [4] The only poems by Blake with more than '60 Plates' is *Jerusalem*, which
eventually ran to one hundred pages.Therefore, unless some etched work has not
survived at all, or unless some of the missing twelve books announced on the
title-page of *Milton* were actually committed to copper, Cumberland's reference
must be to *Jerusalem*, though its title-page is misleadingly dated '1804'. Perhaps
Blake thought for a time that *Jerusalem* with sixty plates, fifteen to a chapter, was
complete, and only gradually expanded it over the next ten years or so.
 [5] BM Add. MSS. 36519G, ff. 307–8.

evidently after further discussion with Blake, Cumberland was more specific:

Blakes new mode of Stopping lights to be published in Nicholson to write further

New Plan for really encouraging the arts by buying Pictures.[1]

Cumberland's suggestion that Blake should publish his 'new mode' in William Nicholson's *Journal of Natural Philosophy, Chemistry, and the Arts* was, however, held in abeyance until he wrote to Blake on December 18th, 1808.

December On Saturday, December 5th Messrs. King and Lochee sold the
5th, copy of 'Blake's Poetical Sketches—1783', which had been
1807 given to Isaac Reed by Nancy Flaxman.[2]

Blake made a 'Design of The Last Judgment' which, as he told his friend Ozias Humphry, 'I have completed by your recommendation for the Countess of Egremont but for you [*it*] might have slept till the Last Judgment'. To explain the complex relationships of the hundreds of figures in the design, Blake sent a letter on January 18th, 1808 to Humphry (who was going blind) with a duplicate copy for Humphry to forward to the wife of Lord Egremont. Humphry was so impressed by this explication that he asked Blake to make yet another copy for the Earl of Bucnan,[3] which he sent to the Earl with a covering letter dated Tuesday, February 9th:

February Not being able to furnish your Lordship with much amusement
9th, myself, I have ventured to inclose, (from the Author himself written
1808 expressly for the purpose) the subject of an important Composition lately made by W. Blake for the Countess of Egremont, of a final Judgment—
 a Subject so vast, & multitudinous was never perhaps, more happily concievd.—

[1] BM Add. MSS. 36519H, f. 336.
[2] Lot 6575 of *'Bibliotheca Reediana* . . . Which Will be Sold by Auction . . . On Monday, Nov. 2, 1807, and 38 following days'. According to M. R. Lowry ('A Census of Copies of William Blake's *Poetical Sketches*, 1783', *Library*, 4th Series, xvii [1936], 354–60), Reed's copy was the one inscribed by Anna Flaxman on May 15th, 1784.
[3] David Steuart Erskine (1742–1829), eleventh Earl of Buchan and a close friend of the Royal Family, was brother of Henry Erskine, the Lord Advocate, and of Thomas Erskine, the Lord Chancellor, and like them he acquired immense wealth, with which he dabbled in art and poetry from his estate in Scotland.

The Size of this drawing is but small not exceeding twenty Inches by fifteen or Sixteen (*I guess*) but then the grandeur of its conception, the Importance of its subject, and the sublimely multitudinous masses, & groups, wᶜʰ it exhibitsIn brief, It is one of the most interesting performanᶜᵉˢ I ever saw; & is, in many respects superior to the last Judgment of Michael Angelo and to give due credit & effect to it, woud require a Tablet, not less than the Floor of Westminster Hall.—

I cannot see to read what I have written . . . [*because of* The unhappy Condition of my Sight.][1]

Flaxman wrote to Hayley on Friday, March 11th to describe the progress of the prints Abraham Raimbach was making for Cowper's translation of Milton's Latin poems: 'I have no doubt from the obliging manners of Mʳ Raimbach that he will readily make the desired alterations—concerning the prices I cannot pretend to judge, this must depend on the value Mʳ R. sets on his time or the agreement he made, I can tell You as I did him that Mʳ Longman paid 5 Guineas each one with another to Messʳˢ Blake, Parker &c for the plates they engraved for the Homer and with which those Artists were highly contented[.]'[2] *March 11th, 1808*

In 1808, for the first time in eight years, Blake exhibited two pictures in the Council Room of the Royal Academy Exhibition, which was open during May: '311 Jacob's Dream:—Vide Genesis, chap. xxviii. ver. 12 *W. Blake*' and '439 Christ in the sepulchre, guarded by angels—*W. Blake*'.[3] *May 1808*

In his notebook for May 1808 George Cumberland reminded himself of a commission he had arranged for Blake many years before: 'Got Blake to Engrave for Athens'.[4] *May 1808*

On Wednesday, May 4th Flaxman wrote to Hayley: 'concerning the [*Romney*] engravings Mʳ Raimbach thought very *May 4th, 1808*

[1] Quoted from the MS. in the Samuel Johnson collection formed by R. B. Adams, now in the possession of Mrs. Donald F. Hyde.

In illustration of his blindness, Humphry wrote on the back of the copy of Blake's letter which he forwarded to the Earl of Buchan: 'The Earl of Buchan—Of this duplicate paper wᶜʰ I have the Honor to inclose I have not been able to read a single Line. O.H.'

[2] No. 33 of a group of Flaxman letters in a green book in the Fitzwilliam.

[3] *The Exhibition of the Royal Academy, M.DCCCVIII*. In the index he appears as 'Blake, W. 17, South Molton street, Oxford street—311, 439'.

[4] BM Add. MSS. 36519ʜ, f. 355. Cumberland had just acquired the first three volumes (1762, 1788, 1794) of Stuart & Revett's *Antiqvities of Athens*. Cumberland's note evidently refers to past, not future engravings, for vol. iv (1816) has no plates signed by Blake, though four plates in vol. iii are signed 'Blake. Sculpᵗ'.

modestly that Mͬ Blake would execute the *outlines* better than himself but it was not possible to take the commission from the person that brought it to town, besides at present I have no intercourse with Mͬ Blake—[.]'¹

June In *The Monthly Magazine* for June 1st and in *The Athenaeum*
1st, *Magazine* for June appeared a notice: 'Mr. Cromek will very
1808 shortly present to the public Mr. William Blake's Illustrations of Blair's Grave, etched by Mr. Louis Schiavonetti.'² The plates themselves were dated May 1st, and Cumberland re-
June corded in his notebook that on '[*Sunday*] 5 June Mͬ Cromac
5th, gave me a proof of Blakes head',³ which served as the frontis-
1808 piece to the edition. Among a list of things dispatched to friends,
June Cumberland jotted down in his notebook '[*Wednesday*] 22ᵈ
22nd, June 1808—Sent . . . 4 Historical [*Drawings*] and tracings of
1808 my own to Mr Blake'.⁴

It may have been in July 1808 that the extraordinarily fashionable portrait painter John Hoppner wrote to Prince Hoare about a puff which he had written for Stothard's picture of the Canterbury Pilgrims, and which Cromek had reprinted at the back of the edition of *The Grave* which Blake illustrated:

[*July?* My Dear Sir,
1808?] My eye is not quick enough to detect any error, if there be one.

¹ No. 34 of a group of Flaxman letters in a green book in the Fitzwilliam. Raimbach wrote (*Memoirs and Recollections of the Late Abraham Raimbach, Esq. Engraver*, ed. M. T. S. Raimbach, London, 1843, p. 110 fn.): 'In the autumn of 1807, on the invitation of Mr. Hayley, I passed a few days at his delightful retreat at Felpham', and apparently he brought a commission for one or more engravings for the life of Romney to town with him—Raimbach's only signed plate is dated like the rest April 14th, 1809. Raimbach's suggestion in the letter above may have been that Blake should lay on the outlines and that Raimbach should finish the engravings. More probably, the '*outlines*' were to be outline engravings by Blake from unfinished sketches by Romney.

² This appears under a regular feature labelled 'Varieties, Literary and Philosopical' in *The Monthly Magazine*, xxv (1808), 353. In Aikin's *Athenaeum*, iii (1808), 567, 'William' is abbreviated to 'Wm.' and the illustrations are called 'celebrated', but otherwise the two notices are identical. A previous announcement in *The Literary Panorama* (Nov. 1807, col. 303) did not mention Blake: 'The Grave, a poem, by Robert Blair, will be re-published in a most splendid manner; it is to be printed in imperial quarto, in Ballantyne's best manner, illustrated with 12 exquisitely finished etchings, by the celebrated Schiavonetti.'

³ BM Add. MSS. 36519ₕ, f. 359.

⁴ BM Add. MSS. 36519ₕ, f. 362. The inserted word '[*Drawings*]' is understood from the preceding entry. The notebook seems to suggest that the drawings were to be delivered by Cromek.

Cromek I believe has copied my nonsense accurately enough, if not my memory is not equal to detect him, and I have no copy.

Respecting Blake's Poems, will you believe me? The merit was all vanished, in my mind at least, on reading them next morning. I therefore took no copy—but if you wish for them Cromek can now refuse you nothing—so I hope you will be modest in your demands of favours of him.[1]

The Monthly Literary Advertiser for Saturday, July 9th *July* announced: 'A magnificent quarto edition of Blair's Grave, *9th,* with thirteen elegant engravings by Sc[*h*]iavonetti, from some *1808* of the finest of Blake's designs, is expected to appear in the course of next month.'[2] The following flyer was probably one of the last to appear before publication:

Blake's / Illustrations of Blair. / Just published, / by Messrs. Cadell [*July* and Davies, London, / a new and splendid edition of / The Grave; *1808*] Printed, in a superior style, by Bensley, in Imperial / Quarto. Price £2. 12s. 6d. in extra Boards. / This work / is illustrated with / Twelve Masterly Etchings, / by L. Schiavonetti, V.A. / executed / from the classical compositions of / William Blake. / Of this unique Performance, the following is an ex / tract from the opinion of Henry Fuseli, Esq. R. A. / Keeper of the Royal Academy [*Here follows paragraph five of Fuseli's puff as given under November 1805, though with somewhat different capitalization.*] A few Copies remain unsold,[3] printed on a large Elephant / Quarto paper, with Proof Impressions of the Plates on / French paper. Price *Four Guineas.* /

[1] Quoted in Anon., 'Blake, Cromek and Hoppner', *TLS*, Oct. 7th, 1926, p. 680. The letter was presumably written between June 6th, 1807, when the puff was first printed in *The Artist* (which Hoare edited) and Aug. 1808, when *The Grave* was published.

Cromek may have had a copy of Blake's *Poetical Sketches*. Neither Cromek nor Hoppner is known to have owned any of Blake's Illuminated Works.

In his *Descriptive Catalogue* (Keynes, 1957, p. 574), Blake indignantly refers to Stothard's 'friend H—', whom Keynes identifies as 'James Heath, engraver', but Blake is in fact quoting Hoppner's commendation of Stothard.

[2] *The Monthly Literary Advertiser*, July 9th, 1808, p. 56. 'The Grave, a Poem, illustrated by Twelve Etchings, executed by Louis Schiavonetti, from the original inventions of William Blake. Royal 4to. 2l. 12s. 6d. in boards' was announced in the 'Monthly List of New Publications' in *The Athenaeum Magazine*, iv (Sept. 1808), 253. In Jan. 1809 the *Edinburgh Review* (xiii, 500) list of books published between Oct. 1808 and Jan. 1809 included 'Blairs Grave, a Poem, illustrated by twelve Etchings, executed by Schiavonetti from the original Designs of William Blake. Royal quarto, 2l. 12s. 6d.'

[3] Only a few copies remained because most had been taken by subscribers.

. . .[1] Liverpool, Printed at the Stanhope Press, by G. F. Harris, Houghton-street.[2] [*See Plates XVIII, XX–XXI, XXIV, XXVI–XXXI, XXXIV, LXV–LXVI, LIII.*]

The Grave contained a frontispiece of Blake, Blake's dedicatory poem 'To the Queen', and the twelve plates etched by Schiavonetti after Blake's designs. There were also an advertisement by Cromek, Fuseli's recommendation of November 1805 (with the capitalized nouns reduced to lower case and the signature all in capitals), and a series of anonymous descriptions of the plates, probably by Malkin (see November 1805). Cromek wrote the

ADVERTISEMENT.

[*August*] The Proprietor of this Work feels highly gratified that it has afforded
1808 him an opportunity of contributing to extend those boundaries of the Art of Design which are in themselves of the greatest beauty and value: he takes no other merit but this to himself, and gratefully acknowledges how much he has been obliged to various gentlemen of refined taste,—artists of high rank, and men of established literary repute,— for the aid they have been kindly pleased to grant.

To the elegant and classical taste of Mr. FUSELI he is indebted for excellent remarks on the moral worth and picturesque dignity of the Designs that accompany this Poem. Mr. PHILLIPS is entitled to his kindest thanks, for the capitally painted Portrait of Mr. WILLIAM BLAKE, which is here presented to the Subscribers; and to Mr. SCHIAVONETTI he is under still greater obligations for a SERIES OF ETCHINGS which, it is not too much praise to say, no other artist could have executed so ably.

That he might know how far he was warranted in calling the attention of the connoisseur to what he himself imagined to be a high and original effort of genius, the Proprietor submitted the Drawings, before they were engraved, to the following gentlemen, members of the Royal Academy of Painting, in London. He would esteem himself culpable if he were to dismiss this Advertisement without publicly

[1] The omitted passage announces Cromek's engraving of Dr. Currie, dedicated to William Roscoe [of Liverpool] which 'may be had' of Mr. Cromek. The copy of this print in the British Museum Print Room is dated 'March 2nd 1807'.

[2] BM Add. MSS. 33397, f. 144. This copy of the prospectus is with Thomas Dodd's brief biography of Blake, and on it is written, apparently by Dodd, 'engraved also Venus & Adonis [*November 21st, 1787, and*] View of Carfax conduit Oxford'. I know of no other record of the second plate, but it is unlikely that Blake engraved it. The prospectus is also found bound with Carey's *Critical Description of the Procession of Chaucer's Pilgrims* (see Nov. 7th, 1808), together with the advertisement for Stothard's Chaucer.

PLATE XXVI

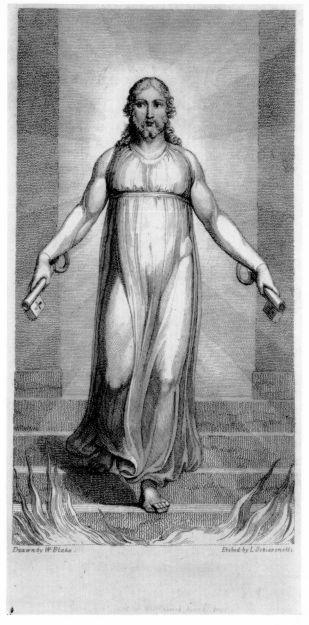

'CHRIST DESCENDING INTO THE GRAVE', a proof of
Schiavonetti's etching for Blair's *Grave* (1808), marked as published
by Cromek rather than by Cadell & Davies as in the final state. *The
Antijacobin Review* lamented the 'prettiness' and femininity of
Christ's face (see p. 203)

acknowledging the honourable and most liberal testimonial they bore
to their excellence.

BENJAMIN WEST, ESQ.
PRESIDENT OF THE ROYAL ACADEMY.

SIR WILLIAM BEECHEY.	WILLIAM OWEN, ESQ.
RICHARD COSWAY, ESQ.	THOMAS STOTHARD, ESQ.
JOHN FLAXMAN, ESQ.	MARTIN ARCHER SHEE, ESQ.
THOMAS LAWRENCE, ESQ.	HENRY THOMSON, ESQ.
JOSEPH NOLLEKENS, ESQ.	HENRY TRESHAM, ESQ.

London, July 1808. R. H. CROMEK.[1]

It is interesting that, in the second paragraph of this Advertise-
ment, Cromek expresses his thanks to Fuseli, Phillips, and
Stothard, but that nowhere is there any breath of gratitude
to Blake or of that 'private Friendship' for Blake he had so care-
fully mentioned in the November 1805 flyer.

Many subscribers clearly bought the book for the morality
Fuseli emphasized. Years later, William Bell Scott wrote that
in his home

the most important of all the illustrated books was perhaps *The Grave*,
with Blake's inventions admirably engraved by Sc[h]iavonetti.
(There was also Young's *Night Thoughts*, engraved as well as de-
signed by Blake himself; but they were so completely inferior that
they had no attractions.) The much-maligned Cromek had visited
Edinburgh, no doubt at the time he was industriously collecting the
Burns and Border scraps of verse he afterwards published, and my
father had become one of his original subscribers for *The Grave*. These
inventions had impressed the paternal mind in the profoundest way:
the breath of the spirit blown through the judgment trump on the
title-page seemed to have roused him as well as the skeleton there
represented. The parting of soul and body after the latter is laid on
the bier; the meeting of a family in heaven—indeed nearly every one
of the prints he looked upon as almost sacred, and we all followed him
in this, if in little else. Would it not be really thus after death? Would
not the emancipated soul look at those remaining behind with new
feelings, and hover over the deserted but still beloved body? To these

[1] R. Blair, *The Grave*, London & Edinburgh, 1808, pp. xi–xii. This 'Advertise-
ment' is a revised version of the flyer of Nov. 1805 (q.v.). The list of academical
supporters is also repeated from the Nov. 1805 advertisement, except that Fuseli,
Northcote, Opie (d. 1807), Hope, and Locke have been dropped from the original
document, and Owen added.

questions we children, very young when the book was published, answered with perfect faith.[1]

For some readers, such as James Montgomery, however, the morality was mitigated by the nudity of some of the figures.

When the 'Grave' was long afterwards published, with Blake's splendid illustrations, he became the possessor of a copy; but, as several of the plates were hardly of such a nature as to render the book proper to lie on a parlour table for general inspection, he sold his copy for the subscription price; a circumstance which he often regretted, as the death of the artist soon afterwards rendered the work both scarce and proportionately more valuable.[2] Those persons who have once seen these illustrations will readily recollect the print representing the angel of the 'last trump' descending to awake the dead. The celestial messenger is seen in an almost perpendicular position, head downwards, and with his trumpet close to the ear of a corpse which is just beginning to revive,—the bones of the figure are apparently uniting, and the flesh and skin slowly creeping over the skeleton! The solemn absurdity of this conception, and the ingenious manner in which it is executed, afforded Montgomery a very amusing topic of conversation on one occasion when we were present.[3]

A good deal of the amusement value of this anecdote was supplied by Montgomery, for there is no hint of creeping flesh and skin in Schiavonetti's etching.

The first review of *The Grave*, by Leigh Hunt's brother

[1] *Autobiographical Notes of the Life of William Bell Scott*, ed. W. Minto, London, 1892, vol. i, pp. 21–22. William Bell Scott (1811–90) was not exactly 'very young' when his father 'Mr. Robert Scott' of Edinburgh subscribed for a copy, for he was not born until three years after it appeared. His account continues: 'Long afterwards in London Dr. Garth Wilkinson introduced me to the *Songs of Innocence* he had just then [1839] reprinted'.

Scott's brother David, in an undated note (printed in W. B. Scott, *Memoirs of David Scott, R.S.A.*, Edinburgh, 1850, p. 238), praised Blake for having 'touched the infinite in expression', 'but [*he was*] very defective in execution', and in 1844 in his own copy of *The Grave* he wrote that these designs 'are the most purely elevated in their relation and sentiment' 'of any series . . . which art has produced'; they 'reach the intellectual or infinite, in an abstract significance, more entirely unmixed with inferior elements and local conventions than any others' (Gilchrist, 1863, p. 377; not in 1942). In the Library of Congress is an undated note from W. B. Scott to 'W.' (W. M. Rossetti?) saying that he has just found a note by his brother David in Blair's *Grave* which may interest 'W'.

[2] 'Mr. Montgomery, Sheffield' was one of the subscribers to *The Grave*. Blake did not die until nineteen years after it was published.

[3] J. Holland and J. Everett, *Memoirs of the Life and Writings of James Montgomery*, London, 1854, vol. i, p. 38. See Plate XXXIV.

Robert, appeared in the Hunts' new journal *The Examiner* for
Sunday, August 7th:

The large, elegant type, superfine paper, and masterly execution of *August*
the twelve highly finished Etchings by SCHIAVONETTI, present an *7th,*
exterior worthy to embody the original and vigorous thoughts of *1808*
ROBERT BLAIR. The Portrait of Mr. BLAKE, the inventor of the designs,
preserves all the nature and spirit of the admirable original by Mr.
PHILLIPS.[1] Rich dotted lines in the half tints, just direction and play-
fulness of line throughout, diversified touch, and vigorous drawing,
rank it among the best Engravings of Portraits in any country. In
anatomical precision, Mr. SCHIAVONETTI has done more than justice
to Mr. BLAKE's Designs. Of these Mr. FUSELI well remarks, that 'the
groups and single figures on their own basis, and considered without
attention to the plan, frequently exhibit those simple graces which
nature and the heart alone can dictate.'[2] I wish his praise of the *plan
itself* was equally just. 'His invention,' says Mr. FUSELI, 'has been
chiefly employed to spread a *familiar* and *domestic* atmosphere round
the most important of all subjects, to *connect the visible and invisible
world* without *provoking probability*, and to lead the eye from the
milder light of time to the radiations of eternity.' In other words, to
perform impossibilities, to convert the pencil into a magical wand, and
with it to work wonders, surpassing any recorded in the Tales of the
Genii. How *'the visible and the invisible world'* can be *connected* by the aid
of the pencil without *'provoking probability,'* nay even without outraging
it, none but such a visionary as Mr. BLAKE, or such a frantic as Mr.
FUSELI, could possibly fancy. The attempt has always failed even in
poetry, notwithstanding its license of fiction and the wide range of
fancy which the indetermination of language gives the reader. The
greatest poets have failed in their attempts 'to connect the visible and
invisible worlds,' and have conveyed no just idea of the incomprehen-
sible and intellectual faculty, whenever they have tried to embody it.
MILTON's Messiah and the Angels must *necessarily* act by the instrumen-
tality of the *five senses*, and others, though denominated *ethereal essences*,
are really modifications of *matter* like *men*. The utter impossibility of
representing the *Spirit* to the eye is proved by the ill effect it has on the
stage. When the spirit *Ariel*, who should be viewless, and always
fleeting as the air, appears, it is by means of legs which run no faster
than those of many of the audience, while her flapless wings are idly

[1] Hunt had probably seen Phillips's portrait when it was exhibited at the
Royal Academy in 1807.

[2] Hunt omits five words after 'exhibit those'. This and the quotes below are
taken, with minor changes and the addition of italics, from Fuseli's critique for
the edition of 1808.

stiff on her shoulders, and though she should sometimes be seen by *Prospero* only, she is equally visible to all around, who must *fancy* her invisible. The effect is equally impracticable in the vain effort of painting to unite to the eye the contrary natures of spirit and body, and it is this which renders allegorical pictures so utterly insipid. Indeed to impose on the spectator fire for water would not be more absurd. They have as close analogy to each other as soul and body. Thus when Mr. BLAKE describes 'the soul exploring the recesses of the grave [*Plate XLVI*]' by a figure clad in drapery, holding a candle, and looking into a tomb, no other idea is suggested but simply of a human being examining a tomb. The corporeal object not only forbids but absolutely prevents the most distant conception that it is a spirit looking into a grave, and SOLOMON, DANIEL, and all the wise men of the East, would not possibly divine such a thought, if the *small* assistance of the title did not help to explain the enigma. It is by the same help we are enabled to discover that by the face of a figure which is springing out of the grave, coming in contact with the face of another figure descending from an opening cloud, is shadowed 'the re-union of the soul and body [*Plate LXV*].' The mouth of the lower figure is certainly a little open, but if this aperture is to admit the body, I beg pardon, the soul above, it is somewhat too small, as it is no longer than the mouth of the upper figure, or soul!! To be sure, that figure is soul, and can therefore enter without any difficulty or squeezing into ever so small a cranny, just as MILTON describes *his* spirits contracting or enlarging at will. But how are we to find out that the figure in the shape of a body is a soul? [*See Plates XLV–XLVI.*]

'The soul hovering over the body, reluctantly parting with life [*Plate XXVIII*]', is thus described by BLAIR:—

> 'In that dread moment, how the frantic soul
> Raves round the walls of her clay tenement,
> Runs to each avenue, and shrieks for help,
> But shrieks in vain. How wishfully she looks
> On all she's leaving, now no longer her's.'

This is a very animated and highly poetic figure, but how absurd is its literal representation in a picture, by a female figure suspended over an expiring body, and looking wishfully in its face. The figure would indeed be an exact personation of a female friend of the dying, if it was not for its hovering in the air, but that circumstance is but a poor solution of its spirituality, which is altogether belied by the more substantial testimony of bones, flesh, and drapery of linen manufacture. But a more serious censure attaches to two of these most heterogeneous and serio-fantastic designs. At the awful day of Judgment, before the throne of God himself, a male and female figure are described

PLATE XXVII

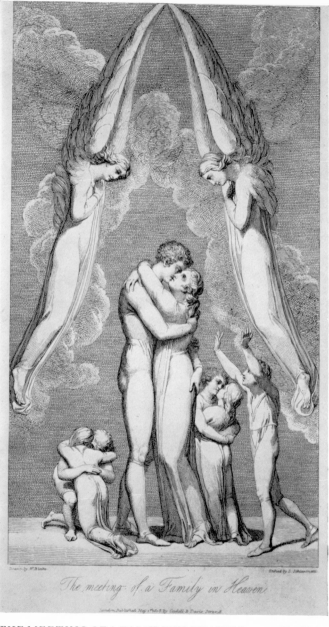

The meeting of a Family in Heaven.

'THE MEETING OF A FAMILY IN HEAVEN', a proof for Blair's
Grave (1808). Robert Hunt lamented the libidinous tenor of this celestial
scene (see p. 197)

in most indecent attitudes. It is the same with the salutation of a man and his wife meeting in the pure mansions of Heaven. This however is as appropriate a display of the chastity of celestial rapture, as solid flesh is of *unseen, untangible*, and *incorporeal* spirit. This is the work that Mr. FUSELI says, 'holds the mirror up to life: less indeed to discriminate character, than those situations which shew what all are born for, what all ought to act for, and what all must inevitably come to.' These valuable purposes are certainly attained in some degree in the other prints, but here an appearance of libidinousness intrudes itself upon the holiness of our thoughts, and counteracts their impression. It may be said that 'to the pure all things are pure.' But beside that the pure must, in proportion to their purity, be disgusted with obscenity, lessons of religion and morality, whether inculcated by picture or discourse, should have more for their object the benefit of the licentious than the amusement of the virtuous. 'They that are whole need not a Physician, but they that are sick.' In fine, there is much to admire, but more to censure in these prints. There are some ideas that awaken the warmest and best feelings of the heart, others which cherish the worst. Whatever is simply natural, such as 'the death of a wicked strong man,' is powerfully conceived and expressed; but nearly all the allegory is not only far fetched but absurd, inasmuch as a human body can never be mi[*s*]taken in a picture for its soul, as the visible can never shadow out the invisible world, 'between which, there is a great gulph fixed' of impenetrable and therefore undescribable obscurity.—The work owes its best popularity to the faithful descriptions and manly poetry of ROBERT BLAIR and to the unrivalled graver of L. SCHIAVONETTI. [*See Plates XXVIII, XXXI, XXVII, XXI.*]

R.H.[1]

The virulence of this and later attacks upon Blake in *The Examiner* may be partially explained by the supposition that the Hunts saw him as an enthusiast, if not a Methodist; their point of view on this topic is made clear by the fact that during this summer the weekly *Examiner* was running an attack on 'the Folly and Danger of Methodism'.

Blake answered the essential assertion of this review in his *Descriptive Catalogue*:

The connoisseurs and artists who have made objections to Mr. B.'s mode of representing spirits with real bodies, would do well to

[1] 'Blake's Edition of Blair's Grave', *The Examiner*, Aug. 7th, 1808, pp. 509–10. The 'R. H.' who signed the article may be confidently identified with Leigh Hunt's brother, for in a letter of 1814 R. Hunt 'acquaints Mʳ Flaxman, that . . . he writes the Articles on the Arts in the Examiner' (BM Add. MSS. 39781, f. 299).

consider that the Venus, the Minerva, the Jupiter, the Apollo, which they admire in Greek statues are all of them representations of spiritual existences, of Gods immortal, to the mortal perishing organ of sight; and yet they are embodied and organized in solid marble. Mr. B. requires the same latitude, and all is well. The Prophets describe what they saw in Vision as real and existing men, whom they saw with their imaginative and immortal organs; the Apostles the same; the clearer the organ the more distinct the object. A Spirit and a Vision are not, as the modern philosophy supposes, a cloudy vapour, or a nothing: they are organized and minutely articulated beyond all that the mortal and perishing nature can produce. He who does not imagine in stronger and better lineaments, and in stronger and better light than his perishing and mortal eye can see, does not imagine at all. The painter of this work asserts that all his imaginations appear to him infinitely more perfect and more minutely organized than any thing seen by his mortal eye. Spirits are organized men. Moderns wish to draw figures without lines, and with great and heavy shadows; are not shadows more unmeaning than lines, and more heavy? O who can doubt this!

On Sunday, August 14th Cromek wrote to Cumberland:

August 14th, 1808 My Dear Sir.

With this you will receive the Book you had ye goodness to subscribe for.

I should feel myself much wanting in Gratitude if I did not beg your acceptance of this book as an acknowledgement, at least, of the many kindnesses, I received from you & your good family when in Bristol.

Through the d—d carelessness of my Printer your Name is omitted in the list; a misfortune that I deplored, & almost raved about for three Days and three Nights.

You are yᵉ only person in Bristol who thoroughly understand[*s*] the Inventions of Blake—Your Name has also some influence, & consequently the affair is to the last degree unlucky—However it is past—...

I need not ask you to speak of the Book as you may think it ought to be spoken of

Your Packet went to Blake. I sent him 2 Copies, but he has not had the common politeness to thank me for them.[1]

August 28th, 1808 On August 28th, three weeks after the first broadside in *The Examiner*, Leigh Hunt himself joined the attack with a list of 'The Ancient and Redoubtable Institution of Quacks, with their present officers, professors, and principal servants'. The

[1] BM Add. MSS. 36501, f. 254. Cromek had evidently stayed as a guest of the Cumberlands in Bristol.

PLATE XXVIII

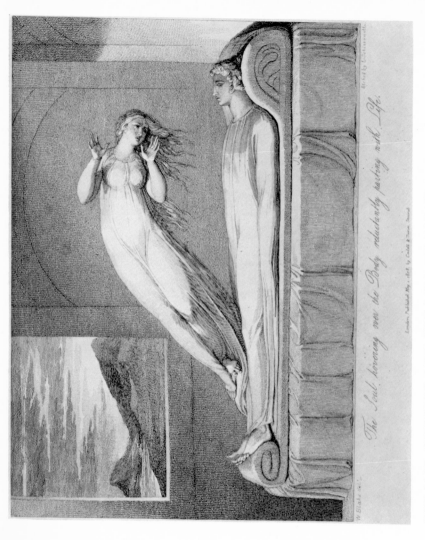

W. Blake inv.

The Soul hovering over the Body reluctantly parting with Life.

London, Published May 1 1808, by Cadell & Davies, Strand.

Etch'd by L. Schiavonetti.

'THE SOUL HOVERING OVER THE BODY RELUCTANTLY PARTING WITH LIFE', a proof of Schiavonetti's etching for Blair's *Grave* (1808). Robert Hunt found the representation of the soul 'obscene' (see p. 196)

Painting Officers are Sir Francis Bourgeois, Copley, Craig and 'Blake', and the poets include Wordsworth and Scott.[1]

On Wednesday, August 31st W. Walker wrote to Hayley:

Dear Sir

I thank you, as for all your Favors to my poor departed Friend, so especially for your benevolent attempt to console me under the Loss of him Mason and I have been talking of printing a few of his poetical Trifles, as an honorable Tribute to the memory of a young man, Who had scarce any advantages from education, but Whose conceptions were sometimes ingenious, and always pious. When I talk of printing, I mean only a few copies for his Friends, Which of course I shall do at my own expence. Mason advises, that We take for a Frontispiece Mr Blakes *departure from the Soul*, and if you wd permit me to add the beautiful Epitaph with which you have favor'd me, our Scheme wou'd be compleat. I had some thoughts of a sketch from a miniature Picture of him in Mrs Bradfords Possession, but besides, that It might look ostentatious, at least to Cynical minds, We shd lose the moral effect Which Mr Blake's fine subject might, and I am persuaded wou'd have on the young People to Whom I shd. present this little Work.[2] I bow down however before your superior Judgment, and beg you will have the Goodness to direct me in my design to honor the memory of our mutual Friend.[3]

August 31st, 1808

When Walker's book was published, it had no Blake plates.

The first article in the November *Antijacobin Review* was an attack on Blake:

A Work that has been so frequently re-printed as *Blair's Grave*, and has so long maintained a distinguished rank in public estimation, would not demand any attention from us but through peculiar circumstances. The poem itself, indeed, we do not intend to criticise any

November 1808

[1] 'Miscellaneous Sketches upon Temporary Subjects, &c.', *The Examiner*, Aug. 28th, 1808, p. 558. The sketch is signed with the editorial pointing finger which Leigh Hunt used to identify his sallies.

[2] The work referred to is probably '*Poetical Pieces* by the late Mr. Thomas Bradford. To which are added A Sonnet on his Death, and His Epitaph, written by William Hayley, Esq. Chichester Printed by William Mason. 1808'. The Editor is anonymous, but facts pointing to the identity of this work and that mentioned in Walker's letter are: (1) the date—the unsigned introduction is dated from Chichester Oct. 1808; (2) Hayley's 'beautiful Epitaph' which praises the piety of the 'youth'; (3) the printing of it by Mason with whom Walker had 'been talking of printing' these 'poetical Trifles'; and (4) the 'miniature Picture of him' mentioned in the book which was owned by Mrs Bradford.

[3] Quoted from the MS. in my own possession. The admired engraving was probably either 'The Soul hovering over the Body reluctantly parting with Life' or 'The Death of The Good Old Man' (Plates XXVIII, XX).

further than by remarking, that its most exquisite beauties are occasionally shaded by too colloquial a phraseology, and a too frequent choice of metaphorical illustrations from low and common objects; possibly however, its enlarged celebrity has been the result of these very defects, and the moral tendency of the whole been increased by its being thus brought within the comprehension and scope of common understandings. What we have now to do is to examine into the presumed merits of the *Original Inventions* with which this edition is embellished; we say presumed merits, because the designs have been trumpeted forth in a way that might lead many to suppose them in possession of all the principles that unite in the perfection of art.

Mr. Blake was formerly an engraver, but his talents in that line scarcely advancing to mediocrity, he was induced as we have been informed,[1] to direct his attention to the art of design; and aided as his friends report, by visionary communications with the spirits of the Raffaeles, the Titians, the Caraccis, the Corregios, and the Michael-Angelos of past ages, he succeeded in producing the 'Inventions' before us; as well as some others on similar principles, which though submitted to public inspection at the Royal Academy,[2] have not yet been subjected to the operations of the *Burin*. Were we to act on the assumption of the above statement being an absolute fact, we should be justified in grounding our opinion of Mr. Blake's productions on much severer laws of criticism than we really mean to be guided by; we should have a right to expect the intire union and concentrated strength of all the above great masters in the designs for the Grave; and to inquire wherefore the graces of the Caracci were not blended with the sweetness of Corregio, and the full and flowing pencil of Titian combined with the majesty of Raffaele, and the grandeur, sublimity, and energy of Michael Angelo? But waving all considerations of supposed spiritual agency and inspiration, we shall judge only of Mr. Blake's designs from the plain principles of taste and common sense, yet not without reference to the high station in the ranks of art which the proprietor (Mr. Cromek,) claims for them. We must here

[1] Can Anon. 'have been informed' by Phillips? He certainly had personal sources of information, and the statement below that Phillips had given the portrait of Blake to Cromek suggests that Anon. may have talked to Phillips himself. See Winter 1807.

[2] The statement that the *Grave* drawings were 'submitted to public inspection at the Royal Academy' is probably inaccurate. In his Advertisement and prospectuses Cromek specifies which Royal Academicians he submitted the drawings to, and the implications are very strong that all who saw them are included in his list, and that all who saw praised. This is scarcely a 'public inspection'. Probably the *Antijacobin* phraseology above is merely careless. The unpublished drawings seen by the reviewer and Robert Hunt (see Aug. 7th) may have been shown by Cromek as specimens at his house.

quote some passages from the advertisement prefixed to this publication.[1]

'The proprietor of this work feels highly gratified that it has afforded him *an opportunity of contributing to extend those boundaries of the Art of Design* which are in themselves of *the greatest beauty and value*: he takes no other merit but this to himself, and *gratefully acknowledges how much he has been obliged to various gentlemen of refined taste, artists of high rank, and men of established literary repute*, for the aid they have been kindly pleased to grant. To the elegant and classical taste of Mr. Fuseli he is indebted for *excellent remarks* on the *moral worth and picturesque dignity* of *the designs* that accompany this poem: and to Mr. SCHIAVONETTI he is under *still greater obligations* for a SERIES of ETCHINGS which, *it is not too much praise* to say, *no other artist* could *have executed so ably*. That he might know how far he was warranted in calling the attention of the connoisseur to what he himself imagined to be *a high and original effort of genius*, the proprietor submitted the drawings *before they were engraved*, to the following gentlemen, members of the Royal Academy of Painting in London. He would *esteem himself culpable* if he were to *dismiss this advertisement without publicly acknowledging* the *honourable* and *most liberal testimony they bore to their excellence.*' The names recorded are those of 'Benjamin West, Esq. P.R.A. Sir William Beachey, Richard Cosway, Esq. John Flaxman, Esq. Thomas Lawrence, Esq. Joseph Nollekens, Esq. William Owen, Esq. Thomas Stothard, Esq. Martin Archer Shee, Esq. Henry Thomson, Esq. and Henry Tresham, Esq.'

There is quackery in more things than medicine;[2] yet we think that Mr. Cromek's *address* (as will occasionally occur in real life,) is somewhat *too broad* to effect his purpose; nor is the recommendatory preface of Fuseli, though far more laboured than 'classical taste' would allow, without its full share of what we should denominate the empiric art. Not however, that we have the least intention of imputing to the *historical professor*,[3] any idea of profiting by the sale of this work; but that we conceive he has hazarded assertions for the benefit of others, which under circumstances wherein his own interest only was concerned, his better judgment must have utterly disclaimed. We must substantiate our opinion by an extract.

—'Conscious that *affectation of originality* and *trite repetition* would equally impede his success, the author of the Moral Series [of designs] [*sic*] before us, has endeavoured to wake sensibility by touching our sympathies with *nearer, less ambiguous*, and *less ludicrous imagery!* than

[1] The matter quoted from *The Grave* is given in full under Aug. 1808, except for Fuseli's opinion, which is under Nov. 1805, and the description of the drawings.

[2] See Aug. 28th, 1808 for an earlier charge of quackery.

[3] Fuseli was Professor of [history] Painting at the Royal Academy.

what mythology, gothic superstition, or symbols as far-fetched as inadequate, could supply. His *invention* has been chiefly employed to spread a *familiar and domestic atmosphere* round the *most important of all subjects, to connect the visible* and the *invisible world without provoking probability, and to lead the eye from the milder light of time to the radiations of eternity*. Such is the plan and the moral part of the author's invention; the technic part and the execution of the artist, though to be examined by other principles, and addressed to a narrower circle, equally claim approbation, sometimes *excite our wonder*, and *not seldom our fears* when *we see him play* on *the very verge of legitimate invention*: but *wildness so picturesque in itself*, so often *redeemed by taste, simplicity and elegance*, what *child of fancy*, what *artist* would *wish to discharge?* The *groups* and *single figures* on their *own basis, abstracted* from the *general composition*, and considered without attention to the plan, *frequently exhibit* those *genuine and unaffected attitudes* those *simple graces* which *nature and the heart alone can dictate*, and *only an eye inspired by both, discover*. EVERY CLASS of ARTISTS, in EVERY STAGE of *their progress or attainments*, from the STUDENT to the FINISHED MASTER, and from the CONTRIVER of ORNAMENT to the PAINTER of HISTORY, will here find'—What? *'materials of art and hints of improvement.'*

Oh! 'lame and impotent conclusion!' why so they might, Mr. Fuseli, even in the rude scrawls that decorate the whig-whams of an untutored Indian. *Materials* of *art*, and *hints* of *improvement*! What a falling off is this, after all the florid commendations implied by the previous members of the paragraph! Did the honourable Professor *feel* that he had said too much, and eloquent though he be in literary composition, prefer descending to the bathos, to the disgrace of rendering his judgement more questionable by continuing an undeserved panegyric? But it is now time to examine the Designs themselves; some of which we must premise, have very little, if any, connection with the Poem they are avowedly published to illustrate. We should not indeed, have been able to discover what all the subjects meant, were it not for an explanatory supplement of four pages; yet that supplement we trust, for the honor of the Republic of Letters, was not written by any of the gentlemen of *'refined taste*, and *established literary repute,'* referred to in Mr. Cromek's advertisement,. In the description, the Designs are arranged very differently to their situations in the book itself; and for this the following reason is given. 'By the arrangement here made, the regular progression of man, from his *first* descent into the vale of death, to his *last* admission into life eternal is exhibited. These designs, detached from the work they embellish, *form of themselves* a *most interesting Poem!!'*

PLATE XXIX

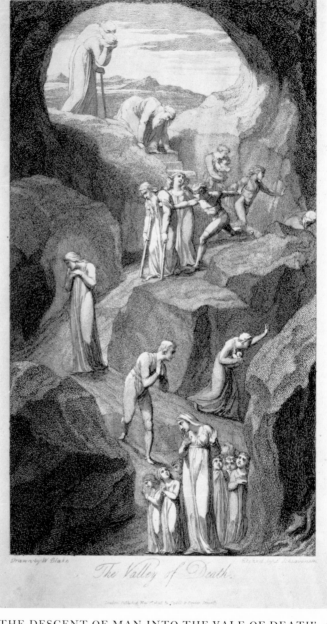

The Valley of Death.

'THE DESCENT OF MAN INTO THE VALE OF DEATH', a
proof with another title of Schiavonetti's etching. *The Antijacobin Review*
pointed out that this design does not quite correspond to the description
given of it in Blair's *Grave* (1808) (p. 203)

The figure of 'Christ descending into the Grave' which is the subject of the first print, is deficient in dignity; and 'expression does not lend its finished glow,' to give the semblance of divinity to the countenance. There is in fact, a prettiness about the face, which were it not for the beard would better consort with the graceful character of a young female, than with the majesty of the

'ETERNAL KING whose *potent arm* sustains
The Keys of Hell and Death.' [*Plate XXVI*]

The 'Descent of Man into the Vale of Death [*Plate XXIX*];[1] has hardly any closer connection with Blair's poem than the words

'Tis here all meet!'

yet to make up the deficiency we have the following full description. 'The pious daughter weeping and conducting her sire onward; age, creeping carefully on hands and knees; an elder, without friend or kindred; a miser; a batchelor, blindly proceeding no one knows where, ready to drop into the dark abyss; frantic youth rashly devoted to vice and passion, rushing past the diseased and old, who totters on crutches; the wan declining virgin; the miserable distracted widow; the hale country youth; and the mother and her numerous progeny, are *among the groups* which speak irresistibly to the feelings.' In this enumeration of *groups*, almost every *single* figure in the piece is included and yet have we sought in vain for the 'elder, without friend or kindred,' unless it be him who is bearing a child and pressing it with parental tenderness to his bosom.[2] The figures are tolerably well drawn; but there is nothing particularly masterly either in the attitudes or expression; nothing that requires more than common abilities either in the composition or grouping. The scene represents a rocky and winding path, leading downward from the entrance of a cavern.

The print of 'Death's Door [*Plate LIII*],' illustrative of the lines,

'Tis but a night, a long and moonless night
We make the grave our bed, and then are gone!'

is thus described—'The door opening, *that* seems to make utter darkness visible; age, on crutehes [*sic*], hurried by a tempest into it. Above is the renovated man seated in light and glory.' Death's door is delineated as a square aperture opening into a rocky recess, into which an aged man, his hair and garment blown forward by the wind, is represented as entering. In this figure the feebleness of age is well depicted, and there is a chasteness and simplicity in it which we vainly seek for in

[1] This semi-colon was clearly meant to be a single quotation-mark.
[2] There does seem to be something puzzling about the description of this drawing.

the 'renovated man seated in light and glory.' The latter excites the idea of pain, and his posture is that of a naked madman rather than that of an inhabitant of the realms of bliss.

The 'Death of the Strong Wicked Man' is conceived with greater energy of mind, and more happily expressed than any other design in the whole work. Where indeed, could be found the artist so dull of thought, as not to have every faculty of his soul animated to exertion by the powerful imagery of Blair [*Plate XXI*].

> '*Strength* too! thou surly and less gentle boast
> Of those that loud laugh at the village ring!
> A fit of common sickness pulls thee down
> With greater ease than e'er thou didst the stripling
> That rashly dar'd thee to the unequal fight.
> What groan was that I heard? Deep groan indeed,
> With anguish heavy laden! Let me trace it:
> From yonder bed it comes, where the strong man,
> By stronger arm belaboured, gasps for breath
> Like a hard hunted beast. How his great heart
> Beats thick! his roomy chest by far to[*o*] scant
> To give the lungs full play! What now avail
> The strong-built sinewy limbs, and well spread shoulders?
> See how he tugs for life, and lays about him,
> Mad with his pain! eager he catches hold
> Of what comes next to hand, and grasps it hard,
> Just like a creature drowning! Hideous sight!
> O how his eyes stand out, and stare full ghastly,
> While the distemper'd rank and deadly venom
> Shoots like a burning arrow 'cross his bowels,
> And drinks his marrow up! Heard you that groan?
> It was his last. See how the great Goliah,
> Just like a child that brawled itself to rest
> Lies still!—

Had Mr. Blake contented himself with pourtraying the death-bed of the strong man, the frantic sorrows of the despairing wife, and the mute yet expressive woes of the afflicted daughter, his picture would have deserved a very enlarged portion of commendation. The extremities convulsed with agony, the expanded chest heaving with inexpressible pain, the swelling muscle, and the breadth of limb, are well adapted to give the idea of strength laid low; but when to all this is superadded a perfectly *corporeal* representation of 'the masculine Soul' of the dying man 'hurried through the casement in flame,' the mind is shocked at the outrage done to nature and probability; and notwithstanding the opinion of Mr. Fuseli, we hesitate not to characterize the

imagination of the artist, as carried far, very far, beyond the 'verge of legitimate invention.'

The 'Death of the good Old Man,' is yet more objectionable. If it were really Mr. Blake's intention 'to connect the visible and the invisible world without provoking probability,' he should have done it with threads of silk and not with bars of iron. The beings of another world when depicted on the same canvas as earthly bodies, should be sufficiently immaterial to be veiled by the gossamer, and not, as they are here designed, with all the fullness and rotundity of mortal flesh. What is yet more absurd, is to see the spirit of the good man borne aloft between two angels, and clothed in the *same habiliments* as the body that lies on the pallet below! Mr. Blake should have recollected, that when the Prophet Elijah was taken up to heaven in a chariot of fire, his mantle 'fell from him.' The other parts of this design are good, and the humility and Christian resignation of the figures are strikingly accordant with the peaceful end of the Good Man, whose hand extended upon the gospels, at once displays his faith, and his confidence.

> 'How calm his exit!
> Night dews fall not more gently on the ground,
> Nor weary worn-out winds expire so soft.
> Behold him in the ev'ning tide of life,
> A life well spent, whose early care it was
> His riper years should not upbraid his green:
> By unperceiv'd degrees he wears away,
> Yet, like the sun, seems larger at his setting.' [*See Plate XX.*]

'The Soul hovering over the Body,' illustrative of the passage

> 'How wishfully she looks
> On all she's leaving, now no longer her's!'

has the same defect of giving *substantial* form to incorporeal substance, and arraying it in earthly habiliments, as the former picture. Neither do we like the position of the soul, which is bending over the body, in a strained and awkward manner [*see Plates XXVIII, XLVI*].

'The Soul exploring the recesses of the Grave,' has no prototype, we believe, in Blair's Grave: it is however thus described. 'The soul prior to the dissolution of the body, exploring through and beyond the tomb, and there discovering the emblems of mortality and immortality.' All this is represented by a female figure bearing a torch, and entering into a cavern, at the extremety of which lies a mouldering body partly surrounded by flames. Upon the top of the cavern stands a fear-struck maniac—we know not what else it can represent, —and in the back-ground are the summits of mountains, some buildings, and the waning moon. What these things mean, we are at a loss

to discover, even with the assistance of the explanation. Certainly the *invention* is *original*; yet if this be a specimen of the 'picturesque wildness,' so 'often redeemed by taste, simplicity, and elegance,' we assuredly 'would wish to discharge' it altogether. Besides, in this design, the artist has departed from his own principles, as far as those principles are exemplified in the deaths of the Good and of the Bad Man; in both which pieces we see the spirit taking its flight to the realms of eternity immediately on the extinction of the mortal breath: in this the soul is made to wait on 'the dissolution of the body.'[1] These inconsistencies must not be tolerated, even in the absurd effusions which we are here so strongly called upon to commend.

'The Councellor, King, Warrior, Mother and Child, in the Tomb [*Plate XXX*],' is conceived in a much better taste; though considered as 'a high and original effort of genius,' we find but little to commend in it. Imagine a recessed Gothic tomb in a church wall, with the sculptured effigies of a departed family of 'the great deceased,' lying within it, and you have a complete idea of this design. *Invention* is here unnecessary; any Cathedral will furnish the prototypes.

'The Skeleton re-animated,' (which is the subject of the Vignette Title [*Plate XXXIV*]) is intended to illustrate this passage:

'When the dread trumpet sounds, the slumb'ring dust,
Not unattentive to the call, shall wake;
And every joint possess its proper place.'

In the design, we behold a naked figure, in nearly a perpendicular attitude, with the head downwards, as if descending from Heaven, sounding a trumpet over the face of the skeleton, which is throwing aside the winding sheet, and slowly rising from the tomb. The latter being partially environed by a few flames and a cloud of smoke, has been magnified by the ingenious writer of the supplementary description into 'the world in flames,' typifying 'the renovation of all things, the end of time, and the beginning of eternity!' The full expression of nudity, even in moral works, is not wholly desirable; and we think, that the descending angel, if angel he be who is coming headlong from on high, but without the least vestige of the angelic character than what mortal man precisely exhibits, might have been furnished with wings to infold his nakedness. To see a corporeal figure 'upborne upon nothing,' and blowing a trumpet in a constrained and ungraceful position, has something in it so repugnant to our feelings, as well as to 'legitimate invention' in art, that were Mr. Fuseli him-

[1] Blake probably meant that *before* death the soul (the imagination) can perceive something of the caverns of the grave, but that when the body dies the soul permanently leaves the vegetable body.

PLATE XXX

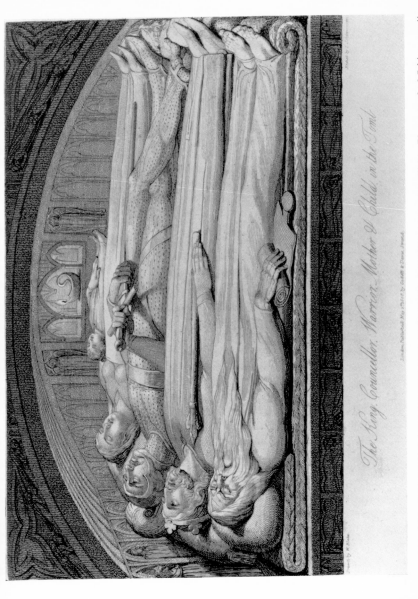

The King, Councellor, Warrior, Mother & Child, in the Tomb

'THE KING, COUNCELLOR, WARRIOR, MOTHER & CHILD IN THE TOMB', a proof of Schiavonetti's etching for Blair's *Grave* (1808). *The Antijacobin Review* found this design in 'much better taste' but too conventional (p. 206)

self 'trumpet-tongued,' and should tell us that such a design merited 'approbation,' we should protest against the soundness of his judgment.

'The Re-union of the Soul and Body,' offers equal violence to true taste, as most of the subjects we have noticed; and there is a *seeming* incongruity in making the one masculine, and the other feminine: we say seeming, because it is difficult to determine whether the body was intended for that of the male or not.[1] Both are equally *substantial* in form and appearance, and were we not told that their action represented the re-union of the soul and body, we should on a first glance suppose, that the body was meant for a young man extending his arms to prevent a youthful female from falling headlong down to the earth.

'The Meeting of a Family in Heaven [*Plate XXVII*]' is another subject for which we may look in vain through the Poem of Blair: we shall therefore insert the description as it stands, in plain prose.

'The sweet felicity, the endearing tenderness, the ineffable affection, that are here depicted, are sufficiently obvious. The husband clasps his wife; the children embrace; the boy recognizes, and eagerly springs to his father.'

It is omitted, that the above is performed under the wings of two angels, who, buoyant in the clouds, extend their pinions till, like the longer sides of an Isosceles triangle, they meet in a point at the top, and diverge outwardly. This gives a pyramidical formality to the whole design, which catches and detains the eye. The positions of the principal figures are also ill chosen; for however expressive they may be of conjugal love, it is of conjugal love *on earth*, and possesses little of that exalted character, which we may conceive to be displayed in the realms of heaven.

We are at length come to the last of these designs, 'The Day of Judgment [*Plate XXXI*];' a production in which there is much to commend, and much to censure. There is an impressive vigour in the general management and plan of the composition that demands approbation, but the figure of the SAVIOUR, who is seated on the throne of judgment, with the book of life open upon his knees, is deficient both in dignity and power; and the action of some of the groups is much too familiar. Mr. Blake's knowledge of drawing, and of the human figure, is better displayed by this, than any other of his designs; and he has executed some very difficult foreshortnings with great success.

We shall here close our remarks upon these designs. Though occasionally invigorated by an imagination chastened by good taste, we regard them in general as the offspring of a morbid fancy; and we think, that this attempt 'to connect the visible with the invisible world, by a familiar and domestic atmosphere,' has totally failed. The

[1] The body seems to be fairly clearly male, see Plate XLV.

curtain that separates these worlds is still undrawn by mortal hands; and so we augur it will continue till that great day, when 'Heaven's portals shall be opened,' and the millions that now lie captive in the grave shall spring

―――― 'into life,
Day-light, and liberty.' ――――

Though all the prints bear the denomination of etchings, we discover the marks of the dry-point in most of them; but in some more than others. They are executed with much spirit and truth, yet we doubt whether Mr. Schiavonetti has done complete justice to the original drawings. A considerable time has elapsed since we had an opportunity of seeing them, but if our memory fails not, the defect of giving strong corporeal semblance to spiritual forms was much less glaring in them, than in the prints. The figures were more shadowy and insubstantial; and consequently, the effect of the whole was greatly improved.

One engraving we have yet to mention, and that is the *Portrait of Mr. Blake*, from a picture by T. Phillips, Esq. R.A. The bold and vigorous manner in which this is executed would alone confer a lasting fame on the talents of Schiavonetti, were all his other works destroyed. It represents a man about the middle period of life, with an open, expressive countenance, but accompanied by a wildness in the eye, by no means inconsistent with the ideas we might form of Mr. Blake, from what has been said above. The portrait itself, which the artist, with a most praiseworthy liberality, has presented to Mr. Cromek,[1] is a very fine and well painted picture; and will doubtless descend with admiration to posterity. We hail the abilities of Mr. Phillips, as fully calculated to support, and even to improve the rising character of the *English School*; for by that honourable term the concentrated productions of English artists ought now to be distinguished.

The dedication of this edition of the Grave to the Queen, written by Mr. Blake, is one of the most abortive attempts to form a wreath of poetical flowers that we have ever seen. Should he again essay to climb the Parnassian heights, his friends would do well to restrain his wanderings by the strait waistcoat. Whatever licence we may allow him as a painter, to tolerate him as a poet would be insufferable. The subscribers to this work amount to about six hundred.[2]

[1] The fact that Phillips *gave* the portrait (Plate XXIV) to Cromek is not known from other references.

[2] Anon., '*The Grave, a Poem, illustrated by Twelve Etchings, executed by Louis Schiavonetti, from the Original Inventions of William Blake*. 4to. pp. 50. £2. 12s. 6d. 1808, Cromek. Cadell and Davis', *The Antijacobin Review and Magazine*, xxxi (1808), 225–34.

In a pamphlet dated November 7th, W. P. Carey wrote: *November 7th, 1808*
'It is but justice to note, that we are indebted to Mr. Cromek
for the first intention of employing Mr. Stothard to paint the
picture of the *Procession of Chaucer's Pilgrims*. The same spirit
conceived the idea of employing that extraordinary Artist,
Blake, to compose his *grand designs* for *Blair's Grave*.'[1]

Two of Cumberland's sons, George Jr. and Sydney, were at
this time living with the Cromeks at 64 Newman Street and
working at the Army Pay Office in Whitehall. Both boys had
artistic inclinations, and their father was anxious that they
should meet men who could advise them well. Therefore in his
letter to George Jr. of Wednesday, November 30th Cumber- *November 30th, 1808*
land sent a long list of addresses, including Mr. S. Rogers,
Esq., Mr. Douce, Mr. Phillips, Mr. Cosway and '—Blake
No 17 South Molton St'.[2] On Thursday, December 1st Cumber- *December 1st, 1808*
land told his son George that his daughter (George's sister) was
coming to London laden down with commissions and errands:
'—I send Blake the Drawings by Georgiana I send Mr
Blake a few old Tracings from Raffaels Pictures in Fresco—
I shall keep a great many for you—and when you come to Draw a
little send them up to you a few at a time—send them to Blake
the first opportunity as things of little value to him being rude
sketches only—for those I keep for you are the best[.]'[3]

The Monthly Review for December 1st commented on Blake's
designs:

The series of engravings which is given under this title, in illus- *December 1st, 1808*
tration of the well known poem of *The Grave*, forms one of the most
singular works ever published in England. In respect to the executive

[1] *Critical Description of the Procession of Chaucer's Pilgrims* to Canterbury, Painted by Thomas Stothard, Esq. R.A. London, Published by T. Cadell and W. Davies, for R. H. Cromek, 64, Newman-Street. 1808. Pp. 10–11 fn. The preface is dated Nov. 7th, 1808. The reference above is printed unchanged (p. 8 fn.) in the second edition of 1818, and on p. v is a statement which also assigns the chief merit for *The Grave* to Cromek: 'His [*Cromek's*] series of engravings by the masterly hand of *Schiavonetti*, from BLAKE's imperishable designs, will for ever class among the finest productions of the British school.'
[2] BM Add. MSS. 36501, f. 298. Three weeks later, on Dec. 20th, George Jr. complained to his father (BM Add. MSS. 36501, ff. 317–18) that he wanted to move. 'It is very unpleasant at M.rs Cromek's . . . they take great liberty's with me, my home & abroad amusements & Study's are frustrated by their selfish dispositions, *true Yorkshire*.'
[3] BM Add. MSS. 36501, ff. 300–1. The letter ends with instructions to go to Church every Sunday, not to play cards, not to be seduced by liquor.

merits of the designs, there is considerable correctness and knowledge
of form in the drawing of the various figures; the grouping is fre-
quently pleasing, and the composition well arranged; some of them
have even an air of ancient art, which would not have disgraced the
Roman school. In the *ideal* part, or that which is supposed to connect
them with the poem, there is a wildness of fancy and eccentricity,
that leave the poet at a very considerable distance. Some are, perhaps,
exceptionable; such as, *The Soul exploring the Recesses of the Grave,*
represented by a female figure bearing a small light in her hand; and
the *Soul rejoining the Body,* under the same appearance of a female
rushing downwards to meet the embraces of the body which she had
left. It is almost needless to say, these are images, or conceptions
rather, which admit of no just graphic representations. *Death's Door*
is the best of the series [*see Plates XLVI, XLV, LIII*].

The author of these designs is an engraver of no mean talents in his
art, and is said to receive the conceptions of them from 'Visions bright,'
which, like the Muse of Milton—

> 'Visit his slumbers nightly, or when morn
> Purples the East.'[1]

A portrait of Mr. Blake is prefixed to the publication, etched with
spirit, from a picture by *Philips.* The head is finished with the graver,
and is an excellent specimen of art, in the utmost degree creditable
to Schiavonetti, by whose hand it is executed. The engraving indeed
is, throughout the whole series, highly commendable. The work is
accompanied by a warm and eloquent panegyric from the pen of
Fuseli, the learned keeper of the Royal Academy.[2]

December 4th, [1808] Young George Cumberland reported to his father on Sunday,
December 4th: 'Mr Blake was very much pleased with the
tracings[;] I thought it a good opportunity to ask him for the
Holy Family, which he gave very readily.'[3] In his reply to his
December 12th, 1808 son, on Monday, December 12th Cumberland began by cor-
recting his son's erratic orthography ('Tracings not tra*i*cings'),
and went on to correct his sense of decorum: '—I hope you did
not ask Blake for the Picture very *importunately*—I must send

[1] *Paradise Lost,* book vii, ll. 29–30. Oddly enough, Blake quoted exactly these
two lines in his letter to Dr. Trusler of Aug. 16th, 1799. Clearly the author of the
review had sources of information not restricted to Blair's *Grave.*

[2] Anon., 'The Grave; a Poem by Blair, illustrated by Twelve Etchings, executed
by Louis Schiavonetti, from the original Inventions of William Blake. 1808', *The
Monthly Magazine,* xxvi (1808), 458.

[3] BM Add. MSS. 36501, f. 302. The letter has no year in the date, but it clearly
answers the preceding letter of Dec. 1st, 1808. 'The Holy Family' is untraced.

him more of those heads, a few I keep for you—I shall retrace them all in Ink—tell me what passed.'[1]

Cumberland was so distressed at the possible indelicacy of his son that he wrote to Blake under cover to his son:

| your Line Dr George is at the end of the Sheet

Dear Blake,

A gentleman of my acquaintance to whom I was shewing your incomparable etchings last night, was so charmed with them, that he requested me to get him a compleat Set of all you have published in the way of *Books* coloured as mine are;[2]—at the same time he wishes to know what will be the price of as many as you can spare him, if all are not to be had, being willing to wait your own time in order to have them as those of mine are.

With respect to the money I will take care that it shall be reced[?] and sent to you through my Son as fast as they are procured.

I find by a Letter from my son that the picture you sent, he asked you for, which is what I do not approve, as I certainly had no such thing in contemplation when I sent you those very slight sketches from Raffael,— I Am glad however that you found them acceptable, and shall certainly send you a few more as soon as I can light on them among my papers.—The Holy family is like all your designs full of Genius and originality—I shall give it a handsome frame and shew it to all who come to my house.

—When you answer this pray tell me if you have been able to do any thing with the Bookseller.—something of that kind would be no bad thing, and might turn out a great one if a competition could be raised by this means among the genuine appre[*cia*]ters of talents of every sort— —You talked also of publishing your new method of engraving[3] —send it to me and I will do my best to prepare it for the Press.— perhaps when done you might with a few specimens of Plates make a little work for subscribers of it—as Du Crow[4] did of his Aqua tinta—

[1] BM Add. MSS. 36501, ff. 310–11.

[2] Cumberland probably owned most of Blake's works, but only *Thel* (A), *Songs of Innocence and of Experience* (F), *America* (F), *Visions* (B), *Song of Los* (D), *Job*, *For Children : The Gates of Paradise* (C), *Poetical Sketches* (D), *Descriptive Catalogue*, and *Europe* (D) can be traced to him.

[3] See Summer 1807. Two further references to this project were apparently made before and after Blake's reply to the letter above:
Blakes new Mode of Engraving to be Published by me at his desire [*In another ink:*] He will publish it—
New Plan for really encouraging the arts by buying Pictures of Moderns— (BM. Add. MSS 36519i, f. 385, some time in 1808). Blake's 'Mode of Engraving' his Illuminated Works is still not known with any certainty.

[4] Probably this is Pierre Ducros (1745–1810), the painter and engraver, whose

selling about 6 Pages for [half *del*] a guinea to non Subbscriers—but if you do not chuse this method, we might insert it in Nicholsons Journal or the Monthly Magazine.[1]—with reference to you for explanations—with best regards to you & yours I am always

Your sincere friend

Culvert St 18 Dec. 1808— G Cumberland

Dear George

[Take the above to Mr Blake, and *del*] Go on receipt of this to Black Friars & when You have been to Sr. R Phillips to know if he got my 24 Pages of Biography[2] sent by *Fromonts* Coach carriage Paid & booked on Wednesday last—take the above to Mr Blake and get him to answer it *directly* on the Sheet of Paper on which you write your answer as to the receit of the Biography of Grignion—but say nothing to his Brother as to where I publish it as yet. I shall ret^n his Papers. All well & all desire love. Yours

GC.

PS. If you have my Lett. through S. R Phillips—it is come safe.[3]

Young George promptly took the letter round to Blake, and persuaded him to write an immediate reply:

Dear Cumberland

I am very much obliged by your kind ardour in my cause & should immediately Engage in reviewing my former pursuits of printing if I had not now so long been turned out of the old channel into a new one that it is impossible for me to return to it without destroying my present course[.] New Vanities or rather new pleasures occupy my thoughts[.] New profits seem to arise before me so tempting that I have already involved myself in engagements that preclude all possibility of promising any thing. I have however the satisfaction to inform you that I have Myself begun to print an account of my various Inventions in Art for which I have procured a Publisher & am de-

landscapes were widely published, collected, and admired (*Biographie Universelle*, 1814).

[1] Cumberland's letter ('Hints on various Modes of Printing from Autographs') to William Nicholson's *Journal of Natural Philosophy*, xxviii (Jan. 1811), 56–59, does not describe Blake's process, though it does say that '*Blake* . . . alone excels in that art' of perusing backwards, or, as a footnote plausibly suggests, of writing backwards.

[2] Cumberland's unsigned 'Sketch of the Biography of Charles Grignion, Esq.' appeared in *The Monthly Magazine*, xxvi (Jan. and Nov. 1809), 548–53 and 377–9.

[3] BM Add. MSS. 36501, ff. 312–13. The reason why this letter is preserved, of course, is that young George Cumberland reclaimed it after Blake had read it, to make sure that he had carried out all his father's commissions. I take the P.S. to mean that if George had received this letter, which his father had enclosed with the parcel to Phillips, he could assume that the parcel with the biography had also 'come safe'.

termind to pursue the plan of publishing what I may get printed without disarranging my time which in future must alone be devoted to Designing & Painting[;] when I have got my Work printed I will send it you first of any body[;] in the mean time believe me to be

Yours Sincere Friend

19 Dec^r 1808[1] Will Blake

According to Gilchrist, Blake's disappointment in publishing his 'Inventions in Art' was not an isolated experience. 'Many an unsuccessful application to the trade, as to undertaking some book of his he, in his time, had to make. "Well, it is published elsewhere," he, after such an one, would quietly say, "and beautifully bound."'[2]

Cromek's edition of *The Grave* was still being offered for sale as late as December 1808,[3] as is demonstrated by the following advertisement leaf published with Cromek's edition of the *Reliques of Robert Burns*, 1808:

Blake's Illustrations of Blair. / *Just published by Messrs. Cadell and Davies,*[4] *elegantly printed in* / *imperial quarto, by* Bensley, *price 2l. 12s. 6d. in extra boards.* / THE GRAVE, / A Poem, by Robert Blair. / Illustrated by 12 Prints, exquisitely engraved by Louis Schiavonetti, from the original inventions of William / Blake. With an introductory Preface to the Designs, by Henry / Fuseli, Esq. R.A. Keeper of the Royal Academy. / The Subjects that compose this Volume.

December 1808

I. *The descent of Christ into the Grave.*

II. *The Descent of Man into the Vale of Death.*

III. *Death's Door.*

[1] This letter (BM Add. MSS. 36501, f. 314) has no cover or address, and was obviously enclosed by George Jr. in a letter to his father.

[2] Gilchrist, 1942, pp. 258-9; 1863, p. 245. This anecdote, particularly the last three words, sounds apocryphal to me. I doubt that Gilchrist had a specific book or quotation in mind.

On July 30th, 1904 Robert Hayley Clarke (son of Jane Austen's patron James Stanier Clarke, who in 1828 bought a copy [E] of *Songs of Innocence*) wrote to Mary J. Matthews (daughter of Garth Wilkinson) that 'Blake's publisher was a Mr. Hunter, Bookseller & Publisher in St. Paul's Churchyard, successor to a Mr. Johnson, who published Cowper's Poems. I remember Mr. Hunter very well —a remarkable and very interesting man—an intimate friend of my Father's' (G. Keynes, 'Blake, Tulk, and Garth Wilkinson', *The Library*, 4 S, xxvi [1945], 192). Johnson's name appeared on the title-pages of only *The French Revolution* (1791, unpublished) and *For Children: the Gates of Paradise* (1793), but no other direct connection between Blake and Hunter is known.

[3] *The Monthly Magazine* announced in its number for Dec. 1808 (vol. xxvi) that Cromek's *Burns* would soon be out.

[4] Cadell & Davies is the only one of the seven publishing firms on the title-page of *The Grave* to be mentioned here because they also published the *Burns*.

IV. *The strong and wicked Man Dying.*
V. *The Good old Man Dying.*
VI. *The Soul reluctantly parting with the Body.*
VII. *The Soul exploring the recesses of the Grave.*
VIII. *The Counseller, King, Warrior, Mother, and Child in the Tomb.*
IX. *The Skeleton re-animated on the sound of the Archangel's Trumpet.*
X. *The re-union of Soul and Body.*
XI. *A Family meeting in Heaven.*
XII. *The last Judgment.*[1]

A very few Copies of this unique and classical work have / been printed on large Paper, with *Proof Impressions* of the / Plates.—Price Four Guineas.

Perhaps the abortive nature of Blake's publishing plan may be explained by Cumberland's note to his son George on January 22nd, 1809: '—Tell *Blake* a Mr Sivewright of Edinburg has just claimed in Home Philosophical Journal of Last Month As his own invention Blakes Method—& calls it Copper Blocks I think.'[2]

January 22nd, 1809

It may have been in the spring of 1809 that the Blakes were visited by a young Irishman, who wrote half a century later: 'I had the felicity of seeing this happy pair in their one appartment in South molton st[;] the Bed on one side and picture of Alfred and the Danes on the wall[.] 1809 M Cregan'.[3]

Spring ? 1809

In August 1809 when Mr. and Mrs. Butts went on holiday to their country place at Epsom, young Tommy wrote to his mother on Monday the 14th: 'This morning I breakfasted with George before I went to South Molton Street; you wished me to do so while you and my Father are out of Town. Mr. and Mrs.

August 14th, 1809

[1] The plates are given in the order of the description 'Of the Designs' rather than in the order in which they were bound.

[2] BM Add. MSS. 36501, ff. 360–1. There is no 'Home Philosophical Journal'. The inventor is probably identical with: (1) 'John Sivewright, Teacher of Music' (*c.* 1770–1846), author of *A Collection of Church Tunes & Anthems* (Edinburgh, *c.* 1805); (2) John Sievwright, Engraver, who, according to Miss Marion Linton, appears in the Edinburgh directories for 1805–15; (3) 'Mr Sivright', to whom W. H. Lizars 'was much indebted' 'during these experiments' to perfect a method of stereotype engraving which sounds very like Blake's (*Edinburgh Philosophical Journal*, ii [1820], 23).

[3] Martin Cregan (1788–1870) wrote this comment beside the account of Blake in his copy (now in the London Library) of Richard and Samuel Redgrave, *A Century of Painters of the English School*, London, 1866, vol. i, p. 448. Cregan was later president of the Royal Hibernian Society. The 'picture of Alfred and the Danes' may be connected with Blake's exhibition picture of 'The Ancient Britons' at 'the last Battle of King Arthur', which Blake so much fancied.

PLATE XXXI

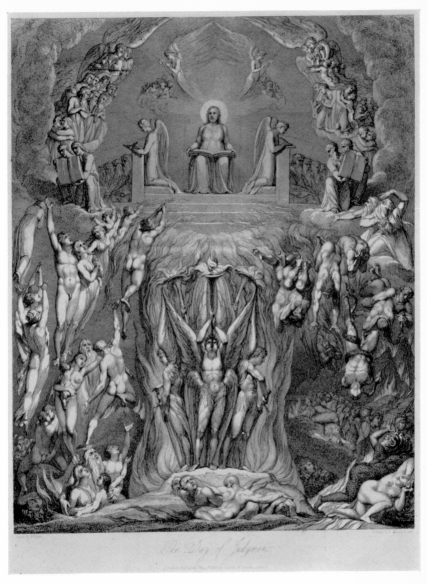

'THE DAY OF JUDGMENT', a proof of Schiavonetti's etching for Blair's *Grave* (1808). Robert Hunt was offended by the 'most indecent attitudes' of the couple near the lower left corner (see pp. 196–7)

Blake are very well, they say I am browner and taller;—they intend shortly to pay the promised visit at Epsom.'[1]

Blake had always been handicapped in his attempts to show his pictures under the auspices of the institutions of his time, and after 1808 he exhibited pictures only once more at the public galleries. In an advertisement of May 15th, 1809 he explained his difficulty and his solution to the problem:

The execution of my Designs, being all in Watercolours, (that is in Fresco) are regularly refused to be exhibited by the *Royal Academy*, and the *British Institution* has, this year, followed its example, and has effectually excluded me by this Resolution; I therefore invite those Noblemen and Gentlemen, who are its Subscribers, to inspect what they have excluded: and those who have been told that my Works are but an unscientific and irregular Eccentricity, a Madman's Scrawls, I demand of them to do me the justice to examine before they decide.... They have ex[c]luded Water-colours; it is therefore become necessary that I should exhibit to the Public, in an Exhibition of my own, my Designs, Painted in Water-colours.

The exhibition of Blake's paintings at his brother's house at 28 Broad Street apparently opened about the middle of May 1809, and was scheduled to continue until September 29th.[2] The only known review of the exhibition was an essay in *The Examiner* for September 17th by Robert Hunt.

If beside the stupid and mad-brained political project of their rulers, the sane part of the people of England resquired [*sic*] fresh proof of the alarming increase of the effects of insanity, they will be too well convinced from its having lately spread into the hitherto sober region of Art. I say hitherto, because I cannot think with many, that the vigorous genius of the present worthy Keeper of the Royal Academy[3] is touched, though no one can deny that his Muse has been on the verge of insanity, since it has brought forth, with more legitimate offspring, *September 17th, 1809*

[1] M. Wilson, *The Life of William Blake*, London, 1948, p. 84, prints this extract but omits to give her source. Presumably it was 'Mrs. Colville-Hyde, widow of Captain Butts', to whom she expresses thanks in her preface (p. xii); see May 13th, 1800. Probably these regular visits to South Molton Street were for his engraving lessons.

[2] The ad is dated in MS. May 15th, 1809, and the catalogue itself announces the terminal date. Clearly, however, the exhibition stayed open beyond Sept. 1809.

[3] Fuseli was Keeper at the Royal Academy. It may well have been with this passage in mind that Blake wrote (Notebook, p. 25):

To H[unt]
You think Fuseli is not a Great Painter[.] Im Glad[:]
This is one of the best compliments he ever had[.]

the furious and distorted beings of an extravagant imagination. But, when the ebullitions of a distempered brain are mistaken for the sallies of genius by those whose works have exhibited the soundest thinking in art, the malady has indeed attained a pernicious height, and it becomes a duty to endeavour to arrest its progress. Such is the case with the productions and admirers of WILLIAM BLAKE, an unfortunate lunatic, whose personal inoffensiveness secures him from confinement, and, consequently, of whom no public notice would have been taken, if he was not forced on the notice and animadversion of the EXAMINER, in having been held up to public admiration by many esteemed amateurs and professors as a genius in some respect original and legitimate. The praises which these gentlemen bestowed last year on this unfortunate man's illustrations of *Blair's Grave*, have, in feeding his vanity, stimulated him to publish his madness more largely, and thus again exposed him, if not to the derision, at least to the pity of the public. That work was a futile endeavour by bad drawings to represent immaterially[1] by bodily personifications of the soul, while it's partner the body was depicted in company with it, so that the soul was confounded with the body, as the personifying figure had none of the distinguishing characteristics of allegory, presenting only substantial flesh and bones. This conceit was dignified with the character of genius, and the tasteful hand of SCHIAVONETTI, who engraved the work, assisted to give it currency by bestowing an exterior charm on deformity and nonsense. Thus encouraged, the poor man fancies himself a great master, and has painted a few wretched pictures, some of which are unintelligible allegory, others an attempt at sober character by caricature representation, and the whole 'blotted and blurred,'[2] and very badly drawn. These he calls an Exhibition, of which he has published a Catalogue, or rather a farrago of nonsense, unintelligibleness, and egregious vanity, the wild effusions of a distempered brain. One of the pictures represents *Chaucer's Pilgrims*, and is in every respect a striking contrast to the admirable picture of the same subject by Mr. STOTHARD, from which an exquisite print is forthcome from the hand of SCHIAVONETTI. 'In this Exhibition,' Mr. BLAKE very modestly observes, 'the grand style of art is restored; and in it will be seen *real* art, as left us by RAPHAEL and ALBERT DURER, MICHAEL ANGELO and JULIO ROMANO, stripped from the ignorances of RUBENS and REMBRANDT, TITIAN and CORREGGIO.'[3] Of the engraving which he proposes to make from his picture of

[1] This is obviously a misprint for 'immateriality'. In his Notebook (p. 62) Blake wrote of the critic 'Who cries all art is fraud & Genius a trick And Blake is an unfortunate lunatic'.

[2] *Descriptive Catalogue.* Most of these quotes are somewhat inaccurate.

[3] Advertisement for the Catalogue. The first nineteen words of the quotation are a paraphrase rather than a direct quote. It may be some justification of Blake's

PLATE XXXII

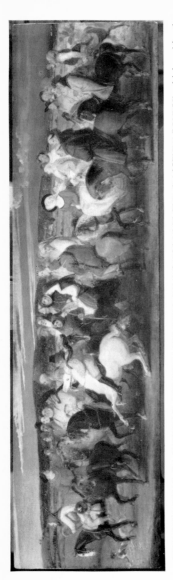

a. STOTHARD'S PAINTING OF 'CHAUCER'S PROCESSION TO CANTERBURY' which evidently made the fortune of Cromek but not of Stothard

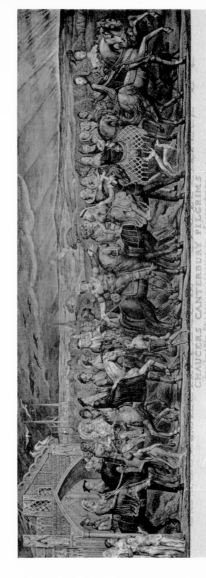

b. BLAKE'S ENGRAVING OF 'CHAUCER'S CANTERBURY PILGRIMS' (1810), the second state, much reduced in size. The painting for this plate was, Blake claimed, the model for Stothard's

the *Canterbury Pilgrims*, and to finish in a year, he as justly, soberly, and modestly observes, 'No work of art can take longer than a year: it may be worked backwards and forwards without end, and last a man's whole life, but he will at length only be forced to bring it back to what it was, and it will be worse than it was at the end of the first twelve months. The value of this artist's year is the *criterion of society*; and as it is valued, so does society *flourish or decay*.'[1] That insanity should elevate itself to this fancied importance, is the usual effect of the unfortunate malady; but that men of taste, in their sober senses, should mistake its unmeaning and distorted conceptions for the flashes of genius, is indeed a phenomenon.

A few extracts from Mr. BLAKE's Catalogue will at once amuse the reader, and satisfy him of the truth of the foregoing remarks. Speaking of his picture of the *Ancient Britons*, in which he has attempted to represent 'the strongest man, the beautifullest man, and the ugliest man', he says—

'It has been said to the artist, take the Apollo for the model of your beautiful man, and the Hercules for your strong man, and the Dancing Fawn for your ugly man. Now he comes to his trial. He knows that what he does is not inferior to the grandest Antiques. *Superior they cannot be, for human power cannot go beyond either what he does, or what they have done; it is the gift of God, it is inspiration and vision.* He has resolved to emulate those precious remains of antiquity; he has done so, and the result you behold; his ideas of strength and beauty have not been greatly different. Poetry as it exists now on earth, in the various re-mains of ancient authors, Music as it exists in old tunes or melodies, Painting and Sculpture as it exists in the remains of antiquity, and in the works of more modern genius, is inspiration, and cannot be sur-passed; it is perfect and eternal. Milton, Shakspeare, Michael Angelo, Rafael, the finest specimens of Ancient Sculpture and Painting, and Architecture, Gothic, Grecian, Hindoo and Egyptian, are the extent of the human mind. The human mind cannot go beyond the gift of God, the Holy Ghost. To suppose that art can go beyond the finest speci-mens that are now in the world, is noi [*sic*] knowing what art is; it is being blind to the gifts of the spirit.'[2]

This picture is a complete caricature: one of the bards is singing to his harp in the pangs of death; and though the colouring of the flesh is exactly like hung beef, the artist modestly observes—

opinion to know that '"He had picked up his notions of Titian," says Mr Palmer, "from picture-dealers' 'Titians'!"' (Gilchrist, 1942, p. 273; 1863, p. 264). We may be confident, however, that, though Titians were often misattributed and forged, Blake had seen some genuine Italian paintings in the collections of friendly con-noisseurs such as the Aders, Egremont, George Cumberland, and others.

[1] Prospectus of Chaucer. See Plate XXXII. [2] *Descriptive Catalogue.*

'The flush of health in flesh, exposed to the open air, nourished by the spirits of forests and floods, in that ancient happy period, which history has recorded, cannot be like the sickly daubs of Titian or Rubens. Where will the copier of nature, as it now is, find a civilized man, who has been accustomed to go naked. Imagination only can furnish us with colouring appropriate, such as is found in the frescos of Rafael and Michael Angelo: the disposition of forms always directs colouring in works of true art. As to a modern man stripped from his load of clothing, he is like a dead corpse. Hence Rubens, Titian, Corregio, and all of that class, are like leather and chalk; their men are like leather, and their women like chalk, for the disposition of their forms will not admit of grand colouring; in Mr. B.'s Britons, the blood is seen to circulate in their limbs; he defies competition in colouring.'[1]

Mr. BLAKE, in another part says, 'Rubens is a most outrageous demon, and by infusing the remembrances of his pictures and style of execution, hinders all powers of individual thought. Corregio is a soft and effeminate, and consequently a most cruel demon, whose whole delight is to cause endless labour to whoever suffers him to enter his mind.'[2] 'The great and golden rule of art, as well as of life, is this: That the more distinct, sharp, and wirey the bounding line, the more perfect the work of art.'[3] Mr. BLAKE concludes thus:—

'If a man is master of his profession, he cannot be ignorant that he is so; and if he is not employed by those who pretend to encourage art, he will employ himself, and laugh in secret at the pretences of the ignorant, while he has every night dropped into his shoe, as soon as he puts it off, and puts out the candle, and gets into bed, a reward for the labours of the day, such as the world cannot give, and patience and time await to give him all that the world can give.'[4]

As the result of such attacks, 'The Cunning sures & the aim at yours' became anathema to Blake, and in a violent doggerel poem about his enemies he associated Hunt, who had bitterly attacked him, with Prince Hoare, who had merely praised his enemy:

> The Examiner whose very name is Hunt
> Calld Death a Madman trembling for the affront

[1] *Descriptive Catalogue.*
[2] *Descriptive Catalogue.* After 'individual thought' ninety words are silently suppressed. [3] *Descriptive Catalogue.*
[4] *Descriptive Catalogue.* Hunt's article is an unsigned one under 'Fine Arts' entitled 'Mr. Blake's Exhibition', *The Examiner*, 17th Sept., 1809, pp. 605–6. (For his authorship, see Aug. 7th 1808.) Clearly Robert Hunt himself had been at the exhibition but his outburst is directed chiefly at the catalogue rather than at the pictures.

Like trembling Hare sits on his weakly paper
On which he usd to dance & sport & caper[.][1]

Blake's exhibition was kept open beyond the scheduled closing date of September 29th in the hope of attracting more of the 'Fit audience' which Blake had anticipated in his Advertisement. One of those who came in October 1809 was evidently young George Cumberland, who wrote to his father with some relish on Saturday the 14th: 'Blakes has published a Cata- *October* logue of Pictures being the ancient method of Frescoe Painting *14th,* *Restored.*—you should tell Mr Barry to get it, it may be the *1809* means of serving your Friend[;] it sells for 2/6. and may be had of J. Blake. 28. Broad St Golden Square at his Brothers— the Book is a great curiosity. He [*h*]as given Stothard a com- pleat set down—give my love to all[.]'[2] Cumberland was evi- dently intrigued by his son's report, for three weeks later, on Sunday, November 5th, he told young George: 'send by Abing- *November* don 2 vols of Blakes work & make my regards to Blake—MC *5th,* will pay you the 5/- for them—'.[3] *1809*

When it came, Cumberland was fascinated by the Catalogue, as were all Blake's contemporaries who came across it, but his comments in his letter to his son of Monday, November 13th were rather kinder than most:

Blakes Cat. is truly original—part vanity part madness—part very *November* good sense—is this the work of his you recommended, and of which I *13th,* gave you a Comm̃ to buy *two* sets one for me and one for Mr Barrys *[1809]* Library?—did he sell many Pictures? and had he many subscribers to the Wife of Bath?— Tell him with my best regards if I was not among the Subscribers it was because I literally cannot afford to lay out a shilling in any thing but *Taxes & necessaries of Life*[.][4]

[1] Notebook, pp. 40, 22. The three-headed mythological figure 'Hand' in the Prophecies may be taken to represent the three editorial Hunts *en masse*, from the pointing-finger symbol used in the *Examiner* to identify pieces written by the editor. 'Hand' appears in *Milton*, pp. 17, 20, and *Jerusalem*, pp. 5, 7–9, 15, 17–19, 21, 32, 34, 36, 42, 43, 58, 60, 67, 70, 71, 74, 80, 82–84, 90.

[2] BM Add. MSS. 36502, f. 83. Mr. Barry was a bookseller of Bristol who is occasionally mentioned in Cumberland's letters. Since the *first* reference to Blake's exhibition is on Sept. 17th, 1809, it seems possible that its opening may have been considerably delayed.

[3] BM Add. MSS. 36502, f. 95.

[4] BM Add. MSS. 36514, f. 216. There is no year in the date, but there can be no doubt this letter is a sequel to that of Nov. 5th, 1809. The answers to Cumberland's questions were, respectively: Yes; No; and No.

November To this young George answered: 'Mʳ Blake has nothing but the
1809 remarks on his Chaucer—have you seen the etching of Mr
Stothard Pilgrims[?] it is finished[.]'[1] (See Plate XXXII.)

Blake had been teaching Tommy Butts since the spring of
1806, and through him he met a young man named Seymour
Stocker Kirkup, then about twenty-one years old. In 1865,
over half a century later, Kirkup still remembered Blake vividly,
and wrote about him to Swinburne:

1809–10 It was Mʳ Butts of the war-office who introduced me to Blake. He
placed his son with him as a pupil to learn engraving that he might
possess a manuel art to serve him as a reso[u]rce in case of any mis-
fortune such as losing his situation. I don't think they knew Blake's
value though he was painting the master-piece at the time, the great
fresco on canvass (an invention of his own) which made such an
impression on my mind that I could draw it now, after a lapse of 55
years or more—although I was a partisan of the colourists, his oppo-
nents, & thought him mad[2]—as I always treated him with respect &
did not presume to contradict him he was very kind & communicative
to me—& so I believe he was to every body except Schiavonetti. I
used to wonder [at] his praise of Fuseli and Flaxman, my two first
masters, for their tastes were so different to his, wʰ Fuseli especially
disliked & he was a magnanimous fellow though a sharp critic[.][3]

Five years later Kirkup was even more explicit in a letter to
Lord Houghton:

¹ BM Add. MSS. 36515, ff. 84–85, n.d.
² Some three months later, on Feb. 27th, 1866, Kirkup wrote to W. M. Rossetti
(*Rossetti Papers*, London, 1903, pp. 177–8): 'I believe I have pretty well exhausted
my recollections of poor Blake in what I wrote to Swinburne. It is so long ago, and
I was ignorant enough to think him mad at the time, and neglected sadly the oppor-
tunities the Buttses threw in my way. I only heard of him as an engraving-master
to my old schoolfellow Tommy. They (Butts) did not seem to value him as we do
now. I was of the opposite party of colourists, and still a great admirer of Flaxman,
Fuseli, and Stothard, who had infinitely more power in drawing than Blake. The
two former were really my friends. Still, the impression which Blake's *Ancient
Britons* made on me (above all others) was so strong that I can answer for the
truth of my sketch, as will be proved if the picture is ever found. . . . [*sic*] Blake
had but little effect in the works that I remember. I should have liked the heads
more English and less Grecian.'
³ The MS. of Kirkup's letter of Nov. 30th, 1865 is in the Library of Trinity
College, Hartford, Connecticut. Fuseli and Flaxman were presumably Kirkup's
'two first masters' in the sense that they oversaw his work at the Royal Academy.
Kirkup apparently had kept in touch with friends of Blake, for he told Swinburne
in conversation 'the story . . . of Mrs. Blake and the Princess Sophie' (see p. 345),
events which occurred when Kirkup was in Italy.

W. Blake. I was much with him from 1810 to 1816, when I came abroad, and have remained in Italy ever since. I might have learned much from him. I was then a student of the Royal Academy, in the antique school,[1] where I gained a medal, and thought more of form than anything else. I was by nature a lover of colour, and my *Beau Ideal* was the union of Phidias and Titian. Blake was the determined enemy of colourists, and his drawing was not very academical. His high qualities I did not prize at that time; besides, I thought him mad. I do not think so now.[2] I never suspected him of imposture. His manner was too honest for that. He was very kind to me, though very positive in his opinion,[3] with which I never agreed. His excellent old wife was a sincere believer in all his visions. She told me seriously one day, 'I have very little of Mr. Blake's company; he is always in Paradise.'[4] She prepared his colours, and was as good as a servant.

[1] According to the record book still kept in the British Museum Print Room, on the recommendation of Fuseli, Seymour Kirkup of Leicester Place was issued a ticket and recorded on Saturday, Nov. 11th, 1809 as one of the first 'Students Admitted to the Gallery of Antiquities' in the British Museum. The tickets were good for six months, and Kirkup received new tickets on Saturday, July 14th and and Saturday, Nov. 10th 1810; Saturday, July 13th, 1811 (having then moved to Harpur Street); Saturday, Feb. 8th and Saturday, Nov. 14th, 1812. It was probably in this period (1809–12) that he was seeing most of Blake.

[2] Seymour Kirkup wrote to W. M. Rossetti on Jan. 19th, 1866 (*Rossetti Papers*, London, 1903, p. 171): 'When I had the short pleasure of seeing you [in 1860], I had long been living an exceptional life of incredible phenomena, and since then they have increased beyond any expectation of mine. Do not think that any early acquaintance I had with W. Blake can have led to it. I thought him mad; and, after I left England in 1816, I heard no more of him, till I heard that Lord Houghton was collecting his works at a great expence! I had picked up Blair's *Grave*, and five little engravings by Blake himself. I have very lately had a sight of his Life by Gilchrist. I don't think him a madman now. . . . Blake was an honest man, and I always thought so—but his sanity seemed doubtful because he could only give his word for the truth of his visions. There were no other proofs, and what was so incredible required the most perfect proofs; such as, with the most jealous, scrupulous, suspicious investigation, have been for eleven years by me directed to the subject.'

[3] This statement seems somewhat at variance with Kirkup's report to Swinburne 'of the courtesy with which, on occasion, Blake would waive the question of his spiritual life, if the subject seemed at all incomprehensible or offensive to the friend with him: he would no more obtrude than suppress his faith, and would practically accept and act upon the dissent or distaste of his companions without visible vexation or the rudeness of a thwarted fanatic.' (A. C. Swinburne, *William Blake*, London, 1868, p. 81.)

[4] On Feb. 24th, 1870 C. E. Norton reported to James Russell Lowell a conversation he had had with Seymour Kirkup in Florence (*Letters of Charles Eliot Norton*, ed. S. Norton and M. A. D. Howe, Boston and N.Y., 1913, vol. i, p. 376): 'Yes, I knew Blake well, and liked him, and respected him, for he was one of the honestest and most upright, and most sincere men I ever knew. I used to think him mad then, but I think now he was quite sound. There never was an honester man than he,

He had no other. It was Mr. Butts who introduced me to him. I was a schoolfellow of his son's, whom he sent to Blake to learn engraving, which was his original art. Let me tell you now of a large picture he painted in my time. I thought it his best work—a battle from the Welsh Triads. The three last men who remained of Arthur's army, and who defeated the enemy—the strongest man, the handsomest man, and the ugliest man. As he was an enemy to oil painting, which he said was the ruin of painting, he invented a method of applying fresco to canvas, and this life-size picture was the result. It made so great an impression on me that I made a drawing of it fifty years afterwards, which I gave to Swinburne. You can see it.[1] It (the picture) must have been about 14 feet by 10. In texture it was rather mealy, as we call it, and was too red; the sun seemed setting in blood. It was not Greek in character. Though the figures reminded one of Hercules, Apollo, and Pan, they were naked Britons. If you should ever hear of it, it is worth seeking. There is more power and drawing in it than in any of his works that I have known, even in Blair's grave, respecting which he was enraged against Schiavonetti for correcting some defects. In general, engravers fail to do justice, and the most precious works have been etched by the painters themselves.[2]

Probably at the same time Blake had another student, William Seguier. Many years later George Darley, an acquaintance of Seguier's, wrote:

He once informed us, as we recollect, of his having been 'taught' by the celebrated William Blake—how different the master and the pupil! how different their lot! Blake earned eighteen shillings a week and immortal renown, while his scholar earned the directorship of almost all the great picture galleries—and such slight memorials as this [*obituary*]! But if he did not imbibe any of that fanciful painter's sublime and singular genius, Nature had bestowed upon him a far more profitable gift—common sense[3]

or one who lived in a finer poverty,—poor but strictly simple in his habits. I remember his wife, who was a very nice good woman, once said to me, "Oh I have very little of Mr. Blake's company, he passes all his life in Paradise" '.

[1] *Rossetti Papers*, p. 72: 'I have just made a sketch of Blake's *Three Heros of Camlan [The Ancient Britons]* from memory, after above half a century. It was his masterpiece.' Neither the original nor Kirkup's copy has survived, but Blake described the picture in some detail in his *Descriptive Catalogue*.

[2] T. W. Reid, *The Life, Letters, and Friendships of Richard Monckton Milnes, First Lord Houghton*, London, 1890, vol. ii, pp. 222–3, quoting Kirkup's letter of March 25th, 1870.

[3] [George Darley], 'Mr. William Seguier', *The Athenaeum*, Nov. 18, 1843, p. 1028; the author is identified in C. Abbott, *The Life and Letters of George Darley*

Blake's fortunes were fast declining at this time. At the end of 1810 he apparently lost his steadiest patron, for there are no receipts from Butts after December 1810. He settled deeper and deeper into obscurity among his contemporaries, and we know very little of how he lived or what he did from 1810 to 1814.

In the spring of 1810 Crabb Robinson began to seek out all he could learn of Blake, and to record it, as he did the conversation of Flaxman, Coleridge, Lamb, Wordsworth, Hazlitt, and others.[1] Years later, when he was compiling his 'Reminiscences', Robinson summarized his early impressions of Blake:

I was amusing myself this Spring [*of 1810*] by writing an account of the insane poet painter & engraver *Blake*—Perthes of Hamburg had written to me asking me to send him an article for a new German magazine entitled Vaterlandische Annalen which he was about to set up and D[r] *Malkin* having, in the the memoirs of his Son given an account of this extraordinary genius with Specimens of his poems I resolved out of these to compose a paper And this I did and the paper was translated by D[r] Julius who many years afterwards introduced himself to me as my translator—It appears in the single number of the Second volume of the Vaterlandische Annalen.

Poet and Critic, London, 1928, p. 165. About this time was painted a portrait inscribed 'From Mr. Fuseli's sale—William Blake—drawn from life by G. Harlow' (Sotheby catalogue of July 29th, 1925, Lot 147). The portrait was not named in the only Fuseli sale known to me, that at Christie's, May 28th, 1827.

[1] All the MSS. of Crabb Robinson quoted here are in Dr. Williams's Library, London. The journals are referred to as follows: (1) The 'Small Diary': a bare record of meetings, expenses, and the like from 1810 on, kept in German in small printed diaries or journals. (2) The 'Diary': a series of larger books with blank leaves wider than they are high, with the entries written-in perpendicularly—i.e., at right angles to the line one would normally expect. These books contain an ordinary diary, beginning in 1811, with about half a page to a day, written at the time of the events they report, and consisting of conversations, impressions, ideas, etc. Occasionally the Diary and the Small Diary do not report identical topics—that is, the larger Diary often deals with matters not found in the smaller one, as will be seen below. There are dozens of volumes of the Diary and the Small Diary. (3) The 'Reminiscences' (so called by HCR): a series of four fat volumes that cover a period beginning with 1810, though written about 1852. The Reminiscences are clearly bulked out from the Diary, which it quotes in extenso. Since these MSS. are clearly organized by date, I shall hereafter refer to them simply as Small Diary, Diary, and Reminiscences, with the date, without further explanation. The Reminiscences, covering chiefly 1825–8, will be found at pp. 535–49. I should point out that I have not attempted to do any original research among these papers, except to correct the transcripts of E. J. Morley and her predecessors, and to turn up the new references in the Small Diary for 1810.

In his Small Diary he jotted down under Thursday, April 19th, 1810: 'Bey Upcott[1] der unter Bibliotheker Lond Instit—zugle mir curiose Sachen v. Blake'.[2]

Robinson's powerful curiosity was stimulated by this conversation, and he noted in his Small Diary for the next day: 'Good Friday. Vorm. copirte Blake's Gedichte[3] bey M^{rs} Iremonger'. Miss Iremonger was 'a literary lady [of some talent and more pretension] who lived in Up: Grovesnor St^t', to whom Robinson 'took . . . a letter of introduc^t from M^{rs} Hare Naylor'. 'She was a Unitarian . . . a sort of free-thinker—She kept good company And I owed her much by introduc^g me to some of my genteelest friends', including 'M^r & Miss Hope, the Brother-in-law, (a widower) & niece of M^{rs} Hare[-*Naylor*]', and 'Miss [*Catherine Louisa*] Shipley too, Sister to M^{rs} Hare[-*Naylor*], and who is my particular friend', whom she invited him to meet at dinners at her house.[4] She was adding to 'My Collection of

[1] William Upcott was the bastard son of Ozias Humphry, to whom Blake sent the advertisement to his Exhibition and a letter in May 1809. Upcott owned *Songs of Experience* (H), *America* (H), and *Europe* (D).

[2] Quoted, like all Robinson's MSS., from the originals in Dr. Williams's Library. Beside the entries for March 8th to 11th, 1810 in the Small Diary Robinson wrote: 'Blake's Catalogue of his Drawings', and sideways beside March 25th, 1810 is 'Blake's Poems'. The conjunction of the entries with these dates, however, is simply coincidental: Robinson had regular spaces for his expenses, had be been recording the purchase of these books. Probably these are merely memoranda jotted down in an odd corner—to remind him to return a borrowed book, or perhaps to buy one.

[3] There are in Dr. Williams's Library Crabb Robinson's transcripts (with only very minor variations from Blake's etched texts or *Vaterländische Museum*) of *To the Muses' and 'Song [How Sweet I Roamed]' from *Poetical Sketches*; *'Introduction', 'The Divine Image', 'Night', 'The Little Black Boy', and 'The Chimney Sweeper' from *Innocence*; *'The Tyger', *'The Garden of Love', 'Introduction', 'Earth's Answer', 'A Little Boy Lost', 'A Poison Tree', 'The Sick Rose', and 'The Human Abstract' from *Experience*; and 'The Dedication of the Designs to Blairs Grave' (starred poems are those printed in *Vaterländische Museum*). There are no transcriptions in Dr. Williams's Library of 'Holy Thursday' from *Innocence* or the fragments from *Europe*, *America*, and the *Descriptive Catalogue* which Robinson gave in *Vaterländische Museum*. Robinson may have seen Upcott's copies of *America* and *Europe*, and he may have acquired *Poetical Sketches* himself (see fn. 2 above); he bought the *Descriptive Catalogue* on April 23rd, 1810.

[4] Robinson's MS. 'Reminiscences 1805'; Miss Iremonger's letters to HCR of Dec. 21st, 1805, Jan. 6th, 1806; and HCR's notes about her written on the letters. According to *Dear Miss Heber*, ed. F. Bamford, London, 1930, pp. 238–40, 248, 268, Elizabeth Iremonger was the daughter of the Revd. Joshua Iremonger and sister of Lascelles and Joshua Iremonger (whose library was sold posthumously at Sotheby's July 28–30, 1817). She was a guest of the dowager Lady Spencer in 1789 (*The Hamwood Papers*, ed. G. H. Bell, London, 1930, p. 186). Thomas Hope,

Livres Choisies' especially in the 1790s, when she wrote: 'Quiet & Retirement, Rural Simplicity & neatness . . . Books to my Taste, & a Friend to my Heart—these are requisite ingredients to my System of Happiness &, possessing these, I have not a Wish for more.'[1]

Next day he noted in his Small Diary under Saturday, April 21st: 'Hab hier. Vorm: spatzierte mit ihm bey *Blake* geschwatz [Abend bey Becker vorgl Blairs Grave (Blake) *del*] mit ihm uber seiner Bruder[.]' *April 21st, 1810*

As soon as he was able to, after Easter week-end, Robinson hurried to see Blake's paintings, as he recorded in his Small Diary for Monday, April 23rd: 'Bey Blake Sah die Exhibition'. And under his expenses for that day is '4 Catalogues Blakes Exhib 10—'. In his 'Reminiscences' Robinson wrote: *April 23rd, 1810*

before I drew up this paper [*for Perthes*] I went to see a Gallery of Blakes paintings—which were exhibited by his brother a hosier in Carnaby Market—The Entrance was 2/6 Catalogue included[.] I was deeply interested by the Catalogues as well as the pictures[.] I took four——telling the brother I hoped he would let me come in again—— He said—'Oh! as often as you please'—I dare say such a thing had never happend before or did afterwards[.]—[2]

On the next Saturday, April 28th, he wrote in his Small Diary: '—Thee bey C Aikin[;] Blake's Grave—gespracht mit D[r] Malkin uber ihn'. Over a week later, on Monday, May 7th, Robinson was back copying Blake's poems again, as he noted in his Small Diary: 'Vorm: bey M[rs] Iremonger Blakes gedichte abschreibend Ab bey M[rs] Clarkson irh Blake's Kupferstuke zeigend'.[3] Two and a half weeks later, on Thursday, May 24th, there was more talk of Blake, according to the Small Diary:'—ab nach Thee bey Wall: Wright ange nihm los Blake's Gedichte *April 28th, 1810 May 7th, 1810 May 24th, 1810*

the dowager Lady Spencer, and both the Hare-Naylors were important patrons of Flaxman, and Catherine Louisa Shipley owned *Songs of Innocence and of Experience* copy D.

[1] *Dear Miss Heber*, pp. 96, 100 (1790, 1791). Miss Iremonger's copy of Blake's *Songs* was sold on April 26th, 1813.

[2] The passage above continues: 'I afterwards became acquainted with Blake And will postpone till hereafter what I have to relate of this extraordinary character whose life has since been written very inadequately by Allan Cunningham in his Lives of the English Artists—[*In the margin is written:*] NB: What I have written about Blake will appear at the end of the Year 1825[.]' On re-reading Cunningham, Robinson's judgement was not so harsh (cf. p. 549).

[3] There are many references to Thomas and Catherine Clarkson in HCR's papers, but they are not known to have owned any of Blake's Illuminated Works.

May 25th, 1810 vor'.[1] And next day Robinson wrote in the Small Diary: 'Abend bey M^rs Iremonger—Gesellescheft de—Regnal Heber—Cheve via—Mallet &c sehr genossen las Devils Walk sprach über Blake'. In his Small Diary for Monday, June 11th Robinson reported that he had taken Lamb and his sister to the exhibition: 'Ganzen Tag mit C. Lamb und Schwester[,] besahen Bond St^t Water Colours, und Blakes gemälde'.

June 11th, 1810

Perhaps it was Robinson who persuaded Robert Southey to go to see Blake's exhibition. Years later, Southey wrote:

That painter of great but insane genius, William Blake, of whom Allan Cunningham has written so interesting a memoir, took this [*Welsh*] Triad for the subject of a picture, which he called The Ancient Britons. It was one of his worst pictures,—which is saying much; and he has illustrated it with one of the most curious commentaries in his very curious and very rare descriptive Catalogue of his own Pictures.

It begins with a translation from the Welsh, supplied to him no doubt by that good simple-hearted, Welsh-headed man, William Owen, whose memory is the great storehouse of all Cymric tradition and lore of every kind.[2]

June 25th, 1810 Two weeks later, on Monday, June 25th, according to the Small Diary, Robinson was engaged in communicating to yet more people his interest in Blake: 'Ab: bey Kent—Josiah Conder Miss Jane Taylor da, bis spät las Blake vor interesssante Gesproche über ihn, Wordsworth, poeme &c'.

When Schiavonetti died on June 7th, with his engraving after Stothard's Canterbury Pilgrims painting still incomplete, Cromek wrote an obituary in which he listed Schiavonetti's seven 'principal performances', which, by an odd coincidence, included three works commissioned by Cromek:

July 1st, 1810 A series of Etchings, from designs by Blake, illustrative of Blair's Grave.
The Portrait of Mr. Blake, after Phillips, for the same work. . . .

[1] There are a number of references to Waller Rodwell Wright in Robinson's papers, but he had no known further connexion with Blake.

[2] [R. Southey] *The Doctor, &c*, London, 1847, vol. vi, pp. 116–17. For illustration and discussion of Southey's extraordinary unreliability in relation to Blake, see May 8th, 1830.

Southey goes on (pp. 117–26) to quote Blake's whole *Catalogue* description of 'The Ancient Britons', and he concludes with the 'Mad Song' of 'this insane and erratic genius'. In vol. vii, p. 161, he quotes the passage from Varley's *Zodiacal Physiognomy* (see Dec. 27th, 1828) about the Ghost of a Flea.

The Etching of the Canterbury Pilgrimage, from Stothard's esteemed
 Picture.

To shew the versatility of his powers, the two finished prints
[*after Van Dyke*] first mentioned, may be compared with the etchings
for Blair's Grave, the finished etching of Mr. Blake's portrait, the
etching of the Pilgrimage, and the Cartoon'. . . . ¹

In the summer of 1810 Blake was the subject of a number of
letters between Charles Henry Bellenden Ker and George
Cumberland. On August 20th Ker wrote: 'Blake's Grave— *August*
What a very fine work it is. and how much justice Schiavonetti *20th,*
has done it[; *it is*] with! excepti[*on*] the best thing of the sort *1810*
which has appear[*ed*] this Century. I wish I were rich enough
to buy it: but *alas!* I am the very Picture of Poverty . . .'²
It may have been about the same time that Ker wrote again:

I meant to have spoken today to you about Blake but I was in such
a state I forgot it—Near 3 Y! ago. When I went to him—I said
M! Blake we (meaning my father) are so near getting the Roxburgh
Cause³ that at your leisure you shall make me 2 Drawings and when
Ive got it I will pay you for them—well the other Day after having
some time before written to him— he sent me home the 2 Drawings
20 GS[.] Now I was I assure you thunderstruck as you as well as he
must know that in my present circumstances it is ludicrous to fancy

¹ R. H. Cromek, 'Account of Mr. Schiavonetti', *The Examiner*, no. 131 (July 1,
1810), p. 414, reprinted exactly in R. H. Cromek, 'Biographical Memoirs of the
Late Lewis Schiavonetti', *Gentleman's Magazine*, lxxx (Supplement to Jan.–June
1810), 664, except that the first paragraph omits the last four words.
 In the Christie Catalogue of 'Messrs. Louis and Nicholas Schiavonetti, deceased',
July 22–23, 1814, Lots 231, 249, 250 are proofs of Schiavonetti's Blair plates, and
Lot 31 was 'Young's Complaint with Blake's Designs, 96 loose designs by Blake'.
An anonymous note in the 1813 Blair extra-illustrated with Blake's plates for
Young (Rosenwald Collection) says it 'was given to me by M! W! Thane. . .
[*who*] knew Blake'.
 ² BM Add. MSS. 36502, f. 269.
 ³ The 'Roxburgh Cause' was fought by the writer's father, John Gawler (1765?–
1842), who took the name John Ker Bellenden on Nov. 5th, 1804, though he was
always known as John Bellenden Ker. John's second cousin William, 7th Baron
Bellenden and 4th Duke of Roxborough, tried to divert his entailed estate and his
title to John Bellenden Ker. After the Duke's death in 1805 the Cause was taken
to the House of Lords, where the case against John Ker was summed up by Lord
Eldon on June 15th–20th, 1809, and decided against him on May 11th, 1812.
 'Near 3 Y! ago', then, must refer to a time after 1805, when the Roxborough
Cause began, and before May 1809, when the tide could be seen to be turning
against the Bellenden Kers. Since the present letter seems to be of about the same
date as that of Aug. 27th, 1810, ' 3 Y! ago' may have been the winter of 1807–8.
The writer's birth-year is not known (1785?–1871), so the fact that he had
recently come of age is little help.

I can or am able to pay 20 Gs. for 2 Drawings not Knowing Where in the World [*to*] get any money. Nor do I at all conceive I am obliged to pay for them—now he desired in his note that the money was paid in a fortnight or part of it—intimating he should take hostile Mode[?] if it was not—now if he thinks proper to pursue the latter he is welcome and I wish you to call on him and shew him this and also that he may be informed of the grounds on which I meant to resist the payment[;] first as to the time when they were ordered which in his letter to me he admits was even then 2 years ago—therefore at that time I was not of age—next a young gentleman who can prove the terms on which they were ordered—these will be the grounds on which I shall rest if he insists on immediate payment and you can tell him my Attorney . . . is Mr Davis 20. Essex Street Strand—but of course the moment either by any success[?] of my father &c I am enabled I shall pay him. You will act as you think best[.]

I trouble you with this as from some[?] peculiar misfortunes I am not able to attend to any thing[.][1]

Cumberland did not reconcile the disputants, for in a letter *August* postmarked August 27th Ker wrote again: 'Blake—I wrote at *27th,* last to propose 15 Gs. no—then to pay the price any mutual *1810* friend or friends sh^d put on them—no—then I proposed to pay 10! first & 10! 3 months afterw^ds no—and then he arrested me[2]—and then defended the action and now perhaps [*his?*] obstinacy will never get a shilling of the 20 L. [*he ori*]ginally intended to defraud me of . . .'.[3]

Blake seems, however, to have gained his cause, for in another undated letter Ker told Cumberland that he had recently called on Stothard with a commission from Lord Digby.

I think it right to tell you this as you recommended me, and you may fancy, that as I disputed with your friend Blake I may with Stothard[.] But Blake is more knave than fool and made me pay 30 [*sic*] Guineas for 2 Drawings which on my word were never orderd and which were as [*word illeg*: unportus(?)] as they are infamously done: You are very shabby not to come near me[.]—I learnt from Stothard you were in town but I take it I am out of favour[4]

On Thursday, November 21st Crabb Robinson wrote in his

[1] BM Add. MSS. 36516, f. 56.

[2] The statement that Blake 'arrested me—and then defended the action' strongly suggests that the case came to trial, but I have found nothing in the Public Record Office to support this supposition. Perhaps Ker settled out of court.

[3] BM Add. MSS. 36502, f. 273.

[4] BM Add. MSS. 36516, f. 18. I cannot identify the disputed drawings.

Small Diary that he read '—Blakes Catalogue'. Some three *November 21st, 1810* months later, on Sunday, January 27th, 1811, he recorded a literary breakfast in his Diary: 'Breakfast with Rough. Con- *January 27th,* versed on Blake, Coleridge &c & Landor the author of Gebir' And on Sunday, March 10th, his Diary reports him showing *1811* off his new purchase of Blake's *Night Thoughts* illustrations: *March 10th, 1811*

—had a call from Turner & from W. Hazlitt. I shewed W. H. Blake's [drawings del] Young. He saw no merit in them as designs[.] I read him some of the Poems— He was much struck with them & expressed himself with his usual strength & singularity[.] [']They are beautiful,['] he said, ['] & only too deep for the vulgar[;] he has no sense of the ludicrous & as to a God a worm crawling in a privy is as worthy an obj! as any other, all being to him indifferent[.] So to Blake the Chimney Sweeper &c[.] He is ruined by vain struggles to get rid of what presses on his brain—he attempts impossibles—[.'] I added—['] he is like a man who lifts a burthen too heavy for him; he bears it an instant, it then falls on & crushes him[.']

W. H. preferred the Chimney Sweeper.

On Sunday, April 28th, Crabb Robinson wrote in his Diary: *April 28th, 1811* 'I had the pleasure of receiving from Perthes his Vaterlandisches Museum in the last N° of which I found a translation of my account of Blake: In most respects well done, but in one or two instances the Sense of the verse was mistaken[.]'[1]

Robinson's Diary for Wednesday, July 24th records that he *July 24th, 1811* Returned late to C. Lamb's[.] Found a very large party there— Southey had been with Blake & admired both his designs & his poetic talents; At the same time that he held him for a decided madman. Blake, he says, spoke of his visions with the diffidence that is usual with such people And did not seem to expect that he sho⁴ be believed. he showed S. a perfectly mad poem called Jerusalem—Oxford Street is in Jerusalem.[2]

Landor S. says is by no means a madman in common life but is quite discreet & judicious.[3]

[1] In his Small Diary for this day HCR noted: 'Erhielt Vaterlandisches Museum'.

[2] Cf. Southey's letter of May 8th, 1830 for an inaccurate account of this visit. Southey got his facts twisted: Oxford Street is *not* in Jerusalem the city; Jerusalem the woman is in Oxford Street, which appears only on p. 38 of Blake's poem.

[3] In his Diary for May 20th, 1838 H. C. Robinson wrote: 'My breakfast party went off very well indeed as far as talk was concerned—I had with me *Landor*, *Milnes*, & Serjᵗ *Talfourd*[.] A great deal of rattling on the part of W. S. L: He maint⁴ Blake to be the greatest of poets—That Milnes is the greatest poet now living in England and that Scotts Marmion is superior to all Wordsworth &

One of Blake's friends, perhaps Malkin or Butts, edited and probably financed *The Prologue and Characters of Chaucer's Pilgrims* with a print by Blake 'Publish'd Dec. 26. 1811'. The Introduction (pp. iii–iv) contained another puff for Blake's engravings:

December 26th, 1811

To the genius and fancy of that celebrated Artist, Mr. Blake, it occurred, that tho' the names and habits of men altered by time, yet their characters remained the same;[1] and as Chaucer had drawn them Four Hundred years past, he might as justly delineate them at the present period, and by a pleasant picture, bring to our imagination the merry company setting out upon their journey.

As the Canterbury Tales may be too long a story for modern amusement, I have selected the Prologue and the Characters, that the heads, as represented by Mr. Blake, may be compared with the lineaments drawn by Chaucer, and I think the merit of the artist will be generally acknowledged.

The original reading is copied from the edition of Thomas Speight, printed Anno. 1687; and the Translation from Mr. Ogle's edition, 1741.

If this small specimen should recommend the Print to the notice of the Encouragers of Art, it will gratify and amply repay the intention of

THE EDITOR.

Blake sent four works to the 1812 exhibition of the Water Colour Society, of which he was a member, which were described as:

1812

254 Sir Jeoffrey Chaucer and Twenty-seven Pilgrims leaving the Tabarde Inn, in the Borough, on their Way to Canterbury, Morning, — — *W. Blake.* . . .

Byron—and the description of the battles better than anything in Homer!!! but Blake furnished chief matter for talk' According to Landor's friend and biographer (J. Forster, *Walter Savage Landor*, London, 1869, vol. ii, pp. 322–3): '[*In 1836*] At an old bookseller's in Bristol he picked up some of the writings of Blake, and was strangely fascinated by them. He was anxious to have collected as many more as he could, and enlisted me in the service; but he as much wanted patience for it as I wanted time, and between us it came to nothing. He protested that Blake had been Wordsworth's prototype, and wished they could have divided his madness between them; for that some accession of it in the one case, and something of a diminution of it in the other, would very greatly have improved both.'

[1] Cf. Blake's *Descriptive Catalogue*: 'Of Chaucer's characters, as described in his Canterbury Tales, some of the names or titles are altered by time, but the characters themselves for ever remain unaltered'. Perhaps Blake's 'Public Address' was originally intended to be published with *The Prologue and Characters of Chaucer's Pilgrims*.

279 The Spiritual Form of Pitt guiding Behemoth: he is that Angel who, pleased to perform the Almighty's orders, rides in the Whirlwind, directing the Storms of War; he is ordering the Reaper to Reap the Vine of the Earth, and the Ploughman to Plough up the Cities and Towers, *W. Blake*.

280 The Spiritual Form of Nelson guiding Leviathan, in whose wreathings are unfolded the Nations of the Earth, — *W. Blake*. . . .[1]

324 Detached Specimens of an original illuminated Poem, entitled *'Jerusalem the Emanation of the Giant Albion,' W. Blake*.[2]

Crabb Robinson's Diary for Sunday, May 24th, 1812 reports a walk across the fields to Hampstead Heath with Wordsworth in the morning: '[*Wordsworth said*] that there is insanity in Lord B[*yron*]'s family and that he believes Lord B to be somewhat cracked— I read W. some of Blake's poems [in Ms. he w *del*] he was pleased with Some of them and considd B as havg the elements of poetry—a thousand times more than either Byron or Scott, but S he thinks superior to Campbell.' *May 24th, 1812*

Eight months later Crabb Robinson wrote in his Diary for Tuesday, January 12th, 1813: 'In the Eveng at Coleridge's lecture. And then at home. Mrs Kenny[,] Barnes & Barron Field there— The usual gossiping chat— F & B. both interested by Blake's poems of whom they knew nothing before[.]—' *January 12th, 1813*

Three days later, on Friday, January 15th, he wrote again: 'A call in the Eveng at C. Aikin's with Blake's Young, but cod not stay'. *January 15th, 1813*

On his spring visit to London in 1813, George Cumberland

[1] The first three pictures were the first three listed in Blake's own 1809 *Descriptive Catalogue*. In the 1809 description of the first, Blake mentions 'nine and twenty Pilgrims' instead of 'Twenty-seven', in the second and in the third the 1809 words are identical except that 'unfolded' had previously been, correctly, 'infolded'. Pitt previously 'rode on [*not in*] the Whirlwind'.

[2] *A Catalogue of the Fifth Annual Exhibition of the Associated Painters in Water Colours* At the Society's Rooms, No. 16, Old Bond Street. Admittance, One Shilling: catalogue, sixpence [London, 1812]. 'W. Blake' is the only one of the fourteen 'Members' without an address.

The following loose pages of *Jerusalem*, watermarked no later than 1802, have been traced (coloured pages *in italics*): 1, *4–5*, 8, *9* (*two copies*), *11*, *18*, *19* (two), 20, *24–25*, *28* (three), *32*, *35*, *37* (*two*), *38* (two), *41*, *45*, *47–48*, 50 (three), *51* (*two*), *53*, 56, 74, 78, 99–100. Of these, the only ones so printed that they could not be used in *Jerusalem*, and water-coloured as if for exhibition are 18, *35*, *37* (Mrs. Malone), *25*, *32*, *41*, *47* (Kerrison Preston), *5* or *53* (BM), and *9* or *11* (Victoria and Albert Museum). Of these, the first two sets are the ones most likely to be referred to above.

*April
12th,
1813* called on Blake on Monday, April 12th: 'Saw Blake who recommended Pewter to Scratch on with the Print— He is Doing L^d Spencer'.[1] Blake's advice was probably the same as that contained in the 'Memorandum' in his own Notebook (p. 10) of about 1807, 'To Woodcut on Pewter'.

A few weeks later the books of Crabb Robinson's old friend Miss Iremonger were sold. The collection was described in the King & Lochée *'Catalogue of the Valuable and Elegant Library, the property of Mrs. E. Iremonger,* Of Upper Grosvenor-Street; including some of the Best Authors in History and Belles Lettres; in the French, Italian, German, and English Languages; many of them enriched by valuable MS. notes and observations; and the whole in the finest possible preservation. Which will be *April
26th,
1813* Sold by Auction . . . On Monday, April 26, 1813, And Two following Days.' In the first day's sale appeared lot '165 Blake (Will.)—Songs of Innocence and Experience, *8vo. elegantly bound*—1789'.[2]

*June
3rd,
1814* In the next spring on Friday, June 3rd, his third day in London, Cumberland 'Called Cosway[3] by[?] *Dayley* N 51 South Molton St facing Poor Blake where he has been 3 Years— (Eagles Cousin)[4] Called Blake—still poor still Dirty—got to Praeds to Dinner at 6 oClock passed even^g with Stothard Newman St—still more dirty than Blake yet full of Genius[.]'[5]

Through his years of obscurity Blake continued to see others of his old friends too.

Flaxman and Fuseli remained; men friendly to him personally, and just to his genius, though, as respects the former, Blake did not always choose to think so. Once in these, or later years, Cary (Lamb's Cary, translator of Dante) was talking with his friend Flaxman of the few Englishmen who followed historical painting, enumerating Stothard, Howard, and others. Flaxman mentioned a few more, and among them Blake. 'But Blake is a wild enthusiast, isn't he?' Ever

[1] BM Add. MSS. 36520c, f. 155. The date is uncertain, but the notebook as a whole covers 1813. Cumberland's reference dates Blake's print of 'Earl Spencer', which G. Keynes (*Engravings by William Blake: The Separate Plates*, Dublin,1956, No. xxxviii) was unable to date more precisely than by the watermark of 1811.

[2] Probably copy D—see HCR's Reminiscences, p. 443 and April 20th, 1810.

[3] See Dec. 27th, 1795.

[4] Dayley may be somehow connected with Cumberland's note of the previous year (BM Add. MSS. 36520c, f. 153): 'Townly N 61 Blake opposite'. Eagles was a Bristol artist and a friend of Cumberland.

[5] BM Add. MSS. 36520D, f. 182. Praed was Cumberland's banker.

loyal to his friend, the sculptor drew himself up, half offended, saying, 'Some think me an enthusiast.'[1]

Flaxman continued to interest himself in Blake, and to look out for his interests. Apparently on his own authority he commissioned Blake to make the thirty-seven engravings from his Hesiod designs about this time,[2] though, according to Gilchrist, this 'kind office Blake did not take quite in good part. He would so far rather have been recommended as a designer! . . . They are sweet and graceful compositions, harmonious and contenting so far as they go, but deficient in *force*, as Blake himself thought Flaxman to have always been'[3] Flaxman also tried to get Blake commissions from other men as well. When John Bischoff inquired about an engraving to be made from one of Flaxman's monuments for Dr. T. H. Whitaker's history of Leeds, Flaxman replied on Sunday, August 19th:

If the Rev^d Doctor should be satisfied with an *outline* of the Monument, such as those published of Homer's Iliad & Odyssey, as well as some in Cowper's translations of Milton's Latin poems, which is now a favorite style of decoration in books, I can make the outline myself & will request the Editor's acceptance of it—the engraving including the Copper plate will cost 6 Guineas if done by M^r Blake the best engraver of outlines[.]—[4]

August 19th, 1814

During these years of obscurity Blake was probably writing and painting as regularly as ever, though we have few records. Gilchrist, in fact, is our chief source of information. 'He was an early riser, and worked steadily on through health and sickness. Once, a young artist called and complained of being very ill: "What was he to do?" "Oh!" said Blake, "I never stop for anything; I work on, whether ill or not."'[5] Apparently he felt as

[1] Gilchrist, 1942, p. 260; 1863, pp. 246–7. The story probably comes through Maria Denman. Elsewhere (1942, p. 321; 1863, p. 323) Gilchrist wrote: 'Even so well balanced a mind as Cary's (the translator of Dante) abandoned, after he came to know him, the notion he had taken up of his "madness," and simply pronounced him an "enthusiast."' Ignoring the 'well balanced' Henry Francis Cary's periodic insanity, we may note the similarity of Gilchrist's two stories, and cautiously doubt that he had any more evidence for Cary's acquaintance with and opinion of Blake's eccentricity than Flaxman's anecdote.

[2] Blake's first Hesiod plate was finished Sept. 22nd, 1814; see p. 579.

[3] Gilchrist, 1942, pp. 260–1; 1863, pp. 247–8.

[4] Quoted from a microfilm of the MS. in the Library of The Historical Society of Pennsylvania. The book, entitled perversely *Loides and Elmete*, was published in 1816, without any plates signed by Blake.

[5] Gilchrist, 1942, p. 259; 1863, p. 246. The 'young friend' may have been Palmer, in which case the anecdote would date from about 1825.

much at ease designing or writing, and it seems probable that his imagination was primarily a visual one, and that he *saw* his visions before he translated them into words or pictures.

He worked at literature and art at the same time, keeping the manuscript beside him and adding to it at intervals, while the graver continued its task almost without intermission. He despised etching needles, and worked wholly with the graver in latter years.[1] He used to say, 'Truth is always in the extremes,—keep them.['] I suppose he meant the same thing in saying, 'If a fool would persist in his folly he would become wise.'[2]

In his early years Blake had been a great walker around the regions south of London. 'A favourite day's ramble of later date was to Blackheath, or south-west, over Dulwich and Norwood hills, through the antique rustic town of Croyden, type once of the compact, clean, cheerful Surrey towns of old days, to the fertile verdant meads of Walton-upon-Thames; much of the way by lane and footpath.'[3] Apparently the walks were almost always to the south. To be sure, the hills were to the north and made for more strenuous walking. Long after he had given up his rambles, Blake wrote to Linnell: 'When I was young Hampstead Highgate Hornsea Muswell Hill & Even Islington & all places North of London always laid me up the day after & sometimes two or three days'.[4]

In later years, however, his imagination needed less and less the stimulus of new scenes and vigorous action. '"I don't understand what you mean by the want of a holiday," he would tell his friends. Art was recreation enough for him. . . . Even while he engraved, he read,—as the plate-marks on his books testify.[5] He never took walks for mere walking's sake, or for pleasure; and could not sympathise with those who did.[6] During one

[1] Blake's Hesiod plates (1814–17) were etched, but, according to a note by Linnell with the Ivimy MSS., *Job* (1824–1826) was 'cut with the graver entirely on copper without the aid of Aqua fortis'. Gilchrist's statement that Blake worked at literature and art simultaneously may be no more than an intelligent conclusion to account for the Notebook and the *Four Zoas* MS., but it rings true.

[2] Gilchrist, 1942, p. 360; 1863, pp. 369–70. The last quote is from *The Marriage*, Plate 7. [3] Gilchrist, 1942, p. 5; 1863, p. 7. [4] Feb. 1st, 1826.

[5] This must mean that 'In the intervals of engraving he read', and that the plates were sometimes carelessly set on open books when they were laid aside for a time. None of Blake's books known to me has a platemark in it.

[6] Gilchrist's earlier statement certainly indicates that Blake *did* at one time walk for pleasure. The present sentiment must be one held by Blake in old age to fend off the vigorous and enthusiastic young Ancients.

period, he, for two years together, never went out at all, except to the corner of the Court to fetch his porter.'[1] This last statement seems highly improbable.

According to his Diary for Monday, January 30th, 1815, Robinson

after dinner went to Flaxman's Fl: was very chatty & pleasant[.] *January* He related some curious anecdotes of *Sharpe* the Engraver who seems *30th,* the ready dupe of any & every religious fanatic & impostor who offers *1815* himself. . . . Sh: tho' deceived by Brothers became a warm partisan of Joanna Southcoat [*after June 1795*]—He endeavoured to make a convert of Blake the engraver,[2] but as Fl: judiciously observed, such men as Blake are not fond of playing the second fiddle—Hence Blake himself a seer of visions & a dreamer of dreams wod not do homage to a rival claimant of the privilege of prophecy—[3] Blake lately told Fl: that he had had a violent dispute with the Angels on some subject and had driven them away. *Barry* partook much of this strange insanity. . . . excessive pride equally denoted Blake & Barry—Sharpe seems of a quieter & more amiable[?] turn of mind[.]

Three months later George and Sydney Cumberland found Blake neglected, active, and outspoken. As George reported to his father on Friday, April 21st:

We call upon Blake yesterday evening[,] found him & his wife *April* drinking Tea, durtyer than ever[;] however he received us well & *21st,* shewed his large drawing in Water Colors of the last Judgement[.] *1815* he has been labouring at it till it is nearly as black as your Hat[4]— the only lights are those of a *Hellish Purple*—his time is now intirely

[1] Gilchrist, 1942, pp. 259–60; 1863, p. 246.

[2] William Sharp was evidently an indefatigable proselytizer. HCR reports a long anecdote told by Flaxman of how Sharp had tried to persuade Flaxman to become a follower of Brothers, and to act as the Architect of the Promised Land (*Diary, Reminiscences, and Correspondence of Henry Crabb Robinson*, ed. T. Sadler, London, 1869, vol. i, pp. 53–54), and Holcroft's diary for 1799 sympathetically tells how Sharp also tried to convert Holcroft to Brothers (T. Holcroft & W. Hazlitt, *The Life of Thomas Holcroft*, ed. E. Colby, London, 1925, vol. i, pp. 245–7).

[3] Some years later, when he knew Blake personally, Robinson was not so ready to take sides against him. In his Diary for May 12th, 1826 he wrote: 'I doubt whether Flaxman sufficiently tolerates Blake.'

[4] On a tracing of an elaborate drawing of the Last Judgment Tatham wrote: 'The original picture was six feet long and about five wide, and was very much spoiled and darkened by over-work; and is one of those alluded to in his Catalogue as being spoiled by the spirits of departed artists, or "blotting and blurring demons."' (Gilchrist, 1863, vol. ii, p. 242.) R. C. Jackson's father later saw Blake's drawing in Fountain Court (R. C. Jackson, 'William Blake at the Tate Gallery', *South London Observer*, 31 Oct. 1913).

taken up with Etching & Engraving—upon which subject I shall ask his advice if I do not shortly Succeed more to my wishes—I have made some pretty things but not worth send you—Blake says he is fearful they will make too great a Man of Napoleon and enable him to come to this Country— M:ˢ B says that if this Country does go to War our K—g ought to loose his head[.]—[1]

Blake had evidently made another copy of his 'Vision of the Last Judgment', which he had finished and described for the Earl of Egremont's wife in January 1808, and he had therefore been labouring at it for over seven years. He might well have taken his own advice written during this period: 'Let a Man who has made a drawing go on & on & he will produce a Picture or Painting but if he chooses to leave it before he has spoild it he will do a Better Thing[.]'[2] Gilchrist says he 'was wont to affirm: "First thoughts are best in art, second thoughts in other matters."' 'He held that nature should be learned by heart, and remembered by the painter, as the poet remembers language. "To learn the language of art, copy for ever, is my rule," said he. But he never painted his pictures from models. "Models are difficult—enslave one—efface from one's mind a conception or reminiscence which was better."'[3]

Catherine's violent radicalism is particularly interesting—'if this Country does go to War our K—g ought to loose his head'. Perhaps the militant pro-French sentiments that the mendacious soldiers attributed to her in 1803 were not so wide of the mark.

[April, 1815] To the letter from his son Cumberland replied briefly but unreservedly: 'You have a free estimate of Blake—& his devilish Works—he is a little Cracked, but very honest— as to his wife she is maddest of the Two—He will tell you any thing he knows[.]'[4] To most of Blake's friends indeed it appeared as if Catherine had absorbed uncritically Blake's beliefs and capacities. Gilchrist says,

[1] BM Add. MSS. 36505, ff. 63–65. The engraving work was probably for Hesiod, Wedgwood, and Rees's *Cyclopaedia* and perhaps for his own Milton designs and *Jerusalem* as well.

[2] Notebook, p. 44. [3] Gilchrist, 1942, p. 361; 1863, p. 370.

[4] BM Add. MSS. 36514, f. 97. The letter is undated and unaddressed, but in it Cumberland clearly answers his son's letter above. For instance, in his letter of April 21st George Jr. had reported that he had received sixty-seven copies of *Thoughts on Outline* from White, and in the undated letter his father replied that on Oct. 11th, 1813 he had 'sent into Whites 74 Copies of Thoughts on outline so that if he has only returned 67—he has sold 7 Copies—'.

PLATE XXXIII

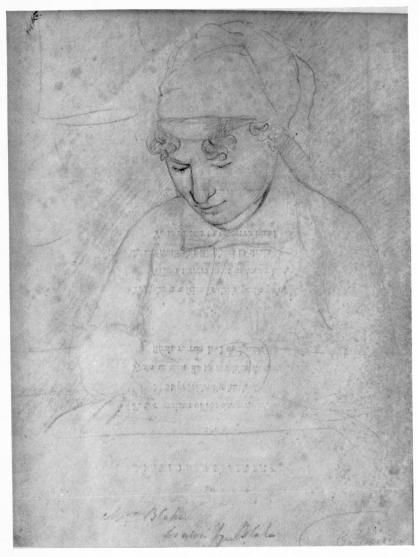

BLAKE'S SKETCH OF CATHERINE BLAKE (after 1802) showing the traces of beauty in poverty which Blake's friends noticed (p. 237). The type showing through from the verso is from Hayley's *Ballads* (1802)

Mrs. Blake's spirit, in truth, was influenced magnetically, if one may so speak, by her husband's. She appears to have had the same *literal* belief in his visions as John Varley; and when he, in his wild way,[1] would tell his friends that King Alfred, or any great historical personage, had sat to him, Mrs. Blake would look at her husband with an awe-struck countenance, and then at his listener to confirm the fact. Not only was she wont to echo what he said, to talk as he talked, on religion and other matters—this may be accounted for by the fact that he had educated her; but she, too, learned to have visions;—to see processions of figures wending along the river, in broad daylight; and would give a start when they disappeared in the water. As Blake truly maintained, the faculty for seeing such airy phantoms can be cultivated. . . .[2] Some of the characteristics of an originally uneducated mind had clung to her, despite the late culture received from her husband:—an exaggerated suspiciousness, for instance, and even jealousy of his friends.[3] But vulgarity there was none. In person, the once beautiful brunette had, with years, grown . . . common and coarse-looking, except 'in so far,' says one who knew her, 'as love made her otherwise, and spoke through her gleaming black eyes.' This appearance was enhanced by the common, dirty dress, poverty, and perhaps age, had rendered habitual. In such cases, the traces of past beauty do but heighten the melancholy of its utter ruin. Amid so much that was beautiful in her affectionate, wifely spirit, these externals were little noticed. To friends who remember Blake in Fountain Court [*1821-7*], those calm, patriarchal figures of Job and his Wife in the artist's own designs, still recall the two, as they used to sit together in that humble room.[4]

In their last years, at least, Blake and Catherine seem to have been agreed on the philosophic bases of love and jealousy.

[1] The testimony is almost unanimous that Blake's *manner* was not 'wild', though his opinions frequently seemed to be.

[2] Gilchrist goes on to mention that Catherine not only 'coloured Blake's designs under his direction', but designed and executed her own drawings as well. One of her drawings he locates in Linnell's possession, only identified as 'so like a work of Blake's, that one can hardly believe it to have been the production of another hand'. This may be the drawing of a face in the fire, now owned by Sir Geoffrey Keynes. Gilchrist also refers to a small pen-and-ink sketch of a seated woman, in the Butts collection (see above, p. 176), 'which I would not hesitate, at first sight, to call a Blake'; I know nothing more about this drawing, unless it is Sir Geoffrey's 'Agnes from the Monk', which Catherine made for Mrs. Butts.

[3] Gilchrist, 1942, pp. 314–15; 1863, p. 316, also says: 'There *had* been stormy times in years long past, when both were young; discord by no means trifling while it lasted. But with the cause (jealousy on her side, not wholly unprovoked,) the strife had ceased also.' I can add nothing to the speculative gossip on this subject. There seems to be practically no external evidence to support it.

[4] Gilchrist, 1942, pp. 315–16; 1863, pp. 316–17; see Plate XXXIII.

'Do you think,' he once said in familiar conversation, and in the spirit of controversy, 'if I came home, and discovered my wife to be unfaithful, I should be so foolish as to take it ill?' Mrs. Blake was a most exemplary wife, yet was so much in the habit of echoing and thinking right whatever he said that, had she been present, adds my informant, he is sure she would have innocently responded, '*Of course not!*' 'But,' continues Blake's friend, 'I am inclined to think (despite the philosophic boast) it would have gone ill with the offenders.'[1]

It was probably in the spring of 1815 that Blake went to the room in the Royal Academy where students copied from casts of classical statues, to prepare a plate for Rees's *Cyclopaedia*. As Frederick Tatham later wrote on the sketch he made: 'This drawing was made by Mʳ Blake in the Royal Academy Somerset House for a small plate he made of the Laocoon for the Article in the Encylopedia. The article itself was on Sculpture being written by Flaxman. When Mʳ B. was drawing this his old friend Fuseli came in & said 'Why Mr. Blake you a student[!] you might teach us'[. *This came*] in[*to*] my possession from Mrs Blake[.]'[2] Tatham repeated the story twice more. On a proof of the engraving (now in the BM Print Room) he wrote: 'Blake went to the Royal Academy & made an original drawing [*from a cast of the Laocoon*] of which this is a print[.] his interview with his friend Fuseli was characteristic[.] Fredᶜ Tatham[.]' And he amplified the story somewhat for Gilchrist: '"What! you here, *Meesther Blake?*" said Keeper Fuseli; "we ought to come and learn of you, not you of us!" Blake took his place with the students, and exulted over his work, says Mr. Tatham, like a young disciple; meeting his old friend Fuseli's congratulations and kind remarks with cheerful, simple joy.'[3]

Perhaps among the students who witnessed this encounter was a young engraver named William Ensom, who was not yet twenty. At some time, evidently in the spring of 1815, Ensom came to know Blake, and persuaded him to sit for his portrait. The sketch Ensom made was apparently highly successful, for he entered it in the competition of the Society for the

[1] Gilchrist, 1942, p. 327; 1863, p. 331.

[2] *Blake's Pencil Drawings*, Second Series, ed. G. Keynes, London, 1956, no. 30. The finished plate was dated Oct. 1st. 1815, so the date of the sketch is probably about spring 1815.

[3] Gilchrist, 1942, p. 261; 1863, p. 248.

Encouragement of Arts, Manufactures, and Commerce, and at the Society's anniversary dinner in the Freemason's Tavern on the evening of Tuesday, May 30th 'the silver medal' was awarded 'To Mr. William Ensom, Swinton Street, Gray's Inn Lane Road, for a pen and ink drawing of a Head [*of William Blake*]'.[1] Ensom may have given Blake commercial as well as moral support, and commissioned him to colour a set of his *Night Thoughts* designs. There is, at any rate, a coloured set inscribed: 'This Copy was colour'd for me by Mr. Blake. W.E.'[2]

May 30th, 1815

It was also apparently in the spring of 1815 that 'Mr Flaxman introduced Blake to Mr Wedgwood. The Designs of the Pottery were made by Mr. Flaxman and engraved by Blake for some work.'[3] Wedgwood naturally had work only of the most menial kind for Blake. During the summer he wrote to the artist encouragingly about his commission:

July 29th, 1815

Etruria 29 July 1815

Sir

I return the drawing you have been so good to send me which I entirely approve in all respects. I ought to have mentioned when the Terrine was sent you that the hole for the ladle in the cover should not be represented & which you will be so good to omit in the engraving.

I presume you would make a drawing of each article that is to be engraved & if it will be agreeable to you to complete the drawings before the engraving is begun I think it may enable me to make the best arrangement of the articles on the copper plates, but if this is not quite as agreeable to you as going on with the drawing & engraving together, I will only beg you to make two or three drawings [.] I will in that case in the mean time consider of the arrangement. I have directed a Terrine to be sent you, presuming you will prefer having only one

[1] *Transactions of the Society, Instituted at London, for the Encouragement of Arts, Manufactures, and Commerce*, xxxiii (1815), 22. The prizes were for the session Oct. 1814–June 1815. In the Sotheby sale of Ensom's effects (Dec. 12th, 1832), Lot 86 was 'Portrait [*by Ensom*] of W. Blake, R.A. *in pen and ink*'. 'For this drawing Mr. Ensom obtained the Silver Medal from the Society of Arts, which, together with the two vouchers of the society, will be given with the drawing.'

[2] This copy is now in the collection of Paul Mellon. The only reason for identifying the buyer as William Ensom is the initials.

[3] This MS. note by Frederick Tatham on a proof plate of the Wedgwood Catalogue is now in the possession of Mrs. Robert D. Chellis.

vessell at a time. If you would have more be so good as to let M^r
Mowbray at my house know who has a list of more articles.

I am Sir

Your mo obt Serv^t

Josiah Wedgwood

M^r Blake 17 South Molton St^1

Six weeks later Blake replied:

Sir

I send Two more Drawings with the First that I did, altered: having taken out that part which expressed the hole for the ladle.

It will be more convenient to me to make all the drawings first before I begin Engraving them as it will enable me also to regulate a System of working that will be uniform from beginning to end. Any Remarks that you may be pleased to make will be thankfully recievd by Sir

17 South Molton Street Your humble Servant
8 Septemb^r 1815 William Blake

The Wedgwood accounts for Blake's work are moderately detailed:

23^d Oct^r 1815.

October 273.—for M^r Blake for designs^2
23rd, China form fruit basket, without handles, & stand—
1815 oval Cream Bowl—N? 888 of Book of Drawings.—
oval rose top Soup Terrine with listel band on Cover. N? 2 Book of Drawings—
Butter Boat, 2 handles, loose stand.

Among the articles mentioned in M^r Wedgwoods *last* list for M^r Blake to make designs from, are the following eight, which have been either sent to him, or set out for him, agreeable to the preceeding list rec^d 8th Aug^t should the patterns be meant for the same, we of course imagine that only *one* of each is meant for him—if otherwise, be pleased

¹ This and most of the other Wedgwood references below are quoted from reproductions of the originals in the Wedgwood Museum. Presumably Blake normally communicated with Wedgwood indirectly, through Mr Mowbray or his other London agents, for there is only one letter from the poet in the Wedgwood Museum.

² At the top of this list of notes, under 'M^r Blake for designs' is a clerical memorandum: 'Return all this relative to M^r Blake to W[*edgwood*] when the[?] orders[?] are entered[?]'.

to mention it—or to enquire of Mr Wedgwood whether any other patterns are intended than those in his list recd the 8th August—
 oval Salad
 Square Do
 round Do
New high oval sauce terrine & Std
round Cream bowl form Do & Do
low oval butter Boat
new oval—Do—
Butter Boat 2 handles fixed std . . .
please to mention likewise whether the oval rose top Soup terrine with listel band on Cover, palm handles,—No 5 Book of Engravings, as noted in Mr Wedgwoods Memm of 29 July—is still to be sent to Mr Blake to make a Design from—as it appears that he recd No 5 Book of *Drawings*, from us, in the first Instance instead of No 5 Book of *Engravings*—If Mr Blake is to have the latter, please to send us one up: together with the others hereon noted.

Even Catherine was pressed into service:

25 Oct. 1815. Mrs. Blake: 1 W. H. Basin 20 in. *October*
 1 Nurse Lamp with *25th,*
 bason top & lip *1815*
 1st Size.[1]

Six weeks later there is a note of progress: 'Orders 5 Decemr *December* 1815 . . . Mr Blake states that he intends very soon sending us *5th,* some of the Drawings:—he has Articles sufficient to go on *1815* with for the present.' And he was as good as his word: 'Memorandum—13th Decr 1815. Mr Blake has left a packet of Draw- *December* ings (forwarded herewith) from some of the Articles,—& *13th,* states that he shall very soon have completed Designs from all *1815* that he has.' It was not until November 11th, 1816 that he was paid £30 for his engravings.

On a Thursday in July 1816 Nancy Flaxman wrote to her husband:

tell me . . . how Hesiod goes on, I have had some discourse with our *July,* Friend about Blakes book & the *little drawings*—It is true he did not *1816* give him anything for he thought It would be wrong so to do after what pass'd between them, for as I understand B— was very violent[,]

[1] The original of this document, quoted by Geoffrey Keynes (*Blake Studies*, London, 1949, p. 73), cannot now be traced in the Wedgwood Museum.

Indeed beyond *all credence* only that he has served you his *best friend* the *same trick [some]* time back as you must well remember—but he *bought* a *drawing* of him, I have nothing to say in this affair[.] It is too tickilish, only I know what has happened both to yourself & me, & other people are not oblig'd to put up with *B s* odd humours—but let that pass[.][1]

'Our Friend' may have been Tulk, to whom there are frequent references in Flaxman's letters of this time; there are also in the Fitzwilliam portraits by Flaxman of Mrs. Tulk and her children, dated 1816. The Tulks owned copies of Blake's *Poetical Sketches*, *Songs of Innocence and of Experience*, and *No Natural Religion*, but none of these would seem to correspond to 'the *little drawings*'. However, Coleridge (February 12th, 1818) called Blake's etchings in the *Songs* 'Drawings'.

It may have been during the summer of 1816 that Blake called upon the enthusiastic bibliographer Thomas Frognall Dibdin, who wrote:

Summer? It was during the progress of working at my Decameron,[2] that I
1816? received visits from two Artists of very different complexion and degrees of reputation: I mean NORTHCOTE and BLAKE. The former was the pupil and biographer of Reynolds—the latter . . . pupil of no Master, but a most extraordinary artist in his own particular element: although I believe he professed to have been a pupil of Flaxman and Fuseli—artists, as opposite in all respects as a chaste severity differs from wild exuberance of style. . . .

I soon found the amiable but illusory Blake far beyond my ken or sight. In an instant he was in his 'third heaven'—flapped by the wings of seraphs, such as his own genius only could shape, and his own pencil embody. The immediate subject of our discussion—and for which indeed he professed to have in some measure visited me—was, 'the minor poems of Milton.'[3] Never were such 'dreamings' poured forth as were poured forth by my original visitor:—his stature mean, his head big and round, his forehead broad and high, his eyes blue, large, and lambent—such as my friend Mr. Phillips has represented

[1] BM Add. MSS. 39780, f. 364.

[2] Dibdin's *Bibliographical Decameron* was published in 1817, so we may presume it was being written in 1816. The first series of dots appear in the original; the others signify I have omitted passages.

[3] It seems likely that Blake wanted to talk specifically about *L'Allegro* and *Il Penseroso*. His drawings in illustration of these poems are on paper watermarked 1816, and he was probably beginning to engrave the whole series in that year too.

him upon his imperishable canvas*. 'What think you, Mr. Blake, of Fuseli's Lycidas—asleep, beneath the opening eyelids of the morn?' 'I don't remember it.' 'Pray see it, and examine it carefully. It seems to me to be the pencil of poetry employed to give intelligence and expression to the pen of the poet'—or words to this effect were, I think, pronounced. I learnt afterwards that my Visitor had seen it— but thought it 'too tame'—tameness from Fuseli! I told Mr. Blake that our common friend, Mr. Masquerier, had induced me to purchase his *'Songs of Innocence,'* and that I had no disposition to 'repent my bargain.†' This extraordinary man sometimes—but in good sooth very rarely—reached the sublime; but the sublime and the grotesque seemed, somehow or the other, to be for ever amalgamated in his imagination; and the choice or result was necessarily doubtful. Yet there are few books of which I love to turn over the leaves, more assiduously and carefully, than 'Young's Night Thoughts,' emblazoned by his truly original pencil‡. When Blake entered the arena with

* This portrait, which gives more elevation and dignity to the original than he should seem actually to have possessed, is nevertheless a most faithful and happy resemblance. And Schiavonetti's burin has done ample justice to the *pencil* of the painter. There is yet *another* 'portrait of the man,' as well worth the contemplation—and that is, the brief, but spirited, and most exceedingly interesting Biography of him by Allan Cunningham, Esq. [*Dibdin's note; see Plate XXIV.*]

† Mr. Cunningham has judiciously quoted one of these songs, among the prettiest, which shall find a place here—from my *own* copy of it thrown by in a portfolio some twenty years ago.— . . .[1] [*Dibdin's note.*]

‡ In the original conformation of these 'REMINISCENCES' I had intended to have devoted an entire chapter to the *Fine Arts*, and therein to have given BLAKE not more than his due. Under this impression, I wrote to my friend, Mr. D'Israeli, to furnish me with the loan of such materials of this master as I knew him to be in the possession of. His reply not only staggered me, but induced me to abandon nearly my whole intention in regard to Blake. It shall here tell its own tale, because I do not know any other pen which could tell that tale with greater felicity of diction.

'*Bradenham House, Wycombe*, 24 *July*, 1835.

'MY DEAR FRIEND,

'It is quite impossible to transmit to you the ONE HUNDRED AND SIXTY[2] designs I possess of Blake's; and as impossible, if you had them, to convey

[1] Dibdin gives the 'Introduction' ('Piping down the vallies wild') from *Innocence* as in Cunningham (p. 483), with minor variants of punctuation and of spelling (''d' for 'ed'). The only change of substance is the substitution of 'Passing' for 'Piping' in the first line, which is probably accidental despite Dibdin's claim that he is quoting not Cunningham but the original.

[2] *Letters of William Michael Rossetti*, ed. C. Gohdes and P. F. Baum, Durham, 1934, p. 5, demonstrates that these designs consist of *Thel* (F), *Visions* (F), *Marriage* (D), *Innocence and Experience* (A), *Urizen* (B), *Europe* (A), and *Song of Los.*

Stothard, as a rival in depicting the *Dramatis Personae* of Chaucer's Canterbury Tales, he seems to have absolutely lost his wits; his pencil was as inferior to that of the former, as his burin was to that of *Cromek*,[1] who engraved Stothard's immortal picture.

Blake was thought important enough by some of his contemporaries to be included in *A Biographical Dictionary of the Living Authors of Great Britain and Ireland*, which may have appeared in the autumn of 1816:

Autumn?
1816

BLAKE, William, an eccentric but very ingenious artist, formerly of Hercules Buildings, Lambeth, afterwards living at Felpham in Sussex, and principally the engraver and publisher of his own designs. Among a variety of other productions, he is the author of
The Gates of Paradise, illustrated by 16 engravings for Children, 12 mo. Lambeth, 1793—Songs of Experience, with plates, *no date.*— America, a Prophecy, fol. Lambeth, 1793.—Europe, a Prophecy, do. 1794.—A Descriptive Catalogue of Pictures, Poetical and Historical Inventions painted by himself, in Water Colours, 12mo. Lond. 1809.[2]

every[3] precise idea of such an infinite variety of these wonderous deleriums of his fine and wild creative imagination. Heaven, hell, and earth, and the depths below, are some of the scenes he seems alike to have tenanted; but the invisible world also busies his fancy; aereal beings which could only float in his visions, and unimaginable chimeras, such as you have never viewed, lie by the side of his sunshiny people. You see some innocent souls winding about blossoms—for others the massive sepulchre has opened, and the waters beneath give up their secrets. The finish, the extreme delicacy of his pencil, in his light gracile forms, marvellously contrast with the ideal figures of his mystic allegories; sometimes playful, as the loveliness of the arabesques of Raffaelle. Blake often breaks into the '*terribil via*' of *Michael Angelo*, and we start amid a world too horrified to dwell in. Not the least extraordinary fact of these designs is, their colouring, done by the artist's own hand, worked to his fancy; and the verses, which are often remarkable for their sweetness and their depth of feeling. I feel the imperfection of my general description. Such singular productions require a commentary.

'Believe me, with regard
'Your sincere well wisher,
'I. D'ISRAELI.[4]

[1] Cromek commissioned but did not engrave Stothard's picture.

[2] [J. Watkins & F. Shoberl], *A Biographical Dictionary of the Living Authors of Great Britain and Ireland*; comprising Literary Memoirs and Anecdotes of their Lives; and a Chronological Register of their Publications, London, 1816. See spring 1819 for a reprint of the bibliography.

[3] D'Israeli probably meant—or wrote—'a very'. Dibdin's own diction was so shoddy that it may well have coloured his reading of his correspondents' letters. It is curious above, for instance, that Blake's '"dreamings"' seem to be illustrated by his appearance.

[4] T. F. Dibdin, *Reminiscences of a Literary Life*, London, 1836, pp. 784–9. For an account of D'Israeli's literary seances, see Aug. 9th, 1824.

Under Hayley is: 'Ballads founded on original and curious anecdotes relating to the instinct and sagacity of Animals sm. 8vo. 1805, (intended to accompany a series of designs by the ingenious but eccentric William Blake)'. There is also an enigmatic entry for 'BLAKE, W. King Edward the Third, a drama, 8vo. 1783', which probably refers to the six-scene fragment of that title in the 1783 *Poetical Sketches* (see p. 34).

A year after the incident Nancy Flaxman reported we find copy O of *Songs of Innocence [and of Experience]* inscribed 'Mʳˢ Flaxman April 1817'.[1] It was in the spring or summer of this same year that John Gibson, a young sculptor from Liverpool who was stopping briefly on his way to Rome, called with letters of introduction on Flaxman, Fuseli, and several other men of artistic note in London: 'I also presented myself without a note of introduction to Mr. Blake, after showing him my designs, he gave me much credit for the invention which they displayed; he showed me his cartoons, and complained sadly of the want of feeling in England for high art, and his wife joined in with him and she was very bitter upon the subject.'[2]

April, 1817

Summer? 1817

At the end of 1817 the enthusiastic artistic hack William Paulet Carey digressed from his analysis of Benjamin West's 'Death on the Pale Horse', to write:

The superior moral influence of paintings from *Sacred* history over those from *profane*, is great indeed. . . . If Blake had designed a series of subjects from heathen story, his genius could not have made so deep and lasting an impression upon the public, as it has done, by his solemn and affecting series of designs, for *Blair's* poem of The Grave, engraved by that lamented artist, Schiavonetti. . . .

December 31st, 1817

FUSELI in his just and forcible introduction to BLAKE's noble series of designs for CROMEK's edition of Blair's poem of the Grave, remarks that, through frequent repetition,—'The serpent, with its tail in its mouth, from a type of eternity, has become a *child's bauble*;

[1] Copy O is irregularly constituted, *Innocence* being uncoloured and of about 1817, and *Experience* being coloured and of about 1800. Nancy already owned an early copy (D) of *Innocence*.

[2] *The Biography of John Gibson, R.A., Sculptor, Rome*, ed. T. Matthews, London, 1911, p. 39, quoting Gibson's fragmentary MS. autobiography, begun in 1851. The passage is given more briefly in *Life of John Gibson, R.A. Sculptor*, ed. [E.] Eastlake, London, 1870, p. 44: 'I made also the acquaintance of Mr. Blake, who showed me his cartoons and complained sadly of the want of feeling in England for high art. His wife joined in with him; she was very bitter upon the subject.' The date is ascertained from the fact that Gibson came to London about March 1817 and left for Rome in September.

even the nobler idea of Hercules passing between Virtue and Vice, or the *varied imagery of Death leading his patients to the grave*, owe their effect upon us more to *technical excellence*, than allegoric utility.'[1] The contexts and the prints may warrant a conclusion that it was, from this conviction, BLAKE, in those imperishable designs, did not attempt to give any defined form of Death the Destroyer, to whom almost any other artist would have assigned a most conspicuous place. The skeleton rising out of the shroud, laid beside the grave, over which an angel sounds the last trumpet, is an emblem of the resurrection of the Dead, not a personification of Death, the insatiate Devourer [*Plate XXXIV.*]

Having mentioned these drawings, by BLAKE, I feel their strong hold upon me: and must obey the impulse. It would be impossible to enumerate, in a restricted space, the succession of beauties, in these affecting groups; yet I cannot, without self-reproach, and an abandonment of a public duty, pass them in silence. They abound in images of domestic gentleness and pathos; in varied grace, and unadorned elegance of form. Their primitive simplicity of disposition and character, is united with bold and successful novelty, and a devotional grandeur of conception. Although obliged to derive almost the entire of his materials from the Sepulchre, there is not an image capable of exciting disgust, or offence in the whole.[2] Even when representing the dread unknown beyond the grave, he still contrives to keep the Fancy within the sphere of human sympathy. His agents, in general, after having shaken off the grosser substance of flesh, still retain the unaltered form. They appear to move round us upon solid earth; like ourselves, enjoy the light of day, and are canopied by an unclouded sky. With a few unimportant exceptions, his style is uniformly chaste. His energy is devoid of extravagance or distortion; his anatomical learning of pedantry; his grandeur free from wildness, and his beauty from affectation. His Spiritual forms are truly 'Angels and Ministers of grace.' His gloom has nothing depressing or sullen; its soothing spell charms the attention and fills the mind with serenity, hope and elevation. His solemn religious fervor, without deeply wounding our self-love, abates the angry passions; whispers an eternal lesson of admonition, and inspires us with *what ought to be the aim of all religious instruction, a love of our Fellow-Travellers in the vale of mortality*. The heart follows the rapt Enthusiast with pleasing sadness, and shares in the mournful delight of his journey, while his placid but melancholy fancy bids the bloom of Beauty triumph over the shadows of Death; breathes a nameless loveliness on things unearthly; and sheds a mild and holy illumination on the night of the grave.

[1] See Nov. 1805; Carey is not painstakingly accurate.
[2] For flatly contradictory impressions see July 1808.

PLATE XXXIV

ETCHED TITLE-PAGE OF BLAIR'S *GRAVE* (1808). James Montgomery was much amused by the 'solemn absurdity' of the design (see p. 194)

I have applied the term 'placid' to the finely tempered spirit of this Artist's genius, as it appears in those affecting compositions, and in the deep serenity expressed in his portrait, by the masculine graver of the elder *Schiavonetti*, from the painting by *Phillips*. I never had the good fortune to see him; and so entire is the uncertainty, in which he is involved, that after many inquiries, I meet with some in doubt whether he is still in existence.[1] But I have accidentally learned, from a Lady, since I commenced these remarks, that he is, certainly, now a resident in London. I have, however, heard enough to warrant my belief that his professional encouragement has been very limited, compared with his powers.

One fact is clear, that the purchaser of his drawings for the 'Grave,' was not a person of *rank* and *independent fortune*. The world is indebted to the superior taste and liberal spirit of that ingenious engraver, CROMEK, as a printseller and publisher, for the engravings of those designs. Beyond the circle of artists, I anxiously look round for the Designer's *Patrons*. In an Engraver, now no more, he found a purchaser, and in the Royal Academy, a recommendation to his country. *Posterity will inquire the rest.* . . .

I would fail in my sense of duty, were I not here to notice a fact, which does honour to the Royal Academy. If my information be not erroneous, and I think it is not, BLAKE is one of those highly gifted men, who owe the vantage ground of their fame, solely to their own powers. I have heard that he was, originally, an engraver of book plates.[2] Yet, far from endeavouring to keep him in the back-ground, or question his merits, in 1808,[3] when he executed the drawings for the 'Grave,' eleven Members of the Royal Academy, bore testimony, in a public advertisement, to their extraordinary excellence. The name of the Venerable President, WEST, appeared at the head of the list; followed by Sir WILLIAM BEECHEY, RICHARD COSWAY, JOHN FLAXMAN, THOMAS LAWRENCE, JOSEPH NOLLEKENS, WILLIAM OWEN, THOMAS STOTHARD, MARTIN ARCHER SHEE, HENRY THOMSON AND HENRY TRESHAM, Esquires.[4] In addition to this powerful recommendation, FUSELI, the Lecturer of that Body, wrote for publication, his high opinion of the series. The truth and eloquence of his remarks, would alone, confer permanent distinction on the designs, even if they had not been consecrated to Posterity, by the inspiration, which they breathe. PHILLIPS, whose best portraits unite a *correct definition of details*, and an admirable truth of resemblance, with grace, spirit, and

[1] Charles Lamb was also in doubt as to whether Blake was alive; see May 15th, 1824.

[2] This statement is inaccurate unless it means commercial engravings for books.

[3] Both the drawings and the testimony date from late 1805, not 1808.

[4] See Aug. 1808.

a noble breadth and harmony of effect, bore testimony to the merits of
BLAKE's drawings, by painting his head for CROMEK, the intended
publisher of the plates.[1] The vigorous character of nature, in this mas-
terly picture, is a fine lesson for the florid and flimsy *Mannerists* of the
day. The countenance, expresses the deep calm of a spirit, lifted above
the little concerns of this world, and, already in imagination, winging
its way beyond the skies. In this honourable effort of the Royal Academi-
cians to draw the attention of the public to the highest department of
invention, portrait painters, sculptors and historical designers, liberally
co-operated.[2]

Early in 1818[3] Blake was found in a rather unusual gathering
of alphabetical nobility, including Lord B, Lady C, and Lord L.
The party was given by Byron's sometime mistress and tor-
mentor, Lady Caroline Lamb, and the impression Blake made
was reported at surprising length by the royalist diarist, Lady
Charlotte Bury:

[1] Phillips's portrait bore 'testimony to the merits of BLAKE's drawings', presu-
mably because his admiration for Blake's designs inspired him to give it to Cromek
to be reproduced. Cf. Nov. 1808.

[2] William Carey, *Critical Description and Analytical Review of 'Death on the
Pale Horse', Painted by Benjamin West, P.R.A.* with Desultory References to the
Works of Some Ancient Masters, and Living British Artists, London, Dec. 31,
1817, pp. 9, 128–36. The first paragraph only is reprinted in the edition of Phila-
delphia April 27th, 1836, p. 20. The second, third, fourth, and fifth paragraphs
were reprinted with minor stylistic changes but without comment as 'Remarks on
Blake's Designs Illustrative of Blair's Grave, (From *'Critical Description of* West's
Death on the Pale Horse,) By Mr. William Carey', *The Repository of Arts, Literature,
Fashions, Manufactures, &c.,* 2 S, V (May 1, 1818), 278–80.

[3] There is some doubt about the date, which rouses suspicion as to the relia-
bility of the whole account. The story of Lady Caroline Lamb's party is not actually
given a year as published, but the previous full date given is June 17th, 1819 and
the next is Sept. 1st, 1820; the clearly implied date is thus Tuesday, Jan. 20th,
1820. However, Jan. 20th did not fall on a Tuesday in 1820, though it did in 1801,
1807, 1818, and 1824. The passage refers to Lady Caroline's *Glenarvon*, which was
published in 1816, and to Princess Caroline, who died in 1821, so the possible time
limits are 1816 and 1821. To confuse matters further, the dates just before and just
after this entry (Monday, Jan. 16th, Tuesday, Jan. 17th, Wednesday, Jan. 21st,
Thursday, Jan. 22nd, 'Friday, 25th', Friday, Feb. 25th) are neither self-consistent
nor correct for 1820. Still more awkwardly, Sir Thomas Lawrence, who is men-
tioned as being present at the Jan. 20th dinner, left England in 1818 and did not
return until March 30th, 1820. Clearly, as these dating difficulties show, the diary is
badly jumbled at this point. Consequently, it seems safest to ignore the implied
date in the published Diary (1820), which is an impossible one, and to substitute
the best possibility, 1818. (Another possibility is that June was misread as Jan, for
June 20th was a Tuesday in 1820.) It is important to recognize at the same time
that almost any year, month, or day between 1816 and 1821 when Lawrence was
in England might be correct, and that it is somewhat difficult either to accept or
to reject the account of the dinner party as a whole.

Tuesday, the 20th of January.—I dined at Lady C. L—'s.[1] She had *January* collected a strange party of artists and literati, and one or two fine *20th,* folks, who were very ill assorted with the rest of the company, and *1818* appeared neither to give nor receive pleasure from the society among whom they were mingled. Sir T. Lawrence, next whom I sat at dinner, is as courtly as ever. . . .

Besides Sir T., there were also present of this profession Miss M[*ee*]., the miniature painter, a modest, pleasing person; like the pictures she executes, soft and sweet. Then there was another eccentric little artist, by name Blake; not a regular professional painter, but one of those persons who follow the art for its own sweet sake, and derive their happiness from its pursuit. He appeared to me full of beautiful imaginations and genius; but how far the execution of his designs is equal to the conceptions of his mental vision, I know not, never having seen them. *Main d'oeuvre* is frequently wanting where the mind is most powerful. Mr. Blake appears unlearned in all that concerns this world, and from what he said, I should fear he was one of those whose feelings are far superior to his situation in life. He looks care-worn and subdued; but his countenance radiated as he spoke of his favourite pursuit, and he appeared gratified by talking to a person who comprehended his feelings. I can easily imagine that he seldom meets with any one who enters into his views; for they are peculiar, and exalted above the common level of received opinions. I could not help contrasting this humble artist with the great and powerful Sir Thomas Lawrence, and thinking that the one was fully if not more worthy of the distinction and the fame to which the other has attained, but from which *he* is far removed. Mr. Blake, however, though he may have as much right, from talent and merit, to the advantages of which Sir Thomas is possessed, evidently lacks that worldly wisdom and that grace of manner which make a man gain an eminence in his profession, and succeed in society. Every word he uttered spoke the perfect simplicity of his mind, and his total ignorance of all worldly matters. He told me that Lady C— L— had been very kind to him. 'Ah!' said he, 'there is a deal of kindness in that lady.' I agreed with him, and though it was impossible not to laugh at the strange manner in which she had arranged this party, I could not help admiring the goodness of heart and discrimination of talent which had made her patronise this unknown artist. Sir T. Lawrence looked at me several times whilst I was talking with Mr. B., and I saw his lips curl with a sneer, as if he

[1] There can be no doubt that the hostess was Lady Caroline Lamb, for her libellous novel *Glenarvon* is discussed by Lady Charlotte Bury under this date. For another reference to a William Blake (though not the poet) in connexion with Lady Caroline Lamb, see 'A Collection of Prosaic William Blakes', *N & Q*, ccx (1965), 176.

despised me for conversing with so insignificant a person. It was very evident that Sir Thomas did not like the company he found himself in, though he was too well-bred and too prudent to hazard a remark upon the subject.[1]

Sir Thomas's uneasiness with Blake was apparently not unusual among men of the world, at least until they came to know Blake. '"They pity me," he would say of Lawrence and other prosperous artists, who condescended to visit him; "but 'tis they are the just objects of pity: I possess my visions and peace. They have bartered their birthright for a mess of pottage."'[2] Whatever Lawrence thought of Blake's personality, he certainly admired his art, for he bought a number of expensive works from Blake and his widow.

Among Blake's less august patrons, as we have seen (July 1816), was Charles Augustus Tulk, who was an 'intimate friend' of both Flaxman and Coleridge. His daughter said he was

an ardent student of the writings of Swedenborg, [and] used to have long conversations on religious subjects with both Flaxman & Coleridge. . . . Flaxman felt so much interested in the Writings as to make many drawings from the *Memorable Relations* read to him by Mr. Tulk. . . .

William Blake, the Poet & Painter, with his wife, were rescued from destitution by Mr. C. A. Tulk, & became much impressed with the Spiritual Truths in Swedenborg's Writings. He made drawings from the Memorable Relations, one of them of a female Angel instructing a number of children in the spiritual world.[3]

When I was a girl, says Mrs. Gordon, I had the satisfaction of studying a large collection of Coleridge's letters to my dear father on spiritual subjects. He was then a receiver of the Writings, but he was not like Flaxman and Blake, he was apt to change his opinions if he got under contrary influences.[4]

[1] [Lady Charlotte Bury], *Diary Illustrative of the Times of George the Fourth*, ed. J. Galt, London, 1839, vol. iii, pp. 345–8. There is no change in the texts of this passage when it appears in Lady Charlotte's *The Court of England under George IV*, London, 1896, vol. ii, pp. 190–1, or in *The Diary of a Lady-in-Waiting*, ed. A. F. Steuart, London and N.Y., 1908, vol. ii, pp. 213–15, except that in the latter Miss Mee's name is filled in.

[2] Gilchrist, 1942, p. 308; 1863, p. 309.

[3] I know nothing further of this drawing.

[4] This MS. in the possession of the Swedenborg Society (Inc.), 20–21 Bloomsbury Way, London, W.C. 1, is identified in a headnote as 'from a memorandum

It was probably Tulk who stimulated Coleridge's interest in Blake. Tulk lent him a copy of the *Songs of Innocence and of Experience*, to which Coleridge referred in a letter to H. F. Cary of Friday, February 6th:

> P.S. I have this morning been reading a strange publication—viz. *February* Poems with very wild and interesting pictures, as the swathing, etched *6th,* (I suppose) but it is said—printed and painted by the Author, W. *1818* Blake. He is a man of Genius—and I apprehend, a Swedenborgian— certainly, a mystic *emphatically.* You perhaps smile at *my* calling another Poet, a *Mystic*; but verily I am in the very mire of common-place common-sense compared with Mr Blake, apo- or rather ana-calyptic Poet, and Painter![1]

It was perhaps on the next 'Thursday Evening' that Coleridge wrote at greater length to Tulk:

> I return you Blake's poesies, metrical and graphic, with thanks. *February* With this and the Book I have sent a rude scrawl as to the order in *12th?,* which I was pleased by the several poems. . . . *1818*

Blake's Poems.

> I begin with my Dyspathies that I may forget them: and have uninterrupted space for Loves and Sympathies. Title page and the

by Mrs. Gordon & Leigh, the mother of Caroline Gordon & Mrs. Charles Harrison.' According to a MS. biography of 'George Harrison Born 1790 died 1859 By his son-in-law Theodore Compton' (which I was kindly allowed to see by its present owner, Miss Ruth Marshall of Rickmansworth, Herts.), C. A. Tulk's second daughter Caroline married John Gordon, barrister, and their daughter Caroline Gordon married Charles Harrison. Thus 'Caroline Gordon & Mrs. Charles Harrison' are the same person, the granddaughter of C. A. Tulk.

Mrs. John (Tulk) Gordon later married a man named Leigh. The 'Gordon & Leigh' MS. above states that 'Caputi of Rome . . . cut a cameo of the head of Swedenborg . . . [*which*] is now in my possession.' M. C. Hume, *A Brief Sketch of the Life, Character, and Religious Opinions of Charles Augustus Tulk* (London, 1890, first edition 1850), p. 17 fn.), says the Caputi cameo was bought at C. A. Tulk's death by Mrs. Ley of Florence, whose family still owns it. Thus we may be reasonably certain that 'Gordon & Leigh' are the two married names of Miss Caroline Tulk.

The date of the MS. is no earlier than 1860, for the 'memorandum' refers to Maria Denman's gift of Flaxman's drawings and casts to University College, London, in 1860.

The context and background of this MS., then, indicate that it was originally dictated by, or summarized from the conversation of, the daughter of C. A. Tulk, and that it was written down by *her* daughter Mrs. Harrison. The ellipses in the memorandum suggest that it was transcribed from a larger whole.

[1] *Collected Letters of Samuel Taylor Coleridge*, ed. E. L. Griggs, Oxford, 1959, vol. iv, pp. 833–4.

following emblem contain all the faults of the Drawings with as few beauties, as could be in the compositions of a man who was capable of such faults+such beauties.—The faults—despotism in symbols, amounting in the Title page to the μισητέον [*odium*], and occasionally, irregular unmodified Lines of the Inanimate, sometimes as the effect of rigidity and sometimes of exossation—like a wet tendon. So likewise the ambiguity of the Drapery. Is it a garment—or the body incised and scored out? The *Limpness* (= the effect of Vinegar on an egg) in the upper one of the two prostrate figures in the Title page, and the *eye*-likeness of the twig posteriorly on the second,—and the strait line down the waist-coat of pinky goldbeater's skin in the next drawing, with the I don't know whatness of the countenance, as if the mouth had been formed by the habit of placing the tongue, not contemptuously, but stupidly, between the lower gums and the lower jaw— these are the only *repulsive* faults I have noticed. The figure, however, of the second leaf (abstracted from the *expression* of the countenance given it by something about the mouth and the interspace from the lower lip to the chin) is such as only a Master learned in his art could produce.

N.B. I signifies,['] It gave me great pleasure. ['] I ['']still greater. ['']
—H ['']and greater still.['] Θ, [']in the highest degree.['] o, [']in the lowest.[']*

Shepherd I. Spring I (last Stanza I). Holy Thursday H[.] Laughing Song I[.] Nurses Song I[.] The Divine Image Θ[.] The Lamb I[.] The little Black Boy Θ: yea Θ+Θ! Infant Joy H. (N.b. for the 3 last lines I should wish—'When wilt thou smile,['] or—[']O smile, o smile! I'll sing the while—.['] For a Babe two days old does not, cannot *smile*—and innocence and the very truth of Nature must go together. Infancy is too holy a thing to be ornamented—.[)] Echoing Green I (the figures I, and of the second leaf H[)]. The Cradle Song I[.] The School boy H. Night Θ[.] On another's Sorrow I[.] A Dream?—The little Boy lost I (the drawing I)[.] The little boy found I. The Blossom o.—The Chimney Sweeper o. The V[oice] of the ancient Bard o.

Introduction I. Earth's Answer I. Infant Sorrow I[.] The Clod and the Pebble I[.] The Garden of Love I. The fly I[.] The Tyger I[.] A little Boy lost I[.] Holy Thursday I.—P. 13. O.[1] Nurse's Song O.

[*] o means that I am perplexed—and have no opinion.

[1] Coleridge comments on the poems in the order they are found in Tulk's copy of the *Songs* (J). This 'P. 13' seems to cover both 'My Pretty Rose Tree', 'Ah! Sun Flower', and 'The Lilly' (all on one plate), and 'The Angel', which would be pp. 12 and 13 if the frontispiece to *Experience* (which is now loose) were then in its proper place. Coleridge also omits 'The Human Abstract' after 'The Little Girl Lost [and] Found'. See Plate XXXV.

PLATE XXXV

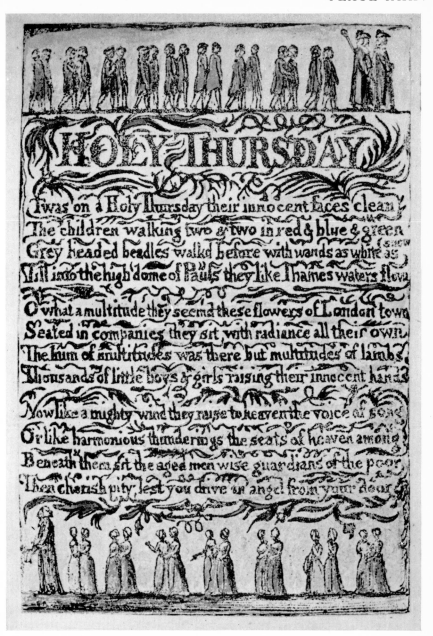

'HOLY THURSDAY' (1789) FROM *SONGS OF INNOCENCE AND OF EXPERIENCE*, the copy (J) which gave Coleridge very great pleasure in 1818 (p. 252)

PLATE XXXVI

ENGRAVING FOR 'HOLY THURSDAY' IN *CITY SCENES* (1818), copying the top of Blake's etching with the children 'walking two & two in red & blue & green' (see p. 253 and Plate XXXV). The anonymous illustrator forgot, however, that the children are supposed to be coming from 'St. Paul's Cathedral'

The little girl lost. And found (the ornaments most exquisite! the poem, I)[.] Chimney Sweeper in the Snow o. To Tirzah—and The Poison Tree I and yet o. A little girl lost—o. (I would have had it omitted—not for the want of innocence in the poem, but for the too probable want of it in many readers[)]. London I[.] The sick Rose I[.] *The little Vagabond*—Tho' I cannot approve altogether of this last poem and have been inclined to think that the [Scholars of Em. Sw. *del*] error, which is most *likely* to beset the Scholars of Em. Sw[*edenborg*] is that of utterly [sub *del*] demerging the tremendous incompatibilities with an evil will that arise out of the essential Holiness of the abysmal Aseity in the Love of the eternal *Person*— and thus giving temptation to *weak* minds to sink this Love itself into *good nature*—yet still I disapprove the mood of mind in this wild poem so much less than I do the servile, blind-worm, wrap-rascal Scurf-coat of FEAR of the *modern Saints* (whose whole Being is a Lie, to them-selves as well as to their Brethren) that I should laugh with good conscience in watching a Saint of the new stamp, one of the Fixt Stars of our eleemosynary Advertisements, groaning in wind-pipe! and with the whites of his Eyes upraised, at the *audacity* of this poem!—Any-thing rather than *this* degradation* of Humanity, and therein of the incarnate Divinity!—

* with which how can we utter 'Our Father'? *S.T.C.*[1]

It may have been in the spring of 1818 that Jane and Ann Taylor's anonymous little children's book called *City Scenes* was reissued, with a new engraving and the second type-printing of Blake's 'Holy Thursday' from *Songs of Innocence* (Plate XXXVI).

The Charity Children.

These charity children are coming from church, with the parish beadle before them. Several thousands of poor children are taught to read, work, and write, in the different charity-schools of London, and to do their duty to God and to their neighbours; which will enable them to become respectable in this world, and tend to make them happy in the next.

Spring? 1818

Once a year, about six thousand charity children, dressed in uni-forms of different colours, assemble in St. Paul's Cathedral, on benches raised to a great height one above the other, circularly, under the dome. The order with which each school finds its own situation, and the union of so many voices, all raised at one moment to the praise of their great Creator, as they chaunt the hundredth psalm on the en-trance of the clergyman, cause a most delightful and affecting sensation

[1] Quoted from a photograph of the MS. in the possession of Sir Anthony Blunt.

in the minds of the spectators. The solemnity of the place, and the hope that so much innocence, under such protection, would be reared to virtue and happiness, must add greatly to the effect.

This uncommon scene is well described in the following lines.

> 'Twas in the pleasant month of June, their hands and faces clean[1]
> The children walking two and two, in red and blue, and green;
> Grey-headed beadles walk'd before, with wands as white as snow,
> Till into the high dome of St. Paul's[1] they, like Thames' waters, flow.
> Oh! what a multitude they seem'd, these flowers of London town!
> Seated in companies they sit, with radiance all their own!
>
> The hum of multitudes was there, but multitudes of lambs;
> Thousands of little boys and girls, raising their innocent hands
> Now like a mighty wind they raise to heaven the voice of song,
> Or like harmonious thunderings, the seats of heav'n among.
> Beneath them sit the aged men, wise guardians of the poor:
> Then cherish pity, lest you drive an angel from your door.[2]

Neither of the anonymous compilers lived in London, but they may have known Blake, for they themselves had been trained as a fourth generation of engravers, and their grandfather, Isaac (1730–1807), had been a good friend of Fuseli. Jane had certainly heard of Blake on June 25th, 1810 (q.v.).

Blake's ideas were reaching a surprisingly wide audience at this time. In one of his public lectures on poetry delivered at *May,* the Surrey Institution in 1818, and published in the same year, *1818* Hazlitt stated: 'Chaucer, it has been said, numbered the classes of men, as Linnaeus numbered the plants. Most of them remain to this day: others that are obsolete, and may well be dispensed with, still live in his description of them.'[3] The passage is ex-

[1] Blake's first line begins 'Twas on a Holy Thursday, their innocent faces clean', and in his fourth line it is 'the high dome of Paul's'.

[2] [Jane and Ann Taylor], *City Scenes*, or A Peep into London. For Children. London. Printed & Sold by Darton, Harvey & Darton, 55, Gracechurch Street. 1818. Price Half a Crown Half Bound. Pp. 67–68. The only other edition I have seen with Blake's poem is *City Scenes*, or A Peep into London. London. Published by Harvey & Darton, Gracechurch Street, 1828. P. 68. Blake's poem is not in previous editions of 1809 and 1814. The source could be Malkin.

[3] *Lectures on the English Poets*, London, 1818, p. 50. The publication of the *Lectures* was announced in the *Monthly Literary Advertiser* for May (p. 35).

traordinarily like Blake's statement in his *Descriptive Catalogue* that 'Names alter, things never alter. I have known multitudes of those who would have been monks in the age of monkery, who in this deistical age are deists. As Newton numbered the stars, and as Linneus numbered the plants, so Chaucer numbered the classes of men.' We know that Crabb Robinson had read Hazlitt some of Blake's poems on March 10th, 1811; perhaps he had lent or given him the *Descriptive Catalogue* as well.

PART V

THE ANCIENTS AND THE INTERPRETER

1818–1827

━━━

I N the summer of 1818 Blake turned a corner in his life. There-
after he was loved, admired, and often supported by the en-
thusiastic group of young artists who called themselves The
Ancients. The first member of the group to meet Blake, and by
far the most important to him, was John Linnell. He was intro-
duced by Cumberland's son George, who said in an undated
letter to his father: 'I have introduced him [*Linnell*] to Blake[,]
they like one another much [and are likely to assist one(?) an-
other(?) *del*] and Linnel has promised to get him some work[.]'¹
Linnell's promise was probably fulfilled promptly, for in his

June Journal² he wrote: '[*Wednesday*] *June 24.* To Mr. Blake even-
24th, ing. Delivered to Mᴿ Blake the picture of Mᴿ Upton & the
1818 Copperplate to begin the engraving.' Years later, when
Linnell was beginning an abortive 'Autobiography', he described
his early relations with Blake thus:

¹ BM Add. MSS. 36515, f. 118. A receipt from Cumberland dated Dec. 27th,
1816 for 'Small painting of Windsor Forest & Lessons on the same [*£*] 5. 0. 0'
(Ivimy MSS., Exercise Book headed 'Art Receipts Not Portraits', copied by A. H.
Palmer) suggests that Linnell had been teaching Cumberland's son.

² This Journal is now known only in two late 19th-century transcripts in the
Ivimy MSS., one by Linnell's grandson Herbert Palmer in an Exercise Book
headed 'Job Revise (2)', and the other by Linnell's son John (less reliable but yet
supplementing Palmer's) in a book headed 'List of John Linnell Senior's Letters'.
Palmer's transcript is quoted here unless otherwise specified. Linnell's Journal is
far from complete, for there is no mention of Blake on many of the days on which,
according to Linnell's Account Books and receipts, he paid money to Blake.

Most of the parts of the Journal relating to Blake were printed by G. Keynes
('William Blake and John Linnell' and 'John Linnell and Mrs. Blake', *TLS*, June
13th and 20th, 1958, pp. 332, 348), to whom I am indebted for many of the facts
elucidating these entries. A few entries in a slightly different form are given by
A. T. Story, *The Life of John Linnell*, London, 1892, vol. i, pp. 171–2, and by
A. H. Palmer, *The Life of Samuel Palmer*, London, 1892, pp. 8–9.

At Rathbone place 1818 my first Child Hannah was born Sep. 8, and here I first became acquainted with William Blake to whom I paid a visit in company with the younger Mr Cumberland. Blake lived then in South Molton St. Oxford St second floor. We soon became intimate & I employed him to help me with an engraving of my portrait of Mr Upton a Baptist preacher which he was glad to do having scarcely enough employment to live by at the prices he could obtain[;] everything in Art was at a low ebb then. Even Turner could not sell his pictures for as many hundreds as they have since fetched thousands[.] I soon encountered Blakes peculiarities and [*was*] somewhat taken aback by the boldness of some of his assertions[.] I never saw anything the least like madness for I never opposed him spitefully as many did but being really anxious to fathom if possible the amount of truth which might be in his most startling assertions I generally met with a sufficiently rational explanation in the most really friendly & conciliatory tone. Even when John Varley[,] to whom I had introduced Blake & who readily devoured all the marvellous in Blakes most extravagant utterances[,] even to Varley Blake would occasionally explain unasked how he beleived that both Varley & I could see the same visions as he saw making it evident to me that Blake claimed the possession of some powers only in a greater degree that all men possessed and which they undervalued in themselves & lost through love of sordid pursuits—pride, vanity, & the unrighteous mammon[.]¹

Some two weeks later Linnell reported in his Journal: '*July 10 [Friday]*. Went with Mʳ Blake to Lord Suffolks to see pictures.' *July 10th, 1818*

¹ The MS. of the 'Autobiography of John Linnell' (in the possession of John S. Linnell) consists of eighty-three loose leaves in the hand of John Linnell, mostly written in the 1850s, but with parts (like this one) apparently recopied and expanded in 1863 and 1864. This quotation (pp. 57–58), for instance, continues: 'As however Blakes life has just been published [*i.e., in 1863*] I shall only say now that several matters related therein are in my opinion great exaggerations— The story for instance of Blake & his Wife acting Adam & Eve & asking Mr Butts to walk in [*see June 24th, 1796*] is so entirely unlike everything I have known of him[,] so improbable from the impracticability of the thing on account of Climate that I do not think it possible but must have grown into the story related in Gilchrist's Life of Blake through its travels 'about town' as stated— Blake was very unreserved in his narrations to me of all his thoughts & actions & I think if anything like this story had been true he wᵈ have told me of it. I am sure he wᵈ have laughed heartily at it if it had been told of him or of any one else, for he was a hearty laugher at absurdity.'

The Autobiography, though of great importance, has long arid stretches of piety, and dwindles off at about 1822. The last words are: 'Blake Job. Drawings for Sir. T[homas]. L[awrence].' (Cf. the fn. to Dec. 24th, 1825.) Fragments from the Autobiography are quoted by A. T. Story, *The Life of John Linnell*, London, 1892, vol. i, pp. 158–62.

Blake and Linnell regularly went on expeditions to see prints and pictures together, as they did again on '[*Friday*] *August* 21. To Colnaghi with Mr Blake.' Only occasionally did Catherine

join their expeditions or social engagements, as she did on Monday, August '24 Mr & Mrs Blake to tea &c.' Some two weeks later the hospitality was returned: '[*Wednesday*]

Septr 9. To W. Blake Evening.' Two days after that Linnell was at the Blakes' again, this time to bring him money: Thursday

September '11. To Mr Blake Evening. paid him £5.' And, as was usual for both men, Linnell was careful to take a receipt.

Blake must have felt justified in asking for more money, because by this time the engraving he was doing for Linnell was all but finished. As Linnell noted in his Journal the next day,

'Sep 12. Mr Blake brought a proof of Mr Uptons plate[,] left the plate & named £15 as the price of what was already done by him. Mr Varley & Mr Constable stayed with Blake[.]'[1] Little is known of the relations between Blake and Constable, but a plausible anecdote has survived that may refer to this evening: 'The amiable but eccentric Blake looking through one of Constable's sketch books, said of a beautiful drawing of an avenue of fir trees on Hampstead Heath, "Why, this is not drawing, but *inspiration*;" and Constable replied, "I never knew it before; I meant it for drawing."'[2]

Varley was obviously much taken with what he saw of

Blake, for less than a week later Linnell wrote in his Journal: Friday September '18. To Mr Blake with Mr Varley Evening.'

Next night the visit was returned: September '19. Dr Thornton called & Mr Blake. went with Mr Blake to Mr Varleys evg.' This is Blake's first recorded contact with the Linnell family doctor, who was to prove a useful though obtuse patron to Blake. Some time during the evening Blake and Linnell also straightened out their accounts, though no money changed hands (see Accounts).

In the spring of 1819 the first part of Robert Watt's *Biblio-*

[1] A. T. Story, *The Life of John Linnell*, London, 1892, vol. i, p. 159, says Linnell was paid £52. 10s. 0d. for the Upton plate. The above is the first occasion on which Varley, a sometimes successful landscape painter and astrologer, is known to have been with Blake.

[2] C. R. Leslie, *Memoirs of the Life of John Constable, Esq. R.A.*, London, 1843, p. 123. This anecdote was not significantly altered in later editions of Leslie's *Memoirs*.

PLATE XXXVII

b. VISIONARY HEAD, subject unknown, perhaps an adolescent Italian Prince

a. VISIONARY HEAD OF RICHARD I, another version of the portrait Blake drew from a vision for Varley, at 12.15 p.m., 14 October 1819 (p. 259). The lines at the top right are probably geomantic

theca Britannica appeared, including under 'BLAKE' a section *Spring?*
1819
simply pirated from *A Biographical Dictionary of Living Authors*
of 1816.[1]

Linnell noted that he went on '[*Thursday*] June 17. To Mr *June*
17th,
1819
Denny, Mr Blake, Mr Stewart.' Perhaps Linnell hoped a
commission might materialize for Blake from Sir Edward
Denny or Anthony Stewart, who painted successful miniatures
of the royal family.

Two months later Linnell reported: '[*Friday*] August 20. *August*
20th,
1819
With Mr Blake to see Harlowe's copy of *Transfiguration'*,
probably at the exhibition in Pall Mall. Next day the two men
went out together again: August '21. With Mr Blake to Mr *August*
21st,
1819
Carpenters. with Mr Holmes to Mr Blake Evening.' The
presence of James Holmes the miniaturist in this group is
natural enough, but was the fourth man William Hookham
Carpenter, the bookseller and print-connoisseur, and was Linnell
trying to find Blake another patron?

The most spectacular fruit of the intimacy between Blake and
Varley was the Visionary Heads which Blake saw in the depth
of the night when he was with Varley, and which he obligingly
sketched for his astonished friend. One of the first of these
Visionary Heads was that of Richard I, on the sketch of which
was written 'Rd Cœur de LION. /Drawn from his Spectre', 'Born *October*
14th,
1819
1156. Died April 6 1199 / ♈ ♑ 10.h. ♎ at Birth', 'W Blake
fecit Octr 14 1819 / at 1/4 Past 12 Midnight'.[2] A few days later
there was another midnight séance, resulting in a drawing
inscribed: 'The Man who built the Pyramids, Drawn by William *October*
18th,
1819
Blake', '[*Monday*]Octr 18. 1819 15 Degrees of Cancer ascending.'[3]

Apparently there was a great variety of nocturnal visitors,

[1] The first of eleven parts was announced in the *Edinburgh Review*, xxxii (July
1819), 250, and according to *DNB* (see Watt) it was printed in Glasgow: 'BLAKE,
William, Artist.—The Gates of Paradise. Illustrated by 16 engravings for Chil-
dren. 1793, 12mo.—Songs of Experience; with plates.—America; a Prophecy.
1793, fol.—Europe; a Prophecy. 1794, fol.—A Descriptive Catalogue of Pictures,
Poetical and Historical Inventions, painted by himself, in Water Colours. Lond.
1809, 12mo.'

[2] Quoted from a photograph of the drawing in the possession of Mr. Joseph
Holland; the date is corrected from the 13th. Linnell later acquired this portrait,
as he did many of Blake's visionary heads. Richard I was born in 1157. Gilchrist
comments: 'In fact, two are inscribed *Richard Coeur de Lion*, and each is different'
(1942, p. 264; 1863, pp. 252–3); the other is in the possession of Mr. F. Bailey
Vanderhoef, Jr. See Plate XXXVII.

[3] *Pencil Drawings by William Blake*, ed. G. Keynes, London, 1927, plate 41.

each of whom provided different problems and opportunities. For instance,

> Among the heads which Blake drew was one of King Saul, who, as the artist related, appeared to him in armour, and wearing a helmet of peculiar form and construction, which he could not, owing to the position of the spectre, see to delineate satisfactorily. The portrait was therefore left unfinished, till some months after, when King Saul vouchsafed a second sitting, and enabled Blake to complete his helmet; which, with the armour, was pronounced, by those to whom the drawing was shown, sufficiently extraordinary.[1]

At other times the visions were not so obliging.

> Sometimes Blake had to wait for the Vision's appearance; sometimes it would come at call. At others, in the midst of his portrait, he would suddenly leave off, and, in his ordinary quiet tones and with the same matter-of-fact air another might say 'It rains,' would remark, 'I can't go on,—it is gone! I must wait till it returns;' or, 'It has 'moved. The mouth is gone;' or, 'he frowns; he is displeased with 'my portrait of him;' which seemed as if the Vision were looking over the artist's shoulder as well as sitting *vis-à-vis* for his likeness. The devil himself would politely sit in a chair to Blake, and innocently disappear. . . .
>
> In sober daylight, criticisms were hazarded by the profane on the character or drawing of these or any of his visions. 'Oh, it's all right!' Blake would calmly reply; 'it *must* be right: I saw it so.["]'[2]

As Linnell noted in his Journal, Varley commissioned him to copy some of the drawings for him: 'October Began a painting in oil colours of two Heads size of Life from Drawings by W Blake of Wallace & Edward 1ˢᵗ for Mʳ Varley.' Many years later a very old man remembered that the inscription on the first of these drawings was as follows: 'William Wallace appeared and stayed long enough for me to paint this portrait of him, when King Edward the First took his place and I painted him also. He promised to come again and bring his wife and children. W. Blake.'[3] Sartain continued: 'Varley,

October, 1819

[1] Gilchrist, 1942, p. 265: 1863, p. 254.

[2] Gilchrist, 1942, p. 263; 1863, pp. 251–2. Many of Gilchrist's general impressions about the Visionary Heads derive from Cunningham, but it is difficult to be certain whether those of his facts and quotations that do not have printed antecedents are authoritative, or are made up to fill out the story. Gilchrist says Blake made forty or fifty such drawings in Varley's presence.

[3] J. Sartain, *The Reminiscences of a Very Old Man 1808–1897*, N.Y., 1899, p. 110. This account was written so many years after the fact that very little reliance can be placed on it. Normally Varley, not Blake, inscribed the portraits.

PLATE XXXVIII

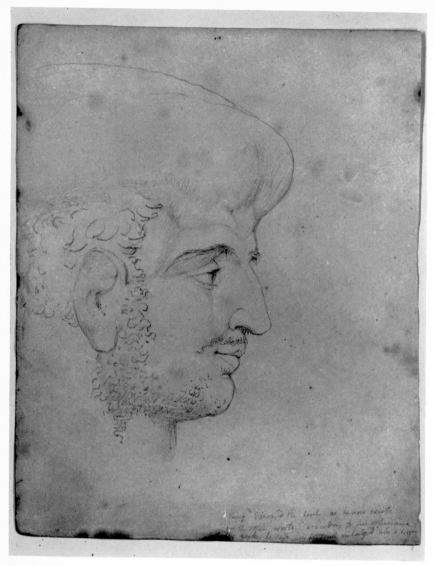

VISIONARY HEAD OF EDWARD I (October 1819) with 'his scull enlarged like a crown' (p. 261)

perceiving my perplexity, said: "I see you don't understand that writing, but it is true. Wallace did really appear to Blake, and that portrait was painted from him and the other also is a faithful portrait of King Edward painted as he saw him." ' The latter is more simply inscribed: 'King Edward the first as he now exists in the other world according to his appearance to Mr Blake. he here has his scull enlarged like a crown[.]'[1]

Years later the origin of these drawings was related by Jane Porter in her *Scottish Chiefs*

as being a something strange and romantic story. The original re-later of it was Mr. Blake, a young painter of remarkable talents; but which were, at times, carried away into wild fancies; a mirage of waking dreams, which he gravely asserted, on describing them, were real visions from the departed world. Soon after the publication of the 'Scottish Chiefs,' his ardent nature had deeply interested him in their fate; but most particularly in that of Wallace; of whose unjust doom he was often in the habit of speaking to a friend of the author of the book,[2] and with a force of language, and indignation at the fact, as if the noble victim's death had been only an event of yesterday.

In one of my friend's calls on the young painter, he found him in an almost breathless ecstacy, which he explained to him, by telling him that he had just achieved two sketches—one of Sir William Wallace, the other of his enemy, Edward the First!—Both chiefs having actually appeared to him successively, and had successively stood, at his earnest request, to allow him to make a hasty sketch of their forms.

While he related this, he placed a small canvas, of the common portrait size, on his easel, before my friend; on which was drawn, in a bold and admirable manner, the head of the young warrior in the prime of his days: as Wallace is described to have been, even at the time in which he was cut off. There was neither helmet, nor any covering on his head, excepting the rich golden-tinted light-hair, that waved high and loosely from off his broad and very elevated forehead. The face was, nearly a front view, remarkably handsome—open in

[1] The drawing with this inscription is now in the Rosenwald Collection. See Plate XXXVIII.

[2] Jane Porter's friend was clearly Varley. It is therefore surprising that her facts about Blake were so awry: Blake, for instance, was not 'young' but fifty-three in 1810 when the *Scottish Chiefs* was published, and sixty-two when Wallace and Edward I were drawn. She might have corrected her facts, if not from Varley, then from other friends of Blake's, for she was a correspondent of the Flaxmans (BM Add. MSS. 39781, f. 423, Feb. 23rd., 1809) and a friend of Crabb Robinson's, who admired her 'fine' and 'stately figure' in 1812 (*Henry Crabb Robinson on Books and their Writers*, ed. E. J. Morley, London, 1938, vol. i, pp. 81 and 82).

its expression, and full of an ardent, generous courage: the blue eye being bright and expanded, and the lips of a noble contour, seemed cheering his devoted followers to deeds of glory. All was gallant sunshine over that fine countenance, which, while you looked on it, might almost induce you to believe the reality of the vision. Also, the high bearing of its corresponding neck and chest. The first was entirely bare; and the latter simply discovered a low breastplate of plain workmanship, half covered by his plaid, broached on the shoulder. This was all which was even outlined in this mysterious portrait. For the painter told my friend, that having turned to dip his pencil[1] for a further touch, when he looked up again, the vision was gone!—While my friend was contemplating this extraordinary portrait, its enraptured artist had described its origin, in this wise:—'He was sitting, meditating, as he had often done, on the heroic actions and hard fate of the Scottish hero, when, like a flash of lightning, a noble form stood before him; which he instantly knew, by a something within himself, to be Sir William Wallace. He felt it was a spiritual appearance; which might vanish away as instantly as it came; and, transported at the sight, he besought the hero to remain a few moments till he might sketch him. The warrior Scot, in this vision, seemed as true to his historical mental picture, as his noble shade was to the manly bearing of his recorded person; for, with his accustomed courtesy, he smiled on the young painter;—and the sketch was outlined, with a tint or two besides. But, while eagerly proceeding, the artist bent his head once too often, to replenish his pencil;[1] and turning again, to pursue the whole contour, the spirit of the "stalworth knight" had withdrawn from mortal ken. But (Blake proceeded to say,) it had not left a Vacancy! Edward the First stood in its place; armed from head to foot, in a close and superb suit of mail; but with the visor of his helmet open!'

The artist, it appears, had as little difficulty in recognising the royal hero; as, when his heart, as well as his eyes, bowing before the august figure just departed, told him it was the Caledonian patriot he beheld. His English loyalty, however, made him rise before the royal apparition. Nevertheless he saluted the monarch with the same earnest privilege of enthusiastic genius, which had dictated the request to the Scottish chief; and he asked the stern-looking, but majestic warrior-king of England, to allow him to make a corresponding sketch. This too, was accorded. And he had arrived at about the same point, as in the former portrait, when the British hero also disappeared;—and Blake was left—not so disappointed at not having accomplished all

[1] For this sketch Blake almost certainly used a lead pencil rather than a brush (the original meaning of pencil) which would have to be dipped. See Plate **XXXIX**.

PLATE XXXIX

William Wallace

VISIONARY HEADS OF WILLIAM WALLACE AND EDWARD I (October 1819). This is presumably the first sketch which was later worked up into the coloured version described by Jane Porter (see pp. 261–3). The two portraits of Edward I (Plates XXXVIII, XXXIX) are strikingly different

he wished, as enraptured at having been permitted to behold two such extraordinary characters; and to have thus far, identified their personal presence to himself; and to the world, to all posterity! For such was his own conviction. The vast expense of life's energies, wrought in this young man, by the over-active exercise of his talents; and the burning enthusiasm, which almost ever over-stimulated their action; swiftly consumed his constitution; and not very long after the painting of these two visionary portraits, he died of a rapid decline[1]—my friend purchased them both; and subsequently showed them to me; recounting the little history, I have just repeated. And, I confess, I looked upon them with no small pleasure; for each bore a strong resemblance to the pictures my mind had before imbibed of both heroes, from all the historical descriptions I had ever heard or read.[2]

The curious relationship between Blake and John Varley, the source of Miss Porter's information, is displayed in Linnell's Autobiography:

Varley could make no way with Blake towards inducing him to regard Astrology with favour. Blake wd say ["]your fortunate nativity I count the worst[;] you reckon that to be born in August & have the notice & patronage of Kings to be the best of all where as the lives of the Apostles & Martyrs of whom it is said the world was not worthy wd be counted by you as the worst & their nativities those of men born to be hanged.["] Varley beleived in the reality of Blakes visions more than even Blake himself—that is in a more literal & positive sense that did not admit of the explanations by which Blake reconciled his assertions with known truth. I have a sketch of the two men as they were seen one night in my parlour near midnight, Blake sitting in the most attentive attitude listening to Varley who is holding forth vehemently with his hand raised. The two attitudes are highly characteristic of the men for Blake by the side of Varley appeard decidedly the most sane of the two. . . . It was Varley who excited Blake to see or fancy the portraits of historical personages—as Edward & Wallace, David, Solomon, the man who built the pyramids &c. &c. most of which I have. I painted in oil the heads of King Edward &

[1] Miss Porter is more dramatic than accurate here. Blake's decline was not rapid (he died eight years later in 1827), and Varley probably bought the drawings soon after they were made, not after Blake's death as Miss Porter implies.

[2] Miss Jane Porter, *The Scottish Chiefs*. Revised, Corrected, and illustrated with A New Retrospective Introduction, Notes, &c., by the author. London [1841], vol. ii, pp. 467–70. (The MS. appeared in the Sotheby sale of June 28th, 1966, Lot 460.) The passage concludes by discrediting the supposedly authentic contemporary portraits of Wallace. Miss Porter clearly saw Linnell's oil painting, showing 'golden-tinted' hair and 'bright' 'blue eye', rather than Blake's sketch.

W^m Wallace for Varley from these drawings in black lead pencil [*by*] Blake, also the Ghost of a Flea [*Plate XLVIII*].[1]

On the back of the last drawing (now in the Tate Gallery) Varley wrote later: 'The Vision of the Spirit which inhabits the Body of a Flea & which appeared to the Late Mr. Blake the designer of the Vignettes for Blair's Grave & the Book of Job. The Vision first appeared to him in my presence & afterwards till he had finished this Picture. A flea he Said drew blood on this . . . [*the rest is illegible.*]' The locale is given by Walter Thornbury,[2] who wrote: 'At the house of the father of my old friend, Leigh, the artist, Blake was a frequent visitor, as was Varley; it was there he drew his "Demon Flea". . . .'. The painter J. M. Leigh was nineteen when Blake died and only about ten when the 'Ghost of a Flea' was drawn,[3] but his evidence is probably reliable.

October 30th, 1819 At the end of October Blake made another drawing which Varley identified as 'Wat Tyler By Wm. Blake from his spectre, as in the act of Striking the Tax Gatherer on the head, Drawn [*Saturday*] Octr. 30, 1819, 1 h. A.M.'[4]

April 24th, 1820 Through Linnell Blake met a number of titled patrons of the arts: '[*Monday*] April 24. Spring Gardens with M^r Blake[;] met the Duke of Argyll. & dunned him for money due on portrait. "The Duke of Argyll appointed tomorrow." '[5] Another

May 8th, 1820 note from Linnell's Journal is: '[*Monday*] May 8. To M^r Wyatt with M^r Blake.' They also went that day to 'Lady Ford—

[1] Autobiography, pp. 57–58, 62.

[2] *British Artists from Hogarth to Turner*, London, 1861, vol. i, p. 28.

[3] James Mathews Leigh (1808–60) was the son of Samuel Leigh, who took over the bookselling business of James Mathews about 1808 (*Holden's Triennial Directory* lists James Mathews at 18 Strand up to 1802; 'Matthews Mrs. E.' at that address for 1805–8; 'Matthews E. & S. Leigh' for 1809; and only 'Leigh Samuel' in 1817). Blake must have become 'a frequent visitor' at 18 Strand sometime after 1808. On Jan. 16th, 1826 he inscribed William Upcott's autograph album 'by the desire of M^r Leigh'.

[4] [E. Wolf 2nd and E. Mongan], *William Blake 1757–1827*, Philadelphia, 1939, item 213. Blake had made an engraving after Fuseli of 'Wat Tyler and the Tax-Gatherer' for Charles Allen's *History of England*, 1798.

[5] Linnell had been since 1813 a member of and regular contributor to the Society of Painters in Oil and Water-Colours (after 1820 called the Old Water-Colour Society), whose exhibitions were held in Spring Gardens. In an Exercise Book (with the Ivimy MSS.) A. H. Palmer copied a receipt from the Duke of Argyle of May 1st, 1820 'for a second painting of the Duchess delivered March 1818 [£]12 12 [0]'.

saw her pictures'.[1] Three days later Linnell was with Blake again: Thursday, May '11. To M^r Denny & to tea with M^r Blake & M^r Varley.' *May 11th, 1820*

When George Cumberland came to London for his spring visit of 1820, he called on Blake on Tuesday, June 6th, and, not surprisingly, met Linnell there too: *June 6th, 1820*

> went to Blakes and read the Courier to him about Queens arrival[.] Mr Linel came in—& I recommended to him the Subject of Spring on a large scale—viz the whole of That Season from the first budding to the full leaf—with many anachronisms[:] To introduce fly Fishing, Rooking[?] Trees Lambing in watered Vallies—later Leaping on exposed Hills—Horses fighting for mares—&c with showers. He likes the idea as does Blake[.]—[2]

The Queen's progress across France to defend herself against the scandalous divorce proceedings in the House of Lords was eagerly reported in *The Courier* and elsewhere in May and June of 1820. Linnell made no record of this visit to Blake.

On one occasion at least Blake himself made a record of people he had seen. On the back of his visionary drawing of 'Old Parr when Young', which is dated 'Aug 1820', is written: 'Saturday M^r Pepper called / Vincent / M^r Sneyd.'[3] *August, 1820*

For *The London Magazine* of September 1820 Fuseli's erstwhile pupil Thomas Griffiths Wainewright wrote:

> Dear, respected, and respectable Editor![4] *August 8th, 1820*
> . . . my exertions to procure crack-contributors have been nearly as zealously unremitting as your own. . . . Talking of articles, my learned friend Dr. Tobias Ruddicombe,[5] M.D. is, at my earnest entreaty, casting a tremendous piece of ordnance,—*an eighty-eight pounder!*

[1] Wyatt was perhaps Henry, the painter, 1794–1840. The second reference comes from A. T. Story, *The Life of John Linnell*, London, 1892, vol. i, p. 172, and not from Palmer's transcript.

[2] BM Add. MSS. 36520H, ff. 384–5.

[3] Quoted from the drawing in the Huntington Library. I cannot identify these callers, unless the second is George Vincent (1796–1836?) the landscape painter.

[4] The respected editor was John Scott, who was wilfully murdered (according to the inquest) a few months later by Christie for his able attacks upon the blackguards of *Blackwood's*.

[5] The pseudonym for Blake may have been a reminiscence of his crisp yellow hair which, according to Tatham (p. 518) 'stood up like a curling flame' in his youth, though by 1820 there was little hair to stand.

which he proposeth to fire off in your next. It is an account of an ancient, newly discovered, illuminated manuscript, which has to name 'Jerusalem the Emanation of the Giant Albion!!!' It contains a good deal anent one '*Los*,' who, it appears, is now, and hath been from the creation, the *sole* and fourfold dominator of the celebrated city of *Golgonooza*! The doctor assures me that the redemption of mankind hangs on the universal diffusion of the doctrines broached in this M.S. —But, however, this is'nt the subject of this *scrinium*, scroll, or scrawl, or whatever you may call it.[1]

Wainewright was a most attractive character socially, and he and Blake became casual friends. In May 1835 James Weale wrote the following note in copy X of *Songs of Innocence and of Experience* (1825): 'This is the most elaborately finished copy of the Songs of Innocence & Songs of Experience I have ever seen—It was executed by the highly gifted artist expressly for his friend, Mr Wainwright; to whom, I am told, he was at the time under considerable pecuniary obligations.' Lamb said that 'kind light hearted Wainwright' 'was a genius of the Lond. Mag.',[2] and his regular contributions to the exhibitions of the Royal Academy were widely admired. He later poisoned a number of relatives, and was deported to Australia in 1837 for forgery.

Linnell's introduction of Blake to Dr. R. J. Thornton in September 1819 had produced for Blake a much needed commission for twenty-seven drawings and twenty-six engravings (three of which were later engraved by another hand) for Thornton's school edition of *The Pastorals of Virgil*. By the autumn of 1820 Blake's plates were well along, and Thornton wrote to Linnell:

September 15th, 1820 [*Friday*] Sept: 15: 1820. 13. Union St Broad St City

My dear Friend

Enclosed you see, what Blake's Augustus—produces in the usual mode of Printing—How much better will be the Stone—provided it turns out well—it will *amalgamate* with Wood—and not injure by comparison—I long to see your Virgil transferred upon the Stone—It has one great advantage—Authority—for the Drawing.—superior

[1] 'Mr. [*Janus*] Weathercock's Private Correspondence, Intended for the Public Eye. George's Coffee House, Tuesday, 8th August, 1820', *The London Magazine*, i (1820), 299–301.

[2] *The Letters of Charles and Mary Lamb*, ed. E. V. Lucas, London, 1935, vol. ii, pp. 395, 323.

PLATE XL

THREE BLAKE WOODCUTS FOR VIRGIL'S *PASTORALS* (1821).
The scenes are reminiscent of Felpham which, like the mile post at the bottom,
was '63 Miles [*from*] London'

execution—& cheap printing—and perpetuity—Permit me to thank
you for your kind exertions. It should be a common cause to get me
out a Virgil worthy of the nation—for the benefit of the rising genera-
tion—& to inspire them with a love for the arts[.]¹

Apparently Thornton was dissatisfied with the woodcuts
Blake had produced—the only ones he ever made—and was
suggesting that they be re-engraved as lithographs. The por-
trait of Virgil appears to have been so altered, for two and a
half weeks later Linnell noted in his journal: '[*Monday*] Oct.ʳ 2
with Dʳ Thornton Dartmouth St Westminster to the Litho-
graphy Press to prove a head of Virgil'. A week later Linnell
went on Monday, October '9. To Dʳ Thornton with Mʳ Blake
&c.' Thornton had apparently been assured that Blake's wood-
cuts were quite unfashionable. 'When Blake had produced his
cuts, which were, however, printed with an *apology*, a shout of
derision was raised by the wood-engravers. "This will never do,"
said they; "we will show what it ought to be"—that is, what the
public taste would like—and [*three of the plates were badly re-
engraved by another hand—see Plates XL–XLI.*]'² Blake's
plates might all have been abandoned, but

*October
2nd,
1820*

*October
9th,
1820*

it fortunately happened that [*Thornton*] meeting one day several
artists at Mr. Aders' table,—Lawrence, James Ward, Linnell, and
others,³—conversation fell on the Virgil. All present expressed warm
admiration of Blake's art, and of those designs and woodcuts in parti-
cular. By such competent authority reassured, if also puzzled, the

¹ Quoted from a transcript by A. H. Palmer in an Exercise Book headed 'J
Linnell Correspondence General' (Ivimy MSS.). Blake's plates of Augustus and
Virgil were printed at vol. i, p. 4. No other evidence is known of the transfer of
these designs to lithography.

² [*Henry Cole*], 'Fine Arts. *The Vicar of Wakefield, With thirty-two Illustrations*.
By W. Mulready, R. A. Van Voorst', *The Athenaeum*, 21 Jan. 1843, p. 165. (The
author is indicated in the marked file of *The Athenaeum* now in the London Office
of *The New Statesman*.) The source of the information here is clearly Linnell, from
whom 'we have obtained the loan of one of Blake's original blocks'. 'That wonder-
ful man Blake' appears only as an incidental illustration of the theme that 'it [*is*]
impossible to get a genuine work of art, unless it come pure and unadulterated
from the mind that conceived it.' Blake's 'blocks, moreover, proved in the first
instance too wide for the page and were, irrespective of the composition, summarily
cut down to the requisite size by the publishers'. (Gilchrist, 1942, p. 280; 1863,
p. 275.)

³ Palmer wrote to E. S. Roscoe ('The Career and Works of Flaxman.—II',
Magazine of Art, iv [1881], 474) that Flaxman too 'was touched by' the Virgil
woodcuts.

good Doctor began to think there must be more in them than he and his publishers could discern. The contemplated sacrifice of the [*seventeen*] blocks already cut was averted. The three other designs, however, had been engraved by another, nameless hand[1]

Blake was fortunate in being discussed in a group which not only admired and rescued his art but, in later years, defended his sanity. The painter

James Ward, who had often met Blake in society and talked with him, would never hear him called mad. . . . 'There can be no doubt,' he writes [*to his son George Raphael in June* 1855], 'of his having been 'what the world calls a man of genius. But his genius was of a peculiar 'character, sometimes above, sometimes below the comprehension of 'his fellow-men. . . . I have considered him as amongst the many 'proofs I have witnessed, of men being possessed of different orders 'of spirits *now*, as well as in the time when the Saviour Christ was 'upon the earth,—although our Established Church (to their shame) 'set themselves against it—some good, some evil, in their different 'degrees. It is evident Blake's was not an evil one, for he was a good 'man, the most harmless and free from guile. But men, and even our 'Church, set down everyone who is eccentric as mad. Alas! how many, 'now in Bedlam, are there for disorders of soul (spirit) and not of the 'body?' A similar suspicion to this Blake himself would sometimes hazard, viz. that 'there are probably men shut up as mad in Bedlam, 'who are not so: that possibly the madmen outside have shut up the 'sane people.'[2]

Indeed, Gilchrist assembles a whole host of witnesses to Blake's sanity from among his best friends in his last years.

'I saw nothing but sanity,' declares one (Mr. Calvert); 'saw noth- 'ing mad in his conduct, actions or character.' Another very unbiassed and intelligent acquaintance—Mr. Finch—summed up his recollec- tions thus: 'He was not mad, but perverse and wilful; he reasoned 'correctly from arbitrary, and often false premises.' . . . 'There was 'nothing mad about him,' emphatically exclaimed to me Mr. Cornelius Varley; 'people set down for mad anything different from themselves.' . . . Mr. Butts . . . I have reason to know, reckoned him eccentric but nothing worse. . . . 'I could see in Blake's wild enthusiasm and ex- 'travagance,' writes another of his personal friends [*Tatham ?*], 'only 'the struggle of an ardent mind to deliver itself of the bigness and 'sublimity of its own conceptions.'[3]

[1] Gilchrist, 1942, pp. 279–80; 1863, p. 273.
[2] Gilchrist, 1942, pp. 321, 322–3; 1863, pp. 323, 325–6.
[3] Gilchrist, 1942, pp. 320, 321; 1863, pp. 323, 324.

PLATE XLI

First Comparison.

Second Comparison.

Third Comparison.

THREE BLAKE DESIGNS ANONYMOUSLY RE-ENGRAVED
FOR VIRGIL'S *PASTORALS* (1821) showing how the conventional
wood-engravers thought they 'ought to be' made (see p. 267)

In '*December*, 1820' 'William Blake' was one of forty-six art authorities, chiefly Royal Academicians, who signed a recommendation for W. P. Carey, who had praised Blake in the past:

We, the undersigned, are of opinion that Mr. Wm. Carey . . . is *December,* eminently qualified by his taste, talents and critical knowledge in *1820* Paintings, Sculpture and Engravings, to discharge the duties of Keeper, Inspector and Arranger of a select and valuable Collection of Paintings, Engravings and other works of Art.

The favorable manner in which his Critical Publications upon the most distinguished Works of the British Artists, have been spoken of by eminent Anglish Artists and Amateurs; and, also, by the Members of the French Academy of the Fine Arts at Paris, are important testimonials of his qualifications, which in our judgment, cannot but operate as a weighty recommendation in his favor as a Critical Selector in forming a Collection.[1]

The signatures included those of Blake's friends Stothard, Ward, Fuseli, Henry Richter, Constable, and John Varley.

Blake's drawings for Young's *Night Thoughts*, which he had made for Richard Edwards, had stayed in the bookselling family. Probably Richard had given or sold them to one of his brothers when he went to Minorca in 1799, but they were not offered for sale in print until 1821, when Richard's brother Thomas Edwards in Halifax published a catalogue, offering:

No. 3. Young's Night Thoughts, the Author's original Copy illus- *1821* trated with drawings, very spirited designs by Mr. Blake, many of them in the Style of Michael Angelo, they occupied nearly two years of the time of this singular and eminent Artist, which renders this work unique, as well as highly valuable, in 2 vols. Atlas Folio, each leaf surmounted with a border and sumptuously bound in red morocco, gilt leaves £300.[2]　　　　　　　　　　　　　　　　　　　　　　　　*1743*

This work is, perhaps, unequalled for the boldness of conception,

[1] This letter was printed in Carey's *Variae*, 1822, and also, with minor variants, about 1823 by 'Clarke, printer, Dublin', with eight untitled pages of 'Documents' in praise of Carey, chiefly letters to and about him dated 1809 to 1823. A footnote to the third word above reads: 'This document was signed during Mr. Carey's absence of four months in Norfolk. The intended office . . . is one, which requires the discharge of important public duties; but the unfavorable times postponed the plan.'

[2] The price asked for the designs was too high and five years later the valuation was reduced to £50.

and spirit of execution exhibited in the masterly designs of Mr. Blake. The Bookbinder from inattention lost the blank leaf with the Author's signature.[1]

1821 In the same year appeared a brief Blake bibliography in a German reference work[2] which was almost entirely lifted from Crabb Robinson's essay on Blake:

2454. Blair, *rb*. The grave, a poem. Illustrated by 12 etchings, executed by Schiavonetti from the original designs of W. Blake. Lond., 1808, f. (*2 Pf. 12 sh. 6 d.*)

D. Zeichnungen des genial. Sonderlings Blake nachen diess Buch vorzügl. merkw.

2455. Blake. *W.* Songs of innocence and of experience, shewing the two contrary states of the human soul. The author and printer W. Blake. *o. O. u. J.* [*i.e., ohne Ort und Jahr*] 12.

Die Buchstab. schein. geätzt zu seyn, u. der Abdruck ist in Gelb gemacht. Rund umher u. zwische. den Zeil, find. sich alle Arten. v. Radirungen: zuweil. gleichen sie den ungestalt. Hieroglyph. der Aegypter, zuweil. bilden sie zierliche Arabesken. Wo sich nach dem Abrucke nach ein leerer Raum fand, ist e. Gemälde hineinge-komm. Diese Miniaturen sind sind v. den lebhaftest. Farben u. oft grotestk, so dass d. Buch ein äusserst seltsam. Anseh. hat. 2 andre ebenso verzierte Gedichte desselb. Vfs. sind. *Europe, a prophecy.* 1794, 4. u. *America, a prophecy.* 1794, 4. — V. dies Schrr. sowie v. dem geistreich. u. genial. Sonderling uberhaubt, s. *Vaterländ. Museum Bd II. Heft 1.* (*Hmb.*, 1811, 8.) S. 107–131 [*see pp. 443, 446*]. . . .[3]

[1] Quoted from T. W. Hanson, 'Edwards of Halifax. Book Sellers, Collectors and Book-Binders', *The Halifax Guardian*, Dec. 21st., 1912, corrected by a transcript which Mr. Hanson kindly sent me in 1961. The 'Author's signature' is apparently that of Edward Young.

[2] Friedrich Adolph Ebert, *Allgemeines Bibliographisches Lexikon*, [2 vols.] Leipzig: F. A. Brockhaus, vol. i [1821], p. 199. See also 1830 for the description of the 1797 *Night Thoughts* in vol. ii.

[3] In the English translation by Arthur Browne (*A General Bibliographical Dictionary*, Oxford, 1837, vol. i, p. 196) this passage reads: 'The letters seem to be etched, and the impression is in yellow. Round about and between the lines are all kinds of etchings: sometimes they resemble misshapen hieroglyphics of the Egyptians, sometimes they form elegant Arabesques. Wherever a vacant space was found after the impression a picture is introduced. These miniatures are of the most lively colours and often grotesque, so that the book has an extremely singular appearance. Two other equally ornamented poems of the same author are, *Europe, a prophecy.* 1794. 4º. and *America, a prophecy.* 1794. 4º.—Concerning these pieces, and particularly their ingenious and talented, though eccentric author, see *Vaterländ. Museum* . . .'.

Four months after the conference with Thornton the occasion for Linnell's Journal entry was probably the publication of the *Virgil*: [*Saturday*] 'Feb.ʸ 3. Dʳ Thornton Dined with me & we went to Mʳ Blakes.' It is not likely that Blake found much in common with the author of *How to Be Rich and Respectable*, and when in 1827 he annotated his 'Most Malignant & Artful' *New Translation of the Lord's Prayer* he asserted that Thornton was a Tory and one of 'the learned that Mouth'. *February 3rd, 1821*

On Friday, February '9. [*Linnell*] Began a small picture of my Mother. Mʳ Blake came in the Evening.' *February 9th, 1821*

Thornton's edition of *Virgil* was entered at Stationers' Hall on February 12th as the 'Property of Willᵐ Harrison', though 'Published by F. C. & J. Rivington'. Blake's designs were accompanied in the book by a printed caveat: 'The Illustrations of this English Pastoral are by the famous BLAKE, the illustrator of *Young's* Night Thoughts, and *Blair's* Grave; who designed and engraved them himself. This is mentioned, as they display less of art than genius, and are much admired by some eminent painters.'[1] The Ancients were enthusiastic. Years afterwards Edward Calvert wrote to his son: 'Some small woodcuts of Blake are in your possession, they are only illustrations of a little pastoral poem by Phillips. They are done as if by a child; several of them careless and incorrect, yet there is a spirit in them, humble enough and of force enough to move simple souls to tears.'[2] Samuel Palmer's description was more elaborate, if not more eloquent: *February 12th, 1821*

I sat down with Mr. Blake's Thornton's *Virgil* woodcuts before me, thinking to give to their merits my feeble testimony. I happened first to think of their sentiment. They are visions of little dells, and nooks, and corners of Paradise; models of the exquisitest pitch of intense poetry. I thought of their light and shade, and looking upon them I found no word to describe it. Intense depth, solemnity, and vivid brilliancy only coldly and partially describe them. There is in all such a mystic and dreamy glimmer as penetrates and kindles the inmost soul, and gives complete and unreserved delight, unlike the gaudy daylight of this world. They are like all that wonderful artist's works the drawing aside of the fleshly curtain, and the glimpse which

[1] *The Pastorals of Virgil*, ed. R. J. Thornton, London, 1821, vol. i, p. 13.
[2] [Samuel Calvert], *A Memoir of Edward Calvert Artist*, London, 1893, p. 19.

all the most holy, studious saints and sages have enjoyed, of that rest which remaineth to the people of God. The figures of Mr. Blake have that intense, soul-evidencing attitude and action, and that elastic, nervous spring which belongs to uncaged immortal spirits.[1]

March 8th, 1821 A month later Linnell went on '[*Thursday*] March 8. To British Gallery with M^r Blake. Dine with me.'

Besides artistic exhibitions, Linnell took Blake to see plays, a thing which Blake is not known to have done much previously.

March 27th, 1821 Tuesday, March '27. To the Theatre Drury Lane with M^r Blake' to see Sheridan's popular *Pizarro* (an adaptation of Kotzebue's *Spaniard of Peru*), followed by a musical piece by J. H. Payne called *Thérèse, the Orphan of Geneva*, with John Braham and Miss Wilson.

April, 1821 Some time early in April 1821 Francis Douce acquired '—Blake's mar. of heaven & hell [*from*] Dyer'.[2]

A month after their last expedition, Linnell was going to see

April 30th, 1821 the recent picture shows: '[*Monday*] April 30 With M^r Blake to Water Col. Exhib: &c'. He also paid him £2 (see Accounts).

May 7th, 1821 And Linnell went on '[*Monday*] May 7. With M^r Blake to Somerset House Ex:' of the Royal Academy.

The villages north of London drew the bright young spirits of the time like a magnet. Keats, Hunt, Shelley, Lamb, Coleridge, and Constable were not the only ones to be attracted to Hampstead and its neighbourhood. According to his Journal Linnell

May 27th, 1821 went for the first time on Sunday, May '27 To Hampstead with M^r Blake', perhaps to look for the cottage he moved into in 1824.

Linnell seems to have been involved with selling some copies of Thornton's Virgil, though whether for Thornton or Blake (who might have been given some free copies) can only

[1] A. H. Palmer, *The Life and Letters of Samuel Palmer*, London, 1892, pp. 15–16. In Sept. 1864 Samuel Palmer sent a friend a sheet with four prints from Virgil on it, accompanied by a note saying they were a 'few drops from the *fountain head*. They are all I have, or you should have a bucketful. Mr. Blake gave this page to me in Fountain Court: impressions taken there, at his own press, by his own hands, and signed by him under my eyes' (A. H. Palmer, *Catalogue of an Exhibition of Drawings, Etchings & Woodcuts by Samuel Palmer and other Disciples of William Blake*, Victoria and Albert Museum, London, 1926, p. 33.)

[2] Quoted from a microfilm of Douce's list of his acquisitions, now in the Bodleian (MS. Douce, e. 67, f. 40^v). There are thirteen entries in April, of which this is the fourth. The former owner was probably Lamb's friend George Dyer, and the copy acquired was B, given by Douce to Bodley in 1835.

guessed. 'June 1. Mr Tatham[1] Alpha Road Evening. Delivered
Dr Thorntons Virgil & recd 18—'.

It may have been during the summer of 1821 that Blake met
his old acquaintance William Frend, the radical, walking in the
Strand with his little daughter. Half a century later the daughter
looked back upon her childhood and recalled:

When I was about ten years old[2] I was walking with my father in
the Strand, when we met a man who had on a brown coat, and whose
eyes, I thought, were uncommonly bright. He shook hands with my
father, and said:

'Why don't you come and see me? I live down here;' and he raised
his hand and pointed to a street which led to the river. *Summer?
1821?*

Each said something about visiting the other, and they parted. I
asked who that gentleman was, and was told:

'He is a strange man; he thinks he sees spirits.'

'Tell me his name,' I said.

'William Blake.'[3]

A week after his last meeting with Blake, Linnell went on
Friday, June '8 To Drury Lane Theatre with Mr Blake' to *June
8th,
1821*
see a 'New Grand Serious Opera' *Dirce, or the Fatal Urn,*
based on Metastasio's *Demofoonte*, with music by Mozart,
Rossini, and others. The principal singers were Charles Edward
Horn, Mr. Sherrif, and Madame Vestris (Lucia Elizabeth
Mathews). The opera was followed by *The Midnight Hour,
a Farce*, translated from *La Ruse contre Ruse, ou Guerre Ouverte*.

Linnell went on Sunday, 'August 26. To Hendon to Mr *August
26th,
1821*
Woodburn's with Mr Blake', perhaps to persuade one of the
three Woodburn brothers to add a Blake drawing to their well-
known collection of pictures.

During the previous years Blake had made a set of twenty-
one drawings for the book of Job for his old patron Thomas
Butts. Apparently Linnell saw these drawings at Butts's house,
and was struck with their beauty. Together he and Blake

[1] Keynes identifies this as Charles Heathcote Tatham, but the surname alone
does not distinguish him from his son Frederick, who lived at home and later be-
came one of The Ancients.

[2] Sophia Elizabeth Frend was born on Nov. 10th, 1809 (p. vii below), but
Blake did not move into Fountain Court, the only house he lived in near the
Strand, until 1821. Since Blake is clearly pointing to Fountain Court, the incident
must have occurred about 1821, when she was eleven and a half.

[3] *Threescore Years and Ten:* Reminiscences of [i.e., by] the late Sophia Elizabeth
[Frend] De Morgan, ed. M. A. De Morgan, London, 1895, pp. 67–68.

decided to reproduce all twenty-one of the pictures in collaboration, and, according to his Journal, a beginning was made on *September 7th, 1821* Friday, '*September* 7 Traced outlines from Mr Blakes designs from Job all day.' The commission came at the lowest ebb of Blake's fortunes, and 'for Linnell, Blake's last years would have been employed . . . [in] making a set of Morland's pig and ploughboy subjects'.[1]

September 8th, 10th, 1821 Next day Linnell recorded: 'Sat 8 Mr Blake & Mr Read with me all Day'.[2] Two days later they were still hard at work: 'Mr Blake finishing the outlines all day Monday 10\underline{th}'.

Since the outlines were completed, it was possible to return the originals to Mr. Butts, and Blake brought another Butts picture for *September 11th, 1821* Linnell to see. Tuesday, September '11. Mr Blake took home the Drawings of Job. 11 Mr Blake Brought Drawing of Cain & Abel.'

September 12th, 14th, 1821 Next day Linnell wrote in his Journal: Wednesday, September '12. Began a copy of Cain & Abel. Finished 14th.' The same day Linnell made the portrait which he inscribed 'Mr. Blake Sept 12 1821 J.L. fect' and perhaps the one dated merely 'Septr 1821'.[3]

It was apparently a month and a half before he saw Blake again: *October 27th, 1821* Saturday, '*October* 27. Mr Blake came to see me in the evening.' On Sunday, 'November. 11. Mr Blake Dined with us.' Four *November 11th, 1821* weeks later he came to the Linnells again: '[*Sunday*] Decr 9. Mr Blake dined here'. It may have been at some such dinner *December 9th, 1821* gathering as this one that Blake met an exquisite little girl, and made an impression upon her that she remembered for the rest of her life. Years later she encountered at another party a Blake enthusiast, who wrote:

The anecdote as I remember it was this:—the Lady was thought very beautiful when a child, and was taken to an evening party and there presented to Blake, he looked at her very kindly for a long while without speaking, and then stroking her head and long ringlets said 'May God make this world to you, my child, as beautiful as it has been

[1] W. M. Rossetti made this note in his copy (now in Harvard) of Gilchrist, (1863), vol. I, p. 283, headed: 'It was, I think, [Alexander] Munro [1825–71] who told me this Nov./63, as if he knew it from some authentic source'. The note was printed in Gilchrist, 1942, p. 288; 1880, p. 329, without reference to W. M. Rossetti or Munro.

[2] This is presumably the same 'Read 'whom Linnell saw with Blake on March 9th, 1925. Keynes (*TLS*, June 13th, 1958, p. 332) identifies the former as D. C. Read, the painter and engraver (who lived in Salisbury), and A. H. Palmer calls the latter '[Reid Engraver]'.

[3] Both drawings are now in the Fitzwilliam Museum.

to me'. She thought it strange at the time, she said, that such a poor old man, dressed in such shabby clothes, could imagine the world had ever been so beautiful to him as it must be to her, nursed in all the elegancies and luxury of wealth; but in after years she understood well enough what he meant and treasured the few words he had spoken to her.[1]

Another four months went by, until Linnell went on '[*Monday*] *April* 8 [*1822*]. To M^r Vine's with M^r Blake.' Presumably their aim was patronage, and if so, they were successful, for James Vine bought copies of *Thel* (O), *Milton* (D), and *Job*.[2] *April 8th, 1822*

Linnell commissioned Blake to reproduce another series of pictures, which he had made originally for Butts. Tuesday, April '9. M^r Blake began copies of his Drawings from Miltons P L.' Though the series was not completed, Linnell eventually bought three magnificent replicas of the *Paradise Lost* set that Blake had created for Butts in 1808.[3] *April 9th, 1822*

There was rarely much money in the Blake house, and there was always some difficulty in persuading Blake to regard its acquisition seriously.

'Money,' says Mr. Palmer, 'he used with careful frugality, but 'never loved it; and believed that he should be always supplied with 'it as it was wanted: in which he was not disappointed. And he worked 'on with serenity when there was only a shilling in the house. Once

[1] Quoted from the MS. in a volume entitled 'William Blake [*MS.*] Letters by Several Hands' in the Library of Congress. The letter, dated Dec. 6th, 1860, is written by Thomas Woolner to Dante Gabriel Rossetti, and begins and ends with the words: 'There were some choice copies of some of Blake's smaller Poems at the party where I met the lady [*whose name he can't remember*] and which belonged to her I believe, but whether they were such as are not accessible at the B. Museum and elsewhere I am unable to say. . . . This [*is*] as near as I can bring it to mind[.]' With the exception of six words changed or added for emphasis, this story appears word for word in Gilchrist, 1942, p. 310; 1863, pp. 310–11.

[2] *Henry G. Bohn's Catalogue of Books*, London, 1847, vol. i, p. 259, offered *Thel* (O) and *Milton* (D) bound together, with the comment: 'This curious and interesting volume was finished in colours, in the style of Drawings, expressly for his principal patron, Mr. Vine of the Isle of Wight, and is believed to be unique in this state[.]' Vine was, of course, far from being Blake's principal patron, and he probably did not live on the Isle of Wight until after Blake's time, for in James Linnell's account book (with the Ivimy MSS, f. 84) is listed 'Mr. Vines Corner Brunswick Square Grenvill Street'. He seems to have been a fairly active patron of the arts, for 'Mr. Vine' was a member of the Artists' Benevolent Fund Committee in June 1825 (J. Pye, *Patronage of British Art*, London, 1845, p. 365). Linnell sold at least three paintings to Mr. Vines in 1817 and 1818 (A. T. Story, *The Life of John Linnell*, London, 1892, vol. i, p. 113; vol. ii, p. 262).

[3] Lots 152–4 in the *Catalogue of the John Linnell Collection*, Christie, March 15, 1918.

'(he told me) he spent part of one of these last shillings on a camel's 'hair brush.' . . . while engrossed in designing, he had often an aversion to resuming his graver, or to being troubled with money matters. It put him out very much when Mrs. Blake referred to the financial topic, or found herself constrained to announce, 'The money is going, 'Mr. Blake.' 'Oh, d— the money!' he would shout; 'it's always the 'money!' Her method of hinting at the odious subject became, in consequence, a very quiet and expressive one. She would set before him at dinner just what there was in the house, without any comment until, finally, the empty platter had to make its appearance: which hard fact effectually reminded him it was time to go to his engraving for a while. At that, when fully embarked again, he was not unhappy; work being his natural element.[1]

However, in the 1820s Blake became poorer, and about 1821 he sold his collection of prints, gathered over almost half a century, to Colnaghi.[2] Even that proved no more than a stopgap. Consequently Linnell made an application on his behalf to the Royal Academy, through George Cumberland's old friend William Collins. According to a note in the Minutes of the Royal Academy Council for Friday, June 28th the secretary:

June Read a letter from M^r Collins R.A. signed also by M^r Cooper re-
28th, commending to the charitable consideration of the President &
1822 Council M^r William Blake an able Designer & Engraver laboring under great distress—

M^r Baily moved & was seconded by M^r Bone that the Treasurer be directed to pay M^r Blake Twenty Five Pounds, which passed unanimously Rich Westmacott P. P.

H^y Howard. Sec^y[3]

Immediately after the weekend Collins wrote:

[July Dear L.
1st, If Mr Blake will send a receipt to M^r Smirke Jun^r Stratford Place
1822] he will be paid. It is not necessary that M^r B should make a personal application.

Yours faithfully

Monday Morn^g. 11 New Cavendish St— William Collins.

[1] Gilchrist, 1942, pp. 311–12; 1863, pp. 312–13. The last intimate details probably came from Catherine via Tatham. Tatham himself reports (p. 525) that Catherine always kept a guinea secreted for emergencies, so 'last shilling' in Blake's mind meant 'last 22s.' to Catherine. [2] See April 3rd, 1830.

[3] Royal Academy Council Minutes, vol. vi, p. 291, which are, of course, in the Royal Academy Library, Burlington House, London. Collins's letter to the Royal Academy has not been preserved in the Royal Academy archives. Linnell's part in this motion is exhibited in his letter of April 3rd, 1830.

And upside down at the top he wrote: 'Let me know the result'.[1] Linnell collected the money for him(see April 3rd, 1830).

Two weeks later Linnell went on Saturday, '*July* 13. To Sir Thos Lawrences with Mr Blake.'[2]

July 13th, 1822

Like Linnell, Varley sometimes introduced Blake into society:

at one time he took Blake to Lady Blessington's house in St. James's Square to dine. . . . although he made his appearance at that house, which was really a sort of menagerie of small lions, in the simplest form of attire as then worn, which included thick shoes and worsted stockings, nobody complained of the strange guest's lack of refinement and gentle manliness.[3]

By early spring of 1823 they were clear enough about ways and means to be able to draw up a contract for *Job*:

Memorandum of Agreeement between William Blake and John Linnell. March 25th 1823—

March 25th, 1823

W. Blake agrees to Engrave the Set of Plates from his own Designs of Job's Captivity in number twenty, for John Linnell—and John Linnell agrees to pay William Blake five Pounds pr Plate or one hundred Pounds for the set part before and the remainder when the Plates are finished, as Mr Blake may require it, besides which J. Linnell agrees to give W. Blake one hundred pounds more out of the Profits of the work as the receipts will admit of it.

Signed J. Linnell Willm Blake [*in his own hand*]
N.B. J.L. to find Copper Plates.[4]
[*On the verso is*] 1823. March 25th Cash on acct of Plates in the foregoing agreement— ———£5. 0. 0
WB.[5]

[1] Ivimy MS. Monday is the only date, but since the R.A. meeting had taken place on a Friday (June 28th), it is reasonable to suppose that this note was written on the next weekday.

[2] In Linnell's Autobiography (p. 76) this is repeated: 'Took Mr Blake to Sir T. Lawrence July 13/22'.

[3] F. G. Stephens, *Memorials of William Mulready*, London and Cambridge, 1867, p. 44. The date must be before August 1822, when the Blessingtons left for nine years on the Continent.

[4] On some of Blake's engravings the marks from the seal can be deciphered as Jones and Pontifex, No .47 Shoe Lane, London'. On March 4th, 1958, H. V. Yorke of The Farringdon Works & H. Pontifex & Sons, Ltd., 9–13 George Street, Manchester Square, London, wrote that the fragmentary company records do not precede 1855.

[5] Quoted from a photostat of the MS. in the Yale University Library. On the

The implicit understanding clearly was that Linnell should pay Blake about a pound a week, as Butts had, for he gave Blake £54 for the Job in 1823, £46. 7s. 9d. in 1824 and £49. 6s. 6d. in 1825.

April 17th, 1823 According to Linnell's Journal, he went on '[*Thursday*] April 17. With Mʳ Blake to the British Museum.'[1] Apparently they had some special business there, for just a week later

April 24th, 1823 appears the same entry: Thursday, April '24. To BritishMuseum with Mʳ Blake.' Shortly after it opened at Somerset House,

May 5th, 1823 Linnell went on '[*Monday*] May 5. To Royal Academy Exhibition with Mʳ Blake.' The same day he paid Blake £10.

June, 1823 During June 1823 appeared the autobiography of Hayley, Blake's Felpham patron, in which were printed a number of references to his sometime protégé.[2]

June 25th, 1823 As he had in 1821, Linnell followed his visit to the Royal Academy Exhibition by an excursion on Wednesday, June '25. With Mʳ Blake to the British Gallery. &c'.

In the summer of Blake's sixty-sixth year James S. Deville asked permission to take a cast of Blake's head (see Plate XLII). George Richmond said that it was

August 1st, 1823 The first mask that the phrenologist took: he wished to have a cast of Blake's head as representative of the imaginative faculty. . . .
That is not like dear Blake's mouth, such a look of severity was foreign to him—an expression of sweetness ˙and sensibility being habitual: but Blake experienced a good deal of pain when the cast was taken, as the plaster pulled out a quantity of his hair. Mrs. Blake did not like the mask, perhaps the reason being that she was familiar with varying expressions of her husband's fine face, from daily observation: indeed it was difficult to please her with any portrait—she never liked Phillips's portrait; but Blake's friends liked the mask.[3]

back is 'Blakes Mem—&c'. A. T. Story, *The Life of John Linnell*, London, 1892, vol. i, pp. 169–70, gives a strangely abbreviated version of this document. The £5 had been paid on March 20th—see the *Job* accounts, p. 603.
 [1] Blake's application to read at the British Museum is not with others preserved there (Add. MSS. 48340).
 [2] *Memoirs of the Life and Writings of William Hayley, Esq.* Written by Himself, Ed. John Johnson, 2 vols., London, 1823. The book is advertised in *The Literary Gazette* for June 7th, 1823. The Blake references will be found printed from MS. under Sept. 22nd, 1800 (*Memoirs*, vol. ii, pp. 22–23); Sept. 3rd, 1801 (125); Oct. 1st, (126); Nov. 8th, (131); Nov. 18th, (132–3); Nov. 22nd, 1801 (134); Feb. 3rd 1802 (135); Feb. 25th, (138); March 11th, (139); March (37–38); March 26th–27th, (42); June 28th, (141–2); Aug. 6th, 180[2] (123–4); Jan. 11th, 1804 (46–47).
 [3] George Richmond's conversation is reported in *Anne Gilchrist: Her Life and*

PLATE XLII

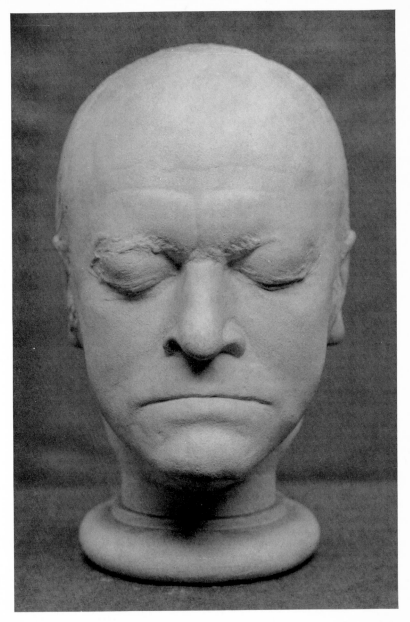

DEVILLE'S LIFE MASK OF BLAKE (1 August 1823). The uncharacteristic
'look of severity' was apparently caused by the pain he experienced when the cast was
removed, pulling 'out a quantity of hair' (p. 278)

The cast of the mask in the National Portrait Gallery is inscribed somewhat crudely 'A 66/PUBd AUG. 1, 1823. I DEVILL [*sic*] / 17 Strand London'.

It may have been in September when, 'In society, once, a cultivated stranger, as a mark of polite attention, was showing him the first number of *The Mechanic's Magazine*. "Ah, sir," remarked Blake, with bland emphasis, "these things we artists HATE!"'[1] *September? 1823?*

For years George Cumberland had been preparing a work which was eventually published as '*An Essay* on the Utility of Collecting the Best Works of the Ancient Engravers of all the Italian Schools; Accompanied by A CRITICAL CATALOGUE, with Interesting Anecdotes of the Engravers, of a Chronological Series of Rare and Valuable Prints, from the Earliest Practice of the Art in Italy to the Year 1549, Now Deposited in the British Museum and Royal Academy, in London', 1827. There were numerous delays in the publication, and while waiting Cumberland showed the manuscript to his friends for their edification and advice. Early in November he wrote in his note-book: 'Lent Blake my Catalogue to read'—and later after the same entry: 'he returned it'.[2] *November, 1823*

In January 1824 was published the catalogue of books in stock of Rivington and Company,[3] in which Blake's name appeared a number of times, most notably under item '11795 Blake's (William) Songs of Innocence and of Experience, shewing the two contrary states of the Human Soul, 54 *plates*, *January, 1824*

Writings, ed. H. H. Gilchrist, London, 1887, p. 261. Richmond's assertion that the mould was 'taken by Deville, when Blake was about fifty years old', that is, about 1807, must be in error. The cast in the National Portrait Gallery is dated 'AUG. 1, 1823' (though the one in the Fitzwilliam is undated), and the *European Magazine* (lxxiv [Oct. 1823], 344) announced that Deville had purchased the original moulds of Nollekens and was offering casts from them for sale: 'His large collection of busts and casts from nature, for the illustration of Phrenology, cannot fail to gratify every visitor of this establishment.' Deville had been selling casts for many years (see Rupert Gunnis, *Dictionary of British Sculptors 1660–1851*, London, 1953), but he may not have begun taking his own 'casts from nature' until 1823. Blake's age when the cast was taken ('A 66') also confirms 1823.

[1] Gilchrist, 1942, p. 325; 1863, p. 328. The first weekly number of *The Mechanic's Magazine* appeared on Aug. 30th, 1823.

[2] BM Add. MSS. 36520i, f. 412. The previous date in the notebook is Nov. 6th and the succeeding one is Nov. 14th.

[3] The appearance of this catalogue is announced in the *Edinburgh Review*, xxxix (Jan. 1824), 505.

engraved in relievo on copper, and coloured to imitate drawings, by
the Author, 8vo. green morocco, extra, g.l. (bound by Charles
Lewis,) 8l. 8s. 1794[.]'¹

*March
24th,
[1824]*
On Wednesday, March 24th William Dixon wrote to Lin-
nell asking whether he should send his portrait of K. Bonning-
ton to the Royal Academy, and he concluded his letter 'With best
respects to M^{rs} L. M^r Varley M^r Blake & hoping they are
well as also your Family I remain Yours very truly Wm
Dixon'.²

In May Blake went with a new young friend, Samuel Palmer,
to the exhibition of the Royal Academy and, as Gilchrist re-
ported some forty years later, Mr. Palmer

*May,
1824*
well remembers a visit to the Academy in Blake's company, during
which the latter pointed to a picture near the ceiling, by Wainwright,
and spoke of it as 'very fine.' It was a scene from *Walton's Angler*,³
exhibited in 1823 or 4.⁴ 'While so many moments better worthy to
remain are fled,' writes Mr. Palmer to me, 'the caprice of memory
presents me with the image of Blake in his plain black suit and *rather*
broad-rimmed, but not quakerish hat, standing so quietly among all
the dressed-up, rustling, swelling people, and myself thinking "How
little you know *who* is among you!" '⁵

Certainly his clothes did not set him off:

In his dress, there was a similar triumph of the man over his poverty,
to that which struck one in his rooms. In-doors, he was careful, for

¹ *A Catalogue of Books*, in various languages, And in Every Department of
Literature, now selling, at the Prices Affixed to Each Article, by Rivingtons and
Cochran, 148, Strand, (near Somerset-House.) London, 1824. This is copy U of
the *Songs*, longed for by Samuel Palmer (Oct. 10th, 1827) bought by Thomas
Edwards and sold by him (May 24th, 1828) indirectly to William Beckford.

² Ivimy MSS. The letter has no year on it, but Dixon told Linnell on June 21st,
1824 that he had sent in the picture of Bonnington. Linnell in his Autobiography
(pp. 23, 24) tells some amusing anecdotes of the improvident Dixon.

³ *The Exhibition of the Royal Academy, M.DCCCXXIV*, No. '268 The milk maid's
song— *T. G. Wainwright*, H[onorary] "Come live with me and be my love."
From the complete Angler. (Isack Walton and Venator listening.)'

⁴ A. H. Palmer says positively that Samuel Palmer did not meet Blake until Oct.
9th, 1824 (*Catalogue of an Exhibition of Drawings, Etchings & Woodcuts by Samuel
Palmer and other Disciples of William Blake*, Victoria and Albert Museum, London,
1926, pp. 4, 33), but Gilchrist's account of the May 1824 Royal Academy Exhibi-
tion is so circumstantial as to be convincing. See also Sept. 1824.

⁵ Gilchrist, 1942, p. 283; 1863, p. 278. The quality of Blake's clothes was of some
relevance, for the Royal Academy made a concerted effort to exclude the ragged
and the impecunious.

economy's sake, but not slovenly: his clothes were threadbare, and his grey trousers had worn black and shiny in front, like a mechanic's. Out of doors, he was more particular, so that his dress did not, in the streets of London, challenge attention either way. He wore black knee breeches and buckles, black worsted stockings, shoes which tied, and a broad-brimmed hat. It was something like an old-fashioned tradesman's dress. But the general impression he made on you was that of a gentleman, in a way of his own.

In person, there was much in Blake which answered to the remarkable man he was. Though low in stature, not quite five feet and a half, and broad shouldered, he was well made, and did not strike people as short. For he had an upright carriage and a good presence; he bore himself with dignity, as not unconscious of his natural claims. The head and face were strongly stamped with the power and character of the man. There was great volume of brain in that square, massive head, that piled up brow, very full and rounded at the temples, where, according to phrenologists, ideality or imagination resides. His eyes were fine—'wonderful eyes,' some one calls them; prominently set, but bright, spiritual, visionary; not restless or wild, but with 'a look of clear heavenly exaltation.' The eyes of some of the old men in his *Job*, recall his own to surviving friends. His nose was insignificant as to size,[1] but had that peculiarity which gives to a face an expression of fiery energy, as of a high-mettled steed,—'a little *clenched* nostril; a nostril that opened as far as it could, but was tied down at one end.' His mouth was wide, the lips not full, but tremulous, and expressive of the great sensibility which characterized him. He was short-sighted, as the prominence of his eyes indicated; a prominence in keeping with his faculty for languages, according to the phrenologists again. He wore glasses only occasionally.[2]

Perhaps it was of this same 1824 visit to the Royal Academy that Palmer wrote:

When looking at the heads of the apostles in the copy of the *Last Supper* [*by Leonardo da Vinci*] at the Royal Academy, he remarked of all but Judas, 'Every one looks as if he had conquered the natural man.' He was equally ready to admire a contemporary and a rival. Fuseli's picture of *Satan building the Bridge over Chaos* he ranked with the grandest efforts of imaginative art, and said that we were two

[1] 'I always thought that Jesus Christ was a Snubby or I should not have worshipd him if I had thought he had been one of those long spindle nosed rascals' (Notebook, p. 64).

[2] Gilchrist, 1942, pp. 313–14; 1863, pp. 314–15. Blake's glasses are now in the Fitzwilliam.

centuries behind the civilization which would enable us to estimate his
Ægisthus.[1]

We do not know when Palmer first met Blake, but years
later he remembered the event vividly. 'The acquaintance com-
menced when Blake was about midway in the task of engraving
his *Job*. "At my-never-to-be forgotten first interview," says
Mr. Palmer, "the copper of the first plate—'Thus did Job
continually'—was lying on the table where he had been working
at it. How lovely it looked by the lamplight, strained through
the tissue paper."'[2] This first meeting was one of profound
importance in Palmer's life, one which he always remembered
and spoke of with something akin to ecstasy. Some thirty years
later he wrote to Gilchrist summarizing his memories of Blake:

I can never forget the evening when Mr. Linnell took me to Blake's
house, nor the quiet hours passed with him in the examination of
antique gems, choice pictures, and Italian prints of the sixteenth cen-
tury.[3] . . .

No man more admired Albert Dürer; yet, after looking over a
number of his designs, he would become a little angry with some of
the draperies, as not governed by the forms of the limbs, nor assisting
to express their action; contrasting them in this respect with the draped
antique, in which it was hard to tell whether he was more delighted
with the general design, or with the exquisite finish and the depth of
the chiselling; in works of the highest class, no mere adjuncts, but
the last development of the design itself.

He united freedom of judgment with reverence for all that is
great. He did not look out for the works of the purest ages, but for
the purest work of every age and country—Athens or Rhodes,

[1] Gilchrist, 1942, pp. 302–3, 1863, p. 303. In his indignant defence of Fuseli's
'Count Ugolino' in June 1806 Blake wrote: 'A gentleman who visited me the other
day, said, "I am very much surprised at the dislike that some connoisseurs shew on
viewing the pictures of Mr. Fuseli; but the truth is, he is a hundred years beyond
the present generation." Though I am startled at such an assertion, I hope the
cotemporary taste will shorten the hundred years into as many hours'

[2] Gilchrist, 1942, p. 299; 1863, p. 297. According to W. Nicholson, *The British
Encyclopedia*, London, 1809, vol. iii, C5r, because 'the uninterrupted light of the
day causes a glare upon the surface of the copper, hurtful and dazzling to the
eyes, it is customary to engrave beneath the shade of silk paper, stretched on a
square frame, which is placed reclining towards the room near the sill of a window.'

[3] Almost certainly Palmer is no longer talking about his first visit to Blake by
the end of this sentence, for the profundity of Blake's poverty in 1824 makes it
extremely unlikely that he still had significant collections of 'antique gems, choice
pictures, and Italian prints of the sixteenth century.'

Tuscany or Britain; but no authority or popular consent could influence him against his deliberate judgment. Thus he thought with Fuseli and Flaxman that the Elgin Theseus, however full of antique savour, could not, as ideal form, rank with the very finest relics of antiquity. Nor, on the other hand, did the universal neglect of Fuseli in any degree lessen his admiration of his best works.

He fervently loved the early Christian art, and dwelt with peculiar affection on the memory of Fra Angelico, often speaking of him as an inspired inventor and as a saint; but when he approached Michael Angelo, the Last Supper of Da Vinci, the Torso Belvidere, and some of the inventions preserved in the Antique Gems, all his powers were concentrated in admiration. . . .

He loved to speak of the years spent by Michael Angelo, without earthly reward, and solely for the love of God, in the building of St. Peter's, and of the wondrous architects of our cathedrals. . . .

His eye was the finest I ever saw: brilliant, but not roving, clear and intent, yet susceptible; it flashed with genius, or melted in tenderness. It could also be terrible. Cunning and falsehood quailed under it, but it was never busy with them. It pierced them, and turned away. Nor was the mouth less expressive; the lips flexible and quivering with feeling. I can yet recal it when, on one occasion, dwelling upon the exquisite beauty of the parable of the Prodigal, he began to repeat a part of it; but at the words, 'When he was yet a great way off, his father saw him,' could go no further; his voice faltered, and he was in tears.[1]

The plates which George Cumberland and Blake engraved for Cumberland's *Thoughts on Outline* had made a deep impression upon the author of the book, though they made next to no impression upon the public. In spite of the slow sale of his work, Cumberland stoutly went ahead with plans for a sequel, which was to use four of the plates Blake had engraved in 1795. Cumberland wrote to his son indignantly on Sunday, May 9th that the price offered for the book by the publisher Prowett was quite inadequate:

What can he mean about the apendix being an additional ex- *May* pence without profit?—*I give the [six] Plates away with the work, ready* *9th,* *engraved* in a better style than he can get them done—*I have them* *1824* and very little used, a Slight retouching would render them new. . . . [*I want the new plates well engraved:*] my friend Stothard spoiled all my tracings of the Athenian Frieze by altering them to fit the Book to

[1] Gilchrist, 1942, pp. 301–3; 1863, pp. 302–3.

please an ignorant publisher—I will not be misrepresented again
Young Stothard would do the outlines I think well—Blake a few—
remember me to them all.[1]

Prowett evidently wrote promptly to Cumberland directly at
this point, for on Friday, May 14th Cumberland replied more
agreeably,

May 14th, 1824 I think with you that a Smaller number of my own designs will do
for the appendix and propose to restrict them to the following 4—
viz. 1 The Conjugal union of Cupid & Psyche 2 Venus councelling
Cupid—3. Ode of Anacreon 52 & 4 The 1ˢ Scene in the clouds of
aristophanes being the most classic of any—These 4 Plates I mean to
present you along with the work. they are by Blake engraved for me
—and may require a little reentering the Lines if you print many.[2]

Coincidentally, while these negotiations were going on,
Blake became briefly the centre of attention for two other men.
Charles Lamb had contributed Blake's 'Chimney Sweeper' to a
volume published by James Montgomery to arouse interest and
money for the plight of the climbing boys,[3] and Bernard Barton,
who had contributed verse of his own, was captivated by Blake's
poem. He wrote to Lamb asking whether the signature to 'The
Chimney Sweeper' was a pseudonym and whether the author
was still living. On Saturday, May 15th Lamb replied:

May 15th, 1824 Blake is a real name, I assure you, and a most extraordinary man,
if he be still living. He is the Robert Blake, whose wild designs accom-
pany a splendid folio edition of the Night Thoughts, which you may
have seen, in one of which he pictures the parting of soul & body by a
solid mass of human form floating off God knows how from a lumpish
mass (fac simile to itself) left behing [*sic*] on the dying bed.[4] He

[1] BM Add. MSS. 36510, ff. 91–92. For the history of the *Outlines*, see *The
Repository*, iii (June 1810), 378; BM Add. MSS. 36520i, ff. 419, 421; 36521B,
ff. 83, 93, c, ff. 179, 183, D, ff. 244, 247, 266, K, f. 469; 36510, ff. 19, 84, 88–90,
105–7, 112, 158–9, 256; 36511, ff. 150–1, 313–15, 318, 331–2; 36512, ff. 41–42,
71–72, 75–76, 170–1, 196–7, 202; 36514, f. 255; 36516, f. 95.

[2] BM Add. MSS. 36510, f. 189, a draft of Cumberland's letter. These are the
plates that were reprinted in the *Outlines from the Antients*.

[3] *The Chimney-Sweeper's Friend, and Climbing-Boy's Album*, London, 1824,
pp. 343–4 (republished 1825). Blake's poem is said to be 'Communicated by Mr.
Charles Lamb, from a very rare and curious little work . . . BLAKE's *Songs of
Innocence*'. The poem as given here differs from the original in only three respects:
in line 3 Lamb gives three 'weeps' for Blake's two; in line 5 Tom Dacre is re-
christened 'Tom Toddy'; and in line 7 the 'it' is omitted.

[4] Lamb has almost certainly confused the *Night Thoughts* plates, which Crabb

paints in water colours, marvellous strange pictures, visions of his brain which he asserts that he has seen. They have great merit. He has *seen* the old welch bards on Snowdon—he has seen the Beautifullest, the Strongest, & the Ugliest Man, left alone from the Massacre of the Britons by the Romans, & has painted them from memory (I have seen his paintings) and asserts them to be as good as the figures of Raphael & Angelo, but not better, as they had precisely the same retro-visions & prophetic visions with himself. The painters in Oil (which he will have it that neither of them practised) he affirms to have been the ruin of art, and affirms that all the while he was engaged in his water-paintings, Titian was disturbing him, Titian the Ill Genius of oil Painting. His Pictures, one in particular the Canterbury Pilgrims (far above Stothard's)[,] have great merit, but hard, dry, yet with grace. He has written a Catalogue of them, with a most spirited criticism on Chaucer, but mystical but full of Vision.[1] His poems have been sold hitherto only in Manuscript. I never read them, but a friend at my desire procured the Sweep Song. There is one to a Tiger, which I have heard recited, beginning

> Tiger Tiger burning bright
> Thro' the deserts of the night—[2]

which is glorious. But alas! I have not the Book, for the man is flown, whither I know not, to Hades, or a Mad House—but I must look on him as one of the most extraordinary persons of the age. Montgomery's Book I have not much hopes from. The Society, with the affected name,[3] have been labouring at it for these 20 Years & made few Converts. I think it was injudicious to mix stories avowedly colour'd by fiction with the sad true statements from the parliamentary records, &c. but I wish the little Negroes all the good that can come from it. I batter'd my brains (not butter'd them—but it is a bad *a*) for a few verses for

Robinson had probably shown him, with one of the plates for *The Grave*—'The Death of the Strong Wicked Man', 'The Soul hovering over the Body', or 'The Death of The Good Old Man'. Some eight years previously Lamb had written, perhaps in reference to the same picture, that 'Death has . . . his damn'd eye upon us, and is wetting his infernal feathered dart every instant, as you see him truly pictured in that impressive moral picture, "The good man at the hour of death" '. (*The Letters of Charles and Mary Lamb*, ed. E. V. Lucas, London, 1935, vol. ii, p. 185.) There is no archer-Death in the *Grave* engravings, but Lamb may have combined in his mind's eye one of the *Grave* plates above with another from the *Night Thoughts* in which Death is clearly shown with a feathered dart—though the dart is not aimed at 'The good man at the hour of death' (Plates XXI, XXVIII, XX).

[1] This account of Blake's ideas on painting is derived, though somewhat roughly, from the *Descriptive Catalogue*.

[2] The second line of 'The Tyger' should begin 'In the forests'.

[3] The affected name was The Society for Ameliorating the Condition of Infant Chimney-Sweepers.

them, but I could make nothing of it. You have been luckier. But Blake's are the flower of the set you will I am sure agree, tho' some of Montgomys at the end are pretty but the Dream awkwardly para-phrased from B.[1]

The friend from whom Lamb had heard of Blake's poems was probably Crabb Robinson, who used to repeat them with en-thusiasm. Years later Linnell told his friends that 'One of his most vivid recollections of those days was of hearing Crabb Robinson recite Blake's poem, "The Tiger," before a distin-guished company gathered around Mr. Aders' table. It was a most impressive performance, and Linnell, catching the spirit of it, used to recite the poem as he had heard it done with great effect.'[2]

May 16th, 1824 To return to the *Outlines from the Antients*: On Sunday, May 16th Cumberland told his son George: 'I think you could do some of the plates . . . let him [*Prowett*] get who he will to do them, unless a Blake or Sc[*h*]iavonetti—they will not justify my deductions from the Designs[.]'[3] This last sentence appa-rently means that only plates by Blake or Schiavonetti would demonstrate Cumberland's principles clearly.

May 18th, 1824 Blake continued to see Linnell, who had on '*March* 6. Moved [*his*] family to Hampstead.' Blake soon began to walk out to Hampstead with some regularity, and Linnell recorded in his Journal his visitors for Tuesday '*May* 18. Mr Vine Mr Tanner[?]. Blake.'

May 24th, 1824 On Monday, May 24th Cumberland wrote to his son George that he was amused by the reference to 'the Coppers, as Mr Prowet calls the plates—I hope he will put the 4 Plates into Blakes hands to reenter the lines & repair, as he will do it, I know carefully having engraved them for me[.]'[4] Blake's friendship with young men of the generation of Cumberland's son is shown by the inscription on copy P of his *Descriptive Catalogue*: 'Frederick Tatham from the Author. [*Saturday*] June 12. 1824'.

June 12th, 1824

[1] Quoted from the MS. in the Huntington Library. The reference in the last line seems to relate Montgomery's prose work in *The Chimney-Sweeper's Friend* to Blake's 'The Dream,' but I can see no significant relationship between Montgo-mery's paraphrase and 'The Dream' or any of Blake's other poems.

[2] A. T. Story, *The Life of John Linnell*, London, 1892, vol. i, pp. 223–4.

[3] BM Add. MSS. 36510, f. 99.

[4] BM Add. MSS. 36510, f. 109. The plates were probably not put in Blake's hands.

Robert Stothard promptly went to work on Cumberland's new outlines, and Cumberland wrote on June 17th that Stothard's new etchings were an improvement, but

As to entering into the doctrine of outline with him or his father, it would be useless; it is sufficient for me to know that even M^r Flaxman owned I was right, confessed his Homer was *done so* to please the public *then uninstructed*;[1] and that Bankes and all the good sculptors of the day as well as all the good draughtsmen at Rome use no other than *an equal outline*.—and as to the possibility of its being done I need only refer him to (what you can shew him,) to all those engraved by Blake from my drawings, particularly plate 14. and 19[2]—of which I have sent up the Plates to be I hope carefully repaired by Blake if they are worn by Printing— *He* understands me, and how to keep a free and equal outline—which is always best. each etching of course should be surrounded by a Single line by way of frame it was not the thickness but the inequality of the Lines I complained of and the want of decision—I send you with this one from Blakes etching from my own design, backgrounded so as to imitate the Greek vases— shew it to M^r Prowett and perhaps he may think it worth while to go to the expence of aquatinting the backgrounds in like manner—as most likely to take with the public, yet not (if carefully done) injuring the outlines[.][3]

June 17th, 18

This letter Cumberland told his son he could show to Stothard and to others if he thought it desirable, but on the same day he wrote George Jr. a private letter expressing more clearly his low opinion of Stothard and his contemporaries:

Those men would make miserable copies from Rafaels drawings, and most likely add a few spirited touches to Mich Angelo—*I know* my old friend Stothard would, who is far indeed from a draughtsman of pure and fine contours, but[?] of Drapery—and even those he is mannered in— I dont want the outlines mended, I dont expect that, unless from such a man as Blake, they may be and certainly are defective even as contours—but if they are copied with feeling they will do very well to explain my ideas of the system of composition and we must be content to get them as well [*engraved*] as we can, in this age of very bad engravers—I dont believe we have half a Dozen engravers

June 17th, 1824

[1] Cumberland referred to the editions of Flaxman's designs for the *Iliad* and *Odyssey* which appeared in 1793 and 1795, before his own *Thoughts on Outline* were published in 1796.

[2] Plates 14 and 19 were 'Venus Councels Cupid' and 'Aristophanes Clouds'.

[3] BM Add. MSS. 36510, ff. 113–14.

in England who know how to draw correctly—but this you must keep to yourself or we shall have them all on our backs at once[.]—[1]

June 21st, 1824 Poor Billy Dixon wrote to Linnell on Monday, June 21st to say that he had finally managed to send in to the Royal Academy his picture of Bonnington, and he concluded by sending his regards to many of Linnell's best friends: '—with best respects to Mʳˢ Linnell Mʳ Varley (by the way I am particularly obliged by his kindness in taking the trouble to go to see my Picture) Mʳ Blake Mʳ Finch &ᶜ hoping you & Family are all well'[2]

[*August 2nd, 1824*] It was probably on 'Monday', August 2nd that Charles Heathcote Tatham wrote to Linnell to say that he and his son Frederick were coming to dinner: 'Can you engage Michael Angelo *Blake* to meet us at yʳ Study, & go up with us?—Such a party of Connoisseurs is worthy apollo & the muses[.]—'[3] Apparently Blake was engageable, for two days later Linnell wrote: *August 4th, 1824* '*August*. 4. Wednesday. Mʳ Varley, Mʳ Tatham & Son Mʳ Blake dined with me at Hampstead.' Perhaps Blake brought with him to the dinner his portrait engraving of Robert Hawker for the elder Tatham, with the following note from his wife:

Mʳ C Tatham
 The humble is formed to adore;
the loving to associate

 with eternal Love
 C Blake[4]

[1] BM Add. MSS. 36510, ff. 115–16. [2] Ivimy MSS.
[3] Ivimy MSS. The letter, which begins 'Chevalier has determined to engage you to engrave the portrait', can be dated between June 15th, 1824 when Thomas Chevalier died (according to the funeral oration in the Ivimy MSS.) and Jan. 1825 when, according to Linnell's Account Book (Ivimy MSS.), Linnell was paid twenty guineas for the Chevalier portrait. The dinner may well be that which took place on Wednesday, Aug. 4th.

On the back of the print of Chevalier engraved by Linnell (published by Colnaghi on May 1st, 1825), which migrated with the Denman collection of Flaxmaniana into the Rosenwald Collection, an early 19th-century hand (Maria Denman's?) has written: '[*Chevalier was a*] Personal friend of W. Blake Owner of the prints in the Scrapbook'. The scrapbook evidently once contained *Visions of the Daughters of Albion* copy a (and presumably other works), which has a note stating: 'This album belonged to Ellen M Chevalier, [(]Mrs Wᵐ Dobinson[)]', the great-granddaughter of the Thomas Chevalier who died in 1824, and also of C. H. Tatham. Another note on the verso of the one above implies that Arthur Tatham, Frederick's brother, gave the *Visions* to his sister, the grandmother of Ellen M. Chevalier.

[4] The engraving with the note affixed to it is now in the Rosenwald Collection.

On Monday, August 9th appeared *The Library Companion*, in which Thomas Frognall Dibdin wrote enthusiastically about Blake's *Night Thoughts* designs:

Wherefore is it, that I love to read that portion of the poem, published in folio form, with the bizarre but original and impressive ornaments by BLAKE? At times, the pencil of the artist* attains the sublimity of the poet: and it is amidst the wild uproar of the wintry elements—when piping winds are howling for entrance round every corner of the turretted chamber, and the drifted snow works its way into the window casement, however closely fastened—it is in moments LIKE THESE that I love to open that portion of the text of Young which has been embellished by the pencil of Blake. My friends will laugh . . . peradventure deride . . . but let us all be endured in these venial moments of hallucination. The soul of poetry itself (we are told) is fiction: and I would feign happiness at such moments.

August 9th, 1824

* A magnificent portrait of Mr. Blake, admirably painted by Phillips, and as admirably engraved by Schiavonetti, is prefixed to the edition of *Blair's Grave*. My friend Mr. D'Israeli possesses the largest collection of any individual of the very extraordinary drawings of Mr. Blake; and he loves his classical friends to disport with them, beneath the lighted Argand lamp of his drawing room, while soft music is heard upon the several corridores and recesses of his enchanted staircase. Meanwhile the visitor turns over the contents of the Blakëan portefeuille. Angels, Devils, Giants, Dwarfs, Saints, Sinners, Senators, and Chimney Sweeps, cut equally conspicuous figures:[1] and the *Concettos* at times border upon the burlesque, or the pathetic, or the mysterious. Inconceivably blest is the artist, in his visions of intellectual bliss. A sort of golden halo envelopes every object impressed upon the retina of his imagination; and (as I learn) he is at times shaking hands with Homer, or playing the pastoral pipe with Virgil. Meanwhile, shadowy beings of an unearthly form hang over his couch, and disclose to him scenes . . . such as no other Mortal hath yet conceived! Mr. Blake is himself no ordinary poet.[2]

[*Dibdin's note; see Plate XIV.*]

The plate is dated May 1st, 1820, and Aug. 4th, 1824 is the only time after 1820 when Blake and C. H. Tatham are known to have been together. The message is a quotation of that part of para. 69 in Lavater's *Aphorsims* (1788) that Blake had underlined in his own copy.

[1] For some account of these 'drawings', which were actually engravings, see Summer 1816. Dibdin's vignette is, of course, highly exaggerated; saints, senators, and dwarfs are extremely hard to identify as such in the works D'Israeli is known to have owned, and no other account mentions Blake shaking hands with his spiritual visitors or playing instruments with them—or doing anything but look at, talk with, and draw them.

[2] T. F. Dibdin, *The Library Companion*, London, 1824, p. 734—or vol. ii, p. 334 in the otherwise identical large-paper edition of the same year. In *The Literary Gazette* for July 31st, 1824, p. 495, the book is announced for publication 'On Monday 9th August'. The ellipses in the quotation appear in the original. When Dibdin was annotating his own copy of his *Library Companion* (now in the British Museum) he did not comment on these Blake passages. Dibdin owned *Thel* (J).

Summer? When the designs to the *Job* series were completed, Linnell
1824? commissioned Blake to make a series of designs for Dante as he
had for *Job*. 'The agreement between the two friends as to the
Dante was, that Mr. Linnell should go on paying Blake 2*l.* or
3*l.* a week, as he wanted money, Blake doing as little or as much
as he liked in return.'¹ As might be expected, Blake plunged
himself enthusiastically into the new project.

With characteristic fervour and activity of intellect, he, at sixty-
seven years of age, applied himself to learning Italian, in order to read
his author in the original. Helped by such command of Latin as he had,
he taught himself the language in a few weeks; sufficiently, that is, to
comprehend that difficult author substantially, if not grammatically:
just as, earlier in life, he had taught himself something of Latin,
French, and even Greek.²

Samuel Palmer wrote to John Linnell in September:

September, I may safely boast that I have not entertain'd a single imaginative
1824 thought these six weeks! While I am drawing from Nature vision
seems foolishness to me—the arms of an old rotten tree trunk more
curious than the arms of Buonaratis Moses—Venus de Medicis finer
than the 'Night' of Lorenzo's tomb & Jacob Ruysdaal a sweeter finisher
than William Blake. However I dare say it is good to draw from the
visible creation love to the little ancients³

¹ Gilchrist, 1942, pp. 329–328–330 [*sic*]; 1863, p. 334. This statement may be
Gilchrist's deduction from Linnell's account books, or an analogy with the *Job*
arrangement, but, equally possibly, he might have had Linnell's authority for it
(see March 9th, 1831). Certainly there is every reason to believe that Gilchrist's
summary here is accurate. The date is derived from Palmer's Oct. 9th, 1824
reference below. See Plate XLIII.

² Gilchrist, 1942, p. 328; 1863, p. 332; cf. Tatham, p. 526. Gilchrist says else-
where (1942, p. 151; 1863, p. 167): 'Blake, who had a natural aptitude for acquiring
knowledge, little cultivated in youth, was always willing to apply himself to the
vocabulary of a language for the purpose of reading a great original author. He
would declare that he learnt French, sufficient to read it, in a few weeks.' Blake told
his brother (Jan. 30th, 1803) that Hayley was then teaching him Hebrew, Greek,
and Latin, but we know nothing else of his French except one use of it about 1808
in his Reynolds marginalia. For the Dante texts Blake used, see Aug. 18th, 1827.

³ Ivimy MSS. Elsewhere Palmer wrote: 'I hope our styles of outline may all be
different as the design of Michael Angelo from his equal, Blake', and he wrote of
Blake as '"The Maker, the Inventor, one of the few in any age,"' and described him
as a fitting companion for Dante and Michael Angelo' (A. H. Palmer, *The Life
and Letters of Samuel Palmer*, London, 1892, pp. 16 and 21). About 1855 Calvert
wrote: 'Now, I feel the full force of Michael Angelo and of Blake's great principles:
UNBROKEN MASSES; UNBROKEN LINES; UNBROKEN COLOURS.' ([Samuel Calvert]
A Memoir of Edward Calvert Artist, London, 1893, p. 155, quoting *Descriptive
Catalogue* [1809], paragraph 50.)

PLATE XLIII

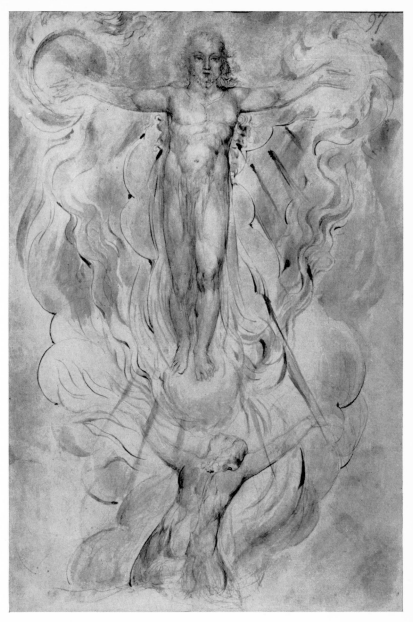

DANTE DESIGN NUMBER 90 (*c.* 1824), perhaps one of the 'sublimest design[*s*]'
which Samuel Palmer saw when he first visited Blake (see p. 291)

Years later Palmer wrote of a visit to Blake:

On Saturday, 9th October, 1824, Mr. Linnell called and went with *October* me to Mr. Blake. We found him lame in bed, of a scalded foot (or leg). *9th,* There, not inactive, though [*almost*] sixty-seven years old, but hard- *1824* working on a bed covered with books sat he up like one of the Antique patriarchs, or a dying Michael Angelo. Thus and there was he making in the leaves of a great book (folio) the sublimest design from his (not superior) Dante.[1] He said he began them with fear and trembling. I said 'O! I have enough of fear and trembling.' 'Then,' said he, 'you'll do.'[2] He designed them (100 I think) during a fortnight's illness in bed! And there, first, with fearfulness (which had been more, but that his designs from Dante had wound me up to forget myself), did I show him some of my first essays in design; and the sweet encouragement he gave me (for Christ blessed little children) did not tend basely to presumption and idleness, but made me work harder and better that afternoon and night. And, after visiting him, the scene recurs to me afterwards in a kind of vision; in this most false, corrupt, and genteelly stupid town, my spirit sees his dwelling (the chariot of the sun), as it were an island in the midst of the sea—such a place for primitive grandeur, whether in the persons of Mr. and Mrs. Blake, or in the things hanging on the walls.[3]

[1] Martin Hardie, *Samuel Palmer*, London, 1928, p. 9 fn., quotes a letter from A. H. Palmer saying that (according to the Accounts in his possession) the Dante could not have been begun in 1824, and that Samuel Palmer's memory therefore must have been wrong. However, Palmer's account seems circumstantial and reliable. It would have been quite possible for Blake to be at work on the Dante drawings for some time before Linnell began to pay him for them by name on Dec. 21st. 1825. Linnell apparently wanted to make steady payments to Blake of a few pounds a week, and he was probably foresighted enough to commission the Dante drawings well before the *Job* was finished, so that no slack time would occur when Blake would be owed nothing for work done.

According to A. T. Story (*The Life of John Linnell*, London, 1892, vol. i, p. 231), who does not present his evidence, 'The first draft of the whole [*of Dante*], or nearly the whole, was made while Blake was in bed with a bad foot. Propped up with pillows, and holding the book before him, he was able to sketch the designs in outline; whereas he could not work on his plates of "Job." '

[2] In an autobiographical letter of Nov. 1st, 1871 Palmer wrote: 'About this time [*after he was 14*] Mr. Linnell introduced me to William Blake. He fixed his grey eyes upon me, and said, 'Do you work with fear and trembling?' 'Yes, indeed,' was the reply. 'Then,' said he, 'you'll do.' No lapse of years can efface the memory of hours spent in familiar converse with that great man.' (F. G. Stephens, 'Samuel Palmer', *The Portfolio*, 1872, p. 164.) Still a third version appears in Gilchrist (1942, p. 360; 1863, p. 370): 'He hated the bold, abrupt, off-hand style of drawing. "Do you work in fear and trembling?" he asked a student who came to him for advice. "Indeed I do, sir." "Then you'll do," was the rejoinder.'

[3] A. H. Palmer, *The Life and Letters of Samuel Palmer*, London, 1892, pp. 9–10. No hint is given of the source of this long quotation. A. H. Palmer remarked when

It may have been after this visit that Palmer made a memorandum to himself in his notebook: 'Look at Mr. Blake's way of relieving subjects, and at his colour.'[1]

Despite the differences between nineteen years and sixty-seven, Palmer and Blake rapidly became firm friends. As Palmer's son wrote years later:

Fortunately for my father, Broad Street lay in Blake's way to Hampstead, and they often walked up to the village together. The aged composer of *The Songs of Innocence* was a great favourite with the [*Linnell*] children, who revelled in those poems and in his stories of the lovely spiritual things and beings that seemed to him so real and so near. Therefore as the two friends neared the farm, a merry troop hurried out to meet them led by a little fair-haired girl of some six years old. To this day she remembers cold winter nights when Blake was wrapped up in an old shawl by Mrs. Linnell, and sent on his homeward way, with the servant, lantern in hand, lighting him across the heath to the main road.[2]

It was Linnell who introduced Blake to John Varley, Frederick Tatham, George Richmond, Edward Calvert, Henry James Richter, and James Holmes.[3] Blake's impression upon all these young men was profound, but 'No one else was affected by Blake in the same way, to the same extent, or so permanently [*as Palmer was*]. No one else ever kissed Blake's bell-handle before venturing to pull it. No one could imagine Palmer arguing with Blake as Richmond did.'[4]

he was transcribing Linnell's Journal for Oct. 1824: 'Entries carelessly made this month & some apparently omitted. No mention of the visit to Blake with S. Palmer'.

[1] A H. Palmer, *The Life and Letters of Samuel Palmer*, London, 1892, p. 15.

[2] A. H. Palmer, *The Life and Letters of Samuel Palmer*, London, 1892, pp. 27–28. Cf. Gilchrist, 1942, p. 299. The little girl was Hannah Linnell, born in 1818, who married Palmer in 1837 and became A. H. Palmer's mother. It is probably A. H. Palmer's own memories which he transcribed in an Exercise Book headed 'Blake Boyd Dante' (Ivimy MSS.): 'The Canterbury Pilgrims was the first work of Art I can remember (hanging in one of the bedrooms at Red Stone wood[?] when I was staying there [*as*] a little child). Tom Dacre, Little Lamb, Tiger Tiger, & other Songs of Innocence & perhaps of Experience were the first poems I ever heard & . . . she who repeated them had heard them as she sat at the authors knee at Hampstead & I heard them when I was about the same age. . . .'

[3] A. T. Story, *The Life of John Linnell*, London, 1892, vol. i, pp. 170–1. It seems likely that Richter at least had known Blake casually for many years, for he received instruction in art from Stothard about 1788. In his Autobiography (p. 42) Linnell wrote in passing of Tatham's 'connection with Blake to whom I introduced him.' On the other hand, Gilchrist (see below) said Calvert 'introduced himself to Blake'.

[4] A. H. Palmer, *Catalogue of an Exhibition of Drawings, Etchings & Woodcuts*

Another of the disciples was George Richmond.

As a lad of sixteen,[1] he met Blake one day at the elder Tatham's, and was allowed to walk home with him. To the boy, it was 'as if he were walking with the Prophet Isaiah';[2] for he had heard much of Blake, greatly admired all he had heard, and all he had seen of his designs. The prophet talked fully and kindly, freely opening his mind, as was his wont with the young—with men of eighteen or twenty say—even more freely and favourably, perhaps, than with their elders. There was more community of sentiment,—a bond of sympathy. On this occasion he talked of his own youth, and of his visions. Just as Mr. Palmer speaks of Blake's tolerant kindness towards young men, Mr. Richmond relates that, in their intercourse, he would himself, as young men are prone to do, boldly argue and disagree, as though they were equals in years and wisdom, and Blake would take it all good-humouredly. 'Never,' adds Mr. Richmond, 'have I known an artist so spiritual, so devoted, so single-minded, or cherishing imagination as he did.' Once, the young artist, finding his invention flag during a whole fortnight, went to Blake, as was his wont, for some advice or comfort. He found him sitting at tea with his wife. He related his distress; how he felt deserted by the power of invention. To his astonishment, Blake turned to his wife suddenly and said: 'It is just so with us,

by *Samuel Palmer and other Disciples of William Blake*, Victoria & Albert Museum, London, 1926, p. 4. According to *The Richmond Papers*, ed. A. M. W. Stirling, London, 1926, p. 25, Richmond 'confessed long years afterwards that never did he enter Blake's house without imprinting a reverent kiss upon the bell-handle which the seer had touched; nor was he alone in this homage, which was practiced by all the band of friends.' I do not know the source of these statements, but since A. H. Palmer was consistently scrupulous in his use of family accounts and A. M. W. Stirling was not, it seems likely that Samuel Palmer was the only bell-handle kisser.

[1] George Richmond (1809–96) was 16 in March 1825. Some confirmation of the date when he met Blake may be found in 'a *gesso* water colour, worked in Blake's favourite "fresco" medium—*The Shepherd Abel* [*which Richmond used to show visitors*] It was George Richmond's first picture; one that was submitted to Blake, who made a careful correction-drawing of the shepherd's arm in his pupil's sketch-book. The picture is dated 1825, and is as fresh as the day it was painted!' (*Ann Gilchrist: Her Life and Writings*, ed. H. H. Gilchrist, London, 1887, p. 262.)

[2] In G. and W. B. Richmond, *The Richmond Papers*, ed. A. M. W. Stirling, London, 1926, p. 24, this quotation is expanded: 'Upon giving an account of it later, my father said: "I felt like walking on air, and as if I had been talking to the Prophet Isaiah."' The whole passage from Gilchrist is repeated, in different words, in *The Richmond Papers*. It is difficult to judge the reliability and originality of these Richmond anecdotes, for they seem to consist of verbal and written memoirs of George Richmond and his son William Blake Richmond which have been mingled, juggled, and silently supplemented by their editor, A. M. W. Stirling, who never indicates the source of her information. I have therefore ignored *The Richmond Papers* as an irresponsible pastiche, except where the material is unique.

is it not, for weeks together, when the visions forsake us? What do we do then, Kate?' 'We kneel down and pray, Mr. Blake.'[1]

It was Blake's power of concentration and vision which particularly struck the young disciples. Blake 'once said to Mr. Richmond, "I can look at a knot in a piece of wood till I am [*f*]rightened at it." '[2] The sharp-eyed young men, however, noticed more than the visionary eyes and the poetic fervour. As George Richmond used to say, 'once Mrs. Blake, in excuse for the general lack of soap and water, remarked to me: *"You see, Mr. Blake's skin don't dirt!"* '[3]

Still another of the young disciples was the twenty-two-year-old Francis Oliver Finch (1802–62).

As a boy, he had heard again and again of Blake from John Varley, whose pupil he was for five years, and his imagination had been much excited by what he had heard. For once, expectation was fulfilled. In Mr. Finch's own felicitous words, Blake 'struck him as *a new kind of man*, wholly original, and in all things. Whereas most men are at the pains of softening down their extreme opinions, not to shock those of others, it was the contrary with him.'[4]

One of the oldest of this group of youngsters gathering around Blake was Edward Calvert (1799–1883), who was married and self-supporting by this time. He may have heard about Blake from the gentle Henry Walter, or from Palmer's cousin John Giles, who spoke rapturously to Calvert about the 'divine Blake', who 'had seen God, sir, and had talked with angels.'[5] Calvert naturally was intrigued by what he heard. 'He introduced himself to Blake, was received most kindly, as if he had been an old friend; and thereafter enjoyed the privilege of

[1] Gilchrist, 1942, pp. 299–300; 1863, pp. 297–8. When Blake felt that he was not profiting by his genius he used to declare that 'he was being devoured by jackals and hyenas.' ([Samuel Calvert], *A Memoir of Edward Calvert Artist*, London, 1893, p. 26.)

[2] A. H. Palmer, *The Life and Letters of Samuel Palmer*, London, 1892, p. 24 fn.; cf. *The Richmond Papers*, p. 25.

[3] *The Richmond Papers*, ed. A. M. W. Stirling, London, 1926, p. 25. M. Wilson reports (*The Life of William Blake*, 1948, p. 386): 'Mrs. Stirling kindly informs me that the story about Mrs. Blake was told to her by Mrs. Arthur Severn's niece.' The chain of evidence for this anecdote is therefore extraordinarily long and weak, but the story itself may not be untrue.

[4] Gilchrist, 1942, p. 300; 1863, pp. 298–9.

[5] [Samuel Calvert] *A Memoir of Edward Calvert Artist*, London, 1893, pp. 50, 17.

calling on and walking with him. . . . *[He and the other Ancients]* would often meet and talk over their views on art[1] Blake and his house used to be familiarly spoken of among them as "The House of the Interpreter." '[2] Clearly The Ancients were thinking of the passage in *Pilgrim's Progress* where Christian 'came at the house of the INTERPRETER *[and said]* . . . I am a man that am come from the City of DESTRUCTION, and am going to Mount ZION; and I was told . . . that if I called here, you would shew me excellent things, such as would be a help to me in my journey.'[3] It may well have been partly as a result of this joke of The Ancients that Blake made his watercolour series of illustrations for *Pilgrim's Progress*, and refurbished his engraving called 'The Man Sweeping the Interpreter's Parlor'.[4]

During the autumn of 1824 young George Cumberland proposed that a portrait of his father should preface his *Essay* on the ancient engravers, and on '21 or 22 Oct' Cumberland replied that the quality of the engraving of such a portrait would be crucial: 'The Dearest are the cheapest—and such as Linnell could do would be the fittest for such a work, or Blake—such prints sell when the author is forgotten[.]'[5] *October 21st or 22nd, 1824*

About this time a prospectus announced:

In NOVEMBER, 1824, *will be published, Price* TWELVE SHILLINGS, A NEW ANNUAL PUBLICATION, DESIGNED FOR A CHRISTMAS PRESENT AND NEW YEAR'S GIFT. CALLED REMEMBER ME! OR, POCKET COMPANION. EMBELLISHED WITH NINETEEN COPPER-PLATES. . . . The Plates are by *[Autumn 1824]*

[1] Samuel Calvert says (*A Memoir of Edward Calvert Artist*, London, 1893, p. 50) that Linnell seldom attended the monthly meetings of The Ancients: 'He had his resources within himself and was confessedly out of touch with the peculiar sentiment which was the bond of union with the "ancients." '

[2] Gilchrist, 1942, p. 300; 1863, pp. 299–300. According to Samuel Calvert (*A Memoir of Edward Calvert Artist*, London, 1893, p. 21), the way Edward 'cherished his reminiscences of Blake was very beautiful and pathetic. He made the most tender allusion to the visions and visitations, the ecstasies and wild indignations that made up the visionary's life'.

[3] John Bunyan, *The Pilgrim's Progress*, ed. Thomas Scott, London, 1801, Part i, pp. 44–46.

[4] G. Keynes, *Engravings by William Blake, The Separate Plates*, Dublin, 1956, no. xi, dates the first version of 'The Man Sweeping the Interpreter's Parlor' *c.* 1794 and the second (apparently on the basis of two watermarks of 1821) *c.* 1821, but the gatherings of The Ancients in 1824 would appear to be an obvious stimulus. The *Pilgrim's Progress* watercolours are from about 1824.

[5] BM Add. MSS. 36520, f. 162. The portrait in the *Essay* was engraved by neither Blake nor Linnell.

Linnell, Blake, and other eminent Artists. . . . [*Among the plates is no.*] 5. The Hiding of Moses, by Blake[.]¹

Blake's lovely little plate accompanied an anonymous description of 'The Hiding of Moses', which related how the baby Moses was placed where Pharaoh's daughters bathed.

This is that precise point where the power of the painter would be called upon to exert the utmost stretch of his talents. He would have to paint the heart-rending solicitude of the fond mother, about to leave the babe in such a perilous situation, amongst the rushes, and her first-born child to the mercy of the waves, and if not a prey to the devouring crocodile, at the disposal of the family of of that monarch, 'who knew not Joseph;' and his power was absolute. None but an artist possessing the imagination and abilities of Mr. Blake could possibly accomplish a task so replete with difficulty that made a painter, when he was trying to represent a father sacrificing his daughter, cover his head in his mantle, feeling that the subject was beyond his power of depicting it.²

It was probably about the same time³ that Blake's nativity was given in an Astrologer's Chronicle called *Urania*:

Nov. 28, 1757. 7H. 45m. P.M. 51°. 32′.

PLANET'S LATITUDE.

☽ 2.220 s. | ♄ 1.14 s. | ♃ 0.42 n. | ♂ 2.02 n.
♀ 2.10 s. | ☿ 0.40 n.

December ? The above horoscope is calculated for the *estimate* time of birth, and
1824 Mr. Blake, the subject thereof, is well known amongst scientific

¹ A copy of this prospectus is in the John Johnson Collection in the Bodleian Library. In the book as published there were fifteen, not nineteen plates.

² *Remember Me!* A New Years Gift or Christmas Present, [*for*] 1825, pp. 33–34. The book was evidently organized by Dr. R. J. Thornton, who signed the 'Introduction', and according to the prospectus wrote the useful reflections and the articles on Botany and Byron. His daughter contributed several stories (unnamed in the prospectus) and the piece on flower painting. Probably Dr. Thornton or his daughter wrote the praise of Blake.

The hope expressed in the prospectus that the work would become 'Annual' was only partly fulfilled; sales were so slow that next year apparently the same sheets (and praise of Blake) were issued with only the dates changed.

³ Four of the articles in the magazine mentioned below are dated Dec. 1824, and the 'Predictions for the Commencement of 1825' covering January and February would have been meaningless if issued *after* Dec. 1824.

characters, as having a most peculiar and extraordinary turn of genius and vivid imagination. His illustrations of the Book of Job have met with much and deserved praise; indeed, in the line which this artist has adopted, he is perhaps equalled by none of the present day. Mr. Blake is no less peculiar and *outré* in his ideas, as he seems to have some curious intercourse with the invisible world; and, according to his own account (in which he is certainly, to all appearance, perfectly sincere), he is continually surrounded by the spirits of the deceased of all ages, nations, and countries. He has, as he affirms, held actual conversations with Michael Angelo, Raphael, Milton, Dryden, and the worthies of antiquity. He has now by him a long poem nearly finished, which he affirms was recited to him by the spirit of Milton;[1] and the mystical drawings of this gentleman are no less curious and worthy of notice, by all those whose minds soar above the cloggings of this terrestrial element, to which we are most of us too fastly chained to comprehend the nature and operations of the world of spirits.

Mr. Blake's pictures of the last judgment, his profiles of Wallace, Edward the Sixth, Harold, Cleopatra, and numerous others which we have seen, are really wonderful for the spirit in which they are delineated. We have been in company with this gentleman several times, and have frequently been not only delighted with his conversation, but also been filled with feelings of wonder at his extraordinary faculties; which, whatever some may say to the contrary, are by no means tinctured with superstition, as he certainly believes what he promulgates. Our limits will not permit us to enlarge upon this geniture, which we give merely as an example worthy to be noticed by the astrological student in his list of remarkable nativities. But it is probable, that the extraordinary faculties and eccentricities of ideas which this gentleman possesses, are the effects of the MOON in CANCER in the twelfth house (both sign and house being mystical), in trine to HERSCHELL from the mystical sign PISCES, from the house of science, and from the mundane trine to SATURN in the scientific sign AQUARIUS, which latter planet is in square to MERCURY in SCORPIO, and in quintile to the SUN and JUPITER, in the mystical sign SAGITTARIUS. The square of MARS and MERCURY, from fixed signs, also, has a remarkable tendency to sharpen the intellects, and lay the foundation of extraordinary ideas. There are also many other reasons for the strange peculiarities above noticed, but these the attentive student will no doubt readily discover.[2]

[1] No long work survives which Blake 'affirms was recited to him by the spirit of Milton'. *Milton*, completed by 1808, was inspired by the Daughters of Beulah, and for *Jerusalem*, perhaps finished in 1820, Blake heard 'the Saviour . . . dictating the words of this mild song' (Plate 4).

[2] Anon., 'Nativity of Mr. Blake, The Mystical Artist', *Urania*, no. 1 (1825),

It may have been the same anonymous author who wrote some years later:

Blake was an embodied sublimity. He held converse with Michael Angelo, yea, with Moses; not in dreams, but in the placid still hours of night—alone—awake—with such powers as he possessed in their full vigour. Semiramis was often bodily before him; he chatted with Cleopatra, and the Black Prince sate to him for a portrait. He revelled in the past; the gates of the spiritual world were unbarred at his behest, and the great ones of bygone ages, clothed in the flesh they wore on earth, visited his studio. He painted from spectres. I have seen several of his pictures—of men who died 'many anno-dominis ago,' taken from their ghosts. The shadow of a flea once appeared to him, and he drew it. . . .

Blake was not the victim of a mere optical delusion. He firmly believed in what he seemed to see. He had no doubt but that the spectre of Edward the Third frequently visited him. He painted the Monarch, in oil,[1] at three sittings. Bruce would now and then call to converse with him. He recognized at a glance the ghost of any great personage the moment it appeared. He had no doubt of its identity. His friend Marc Antony had not sent in his card: no one had announced him: yet he knew the Roman, and named him at sight.

About midnight the illustrious dead used to drop in upon him: sometimes their visits were short, but, frequently, as protracted as he could wish. I have been present on these occasions. One night, while we were engaged in criticizing his own extravagant, yet occasionally sublime illustrations of the book of Job, engraved by himself, he suddenly exclaimed, 'Good God! here's Edward the Third!' 'Where?' 'On the other side of the table; *you* can't see him, but I do; it's his first visit.' 'How do you know him?' 'My spirit knows him—how I cannot tell.' 'How does he look?' 'Stern, calm, implacable; yet still happy. I have hitherto seen his profile only, he now turns his pale face towards me. What rude grandeur in those lineaments!' 'Can you ask him a question?' 'Of course I can; we have been talking all this time, not with our tongues, but with some more subtle, some undefined, some telegraphic organ; we look and we are understood. Language to spirits is useless.' 'Tell him that you should like to know what he

70–72. The fact that the anonymous author knew of the unfinished *Job* suggests that he was fairly close to Blake or Linnell.

[1] Perhaps Anon. is thinking of Linnell's copy in oil of Blake's pencil sketch of Edward I (see Oct. 1819); Blake almost certainly did not make his original sketch in oil. Such discrepancies weaken the authenticity of this account, but since the author says below 'I have been present' it is safest to accept what he says as true in substance but unreliable in minutiae.

thinks of the butcheries of which he was guilty while in the flesh.'
'I have, while you have been speaking.' 'What says his majesty?'
'Briefly this: that what you and I call *carnage* is a trifle unworthy of
notice; that destroying five thousand men is doing them no real in-
jury; that, their important parts being immortal, it is merely re-
moving them from one state of existence to another; that mortality
is a frail tenement, of which the sooner they get quit the better, and
that he who helps them out of it is entitled to their gratitude. For, what
is being hewn down to the chine to be compared with the felicity of
getting released from a dreary and frail frame?' 'His doctrines are
detestable, and I abhor them.' 'He bends the battlement of his brow upon
you; and if you say another word, will vanish. Be quiet, while I take a
sketch of him.'[1]

On Friday, January 2nd, 1825 Samuel Palmer reviewed in his *January*
notebook what he had done since the previous July 15th: 'Mr. *2nd,*
L. called, and looking at my *Joseph*, sepias, and sketch-books, *1825*
did give me indeed sweet encouragement. Soon, by his desire,
I went with him to Mr. B., who also, on seeing my things, gave
me above my hope, over-much praise; and these praises from
equally valued judgements did (God overruling) not in the least
tend to presumption and idleness, and but little to pride'[2]
Another memorandum from Palmer's sketch-book of 1824
illustrates the kind of advice which Blake gave his young
disciples: 'Remember that most excellent remark of Mʳ B's—
how that a tint equivalent to a shadow is made by the outlines of
many little forms in one mass, and then how the light shines on
an unbroken mass near it, such for instance as flesh, &c— This
remark alone if generally acted upon would go a good way to-
ward the much hoped for & prayed for revival of art.'[3] Blake's

[1] Anon., 'Bits of Biography. No. 1. Blake, the Vision Seer, and Martin, the
York Minster Incendiary', *The Monthly Magazine*, xv (March 1833), 244–5. This
article is clearly the source for Anon., 'Hôpital des fous à Londres', *Revue
Britannique*, 3rd Series, iv (July 1833), 183–6. The French author claims to have
visited Bedlam some years before and to have interviewed Martin and 'Blake
surnommé le *Voyant*', 'un homme grand et pâle'. It begins almost as a translation:
'Il n'était pas victime d'une simple hallucination, il croyait fermement, profondé-
ment à la réalité de ses visions; il conversait avec Michel-Ange, il causait avec
Moïse, il dinait avec Sémiramis' It goes on, however, to say that Blake was
found in his cell drawing the ghost of a flea, that he conversed with Richard III,
and so on.

[2] A. H. Palmer, *The Life and Letters of Samuel Palmer*, London, 1892, p. 13.

[3] Quoted from the sketch-book in the BM Print Room. It seems likely that Palmer
was in fact looking over this sketch-book when he reviewed his time as quoted

pictures were clearly an inspiration to The Ancients, but probably few of them ever saw the chief repository of Blake's paintings. As Samuel Palmer wrote regretfully: 'Dear Mr. Blake promised to take me himself to see Mr. Butts' collection —but alas! it never came off.'[1]

January 28th, 1825
Linnell's journal records a visit on 'January. Friday 28. To Cap Buller[?] Rennie. Blake Bank Neale &c'. The chief purpose of this visit to Blake was probably to pay him £10 (see Accounts).

March 5th, 1825
By March the *Job* was nearing completion, and Linnell wrote triumphantly in his Journal that he went on '[*Saturday*] *March 5*. With Mr Blake to Lahee's proving Job.' Apparently Blake and Linnell felt that the engravings were all but finished, for the twenty-two plates are confidently labelled: 'London, Published as the Act directs March 8: 1825 by William Blake No 3 Fountain Court Strand [*see Plate XLIV*].' However, they were not actually printed and published until a year later. Next

March 9th, 1825
day Linnell's journal reports a visit Wednesday, March '9. To Mr Blake. Read[2] Cafe Bollo &c'.

After Cumberland's criticism of Stothard's engravings for his *Outlines from the Antients*, it is not surprising that the commission for the book was put into different hands. An engraver named Henry Moses was recommended, but difficulties arose, and on Tuesday, April 5th Cumberland wrote angrily to his son:

April 5th, 1825
as to Prowett I find by Bob Stothard that it was the little dirty Flaxman who stopped him by saying he had seen the originals, & that they should be used not my copies.—The fellow never forgave my shewing that his outlines were erroneous . . . but I shall be serious with *Prowet* as to my agreement, which was that they should be published & that I should have a certain number of copies, & the original outlines returned— He has paid and has got my Plates so that I think he will not risk my action—could not Blake do them, if Moses cannot?[3]

above. The first pages of the sketch-book are dated July 15th, 1824, and the Blake memorandum is just a few pages on. (Precise reference is difficult because some of the early pages were torn out and given to the Victoria and Albert Museum.)

[1] Quoted by A. H. Palmer (*Catalogue of an Exhibition of Drawings, Etchings & Woodcuts by Samuel Palmer and other Disciples of William Blake*, Victoria & Albert Museum, London, 1926, p. 27) from a letter of Feb. 5th, 1881.

[2] See Sept. 8th, 1821.

[3] BM Add. MSS. 36510, ff. 357–8. F. C. Lewis finally engraved the plates.

PLATE XLIV

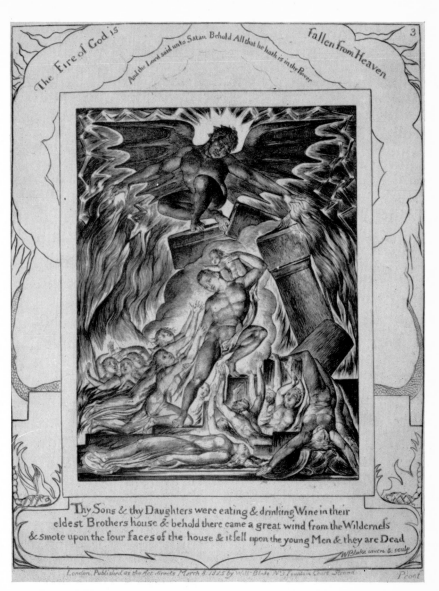

The Fire of God is

And the Lord said unto Satan Behold All that he hath is in thy Power

fallen from Heaven

Thy Sons & thy Daughters were eating & drinking Wine in their
eldest Brothers house & behold there came a great wind from the Wilderneſs
& smote upon the four faces of the house & it fell upon the young Men & they are Dead

W Blake invent & sculp

London, Published as the Act directs March 8. 1825 by Will. Blake N.3 Fountain Court Strand

Proof

BLAKE'S THIRD *JOB* ENGRAVING (1826). The border designs were added at
the last minute directly on the copper (see pp. 326–7)

Linnell noted enigmatically in his journal '[*Friday*] *April* 8 to City Blake'. One purpose of the trip was to pay Blake £3. 10s. 0d. A month later he was going on Tuesday, '*May* 3. To M͏ʳ Blake To Exhibition', presumably of the Royal Academy. He also paid Blake £5. 0s. 0d. *April 8th,*
1825

May
3rd,
1825

Blake was apparently ill in bed most of that summer with shivering fits, and Linnell's friends were deeply concerned for him. On Saturday, August 6th young Edward Thomas Daniell wrote to Linnell: 'I am sorry to hear poor M͏ʳ Blake is so unwell but hope he may recover, again to use [*h*]is pencil and graver—'.[1] *August*
6th,
1825

Happily, Linnell could give him good news, for on that very day he wrote in his Journal: '*August* 6. Sat. To M͏ʳˢ Aders 11, Euston Square with M͏ʳ Blake'. Mr. and Mrs. Aders, a wealthy and cultivated couple, were among the many people to whom Linnell had introduced Blake, and probably at their house Blake also saw Coleridge.[2] At gatherings at the Aders's house Blake was likely to meet all kinds of people, and some of the best-known stories about Blake probably originated there. For instance: *August*
6th,
1825

At one of Mr. Aders' parties—at which Flaxman, Lawrence, and other leading artists were present—Blake was talking to a little group gathered round him, within hearing of a lady whose children had just come home from boarding school for the holidays. 'The other evening,' said Blake, in his usual quiet way, 'taking a walk, I came to a meadow, and at the farther corner of it I saw a fold of lambs. Coming nearer, the ground blushed with flowers; and the wattled cote and its woolly tenants were of an exquisite pastoral beauty. But I looked again, and it proved to be no living flock, but beautiful sculpture.' The lady, thinking this a capital holiday-show for her children, eagerly interposed, 'I beg pardon, Mr. Blake, but *may* I ask *where* you saw this?' '*Here*, madam,' answered Blake, touching his forehead.[3]

Perhaps it was this evening which Samuel Palmer described

[1] Ivimy MSS.

[2] Gilchrist, 1942, p. 330; 1863, pp. 335–6, dates the Aders meeting about 1825 and says he thinks Blake met Coleridge at Linnell's house. However, Mrs. Aders was Linnell's channel of communication with Coleridge (there are several undated letters from her with the Ivimy MSS. suggesting that Linnell should paint Coleridge's portrait), and it seems at least as likely that the chief contact between Blake and Coleridge was at the Aders's parties.

[3] Gilchrist, 1942, p. 317; 1863, pp. 319–20. The dialogue seems highly un-Blakean, but the gist of the story may be authentic.

when he wrote: 'Being irritated by the exclusively scientific talk at a friend's house, which talk had turned on the vastness of space, he cried out, "It is false. I walked the other evening to the end of the earth, and touched the sky with my finger."'[1]

It may well have been about September 1825 that Samuel Palmer persuaded Blake and Mr. and Mrs. Calvert to make an expedition with him to his grandfather's home in Shoreham, Kent, about twenty miles from London.[2] Calvert's son wrote:

[*September?* *1825?*] The journey was, to the satisfaction of all parties, performed in one of those covered stage waggons of the period Edward Calvert and Mrs. Calvert had arranged for seats in the van belonging to Russell the carrier, whose route was from Charing Cross to Tunbridge Wells, and therein, with Blake and Palmer snugly ensconced, and—possibly on this occasion Mrs. Blake—the heavy-wheeled vehicle, drawn by an eight or ten-horse team, jogged on in the good old style. The well-kept horses were caparisoned much after the manner adopted by the Spanish muleteers, with hoops and bells, and those large flapping flanges, or housings as they were called, which Palmer said were the rudiments or degenerate wings of the ancient Pegasus—they are quite extinct now.—Thus was the journey through the delightful Kentish country accomplished. And then came the welcome at the house, or rather cottage, with its quaint gables, heavily thatched and overgrown, such as our Samuel Palmer loved to introduce into his pictures. We see the interesting group disposed around and within the huge chimney hearth, the room having vaulted beams supporting the upper floor. In this room they sat and talked, the elder Palmer in knee breaches and gaiters—quite of the old school.

Calvert and his wife were accorded the best room the house could offer. Mr. Blake being accommodated by a neighbour over the way, while Samuel Palmer had a warm, and no doubt congenial shake-down at the village bakery. The next day Blake took up his position in the far corner of the chimney, with my father and old Palmer seated opposite. They talked of the divine gift of Art and Letters, and of spiritual

[1] A. H. Palmer, *The Life and Letters of Samuel Palmer*, London, 1892, pp. 24–25, quoting a letter to Anne Gilchrist of July 24th, 1862. The anecdote appeared in Gilchrist (1942, p. 324–5; 1863, p. 328) as follows: 'Some persons of a scientific turn were once discoursing pompously and, to him, distastefully, about the incredible distance of the planets, the length of time light takes to travel to the earth, &c., when he burst out, "'tis false! I was walking down a lane the other day, and at the other end of it I touched the sky with my stick". . . .'

[2] The date of this incident is very vague, but it must be after Samuel Palmer came to know Blake fairly well, that is after Jan. 2nd, 1825; it must be in fairly warm weather; and apparently Blake's health would not have permitted such an expedition after Oct. 1825.

vision and inspiration, and of what they termed 'the traverse of sympathy.' And this, naturally enough, elicited from old Palmer the story of the ghost which was said to haunt a half-ruined mansion close by. Some think this was Shoreham Castle, only a mile from Palmer's house

On the proposal of Calvert, it was agreed that the haunted premises should be visited that night, and the eerie mystery investigated. Calvert believed in adventure, and Blake believed in ghosts, and the younger Palmer believed in Blake. And so, providing themselves with candles and lanthorn, they were ready for the exploit.

The usual associations belonging to every respectably haunted house were not wanting. The wind came eddying round, 'moaning through the tortuous fissures and partly dismantled windows.' The moon was down, and a sense of solemnity, not to say awe, took possession of Palmer as, holding the lanthorn, their weird shadows crossed each other on the broken walls. Then, as the story goes, a curious rattling sound was heard, and they hushed and listened. In reality, a tapping, grating noise was distinctly audible. Palmer was transfixed. What Blake did is unfortunately not recorded; but Calvert was curiously interested; and, following the sound, he approached an oriel window, Palmer bringing up the light. Here they discovered a large snail crawling up the mullion, while his shell oscillated on some casement glass with strange significance. . . .

The following evening William Blake was occupied at the table in the large room, or kitchen. Old Palmer was smoking his long pipe in the recess, and Calvert, as was his custom, sat with his back to the candles reading. Young Samuel Palmer had taken his departure more than an hour before for some engagement in London, this time in the coach. Presently Blake, putting his hand to his forehead, said quietly: 'Palmer is coming; he is walking up the road.' 'Oh, Mr. Blake, he's gone to London; we saw him off in the coach.' Then, after a while, 'He is coming through the wicket—there!'—pointing to the closed door. And surely, in another minute, Samuel Palmer raised the latch and came in amongst them.

It so turned out that the coach had broken down near to the gate of Lullingstone Park.[1]

On Tuesday, October 11th Blake wrote to Mrs. Linnell:

I have had the Pleasure to See M^r Linnell set off safe in a very comfortable Coach, & I may say I accompanied him part of the way on his Journey in the Coach for we both got in together & with another

[1] [Samuel Calvert], *A Memoir of Edward Calvert Artist*, London, 1893, pp. 34–36.

Passenger enterd into Conversation when at length we found that we were all three proceeding on our Journey, but as I had not paid & did not wish to pay for or take so long a Ride, we with Some difficulty made the Coachman understand that one of his Passengers was unwilling to Go, when he obligingly permitted me to get out to my great joy, hence I am now enabled to tell you that I hope to see you on Sunday morning as usual which I could not have done if they had taken me to Gloucester[.]

October 13th, 1825 All this Mrs. Linnell faithfully reported to her husband on Thursday, October 13th: 'Mʳ Blake wrote to say he had seen you off safe, and the narrow escape he had of being taken with you, he also says he expects to see us on Sunday, I have engaged Hannah to be with us also on that day[.]'[1]

October 15th, 1825 George Cumberland was in London that autumn, and he noted in his notebook that the Platonist 'Mʳ Taylor of Manor place' had 'breakfast with me Saturday morᵍ', October 15th, 1825. During breakfast they talked of a number of old friends: '—The Duke of Sussex is also Taylors friend—memᵒ to see Blake'.[2]

As Mrs. Linnell's letter of the 13th suggests,

Blake was, at this period [*October 1825*], in the habit, when well, of spending frequent happy Sundays at his friend's Hampstead Cottage, where he was received by host and hostess with the most cordial affection. Mr. Linnell's manner was as that of a son; Mrs. Linnell was hospitable and kind, as ladies well know how to be to a valued friend. The children, whenever he was expected, were on the *qui vive* to catch the first glimpse of him from afar. One of them [*Hannah*], who has now children of her own, but still cherishes the old reverence for 'Mr. Blake,' remembers thus watching for him when a little girl of five or six; and how, as he walked over the brow of the hill and came within sight of the young ones, he would make a particular signal; how Dr. Thornton, another friend and frequent visitor, would make a different one,—the doctor taking off his hat and raising it on a stick. She remembers how Blake would take her on his knee,[3] and recite children's

[1] Ivimy MSS. Hannah was their daughter. The letter is dated Thursday and postmarked Oct. 14th, 1825.

[2] BM Add. MSS. 36520ᴋ, ff. 471, 472. The likelihood that the conjunction of Blake and Taylor in this context is not just coincidental is reinforced by a later note (f. 473) for Oct. 25th: 'Dine with Mr Meredith of 3 Herley[?] Place, & met Mr Taylor of Walworth *He enquired after all his old friends & shewed great Hospitality*' [*my italics*].

[3] E. J. Ellis (*The Real Blake*, London, 1907, p. 424) reported that 'Mr. William

stories to them all: recollects his kind manner; his putting her in the
way of drawing, training her from his own doings. . . .[1]

Mr. Linnell's part of the house,—a later erection than the rest, and
of lower height, with a separate entrance through the garden which
stretches beside,—was small and humble, containing only five rooms.
In front it commanded a pleasant southern aspect. Blake, it is still
remembered, would often stand at the door, gazing in tranquil reverie
across the garden toward the gorse-clad hill. He liked sitting in the
arbour, at the bottom of the long garden, or walking up and down the
same at dusk, while the cows, munching their evening meal, were
audible from the farmyard on the other side of the hedge. He was very
fond of hearing Mrs. Linnell sing Scottish songs, and would sit by the
pianoforte, tears falling from his eyes, while he listened to the Border
Melody, to which the song is set, commencing—

> 'O Nancy's hair is yellow as gowd,
> And her een as the lift are blue.'

To simple national melodies Blake was very impressionable, though
not so to music of more complicated structure. He himself still sang,
in a voice tremulous with age, sometimes old ballads, sometimes his
own songs, to melodies of his own.[2]

In her letter to her husband of Tuesday, October 18th Mary
Ann Linnell reports the events of the previous weekend. Hannah
had come on Saturday night, and

On Sunday morning M^r Blake came as usual, & brought some good *October*
news respecting the Job— He has taken them to M^r Flaxman you *18th,*
1825

Linnell remembers being put on Blake's knee at two years old, but smilingly dis-
claims having any further knowledge of him.' On one visit Blake made the portrait
(now in the Rosenwald Collection) inscribed 'at Hampstead / Drawn by Mr
Blake / from the life 1825. / intended as the Portrait / of J. Linnell'.
 [1] See Oct. 20th, 1825. A. T. Story, *The Life of John Linnell*, London, 1892, vol.
i, p. 149, relying on Linnell family memories, implicitly corrected Gilchrist's
account when he wrote that half a century later the Linnell children remembered
Blake 'as a grave and sedate gentleman, with white hair, a lofty brow, and large
lambent eyes (which would fill with tears when their mother sang one of her favour-
ite Scottish songs), and a kind and gentle manner. He was fond of children, and
often took Mr. Linnell's little ones upon his knee, and talked to them in a grave, yet
withal an amusing manner, telling them stories, and readily falling in with, and
taking part in, their amusements. On one occasion, seeing the eldest girl, Hannah,
busy upon a rude attempt at a face, he took the pencil, and showed her by a few
deft touches how to give it the semblance of a real human countenance.' Story says
that Blake's 'training' of Hannah amounted to no more than this little incident.
 [2] Gilchrist, 1942, pp. 295–7; 1863, pp. 293–4. For the 'Old Border Air', see
Lyric Gems of Scotland (Glasgow: John Cameron, *c.* 1880), Second Series, p. 39.

[*i.e., who*] was delighted beyond all expectation & paid for a copy of them, his approbation M͏ʳ B thinks will be of considerable advantage, I then took a lesson on what I had in hand (I mean the copy from Mich: A[*n*]gelo,) which I think will be of service to me for though I have done but little, yet I feel the want of advice from those more skilled in the art— Just before we sat down to dinner my Father made his appearance so that we had plenty of company till about six oclock when they all departed.[1]

October About two days later Mrs. Linnell wrote to John again: 'M͏ʳ
[*20th?*] Blake has been to see us to-day[2] instead of Sunday, and brought
1825 a Sketch Book,[3] of copy from prints which he made when about
·14 years old. I have kept it to show you.' It was probably of this visit which Gilchrist wrote: 'One day he [*Blake*] brought up to Hampstead an early sketch-book, full of most singular things, as it seemed to the children. But, in the midst of them, they came upon a finished, Pre-Raphaelite-like drawing of a grasshopper, with which they were delighted.'[4]

Blake's visits to the Linnells in Hampstead on Sundays were apparently quite regular, though Blake believed that the north of London was unhealthy. 'On one occasion, for instance, when Mrs. Linnell ventured to express her humble opinion that Hampstead was a healthy place, Blake startled her by saying, "It is a lie! It is no such thing!"'[5]

During these visits to the Linnells at Hampstead, Blake sometimes met men with whom he disagreed sharply. Despite the provocations, his friends remarked upon the natural gentleness of his manners.

'Blake knew nothing . . . [6] of dignified reserve, polite *hauteur*,

[1] Quoted from the transcript by A. H. Palmer in an Exercise Book headed 'Mrs J Linnell Letters', now in the possession of Miss Ivimy. Linnell recorded Flaxman's payment of £3. 3s. 0d. for a plain copy on Oct. 30th. A. H. Palmer remarks in the margin of this transcript that he knew of no other references to Mary Ann Linnell's artistic aspirations; nor do I. Her father was Thomas Palmer.

[2] Beside his transcript of this letter in the same Exercise Book A. H. Palmer wrote that the postmark was Oct. 21st, 1825, so the letter must have been written about Thursday the 20th.

[3] The sketch-book has not been identified.

[4] 1942, p. 296; 1863, p. 293.

[5] A. T. Story, *The Life of John Linnell*, London, 1892, vol. i, p. 148. Cf. Blake's letter of Feb. 1st, 1826.

[6] Gilchrist cites here merely 'the valued correspondent whom I have so frequent occasion to quote', probably meaning Palmer. I cannot more confidently identify the authors of the succeeding quotations.

"bowings out, or condescension to inferiors," nor had he dressed himself for masquerade in "unassuming manners." ' . . . Competent judges describe him as, essentially, 'the politest of men.' . . . 'Very courteous,' 'very polite;' and 'withal there was great meakness and retirement of manner, such as belong to the true gentleman and commanded respect,' says one. In society he was more urbane than many of greater pretension, and in the face often of uncourteous opposition. At Hampstead, one day, Collins the painter,—after having said very rude things such as people of the world, under the consciousness of superior sense and sanity, will indulge in towards those they call 'enthusiasts,'— was obliged to confess Blake had made a very gentlemanly and temperate return.[1]

Occasionally Blake's affability and tolerance had large calls made upon them.

A Historical Painter, of the class endlessly industrious yet forever unknown, was one day pointing out to a visitor some favorite specimen of hopeless hugeness and said: 'M^r Blake once paid me a high compliment on that picture. It was on the last occasion when the old gentleman visited me, and his words were, "Ah! that is what I have been trying to do all my life—to paint *round*—and never could." '[2]

However, Blake's contemporaries normally had to see Blake in gentlemanly surroundings to be able to see him as a gentleman. It was likely to be a different matter when they saw him in his decent poverty at home where

in these latter years he, for the most part, lived on good, though simple fare. His wife was an excellent cook—a talent which helped to fill out Blake's waist-coat a little, as he grew old. She could even prepare a made dish, when need be. As there was no servant, he fetched the porter for dinner himself, from the house at the corner of the Strand. Once, pot of porter in hand, he espied coming along a dignitary of Art—that highly respectable man, William Collins, R.A., whom he had met in society a few evenings before. The Academician was about to shake hands, but seeing the porter, drew up, and did not know him. Blake would tell the story very quietly, and without sarcasm. Another time, Fuseli came in and found Blake with a little cold mutton before him for dinner; who, far from being disconcerted, asked his friend to join him. 'Ah! by G—!' exclaimed Fuseli, 'this is the reason you can

[1] Gilchrist, 1942, p. 307; 1863, pp. 307–8.

[2] This anecdote is given in an undated letter of about April 1880 from D. G. Rossetti to Anne Gilchrist, now in the collection of Mrs. Landon K. Thorne, and was printed without substantive change in Gilchrist, 1942, p. 312; 1880, p. 356 (it is not, of course, in 1863).

do as you like. *Now I can't do this.*'[1] His habits were very temperate. It was only in later years he took porter regularly. He then fancied it soothed him, and would sit and muse over his pint after a one o'clock dinner. When he drank wine, which, at home, of course, was seldom, he professed a liking to drink off good draughts from a tumbler, and thought the wine glass system absurd: a very heretical opinion in the eyes of your true wine drinkers. Frugal and abstemious on principle, and for pecuniary reasons, he was sometimes rather imprudent, and would take anything that came in his way. A nobleman once sent him some oil of walnuts he had had expressed purposely for an artistic experiment. Blake tasted it, and went on tasting, till he had drunk the whole. When his lordship called to ask how the experiment prospered, the artist had to confess what had become of the ingredients. It was ever after a standing joke against him.[2]

November 7th, 1825 Linnell went on Monday '*November* 7 to Mr Blake'. It may have been on Monday, December 5th, 1825 that Linnell received the following note:

[*December 5th, 1825?*] Dear Sir

Are we to have the pleasure of seeing you and Mr Blake on Saturday?—

Monday[3]

Yours truly
Eliza Aders

That there were more such parties may be inferred from another undated note to Linnell in the Ivimy MSS.

Dear Sir

I am ashamed to be so troublesome, but must beg you to send to Mr Blake to know if he will dine with us on Wednesday[;] if he can come will you join us, that is accompany him here—a very early answer this day will greatly oblige

Yours very truly
E Aders

Tuesday Morng
11 Euston Sqre

[1] Probably Fuseli couldn't '*do this*' largely because of his official positions as Keeper and Professor at the Royal Academy. Fuseli died in 1825, so this anecdote dates from a little earlier than the rest of its context.

[2] Gilchrist, 1942, pp. 312–13; 1863, pp. 313–14. The story about the walnut-oil experiments may date from 1790 to 1805, the only period when Blake is alleged to have had noble patrons.

[3] Ivimy MSS. The letter is undated, and unfortunately both occasions on which Blake is known to have been with Linnell and the Aders (Aug. 6th and Dec. 10th, 1825) fell on Saturdays.

Linnell's journal records succinctly that the invitation was
accepted: Saturday, '*December* 10. Dine at M^r Aders's with M^r
Blake & H C Robinson'.

Unfortunately one gets the impression from Linnell's close-
mouthed Journal that nothing remarkable happened on the
visits with Blake which he recorded. Others of Blake's friends,
however, were dazzled by Blake's talk, and only regretted that
they had not preserved more of it. As Samuel Palmer wrote
many years later, 'in conversation he was anything but sec-
tarian or exclusive, finding sources of delight throughout the
whole range of art; while, as a critic, he was judicious and dis-
criminating.' 'His knowledge was various and extensive, and
his conversation so nervous and brilliant, that, if recorded at
the time, it would now have thrown much light upon his
character, and in no way lessened him in the estimation of
those who know him only by his works.'[1]

Crabb Robinson did record Blake's conversation at the time.
In his Diary for December 10th he wrote:

Dine with Aders—a very remarkable & interesting evening. The
party *Blake* the painter Linnell also a painter and engraver to dinner—
In the Even^g came Miss Denman & Miss Flaxman—

10!^h Dec^r. 1825.

Blake.

I will put down as they occur to me without method all I can recol-
lect of the conversation of this remarkable man—Shall I call him
Artist or Genius—or Mystic—or Madman? Probably he is all— He
has a most interesting appearance[.] He is now old—pale with a
Socratic countenance and an expression [almost of fatuity(?) *del*] of
great sweetness but bordering on weakness—except when his features
are animated by [any *del*] expression[.] And then he has an air of
inspiration about him— The conversation was on art and on poetry
and on religion; but it was my object And I was successful, in drawing
him out And in so getting from him an avowal of his *peculiar* senti-
ments— I was aware before of the nature of his impressions or I
sho^d at times have been at a loss to understand him— He was shewn
soon after he enter'd the room some compositions of M^rs Aders' which
he cordially praised[.][2] And he brought with him an engraving of his

[1] Gilchrist, 1942, pp. 302, 301; 1863, pp. 302, 301.
[2] Gilchrist wrote (1942, p. 332; 1863, p. 337): 'Mrs. Aders . . . remembered
Blake [*in later years*] with especial interest, and to the last delighted to talk of him.'

Canterbury pilgrims for Aders[.] One of the figures resembled one in one of Aders' pictures[.]¹ [‘]They say I stole it from this picture, but I did it 20 year's before I knew of the picture—however in my youth I was always studying this kind of [work *del*] paintings. No wonder there is a resemblance[.']— In this he seemed to explain *humanly* what he had done—but he at another time spoke of his paintings as being what he had seen in his visions— And when he said *my visions* it was in the ordinary unemphatic tone in which we speak of trivial matters that [no one *del*] every one understands & cares nothing about— In the same tone he said— repeatedly the 'Spirit told me'— I took occasion to say—[‘]You use the same word as Socrates used— What resemblance do you suppose is there between your Spirit & the Spirit of Socrates?[’ ‘]The same as between our countenances[.']— He paused & added—[‘]I was Socrates.[’] And then as if correcting himself: [: ‘] A sort of brother— I must have had conversations with him— So I had with Jesus Christ— I have an obscure recollection of having been with both of them[.']²—

It was before this, that I had suggested on very obvious philosophical grounds the *impossibility* of supposing an immortal being created—An eternity a parte post—with! an eternity a parte ante— This is an obvious truth I have been many (perhaps 30) years fully aware of[.] His eye brightened on my saying this And he eagerly concurred— [‘]To be sure it is impossible— We are all coexistent with God— Members of the Divine body— We are all partakers of the divine nature'— In this by the bye Bl: has but adopted an ancient Greek idea— Qʸ of Plato[?]— As connected with this idea I will mention here (tho' it formed part of our talk walking homeward) that on my asking in what light he viewed the great question concerning the Divinity of Jesus Christ He said— [‘] *He is the only God*[.']—But then he added--[‘]And so am I and so are you[’]— Now he had just before (And that occa-

¹ According to the catalogue of the 'Collection of Mr. Aders', by M. Passavant, *Tour of A German Artist in England*, London, 1836, vol. i, pp. 201–19, the Aders owned two Van Eyckes, two Van Leydens, four Memlings, and a number of other important pictures by German Renaissance painters. The centrepiece of the collection was probably the 'highly finished and strongly coloured' 'Head of John the Baptist, on a golden dish; a circular picture of about a foot in diameter; the gold ground is shaded as to form the dish' (p. 201). This was attributed to Van Eycke (see the catalogue, and Mrs. Aders' letter to Linnell of Jan. 3rd, 1826 in the Ivimy MSS.), but it was actually a copy after Van Eycke, probably by Petrus Christus.

² It was probably merely this passage which inspired Gilchrist to write, rather irresponsibly: 'Another of Blake's favourite fancies was that he could be, for the time, the historical person into whose character he projected himself: Socrates, Moses, or one of the Prophets. "I am Socrates," or "Moses," or "the prophet Isaiah," he would wildly say: and always his glowing enthusiasm was mirrored in the still depths of his wife's nature.' (1942, p. 97; 1863, p. 116.)

sioned my question—) been speaking of the errors of Jesus Christ[:]
[']he was wrong in suffering himself to be crucified[.] He should not
have attacked the govt[;] he had no business with such matters[.']
On my enquiring how he reconciled this with the Sanctity & divine
qual^s of Jesus—he said [']He was not then become the father[.']—
Connecting as well as one can These fragmentary Sentim^s it would
be hard to fix Blake's station between Christianity Platonism & Spi-
nozism— Yet he professes to be very hostile to Plato & reproaches
Wordsworth with be^g not a Xn but a Platonist[.]

It is one of the subtle remarks of Hume on certain religious specu-
lations that the tendency of them is to make Men indifferent to what-
ever takes place by destroying all ideas of good & evil[.] I took
occasion to apply this remark to something Blake said— [']If so['] I
said—[']There is no use in discipline or education[;] no difference
bet^n good & evil[.']— He hastily broke in on me—[']There is no use
in education[.] I hold it wrong— It is the great Sin [by which evil(?)
del.] It is eating of the tree of the knowledge of good & evil—

[']That was the fault of Plato— he knew of nothing but of the Vir-
tues & Vices and good & evil. There is nothing in all that— Every
thing is good in God's eyes[.']— On my putt^g the obvious question—
Is there nothing absolutely evil in what men do— 'I am no judge of
that[.] Perhaps not in God's Eyes[.']— Tho' on this & other occa-
sions he spoke as if he denied altogether the existence of evil—And as
if we had nothing to do with right & wrong—It being sufficient to
consider all things as alike the work of God— (I interposed with the
German word [']objectivity['] which he approved of—) Yet at other
times he spoke of error as being in heaven— I asked ab^t the *moral*
character of Dante in writ^g his Vision[;] was he *pure*?— 'Pure' said
Blake—[']Do y? think there is any purity in Gods eyes— the angels in
heaven are no more so than we. "he chargeth his Angels with folly."[']^[1]
He afterw^d extended this to the Supreme being— [']he is liable to
error too— Did he not repent him that he had made Ninevah?[']

It is easier to repeat the personal remarks of Blake than these meta-
physical speculation[s] so nearly allied to the most opposite systems—
He spoke with seeming complacency of himself—Said he acted by
command— The spirit said to him 'Blake be an artist & nothing else.
In this there is felicity[.]' His eye glistend while he spoke of the
joy of devoting himself solely to divine art— [']Art is [not(?) *del*]
inspiration[.] When Michael Angelo or Raphael or M^r Flaxman
does any of his fine things he does them in the spirit[.']— Bl said
[']I sh^d be sorry if I had any earthly fame for whatever natural glory

[1] 'He chargeth his angels with folly' is *Job* iv. 18, but the next sentences Blake
seems to quote are not from the Bible. Nineveh alludes to *Job* also.

a man has is so much detracted from his spiritual glory[.] I wish to do nothing for profit [except *del*]. I wish to live for art—[1] I want nothing what[r][.] I am quite happy[.'']²—

Among the [more unexplainable *del*] unintelligible sentim[s] which he was continually expressing is his distinction between the natural & the spiritual world— The natural world must be consumed— Incidentally *Swedenborg* was spoken of— ["]He was a divine teacher— he has done much & will do much good[;] he has correct[d] many errors of Popery and also of Luther & Calvin[.'']— Yet he also said that *Swedenborg* was wrong in endeavour[s] to explain to the *rational* faculty what the reason cannot comprehend[;] he should have left that— As B. mentioned *Swedenb*: & *Dante* together I wished to know whe[r] he considered their visions of the same kind[.] As far as I co[d] collect he does— *Dante* he said was the greater poet— He had *political* objects[.] Yet this tho wrong does not appear in Blakes mind to affect the truth of the vision[.] Strangely inconsis[t] with this was the language of Bl: about Wordsworth[.] W: he thinks is no Xn but a Platonist— He ask[d] me—["]Does he believe in the Scriptures? ["] On my answering in the affirmative he said he had been much pained by read[s] the introduction to the excursion[.] It brought on a fit of illness— The passage was produced & read[:]

> 'Jehovah—with his thunder and the choir
> 'Of Shouting Angels, and the empyreal thrones—
> 'I *pass* them unalarmed.["]

This *pass them unalarmed* greatly offend[d] Blake[.]³ ["]Does M[r] Wordsw: think his mind can *surpass* Jehovah?["] I tried to twist this passage into a Sense correspond[s] with Blake's own theories but

[1] Samuel Palmer wrote (A. H. Palmer, *The Life and Letters of Samuel Palmer*, London, 1892, p. 25) that Blake 'saw everything through art, and in matters beyond its range, exalted it from a witness into a judge.' This statement is amply supported by Blake's writings from 1805 on.

[2] '"If asked," writes Mr. Palmer, "whether I ever knew among the intellectual a happy man, Blake would be the only one who would immediatley occur to me."' (Gilchrist, 1942, pp. 308–9; 1863, p. 309.)

[3] W. Wordsworth, *The Excursion*, London, 1814, p. xi. Eleven years previously Flaxman had been offended by the same passage. On Dec. 19th, 1814 Robinson wrote that he 'Took tea with the Flaxmans and read to them and Miss Vardel Coleridge's *Christabel*, with which they were all delighted, Flaxman more than I expected, and some passages out of Wordsworth's *Excursion*. Flaxman took umbrage at some mystical expressions in the fragment in the preface in which Wordsworth talks of seeing *Jehovah* unalarmed.' And on Dec. 25th 'Flaxman retains his first impression concerning the passage in the fragment in which Wordsworth speaks of passing *Jehovah unalarmed*'. (*Henry Crabb Robinson on Books and Their Writers*, ed. E. J. Morley, London, 1938, vol. i, pp. 156, 157). It would not be surprising if Flaxman and Blake had talked about the offensive passage.

failed [*written* filled] and W was finally set down as a pagan—But still with great praise as the greatest poet of the age-–

Jacob Boehmen was spoken of as a divinely inspired man[.] Bl: praised too the figures in Law's transl.ⁿ as being very beautiful. [']Mich: Angelo coᵈ not have done better[.']¹— Tho' he spoke of his happiness he spoke of past sufferings and of sufferings as necessary— 'There is suffering in Heaven for where there is the capacity of enjoyment, there is the capacity of pain[.']

I have been interruptᵈ by a call from Talfourd in writᵍ this account— And I can not now recollect any distinct remarks, but as Bl has invited me to go & see him I shall possibly have an opportunity again of noting what he says and I may be able hereafter to throw connection, if not System, into what I have written above—

I feel great admiration & respect for him[;] he is certainly a most amiable man. A good creature[.] And of his poetical & pictorial genius there is no doubt I believe in the minds of judges— Wordsworth & Lamb like his poems & the Aders his paintings[.]

A few other detached thoughts occur to me.

Bacon, Locke & *Newton* are the three great teachers of Atheism or of Satan's doctrine[.]

Every thing is *Atheism* which assumes the reality of the natural & unspiritual world[.]²

—*Irving*— He is a highly gifted man[;] he is a sent man—but they who are sent sometimes [exceed their commission *del*] go further than they ought—

[']*Dante* saw Devils where I see none— I see only good— I saw nothing but good in *Calvin's* house—better than in Luther's; he had harlots[']—

Swedenborg Parts of his scheme are dangerous. His sexual religion is dangerous.

[']I do not believe that the world is round. I believe it is quite flat['] — I objected the circumnavigⁿ— We were called to dinner at the moment and I lost the reply—

The *Sun*—[']I have conversed with the—Spiritual Sun— I saw

¹ *The Works of Jacob Behmen* appeared in four volumes in 1764, 1772, and 1781, 'With Figures, illustrating his Principles, left by the Reverend William Law'. These figures, and much of the commentary given in his name, were not by Law at all, but by Dionysius A. Freher, as some of Blake's contemporaries knew. (See C. A. Muses, *Illumination on Jacob Boehme*, N.Y., 1951, esp. pp. 26, 47, 56, 59, 71.) It is tempting therefore to speculate whether the ambiguous reference to 'the figures in Law's translⁿ' may indicate that Blake knew the figures were not in fact by Law. •

² 'It is needless to [*say*] . . . that Bishop Berkeley was one on the list of Blake's favourite authors.' Gilchrist (1942, p. 210; 1863, p. 191) does not say whether this is his own deduction or a report from one of Blake's friends.

him on Primrose-hill[.] He said "Do you take me for the Greek Apollo[?" "]No["] I said "that (and Bl pointed to the sky) that is the Greek Apollo— He is Satan[.""]

'I know now what is true by internal conviction[.] A doctrine is told me—My heart says it must be true—' I corroborated this by remarking on the impossibility of the Unlearned man judging of what are called the *external* evidences of religion in which he heartily concurred[.]

I regret that I have been unable to do more than set down these seeming idle & rambling sentences— The tone & manner are incommunicable[.] There is a natural sweetness & gentility ab! Blake which are delightful And when he is not referring to his Visions he talks sensibly & acutely[.]

His friend Linnel seems a quiet[?] admirer[.]

Perhaps the best thing he said was his comparison of moral with natural evil— ["] Who shall say what God thinks evil— That is a wise tale of the Mahometans—Of the Angel of the Lord that murdered the infant (alluding to The Hermit of Parnell[1] I suppose)[.] Is not every infant that dies of disease in effect murderd by an Angel?["][2]

The opportunity to see fine pictures must have been especially precious to Blake. As Samuel Palmer wrote to Gilchrist many years later:

By the bye, if you want to see a picture bound by a splendid imagination upon the fine firm old philosophy, do go and look at the Julio Romano (Nursing of Jove) in the National Gallery. That is precisely

[1] In Parnell's 'The Hermit' (ll. 150–230), a disguised angel horrified the Hermit when he 'crept Near the clos'd cradle where an infant slept, And writh'd his neck'. However, 'To all but thee in fits he [*the infant*] seem'd to go', and the angel explained later that the deed was done to turn the doting father back to God:

> To what excesses had his dotage run!
> But God to save the father took the son.

(*The Poetical Works of Dr. Tho. Parnell*, London [C. Cooke, 1796?] pp. 46–48.)

[2] Transcribed from the manuscript Diary in Dr. Williams's Library, London. For a note on the forms of HCR's diaries, see April 19th, 1810. Almost all the Blake references were later gathered together in Robinson's Reminiscences (see below, pp. 535–49). They were written about twenty-five years after the events related, and sometimes significantly expand and alter them, though usually the wording is almost identical. It is distressing to find that Robinson altered even quotations in his later versions; obviously his quoted dialogue pretended to nothing more than approximate accuracy. In his Small Diary for this day, Dec. 10th, 1825, HCR noted merely: 'Aders Blake Linnell', but next day he wrote in his Diary: 'Sunday 11ᵗʰ The greater part of the forenoon was spent in writing the preceding acco! of my interview with Blake in which I was interrupted by a call from Talfourd[.]'

the picture Blake would have revelled in. I think I hear him say, 'As fine as possible, Sir. It is not permitted to man to do better.'[1] He delighted to think of Raphael, Giulio Romano, Polidoro, and others, working together in the chambers of the Vatican, engaged, without jealousy, as he imagined, in the carrying out of one great common object; and he used to compare it (without any intentional irreverence) to the co-labours of the holy Apostles. He dwelt on this subject very fondly Among spurious old pictures, he had met with many 'Claudes,' but spoke of a few which he had seen really untouched and unscrubbed, with the greatest delight; and mentioned, as a peculiar charm, that in these, when minutely examined, there were, upon the focal lights of the foliage, small specks of pure white which made them appear to be glittering with dew which the morning sun had not yet dried up. . . . His description of these genuine Claudes, I shall never forget. He warmed with his subject, and it continued through an evening walk. The sun was set; but Blake's Claudes made sunshine in that shady place. . . . Of Albert Dürer, he remarked that his most finished woodcuts, when closely examined, seemed to consist principally of outline;—that they were 'everything and yet nothing.'

A week later Robinson stopped in to see Blake.

[*Saturday*] 17ᵗʰ Decʳ For the sake of connection I will here insert a minute of a short call I this morning made on Blake. He dwells in Fountain Court in the Strand. I found him in a small room which seems to be both a working room and a bed room. Nothing could exceed the squalid air both of the apartment & his dress—but in spite of dirt—I might say, filth[,] an air of natural gentility is diffused over him[,] and his wife notwithstanding the same offensive character of her dress & appearance has a good expression of countenance So that I shall have a pleasure in calling on & conversing with these worthy people[.] But I fear I shall not make any progress in ascertaining his opinions & feelings—That their being really no system or connection in his mind all his future conversation will be but varieties of wildness & incongruity—

I found him at work on Dante—The book (Cary)[2] and his sketches

December 17th, 1825

[1] Up to this point the quotation is taken from an undated letter from Palmer to Mr. Gilchrist in *Anne Gilchrist: Her Life and Writings*, ed. H. H. Gilchrist, London, 1887, p. 59. The rest comes from Gilchrist (1942, p. 311; 1863, p. 312), who omits the first two sentences and does not identify Palmer. The identical quotation suggests that both are quoting the same letter, but the MS. of the letter in the Yale University Library (dated April 1861? in another hand) does not contain Gilchrist's addition.

[2] This was probably Dante's *The Vision; or Hell, Purgatory, and Paradise*. Translated by the Rev. Henry Francis Cary, A.M. In Three Volumes. The Second

both before him— He shewed me his designs, of which I have nothing to say but that they evince a power of grouping & of throwg grace & interest over conceptions most monstrous & disgusting which I shod not have anticipated.

Our conversation began abt Dante[.] 'He was an atheist—A mere politician busied abt this world as Milton was till in his old age he returned back to God whom he had had in his childhood—' I tried to get out from B: that he meant this charge only in a higher sense And not using the word Atheism in its popular meaning[,] But he wod not allow this— Tho' when he in like manner charged Locke with Atheism and I remarked that L: wrote on the evidences of Xnity and lived a virtuous life, he had nothg to reply to me nor reiterated the charge of wilful deception[.] I admitted that Locke's doctrine leads to Atheism And this seemed to satisfy him— From this subject we passed over to that of good & evil on which he repeatedly [*made*] his former assertions more decidedly— He allowed indeed that there is error mistake &c and if these be evil—Then there is evil but these are only negations—Nor would he admit that any [knowldg(?) of *del*] education shod be attempted except that of cultivation of the imagination & fine arts— 'What are called the vices in the natural world, are the highest sublimities in the spiritual world[.'] When I asked wher if he had been a father he would not have grieved if his child had become vicious or a great criminal He ansd ['']I must not regard when I anr endeavouring to think rightly my own any more than other people's weaknesses[.'] And when I again remarked that this doctrine puts an end to all exertion or even wish to change anything He had no reply— We spoke of the Devil And I observed that when a child I thought the Manichaean doctrine or that of two principles a rational one. He assented to this—and in confirmation asserted that he did not believe in the *omnipotence* of God— The language of the Bible on that subject is only poetical or allegorical[.] Yet soon after he denied that the natural world is any thing. It is all nothing and Satan's empire is the empire of nothing[.]

He reverted soon to his favorite expression [visions *del*] my visions— ['']I saw Milton in Imagination And he told me to beware of being misled by his Paradise Lost[.][1] In particular he wished me to

Edition Corrected. With the Life of Dante, Additional Notes, and an Index. London: Printed for Taylor and Hessey, Fleet Street. 1819. The only other editions of this translation published during Blake's lifetime were two ugly 32mo issues in London in 1814, and one in Philadelphia in 1822. The 1819 edition was probably acquired when Blake began his Dante illustrations in 1824.

[1] This passage or independent information may have been the basis of Gilchrist's statement that 'In his familiar conversations with Mr. Palmer and other disciples, Blake would speak in the most matter-of-fact way of recent spiritual visitors. Much

shew the falsehood of his doctrine that the pleasures of *sex* arose from the fall— The fall could not produce any pleasure[.'] I answered the fall produced a state of *evil* in which there was a mixture of good or pleasure. And in that Sense the fall may be said to produce the pleasure —But he replied that the fall produced only generation & death[.] And then he went off upon a rambling state of a Union of Sexes in Man as in God—an androgynous state in which I could not follow him— As he spoke of Milton's appear[g] to him—I asked whether he resembled the prints of him—[1] He answerd—['']All[.']— ['']Of what age did he appear to be[?' ']Various ages—Sometimes a very old man[.'] he spoke of M. as being at one time—A sort of classical Atheist—And of Dante as being now with God—

Of the faculty of Vision he spoke as One he had had from early infancy— He thinks all men partake of it—but it is lost by not being cultiv[d] And he eagerly assented to a remark I made that all men have all faculties to a greater or less degree— I am to renew my visits and to read Wordsworth to him of whom he seems to entertain a high idea.[2]

Robinson recorded in his Diary that on Monday, December 20th he had a conversation with George Hundleby: 'We talked . . . Of Wordsworth, whom I can[t] make him properly enjoy[;] Of Blake whose peculiarities he can as little relish[.]' A few days later, on Saturday, December 24th, he wrote again in his Diary

December 20th, 1825

A call on *Blake*—My 3[d] Interview[.] I read him Wordsworth's incompara[e] Ode which he heartily enjoyed— The same half crazy

December 24th, 1825

of their talk was of the spirits he had been discoursing with, and, to a third person, would have sounded oddly enough. "Milton the other day was saying to me," so and so. "I tried to convince him he was wrong, but I could not succeed." "His tastes are Pagan; his house is Palladian, not Gothic.'" (1942, p. 317; 1863, p. 319.)

[1] In the Reminiscences Robinson is much more specific: 'I ventured to ask, half ashamed at the time, which of the three or four portraits in *Hollis's* Memoirs (Vols in 4to) is the most like— He answ[d] ['"]They are all like, At different Ages— I have seen him as a youth And as an old man with a long flowing beard[.] He came lately as an old man['"]' The book referred to is [*Francis Blackburne*] *Memoirs of Thomas Hollis, Esq. F.R. and A.S.S.* [2 vols.], London Printed 1780. Blake may in fact have worked on some of the plates for the book, for Basire's shop signed nine of the engravings. There are five portraits of Milton (vol. i, pp. 95, 383; vol. ii, pp. 507, 513, 529), all engraved by Cipriani, representing Milton from boyhood to full maturity, but in none does he have a beard. Blake's answer was most sensible, for the portraits in these two volumes are not in conflict, but represent Milton at distinctly different ages.

[2] Robinson's Small Diary for this day says merely that he made a 'Visit to Blake'. The Diary account was written out of sequence, as the entry for Dec. 17th makes clear: '17th Made a visit to Blake of Which I have written fully in a preceding page'.

crotchets abo⸋ the two worlds—the eternal repetition of which must in time become tiresome— Again he repeated to day—['']I fear Wordsworth loves Nature— and Nature is the work of the Devil— The Devil is in us, as far as we are Nature[.'']— On my inquiring whe͏ʳ the Devil woᵈ not be destroyed by God as being of less power— he denied that God has any power—Asserted that the Devil is eternally created not by God—but by God's permission. And when I [*made an*] objection that permission implies power to prevent he did not seem to understand me— It was remarkaᵉ that the parts of Wordsworths ode which he most enjoyed were the most obscure & those I the least like & comprehend[.][1]

Such talk clearly distressed the cautious and the orthodox, like Crabb Robinson, and when Blake's young friends had become considerably more ancient they too were often embarrassed by his clear heterodoxy. In 1855 Linnell wrote:

A saint amongst the infidels & a heretic with the orthodox[,] with all the admiration for Blake it must be confessed that he said many things tending to the corruption of Xtian morals—even when unprovoked by controversy[;] & when opposed by the superstitious the crafty or the proud he outraged all common sense & rationality by the opinions he advanced occasionally even indulging in the support of the most lax interpretation of the precepts of the scripture[.][2]

[1] The Small Diary says only 'Blake', followed by an illegible word.

[2] Transcribed by John Linnell Jr. in the 'List of John Linnell Senior's Letters and Papers', p. 36 (Ivimy MSS.) and labelled 'Mem. by J.L. senʳ, April 1855'. It was clearly part of the information Linnell sent to Gilchrist in his letters of April 1855. (This passage is also given by A. T. Story, *The Life of John Linnell*, London, 1892, vol. i, p. 247.) On the same page John Linnell Jr. transcribed a 'Note by J.L. sen. on strip of paper' '1855?', which was clearly the heads of what Linnell meant to tell Gilchrist of Blake's life:

'Early talent of design 3 years old' [*I cannot explain this.*]
'The Breach in the City' [*Blake's picture exhibited at the R.A. in 1784.*]
'do. belief in his inspiration
 reprov'd by his Father for asserting it.' [*Cf. p. 7.*]
'drawing in W. Abbey, from which he early imbibed the pure & spiritual
 character of the female expression & form.' [*Cf. Malkin, pp. 422–3.*]
'getting up in the Night to write' [*Cf. pp. 525–6.*]
'Sailing expedition with Stothard, &c, [*Cf. Sept. 1780.*]
'Lawrence drawings'— [*Drawings for Lawrence, before 1800?*]
'Hercules Building['']—'Places where he lived'
 ['']good stolen' [*Cf. Tatham, p. 522*] 'Trial at Chichester' [*in Jan. 1804.*]
'Hayley['']
Lord Egremont
Lord Bathurst [*all three Blake's patrons.*]

And a few years later still Samuel Palmer informed Anne Gilchrist:

Blake wrote often in anger and rhetorically; just as we might speak if some *pretender* to Christianity whom we knew to be hypocritical, were *canting* to us in a pharisaical way. We might say, 'If this is your Heaven, give me Hell.' We might say this in temper, but without in the least meaning that that was our deliberate preference.

This is the clue to much of Blake's paradox, and often it carries its own explanation with it. Where it does not, without presumptuously recommending you what to do, I will just say what course *I* should think best. I should let no passage appear in which the word Bible, or those of the persons of the blessed Trinity, or the Messiah were irreverently connected. . . .

I think it would explain matters somewhat if the public knew that Blake sometimes wrote under irritation. Nothing would explain some things in the MS.[1]

Evidently Blake had brought two copies of his *Songs of Innocence and of Experience* to the December 10th dinner party and given them to Crabb Robinson and Mrs. Aders, for on Tuesday, January 3rd, 1826 Mrs. Aders wrote to Linnell: 'I have also to beg you, to put me in the way, of repaying Mr Blake in the way most delicate to his feelings, for the books he brought me, as it was by no means either Mr Robinsons intention or mine, to beg

January 3rd, 1826

'What Lady is where he met so many people of ta[*ste?*]' [*Mrs. Aders? Lady Caroline Lamb?*]
Fuseli
Stothard
Cromec
Butts
[*Richard*] Edwards Godwin, Paine, H. Tooke, &c.—Fuseli [*Then follows the 'saint amongst the infidels' passage, and finally:*]
. . .
'died at his Brother in Laws first floor 3 f[*ountain*] Court[.]'

[1] A. H. Palmer, *The Life and Letters of Samuel Palmer*, London, 1892, 244–5, quoting a letter of July 24th, 1862 in which Palmer recommends heavy blue-pencilling of *The Marriage of Heaven and Hell*: 'I think the whole page at the top of which I have made a cross in red chalk would at once exclude the work from every drawing-room table in England. Blake has said the same kind of thing to me [*as he says on that page?*]; in fact almost everything contained in the book; and I can understand it in relation to my memory of the whole man, in a way quite different to that roaring lion the "press," or that led lion the British Public.' One is reminded that Yeats said Linnell's grown children 'are no little troubled at the thought that maybe he [*Blake*] was heretical. I tried to convince them of his orthodoxy and found it hard to get the great mystic into their little thimble.' (*W. B. Yeats Letters to Katharine Tynan*, ed. R. McHugh, Dublin & London, 1953, p. 106.)

the books, when we ask'd for them of that most interesting Man.'[1]

Some two weeks after his third visit to Blake, on Friday, January 6th according to his Diary, Robinson again made

January 6th, 1826 A call on Blake— I hardly feel it worth while to write down his convers[n]. It is so much a repetition of his former talk— He was very cordial to day[.] I had procured him two Subsc[s] for his Job from Geo; Proctor & Bas: Montagu[.] I p[d] £1 on each—[2] This probably put him in spirits, more than he was aware of— he spoke of his being richer than ever in hav[g] learnd to know me and he told M[rs] [?] A. he & I were nearly of an opin[n][.] Yet I have practiced no deception intentionally unless silence be so— He renewed his complaints, blended with his admiration of Wordsworth[.] The oddest thing he said was that he had been command[d] to do certain things[,] that is to write abo[t] Milton[,] And that he was applauded for refusing[;] he struggled with the Angels and was victor— his wife joined in the conversation[.]—

Orders for *Job* now began to come in to Linnell with some regularity:

Little Tower Street
[*Tuesday*] 31 Jan 1826

January 31st, 1826 My Dear Sir
Our reciprocal friend D[r]. Thornton spent the evening with me yesterday, who informed me of your publication of Job, and that it would please you, for me, to subscribe and pay you for it in Wine,— I shall be ever happy to promote your Interest— . . . Wishing you a prosperous Sale, I remain My Dear Sir

yours truly
William Harrison[3]

February 9th, 1826 By this time the printing was going ahead reliably, as Mrs. Linnell reported to her husband on February 9th: 'I should have written before but have not seen Edward until this even-

[1] Ivimy MSS. The Aders owned copy AA, and HCR owned copy Z of the *Songs*. HCR also had *America* (copy D) and *Visions* (copy O), acquired at a date unknown, in which is written 'bought by him from Blake for he thinks 1 guinea'.

[2] Clearly HCR paid a pound down on his own copy too. The *Job* order is in the *Job* accounts as 'H. Robinson Esq[r] of the Temple 3 copies [£] 9 9 —'. The other £6. 9s. 0d. was paid April 15th. Robinson's Small Diary for Jan. 6th merely says 'Blake'.

[3] Ivimy MSS. Harrison's order was registered in the *Job* accounts as for £2. 12s. 6d. and not for wine. At the end of the list of booksellers for the 1821 *Virgil* was 'Mr. Harrison, 13, Little Tower Street, Agent for Dr. Thornton.'

ing having sent for him by M rs Barling[1] in order to hear respecting the Job &c. He has been every day to Lahees & to Cirencester Place[;][2] from all I can learn the printing is going on well by a man of the name of Freeman[.]'[3]

Robinson passed another morning with Blake on Saturday, February 18th:

Jos: Wedd breakfasted with me— Then called on *Blake*, an amusing chat with him but still no novelty— The same round of extravagt & mad doctrines, which I shall not now repeat, but merely notice their application—

February 18th, 1826

He gave me copied out by himself Wordsworths preface to his Excursion— At the end he has added this note—

'Solomen when he married Pharaohs daughter & became a convert to the Heathen Mythology talked exactly in this way of Jehovah as a very inferior object of man's contemplation, he also passed him by unalarmed & was permitted. Jehovah dropped a tear & followed him by his Spirit into the abstract void. It is called the divine Mercy. Satan dwells in it, but mercy does not dwell in him[.]'[4]

Of Wordsworth he talked as before— Some of his writings proceed from the Holy Ghost, but then others are the work of the Devil— However I found on this Subject Blake's language more in conformity with Orthodox Christianity than before—[5] He talked of the being

[1] Edward was Linnell's nephew Edward Chance, whom Linnell used regularly for errands and petty business. Linnell's two sisters had married men named Chance and Barling.

[2] Lahee was the printer of *Job*, and Cirencester Place was Linnell's address in London.

[3] Copied by A. H. Palmer in an Exercise Book headed 'Mrs J Linnell Letters', now with the Ivimy MSS. In the *Job* accounts under March 1826 is recorded a payment of £1 'to Freeman the workman'.

[4] Blake also copied much of Wordsworth's Preface, from 'It is not the Author's intention' to the end of the poem 'clear on to the end'. The MS. of Blake's transcript is now in Dr. Williams's Library.

[5] Years later, on July 24th, 1862, Samuel Palmer wrote to Anne Gilchrist: 'His real views would now be considered extravagant on the opposite side to that apparently taken in the *Marriage [of Heaven and Hell]* for he quite held forth one day to me, on the Roman Catholic Church being the only one which taught the forgiveness of sins; and he repeatedly expressed his belief that there was more *civil* liberty under the Papal government, than any other sovereignty; nor did I ever hear him express any admiration for the American republic.

'Everything connected with Gothic art and churches, and their builders, was a *passion* with him. St. Teresa was his delight.' (A. H. Palmer, *The Life and Letters of Samuel Palmer*, London, 1892, p. 245.) It seems likely that Palmer considerably exaggerated Blake's conformity for the benefit of the niggling orthodoxy of Macmillan, the publisher of the Gilchrist's *Pictor Ignotus*.

under the direction of *Self*; & *Reason* as the creature of Man & op-
posed to God's grace—And warmly declared that all he knew was in
the Bible[;] but then he understands by the Bible the Spiritual Sense[.]
For as to the natural sense that Voltaire was commissioned by God
to expose— [']I have had much intercourse with Voltaire and he
said to me [''']I blasphemed the Son of Man and it shall be forgiven
me[.] But *they* (the enemies of V:) blasphemed the Holy Ghost in me
and it shall not be forgiven them—['''''] I asked in what languᵉ
Voltaire spoke[;] he gave an ingenious answer—[']To my Sensations
it was English— It was like the touch of a musical key— He touched it
probably French, but to my ear it became English— ['] I spoke again
of the *form* of the persons who appear to him[,] asked why he did not
draw them— [']It is not worth while—There are so many the labour
woᵈ be too great[.] Besides there woᵈ be no Use— As to Shakesp:
he is exactly like the old Engraving—which is called a bad one[.]
I think it very good[.']¹—

I inquired aboᵗ his writings— ['] I have written more than Voltaire or
Rousseau—Six or Seven Epic poems as long as Homer and 20 Tra-
gedies as long as Macbeth[.] He shewed me his Version (for so it
may be called) of Genesis—'as understood by a Christian Visionary' in
which in [the *del*] a style resemblᵍ the Bible—The spirit is given[;]
he read a passage at random[.] It was striking²— He will not print
any more— [']I write[,'] he says[, ']when commanded by the
spirits and the moment I have written I see the words fly aboᵗ the room
in all directions— It is then published and the Spirits can read— My
MSS [*are*] of no further use— I have been tempted to burn my MSS
but my wife wont let me[.' No Said *del* ']She is right[,']
said I—[']You have written these, not from yourself but by a higher
order[.] The MSS. are theirs not your property— You cannot tell
what purpose they may answer; [tho unkn *del*] unforeseen to you[.']—
He liked this And said he woᵈ not destroy them[.]³ his philosophy he

¹ The 'old Engraving' is presumably the one by Droeshout in the first folio.

² There is no known work by Blake which is headed '"as understood by a
Christian Visionary"', nor is there any work which gives what Robinson might
have called 'The spirit' of the Bible. (It is surely neither the 'Genesis' manuscript
which Blake transcribed from Hayley's translation of Tasso's *Le Sette Giornate del
Mondo Creato*, nor the illuminated transcription of the book of *Genesis*, now in the
Huntington, which Blake began for Linnell in 1827 [Gilchrist, 1942, p. 259;
1863, p. 246].) Either Robinson's description of the work as a version of Genesis
is uncharacteristically vague, or the work referred to has not survived.

³ It is of course possible that Blake was not convinced by Robinson's sophistry,
and that he later destroyed some of his manuscripts himself. No MS. of any bulk or
importance, except for the Pickering Manuscript, is known to have come through
the hands of Tatham, to whom Catherine left Blake's effects, and it is conceivable
though not likely that a considerable destruction of Blake's MSS. took place before
Blake died, and therefore that what Tatham destroyed was of trifling importance.

repeated—Denying Causation asserting everything to be the work of God or the Devil[,] That there is a constant falling off from God— Angels becoming Devils [& d *del.*] Every man has a Devil in him and the conflict is eternal between a man's Self and God—&c &c &c &c[.] He told me my copy of his Songs wo^d be 5 Guas And was pleased by my man^r of receiv^g this inform^n[.][1] he spoke of his horror of Money. Of his turning pale when money had been offerd him, &c &c &c—

I afterwards lounged at the Athen: hav^g first written the above Memo:. . . .

Blake's statement that he did not draw his visions because there would be no use in it is curious. He had certainly been drawing the forms of the persons who appeared to him for Varley for many years, and one drawing, for instance, is inscribed by Varley: 'Head of Achilles drawn by William Blake at my request. 1825'.[2]

Blake's report about the bulk of his writings is also strange. Voltaire's works run to some fifty volumes, while Blake's are contained in one. Only three 'Epic poems' of any length by Blake have survived, none of which is as long as the *Iliad* or the *Odyssey*, and no complete play by Blake is known. Unless Blake was grossly exaggerating here, his works must have been destroyed on a Herculean scale.

Next day, Sunday, February 19th,[3] Robinson wrote to Dorothy Wordsworth, suggesting that the next edition of her brother's poems should be organized by classes:

I should like to see brought together all the poems which are founded on that intense love of nature[,] that exquisite discernment of its peculiar charms & that almost deification of nature which poor Blake (but of that hereafter) reproaches your brother with— . . . I have above mentioned *Blake*[.] I forget whether I ever mentioned to you

February [19th], 1826

[1] On the flyleaf of copy Z of the *Songs of Innocence and of Experience* Robinson wrote: 'This copy I received from Blake himself—And coloured by his own hand'. The price of £5. 5s. 0d. was somewhat preferential, since Blake wrote Cumberland on April 12th, 1827, that the cost of the combined *Songs* would be £10. 10s. 0d. In his Small Diary for Feb. 18th, Robinson wrote 'Blake Journal'.

[2] *The Blake Collection of W. Graham Robertson*, ed. K. Preston, London, 1952, p. 233.

[3] The letter itself, now in Dr. Williams's Library, is undated but postmarked Feb. 20th, 1826, and in it Robinson refers to what Blake 'told me yesterday', on the 18th.

this very interesting man, with whom I am now become acquainted[.]
Were the 'memorials' at my hand I should quote a fine passage in the
sonnet on the Cologne Cathedral¹ as applicable to the contemplation
of this [noble *del*] singular being. I gave your brother some poems
in MS by him² and they interested him—As well they might, for there
is an affinity between them As there is between the [inspiration of the
del] regulated imagination of a wise poet And the incoherent dreams
of a poet—Blake is an engraver by trade—a painter and a poet also
whose works have been the subject of derision to men in general, but
he has a few admirers and some of eminence have eulogised his de-
signs— he has lived in obscurity & poverty, to which the constant
hallucinations in which he lives have doomed him— I do not mean
to give you a detailed account of him— A few words will serve to
inform you of what class he is. He is not so much a disciple of Jacob
Bohmen & Swedenborg as a fellow Visionary— He lives as they did
in a world of his own. Enjoying constant intercourse with the world of
spirits—He receives visits from Shakespeare Milton Dante Voltaire
&c &c &c And has given me repeatedly their very words in their
conversations— His paintings are copies of what he sees in his Visions—
his books—(& his MSS. are immense in quantity) are dictations from
the Spirits— he told me yesterday that when he writes—it is for the
Spirits only— he sees the words fly about the room the moment he has
put them on paper And his book is then published— A man so favourd
of course has sources of wisdom & truth peculiar to himself— I will not
pretend to give you an account of his religious & philosophical opinions—
They are a strange compound of Christianity Spinosism & Platonism—
I must confine myself to what he has said about your brother's
works—And [as I am requested to copy a note he has written for the
purpose *all del*] I fear this may lead me far enough to fatigue you in
following me— After what I have said Mᵣ W: will not be flatterd by
knowing that Blake deems him the *only poet* of the age nor much
alarmed by hearing that like Muley Moloch³ Blake thinks that he is
often in his works an *Atheist*[.] Now according to Blake Atheism
consists in worship[p]ing the natural world which same natural world

¹ Wordsworth's 'Sonnet. In the Cathedral at Cologne', *Memorials of a Tour
on the Continent, 1820*, London, 1822, muses on the glories of the unfinished cathe-
dral.

² Robinson is probably referring to his own copies of Blake's poems—see p. 224.

³ 'Muley Moloch' is apparently a combination of Ishmael Muley (1646–1727),
the cruel emperor of Morocco who enthusiastically executed his subjects with his
own hand, and the false idol Moloch to whom children were sacrificed as burnt
offerings (Amos v. 26; Acts vii. 43). Horace Walpole uses the phrase 'Muley
Moloch' in this way in 1788 (*The Letters of Horace Walpole*, ed. P. Toynbee,
Oxford, 1905, vol. xiii, p. 74). Robinson seems to mean here: 'Blake thinks that
Wordsworth, like "Muley Moloch", is often in his *works* an atheist.'

properly speaking is nothing real, but a mere illusion produced by
Satan— Milton was for a great part of his life an Atheist And there-
fore has fatal errors in his Paradise Lost which he has often begged
Blake to confute— Dante (tho' now with God) lived & died an
Atheist— He was the slave of the world & time— But Dante &
Wordsw: in spight of their Atheism were inspired by the Holy Ghost—
Indeed all real poetry is the work of the holy ghost and Wordsworths
poems (a large proportion at least) are the work of divine inspiration—
Unhappily he is left by God to his own illusions—And then the
Atheism is apparent— I had the pleasure of reading to B. in my best
style—(And you know I am vain on that point & think I read W's
poems peculiarly well) the Ode on Immortality— I never witnessed
greater delight in any listener And in general B: loves the poems—
What appears to have disturbed his mind, on the other hand, is the
preface to the Excursion[.] He told me six months ago[1] that it
caused him a bowel complaint which nearly killed him. I have in his
hand a copy of the extract [of the *torn off*] following note[:] 'Solomon
'when he married Pharoahs daughter & became a convert to the
'Heathen mythology talked exactly in this way of Jehovah as a very
'inferior object of man's contemplation[;] he also passed him by
'unalarmed & was permitted[.] Jehovah dropped a tear & followed
'him by his Spirit into the abstract void. It is called the divine mercy.
'Satan dwells in it, but Mercy does not dwell in him[;] he knows not
'to forgive'— When I first saw B. at Mr Aders's he very earnestly
asked me—'Is Mr W: a sincere real Christian'? In reply to my answer
he said—'If so what does he mean by the worlds to which the heaven
'of heavens is but a veil— And who is he that shall pass Jehovah un-
'alarmed?['] It is since then that I have lent B: all the works[2] which
he but imperfectly knew— I doubt whether what I have written will
excite your & Mr W s curiosity—but there is something so delightful
about the Man—tho' in great poverty, he is so perfect a gentleman with
such genuine dignity & independence—Scorning presents & of such
native delicacy in words &c &c &c that I have not scrupled promising
introducing him & Mr W: together—[3] He expressed his thanks
strongly—Saying 'You do me honour[.] Mr W: is a great man—
Besides he may convince me I am wrong about him— I have been
wrong before Now' &c. Coleridge has visited B. & I am told talks
finely about him— That I might not encroach on a third sheet I have
compressed what I had to say about Blake— You must *see* him one of

[1] This should be 'two months ago', referring to Dec. 10th, 1825.
[2] Blake is only known to have read (and annotated) *The Excursion*, 1814, and
Poems: including Lyrical Ballads, and the Miscellaneous Pieces of the Author,
2 vols., 1815.
[3] Wordsworth and Blake never met.

these days And he will interest you at all events, whatever character you give to his mind[.]

A characteristic anecdote of Blake's simplicity and friendliness given by Edward Calvert's son may refer to the winter of 1826:

Winter on one occasion, as my father has told the story, there came lumbering
1826? up the stairs with heavy tread an uncouth visitor who bumped at the door. Blake, somewhat disturbed, rose to open it, but with no ungentlemanly impatience, for he never knew in what shape, or under what circumstances his angels might appear. It was, however, 'the man with the coals,' who, humped up with sack, gigantic and grimy, muttered out, 'Are these 'ere coals for you?' The gentle and commiserating voice of Blake replied, 'I believe not, my good man, but I'll enquire,' and, as my father regretfully said: 'they were *not* poor Blake's coals—they were for the lodger on the floor above.'[1]

In March appeared a review of a book written from spirit-dictation by a nun named Sister Nativity. The reviewer refers to Sister Nativity's visions of angels blowing the last trump and comments in passing that 'Among Blake's strange designs for Blair's poem of the Grave, is one representing the reunion of the body and the soul; the highest genius alone could have conceived it, and only madness have dared to attempt the execution. Sister Nativity's vision is cold in comparison with his vivid and passionate delineation [*Plate XLV*].'[2]

The delay in finishing *Job* may have been due to the addition of the illuminated margins, for 'the borders were an afterthought, and designed as well as engraved upon the copper

[1] [Samuel Calvert], *A Memoir of Edward Calvert Artist*, London, 1893, pp. 21–22. (The source of the story seems to have been Calvert himself rather than the somewhat briefer version in Gilchrist, 1942, p. 308; 1863, p. 308.) Apparently Blake's relations with the coal men were often rather more adventurous, for Stothard's son wrote: 'on one occasion I . . . met him on the stairs, saying to me "he had a battle with the devil below to obtain the coals"' (see J. T. Smith, p. 466 n. 1.) W. Thornbury (*British Artists from Hogarth to Turner*, London, 1861, vol. i, pp. 28, 33) reported on unknown evidence, which presumably came through 'the father of my old friend, Leigh, the artist', that 'he even saw the devil in his coal-cellar'.

[2] Anon., 'Art. V.—*Vie des Révélations de la Soeur Nativité, Religieuse converse au Couvente des Urbanistes de Fougères; écrites sous la Dictée; suivies de sa Vie intérieure, écrite aussie d'après ellemême par le Rédacteur de ses Révélations [the Abbé Genet], et pour y servir de suite.* Paris, 1817. 3 tom. 12mo.', *Quarterly Review*, xxxiiii (March 1826), 390.

PLATE XLV

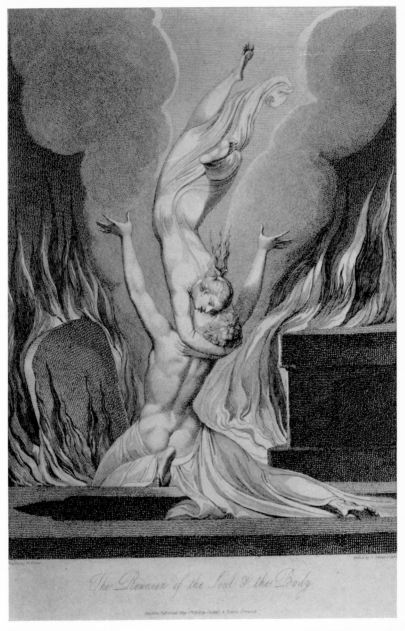

'THE REUNION OF THE SOUL & THE BODY', a proof of Schiavonetti's
etching for Blair's *Grave* (1808). Robert Hunt said the design could not be understood
without 'the *small* assistance of the title' (see p. 196)

without a previous drawing.'[1] Years later Linnell reported that 'about 300 sets including the [150] India proofs & [65] French paper proofs have been printed, they were all taken from the plates when just finished.'[2] According to the label printed for it, the work was finally 'Published by the Author, 3, Fountain Court, Strand, and Mr. J. Linnell, 6, Cirencester Place, Fitzroy Square. March, 1826.' On Tuesday, March 28th Linnell received the following note:

By *this* time I take it *The JOB* of our great genius Blake is ready! If so, would you procure me a set (letting me know the amount which shall be immediately sent). I have lately [been(?) presented(?)] with *del*] purchased M.ʳ Blake's Milton printed in 1804. The title says in <u>12</u> books! My copy has but *3*! yet *'Finis'* is on the last page! How many should there be?—Could you obtain for me a list of all Mʳ B.ˢ *works executed by his own hand*? Pardon me this troublesome request and Believe to be Dear Sir

March 28th, [1826?]

> The sincere admirer of your talents.
> T. G Wainewright.[3]

Next day, Wednesday, March 29th, Wainewright wrote again enclosing five guineas for the *Job* and praising the prints highly.[4]

March 29th, 1826

About April 10th Linnell wrote to the wife of Major-General Sir Henry Torrens:

Mʳ J. Linnell begs to inform Lady Torrens that owing to the great expenses of printing & of the Illustrations of the book of Job he is

April [10th?] 1826

¹ Quoted in *Illustrations of the Book of Job*, ed. P. Hofer, London, 1937, p. 8, from a letter of Linnell to C. W. Dilke in the possession of Sir Geoffrey Keynes which, Sir Geoffrey tells me, is dated Sept. 27th, 1844.

² This letter of Dec. 30th, 1863 from Linnell to Macmillan & Co was transcribed by A. H. Palmer in an Exercise Book (now in the Ivimy MSS.) headed 'Job Revise (2)', p. 6. It continues: there have 'not [been] any taken since. There are no plain impressions left [but there are India proofs at £10 and French at £5] Mr. Linnell does not intend printing any more at present'. On Jan. 29th he wrote further that 'There were 150 of India proofs of Blakes Job taken in 1826'.

³ Ivimy MSS. The date has no year in it, but Linnell's notation in his 'Cash Account' book of receiving 'of T. G. Wainwright Esq for one Copy of Job Proof ——[£]5 5 —' on March 28th, 1826 solves this difficulty. The 'Cash Account' seems to be a day early, however; see the next entry. Wainewright's copy of *Milton* has not been located, but all surviving copies of *Milton* have two books.

⁴ Among the Ivimy MSS. is a volume with a 'List of John Linnell Senior's Letters and Papers In the possession of the Linnell Family at Redstone' made by John Linnell Jr., and under the section 'In Re W. Blake' (p. 22) is: 'March 29 1826 —(T.G.W. to J.L.) encloses £5. 5. 0 (for the Job.). Praises the plates very much, &c.'

under the necessity of begging the favor of ready money from the subscribers to enable him to meet his engagements with the printer[.] M^r L will call the beginning of this week for the purpose of fixing another ring upon the frame of the Picture which he lent when if agreeable he can receive the amount[.][1]

On Tuesday, April 11th E. T. Daniell, a young friend of Linnell's who was an undergraduate at Balliol College, wrote:

April 11th, 1826 I want if possible to have your 'Job' down here, and as I assure you the sending a copy to any of the printsellers here or even to most of the booksellers would be perfectly useless I have not spoken to them, but called my friend Parker with whom I have (for an undergraduate) had considerable dealings; and he has consented on my recommendation to order a copy of the *prints* as he says that even *his* customers who are *the first scholars and Dons* of the University, would not be likely to take proofs, at any rate he dare not risk the £6.ˢ.6.. but he will be obliged by your sending one of prints to Rivingtons for him, and I trust you will send a fine copy as you are aware that the Dons want their fancies to be tickled with every possible little additional beauty, so much so that could I afford it I would on my own account order a copy of proofs, which I would lend to him to keep to shew merely to the few, but that I cannot do. I can only say that should you feel inclined to send him a copy of proofs *with* his impressions, I will if it does not go off in either six or twelve months, take it as my own—but this is as you feel inclined; I have no interest in the affair only on seeing a copy[;] since I saw you [I] have fallen into a violent fit about them and am becoming a speedy convert to your opinion on the subject. If the sort of thing could once become the taste here our Authorities would soon follow one another but the difficulty is to set one off. Rivington has I fancy a letter from Parker, and will pay you whatever the sum may be for the impressions. you may put a letter in the parcel for me, and if you feel inclined to send a copy of the proofs on the condition I have mentioned, I will take care as to its being kept clean for me, that he shews it only to *the few*, and will ever and anon among my nearly daily visits, 'take care of my own'.— You are aware that Parker is *one* of the first classical booksellers & publishers in Europe.[2]

[1] Ivimy MSS., quoted from an undated draft. We can be fairly confident of the date because, according to Linnell's 'Cash Account', on April 15th, 1826 Linnell received 'of Lady Torrens for Job——[£]5 5 —'. In his Autobiography (pp. 62–63) Linnell wrote a rather detailed account of his friendship with Lady Torrens.

[2] Ivimy MSS. The results of these suggestions are to be found in the accounts for *Job*. 'Parker—Bookseller Oxford 1 copy plain—[£]2 12 6' appears in the Yale *Job* accounts under April 29th, while in Miss Ivimy's 'Cash Account' book (p. 595) is recorded payment by Daniell of £5 on Nov. 2nd, 1827. The copy he took for display purposes was not sold.

The first complaints were not long in following.

[*Saturday*] 22 April 1826

April
22nd,
1826

Dear Sir I have received Mr Blakes Illustrations to the Book of Job & perused the work with great attention & much interest.

You will not be offended if I say, your binder has put you to great expense in doing them up, & has thereby *to me* very greatly lessened the pleasure I should have taken in them. The back is so squeezed & pinched, the prints crack & wrinkle[?] every time they are turned over, & *must* in a short time be much damaged.

I cannot handle the book without pain. With your permission therefore I will return it, and ask you for a set on plain paper *loose* & without any fly leaves between. This reduction of the expense, and the Artists allowance, which I am in the habit of receiving, will reduce the cost to what I contemplated & understood when I subscribed vizt 2 guineas; one of which I paid to Mr Blake a considerable time . ago. I am Dr Sir Your very obed: Servt

Robert Balmanno.[1]

Two days later Balmanno wrote again:

Dear sir I am favord with your note & beg to inform you that I have not the honour of being an Artist but [*as*] my labours for the benefit of the profession have been exerted rather zealously, & for many years, I thought I might from an artist have asked the usual allowance (which has been invariably conceded to me by the Print sellers) without its being considered a very great favor[.]

April
24th,
1826

When Mr Blake showed me one of the plates some years ago, I understood the work was for his own benefit & that the price was to be two guineas & I gave him what I believed to be half the subscription: this I intimated to you, but as you have not noticed the circumstance, I will not trouble you to send me the book in any shape. I will see Mr Blake himself & arrange with him[.]

I am Your obed: Hbe: Sevt Robert Balmanno.

23 Mornington Place. [*Monday*] 24th April 1826[2]

[1] Quoted from a transcript by A. H. Palmer in an Exercise Book (p. 8) headed 'Job Revise (2)', with the Ivimy MSS.

[2] Ibid. In the Yale *Job* accounts under 'Cash Paid to Mr Blake on account of Job', Nov. 15th, 1823, is 'Balmano's Sub. [£]1—0'. It is interesting that as early as Nov. 1823 'one of the plates' was finished enough to show to customers. Balmanno apparently did buy the book from Blake for the usual price, for the Yale accounts show he paid £2. 12s. 6d., and when his effects were auctioned (Sotheby *Catalogue of a Very Valuable Collection of Prints, Drawings, Pictures*, &c. &c. the property of A Collector, May 4–12, 1830, item 7) the prints to *Job* 'by the late William Blake, proofs, scarce' were sold to Bentham for £1. 2s. 0d.

About a week later the engraver Haughton wrote to Linnell:

My Dear Sir

May 2nd, 1826 I was sorry that I was from home when you called and left me the Prints after the so justly celebrated Blake—but you must excuse my accepting them—when Dixon told me you would like to have a set of the Prints I engraved after Fuseli—I observed you should have a set if you would give me a Landscape sketch of yours—he then said you would be glad to make the exchange—and the prints I left accordingly. Now we must Keep to the agreement—or I must have my own engravings returned. Now Linnell since it is almost 5 years that you have had the prints this trifle may as well be settled at once[.]

 yours truly
[*Tuesday*] May 2nd 1826 M Haughton
 38 Gt Marlbro' Street—[1]

[May? 1826?] It may have been about this time that Linnell wrote to Samuel Palmer: 'I send you at last yr copy of the Book of *Job*'.[2]

On Wednesday, May 10th Thomas Edwards offered among his stock in trade to be sold at auction in Manchester

May 10th, 1826 1076 *Young's Night Thoughts. The Original Editions*, and the Author's own copies, inlaid on imperial Folio paper, and each page surrounded and illustrated with *original Drawings by Blake*, 2 vols., *most superbly bound in red morocco, gilt leaves, &c.*

 ib. 1742

It would be difficult, if not impossible, to convey to those at a distance and who have not seen this magnificent Work, an adequate, or even a faint idea of the singular nature of these most extraordinary and sublime conceptions of our Artist; but those who have seen his truly original designs for *Blair's Grave*, may form some faint idea of the style and manner of his treating this equally eccentric and original Poem; to embody which, and give it a visible form and reality, required the skill of a great Artist, and the poetic feeling of the original author combined. How far he has succeeded, the present beautiful and sublime Commentary upon his Author, bears ample and delightful evidence; and it may truly be averred, that a more extraordinary, original, and sublime production of art has seldom, if ever, been witnessed since the days of the celebrated *Mich. Agnolo*, whose grandeur and elevation of style it greatly resembles,

[1] Ivimy MSS.

[2] Ivimy MSS. I find no indication of a date in the letter, and Palmer appears in none of the *Job* accounts.

and this, *alone*, if he had left no other work of merit, would be sufficient to immortalize his name, and transmit it to posterity, as that of an Artist of the very highest order. This was the late Mr. Fuseli's opinion.[1] This splendid and *unique* Work, upon which the Artist was employed for more than two years, has never been published,[2] and this circumstance, it must be allowed adds greatly to its interest and value.[3]

The bidding did not reach the reserve of £50, and the book was therefore withdrawn.[4]

On Friday, May 12th Robinson had a party for a number of friends:

Tea & Supper at home The Flaxmans Masqueriers (a Miss Forbes) Blake & Sutton Sharpe[.][5] On the whole the Evenᵍ went off tolerably— Masqu: not precisely the man to enjoy Blake who was however not in an *exalted* state. Allusions only to his par[ticu]lar notions while Masqu: commentᵈ on his opinˢ as if they were those of a man of ordinary notions— Bl asserted that the oldest painters poets were the best— [']Do you deny all progression?['] says Masqu: [']Oh yes![']
I doubt whether Flaxman [enjoy(?) *del*] sufficiently tolerates Blake. But Bl: appreciates Fl: as he ought[.] Bl: relished my stone drawings—[6] They staid till Eleven.
Bl: is more & more convinced that Wordsworth worships *nature* And is not a Bible Xn[.] I have sent him the Sketches[.][7] We shall see whether they convert him[.]

[1] Fuseli did not express this opinion in the prefatory matter of either *The Grave* or the *Night Thoughts*. Since Fuseli's praise is not mentioned in the 1821 catalogue, it seems possible that it was expressed between that time and his death in April 1825.

[2] Of the 537 drawings 43 had, of course, been engraved and published in 1797, but most of the designs have still 'never been published'.

[3] *A Catalogue of the very Valuable, Extensive and Genuine Collection of Books,* (*Selected from the Stock in Trade*) *of Mr. Thomas Edwards, Bookseller of Halifax,* (who is retiring from business) . . . which will be Sold By Auction, By Messrs. Thomas Winstanley & Co. At the Exchange Rooms, Manchester. On Monday the 1st of May next, and following days (Saturday and Sunday excepted.) . . . Halifax, 1826, pp. 65–66.

[4] Mr. T. W. Hanson of Oxford very kindly informed me that in his copy of the 1826 catalogue £50 is entered at the end of the first paragraph, presumably indicating the reserve placed on the book at the auction. Clearly the reserve price was not reached, for Edwards offered the book again in May 1828.

[5] Robinson's Small Diary records: 'Flax Masq Blake S Sharpe'; presumably the Masqueriers brought Miss Forbes on their own initiative.

[6] I do not know what lithographs Robinson owned.

[7] Robinson was apparently going to convert Blake with Wordsworth's *Ecclesiastical Sketches*, London, 1822, rather than the *Descriptive Sketches* of 1793.

That same year Hazlitt wrote:

1826 Flaxman is . . . a profound mystic. This last is a character common to many other artists in our days—Loutherbourg, Cosway, Blake, [*William*] Sharp, Varley, &c.—who seem to relieve the literalness of their professional studies by voluntary excursions into the regions of the preternatural, pass their time between sleeping and waking, and whose ideas are like a stormy night, with the clouds driven rapidly across, and the blue sky and stars gleaming between![1]

May 17th, 1826 Linnell wrote in his Journal: '1826 *May* 17. Wed. To Father's to Mr Blake.' Four weeks later, on Tuesday, June 13th, Crabb Robinson made an even more enigmatic entry in his Small Diary: 'Blake'. But he expanded this in his fuller Diary:

June 13th, 1826 Another idle day— Called early on Blake[.] He was as *wild* as ever with no great novelty, except that he confessed a *practical* notion which wod do him more injury than any other I have heard from him[.] He says that from the Bible he has learned that Eine Gemeinschaft der Frauen statt finden sollte— When I objected that Ehestand [*marriage*] seems to be a divine institution he referred to the Bible— 'that from the beginning it was not so'— He talked, as usual of the spirits[,] asserted that he had committed many murders[,] that reason is the only evil or sin, and that careless gay people are better than those who think &c &c &c[.]

Robinson appears to have been momentarily shocked out of English by Blake's assertion that (as HCR wrote years later, p. 548) 'wives should be in common'. Had he known the Bible as well as Blake, he would have taken him up with some vigour, for Matthew xix. 8 is precisely contrary to Blake's intention: '[*Jesus*] saith unto them, Moses because of the hardness of your hearts suffered you to put away your wives: but from the beginning it was not so.'

July 12th–13th, 1826 On both July 12th and 13th Linnell wrote in his Journal: 'To Mr Blake.' Next day Blake signed two receipts acknowledging that he had been paid for the *Job* (see Accounts).

It may have been an occasion such as this when Blake was feeling particularly grateful to Linnell that he gave him the MS. of *Vala* or *The Four Zoas*.[2] Linnell's son wrote: 'my father *often told me as well as others* that Mr. Blake gave him the MS.

[1] [William Hazlitt], *The Plain Speaker*, London, 1826, vol. i, 223–4.

[2] A. T. Story, *The Life of William Blake*, London, 1892, vol. i, p. 170; *The Poetical Works of William Blake*, ed. J. Sampson, Oxford, 1905, p. 339.

The exact date of the gift he said nothing about, as of no consequence.'[1]

It was probably in late July that Mrs. Aders wrote to Linnell: 'M^r Robinson is in town & eager for his Job—as I am for the songs of Innocence'.[2]

[*Late July? 1826*]

Throughout July Blake had been severely ill, and unable to accept Linnell's repeated pressing invitations to come out to Hampstead, on a visit. Finally on Tuesday, August 1st he wrote to say that he was well enough to come, and apparently he brought with him his Dante drawings: 'Mrs. Collins, of the Farm, still [*in 1863*] remembers Blake as "that most delightful gentleman!" . . . During this visit he was at work upon the *Dante*. A clump of trees on the skirts of the heath is still known to old friends as the "Dante wood."'[3]

August 1st, 1826

It may have been in September 1826 that Blake visited Calvert and his wife at Brixton. Calvert's son wrote: 'I have heard tell that late on the night just mentioned [*as*] Blake and Calvert were trying some etching-ground, and melting it on the fire, the pipkin cracked, setting the chimney in a blaze, and all was flame and convolution of smoke. Here was material for weird suggestion, not unacceptable to Blake, whose anxiety, however, in his kindliness of nature, was not for the fire, but that Mrs. Calvert, who had retired to bed, should not be alarmed.'[4] The fire was of course put out without difficulty.

[*September? 1826?*]

It may have been in the autumn of 1826 that the firm of Ackermann, which had purchased the *Grave* copperplates and printed them in 1813, published them again with a series of poems by the refugee Spanish poet José Joaquin de Mora, with the following introduction:

Las composiciones contenidas en este volumen dehen considerarse solamento como illustraciones de las estampas. Ellas encierran la verdadera poesia de la obra, pues no son menos admirables por la correccion del dibujo, y por el merito de la egecucion, que por el atrevimiento del designio, y por la sublime inteligencia que reina en las alegorias.

[1] E. J. Ellis, *The Real Blake*, London, 1907, p. 411.

[2] Ivimy MSS. Mrs. Aders's copy was probably paid for on July 29th, 1826.

[3] Gilchrist, 1942, p. 346; 1863, p. 353.

[4] [Samuel Calvert], *A Memoir of Edward Calvert Artist*, London, 1893, p. 23. Calvert says (p. 17) that in May 1826 the Calverts moved to 17 Russell Street, Brixton. This incident, therefore, must have taken place after May 1826.

[Autumn?] Dos artistas célebres han contribuido al desempeño de las estampas:
1826 Guillermo Black, el dibujante, cuyo retrato adorna el frontispicio, y
Luis Schiavonetti, el grabador cuyo cincel ha servido de interprete a
tantas obras maestras del arte. Uno y otro salieron de la senda trillada
de la egecucion artistica: fueron verdaderos poetas que conocieron el
secreto de la inspiracion, y que en sus producciones aspiraron a una
esfera mas alta que la que se contiene en la mera representacion
esterior de los obgetos.

El autor de los versos no ha hecho mas que indicar los asuntos de las
estampas, procurando imitar los giros y el estilo que emplearon en la
Poesia Sagrado los hombres eminentes que la cultivaron en España
en el siglo XVI; aunque ha dado mas latitud a la parte filosofica que
a la mistica, pues esta la parece demasiado severa y sublime para en-
trar en el circulo de ideas que forman el dominio de la Literatura. Por
otra parte aunque la Religion no ha perdido en nuestra epoca su augusta
dignidad, los progresos de la razon la han acercado al hombre, si es
licito decirlo, y los trabajos de muchos escritores tan sabios como
virtuosos nos demuestran que el racincinio puede aplicarse, sin vio-
lencia, y sin profanacion, a las verdades eternas como a los preceptos
morale [*See Plate XLVI*].[1]

[*Translation: The compositions in this volume are included solely as
illustrations of the engravings. They concern the true poetry of the work,
which is not more admirable for the correctness of the drawing and for the
merit of the execution than for the achievement of the design and for the
sublime intelligence which reigns in the allegories.*

*Two celebrated artists have contributed to the completion of these en-
gravings: William Black* [sic], *the designer, whose portrait adorns the
frontispiece, and Louis Schiavonetti, the engraver, whose graver has
served to interpret so many master-works. Anyone may follow the hack-
neyed paths of artistic execution: they are true poets who can recognize the
secret of inspiration, and who in their productions aspire to a higher sphere
than that contained in the mere exterior representation of objects.*

*The author of these verses has not done more than to indicate the subjects
of the prints, attempting to imitate the convention and the style which was
employed in sacred poetry by eminent men in Spain in the sixteenth-
century; however, he has given more latitude to the philosophical part than
to the mystical, so that the appearance is bold, severe, and sublime in order
to enter into the circle of ideas which form the dominion of literature.*

*Moreover, although religion in our epoch has not lost its august dignity, the
progress of reason has brought it* [religion] *to men, if it may be said, and
the works of many writers, as learned as they are virtuous, have shown us*

[1] José Joaquin de Mora, *Meditaciones Poeticas*, Londres: Lo Publica R. Acker-
mann, No. 101, Strand; y en su establecimiento en Megico: asimismo en Colombia,
en Bueonos Ayres, Chile, Peru, y Guatemala, 1826, pp. ii–iii.

PLATE XLVI

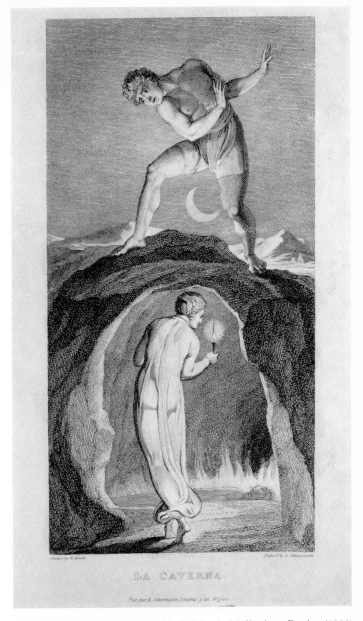

LA CAVERNA.

'LA CAVERNA', the Spanish title in Mora's *Meditaciones Poeticas* (1826)
for Schiavonetti's etching originally for Blair's *Grave* (1808) entitled 'The
Soul exploring the recesses of the Grave'. *The Antijacobin Review* was 'at a
loss to discover' the meaning of the 'fear-struck maniac' (see pp. 205-6)

that rationality can be applied, without violence and without profanation,
to eternal truths as to moral precepts.*]*

On Saturday, November 4th Edward Denny wrote to Linnell:

Dear Sir.[,] I do not know exactly Mr Blakes residence & therefore *November* I have enclosed this letter to you hoping that you will be so obliging *4th,* as to deliver it to him. I should be very much obliged if you could *1826* write me a line to tell me when the Book of Job will be completed & whether Mr Blake is engaged in any other work— I think I remember your telling me that he had some notion of illustrating Dante[.] I shall be glad to know if he has begun it yet or whether he intends to do so[1]

The enclosure said:

Sir [,] If you have a copy of Blair's Grave, with your illustrations to *November* dispose of I should be v[er]y much obliged to you if you could let me *4th,* have it, or if you have not one yourself, would it be asking too much *1826* to request you could be so kind as to procure a copy for me, & if you will send to me——at 'Barbourne House Worcester' I should feel particularly thankful to you— I am very much interested in it, I was shewn the work a day or two ago, & I think it one of the most beauti-ful & interesting things I have seen of yours. I am also much interested in the progress of your illustrations of the Book of Job having seen the unfinished plates some time since in the possession of Mr Linnell. & I hope you will tell me how it is going on & when it is likely to be completed, perhaps also you would let me know whether you are en-gaged in any other performance at present.

 Believe me Sir Yours very truly obliged Edward Denny
Barbourne House Worcester November 4 1826

will you let me know the price of the Grave at the same time that you send it to me[?][2]

[1] Copied by A. H. Palmer in an Exercise Book (now with the Ivimy MSS.) headed 'Linnell Correspondence', p. 28. The omission in the text at the end occurs in Palmer's transcript.

[2] Ibid. Linnell's 'Cash Account' book indicates that he received on Oct. '31 [*1826*] of Ed Denny Esq for a Copy of Job proofs [£] 5. 5. & Blair's Grave [£]2. 12 6——[£]7 17 6' and that he paid on 'Nov 23 to Evans balance of ex-change for Blairs Grave &c.' [but no sum is given]. Palmer wrote that 'Linnell suppressed the letter to Blake & supplied a copy of The Grave himself thus robbing Blake of the profit'. We are not forced, however, to accept Palmer's abrupt con-clusion. Only Linnell could profit from the *Job*, and, since Blake had no property in the *Blair*, he would not get a commission on it either. Blake was probably extremely weak at the time, and Linnell may simply have been saving him trouble. On Aug. 1st, 1826 Blake wrote: 'I am still incapable of riding in the Stage & shall be I fear for Some time being only bones & sinews[,] All strings & bobbins like a

Linnell himself carried out the commissions Blake had been asked to perform, and some two weeks later Denny wrote to Linnell again:

November 20th, 1826
Dear Sir [,] I thank you for your ready compliance with my wishes, and beg you will pardon my tardiness in writing to you. I am much obliged by your letter, and the very interesting information it contains—What shall I say, what *can* I say of the Book of Job[?] I can only say that it is a *great work*—and though I cannot venture to pass my humble comments upon any thing so truly sublime—I do indeed feel its exquisite beauty & marvellous grandeur. It is a privelege to possess such a work & still greater to be able to feel it.— it is I think the most perfect thing I have ever seen from the hands of Mr Blake, & if his Dante is superior, he will, I may almost say, outdo himself— I hope indeed he may complete this most valuable work[.]

I am very sorry to hear that Mr Blake has been in danger & sincerely hope that he is now in perfect health[.]

I congratulate your success in your own affairs & shall be happy to see what you have been doing when I next visit London. I send you a draft upon Puget & Banbridge for £7. 17. 6 the price of the Job & the Grave &. . . . Yours very truly Edward Denny.

Barbourne House [*Monday*] Novr 20th 1826[1]

Robinson wrote to James Masquerier on Saturday, November 25th:

November 26th, 1826
The Aders are well— I have seen but little of them. A coolness has arisen between Mrs A & me[.] Tho' she would perhaps not acknowledge as much She took great offence at my having invited you & the Flaxmans to my chambers without asking her— The F's: assure me they have carefully abstained from mentioning the party And Blake I believe they have not seen[,] Nor is he likely to have spoken of it[.] I fear Mrs Masq: whose frankness & communicativeness are amiable qualities but sometimes lead to inconvenient results—has inadvertently spoken of this Tho' I cautioned her against doing so[.]—[2]

December 7th, 1826
Blake's old and faithful friend Flaxman died two weeks later, and Robinson noted in his Diary for Thursday, December 7th that on hearing of his death

I walked out & called at Mr Soane's. he was from home[.] I then called on Blake, Desirous to see how with his peculiar feelings &

Weavers Loom. Walking to & from the Stage would be to me impossible'. And in Feb. 1827 he was 'still feeble & tottering', despite the fine weather.

[1] A. H. Palmer transcript as above; the omission appears in the transcript too.
[2] Dr. Williams's Library. The party referred to was on May 12th, 1826.

opinions he would receive the intelligence. It was much as I expected—
he had himself been very ill during the Summer and his first observa-
tion was with a Smile—[']I thought I should have gone first['.'] He
then said— [Death *del* ']I cannot consider death as any thing but
[a passage from *del*] a removing from one room to another['.']— One
thing led to another and he fell into his wild rambling way of talk—
Men are born with a devil & an angel but this he himself interpreted
body & Soul. Of the old testam^t he seemed to think not favorably—
[']Xt[,'] said he[, ']took much after his *mother* (the law) and in
that respect was one of the worst of men['.']— On my requiring an
explan^n he said— [']There was his turning the money changers out
of the Temple— He had no right to do that['.']— B: then decl^d ag^t
those who sat in judgement on others— [']I have never known a very
bad man who had not something very good about him['.']— He spoke
of the Atonement[,] Said—[']It is a horrible doctrine— If another
man pay your debt I do not forgive it—['] &c &c &c[.] He pro-
duced *Sintram* by Fouqué—[2] ['] This is better than my things![.']²

Probably towards the end of December Linnell wrote to
D. Colnaghi, the bookdealer of Pall Mall East, about Blake's
engravings: 'I send you a set of proofs of *the Book of Job* & will
call upon you in a few days[.']³ *[Decem-ber?] 1826*

A little later Linnell heard from another agent for the *Job*:

Dear Sir

I have returned the Illustrations of Job[.] I should not have kept it *January 5th, [1827]*
so long but had no opportunity of sending it before without expense—
I have been unable to find a customer for it[;] in fact Salisbury being
a place in which the Arts are but little cultivated It is difficult to find
any person to appreciate much less purchase a work of this description[.]
My Father admired one or two of the designs but as I expected it is not
at all the style which pleases him. I have inclosed it in a package to
M^r Dirkson Great Portland St and have requested him to deliver it—

> I remain
> Dear Sir
> Yours very truly
> H S C Shorts

Salisbury [*Friday*] Jan^y 5^th [*1827*]⁴

¹ Frederic Baron de La Motte Fouqué, *Sintram and his Companions: A Romance*,
[Translated] From the German [by Julius C. Hare, HCR's friend]. London, 1820.
² In his Small Diary for this day Robinson wrote 'Flaxman died' and 'Blake'.
³ Quoted from a photostat of the MS. in the Pierpont Morgan Library. The
MS. is dated 1826, but Colnaghi & Co. did not pay for their two sets of proofs
until 1827, according to Linnell's *Job* accounts.
⁴ Ivimy MSS. The signature is difficult to make out, and John Linnell, Jr. (in

January 9th, 1827 In his journal Linnell noted that he gave on Tuesday, '*January 9. To M*ʳ Blake £5.*'

On Friday, February 2nd Crabb Robinson wrote in his Diary: 'Gotzenberg[*er*] the young painter from Germany called on me and I accompanied him to Blake[.] We looked over Blakes Dante— Gotzenberger seemed highly gratifᵈ by the designs and Mʳˢ Aders says G. considers[?] B as the first & Flaxman as the second man he has seen in England— The conversⁿ was slight— I was interpreter betⁿ them and nothing remarkable was said by Blake—he was interested apparently by Götzenberger[.]'[1]

Linnell was becoming more and more concerned about Blake's health. On May 19th, 1826 Blake had written of a 'Shivering Fit' which 'intirely prevents me from the pleasure of seeing you on Sunday at Hampstead as I fear the attack again when I am away from home'. That summer Linnell 'proposed taking lodgings for him in the neighbourhood of his own cottage at Hampstead',[2] but the plan came to nothing. Linnell persisted, however, in his desire to move Blake closer to him, as he wrote *February 7th, 1827* in his Journal: Wednesday '*February 7. To M*ʳ Blake to speak to him @ living at C[*irencester*] P[*lace*].*'[3] A few days later Blake wrote:

I have Thought & thought of the Removal, & cannot get my Mind out of a State of terrible fear at such a Step, the more I think the more I feel terror at what I wishd at first & thought it a thing of benefit & Good hope[;] you will attribute it to its right Cause[,] Intellectual Peculiarity that must be Myself alone shut up in Myself or Reduced to Nothing. I could tell you of Visions & Dreams upon the Subject[.] I have asked & intreated Divine help but fear continues upon me & I must relinquish the step that I had wished to take & still wish but in vain[.]

February 8th, 1827 On Thursday, February '8 [*Linnell*] Left with Sir Thomas Lawrence Blakes Drawings of Paradise Regained price £50'.

the volume with the 'List of John Linnell Senior's Letters', p. 82) reads it 'H. H. Shorto'. There can be little doubt that the year should be 1827.

[1] In his Small Diary for this day Robinson wrote 'Gotzenberg Blake'.

[2] Gilchrist, 1942, p. 343; 1863, p. 350. Blake's letters of that summer hint at such a move.

[3] The reference does not make clear whether the Blakes were to move into Linnell's studio, into independent lodgings, or into the building where Blake's brother James lived—see Residences, pp. 563–4.

The *Paradise Regained* series remained in the Linnell family. In fact, Linnell

recommended him to all he thought likely purchasers: Chantrey, who (as we said) declined the *Paradise Regained* [at £20], but took a highly finished copy of the *Songs of Innocence and Experience*, at 20l;[1] Lord Egremont, Sir Thomas Lawrence, Mr. Tatham, and others. They considered it almost giving the money, even when they chose copies of the obviously beautiful *Songs*. Some of the last drawings executed, or at least finished by Blake, were two commissioned by Sir Thomas Lawrence Sir Thomas gave fifteen guineas apiece for these designs of Blake's. One was *The Wise and Foolish Virgins*,[2] the other *The Dream of Queen Katharine*; both repetitions, though not literal ones, of careful drawings made for Mr. Butts.[3]

About this time Wainewright wrote a letter to Linnell that has been summarized as follows:

asks the price for a head in oil (small) for a Physician belonging to the King's household, & of good connection, &c,—Asks after M^r Blake,— & commends J.L. for his care of him.— 'His Dante is the most wonderful emanation of imagination that I have ever heard of'—&c— He has asked him to let him have a coloured copy of the '*Songs of Innocence*' & the '*Marriage* of Heav- & Hell', &c[.][4]

February, 1827

A few days later, the King's physician wrote to Linnell:

Dear Sir

If you will order such a copy of Blakes Job as you would select for the Kings Library, to be sent to M^r Calkin Bookseller, Pall Mall,

[*February 22nd, 1827?*]

[1] Elsewhere (1942, p. 104; 1863, pp. 124–5) Gilchrist says: 'In the last years of his life, Sir Thomas Lawrence, Sir Francis Chantrey, and others, paid as much as twelve and twenty guineas [for the SONGS]; Blake conscientiously working up the colour and finish, and perhaps over-labouring them, in return; printing off only one side of the leaf, and expanding the book by help of margin into a handsome quarto.' On this statement Keynes & Wolf (1953, p. 54) comment succinctly: 'No authority is given for these facts, and no reliance can be placed on some of them.' No copies of the *Songs* are known to have belonged to Lawrence or Chantrey; and *most* of the late copies of the *Songs* are printed on one side of the paper only (copies A, I, J, M–S, U–AA).

[2] See May 21st, 1830, when it was sold. A modern inscription on the watercolour of the 'Resurrection', now in the Fogg, states that it came from the collection of Sir Thomas Lawrence also, but I know no other evidence for the assertion.

[3] Gilchrist, 1942, p. 349; 1863, pp. 357–8; cf. 1942, p. 330.

[4] Paraphrased by John Linnell Jr. in the volume (in the Ivimy MSS.) with the 'List of John Linnell Senior's Letters', p. 22. It begins '(Feb^y 1827) (T.G.W. to J.L.)'.

saying that it is by my direction I will take care that it is sent with a proper explanation. M^r Calkin will pay for it, or, say when he will—

<div align="right">yours truly
R Gooch[1]</div>

February 23rd, 1827 Next day Linnell noted in his Journal: Friday February '23 Sent a Copy of Job (Proofs) to D^r Gooch [*who*] Prom^d to take them for the Kings Library.'[2]

Blake's brother James seems to have retired from the hosiery shop on a modest annuity to a house on Cirencester Place. He may have tried to eke out this scanty independence through the influence of Blake's patron Thomas Butts. According to *The Imperial Calendar* for 1814–16, James Blake was one of the clerks under Thomas Butts in the office of the Commissary General of Musters, though he does not appear in the manuscript accounts of the office now in the Public Record Office.[3] The last few years of his life are extremely obscure, and even the last melancholy statistic is not quite certain. We do not know with confidence the cause or place of his death and it is only a strong probability that the 'James Blake [*aged*] 71 Yr^s [*who was brought from*] Cirencester Place' to be buried *March 2nd, 1827* in Bunhill Fields on March 2nd, 1827 is the poet's brother.[4] Certainly no reference in the poet's letters would suggest that he was mourning a brother in the late winter of 1827.

Blake sent a copy of *Job* to Cumberland in Bristol, but Cumberland was unable to find any buyers for it at all, and on *March 5th, 1827* Monday, March 5th he noted in his diary that he 'Sent . . . Lett. . . . to *Blake*',[5] probably apologizing for his ill success. Blake did not reply until April 12th:

Dear Cumberland

I have been very near the Gates of Death & have returned very weak & an Old Man feeble & tottering, but not in Spirit & Life not in The Real Man The Imagination which Liveth for Ever. In that I

[1] Ivimy MSS., n.d. The date may be inferred from the note for Feb. 23rd.

[2] On June 20th Linnell acknowledged receipt in his 'Cash Account' from 'Mess Budd & Calkin, Booksellers for, the Copy of Job sent to the King——[£]10 10—'.

[3] See 'Thomas Butts, White Collar Maecenas', *PMLA*, lxxi (1956), 1058.

[4] Bunhill Fields Indexes in Somerset House, vol. xxv, p. 76. The age is wrong by three years (Blake's brother would have been almost seventy-four in March 1827), but the fact that he was brought from Cirencester Place, where Blake's brother lived, and was buried in Bunhill Fields, where his parents and brother were buried, suggests that this James Blake is the poet's brother.

[5] BM Add. MSS. 36521B, f. 87.

am stronger & stronger as this Foolish Body decays. I thank you for the Pains you have taken with Poor Job. . . .

You are desirous I know to dispose of some of my Works & to make them Pleasin[*g.*] I am obliged to you & to all who do so But having none remaining of all that I had Printed I cannot Print more Except at a great loss for at the time I printed those things I had a whole House to range in[:][1] now I am shut up in a Corner therefore am forced to ask a Price for them that I scarce expect to get from a Stranger. I am now Printing a Set of the Songs of Innocence & Experience for a Friend[2] at Ten Guineas which I cannot do under Six Months consistent with my other Work, so that I have little hope of doing any more of such things.

According to his Journal, Linnell went on Tuesday, '*April* 17. To M*r* Ottley with M*r* Blake.' Eight days later, on the 25th, Blake wrote to thank Linnell 'for the prospect of M*r* Ottleys advantageous acquaintance'. The acquaintance did prove advantageous, for Ottley took a plain copy of *Jerusalem* for which he paid £5. 5*s*. 0*d*.[3] On Tuesday, '*May* 15. [*Linnell went*] to Bank. M*r* Blake &c'. And two months later he made visits on Wednesday, '*July* 11. To Somerset House M*r* Blake &c'. Next week he went on Tuesday, '17. to Bank M*r* Blake. Cochran &c.'

In his Journal Linnell recorded a trip '*August* Friday. 3. To M*r* Blake.' Part of the purpose of his trip was to give Blake £2. And a week later he went again: August, 'Friday 10. To M*r* Blake. Not expected to live.' To rivet the scene in his memory he made a tiny sketch of Blake lying in bed wearing a black skull-cap, with his head sunk on a great pillow, his face thin and drawn, and his dark eyes hollow but dominant. Even during these last days, however, Blake was still working, and 'One of the very last shillings spent was in sending out for a pencil.'[4]

April 17th, 1827

May 15th, 1827

July 11th, 1827

July 17th, 1827

August 3rd, 1827

August 10th, 1827

[1] This suggests that Blake printed off a considerable number of his works in Illuminated Printing while he was living (1790–1800) at Hercules Buildings in Lambeth in a whole house to himself. It is clear from the watermarks, however, that he also printed off numbers of the works in South Molton Street, where he lived from 1803 to 1821. In his cramped rooms in Fountain Court he must have had little room for his press.

[2] The friend was probably Wainewright, who told Linnell in Feb. 1827 that he had commissioned Blake to complete a set of the *Songs* for him.

[3] See Accounts for Aug. 1827, p. 594. In the July 21st, 1837 Sotheby *Catalogue of the Valuable Collection . . . of the late Willam Young Ottley, Esq.* Lot '306 Jerusalem: The Emanation of the Giant Albion, *one hundred engravings from wood, printed by W. Blake* 1804' was sold to Bohn for £3. 18*s*. 0*d*.

[4] Gilchrist, 1942, p. 352; 1863, p. 360. Cf. J. T. Smith, pp. 471, 475.

August 12th, 1827

Two days later Linnell wrote abruptly in his Journal: 'Sunday [*August*] 12. M͏ͬ Blake died.' When death came in the early evening, Blake sank with a song of glory in his lips and rapture in his eyes. 'A humble female neighbour, her [*Catherine's*] only other companion, said afterwards: "I have been at the death, not of a man, but of a blessed angel." '[1]

Eighteen-year-old George Richmond, who came in just after he died, 'closed the poet's eyes and kissed William Blake in death, as he lay upon his bed, in the enchanted work-room at Fountain Court.'[2]

There were naturally many expenses which Catherine had to deal with promptly, such as for medicine and the woman who had helped her, and Linnell was the one best able to help out: 'Mrs. B. borrowed 8/12/27—£5. & repaid it'.[3]

August 13th, 1827

There were dozens of practical details to take care of. The first was to arrange with the undertakers, and, according to his Journal, Linnell went 'Monday [*August*] 13. To M͏ͬˢ Blake. To B. Palmer @ M͏ͬ Blakes Funeral.' An elegantly engraved bill describing what would be provided was made out on the spot:

<div align="center">

M͏ͬ Linnell— *London* Aug. 13ᵗʰ 1827–
To Palmer and Son,
Upholsterers & Cabinet Manufacturers,
N⁰ 175, Piccadilly,
opposite the Burlington Arcade.
Funerals Performed *Sawyer & Son. Sc 43 Dean St. Soho*

</div>

For Funeral of M͏ͬ W͏ᵐ Blake,

a 5 ft. 9: Elm Coffin covered with black flannel & ⎫
finished with black varnished Nails, a plate of In- ⎬ 2. 14. 0
scription, 3 pair handles, lined ruffled & pitched ⎭

[1] Gilchrist, 1942, p. 353; 1863, p. 361. This may be just a paraphrase of Richmond's letter of Aug. 15th, 1827, q.v. In the margin of his heavily annotated copy (now in my possession) of [Watkins & Shober,] *A Biographical Dictionary of the Living Authors* (see Autumn 1816), beside the entry for Blake, William Upcott wrote 'Died 1827'.

[2] *Anne Gilchrist: Her Life and Writings*, ed. H. H. Gilchrist, London, 1887, p. 259. Richmond says nothing in his letter of Aug. 15th of having been by when Blake died, but the above account told to Gilchrist is very positive. It seems likely, therefore, that Richmond called shortly after Blake died.

[3] Note by John Linnell Jr. (in the book in the Ivimy MSS. with the 'List of John Linnell Senior's Letters', p. 42) at the end of a list of 'Cash paid by J. Linnell to Mrs. Blake' (see Accounts, p. 606). Presumably this day Catherine also gave notice to her landlord, for exactly a month later (Sept. 11th, 1827) she moved out.

a Shroud, pillow & Bed 17. 0
2 Men carrying in do. and dressing Body 3. –
Use of a best Velvet Pall 5. –
do. of 6 Gent⁹ Cloaks 6. –
do. of 6 Crape Hatbands, & 3 pair Gloves . .	. 4. 6
2 Men as Porters in Gowns & proper dresses . .	. 12. –
a Hearse & pair & a Coach & pair to Bunhill Fields.—	2. 8. –
2 Coachmens Cloaks 2. –
4 Men as Bearers 12. –
a Man to attend & conduct Funeral 5. –
3 crape Hatbands & Gloves for Porters and attender—	. 13. 6
Paid for Lime to make up Coffin 2. –
Paid Men's allowance for refreshment on taking in ⎫ the Coffin & on Morning of Funeral ⎭	. 6. 6
Paid Dues at Bunhill Fields, Clergyman, Grave diggers &c	1. 7. 6

£10. 18. 0[1]

The next problem was how to care for Mrs. Blake, and a providential letter came to Linnell next day:

My dear Sir

I am much concerned at the death of poor Mr Blake.

I hope our Charity will do something handsome for the widow as *August* it is now in its power. if the Case of the poor widow is urgent an *14th,* especial meeting of directors [must *del*] can be held immediately— *1827* and I will make it a point to attend. But You had better lose no time in seeing or writing to Mʳ Roper our Secretary (14 Duke St.) and he will inform you what to do[.]

Yours truly
John Constable

35 Charlotte St
 Fitzroy Sqre
[*Tuesday*] Augsᵗ 14 1827[2]

[1] Quoted from a photostat of the bill now in the Huntington Library. The parts in italics above are printed on the original. Benjamin Palmer was probably Mrs. Linnell's uncle. The bill apparently was not paid until Jan. 1828 (see Accounts, p. 595).

There seems to be a difference between the porters (of whom there were two) and the bearers (of whom there are four). The eight cloaks are for the two coachmen, the four bearers and the two porters. The nine crape hatbands are for each of these plus the 'attender'. The Bunhill Fields Dues were 19*s*., not £1. 7*s*. 6*d*., but perhaps the extra 8*s*. 6*d*. was the cost of the clergyman and grave-diggers, not included in these Dues.

[2] Ivimy MSS. This suggestion is the more creditable to Constable as he seems to have acted rather badly to Linnell previously, according to Linnell's autobiography (pp. 28–30).

On the back of this letter Linnell made a series of enigmatic notes to himself, many of which seem to concern Blake:

[English Don Quixote trans(?) *del*]¹ Wilberforce tuesday²
Stover³
Ottley⁴
⎧ to Keen
5⎨ Trowsers
 ⎪ Blake &c
 ⎩ String
See Mʳ Knighton⁶
fram 5. 15. 6
Edᵈ to enquire
at Battersea @
Mʳˢ Blakes Certᵗᵉ⁷
⎰ Lythms[?]
⎱ gems
Butts—⁴
Mʳˢ Blake 5.5.⁸

¹ Can this refer to *The History and Adventures of the Renowned Don Quixote*, which appeared in *The Novelist's Magazine*, vol. viii (1782), and for which Blake made two engravings? Or is it a book Blake owned?

² This may mean that Linnell intended to call on William Wilberforce, to see if anything could be done in the way of charity for Catherine.

³ When A. H. Palmer copied this letter and these notes on pp. 5–6 of an Exercise Book headed 'J Linnell Correspondence General' (Ivimy MSS.), he explained succinctly that 'Stover' was 'J L's Governess', but he did not suggest what relevance she might have had here. Was Linnell thinking that Catherine might find employment as a governess? Or that she might get advice from Miss Stover?

⁴ Linnell was probably getting in touch with W. Y. Ottley, Thomas Butts, S. Woodburn, George Cumberland, and T. G. Wainewright because they had all admired Blake and bought his works, and might be persuaded to help his widow. In particular, Linnell wanted to remember to send Ottley his copy of *Jerusalem*—see Aug. 16th.

⁵ 'Keen' may be the sensationally popular actor Edmund Kean, but this entry and 'Trowsers Blake &c String' mean nothing to me and are not explained by A. H. Palmer.

⁶ Sir William Knighton was the Keeper of the Privy Purse to George IV, who had ordered a copy of *Job* for the King (see Accounts, for June 20th, 1827, p. 599), and from whom Linnell may have hoped to get a pension for Catherine.

⁷ Edward Chance was presumably going to get a certificate of Catherine's marriage to qualify her for a pension from the government or the Royal Academy. According, for instance, to *The Rules, Orders, and Regulations of the Society of Engravers*, London, 1804 (of which Society Blake does not seem to have been a member), 'Every widow claiming on the Society shall produce, if required by the Committee, copies of the registers of her marriage . . .' (p. 48).

⁸ This five-guinea payment to Catherine is probably for Ottley's copy of *Jerusalem*.

D°——2.2.
Book with Haleys
verses[1]
Dante—
Drawing Book—
Plates Vasari[2]
Woodburn[3]
@ Mark Antonio
Dante Coppers Crack
off
{ 17 Kupell St
{ North Brixton[4]
Cumberland[3]
Wainright[3]

Someone, perhaps Linnell,[5] evidently wrote to the King's sister, Princess Sophia, about Catherine's situation, for 'after Blake's death a gift of £100 was sent to his widow by the Princess Sophia Mrs. Blake sent back the money with all due thanks, not liking to take or keep what (as it seemed to her) she could dispense with, while many to whom no chance or choice was given might have been kept alive by the gift'[6]

Linnell promptly took up Constable's suggestion. However,

[1] Perhaps the book with Hayley's *verses* was the copy of *Triumphs of Temper* with the poem to Blake which Hayley gave Blake in July 1800.

[2] The Dante Drawing Book was clearly the one Blake had been making his Dante sketches in. The Plates were presumably the copperplates of Dante which Blake had begun—Linnell already had the plates to *Job*. 'Vasari' was probably Blake's copy of the *Lives of the Artists*, which he cited, for instance, in his indignant notes to Reynolds of about 1808.

[3] See note 4 on p. 344.

[4] Both A. H. Palmer and I read this with some confidence as '17 Kupell St', but it should probably be '17 Russell St Brixton', where Blake's friend Edward Calvert lived from May 1826. I have no guesses to make about the preceding 'Dante Coppers Crack off'.

[5] In his 'Cash Account' book (Ivimy MSS.) Linnell noted receipt of £102. 10s. from H.R.H. Princess Sophia on Feb. 25th, 1822. The following undated note from Samuel Rogers (transcribed by A. H. Palmer, under 'J Linnell Correspondence General' in the Ivimy MSS.) probably refers to Linnell's much-appreciated miniature of the princess, though it could refer to Catherine Blake: 'The Princess Sophia will thank M‍ʳ Linnell to call either Morning or Evening whichever is most convenient to Kensington Palace & that he will bring with him a stamp recipe when the money will be paid instantly. If he cannot call it will be the same to the Princess if he send a trusty person in whose hands the money may be placed—'.

[6] A. C. Swinburne, *William Blake*, London, 1868, p. 81, whose authority, Kirkup, must in turn have derived his information from a correspondent, for he had lived in Italy from 1816.

instead of going to the Secretary of the Royal Academy, as
Constable had suggested, he went on Tuesday, August '14.
To Sir Thomas Lawrence @ M^rs Blake', to see what the
President of the Academy could do.[1] He probably took with him
a statement of

August 14th, 1827

'The Case of Mrs. Blake Widow of Wm. Blake Historical
Painter & Engraver'

—setting forth, W.B. as man of first rate talent in the art of design,
&c—states his more popular works,—*Blairs G[rave]. Young N[ight].*
Thoughts, the *Cant[erbury]. Pil[grims].;—Book of Job*—. He always
lived a temperate life, beloved by his friends,—in perfect harmony with
his wife. never had but small prices for his works, & so though he
lived with the utmost economy, he could not save anything—& has
left nothing for his widow but a few Plates & drawings which if sold
would produce nothing adequate to defray even present expenses.[2]

Assuming that Linnell wrote promptly to Wainewright,
it was probably the next day, Wednesday, August 15th, that
Mrs. Wainewright replied:

[August 15th?, 1827]

Dear Sir,

M^r Wainewright is out, but I beg in his name that you will accom-
plish your intention of favouring us tomorrow. We shall indeed *deeply*
sympathise with you on the loss of so great an Artist, and I fear M^r
Ws regrets will be most poignant that he did not enjoy once again
the pleasure of an hour with him.

Yours truly Dear Sir
E. F. Wainewright[3]

Samuel Palmer happened to be out of town at the time, and
George Richmond hastened to write to him on August 15th:

August 15th, 1827

Wednesday Even^g—

My D^r Friend

Lest you should not have heard of the Death of M^r Blake I have
written this to inform you— He died on Sunday Night at 6 Oclock in

[1] At this point in his transcription of Linnell's Journal A. H. Palmer calculates
that Linnell had sixty-one interviews with Blake from 1818 to 1827, or about
seven a year, 'But the journal was mostly professional.' From the Journal entries
recorded by Palmer, however, I make the total only fifty-eight.

[2] Summarized by John Linnell Jr. in his 'List of John Linnell Senior's Letters'
(p. 28) (Ivimy MSS.), headed 'A. pencil writing, *by J.L.*, concerning W. Blake,—
(put with letters)—', and concluding '[substance] ?[a paper apparently given to
Mrs Blake]'. The application to the charity of the Royal Academy proved unsuccess-
ful. [3] Ivimy MSS., undated.

PLATE XLVII

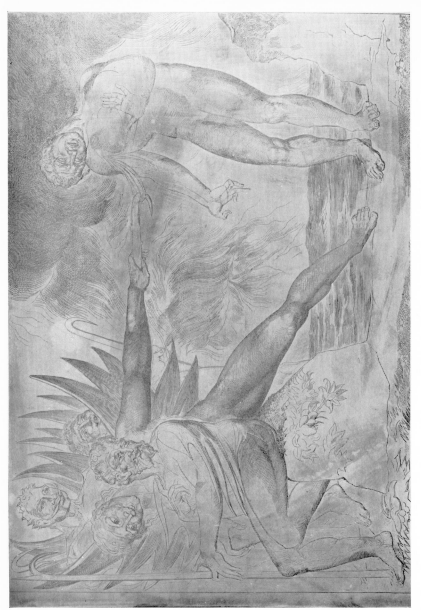

BLAKE'S ENGRAVING FOR DANTE (1827) pl. 2

a most glorious manner[.] He said He was going to that Country he had all His life wished to see & expressed Himself Happy hoping for Salvation through Jesus Christ—Just before he died His Countenance became fair— His eyes brighten'd and He burst out in Singing of the things he Saw in Heaven[.] In truth He Died like a Saint as a person who was standing by Him Observed— He is to be Buryed on Fridayay at 12 in morng[.] Should you like to go to the Funeral[?]—If you should there will be room in the Coach.

<div align="right">Yrs Affectiony
G Richmond</div>

Excuse this wretched scrawl[.]¹

On 'Thurs [*August*] 16. [*Linnell*] Sent Mr Blakes Jerusalem to Mr Ottly', which had been paid for a few days previously. *August 16th, 1827*

Next day the body of 'William Blake [*age*] 69 [*was brought from*] Fountain Court Strand [*and buried in a Grave*] 9 feet [*E. and W.*] 77 [*N. and S.*] 32 [*fee for the Minst*] 3/- [*Bunhill Fields Burying Ground dues* £]1. 2. 0. [*buried*] Friday one o'clk.—17 [*August 1827 by the undertaking firm of*] Palmer & Son, 175. Piccadilly.—'² *August 17th, 1827*

¹ Quoted from a photostat of the MS. in the possession of Mr. Joseph Holland. In the last sentence before the signature 'there' was accidentally written as both the last word on the recto and the first word on the verso.

² This is transcribed from the Bunhill Fields Burying Ground Order Book (now in Guildhall Library); the Order Book recorded preliminary arrangements, and the Registers (below) recorded accomplished facts. The same details, up to '[*N. and S.*] 32', are given in the Bunhill Fields Registers (in Somerset House, pressmark 194), but there the only fee—and the only other detail—is 19s.

GEORGE CUMBERLAND'S MESSAGE CARD

Blake's last engraving, left unfinished at his death (see pp. 357–67.)

PART VI

A FADING SHADOW

1827–1831

My hands are labourd day & night
And Ease comes never in my sight[.]
My Wife has no indulgence given
Except what comes to her from heaven[.]
We eat little we drink less[;]
This Earth breeds not our happiness[.][1]

In the first few years after Blake's death there was more printed praise of him than might have been expected. The day after the funeral, on Saturday, August 18th, an influential obituary appeared in the *Literary Gazette*:

William Blake;
The Illustrator of the Grave, &c.

August 18th, 1827 To those few who have sympathies for the ideal and (comparatively speaking) the intellectual in art, the following notice is addressed. Few persons of taste are unacquainted with the designs by Blake, appended as illustrations to a 4to edition of Blair's Grave. It was borne forth into the world on the warmest praises of all our prominent artists, Hoppner, Phillips, Stothard, Flaxman, Opie, Tresham, Westmacott, Beechey, Lawrence, West, Nollekins, Shee, Owen, Rossi, Thomson, Cosway, and Soane; and doubly assured with a preface by the learned and severe Fuseli, the latter part of which we transcribe:—'The author of the moral series before us [*has given us*] . . . materials of art and hints of improvement'![2]

When it is stated, that the pure-minded Flaxman pointed out to an eminent literary man the obscurity of Blake as a melancholy proof of English apathy towards the grand, the philosophic, or the enthusiasti-

[1] Letter of Nov. 22nd, 1802.

[2] Fuseli's puff is taken from the book or prospectus (see Nov. 30th, 1805), and the praisers seem to have been chosen from the subscription list.

cally devotional painter; and that he, Blake, has been several times employed for that truly admirable judge of art Sir T. Lawrence, any further testimony to his extraordinary powers is unnecessary. Yet has Blake been allowed to exist in a penury which most artists,*— beings necessarily of a sensitive temperament,—would deem intolerable. Pent, with his affectionate wife, in a close back-room in one of the Strand courts, his bed in one corner, his meagre dinner in another, a ricketty table holding his copper-plates, his colours, books (among them his Bible, a Sessi Velatello's Dante,[1] and Mr. Carey's translation,[2] were at the top), his large drawings, sketches and MSS.;—his ancles frightfully swelled, his chest disordered, old age striding on, his wants increased, but not his miserable means and appliances: even yet was his eye undimmed, the fire of his imagination unquenched, and the preternatural, never-resting activity of his mind unflagging. He had not merely a calmly resigned, but a cheerful and mirthful countenance; in short, he was a living commentary on Jeremy Taylor's beautiful chapter on Contentedness.[3] He took no thought for his life, what he should eat, or what he should drink; nor yet for his body, what he should put on; but had a fearless confidence in that Providence which had given him the vast range of the world for his recreation and delight.

Blake died last Monday![4] Died as he lived! piously cheerful! talking calmly, and finally resigning himself to his eternal rest, like an infant to its sleep. He has left *nothing* except some pictures, copper-plates, and his principal work, a Series of a hundred large Designs from Dante.[5]

William Blake was brought up under Basire, the eminent engraver. He was active in mind and body, passing from one occupation to another, without an intervening minute of repose. Of an ardent, affectionate, and grateful temper, he was simple in manner and address, and displayed an inbred courteousness of the most agreeable character. Next November he would have been *sixty-nine*. At the age of sixty-six[6]

* The term is employed in its generic and comprehensive sense.

[1] There were editions of Allessandro Vellutello's *Dante* in 1551, 1554, 1564, 1571, 1578, and 1596, which were not very expensive in Blake's time—Malkin's copy of the 1564 edition was sold for £2. 2s. 6d. by Evans on March 22nd, 1828.

[2] *The Vision; or Hell, Purgatory, and Paradise,* tr. H. F. Cary, London, 1819— see Dec. 17th, 1825.

[3] In Taylor's *Rule and Exercises of Holy Living* appears a section 'Of Contentedness in all estates and accidents'.

[4] Blake died on Sunday, Aug. 12th.

[5] Cunningham (p. 506), among others, testifies that Blake also left voluminous MSS.

[6] Blake would have been *seventy* in Nov. 1827. Therefore the 'age of sixty-six' which presumably refers to 1824, should be converted to 'sixty-seven'.

he commenced the study of Italian, for the sake of reading Dante in the original, which he accomplished!

His widow is left (we fear, from the accounts which have reached us) in a very forlorn condition, Mr. Blake himself having latterly been much indebted for succour and consolation to his friend Mr. Linnell, the painter. We have no doubt but her cause will be taken up by the distributors of those funds which are raised for the relief of distressed artists, and also by the benevolence of private individuals.

When further time has been allowed us for inquiry, we shall probably resume this matter; at present, (owing the above information to the kindness of a correspondant,) we can only record the death of a singular and very able man.[1]

August 18th, 1827

The day after Blake was buried Linnell went again on 'Sat [*August*] 18. To Mʳˢ Blake', perhaps to help her decide what to do with her rolling press. Linnell wrote to the *Job* printer, Lahee, asking if he wanted to buy Blake's press, and it may have been on the same day, Saturday the 18th, that Lahee replied:

August 18th? 1827

Sir

In answer to your note as to Mʳˢ Blakes press I beg to say that I am not in want of a very large press at this moment, but if it happens not to be larger than Grand Eagle, and it is a good one in other respects I have one idle which would answer Mʳˢ B's purpose, and which I would exchange with her for but the fact is that wooden presses are quite gone by now & it would not answer me to give much if any Cash; notwithstanding the circumstances you mention would prevent my attempting to drive a hard bargain— I can't come out myself before Monday morning but my man shall look in upon you about 1- oC. who will report to me how he finds it & if likely to answer. I should wish a trial of it for a week[.]

> I remain Sir
> Your ob Sᵗ J. Lahee[2]

[1] Anon., 'William Blake: The Illustrator of The Grave, &c.', *Literary Gazette*, Aug. 18th, 1827, pp. 540–1. No sequel appeared. With minor variations, this obituary was reprinted in *The Gentleman's Magazine* (Nov. 1st, 1827), *The Monthly Magazine* (Oct. 1827), *The New Monthly Magazine* (Dec. 1st, 1827), *The Annual Register* (1828), and *The Annual Biography* (1828).

According to the editor of *The Literary Gazette* (*The Autobiography of William Jerdan*, London, 1852, vol. ii, p. 176), 'William Carey was the chief contributor' to the early numbers of the magazine, and he was probably primarily in charge of the sections on Art. Since Carey was a known Blake enthusiast (see Nov. 7th, 1808 and Dec. 31, 1817), it seems likely that he was the author of this eloquent obituary.

[2] Ivimy MSS. There is no date, but 'the circumstances you mention' surely

In his Journal Linnell recorded that on 'Tues [*August*] 21 M^r F. Tatham came @ M^rs Blake'. Apparently Lahee's man did not find the old wooden press 'likely to answer', and Linnell went on 'Wed. [*August*] 22.[1] [*to*] M^rs Blake to arrange about Moving Printing Press &c'. Catherine evidently agreed, and Linnell reported: 'Wed [*August*] 29 M^rs Blakes press moved to C[*irencester*]. Place' where Linnell had a house and where Catherine moved two weeks later.

August 21st, 1827

August 29th, 1827

In the September issue of *The Monthly Magazine*, under 'Deaths', appeared the brief notice '[*Aged*] 68, Mr. W. Blake, engraver.'[2] A full obituary, with dates even more inaccurate, appeared next month. A full and informed obituary appeared in *The Literary Chronicle* the same day:

September 1st, 1827

The late Mr. William Blake, whose recent decease has been publicly notified, may be instanced as one of those ingenious persons which every age has produced, whose eccentricities were still more remarkable than their professional abilities, the memory of which extra circumstances have largely contributed to the perpetuation of their fame.

Mr. Blake, celebrated for his graphic illustrations of Blair's poem of the Grave, however ingenious that series of designs, was still more remarkable, as before observed, for the singularity of his opinions, and for his pretended knowledge of the world of spirits.

It is not our intention to speak of the aberrations of men of genius with levity, but would rather advert [*to*] them, with commiseration and pity. Yet, to dwell upon the pursuits, or to relate the opinions of such visionaries as the late Mr. Blake with seriousness, would be an attempt beyond the extremest limits of our editorial gravity.

That he *believed* to have *seen* and *conversed* with those with whom he pretended acquaintance, we no more doubt than that he is now incorporated with those incorporeal beings with whom he was so familiar. But still more strange, perhaps, is that which is no less true—that there are those, men of sense and of quick perception too, who actually believe what he believed to have seen to be true!

Mr. Blake, in our hearing, with, apparently, the powers of reasoning

indicate that Blake had just died, and Linnell would probably have made inquiries *before* he moved the heavy press to Cirencester Place. A standard copper-plate rolling press was an extremely bulky and heavy object, forming a rectangle about four and a half feet high and long, and two and a half feet wide (see J. Johnson, *Typographia*, London, 1824, vol. ii, pp. 801–2, where details of using the machine are also given).

[1] A. H. Palmer transcribed the date 'Wed. 21', but the day of the week indicates that the date of the month was the 22nd.

[2] *Monthly Magazine*, N.S., iv (Sept. 1827), 330.

on the objects before him, as clearly, distinctly, and rationally as the most sane logician, has declared, that he had frequently seen and conversed with the ancient kings and prophets. With David, Saul, Hezekiah and other great personages mentioned in Holy Writ; nay, that he drew their portraits in his sketch-book, which portraits we have seen. 'Seeing is believing,' saith the adage. We have seen these—ergo, we believe, as aforesaid, that Mr. Blake thought that he had seen, and confirmed the fact by sketching their portraits.

In illustration of which, it may be worth relating here, that which he related to us, namely—

That the first time he saw King Saul, he was clad in armour. That his helmet was of a form and structure unlike any that he had seen before, though he had been in the armories of all nations since the flood. Moreover, that King Saul stood in that position which offered only a view in part of the said helmet, and that he could not *decently* go round to view the whole.

Thus the sketch of the helmet,—for artists have a rule not to touch at home upon that which they have sketched abroad, neither from nature or the life; this rule, Mr. Blake invariably maintained, wherein the material of his art was exercised upon those of his sitters, who were immaterial. This sketch of the helmet then remained as he first sketched it—incomplete.

'Some months after' (the first sitting,) said Mr. Blake, 'King Saul appeared to me again (when he took a second sitting,) and then I had an opportunity of seeing the other part of the helmet.'

We saw the said helmet when completed, and, in sober truth can assert, that the helmet and the armour are most extraordinary!

The MAN FLEA.—Mr. Blake had a conversation with a *flea*, which, on being related to us, naturally enough reminded us of the saying of the great Napoleon, 'that from the sublime to the ridiculous—was but a step.'

The flea communicated to Mr. Blake what passed, as related to himself, at the *Creation*. 'It was first intended,' said he (the flea) 'to make me as big as a bullock; but then when it was considered from my construction, so armed—and so powerful withal, that in proportion to my bulk, (mischievous as I now am) that I should have been a too mighty destroyer; it was determined to make me—no bigger than I am.'

It must, in justice to the genius and professional renown of Mr. Blake, be added, that he made a drawing, composed in a poetic mood, of this little pernicious *vampire*, enlarging it to the figure of a man, encased in armour, folded somewhat analogously to the rhinoceros-like coat of the flea, and denominated it—*The Man Flea*; and, to speak without *hyperbole*, it is indubitably the most ingenious, and able personi-

fication of a *devil*, or a malignant and powerful *fiend*, that ever emanated from the inventive pencil of a painter.

Apropos—In a book of autographs, in the possession of the librarian of the London Institution, is the autograph of this artist, who has added to a very clever drawing, 'William Blake, born in 1765, has died several times since!!!'[1]

Linnell's young Oxford friend wrote about *Job*:

<div style="text-align: right">

St. Giles Norwich
[*Tuesday*] Sept. 4th 1827.

</div>

September 4th, 1827

Sir,

I must crave your pardon for having so long neglected making any arrangements concerning Ṃʳ Blakes book.—I have, since I received your last letter, been much occupied in preparing for my final examination, for which I am to proceed to Oxford next month. If you will be kind enough to pay my £5 or whatever the subscription is for me I shall be much obliged and you may depend on seeing me on my way to Oxford when I will repay you. I fear Mʳ Parker has never sold his impressions so that at present I know of no new customer.— . . . I shall probably be in London about Monday 5 weeks E. T. Daniell

P.S.

Should the above arrangement be agreeable to you, you need not trouble yourself to answer this letter as I shall take it for granted you have received it.—

On the back of this letter Linnell wrote:

Dʳ Sir,

If I am not at Home when you call—pray have the goodness to pay M̱ʳ̱ˢ Blake who lives with me now here[.]

<div style="text-align: right">

your Obliged
J. Linnell[2]

</div>

£5.5.—

[1] Anon., 'William Blake', *The Literary Chronicle And Weekly Review*, Sept. 1, 1827, pp. 557–8. Blake's inscription in William Upcott's autograph album begins: 'William Blake . . . Born 27 Novʳ 1757 in London & has died several times since.'

[2] Ivimy MSS. Daniell actually came five weeks from Thursday, and apparently only brought £5 with him, for Linnell's 'Cash Account' (p. 595) shows a receipt for '[*November*] 2 of Mʳ Daniel for Book of Job p[*rin*]tˢ 5ˢ owing—[£]5 —'. Presumably Linnell was home when Daniell arrived, and Mrs. Blake did not need to use the receipt Linnell had provided her with.

There may have been some connexion between Daniell's purchase of the *Job* from Mrs. Blake and the print from *Urizen* Plate 3 which, according to a late inscription on the back, was sold to 'E. Danniels, 53 Mortimer Street, by either

September 11th, 1827 About the time Linnell made out this receipt for Daniell he wrote in his Journal: 'Sept^r Tues 11 M^rs Blake moved to Cirencester Place'.[1]

In October *The Monthly Magazine* published an obituary of Blake which was silently borrowed, except for a sentence about Varley, wrong dates, and debased phraseology, from the August 18th account in the *Literary Gazette*. *The Monthly Magazine* said:

William Blake.

October 1827 William Blake, born about the year 1761, was a very remarkable, and a very eccentric character. He was brought up under Basire, an eminent engraver; but his exertions were not confined to the burin. His designs, illustrating a quarto edition of Blair's Grave, and ushered into the world by a preface from the pen of the learned and severe Fuseli, are well known. Flaxman pointed out Blake to an eminent literary man, as a melancholy example of English apathy towards the grand, the philosophic, or the enthusiastically devoted painter. By Sir Thomas Lawrence, too, whose judgment in art has never yet been questioned, he was repeatedly employed; notwithstanding which he existed in a state of penury, which most artists—creatures necessarily of a sensitive temperament—would deem intolerable. He has been seen living, or rather vegetating, with his affectionate wife, in a close back-room in one of the courts of the Strand; his bed in one corner, his meagre dinner in another; a ricketty table, holding his copper plates in progress, his large drawings, sketches, &c., MSS., his colours, books, &c.; amongst which his Bible, a Sessi Vellutello's Dante, & Mr. Carey's Translation, were at the top. At this time his ancles were

Mrs. Blake or a relation of hers' (*The Blake Collection of W. Graham Robertson*, ed. Kerrison Preston, London, 1952, p. 254; the print is now in the Keynes collection).

Perhaps it was Tulk who acquired Blake's 'Good and Evil Angels' and wrote on the back of it: 'Bought from the widow for £5' (M. Butlin, 'The Bicentenary of William Blake', *Burlington Magazine*, c (1958),42).

[1] With the Ivimy MSS., in what appears to be John Linnell's hand, is a scrap of paper which is perhaps related to the notes he made for J. T. Smith. It reads:

June 5. 1822 Went to Lodge with M^rs Hard at Hampstead
March 6. 1824 moved family to Hampstead *Collin's Farm*
M^r Blake Died Augt 12 (Sunday) 1827

M^rs Blake moved from Fountain Court Strand to M^r Linnell's 6 Cirencester place, Fitzroy Sqr Sept. 11. 1827. left some time before Midsummer 1828.

John Linnell, Jr. ('List of John Linnell Senior's Letters', p. 41, Ivimy MSS.) thinks, very plausibly, that she probably left at Lady Day (March 25, 1828) when Linnell moved to Porchester Terrace and let the Cirencester Place house on a lease to a Mr. King. See also Tatham, p. 534, and Residences, p. 567.

frightfully swelled, his chest was disordered, old age striding on, and his wants increasing, but not the means of supplying those wants. Yet his eye was undimmed, the fire of his imagination was unquenched, the preternatural never-resting activity of his mind was unflagging. He was calm, he was cheerful, at times he was even mirthful. At the age of 66, Mr. Blake commenced the study of Italian, for the sake of reading Dante in the original; and he succeeded in the undertaking. At one period, if we mistake not, he was upon intimate terms with John Varley, another eccentric, but highly gifted author. In temper he was ardent, affectionate, and grateful; in manners and address, simple, courteous, and agreeable. He died calmly and piously, like an infant sinking into its last slumber, on the 13th of July. He has left nothing behind, except some pictures, copper-plates, and his principal work—a series of a hundred large designs from Dante.[1]

In his letter to Linnell of Wednesday, October 10th Samuel Palmer wrote: 'Will you have the goodness particularly Sir to remember me to M.ʳˢ Blake'. And sideways in the margin he scribbled: *October 10th 1827*

If that reduced price copy of Songs of Innocence at Rivington's be to be had & you should be going Sir that way perhaps you would be kind enough to buy it for me, unless it be an inferior copy— There is a little book Sir, Hayley's Ballads, which perhaps you have not got, containing 5 or 6 designs by Mr. Blake engraved by himself—I have it. You may pick it up about town for 2 shillings or 2/6. I wish I could get that terrific poem on the French Revolution[.][2]

Palmer must already have been to Rivington's once, where he had seen the *Songs of Innocence and of Experience* (see January 1824). If 'that terrific poem on the French Revolution' was the *French Revolution*, Palmer apparently did not know that it only survived in a fragmentary proof copy in Linnell's possession.

Palmer is not known to have owned any of Blake's works in Illuminated Printing, but he carefully acquired all the Blakeana his limited means could afford, and his son wrote in the copy of Dante which Blake annotated: 'This volume, as far back as I can remember, stood upon one of my father's book-shelves by the side of books annotated or illustrated by Blake. Among them

[1] Anon., 'William Blake', *Monthly Magazine*, N.S., iv (Oct. 1827), 435. For annotation see Aug. 18th, 1827.
[2] Ivimy MSS.

was the now well-known copy of Lavater's "Aphorisms." . . .
Bacon's Essays with Blake's notes were there, Hayley's Ballads
[*1802*]; and a Copy of Thornton's edition of Ambrose Philips'
[*translation of Virgil's*] Pastorals.'[1]

Apparently at this time George Cumberland knew none of
Blake's immediate friends in London, for he seems to have
learned of Blake's death from a published obituary such as that
in *The Monthly Magazine.* On Tuesday, October 23rd he wrote
October in his Diary: 'Heard that My old friend Blake was Dead—but
23rd,
1827 no particulars. have his Job to Sell for widow for 3.3 —'.[2]

The fourth obituary of Blake appeared about November 1st
in *The Gentleman's Magazine*, derived largely from the account
in *The Literary Gazette*, but with some added bibliographical
information.

November *Aug.* 12. Aged 68,[3] Mr. William Blake, an excellent, but eccentric,
1st, artist.
1827
He was a pupil of the engraver Basire; and among his earliest pro-
ductions were eight beautiful plates in the Novelist's Magazine. In
1793 he published in 12mo, 'The Gates of Paradise,' a very small book
for children, containing fifteen plates of emblems,[4] and 'published by
W. B. 13, Hercules Buildings, Lambeth;' also about the same time,
'Songs of Experience, with plates;' 'America; a Prophecy,' folio, and
'Europe, a Prophecy, 1794,' folio. These are now become very scarce.
In 1797 he commenced, in large folio, an edition of Young's Night
Thoughts, of which every page was a design;[5] but only one number
was published. In 1805 were produced in 8vo numbers, containing
five engravings by Blake, some Ballads by Mr. Hayley, but which also
were abruptly discontinued.[6] Few persons of taste are unacquainted

[1] The original is in the possession of Sir Geoffrey Keynes. It was perhaps Palmer
who made a careful watercolour copy (now in the collection of Paul Mellon) of the
marginal design from 'The Lamb' from *Songs of Innocence* and inscribed it: ' "I have
formed thee for my Praise". / from—. W. Blake.'

[2] BM Add. MSS. 36521B, f. 120. [3] Blake was sixty-nine when he died.

[4] Not counting the frontispiece and title-page, there are sixteen plates of
emblems in *For Children: The Gates of Paradise.*

[5] Many pages in Blake's *Night Thoughts* have no illustration at all. The same
strange list of Blake's writings is also given, with slightly different details, in
Watkins & Shoberl, *Biographical Dictionary* (see Autumn 1816); in R. Watt,
Bibliotheca Britannica (see Spring 1819); and in Crabb Robinson's 1811 *Vater-
ländisches Museum* article. Robinson also quotes exactly the same passage by Fuseli
from *The Grave*, but adds *Songs of Innocence* to the bibliography.

[6] This reference seems to confuse the 1802 *Designs to A Series of Ballads*, issued
in quarto numbers with fifteen plates, and the 1805 *Ballads*, in octavo with five
different engravings.

with the designs by Blake, engraved by Schiavonetti, as illustrations
to a 4to edition of Blair's Grave. They are twelve in number, and an
excellent portrait of Blake, from a picture by T. Phillips, R.A. is pre-
fixed [*Plate XXIV*]. It was borne forth into the world[1]

In 1809 was published in 12mo, 'A Descriptive Catalogue of
[sixteen] [*sic*] Pictures, poetical and historical inventions, painted
by William Blake, in watercolours, being the ancient method of fresco
painting restored, and drawings, for public inspection, and for sale by
private contract.' Among these was a design of Chaucer's pilgrimage to
Canterbury, from which an etching has been published. Mr. Blake's
last publication is a set of engravings to illustrate the book of Job.
To Fuseli's testimonial of his merit above quoted, it is sufficient to
add, that he has been employed by that truly admirable judge of art
Sir Thomas Lawrence; and that the pure-minded Flaxman pointed
him out to an eminent literary man as a melancholy proof of English
apathy towards the grand, the philosophic, or the enthusiastically
devotional painter. Blake has been allowed to exist in a penury[2]

Cumberland wrote to his son George on Saturday, November
3rd: 'Tell me of what Blake Died & how, & how he has left his
widow—*all you can learn of him*— I have the *Job* to sell and if
she *wants* the money, *must*, if I cannot sell it, take it myself.'[3]
The first news young George obtained was in an unsolicited
letter from Linnell written on Monday, November 12th: *November 3rd, 1827*

Dear Sir/ *November 12th, 1827*
I take it for granted that you are acquainted with the death of our
friend Mr Blake and I now wish to inform you that Mrs Blake is
living with me here and has the small card Plate ready for you when-

[1] Most of the two preceding sentences and the rest of this paragraph come word
for word from the *Literary Gazette* obituary, paragraph one.

[2] Anon., 'Mr. William Blake', *Gentleman's Magazine*, xcviii (Oct. '[Pub-
lished Nov. 1.]' 1827), 377–8.
Most of the preceding sentence, all the rest of this paragraph, and a last para-
graph are taken word for word from the *Literary Gazette* obituary (see Aug. 18th),
with the following exceptions: (1) The footnote is omitted; (2) 'in progress' is
added to the phrase 'a ricketty table holding his copper-plates'; (3) The second
paragraph of the *Gazette* obituary is continued with the second sentence and follow-
ing of the fourth paragraph; (4) In the second sentence following, the redundant
'of address' is omitted, as is the whole succeeding sentence ('Next November he
would have been *sixty-nine*') which was out of place in the November issue of the
Gentleman's Magazine, as well as wrong; (5) After the next sentence a new para-
graph adapts the third *Gazette* paragraph ('William Blake died as he had lived
His effects are *nothing*, except some pictures'); (6) And the last paragraph is
the fifth one from the *Gazette*.

[3] BM Add. MSS. 36512, ff. 41–42.

ever you will call for it. will you have the goodness to inform yr
Father respecting it & also to say that it will be expected that he will
pay for the Book of Job he had of Mr Blake at the same time[?] an
early attention to the above will be esteemed a favor[.][1]

On receipt of this note George wrote to his father:

November —I can tell you nothing as yet about your old friend Blake for Mr
1827 Linnell is living at Ham[p]stead & [h]as promised to see me when
he comes to town, All I know is that you are expected to take the
Jobe & that your Card is ready for you I suppose finished according
to your request [*see page 347.*]—[2]

November George persisted in his efforts, and his brother Sydney re-
1827 ported to their father: 'Geo: has seen the widow of Blake, but
knows no particulars yet of his death— She is living with Mr
Linnell the artist: she told Geo: that he died like an angel.
you are expected to take the Job.'[3] It was probably about
November 27th that Cumberland's son wrote to Linnell:

November Dr Sir/
27th?
1827 As I find it will be inconvenient for me to call upon you with the
uncertainty of finding you at home living as I do now at Old Brompton,
you will oblige me by Sending my Fathers Card to the Army Pay
office (any hour in the day it can be left for me with the Servants)
at the same time you will oblige m[e] with a line to say what charg[e]
is to be made for it—
The enclosed letter for Mrs Blake I conceive will explain my
Fathers intentions resp[ect]ing the Job, left with him for Sale— rest
assure[d] I shall call the first opportunity & believe
me Dr Sir
Yours very truly
G Cumberland Jr

Army Pay Office
Whitehall[4]

The letter to Catherine which he enclosed was as follows:

Bristol [*Sunday*] 25. Nov. 1827.
My dear Madam.
It was only very lately that I heard of the death of my excellent
friend, your departed husband; and this week by an enclosure from my

[1] BM Add. MSS. 36512, ff. 45–46.The next (and last surviving) word is 'by'
and the signature is cut off, but there can be no doubt that the letter was written
by Linnell.
[2] BM Add. MSS. 36512, ff. 63–65, n.d.
[3] BM Add. MSS. 36512, ff. 52–53, n.d.　　　　　[4] Ivimy MSS.

Son I find a Lettr to him from Mr Linell stating that the card plate was ready for me, and that it will be expected that I pay for the Book of Job at the same time.— I have in consequence written to him, by this conveyance, to call for the Card Plate, and now assure you, that if I do not succeed in Selling the Job (which was sent to me for that purpose from Mr Blake,) I shall certainly take it for myself and remit you the money as soon as I conveniently can.

That elaborate work, I have not only shewn to all our amateurs and artists here without success but am now pushing it through Clifton, by means of *Mr Lane* the Bookseller there, having previously placed it with Mr *Tyson*, Mr *Trimlet*, and another of our Print Sellers here without success—and as that is the case, and that even those who desired me to write to my friend for a List of his works and prices, (among whom were his great admirers from having seen what I possessed—viz. Dr King of Clifton & Mr Rippengale the Artist.) declined giving him any orders, on account, as they said, of the prices—[1] I should not recommend you to send any more here—but rather to fix a place in London where all his works may be disposed of offering a complete set for Sale to the British Museum Print room, as that will make them best known.—better even than their independant author who for his many virtues most deserved to be so—a Man who has stocked the english school with fine ideas,—above trick, fraud, or servility.

With my best wishes for your happiness I

I am My dear Madam
Yours very truly
G. Cumberland.

PS.

The reason I did not continue to purchase everything Mr Blake engraved, was that latterly I have not only been unable to continue Collecting but have even sold all I had Collected—yet still preserving all I possessed of his graver[.]

If you have occasion to write, let the Lettr be left for me with my Son George at the army Pay Office and he will get it franked.[2]

The New Monthly Magazine for December 1st published yet another obituary of Blake, silently copied from *The Gentleman's Magazine* of November 1st 1827.[3] December 1st, 1827

[1] Blake's prices are in his letter of April 12th, 1827.

[2] Ivimy MSS. The address is 'Mrs Blake at Mr Linells 6 Cirencester Place'. For the works Cumberland owned, see December 18th, 1808. Cumberland wrote in his diary (BM Add. MSS. 36521B, f. 125) 'Wrote to . . . Mrs Blake'. The date of the entry, Nov. 27th, must be a mistake.

[3] Anon., 'Mr. William Blake', *New Monthly Magazine*, xxi ([Part iii, Historical

On Monday, December 3rd Cumberland wrote to his son George:

December 3rd, 1827 When *Linell* calls on you, he will probably bring an answer to my Lett.ʳ to Mʳˢ Blake—& bring the Plate—which I sent up to have a few ornaments engraved or etched round my Name—as to the Job, it was sent to me to get Sold, and they have no right to demand me to take it— I will, however inconvenient it may be, do so, if I cannot sell it for the Sake of my old friends widow—who leaves me the Legacy, to pay not to receive—I have tried all shops & acquaintance in vain hitherto—it is a Sad work yet full of Imagination.[1]

About a week later, Linnell was sent another discouraging letter about the *Job*:

December 11th, 1827 Plymouth [*Tuesday*] Decʳ 11. 1827

Dear Sir

You recollect perhaps my calling on you in company with Mʳ Calvert and bringing down with me a copy of Blake's Job PROOF impressions. I have not I am sorry to say been able to do much for the work but a friend of mine is desirous of having a copy. The object of this is to say that he will take the proof copy provided you can make the usual allowance of 25 pʳ Cᵗ but if this is not within the plan of your arrangements I will thank you to send a good common copy by *the waggon* which I will pay for when I come to Town which I hope will be in the course of next sumʳ when I will return your copy if it should not be sold. I remⁿ

> Dʳ Sir
> yʳˢ most truly
> A B Johns.[2]

North Hill Cottage

Young George Cumberland evidently sent Linnell's November 12th letter to his father, for on Wednesday, December 26th his father replied:

December 26th, 1827 My Dear George

Your always welcome Lett.ʳ I recd on Xmas day, and Mr Linnels polite Christmas Box enclosed—which I only think ignorant not impu-

Register] Dec. 1st, 1827) 535–6; except for punctuation and paragraph changes, this obituary differs from its predecessor only in the sentences with which it begins ('MR. WILLIAM BLAKE. Lately, aged 68, Mr. William Blake, an excellent but eccentric artist. He was a pupil') and ends ('Her cause, it is to be hoped, will be taken up'). [1] BM Add. MSS 36512, ff. 56–57.

[2] Ivimy MSS. Ambrose Bowden Johns was a little-known landscape painter whose works were occasionally sold as Turner's.

dent, your Cockneys are all so *direct* and having had probably little intercourse with Gentlemen are *brusque*, and unreflecting— If I really in the Lettᵣ I wrote to poor honest Blake, who always acted and meant well[,] I [*sic*] have said I would take it if it did not sell here—he may think I want now he is gone to evade that proposal or promise—but I much doubt if he can shew you any thing of the sort, not because I was not at all times affectionate to our simple honest friend, and willing to serve him, as my former purchases of nearly all his singular works will prove, will Shew.=[*sic*] and I might in feeling it was a delicate way of Serving him have indicated such intention as the taking the Job— although I never could consider it as equal to his other performances— I therefore, without entering into any discussions with Mr. L.[,] could which [*i.e., wish*] you could take the 2.12.6 wh she asks for the Job, and £3.3 — making £5.15.6 of Sydney as part of my Quarters rent,—and call on Mᵣˢ Blake herself to explane every thing clearly to her—taking the copper Plate and her receit for the same on a proper Stamp—for we must be so careful to shew it is settled properly in form—as to the Plate you will say I have never received it or any proof of it, or notice & till Mr Linel demanded the money I knew not it was ever done at all—

At the same time let her know that I have always taken every measure to promote the sale of Mr B works among my friends here without the smallest Success, the prices having always been a hindrance—That I heartily wish her every success, and shall still do all I can to serve her, but take no more Prints of any one to sell here by the Booksellers, as nothing does here, and if sold it is difficult to get the money without a long while— I suppose by her charging 3 Gui. he has made a new Plate instead of my old one which I sent to be ornamented on the Margin—and if so you will take that I sent back as a plain one may be more useful— I long much to see what he has done— but if it is ever so trifling take it at her price—as it is the last call I shall ever have on that feeling—which I often am forced to restrain— and now in particular, not having £10 to last me here till my Quarter age comes[.]¹

In the first week of January 1828 appeared *The Annual Biography and Obituary for the Year 1828*, bearing a derivative biography of Blake,² and an important account of Flaxman which contained an interesting passing reference to Blake:

¹ BM Add. MSS. 36512, ff. 60–61.

² Anon., 'Biographical Index of Deaths, for 1827. Compiled in part from original papers, and in part from contemporary publications', *Annual Biography and Obituary for 1828*, xii (1828), 416–18. This account, with very minor capitalization, punctuation, and orthographical changes, was reprinted from *The Gentleman's*

January 1828 in early life he [*Flaxman*] was in the habit of frequently passing his evenings in drawing and designing in the company of that excellent painter Mr. Stothard, Mr. Blake, the engraver (lately deceased), so remarkable for the eccentricity of his opinions and designs, Mr. George Cumberland, and Mr. Sharp. The works of the two first-mentioned artists, together with Mr. Flaxman's own, partake, although in different degrees, of the same character; which appears to be founded on the style of the very eminent English sculptor, Banks, whose basso-relievos of 'Thetis and Achilles,' and 'Caractacus before Claudius,' will furnish, to those who examine them, sufficient proofs of the validity of this supposition.[1]

January? 1828 Perhaps it was at the same time that a highly derivative obituary appeared in *The Annual Register*.[2]

On Tuesday, January 8th, 1828 Crabb Robinson reported in his Diary that he

January 8th, 1828 Walked with Field to Mrs Blake[.] The poor old lady was more affected than I expd yet she spoke of her husband as dying like an angel[.] She is the housekeeper of Linnel the painter & engraver— And at present her Services must well pay for her board— A few of her husbands works are all her property— We found that Job is Linnells property and the print of Chaucers pilgrimage hers— Therefore Field bought a proof and I two prints— @ 2 1/2 guas each— I mean one for Lamb— Mrs Blake is to look out some engravings for me hereafter[.]

Clearly Robinson was suspicious of Linnell. Years later, on

Magazine (Nov. 1st. 1827). The *Annual Biography* account begins: 'BLAKE, Mr. William, Aug. 13, aged 68. This excellent but eccentric artist was a pupil of the engraver Basire, and among his earliest productions . . .'. It concludes with the reference to the 'benevolence of private individuals.—*Literary Gazette* and *Gentleman's Magazine*.'

[1] 'No. II. John Flaxman, Esq. R.A. Professor of Sculpture at the Royal Academy', *The Annual Biography and Obituary for the Year 1828*, xii (1828) 21.

[2] The Blake obituary, under 'Deaths' in the 'Appendix to the Chronicle' of *The Annual Register* [for 1827], lxix (1828), 253–4, is copied accurately but without acknowledgement from *The Gentleman's Magazine* (Nov. 1st, 1827). The changes are extremely minor, including punctuation and word shifts such as the following in paragraph one: 'by Mr. Hayley, which were also discontinued abruptly'. The section on *The Grave* is omitted, from 'a picture by T. Phillips, R.A. is prefixed' up to 'enthusiastically devotional painter'. The next sentence and a half read: 'Notwithstanding his talents, Blake was allowed to exist in a penury which most artist[s] would have deemed intolerable. Pent up, with his wife . . .'. The *Annual Register* account ends: 'his wants increased, but not his miserable means and appliances,—even in these circumstances, he had not merely a calmly resigned, but a cheerful and mirthful countenance. He was active in mind and body . . . which he accomplished.'

August 4th, 1836, he happened to meet Samuel Palmer on a walking tour in Wales, and struck up an acquaintance with him.

He incidentally spoke of *Blake* as the greatest genius in art of modern times tho' little known— This made me more interested in him— I spoke at length of Blake and my acquaintance with him And soon satisfied him that in calling B *insane* I was not repeating the commonplace declamation against him. He at length yielded to my statem^t— Tho' he at first tried to maintain that in asserting the actuality of spirits he was but giving personality to ideas as Plato had done before[.] On my mentioning my name he said he had heard of me both from Blake & his Wife— I found too that he had been to see Aders pictures and had heard of Gotzenberg[.] I inquired whether *Linnel* is not a man of worldly wisdom— He understood the insinuation And said only *defensively* And he represented Linnels conduct as hav^g been very generous towards Blake— This is contrary to my impression concern^g L:

Other old friends and patrons came round to see Catherine and to buy some of Blake's works. 'Among these Lord Egremont visited her and, recalling Blake's Felpham days, said regretfully, "Why did he leave me?" The Earl subsequently purchased, for the handsome sum of eighty guineas, a large water-colour drawing containing "The Characters of Spenser's *Faerie Queen*," grouped together in a procession, as a companion picture to the *Canterbury Pilgrims*.'[1] The munificence of the price for 'The Faerie Queen' must have been sufficient to remove most of Catherine's financial worries.

Mr. Cary, the translator of Dante, also purchased a drawing— *Oberon and Titania*: and a gentleman in the far north, Mr. James Ferguson, an artist who writes from Tynemouth, took copies of three or four of the Engraved Books.[2] . . . She was an excellent sales-

[1] Gilchrist, 1942, p. 356; 1863, p. 365. Egremont had three Blake pictures at Petworth: (1) 'Satan calling up his Legions', which was 'executed for a Lady of High rank' (probably his wife) according to Blake's *Catalogue*, the drawing for which was exhibited in 1809; (2) 'The Last Judgment' of 1807, painted for the Earl's wife and described in a letter of 1808 to Ozias Humphry, through whom the commission came; and (3) 'The Faerie Queen' above. Particular inquiry for other Blake or Linnell materials at Petworth House has been unsuccessful, but the regret expressed above by Lord Egremont suggests that his contacts with Blake may have been more extensive than our records show. Can it have been at Petworth House that Blake was a tutor for a time?

[2] According to Gilchrist (1863, ii. 262), Catherine offered Ferguson an otherwise unknown '*work called Outhoun . . . Price*, £2 2s .0d.', but no printed works are now known to have belonged to him or to Cary.

woman, and never committed the mistake of showing too many things at one time. Aided by Mr. Tatham she also filled in, within Blake's lines, the colour of the Engraved Books; and even finished some of the drawings—rather against Mr. Linnell's judgment. Of her husband she would always speak with trembling voice and tearful eyes as 'that wonderful man,' whose spirit, she said, was still with her, as in death he had promised. Him she worshipped till the end.[1]

Linnell was having difficulty selling *Job* anywhere, as the following letter from A. B. Johns suggests:

January North hill Cottage [*Friday*] Jan.ʸ 11. 1828
11th, Dear Sir
1828 I have just heard from my friend abᵗ the Illustrations of Job the purport of which is briefly this. He likes the work but says he cannot afford the proof copy[;] he has therefore requested me to say that if you think proper to send a common copy for him to see and he does not find them very inferior he will take it— I may add that I know him to be a most honorable man and that it is not likely the copy will be retᵈ; but I leave it to yourself to do as you please in regard to it. I hope by this time your health is better[;] if it is put the copy under your arm and come down and spend a few weeks in this mild air I open this letter to say that the Proof copy is brought by the cousin of my friend who will remit you the five Guineas for it[.]—[2]

Meanwhile George Cumberland was looking after his father's
January instructions. On Tuesday, January 15th he reported that his
15th, brother 'Syd gave me the money for Mrˢ Black too late in the
1828 day for me to attend to it—'.[3] George went out to take care of the matter the very next day (see Accounts, p. 583).

It was probably the next day, January 17th, that E. J. Chance explained in an undated letter from 6 Cirencester Place to his 'Dr Uncle' that he hadn't written earlier,

January not having any thing more to inform you, than what Mrˢ Blake sent
17th? word every day
1828

[1] Gilchrist, 1942, p. 357; 1863, p. 366.
[2] Ivimy MSS. Cf. Jan. 23rd, 1828. On the back of the letter is a pencil note, in J.L.'s hand, partly torn off: 'Gave Mrˢ Blak . . . 3£ to pay . . . 5.10 —'. The money itself probably came from George Cumberland Jr. (see below, Jan. 16th). In his book summarizing 'John Linnell Senior's Letters and Papers' (in the Ivimy MSS.) John Linnell, Jr. noted that Linnell paid Mrs. Blake in '(1828) Jan. £2.— (Burial of Mr. Blake) £10.15.0'. The £3, then, may have been part of this £10.15s.0d. to pay for Blake's burial.
[3] BM Add. MSS. 36512, ff. 71–72.

Mrs Blake desires me to say that every thing is right at home[.] The
Bricklayer has not been. Coll Moore called to see the miniature of his
Friend & was very sorry that he could not see it as he feared he should
not be able to call again[.]
 Mr Pye & Mr Field called but left no message—
 Mr G. Cumberland called[.]¹

In his Journal for the same day Linnell wrote: '1828 Jany Th
17 Mr Cumberland came & paid Mrs Blake for the card plate
3 gns & for the copy of Job 2.12.6'.²
 Very shortly thereafter young George wrote to his father
again:

January
17th,
1828

Mrs Blake sends her Compts with many thanks[;] she tells me that
the Card would have been more finished if WB had lived[,] that it was
the last thing he attempted to engrav[e,] that the Job is Mr Linnells
property now— her late husbands works she intends to prin[t] with
her own hands and trust to their sal[e] for a livelihood— I saw
Mr Linnell this morning & am sorry to say he is in a very bad state of
health[,] a nervous affection from over applicat[ion.] Dr Thornton
whose Card I enclose was with him[.]³

January
1828

 A few days later George again wrote to his father:

January
1828

The Card which I had not time to get printed represents the Seasons [.]
I shall only give them to those likely to serve Mrs B[.] it might
be as well to reserve them till the Widow has printed her late
husbands works which She intends to do and then send it to your
friends[.]—⁴

 Meanwhile Cumberland in Bristol was left in some puzzle-
ment as to what he had in fact purchased, and on Sunday,
January 20th he wrote rather querulously to his son George:

As you have sent me no proof of Blakes engraving I cannot tell what
to make of it—and here we have no one who could make a proof with-

January
20th,
1828

¹ Ivimy MSS. Probably Catherine sent oral messages, for no hint of letters
from her have survived. The miniature of Col. Moore's friend would, of course,
have been by Linnell. Baron Field presumably came by to see if Catherine had
looked out any of Blake's engravings yet.
² This sum is mistakenly entered under Jan. 7th in Linnell's 'Cash Account'
book.
³ BM Add. MSS. 36512, f. 62, n.d. The letter mentions George Jr.'s salary
of £300 a year, which his father refers to on Jan. 20th. George Jr.'s undated
letter must therefore shortly precede Jan. 20th.
⁴ BM Add. MSS. 36512, ff. 66–67, n.d. This letter seems to have been written
just before his father's letter of Jan. 20th, in which he complains of having re-
ceived 'no proof of Blake's engraving'.

out Spoiling the Engraving— I expected you would have taken off a few for yourself, and shall give you some when I can get them printed off—as I wish by means of it to spread my old friends fame and promote his wifes Interest—by making him thus the subject of conversation and his works—which by the bye—I think of as well as that of another friend T. Stothard, I fear I must sell for want of money as I never in my Life was before so bare of Cash as just now— Could not Colnaghi Sell them think you by private contract, or might not the Museum be glad of such Singular works—which are so rare[.]—[1]

A few days later Linnell was paid for the proof of *Job* which seemed to have been left unsold at Plymouth:

January 23rd, 1828

Sir

At M^r John's desire I enclose a check for £5. .5 for a copy of Blake's Illustrations of Job which I have received from him.

I am

yr very obed^t Servant

W C Younge

Otterbourn
[*Wednesday*] January 23^rd
[1827 *corrected in pencil to*] 1828[2]

January 27th, 1828

A week after Cumberland's son wrote, the plate of the calling card had arrived, and Cumberland had managed to have copies made, for in his diary for Sunday, January 27th he noted that he 'Wrote to Sydney, & sent Card a proof of Blake'.[3]

January 31st, 1828

On the last day of the month A. B. Johns wrote again to Linnell about his *Job* sales in Plymouth: 'Your parcel came duly to hand but I have not yet seen the Gentleman to shew him the two copies, as soon as I have I will let you know the result. I am sorry you can give me no better account of your health which I hope will soon be better— Please to rem^r me kindly to M^rs Blake. I shall at all times be happy if I can in any way promote the sale of your work which as I like it myself I can with much truth recommend to others[.]'[4]

[1] BM Add. MSS. 36512, ff. 73–74. Cumberland's Blake collection was mostly sold at Christie's on May 6th, 1835.

[2] Ivimy MSS. In his 'Cash Account' book Linnell entered on Jan. 26th, 1828 the receipt 'of M^r Younger for a Copy of Job—5 5 —', but in the Yale *Job* accounts this appears as 'Mr Young of Devonshire by Mr Johns 1 copy 5 — –'; the latter sum is clearly a mistake.

[3] BM Add. MSS. 36521c, f. 166.

[4] Ivimy MSS.

Cumberland explained his progress with the calling card in a postscript to his letter to his son George of Friday, February 1st: 'I send you and Syd half a Dozen of the Cards— I could only get 20 Printed since I got it—they cost near 1d each here for fast[?] Prints[;] do you know what it means?'[1]

February 1st, 1828

On Tuesday, March 11 H. Dumaresq wrote to Linnell:

I have shewn the Illustrations of the Book of Job to many of my friends, but I have not yet found them in general impressed with any sense of their beauty nor inclined to purchase the work. It will be valued only by Artists, I suspect altho the encomium of those distinguished persons named in your former note would induce one to hope for the credit of the public taste that designs so highly thought of by them might find abundance of purchasers.[2]

March 11th, 1828

About a week later, Linnell wrote in his Journal: 'March Mon 17 Two Ladies called to [see] [*sic*] the book of Job & gave Mrs Blake 4/-'. Though they did not buy the *Job*, they may have come back later for other works, for on the back of Blake's painting of 'Lear & Cordelia' Mrs Samuel Smith wrote: 'Bought of Mrs Blake the first or second year after her husbands death[.] Price for this and the Grave was about £8 8.'[3] And on the back of the drawing for *The Grave* the same hand wrote: 'Bought of Mrs. Blake by Mrs. S[amuel]. Smith & Miss J[ulia]. Smith the first or second year after W. Blake's death—the price as near as J. S. recollects was about 8.8 for this and the Lear and Cordelia.'[4]

March 17th, 1828

In his Diary for Sunday, April 6th Crabb Robinson wrote of dropping in 'At the Rutts where I stayed till late gossiping about Blake & his interesting insanities'. And on Thursday, May 22nd he reported the delivery of the Blake purchase which he had made for Charles Lamb in January: 'Rose early & finding Lamb bent on going away made up a fire & breakft for him and accompd him to the Enfield stage Loading him with

April 6th, 1828

May 22nd, 1828

[1] BM Add. MSS. 36512, ff. 76–76. I do not know what it means.

[2] Copied by A. H. Palmer in the Exercise Book headed 'Linnell Correspondence' in the Ivimy MSS.

[3] Quoted from the drawing in the Tate Gallery. The scene illustrated is from Nahum Tate's version of *King Lear*, not Shakespeare's.

[4] Quoted from the catalogue description when the work was sold at Sotheby's, March 6th, 1934, Lot 338. The Smith ladies are there said to be aunts of Florence Nightingale.

books a print of Blake's Chaucer Pilgrims and a bottle of shrub'.[1]

A few days later, on May 24th, Blake's five hundred and thirty-seven *Night Thoughts* drawings were again offered for sale by Thomas Edwards, with a description abstracted from the Catalogue of 1826:

May 24th, 1828

1130 Young's (E.) Night Thoughts. The original edition of 1742, and the Author's own Copies, *inlaid upon imperial folio paper, which is again inlaid to a larger size.* Each page is surrounded with original Drawings in Colours by Blake, *bound in 2* vol. *red morocco extra, gilt leaves, joints, &c.* —— *1742*

> *It is scarcely possible to present the collector with an adequate, or even faint idea of the singular nature of these most extraordinary and sublime conceptions of the artist. They are in the style and manner of his designs for 'Blair's Grave.' In point of composition and design, the present production is certainly superior, and is alone sufficient to immortalize the name of* Blake *as an artist of the highest order.*[2]

In the same sale appeared lot

> 940 SONGS OF INNOCENCE. Designed and Engraved by BLAKE, *bound by Lewis in venetian morocco extra, gilt leaves.*
> *The above Work is one of the early productions of this extraordinary Artist, and coloured by himself: the whole, with the subscriptions, are engraved on wood.*—EXTREMELY RARE. *The present Copy was from the Collection of the late James Boswell, Esq.*[3]

This was bought by Clarke for £2. 13s. 0d.

July 1st, 1828

Later that summer, on Tuesday, July 1st, the Christie sale of the property of Flaxman included :

[1] The last five words, which are in shorthand, I have transcribed from *Henry Crabb Robinson on Books and their Writers*, ed. E. J. Morley, London, 1938, vol. i, p. 356.

[2] Fuseli's praise of Blake in the last line is no longer attributed to him as it was in the May 10th, 1826 catalogue. In the priced copy of the 1828 catalogue, in the BM, no buyer is entered for the *Night Thoughts* drawings, but instead in the left margin is a note which I cannot read and in the right margin is '52.10. W', apparently meaning that the work was withdrawn at fifty guineas.

[3] *A Catalogue of the Splendid and Valuable Collection of Books, Manuscripts, and Missals, the property of Thomas Edwards, Esq.* (Late of Halifax, Yorkshire.) Comprising... Young's Night Thoughts, with the Original Drawings by Blake ... Which Will Be Sold By Auction, by Messrs. Stewart, Wheatley, & Adlard On Thursday, May 15th, 1828, and eight following days. This copy (F?) of *Innocence* does not appear in Sotheby's *Bibliotheca Boswelliana*, May 24th–June 3rd, 1825.

61 A singularly grand drawing of the Last
Judgment, by Blake [6/-]

. . . .

85 A COPY OF GRAY'S POEMS, illustrated by
W. Blake, with his Portrait by Mr
Flaxman[1] [£8. 8. 0]

On Friday, August 29th Samuel Palmer wrote to Linnell from *August* *29th,* Shoreham: 'My Father presents best respects—I think he would *1828* be very much amused by a sight of Mr. Blake's annotations on Dr. T.s Lord's Prayer[.]'[2]

It was probably in September that A. B. Johns wrote discouragingly to Linnell again:

My dear Sir/
Herewith you will receive the Proof copy of Blakes illustrations of *September?* Job—which is the only one unsold, and which I am sorry to say I have *1828* not the least hope of disposing of[.] I therefore think it better in your hands as it might suffer from being kept here. You do not say if M<u>r</u> Calvert has called on you to pay for the common paper copy w<u>h</u> was sold, but if he has not he will soon, as I have lately remitted him some money to pay some small Bills and yours amongst the rest— I begged him not to go on purpose but any time he was coming to you to do me this kindness[;] it may not therefore have been convenient to him as his time is much engaged. I mention this to prevent any mistake. . . .

Please to rem<u>r</u> me most kindly to M<u>rs</u> Blake.[3]

Linnell reported in his Journal that 'Sept. Mon 8 M<u>r</u> Calvert *September* brought impressions of Blakes woodcuts' for Virgil.[4] *8th,* *1828*

[1] The prices are entered in MS. in the British Museum Print Room copy. The Gray was bought by 'Clarke', probably the dealer William Clarke in New Bond Street, and eventually it found its way into the Hamilton Palace Library, probably through William Beckford. 'Blakes Illustrations of the Book of Job 1826' had been at Flaxman's sale at Christie's on June 12th, 1828. The only Illuminated Works Flaxman is known to have owned, copy D of *Innocence* and copy O of *Songs of Innocence and of Experience*, were sold at Christie's April 26th, 1876 (Lots 4–6) and Feb. 26th–27th, 1883 (Lots 244–5).

[2] Ivimy MSS. Linnell had acquired Blake's copy of Dr. Thornton's translation of *The Lord's Prayer*.

[3] Ivimy MSS. In his 'Cash Account' book Linnell recorded his receipt on 'Sept 8 [1828] of M<u>r</u> Johns by the Hands of M<u>r</u> Calvert—for a Copy of Job— [£]3 – –', which gives the approximate date of this letter.

[4] See p. 595, Accounts, under Sept. 16th, 1825. On the same day Calvert also brought A. B. Johns's money for *Job*—see footnote 3 above.

September 19th, 1828 By this time Catherine had moved to Tatham's house to be his housekeeper, and Linnell went on 'Fri 19 To M^rs Blake'.

It was probably in October that a prospectus appeared announcing a work by Varley to be published in four numbers *October? 1828* with the title of *Zodiacal Physiognomy*: 'In a Memoir of the late William Blake, under the article "Cancer," will be found an account of some of his remarkable Visions, with engravings from some of the most curious of them, including portraits of King Edward the First, Nebuchadnezzar, &c. &c.'[1] This paragraph struck the writer for the *Literary Gazette*, who protested indignantly on Saturday, October 11th:

October 11th, 1828 Mr. Varley (the water-colour artist) announces for publication a Treatise on Zodiacal Physiognomy! This is a work of really too absurd a nature to be tolerated in the present age.... Let him leave the study of astrology for the study of leaves—nor extend the effect of skies beyond the landscape. Then, indeed, will we commend his knowledge of 'natural philosophy.' But seriously speaking, the madness of poor Blake (sublime as in some remains of him which we possess, it was) is too serious a subject to be jested with.[2]

October 11th, 1828 On the same day Charles Lamb echoed this reference to Blake's 'madness' when he wrote to Bernard Barton that he thought the lines to the new edition of Bunyan just published were like 'Blake's ravings made genteel.'[3]

The first Blake biography appeared at the end of October[4] in a history of *Nollekens and his Times*, and Linnell probably wrote promptly to the author, J. T. Smith, about the book. It may have been in early November that Smith replied:

November? 1828
 22 Carmarthen St:
My worthy friend,

I *sincerely* crave your pardon for not having answered your application for the loan of a Copy of 'Nollekens and his Times'—believe me

¹ A copy of this prospectus is in the British Museum, pressmark 1879.b.1 (vol. iv). One of the two Blake plates in the only number published of the *Zodiacal Physiognomy* represents 'The Ghost of a Flea', but another plate, engraved but not used, represented a 'Coin of Nebuchadnezzar' and a head of 'Cancer' after Blake.

² Anon., 'Literary Novelties', *Literary Gazette*, Oct. 11th, 1828, p. 654. For evidence that W. P. Carey was the author of the regular feature, 'Literary Novelties', see the note to Aug. 18th, 1827.

³ *The Letters of Charles and Mary Lamb*, ed. E. V. Lucas, London, 1935, vol. iii, p. 179. The lines were not by Felicia Hemans, as Lamb thought, but by Barton himself.

⁴ *Nollekens and his Times* was announced for publication 'In a few days' in the *Literary Gazette* for Oct. 11th, 1828 (p. 656).

I should receive great pleasure in complying with your request but *upon my word* I have only one copy for myself and that has been taken to pieces for illustration or with *the greatest readiness* it should have been forwarded to you.

What I have said of your worthy friend Blake I am *fully* aware has been servisable to his widow and *this* I am fully aware, *no* one *can possibly* receive more delight in than yourself— . . .

N.B. The book is not my property[.] I sold it, as the saying is, *for a Song!*
I hope you will be pleased with what I have said of *you* in my notice of Blake[.] I am *quite* sure I have only done you common justice.[1]

Linnell later (in 1855) made fairly elaborate and appreciative comments on Smith's life of Blake,[2] but Cumberland was much less impressed, though he does not mention Blake. He had known '[The fool *del*] the ignorant Mr Smith'[3] for many years, but he had nothing but scorn for the 'wicked Biographer' of Nollekens and 'his infamous book'.[4] It was probably at this time that Cumberland wrote on the back of Blake's last letter to him of April 12th, 1827 (now in the Fitzwilliam):

He died aug 12: 1827 in the back room of the first floor of N 3 Fountain Court in the Strand, and was buried in Bunhill fields burying ground on the 17 aug 25 feet from the north wall N 80.
T. Smith, says his desease was the bile mixing with his blood—in his random way of writing—and considering the malignity of this Smith in his infamous biography of Nollekens it is fortunate that he speaks no ill of him.
my little message card was the last thing he executed and he dates it thus—W. Blake inv & sc.

A AE. 70 1827

The widow charged me 3.3 for it and £3. 3.– [*read* £2. 12. 6] for the Job[.]

All the facts above come from J. T. Smith.

Crabb Robinson wrote in his Diary on Sunday, November 9th: 'Read lately *Nollekens* and his Times—A very paltry book indeed— But still I read it with interest on account of the persons it speaks of[.] Smith the author is an admirer both of Flaxman & Blake[.]'

November 9th, 1828

[1] Ivimy MSS.
[2] Cf. pp. 459–61, 463–4, 466.
[3] BM Add. MSS. 36520ı, f. 405 (1823).
[4] BM Add. MSS. 3651c, f. 2217.

Blake's example continued to fire and inspire his young disciples. Samuel Palmer wrote to George Richmond: 'Mr. Linnell tells me that by making studies of the Shoreham scenery I could make a thousand a year directly ... [*But*] I will not be a naturalist by profession.' Richmond replied from Calais with cheers on November 19th:

November 19th, 1828 —I was delighted to hear of your inflexibility about the Figure— for though it is certain *you will not* any more than M*r* *Blake* get a thousand a year by it, yet you will have what he had[,] a contentment in your own mind such as gold cannot purchase—or flimsy praise procure— M*r* Linnell is an *extraordinary man* but he is not a M*r* Blake— Be pleased when you see Mrs B to present my best respects to her. I hope she is now settled. Have you read M*r* Smiths life of Nolekin. if you have tell me what he says of M*r* Blake—though I hope to get it in *Paris*[.][1]

By the end of December 1828 Varley's strange book on *Zodiacal Physiognomy* was published, and on the 27th a review in *The Literary Gazette* quoted in passing the entire section about Blake to prove 'that our friend Varley is the only man alive who understands the true principles of human nature, which we take to be a proper mixture of credulity, insanity, and unconscious obedience to incomprehensible influences.'

December 27th, 1828 Hitherto we trust that we have gone on intelligibly, and much to the edification of the public; but we confess we must leave the annexed extract to explain itself, only stating that Blake was the artist who illustrated Blair's Grave, &c., and that he was so much of an *enthusiast*, that he could call up from the vasty deep any spirits or corporeal or other forms desired for the nonce.

['']With respect to the vision of the ghost of the Flea, seen by Blake, it agrees in countenance with one class of people under Gemini, which sign is the significator of the Flea; whose brown colour is appropriate to the colour of the eyes in some full-toned Gemini persons. And the neatness, elasticity, and tenseness of the Flea, are significant of the elegant dancing and fencing sign of Gemini. This spirit visited his imagination in such a figure as he never anticipated in an insect. As I was anxious to make the most correct investigation in my power,

[1] Palmer's letter and part of Richmond's reply are given by A. H. Palmer, *Catalogue of an Exhibition of Drawings, Etchings & Woodcuts by Samuel Palmer and other Disciples of William Blake*, Victoria & Albert Museum, London, 1926, pp. 8 & 9, but I quote the second from the original in the Ivimy MSS.

PLATE XLVIII

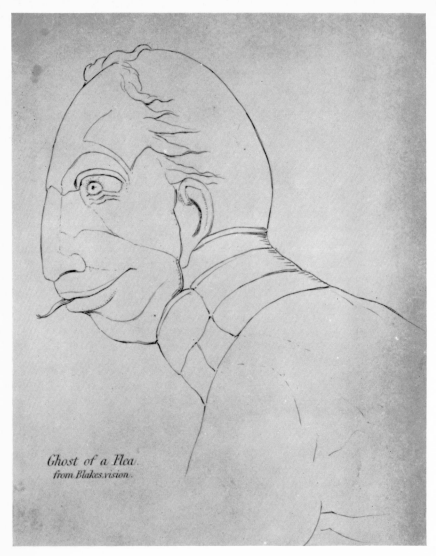

Ghost of a Flea.
from Blakes.vision.

BLAKE'S 'GHOST OF A FLEA' ENGRAVED FOR VARLEY'S *ZODIACAL PHYSIOGNOMY* (1828), representing the soul of a man 'by nature blood-thirsty to excess' (p. 373). Another design in the Tate shows the flea's whole figure

of the truth of these visions, on hearing of this spiritual apparition of a Flea, I asked him if he could draw for me the resemblance of what he saw: he instantly said, "I see him now before me." I therefore gave him paper and a pencil, with which he drew the portrait, of which a fac-simile is given in this number. I felt convinced by his mode of proceeding, that he had a real image before him, for he left off, and began on another part of the paper, to make a separate drawing of the mouth of the Flea, which the spirit having opened, he was prevented from proceeding with the first sketch, till he had closed it. During the time occupied in completing the drawing, the Flea told him that all fleas were inhabited by the souls of such men, as were by nature blood-thirsty to excess, and were therefore providentially confined to the size and form of insects; otherwise, were he himself for instance the size of a horse, he would depopulate a great portion of the country. He added, that if in attempting to leap from one island to another, he should fall into the sea, he could swim, and should not be lost. This spirit afterwards appeared to Blake, and afforded him a view of his whole figure, an engraving of which I shall give in this work.['] We look for its continuance anxiously.[1]

On Wednesday, January 21st, 1829 George Stephen wrote to Linnell: 'I return by the bearer The Book of Job & will thank you to send back by him *Miss R.'s* portraits.'[2] About a week later Linnell went, as he recorded in his Journal, '1829 Jan Tues 27. To Mrs Blake who said that Mr Blake told her he thought I should pay 3 gs a piece for the plates of Dante.'[3]

January 21st, 1829

January 27th, 1829

Apparently Blake continued to advise Catherine to the end of her life.

His widow, an estimable woman, saw Blake frequently after his decease: he used to come and sit with her two or three hours every day. These hallowed visitations were her only comforts. He took his chair

[1] Anon., 'A Treatise on Zodiacal Physiognomy', *Literary Gazette*, Dec. 27th, 1828, p. 824. (For evidence that this review may have been written by W. P. Carey, see Aug. 18th, 1827.) The second paragraph of the review I have quoted directly from John Varley, *A Treatise on Zodical Physiognomy*, London, 1828, pp. 54–55, rather than from the *Literary Gazette*, except that the last sentence in the paragraph was added in the review. The only differences in the quotation as it appears in the review are that the word 'Flea' is not capitalized, and commas were omitted almost at random. Only the first etching of the flea (the portrait) was published here, see Plate XLVIII.

[2] Ivimy MSS. Other letters from Stephen in this collection indicate that Linnell knew him well, but I have no information as to whether he was the Sir George Stephen who was born in 1794 and died in Australia in 1879.

[3] That is, Linnell should pay £3.3.0 apiece more for the copperplates than he had already paid; cf. March 16th, 1831.

and talked to her, just as he would have done had he been alive: he advised with her as to the best mode of selling his engravings. She knew that he was in the grave; but she felt satisfied that his spirit visited, condoled, and directed her. When he had been dead a twelvemonth, the devoted and affectionate relict would acquiesce in nothing 'until she had had an opportunity of consulting Mr. Blake.'[1]

Linnell was not the only one having problems with Mrs. Blake, however. Joseph Hogarth wrote at the end of his copy of J. T. Smith's life of Blake:

Fred Tatham was Blake's executor and possessed several of his drawings, many of which I purchased from him. Mrs Blake was hardly the passive cre[a]ture here described—at all events Tatham did not find her so for she was opposed to everything he did for her benefit and when she submitted to his views it was always with the words she 'Had no help for it'—that at last Tatham tired with her opposition threw the Will behind the fire and burnt it saying There now you can do as you like for the Will no longer exists and left her. Early the following morning she called upon [him] saying William had been with her all night and required her to come to him and renew the Will which was done and never after did she offer any objection to Tatham's proceedings.[2]

This account of Blake's will is very odd, for no such will was ever registered,[3] and wills cannot be 'renewed' as casually as Catherine or Hogarth thought they could. This sounds very like a nuncupative will. Tatham wrote (p. 528) that 'After having answered a few questions concerning his Wifes means

[1] Anon., 'Bits of Biography. No. 1. Blake, the Vision Seer, and Martin, the York Minster Incendiary', *The Monthly Magazine*, xv (March 1833), 245. Anon. claims to have had first-hand evidence, and his account seems consistent with what else we know of Catherine.

[2] W. Partington, 'Some Marginalia', *TLS*, Jan. 28th, 1939, p. 64. The account is signed 'J.H. 1877', while on the title-page is 'Eliz^th Hogarth West Drayton'. In the July 7th–30th, 1854 Southgate & Barrett auction of the 'highly important Stock' of Joseph Hogarth were seventy-eight pictures by Blake. His account seems to come straight from Tatham, and I know no reason to doubt it.

[3] Neither William nor Catherine Blake's will is to be found among those registered at the Court of the Archdeaconry of Middlesex (in Middlesex County Record Office), where Blake's will should be; in the Peculiar Court of the Dean and Chapter of St. Paul's Cathedral (in St. Paul's), where Catherine's will should be; in the Prerogative Court of Canterbury (in Lambeth Palace), where appeals should go; or in the London Commissary Court, London Division (Guildhall Library). It would, of course, be possible to have a will but to refrain from proving it and taking out letters of administration.

of living after his decease, & after having spoken of the writer of this, as a likely person to become the manager of her affairs, his spirit departed like the sighing of a gentle breeze'. Evidently someone present at Blake's death, perhaps Catherine, wrote down Blake's dying intentions, and this nuncupative will may even have been duly witnessed. Since the widow would have inherited Blake's effects *without* such a will, its chief force probably lay in directions as to who was to care for Catherine. The destruction and renewal of the will were therefore moral and psychological gestures rather than legal acts. Catherine had evidently felt bound by the will, and its renewal represented her renewed acknowledgement of her bond—and of Tatham's kindness to her.

On Monday, July 20th Allan Cunningham wrote to Linnell:

Sir,

I have published one volume of the Lives of the Eminent British Painters, and I have another in progress—. . . [*which*] will contain amongst others West, Barry, Fuseli Opie, and Blake if I can find suitable materials. Mr Varley from whom I have received much curious information tells me that you can aid me much in this matter. I write therefore to request that you will have the goodness to inform me of a few of the leading circumstances of Blakes life—give me a list of his works—and oblige me with the loan of the Illustrations of Job. I know Blakes character for I knew the man. I shall make a *judicious* use of my materials and be merciful where sympathy is needed.

I ought to offer many apologies for this intrusion and trouble. I know enough of you to know you are an admirer of the Artist and as a matter of love will assist one who knows his genius and esteems his Memory as a man.[1]

July 20th, 1829

In 1830 the second volume of Ebert's *Lexikon* appeared, with a description of Blake's edition of *Night Thoughts*:

24184.—the complaint and the consolation, or night-thoughts. Lond., Noble, 1797, f. *mit* KK. [*copperplates*]. Es. giebt. auch Exx. [*examples*] mit ill. KK. Diese unvollendete Ausg., welche nicht mehr im Handel zu haben und äusserst selten ist, enthält blos die 4 ersten

1830

[1] Ivimy MSS. Linnell obliged with reminiscences and papers, to his subsequent sorrow. On Nov. 28th, 1860 he wrote to Gilchrist (Ivimy MSS.): 'I have been terrified at lending anything of Blakes through having lost one[?] of his letters which I lent to Allan Cunningham.' The only Blake letter Cunningham quoted was one to Flaxman, which he purloined from J. T. Smith's book. This lost letter could, however, be Cromek's letter *to* Blake, which came into Cunningham's possession.

Bucher. Der Text steht in der Mitte und um ihn herum am Rande Radirungen von dem genialen Sonderling W. Blake nach seinen eigenen Zeichnungen, welche, abwohl von sehr ungleichem Werthe, doch oft sehr ausgezeichnet sind, aber die unglückliche Idee haben, Young buchstäblich überstetzen zu wollen.[1]

It may have been in this January that Linnell wrote to Colnaghi:

January?
1830

With respect to the Book of Job I shall be happy to adopt your suggestion—& make you the seller with a liberal allowance—but I shall be obliged if you will inform me (previous to any step being taken) upon what terms I am to supply you with the Copies—it must be some definite plan—I shd prefer that you shd purchase a certain number say six Copies & settle for them at the time. say what allowance you wd require for this mode supposing it was by Bill at 3 months—or if you object to this I see no other way but sending you six Copies & giving you a twelvemonth credit[;] in either Case it wd not suit me unless the Copies sent out from me were *sold & not to be returned.*

Have the goodness to give me your Ideas upon the subject only be so good as to make it simple, without the addition of 7 for 6 & so on.

The work has never yet been advertized & I have hopes that if once well known wd sell largely.[2]

[1] See 1821, when the first volume appeared. When Ebert's book was translated into English in 1837 (vol. iv, p. 2018), this passage was given as follows: 'There are also copies with illuminated plates. This unfinished edition, which is no longer to be met with in the market, and is extremely scarce, contains only the first 4 books. The text is in the middle of the page, and in the margin around it are etchings by that eccentric genius W. Blake, from his own designs, which, although very unequal, are yet often of superior merit, but express the unfortunate idea of wishing to interpret Young literally.'

[2] Quoted from a reproduction of the MS. in the Osborn Collection. The letter is addressed to 'D Colnaghi Esq' and is docketed '1830 Mr Linnell'.

The negotiations with Colnaghi broke down, and Linnell took up the matter with 'Messrs. Longman, Brown, Green, and Longmans' between 1841 and 1856 (the only period during which the firm was so named, according to H. Cox and J. E. Chandler, *The House of Longman*, London, 1925, p. 94). On an uncompleted printed contract (now with the Ivimy MSS.) Linnell made notes beside the relevant text, which is given in italics below:

Messrs. Longman and Co. shall publish at their own expense and risk **and** *after deducting from the Produce of the sale thereof all the Expenses of Printing, Paper, Advertising, and other incidental Expenses, the Profits remaining of every edition that may be printed of the Work, during the legal term of Copyright, are to be divided into two equal Parts, one Moiety to be paid to the said* **and the other** *Moiety to belong to Messrs. Longman and Co.*

[*In pencil in the margin is:*] This means the whole expense of printing & engraving if an illustrated work—to be reckoned against the invention & copyright

On January 13th, the first day of the Sotheby sale of the books *January* of Blake's old friend Robert Balmanno, appeared lot '41 Blake's *13th, 1830* Phantasies, Songs of Innocence and of Experience, on 55 PLATES, *brown calf, elegant, very rare v.y.'*, which was bought by Glynn for just a pound.[1]

The publication of Cunningham's life of Blake provoked a spate of comment upon Blake in the spring of 1830. The first, which appeared in *The Athenaeum* for Saturday, February 6th, consisted mostly of excerpts demonstrating that Blake was 'extraordinary' for the quality of his visions and the felicity of his marriage.[2] It explained that Cunningham had

found ample materials for most interesting Memoirs, in those extra- *February* ordinary men, Barry, Blake, Morland, and Fuseli. . . . *6th,*

We regret that our space will not allow of our extracting copiously *1830* from the very interesting life of Blake, and quoting Mr. Cunningham's accounts of the visions into which this extraordinary man construed his own conceptions. He seemed literally to realize the idea of Fuseli, —that a painter, before be began his work, should hold his subject

& therefore if designs ready engraved are handed over to L. & co a sum shd be paid for the engravings as a part of the contemplated outlay.

[*At the bottom of the sheet is:*] Why shd not cost of engraving &c be paid for (previous to division of profits) as well as *Letterpress* &c[?] What becomes of Copies if not sold?

[*On the verso is:*] In the case of the Job the designs are the work proposed to be published & it is a question of policy whether a letter press shall accompany them or not—if therefore the Designs are the property of A. & it is proposed that B shall publish them on the above terms it wd be only carrying out those terms for B. to pay the expense of engraving the Designs and making that expense one item to be repaid before a division of profits[.]

Longmans, Green & Co. Ltd. today preserve no record of negotiations with Linnell, but clearly the contract was never completed because Messrs. Longman did not see eye to eye with Linnell about the definition of 'incidental Expenses'.

[1] The British Museum identifies this Jan. 13th, 1830 Sotheby sale as Balmanno's. No copy of the combined *Songs* with fifty-five plates has been traced. Balmanno evidently owned copy U of *Innocence*.

[2] Anon., '*The Lives of the Most Eminent British Painters, Sculptors, and Architects*. By Allan Cunningham. [*First edition.*] Vol. II. London: Murray', *Athenaeum*, Feb. 6th, 1830, pp. 66–68.

Another anonymous account of Blake, derived almost entirely from Cunningham, was translated as 'Züge aus dem Leben des Künstlers Blake', *Zeitgenossen*, iii ([Leipzig], 1830), 170–8, which translated paragraphs 8–10, 23–24, 36–39, 41–44, 47–49 (omitting the first sentence of paragraph 23). Except for uncertainties in translation, the only additions made to Cunningham's account of Blake's visions are in two footnotes, one likening Blake's visions to Swedenborg's, and one supposing (correctly) that Blake's 'Ancient of Days' must have been an engraving.

palpably depicted in his mind's eye. We cannot resist transferring to our columns the following sketch of domestic felicity.

Model of a Painter's Wife.

[*Paragraphs 9, 10, first three sentences of paragaph 11.*] . . . p. 147–149.

It is delightful to find that the devotion of this excellent partner of a man of genius, lasted during life, and was repaid by the affection of the object which excited it. The last moments of Blake afford a touching proof of the constancy of their mutual attachment, and of his grateful sensibility to the value of the treasure he possessed in such a helpmate.

[*Paragraphs 47–48.*] . . . p. 175–6.[1]

February 6th, 1830 On the same day *The London Literary Gazette* praised Cunningham's *Lives* as 'a most delightful work': 'the memoir of Blake is so curious a sketch of a very extraordinary mind, that we cannot but choose it for our illustration, and make an extract or two [*paragraphs 8–10, 23–24, 36–44, 47–49*] which will also come recommended to the generality of our readers by their novelty.'[2]

February 8th, 1830 On Monday, February 8th the Royal Academician Abraham Cooper wrote to Linnell: 'Dear Sir I have been for some years past endeavouring to collect a slight Sketch by many Artist[*s*] of note together with a Letter by him either addressed to myself or otherwise— Will you permit me to ask you if you can assist me with a Letter & a Slight Sketch of your late friend Blake[,] their being a very fine portrait of him after Phillips which I am anxious to add to my collection but in the absence of the above things cannot consistently do it[?]'[3] Linnell was happy

February 10th, 1830 to comply, and in his Journal he wrote: '1830 Feb Wed 10 Sent to M^r Cooper RA. a sketch by M^r Blake & a letter of his also for his collection of autographs'. He was, however, careful to make a 'Copy of letter [*from Blake to John Linnell of March 31st 1826*] given to M^r Cooper R A', so that it would not disappear entirely.[4] Two days later Cooper replied gratefully: 'Dear Sir Please to accept my best thanks for the Sketch & Letter

[1] For a reprint, beginning at 'Model of a Painter's Wife', see May 13th, 1830.

[2] Anon., '*The Family Library, No. X. The Lives of the most eminent British Painters, Sculptors, and Architects.* By Allan Cunningham. Vol. II. London, 1830. J. Murray', *London Literary Gazette*, Feb. 8th, 1830, pp. 85–86.

[3] Ivimy MSS. The letter is dated simply 'Monday', but Linnell's reply below supplies the date. [4] Ivimy MSS.

by Blake which are precisely what I wished—as my object is
only to possess a genuine memento[.]'[1]

Linnell wrote in his Journal for Tuesday, February 25th:
'Mr. Haviland Burke called about Mrs. Blake, from the Bishop
of (Limerick). Shewed me a letter from the Bishop enquiring
how he could best serve Mrs. Blake. Advised him to recommend
to the Bishop to purchase the works of Mr. Bl *from Mrs. B.*'[2]

On Tuesday, March 2nd 'Mr. H. Burke called & appointed to-
morrow to go to Mrs. Blake with me.' Next day Linnell 'Went
with Mr. H. Burke to Mrs. Blake & selected two drawings
8 gs.—two Prints of Job & Ezekiel, 2 gs.[3]—& the coloured
copy of the Songs of Innocence & Experience, making 20 gs.—
which the Bishop of Limerick sent Mr. Burke to lay out with
Mrs. Blake'.[4]

Another cursory review of Cunningham appeared in *The
Monthly Review* for March:

From Barry we turn to William Blake, an extraordinary lunatic;
his whole time, and a genius of no common cast, were devoted to the
embodying of those wild and absurd visions, in which the poor man
constantly indulged to the hour of his death. A due estimate of his
excesses can be formed alone by a perusal of his very singular histories.
He has published some works . . .

[*Paragraph 34*]—vol. ii. pp. 166–167.

It appears, however, that Blake was an excellent tinter, and that

[1] Ivimy MSS., dated only 'Friday'.

[2] Quoted from John Linnell, Jr.'s transcript in his 'List of John Linnell Senior's
Letters and Papers', p. 42 (Ivimy MSS.), as are the Journal references immediately
following, up through 1830.

[3] These two prints of Job (1786?) and Ezekiel (1794) descended, through
Bishop Jebb's unpaid chaplain (the Revd. Charles Forster), to the chaplain's daugh-
ter (Miss Laura Forster), to the daughter's nephew E. M. Forster, and from him
to the Fitzwilliam Museum.

[4] These firm contemporary facts are not shaken by the family tradition that the
£21 was a gift. With this copy (W) of the *Songs*, now in King's College Library,
Cambridge, is a letter from Mrs. L. M. Forster to E. M. Forster, May 14th, 1923,
saying that she had 'often talked' about this copy of the *Songs* (which her father had
given her) with George Richmond: 'He had often spoken of M[rs] Blake's having
said she wished the Bishop to accept it not as a work of art, but as a token of grati-
tude and hoped he would care for it as having been her husband's own copy of his
favourite work. . . . M[r] Richmond did not know Bishop Jebb and my father until
about 1830 or 31. . . .' This family version had been confirmed by Gilchrist (1942,
p. 356; 1863, p. 365), who said this copy was "in her [*Catherine's*] estimation,
especially precious from having been Blake's own" and controverted by A. T. Story
(*The Life of John Linnell*, 1892, pp. 243–4), but it is clear that the facts are on
Story's side.

he was the companion of Flaxman and Fuseli. After residing for seventeen years in South Molton-Street, he removed to Fountain Court, in the Strand, where he died, in the 71st year of his age, in 1828.[1]

A far more remarkable piece of work was the anonymous essay entitled 'The Inventions of William Blake, Painter and Poet', which appeared in *The London University Magazine* for March 1830. The unconventionality of its sympathy with Blake is put into the clearest light when its opening paragraphs are compared with the orthodox dicta of the *Edinburgh Review* a few years later: 'Mr Cunningham's partialities in favour of some artists . . . [are] a little shown even in the selection of some of those who have been recorded among "*eminent*" British painters; . . . Blake, the able, but, alas! insane author of some very striking and original designs, could scarcely be considered a painter'[2] The author of the *London University Magazine* essay complains:

March 1830 first, of the insertion [*by Cunningham*] of stories which are falsely coloured; then of the stealing, borrowing, or copying a considerable portion of the life from Nolleken's Own Times; and, last of all, of a smile of contempt when speaking of Blake's private sentiments and feelings, which certainly is not becoming or respectful in a fellow artist. In our opinion, it was rather foolish of Mr. Cunningham to attempt the life of so extraordinary a man as Blake, the peculiar character of whose mind he could no more comprehend, than he could produce rival works in either poetry or painting. Thus far with Mr. Allan; we will now proceed to a subject far more agreable than a mere review of the Lives of the Painters. The public have only had a slight glimpse of the noble Songs of Innocence and Experience, by William Blake, but even that has laid open great beauties to its view. It is a curious circumstance, and well worthy the attention of all persons, that in this age of reason, Englishmen should have allowed two such men as Flaxman and Blake, to pass from this life without evincing the smallest regard for them. Perhaps 'reason stumbles all night over bones of the dead,' as Blake has elegantly expressed it,[3] and pays but small attention

[1] Anon., 'Art. X.—*Lives of the Most Eminent British Painters, Sculptors, and Architects*. By Allan Cunningham, Esq. 2 vols. 12mo. [*First edition.*] London: J. Murray. 1830', *Monthly Review*, xiii (1830), 453–4. Blake died in his seventieth year in 1827.

[2] Anon., 'Art. III. *Lives of the most Eminent British Painters, Sculptors, and Architects*. By Allan Cunningham. 6 vols. 12mo. London: 1830–1–2–3', *Edinburgh Review*, lix (April 1834), 53.

[3] In 'The Voice of the Ancient Bard' it is those who are perplexed by 'Doubt' and 'clouds of reason' who 'stumble all night over bones of the dead'.

to real genius; or it may be partly accounted for through the want of a good philosophy, which, Mad. De Stael says, has not as yet been taught in England. These, perhaps, are a few of the many reasons why Blake and Flaxman have been buried in obscurity; but we have a confident hope that Coleridge, Blake, and Flaxman are the forerunners of a more elevated and purer system, which has even now begun to take root in the breast of the English nation; they have laid a foundation for future minds—Coleridge, for the development of a more internal philosophy—Blake and Flaxman, for a purer and more ennobling sentiment in works of art.

After having preluded in this manner, let us direct our eyes to the beauties of Blake's poems.

THE INTRODUCTION TO THE SONGS OF EXPERIENCE.[1]

Hear the voice of the Bard,
Who present, past, and future sees,
Whose ears have heard
The holy word
That walked among the ancient trees,

Calling the lapsed soul,
And weeping in the evening dew,
That might control
The starry pole,
And fallen, fallen light renew.

O Earth, O Earth, return!
Arise from out the dewy grass!
Night is worn,
And the morn
Rises from the slumberous mass.

Turn away no more!
Why wilt thou turn away?
The starry floor,
The watry shore,
Is given thee till break of day.

Around these lines the stars are rolling their resplendent orbs, and in the cloud on which the song floats, a human form is lying, anxiously surveying their courses: these are a few wild notes struck forth by the hand of a master. But let us continue to look over his notes, bright

[1] The 'Introduction' to the *Songs of Experience* is here reprinted for the first time.

both with poetry and forms divine, which demonstrate an intimate knowledge of the passions and feelings of the human breast.

THE POISON TREE.

I was angry with my friend,
I told my wrath, my wrath did end;
I was angry with my foe,
I told it not, my wrath did grow.

Then I wat'red it in fears,[1]
Night and morning, with my tears,
And I sunned it with smiles,
And with soft, deceitful wiles.

And it grew both day and night,
Till it bore an apple bright;
And my foe beheld it shine,
And he knew that it was mine.

And he into[2] my garden stole,
When the night had veiled the pole;
In the morning, glad, I see
My foe outstretch'd beneath the tree.

If Blake had lived in Germany, by this time he would have had commentators of the highest order upon every one of his effusions; but here, so little attention is paid to works of the mind, and so much to natural knowledge, that England, in the eyes of the thinking world, seems fast sinking into a lethargy, appearing as if the *Poison Tree* had poured the soporific distillation over its body, which now lies under it almost dead and lifeless. . . . The powers, then, of both mind and body having been freely exercised, the result is a genius, who stands forth as a representative of his race; and thus we may say, Blake in his single person united all the grand combination of art and mind, poetry, music, and painting; and we may carry the simile still further, and say, that as England is the least fettered by the minds of other nations, so Blake poured forth his effusions in his own grand style, copying no one, (nolumes leges Angliae mutari,) but breathing spirit and life into his works; and though shaping forms from the world of his creative and sportive imagination, yet he still remembered he was a

[1] In Blake's version of 'A Poison Tree', here reprinted for the first time, the line begins 'And I waterd'.

[2] Blake's line reads 'And into my garden stole'.

moral as well as intellectual citizen of England, bound both to love and instruct her. These ought to be the ruling principles of all artists and poets. Flaxman and Blake thought it a still higher honour to be celebrated for their innocence and beauty of sentiment, than for a mere sensual representation of forms. Their internal esthetic produced a similar external, not by any means inferior to the mere form-painter, and in this respect superior, that there was a Promethean fire which glowed in their productions, purifying the soul from the gross imperfections of the natural mind. . . .

This grand combination of art succeeded in every particular, painting being the flesh, poetry the bones, and music the nerves of Blake's work.

The figures surrounding and enclosing the poems, produce fresh delight. They are equally tinged by a poetical idea, and though sometimes it is difficult to understand his wandering flights, yet the extraordinary power developed in the handling of both arts astonish[es] as well as delight[s]. Here and there figures are introduced, which, like the spirits in Macbeth, pass quickly from the sight; yet they every one of them have been well digested in the brain of a genius; and we should endeavour rather to unlock the prison-door in which we are placed, and gain an insight into his powerful mind than rail and scoff at him as a dreamer and madman.

For instance, Albion, with which the world is very little acquainted, seems the embodying of Blake's ideas on the present state of England; he viewed it, not with the eyes of ordinary men, but contemplated it rather as a province of one grand man,[1] in which diseases and crimes are continually engendered, and on this account he poured forth his poetical effusions somewhat in the style of Navalis, mourning over the crimes and errors of his dear country: and it is more extraordinary still that, like Novalis, he contemplated the natural world as the mere outbirth of the thought, and lived and existed in that world for which we are created. Horrid forms and visions pervade this Albion, for they were the only representatives, in his opinion, of the present state of mankind. No great genius wrote without having a plan, and so in this, a light is frequently thrown across the pictures, which partly discover the interior design of the Poet. We are perfectly aware of the present state of public opinion on this kind of men, but we know at the same time, that every genius has a certain end to perform, and always runs before his cotemporaries, and for that reason is not generally under-

[1] The author had apparently seen a copy of *Jerusalem* (one copy at this time was in the hands of Linnell, another with Catherine, and a third with W. Y. Ottley), for it is only in *Jerusalem* that Albion comes to dominate Blake's myth. Tatham, who later acquired the only complete coloured copy of *Jerusalem*, similarly emphasized the importance of Albion.

stood.—This is our candid opinion with respect to Blake, but we hope that hereafter his merits will be more generally acknowledged. We now proceed to the other poems.

A CRADLE SONG

Sweet dreams form a shade
O'er my lovely infant's head;
Sweet dreams of pleasant streams
By happy, silent, moony beams.

Sweet sleep, with softest down
Weave thy brows an infant crown;
Sweet sleep, angel mild,
Hover o'er my happy child.

Sweet smiles in the night
Hover over my delight,
Sweet smiles, mother's smiles,
All the livelong night beguiles.

Sweet moans, dovelike sighs,
Chase not slumber from thine eyes![1]
Sweet moans, sweeter smiles,
All the dovelike moans beguiles.

Sleep, sleep, happy child,
All creation slept and smil'd,
Sleep, sleep, happy sleep,
While o'er thee the mother weep.[2]

Sweet babe, in thy face
Holy image I can trace;
Sweet babe, once like thee
Thy Maker lay and wept for me:

Wept for me, for thee, for all,
When he was an infant small;
Thou his image ever see,
Heav'nly face that smiles on thee:

[1] 'A Cradle Song' is first reprinted here. Blake's version in *Innocence* reads 'thy eyes'.
[2] 'thy mother weep'.

Smiles on thee, on me, on all,
Who became an infant small,
Infant smiles are his own smiles,
Heav'n and earth to peace beguiles. . . .[1]

This [*'The Garden of Love'*] is a curious and mystical poem, which
as yet can be but partially understood—but at the same time it is
highly poetical. Now approaching a new subject, the elegant dream of
Thel, which seems born in the perfume of the lily, so charming, so
fairy-like, are all its illustrations, there is only one work that we re-
member like it in elegance, the Sakontola, for it wears all the fresh-
ness of Indian simplicity and innocence.

THEL.

The title-page of this mazy dream contains a specimen of his utmost
elegance in design:—two beautiful figures are chasing one another in
gentle sport, and the Peri Thel is looking on the fairy land. A few
specimens of this poem will suffice to show its merit.

A Speech addressed to Thel by a Cloud.

Virgin,[2] know'st thou not our steeds drink of the golden springs
Where Lovah[3] doth renew his horses? Look'st thou on my youth,
And fearest thou, because I vanish and am seen no more:
Nothing remains? O maid, I tell thee, when I pass away,
It is to tenfold life, to love, to peace, to raptures holy;
Unseen descending, weigh my light wings on balmy flowers,
And court the fair-eyed dew to take me to her shining tent:
The weeping virgin, trembling kneels before the risen sun,
Till we arise linked in a golden band and never part—
But walk united, bearing food to all our tender flowers.

Dost thou, O little cloud? I fear I am not like thee;[4]
For I walk through the vales of Har, and smell the sweetest flowers,
But I feed not the little flowers; I hear the warbling birds,
But I feed not the warbling birds, they fly and seek their food:
But Thel delights in these no more, because I fade away,
And all shall say, without a use this shining woman lived,
Or did she only live to be at death the food of worms?

[1] 'The Divine Image' from *Songs of Innocence* and 'The Garden of Love' from
Songs of Experience, which are quoted here, were first reprinted by B. H. Malkin
and H. C. Robinson.
[2] *Thel* here appears in conventional type for the first time. Blake's line begins
'O virgin'.
[3] This is a misprint for 'Luvah'. [4] 'I fear that I am not like thee'.

The cloud reclined upon its[1] airy throne, and answered thus:
Then if thou art the food of worms, O virgin of the skies,
How great thy use, how great thy blessing; every thing that lives,
Lives not alone, nor for itself: Fear not, I will call[2]
The weak worm from its lowly bed, and thou shalt hear its voice:
Come forth, worm of the silent valley, to thy pensive queen!
The helpless worm arose, and sat upon the lily's leaf,
And the bright cloud sailed on to find his partner in the vale.

This little work is the fanciful production of a rich imagination, drawing, colouring, poetry, have united to form a beautiful whole; all the figures teem with elegance, and convey sentiments which are noble, though veiled under a fairy tale. With this last extract we conclude for the present, earnestly recommending the works of our author to the attention of the English nation, whereby their taste may be improved in the fine arts, as well as gratification derived from the perusal of his poetry. *

Why cannot the ear be closed to its own destruction,
 Or the glittering[3] eye to the poison of a smile?
Why are the eyelids stored with arrows ready drawn,
 When[4] a thousand fighting men in ambush lie?
Or an eye of gifts and graces, showing fruits and coin'd gold,[5]
 Why a tongue impressed with honey from every wind,
Why an ear, a whirlpool fierce to draw creations in,
 Why a nostril wide, inhaling terror, trembling, and affright?
Why a tender curb upon the youthful burning boy,
 Why a little curtain of flesh on the bed of our desire!

The virgin started from her seat, and with a shriek,
Fled back unhindered, till she came into the vale of Har.[6]

* Blake and Coleridge, when in company, seemed like congenial beings of another sphere, breathing for a while on our earth; which may easily be perceived from the similarity of thought pervading their works. [*Reviewer's note.*]

March
1830

In *Fraser's Magazine* for March appeared a tautological article entitled 'The Last of the Supernaturalists', which begins:

The world is, without contradiction, a fitting habitation for spirits of only a like order. This truth, which is obvious to many, was a secret

[1] 'upon his airy throne'.
[2] 'Fear not and I will call'.
[3] 'glistning eye' (From *Thel*).
[4] 'Where a thousand'.
[5] 'show'ring fruits & coined gold'.
[6] Anon., 'The Inventions of William Blake, Painter and Poet', *The London University Magazine*, ii (March 1830), 318–23.

to William Blake to the hour of his death: it was a true sibylline leaf to his uninitiated sense. Happy for him had it been otherwise!

The history of this much-canvassed individual is, indeed, a 'psychological' curiosity, according to the favourite term, in writing as well as speaking, of Samuel Taylor Coleridge. By all the world Blake was thought a madman: this is the fate of those who differ in thought, word, or action, from the every-day sillinesses of visible life. Thus we have heard it said that Jeremy Bentham was a madman . . . [*as well as*] Samuel Taylor Coleridge . . . Professor Wilson . . . De Quincey . . . Wordsworth . . . Byron . . . Thomas Campbell[1] Let, then, the sentence which asserts that

'Great wits to madness are allied,'

be placed amongst the most drivelling pieces of nonsense that have been uttered by the charnel-fuming lips of the *persifleur* and scoffer. . . .

And now, having described the only species of madman whom we are pleased to recognise, that is, those of the inferior order of created beings, we come to the true subject of our paper,—William Blake, the mystic, the spiritualist, the supernaturalist. Was he a madman? In our opinion he was not. Did he, then, purchase his exemption by participating in the fraternity of exalted talent? He had no part or parcel in that high order. What is, then, our meaning? may well be demanded by the wondering reader. Have a moment's patience, very courteous sir, and you shall hear.

Nature, in her bounty, had done her part generously and nobly by William Blake—Art had done nothing. (Understand us well, good reader; by ART we do not mean the *art* of copperplate engraving, or painting.) When that combination is perfect, you will have a perfect man . . . [*like*] Göthe. Had the circumstances of life favoured the formation of nature in William Blake, he, too, would have been a perfect man, and, yielding in merit to few of his prophetic brethren, would have been honoured by them and by mankind as a truly inspired *Vates*. But, alas! the boy exceeded his condition of life: he anticipated the generation of his family. The part in him which Nature had bestowed she sedulously fostered and perfected, and his imagination grew to its fulness of strength, and was competent to attain the highest and loftiest landmarks which the most adventurous and daring of men had ever set for the attainment of their comprehension. But the part which art and parental anxiety had taken in his education was trifling in the

[1] The whole of the essay is about 14,500 words, of which some 6,500 are quoted from the first edition of Cunningham's biography (about two-thirds of the Blake biography is quoted), and a very large proportion of the rest (over 4,000 words) are irrelevant to Blake or to supernaturalism.

extreme. Heaven poured on the tender plant its genial sunshine; but without sufficient moisture in the soil, the plant could not grow to maturity; and earth—its parent earth—refused it the waters of the smallest rill or gushing fountain. When Blake grew up, he felt a secret pain—a gnawing—a sense of weakness, though indescribable, in his body. His mind prompted him to action—his limbs collapsed with weakness at the moment of trial: he was like the chained Titan[1]

Blake was, in secret longing, like the student Anselmus of Hoffman's tale: he felt that the earth, as it is at present peopled, was no fitting habitation for one of his order; here all was cold selfishness and empty folly. Had he known of the history of that student of Dresden, he too, with the fervour of the romance-writer, would have exclaimed:— 'Ah, happy Anselmus! who hast cast away the burden of weekday life'[2]

William Blake was a man who stood alone in the world: men laughed at him, and scoffed him, as they would treat some paltry, petty, conjuror and sleight-of-hand trickster at a country fair. Yet the good man bore up with patience, and even apparent cheerfulness, against all the contumelies of the never-thinking world. Had men examined his case,—had they investigated the poor creature's heart—his principles of thought,—had they traced the stream of imagination through its green savannas, its tangled brakes, its overhanging precipices, and interminable forests, to its primal source, they would have found wherewithal to startle their weak, pre-conceived notions of geological aptitude,—a fountain of the sweetest and Blandusian waters issuing from a rock of salt more detestable to the taste than the ashy apples of the Asphaltic lake. The Psalmist has wisely and beautifully said, 'It is good for me to have been in trouble, that I might know THY precepts.' Adversity was the bitter, every-day food of the good old man; yet to him it was of the divinest support; for it enabled him to attain those things which are the most glorious of earthly possessions, undying hope, universal charity, inextinguishable love for God. Ministers of state, men in affluence, 'dominations, princedoms, powers,' pause ye in your career of earthly nothingness, and gaze and ponder over the dying scene, the last words, the expiring utterance of this glorious piece of mortality. Thus is it most simply described by his biographer [*Cunningham, paragraphs 46–47*]. . . .

But adversity has the same tendency as prosperity: it disturbs the serenity of the mind, and makes that which should be, as it were, a translucent lake, shewing the beautiful azure of the heavens, and every

[1] The omitted lines include a passage quoted inaccurately from Shelley's *Prometheus Unbound*, Act I, lines 24–30.

[2] The footnote identifies these lines as from 'Specimens of German Romance. By Thomas Carlyle, Esq. Vol. ii.'

luxuriant bush and leaf that hangs enamoured over the banks, a spectacle of 'dismal and foaming brine!' Where, in this land, and among the great ones of her metropolitan Babel, shall we see a human being calm and undisturbed at the temptations of his prosperous circumstances, as was the poor, bed-ridden, starving, aged, yet happy, William Blake, in his sorry crib and his wretched lodgement?

Let us now descend to the facts of Blake's life.

William Blake was the son of a hosier. What! do you start in wild amaze, my young limb of fashion and sentiment—my formless flyblow of college education? Gape on, and stare with your ugly goggle eyes in open wonder. Ay, we repeat it, and repeat it with pride, William Blake was the son of a hosier—Robert Burns was an untutored clown—James Hogg was an uncouth shepherd boy—John Clare is a Northamptonshire peasant

The following extract from Allan Cunningham's biography will introduce the subject fully before the reader [*Paragraphs 2-8*]. . . .

And this was the boy whom Fortune had bound down to daily toil for the supply of the daily necessaries of life. Alas! for her crocketty caprices and her wanton favours! While some longeared lordling is lolloping his asinine length upon the sofa, complaining of the difficulty he has in killing that worst of enemies, Time . . . the poor children of misery and misfortune, such as Heyne, Vitalis, Blake, lie in their ricketty garrets, have not wherewithal to warm their frosty blood into a wholesome circulation, save the agonising pangs of disappointment shooting with electric rapidity along their veins and sinews, and burning with the woful flame of consuming fire. And yet the crumbs which fell from the very servants' table of the above-named '*laudator temporis acti*' at hunts, *coulisse*-intrigues, and green-rooms, racing grounds and platter-and-dish dalliance, would have been ample for the food of those wretched and starving sons of genius, and sent them in gladness of heart, and with a fervent blessing on their lips, to pursue the stony path that leads to the temple of renown, where that soul only

> 'Shall enter, which hath earned
> The privilege by virtue!'

Vitalis, however, was a man of sterner, ruder materials, than our William Blake; the misery of life could not bend into submission his too stubborn heart, but its strings burst in twain even with the very effort of resistance. William Blake had a calmer, quieter, more gentle, tractable spirit, and he lived onward to a ripe old age, a happy, cheerful man, though one engaged in daily struggles with poverty. Both wanted in early life the one thing essential to every individual, of whatever nature or degree of intellect,—a kind, compassioning

adviser;—a true friend;[1]—one who would have chided gently and encouraged much: who would have listened to the tale of sorrow: not checked by coldness or sarcasm the tear struggling for a passage through the lowered fringes of the strained, blood-shot eye: and with quiet movement and soothing speech taught the young gladiators with self, how to struggle with error: instructed these inexperienced mariners how to trim their vessels, avoiding all the shoals and quicksands of a siren-thronged world: how to repair into the tranquil haven, how to produce their freight, and deal in an advantageous traffic with the inhabitants on shore, thereby gaining uncountable riches! . . . The secrets of existence, however, are dark—dark and unfathomable; yet the lives of Vitalis and Blake proclaim this manifest moral: 'Youth, arise, and be a-doing in the path marked out for thy career of life by the omniscient and omnipotent Taskmaster in heaven!'

Enough of this: Allan Cunningham next comes to speak of Blake's marriage. The process of love-making and pairing was characteristic of the man [*Paragraphs 9–12, 14–28*]. . . .

The singularity of the man attracted public attention; yet he never had a companion, save one person, well enough known for his eccentricity. This eccentricity, however, we have the very best reason in the world for knowing,[2] was assumed for the purpose of getting a name, in which he has partially succeeded, and has thereby put certain golden guineas into his pockets by the exercise of his profession. But this individual had not that transcendental perception into the supernatural, which would have given him the privilege of claiming kin and brotherhood with Blake. One was the genuine, true, and all-convinced mystic; the other was like the superficial tyro, waiting by his master to hear his words of wisdom, to note down the words explanatory of the esoteric doctrines of what he, in his ignorance, thought to be mere craft This man, therefore, is a buffoon and knave, 'not by spherical predominance,' but by artifice, that he may put money in his purse, and get rich.

But it was otherwise with poor William Blake. That he was no knave, will appear from the following anecdote, which must bring us to a conclusion directly the contrary of what it appears likely to induce. In other men, this conduct manifested on Blake's part would have proved the existence of a mendacious spirit [*Cunningham, paragraph 28*]. . . .

[1] Blake certainly had friends such as Flaxman, Hayley, Cumberland, and Fuseli who fit these descriptions.

[2] Anon. implies that he himself had been cheated by this 'tyro', who is described below as a painter and 'judicial astrologer'. He appears to be referring to John Varley, but his implication that Varley was successful in his 'purpose' of getting rich is preposterous, for Varley was regularly arrested for debt.

Now, no man in his mortal senses would have asserted what Blake is described to have done, without a conviction that the assertion was founded on truth. But it was wholly false, and yet Blake kept on persisting in its correctness, though accumulated evidence from almost every quarter of the town could be, and was, immediately brought forward to prove its nothingness. If Blake had been really an impostor, he would have calculated the chances of detection. This he never seems to have done: by no process of prudent conduct would a man deliberately write himself down a liar, when exposure was easy and certain. What shall we say, then, in Blake's extenuation? Simply this, that by severe abstraction, Blake's brain became fevered: he mistook the dreams of fancy for reality.[1] Poor, unfortunate, ill-fated son of genius!

Therein lies the whole mystery of the man's existence; and the mystery yields and is unravelled by the slightest investigation. Had Blake been perfect in mind, as he was in body[2] (which combination alone makes the first-rate character), it had been well for him: had he been an educated man, and a man of the world, it had been well for him: had he been the pupil or the friend of a strong-minded, well-educated man, and a man of the world, it had been well for him. But he was deficient in all these necessaries for the Voyage of life. The world's neglect, the want of a friend, turned him to abstract speculations. Had vigour of mind *then*, as it were by some sudden revelation, come upon him, the milk of human love around his heart would have been curdled from disgust to gall and bitterness; and the young artist would have become an inveterate, irrecoverable sceptic. But blindness of faith is the usual comforter of weak minds in affliction; the poor youth, rejected of men, turned his thoughts and devotion from worldly concerns to the worship of his Maker; and, well aware of the all-lovingness of God, and, in his frenzied adoration, forgetting the weakness of mortal flesh, he imagined that his bruised and broken soul had found refuge in the bosom of the One True and Universal Friend. This was his spirit, indeed, regenerated, and with mortal utterance it spoke of the immortal wonders of another and a better world. To such a pass did the world's neglect, and the victory of disappointment, bring this man, the whiteness of whose soul was as immaculate as new-fallen snow upon mountain-tops. Thus very excess of virtue became in him an evil; yet he proceeded in his fatal error:—for how were it otherwise? William Blake had, for the voyage of life, neither Compass nor Ballast: he had, for the trials of life, neither Friend nor Adviser!

[1] This sounds startlingly close to the madness which Anon. had categorically denied on p. 387.

[2] Anon. has now cured Blake of a most distressing 'secret pain—a gnawing—a sense of weakness, though indescribable, in his body', which was so debilitating that 'his limbs collapsed with weakness at the moment of trial' (p. 388).

Nevertheless was the suffering transcendentalist happy, gay, and unsubdued, even to the last, by the cares of this world of grief. His mind was constantly active—not a brook or a stone—not a leaf, a flitting shadow, or a gleam of sunshine, but carried to his head a silent, and consolatory meaning. How well do Burton's lines apply to him!

> 'When to myself I act and smile,
> With pleasing thoughts the time beguile,
> By a brook-side, or wood so green,
> Unheard, unsought for, and unseen;
> A thousand pleasures do me bless,
> And crown my soul with happiness:
> All my joys besides are folly,
> None so sweet as melancholy.
>
> * * * * *
>
> 'Methinks I hear, methinks I see,
> Sweet music, wondrous melody;
> Towns, palaces, and cities fine,
> Here now, then there, the world is mine;
> Rare beauties, gallant ladies shine,
> Whate'er is lovely or divine:
> All other joys to this are folly,
> None so sweet as melancholy.'

Stronger beings than Blake have believed in the supernatural. Johnson's theory has been put into the mouth of the sage Imlac, and is sufficiently known. What man that exists but has in his mind a faint adumbration of supernatural agency? This is the constant accompaniment of conscience; and so long as that monitor shall be active in the breast of man, so long will the sense of supernatural agency remain with him. But though a sense of the supernatural accompanies conscience, springing from the perpetration of evil; yet is it also the associate of Love for the purposes of good, as was the case with William Blake. Thus was it with Max. in Schiller's *Wallenstein*. . . .

Blake, it appears, published a catalogue of his pictures, in which he set forth the principles of his art according to his conception. All this is well described by our friend Allan Cunningham [*Paragraphs 29–34*]. . . .

The following extracts are descriptive of some paintings which we ourselves have seen. Let the reader give his earnest attention to it [*Paragraphs 36–39, 41*]. . . .

Blake had now arrived at a good old age, and felt himself to be dying. Still he kept touching and retouching his favourite painting. At last, he 'threw it from him, exclaiming, "There! that will do! I

cannot mend it." He saw his wife in tears—she felt this was to be the last of his works'

This woman, says the writer of this singular piece of biography, is still alive, 'to lament the loss of Blake—and *feel* it.' Ye self-styled saints on earth, and ye distributors of private charity, ye need not go far in search of a fitting object on whom to bestow the golden guineas in your purses. Behold her here.

For the facts relative to Blake contained in this our paper, we are indebted to Allan Cunningham's volumes, entitled 'The Lives of English Painters,' &c., and forming a portion of the *Family Library*, published by Don John Pomposo,[1] of Albemarle-street. Gentle reader, go and purchase these Lives; or, if you will, the whole collection, for they are well worth every farthing of the money which you will pay.

As for Blake—peace to his sacred ashes!—his soul is now far beyond the sound of the jeers and the mockery of his earthly detractors: and for those detractors, we will quote some words from a book of which perhaps they know little—it is worth their perusal: 'CAST OUT THE BEAM OUT OF THINE OWN EYE; AND THEN SHALT THOU SEE CLEARLY TO CAST OUT THE MOTE OUT OF THY BROTHER'S EYE.'[2]

John Varley managed to scrape enough money together to have his copies of *Job* hung:

March 8ᵗʰ 1830 Memorandum, I left with Mr [*James*] Linnell, 34 Hart St, Bloomsbury 10 prints of Job, framed & Glazed by Order of my father[.]

March 8th, 1830

J Varley
C Varley[3]

I assume that this is an order, and that 'to be framed & Glazed' is the intention, but it is possible that Varley was leaving the prints in pawn.

[1] Alias John Murray.

[2] Anon., 'The Last of the Supernaturalists', *Fraser's Magazine*, ii (March 1830), 217–35. The authorship has been attributed to Carlyle (J. A. S. Barrett, 'Carlyle on Blake and Vitalis', *TLS* April 26th, 1928, p. 313) and to John Abraham Heraud or William Maginn (T. M. H. Thrall, *Rebellious Fraser's*, N.Y., 1934, p. 268), but all seem unlikely since Anon. had seen Blake's exhibition in 1809, Carlyle and Maginn were not in London when the exhibition was open, and Heraud was only 10 years old in 1809.

[3] Quoted from a little book with the Ivimy MSS., which contains many receipts from James Linnell and his son John, expenses for tea, coffee, Xmas pudding, soap, 'moist', etc, but which later seems to turn into the account book for James Linnell's frame-making establishment in Hart Street.

Three days later most of the rest of the set was sent:

March
11th,
1830

11ᵗʰ	delivered to Mʳ Linnell	
march	7 Fram Blaches Jobe	
1830	H Varley[1]	

One of the most interesting responses to Cunningham's life of Blake was that of the Quaker poet Bernard Barton. In his admiration for Blake's patron, he wrote a poem on John Linnell, one of the first poems to mention Blake, and sent a copy to its subject:

To Mr. Linnell, of Bayswater.

'Yet was he reduced, one of the ornaments of the age, to a miserable garret and a crust of bread, and would have perished from want, had not some friends, neither wealthy nor powerful, averted this disgrace from coming upon our country.'—*Cunningham's 'Life of Blake.'*

> 'Patron and friend of him who had but few
> Of either, justly worthy of thy name,
> To smooth his rough and thorny path to fame;
> Methinks with honest pride thou must review
> That best of patronage, which took the hue
> And form of friendship, by its generous aim,
> To save our age and country from the shame
> Which from neglected genius must accrue!
> Nor wealth nor power the wretched garret sought,
> Where he, the gifted artist, toil'd for bread.
> 'Twas thine the balm of sympathy to shed,
> To soothe his wounded feelings while he wrought
> Bright forms of fancy, images of thought,
> Or held high converse with the glorious dead.'[2]

Linnell's reply was curious but cordial:

To Mʳ Barton Porchester Terrace Bayswater
of Woodbridge Suffolk [*Saturday*] April 3ᵈ 1830

*April
3rd,
1830*

Dʳ Sir

I thank you sincerely for the very beautiful sonnet but as it is not applicable to me I hope you will not upon any account publish it with my name or with any hint that it is intended for me for I assure you I have

[1] Quoted from the same account book. I take this, rather hesitantly, to mean that he delivered seven prints from Blake's *Job* to be framed.

[2] A. T. Story, *The Life of John Linnell*, London, 1892, vol. i, p. 194.

not the least claim to it—and even if I had I shd equally dislike it, for if ever I have the happiness to be of any service to a friend I shd avoid the Public praise of men that the Pharisee's reward might not be my lot— I do not see however why the sonnet may not be publis[h]ed without the name of Mr. Blake or myself but simply addressed to the Friend of neglected genius or something like that. I am very glad you were so kind as to send me a Copy before publication because it gives me the opportunity of correcting a mistake which is a sufficient reason why the names shd not be mentioned—it is that Mr. Blake never was reduced to live in a garrett as asserted in the memoir— and I am sorry Mr Cunningham did not avail himself of the information I offered him as he might have made his very interesting memoirs the more instructive & far more creditable to Mr Blake by the alteration of some things & the addition of others with which I cd have furnished him[.]

When I first became acquainted with Mr Blake he lived in a first floor in South Molton Street and upon his Landlord leaving off business & retiring to France,[1] he moved to Fountain Court Strand, where he died. here he occupied the first floor & [*words deleted*] it was a private House Kept by Mr Banes whose wife was sister to Mrs Blake[;][1] it was here that he began to feel the want of employment and before I knew his distress he had sold all his collection of old prints to Mess Colnaghi & Co.—[2] after that I represented his case to Sir Thos Lawrence, Mr Collins, R.A. & some other members of the Royal academy who kindly brought it before the Council & they voted him a donation of 25 £ which was sent to him through my hands & for which he expressed great thankfulness— this however was not enough to afford him permanent support & it was in hopes of obtaining a profit sufficient to supply his future wants that the publication of Job was begun at my suggestion & expense[.] But as I had also the expectation & have still of remuneration (the Plates being my property) I have no claim to any notice upon that account—and though we were both disappointed in our expectations as to the extent of sale, yet the few buyers of the work being among the most distinguished for taste & learning we were sufficiently encouraged to commence another work which Mr Blake did not live to complete, it was the Illustrating of Dantè— he made one hundred folio drawings some of which are highly

[1] For the difficulties caused by this statement, see Residences, p. 563.

[2] On February 9th, 1961 H. Wright, Director of P. & D. Colnaghi & Co. Ltd., 14 Old Bond Street, London, W.1, wrote me that all the Colnaghi records for periods up to the Second World War have gone, and that consequently they have no contemporary records of Blake. Blake's collection of old prints must have been sold between 1821, when he moved into Fountain Court, and June 28th, 1822, when the Royal Academy made its grant to him.

finished & began seven plates (all in my possession)[.] This work however answered the purpose of furnishing him with the means of comfortable subsistence to his death.

I have thought this w.^d not be uninteresting to you and c.^d add much more but I am not able to write long— there is one thing I must mention— I never in all my conversations with him c.^d for a moment feel there was the least justice in calling him insane— he could always explain his paradoxes satisfactorily when he pleased but to many he spoke so that 'hearing they might not hear'— he was more like the ancient patterns of virtue than I ever expected to see in this world— he feared nothing so much as being rich lest he sh.^d lose his Spiritual riches— he was at the same time the most sublime in his Expressions with the simplicity & gentleness of a child, though never wanting in energy when called for.

If you are in London & will favor me with a visit I shall be most glad to shew you his works in my possession & communicate what I know respecting him.

<div style="text-align: right">
I am D^r Sir

yours respectfully

John Linnell
</div>

P.S.

I have sent a plain Copy of the *Job* for your inspection[;] the price to you will be the same as the trade price. 2.12.6.—

the Print you are so good as to offer me I must decline, I do not collect modern prints & indeed I have left off buying any as my Family is large and the work of Job not having yet paid its expenses.

you are welcome to keep the Book for a fortnight—perhaps some friend may like to have it if you do not purchase it. at any rate you are perfectly welcome to the perusal of it[.][1]

On Monday, April 12th Barton replied:

April 12th, 1830

My dear Friend,

Thy packet containing the copy of Blake's Inventions for the Book of Job duly reached me the early part of last week, but absence from home, together with indisposition, and almost incessant engagements since, have prevented me from sooner thanking thee for a sight of so extraordinary a production. Were I a rich man, I would gladly and instantly purchase it for its curiosity; but since I cannot do this, I am the more indebted to thy courtesy for allowing me the gratification of inspecting it. If I can sell it for thee I will do so with pleasure, though I doubt its finding a purchaser; but I will answer for its transmission by coach safely packed up and carriage paid, at the time stated in thine

[1] Quoted from a photostat of the MS. in the Pierpont Morgan Library.

if I am unable to dispose of it— in the interim every possible care shall be taken of it.[1]

Ten days later, on Thursday, April 22nd, Barton wrote again:

My dear Friend,

I have been a good deal indisposed for a day or two, or I should *April 22nd, 1830* have returned Blake punctually to the day appointed; and I feel by no means well enough even now to write such a letter announcing the despatch of the book as it deserves. I cannot, however, do less than repeat my cordial thanks for the sight of so curious and extraordinary a volume; and the very first time I go to town I hope to have the pleasure of adding my personal to these written acknowledgements for the treat afforded me, as well as the gratification of seeing and conversing with one whose friendship for Blake has so highly prepossessed me in his favour; but my visits to town are, alas! few and far between; nor do I at present see a chance of paying one this summer.

Unwell as I have been, and incapable of doing more than attend to the routine of daily duties, I would have asked someone else to pack up and forward the Inventions had I not waited in the hope of finding a purchaser for the set, and the only person I could call to mind in this vicinity as likely to buy them I could not see till last evening—but I have seen him in vain. There is a dryness and hardness in Blake's manner of engraving which is very apt to be repulsive to print-collectors in general— to any, indeed, who have not taste enough to appreciate the force and originality of his conceptions, in spite of the manner in which he has embodied them. I candidly own I am not surprised at this; his style is little calculated to take with admirers of modern engraving. It puts me in mind of some old prints I have seen, and seems to combine somewhat of old Albert Durer with Bolswert. I cannot but wish he could have clothed his imaginative creations in a garb more attractive to ordinary mortals, or else given simple outlines of them. The extreme beauty, elegance, and grace of several of his marginal accompaniments induce me to think that they would have pleased more generally in that state. But his was not a mind to dictate to; and what he has done is quite enough to stamp him as a genius of the highest order. A still prouder and more enduring meed of praise is due to the excellence and sterling worth of the man: his child-like simplicity, his manly independence, his noble aspirations after the purest and loftiest of all fame, appear to me to form a singular union of those virtues which distinguished the better citizens of Greece and Rome with the milder graces which adorned the primitive Apostles.

[1] A. T. Story, *The Life of John Linnell*, London, 1892, vol. i, p. 175.

To have been the friend of such a man is a proud and enviable distinction.[1]

Another who was stimulated by Cunningham's life of Blake was Caroline Bowles, who wrote to Robert Southey on Tuesday, April 27th:

April 27th, 1830 I am longing to see some of Blake's engravings from his own extraordinary designs, of which I first heard from yourself. Do you know whether they are scarce, or dear? They are certainly not generally known. Cunningham's life of him in the *Family Library* has strengthened the interest for Blake and his works with which your account first inspired me. Mad though he might be, he was gifted and good, and a most happy being. I should have delighted in him, and would fain know how it fares with the faithful, affectionate partner of his honourable life. I hope she is not in indigence.[2]

Cunningham's life was also the stimulus for the first known North American interest in Blake. Five paragraphs appeared in the Philadelphia *Casket* for May 1830, and the first two of these were inaccurately copied into the Hartford *New-England Weekly Review* for May 3rd, illustrating Blake's eccentricity from his visions.[3]

On Saturday, May 8th Southey replied to Caroline Bowles:

May 8th, 1830 I have nothing of Blake's but his designs for Blair's *Grave*, which were published with the poem. His still stranger designs for his own compositions in verse were not ready for sale when I saw him, nor did I ever hear that they were so.[4] Much as he is to be admired, he was at that time so evidently insane, that the predominant feeling in conversing with him, or even looking at him, could only be sorrow and com-

[1] Story, vol. i, pp. 176–7. Linnell and Barton never met.

[2] *The Correspondence of Robert Southey with Caroline Bowles*, ed. E. Dowden, London & Dublin, 1881, p. 192. Her concern for Mrs. Blake was aroused by Cunningham's moving account (p. 504): 'She still lives to lament the loss of Blake—and *feel* it.' Her copy of the 1797 *Night Thoughts* was sold at the Parke-Bernet Galleries, Nov. 29th, 1961, Lot 102.

[3] Anon., 'Visions of Blake the Artist', *The Casket*, v, (May 1830), 231–2, partly reprinted in 'Visions of Blake the Artist', *New-England Weekly Review*, May 3rd, 1830, p. 1, the latter with minor omissions and mistakes such as 'sisters' for 'sitters'. The first reprints paragraphs 36–39 and 41 of Cunningham with acknowledgements; the second acknowledges Cunningham but not *The Casket*.

[4] This sentence and much of the rest of Southey's letter are highly unreliable. Blake's poems had, of course, been 'ready for sale' since at least 1789, as Southey might have learned if he had asked his friend Crabb Robinson. Southey's statement probably refers specifically to *Jerusalem*, part of which he had seen, and which was evidently not completed when he saw it.

passion. His wife partook of his insanity in the same way (but more happily) as Taylor the pagan's wife caught her husband's paganism. And there are always crazy people enough in the world to feed and foster such craziness as his. My old acquaintance William Owen, now Owen Pugh, who, for love of his native tongue, composed a most laborious Welsh Dictionary, without the slightest remuneration for his labour, when he was in straitened circumstances, and has, since he became rich, translated *Paradise Lost* into Welsh verse, found our Blake after the death of Joanna Southcote, one of whose four-and-twenty elders he was. Poor Owen found everything which he wished to find in the Bardic system, and there he found Blake's notions, and thus Blake and his wife were persuaded that his dreams were old patriarchal truths, long forgotten, and now re-revealed.[1] They told me this, and I, who well knew the muddy nature of Owen's head, knew what his opinion upon such a subject was worth. I came away from the visit with so sad a feeling that I never repeated it.[2]

The exhibition of his pictures, which I saw at his brother's house near Golden-square, produced a like melancholy impression. The colouring of all was as if it had consisted merely of black and red ink in all intermixture. Some of the designs were hideous, especially those which he considered as most supernatural in their conception and likenesses. In others you perceived that nothing but madness had prevented him from being the sublimest painter of this or any other country.[3] You could not have delighted in him—his madness was too evident, too fearful. It gave his eyes an expression such as you would expect to see in one who was possessed.

Whoever has had what is sometimes called the vapours, and seen faces and figures pass before his closed eyes when he is lying sleepless in bed, can very well understand how Blake saw what he painted. I am sure I can, from this experience; and from like experience can tell how sounds are heard which have had no existence but in the brain that produced them.[4]

[1] For another suggestion about Owen Pugh, see June 11th, 1810.

[2] For the chaotic chronology of this account, see below.

[3] Southey told Haydon in a letter of March 27th, 1818: 'In matters of Art I am entirely ignorant' (*Life of Benjamin Robert Haydon*, ed. T. Taylor, London, 1853, vol. i, p. 396).

[4] *The Correspondence of Robert Southey with Caroline Bowles*, ed. E. Dowden, London and Dublin, 1881, pp. 193–4. Professor Kenneth Curry, of the University of Tennessee, reported (Jan. 10th, 1960) that he had seen Southey's letters to Caroline when they were owned by Mrs. F. H. Boult, and that Dowden had apparently printed the texts fairly accurately. Unfortunately, the Southey letter above did not go to the British Museum with other Southey letters from Mrs. Boult's collection, and neither Professor Curry nor I have been able to trace either of the Southey–Bowles letters which refer to Blake.

Despite its seeming confidence and matter-of-factness, this story is extraordinarily jumbled and misremembered. Southey says he made only one visit to Blake, and according to Crabb Robinson this visit was made about June 24th, 1811. Southey says, however, that at the 1811 visit he learned what Owen Pugh had told Blake 'after the death of Joanna Southcote', which occurred in 1814. Blake's contact with Owen Pugh seems likely enough, but clearly Southey's chronology is worthless.

May 13th, 1830　　On May 13th the Philadelphia *Literary Port Folio* reprinted without acknowledgement all but the first paragraph of the Blake section of the *Athenaeum* review of Cunningham.[1]

May 21st, 1830　　On Friday, May 21st Christie's sold part of the collection of Sir Thomas Lawrence, including 'W. Blake' lots

> 234 The Five Wise and the Five Foolish Virgins, highly finished in colours
>
> 235 The Dream of Queen Catherine, from Shakespeare, same manner

The first was bought by 'Money' for £8. 15*s*. 0*d*. and the second by Kennedy for £4. 6*s*. 0*d*. Though Lawrence had originally paid £15. 15*s*. 0*d*. apiece for the drawings (see February 8th, 1827), the buyer of the first thought them dear at half the price. It was 'Purchased by me (after some competition) on 20 [*sic*] May 1830 at Christie's It was Sir Thomas's favourite drawing, and he commonly kept it on his table in his studio as a study. I paid a high price.'[2]

June 15th, 1830　　In the meanwhile Linnell had written to Barton and sent one of Blake's Dante engravings, and on Tuesday, June 15th Barton replied: 'I thank thee very cordially for Blake's illustration of a scene in Dante, and feel myself equally, if not more, thy debtor for the pretty little pastoral etching of thy own. At the risk of being thought to possess a tame and insipid taste, I must confess I prefer it to Blake's. I admire the imaginative genius

[1] Anon., 'Model of a Painter's Wife', *Literary Port Folio*, i (1830), 150. The *Athenaeum* review appeared in the number for Feb. 6th, 1830.

[2] When this copy of 'The Wise & Foolish Virgins' (now in the possession of Phillip Hofer) was exhibited at the National Gallery in 1913, A. G. B. Russell gave in the Catalogue this passage from the diary of John Poynder (1779–1849, theological writer and book collector), the grandfather of the then owner, Miss Carthew. 'Mr. Money', listed as a Blake collector in Gilchrist, 1863, vol. ii, p. 255, must have bought the picture for Poynder.

displayed in the latter, but I love the simple feeling and truth
to Nature evinced in the former.'¹ Eight years later Barton's
taste was still as timid and insipid, for he wrote to Linnell on
August 8th, 1838 of Blake's

too besetting faults, extravagance and distortion, as well as that
hardness which too frequently mars some of his most graceful ideali-
ties. . . .

I am also extremely obliged to thee for the copy of Blake's 'Job.'
I wish I were a man of more leisure, for if I were I should gladly run
up to town for the sake of giving thee a look and having some talks
about Blake—to saying nothing of the delight I should feel in seeing
some of his extraordinary drawings. Were I a rich man, I can scarce
tell what I would not give to be the possessor of one of his imaginary
portraits—I mean one of those drawn from a supposed sitter, famous
in the olden time. I forget whether he ever drew Guy Fawkes; he
would have been a good subject for him.²

In James Linnell's account book is: 'Augt 13ᵗʰ 1830 Recd by
Mʳ W: Thorn 3 Prints of Blakes Job, and the key[?] all
framed W Thorn One Glass Broke Witness to this: Ed
Chance'.³

In his Journal for Friday, September 3rd Linnell noted that
he went 'to Town, to Mr. Varley, [word illeg.], Mrs. Blake, &c'.⁴

Varley was probably the source of information for the following
dialogue by Bulwer Lytton which was first printed in the Decem-
ber *New Monthly Magazine*:

A. Of all enthusiasts, the painter Blake seems to have been the most
remarkable. With what a hearty faith he believed in his faculty of
seeing spirits and conversing with the dead! And what a delightful
vein of madness it was—with what exquisite verses it inspired him!

L. And what engravings! I saw a few days ago, a copy of the 'Night
Thoughts,' which he had illustrated in a manner at once so grotesque,
so sublime—now by so literal an interpretation, now by so vague and
disconnected a train of invention, that the whole makes one of the

[margin: August 13th, 1830]

[margin: September 3rd, 1830]

¹ A. T. Story, *The Life of John Linnell*, London, 1892, vol. i, p. 179.
² Story, vol. ii, p. 192.
³ Quoted from James Linnell's account book as above. I take this to mean that
when Linnell's frames were delivered to Thorn one glass was broken, and that
Linnell was acknowledging his responsibility. I do not know what 'the key' may
have been. Thorn does not appear in the *Job* accounts.
⁴ Quoted from John Linnell, Jr.'s transcript cited above. J.L. Jr. notes here that
John Varley was moving into Linnell's Porchester Terrace house at this time.

most astonishing and curious productions which ever balanced between the conception of genius and the ravings of positive[1] insanity.

I remember two or three [of his illustrations], but they are not the most remarkable. To these two fine lines—

> ' 'Tis greatly wise to talk with our past hours,
> And ask them what report they bore to heaven;'[2]

he has given the illustration of one sitting and with an earnest countenance conversing with a small shadowy shape at his knee, while other shapes, of a similar form and aspect, are seen gliding heavenward, each with a scroll in its hands. The effect is very solemn. Again, the line—

> 'Till death, that mighty hunter, earths them all,'

is bodied forth by a grim savage with a huge spear, cheering on fiendish and ghastly hounds, one of which has just torn down, and is griping by the throat, an unfortunate fugitive: the face of the hound is unutterably death-like.

The verse—

> 'We censure Nature for a span too short [*see Plate VII*],'

obtains an illustration, literal to ridicule.—A bearded man of gigantic statu[r]e is spanning an infant with his finger and thumb. Scarcely less literal, but more impressive, is the engraving of the following:—

> 'When Sense runs savage, broke from Reason's chain,
> And sings false peace till smother'd by the pall!' [*See Plate IX.*]

You perceive a young female savage, with long locks, wandering alone, and exulting—while above, two bodiless hands extend a mighty pall, that appears about to fall upon the unconscious rejoicer.

A. Young was fortunate. He seems almost the only poet who has had his mere metaphors illustrated and made corporeal.[3]

[1] In the first printing, from which I quote, there are very minor differences of punctuation and capitalization from the later editions. There are, however, a few verbal differences: the word 'positive' here does not appear later; the insertions in brackets [*except for plate references*] were added in later printings; and in the penultimate paragraph 'extend' was changed to 'expand'.

[2] *L.* has a remarkably good memory, for he happens to 'remember' almost word for word the starred lines on pp. 31, 70, 23, and 46 of Blake's *Night Thoughts*.

[3] [Edward Bulwer Lytton], 'Conversation with an Ambitious Student in Ill Health', *New Monthly Magazine*, xxix (1830), 518–19; reprinted as *The Student*, London, 1835, vol. ii, pp. 152–5 (two editions); *L'Etudiant*, Paris, 1835, vol. ii, pp. 159–61. An even more casual reference to Blake appears in [Bulwer Lytton's] 'A Strange Story', *All the Year Round*, vi (Jan. 18th. 1862), 368 (reprinted in *A Strange Story*, London, 1862, vol. ii, p. 168), one of the characters in which is a mad girl whose 'drawings were strange and fantastic: they had a resemblance to

Catherine had become suspicious and mistrustful of Linnell's motives, and after she moved in with him Tatham defended her position. Together Tatham and Catherine persistently claimed that the Dante drawings and plates should belong to Catherine and not to Linnell. This may be the reason for Linnell's Journal note of Monday, January 10th, 1831, saying he was occupied 'every morning & evening with tracings of Mr Blake's drawings from Dante; began them ten days back or thereabouts'.[1] The task occupied him for over a month, for he wrote in his Journal that he was making 'tracings of Dante' on January 13th, 18th, 27th, February 2nd, 7th, and 19th.

January 10th, 1831

January 13th, 18th, 27th, February 2nd, 7th, 19th, 1831

When the tracings were completed, Linnell agreed that Blake's Dante materials should be Catherine's, if his own expenses were first met. Consequently on March 9th he provided an account to make clear the position of affairs:

The sum paid by me to Mr Blake on acc^t of Dante is 103 £ & to M^rs B. 47—20 £ however I deduct for House Keeping thus leaving a clear sum of 130 £ to be paid if the Drawings are sold.

March 9th, 1831

> yours truly
> J L.

Copy Sent to F. Tatham
March 9^th 1831[2]

Assuming that everything paid to Blake simply 'on account' from December 1825 to 1827 was 'on account of Dante', Linnell recorded payment of £92. 12s. 0d. to Blake for Dante in his accounts. Either Linnell paid Blake £10. 8s. 0d. for Dante which he did not record, or his present total of £103 is too high. It seems quite possible, however, that Linnell kept a separate account for *Dante* as he did for *Job*, and that this Dante account, which has not survived, contained entries which were not transferred to his other account books.

those with which the painter Blake, himself a visionary [*i.e., in this case apparently, madman*], illustrated the Poems of the "Night Thoughts" and "The Grave."' A. T. Story (*James Holmes and John Varley*, London, 1894, p. 254) wrote that Bulwer-Lytton went to John Varley for advice about the occult. 'He and Varley worked at astrology together, and in the occult machinery of the works named [ZANONIA *and* A STRANGE STORY] Bulwer is said to have been much indebted to suggestions given to him by the artist.'

[1] This and the next reference come from G. Keynes, 'John Linnell and Mrs. Blake', *TLS*, June 20th, 1958, p. 348. I have not found the originals among the Ivimy MSS. [2] Ivimy MSS.

The whole summary is somewhat disingenuous, as the account of 'Cash paid . . . to Mrs Blake' makes clear. Linnell calculated that between September 1827 and September 1828 (the period when Catherine was living with him) he gave Catherine a total of £47. 19s. 6d. These sums, however, were not, as his letter would seem to imply, all free gifts which could therefore be counted as payments 'on acc^t of Dante'. At least £1. 5s. 0d. was for 'Proofs, &c'; 14s. was for proofs of the *Canterbury Pilgrims* (one of which Linnell sold to Samuel Boddington on March 30th, 1835 for £3. 3s. 0d.); and £1. 10s. 0d. was for 'Furniture sold'. Assuming that the other sums listed were freely given and were not in return for specific goods or services, the total to be counted for Dante and 'House Keeping' is only £44. 10s. 6d.

About the same time, perhaps the same day, Linnell wrote to Tatham explaining his financial arrangements with Blake in some detail:

*March 9th?
1831*

D^r Sir

In answer to your request respecting the sum to be refunded to me in the event of the Drawings by M^r Blake from Dante being sold I beg to say that from Dec^r 1825 to august 1827 I paid to M^r Blake in various sums (the particulars of which may be seen) 103 £ on account of the Drawings from the Poem of Dante's Inferno, Purgatorio &c the Plates & whatever else he might intend for me—with the distinct understanding as I can prove by his letters to me at the time that what he had in mind for me, was in return for the money advanced by me;[1] it was left entirely to him to do little or much as most convenient or agreeable, but what was done was considered paid for: as[,] however[,] much was done for the time he employed himself upon the Drawings[,] it is now my intention, as I have intimated[,] to dispose of the Drawings for any larger sum that may be thought proper to demand and the surplus (after my being repaid) to be handed over to M^rs Blake for whose benefit alone I disire or consent to part with the Drawings—

In addition to the sum of 103 £ p^d to Mr Blake I paid 47 to M^rs Blake for the Funeral—the rent of fountain Court &c[2] 20 of which

[1] None of the surviving letters from Blake testifies to the 'distinct understanding' which Linnell posits, though the understanding itself seems to have been clear enough.

[2] The funeral expenses for which Linnell paid in Jan. 1828 were £10. 18s. 0d., and the annual rated value of Fountain Court (of which the Blakes rented only a part) was only £25, so Linnell's '&c' must have been fairly substantial.

however I sh⁴ deduct for taking Care of House &c in Cirencester Place, leaving 130£ clear to be paid to me before the drawings are given up.

All arrangements for shewing the Drawings must be made with my Consent and anything else can be settled personally.

With sincere regards for Mʳˢ Blake

I remain Dʳ Sir
yours truly, J. Linnell.

P.S. The seven copperplates of Dante shall be given up to Mʳˢ B when the Drawings are sold.[1]

Tatham took some time to digest this information:

20 Lisson Grove North
Tuesday March 15. 1831.

Dear Sir

After a weeks consideration, it occurred to me that I ought not to withold from Mʳˢ Blake that you had made Tracings of the Dante. The more I consider of it, the more covetous & unfair it appeared to me, as it depreciates the drawings full 25 per Cent. I could not therefore allow a thing that appeared in such a light to me, (upon due reflection) to fester in my secrecy— Up to that transaction I espoused yʳ cause & frequently to my own great annoyance. Mʳˢ Blake thinks as I do upon it. She has I now recollect mentioned her suspicions to me upon several occasions but I would not hear them. I received yʳ note & mentioned to her the contents. I think it is better you should see her, or rather, she wishes you to do so. would you therefore make an early apppointment to meet her here. She wishes me to be present at the Interview.

March 15th, 1831

I remain, Dʳ Sir
yʳˢ truly
Frederick Tatham.[2]

[1] The draft of this letter is with the Ivimy MSS., where there is also another draft of the first paragraph. The context indicates the recipient. In the final copy of the letter Linnell probably added something (omitted in this rough draft) about the tracings of *Dante*, to which Tatham refers in the next letter. According to A. T. Story (*The Life of John Linnell*, London, 1892, vol. i, p. 241), 'After her husband's death Mrs. Blake sent the book containing the [DANTE] designs to Mr. Linnell with a note, saying that, as he had paid for them, they were his.' I am, however, suspicious of this statement. Not only does the note not appear to have survived, but surely, had it existed, Linnell would have referred to such a useful document in his letters to Tatham. A note from Catherine acknowledging his right to the *Dante* would have been decisive, at least in any legal sense.

[2] Ivimy MSS.

Linnell replied about the 16th:[1]

Dr Sir

March
16th,
1831 Before you had decided against me I think you might have waited until any one who was about to purchase the Dante Drawings had objected to there being any tracings by my children of them (for they are partly done by them)[.]

I consider that I am very Ill used in the whole affair and I shall feel it my duty to myself and family to consult with other friends than yourself before anything more is done respecting the Drawings. If however Mrs Blake can procure any friends who will advance what they cost me (viz 130 \pounds) I will give them up to her with the plates & she can make what she pleases of them[.] [It can never hurt her or any one else my having outlines by my Children of the subjects & nothing but prejudice could ever suggest *del.*]

[Am I therefore under those circumstances to be called to an account for assisting my children to make a tracing of any of the Drawings. I think not, nor do I think any one else but yourself and Mrs B would judge as you have *all del.*][2]

It can answer no end but to create irritation on both sides for me to meet either yourself or Mrs Blake upon the subject of the Dante. I cannot afford the time which such discussions take up or what is more the time lost through the agitation they create in the mind[.] I have endure[*d*] much already from Mrs B. & yourself upon the subject and must now decline any further personal intercourse until this affair is settled—

I will inform Mrs Blake When I hear from anyone respecting the Dante and will receive any written communication from her upon the subject[.] I have volunteered from conscientious motives to part with

[1] The date is conjecturally derived from the clarity with which the contents of this letter answer Tatham's of March 15th. Linnell's very rough draft of this letter is in the Ivimy MSS.

[2] This deleted marginal paragraph is not marked for entry, and its position is therefore conjectural.

A. H. Palmer noted (in an Exercise Book headed 'Blake Boyd Dante' [p. 32] with the Ivimy MSS.) that at this date Linnell's children were aged 13 (Hannah), 11 (Elizabeth), 10 (John), and 8 (James T.). He also remarked (p. 47) that Linnell always kept the *Dante* drawings carefully locked up, and only showed them to favoured friends (A. H. Palmer, for instance, never saw them), whereas Blake's other works, such as the *Job*, were freely shown. On the other hand, Linnell's granddaughter, Mrs. Ivimy, told me in London in 1959 that his children and grandchildren were not allowed to handle the *Vala* or *Dante* manuscripts themselves, but that they were allowed to look at them with an adult.

Further suspicion is cast upon Linnell's assertion, that his children helped in tracing the *Dante*, by the omission of any such reference in his Journal. The ninety-nine *Dante* tracings now in Yale do not seem the work of childish hands.

the Drawings upon being remunerated the price they cost me. I cannot perceive that it is my duty to submit to everything that you or M͏ͬ͘ˢ B. may impose upon me. What however was to be required of me I never yet c͏ᵈ yet learn for all the information I c͏ᵈ get from M͏ͬ͘ˢ Blake upon the subject was that M͏ͬ͘ Blake told her he was to have about two or three Guineas more for each of the copper Plates. She never even made the Drawings any subject of Complaint until I offered of my own accord to dispose of them in the above manner for her benefit —and I c͏ᵈ never obtain any definite account of what she expected or wished me to do[.] what I paid since M͏ͬ͘ Blake's death I am persuaded is fully adequate to what M͏ͬ͘ B. W͏ᵈ have thought it right for *me* to pay & more for I can prove by his letters that he considered himself paid even by what he had received himself and it was only upon that understanding with him that I ever could or would have gone on as I did advancing money to him for I never intended to be nor ever was in M͏ͬ͘ Blake's debt as he was always paid before hand for what he did for me—[1] now if I give M͏ͬ͘ B. a sum of money telling him to do what he pleases for me for it & he does for me what is worth more am I bound to pay more. Certainly not for I gave all that I could afford & it is unjust to call upon me for more under those circumstances— There are points that you & M͏ͬ͘ˢ B. seem to have lost sight of or refuse to look at[;] indeed M͏ͬ͘ˢ B. always treated the affair in an abstracted manner. She only considered that there were so many Drawings for which I had paid what She thought an inadequate price & therefore ['']I was to pay[''] became a very unfair conclusion, because whatever they were [*they were*] what M͏ͬ͘ B. had intended for me in payment for money advanced to him with the express understanding that I was not incurring a debt to him but that he was doing as little or as much as he pleased for me in return. if they had been ever so slight or few they were all I sh͏ᵈ have had for what I gave him[.]

Besides Sir the Sum paid by me for the Dante Drawings & Plates was I can prove fully, in proportion to what I had been in habit & others also of paying M͏ͬ͘ B for other Drawings which he did willingly & considered himself sufficiently paid for by me situated as I am with a large family; he did not expect me to pay him like a nobleman—he knew that it was from no covetous feeling that I laid out above 300 £ with him for which I [*have*] not received anything in return in money[2]

[1] This statement, though generally true, does not apply to Blake's engraving of Linnell's portrait of Upton: see Sept. 1818.

[2] Not counting the £27 which Linnell gave to Catherine or the £10. 8s. 0d. for *Dante* which is not in the accounts that survive, Linnell paid Blake £305. 11s. 9d. for various goods and services. He did, however, receive at least £35. 15s. 0d. 'in money' in return for the engraving Blake did on the portraits of Upton and Lowery for Linnell.

(the Job only paid the expenses of printing & paper).[1] When you have done as much for anyone you will know better how to consider the subject.

[I have therefore come to the Conclusion that the Drawings shall upon no account go out of my possession unless I am first repaid the sum of 130£ paid by me for the Drawings & Plates[.] I expect (?) that I will myself send them to Lord Egremont if he wishes to (*see them*) but it must be understood that they are to be returned to me from his Lordship unless they are Purchased by him and in that case the above sum is to be paid to me by his Lordship & the additional sum whatever it may be to Mʳˢ Blake. *Paragraph del.*]

If Lord Egremont desires it *I* will send the Drawings to his Lordship or shew them to him at my House—[any other Place for disposing of them to any other party I will arrange (?) when I hear of it *del.*] This is all I can say at present[.]

There is no doubt that Linnell was exceedingly generous to Blake, but his credit would be clearer had he not tried to whitewash it.

To protect himself and his reputation from Tatham and Mrs. Blake, Linnell probably sat down immediately[2] to write to an old friend of Blake's:

March 16th? 1831　　Mʳ J Linnell begs leave to enclose to the Earl of Egremont a work[3] by the Late Mʳ Blake, for his Lordship's inspection and will send again to know if his Lordship wishes to possess it.

Mʳ L was intimately acquainted with the Author & was his employer in the above work when he had nothing else to do. Mʳ L's means were not adequate to pay Mʳ Blake according to his merit or such a work shᵈ have placed him in moderate independence, the work however has not yet paid its expenses although highly esteemed & in the Collections of the best Judges.

Mʳ L. begs permission also to mention that he has in his possession about one hundred original Designs by Mʳ Blake on a larger scale forming a complete illustration to the whole of Dantè[.] Many are in an unfinished state but the greater part are more powerfully colorᵈ & finished than he usually did. They were Done for Mʳ L in return for monies advanced to Mʳ B. when he had no other resources. The

[1] According to Linnell's own *Job* and general accounts, he had received £176 4s. 6d. for *Job* up to Dec. 27th 1830, while the cost of 'printing & paper' for *Job* came to £124. 12s. 1d.

[2] The date comes from Linnell's letter to Tatham above, in which he says, 'I will myself send them [*i.e., the* DANTE *drawings*] to Lord Egremont'.

[3] This work is clearly *Job*.

sum however was inconsiderable compared to the value of the Draw-
ings & Mr L's object being only to relieve the necessities of his
Friend as far as he was able he is now willing to part with the Drawings
for the benefit of the widow & if he can obtain a price something more
adequate he will engage to hand the difference to Mrs Blake[.] Mr
L begs leave therefore to be allowed to shew the Drawings to Lord
Egremont & will wait upon his Lordship with them or be at Home at
any time appointed.

<div align="center">

Porchester Terrace Bayswater

6th House on the left.[1]

</div>

For advice in approaching such a lavish patron, Linnell
apparently enclosed this letter to the Royal Academician
Augustus Callcott, and Callcott replied, probably promptly:
'Dear Linnell I enclose to you a letter I have written to Lord *March*
Egremont on the subject of your wishes. As he is not in Town *18th?*
nor likely to be so & you must therefore write your note again. *1831*
I think you had better mention the sum you advanced for the
drawings and the additional sum you think them worth[.]
Yours truly [no signature] P.S. You can enclose your note with
mine in my cover.'[2] Disappointed in his hope of finding Lord
Egremont at his town house, Linnell probably wrote to his
Sussex home, enclosing the *Job* engravings and suggesting
that he would be happy to show his lordship the Dante drawings
when he next came to town. To this effort the discouraging reply
seems to have been only a brief, formal note: 'Ld Eg. regrets
not being able to call upon J L. He is going to Italy, & sends
6 gns for J L (for the *Job*)[.]'[3]

At this time Linnell apparently sent another copy of *Job* to *April?*
George Young, the brother of the amazing actor C. M. Young, *1831*
for on Wednesday, May 11th G. Young replied: 'The Book of

[1] This letter was transcribed by A. H. Palmer in an Exercise Book headed 'Blake
Boyd Dante' (p. 36), with the Ivimy MSS., and 'carefully corrected by Linnells
copy'. It was transcribed less meticulously by A. T. Story, *The Life of John Linnell*,
London, 1892, vol. i, pp. 244–5.

[2] Transcribed by A. H. Palmer in the notebook above, p. 36. Presumably the sig-
nature was cut off for an autograph collector—though Palmer showed no hesitation
in identifying the author. Palmer notes that he had not found Linnell's second letter.

[3] This note was copied by John Linnell, Jr. in the margin of his copy of Story's
Life of John Linnell beside Linnell's letter to Egremont (March 16th, 1831), and
transcribed from there by A. H. Palmer in an Exercise Book, now with the Ivimy
MSS., headed 'Blake Boyd Dante' (p. 38). (Miss Ivimy has inquired unsuccess-
fully for me among her family about annotated copies of biographies of Palmer,
Linnell, Calvert, and others of The Ancients.) I cannot explain why this £6. 6s. 0d.
was entered in Linnell's Account Books under July 24th, 1830.

Job I return as I gave away my former copy[;] accept however
my best thanks for your kind intention.'[1]

May 22nd, 1831 On Sunday, May 22nd George Darley wrote to Cunningham:
'Your Blake is the only thing better than your Flaxman, and
your Hogarth than your Nollekens.'[2]

June 1831 In June the *American Monthly Magazine* (iii, 164–71) quoted
paragraphs 1–2, 9–12, 14, 19–22, parts of 23 and 24, and all of
38, 39, 41, and 48 from Cunningham's biography of Blake to
'give one of the most singular pictures of a mind we have ever
met'. On the 21st a poem called 'A Fairy's Funeral' by 'A' and
clearly based upon Cunningham's account of the fairy funeral
Blake spoke of, was published in the *New York Mirror* (xi, 406.)

Evidently during the summer of 1831 Catherine's health was
failing, and by autumn she was sinking fast.

When told by the doctor that the severe attack of inflammation of
the bowels which had seized her and which, always self-negligent, she
had suffered to run to a height before calling in medical aid, would
terminate in mortification, she sent for her friends, Mr. and Mrs.
Tatham, and, with much composure, gave minute directions for the
performance of the last sad details; requesting, among other things,
that no one but themselves should see her after death, and that a bushel
of slaked lime should be put in the coffin, to secure her from the dis-
secting knife.[3] She then took leave of Miss Blake, and passed the re-
maining time—about five hours—calmly and cheerfully; 'repeating
texts of scripture, and calling continually to her William, as if he were
only in the next room, to say she was coming to him, and would not
be long now.' This continued nearly till the end. She died in Mrs.
Tatham's arms, at four o'clock in the morning, on or about the 18th
of October, 1831, at the age of sixty-five;[4] and was buried beside her
husband in Bunhill Fields. The remaining stock of his works, still
considerable, she bequeathed to Mr. Tatham,[5] who administered her
few effects[6]

[1] Ivimy MSS. Young had bought his copy of *Job* about April 1826.

[2] C. C. Abbbott, *The Life and Letters of George Darley Poet and Critic*, London,
1928, p. 97.

[3] Gilchrist remarks elsewhere (1942, p. 355; 1863, p. 364): 'in 1831–32, when
resurrection work [*i.e., grave robbing for medical experiments*] was so active, a
nightly guard of two watchmen had to be set on foot, and was continued till the
closing of the [*Bunhill Fields Burying*] ground.'

[4] Catherine died at 7.30 a.m., October 18th, in her 70th year.

[5] The bequest here was clearly nuncupative, and its validity was indignantly
denied by Linnell (see below).

[6] Gilchrist, 1942, p. 357; 1863, pp. 366–7. Gilchrist's account here is clearly

The next communication between Tatham and Linnell since their last sharp exchange was under very different circumstances.

<div style="text-align:right">

17 Charlton Street
Fitzroy Sq:
Tuesday Oct. 18, 1831.

</div>

Dear Sir,

October 18th, 1831

I have the unpleasant duty of informing you of the death of M^rs Blake, who passed from death to life this morning, at 1/2 past 7— After bitter pains, lasting 24 hours, she faded away as the whisper of a breeze.

M^rs Tatham & myself have been with her during her suffering & have had the happiness of beholding the departure of a saint for the rest promised to those who die in the Lord. That we all may thus be transferred from wretchedness to joy, from pain to bliss

<div style="text-align:center">

Is Sir
The sincere desire of y^r
obliged Servant
Frederick Tatham

</div>

After a night of painful anxiety & watching I write this hardly knowing whether to rejoice or tremble[.]¹

The funeral arrangements were made on October 20th for 'Catherine Sophia Blake [*age*] 65 [*to be brought from*] 17 Upper Charlton St Fitzroy Squ^e [*and buried in a grave in Bunhill Fields*] 12 ft [*E & W*] 7 [*N & S*] 31..32—[*Min^r*] 3/ [*other fees £*] 1..8..0 [*The ceremony to take place*] Sunday 3 o clock 23^d [*arranged by the undertaker*] M^r Balls Oxford Street'.¹

October 20th, 1831

There were only six mourners when she was buried on October 23rd: Mr. Bird, Mr. and Mrs. Tatham, Mr. Denham, and Mr. and Mrs. Richmond. To the first of these Tatham presented a copy of Blake's *For the Sexes: The Gates of Paradise*, with the following inscription: 'Frederick Tatham to M^r Bird

derived directly from Tatham rather than from Tatham's biography of Blake, which is here supplemented.

¹ Ivimy MSS.

² This information is transcribed from the Bunhill Fields Burying Ground Order Book in Guildhall Library. Exactly the same information is given in the Bunhill Fields Register in Somerset House, under date of Oct. 23rd, 1831, the day she was buried, except that the fee is given as £1. 5s. 0d., and the information following the fee is omitted. Conceivably the difference in cost means that as it turned out there was no minister. Tatham (p. 535) says that her age was only a guess; this explains why her age as given is wrong by four years. It will be noticed that none of the Blakes in Bunhill Fields seems to have been buried near one another.

on his attendance at the Funeral Oct 23ʳᵈ 1831 being the day on which the widow of the author was Buried in Bunhill Fields church yard'.[1]

[1] This copy of *The Gates* is now in the Huntington Library. The list of those at the funeral is given by Tatham, p. 535.

POSTSCRIPT

'GOD PROTECT ME FROM MY FRIENDS'

1831–1833

—

O God protect me from my friends that they have
not power over me[.]
Thou hast giv'n me power to protect myself from my
bitterest enemies.

(Milton, p. 7)

THERE was a bitter aftermath to Catherine's death. Blake
left no will, and all his property had naturally gone to Catherine.
Catherine also left no will, but the disposition of her little
property was not so obvious. Ordinarily it might have been
expected to go to Blake's sister Catherine, or perhaps to Linnell,
Blake's chief patron, but the widow clearly disliked both of
them, and apparently her property simply came into Tatham's
hands after her death. Tatham's view of his claims is expressed
in an undated letter he wrote to 'Sir John Soane Knt':

<div align="right">

3 Grove Terrace
Lisson Grove

</div>

Sir,
 May I take the liberty to inform you that at the demise of the
Widow of the celebrated William Blake the Engraver & Fresco
Painter . . . I became possessed of all the residue of his Works being
Drawings Sketches & Copper Plates of a very extraordinary description.
 Hearing that your Collection is deservedly celebrated I beg to say
that should you wish to add any of this very great mans productions
to it I shall be happy to offer any portion of them to you at a reasonable
rate.
There are none now for Sale nor is it likely there will be but these in
my possession[.]
 Should you wish to see any of his very beautiful Drawings I should
be happy of the honour of yr Commands for that purpose[.]—[1]

—

[1] Quoted from the unwatermarked MS. in the Sir John Soane Museum, Lon-
don. The date is between 1831, when Catherine died and Sir John was knighted,

Tatham tried to claim the Dante drawings from Linnell, and sixteen months after Catherine's death he wrote to Linnell:

> 20 Lisson Grove North
> Friday March 1. 1833

March 1st, 1833

Dear Sir

If convenient to you I will attend upon you tomorrow to come to some settlement concerning the Dante &c[.] I have no doubt we shall be able to settle it satisfactorily to both.

Any time from 2 to 4 I will be with you if it suits you—

> I am, D^r Sir,
> Y^rs truly,
> Frederick Tatham[1]

Half a century later Linnell's son John wrote that this letter 'must have been brought by W[illiam] Palmer to J. L. & he must have sent [a] verbal answer, refusing to see F. T. & asking him to write down what he wishes to say[.]'[2] Tatham therefore wrote again:

> 20 Lisson Grove North
> March 1, 1833.

March 1st, 1833

D^r Sir

It is not my intention in any way to commit myself in writing[.] Therefore if you will give me the name of your Solicitor mine shall confer with him, but upon this consideration that as you have refused to see me you must pay the costs of such arrangement[.]

> I am D^r Sir
> Y^r ob^t Ser^t
> Fred^k Tatham[3]

John Linnell, Jr. continues:

I believe to this note, also brought by hand of W. Palmer, J. L. sent *no reply*. As to subsequent verbal messages brought from F. T.

and 1837, when Sir John died; 1833, when Tatham was first confident of his claim to Blake's remains and first selling them, is a safe guess. It is remarkable that Tatham mentions neither manuscripts nor illuminated books, though he is known to have later burned the one and sold the other. Soane is not known to have owned anything by Blake, except the 1808 Blair and a coloured *Night Thoughts* (*The Portrait of John Soane, R.A.*, ed. A. T. Bolton, London, 1927; see pp. 485–6), and his reply to this letter has not been traced.

[1] Ivimy MSS.

[2] Quoted from p. 44 of John Linnell, Jr.'s 'List of John Linnell Senior's Letters' in the Ivimy MSS.

[3] Ivimy MSS.

to J. L. by W. P, J. L. said '*no answer*'[.] This I *remember myself*,— at Bayswater, seeing W. P. & hearing his mes[*sage*].— The last of these verbal messages, W. P. brought when J. L. was away from home, & Mrs. L. received it.— It was 'that if J. L. would give a statement in writing that he (J. L.) had no claim upon F. T. that F. T. would also give a similar statement to J. L, that F. T. had no claim upon J. L.'— This Mrs L told J. L. when he returned home, & he said that F. T. 'let *the cat out of the bag*' by this prob. having some surmise, from J. L.'s silence, that F. T. might be called to account about, appropriating all Mrs. Blake's effects, &c.

F. Tatham never shewed any thing in proof of his assertion, that all Mrs. Blake's property was left to himself,—he only gave his word for it.— This J. L. used to remark & it prob. caused him to disbelieve F. Tatham.[1]

The Dante drawings stayed in the Linnell family until long after his death.

In his struggle to break Tatham's hold on Blake's effects, Linnell turned to Blake's family, who might have been expected to take a proprietary interest in the family property.

Blake left no surviving blood relative, except his sister, concerning whom only the scantiest particulars are now to be gleaned. She had had in her youth, it is said, some pretensions to beauty, and even in age retained the traces of it; her eyes, in particular, being noticeably fine. She was decidely a *lady* in demeanour, though somewhat shy and proud; with precise old-maidish ways. To this may be added that she survived her brother many years, and sank latterly, it is to be feared, into extreme indigence; at which point we lose sight of her altogether. Where or when she died, I have been unable to discover.[2]

Linnell wrote in his Journal: '"Monday" 1st July 1833 To M͏ͬ Geo Stephens[,] Coleman St[,] to meet Miss Blake @ Administrating to her Brothers Effects. with M͏ͬ S & Miss B. to Proctor's &c.'[3] *July 1st, 1833*

[1] 'List of John Linnell Senior's Letters', p. 44 (Ivimy MSS.). Beside Gilchrist's statement that Catherine bequeathed the substantial remaining stock of Blake's works to Tatham, 'Linnell wrote an emphatic "No."' (A. T. Story, *The Life of John Linnell*, London, 1892, vol. i, p. 241.)

[2] Gilchrist, 1942, p. 358; 1863, p. 367.

[3] A. H. Palmer transcribed this Journal entry twice, once in an Exercise Book headed 'Job Revise (2)', p. 39, as above, and once in an Exercise Book headed 'Blake Boyd Dante', p. 39 (also in the Ivimy MSS.), as follows: '1833. May 1ˢͭ To M͏ͬ Geo Stephens to Meet Miss Blake @ Administering to her Brothers effects. With M͏ͬ S. & Miss B to Proctors &c'. The former seems the more reliable, because

They seem to have been told that there was no legal way to separate Tatham from Mrs. Blake's effects, and the next relevant

July 7th, 1833 entry in Linnell's Journal is: 'Thursday [*i.e. Sunday?*] 7. Jy. To Miss Blake Pimlico. &c'. Some three weeks later Linnell went 'Friday 26 July. To Lisson Grove to look at F. Tatham's effects on sale.' Tatham apparently actually held a 'sale' of Blake's effects, for one buyer wrote on the flyleaf of Blake's copy of Swedenborg's *Wisdom of Angels, concerning Divine Love and Divine Wisdom* (now in the British Museum): 'The Ms. notes by Blake the Artist—acc[?] sale[?] [*i.e., acquired at the sale of?*] Mʳ Tatham (an architect) a friend of Blake, from whose possession the Volume came. Jan. 1. 1839.'[1]

Tatham certainly gave out the impression that he had inherited everything, for on November 6th, 1838 J. J. G. Wilkinson wrote: 'A few days ago I was introduced by my friend Mr Elwell to a Mr. Tathans, an artist, who possesses all the drawings left by Blake.'[2] Besides drawings Tatham clearly had proofs of Blake's engravings, copies of the Illuminated Works, and Blake's copperplates,[3] from which he printed copies of *America* (1), *Europe* (1), *Jerusalem* (3) and *Songs of Innocence and of Experience* (16) about 1831 and 1832. Anne Gilchrist, who was familiar with both Tatham and Blake, summarized for W. M. Rossetti Tatham's

relations with Blake—of course it could only have been during the last year or so of Blake's life that Tatham, then a very young man, knew him. His acquaintance was mainly with Mrs. Blake when a widow. And it is inexplicable, and take it how you will, an ugly circumstance that while Miss Blake, the sole surviving relative and natural heiress to what was left of Blake's possessions after the widow's death—while Miss Blake I say, lived in such penury, such absolute want, that I have heard a rumour she died of her own hand rather than continue in life on such terms of misery—Tatham came into posses-

July 1st, 1833 *was* a Monday whereas May 1st was a Wednesday, and because the events of July 7th and 26th form a clear sequel.

'Mʳ S' was probably the 'George Stephen' who had written to Linnell on Jan. 21st, 1829. A proctor is an officer of the Crown who acts in cases of nullity when collusion or irregularity is alleged.

[1] I take the date to be that of the note rather than that of the purchase.
[2] C. J. Wilkinson, *James John Garth Wilkinson*, London, 1911, p. 29.
[3] G Keynes ('Blake's Copper Plates', *TLS*, Jan. 24th, 1942, p. 48) estimates that Blake made at least 363 plates of his own works. Of these, only one fragment has survived, together with electrotypes of sixteen plates for the *Songs*.

sion[1] of so large a stock of Designs and engraved Books, that he has, by his own confession, been selling them 'for thirty years' and at 'good prices.' It is quite possible that Mrs. Blake may have bequeathed them to him however—for she and Miss Blake got on very ill together; and latterly never met at all.[2] Even this, however, would not wholly acquit Tatham, I think.

There was another matter of which it is more difficult to get at the rights:—Linnell, as I dare say you know, during the last few years of Blake's life when nearly all other buyers failed him, took all Blake did (though himself a struggling man then, with large family) at fair though not high prices, paid in the most convenient way to Blake— so much a week. After his death Linnell fetched away the Dante Drawings as his own, having been paid for in this way. But Mrs. Blake— who appears to have always much disliked Linnell—said that a considerable sum was still due on them; which Tatham claimed in her behalf (and afterwards on his own): hence arose a quarrel; and Tatham and Linnell have never spoken since. Now my Husband, who had sifted the matter, and knew both parties, thought Linnell an upright truthful, if somewhat hard man, and that towards Blake his conduct had been throughout admirable. He also inclined to think, that Mrs. Blake retained one trait of an uneducated mind—an unreasonable suspiciousness. But Tatham would of course be disposed to give an entirely different account of the affair. You know I believe the reason he assigns for the destruction of the manuscripts?[3] Tatham was at that

[1] Tatham himself later wrote (see Jan. 1791) 'of the possessions into which I came by legacy from Mrs. Blake'. He seems to have been overstating his clear moral right as if it were an official one. 'Legacy' in the normal sense is too strong and explicit a word here. Catherine's will was presumably nuncupative, and the witnesses of her oral statement were never called forward to make affidavits of it. Surely Linnell's consultation of lawyers of July 1st, 1833 established Tatham's clear presumptive right to Mrs. Blake's effects, and Linnell did not think it worth while to take the matter further.

[2] They met when Catherine was dying; see under June 1831.

[3] Previously in this letter Mrs. Gilchrist wrote: 'He is the actual Tatham who knew Blake and enacted the holocaust of Blake manuscripts—not designs, I think, as I have heard from his own lips.' Edward Calvert's son wrote (*A Memoir of Edward Calvert Artist*, London, 1893, p. 59) that Calvert, fearing such a holocaust, had gone 'to Tatham and implored him to reconsider the matter, and spare "the good man's precious work;" notwithstanding which, blocks, plates, drawings, and MSS., I understand, were destroyed.' The evidence is further confused by Richard Garnett's contradictory reports that when Garnett saw Tatham about 1860 Tatham 'sought to convey that they [relics of Blake] had been sold, not destroyed' (R. Garnett, *William Blake Painter and Poet*, London and N.Y., 1895, p. 71), and that at the same time 'Tatham had said, without giving any explanation, that he had destroyed some of Blake's manuscripts and kept others by him, which he had sold from time to time' (A. Symons, *William Blake*, 1907, pp. 240–1). It seems quite clear that Tatham destroyed enormous amounts of material, for Cunningham (pp. 506–7)

time a zealous Irvingite and says he was instigated to it by some very influential members of the Sect on the ground that Blake was inspired; but quite from a wrong quarter—by Satan himself—and was to be cast out as an 'unclean spirit.' Carlyle says he is quite certain Irving himself never had anything at all to do with this.[1]

Clearly, even among his dearest friends, Blake was, as Cromek had said in 1807, '*the voice of one crying in the wilderness!*'

said Blake 'left volumes of verse, amounting, it is said, to nearly an hundred, prepared for the press', and Blake told Crabb Robinson (Feb. 18th, 1826) that he had 'written more than Voltaire or Rousseau—Six or Seven Epic poems as long as Homer and 20 Tragedies as long as Macbeth'. Nothing remotely like this quantity has survived, and there is no reason to exculpate Tatham. The destruction probably consisted largely of Prophecies—it is remarkable that even in 1831–2 Tatham did not print the Prophecies which attack conventional morality and religion most explicitly (*Visions of the Daughters of Albion, The Marriage of Heaven and Hell, Urizen*). Tatham's authenticating signature on many surviving drawings indicates that he thought these were less Satanic—or perhaps more saleable.

[1] *Anne Gilchrist: Her Life and Writings*, ed. H. H. Gilchrist, London, 1887, pp. 129–31.

APPENDIX

―――――

SECTION I. EARLY ESSAYS ON BLAKE

SECTION II. BLAKE RESIDENCES

SECTION III. BLAKE ACCOUNTS

SECTION IV. ENGRAVINGS BY AND AFTER BLAKE

SECTION I

EARLY ESSAYS ON BLAKE

A

BENJAMIN HEATH MALKIN

(from *A Father's Memoirs of His Child*, 1806)

Malkin's biographical and critical essay on Blake was printed as the intro-
ductory letter, dated 4 January 1806, to Thomas Johnes in Malkin's
A Father's Memoirs of His Child, London, 1806, pp. xvii–xli. The factual
parts of the essay are careful, reliable, and original, and were apparently
derived from Blake himself.
The introductory letter links, in passing, the genius of Malkin's son
with that of Blake.

I AM confident that you, and my other readers of taste and feeling,
will readily forgive my travelling a little out of the record, for the
purpose of descanting on merit, which ought to be more conspicuous,
and which must have become so long since, but for opinions and habits
of an eccentric kind.

It is, I hope, unnecessary to call your attention to the ornamental
device, round the portrait in this book; but I cannot so easily refrain
from introducing you to the designer.

Mr. William Blake, very early in life, had the ordinary opportuni-
ties of seeing pictures in the houses of noblemen and gentlemen, and
in the king's palaces.[1] He soon improved such casual occasions of study,
by attending sales at Langford's, Christie's, and other auction-rooms.

[1] These 'ordinary opportunities' were probably never very extensive. The
difficulties of seeing the collections of the rich were notorious: 'The fawning,
cringing addresses to those who have it in their power to show them, together with
their gaping expectations of what you will give them, is very disagreeable; and
what is still worse, if you do not satisfy them according to their liking it is ten to
one but you are insulted.' (Quoted by W. T. Whitley, *Artists and their Friends in
England, 1700–1799*, London, 1928, vol. i, p. 167. The source is given merely as
'a newspaper in 1764'.) According to the Anonymous *English Connoisseur*, London,
1766, vol. i, p. viii, though 'many of the collections of the great, are ever open to
the inspection of the curious . . . it must be lamented that some are not accessible
without difficulty and interest.'

At ten years of age he was put to Mr. Pars's drawing-school in the Strand, where he soon attained the art of drawing from casts in plaster of the various antiques. His father bought for him the Gladiator, the Hercules, the Venus of Medicis, and various heads, hands, and feet. The same indulgent parent soon supplied him with money to buy prints; when he immediately began his collection, frequenting the shops of the print-dealers, and the sales of the auctioneers. Langford called him his little connoisseur; and often knocked down to him a cheap lot, with friendly precipitation. He copied Raphael and Michael Angelo, Martin Hemskerck and Albert Durer, Julio Romano, and the rest of the historic class, neglecting to buy any other prints, however celebrated. His choice was for the most part contemned by his youthful companions, who were accustomed to laugh at what they called his mechanical taste. At the age of fourteen, he fixed on the engraver of Stuart's Athens and West's Pylades and Orestes[1] for his master, to whom he served seven years apprenticeship. Basire, whose taste was like his own, approved of what he did. Two years passed over smoothly enough, till two other apprentices were added to the establishment,[2] who completely destroyed its harmony. Blake, not chusing to take part with his master against his fellow apprentices, was sent out to make drawings. This circumstance he always mentions with gratitude to Basire, who said that he was too simple and they too cunning.

He was employed in making drawings from old buildings and monuments, and occasionally, especially in winter, in engraving from those drawings. This occupation led him to an acquaintance with those neglected works of art, called Gothic monuments. There he found a treasure, which he knew how to value. He saw the simple and plain road to the style of art at which he aimed, unentangled in the intricate windings of modern practice. The monuments of Kings and Queens in Westminster Abbey, which surround the chapel of Edward the Confessor, particularly that of King Henry the Third, the beautiful monument and figure of Queen Elinor, Queen Philippa, King Edward the Third, King Richard the Second [*see Plates XLIX–L*] and his Queen,[3] were among his first studies. All these he drew in every point he could catch, frequently standing on the monument, and viewing the figures from the top. The heads he considered as portraits; and all the

[1] Benjamin West's 'Pylades and Orestes' was first exhibited in 1766.

[2] Only during the last nine weeks of his term under Basire did Blake have two fellow apprentices (see under Aug. 4th, 1772). If quarrels took place among Basire's apprentices, they were clearly between Blake and Parker. The third boy working with Basire may have been one of Basire's sons who was not yet formally apprenticed.

[3] The engravings of these subjects (signed by Basire) appear in the order given by Malkin in [Richard Gough], *Sepulchral Monuments in Great Britain*, vol. i, London, 1786 and 1796.

PLATE XLIX

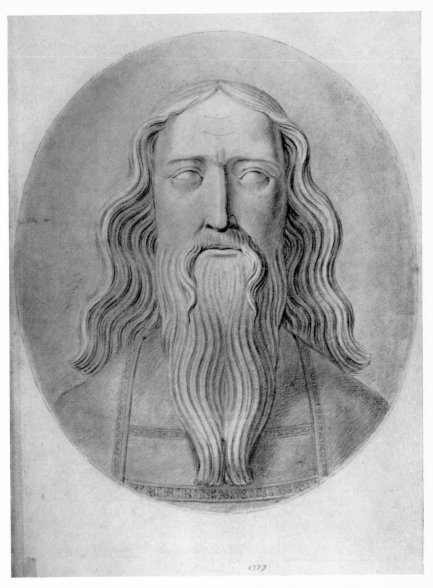

1777

BLAKE'S APPRENTICE DRAWING OF EDWARD III (*c.* 1778), drawn from the monument in Westminster Abbey for Basire to be engraved for Gough's *Sepulchral Monuments in Great Britain* (1786) (see p. 422)

PLATE L

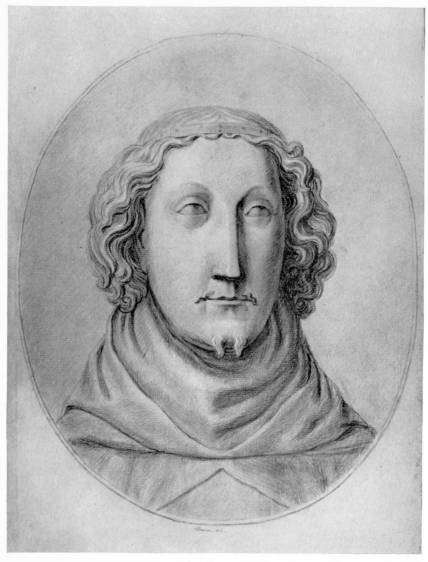

BLAKE'S APPRENTICE DRAWING OF RICHARD II (*c.* 1788) made in the
Abbey for Basire on commission from Gough. Malkin (p. 422) is the authority for attributing
these drawings to Blake

ornaments appeared as miracles of art, to his Gothicised imagination. He then drew Aymer de Valence's monument, with his fine figure on the top. Those exquisite little figures which surround it, though dreadfully mutilated, are still models for the study of drapery. But I do not mean to enumerate all his drawings, since they would lead me over all the old monuments in Westminster Abbey, as well as over other churches in and about London.[1]

Such was his employment at Basire's. As soon as he was out of his time, he began to engrave two designs from the History of England, after drawings which he had made in the holiday hours of his apprenticeship.[2] They were selected from a great number of historical compositions, the fruits of his fancy. He continued making designs for his own amusement, whenever he could steal a moment from the routine of business; and began a course of study at the Royal Academy, under the eye of Mr. Moser.[3] Here he drew with great care, perhaps all, or certainly nearly all the noble antique figures in various views. But now his peculiar notions began to intercept him in his career. He professes drawing from life always to have been hateful to him; and speaks of it as looking more like death, or smelling of mortality. Yet still he drew a good deal from life, both at the academy and at home. In

[1] It seems likely that Blake helped Basire with many commissions from Gough and the Royal Society of Antiquaries in and near London, though the only positive evidence to this effect is in Malkin. For instance, in 1775 a painting, twenty-five feet long, representing a siege of a port, was discovered in The Rose Tavern, just without Temple Bar. 'A Drawing thereof was taken by Mʳ Basire, at Mʳ Gough's Expense, & Shewn to the Society [*of Antiquaries*] the 9ᵗʰ May 1776.' (This note is from the minute book of the Society [in Burlington House, London] for 1775, pp. 248–9.) As one of Basire's two apprentices at the time, Blake almost certainly helped to record this enormous painting.

Gough also sent Basire and other artists all over England to record ancient monuments, and they sent back descriptions as well as drawings of what they found. Beside the passage in his book (Part i, p. xciii) in which 'Geraldus' account of the finding of ARTHUR's body' is given, Gough wrote in his proof copy: 'Blake at George inn Glastenb. pretended to have one of planks of Arthur's coffin.' (Gough Prints 221, Bodleian Library. There was a 'George Inn' at Glastonbury, at which the local abbot used to entertain pilgrims, and many relics were preserved there.) Despite the poet's enthusiasm for Arthurian legend, however, this 'Blake' is probably a resident of Glastonbury and an employee of the George Inn.

[2] Blake's 'Prospectus' of Oct. 10th, 1793 mentions 'two large highly finished engravings (and two more are nearly ready) which will commence a Series of subjects from the Bible, and another from the History of England', and these are clearly separate from 'The History of England, a small book of Engravings. Price 3s.' which was 'now published'. One of the large engravings was probably 'Edward & Elinor', though it was not published until Aug. 18th, 1793. The other might be 'The Penance of Jane Shore', which Blake said in his *Descriptive Catalogue* of 1809 'was done above Thirty Years ago'.

[3] Blake became a student of the Royal Academy on Oct. 18th, 1779, when Moser was Keeper for all the students.

this manner has he managed his talents, till he is himself almost become a Gothic monument. On a view of his whole life, he still thinks himself authorized to pronounce, that practice and opportunity very soon teach the language of art: but its spirit and poetry, which are seated in the imagination alone, never can be taught; and these make an artist.

Mr. Blake has long been known to the order of men among whom he ranks; and is highly esteemed by those, who can distinguish excellence under the disguise of singularity. Enthusiastic and high flown notions on the subject of religion have hitherto, as they usually do, prevented his general reception, as a son of taste and of the muses. The sceptic and the rational believer, uniting their forces against the visionary, pursue and scare a warm and brilliant imagination, with the hue and cry of madness. Not contented with bringing down the reasonings of the mystical philosopher, as they well may, to this degraded level, they apply the test of cold calculation and mathematical proof to departments of the mind, which are privileged to appeal from so narrow and rigorous a tribunal. They criticise the representations of corporeal beauty, and the allegoric emblems of mental perfections; the image of the visible world, which appeals to the senses for a testimony to its truth, or the type of futurity and the immortal soul, which identifies itself with our hopes and with our hearts, as if they were syllogisms or theorems, demonstrable propositions or consecutive corollaries. By them have the higher powers of this artist been kept from public notice, and his genius tied down, as far as possible, to the mechanical department of his profession. By them, in short, has he been stigmatised as an engraver, who might do tolerably well, if he was not mad. But men, whose names will bear them out, in what they affirm, have now taken up his cause. On occasion of Mr. Blake engaging to illustrate the poem of The Grave, some of the first artists in this country have stept forward, and liberally given the sanction of ardent and encomiastic applause. Mr. Fuseli, with a mind far superior to that jealousy above described, has written some introductory remarks in the Prospectus of the work. To these he has lent all the penetration of his understanding, with all the energy and descriptive power characteristic of his style. Mr. Hope and Mr. Locke have pledged their character as connoisseurs, by approving and patronising these designs. Had I been furnished with an opportunity of shewing them to you, I should, on Mr. Blake's behalf, have requested your concurring testimony, which you would not have refused me, had you viewed them in the same light.[1]

[1] See Nov. 1805. 'Thomas Johnes, Esq., M.P., Hafod' did in fact subscribe to *The Grave*.

Neither is the capacity of this untutored proficient limited to his professional occupation. He has made several irregular and unfinished attempts at poetry. He has dared to venture on the ancient simplicity; and feeling it in his own character and manners, has succeeded better than those, who have only seen it through a glass. His genius in this line assimilates more with the bold and careless freedom, peculiar to our writers at the latter end of the sixteenth, and former part of the seventeenth century, than with the polished phraseology, and just, but subdued thought of the eighteenth.[1] As the public have hitherto had no opportunity of passing sentence on his poetical powers, I shall trespass on your patience, while I introduce a few specimens from a collection, circulated only among the author's friends,[2] and richly embellished by his pencil.

LAUGHING SONG.

When the green woods laugh with the voice of joy,
And the dimpling stream runs laughing by,
When the air does laugh with our merry wit,
And the green hill laughs with the noise of it,

When the meadows laugh with lively green,
And the grasshopper laughs in this merry scene,[3]
When Mary and Susan and Emily,
With their sweet round mouths, sing Ha, ha, he!

When the painted birds laugh in the shade,
Where our table with cherries and nuts is spread,
Come live and be merry and join with me,
To sing the sweet chorus of Ha, ha, he!

The Fairy Glee of Oberon, which Stevens's exquisite music has familiarised to modern ears,[4] will immediately occur to the reader of these laughing stanzas. We may also trace another less obvious resemblance to Jonson, in an ode gratulatory to the Right Honourable Hierome, Lord Weston, for his return from his embassy, in the year

[1] M. R. Lowery, *Windows of the Morning*, New Haven and London, 1940, effectively asserted for the first time that Blake's major poetic sources were in the eighteenth century, though the importance of Malkin's earlier influence is acknowledged.

[2] There is no reason to think that *Songs of Innocence* was not sold to whoever wanted it.

[3] 'the merry scene'. The 'Laughing Song' is from *Songs of Innocence*, as are 'Holy Thursday' and 'The Divine Image' below.

[4] Richard John Samuel Stevens (1757–1837) set the lovely glee 'From Oberon in Fairy Land', evidently one of the songs from Jonson's *Oberon the Faery Prince*.

1632.[1] The accord is to be found, not in the words nor in the subject; for either would betray imitation: but in the style of thought, and, if I may so term it, the date of the expression.

> Such pleasure as the teeming earth
> Doth take in easy nature's birth,
> When she puts forth the life of every thing:
> And in a dew of sweetest rain,
> She lies delivered without pain,
> Of the prime beauty of the year, the spring.

> The rivers in their shores do run,
> The clouds rack clear before the sun,
> The rudest winds obey the calmest air:
> Rare plants from every bank do rise,
> And every plant the sense surprise,
> Because the order of the whole is fair!

> The very verdure of her nest,
> Wherein she sits so richly drest,
> As all the wealth of season there was spread;
> Doth show the graces and the hours
> Have multiplied their arts and powers,
> In making soft her aromatic bed.

> Such joys, such sweets, doth your return
> Bring all your friends, fair lord, that burn
> With love, to hear your modesty relate
> The bus'ness of your blooming wit,
> With all the fruit shall follow it,
> Both to the honour of the king and state.

The following poem of Blake is in a different character. It expresses with majesty and pathos, the feelings of a benevolent mind, on being present at a sublime display of national munificence and charity.

HOLY THURSDAY. [*See p. 254.*] . . .

The book of Revelation, which may well be supposed to engross much of Mr. Blake's study, seems to have directed him, in common with Milton, to some of the foregoing images. 'And I heard as it were the voice of a great multitude, and as the voice of many waters, and as the voice of mighty thunderings, saying, Alleluia: for the Lord God

[1] Jonson's poem, 'To the Right Honourable Hierome Lord Weston, an Ode Gratulatory, for his Return from his Embassy MDCXXXII', is given from his *Underwoods*, and has five stanzas in the original.

omnipotent reigneth.'[1] Milton comprises the mighty thunderings in the epithet 'loud,' and adopts the comparison of many waters, which image our poet, having in the first stanza appropriated differently, to their flow rather than to their sound, exchanges in the last for that of a mighty wind.

> He ended; and the heav'nly audience loud
> Sung hallelujah, as the sound of seas,
> Through multitude that sung.
>
> PARADISE LOST, Book x. 641.

It may be worth a moment's consideration, whether Dr. Johnson's remarks on devotional poetry, though strictly just where he applies them, to the artificial compositions of Waller and Watts, are universally and necessarily true. Watts seldom rose above the level of a mere versifier. Waller, though entitled to the higher appellation of poet, had formed himself rather to elegance and delicacy, than to passionate emotions or a lofty and dignified deportment. The devotional pieces of the Hebrew bards are clothed in that simple language, to which Johnson with justice ascribes the character of sublimity. There is no reason therefore, why the poets of other nations should not be equally successful, if they think with the same purity, and express themselves in the same unaffected terms. He says indeed with truth, that 'Repentance trembling in the presence of the judge, is not at leisure for cadences and epithets.'[2] But though we should exclude the severer topics from our catalogue, mercy and benevolence may be treated poetically, because they are in unison with the mild spirit of poetry. They are seldom treated successfully; but the fault is not in the subject. The mind of the poet is too often at leisure for the mechanical prettinesses of cadence and epithet, when it ought to be engrossed by higher thoughts. Words and numbers present themselves unbidden, when the soul is inspired by sentiment, elevated by enthusiasm, or ravished by devotion. I leave it to the reader to determine, whether the following stanzas have any tendency to vindicate this species of poetry; and whether their simplicity and sentiment at all make amends for their inartificial and unassuming construction.

THE DIVINE IMAGE.

> To Mercy, Pity, Peace, and Love,
> All pray in their distress,
> And to these virtues of delight
> Return their thankfulness.

[1] Revelation xix. 6; cf. xiv. 2.

[2] This quotation is taken from the end of Johnson's essay on Waller in the *Lives of the Poets*.

For Mercy, Pity, Peace, and Love,
Is God our Father dear:
And Mercy, Pity, Peace, and Love,
Is man, his child and care.

For Mercy has a human heart;
Pity, a human face;
And Love, the human form divine,
And Peace, the human dress.

Then every man, of every clime,
That prays in his distress,
Prays to the human form divine,
Love, Mercy, Pity, Peace.

And all must love the human form,
In Heathen, Turk, or Jew!
Where Mercy, Love, and Pity dwell,
There God is dwelling too.

Shakspeare's Venus and Adonis, Tarquin and Lucrece, and his Sonnets, occasioned it to be said by a contemporary, that, 'As the soul of Euphorbus was thought to live in Pythagoras, so the sweet witty soul of Ovid lives in mellifluous honey-tongued Shakspeare.'[1] These poems, now little read, were favourite studies of Mr. Blake's early days. So were Jonson's Underwoods and Miscellanies, and he seems to me to have caught his manner, more than that of Shakspeare in his trifles. The following song is a good deal in the spirit of the Hue and Cry after Cupid, in the Masque on Lord Haddington's marriage. It was written before the age of fourteen, in the heat of youthful fancy, unchastised by judgment. The poet, as such, takes the very strong liberty of equipping himself with wings, and thus appropriates his metaphorical costume to his corporeal fashion and seeming. The conceit is not unclassical; but Pindar and the ancient lyrics arrogated to themselves the bodies of swans for their august residence. Our Gothic songster is content to be encaged by Cupid; and submits, like a young lady's favourite, to all the vagaries of giddy curiosity and tormenting fondness.

How sweet I roamed from field to field,
And tasted all the summer's pride,
Till I the prince of love beheld,
Who in the sunny beams did glide!

[1] This quotation comes originally from Francis Meres, *Palladis Tamia*, London, 1598 (Gerald Eades Bentley, *Shakespeare, A Biographical Handbook*, New Haven, 1961, pp. 153, 226).

He shewed me lilies for my hair,
 And blushing roses for my brow;
He led me through his gardens fair,
 Where all his golden pleasures grow.

With sweet May dews my wings were wet,
 And Phoebus fired my vocal rage;
He caught me in his silken net,
 And shut me in his golden cage.

He loves to sit and hear me sing,
 Then, laughing, sports and plays with me;
Then stretches out my golden wing,
 And mocks my loss of liberty.[1]

The playful character ascribed to the prince of love, and especially his wanton and fantastic action while sporting with his captive, in the two last stanzas, render it probable that the author had read the Hue and Cry after Cupid. If so, it had made its impression; but the lines could scarcely have been remembered at the time of writing, or the resemblance would have been closer. The stanzas, to which I especially allude, are these.

Wings he hath, which though ye clip,
 He will leap from lip to lip,
 Over liver, lights, and heart,
 But not stay in any part;
 And, if chance his arrow misses,
 He will shoot himself, in kisses.

Idle minutes are his reign;
 Then the straggler makes his gain,
 By presenting maids with toys,
 And would have ye think 'em joys:
 'Tis th'ambition of the elf,
 To have all childish as himself.

The two following little pieces are added, as well by way of contrast, as for the sake of their respective merits. In the first, there is a simple and pastoral gaiety, which the poets of a refined age have generally found much more difficult of attainment, than the glitter of wit, or the affectation of antithesis. The second rises with the subject. It wears that garb of grandeur, which the idea of creation communicates to a mind of the higher order. Our bard, having brought the topic he descants on from warmer latitudes than his own, is justified in adopting an imagery, of almost oriental feature and complection.

[1] This and the next 'Song' are from the *Poetical Sketches*.

SONG.

I love the jocund dance,
The softly breathing song,
Where innocent eyes do glance,
 And where lisps the maiden's tongue.

I love the laughing gale,
I love the echoing hill,
Where mirth does never fail,
 And the jolly swain laughs his fill.

I love the peasant cot,
I love the innocent bower,
Where white and brown is our lot,
 Or fruit in the mid-day hour.

I love the oaken seat,
Beneath the oaken tree,
Where all the old villagers meet,
 And laugh our sports to see.

I love our neighbours all,
But, Kitty, I better love thee;
And love them I ever shall;
 But thou art all to me.[1]

THE TIGER.

Tiger, Tiger, burning bright,
In the forest of the night!
What immortal hand or eye
Could frame thy fearful symmetry?

[1] In a book (now in Dove Cottage, Grasmere) which begins 'Wm Wordsworth Grasmere Janry 1800' and ends with part of a letter dated June 5th, 1808, 'Holy Thursday', 'Laughing Song', 'The Tyger', and 'I Love the Jocund Dance' were copied out from Malkin by Dorothy and William Wordsworth, with other extracts from books 'which presumably they did not possess then' (M. Moorman, 'Wordsworth's Commonplace Book', *N & Q*, ccii [1957], 401–3). In July 1959 Professor Stephen M. Parrish very kindly transcribed the four poems from the MS. for me (with the exception of parts of stanzas two and three of 'Laughing Song', which proved indecipherable). Except for punctuation and tiny spelling variants (e.g. 'seem'd' for 'seemed'), the first two poems are identical in Blake, Malkin, and Wordsworth. There are a few careless readings in 'The Tyger' not found in either Blake or Malkin. (In stanzas 1 and 6 'forest' is twice plural in Blake, first singular and then plural in Malkin, and twice singular in Wordsworth; in stanza 3 Blake wrote 'And when thy heart', Malkin printed 'When the heart', and Wordsworth wrote 'When thy heart'; in the last line Wordsworth has 'Did' for the 'Dare' of Malkin and Blake.) All other variants, however, follow Malkin and not Blake: in lines 12 and 16 of 'The Tyger' Wordsworth has 'forged thy' and 'Dared' with Malkin, not '& what' and 'Dare' with Blake; and in line 5 of 'I Love the Jocund Dance' Wordsworth repeats Malkin's misprint of 'gale' for 'vale'.

In what distant deeps or skies,
Burnt the fire of thine eyes?
On what wings dare he aspire?
What the hand dare seize the fire?

And what shoulder, and what art,
Could twist the sinews of thy heart?
When thy heart began to beat,
What dread hand forged thy dread feet?[1]

What the hammer? What the chain?
In what furnace was thy brain?
What the anvil? What dread grasp
Dared its deadly terrors clasp?

When the stars threw down their spears,
And watered heaven with their tears,
Did he smile his work to see?
Did he, who made the lamb, make thee?

Tiger, tiger, burning bright,
In the forests of the night;
What immortal hand or eye
Dare frame thy fearful symmetry?

Besides these lyric compositions, Mr. Blake has given several specimens of blank verse.[2] Here, as might be expected, his personifications are bold, his thoughts original, and his style of writing altogether epic in its structure. The unrestrained measure, however, which should warn the poet to restrain himself, has not unfrequently betrayed him into so wild a pursuit of fancy, as to leave harmony unregarded, and to pass the line prescribed by criticism to the career of imagination.

But I have been leading you beside our subject, into a labyrinth of poetical comment, with as little method or ceremony, as if we were to have no witness of our correspondence. It is time we should return from the masquing regions of poetry, to the business with which we set out. . . .

[1] Normally this line is 'What dread hand? & what dread feet?'. In copy P, however, it is altered as in Malkin, except that the verb is 'Formd'. In his copy of Malkin, Beckford wrote: 'Some splendid specimens from that treasury of Non-sense. Mr. Blake the mad draughtsman's poetical compositions: "Tiger, Tiger burning bright, In the forest of the night, etc." Surely the receiver and disseminator of such trash is as bad as the thief who seems to have stolen them from the walls of Bedlam.' (F. Rosebery, 'Books from Beckford's Library now at Barnbougle', *Book Collector*, xiv [1965], 327.)

[2] Apparently 'King Edward the Third' and 'Fourth'.

B

HENRY CRABB ROBINSON

ESSAY ON BLAKE

(from *Vaterländisches Museum*, 1811)

Crabb Robinson's unsigned essay was printed in *Vaterländisches Museum*, i (January 1811), 107–31. There can be no doubt about who wrote it, for in his 'Reminiscences' for 1810 Robinson noted that he had compiled an account of Blake for what he called *Vaterländische Annalen*, which 'was translated by Dr. [*Nikolaus Heinrich*] Julius'. Robinson himself wrote that the essay 'has nothing in it of the least value' (p. 537), but this judgement is too severe. Much of the essay is devoted to quotations from Blake or to echoes from Malkin, but there are a number of biographical details of the first importance. Robinson's references to the value Edwards placed upon Blake's *Night Thoughts* drawings and to the invitation to Blake to join the Swedenborgians under Proud, for instance, are probable and are not mentioned by any other early writer on Blake.

In the German text below, I have made no attempt to reproduce the varieties of type, nor vagaries such as upside-down letters, with which the text is generously sprinkled. The translation of the text that follows is adapted from that of K. A. Esdaile, 'An Early Appreciation of William Blake', *The Library*, 3rd series, v (1914), 236–56.

WILLIAM BLAKE,

KÜNSTLER, DICHTER, UND RELIGIÖSER SCHWÄRMER.

The lunatic, the lover, and the poet,
Are of imagination all compact.

SHAKESPEARE.

Unter allen den Gegenständen, welche den philosophischen Seelen-forscher zu reizen vermögen, giebt es gewiss keinen anlockenderen, als die Vereinigung von Genie und Wahnwitz in einzelnen merkwür-digen Gemüthern, welche, indem sie auf der einen Seite unsere Hochachtung durch ausgezeichnete Geistesfähigkeiten erzwingen, auf der anderen durch Ansprüche auf übernatürliche Kräfte wieder unser Mitleiden erregen. Von dieser Art ist nun das ganze Geschlecht von Verzückten, Mystikern, Sehern von Gesichten und Träumern von Träumen, deren Verzeichniss wir einen neuen Namen, William Blake, beyzufügen haben.

Dieser ausserordentliche Mensch, welcher gegenwärtig in London lbet, beginnt, obgleich schon mehr als fünfzig [*sic*] Jahre alt, erst jetzt

aus der Dunkelheit hervorzutreten, auf welche ihn die seltsame Richtung seiner Talente, und das Wunderliche seines persönlichen Charakters beschränkt hatten. Wir wissen zu wenig von seiner Geschichte, um Anspruch auf eine vollständige Beschreibung seines Lebens zu machen, zu der wir nur aus sehr neuen Quellen Belege schöpfen konnten. Vorläufig genüge uns, zu wissen, dass er, zu London von nicht sehr wohlhabenden Eltern geboren, früh seiner eigenen Leitung oder Missleitung überlassen ward. Im zenten Jahre kam er in eine Zeichenschule, im vierzehnten zu einem Kupferstecher, Namens Basire, der vorzüglich durch Stuarts Beschreibung von Athen, und durch West's Orestes und Pylades bekannt ist. Schon als Knabe zeichnete sich Blake durch die Sonderbarkeit seines Geschmacks aus. Leidenschaftlich für die gothische Baukunst eingenommen, brachte er Tage lang damit zu, die Denkmäler der Westminster-Abbey abzuzeichnen. Nebenher sammelte er Kupferstiche, vorzüglich nach Raphael und Michel Angelo, und vergötterte Albrechte Dürer und Heemskerk.[1]

Obgleich er nachher auf der königlichen Akademie studirte, hatte er seine Richtung doch schon einmal auf eine so eigene Art genommen, dass er, von seinen Mitschülern isolirt, aller gewöhnlichen regelmässigen Beschäftigung entwöhnt ward. Man findet desshalb seinen Namen nur unter sehr geringen Platten zu Kinderbüchern;[2] indem er aber Ansichten von der Kunst hegte, die dem Geschmack der Kunstbeschützer völlig entgegen standen, und die neueren Moden sowehl im Zeichnen als Kupferstechen als Versündigungen an der Kunst betrachtete, zog er nach seinem eigenen Ausdrucke vor, lieber ein 'Märtyrer' seiner Religion,[3] d.h. seiner Kunst zu werden, als seine Talente durch eine feige Nachgiebigkeit gegen die Ausübung der Kunst, in einem verderbten Zeitalter derselben, herabzuwürdigen. Da nun ausserdem seine religiösen Ueberzeugungen ihm den Ruf eines vollendeten Tollhäuslers zuwege gebrachte hatten, bleibt es kaum zu verwundern, dass, während Kenner von Profession nichts von ihm wissen, selbst seine Gönner nicht umhin können, neben ihrer Bewunderung für ihn, auch ihr Mitleiden zu äussern. In der That gelang bis jetzt erst ein Versuch, ihn bey dem grössern britischen Publikum einzuführen, durch seine Zeichnungen zu Blair's Grab, einem bey ernsten Gemüthern sehr beliebten, religiösen Gedicht, welches die Kunstrichter, in

[1] All the information in this paragraph comes from Malkin, pp. 422–3.

[2] This might refer to Hayley's *Designs to A Series of Ballads*, 1802; to the new edition of 1805 called simply *Ballads*; to Mary Wollstonecraft's *Original Stories from Real Life*, 1791 and 1796; or perhaps to Blake's own *For Children: The Gates of Paradise*, 1793.

[3] This does not sound like Blake's own expression. Since Robinson had not met Blake at this time, it is likely that the phrase became distorted in transmission through intermediaries to Robinson.

Betracht seiner Schönheiten und Auswüchse, gleich merkwürdig finden,
und wegen des Mangels an Geschmack und Zarheit tadeln, während sie
die Kraft und Erfindungsgabe des Dichters bewundern. Man trug
Blake, obgleich er eigentlich Kupferstecher war, dennoch nicht den
Stich seiner eigenen Zeichnungen auf, sondern Schiavonetti musste
dieselben aus Gründen, die wir bald hören werden, ausführen, was er
auch mit grosser Sauberkeit, aber mit einer solchen Beymischung von
Pünktchen und Linien that, dass es den Zeichner empören musste.
Dieses Werk, welches aus zwölf Zeichnungen von Blake, einem vortre-
flichen Kopfe von ihm, und dem Originaltexte besteht, kostet zwey und
eine halbe Guinee. Voran gehen einige Bemerkungen von Füssli,
welche wir hier als ein Zeugniss für das Verdienst unsers Künstlers
einrücken, da wir eine unmittelbare Anschauung seiner Werke nicht
zu liefern vermögen. Füssli sagt, nachdem er vom sittlichen Nutzen
einer Reihe so ernster Zeichnungen in einem so leichtfertigen Zeitalter
als das unsrige, wo die Allegorieen des Alterthums verbraucht und
erschöpft sind, gesprochen hat, 'der Künstler versucht, unser Gemüth
zu bewegen,[1] . . .' Man sieht, dass dieses 'kein Verdammen durch ver-
stelltes Lob'[2] sey, denn nur zu deutlich ist der Tadel, welchen der
Künstler zu befahren hat, ausgedrückt. Die Warheit ist, dass von allen
Zeichnern, welche je lebten, auch nicht einer die von Göthe in seinem
ergötzlichen 'Sammler und die Seinigen' (S. Propyläen B.2. St. 2.)[3]
unter der Benennung von Poetisirern, Phanstomisten u.s.w. geschil-
derten Einseitigkeiten, so genau an sich darstellte, als unser Künstler.

Wir werden noch zu diesen Zeichnungen zurückkommen, und
wollen jetzt von dem kleinen Buche reden, aus welchem wir vorzüglich
diese Nachrichten geschöpft haben, und welches gewiss eins der
sonderbarsten ist, die je erschienen.

Die Zeichnungen zum Grabe, wenn gleich vielleicht nur von wenigen
bewundert, wurden grade von diesen laut und übermässig gepriesen.
Blake, der durch sie bekannt wurde, beschloss nun, ohne Scheu öffent-
lich hervorzutreten. Er eröffnete daher voriges Jahr eine Ausstellung
seiner Freskogemählde, und kündigte an, dass er die verlorne Kunst
der Freskomahlerey wieder erfunden habe. Er forderte diejenigen,
welche angenommen hatten, seine Werke seyen ohne Wissen und
ohne Ebenmaas, Sudeleyen eines Tollhäuslers, auf, sie jetzt genauer
zu untersuchen. 'Sie würden finden,' fügte er hinzu, 'dass, wenn
'Italien durch Raphael reich und gross geworden, wenn Michel Angel
'sein höchster Ruhm, wenn die Kunst der Stolz der Nation geworden

[1] The last two paragraphs of Fuseli's critique of Nov. 1805 are translated here.
[2] The phrase 'damn with faint praise' comes from Pope's 'Epistle to Dr.
Arbuthnot', line 193.
[3] 'Der Sammler und die Seinigen', *Propyläen* [Herausgegeben von Goethe],
vol. ii, part 2 (1799), pp. 26–122.

'wäre, wenn die menschliche Gesellschaft aus Genie und Begeisterung
'hervorgegangen, auch durch sie verbunden bliebe, dass dann sein
'Vaterland bey der Auszeichnung, welche seine Werke von denjenigen,
'welche es am besten verständen, erhielten, die Ausstellung derselben
'als eine der heiligsten Pflichten von ihm forderte.'[1]
Zu gleicher Zeit gab er ein beschreibendes Verzeichniss dieser
Freskogemählde heraus, aus dem wir, da es in einem durchgängigen
Mischmasch, ohne Plan und Ordnung, von abgerissenen Bemerkungen
über Kunst und Religion besteht, und da die Besonderheiten des Ver-
fassers am besten daraus hervorgehn, gleiche nur lose verbundene
Auszüge liefern wollen.
Zu den fixen Ideen des Verf. gehört die Heftigkeit, mit welcher er
durch das ganze Buch gegen die Oelmahlerey und gegen die Künstler
aus den venetianischen und niederländischen Schulen loszieht. Seine
Vorrede fängt mit folgenden Worten an:[6] 'Das Auge, welches im
'Stande ist, Rubens und Titians Colorit dem des Rafael und Michel
'Angelo vorzuziehn, sollte bescheiden seyn, und seinem eigenen Ur-
'theil misstrauen.'[2] Diess ist indess nur noch ein leichter Tadel, und wie
er in seinen Beschreibungen fortfährt, wächt seine Wuth gegen die
falschen Mahlerschulen, und er klagt im heiligen Eifer die verhassten
Künstler als böse Geister, und die neuere Kunst als eine Geburt der
Hölle an. Helldunkel nennt er schlechtweg 'ein höllisches Werkzeug
'in der Hand venetianischer und niederländischer Teufel.'[3] Aus dem
Folgenden geht hervor, dass diese Ausdrücke nicht bloss als redner-
ische Wendungen zu nehmen sind. So nennt er Corrggio [*sic*] 'einen
'weichlichen, weibischen, und daher höchst grausamen Teufel.'[3] Rubens
ist 'ein gewaltthätiger, hochfahrender Teufel.' Diese Künstler sind
nebst Titian und Rembrandt die immerwährenden Gegenstände seines
Tadels, und zum Schluss sagt er: 'bis wir uns ihrer entledigen, werden
'wir nie Rafael und Albrecht Dürer, Michel Angelo und Giulio Romano
'beykommen.'[3] Er verbirgt den Grund dieses Vorzuges nicht, und die
folgende Stelle enthält, indem sie uns die Ansicht des Künstlers über
das Mechanische seiner Kunst eröffnet, eine Wahrheit, die nicht
abgeleugnet werden kann, und die seiner ganzen Lehre zum Grunde
liegt. 'Die grosse und goldene Regel der Kunst, wie des Lebens, ist,
'dass, je bestimmer, schärfer und genauer die umgränzende Linie ist,
'desto vollkommener auch das Kunstwerk, und je weniger scharf und
'schneidend jene, desto grösser die Gewissheit schwacher Nachahmung,
'Diebstahls und Pfuscherey. Zu allen Zeiten mussten diess grosse
'Erfinder. Protogenes und Apelles erkannten sich an dieser Linie.

[1] In this paragraph the direct and indirect quotations come from the advertise-
ment for Blake's 'Exhibition of Paintings in Fresco', dated in MS. May 15th, 1809.
[2] Preface to the *Descriptive Catalogue*.
[3] *Descriptive Catalogue*.

'Rafael und Michel Angelo und Albrecht Dürer sind durch sie und durch
'sie allein bekannt. Der Mangel an dieser bestimmten und begränzen-
'den Form, beweisst den Mangel des Künstlers an Ideen, und die durch-
'gängige Unverschämtheit und Anmaassung des Diebes. Wodurch
'unterscheiden wir die Eiche von der Buche, das Pferd vom Ochsen, als
'durch die begränzende Linie und durch ihre unendlich mannichfaltigen
'Biegungen und Bewegungen? Was baut denn ein Haus und pflanzt
'einen Garten, als das Bestimmte und Festgessetzte? Was unter-
'scheidet Ehrlichkeit von Büberey, als die harte und scharfe Linie des
'Richtmaasses und der Zuverlässigkeit in Handlungen und Gesinnun-
'gen? Nehmt diese Linie weg, und ihr nehmt das Leben selbst, alles ist
'wieder Chaos, und der Allmächtige muss wieder in deinselben die Linie
'vorziehn, ehe Mensch oder Thier nur daseyn können. Redet daher
'nicht mehr von Correggio oder Rembrandt, oder irgend einem jener
'Diebe aus Venedig und Flandern. Sie waren nur die lahmen Nachahmer
'der von ihren Vorgängern ihnen vorgezogenen Linien.'[1] Diese Stelle
reicht hin, um zu erklären, warum man unserm Künstler nicht erlaubte,
seine eigenen Zeichnungen zu stechen. In demselben Geiste leugnet er
die Gültigkeit der neuern Unterscheidung zwischen einem Gemählde
und einer Zeichnung. 'Wenn das Wesen eines Gemähldes im Ver-
'wischen und Verliehren der Aussenlinie besteht, so wird Blake nie so
'thöricht seyn, eins zu machen.—Raphaels Freskogemählde waren bloss
'mehr ausgeführt als seine Cartons'.[2] Er spricht Titian, Rubens und
Correggio alles Verdienst im Colorit ab, und sagt: 'ihre Männer sind
'wie Leder und ihre Frauen wie Kreide.'[1] In seinem Hauptgemählde
sind die nackten Gestalten fast purpurroth. Es sind alte Britten, von
denen er sagt: 'Das Uebermaass von Gesundheit im Fleisch, was der
'freyen Luft ausgesetzt, durch die Geister der Wälder und Wellen in
'jener alten glücklichern Zeit genährt wurde, kann nicht den krank-
'haften Tinten des Titian und Rubens gleichen. Ein Mensch aus unsrer
'Zeit, seiner Kleiderbürde entledigt, gleicht einem todten Leichnam'.[1]

Wir gehen jetzt vom mechanischen Theile der Kunst zur Erfindung
und zum poetischen Theile, wo die Eigenheiten unseres Künstlers noch
auffallender hervortreten, über. Sein grösster Genuss besteht in der
Verkörperung geistiger Wesen. So hat er in seinem Grabe Geist und
Körper zu wiederholtenmalen getrennt dargestellt, und beyden bey
gleicher Stärke der Umrisse, auch gleich Masse gegeben. In einer
seiner besten Zeichnungen 'der Tod des starken und bösen Menschen',
liegt der Körper im Todeskampf körperlicher Leiden, und ein zer-
brochenes Gefäss, dessen Inhalt ausfliesst, deutet den Augenblick des
Todes an, während die Seele in eine Flamme gehüllt, vom Kopfküssen

[1] *Descriptive Catalogue.*

[2] *Descriptive Catalogue*; the dash was apparently intended to indicate that the
second sentence should in fact precede the first.

aufsteigt. Diese ist zugleich eine Nachbildung des Leichnams, wenn gleich in veränderrter Stellung, mit dem gut getroffenen Ausdrucke des Schreckens aus dem Fenster fliehend. In andern gestochenen Zeichnungen erscheint die Seele über dem Leichnam schwebend, den sie nur ungern verlässt, in andern die Wiedervereinigung beyder bey der Auferstehung u.s.w. Dies sind ungefähr seine anstössigsten Erfindungen.

In seinem Verzeichnisse finden wir noch folgende Rechtfertigung gegen die seinem frühern Werke gemachten Einwürfe. 'Soll die 'Mahlerey bloss auf schmutzige, sterbliche und verderbliche Gegen- 'stände eingeschränkt bleiben, soll sie sich nicht so gut wie Poesie und 'Tonkunst zu der ihr gebührenden Höhe der Erfindung und begeisterter 'Verzückung erheben?'[1] Darauf beruft er sich auf die Bildsäulen der griechischen Gottheiten, als auf eben so viele körperliche Abbildungen geistiger Wesen. 'Ein Geist und eine Erscheinung sind nicht wie die 'neuere Philosophie annimmt, entweder ein nebelhaftes Gebilde oder 'gar nichts, sie sind vielmehr organische mit allem bis aufs kleinste 'versehene Wesen, von einer Vollkommenheit, wie sie gar keine 'sterbliche und vergängliche Natur hervorbringen kann. Wer sich nicht 'bedeutendere und schönere Lineamente in einer bedeutenderen und 'schöneren Beleuchtung als sein sterbliches Auge zu sehen vermag, 'denken kann, der denkt gar nicht. Der Mahler des vorliegenden Werks 'behauptet daher, dass ihm all sein Gedachtes unendlich vollkommner 'und feiner organisirt, als alles, was sein sterbliches Auge je sah, vor- 'komme. Geister sind organisirte Menschen'.[1]

In gewissen Sinne wird jeder erfindende Künstler das nehmliche behaupten müssen, aber zweydeutig wird es immer bleiben, in welchem Sinne unser Künstler diese Ausdrücke gebraucht. Denn in seiner eigenen Beschreibung seiner allegorischen Gemählde, wie Pitt den Behemoth und Nelson den Leviathan führt, (Gemählde, welche Schreiber dieses, obgleich er sie gesehen hat, nicht zu beschreiben wagt) sagt er: diese Gemählde glichen den Vergötterungen, die man auf persischen, indischen und ägyptischen Alterthümern findet. Er setzt hinzu: 'Der Künstler, in einem Gesichte in jene alten Republiken, 'Monarchien und Patriarchate Asiens versetzt, sah die bewunderns- 'würdigen Urbilder, welche die heilige Schrift Cherubim nennt, und 'welche sich an den Mauern der Tempel ausgehauen und gemahlt 'befanden, die in den sehr gebildeten Staaten von Aegypten, Moab, 'Edom, Aram, zwischen den Flüssen des Paradieses errichtet waren, 'Urbilder, welche die Griechen und Hetrusker im farnesischen Herkules 'und andern Bildsäulen nachahmten. Mit Ausnahme des Torso waren 'sie alle augenscheinlich Copien, denn die griechischen Musen als

[1] *Descriptive Catalogue.*

'Töchter der Mnemosyne oder des Gedächtnisses, nicht aber der 'Begeisterung oder der Erfindung, konnten unmöglich so erhabene 'Ideen einflössen'.[1] Da diese Einbildung unseres Künstlers von seiner Gemeinschaft mit der geistigen Welt, deren wie Swedenborg zu geniessen, er zu gestehen kein Bedenken trägt, mehr als irgend etwas anders seinem Rufe geschadet hat, so fügen wir noch eine merkwürdige Stelle aus seinem Verzeichnisse, dem Gesagten bey.

Sein grösstes und vollendetstes Werk hat den Titel: Die alten Britten. Es gründet sich auf eines jener seltsamen Ueberbleibsel der alten Walisischen Dichtkunst, welches Owen unter dem Namen von Triaden, folgendermassen giebt:

In der letzten Schlachte die Arthur focht, war der Schönste einer
Der wiederkehrte, und der Stärkste ein andrer: mit ihnen kehrte auch
wieder
Der Hässlichste, und kein andrer kehrte wieder vom blutigen Felde.

Der Schönste, Rom's Krieger bebten vor ihm und dienten.
Der Stärkste, sie schmolzen vor ihm und zerstoben in seiner Nähe.
Der Hässlichste, sie flohen mit Geschrey und Verdrehung ihrer Glieder.[2]

Diese dunkle Rede hat folgenden noch dunkleren Commentar zu Wege gebracht. 'Der starke Mann stellt das Erhabene im Menschen 'vor, der schöne Mann das Leidenschaftliche im Menschen, was in 'Eden's Kriegen in das Männliche und Weibliche getheilt erschien, der 'hässlichste Mann endlich die Vernunft im Menschen. Sie waren 'ursprünglich Ein Mensch, der vierfach war; dieser war in sich selbst 'getheilt, und sein eigentliches Menschseyn im Augenblicke der Zeu-'gung vernichtet. Die Gestalt des vierten war aber wie der Sohn 'Gottes. Wie er aber getheilt wurde, ist ein Gegenstand von grosser 'Erhabenheit und Leidenschaftlichkeit. Der Künstler hat es, wie ihm 'solches eingegeben worden, niedergeschrieben, und wird es mit gött-'licher Hülfe bekannt machen. Es ist von grossem Umfange, und 'enthält die alte Geschichte von Britannien und die Welt Adams und 'Satans'.[3] Das Gemählde stellt diese drey Wesen im Kampfe mit den Römern begriffen vor, jedoch wollen wir lieber den Künstler selbst von seinem Werke reden lassen. 'Man hat zum Künstler gesagt, nimm das 'Modell zu deinem schönen Mann vom Apollo, zu deinem starken 'Mann vom Herkules, und zu deinem hässlichen Mann vom tanzenden 'Faun; aber hier muss er nun für sich selbst stehen. Er weiss dass, was 'er leistet, den grössten Antiken nicht nachsteht, und dass diese nicht

[1] *Descriptive Catalogue*, with some omissions.
[2] This passage comes not from the *Descriptive Catalogue* but from the Advertisement.
[3] *Descriptive Catalogue*.

'höher stehn können, denn menschliche Kraft vermag nicht, sich über
'das, was er und was sie geleistet haben, zu erheben. Es ist die Gabe
'Gottes, es ist Eingebung und Gedicht.[1] Poesie, wie sie jetzt auf Erden
'in den verschiedenen Ueberresten alter Dichter lebt; Musik, wie sie in
'alten Lauten und Weisen webt; Mahlerey und Bildhauerey, wie sie
'sich noch im Nachlasse des Alterthums zeigen, sind Eingebung und
'können nicht übertroffen werden. Sie sind vollkommen und ewig.
'Milton, Shakespear, Michel Angelo, Raphael, die schönsten Hervor-
'bringungen alter Bildhauerey, Mahlerey und Baukunst, gothisch,
'griechisch, indisch und ägyptisch, sie sind das Aeusserste des mensch-
'lichen Geistes. Der menschliche Geist kann nicht weiter gehn als die
'Gabe Gottes, der heilige Geist'.[2] Anderswo sagt er, dass Adam und
Noah Druiden waren, and dass er selbst ein Bewohner Edens sey.[3]

Blake's religiöse Meynungen schienen diejenigen eines recht-
gläubigen Christen zu seyn,[4] und dennoch kommen wieder Stellen
über alte Mythologie vor, welche hierüber einigen Zweifel einflössen
könnten. Diese Stellen finden sich in seiner Nachricht über sein
Gemähide von Chaucer's Pilgrimmen vor, gewiss dem bestaus-
geführten seiner Werke, weil er, durch seinen Vorwurf gebunden,
nicht auf eine zurückstossende Art ausschweifen konnte. Wir wün-
schen daher den Stich desselben, wozu man Unterschriften gesammelt
hat, ausgeführt zu sehn. Er bemerkt, 'jeder Charakter beym Chaucer
'ist eine antike Bildsäule, das Bild einer Gattung, nicht aber eines
'unvollkommnen Individuums'.[5] Zugleich behauptet er, diess seyen
auch die Charaktere der griechischen Mythologie. 'Chaucer hat den
'alten Charakter des Herkules zwischen seinem Müller und Pflüger
'vertheilt.[6] Der Pflüger ist Herkules in seinem höchsten ewigen Zu-
'stande, entkleidet von seinem gespensterartigen Schatten, welches der
'Müller ist, ein furchtbarer Kerl, wie es deren an allen Orten und zu
'allen Zeiten zur Zuchtruthe der Menschen giebt, die ganze Nachbar-
'schaft erschreckend, durch brutale Stärke und Muth, reich und mächtig
'geworden, dass Selbstgefühl der Menschen zu verhöhnen, während
'Menschenfreundlichkeit und Wohlwollen der Hauptzug im Charakter
'des Pflügers ist. Gesichte von diesen ewigen Grundzügen oder
'Charakteren des menschlichen Lebens, erscheinen den Dichtern zu
'allen Zeiten. Die griechischen Gottheiten waren die alten Cherubim
'Phönicien's, aber die Griechen, und nach ihnen die neuern versäumten
'die Götter des Priamus zu unterjochen. Diese Götter sind blosse
'Gesichte der Attribute der Ewigen, oder göttliche Namen. Erst als

[1] A sentence is omitted here.
[2] *Descriptive Catalogue*, with minor omissions. [3] *Descriptive Catalogue.*
[4] Cf. Dec. 17th, 1825. [5] *Descriptive Catalogue*, quoted rather roughly.
[6] One hundred and sixty-one words are omitted here, most of which are inserted
after the next sentence.

'man sie zu Göttern erhob, wurden sie für die Menschheit verderblich. 'Sie sollten die Diener und nicht die Herren des Menschen oder der 'Gesellschaft seyn. Sie sollten genöthigt werden dem Menschen zu 'opfern, nicht aber der Mensch ihnen, denn getrennt vom Menschen 'oder der Menschheit, welches Jesus der Heiland, der Weinstock der 'Ewigkeit ist, sind die Diebe, Empörer und Verderber'.[1] Diese Stelle könnte erklärt werden, als die Sprache eines eisrigen Monotheisten gegen die Vielgötterey, indess da unser Verfasser anderswo den Satz aufstellt; 'die Alterhümer jeder Nation seyen so heilig als die der 'Juden',[2] so bleibt sein System dadurch wieder mehr der Gleichgültigkeit und Duldsamkeit des Heydenthums als der wesentlichen Strenge des Christenthums verwandt.

Diess sind die ausschweifendsten und wildesten Stellen des Buchs, welche zu der Betrachtung führen, mit der wir diesen Bericht eröffneten. Man wird indess zugleich nicht leugnen können, dass grade in jenen Auswüchsen Streiflichter von Vernunft und Geist hindurchblitzen, so wie sich überhaupt im ganzen Verzeichnisse eine Menge von Ausdrücken findet, die man eher von einem Deutschen als von einem Engländer erwartet hätte. Der protestantische Verfasser der 'Herzensergiessungen eines kunstliebenden Klosterbruders'[3] schuf den Charakter eines Katholiken, in dem Religion und Kunstliebe zu einem Wesen verschmolzen waren, und dieser nehmliche Charakter kam, bewundernswürdig genug, im protestantischen England zum Vorschein. Jedoch gehört Blake nicht zur bischöflichen Kirche, sondern von Geburt zu einer dissentirenden Gemeinde,[4] obgleich wir nicht glauben, dass er sich regelmässig zu irgend einer christlichen Kirche halte.[5] Er wurde eingeladen, sich an die Swedenborgianer unter Proud anzuschliessen,[6] was er aber ausschlug, ungeachtet er eine grosse

[1] *Descriptive Catalogue*, somewhat jumbled and selected.

[2] *Descriptive Catalogue*, with two words omitted.

[3] [Wilhelm Heinrich Wackenroder] *Herzensergiessungen eines kunstliebenden Klosterbruders* [ed. J. L. Tieck], Berlin, 1797.

[4] This plain statement that Blake's parents were dissenters is of considerable importance.

[5] J. T. Smith (p. 458) is more positive on this point: 'he did not for the last forty years [*1787–1827*] attend any place of Divine worship'.

[6] This important but unverifiable fact, that Blake was invited to join the Swedenborgians under Proud, is not given elsewhere. Joseph Proud (1745–1826) was an extraordinarily popular preacher who had been a Baptist minister until he was unanimously accepted on June 7th, 1790 by the Swedenborgian group to which Blake for a time belonged (according to the 'Minute Book of the Society for Promoting the Heavenly Doctrines of the New Jerusalem Church. Eastcheap. London. 7. May 1787. to 7. Nov. 1791', which is now at the New Church College, Woodford Green, Essex). He was ordained on May 3rd, 1791, and promptly opened a church in Birmingham. He came to London and opened a church in Hatton Garden, off Holborn Circus, on July 30th, 1797. Here too he had enormous congregations, but on Sept. 29th, 1799 he left for York Street, where he stayed for four-

Meynung von Swedenborg hegt, und von ihm sagt: 'die Werke dieses
'Sehers sind alle der Aufmerksamkeit der Mahler und Dichter werth,
'sie enthalten den Grund zu grossen Dingen. Der Grund, warum sie
'weniger beachtet worden sind, ist, weil fleischliche böse Geister das
'Uebergewicht erlangt haben.'[1] Unser Verfasser steht, wie Sweden-
borg, in Gemeinschaft mit den Engeln. Er erzählte jemand, aus dessen
Munde wir es haben, dass, als er einst ein Gemählde, welches er für
eine Dame von Stande verfertigt, nach Hause getragen, und sich dabey
in einem Wirthshause habe ausruhen wollen, habe ihm der Engel
Gabriel auf die Schulter geklopft und gesprochen: Blake, warum weilst
Du hier? Geh zu, Du sollst nicht müde werden! Er sey darauf auch
weiter gegangen, ohne zu ermüden.[2] Eben dieses Vorrecht übernatür-
licher Eingebung macht ihn taub gegen die Stimme der Kunstrichter,
denn er antwortet auf die gegen seine Werke gemachten Einwürfe,
woran es natürlich nicht fehlen kann: 'ich weiss, dass es ist wie es
'seyn muss, denn es ist eine genaue Nachbildung dessen, was ich in
'einem Gesichte sah, und muss daher schön seyn.'
 Es ist unnöthig, die Gegenstände von Blake's Hand aufzuzählen.
Der vornehmsten haben wir schon erwähnt, und die übrigen sind
entweder allegorisch, oder Werke der Feder. Wir müssen, ehe wir
aufhören von ihm als Künstler zu reden, nur noch eines seiner Werke
erwähnen. Diess ist eine äusserst merkwürdige Ausgabe der ersten
vier Bücher von Youngs Nachtgedanken, welche im Jahre 1797 in
Folio erschien, und gar nicht mehr im Buchladen zu haben,[3] so wie
überhaupt äusserst selten geworden ist. In dieser Aussgabe steht der
Text in der Mitte der Seite; auf den Seiten so wie oben und unten,
Radirungen von Blake nach seinen eigenen Zeichnungen. Sie sind von
sehr ungleichem Werthe: zuweilen wetteifern die Erfindungen des
Künstlers mit denen des Dichters, oft sind sie aber nur eine wider-
sinnige Uebersetzung derselben, durch die unglückseelige, Blake
eigene Idee, dass alles, was die Phantasie dem geistigen Auge vor-
spiegelt, auch wiederleuchtend dem körperlichen zu schmecken gege-
ben werden müsse. So ist Young büchstablich übersetzt, und sein
Gedicht in ein Gemählde verwandelt worden. So stellt z. B. der
Küntsler in einer Zeichnung vor, wie der Tod Kronen mit Füssen tritt,
die Sonne herablangt, u.s.w. Dennoch sind diese Radirungen oft sehr
ausgezeichnet. Wir hören, dass der Herausgeber noch nicht ein Viertel

teen years. Probably the invitation to Blake was made when Proud was at Hatton
Garden (1797–9), where for a time Flaxman was a member of his congregation.
 [1] *Descriptive Catalogue.*
 [2] Perhaps the picture was 'Satan calling up his Legions', which was 'executed
for a lady of high rank' (Lord Egremont's wife), according to the *Descriptive
Catalogue.*
 [3] HCR bought a copy of the 1797 *Night Thoughts* on Dec. 27th, 1810.

der ihm vom Künstler gelieferten Zeichnungen bekannt gemacht, und sich zugleich geweigert hat, die Handzeichnungen zu verkaufen, ungeachtet ihm eine ansehnliche Summe dafür geboten wurde.[1] Wir haben jetzt unsern Künstler als Dichter einzuführen, wobey wir zugleich einige Proben seiner Werke in diesem Zweige der Kunst geben werden, denn er selbst hat eigentlich nichts bekannt gemacht. Diese athmen einen gleichen Geist, und sind durch gleiche Eigenheiten ausgezeichnet, als seine Zeichnungen und seine kritische Prose. Schon im Jahre 1783 ward ein kleines Bändchen unter dem Titel: Poetische Versuche, gedruckt. (Poetical Sketches by W. B.) Auf dem Titel ist kein Drucker genannt, und in der Vorrede heisst es, dass die Gedichte zwischen dem 13ten und 20sten Jahre verfertigt wurden. Sie sind von sehr ungleichem Werthe. Der Versbau ist meistentheils so lose und sorglos, dass er eine völlige Unwissenheit der Kunst verräth, wobey zugleich die meisten Stücke von empörender Rohheit und sehr zurückstossend sind. Dagegen findet sich auf der andern Seite in einigen dramatischen Bruchstücken wieder eine Wildheit und Grösse der Phantasie, die ein ächt dichterisches Gefühl beglaubigen. Gegenwärtige Probe mag zum Maassstabe der damaligen Vollendung des Dichters dienen.

To the Muses. . . .

An die Musen.

Weilt ihr auf des Ida Höh'n,
Oder auf des Ostens Thron,
Wo die Sonne pranget schön,
Stumm ist alter Lieder Ton?

Weilt ihr in des Himmels Luft,
Oder auf der Erde Grün,
Wo in blauer Töne Duft
Sich melodisch Winde ziehn?

Weilt ihr auf krystallnem Fels,
Tief im Busen grauer See'n,
Mög't ihr in der Perlen Schmelz
Durch Korallen-Grüfte gehn?

Wird alte Lieb' nicht mehr verspürt?
War't sonst für Bardendienst nicht kalt.
Die Harfe wird noch kaum gerührt,
Der Klang ist matt, der Ton verhallt.

[1] Only four of the nine Nights were issued with Blake's illustrations, and only forty-three of the 537 drawings were engraved. No one else records that Edwards had refused a handsome price for the drawings. They were offered at £300 in 1821 and at £52. 10s. 0d. in 1826 and on May 15th, 1828, but found no takers.

Es giebt indessen ein noch merkwürdigeres Bändchen Gedichte unsers Verfassers, welches nur noch bey Sammlern angetroffen wird. Es ist in Duodez, und hat den Titel: 'Gesänge der Unschuld und Er-'fahrung, die beyden entgegengesetzten Zustände des menschlichen 'Gemüths erklärend, verfasst und gedruckt von W. Blake.' (Songs of Innocence and of experience, shewing the two contrary states of the human soul. The Author and Printer W. Blake) Die Buchstaben scheinen geätzt zu seyn, und der Abdruck ist in Gelb gemacht.[1] Rund umher und zwischen den Zeilen finden sich alle Arten von Radirungen: zuweilen gleichen sie den ungestalten Hieroglyphen der Aegypter, zuweilen bilden sie wieder nicht unzierliche Arabesken. Wo sich nach dem Abdrucke noch ein leeres Plätzchen fand, ist ein Gemählde hineingekommen. Diese Miniatürgemählde sind von den lebhaftesten Farben, und oft grotesk, so dass das Buch ein äusserst seltsames Ansehen bekommen hat. Vom Text ist es nicht leicht, ein allgemeines Urtheil zu fällen, denn auf die Gedichte passt jedes Lob und—jeder Tadel. Einige sind kindliche Lieder von grosser Schönheit und Einfalt: diess sind die Gesänge der Unschuld, unter denen jedoch viele äusserst kindisch sind. Die Gesänge der Erfahrung sind hingegen metaphysische Räthsel und mystiche Allegorieen. Man findet unter ihnen poetische Gemählde von der höchsten Schönheit und Erhabenheit, und wieder dichterische Phantasieen, die bloss den Eingeweihten verständlich seyn können.

Da wir unsern Verfasser gern so bekannt als möglich machten, so wollen wir von jeder Art eine Probe geben. Das Buch hat eine Einleitung, von der wir hier die erste und die beyden letzten Strophen (die vierte und fünfte) einrücken.

> Piping down the valleys wild,
> Piping songs of pleasant glee,
> On a cloud I saw a child,
> And he laughing said to me:
>
> 'Piper, sit thee down and write
> In a book that all may read.'
> So he vanish'd from my sight,
> And I pluck'd a hollow reed,
>
> And I made a rural pen,
> And I stained the water clear,
> And I wrote my happy songs,
> Every child may joy to hear.

[1] This is probably copy D which HCR saw at Miss Iremonger's house (see April 20th, 1810); this copy, partly printed in yellow-brown, bears the signature of Miss Iremonger's friend Miss C. L. Shipley. Robinson's own copy (Z) was not bought until Feb. 18th, 1826.

Pfeifend ging ich durch das Thal,
Pfeifend Lieder ohne Zahl;
Sah ein Kind von Luft getragen,
Hört' es lächelnd zu mir sagen:

'Pfeifer, setz dich hin und schreib,
Dass dein Lied im Sinne bleib.'
So erklangs vor meinem Ohr,
Und ich schnitt ein hohles Rohr,

Schnitzte eine Feder dran,
Macht' aus Wasser Dinte dann,
Schrieb die Lieder hin zur Stund,
Dass sie sing der Kinder Mund.

Von diesen frohen lieblichen Liedern können wir nur eine einzige
Probe geben. Sie hat den Titel, Gründonnerstag, und beschreibt den
an diesem Tage gewöhnlichen Zug der versammelten Kinder aus der
Charity nach der St. Pauls Kirche.

Holy Thursday. . . . [*See Spring 1818*]

Es war am grünen Donnerstag, man sahe die Kinder ziehn,
Sauber gewaschen, paarweis', gekleidet in roth und in blau und in grün;
Grauköpfige Zuchtmeister mit schneeweissen Ruthen voran.
In St. Pauls hohen Dom wie der Themse Fluthen strömen sie dann.

O! wie zahllos erscheinen sie da, diese Blumen von Londons Macht;
Abgetheilt sitzend in Rotten, ganz in der eignen Unschuld Pracht.
Es ersummt wie eine Menge, doch der Lämmer Menge nur allein.
Tausend kleine Knaben und Mädchen erheben ihre Händchen so rein.

Jetzt wie ein Wirbelwind steigt zum Himmel Gesanges Chor,
Wie ein harmonisch Gewitter zu den Sitzen der Engel empor.
Zwischen den Kleinen die Alten, der Armuth weiser Hort—
Drum erbarme dich vor deiner Thür, oder du treibst einen Engel fort.

Wir können nicht besser die mannichfaltigen Talente unsers
Dichters ins Licht setzen, als indem wir auf dieses ausnehmend zarte
und einfache Gedicht, die wahrhaft eigenthümliche und erhabene
Beschreibung des Tigers folgen lassen.

The Tyger. . . .[1]

Der Tiger.
Tiger, Tiger, Flammenpracht,
In den Wäldern düstrer Nacht!

[1] In lines 7 and 8 HCR gives 'dares', and in line 24 he gives 'Could', where
Blake had written 'dare'; see Malkin, pp. 430–1.

Sprich, wess Gottes Aug und Hand,
Dich so furchtbar schön verband?

Stammt vom Himmel, aus der Höll',
Dir der Augen Feuerquell?
Welche Flügel trägst du kühn?
Wer wagt wohl zu nah'n dem Glühn?

Welche Stärke, welche Kunst,
Wob so sinnreich Herzenbrunst?
Als dein Herz den Puls empfand,
Welch ein Fuss? und welche Hand?

Was ist Hammer? Kettenklirrn?
Welche Esse schmolz dein Hirn?
Was ist Amboss? Welcher Held
Muth in deinem Arm behält?

Aus den Sternen flog der Speer,
Thränend ward der Himmel Meer:
Schaut' er lächelnd da auf dich?
Der das Lamm schuf, schuf er dich?

Tiger, Tiger, Flammenpracht
In den Wäldern düstrer Nacht!
Sprich, wess Gottes Aug' und Hand
Dich so furchtbar schön verband?

Von den allegorischen Gesängen wollen wir lieber einen anführen, den wir zu verstehen glauben, als einen uns völlig unverständlichen. Folgender Gesang der Erfahrung soll wahrscheinlich den Menschen nach dem Verlust seiner Unschuld darstellen, wie er sehnsüchtig auf seinen früheren Zustand zurückblickt, gebunden durch das Gesetz und die Priester dessen Diener, wo früher kein Gebot, keine Pflicht, und nichts als reine Liebe und freywilliges Opfern statt fand.

The Garden of Love.

I went to the garden of love,
And saw what I never had seen.
A chapel was built in the midst,
Where I used to play on the green.

And the gates of the Chapel[1] were shut,
And 'Thou shalt not' writ on the door.[2]
So I turned to the garden of love,
That so many sweet flowers bore.

[1] 'the gates of this Chapel'.	[2] 'writ over the door'.

And I saw it was filled with graves,
And tomb stones where flowers should be,
And Priests in black gowns, were walking their rounds,
And binding with briars my joys and desires.

Der Garten der Liebe.

Ich ging einst zum Garten der Liebe,
Und sah was ich nimmer gesehn.
Am Rasen stand eine Capelle,
Wo sonst ich pflog spielend zu gehn.

Und zu war die Thür der Capelle,
Und 'Du sollst nicht' stand auf dem Thor.
So kehrt' ich zum Garten der Liebe,
Der Blumen sonst brachte hervor.

Und ich sah ihn mit Gräbern gefüllet,
Und Grabstein' wo Liebe sollt' seyn;
Und Priester in Trau'r umgingen die Mau'r,
Und senkten in Schmerz mein liebendes Herz.

Ausser diesen Gesängen sind uns noch zwey andere Werke der Poesie und Mahlerey von Blake zu Gesichte gekommen, von denen wir aber uns ausser Stande bekennen müssen, eine genügende Beschreibung zu geben. Es sind zwey 1794 erschienene Quartbände, gedruckt und verziert wie die Gesänge, unter dem Titel: Europa, eine Weissagung, (Europe, a prophecy) und: Amerika, eine Weissagung, (America, a prophecy).[1] Dunkler sind selbst die 'Weissagungen des Bakis'[2] nicht. Amerika scheint zum Theil eine poetische Erzählung der Revolution zu bilden, denn es enthält die Namen mehrerer Parteyhäupter. Die Handelnden darin sind eine Art von Schutzengeln. Wir geben nur eine kurzes Pröbchen, von dem wir aber nicht zu entscheiden wagen, ob es Prosa oder Versen seyn soll.

On these vast shady hills between America's[3] and Albion's shore,
Now barred out by the Atlantic Sea: called Atlantean hills,
Because from their bright summits you may pass to the golden world,
An ancient palace, archetype of mighty empires,[4]
Rears it's immortal summit,[5] built in the forests of God,
By Ariston the King of heaven[6] for his stolen bride.

Auf jenem weiten Hayngebürge zwischen Amerika's Küsten und Albions,
Nun ausgehöhlt von dem atlantischen Meer; einst der Atlantis Hügeln,

[1] Blake dated *America* 1793 and *Europe* 1794. [2] By Goethe.
[3] 'On those vast shady hills between America'.
[4] 'mighty Emperies'. [5] 'its immortal pinnacles'.
[6] 'the king of beauty', from *America*, Plate 10. See Plate LI.

PLATE LI

Thus wept the Angel voice & as he wept the terrible blasts
Of trumpets, blew a loud alarm acrofs the Atlantic deep.
No trumpets answer; no reply of clarions or of fifes,
Silent the Colonies remain and refuse the loud alarm.

On those vast shady hills between America & Albions shore;
Now barrd out by the Atlantic sea: call'd Atlantean hills:
Because from their bright summits you may pafs to the Golden world
An ancient palace, archetype of mighty Emperies.
Rears its immortal pinnacles, built in the forest of God
By Ariston the king of beauty for his stolen bride.

Here on their magic seats the thirteen Angels sat perturb'd
For clouds from the Atlantic hover oer the solemn roof.

AMERICA (1793) pl. 10, (copy P) containing the passage transcribed (from another copy)
by Crabb Robinson in 1810 (p. 446)

Weil du von ihrem Strahlengipfel kömmst zur Welt des Goldes,
Erhebet uralt ein Pallast, Urbild mächtiger Weltreiche,
Hoch sein unsterblich Haupt, erbaut in den Wäldern Gottes,
Durch Ariston den König des Himmels, fur seine gestohlne Braut.

Die Dunkelheit dieser Zeilen wird man in einem solchen Gedichte,
von solch einem Manne, gern übersehen.

Europa ist eine ähnliche geheimnissvolle, unverständliche Rhap-
sodie, welche wahrscheinlich des Verfassers politische Ansichten der
Zukunst enthält, aber ganz unerklärbar ist. Sie scheint in Versen seyn
zu sollen, und diess sind die vier ersten Zeilen.[1]

> I wrap my turban of thick clouds around my lab'ring head,
> And fold the sheety waters as a mantle round my limbs;
> Yet the red Sun and Moon
> And all the overflowing stars rain down prolific pains.

Ich winde die dunkeln Wolken zu einem Bund um mein arbeitend
Haupt,
Und schlage um meinen Leib den Mantel der wallenden Gewässer,
Dennoch regnen die rothe Sonne und der Mond
Und die überfliessenden Sterne fortzeugende Qualen herab.

Diese Weissagungen scheinen wie die Gesänge nie zur Kunde des
grösseren Publikums gekommen zu seyn.

So hätten wir demnach Rechenschaft von allen uns auch nur flüchtig
zu Gesicht gekommenen Werken dieses ausserordentlichen Mannes
gegeben. Weitläuftig genug, um die Aufmerksamkeit Deutschlands auf
einen Mann zu ziehen, in dem alle Bestandtheile der Grösse, wenn
gleich in unziemlichem Verhältnisse vermischt, unstreitig gefunden
werden. Nähere Untersuchung, als uns vergönnt war, möchte vielleicht
lehren, dass er als Künstler nie vollendete und unsterbliche, und als
Dichter niemals fleckenlose Werke hervorbringen wird; aber diess
wird gewiss nicht den Antheil vermindern können, den alle Menschen,
und die deutsche Nation gewiss in noch höherem Grade als selbst die
englische, an der Betrachtung eines solchen Charakters nehmen
müssen. Wir wollen nur an die Bemerkung eines geistreichen Schrift-
stellers erinnern, dass diejenigen Gesichter am anziehendsten sind, in
welche die Natur etwas Grosses legte, dabey aber die Ausführung
vernachlässigte; denn ein Gleiches möchte wohl vom Gemüthe gelten.

[1] These are lines 11–15 of Plate 1 of the Preludium. HCR may have seen
America copy H and *Europe* copy D owned by Upcott, whom he saw on April
19th, 1810. Blake later gave HCR *America* copy D.

Appendix: Section I

[*Modern translation*]

WILLIAM BLAKE,

ARTIST, POET, AND RELIGIOUS MYSTIC

The lunatic, the lover, and the poet
Are of imagination all compact.

SHAKESPEARE.

Of all the conditions which arouse the interest of the psychologist, none assuredly is more attractive than the union of genius and madness in single remarkable minds, which, while on the one hand they compel our admiration by their great mental powers, yet on the other move our pity by their claims to supernatural gifts. Of such is the whole race of ecstatics, mystics, seers of visions, and dreamers of dreams, and to their list we have now to add another name, that of William Blake.

This extraordinary man, who is at this moment living in London, although more than fifty years of age, is only now beginning to emerge from the obscurity in which the singular bent of his talents and the eccentricity of his personal character have confined him. We know too little of his history to claim to give a complete account of his life, and can do no more than claim to have our information on very recent authority. It must suffice to know by way of introduction that he was born in London of parents of moderate means, and early gave himself up to his own guidance, or rather, misguidance. In his tenth year he went to a drawing school, in his fourteenth (as apprentice) to an engraver of the name of Basire, well known by his plates to Stuart's *Athens* and his engraving of West's 'Orestes and Pylades'. Even as a boy, Blake was distinguished by the singularity of his taste. Possessed with a veritable passion for Gothic architecture, he passed whole days in drawing the monuments in Westminster Abbey. In addition he collected engravings, especially after Raphael and Michael Angelo, and idolised Albert Dürer and Heemskerk.

Although he afterwards worked as a student at the Royal Academy, he had already shown his bent to an art so original that, isolated from his fellow-students, he was far removed from all regular or ordinary occupation. His name is nevertheless to be found under some very commonplace plates to children's books; but while he cherished artistic visions utterly opposed to the taste of connoisseurs, and regarded more recent methods in drawing and engraving as sins against art, he preferred, in his phrase, to be a martyr for his religion—i.e., his art—to debasing his talents by a weak submission to the prevailing fashion of art in an age of artistic degradation. Moreover, as his religious convictions had brought on him the credit of being an absolute lunatic, it is hardly to be wondered at that, while professional connoisseurs know

nothing of him, his very well-wishers cannot forbear betraying their compassion, even while they show their admiration. One attempt at introducing him to the great British public has indeed succeeded, his illustrations to Blair's *Grave*, a religious poem very popular among the serious, which connoisseurs find remarkable alike for its beauties and defects, blaming its want of taste and delicacy, while admiring the imaginative powers of the poet. Blake, although properly speaking an engraver, was not commissioned to engrave his own drawings, the execution being entrusted, for reasons which we shall soon hear, to Schiavonetti, who executed his task with great neatness, but with such an admixture of dots and lines as must have aroused the indignation of the artist. This work, which besides the twelve drawings contains an excellent portrait of Blake and the original text, costs two and a half guineas. It is preceded by some remarks of Fuseli's, which we insert as a proof of the merits of our artist, since we cannot give an actual reproduction of his work. After mentioning the utility of such a series of moral designs in an age so frivolous as ours, before which the allegories of antiquity faint and fail, Fuseli continues, 'the author of the moral series before us . . . [*see November 1805.*]' One can see this is no 'damning with feigned praise', for the faults indicated by Fuseli are only too apparent. In fact, of all the artists who ever lived, even of those perverted spirits described by Goethe in his entertaining 'Sammler und die Seinigen' (*Propyläen*, vol. ii, part 2) under the title of poetisers, phantom-hunters, and the like, none so completely betrays himself as our artist.

We shall return to these drawings later, and will now proceed to speak of the little book on which we have specially drawn, a book, besides, which is one of the most curious ever published.

The illustrations to the *Grave*, though only perhaps admired by the few, were by these few loudly and extravagantly praised. Blake, who had become known by their praises, now resolved to come forward. Only last year he opened an exhibition of his frescoes, proclaiming that he had rediscovered the lost art of fresco. He demanded of those who had considered his works the slovenly daubs of a madman, destitute alike of technical skill and harmony of proportion, to examine them now with greater attention. 'They will find,' he adds, 'that if Italy is enriched and made great by Rafael, if Michael Angelo is its supreme glory, if Art is the glory of a Nation, if Genius and Inspiration are the great Origin and Bond of Society, the distinction my Works have obtained from those who best understand such things calls for my Exhibition as the greatest of Duties to my Country.'

At the same time he published a *Descriptive Catalogue* of these fresco pictures, out of which we propose to give only a few unconnected

passages. The original consists of a veritable folio of fragmentary utterances on art and religion, without plan or arrangement, and the artist's idiosyncracies will in this way be most clearly shown.

The vehemence with which, throughout the book, he declaims against oil painting and the artists of the Venetian and Flemish schools is part of the fixed ideas of the author. His preface begins with the following words: 'The eye that can prefer the Colouring of Titian and Rubens to that of Michael Angelo and Rafael, ought to be modest and doubt its own powers,' but, as he proceeds with his descriptions his wrath against false schools of painting waxes, and in holy zeal he proclaims that the hated artists are evil spirits, and later art the offspring of hell. Chiaroscuro he plainly calls 'an infernal machine in the hands of Venetian and Flemish Demons.' The following will make it appear that these expressions are not merely theoretical phrases. Correggio he calls 'a soft and effeminate, and consequently a most cruel demon.' Rubens is 'a most outrageous demon.' . . . He does not conceal the ground of this preference [*for Raphael and Michael Angelo*], and the following passage, while it reveals the artist's views on the technique of his art, contains a truth which cannot be denied, and which underlies his whole doctrine. 'The great and golden rule of art, as well as of life, is this: That the more distinct, sharp, and wirey the bounding line, the more perfect the work of art. . . .' This passage is sufficient to explain why our artist was not permitted to engrave his own designs. In the same spirit he proclaims the guilt of the recent distinction between a painting and a drawing. 'If losing and obliterating the outline constitutes a Picture, Mr. B. will never be so foolish as to do one.—There is no difference between Rafael's Cartoons and his Frescos, or Pictures, except that the Frescos, or Pictures, are more finished.' He denies Titian, Rubens and Correggio all merit in colouring, and says, 'their men are like leather, and their women like chalk.' In his own principal picture his naked forms are almost crimson. They are Ancient Britons, of whom he says, 'The flush of health in flesh exposed to the open air, nourished by the spirits of forests and floods in that ancient happy period, which history has recorded, cannot be like the sickly daubs of Titian or Rubens. As to a modern Man, stripped from his load of cloathing, he is like a dead corpse.'

We now pass from the technique of his art to the meaning and poetical portions in which the peculiarities of our artist are still more clearly seen. His greatest enjoyment consists in giving bodily form to spiritual beings. Thus in the *Grave* he has represented the re-union of soul and body, and to both he has given equal clearness of form and outline. In one of his best drawings, the 'Death of the Strong Wicked Man,' the body lies in the death agony, and a broken vessel, whose

contents are escaping, indicates the moment of death, while the soul, veiled in flame, rises from the pillow. The soul is a copy of the body, yet in altered guise, and flies from the window with a well-rendered expression of horror. In other engravings the soul appears hovering over the body, which it leaves unwillingly; in others we have the Re-union of both at the Resurrection and so forth. These are about the most offensive of his inventions.

In his Catalogue we find still further vindication of the reproaches brought against his earlier work. 'Shall Painting be confined to the sordid drudgery of fac-simile representations of merely mortal and perishing substances, and not be as poetry and music are, elevated into its own proper sphere of invention and visionary conception?' He then alleges that the statues of the Greek gods are so many bodily represen-tations of spiritual beings. 'A Spirit and a Vision are not, as the modern philosophy supposes, a cloudy vapour, or a nothing: they are organized and minutely articulated beyond all that the mortal and perishing nature can produce. Spirits are organized men.'

In a certain sense every imaginative artist must maintain the same, but it will always remain doubtful in what sense our artist uses these expressions. For in his own description of his allegorical picture of Pitt guiding Behemoth, and Nelson Leviathan (pictures which the present writer, although he has seen them, dares not describe) he says, ["]these pictures are similar to those Apotheoses of Persian, Hindoo, and Egyptian antiquity, which are still preserved on rude monuments.["] ... As this belief of our artist's in the intercourse which, like Swedenborg, he enjoys with the spiritual world has more than anything else injured his reputation, we subjoin another remarkable passage from his *Catalogue*. His greatest and most perfect work is entitled 'The Ancient Britons.' It is founded on that strange survival of Welsh bardic lore which Owen gives thus under the name of Triads:

> In the last battle that Arthur fought, the most Beautiful was one
> That return'd, and the most Strong another: with them also return'd
> The most Ugly, and no other beside return'd from the bloody Field.

> The most Beautiful, the Roman Warriors trembled before and wor-
> shipped:
> The most Strong, they melted before him and dissolved in his pres-
> ence:
> The most Ugly they fled with outcries and contortions of their Limbs.

These dark words are explained by a yet darker commentary. 'The Strong Man represents the human sublime. ...' The picture represents these three beings fighting with the Romans; but we prefer to let the artist speak of his own works. 'It has been said to the Artist, "take the Apollo for the model of your beautiful Man" '

Elsewhere he says that Adam and Noah were Druids, and that he himself is an inhabitant of Eden. Blake's religious convictions appear to be those of an orthodox Christian; nevertheless, passages concerning earlier mythologies occur which might cast a doubt on it. These passages are to be found in his account of this picture of Chaucer's Pilgrims, certainly the most detailed and accurate of his works since, kept within limits by his subject, he could not run riot in his imagination. . . . These passages could be explained as the diatribes of a fervid monotheist against polytheism; yet, as our author elsewhere says, 'The antiquities of every nation under Heaven, is no less sacred than those of the Jews,' his system remains more allied to the stoical endurance of Antiquity than to the essential austerity of Christianity.

These are the wildest and most extravagant passages of the book, which lead to the consideration with which we began this account. No one can deny that, as even amid these aberrations gleams of reason and intelligence shine out, so a host of expressions occur among them which one would expect from a German rather than an Englishman. The Protestant author of *Herzensergiessungen eines kunstliebenden Klosterbruders* created the character of a Catholic in whom Religion and love of Art were perfectly united, and this identical person, singularly enough, has turned up in Protestant England. Yet Blake does not belong by birth to the established church, but to a dissenting sect; although we do not believe that he goes regularly to any Christian church. He was invited to join the Swedenborgians under Proud, but declined, notwithstanding his high opinion of Swedenborg, of whom he says: 'The works of this visionary are well worthy the attention of Painters and Poets; they are foundations for grand things; the reason they have not been more attended to is because corporeal demons have gained a predominance.' Our author lives, like Swedenborg, in communion with the angels. He told a friend, from whose mouth we have the story, that once when he was carrying home a picture which he had done for a lady of rank, and was wanting to rest in an inn, the angel Gabriel touched him on the shoulder and said, Blake, wherefore art thou here? Go to, thou shouldst not be tired. He arose and went on unwearied. This very conviction of supernatural suggestion makes him deaf to the voice of the connoisseur, since to any reproach directed against his works he makes answer, why it cannot in the nature of things be a failure. 'I know that it is as it should be, since it adequately reproduces what I saw in a vision and must therefore be beautiful.'

It is needless to enumerate all Blake's performances. The most famous we have already mentioned, and the rest are either allegorical or works of the pen. We must, however, mention one other of his works before ceasing to discuss him as an artist. This is a most

remarkable edition of the first four books of Young's *Night Thoughts*, which appeared in 1797, and is no longer to be bought, so excessively rare has it become. In this edition the text is in the middle of the page; above and below it are engravings by Blake after his own drawings. They are of very unequal merit; sometimes the inventions of the artist rival those of the poet, but often they are only preposterous translations of them, by reason of the unfortunate idea peculiar to Blake, that whatsoever the fancy of the spiritual eye may discern must also be as clearly penetrable to the bodily eye. So Young is literally translated, and his thought turned into a picture. Thus for example the artist represents in a drawing Death treading crowns under foot, the sun reaching down his hand, and the like. Yet these drawings are frequently exquisite. We hear that the publisher has not yet issued a quarter of the drawings delivered to him by the artist and has refused to sell the drawings, although a handsome sum was offered him for them.

We have now to introduce our artist as poet, so as to be able to give some examples of his work in this branch of art, since he himself has published nothing in the proper sense of the word. The poems breathe the same spirit and are distinguished by the same peculiarities as his drawings and prose criticisms. As early as 1783 a little volume was printed with the title of *Poetical Sketches* by W. B. No printer's name is given on the title-page, and in the preface it states that the poems were composed between his thirteenth and twentieth years. They are of very unequal merit. The metre is usually so loose and careless as to betray a total ignorance of the art, whereby the larger part of the poems are rendered singularly rough and unattractive. On the other hand, there is a wildness and loftiness of imagination in certain dramatic fragments which testifies to genuine poetical feeling. An example may serve as a measure of the inspiration of the poet at this period.

To the Muses. . . .

A still more remarkable little book of poems by our author exists, which is only to be met with in the hands of collectors. It is a duodecimo entitled 'Songs of Innocence and Experience, shewing the two contrary states of the human soul. The Author and Printer W. Blake.' The letters appear to be etched, and the book is printed in yellow. Round and between the lines are all sorts of engravings; sometimes they resemble the monstrous hieroglyphs of the Egyptians, sometimes they represent not ungraceful arabesques. Wherever an empty space is left after the printing a picture is inserted. These miniature pictures are of the most vivid colours, and often grotesque, so that the book presents a most singular appearance. It is not easy to form a comprehensive opinion of the text, since the poems deserve the highest praise and the

gravest censure. Some are childlike songs of great beauty and sim-
plicity; these are the *Songs of Innocence*, many of which, nevertheless,
are excessively childish. The *Songs of Experience*, on the other hand,
are metaphysical riddles and mystical allegories. Among them are
poetic pictures of the highest beauty and sublimity; and againt here are
poetical fancies which can scarcely be understood even by the initiated.

As we wish to make the knowledge of our author as complete as pos-
sible, we will give an example of either kind. The book has an 'Intro-
duction' from which we here insert the first and the two last stanzas
(the fourth and fifth). . . .

We can only give one more example of these joyous and delicious
songs, that called 'Holy Thursday,' which describes the procession of
children from all the charity schools to St. Paul's Cathedral which
always takes place on this day. . . .

We cannot better set forth the many-sided gifts of our poet than by
following up this singularly delicate and simple poem with this truly
inspired and original description of 'The Tyger'. . . .

Of the allegorical poems we prefer to give one which we think we
understand, rather than one which is to us wholly incomprehensible.
The following *Song of Experience* probably represents man after the
loss of his innocence, as, bound by the commandment and the priests
its servants, he looks back in longing to his earlier state, where before
was no commandment, no duty, and nought save love and voluntary
sacrifice.

The Garden of Love. . . .

Besides these songs two other works of Blake's poetry and painting
have come under our notice, of which, however, we must confess our
inability to give a sufficient account. These are two quarto volumes
which appeared in 1794, printed and adorned like the *Songs*, under the
titles of *Europe*, a Prophecy, and *America*, a Prophecy. The very
'Prophecies of Bakis' are not obscurer. *America* appears in part to give
a poetical account of the Revolution, since it contains the names of
several party leaders. The actors in it are a species of guardian angels.
We give only a short example, nor can we decide whether it is intended
to be in prose or verse. . . .

The obscurity of these lines in such a poem by such a man will be
willingly overlooked.

Europe is a similar mysterious and incomprehensible rhapsody,
which probably contains the artist's political visions of the future, but
is wholly inexplicable. It appears to be in verse, and these are the first
four lines

These Prophecies, like the *Songs,* appear never to have come within the ken of the wider public.

We have now given an account of all the works of this extraordinary man that have come under our notice. We have been lengthy, but our object is to draw the attention of Germany to a man in whom all the elements of greatness are unquestionably to be found, even though those elements are disproportionately mingled. Closer research than was permitted us would perhaps shew that as an artist Blake will never produce consummate and immortal work, as a poet flawless poems; but this assuredly cannot lessen the interest which all men, Germans in a higher degree even than Englishmen, must take in the contemplation of such a character. We will only recall the phrase of a thoughtful writer, that those faces are the most attractive in which nature has set something of greatness which she has yet left unfinished; the same may hold good of the soul.

C

JOHN THOMAS SMITH

(from *Nollekens and his Times,* 1828)

John Thomas Smith's anecdotes about Blake were printed in the second volume (pp. 454–88) of his biography, *Nollekens and his Times*: comprehending a Life of that Celebrated Sculptor; and memoirs of several Contemporary Artists, from the time of Roubiliac, Hogarth and Reynolds, to that of Fuseli, Flaxman, and Blake, London, 1828. Smith was primarily concerned with Blake as an artist. The poetry he mentioned simply to contradict the current impression that it was totally worthless and obscure.

The facts are quite uniformly reliable. Clearly Smith had not only known Blake personally for over forty years, but he had made profitable inquiries about Blake among his friends. Among his chief merits are the facts he gives about Blake's early life, particularly concerning the Mathew circle.

BLAKE

I believe it has been invariably the custom of every age, whenever a man has been found to depart from the usual mode of thinking, to consider him of deranged intellect, and not unfrequently stark staring mad; which judgment his calumniators would pronounce with as little hesitation, as some of the uncharitable part of mankind would pass sentence of death upon a poor half-drowned cur who had lost his master, or one who had escaped hanging with a rope about his neck. Cowper, in a letter to Lady Hesketh, dated June 3d, 1788, speaking of a dancing-master's advertisement, says, 'The author of it had the good hap to be crazed, or he had never produced any thing half so clever; for

you will observe, that they who are said to have lost their wits, have more than other people.'[1]

Bearing this stigma of eccentricity, William Blake, with most extraordinary zeal, commenced his efforts in Art under the roof of No. 28, Broad-street, Carnaby-market; in which house he was born, and where his father carried on the business of a hosier. William, the subject of the following pages, who was his second son,[2] showing an early stretch of mind, and a strong talent for drawing, being totally destitute of the dexterity of a London shopman, so well described by Dr. Johnson, was sent away from the counter as a booby, and placed under the late Mr. James Basire, an Artist well known for many years as Engraver to the Society of Antiquaries. From him he learned the mechanical part of his art, and as he drew carefully, and copied faithfully, his master frequently and confidently employed him to make drawings from monuments to be engraven.

After leaving his instructor, in whose house he had conducted himself with the strictest propriety, he became acquainted with Flaxman,[3] the Sculptor, through his friend Stothard, and was also honoured by an introduction to the accomplished Mrs. Mathew, whose house, No. 27, in Rathbone-place, was then frequented by most of the literary and talented people of the day. This lady, to whom I also had the honour of being known, and whose door and purse were constantly open and ready to cherish persons of genius who stood in need of assistance in their learned and arduous pursuits, worldly concerns, or inconveniences,—was so extremely zealous in promoting the celebrity of Blake, that upon hearing him read some of his early efforts in poetry, she thought so well of them, as to request the Rev. Henry Mathew,[4] her husband, to join Mr. Flaxman in his truly kind offer of defraying the expense of printing them; in which he not only acquiesced, but, with his usual urbanity, wrote the following advertisement, which precedes the poems.

'The following sketches were the production of an untutored youth,[5] commenced in his twelfth, and occasionally resumed by the author till his twentieth year; since which time, his talents having been wholly directed to the attainment of excellence in his profession, he has been deprived of the leisure requisite to such a revisal of these sheets, as might have rendered them less unfit to meet the public eye.

[1] W. Hayley, *The Life, and Posthumous Writings, of William Cowper, Esqr.*, London, 1803, vol. i, pp. 302–3.

[2] Blake was the third son, but the second who survived to manhood.

[3] Tatham (p. 521) says Flaxman and Blake 'had known each other from boyhood', but Smith, as a contemporary of the events he describes, may be taken as the more reliable witness.

[4] This should be the Revd. Anthony Stephen Mathew.

[5] 'of untutored youth'.

'Conscious of the irregularities and defects to be found in almost every page, his friends have still believed that they possessed a poetical originality,[1] which merited some respite from oblivion. These, their opinions, remain, however, to be now reproved or confirmed by a less partial public.'

The annexed Song is a specimen of the juvenile playfulness of Blake's muse, copied from page 10 of these Poems.*

<div align="center">

SONG. [*See pp. 428–9.*]

'How sweet I roam'd . . .'

</div>

But it happened, unfortunately, soon after this period, that in consequence of his unbending deportment, or what his adherents are pleased to call his manly firmness of opinion, which certainly was not at all times considered pleasing by every one, his visits were not so frequent. He however continued to benefit by Mrs. Mathew's liberality, and was enabled to continue in partnership, as a Printseller, with his fellow-pupil, Parker, in a shop, No. 27, next door to his father's, in Broad-street; and being extremely partial to Robert, his youngest brother, considered him as his pupil.[2] Bob, as he was familiarly called, was one of my playfellows, and much beloved by all his companions.[3]

Much about this time, Blake wrote many other songs, to which he also composed tunes. These he would occasionally sing to his friends; and though, according to his confession, he was entirely unacquainted with the science of music, his ear was so good, that his tunes were sometimes most singularly beautiful, and were noted down by musical professors. As for his later poetry, if it may be so called, attached to his plates, though it was certainly in some parts enigmatically curious

* The whole copy of this little work, entitled 'Poetical Sketches, by W.B.' containing seventy pages, octavo, bearing the date of 1783, was given to Blake to sell to friends, or publish, as he might think proper.

[1] 'a poetic originality'.

[2] The wording of this passage is obscure, but the chronology suggests that Mrs. Mathew somehow helped Blake and Parker to open their print shop late in 1784, some time after the 1783 *Poetical Sketches* were printed. Smith himself joined the Mathew circle in 1784 (J. T. Smith, *A Book for a Rainy Day*, London, 1845, p. 81), so though his information about the printing of the *Poetical Sketches* was necessarily second-hand, that about the print shop may be first hand. If he meant, not that Mrs. Mathew helped them to open the Broad Street print shop, but that she helped them to keep it open in partnership, her help must have been in 1785 and rather ineffectual, for Blake moved to Poland Street within a year, by Christmas quarter 1785.

[3] Bob and J. T. Smith were almost of an age, fourteen and sixteen, in 1782, when Bob may have been living with his brother in Green Street, and Smith was presumably at his father's print shop at the sign of Rembrandt's Head, May's Buildings, St. Martin's Lane, about two streets away.

as to its application, yet it was not always wholly uninteresting; and I have unspeakable pleasure in being able to state, that though I admit he did not for the last forty years attend any place of Divine worship,[1] yet he was not a Freethinker, as some invidious detractors have thought proper to assert,[2] nor was he ever in any degree irreligious. Through life, his Bible was every thing with him; and as a convincing proof how highly he reverenced the Almighty, I shall introduce the following lines with which he concludes his address to the Deists.[3]

> 'For a tear is an intellectual thing;
> And a sigh is the sword of an Angel-King;
> And the bitter groan of a Martyr's woe
> Is an arrow from the Almighty's bow.'

Again, at page 77, in his address to the Christians:

> 'I give you the end of a golden string;
> Only wind it into a ball,
> It will lead you in at Heaven's gate,
> Built in Jerusalem's wall.'

In his choice of subjects, and in his designs in Art, perhaps no man had higher claim to originality, nor ever drew with a closer adherence to his own conception; and from what I knew of him, and have heard related by his friends, I most firmly believe few artists have been guilty of less plagiarisms than he. It is true, I have seen him admire and heard him expatiate upon the beauties of Marc Antonio and of Albert Durer; but I verily believe not with any view of borrowing an idea; neither do I consider him at any time dependent in his mode of working, which was generally with the graver only; and as to printing, he mostly took off his own impressions.

[1] 'If it *must* be told, that he did not go to church, it should also be told that he was no scoffer at sacred mysteries; and, although thus isolated from the communion of the faithful, ever professed his preference of the Church to any sort of sectarianism. On one occasion, he expressed the uneasiness he should have felt (had he been a parent) at a child of his dying unbaptized. One day, rather in an opposing mood, I think, he declared that the Romish Church was the only one which taught the forgiveness of sins.' So writes Gilchrist (1863, p. 330; not reprinted later), quoting the letter of 'another friend of Blake's'. The friend is clearly one of Blake's orthodox young disciples (perhaps Palmer), who were only qualified to speak about his last years.

Blake certainly was a scoffer at sacred mysteries, for instance in *The Marriage of Heaven and Hell*, and his preference for the Church of England is scarcely demonstrated by his desire to be buried in a Dissenting cemetery.

[2] Smith's repeated references to Blake's invidious detractors apparently refer to private rather than printed gossip.

[3] *Jerusalem*, Plate 52,

After his marriage, which took place at Battersea, and which proved a mutually happy one, he instructed his *beloved*, for so he most frequently called his Kate,* and allowed her, till the last moment of his practice, to take off his proof impressions and print his works, which she did most carefully, and ever delighted in the task: nay, she became a draughtswoman; and as a convincing proof that she and her husband were born for each other's comfort, she not only entered cheerfully into his views, but, what is curious, possessed a similar power of imbibing ideas, and has produced drawings equally original, and, in some respects, interesting.[1]

Blake's peace of mind, as well as that of his Catherine, was much broken by the death of their brother Robert, who was a most amicable link in their happiness; and, as a proof how much Blake respected him, whenever he beheld him in his visions, he implicitly attended to his opinion and advice as to his future projected works.[2] I should have stated, that Blake was supereminently endowed with the power of disuniting all other thoughts from his mind, whenever he wished to

* A friend has favoured me with the following anecdotes, which he received from Blake, respecting his courtship. He states that 'Our Artist fell in love with a lively little girl, who allowed him to say every thing that was loving, but would not listen to his overtures on the score of matrimony. He was lamenting this in the house of a friend, when a generous-hearted lass declared that she pitied him from her heart. 'Do you pity me?' asked Blake. 'Yes; I do, most sincerely.'—'Then,' said he, 'I love you for that.'—'Well,' said the honest girl, 'and I love you.' The consequence was, they were married, and lived the happiest of lives.'

[1] According to the 'List of John Linnell Senior's Letters and Papers', pp. 39–40 (Ivimy MSS.), Gilchrist wrote to Linnell on April 23rd, 1855 and asked him to look through J. T. Smith's life of Blake '& to mark in the margin anything which strikes him as inaccurate[.] "The first virtue of Biography is entire veracity[.]" ' On the 27th Gilchrist wrote again to thank Linnell for the parcel of Blake materials '& especially for the *notes*, made by J. L., giving "modifications of statements already current" concerning Blake'. I have not traced the volume with Linnell's annotations, but Linnell prudently kept a transcript of his notes on four sheets of paper which are now with the Ivimy MSS. The page references indicate that Linnell was using the second edition of *Nollekens and his Times*, of 1829. Linnell's transcripts of his own notes are given below attached to the passages which they illuminate.

'Page 467. There is very little evidence left that M^rs Blake produced Drawings equally original with her husbands[.] The only one they ever shewed me which they affirmed to be her Design & execution is in my possession & is certainly so like one of Blake's own that it is difficult to believe it to be the production of any other mind. J.L[.]'

Sir Geoffrey Keynes owns a drawing by Catherine of a face which she saw in the fire.

[2] Linnell commented: 'M^r Blake told me that he sat up for a whole fortnight with his brother Robert during his last illness & upon his going to bed which he did as soon as Robert died he slept for three days and nights. M^rs Blake confirmed this[.] J.L[.]'

indulge in thinking of any particular subject; and so firmly did he believe, by this abstracting power, that the objects of his compositions were before him in his mind's eye, that he frequently believed them to be speaking to him. This I shall now illustrate by the following narrative.

Blake, after deeply perplexing himself as to the mode of accomplishing the publication of his illustrated songs, without their being subject to the expense of letter-press, his brother Robert stood before him in one of his visionary imaginations, and so decidedly directed him in the way in which he ought to proceed, that he immediately followed his advice, by writing his poetry, and drawing his marginal subjects of embellishments in outline upon the copper-plate with an impervious liquid,[1] and then eating the plain parts or lights away with aquafortis considerably below them, so that the outlines were left as a stereotype. The plates in this state were then printed in any tint that he wished, to enable him or Mrs. Blake to colour the marginal figures up by hand in imitation of drawings.

The following are some of his works produced in this manner, viz.; 'Songs of Innocence and Songs of Experience,' 'The Book of Jerusalem,'[2] consisting of an hundred plates, 'The Marriage of Heaven and Hell,' 'Europe and America;'[3] and another work, which is now very uncommon, a pretty little series of plates, entitled 'Gates of Paradise.'[4]

Blake, like those artists absorbed in a beloved study, cared not for money beyond its use for the ensuing day; and indeed he and his 'beloved' were so reciprocally frugal in their expenses, that, never sighing for either gilded vessels, silver-laced attendants, or turtles' livers, they were contented with the simplest repast, and a little answered their purpose. Yet, notwithstanding all their economy, Dame Fortune being, as it is pretty well known to the world, sometimes a fickle jade, they, as well as thousands more, have had their intercepting clouds.

As it is not my intention to follow them through their lives, I shall

[1] Linnell wrote and deleted the following note on this passage: 'page 468[.] The liquid mentioned by M^r Smith with which he says Blake used to Draw his subjects in outline on his copper plates was nothing more I beleive than the usual stopping as it is called used by engravers made chiefly of pitch and diluted with Terps. The most extraordinary facility seems to have been attained by Blake in writing backwards & that with a brush dipped in a glutinous liquid for the writing is in many instances highly ornamental & varied in character as may be seen in his Songs of Innocence and the larger work of one hundred plates called Jerusalem[.]'

[2] i.e. *Jerusalem*; 'The Book of' has no authority.

[3] *Europe* and *America* are separate works, though often bound together.

[4] In the second edition of Smith's life (1829) occurred a typographical error which Linnell carefully corrected: '469 For "Gate of Paradise" read Gates of Paradise'.

confine myself to a relation of a few other anecdotes of this happy pair; and as they are connected with the Arts, in my opinion they ought not to be lost, as they may be considered worthy the attention of future biographers.

For his marginal illustrations of 'Young's Night Thoughts,' which possess a great power of imagination, he received so despicably low a price, that Flaxman, whose heart was ever warm, was determined to serve him whenever an opportunity offered itself; and with his usual voice of sympathy, introduced him to his friend Hayley, with whom it was no new thing to give pleasure, capricious as he was. This gentleman immediately engaged him to engrave the plates for his quarto edition of 'The Life of Cowper,' published in 1803–4;[1] and for this purpose he went down to Felpham, in order to be near that highly respected *Hermit*.[2]

Here he took a cottage, for which he paid twenty pounds a-year, and was not, as has been reported, entertained in a house belonging to Mr. Hayley rent-free. During his stay he drew several portraits, and could have had full employment in that department of the Art; but he was born to follow his own inclinations, and was willing to rely upon a reward for the labours of the day.

Mr. Flaxman, knowing me to be a collector of autographs, among many others, gave me the following letter, which he received from Blake immediately after his arrival at Felpham, in which he styles him

'DEAR SCULPTOR OF ETERNITY.

'We are safe arrived at our cottage, which is more beautiful than I thought it, and more convenient. It is a perfect model for cottages, and, I think, for palaces of magnificence; only enlarging, not altering, its proportions, and adding ornaments and not principals. Nothing can be more grand than its simplicity and usefulness. Simple without intricacy, it seems to be the spontaneous effusion of humanity, congenial to the wants of man. No other-formed house can ever please me so well; nor shall I ever be persuaded, I believe, that it can be improved either in beauty or use.

'Mr. Hayley received us with his usual brotherly affection. I have begun to work. Felpham is a sweet place for study, because it is more spiritual

[1] Linnell adds: '470 The copper plates which Blake engraved to illustrate Haley's life of Cowper were as he told me printed entirely by himself and his wife in his own press—a very good one which cost him forty pounds.' On Jan. 30th, 1803 Blake wrote to his brother James: 'My Wife has undertaken to Print the whole number of the Plates for Cowpers work which She does to admiration & being under my own eye the prints are as fine as the French prints & please every one[.]'

[2] The chronology is distorted here. Flaxman first talked and wrote to Hayley about Blake in 1784. Blake was presumably paid for his *Night Thoughts* illustrations in 1796 or early 1797, but Hayley was commissioning drawings from Blake in June 1796. When Blake was invited to Felpham, in July 1800, Hayley did not yet know that he was to be the author of Cowper's life.

than London. Heaven opens here on all sides her golden gates; her windows are not obstructed by vapours; voices of celestial inhabitants are more distinctly heard, and their forms more distinctly seen, and my cottage is also a shadow of their houses. My wife and sister are both well, courting Neptune for an embrace.

'Our journey was very pleasant; and though we had a great deal of luggage, no grumbling. All was cheerfulness and good-humour on the road, and yet we could not arrive at our cottage before half-past eleven at night, owing to the necessary shifting of our luggage from one chaise to another; for we had seven different chaises, and as many different drivers. We set out between six and seven in the morning of Thursday, with sixteen heavy boxes, and portfolios full of prints.

'And now begins a new life, because another covering of earth is shaken off. I am more famed in Heaven for my works than I could well conceive. In my brain, are studies and chambers filled with books and pictures of old, which I wrote and painted in ages of eternity, before my mortal life; and those works are the delight and study of archangels. Why then should I be anxious about the riches or fame of mortality? The Lord, our father, will do for us and with us according to his Divine will for our good.

'You, O dear Flaxman! are a sublime Archangel, my friend and companion from eternity. In the Divine bosom is our dwelling-place. I look back into the regions of reminiscence, and behold our ancient days before this earth appeared in its vegetated mortality to my mortal-vegetated eyes. I see our houses of eternity which can never be separated, though our mortal vehicles should stand at the remotest corners of Heaven from each other.

'Farewell, my best friend! Remember me and my wife in love and friendship to our dear Mrs. Flaxman, whom we ardently desire to entertain beneath our thatched roof of rusted gold; and believe me for ever to remain,

'Your grateful and affectionate,

WILLIAM BLAKE.'

'Felpham, Sept. 21st, 1800.
'Sunday morning.'

In a copy of Hayley's 'Triumphs of Temper,' illustrated by Stothard,[1]

[1] Gilchrist (1942, p. 125; 1863, p. 147) identifies this as the tenth edition of 1799.

The draft of this poem, headed 'From Thomas Hayley to Wm Blake', is in the Allan R. Brown William Blake Collection in the library of Trinity College, Hartford, Connecticut. This version, which was written very hastily, has a number of minor variants which may be tentatively read through the deletions:

```
                  my gentle
    Accept [most (?) del] visionary Blake
      Sublime fanciful & kindly mild
    Accept and fondly keep
    [And favorable(?) guard(?) del] for friendships sake
      This favored vision my poetic Child
```

which had been the one belonging to the Author's son, and which he gave after his death to Blake, are these verses in MS. by the hand of the donor.

'Accept, my gentle visionary, Blake,
Whose thoughts are fanciful and kindly mild;
Accept, and fondly keep for friendship's sake,
This favor'd vision, my poetic child.

'Rich in more grace than fancy ever won,
To thy most tender mind this book will be,
For it belong'd to my departed son;
So from an angel it descends to thee.

'W. H.
July, 1800.' *

Upon his return from Felpham,[1] he addressed the public, in page 3 of his Book of Jerusalem, in these words, 'After my three years' slumber on the banks of the ocean, I again display my giant-forms to the public,' &c.

Some of the 'giant-forms,' as he calls them, are mighty and grand, and if I were to compare them to the style of any preceding artist, Michel Angelo, Sir Joshua's favourite, would be the one; and were I to select a specimen as a corroboration of this opinion, I should instance the figure personifying the 'Ancient of Days,' the frontispiece to his 'Europe, a Prophecy.' In my mind, his knowledge of drawing, as well as design, displayed in this figure, must at once convince the informed reader of his extraordinary abilities.

* I copied the above from the book now in the possession of Mrs. Blake.

Rich in
[To give it *del*] more Grace than Fancy ever won
To thy most tender mind this Book will be
For it
[The Book *del*] belonged to my departed Son
So
[Thus *del*] from an angel it descends to Thee

The book with Hayley's poem in it has not been traced.

[1] Linnell wrote beside this passage: '473 Before Blakes return from Felpham he was tried for high treason at chichester[;] his account of this affair was that a Drunken Soldier forcibly entered his garden at Felpham whom he turned out with great vehemence & according to his account frightened the man[.] This I beleive to be very probable[.] The man swore that Blake Damned the King, and it is not impossible that something of that sort might have been uttered by Blake in reply to the Soldiers using the Kings name with threats to try and intimidate Blake who very likely included the man & his master in one curse—an absurd thing truly to found a charge of high treason upon. However Blake was acquitted for all the neighbouring Farmers & inhabitants of the place who knew Blake came forward & gave him so high a character that the Soldiers evidence was not beleived[.]'

I am now under the painful necessity of relating an event promulgated in two different ways by two different parties; and as I entertain a high respect for the talents of both persons concerned, I shall, in order to steer clear of giving umbrage to the supporters of either, leave the reader to draw his own conclusions, unbiassed by any insinuation whatever of mine.[1]

An Engraver of the name of Cromek, a man who endeavoured to live by speculating upon the talents of others, purchased a series of drawings of Blake, illustrative of Blair's 'Grave,' which he had begun with a view of engraving and publishing.[2] These were sold to Mr. Cromek for the insignificant sum of one guinea each, with the promise, and indeed under the express agreement, that Blake should be employed to engrave them; a task to which he looked forward with anxious delight. Instead of this negotiation being carried into effect, the drawings, to his great mortification, were put into the hands of Schiavonetti. During the time this artist was thus employed, Cromek had asked Blake what work he had in mind to execute next. The unsuspecting artist not only told him, but without the least reserve showed him the designs sketched out for a fresco picture; the subject Chaucer's 'Pilgrimage to Canterbury;' with which Mr. Cromek appeared highly delighted. Shortly after this, Blake discovered that

[1] Linnell's note on this passage reads:

474 Mr Smith's account of the affair of the Drawings for Blair's grave is I beleive correct, but respecting the Canterbury Pilgrims his account is dificient in those particulars which Mr Blake affirmed to me & which certainly explain his version of the case [& the occasion of it—*del*.] Cromec according to Blake employed or engaged him to finish the frescoes as he called it of the Canterbury Pilgrims for him for 20 Guineas with the understanding that the remuneration for the whole would be made adequate by the price to be paid to Blake for the Engraving [of the same *del*] which [Blake *del*] stipulated he should execute, but as Cromec secretly negociated with [Schiavonetti *del*] Bromley to engrave this subject from Blakes Drawing which he tried to obtain from Blake without paying more than the 20 Gs but Blake who had some good reason to suspect Cromec refused to let him have it & Blake supposed that Cromec then went to Stothard and commissioned him to paint his Canterbury pilgrims of the [exact *del*] size & character that it had been arranged[?] by Blake to engrave his Drawing & when he heard that Mr Stothard had begun a picture for Cromec of the same subject & [exactly the same *del*] size he immediately set about the engraving his own Drawing [and partially(?) completed it before the picture by Stothard was finished *del*] published it in 1810[.]

Stothard['s] account of the affair may be to a great extent veracious as far as he is concerned because when Cromec went to him to commission him to paint the subject [of the pilgrims *del*] having been disappointed in the trick he attempted with Blake he of course said nothing to Stothard about Blakes design though he must have suggested the size and treatement as they are so much alike in these respects.

[2] The phrasing here is obscure, but Smith apparently means that Blake had originally intended to publish the twenty drawings himself.

Stothard, a brother-artist to whom he had been extremely kind in early days, had been employed to paint a picture, not only of the same subject, but in some instances similar to the fresco sketch which he had shown to Mr. Cromek.[1] The picture painted by Stothard became the property of Mr. Cromek, who published proposals for an engraving from it, naming Bromley as the engraver to be employed. However, in a short time, that artist's name was withdrawn, and Schiavonetti's substituted, who lived only to complete the etching; the plate being finished afterwards by at least three different hands. Blake, highly indignant at this treatment, immediately set to work, and proposed an engraving from his fresco picture, which he publicly exhibited in his brother James's shop window, at the corner of Broad-street, accompanied with an address to the public, stating what he considered to be improper conduct.

So much on the side of Blake.* On the part of Stothard, the story runs thus. Mr. Cromek had agreeed with that artist to employ him upon a picture of the Procession of Chaucer's Pilgrimage to Canterbury, for which he first agreed to pay him sixty guineas, but in order to enable him to finish it in a more exquisite manner, promised him forty more, with an intention of engaging Bromley to engrave it; but in consequence of some occurrence, his name was withdrawn, and Schiavonetti was employed. During the time Stothard was painting the picture,

* In 1809, Blake exhibited sixteen poetical and historical inventions, in his brother's first-floor in Broad-street; eleven pictures in fresco,[2] professed to be painted according to the ancient method, and seven drawings, of which an explanatory catalogue was published, and is perhaps the most curious of its kind ever written. At page 7, the description of his fresco painting of Geoffrey Chaucer's Pilgrimage commences. This picture, which is larger than the print, is now in the possession of Thomas Butts, Esq. a gentleman friendly to Blake, and who is in possession of a considerable number of his works.

[1] A highly improbable version of the affair is given by John Sartain (*The Reminiscences of a Very Old Man 1808–1897*, N.Y., 1899, p. 112), on the authority of Henry Richter Jr. Richter's 'father was really at the bottom of the affair. Richter [*Sr.*], the worker in scagliola, and Stothard and Cromek were all neighbours in Newman Street, Oxford Street. Richter wanted to get his son Henry [*Jr.*], into Stothard's studio as a pupil, and in order to lay the latter under an obligation, he induced Cromek to give the commission as he did. Stothard, however, declined to receive the son, and when the elder Richter reproached him for being ungrateful, Stothard replied that teaching was not in his line, or words to that effect.' Sartain had not known Blake, but he had known Catherine when she lived with Tatham, and he had been Richter's pupil for eight months in 1827 and 1828. He therefore might have had good information. However, besides the inherent improbabilities of Sartain's version, we may note (1) that Stothard *did* take pupils; (2) that in fact the younger Richter *had* been his pupil about 1787; and (3) that Richter would have been 35 in 1807, and long past the stage when he might have been anyone's pupil.

[2] Smith's numbers are not mutually consistent here. There were in fact nine pictures in fresco, not eleven.

Blake called to see it, and appeared so delighted with it, that Stothard, sincerely wishing to please an old friend with whom he had lived so cordially for many years, and from whose works he always most liberally declared he had received much pleasure and edification, expressed a wish to introduce his portrait as one of the party, as a mark of esteem. . . .

In 1810, Stothard, to his great surprise, found that Blake had engraved and published a plate of the same size, in some respects bearing a similarity to his own.* Such are the outlines of this controversy.

Blake's ideas were often truly entertaining, and after he had conveyed them to paper, his whimsical and novel descriptions frequently

* I must do to Mr. Stothard the justice to declare,[1] that the very first time I saw him after he had read the announcement of Blake's death, he spoke in the handsomest terms of his talents, and informed me that Blake made a remarkably correct and fine drawing of the head of Queen Philippa, from her monumental effigy in Westminster Abbey, for Gough's Sepulchral Monuments, engraved by Basire. The collectors of Stothard's numerous and elegant designs, will recollect the name of Blake as the engraver of several plates in the Novelist's Magazine, the Poetical Magazine, and also others for a work entitled the Wit's Magazine, from drawings produced by the same artist.[2] Trotter, the engraver, who received instructions from Blake,[3] and who was a pattern-draughtsman to the calico-printers, introduced his friend Stothard to Blake, and their attachment for each other continued most cordially to exist in the opinion of the public, until they produced their rival pictures of Chaucer's Canterbury Pilgrimage.

[1] Linnell remarked on this passage: '478 At the Artists Fund dinner held at the Free Masons Tavern[.] Blake During the Conversation in the Ante Room before dinner went up to Stothard & offered his hand which was refused by his old acquaintance who turned away in silence.' Linnell apparently told Gilchrist more of this story later, for Gilchrist continues it (1942, p. 248; 1863, p. 232): 'Another time, Stothard was ill: Blake called and wished to see him and be reconciled, but was refused.'

On the other hand, Stothard's son wrote (R. T. Stothard, 'Stothard and Blake', *The Athenaeum*, no. 1186 [1863], p. 838): 'I cannot admit Mr. Gilchrist's assertion that there was any apparent ill-will between my father and Blake; for on one occasion I was sent to Blake with a message from my father, when I found him living in a court off the Strand, and met him on the stairs, saying to me "he had a battle with the devil below to obtain the coals," which seemed to me to indicate madness.' Stothard's facts are probably as confused as his diction (what has madness to do with ill-will?); certainly Linnell is the more reliable witness.

The Artists Fund Dinner is probably that of the Artists' General Benevolent Association, whose second meeting on June 4th, 1816 at the Free Mason's Tavern was described in *Annals of the Fine Arts*, i (1816), 103.

[2] There is no *Poetical Magazine* within fifteen years of this period (1782–5). Smith may have been thinking of the *Lady's Poetical Magazine* (1782–4) or the *Lady's Pocket Book* (1782); both have designs by Stothard, and the second has two plates by Blake.

[3] These instructions must have been of a very informal kind.

surpassed his delineations; for instance, that of his picture of the Transformation of the Flea to the form of a Man, is extremely curious. This personification, which he denominated a Cupper, or Blood-sucker, is covered with coat of armour, similar to the case of the flea, and is represented slowly pacing in the night, with a thorn attached to his right hand, and a cup in the other, as if ready to puncture the first person whose blood he might fancy, like Satan prowling about to seek whom he could devour. Blake said of the flea, that were that lively little fellow the size of an elephant, he was quite sure, from the calculations he had made of his wonderful strength, that he could bound from Dover to Calais in one leap.* Whatever may be the public opinion hereafter of Blake's talents, when his enemies are dead, I will not presume to predict;† but this I am certain of, that on the score of industry at least, many artists must strike to him. Application was a faculty so engendered in him that he took little bodily exercise to keep up his health:¹ he had few evening walks and little rest from labour, for his mind was ever fixed upon his art, nor did he at any time indulge in a game of chess, draughts, or backgammon; such amusements, considered as relaxations by artists in general, being to him distractions. His greatest pleasure was derived from the Bible,—a work ever in his hand, and which he often assiduously consulted in several languages. Had he fortunately lived till the next year's exhibition at Somersethouse, the public would then have been astonished at his exquisite finishing of a Fresco picture of the Last Judgment, containing upwards of one thousand figures, many of them wonderfully conceived and

* This interesting little picture is painted in Fresco. It is now the property of John Varley, the Artist, whose landscapes will ever be esteemed as some of the finest productions in Art, and who may fairly be considered as one of the founders of the Society of Artists in Water Colours; the annual exhibitions of which continue to surpass those of the preceding seasons.

† Blake's talent is not to be seen in his engravings from the designs of other artists, though he certainly honestly endeavoured to copy the beauties of Stothard, Flaxman, and those masters set before him by the few publishers who employed him; but his own engravings from his own mind are the productions which the man of true feeling must ever admire, and the predictions of Fuseli and Flaxman may hereafter be verified—'That a time will come when Blake's finest works will be as much sought after and treasured up in the portfolios of men of mind, as those of Michel Angelo are at present.'²

¹ This statement applies only to Blake's middle and old age, for Tatham (p. 527) reports that he and Catherine often walked twenty miles and back just to dine at some country inn.

² In the margin of his copy of Smith's life of Blake, Joseph Hogarth wrote: 'Fuseli said to Flaxman "By gare Flaxman all that we do know we have acquired from Mishter Blake." ' (W. Partington, 'Some Marginalia', *TLS*, Jan. 28th, 1939, p. 64.)

grandly drawn.[1] The lights of this extraordinary performance have the appearance of silver and gold; but upon Mrs. Blake's assuring me that there was no silver used, I found, upon a closer examination, that a blue wash had been passed over those parts of the gilding which receded, and the lights of the forward objects, which were also of gold, were heightened with a warm colour, to give the appearance of the two metals.

It is most certain, that the uninitiated eye was incapable of selecting the beauties of Blake; his effusions were not generally felt; and in this opinion I am borne out in the frequent assertions of Fuseli and Flaxman. It would, therefore, be unreasonable to expect the booksellers to embark in publications not likely to meet remuneration. Circumstanced, then, as Blake was, approaching to threescore years and ten, in what way was he to persevere in his labours? Alas, he knew not! until the liberality of Mr. Linnell, a brother-artist of eminence, whose discernment could well appreciate those parts of his designs which deserved perpetuity, enabled him to proceed and execute in comfort a series of twenty-one plates, illustrative of the Book of Job.[2] This was the last work he completed, upon the merits of which he received the highest congratulations from the following Royal Academicians: Sir Thomas Lawrence,[3] Mr. Baily, Mr. Philips, Mr. Chantrey, Mr. James Ward, Mr. Arnald, Mr. Collins, Mr. Westmacott,[4] and many other artists of eminence.

As to Blake's system of colouring, which I have not hitherto noticed, it was in many instances most beautifully prismatic. In this branch of the art he often acknowledged Apelles to have been his tutor, who was, he said, so much pleased with his style, that once when he appeared before him, among many of his observations, he delivered the following:—'You certainly possess my system of colouring; and I now wish you to draw my person, which has hitherto been untruly delineated.'

I must own that until I was favoured by Mr. Upcott with a sight of some of Blake's works,[5] several of which I had never seen, I was not so

[1] Gilchrist says (1942, p. 350; 1863, p. 358): 'Nobody could be found to give twenty-five guineas for it then.'

[2] Including the engraved title-page, there are twenty-two plates.

[3] Hogarth wrote by this passage (W. Partington, 'Some Marginalia', *TLS*, Jan. 28th, 1939, p. 64): 'For Sir Thomas Lawrence, Blake made two Drawings— one of the Wise and Foolish Virgins—the other Shadrach and his companions coming from the Fiery furnace—for which Lawrence paid him twenty five guineas each.—J.H.'

[4] Sir Thomas Lawrence, Ed. Hodges Bailey, Westmacott, and Chantrey purchased copies for themselves (see the *Job* Accounts), but the others probably saw the copy which Lawrence deposited in the Library of the Royal Academy. Their praise of the work was presumably reported by Linnell.

[5] Keynes and Wolf do not note that Upcott clearly inherited Humphry's Blake collection, which included *Songs of Experience* (H) and 'A Small Book of Designs' (A).

fully aware of his great depth of knowledge in colouring. Of these most interesting specimens of his art, which are now extremely rare, and rendered invaluable by his death, as it is impossible for any one to colour them with his mind, should the plates remain, Mr. Richard Thomson, another truly kind friend, has favoured me with the following descriptive lists.

['] SONGS OF EXPERIENCE. The author and printer, W. Blake. Small octavo; seventeen plates, including the title-page.[1] Frontispiece, a winged infant mounted on the shoulders of a youth. On the title-page, two figures weeping over crosses [*i.e. corpses*].

Introduction. Four Stanzas on a cloud, with a night-sky behind, and beneath, a figure of Earth stretched on a mantle.

Earth's Answer. Five Stanzas; a serpent on the ground beneath.

The Clod and the Pebble. Three Stanzas; above, a headpiece of four sheep and two oxen; beneath, a duck and reptiles.

A Poison Tree. Four Stanzas. The tree stretches up the right side of the page; and beneath, a dead body killed by its influence.

The Fly. Five Stanzas. Beneath, a female figure with two children.

Holy Thursday. Four Stanzas. Head-piece a female figure discovering a dead child. On the right-hand margin a mother and two children lamenting the loss of an infant which lies beneath. Perhaps this is one of the most tasteful of the set. [*See Plate XXXV.*]

The Chimney-Sweeper. Three Stanzas. Beneath, a figure of one walking in snow towards an open door.

London. Four Stanzas. Above, a child leading an old man through the street; on the right-hand, a figure warming itself at a fire. If in any instance Mr. Blake has copied himself, it is in the figure of the old man upon this plate, whose position appears to have been a favourite one with him.

The Tiger. Six Stanzas. On the right-hand margin, the trunk of a tree; and beneath, a tiger walking.

A Little Boy Lost. Six Stanzas. Ivy-leaves on the right-hand, and beneath, weeping figures before a fire, in which the verses state that the child had been burned by a Saint [*i.e. 'Priest'*].

The Human Abstract. Six Stanzas. The trunk of a tree on the right-hand margin, and beneath, an old man in white drawing a veil over his head.

The Angel. Four Stanzas. Head-piece, a female figure lying beneath a tree and pushing from her a winged boy.

My Pretty Rose Tree. Two Stanzas: Succeeded by a small vignette, of a figure weeping, and another lying reclined at the foot of a tree. Beneath, are two verses more, entitled, *Ah! Sun Flower*; and a single stanza, headed *The Lilly*.

Nurse's Song. Two Stanzas. Beneath, a girl with a youth and a female child at a door surrounded by vine-leaves.

[1] Upcott's *Songs of Experience* (H) omits 'The Little Girl Lost [*and* Found]', 'The Sick Rose', 'The Garden of Love', 'The Little Vagabond', 'Infant Sorrow', 'To Tirzah', 'The School Boy', and 'The Voice of the Ancient Bard'.

A Little Girl Lost. Seven Stanzas; interspersed with birds and leaves, the trunk of a tree on the right-hand margin.

['] The whole of these plates are coloured in imitation of fresco. The poetry of these songs is wild, irregular, and highly mystical, but of no great degree of elegance or excellence, and their prevailing feature is a tone of complaint of the misery of mankind.

['] AMERICA: *a Prophecy*. Lambeth: Printed by William Blake, in the year 1793; folio; eighteen plates or twenty pages, including the frontispiece and title-page.[1] After a preludium of thirty-seven lines commences the Prophecy of 226, which are interspersed with numerous head-pieces, vignettes, and tail-pieces, usually stretching along the left-hand margin and enclosing the text; which sometimes appears written on a cloud, and at others environed by flames and water. Of the latter subject a very fine specimen is shown upon page 13, where the tail-piece represents the bottom of the sea, with various fishes coming together to prey upon a dead body. The head-piece is another dead body lying on the surface of the waters, with an eagle feeding upon it with outstretched wings. Another instance of Mr. Blake's favourite figure of the old man entering at Death's door, is contained on page 12 of this poem. The subject of the text is a conversation between the Angel of Albion, the Angels of the Thirteen States, Washington, and some others of the American Generals, and "Red Orc," the spirit of war and evil. The verses are without rhyme, and most resemble hexameters, though they are by no means exact; and the expressions are mystical in a very high degree.

['] EUROPE: *a Prophecy*. Lambeth: Printed by William Blake, 1794; folio; seventeen plates on the leaves, inclusive of the frontispiece and title-page. Coloured to imitate the ancient fresco painting.[2] The Preludium consists of thirty-three lines, in stanzas without rhyme, and the Prophecy of two hundred and eight; the decorations to which are larger than most of those in the former book, and approach nearest to the character of paintings, since, in several instances, they occupy the whole page. The frontispiece is an uncommonly fine specimen of art, and approaches almost to the sublimity of Raffaelle or Michel Angelo. It represents "The Ancient of Days," in an orb of light surrounded by dark clouds, as referred to in Proverbs viii. 27, stooping down with an enormous pair of compasses to describe the destined orb of the world,* "when he set a compass upon the face of the earth."[3]

* He was inspired with the splendid grandeur of this figure, by the vision which he declared hovered over his head at the top of his staircase; and he has been fre-

[1] Copy H; no copy has 20 pp.
[2] Evidently this means colour-printed, as it does with *Experience* (H), suggesting this is *Europe* copy D. [3] 'the face of the deep'.

PLATE LII

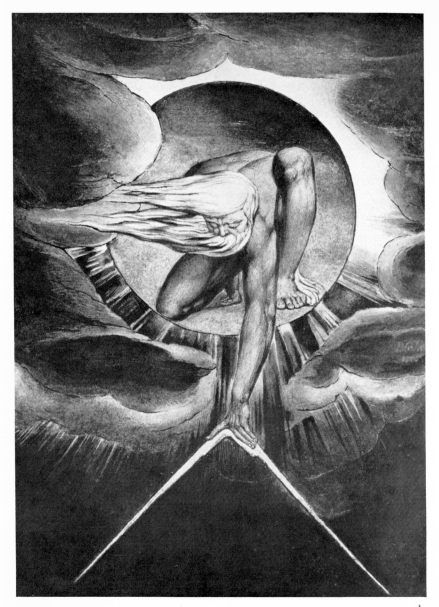

'THE ANCIENT OF DAYS' (1794), the print Blake coloured for Tatham on his deathbed. J. T. Smith said this sublime figure, one of Blake's favourites, was inspired 'by the vision which he declared hovered over his head at the top of his staircase' (see p. 470)

"—— in His hand
He took the golden compasses, prepar'd
In God's eternal store, to circumscribe
This universe and all created things:
One foot he centr'd, and the other turn'd
Round through the vast profundity obscure;
And said, 'Thus far extend, thus far thy bounds,
This be thy just circumference, O World!' "

<div align="right">Paradise Lost, Book vii, line 236.</div>

['] Another splendid composition in this work, are the two angels pouring out the black spotted plague upon England, on page 9; in which the fore-shortening of the legs, the grandeur of their positions, and the harmony with which they are adapted to each other and to their curved trumpets, are perfectly admirable. The subject-matter of the work is written in the same wild and singular measures as the preceding, and describes, in mystical language, the terrors of plague and anarchy which overspread England during the slumbers of Enitharmon for eighteen hundred years; upon whose awaking, the ferocious spirit Orc bursts into flames "in the vineyards of red France."[1] At the end of

quently heard to say, that it made a more powerful impression upon his mind than all he had ever been visited by. This subject was such a favourite with him, that he always bestowed more time and enjoyed greater pleasure when colouring the print, than any thing he ever produced. [*See Plate LII.*]

Mr. F. Tatham employed him to tint an impression of it, for which I have heard he paid him[2] the truly liberal sum of three guineas and a half. I say liberal, though the specimen is worth any price, because the sum was so considerably beyond what Blake generally had been accustomed to receive as a remuneration for his extraordinary talents. Upon this truly inestimable impression, which I have now before me, Blake worked when bolstered-up in his bed only a few days before he died; and my friend F. Tatham has just informed me, that after Blake had frequently touched upon it, and had as frequently held it at a distance, he threw it from him, and with an air of exulting triumph exclaimed, 'There, that will do! I cannot mend it.' However, this was not his last production; for immediately after he had made the above declaration to his beloved Kate, upon whom his eyes were steadfastly fixed, he vociferated, 'Stay! keep as you are! *you* have ever been *an angel* to me, I will draw you;' and he actually made a most spirited likeness of her, though within so short a period of his earthly termination.

[1] *Europe*, Plate 15.
[2] Unless Tatham paid in advance, he must have paid Mrs. Blake, for he says (p. 528) that Blake died within hours of finishing the tinting of this plate.

Tatham quotes Blake in slightly different words in a letter to W. M. Rossetti of Dec. 16th, 1862, which says that when the frenzied sketch of Catherine was 'done he sang himself joyously and most happily—literally with songs—into the arms of the grim enemy, and yielded up his sweet spirit.' (W. M. Rossetti, *Rossetti Papers 1862 to 1870*, London, 1903, pp. 19–20.)

this poem, are seven separate engravings on folio pages, without letter-press, which are coloured like the former part of the work, with a degree of splendour and force, as almost to resemble sketches in oil-colours.[1] The finest of these are a figure of an angel standing in the sun, a group of three furies surrounded by clouds and fire, and a figure of a man sitting beneath a tree in the deepest dejection; all of which are peculiarly remarkable for their strength and splendour of colouring. Another publication by Mr. Blake, consisted only of a small quarto volume of twenty-three engravings of various shapes and sizes, coloured as before, some of which are of extraordinary effect and beauty.[2] The best plates in this series are,—the first of an aged man, with a white beard sweeping the ground, and writing in a book with each hand, naked; a human figure pressing out his brain through his ears; and the great sea-serpent; but perhaps the best is a figure sinking in a stormy sea at sun-set, the splendid light of which, and the foam upon the black waves, are almost magical effects of colouring. Beneath the first design is engraven *"Lambeth, printed by W. Blake, 1794."* [']

Blake's modes of preparing his ground, and laying them over his panels for painting, mixing his colours, and manner of working, were those which he considered to have been practised by the earliest fresco-painters, whose productions still remain, in numerous instances, vivid and permanently fresh. His ground was a mixture of whiting and carpenter's glue, which he passed over several times in thin coatings: his colours he ground himself, and also united them with the same sort of glue, but in a much weaker state. He would, in the course of painting a picture, pass a very thin transparent wash of glue-water over the whole of the parts he had worked upon, and then proceed with his finishing.

This process I have tried, and find, by using my mixtures warm, that I can produce the same texture as possessed in Blake's pictures of the Last Judgment, and others of his productions, particularly in Varley's curious picture of the personified Flea. Blake preferred mixing his colours with carpenter's glue, to gum, on account of the latter cracking in the sun, and becoming humid in moist weather. The glue-mixture stands the sun, and change of atmosphere has no effect upon it. Every carpenter knows that if a broken piece of stick be joined with good glue, the stick will seldom break again in the glued parts.

That Blake had many secret modes of working, both as a colourist and an engraver, I have no doubt. His method of eating away the plain

[1] 'A Large Book of Designs' (A) was originally bound with copy D of *Europe*.
[2] This collection, called by Keynes and Wolf 'A Small Book of Designs', exists in only two copies, one of which (A) was made for Ozias Humphry.

copper, and leaving his drawn lines of his subjects and his words as stereotype, is in my mind perfectly original. Mrs. Blake is in possession of the secret, and she ought to receive something considerable for its communication, as I am quite certain it may be used to the greatest advantage both to artists and literary characters in general.

That Blake's coloured plates have more effect than others where gum has been used, is, in my opinion, the fact, and I shall rest my assertion upon those beautiful specimens in the possession of Mr. Upcott, coloured purposely for that gentleman's godfather,[1] Ozias Humphrey, Esq. to whom Blake wrote the following interesting letter.

To OZIAS HUMPHREY, ESQ.

'The design of The Last Judgment, which I have completed by your recommendation for the Countess of Egremont, it is necessary to give some account of; and its various parts ought to be described, for the accommodation of those who give it the honour of their[2] attention.

'Christ seated on the Throne of Judgment: the Heavens in clouds rolling before him and around him, like a scroll ready to be consumed in the fires of the Angels; who descend before his feet, with their four trumpets sounding to the four winds.

'Beneath, the Earth is convulsed with the labours of the Resurrection. In the caverns of the earth is the Dragon with seven heads and ten horns, chained by two Angels; and above his cavern, on the earth's surface, is the Harlot, also seized and bound by two Angels with chains, while her palaces are falling into ruins, and her counsellors and warriors are descending into the abyss, in wailing and despair.

'Hell opens beneath the harlot's seat on the left hand, into which the wicked are descending.

'The right hand of the design is appropriated to the Resurrection of the Just: the left hand of the design is appropriated to the Resurrection and Fall of the Wicked.

'Immediately before the Throne of Christ, are Adam and Eve,[3] kneeling in humiliation, as representatives of the whole human race; Abraham and Moses kneel on each side beneath them; from the cloud on which Eve kneels, and beneath Moses, and from the tables of stone which utter lightning,[4] is seen Satan wound round by the Serpent, and falling headlong; the Pharisees appear on the left hand pleading their own righteousness before the Throne of Christ: The Book of Death is opened on clouds by two Angels; many groups of figures are falling from before the throne, and from the sea of fire, which flows before the steps of the throne; on which are seen the seven Lamps of the Almighty, burning before the throne. Many figures chained and bound together fall through the air, and some are scourged by Spirits with flames of fire into the abyss of Hell,

[1] That is, his father; William Upcott was Ozias Humphry's natural son.
[2] The word 'their' is not in the original.
[3] 'is Adam & Eve'. [4] 'lightenings'.

which opens to receive them beneath, on the left hand of the harlot's seat; where others are howling and descending into the flames, and in the act of dragging each other into Hell, and of contending in fighting with each other on the brink of perdition.

'Before the Throne of Christ on the right hand, the Just, in humiliation and in exultation, rise through the air, with their Children and Families; some of whom are bowing before the Book of Life, which is opened by two Angels on clouds: many groups arise with exultation; among them is a figure crowned with stars, and the moon beneath her feet, with six infants around her, she represents the Christian Church. The green hills appear beneath; with the graves of the blessed, which are seen bursting with their births of immortality; parents and children embrace and arise together, and in exulting attitudes tell each other, that the New Jerusalem is ready to descend upon earth; they arise upon the air rejoicing; others newly awaked[1] from the grave, stand upon the earth embracing and shouting to the Lamb, who cometh in the clouds with power and great glory.

'The whole upper part of the design is a view of Heaven opened; around the Throne of Christ, four living creatures filled with eyes, attended by seven Angels with seven vials[2] of the wrath of God, and above these seven angels with the seven trumpets compose the cloud, which by its rolling away displays the opening seats of the Blessed, on the right and the left of which are seen the four-and-twenty Elders seated on thrones to judge the dead.

'Behind the seat and Throne of Christ appears the Tabernacle with its veil opened, the Candlestick on the right, the Table with Shew-bread on the left, and in the midst, the Cross in place of the Ark, with the two Cherubim bowing over it.

'On the right-hand of the Throne of Christ is Baptism, on his left is the Lord's Supper—the two introducers into Eternal Life. Women with infants approach the figure of an aged Apostle, which represents Baptism; and on the left-hand the Lord's Supper is administered by Angels, from the hands of another aged Apostle; these kneel on each side of the Throne, which is surrounded by a glory: in the glory many infants appear, representing Eternal Creation flowing from the Divine Humanity in Jesus; who opens the Scroll of Judgment upon his knees before the living and the dead.

'Such is the design which you, my dear Sir, have been the cause of my producing, and which, but for you, might have slept till the Last Judgment.

'WILLIAM BLAKE.

'January 18, 1808.'

Blake and his wife were known to have lived so happily together, that they might unquestionably have been registered at Dunmow. 'Their hopes and fears were to each other known,' and their days and nights were passed in each other's company, for he always painted, drew, engraved and studied, in the same room where they grilled,

[1] 'newly awakend'. [2] 'with the Seven Vials'.

boiled, stewed, and slept;[1] and so steadfastly attentive was he to his beloved tasks, that for the space of two years he had never once been out of his house;[2] and his application was often so incessant, that in the middle of the night, he would, after thinking deeply upon a particular subject, leap from his bed and write for two hours or more; and for many years, he made a constant practice of lighting the fire, and putting on the kettle for breakfast before his Kate awoke.

During his last illness, which was occasioned by the gall mixing with his blood, he was frequently bolstered-up in his bed to complete his drawings, for his intended illustration of Dante; an author so great a favourite with him, that though he agreed with Fuseli and Flaxman, in thinking Carey's translation superior to all others, yet, at the age of sixty-three years,[3] he learned the Italian language purposely to enjoy Dante in the highest possible way. For this intended work, he produced seven engraved plates of an imperial quarto size, and nearly one hundred finished drawings of a size considerably larger; which will do equal justice to his wonderful mind, and the liberal heart of their possessor, who engaged him upon so delightful a task at a time when few persons would venture to give him employment, and whose kindness softened, for the remainder of his life, his lingering bodily sufferings, which he was seen to support with the most Christian fortitude.

On the day of his death, August 12th,* 1827, he composed and uttered songs to his Maker so sweetly to the ear of his Catherine, that when she stood to hear him, he, looking upon her most affectionately, said, 'My beloved, they are not mine—no—they are not mine.'[4] He expired at six in the evening, with the most cheerful serenity. Some short time before his death, Mrs. Blake asked him where he should like to be buried, and whether he would have the Dissenting Minister, or the Clergyman of the Church of England, to read the service: his

* Not the 13th, as has been stated by several Editors who have noticed his death.

[1] This was only true in their last residence, 3 Fountain Court, Strand, where the space seems to have been painfully restricted. It was clearly not true, for instance, of their apartment in Hercules Buildings, which Tatham said (p. 522) had eight or ten rooms and a maid.

[2] This extraordinary story is confirmed by no other account. In the unlikely event that it is true, the most likely dates would be 1813–14, when almost nothing is known of Blake.

[3] It seems likely that Blake began his Italian studies not in 1820, but in 1824–5 when he began working on *Dante*. On the other hand, Smith's dating is persuasively precise here.

[4] Gilchrist remarks (1942, p. 352; 1863, p. 360) that J. T. Smith 'had his account from the widow' when he quotes this passage. Gilchrist may have learned this fact from Tatham.

answers were, that as far as his own feelings were concerned, they might bury him where she pleased, adding, that as his father, mother, aunt,[1] and brother, were buried in Bunhill-row, perhaps it would be better to lie there, but as to service, he should wish for that of the Church of England.

His hearse was followed by two mourning-coaches, attended by private friends: Calvert, Richmond, Tatham, and his brother, promising young artists, to whom he had given instructions in the Arts, were of the number.[2] Tatham, ill as he was, travelled ninety miles to attend the funeral[3] of one for whom, next to his own family, he held the highest esteem. Blake died in his sixty-ninth year,[4] in the back-room of the first-floor of No. 3, Fountain-court, Strand, and was buried in Bunhill-fields, on the 17th of August, at the distance of about twenty-five feet from the north wall, numbered eighty.

Limited as Blake was in his pecuniary circumstances, his beloved Kate survives him clear of even a sixpenny debt; and in the fullest belief that the remainder of her days will be rendered tolerable by the sale of the few copies of her husband's works, which she will dispose of at the original price of publication; in order to enable the collector to add to the weight of his book-shelves, without being solicited to purchase, out of compassion, those specimens of her husband's talents which they ought to possess.[5]

D

ALLAN CUNNINGHAM

(from *Lives of the Most Eminent British Painters, Sculptors, and Architects*, 1830)

Allan Cunningham's life of 'William Blake' in the Family Library[6] was more important than any other factor in keeping Blake's name alive until 1863. The series of which it formed a part was enormously popular from its first publication. Within a few months of its first appearance, in 1830, Cunningham was writing that, despite the printing of twelve thousand

[1] This aunt has not been identified, and it is not known whether she was a relative by birth or by marriage, or whether she was single or a Blake. Not counting the poet's mother and wife, between 1753 and 1838 there were Blakes named Elizabeth, Hester, Juda, Hephzibah, Jane (2), Mary (3), Sarah (2), Deborah, Rebecca, and Susanah, who were buried in Bunhill Fields.

[2] Tatham's brother was not a promising young artist but a fledgling priest, having just entered Cambridge to study for the ministry.

[3] In Tatham's account this fact is modestly suppressed.

[4] Blake died in his seventieth year.

[5] For Joseph Hogarth's notes on this page, see 1829.

[6] Allan Cunningham, *The Lives of the Most Eminent British Painters, Sculptors and Architects*, 6 vols., London, 1830, etc., vol. ii, pp. 140–79; Second Edition, 1830, vol. ii, pp. 143–88.

copies, vol. iii was 'already out of print',[1] and the demand for it was steady on both sides of the Atlantic for over sixty years. This success was well deserved, for Cunningham had good if not original information, and he was a first-rate storyteller.

The second edition of Cunningham's memoir differs markedly from the first, though the latter was repeatedly reprinted for fifteen years,[2] while the former was largely ignored until the end of the century.[3] In the first edition the emphasis is strong upon a schizophrenic interpretation of Blake's personality, showing him sane and engraving other men's works by day, and mad and composing his own poetry by night. There Cunningham scorned Blake's 'utterly wild' poetry, and he clearly thought the designs far more important than the verses they accompanied. All this survives in the second edition of the memoir, but it is balanced to a certain extent by a long and much more sympathetic appreciation of Blake added at the end. I have here printed the second edition (1830) with the substantive differences from the first edition duly noted in the footnotes. The paragraph numbers are mine.

WILLIAM BLAKE

1 Painting, like poetry, has followers, the body of whose genius is light compared to the length of its wings, and who, rising above the ordinary sympathies of our nature, are, like Napoleon, betrayed by a star which no eye can see save their own. To this rare class belonged William Blake.

2 He was the second son[4] of James Blake and Catharine his wife, and born on the 28th of November, 1757, in 28, Broad Street, Carnaby Market, London. His father, a respectable hosier, caused him to be educated for his own business, but the love of art came early upon the boy; he neglected the figures of arithmetic for those of Raphael and Reynolds; and his worthy parents often wondered how a child of theirs should have conceived a love for such unsubstantial vanities. The boy, it seems, was privately encouraged by his mother. The love of designing and sketching grew upon him, and he desired anxiously to be an artist. His father began to be pleased with the notice which his son obtained—and to fancy that a painter's study might after all be a fitter place than a hosier's shop for one who drew designs on the backs of all the shop bills, and made sketches on the counter. He consulted an

[1] D. Hogg, *Life of Allan Cunningham*, Dumfries, Edinburgh, and London, 1875, p. 300, quoting a letter of May 29th, 1830.

[2] The first version was reprinted in 1831, 1837, 1839, 1842, 1844, 1846, and 1907.

[3] The second version was reprinted in 1880, 1886, and 1893.

[4] William was the third son of James and Catherine Blake, but the second of those who survived to maturity. The account of Blake's childhood here is largely fanciful, but whether the fancy is Cunningham's or that of his informant Tatham it is difficult to say. The mistake about the number of children in the family, however, is common to J. T. Smith and Tatham.

eminent artist, who asked so large a sum for instruction, that the prudent shopkeeper hesitated, and young Blake declared he would prefer being an engraver—a profession which would bring bread at least, and through which he would be connected with painting.[1] It was indeed time to dispose of him. In addition to his attachment to art, he had displayed poetic symptoms—scraps of paper and the blank leaves of books were found covered with groups and stanzas. When his father saw sketches at the top of the sheet and verses at the bottom, he took him away to Basire, the engraver, in Green Street,[2] Lincoln's Inn Fields, and bound him apprentice for seven years. He was then fourteen years old.

3 It is told of Blake that at ten years of age he became an artist, and at twelve a poet. Of his boyish pencillings I can find no traces—but of his early intercourse with the Muse the proof lies before me in seventy pages of verse, written, he says, between his twelfth and his twentieth year,[3] and published, by the advice of friends, when he was thirty.[4] There are songs, ballads, and a dramatic poem; rude sometimes and unmelodious, but full of fine thought and deep and peculiar feeling. To those who love poetry for the music of its bells, these seventy pages will sound harsh and dissonant; but by others they will be more kindly looked upon. John Flaxman, a judge in all things of a poetic nature, was so touched with many passages, that he not only counselled their publication, but joined with a gentleman of the name of Matthews[5] in the expense, and presented the printed sheets to the artist to dispose of for his own advantage.[6] One of these productions is an address to the Muses—a common theme, but sung in no common manner. . . .[7]

[1] The source of this story was Tatham, who also gave it later (p. 511).

[2] Basire was in Great Queen Street, Lincoln's Inn Fields.

[3] This statement in the preface to the *Poetical Sketches* is obviously not by Blake.

[4] In 1783, when he was twenty-six.

[5] Blake's patron was Anthony Stephen Mathew. This account clearly comes from J. T. Smith (p. 456).

[6] In his life of Flaxman (vol. iii, p. 277), Cunningham wrote that Mathew 'aided Flaxman in befriending Blake'. In 1835, when she was sending Allan Cunningham some impetuous comments on the life of her brother-in-law, Maria Denman wrote: 'Mr Flaxman befriended Blake, as well as many others—but without being assisted by any one—besides recommending him to many of his friends' (quoted from a microfilm of the MS. in the National Library of Scotland). It seems equally clear that Miss Denman was not thinking of the *Poetical Sketches* in this passage, and that Cunningham was. On this question there seems to be more reason to trust Cunninhgam's source, J. T. Smith, who was a contemporary of the events he describes, than Miss Denman, who was only four in 1783.

[7] Cunningham gives 'To the Muses' correctly except that for 'poetry' he reads 'poesie', and for 'do scarcely' he gives 'now scarcely'.

4 The little poem called 'The Tiger' has been admired for the force and vigour of its thoughts by poets of high name. Many could weave smoother lines—few could stamp such living images. . . .[1]

5 In the dramatic poem of King Edward the Third there are many nervous lines, and even whole passages of high merit. The structure of the verse is often defective, and the arrangement inharmonious; but before the ear is thoroughly offended, it is soothed by some touch of deep melody and poetic thought. The princes and earls of England are conferring together on the eve of the battle of Cressy—the Black Prince takes Chandos aside, and says—

> 'Now we're alone, John Chandos, I'll unburthen[2]
> And breathe my hopes into the burning air—
> Where thousand Deaths are posting up and down,
> Commissioned to this fatal field of Cressy:
> Methinks I see them arm my gallant soldiers,
> And gird the sword upon each thigh, and fit
> The shining helm,[3] and string each stubborn bow,
> And dancing to the neighing of the steeds;—[4]
> Methinks the shout begins—the battle burns;—
> Methinks I see them perch on English crests,
> And breathe the wild flame[5] of fierce war upon
> The thronged enemy.'

6 In the same high poetic spirit Sir Walter Manny converses with a genuine old English warrior, Sir Thomas Dagworth.

> 'O, Dagworth!—France is sick—the very sky
> Though sunshine light, it seems to me as pale[6]
> As is the fainting man[7] on his death-bed,
> Whose face is shown by light of one weak taper—[8]
> It makes me sad and sick unto the heart;[9]
> Thousands must fall to-day.'

Sir Thomas answers.

> 'Thousands of souls must leave this prison-house
> To be exalted to those heavenly fields

[1] 'The Tyger' from *Experience* is given as in Malkin (pp. 430–1), except for: l. 4 'Framed' for 'Could frame'; l. 6 'Burned the fervour' for 'Burnt the fire'; l. 12 'formed' for 'forged'; l. 14 'Formed thy strength and forged thy brain' for 'In what furnace was thy brain'; l. 16 'thy' for 'its'; l. 17 'spheres' for 'spears'; l. 18 'sprinkled' for 'watered'; the omission of the last stanza.

[2] 'Now we are alone, Sir John, I will unburden'. [3] 'Each shining helm'.
[4] 'And dance to the neighing of our steeds'. [5] 'And roar the wild flames'.
[6] 'Tho' sunshine light it, seems to me as pale'.
[7] 'As the pale fainting man'. [8] 'light of sickly taper'.
[9] 'sick at very heart'.

Where songs of triumph, psalms of victory,[1]
Where peace, and joy, and love, and calm content,
Sit singing on the azure clouds,[2] and strew
The flowers of heaven upon the banquet table.[3]
Bind ardent hope upon your feet, like shoes,
And put the robe of preparation on.[4]
The table, it is spread in shining heaven.
Let those who fight, fight in good steadfastness;
And those who fall shall rise in victory.'[5]

7 I might transcribe from these modest and unnoticed pages many such passages. It would be unfair not to mention that the same volume contains some wild and incoherent prose,[6] in which we may trace more than the dawning of those strange, mystical, and mysterious fancies on which Blake subsequently[7] misemployed his pencil. There is much that is weak, and something that is strong, and a great deal that is wild and mad, and all so strangely mingled, that little or no meaning[8] can be assigned to it; it seems like a lamentation over the disasters which came on England during the reign of King John.

8 Though Blake lost himself sometimes[9] in the enchanted region of song, he seems not to have neglected to make himself master of the graver, or to have forgotten his love of designs and sketches. He was a dutiful servant to Basire, and he studied occasionally under Flaxman and Fuseli;[10] but it was his chief delight to retire to the solitude of his

[1] 'palms of victory'.
[2] 'in the azure clouds'.
[3] 'Flowers of heaven's growth over the banquet-table'.
[4] 'Put on the robe of preparation'.
[5] 'The table is prepar'd in shining heaven,
 The flowers of immortality are blown;
 Let those that fight, fight in good stedfastness,
 And those that fall shall rise in victory.'

[6] This apparently refers to the 'Prologue to King John' and perhaps also to 'The Couch of Death', 'Contemplation', and 'Samson'.
[7] The first edition reads 'on which he subsequently'.
[8] The first edition reads 'so strangely mingled, that no meaning can be assigned to it'.
[9] First edition: 'Blake lost himself a little'.
[10] Cunningham mentions Blake several times in his biographies of Flaxman and Fuseli (vol. iii, pp. 283, 308, vol. ii, p. 333). As a young man, 'His [*Flaxman's*] chief companions were Blake and Stothard: in the wild works of the former he saw much poetic elevation, and in those of the latter that female loveliness and graceful simplicity which have given his name a distinguished place amongst the worthies of art. With Blake, in particular, he loved to dream and muse, and give shape, and sometimes colour, to those thick-coming fancies in which they both partook.' In Flaxman's *Dante* illustrations, 'There are gigantic figures too, and not of the happiest, especially an attempt to pourtray Lucifer himself, which looks more like

room,[1] and there make drawings, and illustrate these with verses, to be hung up together in his mother's chamber. He was always at work; he called amusement idleness, sight-seeing vanity, and money-making the ruin of all high aspirations. 'Were I to love money,' he said, 'I should lose all power of thought; desire of gain deadens the genius of man. I might roll in wealth and ride in a golden chariot, were I to listen to the voice of parsimony. My business is not to gather gold, but to make glorious shapes, expressing god-like sentiments.' The day was given to the graver, by which he earned enough to maintain himself respectably; and he bestowed his evenings upon painting and poetry, and intertwined these so closely in his compositions, that they cannot well be separated.

9 When he was six-and-twenty years old,[2] he married Katharine Boutcher, a young woman of humble connexions—the dark-eyed Kate of several of his lyric poems.[3] She lived near his father's house,[4] and was noticed by Blake for the whiteness of her hand, the brightness of her eyes, and a slim and handsome shape, corresponding with his own notions of sylphs and naïads. As he was an original in all things, it would have been out of character to fall in love like an ordinary mortal; he was describing one evening in company the pains he had suffered from some capricious lady or another, when Katharine Boutcher said, 'I pity you from my heart.' 'Do you pity me?' said Blake, 'then I love you for that.' 'And I love you,' said the frank-hearted lass, and so the courtship began. He tried how well she looked in a drawing, then how her charms became verse; and finding moreover that she had good domestic qualities, he married her. They lived together long and happily.

10 She seemed to have been created on purpose for Blake:—she believed him to be the finest genius on earth; she believed in his verse—

one of the maddest of the mad imaginations of Blake than the conceptions of the classic Flaxman.'

Fuseli's sharp tongue is illustrated by the following story: 'When Blake, a man infinitely more wild in conception than Fuseli himself, showed him one of his strange productions, he said, "Now some one has told you this is very fine."—"Yes," said Blake, "the Virgin Mary appeared to me, and told me it was very fine: what can you say to that?"—"Say?" exclaimed Fuseli, "why nothing—only her ladyship has not an immaculate taste." '

[1] The first edition substituted 'his chamber'.

[2] Blake was twenty-four when he was married in Aug. 1782.

[3] The three poems in *Poetical Sketches* which refer to a Kitty or Kate (two called 'Song', and 'Blind-Man's Buff') can scarcely allude to Blake's wife, for according to the Advertisement they were written no later than 1777 or 1778, years before Blake met Catherine Boucher.

[4] Catherine lived at Battersea, far from Blake's house. Obviously most of this account of Blake's courtship originated in Cunningham's fertile imagination, except that the dialogue comes almost word for word from J. T. Smith (p. 459).

she believed in his designs; and to the wildest flights of his imagination she bowed the knee, and was a worshipper. She set his house in good order, prepared his frugal meal, learned to think as he thought, and, indulging him in his harmless absurdities, became, as it were, bone of his bone, and flesh of his flesh. She learned—what a young and handsome woman is seldom apt to learn—to despise gaudy dresses, costly meals, pleasant company, and agreeable invitations—she found out the way of being happy at home, living on the simplest of food, and contented in the homeliest of clothing. It was no ordinary mind which could do all this; and she whom Blake emphatically called his 'beloved,'[1] was no ordinary woman. She wrought off in the press the impressions of his plates—she coloured them with a light and neat hand—made drawings much in the spirit of her husband's compositions, and almost rivalled him in all things save in the power which he possessed of seeing visions of any individual living or dead, whenever he chose to see them.

11 His marriage, I have heard, was not agreeable to his father; and he then left his roof and resided with his wife in Green Street, Leicester Fields. He returned to Broad Street, on the death of his father, a devout man, and an honest shopkeeper, of fifty years' standing,[2] took a first floor and a shop, and in company with one Parker, who had been his fellow-apprentice, commenced printseller. His wife attended to the business, and Blake continued to engrave, and took Robert, his favourite brother, for a pupil. This speculation did not succeed—his brother too sickened and died; he had a dispute with Parker—the shop was relinquished, and he removed to 28, Poland Street.[3] Here he commenced that series of works which give him a right to be numbered among the men of genius of his country. In sketching designs, engraving plates, writing songs, and composing music, he employed his time, with his wife sitting at his side, encouraging him in all his undertakings. As he drew the figure he meditated the song which was to accompany it, and the music to which the verse was to be sung, was the offspring too of the same moment. Of his music there are no specimens—he wanted the art of noting it down—if it equalled many of his drawings, and some of his songs, we have lost melodies of real value.

12 The first fruits were the 'Songs of Innocence and Experience,'[4] a work original and natural, and of high merit, both in poetry and in

[1] This detail is from J. T. Smith (p. 459).

[2] James Blake was probably a shopkeeper only from 1743 to 1784.

[3] The chronology is confused here. Robert died in 1787, and Blake left Parker (and presumably the print-selling business) in 1785 for Poland Street.

[4] His first published lyrics in Illuminated Printing were in the *Songs of Innocence* of 1789. Cunningham quotes nothing from *Experience* (1794) except 'The Tyger', which he puts in the *Poetical Sketches*.

painting. It consists of some sixty-five or seventy scenes,[1] presenting
images of youth and manhood—of domestic sadness, and fireside joy—
of the gaiety, and innocence, and happiness of childhood. Every scene
has its poetical accompaniment, curiously interwoven with the group
or the landscape, and forming, from the beauty of the colour and the
prettiness of the pencilling, a very fair picture of itself. Those designs
are in general highly poetical; more allied, however, to heaven than to
earth—a kind of spiritual abstractions, and indicating a better world
and fuller happiness than mortals enjoy. The picture of Innocence is
introduced with the following sweet verses.

> 'Piping down the valleys wild,
> Piping songs of pleasant glee,
> On a cloud I saw a child,
> And he laughing said to me—
>
> Pipe a song about a lamb;
> So I piped with merry cheer.
> Piper, pipe that song again—
> So I piped—he wept to hear.
>
> Drop thy pipe, thy happy pipe,
> Sing thy songs of happy cheer—
> So I sung the same again,
> While he wept with joy to hear.
>
> Piper, sit thee down and write
> In a book that all may read—
> So he vanished from my sight:
> And I plucked a hollow reed,
>
> And I made a rural pen,
> And I stained the water clear,
> And I wrote my happy songs,
> Every child may joy to hear.'

13 Another song, called 'The Chimney Sweeper', is rude enough truly,
but yet not without pathos.[2]

> 'When my mother died I was very young,
> And my father sold me while yet my tongue
> Could scarcely cry—weep! weep! weep! [*weep*]
> So your chimneys I clean[3] and in soot I sleep.

[1] Most copies of *Innocence and Experience* have fifty-four plates, but a few plates
may be said to have more than one 'scene' on them. There are forty-three poems in
Innocence and Experience.

[2] This poem and the introduction to it are not in the first edition (1830).

[3] 'So your chimneys I sweep'.

There's little Tom Dacre, who cried when his head,
That curl'd like a lamb's back, was shaved; so I said,
Hush, Tom, never mind it, for when your head's bare,
You know that the soot cannot spoil your white hair.

And so he was quiet—and on that very night,[1]
As Tommy was sleeping,[2] he had such a sight;
There thousands of sweepers, Dick, Joe, Ned, and Jack,
Were all of them locked up in coffins of black;

And by came an Angel, who had a bright key,
He opened the coffins[3] and set them all free;
Then down a green vale,[4] leaping, laughing they run,
And wash in a river, and shine like the sun.[5]

Then, naked and white, all their bags left behind,
They rise up on pure clouds[6] and sport in the wind:
And the Angel told Tom, if he'd be a good boy,
He'd have God for his father and never want joy.

And so Tommy awoke[7] and we rose in the dark,
And got with our bags and our brushes to work;
Though the morning was cold, he was happy and warm,[8]
So, if all do their duty, they need not fear harm.'

14 In a higher and better spirit he wrought with his pencil. But then he imagined himself under spiritual influences; he saw the forms and listened to the voices of the worthies of other days; the past and the future were before him, and he heard, in imagination, even that awful voice which called on Adam amongst the trees of the garden.[9] In this kind of dreaming abstraction, he lived much of his life; all his works are stamped with it; and though they owe much of their mysticism and obscurity to the circumstance, there can be no doubt that they also owe to it much of their singular loveliness and beauty. It was wonderful that he could thus, month after month, and year after year, lay down his graver after it had won him his daily wages, and retire from the battle for bread, to disport his fancy amid scenes of more than earthly splendour, and creatures pure as unfallen dew.

[1] '& that very night'. [2] 'As Tom was a-sleeping'.
[3] 'And he opened the coffins'. [4] 'down a green plain'.
[5] 'and shine in the Sun'. [6] 'They rise upon clouds'.
[7] 'And so Tom awoke'. [8] 'Tom was happy and warm'.
[9] This apparently refers to the 'Introduction' to *Experience*:

> Hear the voice of the Bard!
> Who Present, Past, & Future, sees
> Whose ears have heard,
> The Holy Word,
> That walk'd among the ancient trees.

15 In this lay the weakness and the strength of Blake, and those who desire to feel the character of his compositions, must be familiar with his history and the peculiarities of his mind. He was by nature a poet, a dreamer, and an enthusiast. The eminence which it had been the first ambition of his youth to climb, was visible before him, and he saw on its ascent or on its summit those who had started earlier in the race of fame. He felt conscious of his own merit, but was not aware of the thousand obstacles which were ready to interpose. He thought that he had but to sing songs and draw designs, and become great and famous. The crosses which genius is heir to had been wholly unforeseen—and they befel him early; he wanted too the skill of hand,[1] and fine tact of fancy and taste, to impress upon the offspring of his thoughts that popular shape, which gives such productions immediate circulation. His works were therefore[2] looked coldly on by the world, and were only esteemed by men of poetic minds, or those who were fond of things out of the common way. He earned a little fame, but no money by these speculations, and had to depend for bread on the labours of the graver.

16 All this neither crushed his spirit, nor induced him to work more in the way of the world; but it had a visible influence upon his mind. He became more seriously thoughtful, avoided the company of men, and lived in the manner of a hermit, in that vast wilderness, London. Necessity made him frugal, and honesty and independence prescribed plain clothes, homely fare, and a cheap habitation. He was thus compelled more than ever to retire to worlds of his own creating, and seek solace in visions of paradise for the joys which the earth denied him. By frequent indulgence in these imaginings, he gradually began to believe in the reality of what dreaming fancy painted—the pictured forms which swarmed before his eyes assumed, in his apprehension, the stability of positive revelations, and he mistook the vivid figures, which his professional imagination shaped, for the poets, and heroes, and princes of old. Amongst his friends, he at length ventured to intimate that the designs on which he was engaged, were not from his own mind, but copied from grand works revealed to him in visions; and those who believed that, would readily lend an ear to the assurance that he was commanded to execute his performances by a celestial tongue!

17 Of these imaginary visitations he made good use, when he invented his truly original and beautiful mode of engraving and tinting his plates. He had made the designs of his Days of Innocence,[3] and was

[1] The first edition omits 'too'.

[2] First edition: 'His works were looked coldly on'.

[3] 'Days of Innocence' is clearly a misreading of 'Songs of Innocence', though it appears in both the first and the second editions. The first edition reads: 'He had made the sixty-five designs of his Days of Innocence', but the 'sixty-five' was

meditating, he said, on the best means of multiplying their resemblance in form and in hue; he felt sorely perplexed. At last he was made aware that the spirit of his favourite brother Robert was in the room, and to this celestial visitor he applied for counsel. The spirit advised him at once: 'write,' he said, 'the poetry, and draw the designs upon the copper with a certain liquid (which he named, and which Blake ever kept a secret); then cut the plain parts of the plate down with aqua-fortis, and this will give the whole, both poetry and figures, in the manner of stereotype.' The plan recommended by this gracious spirit was adopted; the plates were engraved, and the work printed off. The artist then added a peculiar beauty of his own. He tinted both the figures and the verse with a variety of colours, amongst which, while yellow prevails, the whole has a rich and lustrous beauty, to which I know little that can be compared.[1] The size of these prints is four inches and an half high by three inches wide. The original genius of Blake was always confined, through poverty, to small dimensions. Sixty-five plates of copper were an object to him who had little money. The Gates of Paradise, a work of sixteen[2] designs, and those exceedingly small, was his next undertaking. The meaning of the artist is not a little obscure; it seems to have been his object to represent the innocence, the happiness, and the upward aspirations of man. They bespeak one intimately acquainted with the looks and the feelings of children. Over them there is shed a kind of mysterious halo which raises feelings of devotion. The Songs of Innocence, and the Gates of Paradise, became popular among the collectors of prints. To the sketch-book and the cabinet the works of Blake are unfortunately confined.

18 If there be mystery in the meaning of the Gates of Paradise, his succeeding performance, by name Urizen, has the merit or the fault of surpassing all human comprehension. The spirit which dictated this strange work was undoubtedly a dark one; nor does the strange kind of prose which is intermingled with the figures serve to enlighten us. There are in all twenty-seven designs,[3] representing beings human, demoniac, and divine, in situations of pain and sorrow and suffering. One character—evidently an evil spirit—appears in most of the plates; the horrors of hell, and the terrors of darkness and divine wrath, seem his sole portion. He swims in gulphs of fire—descends in cataracts of flame—holds combats with scaly serpents, or writhes in anguish with-

omitted in the second edition because it applies not to *Innocence* by itself but to the combined *Innocence and Experience*.

[1] Except that it has been recast as dialogue, this account comes from J. T. Smith (p. 460).

[2] *For Children: The Gates of Paradise* (1793) has eighteen plates; *For the Sexes: The Gates of Paradise* (1818?) has twenty-one.

[3] Only one copy of *The First Book of Urizen* (G) has twenty-seven leaves.

out any visible cause. One of his exploits is to chase a female soul through a narrow gate and hurl her headlong down into a darksome pit. The wild verses, which are scattered here and there, talk of the sons and the daughters of Urizen. He seems to have extracted these twenty-seven scenes out of many visions—what he meant by them even his wife declared she could not tell, though she was sure they had a meaning, and a fine one. Something like the fall of Lucifer and the creation of Man is dimly visible in this extravagant work; it is not a little fearful to look upon; a powerful, dark, terrible, though undefined and indescribable, impression is left on the mind—and it is in no haste to be gone. The size of the designs is four inches by six; they bear date, 'Lambeth, 1794.' He had left Poland Street, and was residing in Hercules Buildings.

19 The name of Blake now began to be known a little, and Edwards, the bookseller, employed him to illustrate Young's Night Thoughts. The reward in money was small, but the temptation in fame was great: the work was performed something in the manner of old books with illuminated margins. Along the ample margins which the poetry left on the page the artist sketched his fanciful creations; contracting or expanding them according to the space. Some of those designs were in keeping with the poems, but there were others which alarmed fastidious people: the serious and the pious were not prepared to admire shapes trembling in nudity round the verses of a grave divine. In the exuberance of Young there are many fine figures; but they are figures of speech only, on which art should waste none of its skill. This work was so much, in many parts, to the satisfaction of Flaxman, that he introduced Blake to Hayley the poet, who, in 1800, persuaded him to remove to Felpham in Sussex, to make engravings for the Life of Cowper. To that place he accordingly went with his wife and sister, and was welcomed by Hayley with much affection.[1] Of his journey and his feelings he gives the following account to Flaxman, whom he usually addressed thus, 'Dear Sculptor of Eternity.'

20 'We are arrived safe at our cottage, which is more beautiful than I thought it, and more convenient. It is a perfect model for cottages, and I think for palaces of magnificence, only enlarging and not altering its proportions, and adding ornaments and not principals. Nothing can be more grand than its simplicity and usefulness. Felpham is a sweet place for study, because it is more spiritual than London. Heaven opens here on all sides her golden gates; her windows are not obstructed by vapours; voices of celestial inhabitants are more distinctly heard, and

[1] The biographical details of this section come from J. T. Smith (p. 461), as does the Flaxman letter quoted below, which Smith quoted accurately and Cunningham copied very shoddily.

their forms more distinctly seen, and my cottage is also a shadow of their houses. My wife and sister are both well, and are courting Neptune for an embrace.'

21 Thus far had he written in the language and feelings of a person of upper air; though some of the expressions are tinctured with the peculiar enthusiasm of the man, they might find shelter under the license of figurative speech, and pass muster as the poetic language of new-found happiness. Blake thus continues:—

22 'And now begins a new life, because another covering of earth is shaken off. I am more famed in heaven for my works than I could well conceive. In my brain are studies and chambers filled with books and pictures of old, which I wrote and painted in ages of eternity before my mortal life, and those works are the delight and study of archangels. Why then should I be anxious about the riches or fame of mortality? You, O dear Flaxman, are a sublime archangel, my friend and companion from eternity. Farewell, my dear friend, remember me and my wife in love and friendship to Mrs. Flaxman, whom we ardently desire to entertain beneath our thatched roof of russet gold.'

23 This letter, written in the year 1800, gives the true two-fold image of the author's mind. During the day he was a man of sagacity and sense, who handled his graver wisely, and conversed in a wholesome and pleasant manner: in the evening, when he had done his prescribed task, he gave a loose to his imagination. While employed on those engravings which accompany the works of Cowper, he saw such company as the country where he resided afforded, and talked with Hayley about poetry with a feeling to which the author of the Triumphs of Temper was an utter stranger; but at the close of day away went Blake to the sea shore to indulge in his own thoughts and

'High converse with the dead to hold.'

Here he forgot the present moment and lived in the past; he conceived, verily, that he had lived in other days, and had formed friendships with Homer and Moses; with Pindar and Virgil; with Dante and Milton. These great men, he asserted, appeared to him in visions, and even entered into conversation. Milton, in a moment of confidence, entrusted him with a whole poem of his, which the world had never seen; but unfortunately the communication was oral, and the poetry seemed to have lost much of its brightness in Blake's recitation. When asked about the looks of those visions, he answered, 'They are all majestic shadows, gray but luminous, and superior to the common height of men.' It was evident that the solitude of the country gave him a larger swing in imaginary matters. His wife often accompanied him to these strange interviews; she saw nothing and heard as little, but she was certain that her husband both heard and saw.

24 Blake's mind at all times resembled that first page in the magician's book of gramoury, which made

> 'The cobweb on the dungeon wall,
> Seem tapestry in lordly hall.'

His mind could convert the most ordinary occurrence into something mystical and supernatural. He often saw less majestic shapes than those of the poets of old. 'Did you ever see a fairy's funeral, madam?' he once said to a lady, who happened to sit by him in company. 'Never, sir!' was the answer. 'I have,' said Blake, 'but not before last night. I was walking alone in my garden, there was great stillness among the branches and flowers and more than common sweetness in the air; I heard a low and pleasant sound, and I knew not whence it came. At last I saw the broad leaf of a flower move, and underneath I saw a procession of creatures of the size and colour of green and gray grasshoppers, bearing a body laid out on a rose leaf, which they buried with songs, and then disappeared. It was a fairy funeral.'[1] It would, perhaps, have been better for his fame had he connected it more with the superstitious beliefs of his country—amongst the elves and fairies his fancy might have wandered at will—their popular character would perhaps have kept him within the bounds of traditionary belief, and the sea of his imagination might have had a shore.

25 After a residence of three years in his cottage at Felpham, he removed to 17, South Molton Street, London, where he lived seventeen years. He came back to town with a fancy not a little exalted by the solitude of the country, and in this mood designed and engraved an extensive and strange work which he entitled 'Jerusalem.' A production so exclusively wild was not allowed to make its appearance

[1] Varley was probably the source of the faery's funeral story (see July 20th, 1829), as he was of the following account. In Walter Cooper Dendy's *The Philosophy of Mystery*, London, 1841, p. 90, Astrophel argues with Evelyn that opium doesn't make a poet: Look at Shakespeare; 'Look on the wild pencillings of Blake, another poet painter [*besides Fuseli*], and you will be assured that they were ghost-seers. An intimate friend of Blake, himself a reader of the stars, has told me the strangest tales of his visions. In one of his reveries he witnessed the whole ceremony of a fairy's funeral, which he peopled with mourners and mutes, and described with high poetic beauty. He was engaged, in one of these moods, in painting King Edward I., who was sitting to him for his picture. While they were conversing, Wallace suddenly presented himself on the field, and by this uncourteous intrusion marred the studies of the painter for that day.

'Ev. A most unhappy comparison, Astrophel. The difference between Shakspere and Blake is *antipodean*. Blake was a visionary, and thought his fancies real—he was mad. Shakspere was a philosopher, and knew all his fancy was but imagination, however real might be the facts he wrought from.'

It is of course possible that the 'told me' above is philosophic licence, and that Dendy's whole account came from Cunningham.

in an ordinary way: he thus announced it.[1] 'After my three years' slumber on the banks of the ocean, I again display my giant forms to the public.' Of these[2] designs there are no less than an hundred; what their meaning is the artist has left unexplained. It seems of a religious, political, and spiritual kind, and wanders from hell to heaven, and from heaven to earth; now glancing into the distractions of our own days, and then making a transition to the antediluvians. The crowning defect is obscurity; meaning seems now and then about to dawn; you turn plate after plate, and read motto after motto, in the hope of escaping from darkness into light. But the first might as well be looked at last; the whole seems a riddle which no ingenuity can solve. Yet, if the work be looked at for form and effect rather than for meaning, many figures may be pronounced worthy of Michael Angelo. There is wonderful freedom of attitude and position; men, spirits, gods, and angels, move with an ease which makes one lament that we know not wherefore they are put in motion. Well might Hayley call him his 'gentle visionary Blake.'[3] He considered the Jerusalem to be his greatest work, and for a set of the tinted engravings charged[4] twenty-five guineas. Few joined the artist in his admiration. The Jerusalem, with all its giant forms, failed to force its way into circulation.

26 His next work was the Illustrations of Blair's Grave, which came to the world with the following commendation by Fuseli. 'The author of the moral series before us, has endeavoured to awaken sensibility by touching our sympathies with nearer, less ambiguous, and less ludicrous imagery, than what mythology, gothic superstition, or symbols, as far fetched as inadequate could supply. His avocation has been chiefly employed to spread a familiar and domestic atmosphere round the most important of all subjects, to connect the visible and the invisible world without provoking probability, and to lead the eye from the milder light of time to the radiations of eternity.' For these twelve 'Inventions,' as he called them, Blake received twenty guineas from Cromek,[5] the engraver—a man of skill in art and taste in literature. The price was little, but nevertheless it was more than what he usually received for such productions; he also undertook to engrave them. But Blake's mode of engraving was as peculiar as his style of designing; it had little of that grace of execution about it which attracts customers, and the Inventions, after an experiment or two,

[1] It is curious that Cunningham quotes exactly the words J. T. Smith does (p. 463) and no more, but the succeeding details demonstrate that he had actually examined a copy of *Jerusalem*, presumably Mrs. Blake's.

[2] First edition: 'Of those'. [3] Cf. J. T. Smith (p. 463).

[4] The first edition read 'engravings he charged'. The price of twenty-five guineas is given in Blake's letter to Cumberland of April 12th, 1827.

[5] The name is consistently mis-spelled 'Cromeck' in the first edition.

PLATE LIII

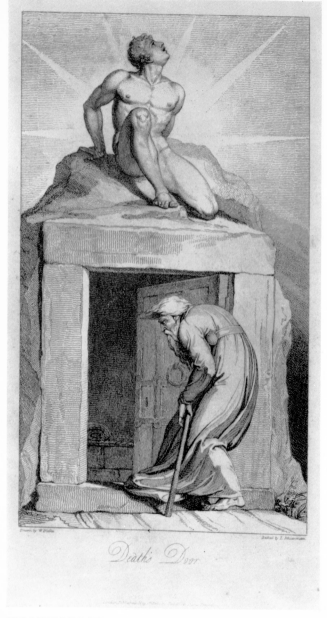

'DEATH'S DOOR', proof of Schiavonetti's etching for Blair's *Grave* (1808). *The Antijacobin Review* said the man at the top resembled 'a naked madman rather than . . . an inhabitant of the realms of bliss' (see p. 204)

were placed under the fashionable graver of Louis Schiavonetti. Blake
was deeply incensed—he complained that he was deprived of the profit
of engraving his own designs, and, with even less justice, that Schia-
vonetti was unfit for the task.[1]

27 Some of these twelve *Inventions* are natural and poetic, others
exhibit laborious attempts at the terrific and the sublime. The old
Man at Death's Door is one of the best—in the Last Day there are
fine groups and admirable single figures—the Wise Ones of the Earth
pleading before the inexorable Throne, and the Descent of the Con-
demned, are creations of a high order. The Death of the Strong Wicked
Man is fearful and extravagant, and the flames in which the soul
departs from the body have no warrant in the poem or in belief. The
Descent of Christ into the Grave is formal and tame; and the hoary old
Soul, in the Death of the Good Man, travelling heavenward between
two orderly Angels, required little outlay of fancy. The frontispiece—a
naked Angel descending headlong and rousing the Dead with the Sound
of the last Trumpet—alarmed the devout people of the north, and made
maids and matrons retire behind their fans. [*See Plates LIII, XXXI,
XXI, XXVI, XX, XXXIV.*]

28 If the tranquility of Blake's life was a little disturbed by the dispute
about the twelve 'Inventions,' it was completely shaken by the contro-
versy which now arose between him and Cromek respecting his Canter-
bury Pilgrimage, and the famous one by Stothard.[2] That two artists at
one and the same time should choose the same subject for the pencil,
seems scarcely credible—especially when such subject was not of a
temporary interest. The coincidence here was so close, that Blake
accused Stothard of obtaining knowledge of his design through
Cromek, while Stothard with equal warmth asserted that Blake had
commenced his picture in rivalry of himself. Blake declared that
Cromek had actually commissioned him to paint the Pilgrimage before
Stothard thought of his; to which Cromek replied, that the order had
been given in a vision, for he never gave it. Stothard, a man as little
likely to be led aside from truth by love of gain as by visions, added to
Cromek's denial the startling testimony that Blake visited him during
the early progress of his picture, and expressed his approbation of it in
such terms, that he proposed to introduce Blake's portrait in the pro-
cession, as a mark of esteem.[3] It is probable that Blake obeyed some
imaginary revelation in this matter, and mistook it for the order of an
earthly employer; but whether commissioned by a vision or by mortal

[1] This account of the *Grave* transaction is clearly compressed from J. T. Smith.

[2] The words 'and the famous one by Stothard' do not appear in the first
edition. See Plate XXXII.

[3] This account is largely a résumé of Stothard's position as given by J. T. Smith
(pp. 464–6), with some *ad hoc* dialogue thrown in.

lips, his Canterbury Pilgrimage made its appearance in an exhibition of his principal works in the house of his brother, in Broad Street, during the summer of 1809.

29 Of original designs, this singular exhibition contained sixteen—they were announced as chiefly 'of a spiritual and political nature'[1]—but then the spiritual works and political feelings of Blake were unlike those of any other man. One piece represented 'The Spiritual Form of Nelson guiding Leviathan.' Another, 'The Spiritual Form of Pitt[2] guiding Behemoth.' This, probably, confounded both divines and politicians; there is no doubt that plain men went wondering away. The chief attraction was the Canterbury Pilgrimage, not indeed from its excellence, but from the circumstance of its origin, which was well known about town, and pointedly alluded to in the catalogue. The picture is a failure. Blake was too great a visionary for dealing with such literal wantons as the Wife of Bath and her jolly companions. The natural flesh and blood of Chaucer prevailed against him. He gives grossness of body for grossness of mind,—tries to be merry and wicked—and in vain.

30 Those who missed instruction in his pictures, found entertainment in his catalogue, a wild performance, overflowing with the oddities and dreams of the author—which may be considered as a kind of public declaration of his faith concerning art and artists. His first anxiety is about his colours. 'Colouring,' says this new lecturer on the *Chiaro-Scuro*, 'does not depend on where the colours are put, but on where the lights and darks are put, and all depends on form or outline. Where that is wrong[3] the colouring can never be right, and it is always wrong in Titian and Correggio, Rubens and Rembrandt; till we get rid of them[4] we shall never equal Raphael and Albert Durer, Michael Angelo and Julio Romano.[5] Clearness[6] and precision have been my chief objects[6] in painting these pictures—clear colours and firm determinate lineaments,[7] unbroken by shadows—which ought to display and not hide[8] form, as is the practice of the later schools[9] of Italy and Flanders. The picture of the Spiritual Form of Pitt,[10] is a proof of the power of colours unsullied with oil or with any cloggy vehicle. Oil has been falsely supposed[11] to give strength to colours, but a little consideration must show the fallacy of this opinion. Oil will not drink or absorb colour enough

[1] I do not know the authority for this quotation.
[2] In the first edition 'Pitt' was 'Seth'.
[3] *Descriptive Catalogue*: 'or Outline, on where that is put; where that is wrong...'.
[4] 'Till we get rid of Titian and Correggio, Rubens and Rembrandt, We shall...'.
[5] The 'Index of the Catalogue' and other matter are omitted here.
[6] Blake wrote 'the chief objects'.
[7] 'Clear colours unmuddied by oil, and firm and determinate lineaments'.
[8] 'and not to hide'. [9] 'the latter schools'.
[10] These eight words are a conflation of several lines.
[11] 'Oil has falsely been supposed'.

to stand the test of any little time[1] and of the air.[2] Let the works of artists[3] since Rubens' time witness to the villainy of those who first[4] brought oil painting into general opinion and practice, since which we have never had a picture painted that would show itself[5] by the side of an earlier composition.[6] This is an awful thing to say to oil painters; they may call it madness, but it is true. All the genuine old little pictures are in fresco[7] and not in oil.'

31 Having settled the true principles and proper materials of colour, he proceeds to open up the mystery of his own productions. Those who failed to comprehend the pictures on looking at them, had only to turn to the following account of the Pitt and the Nelson. 'These two pictures,'[8] he says, 'are compositions of a mythological cast, similar to those apotheoses of Persian, Hindoo, and Egyptian antiquity, which are still preserved in rude monuments,[9] being copies from some stupendous originals now lost, or perhaps buried to some happier age.[10] The Artist, having been taken, in vision, to the ancient republics,[11] monarchies, and patriarchates of Asia, has seen those wonderful originals, called in the sacred Scriptures the cherubim, which were painted and sculptured on the walls of temples, towns, cities,[12] palaces, and erected in the highly cultivated states of Egypt, Moab, and Edom, among the rivers[13] of Paradise, being originals from which the Greeks and Hetrurians copied Hercules, Venus, Apollo, and all the ground-works of ancient art.[14] They were executed in a very superior style to those justly admired copies, being with their accompaniments terrific and grand in the highest degree. The artist has endeavoured to emulate the grandeur of those seen in his vision, and to apply it to modern times[15] on a smaller scale.[16] The Greek Muses are daughters of Memory,[17] and not of Inspiration or Imagination, and therefore not authors[18] of such sublime conceptions: some of these wonderful originals were one

[1] 'test of very little time'. [2] A sentence is omitted here.
[3] 'Let the works of modern Artists'.
[4] 'witness the villany of some of that time, who first'.
[5] 'that could show itself'.
[6] 'an earlier production'. Some 530 words are omitted here.
[7] 'little pictures, called Cabinet Pictures, are in fresco'.
[8] These three words should not have quotation marks round them.
[9] 'still preserved on rude monuments'.
[10] 'buried till some happier age'. [11] 'into the ancient republics'.
[12] 'which were sculptured and painted on the walls of temples, Towers, cities'.
[13] 'Moab, Edom, Aram, among the rivers'.
[14] 'Hercules Farnese, Venus of Medicis, Apollo Belvidere, and all the grand works of ancient art'.
[15] 'to apply it to modern Heroes'.
[16] Sixty-three words are silently omitted here.
[17] 'daughters of Mnemosyne, or Memory'.
[18] 'Inspiration or Imagination, therefore not authors'.

hundred feet in height;[1] some were painted as pictures, some were carved as bass-relievos,[2] and some as groups of statues, all containing mythological and recondite meaning.[3] The artist wishes it was now the fashion to make such monuments, and then he should not doubt of having a national commission to execute those pictures of Nelson and Pitt on a scale suitable[4] to the grandeur of the nation who is the parent of his heroes, in highly finished fresco,[5] where the colours would be as permanent[6] as precious stones.'

32 The man who could not only write down, but deliberately correct the printer's sheets which recorded, matter so utterly wild and mad, was at the same time pefectly sensible to the exquisite nature of Chaucer's delineations, and felt rightly what sort of skill his inimitable Pilgrims required at the hand of an artist. He who saw visions in Cœle-Syria and statues an hundred feet high, wrote thus concerning Chaucer: 'The characters of his pilgrims[7] are the characters which compose all ages and nations: as one age falls another rises, different to mortal sight, but to immortals only the same: for we see the same characters repeated again and again, in animals, in vegetables, and in men;[8] nothing new occurs in identical existence. Accident ever varies; substance can never suffer change nor decay. Of Chaucer's characters, some[9] of the names or titles are altered by time, but the characters themselves for ever remain unaltered, and consequently they are the physiognomies of universal human life, beyond which nature never steps. Names alter—things never alter; I have known multitudes of those who would have been monks in the age of monkery, who in this deistical age are deists. As Linnæus numbered the plants,[10] so Chaucer numbered the classes of men.'

33 His own notions and much of his peculiar practice in art are scattered at random over the pages of this curious production. His love of a distinct outline made him use close and clinging dresses; they are frequently very graceful—at other times they are constrained, and deform the figures which they so scantily cover. 'The great and golden rule of art, (says he,) is this:[11]—that the more distinct and sharp and wiry[12] the bounding line, the more perfect the work of art; and the less

[1] 'conceptions. Those wonderful originals seen in my visions, were some of them one hundred feet in height'.
[2] 'and some carved as basso relievos'.
[3] 'recondite meaning, where more is meant than meets the eye'.
[4] 'these two Pictures on a scale that is suitable'.
[5] 'in high finished fresco'. [6] 'would be as pure and as permanent'.
[7] 'The characters of Chaucer's Pilgrims'.
[8] 'in animals, vegetables, minerals, and in men'.
[9] 'characters, as described in his Canterbury Tales, some'.
[10] 'As Newton numbered the stars, and as Linneus numbered the plants'.
[11] 'of art, as well as of life, is this'. [12] 'distinct, sharp and wiry'.

keen and sharp this external line, the greater[1] is the evidence of weak imitative plagiarism[2] and bungling: Protogenes and Apelles knew each other by this line.[3] How do we distinguish the oak from the beech, the horse from the ox; but by the bounding outline? How do we distinguish one face or countenance from another, but by the bounding line and its infinite inflexions and movements?[4] Leave out this line and you leave out life itself: all is chaos again, and the line of the Almighty must be drawn out upon it before man or beast can exist.'[5]

These abominations—concealed outline and tricks of colour—now bring on one of those visionary fits to which Blake was so liable, and he narrates with the most amusing wildness sundry revelations made to him concerning them. He informs us that certain painters were *demons*—let loose on earth to confound the 'sharp wiry outline,' and fill men's minds with fears and perturbations. He signifies that he himself was for some time a miserable instrument in the hands of Chiaro-Scuro demons, who employed him in making 'experiment pictures in oil.' 'These pictures,' says he, 'were[6] the result of temptations and perturbations labouring to destroy imaginative power by means of that infernal machine called Chiaro-Scuro, in the hands of Venetian and Flemish demons, who hate the Roman and Florentine schools.[7] They cause that every thing in art shall become a machine; they cause that the execution shall be all blocked up with brown shadows; they put the artist[8] in fear and doubt of his own original conception. The spirit of Titian was particularly active in raising doubts concerning the possibility of executing without a model.[9] Rubens is a most outrageous demon, and by infusing the remembrances of his pictures, and style of execution, hinders all power of individual thought.[10] Correggio is a soft and effeminate, consequently[11] a most cruel demon, whose whole delight is to cause endless labour to

[1] 'the less keen and sharp, the greater'.

[2] 'evidence of weak imitation, plagiarism'.

[3] Forty-one words are omitted here.

[4] Thirty-nine words are suppressed here.

[5] In an undated letter Samuel Palmer wrote that a Blake drawing he enclosed was 'perhaps from the Pilgrim's Progress—the first inventive lines—from which he was always most careful not to depart' (B.M. Print Room, English Drawings, Period IV, vol. 12 [1940-10-12-1]). A careful examination of the hundreds of sketches for *The Four Zoas*, *Night Thoughts*, and *Dante* (among others) makes it quite clear, however, that Blake did not hesitate to depart from his 'first inventive lines' if he thought his second or third thoughts were better.

[6] 'These Pictures, among numerous others painted for experiment, were'.

[7] These seven words summarize twenty-nine of Blake's. In the first edition the phrase is misprinted 'who hate the Roman and Venetian schools'.

[8] 'they put the original artist'. [9] 120 words are left out here.

[10] Ninety-one words are omitted at this point.

[11] 'Correggio is a soft and effeminate, and consequently'.

whoever suffers him to enter his mind.' When all this is translated into the language of sublunary life, it only means that Blake was haunted with the excellencies of other men's works, and, finding himself unequal to the task of rivalling the soft and glowing colours and singular effects of light and shade of certain great masters, betook himself to the study of others not less eminent, who happened to have laid out their strength in outline.

35 The impression which the talents and oddities of Blake made on men of taste and genius, is well described by one whose judgment in whatever is poetical no one will question. Charles Lamb had communicated to James Montgomery's book on chimney sweepers the little song by Blake, which I have already quoted; it touched the feelings of Bernard Barton so deeply, that he made inquiries of his friend about the author, upon which he received the following letter in explanation, written some six years ago.—'Blake is a real name I assure you,' says Lamb; 'and a most extraordinary man he is if he be still living. . . .'[1]

36 To describe the conversations which Blake held in prose with demons and in verse with angels, would fill volumes, and an ordinary gallery could not contain all the heads which he drew of his visionary visitants.[2] That all this was real, he himself most sincerely believed; nay, so infectious was his enthusiasm, that some acute and sensible persons who heard him expatiate, shook their heads, and hinted that he was an extraordinary man, and that there might be something in the matter. One of his brethren,[3] an artist of some note, employed him frequently in drawing the portraits of those who appeared to him in visions. The most propitious time for those 'angel-visits' was from nine at night till five in the morning; and so docile were his spiritual sitters, that they appeared at the wish of his friends. Sometimes, however, the shape which he desired to draw was long in appearing, and he sat with his pencil and paper ready and his eyes idly roaming in vacancy; all at once the vision came upon him, and he began to work like one possest.

37 He was requested to draw the likeness of Sir William Wallace—the eye of Blake sparkled, for he admired heroes. 'William Wallace!' he exclaimed, 'I see him now—there, there, how noble he looks—reach me my things!' Having drawn for some time, with the same care of hand and steadiness of eye, as if a living sitter had been before him, Blake stopt suddenly, and said, 'I cannot finish him—Edward the First has stept in between him and me.' 'That's lucky,' said his friend, 'for I want the portrait of Edward too.' Blake took another sheet of paper,

[1] This paragraph does not appear in the first edition. For Lamb's letter, see May 15th, 1824.

[2] This entire sentence is hyperbolical.

[3] This brother artist is apparently John Varley.

and sketched the features of Plantagenet; upon which his majesty politely vanished, and the artist finished the head of Wallace. 'And pray, Sir,' said a gentleman, who heard Blake's friend tell his story— 'was Sir William Wallace an heroic-looking man? And what sort of personage was Edward?' The answer was: 'there they are, Sir, both framed and hanging on the wall behind you, judge for yourself.' 'I looked (says my informant) and saw two warlike heads of the size of common life. That of Wallace was noble and heroic, that of Edward stern and bloody. The first had the front of a god, the latter the aspect of a demon.' [*See Plate XXXVIII.*]

38 The friend who obliged me with these anecdotes[1] on observing the interest which I took in the subject, said,' I know much about Blake—I was his companion for nine years. I have sat beside him from ten at night till three in the morning, sometimes slumbering and sometimes waking, but Blake never slept; he sat with a pencil and paper drawing portraits of those whom I most desired to see. I will show you, Sir, some of these works.' He took out a large book filled with drawings, opened it, and continued, 'Observe the poetic fervour of that face—it is Pindar as he stood a conqueror in the Olympic games. And this lovely creature is Corinna, who conquered in poetry in the same place. That lady is Lais, the courtesan—with the impudence which is part of her profession, she stept in between Blake and Corinna, and he was obliged to paint her to get her away. There! that is a face of a different stamp—can you conjecture who he is?' 'Some scoundrel, I should think, Sir.' 'There now—that is a strong proof of the accuracy of Blake—he is a scoundrel indeed! The very individual task-master whom Moses slew in Egypt. And who is this now—only imagine who this is?' 'Other than a good one, I doubt, Sir.' 'You are right, it is a fiend[2]—he resembles, and this is remarkable, two men who shall be nameless; one is a great lawyer, and the other—I wish I durst name him—is a suborner of false witnesses. This other head now?—this speaks for itself—it is the head of Herod; how like an eminent officer in the army!'

39 He closed the book, and taking out a small panel from a private drawer, said, 'this is the last which I shall show you; but it is the greatest curiosity of all. Only look at the splendour of the colouring and the original character of the thing!' 'I see,' said I, 'a naked figure

[1] The account becomes confusing at this point, because *this* friend also appears to be John Varley, who is the only man known to have 'employed him frequently' in drawing visionary heads. But Varley also owned the 'Ghost of a Flea'. It is just possible that the first artist was Linnell.

[2] In the first edition 'a fiend' was 'the Devil'. The spirit was presumably demoted because for the second edition Cunningham added a paragraph (40) describing the drawing Blake made on the only occasion when he saw the Devil. See Plate XLVIII.

with a strong body and a short neck—with burning eyes which long for moisture, and a face worthy of a murderer, holding a bloody cup in his clawed hands,[1] out of which it seems eager to drink. I never saw any shape so strange, nor did I ever see any colouring so curiously splendid—a kind of glistening green and dusky gold, beautifully varnished. But what in the world is it?' 'It is a ghost, Sir—the ghost of a flea—a spiritualization of the thing!' 'He saw this in a vision then,' I said. 'I'll tell you all about it, Sir. I called on him one evening, and found Blake more than usually excited. He told me he had seen a wonderful thing—the ghost of a flea! And did you make a drawing of him? I inquired. No, indeed, said he, I wish I had, but I shall, if he appears again! He looked earnestly into a corner of the room, and then said, here he is—reach me my things—I shall keep my eye on him. There he comes! his eager tongue whisking out of his mouth, a cup in his hand to hold blood, and covered with a scaly skin of gold and green;—as he described him so he drew him.'

40 Visions, such as are said to arise in the sight of those who indulge in opium, were frequently present to Blake, nevertheless he sometimes desired to see a spirit in vain.[2] 'For many years,' said he, 'I longed to see Satan—I never could believe that he was the vulgar fiend which our legends represent him—I imagined him a classic spirit, such as he appeared to him of Uz,[3] with some of his original splendour about him. At last I saw him. I was going up stairs in the dark, when suddenly a light came streaming amongst my feet, I turned round, and there he was looking fiercely at me through the iron grating of my staircase window.[4] I called for my things—Katherine thought the fit of song was on me, and brought me pen and ink—I said, hush!—never mind—this will do—as he appeared so I drew him—there he is.' Upon this, Blake took out a piece of paper with a grated window sketched on it, while through the bars glared the most frightful phantom that ever man imagined. Its eyes were large and like live coals—its teeth as long as those of a harrow, and the claws seemed such as might appear in the distempered dream of a clerk in the Herald's office. 'It is the gothic fiends of our legends, said Blake—the true devil—all else are apocryphal.'

41 These stories are scarcely credible, yet there can be no doubt of

[1] The first edition reads 'its' for 'his clawed hands'. See Plate XLVIII.

[2] This paragraph does not appear in the first edition.

[3] 'him of Uz' is, of course, Job.

[4] A disturbingly similar story is told by J. T. Smith (p. 470, footnote) about a different picture, 'The Ancient of Days'. It is difficult to tell whether one or the other has confused the story (the source of which was presumably Tatham or Mrs. Blake), or whether there was a positive queue of spirits lurking outside Blake's staircase window, the Creator jostling with 'the true devil'.

their accuracy. Another friend, on whose veracity I have the fullest
dependence, called one evening on Blake, and found him sitting with
a pencil and a panel, drawing a portrait with all the seeming anxiety
of a man who is conscious that he has got a fastidious sitter; he looked
and drew, and drew and looked, yet no living soul was visible.
'Disturb me not,' said he, in a whisper, 'I have one sitting to me.'
'Sitting to you!' exclaimed his astonished visitor, 'where is he, and
what is he?—I see no one.' 'But I see him, Sir,' answered Blake
haughtily, 'there he is, his name is Lot—you may read of him in the
Scripture. *He* is sitting for his portrait.'

42 Had he always thought so idly, and wrought on such visionary
matters, this memoir would have been the story of a madman, instead
of the life of a man of genius, some of whose works are worthy of any
age or nation. Even while he was indulging in these laughable fancies,
and seeing visions at the request of his friends, he conceived, and
drew, and engraved, one of the noblest of all his productions—the
Inventions for the Book of Job. He accomplished this series in a small
room, which served him for kitchen, bedchamber, and study, where he
had no other companion but his faithful Katherine, and no larger income
than some seventeen or eighteen shillings a week. Of these Inventions,
as the artist loved to call them, there are twenty-one,[1] representing
the Man of Uz sustaining his dignity amidst the inflictions of Satan,
the reproaches of his friends, and the insults of his wife. It was in such
things that Blake shone; the Scripture overawed his imagination, and
he was too devout to attempt aught beyond a literal embodying of the
majestic scene.[2] He goes step by step with the narrative; always simple,
and often sublime—never wandering from the subject, nor overlaying
the text with the weight of his own exuberant fancy.

43 The passages, embodied, will show with what lofty themes he
presumed to grapple. 1. Thus did Job continually. 2. The Almighty
watches the good man's household.[3] 3. Satan receiving power over
Job. 4. The wind from the wilderness destroying Job's children. 5.
And I alone am escaped to tell thee.[4] 6. Satan smiting Job with sore
boils. 7. Job's friends comforting him. 8. Let the day perish wherein
I was born. 9. Then a spirit passed before my face. 10. Job laughed to
scorn by his friends. 11. With dreams upon my bed thou scarest me—
thou affrightest me with visions. 12. I am young and ye are old,
wherefore I was afraid. 13. Then the Lord answered Job out of the
whirlwind. 14. When the morning stars sang together, and the sons
of God shouted for joy. 15. Behold now Behemoth, which I made with

[1] Counting the engraved title-page, there are twenty-two *Job* plates.
[2] This now appears to be a simplification.
[3] The wording of numbers 2, 3, 4, and 7 is entirely Cunningham's.
[4] Cunningham appears to have reversed numbers 4 and 5.

thee. 16. Thou hast fulfilled the judgment of the wicked. 17. I have heard thee with the hearing of my ear, but now my eye rejoiceth in thee. 18. Also the Lord accepted Job. 19. Every one also gave him a piece of money. 20. There were not found women fairer than the daughters of Job. 21. So the Lord blessed the latter end of Job more than the beginning.

44 While employed on these remarkable productions, he was made sensible that the little approbation which the world had ever bestowed on him was fast leaving him. The waywardness of his fancy, and the peculiar execution of his compositions, were alike unadapted for popularity; the demand for his works lessened yearly from the time that he exhibited his Canterbury Pilgrimage; and he could hardly procure sufficient to sustain life, when old age was creeping upon him. Yet, poverty-striken as he was, his cheerfulness never forsook him—he uttered no complaint—he contracted no debt, and continued to the last manly and independent. It is the fashion to praise genius when it is gone to the grave—the fashion is cheap and convenient. Of the existence of Blake few men of taste could be ignorant—of his great merits multitudes knew, nor was his extreme poverty any secret. Yet he was reduced—one of the ornaments of the age—to a miserable garret and a crust of bread, and would have perished from want, had not some friends, neither wealthy nor powerful, averted this disgrace from coming upon our country. One of these gentlemen, Mr. Linnel, employed Blake to engrave his Inventions of the Book of Job; by this he earned money enough to keep him living—for the good old man still laboured with all the ardour of the days of his youth, and with skill equal to his enthusiasm. These engravings are very rare, very beautiful, and very peculiar. They are in the earlier fashion of workmanship, and bear no resemblance whatever to the polished and graceful style which now prevails. I have never seen a tinted copy, nor am I sure that tinting would accord with the extreme simplicity of the designs, and the mode in which they are handled. The Songs of Innocence, and these Inventions for Job, are the happiest of Blake's works, and ought to be in the portfolios of all who are lovers of nature and imagination.

45 Two extensive works, bearing the ominous names of Prophecies, one concerning America, the other Europe, next made their appearance from his pencil and graver.[1] The first contains eighteen, and the other seventeen plates, and both are plentifully seasoned with verse, without the incumbrance of rhyme. It is impossible to give a satisfactory description of these works;[2] the frontispiece of the latter,

[1] The chronology is badly distorted here. *Job* appeared in 1826, and *America* and *Europe* were published in 1793 and 1794.

[2] It was impossible for Cunningham to give a satisfactory description of these

representing the Ancient of Days, in an orb of light, stooping into chaos, to measure out the world, has been admired less for its meaning than for the grandeur of its outline. A head and a tail-piece in the other have been much noticed—one exhibits the bottom of the sea, with enormous fishes preying on a dead body—the other, the surface, with a dead body floating, on which an eagle with outstretched wings is feeding. The two angels pouring out the spotted plague upon Britain —an angel standing in the sun, attended by three furies—and several other Inventions in these wild works, exhibit wonderful strength of drawing and splendour of colouring. Of loose prints—but which were meant doubtless to form part of some extensive work—one of the most remarkable is the Great Sea Serpent; and a figure, sinking in a stormy sea at sunset—the glow of which, with the foam upon the dark waves, produces a magical effect.[1]

46 After a residence of seventeen years in South Molton Street, Blake removed (not in consequence, alas! of any increase of fortune,) to No. 3, Fountain Court, Strand. This was in the year 1823.[2] Here he engraved by day and saw visions by night, and occasionally employed himself in making Inventions for Dante; and such was his application that he designed in all one hundred and two, and engraved seven. It was publicly known that he was in a declining state of health; that old age had come upon him, and that he was in want. Several friends, and artists among the number, aided him a little, in a delicate way, by purchasing his works, of which he had many copies. He sold many of his 'Songs of Innocence,' and also of 'Urizen,'[3] and he wrought incessantly upon what he counted his masterpiece, the 'Jerusalem,' tinting and adorning it, with the hope that his favourite would find a purchaser. No one, however, was found ready to lay out twenty-five guineas on a work which no one could have any hope of comprehending,[4] and this disappointment sank to the old man's heart.

47 He had now reached his seventy-first year,[5] and the strength of nature was fast yielding. Yet he was to the last cheerful and contented. 'I glory,' he said, 'in dying, and have no grief but in leaving you, Katherine; we have lived happy, and we have lived long; we have been

works because apparently he had never seen them. All his details are taken from J. T. Smith (pp. 470–2).

 [1] Cunningham's details, but not the vagueness, come from J. T. Smith (pp. 470–2).

 [2] By Cunningham's own account ('seventeen years' from 1804), and in fact, the year should be 1821.

 [3] It is unlikely that the *Songs of Innocence* was sold extensively by itself as late as this, and the seven surviving copies of *Urizen* testify to the limited nature of its sale.

 [4] Tatham acquired from Blake's widow the only complete coloured copy of *Jerusalem*.

 [5] Blake died in his seventieth year.

ever together, but we shall be divided soon. Why should I fear death? Nor do I fear it. I have endeavoured to live as Christ commands, and have sought to worship God truly—in my own house, when I was not seen of men.' He grew weaker and weaker—he could no longer sit upright; and was laid in his bed, with no one to watch over him, save his wife, who, feeble and old herself, required help in such a touching duty.

48 The Ancient of Days was such a favourite with Blake, that three days before his death, he sat bolstered up in bed, and tinted it with his choicest colours and in his happiest style. He touched and retouched it—held it at arm's length, and then threw it from him, exclaiming, 'There! that will do! I cannot mend it.'¹ He saw his wife in tears—she felt this was to be the last of his works—'Stay, Kate! (cried Blake) keep just as you are—I will draw your portrait—for you have ever been an angel to me'—she obeyed, and the dying artist made a fine likeness.

49 The very joyfulness with which this singular man welcomed the coming of death, made his dying moments intensely mournful. He lay chaunting songs, and the verses and the music were both the offspring of the moment. He lamented that he could no longer commit those inspirations, as he called them, to paper [.] 'Kate,' he said, 'I am a changing man—I always rose and wrote down my thoughts, whether it rained, snowed, or shone, and you arose too and sat beside me—this can be no longer.' He died on the 12th of August, 1828,² without any visible pain—his wife, who sat watching him, did not perceive when he ceased breathing.

50 William Blake was of low stature and slender make, with a high pallid forehead, and eyes large, dark, and expressive. His temper was touchy, and when moved, he spoke with an indignant eloquence, which commanded respect. His voice, in general, was low and musical, his manners gentle and unassuming, his conversation a singular mixture of knowledge and enthusiasm. His whole life was one of labour and privation,—he had never tasted the luxury of that independence, which comes from professional profit. This untoward fortune he endured with unshaken equanimity—offering himself, in imagination, as a martyr in the great cause of poetic art;—*pitying* some of his more fortunate brethren for their inordinate love of gain; and not doubting that whatever he might have won in gold by adopting other methods, would have

¹ Cunningham obviously had talked to Tatham, but since this dialogue is almost word for word from J. T. Smith (p. 471), it seems likely that the detail of 'three days before his death' is a mere improvisation. Tatham himself (pp. 527–8) says that Blake was interrupted in his colouring of 'The Ancient of Days' by a spasm of his illness, and only returned to it on the day of his death. See Plate LII.

² Blake died in 1827.

been a poor compensation for the ultimate loss of fame. Under this agreeable delusion, he lived all his life—he was satisfied when his graver gained him a guinea a week—the greater the present denial, the surer the glory hereafter.

51 Though he was the companion of Flaxman and Fuseli, and sometimes their pupil, he never attained that professional skill, without which all genius is bestowed in vain. He was his own teacher chiefly; and self-instruction, the parent occasionally of great beauties, seldom fails to produce great deformities. He was a most splendid tinter, but no colourist, and his works were all of small dimensions, and therefore confined to the cabinet and the portfolio. His happiest flights, as well as his wildest, are thus likely to remain shut up from the world. If we look at the man through his best and most intelligible works, we shall find that he who could produce the Songs of Innocence and Experience, the Gates of Paradise, and the Inventions for Job, was the possessor of very lofty faculties, with no common skill in art, and moreover that, both in thought and mode of treatment, he was a decided original. But should we, shutting our eyes to the merits of those works, determine to weigh his worth by his Urizen, his Prophecies of Europe and America, and his Jerusalem, our conclusion would be very unfavourable; we would say that, with much freedom of composition and boldness of posture, he was unmeaning, mystical, and extravagant, and that his original mode of working out his conceptions was little better than a brilliant way of animating absurdity. An overflow of imagination is a failing uncommon in this age, and has generally received of late little quarter from the critical portion of mankind. Yet imagination is the life and spirit of all great works of genius and taste; and, indeed, without it, the head thinks and the hand labours in vain. Ten thousand authors and artists rise to the proper, the graceful, and the beautiful, for ten who ascend into 'the heaven of invention.' A work—whether from poet or painter—conceived in the fiery extasy of imagination, lives through every limb; while one elaborated out by skill and taste only will look, in comparison, like a withered and sapless tree beside one green and flourishing. Blake's misfortune was that of possessing this precious gift in excess. His fancy overmastered him—until he at length confounded 'the mind's eye' with the corporeal organ, and dreamed himself out of the sympathies of actual life.

52 His method of colouring was a secret which he kept to himself, or confided only to his wife; he believed that it was revealed in a vision, and that he was bound in honour to conceal it from the world. 'His modes of preparing his grounds,' says Smith,[1] in his Supplement to the Life of Nollekens, 'and laying them over his panels for printing,

[1] pp. 472–3, q.v.

mixing his colours, and manner of working, were those which he considered to have been practised by the early fresco painters, whose productions still remain in many instances vividly and permanently fresh. His ground was a mixture of whiting and carpenters' glue, which he passed over several times in the coatings; his colours he ground himself, and also united with them the same sort of glue, but in a much weaker state. He would, in the course of painting a picture, pass a very thin transparent wash of glue-water over the whole of the parts he had worked upon, and then proceed with his finishing. He had many secret modes of working, both as a colourist and an engraver. His method of eating away the plain copper, and leaving the lines of his subjects and his words as stereotype, is, in my mind, perfectly original. Mrs. Blake is in possession of the secret, and she ought to receive something considerable for its communication, as I am quite certain it may be used to advantage, both to artists and literary characters in general.' The affection and fortitude of this woman entitle her to much respect. She shared her husband's lot without a murmur, set her heart solely upon his fame, and soothed him in those hours of misgiving and despondency which are not unknown to the strongest intellects. She still lives to lament the loss of Blake—and *feel* it.[1]

53 Of Blake's merits as a poet I have already spoken—but something more may be said—for there is a simplicity and a pathos in many of his snatches of verse worthy of the olden muse. On all his works there is an impress of poetic thought, and what is still better a gentle humanity and charitable feeling towards the meanest work of God, such as few bards have indulged in. On the orphan children going to church on Holy Thursday, the following touching verses were composed —they are inserted between the procession of girls and the procession of boys in one of his singular engravings. . . .[2] [*See Plate XXXV.*]

54 Under the influence of gayer feelings, he wrote what he called the Laughing Song—his pencil drew young men and maidens merry round a table, and a youth, with a plumed cap in one hand and a wine-cup in the other, chaunts these gladsome verses. . . .[3]

55 In the Song of the Lamb, there is a simplicity which seems easily attained till it is tried, and a religious tenderness of sentiment in perfect keeping with the poetry. A naked child is pencilled standing beside a group of lambs, and these verses are written underneath.[4]

[1] Everything following this paragraph was not in the first edition.

[2] 'Holy Thursday' from *Songs of Innocence* is quoted as in Malkin (p. 426), except for: l. 2 'walked forth' for 'walking'; l. 4 'Into the high dome of St. Paul's, like Thames' waves they flow'; for 'Till into the high dome of Paul's they like Thames' waters flow'; l. 6 'company' for 'companies'; l. 9 'How' for 'Now'.

[3] 'Laughing Song' from *Songs of Innocence* is given as in Malkin (p. 425).

[4] These verses are written *above* the engraving of the child and lambs.

'Little lamb, who made thee?
Little lamb, who made thee?[1]
Gave thee life, and bade thee feed,[2]
By the stream and o'er the mead;
Gave thee clothing of delight,
Softest clothing—woolly bright;
Gave thee such a tender voice,
Making all the vales rejoice?
Little lamb, who made thee?
Dost thou know who made thee?

Little lamb, I'll tell thee;
Little lamb, I'll tell thee;
He is called by thy name,
For he calls himself a lamb;
He is meek, and he is mild,
He became a little child;
I a child, and thou a lamb,
We are called by his name.
Little lamb, God bless thee;
Little lamb, God bless thee.'

56 It would be unjust to the memory of the painter and poet to omit a
song which he composed in honour of that wife who repaid with such
sincere affection the regard which he had for her. It has other
merits. . . .[3]

57 Images of a sterner nature than those of domestic love were, how-
ever, at all times, familiar to his fancy; I have shown him softened
down to the mood of babes and sucklings; I shall exhibit him in a more
martial temper. In a ballad, which he calls Gwinn,[4] King of Norway,
there are many vigorous verses—the fierce Norwegian has invaded
England with all his eager warriors.

'Like reared stones around a grave
They stand around their king.'[5]

But the intrepid islanders are nothing dismayed; they gather to the
charge; these are the words of Blake forty-six years ago;—and this

[1] 'Dost thou know who made thee?'

[2] 'and bid thee feed'.

[3] It seems extremely unlikely that the Kitty of 'I love the jocund dance' from
Poetical Sketches became Blake's wife. The poem is given as in Malkin (p. 430),
except for: l. 4 'where' is omitted; l. 5 'gale' corrected to 'vale'; l. 7 'is never mute'
for 'does never fail'; l. 8 'jolly lads laugh their fill' for 'the jolly swain laughs his
fill'; l. 11 'bread' for 'and white'; l. 12 'And' for 'Or'; l. 18 'Kate, I most' for 'Kitty,
I better'; l. 19 'thee' for 'them'; l. 20 'For' for 'But'.

[4] Blake's 'Gwin' has only one 'n'. [5] 'the King'.

man's poetry obtained no notice, while Darwin and Hayley were gorged with adulation.

'The husbandman now leaves his plough,[1]
To wade through fields of gore,
The merchant binds his brows in steel,
And leaves the trading shore.

The shepherd leaves his mellow pipe,
And sounds the trumpet shrill,
The workman throws his hammer down,
To heave the bloody bill.

Like the tall ghost of Barraton,
Who sports in stormy sky,
Gwinn leads his host, as black as night
When pestilence doth fly.

With horses and with chariots,
There all his spearmen bold[2]
March to the sound of mournful song,
Like clouds around him rolled.[3]

The armies stand like balances
Held in the Almighty's hand,
Gwinn, thou hast filled thy measure up,
Thou'rt swept from English land.[4]

Earth smokes with blood, and groans and shakes
To drink her children's gore,
A sea of blood! nor can the eye
See to the trembling shore.

And on the verge of this wild sea
Famine and Death do cry,[5]
The shrieks[6] of women and of babes
Around the field do fly.'[7]

58 As Blake united poetry and painting in all his compositions,[8] I have endeavoured to show that his claims to the distinction of a poet were not slight. He wrought much and slept little, and has left volumes of verse, amounting, it is said, to nearly an hundred, prepared for the

[1] 'does leave his plough'. [2] 'And all his spearmen bold'.
[3] A stanza is omitted here.
[4] 'from out the land'. The battling stanza succeeding this is omitted.
[5] 'doth cry'. [6] 'The cries'.
[6] 'Over the field doth fly'. Nine concluding stanzas are omitted.
[7] Blake did not, of course, unite 'poetry and painting' in the *Poetical Sketches* from which Cunningham has just quoted.

press.[1] If they are as wild and mystical as the poetry of his Urizen, they are as well in manuscript—if they are as natural and touching as many of his songs of Innocence, a judicious selection might be safely published.

E

FREDERICK TATHAM

(MS.) '*Life of Blake*' *c.* 1832

The last section of Tatham's 'Life of Blake' (pp. *533–5*) was composed less than a year after 'the 17th of October [*1831*] last" (p. *535*), when Catherine died; the preceding part may have been drafted somewhat earlier. Tatham's purpose was in part to advertise for sale impressions of Blake's works which he inherited from Catherine (p. *533*), particularly the coloured copy of *Jerusalem* (copy E, now in the collection of Mr. Paul Mellon), to which the 'Life' refers from time to time and with which it is bound. The manuscript is written in a beautifully clear hand on both sides of twelve large sheets of paper (about 11 inches by 13½) watermarked "J. WHATMAN/TURKEY MILL/ 183[2?]".

Despite the delightful clarity of the handwriting, there are a number of idiosyncracies in the text which defy easy translation into conventional print. Not only is the punctuation sparse, but Tatham has invented some punctuation marks of his own, such as two parallel lines (=), or three dots one above the other (∴) or a curlicue at the end of a line. These terminal marks of punctuation I have silently converted to periods, and crucial missing punctuation I have supplied within square brackets. Conventional but wrong punctuation, such as a semicolon for a comma or a period for a question-mark, I have regretfully allowed to stand. A number of sentences begin with a clear lower-case letter even though the preceding sentence ends with a period. I have capitalized these initial letters, but italicized them as well to indicate that the MS original was lower case.

Tatham's spacing is also quixotic. He has far too few paragraphs, but occasionally in the middle of a paragraph there will be a gap of as much as two inches between the end of one sentence and the beginning of the next on the same line. This space I have ignored. Further, sometimes a new line begins with a new sentence very slightly (perhaps a quarter of an inch) indented, though the sense demands that the paragraph should continue. For the sake of the sense and the reader, I have ignored these disrupting and perhaps accidental irregularities.

With these exceptions, the manuscript is reproduced here literally.

As a source of biographical facts the 'Life' is of dubious value. **On the** one hand, Tatham not only knew Blake better than any of his other biographers, but he actually lived with and supported Catherine, who

[1] The number seems enormous, but it accords with Blake's own account of his writings to Crabb Robinson (Feb. 18th, 1826): 'I have written more than Voltaire or Rousseau—six or seven epic poems as long as Homer and twenty tragedies as long as Macbeth'.

apparently doted upon Tatham and his wife. Some of the anecdotes he relates, such as the one about the guinea which Catherine always kept concealed even from her husband, could have come from no one but Catherine, and many of Tatham's stories are not recorded elsewhere. The incidents involving Astley, the sick artist, Blake's loan to the ungrateful philosopher, and John Blake's apprenticeship to a baker, among others, appear first in Tatham's 'Life'.

On the other hand, there are very serious defects in the 'Life' both as a piece of writing and as a biography. Tatham's vigorous but naïve piety both colours his views and repeatedly leads him from his subject. Further, Tatham's facts are not uniformly reliable. With disturbing frequency those parts of his narrative which can be checked are significantly distorted. Clearly, Tatham took no pains to verify the authenticity of his stories.

We may, however, be able to absolve Tatham of some of the responsibility for his inaccuracy. Tatham's intimacy with Catherine Blake, which gave rise to the peculiar merit of his biography of Blake, may also be the cause of its defects. It is well to remember that Catherine was an uneducated woman, perhaps illiterate when she was married, and that Blake himself was concerned with visionary truth rather than factual precision. It is possible that the minor details of Tatham's stories, such as where Blake saw Astley's boy, are the only parts of the stories that are inaccurate, and that Tatham was simply remembering general family anecdotes, heightened as such stories almost invariably are for general effect. Tatham is not very trustworthy, but it is probably best to trust him until we have cause not to.

LIFE OF BLAKE

William Blake was born on the 20th of November[1] 1757, at 28 Broad Street Carnaby-Market London, a House now inhabited by Mr Russell [,] Apothecary: He was the 2nd of 5 Children.[2] His Father James Blake, was a Hosier of respectable Trade & easy habits & seems to have been a Man well to do, of moderate desires, moderate Enjoyments, & of substantial Worth, his disposition was gentle, & by all accounts, his Temper amiable, & was by his Sons description, a lenient & affectionate Father, always more ready to encourage than to chide. Catherine Blake, his Wife, & the Mother of the Artist, has been represented as being possessed of all those Endearing Sympathies, so peculiar to maternal tenderness. The Eldest Son, John,[3] was the favourite of his Father & Mother, & as frequently in life, the object least worthy is most cherished, so he, a dissolute disreputable youth, carried away the principal of his Parents attachment, leaving the four others William, James, Catherine, & Robert, to share the Interest between them. William often remonstrated, & was as often told to be quiet, & that he would bye & bye beg his bread at Johns Door; but as

[1] Nov. 28th. [2] He was the third of seven children, two of whom died young.
[3] The oldest son was James. John 'the evil one' was the fourth son.

is sometimes proved to parents Sorrow, their pet will not be petted into honour, nor their darling into any other admiration than their own. John was apprenticed to a Gingerbread Baker with an Enormous premium,[1] served his apprenticeship with reluctance, became abandoned & miserable & literally, contrary to his parents presage, sought bread at the Door of William. He lived a few reckless days, Enlisted as a Soldier & died.[2]

James continued the business at the death of his Father & Mother, & having a saving somniferous mind, lived a yard & a half life, pestered his brother the Artist with timid sentences of bread & cheese advice, got together a little annuity upon which he supported his only Sister & vegetating to a moderate Age, died about 3 years before his brother William.[3] Robert the youngest Son [*was*] the affectionate companion of William, they sympathized in their pursuits & sentiments, like plants planted side by side, by a stream they grew together, & entwined the luxuriant Tendrils of their Expanding minds. They associated and excelled together, & like all true lovers delighted in & enhanced each others beauties.

'For they were nursed upon the selfsame Hill'
Fed the same Flock by fountain shade & rill[.]'

[1] It seems extremely unlikely that John Blake was 'apprenticed' to a baker for a premium which would seem 'enormous' beside the fifty-guinea fee for the poet's apprenticeship. 'The Money they [*bakers*] take with an Apprentice is from 5 *l.* to 20 *l.* and which they seldom exceed' (Anon., *General Description of All Trades*, London, 1747, p. 10, echoed very closely by J. Collyer, *The Parent's and Guardian's Directory*, London, 1761, pp. 57, 146, etc.), and in 'The Book for Entering the Names of Apprentices Bound at Bakers Hall' (now in Guildhall Library) the fees from 1768 to 1780 reached a maximum of £20. The poet's brother John appears neither in this list of bakers' apprentices nor in the typescript index (in Guildhall Library) of the list in the Public Record Office of *all* apprentices who paid an apprenticeship fee. The last fact indicates that William's brother John was never apprenticed for a fee to any trade.

However, John Blake was a baker (see 29 Broad Street, Residences, p. 558). Perhaps he learned the baking trade from relatives such as Robert and Peter Blake, the bakers in Rupert Street (see 28 Broad Street, under Residences), borrowed a sizeable amount of money from his parents to set himself up in business (*General Description* and J. Collyer agree that about £100 would serve pretty well to begin with), lost it all through sloth and recklessness, and threw himself upon the mercy of his brothers. The evidence from Residences suggests that he lost the business about 1793, after both his parents had died.

[2] The place and date of John's death are not known, but he died between 1793, when he 'ran away' from 29 Broad Street, and 1801, when Blake writes of him as dead (letter of Nov. 22nd, 1802).

[3] Almost all the information in this sentence is not to be found elsewhere. The account here is probably somewhat telescoped. James Blake left the 28 Broad Street shop in 1812, and apparently entered the Office of the Muster-Master General under Blake's friend Thomas Butts, from which he probably received a pension when it was abolished in 1817 (see 'Thomas Butts, White Collar Maecenas', *PMLA*, lxxi [1956], pp. 1058–9). He apparently died in Feb. 1827.

Robert was of amiable & docile temper, & of a tender & affectionate mind, & like many of those who appear born for early death, his short life was but as the narrow porch to his Eternal Lot: he died of consumption at 24 Years of age.[1] Miss Catherine the only daughter is still living having survived nearly all her relations.[2] William, the Artist, appears to have possessed from a Child, that daring impetuous & vigorous temper, which was in latter life so singularly characteristic, both of him & his sublime Inventions. Although easily persuaded, he despised restraints & rules, so much that his Father dare[*d*] not send him to School. Like the Arabian Horse, he is said to have so hated a Blow that his Father thought it most prudent to withhold from him the liability of receiving punishment. He picked up his Education as well as he could. His talent for Drawing manifesting itself as spontaneously as it was premature, he was always sketching, & after having drawn nearly everything around him with considerable ability he was sent to Draw with Pars a Drawing master in the Strand at 10 years of age.[3] He used also at this time to frequent Langfords the Auctioneer, where he saw pictures & bought prints from Raphael[,] Michael Angelo[,] Albert Durer, Julio Romano & others of the great designers of the Cinque Cento, & refused to buy any others, however celebrated. Langford favoured him by knocking down the lots he bought so quickly, that he obtained them at a rate suited to the pocket savings of a lad.[4] Langford called him his little Connoisseur. Even at this time he met with that opposition & ridicule from his Cotemporaries, (many of whom have since become men of Note) that harassed him afterwards—they laughed at his predilection for these great masters.[5] His love for Art increasing, & the time of life having arrived, when it was deemed necessary to place him under some Tutor, a painter of Eminence was proposed & necessary applications were made, but from the huge premium required, he requested with his characteristic generosity that his Father would not on any account

[1] He was almost certainly 19 when he died; see the record of his registration as a student at the Royal Academy, April 2nd, 1782.

[2] Practically nothing is known of Catherine, not even her death date, but she certainly was not buried in Bunhill Fields before 1838.

[3] Henry Pars's academy was by Beaufort Buildings in the Strand. The fact that Blake attended it was first given by Malkin, p. 422.

[4] This account of Langford comes straight from Malkin, p. 422, who specifies, however, that his father 'supplied him with money to buy prints'. Abraham Langford (1711–74) died when Blake was sixteen, so the start of Blake's print collection can be dated well before then. Malkin's chronology suggests that it began before 1772.

[5] The eccentricity of Blake's taste for cinquecento painters may be illustrated by an anecdote from Linnell's Autobiography (p. 26): 'There was a dealer who was so bitter upon this point that he said to me one day when I had asserted my belief that fine color was to be found in M. Angelo's frescoes—"I'll tell you what" he said. "I think Michael Angelo was a pinkyfied son of a bitch" [.]'

spend so much money on him, as he thought it would be an injustice to his brothers & sisters; he therefore himself proposed Engraving as being less expensive & sufficiently eligible for his future avocations.[1] Of Basire therefore, for a premium of fifty Guineas he learnt the Art of modern Engraving. The trammels of this Art, which he never till his very last days overcame, he spent money & time to learn & had it not been for the circumstance of his having frequent quarrels with his fellow apprentices, concerning matters of intellectual argument, he would perhaps never have handled the pencil & would consequently have been doomed forever to furrow upon a Copper Plate, monotonous & regular lines, placed at even distances, without Genius & without Form. These quarrels existing between the 3 boy's, Basire thought he could not do better than to send Blake out drawing; as he was about to Engrave a Work for the Antiquarian Society, he sent him therefore to Westminster Abbey. 'There he found a treasure which he knew how to value. He saw the simple & plain road to the style of Art at which he aimed, unentangled in the intricate mazes of modern practice. The Monuments of Kings & Queens in Westminster Abbey, which sur-round the Chapel of Edward the Confessor, particularly that of Henry the third, the beautiful monument & figure of Queen Elenor, Queen Philippa & Edward the third, King Richard the 2.ⁿᵈ & his Queen, were among his first studies; the heads he considered as portraits & all the ornaments appeared as miracles of Art[.]' See Malkins life of his Child[2] in which there is a short sketch of Blake written during his lifetime. If all his Drawings were enumerated from Westminster Abbey, as well as many other Churches in & about London, the Multitude would no doubt astonish the Calculator, for his Interest was highly excited & his

[1] It seems likely that this story is the parent, or perhaps a cousin, of one which Gilchrist relates (1942, pp. 10–11; 1863, p. 13): 'There had been an intention of apprenticing Blake to Ryland, a more famous man than Basire With the view of securing the teaching and example of so skilled a hand, Blake was taken by his father to Ryland; but the negotiation failed. The boy himself raised an unexpected scruple. . . . "Father," said the strange boy, after the two had left Ryland's studio, "I do not like the man's face: *it looks as if he will live to be hanged!*" ' (He was hanged for forging a cheque in 1783. Blake's forecast may have been aided by the knowledge that Ryland's printselling business had gone bankrupt just a few months before, in Dec. 1771.)

The fee of Ryland, in 1772 the wonderfully fashionable stipple Engraver to the King, would probably have been too high for the Blakes, for, according to the records in Stationers' Hall, Thomas Strutt paid £100 when his son Joseph was bound on March 6th, 1764 to William Wynn Ryland of Russell Street, Covent Garden, History Engraver. Ryland, then, might have been the 'painter' Tatham mentions, whose 'huge premium' may have combined with Blake's prophecy as (in Gilchrist) to compel another choice of master for Blake.

[2] This is taken from Malkin (pp. 422–3), with minor omission and alterations. All the other facts up to this point in the paragraph come from Malkin as well.

industry equally inexhaustible.[1] These things he drew beautifully; ever attentive to the delicacies & timorous lineaments of the Gothic Handling, he felt & pourtrayed their beauties so well that his Master considered him an acquisition of no mean capacity. An Incident showing the suddenness of his Temper is related. The Westminster boys were then permitted to roam & loiter about the Abbey at their leisure,[2] & among their jokes, they chose to interrupt the careful young Student, whose rivetted attention & absorbed thought, became an object of their mischievous Envy, one of them is said after having already tormented him to have got upon some pinnacle on a level with his Scaffold in order better to annoy him. In the Impetuosity of his anger, worn out with Interruption, he knocked him off & precipitated him to the ground, upon which he fell with terrific Violence. The young draughtsman made a complaint to the Dean, who kindly ordered that the Door should be closed upon them & they have never since been allowed to extend their tether to the Interior of the Abbey.[3] Blake pursued his Task & his absorption gathered to itself impressions that were never forgotten. His Imagination ever after wandered in a cloister, or clothing itself in the dark Stole of mural sanctity, it dwelt amidst the Druid terrors. His mind being simplified by Gothic Forms, & his Fancy imbued with the livid twilight of past days, it chose for its quaint Company, such sublime but antiquated associates as the Fearful Merlin, Arthur & the Knights of his Round Table, the just & wise Alfred, King John, and every other hero of English History & Romance. These Indigenous

[1] The implication that the number of drawings was chiefly due to Blake's enthusiasm is misleading. Most were done on the direction of Basire for Gough's *Sepulchral Monuments*.

[2] In the 18th century schoolboys were a rough lot, sometimes taught but always beaten. At Westminster School the boys played football in the Abbey cloisters and hide-and-seek among the effigies in the Abbey itself, reckless alike of pious visitors and ancient proprieties. A short time before Blake worked there, Horace Walpole wrote that he 'literally had not courage to venture alone among the Westminster boys at the Abbey', even to visit the tomb of his mother (*The Letters of Horace Walpole*, ed. P. Toynbee, Oxford, 1903, vol. iii, p. 249, letter of July 9th, 1754 to Richard Bentley). And a boy who was at the school some thirty years later remembered: 'When I was a boy at Westminster, . . . the boys fought one another, they fought the Masters, the Masters fought them, they fought outsiders; in fact, we were ready to fight everybody' (J. Sargeaunt, *Annals of Westminster School*, London, 1898, p. 215, quoting Bishop Augustus Short, 1802–83).

[3] Mr. A. Prag of Westminster School tells me that no tradition or record of this incident is preserved in the school, and I have been unable to trace the incident in the Abbey records. Mr. Prag also points out that 'The Royal College of St. Peter's at Westminster' comprised the Abbey *and* the School, and that the School goes to the Abbey for its own daily service. Therefore the Dean could not have excluded the boys from the Abbey entirely. If there is a kernel of truth in Tatham's story, perhaps we may find it in a temporary exclusion of the boys from one of the Royal Chapels where Blake was working and where they ordinarily had special privileges.

Abstractions for many of the following years occupied his hand, & ever after tinctured his thoughts & perceptions. The backgrounds of his pictures, nearly always exhibited Druidical Stones & other Symbols of English Antiquity. Albion was the Hero of his Pictures, Prints & Poems. He appeared to be the Human Abstract of his mystical thoughts. He recounted his deeds, he exhausted the Incidents of his History & when he had accomplished this 'he then imagined new.' He made him a spiritual Essence—representing the Country of Brittain under this one personification he has made him the Hero of nearly all his Works—[.]¹ He has connected Albion with Jerusalem & Jerusalem with other mysterious Images of his own fancy, in such a manner, as will be difficult to unravel, but not entirely impossible, it is imagined, after reading the remainder of his writings, which will absorb time & pains[,] much indeed of both for his pen was quite as active in his indefatigable hand, as was his Graver or his Pencil; he used all with equal temerity & complete originality.

Between the age of 12 & 20 he wrote several poems afterwards published by the advice & with the assistance of Flaxman, Mʳˢ Matthews² & others of his friends—they are succinct[,] original, fanciful & fiery but as a general criticism, it may be said that they are more rude than refined, more clumsy than delicate. Two of them are equal to Ben Johnson [*sic.*]

Song. [*'How sweet I roamed'*] . . .³

Song

'Love & Harmony combine,
And around our souls entwine,
While thy branches mix with mine,
And our roots together join.

2

Joys upon our branches sit,
Chirping loud & singing sweet,
Like gentle streams beneath our feet,
Innocence & virtue meet;

¹ Albion only appears in Blake's Prophecies from 1793 on, and even then for a time he plays a negligible part. In fact, when Tatham talks about Blake's myth he really means *Jerusalem*.

² This should be Harriet Mathew. This information presumably comes from J. T. Smith (p. 456), the only contemporary recorder of the period. If so, the addition of 'others of his friends' must refer to the 'advice' and not the 'assistance' in publishing Blake's *Poetical Sketches*. The dates of composition of the *Sketches* are given in its Advertisement.

³ This 'Song' is quoted as in Malkin (pp. 428–9), except that in l. 4 Tatham gives 'Summer' for 'sunny', and in l. 14 'Then' for 'And'.

3

Thou the golden fruit dost bear,
 I am clad in flowers fair.
Thy sweet boughs perfume the Air,
 And the Turtle buildeth there.

4

Then[1] she sits & feeds her young
 Sweet I hear her mournful Song,
And thy lovely leaves among,
 There is love I hear his tongue.

5

There his charming nest doth lay,
 There he sleeps the night away,
There he sports along the day,
 And doth among our branches play.'

The others although well for a lad are but moderate. His blank verse is prose cut in slices, & his prose inelegant, but replete with Imagery. The following[2] is a specimen[:]

'Who is this with unerring step doth tempt the Wilds;[3] where only' 'natures foot hath trod. 'Tis Contemplation, daughter of Grey Morn-' 'ing.[4] Majestical she steppeth & with her pure quill on every flower' 'writeth Wisdoms name. Now lowly bending, whispers in mine Ear, O' 'man how great how little art thou.[5] O man slave for each moment,'[6] 'Lord of Eternity, Seest thou where mirth sits on the painted cheek;' 'doth it not seem ashamed & grow[7] immoderate to brave it out. O' 'what a humble[8] Garb true Joy puts on. Those who want happiness' 'must stoop to find it, it is a flower that grows in every Vale. Vain' 'foolish man that roams on lofty rocks! where because[9] his garments' 'are swollen with wind he fancies he is grown into a Giant.' The Aphorism on happiness is worthy of his after days,—he seems at this time to have sighed after something invisible for he complains in these words[:] 'I am wrapped in Mortality, my flesh is a prison & my bones[10] the Bars of Death.'

About this time[11] Blake took to painting, & his success in it being a

[1] 'There she sits'. [2] From the beginning of 'Contemplation'.
[3] 'that with unerring step dares tempt the wilds'.
[4] 'daughter of the grey Morning!' [5] 'how little thou!
[6] 'slave of each moment'. [7] 'ashamed of such a place, and grow'.
[8] 'an humble'. [9] ''cause his garments'.
[10] 'prison, my bones'; also from 'Contemplation'.
[11] The chronology is obscure here, but probably Tatham means about 1777, the presumptive date of 'Contemplation', rather than 1783, the publication date of the *Poetical Sketches*.

matter of opinion it will require some care to give a fair account. Oil painting was recommended to him, as the only medium through which breadth, force, & sufficient rapidity could be obtained; he made several attempts, & found himself quite unequal to the management of it; his great objections were, that the picture after it was painted, sunk so much that it ceased to retain the brilliancy & luxury that he intended, & also that no definite line, no positive end to the form could even with the greatest of his Ingenuity be obtained, all his lines dwindled & his clearness melted, from these circumstances it harassed him, he grew impatient & rebellious, & flung it aside tired with ill success & tormented with doubts. He then attacked it with all the Indignation he could collect, & finally relinquished it to men, if not of less minds of less ambition. He had Michael Angelo on his side without doubt & a great many of the old genuine painters. Desiring that his colours should be as pure & as permanent as precious stones,[1] he could not with Oil obtain his End. The writer of this being a Sculptor he has not had the opportunity of collecting materials for M.r Blakes defence, but he has no doubt that his hatred to Oil as a Vehicle was produced by some great defect in it, as he has also no doubt in spite of what Cavillers have irritated Blake to say, that he possessed too much sound sense & judgment to be absolutely wrong, although he might in his Violence have said more than he could prove. Blake seemed intended for the 15 Century, when real energy of mind gained the appropriate rapidity of hand, and when the Vehicle, if not such as he invented was in much better command for sublime compositions. There might have been some variation in the Vehicle, that was enough to make all the difference, & that Vehicle might have been such an one as he would not have complained of. The Author has seen pictures of Blakes in the possession of W.m2 Butts Esq.re Fitzroy Square, that have appeared exactly like the old cabinet pictures of the 14 & 15, Century where he has touched the lights with white compound of whiting & glue, of which material he laid the ground of his Panel. Two of these pictures are of the most sublime composition & artistlike workmanship: they are not drawings on Canvas as some of his others, but they are superlative specimens of genuine painter-like handling & force, & are little inferior in depth, tone & colour to any modern Oil picture in the Country.

During these paroxysms of indignation, he is said to have come in contact with Sir Joshua Reynolds, but it is very odd that the man whose pictures were already cracked & split & likely to be much more so, from the insufficiency or the misuse of his Vehicle, turned his deaf side

[1] The ideas, though not the facts, for this section are taken from the *Descriptive Catalogue*, particularly the claim that his 'colours would be as pure and permanent as precious stones'.

[2] The Christian name of Blake's patron was Thomas.

to his remarks, nay he is said to have been quite angry with him for scrutinizing so tender a subject——Sir Joshua Reynolds was indeed a clever painter, but he was too fond of the comforts of life to give even an hour a day for any other experiments but those which would enable him to paint with greater celerity. Sir Joshua made experiments they say, no doubt he did, well then the least that can be said, is that he began at the wrong End like any other blunderer, & concluded in making his colours so bad that many of his Pictures now possess no other quality than those which they still would have had if they had been always divested of colour; bold handling, fine judgment, able delineation of form & great knowledge of nature—some of his pictures were coloured once, but are not coloured now, for they have cracked & split & flown, worse than those of any other painter Extant. *W*as he then the man to sneer at what might have been an Improvement if it had been tried by more than one. It is irritating to hear a sick man curse the salve of his sore place. Very singular it is to know that many of the best painters do not paint with the Oil Vehicle or if they do in a very small quantity. Fuseli painted with very little Oil, but then Oil painters consider Fuseli no colourist. What is Colouring? It is a most vague term, & is generally used in a still more vague manner. Blake wrote thus upon it.

'The Eye that can prefer the colouring of Titian & Corregio &' 'Rubens ought to be modest & doubt its own powers.[1] Connoisseurs' 'talk as if Raphael & Michael Angelo had never seen the colouring of' 'Titian & Corregio,[2] they ought to know that Corregio was born 2' 'years before Michael Angelo & Titian but 4 years after: both Raphael' '& Michael Angelo knew the Venetian & contemned & rejected all he' 'did with the utmost disdain, as that which is fabricated for for[*sic*] the' 'purpose of destroying Art.[3] The eyes of stupid Cunning will never[4]' 'be pleased with the work any more than the look[5] of self devoting' 'genius. The quarrel of the Florentine with the Venetian is not because' 'he does not understand Drawing but because he does not understand' 'Colouring; how should he when he does not know how to draw a hand' 'or foot[6] know how to colour it[?] Colouring does not depend on where 'the colours are put but on where the lights & darks are put & all' 'depends on form or outline, on where that is put, where that is wrong' 'the colouring never can be right.' Fuseli was expected to paint his Witches with the Carnations of Flora & Venus, and the author of the

[1] This line in the Preface to the *Descriptive Catalogue* should read: 'Colouring of Titian and Rubens to that of Michael Angelo and Rafael, ought to be modest and to doubt its own powers.'

[2] 'or Correggio'.

[3] 'to destroy art.' A sentence is omitted at this point.

[4] 'never will'.

[5] 'than with the look'.

[6] 'or a foot'.

caverns depths of the Sistine Chapel, is deemed unworthy to hold the pallet or to use the Brush. Because Fuseli coloured a Witch like a Witch & Michael Angelo coloured a Prophet like a Prophet, these men are called no colourists. That the greatest men should colour worst is an Enigma perfectly inexplicable, but after apologyzing for the digression, if the reader should want any more light upon this obscure subject, he must ask the picture Dealers or their fry, it will of them be learnt that nobody can colour well but those that can draw ill, in an equivalent ratio. Blake painted on Panel or canvass covered with 3 or 4 layers of whitening & carpenters Glue; as he said the nature of Gum was to crack, for as he used several layers of colour to produce his depths, the Coats necessarily in the deepest parts became so thick, that they were likely to peel off. Washing his Picture over with glue in the manner of a Varnish, he fixed the Colours, and at last varnished with a white hard varnish of his own making. It must however be confessed that his pictures mostly are not very deep, but they have an unrivalled tender brilliancy. He took infinite pains with them, coloured them very highly & certainly without prejudice, either for or against, has produced as fine works, as any ancient painter. He can be excelled by none where he is successful. Like his thoughts his paintings seem to be inspired by fairies & his colours look as if they were the bloom dropped from the brilliant Wings of the Spirits of the Prism. This may appear too much to be said of the mad Blake as he was called by those too grovelling & too ignorant to discern his merits. Mʳ Butts' collection is enough in all conscience to prove this & more & whoever does not perceive the beauties of this splendid collection ought indeed to find fault with modesty & censure with a blush.

In his 24ᵗʰ year he fell in love with a young woman who by his own account & according to his own knowledge was no trifler, he wanted to marry her but she refused, & was as obstinate as she was unkind.[1] He became ill & went to Kew near Richmond for a change of air & renovation of health & spirits & as far as is possible to know lodged at the House of a market Gardener whose name was Boutcher. The Boutchers appear to have been a respectable & industrious family. He was relating to the daughter, a Girl named Catherine, the lamentable story of Polly Wood, his implacable Lass, upon which Catherine expressed her deep sympathy, it is supposed in such a tender & affectionate manner, that it quite won him, he immediately said with the suddenness peculiar to him 'Do you pity me?' ['']Yes indeed I do' answered she[.] 'Then I love you' said he again. Such was their

[1] It may be this account which was amplified by Gilchrist (1942, pp. 31–32; 1863, p. 37); see under Aug. 1782. Tatham is also probably responsible for the repetition of the story by J. T. Smith (p. 459) and Cunningham (p. 481).

courtship. He was impressed with her tenderness of mind & her answer indicated her previous feeling for him. For she has often said that upon her mother asking her who among her acquaintances she could fancy for a Husband, she replied that she had not yet seen the man & she has further been heard to say that when she first came into the Room in which Blake sat she instantly recognized (like Britomart in Merlins wondrous glass) her future partner, & was so near fainting that she left his presence until she had recovered. After this interview, Blake left the House having recruited his health & spirits, & having determined to take Catherine Boutcher to Wife. He returned to his Lodgings, & worked incessantly that he might be able to accomplish this End at the same time resolving that he would not see her until he succeeded. This interval which she felt dolefully long was one whole year, at the expiration of which with the approbation & consent of his parents he married this Interesting beautiful & affectionate Girl.[1] Nimble with joy & warm with the glow of youth, this bride was presented to her noble bridegroom. The morning of their married life was bright as the noon of their devoted love, The noon as clear as the serene Evening of their mutual equanimity. Although not handsome he must have had a noble countenance, full of expression & animation, his hair was of a yellow brown, & curled with the utmost crispness & luxuriance. His locks instead of falling down stood up like a curling flame, and looked at a distance like radiations, which with his fiery Eye & expansive forehead, his dignified & cheerful physiognomy must have made his appearance truly prepossessing. After his Marriage he took lodgings in Green St Leicester Square.

It is now necessary to mention somewhat concerning the fanciful representations that Blake asserted were presented to his minds Eye: difficult as this subject is, it cannot be omitted without a sacrifice to the memory of this great man. He always asserted that he had the power of bringing his Imagination before his minds Eye, so completely organized, & so perfectly formed & Evident, that he persisted, that while he copied the vision (as he called it) upon his plate or canvas, he could not Err; & that error & defect could only arise from the departure or inaccurate delineation of this unsubstantial scene. He said that he was the companion of spirits, who taught, rebuked, argued, & advised, with all the familiarity of personal intercourse. What appears more odd still was the power he contended he had, of calling up any personage of past days, to delineate their forms & features, & to converse upon the topic most incidental to the days of their own existence: how far this is probable must be a question, left either to the credulity or the faith of

[1] Since Blake was married on Aug. 18th, 1782, about a year after he met Catherine, the meeting probably took place about July 1781, when he was 24½.

each person: it is fair however to say that what Blake produced from these characters, in delineating them, was often so curiously original, & yet so finely expressed, that it was difficult if prejudices were cast away, to disbelieve totally this power. It is well known to all enquiring men that Blake was not the only individual who enjoyed this peculiar gift.

A great & learned German, Emanuel Swedenborg,[1] whose writings as well as being so peculiar, are so interesting; saw Visions of Eternity, a full account of which he gives in his Voluminous Writings. After having applied himself in early life, to the minutest studies of philosophy, mathematics, mechanics & every skilful & theoretical occupation, after having been employed by his Country in the most conspicuous & responsible offices; he suddenly (being as suddenly called by a Vision) devoted his life to the most abstruse, theological discussions, & dilations, which after having been developed in Vision, he wrote. Such things indeed are they that unquestionably could not be invented by one ever so ingenious—(Vide life of Swedenborg). Swedenborg was not a madman, nor does he appear to have been considered so, by his cotemporaries, his tenets after his death propagated; & like all religious creeds soon formed a Sect, which Sect has at some periods been very numerous. Flaxman belonged to them[2] as have many other as judicious men.

Although it would not be irrelevant it would be tedious to narrate Swedenborgs opinions, or rather Swedenborgs visions, for he asserted that he only gave a detail & history of what he saw & heard; all that is necessary to prove now is, that other men, other sensible men, such as scarcely could be designated as mad or stupid, did see into an immaterial life denied to most— *A*ll that is proposed here, further, is, that it is a possible thing—that it does not require either a madman to see, or an Idiot to believe, that such things are. Blake asserted from a Boy that he did see them, even when a Child his mother beat him for running in & saying that he saw the Prophet Ezekiel under a Tree in the Fields. In this incredulous age it is requisite before this possibility is admitted, even as a doubt or question, that it should be said, that he who inefficiently attempts to defend this power, never has been accustomed to see them, although he has known others besides Blake, on whose veracity & sanity he could equally well rely, who have been thus favoured. The Cock lane Ghost story, the old womens tales, & the young bravo, who defies the Ghost in the Tap-Room, that he shudders at in his walk home, are foolishly mixed up with Blakes

[1] Swedenborg came, of course, from Sweden.

[2] Flaxman was never actually a member of the New Jerusalem Church, though he sympathized with most of their beliefs.

Visions: they are totally different: they are mental abstractions, that are not necessarily accompanied with fear, such as Ghosts & Apparitions, which either appear to be, or are, seen by the mortal Eyes which circumstance alone horrifies. These visions of Blake seem to have been more like peopled imaginations, & personified thoughts, they only horrified where they represented any scene in which horrors were depicted as a picture or a Poem. Richard Brothers has been classed as one possessing this power, but he was really a decided madman, he asserted that he was nephew to God the Father, & in a mad House he died as well indeed he might. Brothers is only classed with Swedenborg in order to ridicule Swedenborg, & bring him into Contempt. Blake & Brothers therefore must not be placed together.

Again in reference to the authenticity of Blakes Visions, let any one contemplate the designs in this Book;[1] Are they not only new in their method & manner; but actually new in their class & origin. Do they look like the localities of common circumstances, or of lower Worlds? The combinations are chimerical, the forms unusual, the Inventions abstract, the poem not only abstruse but absolutely according to common rules of criticism as near ridiculous, as it is completely heterogeneous. *W*ith all that is incomprehensible in the poem, with all that might by some be termed ridiculous in the plan, the designs are possessed of some of the most sublime Ideas, some of the most lofty thoughts, some of the most noble conceptions possible to the mind of man. You may doubt however the means, & you may criticise the peculiarity of the notions, but you cannot but admire nay 'wonder at with great admiration' these Expressive, these sublime, these awful diagrams of an Etherial Phantasy. Michael Angelo, Julio Romano or any other great man never surpassed Plates 25, 35, 37, 46 [*Plate LIV*], 51, 76, 94, and many of the stupendous & awful scenes with which this laborious Work is so thickly ornamented.

> 'Visions of glory spare my aching sight
> Ye unborn ages crowd not on my Soul.'

Even supposing the poetry to be the mere Vehicle or a mere alloy for the sake of producing or combining these wonderful thoughts it should at all events be looked upon with some respect.

But to return to the Biography. Blake continued to apply himself as heretofore, to the Art he so dearly loved & so implicitly followed. He removed to a House in Poland Street Oxford Street, where he lived some years. He then changed his residence to Hercules Buildings Lambeth, at which place, he wrote & designed, some of his largest & most important Works. It was here, that Flaxman used to come & see

[1] 'this Book' is the only coloured copy of *Jerusalem*.

PLATE LIV

Bath. mild Physician of Eternity. mysterious power.
Whose springs are unsearchable & knowledg infinite.
Hereford, ancient Guardian of Wales, whose hands
Builded the mountain palaces of Eden, stupendous works!
Lincoln, Durham &, Carlisle. Councellors of Los.
And Ely, Scribe of Los, whose pen no other hand
Dare touch: Oxford, immortal Bard, with eloquence
Divine, he wept over Albion: speaking the words of God
In mild perswasion: bringing leaves of the Tree of Life.

Thou art in Error Albion, the Land of Ulro:
One Error not removd, will destroy a human Soul,
Repose in Beulahs night, till the Error is removd
Reason not on both sides. Repose upon our bosoms
Till the Plow of Jehovah, and the Harrow of Shaddai
Have passed over the Dead, to awake the Dead to Judgment.
But Albion turnd away refusing comfort.

Oxford trembled while he spoke, then fainted in the arms
Of Norwich, Peterboro. Rochester. Chester awful. Worcester.
Litchfield. Saint Davids. Landaff. Asaph. Bangor. Sodor.
Bowing their heads devoted: and the Furnaces of Los
Began to rage. thundering loud the storms began to roar
Upon the Furnaces, and loud the Furnaces rebellow beneath

And these the Four in whom the twenty-four appeard four-fold:
Verulam. London. York. Edinburgh, mourning one towards another
Alas!——The time will come. when a mans worst enemies
Shall be those of his own house and family: in a Religion
Of Generation. to destroy by Sin and Atonement, happy Jerusalem,
The Bride and Wife of the Lamb. O God thou art Not an Avenger!

JERUSALEM (?1820) Pl. 46 (copy H), one of 'these Expressive, these sublime, these awful diagrams of Etherial Phantasy', which Tatham singled out for praise (p. 520)

him & sit drinking Tea in the Garden, under the shadow of a Grape Vine which M^{rs} Blake had very carefully trained. M^r and M^{rs} Flaxman were highly delighted with Blakes Arcadian Arbour, as well indeed they might, for they all sat with ripe fruit hanging in rich clusters around their heads.[1] These 2 great men had known each other from boyhood.[2] Flaxman was a cheerful lively young man, was very good company & sang beautifully, having an excellent & musical Voice[3] as well as almost all of the qualities requisite for good-fellowship & innocent convivial mirth— This House & garden was adjoining the Old Astleys Theatre[4] & an anecdote showing his courage, as well as his utter detestation of human slavery is too interesting & characteristic to remain untold. Blake was standing at one of his Windows, which looked into Astleys premises (the Man who established the Theatre still called by his name) & saw a Boy hobbling along with a log to his foot such an one as is put on a Horse or Ass to prevent their straying. Blake called his Wife & asked her for what reason that log could be placed upon the boys foot: she answered that it must be for a punishment, for some inadvertency. Blakes blood boiled & his indignation surpassed his forbearance, he sallied forth, & demanded in no very quiescent terms that the Boy should be loosed & that no Englishman should be subjected to those miseries, which he thought were inexcusable even towards a Slave. After having succeeded in obtaining the Boys release in some way or other he returned home. Astley by this time having heard of Blakes interference, came to his House & demanded in an equally peremptory manner, by what authority he dare come athwart his method of jurisdiction; to which Blake replied with such warmth, that blows were very nearly the consequence. The debate

[1] This story of the grapes is flatly contradicted by Gilchrist (1942, p. 85; 1863, p. 100): 'A lady, who as a girl used with her elders to call on the artist here, tells me Blake would on no account prune this vine, having a theory it was wrong and unnatural to prune vines: and the affranchised tree consequently bore a luxuriant crop of leaves, and plenty of infinitesimal grapes which never ripened.' I cannot reconcile these accounts except by supposing that they apply to different years. Gilchrist's informant was Maria Denman, of whom he said (1942, pp. 346, 307; 1863, pp. 354, 307): 'My own obligations to her appear in more than one page of this volume. As a girl she had seen and reverenced Blake, so long ago as when he was living in Hercules Buildings [1790–1800]. ... [She] observed to me with some emotion, "One remembers even in age the kindness of such a man." '

[2] J. T. Smith (p. 456) more plausibly says Flaxman met Blake about 1779.

[3] Palmer wrote to E. S. Roscoe ('The Career and Works of Flaxman,—II', *Magazine of Art*, iv [1881], 473) that Flaxman's 'voice was pleasant, William Blake told me that he had heard him sing some of the ancient melodies beautifully.'

[4] According to the rate books, Astley's theatre was perhaps a quarter mile from no. 13 Hercules Buildings, but Astley's own house was built in behind no. 11, in the next garden but one to Blake's. The story about the chained boy is therefore possible if, for 'adjoining the old Astley's Theatre', we read 'very near Astley's house'.

lasted long, but like all wise men whose anger is unavoidably raised, they ended in mutual forgiveness & mutual respect. Astley saw that his punishment was too degrading & admired Blake for his humane sensibility & Blake desisted from wrath when Astley was pacified: As this is an Example truly worthy of imitation, to all those whose anger is either excited by indignation or called forth by defence, it may not be out of place to say, if all quarrels were thus settled the time would shortly come, when the Lion would lie down with the Lamb & the little child would lead them. Blake resided in Hercules Buildings in a pretty clean House of 8 or 10 Rooms & at first kept a servant, but finding (as Mrs Blake declared & as every one else knows) the more service the more Inconvenience, she like all sensible women, who are possessed of industry & health & only moderate means, relinquished this incessant Tax upon domestic comfort,[1] did all the Work herself, kept the House clean, & herself tidy, besides printing all Blakes numerous Engravings, which was a Task alone sufficient for any industrious Woman, but however as there is no state, or scheme, or plan, without its accompanying Evil Blake had reason to regret his having left no one in possession of his House during his & Mrs Blakes absense for one day paying some friendly visit, some Thieves entered it & carried away Plate to the Value of 60 Pounds & clothes to the amount of 40 more.[2] Some persons may say had poor Blake ever in his whole life 60 pounds worth of Plate to lose? Had poor half starved Blake ever a suit of clothes beyond the tatters on his Back? Yes!!! he enjoyed in the early part of his life not only comforts but necessaries [*sic*]; & in the latter part of his life, be it said in vindication of a Divine Providence, that never forsakes the devout & excellent, he always possessed such external & substantial means of solace & happiness, that together with his own contented disposition, & Mrs Blakes excellent management, left him even in person, although far from gross, round & comfortable, & at one time nearly what may be called portly. By way of contradiction to the report of Blakes poverty, be it known that he could even find money enough to lend; for when a certain free thinking Speculator, the Author of many very elaborate Philosophical Treatises, said, that his children had not a dinner Blake lent him £40[,] nearly all he had at that time by him, & had the mortification upon calling upon him on the following Sunday, to find that his Wife, who was a dressy & what is called a pretty woman, had squandered some large portion of the money, upon her worthless sides. She had the audacity to ask Mrs Blakes opinion of a very gorgeous dress, purchased the day following Blakes compasionate gift, for there is little doubt so great a difficulty as the payment of

[1] Fuseli reported on June 24th, 1796 that the Blakes then had no servant.
[2] For a possible date, see Sept. 1795.

a debt, never was attempted by such careless ones as these:[1] Such people are a prey upon the assiduous & a heavy drag to the never failing industry of the active man, whose sagacity is wealth, whose energy is gain, & whose labours are ever blessed with the abundance they deserve. Industry & frugality accompany each other through lands fat with plenty & meadows fed with the streams of exuberance, they enjoy & praise[,] are satisfied & rejoice. Idleness & extravagance prowl through the deserts of want & where should it happen they find a repast, in unthankfulness & ignorance they gorge & gormandize. They then loiter during the interval of their sloth, until their wants have again returned, & their ungrateful entrails are demanding more. Emptiness is indeed their curse & repletion the utmost paradise of their vacant thoughts.

Another anecdote may be given to shew that Blake could not have suffered much from absolute want: About this time he taught Drawing & was engaged for that purpose by some families of high rank; which by the bye he could not have found very profitable, for after his lesson he got into conversation with his pupils, & was found so entertaining & pleasant, possessing such novel thoughts & such eccentric notions, together with such jocose hilarity & amiable demeanour, that he frequently found himself asked to stay dinner, & spend the Evening in the same interesting & lively manner, in which he had consumed the morning. Thus he stopped whole days from his work at home, but nevertheless he continued teaching, until a remarkable effort & kind flirt of fortune, brought this mode of livelihood to an inevitable close. He was recommended & nearly obtained an Appointment to teach Drawing to the Royal Family. Blake stood aghast; not indeed from any republican humours, not from any disaffection to his superiors, but because he would have been drawn into a class of Society, superior to his previous pursuits & habits; he would have been expected to have lived in comparative respectability, not to say splendour, a mode of

[1] It has been conjectured (M. Schorer, *William Blake*, N.Y., 1946, p. 173; D. V. Erdman, *Blake Prophet Against Empire*, Princeton, 1954, p. 146) that the philosopher could have been Godwin, and Erdman even isolates a possible date (Jan. 10th, 1819). The description of the borrower does seem aimed at Godwin, who was apparently ready at all times to borrow money from anybody, but the facts from Blake's side will scarcely fit. It is extremely unlikely that after 1809 Blake had £40 to lend, and, besides, after that time Mrs. Godwin could scarcely have been called 'a pretty woman'. It could not have been before 1803, for before 1800 Godwin did not have both wife and 'children' at the same time, and Blake was in Felpham from 1800 to September 1803. In 1803 Blake certainly felt independent financially, but, according to Cromek (see May 1807), by the end of 1805 Blake had been reduced to live on half a guinea a week. Tatham's story of Blake's fall from affluence may thus be dated about 1804–5. Godwin is a possible but unlikely participant in the events of the story.

life, as he thought, derogatory to the simplicity of his designs & deportment. *H*e had again, as about oil Painting, Michael Angelo on his side, who tho' rich, preferred living as a poor man the habits of whom it must be confessed are the most conducive & congenial to study & application[.]

His friends ridiculed & blamed him by turns but Blake found an Excuse by resigning all his other pupils,[1] & continued to suffice himself upon his frugality, to find plenty in what others have called want, & wealth in the efforts of his own mind. Another anecdote for the same purpose. His friend Hayley as will afterwards be more fully shewn begged him to take to painting miniatures which he could do & had before done so beautifully. He painted & he pleased, his connexion increased without much effort, & he obtained sufficient to occupy the whole of his time, but sighing after his fancies & visionary pursuits, he rebelled & fled 50 miles away[2] for refuge from the lace Caps & powdered Wigs of his priggish sitters, & resumed his quaint dreams & immeasurable phantasies[,] never more to forsake them for pelf & portraiture. A beautiful story may be related in which Blakes means as well as his sympathetic nature may be farther established. A young man passed his House daily whose avocations seemed to lead him backward & forward to some place of study, carrying a Portfolio under his Arm. He looked interesting & eager, but sickly. *A*fter some time Blake sent Mʳˢ Blake to call the young man in; he came & he told them, that he was studying the Arts. Blake from this took a high interest in him & gave him every instruction possible, but alas! there was a worm lying at the root, whose bite, however, Blake was raised up to assuage.

[1] The only other reference to such an incident as is detailed in this paragraph is given by Gilchrist (1942, p. 140; 1880, pp. 161–2—not in 1863): 'He [*Blake*] was wont to say he had refused but one commission in his life—to paint a set of hand-screens for a lady of quality, one of the great people to whom Hayley had introduced him; *that* he declined! For Lady Bathurst it was, I think. . . . Blake taught for a time in her family, and was admired by them. The proposal was, I believe, that he should be engaged at a regular annual salary for tuition and services such as the above; as painter in ordinary, in fact, to this noble family.' Lady Bathurst is presumably Tryphena (d. 1807), the widow of Henry Bathurst, the Lord Chancellor. She might well have recommended Blake to the King. Gilchrist, however, presents elsewhere (1942, p. 257; 1863, p. 244) a less complimentary reason for Blake's escape from royal patronage. ' "Take them away! take them away!" was the testy mandate of disquieted Royalty, on some drawings of Blake's being once shown to George the Third.'

Another difficulty with Tatham's story is that Blake's best-known pupils, Tommy Butts and William Seguier, were being taught after this Felpham anecdote. In fact, all the details of noble patronage seem improbable.

[2] i.e. from Felpham to London. Blake's gradual disillusionment with miniature painting was obviously only one of many reasons for his retreat to London. And, of course, he abandoned neither his visions at Felpham nor miniature painting in London. His miniature of Mrs. Butts (now in the B.M.) is dated 1809.

*T*he young man shortly after fell sick, & was laid upon his bed, his illness was long & his suffereings were great during which time, M̠ᶳ Blake or Blake never omitted visiting him daily & administering medicine, money, or Wine & every other requisite until death relieved their adopted of all earthly care & pain. Every attention, every parental tenderness, was exhibited by the charitable pair.[1] Blake could not therefore have been poor or at all events he could not possibly be in starvation, to have been able to have rendered such timely & such benevolent assistance to others. Besides it is a fact known to the writer that M̠ᶳ Blakes frugality always kept a guinea or sovereign for any Emergency, of which Blake never knew, even to the day of his Death. *T*his she did for years, & when a man has always got a Sovereign in his pocket & owes nothing he is in this land of Debt decidedly otherwise than poor.

Through the medium of Flaxman he was introduced to Hayley, who being much interested, requested him to come down to Felpham, in Sussex to a Cottage near his residence to Engrave plates from his Poems & also to assist him in gathering his materials for the life of Cowper afterwards published. During his stay of 3 Years he was thus occupied & also in making life sized Circular Portraits of all the great Poets for the library of Felpham House;[2] but in consequence of Hayleys acquaintances being so desirous to possess miniatures by him (as before mentioned) he left for N̠ᵒ 3 Fountain Court[3] (a House belonging to his Wifes brother) the lodging in which he lived during the whole of his latter days, & in which he died. Blake had in this House 2 good sized rooms & Kitchens. He fixed upon these lodgings as being more congenial to his habits, as he was very much accustomed to get out of his bed in the night to write for hours, & return to bed for the rest of the night, after having committed to paper pages & pages of his mysterious Phantasies. He wrote much & often & he sometimes thought that if he wrote less, he must necessarily do more graving & painting & he has debarred himself of his pen for a month or more, but upon comparison has found by no means so much work accomplished & the little that was done by no means so vigorous.

He was a subject of much temptation & mental suffering & required sometimes much soothing— He has frequently had recourse to the

[1] No detail reveals the date at which this may have taken place, but the chronology seems to suggest a time after 1803.

[2] Blake's eighteen heads for Hayley's Marine Turret (now in the Art Gallery, Manchester) are of varying sizes, mostly less than life size.

[3] Blake moved in 1803 into 17 South Molton Street, and stayed there until 1821, when he moved to 3 Fountain Court, Strand. See Linnell's letter of April 3rd, 1830: 'it was a private House kept by M̠ʳ Banes whose wife was sister to M̠ᶳ Blake'. See Residences, p. 564.

following stratagem to calm the turbulence of his thoughts. His wife being to him a very patient Woman, he fancied, that while she looked on at him, as he worked, her sitting quite still by her [*i.e. his*] side, doing nothing, soothed his impetuous mind, & he has many a time when a strong desire presented itself to overcome any difficulty in his Plates or Drawings, has in the middle of the night risen, & requested her to get up with him & sit by his side, in which she as cheerfully acquiesced.[1]

When roused or annoyed he was possessed of a Violent Temper, but in his Passions there was some method, for while he was engraving a large Portrait of Lavater,[2] not being able to obtain what he wanted, he threw the plate completely across the Room. Upon his relating this he was asked whether he did not injure it, to which he replied with his usual fun 'O I took good care of that'. He was a subject often of much internal perturbation & over anxiety, for he has spoilt as much work (which every Artist knows is not only easy but common) by over-labour, as would take some a whole life of ordinary industry to accomplish. Mʳˢ Blake has been heard to say that she never saw him except when in conversation or reading; with his hands idle, he scarcely ever mused upon what he had done. *S*ome men muse & call it thinking, but Blake was a hard worker, his thought was only for action, as a man plans a House, or a General, consults his Map, & arranges his forces for a Battle. His mental acquirements were incredible, he had read almost every thing in whatsoever language, which language he always taught himself.[3] *H*is conversation therefore was highly interesting & never could one converse on any subject with him, but they would gain something quite as new, as noble from his eccentric & Elastic mind. It is a remarkable fact, that among the Volumes bequeathed by Mʳˢ

[1] Tatham expressed this in slightly different words to Gilchrist (1942, p. 315; 1863, p. 317): ' "Having never been a mother," says the same cordially appreciative friend, who saw much of her in later years, and whose words I have already often borrowed, "to this devoted wife Blake was at once lover, husband, child. She would get up in the night, when he was under his very fierce inspirations, which were as if they would tear him asunder, while he was yielding himself to the Muse, or whatever else it could be called, sketching and writing. And so terrible a task did this seem to be, that she had to sit motionless and silent; only to stay him mentally, without moving hand or foot: this for hours, and night after night. Judge of the obedient, unassuming devotion of her dear soul to him!" '

[2] Blake's engraving of Lavater is dated May 1st, 1800.

[3] Blake was taught Latin, Greek, and Hebrew by Hayley, according to Blake's letter of Jan. 30th, 1803, though he had a smattering of Hebrew before. (There is Hebrew lettering on one of the 1796 *Night Thoughts* drawings, no. 435 of the series now in the B.M.) He quotes Voltaire in French about 1808 in his Reynolds marginalia, and he taught himself Italian about 1824. There is no evidence that he knew any other language—though delightful attempts have been made to prove that his native tongue was Gaelic.

Blake to the Author of this Sketch, the most thumbed from use are his Bible & those books in other languages. He was very fond of Ovid, especially the Fasti. He read Dante when he was past 60, altho' before he never knew a word of Italian & he drew from it a hundred such designs, as have never been done by any Englishman at any period or by any foreigner since the 15ᵗʰ Century, & then his only competitor was Michael Angelo.

It now becomes from the brevity of the present manuscript the painful duty of the Biographer to traverse to the period, to which Blake's own lines are immediately applicable. His pilgrimage was nearly at an End & of such he thus spake:

> 'But when once I did descry,'
> 'The Immortal man that cannot die',
> 'Thro evening shades I haste away'
> 'To close the labours of my day.'[1]

It has been supposed his Excessive labour, without the exercise he used formerly to take, (having relinquished the habit of taking very long Walks) brought on the complaint which afterwards consumed him. In his youth he and his Wife would start in the Morning early, & walk out 20 miles & dine at some pretty & sequestered Inn & would return the same day home having travelled 40 miles. Mʳˢ Blake would do this without excessive fatigue. Blake has been known to walk 50 Miles in the day, but being told by some Physician, that such long walks were injurious, he discontinued them, & went so far to the other extreme, that it has been said he remained in the House, so long that [*it*] was considered far from extraordinary his days were shortened. About a year before he died he was seized with a species of Ague, (as it was then termed[)], of which he was alternately better & worse. *H*e was at times very ill but rallied & all had hopes of him, indeed such was his energy that even then, tho' sometimes confined to his Bed, he sat up Drawing his most stupendous Works. In August he gradually grew worse & required much more of his Wife's attention, indeed he was decaying fast; his patience during his agonies of pain is described to have been exemplary.

Life however like a dying flame flashed once more, gave one more burst of animation, during which he was cheerful, & free from the tortures of his approaching end. *H*e thought he was better, and as he was sure to do, asked to look at the Work over which he was occupied when seized with his last attack: it was a coloured print of the Ancient of Days, striking the first circle of the Earth, done expressly by commission for the writer of this. After he had worked upon it he

[1] From *For the Sexes: The Gates of Paradise*.

exclaimed 'There I have done all I can[;] it is the best I have ever finished[.] I hope Mᴿ Tatham will like it.['] He threw it suddenly down & said["]Kate you have been a good Wife, I will draw your portrait.['] She sat near his Bed & he made a Drawing, which though not a like-ness is finely touched & expressed. He then threw that down, after having drawn for an hour & began to sing Hallelujahs & songs of joy & Triumph which Mᴿˢ Blake described as being truly sublime in music & in Verse. He sang loudly & with true extatic energy and seemed too happy that he had finished his course, that he had ran his race, & that he was shortly to arrive at the Goal, to receive the prize of his high & eternal calling. After having answered a few questions concerning his Wifes means of living after his decease, & after having spoken of the writer of this, as a likely person to become the manager of her affairs, his spirit departed like the sighing of a gentle breeze, & he slept in company with the mighty ancestors he had formerly depicted. He passed from Death to an Immortal life on the 12ᵗʰ of August 1827 being in his 69ᵗʰ Year.[1] Such was the Entertainment of the last hour of his life[.] His bursts of gladness made the room peal again. The Walls rang & resounded with the beatific Symphony. It was a prelude to the Hymns of Saints. It was an overture to the Choir of Heaven. It was a chaunt for the response of Angels.

No taught hymns, no psalms got by rote from any hypocritical Sty of Cant, no sickly sanctified Buffoonery; but the pure & clear stream of divine fervour, Enlivened by firm faith & unrelenting hope. 'By the rivers he had sat down & wept[;] he had hung his Harp upon the Willow: for how should he sing the Lords Song in a Strange land.'[2] But he is now on the borders of his promise, he is tuning his strings[,] he is waking up his Lyre. He is lifting up the throat as the lark in the clouds of morn. He is rising[,] he is on the Wing, Sing ye Sons of Morning for the Vapours of Night are flown, & the dews of Darkness are passed away.

'There entertain him all the Saints above'
'In solemn troops & sweet societies'
'That sing & singing in their glory move'
'And wipe the tears for ever from his Eyes.'

He was buried on the 17ᵗʰ & was followed to the grave by Mᴿ Calvert of Brixton Painter & Engraver, Mᴿ Richmond Painter, the writer of this & his Brother a Clergyman.[3] He was interred in Bunhill Fields. His complaint turned out to be the Gall mixing with the Blood.

[1] Blake died in his 70th year. [2] Psalm cxxxvi. 1–4, roughly paraphrased.
[3] Mrs. Blake apparently was at the burial also; see below. Tatham's brother Arthur (1809–74) was not ordained until 1832. In Aug. 1827 he was only 18,

William Blake, in stature was short, but well made, & very well proportioned, so much so that West, the great History Painter, admired much the form of his limbs. He had a large head & wide shoulders. Elasticity & promptitude of action were the characteristics of his Contour. His motions were rapid & energetic, betokening a mind filled with elevated Enthusiasm. His forehead was very high & prominent over the Frontals. His Eye most unusually large & glassy, with which he appeared to look into some other World. The best & only likeness of this glowing feature, that can be produced, is Shakespeare's description of the Eye of the Inspired Poet, in his midsummer nights Dream

> 'The Poets Eye with a fine frenzy rolling,'
> Doth glance from Heaven to Earth, from Earth to Heaven:
> And as Imagination bodies forth,
> The forms of things unknown, the poets pen
> Turns them to shapes, & gives to airy nothing,
> A local habitation & a Name.'

In youth he surprized every one with his Vigour & activity. In age he impressed all with his unfading ardour & unabated Energy. His beautiful grey locks, hung upon his Shoulders; & dressing as he always did in latter years, in Black, he looked even in person, although, without any effort towards Eccentricity, to be of no ordinary character. In Youth he was nimble, in old age Venerable. His disposition was cheerful & lively, & was never depressed by any cares, but those springing out of his Art. He was the attached friend of all who knew him & a favourite with every one but those who oppressed him & against such his noble & impetuous Spirit boiled & fell upon the aggressor like a Water spout from the troubled deep. Yet like Moses he was one of the meekest of Men, his patience was almost incredible, he could be the Lamb; he could plod as a Camel, he could roar as a Lion. He was every thing but subtle, the serpent had no share in his nature. Secresy was unknown to him. He would relate those things of himself that others make it their utmost endeavour to conceal. He was possessed of a peculiar obstinacy that always bristled up when he was either unnecessarily opposed or invited out to show like a lion or a bear. Many anecdotes could be related in which there is sufficient evidence to prove, that many of his Eccentric speeches, were thrown forth more as a piece of sarcasm, upon the Enquirer, than from his real opinion. If he thought a question were put merely from a desire to learn, no man could give advice more seasonably & more kindly but if that same question were

having been admitted at Magdalene College, Cambridge, some four months previously. J. T. Smith (p. 476) remarks that Tatham, though ill, travelled ninety miles to attend the funeral. He is also apparently the source of Tatham's diagnosis.

put for idle Curiosity, he retaliated by such an Eccentric answer, as left the Enquirer more afield than Ever. He then made an Enigma of a plain question. Hence arose many vague reports of his oddities. He was particularly so upon religion. His writings abounded with these sallies of independant opinion. *H*e detested priestcraft & religious Cant. He wrote much upon controversial subjects, & like all controversies these writings are inspired by doubt & made up of vain conceits & whimsical Extravagancies. A bad cause requires a long Book. Generally advocating one in which there is a flaw, the greatest controversialists are the greatest doubters. They are trembling needles between extreme points— Irritated by hypocrisy & the unequivocal yielding of weak & interested men, he said & wrote unwarrantable arguments, but unalloyed & unencumbered by opposition, he was in all essential points orthodox in his belief,[1] but he put forth ramifications of doubt, that by his vigorous & creative mind, were watered into the empty enormities of Extravagant & rebellious thoughts.

He was intimate with a great many of the most learned & eminent men of his time, whom he generally met at Johnsons, the Bookseller of S! Pauls Church Yard[.] It was there he met Tom Paine & was the cause of his Escaping to America, when the Government were seeking for him, for the punishment of his seditious & refractory writings. Blake advised him immediately to fly, for he said 'if you are not now sought I am sure you soon will be.' Paine took the hint directly, & found he had just escaped in time.[2] In one of their conversations, Paine

[1] It is difficult to know what Tatham, who later became an Irvingite and burnt Blake's works in an excess of piety, may have meant by orthodoxy.

[2] Gilchrist (1942, pp. 81–82; 1863, p. 95) later amplified and corrected this story, perhaps on the authority of Tatham: 'One day in this same month [*of September in which he was to be tried*], Paine was giving at Johnson's an idea of the inflammatory eloquence he had poured forth at a public meeting of the previous night. Blake, who was present, silently inferred from the tenor of his report that those in power, now eager to lay hold of noxious persons, would certainly not let slip such an opportunity. On Paine's rising to leave, Blake laid his hands on the orator's shoulder, saying, "You must not go home, or you are a dead man!" and hurried him off on his way to France, whither he was now in any case bound, to take his seat as a French legislator. By the time Paine was at Dover, the officers were in his house . . . and some twenty minutes after the Custom House officials at Dover had turned over his slender baggage with, as he thought, extra malice, and he had set sail for Calais, an order was received from the Home Office to detain him. England never saw Tom Paine again.'

While he waited for his trial, Paine moved freely among Blake's friends. According to the *Morning Chronicle*, Romney was painting his portrait on June 11th (A. O. Aldridge, *Man of Reason*, Philadelphia and N.Y., 1959, p. 164), and on May 29th Fuseli had written about the mechanical help Paine had been giving him and Sharp. In early September Paine was elected a member for Calais, and M. Audibert came to London to escort him back to France with fitting formality. Therefore Blake, his friends, and the government must have known of Paine's imminent departure. On

said that religion was a law & a tye to all able minds. Blake on the other hand said what he was always asserting, that the religion of Jesus, was a perfect law of Liberty: Fuseli was very intimate with Blake & Blake was more fond of Fuseli, than any other man on Earth: Blake certainly loved him, & at least Fuseli admired Blake & learned from him as he himself confessed, a great deal. Fuseli & Flaxman both said, that Blake was the greatest man in the Country & that there would come a time when his works would be invaluable.[1] Before Fuseli knew Blake he used to fill his Pictures with all sorts of fashionable ornaments & tawdry Embellishments. Blake's simplicity imbued the minds of all who knew him. *H*is life was a pattern, & has been spoken of as such from the Pulpit. *H*is abstraction from the World, his powers of sel denial, his detestation of hypocrisy & gain, his hatred of Gold & the things that perish, rendered him indeed well able to have exclaimed,

'In innocency I have washed my hands[.]'[2]

His poetry (& he has written a great deal) was mostly unintelligible, but not so much so as the Works written in the manner of this present one. Generally speaking, he seems to have published those [*which were*] most mysterious.[3] That which could be discerned was filled [*with*] Imagery & fine Epithet. What but admiration can be expressed of such Poetry as this[:]

London
'I wander thro' each chartered Street,
'Near where the winding Thames[4] does flow,
'And mark in every face I meet,
'Marks of weakness, marks of woe.

Sept. 12th Paine went to Dover—and was kept under surveillance all the way by government agents (Aldridge, p. 167). On the 13th J. Mason, who was not sympathetic to Paine, wrote a letter describing the tedious indignities Paine had received at the hands of the customs officers (Historical Manuscripts Commission, *The Manuscripts of J. B. Fortescue, Esq.*, London, 1894, vol. ii, pp. 316–17). The anti-climactic arrival of the order from the Home Office twenty minutes late does not appear in the contemporary accounts, though it is found in Gilchrist's early source (J. Cheetham, *The Life of Thomas Paine*, London, 1817, p. 85).

It therefore seems likely enough that Blake was seeing Paine during the summer of 1792; that he and other friends urged Paine not to delay his departure; that Paine's departure was well known and not hasty; and that the government was not frustrated but relieved when he was gone. The melodramatic hairbreadth escape, so dear to all Paine's biographers and so enthusiastically adapted by Gilchrist, is probably apocryphal. (The account of the incident given by D. V. Erdman [*Blake Prophet Against Empire*, Princeton, 1954, pp. 140–1] is, as usual, trenchant and perspicuous.)

[1] J. T. Smith (p. 467) says almost the same thing, and it is difficult to know whether one was quoting the other (it could have gone either way), or whether they are independent witnesses.

[2] Psalm xxvi. 6: 'I will wash mine hands in innocency'.

[3] This seems to suggest that the works Tatham destroyed offended by their explicitness. [4] 'charter'd Thames', from *Songs of Experience*.

2

'In every cry of every man,
 'In every infants cry of fear,
'In every voice of every ban,[1]
 'The mind Forged Manacles I hear.

3

'How the chimney sweepers cry,
 'Every blackening church appals,
'And the hapless soldiers sigh
 'Runs in blood down palace Walls;

4

But most through midnight streets I hear,
 How the youthful Harlots curse,
Blasts the new born infants tear:
 And blights with plagues the marriage hearse.

The Tiger [*see pp. 430–1*]. . . .

A beautiful Stanza selected from the following Work
— — — — —

The Rhine was red with human blood,
 The Danube rolled in purple tide,[2]
O'er the Euphrates[3] Satan stood,
 And over Asia stretched his pride.

— — — — —

Another[4]
— —

For a tear is an Intellectual thing
And a sigh is the sword of an Angel King
And the bitter groan of a martyrs woe
Is an Arrow from the Almighty's Bow[.]

It may well be said of such poetry as this[,] such thrilling lines as these
that they are 'Thoughts that breathe & words that burn'[.] There is
another very tender—

The Lamb. . . .[5]

There is another in which is beautifully related the tender &
exquisite circumstance of a mother looking on her Sleeping Infant
which he calls a cradle Song. . . .[6]

[1] 'in every ban'. [2] 'a purple tide', from Plate 27 of *Jerusalem*.
[3] 'On the Euphrates'. [4] From *Jerusalem*, Plate 52.
[5] 'The Lamb' from *Songs of Innocence* is given accurately (not as in Cunningham,
p. 505), except for l. 6, 'bright' for 'light'.
[6] Tatham prints only the last three of eight stanzas of 'A Cradle Song' from
Songs of Innocence (see March 1830).

These quotations are from the Songs of Innocence & Experience Engraved on Type plates which work the Author of this is now in possession of by the kindness of M^{rs} Blake who bequeathed them to him as well as all of his Works that remained unsold at his [*i.e. her*] Death being writings, paintings, & a very great number of Copper Plates, of whom Impressions may be obtained.

<div align="right">Frederick Tatham</div>

Catherine Blake the buttress of her husbands hopes, the stay to his thoughts[,] the admirer of his genius[,] the Companion of his Solitude & the solace of his days was now left without the protecting hand of the most affectionate of husbands. She grieved much but she had a hopeful & a trustful mind in the providence of her maker.— She endured with almost unexampled fortitude this afflicting dispensation of Almighty Power. No children to soothe, scarcely a relation to console, no one with whom she had ever been accustomed to assimilate, she thus stood with every outward mark of Widowhood— Her heaviness was great and her trial excessive, but she was indeed a Tower standing in a desert plain. She had in the Cellars of her Faith an Army of Courageous defenders, who had she been ever so encamped against, should, must, & would, have prevailed, through him who is of the widow the protector & to the fatherless a friend.

Always like a true Wife leaning on her husband for advice & for all spiritual strength, her shaft broken & her prop dismembered, she had been forlorn, she had been withered, she had drooped, nay she had fallen, but for the gourd of her faithful Saviour & her pitiful Redeemer.

So let it tell against the day of fear, so let it tell against the hour of bereavement that your Saviour holds the Salver for your tender Tears.

Hear this o Wife cherishing your sickly partner, dreading the hour of Separation & division. Hear this ye Children, looking at your only parent sinking into dust. God is a husband to the widow & a father to those whose parents are departed to his heavenly bosom. A Cry is heard[,] a voice of joy is sounding in the Streets[.] The bereaved widow has found an Husband & the fatherless family a trustworthy friend. Touch not their little ones[,] trample not upon their borders, break not down their hedges for their friend is a strong foe & their defender a Mighty man[.]

She suffered the remains of her dear husband to leave the House & went through the awful day of seperation, with a fortitude nearly unprecedented, & a courage by no means to be expected. She who afterwards fretted herself, pining like Rachel for her little ones, into a grave ere long to be inhabited, by that Temple of obedience, those hands of unwearied labour & those limbs of constant Exercise; set out herself

the refreshments of the Funeral, saw with her own Eye the last offices of Concealment & parted with him with a smile.

The widow loosing her husband so constantly in her company, so continually by her side, was no common circumstance in her days. She who during a marriage of more than 40 Years[1] never parted with him, save for a period that would make altogether about 5 Weeks,[2] who soothed & in return was cherished, who waited upon & in return was protected, found this trial too great to be endured as a trivial Calamity —it consumed her body although she maintained her mind. Such a husband as he, was a treasure that sweeping the House with the utmost industry would not again restore. It was hidden—it was lost— until it shall be again found set in a precious & Eternal ore to be worn upon the fair neck of a descending Church, bedecked & jewelled for her wedding with the Lamb.

Such was she at his Death & however needless this History may render it to enquire what she was during his life, it is now a pleasure to record the intrinsic worth of such a Character. Was she a woman dressed in all the frippery of fashion? *No.* *S*he was clean but in the plainest attire. *W*as she an idle drab that brings naught but ruin & disgrace? No! nor was she the medium between all these things. She was the hard working burden bearer to her industrious husband. She fetched with a free will & brought with the spirit of a Willing mind the materials with which he was to build up the fabric of his Immortal Thoughts.

She even laboured upon his Works[,] those parts of them where powers of Drawing & form were not necessary, which from her excellent Idea of Colouring, was of no small use in the completion of his labourious designs. This she did to a much greater extent than is usually credited.

After the death of her husband she resided for some time with the Author of this,[3] whose domestic arrangements were entirely undertaken by her; until such changes took place that rendered it impossible for her strength to continue in this voluntary office of sincere affection & regard.

She then returned to the lodging in which she had lived previously to this act of maternal loveliness[4]—in which she continued until she

[1] Blake was buried the day before their 45th wedding anniversary.

[2] The only times Blake is known to have been separated from his wife were when he went alone to Felpham in July 1800 and January 1804, a total of about a fortnight. The other three weeks presumably are to be made up of overnight absences.

[3] For the first few months Catherine lived as a housekeeper with the Linnells; see Sept. 11th, 1827.

[4] According to Gilchrist (1942, p. 355; 1863, p. 365): 'she remained some nine months [*with Linnell*]; quitting, in the summer of 1828, to take charge of Mr.

was decayed by fretting & devoured with the silent Worm of grief, which, not from any distrust of the providence of her heavenly protector, but from that pathetic clinging to the stem of her existence, wasted her, & she withered only from holding fast to those dead branches which were her former life & shadow. Ever since his death her stomach had proved restless & painful, & on the morning of the 17th of October last, she was attacked with Cramps & Spasms & after having exhibited great patience & endured great pain for 24 hours, on the following Morning at 1/2 past 7 OC. being the 18th of Octr 1831, she yielded up the Ghost, having survived her husband only 4 Years. Her age not being known but by calculation, 65 Years were placed upon her Coffin[.]—

She was buried according to her own directions at Bunhill Fields with the same Funeral decorations as her husband which also was her desire, & was followed to her grave by 2 whom she dearly loved, nay almost idolized, whose welfare was interwoven with the chords of her life & whose well being was her only solace, her only motive for exertion & her only joy. The news of any success to them was a ray of Sun in the dark twilight of her life. Their cares were hers, their sorrows were her own. To them she was as the fondest mother, as the most affectionate Sister & as the best of friends[;] these had the satisfaction of putting into her trembling hands the last cup of moisture she applied to her dying lips & to them she bequeathed her all—but as the affectionate Remembrances would call forth as many pages as can now be afforded in Words Some future & more lengthened praises must exhibit that gratitude which nothing but a whole Book could expatiate.

Four other friends being Mr Bird Painter Mr Denham Sculptor Mr & Mrs Richmond followed with them the remains of this irradiated Saint.

<div style="text-align: right">

Frederick Tatham
Sculptor
Lisson Grove North—
London

</div>

F

HENRY CRABB ROBINSON

(from 'Reminiscences', 1852)

Crabb Robinson's 'Reminiscences' are a revised version of his Diary (see April 19th, 1810), which was written contemporaneously with the events

Tatham's chambers. Finally, she removed into humble lodgings at No. 17, Upper Charlotte Street, Fitzroy Square, in which she continued till her death; still under the wing, as it were, of this last-named friend.' This is apparently a mistake for Charlton Street; see Residences, pp. 567–8.

it describes. The 'Reminiscences' were composed in February and March of 1852, and the dates of composition—e.g. ⁶19–2.52' for February 19th, 1852—are entered between some of the paragraphs.

The 'Reminiscences' are not very different from the Diary in many respects, though there are many differences of nuance which make them valuable. Occasionally passages were added that do not appear in the Diary, such as the portraits of Milton with which Robinson wanted Blake to compare his visions, and sometimes an anecdote is omitted, but generally the same incidents are described in very similar words. Consequently most of the annotation required will be found under the dates of the original Diary entries.

WILLIAM BLAKE

———

19–2.52.

It was at the latter end of the year 1825 that I put in writing my recollections of this remarkable man[.]— The larger portion are under the date of the 10ᵗʰ of Decʳ[.]— He died in the year 1827. I have therefore now revised what I wrote on the 10ᵗʰ of Decʳ and afterwards— And without any attempt to reduce to order, or make consistent the wild & strange strange rhapsodies utterd by this insane man of genius, thinking it better to put down what I find as it occurs—tho' I am aware of the objection that may justly be made to the recording the ravings of insanity in which it may be said there can be found no principle, as there is no ascertainable law of mental association which is obeyed; and from which therefore nothing can be learned[.]—

This would be perfectly true of *mere* madness—but does not apply to that form of insanity or lunacy called Monomania and may be disregarded in a case like the present in which the subject of the remark —was unquestionably what a German wd. call a *Verüngluckter Genie*— whose theosophic dreams bear a close resemblance to those of *Swedenborg*—: whose genius as an artist was praised by no less men than *Flaxman* & *Fuseli*—And whose poems were thought worthy republication by the biographer of *Swedenborg Wilkinson* And of which Wordsworth said after reading a number—They were the 'Songs of [Ignorance *del*] Innocence & Experience—Shewing the two opposite states of the Human Soul'[—] ['']There is no doubt this poor man was mad, but there is something in the madness of this man which interests me more than the Sanity of Lord Byron & Walter Scott!['']— The German painter *Gotzenberger* (a man indeed who ought not to be named *after the others* as an authority for my writing about Blake) said on his returning to Germany about the time at which I am now arrived—'I saw in England many men of talents, but only three men of Genius Coleridge, Flaxman & Blake—And of these, Blake was the greatest[.']— I do not mean to intimate my assent to this opinion—Nor to

do more than supply such materials as my intercourse with him
furnishes to an uncritical narrative to which I shall confine myself[.]—
I have written a few Sentences in these reminis[*cen*]ces already—
Those of the year 1810[;]—I had not then begun the regular journal
which I afterwards kept[.]— I will therefore go over the ground again
and introduce these recollections of 1825 by a reference to the slight
knowledge I had of him before And what occasioned my taking an
interest in him[,] not caring to repeat what Cunningham has recorded
of him in the Volume of his Lives of the British Painters &c &c Except
thus much[:] It appears that he was born [.] D.̲ *Malkin* our
Burry Grammar School Head Master published in the year 1806 a
memoir of a very precocious child who died Years old[,] And he
prefixed to the Memoir an engraving of a portrait of him by Blake
And in the Vol: he gave an account of Blake as a painter & poet and
printed some specimens of his poems—Viz 'The Tiger', And ballads
and mystical lyrical poems—All of a wild character—And M gave an
account of Visions which Blake related to his acquaintance[.]—[On
my being acquainted with Flaxman I found *del*] I knew that Fl: thought
highly of him and tho' he did not venture to extol him as a genuine
Seer—Yet he did not join in the ordinary derision of him as a mad-
man[.]— Without having seen him, Yet I had already conceived a high
opinion of him And thought he would furnish matter for a paper
interesting to Germans—And therefore when Fred: Perthes the
patriotic publisher at Hamburg wrote to me in 1810 requesting me to
give him an article for his Patriotische Annalen I thought I cd do no
better than send him a paper on Blake, which was transl.ᵈ into German
by D.ͬ *Julius* filling[,] with a few small poems copied & translated[,]
24 pages[.]— These appeared in the first & last N.̣ of Vol: 2.ᵈ of the
Annals[.]— In order to enable me to write this paper, which by the
bye, has nothing in it of the least value—I went to see an exhibition
of Blake's Original paintings at a Hosiers in Carnaby Market[,]
Blake's brother[.] These paintings filled several rooms of an ordinary
dwelling house And for the Sight a half crown was demanded of the
Visitor for which he had also a Catalogue[.]— This catalogue I possess
And it is a very curious exposure of the state of the artists mind[.]—
I wished to send it to Germany and to give a copy to Lamb & others—
So I took four & giving 10/ bargained that I should be at liberty to
go again[.]—'Free! As long as you [like *del*] live' said the brother—
astonished at such a liberality, which he had never experienced before
nor I dare say did afterwards[.]— *Lamb* was delighted with the
Catalogue—especially with the description of a painting afterwards
engraved—And connected with which is an anecdote that [alone *del*]
unexplained would reflect discredit on a most amiable & excellent
man but which Flaxman considered to have been not the wilful act of

Stodart [i.e. Stothard.]— It was after the friends of Blake had circulated
a subscription paper for an engraving of his *Canterbury* Pilgrim's that
Stodart was made a party to an engraving of a painting of the same
subject by himself[.] Stoddarts work is well Known—Blake's is known
by very few[.]— Lamb preferred it greatly to Stoddart's and declared
that Blakes description was the finest criticism he had ever read of
Chaucer's poem[.]—

In this Catalogue Blake writes of himself in the most outrageous
language—Says 'This Artist defies all competition in colouring'—
That none can beat him, for none can beat the Holy Ghost—That he
& Raphael & Michael Angelo were under divine influence—while
Corregio & Titian worshipped a lascivious and therefore cruel devil—
Reubens a proud [& cruel *del*] devil &c[.] He declared speaking of
Colour Titians men to be of leather & his [wife *del*] women of chalk
—And ascribed his own perfection in colouring to the advantage he
enjoyed in seeing daily the primitive men walking in their native
nakedness in the mountains of Wales[.]— There were about 30 Oil
paintings [*i.e.* 16 *drawings and paintings*]—The colouring excessively
dark & high[,] The veins black and the [male *del*] colour [of the primi-
tive men *del*] very like that of the red Indians [.] In his estimation they
would probably be the primitive men[.]— Many of his designs were
unconscious imitations[.] This appears also in his published works—
The designs to *Blair's Grave*, which Fuseli and Schiavonetti highly
extolled—And in his designs to illustrate *Job* published after his death
for the benefit of his Widow[.]

23, 2. 52

To this Catalogue And to the printed poems, the small pamphlet
which appeared in 1783—The edition put forth [*in 1839*] by Wilkinson
of 'The Songs of Innocence'[,] other works &c already mentioned,
to which I have to add the first four books of Youngs Night Thoughts,
And Allan Cumberland's [*i.e. Cunningham's*] Life of him[,] I now refer
and will confine myself to the memorandums I took of his conversa-
tion[.]— I had heard of him from [the *del*] Flaxman and for the first
time dined in his company at the aders', *Linnel* the painter was there
also—an artist of considerable talent, And who [took *del*] professed to
take a deep interest in Blake, and his works[,] whether of a perfectly
disinterested character may be doubtful, as will hereafter appear[.]—
This was on the 10th of December[.]— I was aware of his idiosyncracies
And therefore to a great degree prepared for the sort of conversation
which took place at and after dinner[,] an altogether unmethodical
rhapsody on art, religion—He Saying the most strange things in
the most unemphatic manner, speaking of his *visions* as any man would
of the most ordinary occurrence[.] He was then 68 Years of Age[.]

He had a broad pale face[,] a large full eye with a benignant expression
—[with an air of feebleness *del*] at the same time a look of languor ex-
cept when excited[,] and then he had an air of inspiration—But not
such, as without a previous acquaintance with him, or attending to *what*
he said, would suggest the notion that he was insane. There was no-
thing *wild* about his look—And tho' very ready to be drawn out to the
assertion of his favorite ideas, Yet with no warmth as if he wanted to
make proselytes—Indeed one of the peculiar features of his scheme as
far as it was consistent, was indifference And [the entire absence of any-
thing like (blame *del*) reproach—and I do not recollect that I ever
heard him blame anything then or afterwards *all del*] a very extra-
ordinary degree of tolerance and satisfaction with what had taken place
[—]A sort of pious & & [*sic*] humble Optimism—not the scornful
Optimism of Candide[.]— But at the same time that he was very ready
to praise he seemed incapable of envy, as he was of discontent[.]— He
warmly praised some composition of M^rs Aders And having brought for
A an Engraving of his Canterbury Pilgrims he remarked that one of the
figures resembled a figure in one of the works then in Aders' room—So
that he had been accused of having stolen from it[.]— But he added—
That he had drawn the figure in question 20 Years before he had seen
the *original* [of that *del*] picture[.]— However, there is 'no wonder in
the resemblance, as in my youth I was always studying that class of
painting'[.]— I have forgotten what it was but his taste was in close
conformity with the old German school[.]

This was somewhat at variance with what he had said both this day &
afterwards—implying that he copies [the *del*] his Visions[.]— And it
was on this first day that in answer to a question from me he said—
'*The Spirits told* me'[.]— This led me to say—[']Socrates used pretty
much the same language— He spoke of his Genius[.] Now what affinity
or resemblance do you suppose was there between the *Genius* which
inspired Socrates and your *Spirits*?['] He smiled, and for once it seemed
to me as if he had a feeling of vanity gratified—[Pretty much *del*]
[']The same as in our countenances[;'] he paused And said 'I was
Socrates[']—And then as if he had gone too far in that—[']Or a sort of
brother—I must have had conversations with him[.]— So I had with
Jesus Christ[.] I have an obscure recollection of having been with both
of them[.']— As I had for many years been familiar with the idea that
an an [*sic*] eternity a parte post [presupposed *del*] was inconceivable
without an eternity a parte ante I was naturally led to express that
thought on this occasion[.]— His eye brightened on my saying this—
He eagerly assented[.] To be sure—'We are all coexistent with God—
Members of the Divine Body—And partakers of the divine nature[.']
— Blake's having adopted this Platonic idea led me on in our tete à tete
walk home at night to put the popular question to him—Concerning the

imputed Divinity of Jesus Christ[.] He answered—[']He is the only God[']—but then he added—[']And so am I and So are you[.']— Yet he had before said—And that led me to put the question—That Christ ought not to have sufferd himself to be crucified[.]— 'He should not have attacked the govern[t][.] He had no business with such matters[.']— On my representing this to be inconsistent with the sanctity & divine qualities he said Christ was not yet become the father[.]— It is hard on bringing together these fragmentary recollections to fix Blakes position in relation to Christianity Platonism & Spinosism[.] It is one of the subtle remarks of *Hume* on the tendency of certain religious notions to reconcile us to whatever occurs, as Gods will[,] And applying this to something B: said And drawing the inference that then there is no use in education he hastily rejoined 'There *is* no 'use in education[.]— I hold it wrong[.]— It is the great Sin[.]— It is 'eating of the tree of Knowledge of Good and Evil[.]— That was the 'fault of Plato[.]— He Knew of nothing but the Virtues & Vices[.]— 'There is nothing in all that[.]—Everything is good in God's Eyes[.']— On my asking whether there is nothing absolutely evil in what man does—he answerd—'I am no judge of that—perhaps not in Gods eyes'[.]— Nothwithstand[g] this he however at the same time spoke of error as being in heaven—for on my asking Whether Dante was pure in writing his *Vision* [,] 'Pure' said Blake [, ']Is there any purity in Gods eyes—? No[.] "He chargeth his angels with [his *del*] folly[.''] He even extended this liability to error to the Supreme Being[.] 'Did he not repent him that he had made Nineveh?['] My journal here has the remark that it is easier to repeat his personal remarks than to reconcile those which seemed to be in conformity with the most opposed abstract systems[.]— He spoke with Seeming complacency of his own life in connection with Art[.] In becoming an artist, he 'acted by Command'[.] The Spirits said to him ['] Blake be an artist'[.]— His eye glistened while he spoke of the joy of devoting himself to *divine* art alone[.] 'Art is inspiration[.] When Mich: Angelo or Raphael in their 'day or M[r] Flaxman does any of his fine things, he does them in the 'Spirit[.']— Of fame he said [']I should be sorry if I had any earthly fame, for whatever natural glory a man has is so much detracted from his spiritual glory [.] I wish to do nothing for profit [.] I want nothing [.]— I am quite happy[.]'— This was confirmed to me on my subseq interviews with him[.]— His distinction between the Natural & Spiritual worlds was very confused[.] Incidentally Swedenborg was mentioned[.]— He declared him to be a Divine Teacher. He had done and would do much good[.]— Yet he did wrong in endeavouring to explain to the *reason*, what it could not comprehend[.]— He seemed to consider, but that was not clear, the Vision of Swedenborg and Dante as of the same kind[.] [']Dante was the greater poet. He too was

wrong in occupying his mind about political objects[.]' Yet this did not appear to[1] affect his estimation of Dante's genius or his opinion of the [truth of his visions—Indeed even the imputation of *del*] truth of Dantes visions[.]— Indeed when he even declared Dante to be an Atheist, it was accomp[d] by expression of the highest admiration tho' said he ["]Dante saw Devils where I saw none['.]

I put in my journal the following insulated remarks[.]— *Jacob Bohmen* was placed among the divinely inspired men[.]— He praised also the designs to *Laws* Translation of Bohmen[.]— 'Michael Angelo could not have surpassed them[.']

'*Bacon Locke* & *Newton* are the three great teachers of Atheism **or** Satan's Doctrine'—he asserted[.]—

'*Irving* is a highly gifted man—He is a sent man[.] But they who are sent sometimes go further than they ought[.]'

Calvin—['] I saw nothing but good in *Calvins* house[.]— In *Luther's* there were *Harlots*[.']— He declared his opinion that the Earth is flat not round and just as I had objected the circumnavig[n] dinner was announced[.]— But objections were seldom of any use[.]— The wildest of his assertions was made with the [most unconscious simplicity *del*] veriest indifference of tone as if altogether insignificant[.]— It respected the natural & spiritual worlds[.]— By way of example of the difference between them he said—'*You* never saw the spiritual Sun[.]— 'I have[.]— I saw him on Primrose Hill[.]— He said ["'] Do you 'take me for the Greek Apollo?["'] ["']No![''] I said[.]— ["'] *That* '(pointing to the Sky) That is the Greek Apollo—He is Satan[."]'

Not everything was thus absurd and there were glimpses and flashes of truth & beauty As when he compared moral with physical Evil[.] 'Who shall say what God thinks Evil? That is a wise tale of 'the Mahometans Of the Angel of the Lord who murderd the Infant'— The Hermit of Parnell I suppose[.]— Is not every Infant that dies of a natural death, in reality slain by an Angel?

[1] affect the truth of Dantes visions to Blakes mind[.] I could not reconcile this with his blaming Wordsworth for being a Platonist—not a Christian[.] He asked whether W. acknowledged the Scriptures as Divine—and declared on my answering in the affirmative that the Introduction to the Excursion had troubled him so as to bring on a fit of Illness[.]— The passage that offended Blake was

> Jehovah with his thunder and the Choir
> Of Shouting Angels and the Empyreal throne
> I pass them unalarmed[.]—

'Does M[r] W.' said Bl: 'think his mind can *sur*pass Jehovah's'? I tried in vain to rescue W. from the imputation of being a Pagan—or perhaps an Atheist—but this did not rob him of the character of being the first poet [.]— Indeed Atheism meant but little in Blakes mind as will hereafter appear[.]— Therefore when he. [*All this passage is deleted and in the margin is:*] See of Wordsworth as Blake judged of him p: 46 et seq[.]

And when he joined to the assurance of his happiness, that of his having sufferd, and that it was necessary he added 'There is suffering 'in Heaven—for where there is the capacity of enjoyment, there is the 'capacity of pain[.']—

I include among the glimpses of truth his assertion—[']I Know what is true by internal conviction. A doctrine is stated—My heart tells me It *must* be true[.]—' I remarked in confirmation of it—That to an unlearned man, What are called the *external* evidences of religion can carry no conviction with them—and this he assented to.

After my first evening with him at Aders s I made the remark in my journal that his observations apart from his visions and references to the spiritual world, were sensible and acute[.]— In the sweetness of his countenance & gentility of his manner he added an indescribable grace to his conversation[.] I added my regret, which I must now repeat[,] at my inability to give more than incoherent thoughts—Not altogether my fault perhaps[.]

$$25 = 2.52.$$

On the 17th I called on him in his house in Fountain's Court in the Strand[.] The interview was a short one And what I saw was more remarkable than what I heard[.]— He was at work engraving in a small bedroom, light and looking out on a mean yard—Everything in the room squalid and indicating poverty except himself[,] And there was a natural gentility about and an insensibility to the seeming poverty which quite removed the impression[.]— Besides, his linen was clean, his hand white and his air quite unembarrassed when he begged me to sit down, as if he were in a palace[.]—There was but one chair in the room besides that on which he sat[.]— On my putting my hand to it, I found that it would have fallen to pieces if I had lifted it, So, as if I had been a Sybarite, I said with a smile, will you let me indulge myself? And I sat on the bed—and near him[,] [He smiled *del*] And during my short stay there was nothing in him that betrayed that he was aware of what to other persons might have been even offensive not in his person, but in all about him[.][1]

His wife I saw at this time—And she seemed to be the very woman to make him happy[.] She had been formed by him Indeed, otherwise she could not have lived with him; notwithstanding her dress which was poor, and dirty[,] She had a good expression in her countenance— And with a dark eye had [marks *del*] remains of beauty in her youth[.] She had that virtue of virtues in a wife[,] an implicit reverence of her husband[.] It is quite certain that she believed in all his visions And on one occasion, not this day, speaking of his Visions she said—'You

[1] This anecdote about the chair does not appear in the Diary account for this day.

'know, dear, the first time you saw God was when You were four years
'old And he put his head to the window and set you ascreaming[.']—[1]
In a word—She was formed on the Miltonic model—And like the first
Wife Eve worshipped God in her Husband—He being to her what
God was to him. Vide Miltons Paradise Lost—*passim*[.]

26,2,52

He was making designs or engraving, I forget which[.]— Cary's
Dante was before [*him*.]— He shewed me some of his Designs from
Dante, of which I do not presume to speak[.]— They were too much
above me[.]—But Götzenberger, whom I afterwards took to see them,
expressed the highest admiration of them. They are in the hands of
Linnell—the painter And it has been suggested, are reserved by him
for publication when Blake may have become an object of interest to
a greater number than he can be at this age[.]—

Dante was again the subject of our Conversation—And Bl: declared
him a mere politician and atheist busied about this world's affairs—As
Milton was till in his (M's) old age he returned back to the God he
had abandoned in childhood[.]— I in vain endeavoured to obtain from
him a qualification of the term *atheist* So as not to include him in the
ordinary reproach[.]— And yet he afterwards spoke of Dante as being
then with God[.] I was more successful when he also called Locke an
Atheist and imputed to him wilful deception—And Seemed satisfied
with my admission that Lockes philos[y] led to the Atheism of the French
school[.]—He reiterated his former strange notions on morals—
Would allow of no other education than what lies in the cultivation of
the fine arts & the imagination[.] 'What are called the Vices in the
natural world, are the highest sublimities in the spiritual world[.']
And when I supposed the case of his being the father of a vicious Son
And asked how he would feel[,] he evaded my question by saying that
in trying to think correctly he must not regard his own weaknesses
more than other people's[.]— And he was silent to the observation
that his doctrine denied evil[.]— He seemed not unwilling to admit the
Manichaen doctrine of two principles, as far as it is found in the idea of
the Devil[,] And said expressly Said he did not believe in the Omni-
potence of God[.] The language of the Bible is only poetical or
allegorical on that subject[.] Yet he at the same time denied the *reality*
of the natural world. Satans empire is the empire of nothing[.]—

As he spoke of frequently Seeing Milton, I ventured to ask, half
ashamed at the time, which of the three or four portraits in *Hollis's*
Memoirs (Vols in 4to) is the most like[.]— He answ[d] ['']They are all
like, At different Ages[.]— I have seen him as a youth And as an old

[1] This story of seeing God does not appear in the Diary.

man with a long flowing beard[.][1] He came lately as an old man[.]—
He said he came to ask a favor of me[.]— He said he had committed
an error in his Paradise Lost, which he wanted me to correct, in a poem
or picture; but I declined[.] I said I had my own duties to perform[.]—
It is a presumptuous question[.'] I replied—['']Might I venture to
ask—What that could be[?']—['] He wished me to expose the false-
hood of his doctrine, taught in the Paradise Lost—That Sexual inter-
course arouse out of the Fall[.]— Now that cannot be, for no good can
spring out of Evil[.' ']But['], I replied, ['']if the consequences were
Evil, mixed with Good, then the good might fairly be ascribed to the
common cause[.']— To this he answerd—by a reference to the
Androgynous state, in which I could not possibly follow him[.]— At
the same time that he asserted his own possession of this gift of Vision,
he did not boast of it as *peculiar to* himself; All men might have it if
they would[.]—

27,2,52

1826 On the 24ᵗʰ [*of December 1825*] I called a second time on him—
And on this occasion it was that I read to him *Wordsworth's Ode* on the
supposed preexistent State And the subject of Wordsworths religious
character was discussed when we met on the 18ᵗʰ of Feb. and the 12ᵗʰ
of May[.]— I will here bring together W. Blake's declarations con-
cerning Wordsworth—And set down his marginalia in the 8vo: Edit.
A.D. 1815—Vol i[.]— I had been in the habit when reading this mar-
vellous Odes [*sic*] to friends, to omit one or two passages—especially
that beginning

But there's a tree of many one,[2]

lest I should be rendered ridiculous, being unable to explain precisely
what I admired[.]— Not that I acknowledged this to be a fair test: But
with Blake I could fear nothing of the Kind, And it was this very
Stanza which threw him almost into an hysterical rapture[.]— His
delight in Wordsworths poetry was intense [And seeming undimin-
ished *del*] nor did it seem less nothwithstandᵍ by the reproaches he
continually cast on W [which I have anticipated and which he charac-
terised as Atheism that is, in worshipping nature *del*] for his imputed
worship of nature—which in the mind of Blake constituted Atheism[.]

28,2 52

The combination of the warmest praise with imputations which
from another would assume the most serious character And the liberty

[1] The account of Milton's appearance is different in the Diary.
[2] Line 51 of 'Ode: Intimations of Immortality from Recollections of Early
Childhood'. In the Diary Robinson does not specify the passage in the Ode which
enchanted Blake.

he took to interpret as he pleased, rendered it as difficult to be offended
as to reason with him[.]— The eloquent descriptions of Nature in
Wordsworth's poems were conclusive proof of Atheism, for whoever
believes in Nature said B: disbelieves in God—For Nature is the work
of the Devil[.] On my obtaining from him the declaration that the Bible
was the work of God, I referred to the commencem^t of Genesis—In the
beginning God created the Heaven & the Earth[.]— But I gained
nothing by this for I was triumphantly told that this God was not
Jehovah, but the Elohim,[1] and the doctrine of the Gnostics repeated
with sufficient consistency to silence one so unlearned as myself[.]—

The Preface to the Excursion especially the Verses quoted from book
1. of the Recluse, so troubled him as to bring on a fit of illness[.]—
These lines he singled out—

> Jehovah with his thunder And the Choir
> Of Shouting Angels And the Empyreal throne
> I pass them unalarmed[.]

Does M^r W think he can surpass Jehovah? [He gave me *del*] There
was a copy of [these lines in his *del*] the whole passage in his own hand
[With this note at the end *del*] in the vol of Wordsworths poem sent
to my chambers after his death[.]— There was this note at the end[:]
'Salomon when he married Pharoahs daughter & became a Convert to
the Heathen Mythology talked exactly in this way of Jehovah as a very
inferior object of man's Contemplations, he also passed him unalarmed
And was permitted[.] Jehovah dropped a tear & followed him by his
Spirit into the abstract Void[.]— It is called the Divine Mercy[.]
Satan dwells in it, but Mercy does not dwell in Him[.]'—

Some of W s poems he maintained were from the Holy Ghost,
others from the Devil. I lent him the 8vo: Edition of 2 Vols of W s
poems which he had in his possession at the time of his death[.]—They
were sent to me then[.]— I did not recognise the pencil notes he made
in them to be his for some time And was on the point of rubbing them
out under that impression *when* I made the discovery.

The following are found in the 5^th Vol:[2]—In the fly-leaf under the
words

Poems referring to the Period of Childhood

29,2.52.

'I see in Wordsworth the Natural man rising up against the Spiritual

[1] In the Hebrew text of Genesis, the plural word Elohim is used instead of the
singular Jehovah.
[2] This should be 'the first volume'. Naturally none of these marginalia appeared
in the Diary.

man continually, and then he is no poet, but a Heathen Philosopher at Enmity against all true poetry or inspiration[.]'

Under the first poem—

$$-\begin{cases} 3 & \text{'And I could wish my days to be} \\ & \text{'Bound to each by natural piety'} \end{cases}$$

He had written 'There is no such thing as natural piety, because the natural man is at Enmity with God.'

page 43 under the Verses 'to H C Six Years old[']—

'This is all in the highest degree imaginative & equal to any poet, 'but not superior[.] I cannot think that real poets have any compe- 'tition[.] None are greatest in the Kingdom of heaven[.]— It is so in 'poetry[.]' page 44 'On the influence of natural objects' at the bottom of the page[:] 'Natural objects always did & now do weaken deaden & obliterate Imagination in me. Wordsworth must know that what he writes valuable is not to be found in Nature[.] Read Michael Angelos Sonnet Vol II, p 179'[,] That is, the one beginning

'No mortal object did these eyes behold'
'When first they met the placid light of thine[.]'

It is remarkable that Blake whose judgements were on most points so very singular, on one subject closely connected with Wordsworths poetical reputation should have taken a very common place view[.]— Over the heading of the 'Essay Supplementary to the Preface' at the end of the Vol: he wrote 'I do not know who wrote these Prefaces[.] They are very mischievous & direct contrary to Wordsworths own practice' (p. 341)[.] This is not the defence of his own style in opposi- tion to what is called Poetic Diction but a sort of historic vindication of the *unpopular* poets[.] On Macpherson p 364. W. Wrote with the severity with which all great writers have written of him[.] Blake's comment below was 'I believe both Macpherson & Chatterton, that what they say is ancient is so.' And in the following page 'I own myself 'an admirer of Ossian equally with any other poet whatever Rowley & 'Chatterton also[.]— And at the end of this Essay he wrote 'It appears 'to me as if the last paragraph beginning "Is it the result of the whole" 'was written by another hand & mind from the rest of these Prefaces[.] 'They are the opinions of [1] landscape painter[.] Imagination is 'the divine vision not of the World, nor of Man, nor from Man as he is

[1] The difficult words HCR could not read have been deciphered by George H. Healey, Curator of the Cornell Rare Book Department (where the annotated volume now is), as 'Sʳ G Beaumont the'.

'a natural man but only as he is a spiritual Man[.] Imagination has
'nothing to do with Memory[.]'

1.3.52

1826 —19ᵗʰ Feb: It was this day in connection with the assertion that
the Bible is the word of God And all truth is to be found in it—he
using language concerning man's reason being opposed to Grace very
like that used by the Orthodox Christian, that he qualified And as the
same Orthodox would say wholly nullified all he said by declaring that
he understood the Bible in a Spiritual Sense[.] As to the natural Sense
he said '*Voltaire* was commissioned by God to expose that[.']— 'I have
had,['] he said ["]much intercourse with Voltaire—And he said to me
"I blasphemed the Son of Man And it shall be forgiven me—but they"
(the enemies of Voltaire) ["']blasphemed the Holy Ghost in me, and
it shall not be [forgotten *del*] forgiven to them[."'] I asked him in
what language Voltaire spoke[.]— His answer was injenious and gave
no encouragement to cross questioning[.] 'To my Sensations it was
English[.] It was like the touch of a musical Key—he touched it prob-
ably French, but to my ear it became English[.'] I also enquired as I
had before about the form of the [Spirits *del*] persons who appeared to
him And asked Why he did not *draw* them[.]— [']It is not worth
while,['] he said, ["]Besides there are so many that the labour would
be too great—And there would be no use in it[.]'— In answer to an
enquiry about Shakespear 'he is exactly like the *old* Engraving—Which
is said to be a bad one[.]— I think it very good[.]' I inquired about his
own writings[.] [']I have written,['] he answerd, ["]more than
Rousseau or Voltaire—Six or Seven Epic poems as long as Homer And
20 Tragedies as long as Macbeth[.'] He shewed me his ['Vision of
Genesis, as *del*] Version of Genesis for so it may be called 'As under-
stood by a Christian Visionary'[.] He read a wild passage in a sort of
Bible Style[.] [']I shall [write *del*] print no more[.']—he said[.]—
[']When I am commanded by the Spirits then I write, And the moment
I have written, I see the Words fly about the room in all directions[.]
It is then published[.]— The Spirits can read and my MS: is of no
further use[.]— I have been tempted to burn my MS, but my wife
wont not let me[.]'—¹ [']she is right[,'] I answerd[.] 'You wrote not
from yourself but from higher order[.]— The MSS are their property
not yours[.]— You cannot tell what purpose they may answer[.]'—
This was addressed ad hominem—And indeed amounted only to a
deduction from his own premises[.] He incidentally denied *causation*[,]
Every thing being the work of God or Devil[.] Every Man has a
Devil in himself And the conflict between his *Self* and God is

¹ The accidental extra negative is not found in the Diary, and is therefore
HCR's solecism, not Blake's.

perpetually carrying on[.] I orderd of him to day a copy of his Songs for 5 Guns[.]— My manner of receiving his mention of price pleased him[.]— He spoke of his horror of money and of turning pale when it was offerd him—And this was certainly unfeigned[.]— In the N? of the Gents Magazine for last Jan: there is a letter by *Cromek*[1] to Blake printed in order to convict B. of selfishness[.]— It cannot possibly be substantially true—I may elsewhere notice it.

13.ᵗʰ June I saw him again in June—He was as wild as ever, says my journal, but he was led to day to make assertions more palpably mischievous if capable of influencing other minds & immoral supposing them to express the will of a responsible agent than anything he had said before—As for instance, that he had learned from the Bible that wives should be in common[.] And when I objected that marriage was a Divine institution he referred to the Bible 'that from the beginning it was not so' [.]— He affirmed that he had committed many murders, And repeated his doctrine, that reason is the only Sin And that careless gay people are better than those who think &c &c[.]

It was I believe on the 7ᵗʰ of December that I saw him last. I had just heard of the death of Flaxman, a man whom he professed to admire And was curious how he would receive the intelligence. It was as I expected[.] He had been ill during the Summer And he said with a Smile ['']I thought I should have gone first[.'']— He then said ['']I cannot think of Death as more than the going out of one room into another['']—And Flaxman was no longer thought of[.] He relapsed into his ordinary train of thinking[.] Indeed I had by this time learned that there was nothing to be gained by frequent intercourse—And therefore it was that after this interview I was not anxious to be frequent in my visits[.] This day he said 'Men are born with an Angel & a Devil[.'']— This he himself interpreted as Soul & Body—And as I have long since said of the strange sayings of a man who enjoys a high reputation —'it is more in the language than the thoughts that the singularity is to be looked for[.'']— And this day he spoke of the Old Testament as if it were the evil element[.]— Christ he said, took much after his Mother And in so far he was one of the worst of men[.]— On my asking him for an instance—He referred to his turning the money change[r]s out of the Temple[;]—he had no right to do that[.]— He digressed into a condemnation of those who sit in judgment on others[.] 'I have never known a very bad man who had not something very good about him[.']

Speaking of the Atonement in the ordinary Calvinistic Sense, he said 'It is a horrible doctrine; If another pay your debt, I do not forgive it'[.]

[1] See May 1807. HCR did not notice it elsewhere.

I have no account of any other call—but this is probably an Omis-
sion[.]— I took Götzenberger to see him—And he met the Mas-
queriers in my Chambers[.]— Masquerier was not the man to meet
him[.]— He could not humour B:, nor understand the peculiar Sense in
which B was to be [understood *del*] received[.]

1827 My journal of this year contains nothing abt Blake But in
January 1828 Barron Field & myself called on M̲r̲s̲ Blake [.] The poor
old lady was more affected than I expected she would be at the sight of
me[.] She spoke of her husband as dying like an Angel[.]—She in-
formed us that she was going to live with Linnell as his housekeeper—
And we understood that she would live with him. And he, as it were,
to farm her Services and take all she had[.]—[1] The Engravings of Job
were his already[.] Chaucers Canterbury Pilgrims were hers[.]— I
took two copies, One I gave to C: Lamb—Barron Field took a proof[.]

M̲r̲s̲ Blake died within a few years And since Blakes death Linnell
has not found the market I took for granted he would seek, for Blake's
works[.]— Wilkinson printed a small edition of his poems includ[*ing*]
the 'Songs of Innocence & Experience' a few years ago And Monkton
Milne talks of printing an edition[.]— I have a few coloured engrav-
ings—but B is still an object of interest exclusively to men of imagina-
tive taste and psychological curiosity[.]— I doubt much whether these
mems: will be of any use to this small class[.]—

1.3.52

I have been reading since the Life of Blake by Allan Cunningham
Vol II p 143 of his Lives of the Painters[.] It recognises perhaps more
of Blakes merit than might have been expected of a *Scotch* realist[.]—

22.3.52.

[1] This sentence is not authorized by Robinson's Diary or by the probable facts.

SECTION II

BLAKE RESIDENCES

This Section gathers together in chronological order all the reliable information I have discovered about residences of the known or probable members of Blake's family. Each entry begins with the address of the building, the years during which it was occupied by Blake or by one of his relatives, and the name of the significant occupant. Only a few of the entries are for Blakes other than the poet.

The background material in this Section does not pretend to be exhaustive. I have merely attempted to give, where my evidence extended so far, some indication of the character of the neighbourhoods in which Blake lived.

Most of the Rate Books except those for Lambeth (1790–1800) and Felpham (1800–3) are in the Westminster Public Library, Buckingham Palace Road, London. Those for Lambeth are in the Tate Central Library, Brixton Oval, London. There appear to be no Rate Books for Felpham. The Rate Books are identified by Parish and Ward, and then by year and kind of rate (Watch, Scavenger, Poor, Paving, Church, Preacher Assistant, etc.). For the years when Blake himself was paying the rates, all available Rate Books were checked; when the residence was only that of a relative or landlord, a spot check was made of years and kinds of rates. The only Rate Books for Lambeth that survive are the Poor Rate Books.

The valuation at which a building was assessed in the rate books was little more than a proportional guide for the calculation of rates, at so many shillings per pound valuation. At one time, presumably, the assessed value and the rental value per year more or less coincided, but by the late eighteenth century the assessed values were archaic and were probably almost always significantly less than the real value.

The houses in this Section have been assigned street numbers, despite the fact that these street numbers do not appear in the Rate Books. Most houses in London were not numbered until the latter part of the eighteenth century, and numbers do not begin to creep into the Rate Books until the early nineteenth century. However, the house numbers are given in R. Horwood's magnificent *Plan of the Cities of London and Westminster, the Borough of Southwark and Parts Adjoining showing every house*, London, 1792–9. For ease of reference I have transferred numbers from Horwood to houses mentioned in the Rate Books by counting from the nearest intersection referred to in the Rate Books (since the rates were collected from house to house in a set pattern), and then tallying with Horwood.

ROTHERHITHE

1737

JAMES BLAKE was a resident of Rotherhithe when he was apprenticed as a hosier on July 14th, 1737 (q.v.). Unhappily I have been unable to confirm this statement with independent records, for the relevant rate books appear to be chaotically scattered.[1]

Rotherhithe is, and was, a rather unsavoury offshoot of the City of London, just across London Bridge on the south side of the Thames.

5 GLASSHOUSE STREET

1743

JOHN BLAKE, who was probably William Blake's uncle, moved into 5 Glasshouse Street, south-west of Golden Square, Westminster, in 1743.[2] The evidence that John Blake was related to the poet's father consists simply in the fact that they lived in the same house (see below).

1744–1753

JAMES BLAKE lived at 5 Glasshouse Street from 1744 to 1753.[3] This James Blake can be confidently identified as the poet's father because, when he voted in 1749, he was registered as 'James Blake Glasshouse S⁺ Hosier'.[4] Further, he left this residence at exactly the time when it is known that Blake's parents, James and Catherine Blake, moved into 28 Broad Street.

28 BROAD STREET (See Plate LV)

1748–1753

— ARMITAGE paid the rates at 28 Broad Street, north-east of Golden

[1] The irregularly collected Sewage Rates for 1731 and 1743 (now in the possession of the London County Council) mention no Blakes, but this omission may not be significant, as only those houses near the sewage ditches were rated for their upkeep. The Bermondsey Borough Council has thousands of unsorted records and Rate Books for Bermondsey and Rotherhithe, but the only relevant materials discovered in a half-day's dusty search were the Rotherhithe Poor Rate Books for 1757 and 1767. Neither of these listed any Blakes as ratepayers. There is no information about the poet's family in G. Mozley, *The Blakes of Rotherhithe*, 1935.

[2] The Watch Rates for Church Ward of the Parish of St. James show that the house was vacant in 1742, and that Jno Blake came in in 1743. The house was consistently valued at £18.

[3] Watch Rates for Church Ward, 1743, 1744, 1746–8, 1750, 1752, 1753.

[4] All the surviving Westminster Poll Books are in the Middlesex County Record Office.

Square, Westminster, from 1748 to 1753.[1] This Armitage is surely either the Catherine 'Harmitage' whom James Blake married on October 15th, 1752, or, more probably, her father or mother.

In 1753 the '— Armitage' was deleted in the Rate Book and instead 'James Blake. Xmas' was inserted.

1753–1812

J A M E S B L A K E paid the rates for 28 Broad Street from 1753 to 1812.[2] This listing obviously includes both William Blake's father and his brother, for the senior James Blake died in 1784, and his house and business were taken over by his eldest son, James. Curiously enough, a Stephen Blake, haberdasher, is listed for this address in 1783 in *The New Complete Guide* and in 1784 in *Lowndes's London Directory*.[3]

James Blake, Hosier, Broad Street, Golden Square, appears in *The Universal British Directory*, vol. i (1790). 'Blake & Son, Hosiers & Haberdashers, 28 Broad-str. Carnaby-mar.' appear in *Kent's Directory for the Year 1793*, and continue with the separate addition of 'Blake, James, Hosier' at the same address from 1794 to 1800. James Blake continues by himself in *Kent's Directory* in 1801, 1802, 1804–8, and 1810, but disappears by 1814. (The gaps in these lists reflect those in the British Museum.) In [W.] *Holden's Triennial Directory*, 'Blake and Son, hosiers and haberdashers' for 1802–4 alternate with plain James Blake, hosier, for 1799 and 1805–11. 'Blake and Son, Hosiers & Haberdashers, 28, Broad-st, Soho' appear in *The New Annual Directory for the Year[s] 1800, 1801, and 1803, but are replaced by James Blake in 1806–13 (he is only a hosier in 1812–13).

The house in Broad Street was consistently valued in the Rate Books at £21, with varying proportional rates, until 1792, when it was suddenly valued at £30. James Blake evidently protested at this new

[1] Poor Rates for Church Ward, 1747–9, 1751–3; Golden Square Watch Rates for 1748–51 (D.501–2, D.509–10, D.516–17). No Christian name is ever given. According to the Poor Rate Book, no Armitage–Harmitage paid rates in all Westminster in 1747.

[2] The Poor Rates were checked for 1752–5, 1758, 1764, 1770, 1775, 1780–90, 1792, 1797, 1802, 1807, and 1812; in 1812 the name is deleted. For most years the house is actually listed in Marshall Street, because it was on the corner of Broad and Marshall Streets, and the main entrance was in Marshall Street.

[3] This may well be the Stephen, son of George Blake, who was apprenticed to Wm. Terry of Bentworth, Hants, a tailor, for £10. 10s. 0d. in 1752, according to the typescript index in Guildhall Library of the Apprentice Registers for 1710–62 in the Public Record Office. This Stephen may have been a relation, say a nephew or a cousin, of Blake's father, who joined in partnership with James Jr. when the father was declining and dying in 1783 and 1784. Indeed, the 'Blake & Son' in the later directories may have been intended to convey that it was a family business, though not necessarily a strictly patrilineal one.

PLATE LV

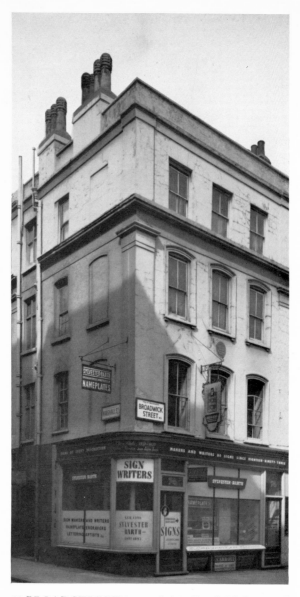

28 BROAD STREET (now called 74 Broadwick Street and
torn down about 1963), where Blake was born and grew up
(1757–82), and next door to which he had a print-selling shop
(1785) (see pp. 551–8)

valuation, for a note in the Poor Rate Book for that year says that it was 'taken at £22 . . .'. Perhaps the proposed new rate had been based on James Blake's improvements. According to the Minutes of the Commissioners for Paving, on August 11th, 1790 there was a request relative to the 'Columns of Wood erected by M͟r Blake in Broad Street.' 'M͟r Blake . . . asked leave [*which was granted*] to take up the Paving to erect Stone Columns in the stead of those now placed before his House.'[1] One can only surmise that the columns formed a kind of ornamental classical portico; they were not there in 1959.

'James Blake Broad S͟t Carnaby Mark͟t Hosier & Haberdasher' voted for Earl Percy and Lord Clinton on October 12th, 1774, and in 1780 and 1784, now listed only as a 'Hosier', Blake's father voted for Fox and wasted his second vote. The poet himself never voted in Westminster, though he paid rates in 1788 and 1790 and was presumably eligible to vote then as James Parker did.

Unlike the neighbouring parish of St. Anne's, the area around Golden Square was thick with Blakes, of whom the following may be only a sample: (1) *William Blake, poulterer*, of Marshall Street, Carnaby Market, voted in 1749 and 1774. (2) In the Poor Rate Books in 1781 and 1782 there is a *Kitty Blake* some sixteen doors away from James Blake, at about 22 Marshall Street. (3) At midsummer 1792 *Thomas Blake* moved into 20 Marshall Street, and when he voted in 1818 he was registered as a *tailor*. (4) In 1808 (the last year the poet entered a picture) 'Blake, B. 37, Broad Street, Soho' exhibited two pictures, including a 'Last Judgment', at the exhibition of the Royal Academy. This *B. Blake* was primarily a landscape artist (in 1816, for instance, he exhibited a 'Sketch from Nature' and 'Landscape and figures'), and his 1808 address may have been only temporary. In the 1807 Royal Academy catalogue he gave his address as Winchester Row, Paddington; in 1811 he was at Great Dunford, near Salisbury; in 1812 at 25 Tothill Street, Westminster; in 1816 and 1817 at 2 Wellington Street, Camden Town; in 1821 he gave no address; and in 1825 he was at 55 Augustus Street, Regent's Park. (5) On April 15th, 1738 *James Blake* married Elizabeth Bateman at St. James, Piccadilly. (6) *Reuben, son of John and Frances Blake*, was christened in St. James, the Golden Square Parish Church, on February 20th, 1752. (7) *Charles, son of James and Mary Blake*, was christened at St.

[1] In Westminster Public Libraries, vol. viii, pressmark D. 1915, pp. 258–9. According to M. Rouquet (*The Present State of the Arts in England*, London,1755, p. 120), 'Within these few years the custom has been introduced [*by Londoners*] of dressing the front of their shops, particularly the mercers, with some order of architecture. The columns, the pilasters, the freeze, the cornish, every part in fine preserves its proportion, and bears as great a resemblance to the gate of a little temple, as to that of a warehouse.'

James on January 4th, 1758. (8) *William Blake, son of John and Sarah,* was christened on June 9th, 1767 at St. James. (9) *John and Margaret Blake* had *their daughter Maria* christened on February 7th, 1760 (and buried February 22nd, 1760), and *another daughter Elizabeth* christened on January 22nd, 1769 at St. James. The father could be the linen draper of Coventry Street who voted in 1780.

The voting lists also show: (10) *Daniel Blake, shoemaker* of Little Poultney Street, 1774; (11) *Robert Blake, baker* of Rupert Street, 1774 (see also no. 14 below); (12) *William Blake, gentleman* of Berwick Street, 1774, 1784, 1788, 1790; (13) *William Blake, carpenter* of Little Windmill Street, 1784, 1788; (14) *Peter Blake, baker* of Rupert Street, 1788 (see also no. 11 above); (15) *Thomas Blake, coffeeman* of Pall Mall, 1788; (16) *Barnabas Blake, hotel keeper* of 56 Jermyn Street, 1806; (17) *Thomas Blake, hair cutter* of Burlington Gardens, 1806.

William Blake the poet was born and brought up in 28 Broad Street, Carnaby Market, and there he lived presumably until his marriage in 1782. Certainly that is the address he gave when his first picture was listed in *The Exhibition of the Royal Academy [May] M.DCC.LXXX.*

Broad Street and Golden Square were inhabited by artists and people of fashion through most of the eighteenth century. In 1726 Mr. Cock had a 'New-Auction Room in Poland-street, the Corner of Broad-street near Golden Square' where he sold pictures, and in 1749 Canaletto advertised that his 'View of St. James's Park' could be seen where 'He lodges at Mr. Wiggan's, cabinetmaker, Silver Street, Golden Square' parallel to Broad Street and one street from it.[1] In 1754 the exotic Liotard lodged in Golden Square at the sign of the Two Yellow Lamps and held an exhibition there,[2] and about 1760 Matthew Bramble and the entourage of Smollett's *Humphry Clinker* stayed at Mrs. Norton's in Golden Square. The great anatomist John Hunter had a house in Golden Square in 1763; Angelica Kauffmann, the fashionable woman painter, lived in the square about 1767, and Dr. John Hill, who made his fortune by quackery and his reputation by literary squabbling, died there in 1775. The stipple engraver Bartolozzi lived in Broad Street from 1768 to 1774. From 1777 to 1781 John Henry Fuseli resided at 1 Broad-street, corner of Poland Street,[3] and the engraver James Heath, with whom Blake worked frequently on books, lived in Broad Street, Carnaby Market, at the same time, and engraved the Gordon 'Riots in Broad Street' after Francis Wheatley

[1] W. T. Whitley, *Artists and their Friends in England 1700–1799*, London, 1928, vol. i, pp. 17 and 115, the latter citing merely 'a London newspaper'.

[2] Ibid., vol. i, p. 269.

[3] This is the address he gave for the Royal Academy catalogues for 1777, 1780, and 1781. In 1782 he was at 100 St. Martin's Lane.

in 1780.[1] The engraver Philip Dawe lived nearby in Brewer Street, and his son George (R.A.) was born there in 1781. In 1797 David Hartley, for whose edition of his father's *Observations on Man* Blake had made engravings, lived in Golden Square;[2] John Varley lived in Broad Street from about 1805, and William Mulready, the painter, lived with him there when John Linnell first met them. In 1816 (according to the *Annals of the Fine Arts*), the painter J. Allen lived at 18 Golden Square, and Isaac Pocock (1782–1835), a fellow student with Thomas Hayley under Flaxman, was at Brewer Street, Golden Square.

By the early years of the nineteenth century, however, the area was fast becoming disreputable, and when Blake's brother moved out in 1812 it was probably far advanced in decay. When Blake's exhibition was held at the old family house in 1809, the square probably looked as Dickens saw it some years later:

Although few members of the graver professions live about Golden Square, it is not exactly in anybody's way to or from anywhere. It is one of the squares that have been; a quarter of the town that has gone down in the world, and taken to letting lodgings. Many of its first and second floors are let furnished to single gentlemen, and it takes boarders besides. It is a great resort of foreigners. The dark-complexioned men who wear large rings, and heavy watch-guards, and bushy whiskers, and who congregate under the Opera Colonnade, and about the box-office in the season, between four and five in the afternoon, when Mr. Saqvin gives away the orders,— all live in Golden Square, or within a street of it. Two or three violins and a wind instrument from the Opera band reside within its precincts. Its boarding-houses are musical, and the notes of pianos and harps float in the evening time round the head of the mournful statue, the guardian genius of a little wilderness of shrubs, in the center of the square. On a summer's night, windows are thrown open, and groups of swarthy moustachio'd men are seen by the passer-by lounging at the casements, and smoking fearfully. Sounds of gruff voices practising vocal music invade the evening's silence, and the fumes of choice tobacco scent the air. There, snuff and cigars, and German pipes and flutes, and violins, and violoncellos, divide the supremacy between them. It is the region of song and smoke. Street bands are on their mettle in Golden Square; and itinerant glee-singers quaver involuntarily as they raise their voices within its boundaries.[3]

The house that Blake lived in was dismal and forlorn just before it was condemned to make way for an 'improvement' development. Numbers 27 and 28 Broad Street (now 72 and 74 Broadwick Street)

[1] The subscription list to Edward Kimpton's *New and Complete Universal History of the Holy Bible*, London, [1781?], gives Heath's address.

[2] *The Universal British Directory*, London, [1797], vol. v, index.

[3] C. Dickens, *The Life and Adventures of Nicholas Nickleby*, London, 1839, pp. 5–6. The time referred to is probably about 1825.

each consisted of four floors and a sizeable basement, occupied by, among others, a sign painter, a tailoring establishment, and a prostitute. One went up the narrow stair-well opening on Broad Street to what used to be the sleeping quarters above. The first floor up consisted entirely of a low-ceilinged room about 20 ft. by 20 ft., with five or more people furiously cutting and sewing in it. The room was cramped and ill lit, but it was once divided into two or even three rooms. There were two fireplaces, a window, and a window bricked-up on each floor on the Marshall Street side, and three windows on the Broad Street wall adjoining it.[1] In Blake's time this room just over the shop was probably the best in the house. There was not much room to spare, but the Blakes were far more comfortably and solidly housed than the vast majority of their countrymen.

31 GREAT QUEEN STREET
1772–1779

F ROM the end of his 14th year till the end of his 21st *William Blake* almost certainly lived at the home of his master, *James Basire*, at 31 Greet Queen Street, about a mile east of his father's house.[2] The area had once been artistically fashionable, and Godfrey Kneller, Thomas Hudson, and Joshua Reynolds (as an apprentice) lived there at various times. No. 31, almost opposite the Free Mason's Tavern, was a seventeenth-century house which was refaced in Georgian times, and painted green. It had been converted to commercial purposes, with an old-fashioned shop window, and, as William Hayley wrote, the visitor 'will easily find the House by the name *Basire* on the door—'.[3]

HOG LANE, SOHO
1778–1788

J OHN B LAKE paid the Poor Rates from 1778 to 1788 on a house valued at £20 on the east side of Hog Lane, midway between Sutton Street and Falconbridge Court (the house is not numbered by Horwood), due east of Soho Square. By 1792 Hog Lane was more decorously named Crown Street, and it is now, more or less, Charing

[1] See the photograph of the exterior of the building reproduced in T. Wright, *The Life of William Blake*, Olney, 1928, vol. i, p. 4 and in J. S. Ogilvy, *Relics & Memorials of London Town*, London, N.Y., Toronto, 1911, p. 196. One of the rooms was large enough for Blake's 'Ancient Britons', 14 ft. by 10 ft., to be exhibited in—see 1809–10.

[2] For the probabilities of the case, see Aug. 4th, 1772. The general description of the house below derives from Gilchrist, who saw it about 1860. No. 31 is now occupied by the Royal Masonic Institution for Girls.

[3] Hayley was directing his wife to where he was staying, next door to Basire, in a letter of April 16th, 1789 (in the possession of James Osborn of New Haven). Hayley had lived in Kneller's house at 5 Great Queen Street from 1769 to 1774.

Cross. The last rites for William Blake's father were probably held in this John Blake's house before he was taken from 'Soho Square' to be buried in Bunhill Fields in July 1784.

The John Blake of Hog Lane (1778–88) must not be confused with the John Blake at 29 Broad Street (1784–93), though he may be the same man who took 5 Glasshouse Street in 1743. According to the Rate Books of 1784 there was no other Blake at all in the parish of St. Anne's where Soho Square is located.[1]

23 GREEN STREET

1782–1784

THE Rate Books show a Thomas Taylor (not the Platonist, who was at 9 Manor Place, Walworth, from 1778 to 1830) at 23 Green Street, Leicester Fields, for these years, but 23 Green Street is the address which Blake gave for the *Exhibition of the Royal Academy, M.DCC.LXXXIV*. Clearly the Blakes were simply lodgers in a few rooms. It seems likely that Blake moved in when he was married in 1782, and stayed until he moved to 27 Broad Street in 1784. The great engraver William Woollett lived in Green Street, and John Hunter and Sir Joshua Reynolds lived round the corner in Leicester Fields. The square was still open and peaceful, and in the summer of 1771 Northcote, who was living with Sir Joshua, wrote happily: 'I often hear the cock crow and have seen a hen and chickens strut as composedly through the street as they would at Plymouth.'[2]

27 BROAD STREET

1784–1785

WILLIAM BLAKE was next door to his brother's house at 27 Broad Street in partnership with his old fellow apprentice James Parker from the end of 1784 until the Christmas quarter of 1785.[3] This is the address

[1] The only exception is Charles Blakes in Little Newport Street North, which is some six streets south of Soho Square, and surely would have been identified with Leicester Square instead. In *The [Lowndes] London Directory* for the Year 1792 he is called Charles Blake, hosier.

[2] W. T. Whitley, *Artists and their Friends in England 1700–1799*, London, 1928, vol. ii, p. 282. Hogarth lived at the sign of the Golden Head in Leicester Square from 1733 to 1769.

[3] In the Paving Rates for 1784 (Golden Square Ward, pressmark D.1212), the occupant is listed as William Neville, but in the margin is written 'Blake & Parker'. In the 1784 Golden Square Watch Rate Books they are entered fully as 'James Parker & W^m Blake [*value*: £]18–[*rate*:]–7–6'. They do not appear in the Poor Rate for 1784 (D.105), but some variant of 'Ja^s Parker & W^m Blake' is given in 1785 for the Parish Poor Rate (D.106, rate £2. 2s. 0d.), Golden Square Watch Rate (D.809, 7s. 6d.), and Golden Square Paving Rate (D.1213, 16s. 8d.). The

he gave at *The Exhibition of the Royal Academy, M.DCC.LXXXV*. It seems likely that the Blakes and Parkers moved in very shortly after Blake's father died in July 1784, perhaps with some inheritance money to help start the business. Blake's partner Parker continued next door to Blake's birthplace until 1794, and must have seen a great deal of Blake's brother and sister, who continued to live at No. 28 until 1812.[1]

29 BROAD STREET

1784–1793

JOHN BLAKE paid the Poor Rates from 1784 to 1793 on a house just across the street from 28 Broad Street, on the south-east corner of Broad and Marshall Streets, which was valued at £9. He apparently moved in shortly before his elder brother James took over the family house at 28 Broad Street at their father's death in 1784. When he voted in 1784 and 1788 for Fox and Hood he was listed as 'John Blake Marshal street Baker', and on the first occasion he came in with his father and voted as he did.

For nine years he paid the rates faithfully, but in the first and second quarters of 1793 the Poor Rates for this house were 'Deficient on Account of Poor Persons', and the house was empty for the last two quarters because its occupant had 'run away'.[2] These facts correspond well enough with the bits of information we have about Blake's brother John, who is reported by Tatham (p. 509) to have been a 'Ginger bread Baker' who 'lived a few reckless days, Enlisted as a Soldier & died.'

28 POLAND STREET

1785–1790

WILLIAM BLAKE moved round the corner from Broad Street and about three streets north to 28 Poland Street in the autumn of 1785,

Poland Street Rate Books make it clear that Blake moved out of 27 Broad Street at the end of 1785, but his name still appears as joint rate-payer for 27 Broad Street in 1786 in the books for the Parish Poor Rates (D.107), Golden Square Paving Rates (D.1214), and the Golden Square Watch Rates (D.810 and D.811). In 1787 in the Golden Square Watch Rate (D.812, D.813) and in the Golden Square Paving Rate (D.1215) the 'Blake' is deleted. In the Parish Poor Rate Book (D.107) for 1786 Parker & Blake are entered, but '& Blake' is deleted.

[1] Parker is listed at 27 Broad Street in the Poor Rate Books for 1785–94, but after 1795 he is replaced by John Mayhew Jr. Parker's next known residence is given by Flaxman on Nov. 7th, 1804 as Spring Place, Kentish Town, near London. 'James Parker N°27 Broad Street' voted for Townshend in 1788 and for Fox in 1790.

[2] The house does not appear to have attracted reliable tenants, for John Blake was followed by 'Nathaniel Ridge [*who came in*] Xmas 93', and was in turn followed by 'Thos. Wright [*who came in*] Lady day [*1794*] both run away—'.

and stayed there until 1790.[1] He certainly did not move from this house until late summer of 1790, for his engraving of Fuseli's Timon and Alcibiades was 'Published by W. Blake, Poland St. July, 28: 1790.'

The house was a narrow one,[2] and behind the back garden was a timber yard instead of the St. James Infirmary Burying Ground which was behind the houses in Broad Street. One of the pleasant amenities of the new house, however, may have been the nearby pub called, today at least, the King's Arms, which was only a few doors away at no. 22 Poland Street. It may even at this time have been a gathering place for young artists. Twenty years later (in 1805) Wilkie wrote that he regularly

dine[*d*] at an ordinary [*in Poland Street*], a place where about a dozen gentlemen meet at 2 o'clock, and have a dinner served up that only costs them 13*d*. a head, which I am sure is as cheap as any person can have such a dinner in any part of Great Britain: besides, we have the advantage of hearing all the languages of Europe talked with the greatest fluency, the place being mostly frequented by foreigners: indeed, it is a very rare thing to see an Englishman; while there are Corsicans, Italians, French, Germans, Welsh and Scotch.[3]

Probably Blake ate there on occasion, or at least bought his porter at the King's Arms. One wonders whether he happened to be there on his 24th birthday when, according to the present inscription on the wall, 'In this Old King's Arms Tavern the ANCIENT ORDER OF DRUIDS was revived 28th November 1781'. It may have been here that he met enthusiasts who later turned his mind and myth into Druid

[1] Previous to 1785 the house was occupied by a man named Thomas Singer. In the Parish Poor Rate Book for 1785 (D.106) in the Observation column is written 'Nicho§ Charine', and underneath this is '3 2ᵈ Empty [1/2 *del*]', presumably meaning that it was empty from about March to September. Underneath these numbers is 'Wᵐ Blake—Xmas' quarter. This is confirmed by the 1785 Great Marlboro Ward Watch Rate (D.849) Observation: 'Wᵐ Blake Christ 1785 Empty 2 quarters'; and in the Great Marlboro Ward Church Rate for 1786 (D.1550): 'Wᵐ Blake Ch 85'. The 1786 Poor Rate (D.107) was £2. 2s. 0d. for a house valued at £18. Blake consistently paid the taxes for the Great Marlboro Ward Paving Rates (18s. 9d.) for 1786–90 (D.1263–8), except that in the last year 'John Davidge' is written in the margin; for Great Marlboro Watch Rates (7s. 6d.) for 1786–90 (D.851–60), though in the last year (D.859) also 'John Davidge' is entered; and for the Great Marlboro Church Rates (7s. 6d. in 1786–7, 9s. in 1788) for 1786–8 (D.1550, 1552–4)—the Great Marlboro Church Rates for 1789–91 have not survived.

[2] See the photograph of the exterior in T. Wright, *The Life of William Blake*, Olney, 1928, vol. ii, p. 4.

[3] A. Cunningham, *The Life of Sir David Wilkie*, London, 1843, vol. i, p. 80. Not many years later Shelley was lodging at 15 Poland Street and perhaps eating at the King's Arms.

channels, which appear particularly in *Milton* and *Jerusalem*. And it was surely while he was living in Poland Street that Blake met Thomas Butts, who by 1789 was living in a fine large house (rated at £44) about number 9, on the north side of Great Marlborough Street, not more than a street away from Blake.[1]

13 HERCULES BUILDINGS, LAMBETH (See Plate LVI)

1790–1800

WILLIAM BLAKE apparently moved into 13 Hercules Buildings, Lambeth, across Westminster Bridge and far from his old haunts, in the autumn of 1790, and he stayed there for ten years, until September 1800.[2] It was from this address that he sent in his drawing of 'The last supper' to *The Exhibition of the Royal Academy, M.DCC.XCIX.*

This house was, Tatham says (p. 522), 'a pretty, clean House of eight or ten Rooms',[3] and of the twenty-six attached houses in Hercules Buildings, Blake's was among the largest.[4] In the garden of no. 15 Hercules Buildings was a house owned by Philip Astley,[5] whose popular circus was only about three streets away.

While he was living in Hercules Buildings from 1790 to 1800 Blake

[1] Butts appears in the Poor Rates (D.110) for 1789, though he had not been there in 1787 (D.108). In 1816 many artists lived in Great Marlborough Street (including B. R. Haydon at No. 41), and the painter William Brockedon (1787–1854) lived in Poland Street (according to *Annals of the Fine Arts*, 1816). The architect Sir William Chambers lived in Poland Street about 1756–72; Dr. Charles Burney had been there 1760–70; and Paul Sandby the water-colourist moved from Dufours Court, Broad Street (a street away from no. 27), to Poland Street and stayed there from 1766 to 1772.

[2] According to the Rate Books 'William Blake' consistently paid the Poor Rates from 1791 (the authorization date for collection is March 9th) to 1800 (the last date in the Poor Rate book for 1800 is June 5th). The rates varied from 10*s.* to £1 a quarter, but were generally about 15*s.* (average 14*s.* 7½*d.*). In the first two quarters of 1790 the house was vacant, though 'Wm Clay' is entered in the margin for the second quarter. 'Wm Clay' is also there in the last two quarters (the last dated December), but this must be a mistake, perhaps from the similarity in the sounds of the names Blake and Clay. Certainly Blake left 28 Poland Street before the end of 1790, though he dated one plate from 'Poland St. July, 28: 1790'. Blake is replaced by Rebecca Arnold in the first 1801 Lambeth Poor Rate of March 6th.

[3] See the photograph of the exterior in T. Wright, *The Life of William Blake*, Olney, 1928, vol. i, p. 4.

[4] One house in the building was valued at £30, one at £21, two (including Blake's) at £20, and the other twenty-two at less. Hercules Buildings was torn down between 1928 and 1931, and the Corporation of London has built a rather humble residential structure called Blake Buildings on the site.

[5] The rates were paid from 1788 to 1800 by John Conway Philip Astley. The rate books for the area do not antedate 1788, so that it is impossible to tell from them when these buildings went up. For a story concerning Astley and Blake, see Tatham, pp. 521–2.

PLATE LVI

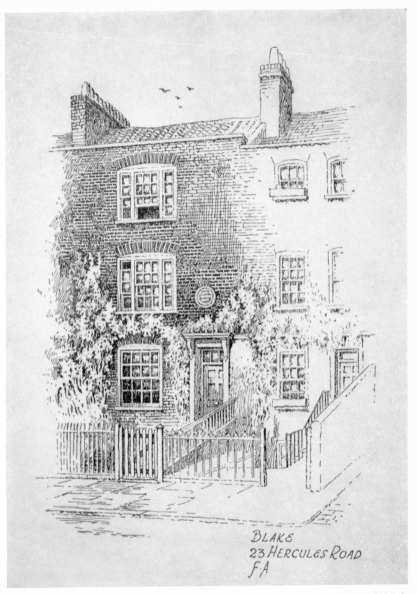

BLAKE
23 HERCULES ROAD
F.A

**SKETCH BY FREDERICK ADCOCK OF 13 HERCULES BUILDINGS,
LAMBETH,** where Blake lived from 1790 to 1800 and where he produced most of his
best-known works (see pp 560–1)

PLATE LVII

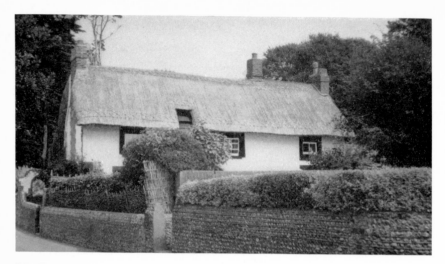

BLAKE'S COTTAGE IN FELPHAM where he lived near Hayley (1800–3) and probably wrote much of *The Four Zoas*

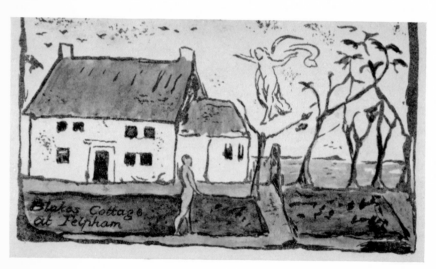

MILTON (?1808), pl. 36 (copy A) showing Blake's garden at Felpham, where the fairy Ololon descended to him, and from which, on another occasion, he ejected Private Scholfield

was more financially successful than at any other time of his life. Tatham's stories (pp. 522–5) defending Blake from the allegation of poverty may be associated with this period. One reason for his unwonted success may have been an improvement in his business methods. One of the few occasions on which he is known to have managed to enter his name in a London directory was in the spring of 1799, when the following striking constellation appears in [W.] *Holden's Triennial Directory* [Corrected to the end of April] 1799, p. 63:

Blake W. S.	*Engraver and Printer*	16, 'Change-alley, Cornhill
Blake William	*Engraver*	Lambeth Green
.
Blake James	*Hosier*	28, Broad-street, Carnaby-market

Lambeth in the 1790s was little more than a series of houses built along the roads and lanes through the meadows and marshes, and between Blake's house and Lambeth Palace (the residence of the Archbishop of Canterbury) on the south, and Blackfriars Bridge on the north, there was little but open fields. It was here that much of Blake's greatest and most characteristic work was done, 'At Lambeth beneath the poplar trees'.[1] *Tiriel, Thel,* and *The Songs of Innocence* were the products of Poland Street, but at Lambeth he wrote, designed, engraved, and printed much of the work for which he is best known: *The Marriage of Heaven and Hell, Visions of the Daughters of Albion, America, Europe, For Children: The Gates of Paradise, Urizen, Ahania, The Book of Los, The Song of Los, Songs of Experience, Vala,* and his hundreds of drawings and engravings for Young's *Night Thoughts.*

FELPHAM, SUSSEX (See Plate LVII)

1800–1803

WILLIAM BLAKE is known to have moved to his cottage in Felpham on Thursday night, September 18th, 1800.[2] His new home was a sturdy two-story thatched cottage of six rooms, for which he paid £20 a year to the landlord of the Fox Inn, some fifty yards away.[3] The ocean thundered on their swimming-beach close by, and 'Often, in after years, Blake would speak with enthusiasm of the shifting lights on the

[1] Notebook, p. 5. [2] Letter of Sept. 21st, 1800.

[3] See J. T. Smith, p. 461 and Gilchrist, 1942, p. 125; 1863, p. 147. The cottage still survives in private hands, apparently little changed, though the village has degenerated into a resort. Mr. Francis W. Steer, Archivist of the West Sussex County Council, tells me that the Rate Books for Felpham for the period Blake lived there have not been traced.

sea he had watched from those windows.'[1] At first he and Catherine were delighted with their new home—'It is a perfect Model for Cottages & I think for Palaces of Magnificence'[2]—but later it proved damp and cold, and troubles with Hayley must have embittered it for them.

Three years later to the day they were back in London,[3] and presumably for the first weeks they stayed with Blake's brother James in the family house at 28 Broad Street. As late as November 1803 George Cumberland reminded himself that ' *Blake [is]* now at his Brothers a Stocking Shop—Broad Street Carnaby Market'.[4] However, his information was a little out of date, for Blake's letters from October 26th, 1803 on are written from 'South Molton Street'.

17 SOUTH MOLTON STREET (See Plate LVIII*a*)
1803–1821

WILLIAM BLAKE lived at 17 South Molton Street, about a mile north-west of Golden Square, from the autumn of 1803 until 1821. The new house must have been a bitter contrast with Felpham, with 'neither garden nor tree'[5] to remind him of the open fields he had loved. It was perhaps here that George Cumberland saw most of Blake. Certainly he was always jotting down this address against Blake's name, often in conjunction with the addresses of his patrons. In 1808 he wrote in his notebook, 'Blake N 17 South Molton St', and later in the same book:[6]

Mr. Butts Fitzroy Square Corner of Grafton Square 27 [*illeg*]
Blake N 17 South Molton St

And that year, among a list of things to do and people to see, he included 'Edgerton & Blake'.[7] Next year he repeated that he would find 'Blake N 17 South Molton St', and just below this he noted 'Mr Malkin Hackney'.[8] In 1810 he reversed the names:[9]

[1] Gilchrist, 1942, p. 137; 1863, p. 157. Blake wrote of his wife and sister 'courting Neptune for an Embrace' on Sept. 23rd, 1800. Blake told R. C. Jackson's father that he drew 'The Deluge' 'on the sea-shore on a rough day at Felpham' (R. C. Jackson, 'William Blake at the Tate Gallery', *South London Observer*, 31 Oct. 1913). [2] Sept. 21st, 1800.

[3] On Sept. 19th, 1803, Blake wrote to Hayley on his arrival in London.

[4] BM Add. MSS. 36519D, f. 177; n.d. the next entry is Nov. 22nd, 1803.

[5] Gilchrist, 1942, p. 176; 1863, p. 183.

[6] BM Add. MSS. 36519I, ff. 385 and 401. On Nov. 30th, 1808 (BM Add. MSS. 36501, f. 298) Cumberland sent his son George a list of addresses which included S. Rogers, Douce, Phillips, Cosway and '—Blake No 17 South Molton St'. Perhaps he picked up Blake's address from the 1808 Royal Academy Exhibition catalogue.

[7] BM Add. MSS. 36519I, f. 412. 'Edgerton' may be the popular actor Daniel Egerton (1772–1835). It seems likely that Cumberland's note was made in September, for his quarterly dividend is entered on the same page.

[8] BM Add. MSS. 36519K, f. 471.

[9] BM Add. MSS. 36520A, f. 6. Cumberland may have known Malkin through their close mutual friend, Thomas Johnes of Hafod.

PLATE LVIII

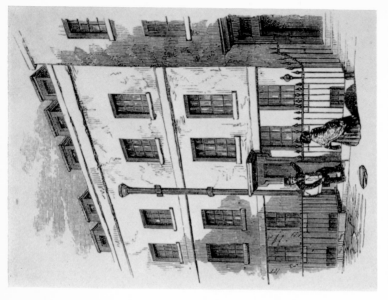

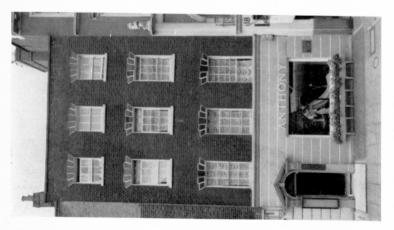

3 FOUNTAIN COURT, STRAND, where The Ancients knew Blake, and where he died (see pp. *564–7*)

17 SOUTH MOLTON STREET, where Blake lived from 1803 to 1821, and where he created *Milton* (?1808), *Jerusalem* (?1820), his Milton designs, and most of his Visionary Heads

Mr Malkin Hackney
Blake n 17 South Molton

Apparently by this time he had memorized the address, for though he still called on Blake from time to time, he only noted where Blake lived once more (1813), and then just to fix another address in his mind:

Townly N 61
Blake opposite[.]¹

At this address the rates were paid by a Mark Martin, who was presumably Blake's landlord. It seems probable that the Blakes had only rooms, not a whole house. Linnell wrote on April 3rd, 1830: 'When I first became acquainted with Mʳ Blake he lived in a first floor in South Molton Street and upon his Landlord leaving off business & retiring to France he moved to Fountain Court Strand, where he died.'² It is tempting to speculate whether Martin retired to France because his wife was French, and, if she was, whether Blake was referring to her when he said of his fresco of 'The Last Judgment': 'I spoiled that— made it darker; it was much finer, but a Frenchwoman here (a fellow lodger) didn't like it.'³

There were other lodgers in the house as well, including 'our Kind & attentive fellow inhabitant, the young & very amiable Mʳˢ Enoch, who gave my wife all the attention that a daughter could pay to a mother' until Blake's return from his trial on January 14th, 1804. One wonders if there can be a connexion between this 'fellow inhabitant' and Blake's separate engraving of Enoch of about 1807.

¹ BM Add. MSS. 36520c, f. 153. Cumberland's note is only roughly right, for 17 South Molton Street on the east is opposite no. 50 on the west. Probably the number should be 51; cf. June 3rd, 1814. The only figure of artistic note who lived in South Molton Street (according to *Annals of the Fine Arts* for 1818) was Cumberland's close friend, Edward Bird, who gave his addresses as 29 South Molton Street and Portland St, Kingsdown, Bristol. 'Blake, William, South Molton-street' appears under 'Engravers' (but not under painters) in 1816–19 in the *Annals of the Fine Arts* list of 'Names and Residences of the principal living Artists residing or practising in the Metropolis, with the Line of Art they profess, corrected up to the 1st of January'.

² However, Martin continued to pay the rates (according to the Rate Books) for some years after 1821, when Blake moved out.

For the parish of St. George, which includes South Molton Street, the information in the Rate Books is repeated but not amplified in the Land Tax records in the Middlesex County Record Office. (For Marlborough Ward, which includes the Broad Street area, the Land Tax records do not antedate 1825.)

³ Gilchrist, 1942, p. 350; 1863, p. 358. According to George Cumberland's son, the picture was already 'as black as your hat' on April 21st, 1815, so that the advice must have been given when Blake was still in South Molton Street.

CIRENCESTER PLACE

1812?–1827?

JAMES BLAKE appears to have lived in Cirencester Place from the time he retired from his business at 28 Broad Street in 1812 until 1827. It is difficult to trace his movements during this period, but according to Gilchrist (see June 15th, 1751) James Blake 'retired on a scanty independence and lived in Cirencester Street [*previously called Cirencester Place*]'. Cirencester Place first appears in the Rate Books in 1818, and James Blake's name occurs in them from 1818 to 1825.[1] Apparently he continued to live at the same address until his death, for on March 2nd, 1827, his body was brought from 'Cirencester Place' to be buried in Bunhill Fields. Perhaps for the last two years (1826–7) he was suffering from declining health or fortune and therefore took a smaller number of rooms in the same or a nearby house. He might even have lived with his near-neighbour in Cirencester Place, John Linnell.

3 FOUNTAIN COURT (See Plate LVIII*b*)

1821–1827

WILLIAM BLAKE lived at 3 Fountain Court, Strand, from 1821 to 1827; 'here he occupied the first floor & it was a private House Kept by M! Banes whose wife was sister to M!! Blake', according to Linnell's letter of April 3rd, 1830. The Rate Books confirm that the ratepayers were Henry and Mary Baines (or Banes) from 1820 to 1829.[2] It was in this house that The Ancients and Crabb Robinson met and knew Blake, and consequently there are more descriptions of it than of all his other residences put together. The gist of their impressions is that the rooms were small and dark, but that they were illuminated by a narrow view of the Thames and by the radiance of their occupants.

[1] This information was kindly sent to me by Ann Cox Johnson, Librarian-in-Charge of the Local Collection, Public Library, St. Marylebone, London, N.W. 1.

[2] The Poor Rate for Savoy Ward of St. Clement Danes, Parish of Westminster, give Henry Ba[i]nes for 1820–2, 1826–8; Mary Banes for 1823; and both for 1824 and 1825. The building is specifically called a 'House' to distinguish it from the warehouses in the area, and it was valued at £25. In 1829 Henry Banes is replaced by Richard Best. The marriage of Mary Boucher and Henry Baines is not recorded in her parish church at Battersea. None of Catherine Blake's sisters was christened in Battersea Church with the name of their mother, Mary, but perhaps Martha, Hester, Jane, or Sarah was so called.

According to *The New Complete Guide*, London, 1772, Andrew Blake, merchant, lived at 12 Fountain Court, but there is no evidence that he was related to the poet's family. W. Whitten (ed., J. T. Smith, *Nollekens and his Times*, London, 1920) said that Fountain Court was pulled down in 1902.

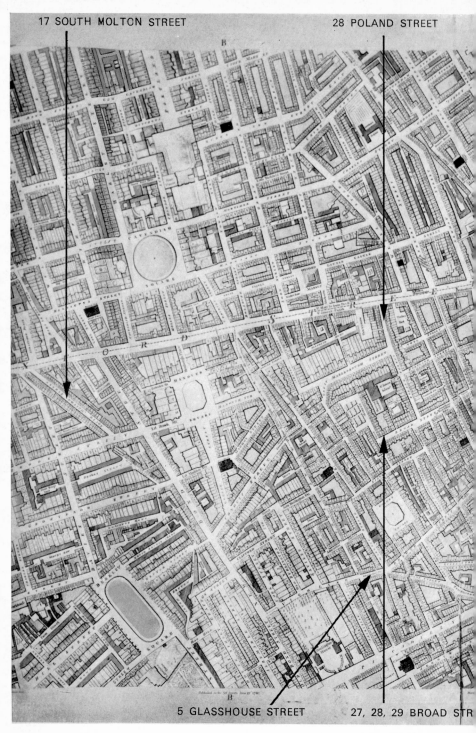

17 SOUTH MOLTON STREET 28 POLAND STREET

5 GLASSHOUSE STREET 27, 28, 29 BROAD STR

A small part (much reduced) of Horwood's splendid *Plan of the Cities of*

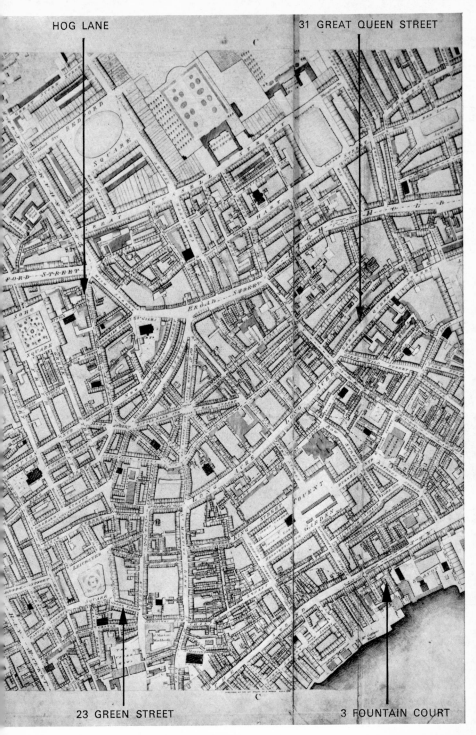

PLATE LIX

HOG LANE

31 GREAT QUEEN STREET

23 GREEN STREET

3 FOUNTAIN COURT

and Westminster (1792–99), showing Blake's residences in Westminster

The fullest account comes from Gilchrist, who reports:

Blake's two rooms on the first floor were approached by a wainscoted staircase, with handsome balustrades, such as we find in houses of Queen Anne's date, and lit by a window to the left, looking out on the well-like back yard below. Having ascended, two doors faced you, opening into the back and front rooms. That in front, with the windows looking out on Fountain Court, its panelled walls hung with *frescos*, *temperas*, and drawings of Blake's, was used as a reception room. From it a door opened into the smaller back room, the window of which (a side one) looked down a deep gap between the houses of Fountain Court and the parallel street; in this way commanding a peep of the Thames with its muddy banks, and of distant Surrey or Kent hills beyond.[1]

This was, at once, sleeping and living room, kitchen[2] and studio. In one corner was the bed; in another, the fire at which Mrs. Blake cooked. On one side stood the table serving for meals, and by the window, the table at which Blake always sat (facing the light), designing or engraving.[3]

There was an air of poverty as of an artisan's room; but everything was clean and neat; nothing sordid.[4] Blake himself, with his serene, cheerful, dignified presence and manner, made all seem natural and of course. . . . 'I should only like to go in this afternoon!' declared one friend, while talking of them to me. 'And, ah! that divine window!' exclaimed another. Charming and poetic the view from it seemed to those accustomed to associate Blake's person and conversation with it. While a third with brisk emphasis affirms, 'There is no "misery" in Blake's rooms, for men who love art, a 'good table' (not, of course, in the epicure's sense), 'and warmth.' 'I never

[1] Samuel Palmer wrote Gilchrist on Aug. 23rd, 1855 (1942, p. 301; 1863, p. 301): 'the high, gloomy buildings between which, from his study window, a glimpse was caught of the Thames and the Surrey shore, assumed a kind of grandeur from the man dwelling near them'. See the sketch by F. J. Shields of the interior of this room, with the window, in T. Wright, *The Life of William Blake*, Olney, 1928, vol. ii, p. 108, and the picture of the exterior of the building in F. W. Fairholt, 'Tombs of English Artists. No. 7.—William Blake', *Art Journal*, iv (1858), 236, revealing spiked iron railings in front of no. 3.

[2] Tatham (p. 525) says the apartment consisted of '2 good sized rooms & Kitchens', but presumably by 'Kitchens' he meant pantries and cupboards.

[3] Palmer wrote on Aug. 23rd, 1855 (1942, p. 303; 1863, p. 303): 'He delighted in Ovid, and, as a labour of love, had executed a finished picture from the *Metamorphoses*, after Giulio Romano. This design hung in his room, and, close by his engraving table, Albert Dürer's *Melancholy the Mother of Invention*, memorable as probably having been seen by Milton, and used in his *Penseroso*. There are living a few artists, then boys who may remember the smile of welcome with which he used to rise from that table to receive them.'

[4] In a letter of May 3rd, 1860 Palmer protested (1942, p. 306; 1863, p. 306): 'whatever was in Blake's house, there was no squalor. Himself, his wife, his rooms, were clean and orderly; everything was in its place. His delightful working corner had its implements ready—tempting to the hand. The millionaire's upholsterer can furnish no enrichments like those of Blake's enchanted rooms.'

'look upon him as an unfortunate man of genius. He knew every great man 'of his day, and had enough.' . . .[1]

'There was a strange expansion,' says one of his friends, 'and sensation 'of FREEDOM in those two rooms *very* seldom felt elsewhere.' And another, who as a little girl, visited the rooms with her father, can only remember the beautiful things she saw on the walls, and Blake's kind manner to herself.[2]

. . . Blake's fellow lodgers were humble but respectable. The court did not, in those days, present, as now, its idle groups of women, hanging about outside the doors, with free and easy, not to say unfinished, toilets.[3] There was no excessive noise of children in the court. Children at play there doubtless often were, as one of Mr. Palmer's anecdotes would indicate.[4]

These rooms were enchanted ground for many of Blake's young friends, and years later George Richmond drew a plan of them to revive his memory:—'The fire-place was in the far right-hand corner opposite the window; their bed in the left hand, facing the river; a long engraver's table stood under the window (where I watched Blake engrave the *Book of Job*. He worked facing the light), a pile of port-folios and drawings on Blake's right near the only cupboard; and on the poet-artist's left—a pile of books placed flatly one on another; no bookcase.'

Were there any pictures on the walls?

'No, not many in the work-room but a good number in his show-room, which was rather dark.'

'Blake often spoke of the beauty of the Thames, as seen from the window, the river looking "like a bar of gold." '[5]

But wherever he was living, whether in a delicious cottage as in Felpham, or in a couple of cramped rooms up an alley off the Strand,

[1] Gilchrist, 1942, pp. 305–6; 1863, pp. 305–6; these impressions were 'gleaned from the recollections of others who knew him there'.

[2] Gilchrist, 1942, p. 306; 1863, p. 307; the 'little girl' was probably Linnell's daughter.

[3] Elsewhere Gilchrist wrote (1942, p. 282; 1863, p. 277): 'No. 3, then a clean red-brick house, is now a dirty stuccoed one, let out, as are all in the court, in single rooms to the labouring poor. That which was Blake's front room was lately [*about 1860*] in the market at four and sixpence a week, as an assiduous inquirer found.'

[4] Gilchrist, 1942, p. 308; 1863, p. 308. Palmer's anecdote is presumably the one in his letter of Aug. 23rd, 1855 (1942, p. 301; 1863, p. 301): 'His voice and manner were quiet, yet all awake with intellect. Above the tricks of littleness, or the least taint of affectation, with a natural dignity which few would have dared to affront, he was gentle and affectionate, loving to be with little children, and to talk about them. "That is heaven," he said to a friend, leading him to the window, and pointing to a group of them at play.' Elsewhere in the same letter Palmer wrote: 'he thought that no one could be truly great who had not humbled himself "even as a little child." This was a subject he loved to dwell upon, and to illustrate.'

[5] The dialogue is reported in *Anne Gilchrist: Her Life and Writings*, ed. H. H. Gilchrist, London, 1887, pp. 261–2.

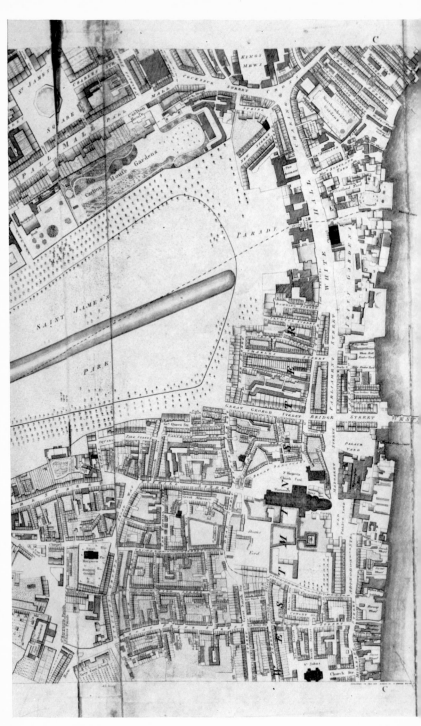

Another part of Horwood's *Plan* (1792–99), showing Blake's house in La

PLATE LX

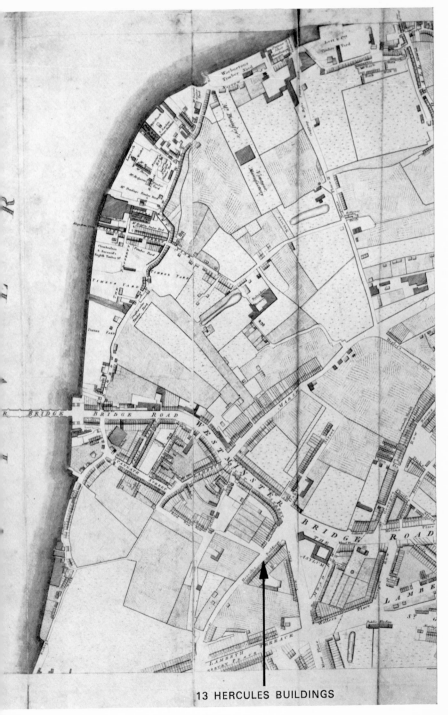

13 HERCULES BUILDINGS

the right and Westminster Abbey and the Houses of Parliament across the river

Blake's thoughts were elsewhere. ' "I live in a hole here," he would say, "but God has a beautiful mansion for me elsewhere." "Poor, dear man," exclaimed one of his friends to me, "to think how ill he was used, and yet he took it all so quietly." '[1]

CIRENCESTER PLACE
1827–1828

CATHERINE BLAKE lived with John Linnell from September 11th, 1827 (q.v.) until about March or June 1828 (see Tatham, p. 534) at his house in Cirencester Place. Here she was Linnell's housekeeper, for which she was paid about £20 (see March 9th, 1831). It does not seem to have been a very happy arrangement, for Catherine appears to have disliked Linnell and to have suspected him of using Blake for his own profit.

20 LISSON GROVE
1828–1831?

CATHERINE BLAKE lived as housekeeper to Frederick Tatham and his wife at their house at 20 Lisson Grove from 1828 probably until early in 1831 (see Tatham, p.535). Tatham merely says that Catherine lived with them until she was too 'decayed' to be able to continue to help. It seems likely from Tatham's account that she lived with the young couple, to whom she was deeply devoted, until a few months before her death. While she was with them she made a sketch, which Tatham inscribed: 'A Drawing made by Mrs. Blake taken from something she saw in the Fire during her residence with me'.[2]

17 CHARLTON STREET
1831

CATHERINE BLAKE lived at 17 Charlton Street for the last few months of her life. According to Gilchrist, 'she removed into humble lodgings at No. 17, Upper Charlotte Street, Fitzroy Square, in which she continued till her death' (see Tatham, p. 534). Gilchrist's 'Charlotte Street' is clearly meant for 'Charlton Street'. Tatham wrote from 17 Charlton Street on October 18th, 1831 to tell Linnell that he had been with Catherine when she died that morning,[3] and on October 23rd her body was brought from '17 Upper Charlton St Fitzroy Square' and buried in Bunhill Fields. She must have been merely a lodger at this address, however, for the rates were paid by Henry Heather from 1825

[1] Gilchrist, 1942, p. 308; 1863, p. 309.

[2] Geoffrey Keynes, *Bibliotheca Bibliographici*, London, 1964, no. 474.

[3] Since Tatham's own address was 20 Lisson Grove North, from which he wrote to Linnell on March 15th, 1831 and March 1st, 1833, Tatham must have been at Catherine's lodgings, rather than vice versa.

to 1834.[1] George Cumberland made a note of her address in his copy of *For Children: The Gates of Paradise* (C): 'M^rs Blake now lives at N 17 Charlton St Fitzroy Square at a Bakers. 1830', and in successive years he wrote in his notebooks: 'M^rs Blake 17 Charlton St Fitzroy Sq'; 'M^r Blake Wid? 17 Charlotte St. Fitzroy Sq.'; 'Mr. Blakes wid? 17 Charlotte St. Fitzroy Sq.';[2] but he was clearly out of touch with Catherine, for the last two entries were made long after her death.

[1] This information from the Rate Books was generously sent to me by A. J. D. Stonebridge of the St. Marylebone Public Library.

[2] BM Add. MSS. 36521F, f. 362 (1831); G, f. 431 (1832); H, f. 489 (1833).

SECTION III

BLAKE ACCOUNTS

═══

This Section presents Blake Accounts, covering his and his wife's lifetimes. It aims to give all records of his receipts and of payments relating to him, in chronological order.

There are four independent groupings of Accounts which are linked to each other and to the main text above by cross-references. These are:

A. Separate Accounts, receipts, and isolated records (1783–1831).

B. Linnell's General Account Book, pruned of all but Blake references (1818–36).

C. Linnell's *Job* Accounts, including various other payments relating to Blake, given in toto (1823–34).

D. Linnell's payments to Mrs. Blake (1827–28).

At the end is a Summary of Accounts year by year.

A

SEPARATE ACCOUNTS, 1783–1831

For '*The Fall of Rosamund*, from Stothart, [*engraved*] by Blake, [*and published October 1st, 1783, Macklin paid*] 80 l.'[1]

October 1st, 1783

Early in 1795 Flaxman 'Pd for . . . Blakes Book . . . 10[s] 6', and in October he paid for 'Blake's Engravings —— 4[s] —'.[2]

October, 1795

In Flaxman's 'Study Account for 1796' under July [24th?] is 'Blake —— 5 5 –'.[3]

July 24th, 1796

Blake's eight plates for Cumberland's *Thoughts on Outline* 'cost me [*Cumberland*] Two guineas each and the coppers'.[4]

In his account book, Flaxman noted, between May 6th and 13th 1797, that he paid for 'Blake's book, binding, 3[s] —'.[5]

May 6–13, 1797

[1] Anon., 'Monthly Retrospect of the Fine Arts', *Monthly Magazine*, xi (April 1801), 246, an 'Account of some of the Prices paid to Engravers by the late Mr. Macklin'.

[2] BM Add. MSS. 39784G, ff. 3, 13. [3] BM Add. MSS. 39784H, f. 13.

[4] Letter to Longman & Rees, Jan. 10th, 1804 (now in the files of Longmans, Green & Co. Ltd.).

[5] BM Add. MSS. 39784H, f. 29. The Flaxmans are known to have owned *Innocence* (D, 1790?), *Innocence and Experience* (O, the former dated 'April 1817', the latter perhaps 1800), and *Poetical Sketches* (F, inscribed May 15th, 1784).

October, Flaxman paid 'Blake —— 2 2 –' in early October 1797.[1]
1797 The note 'Blake —— 5 1 –'[2] in Flaxman's account book for the early
October part of the week ending October 12th, 1799, may represent part payment
5th– for Blake's plates in Flaxman's *Letter to The Committee for Raising the*
12th, *Naval Pillar,* 1799.
1799 The receipt for the full payment reads:

December Received [*Saturday*] Dec^r 14 1799 of M^r Flaxman the Sum of Eight
14th, pounds Eight shillings for Engraving Three Plates for the Statue of
1799 Britannia & Twelve Shillings & Eight pence for Copper

Will^m Blake

 8. 8. 0
 0. 12. 8
 ———————
 £9. 0. 8[3]

August Blake signed a receipt for Thomas Butts amounting to £14. 14s. 0d.
20th, for eleven drawings, including 'The Three Maries', delivered on July
1803 8th and August 20th, 1803.[4]

These appear to be among the last drawings for the 'order for Fifty small Pictures [from the Bible] at one Guinea each' which Blake told Cumberland about on August 26th, 1799 (though he did not name 'my employer'). When Blake went to Felpham he had apparently already completed twenty-nine of these drawings, for he still had twenty-one to do. He had taken with him three specific canvases and orders (November 22nd, 1802), but though he had begun work on the 'Three Maries' on October 2nd, 1800, he admitted to neglect of Butts's order on September 11th, 1801, and clearly the neglect lasted longer than that. At last on November 22nd, 1802 he sent 'Two Pictures', un-named, said that other work, presumably including the 'Three Maries', was 'in great forwardness', and reminded Butts 'that the remaining Number of Drawings which you gave me orders for is Eighteen'. (This presumably means 'Drawings for which subjects have not yet been specified', and would therefore not count the 'Two Pictures' just sent or the 'Three Maries'.) On July 6th, 1803 Blake sent his 'Riposo', and said: 'I have now on the Stocks [in great forwardness] the follow-ing drawings for you 1 Jephthah sacrificing his Daughter 2. Ruth &

[1] BM Add. MSS. 39784i, f. 6.
[2] BM Add. MSS. 39784j, f. 18.
[3] Transcribed from a photostat of the MS. in the Haverford College Library. This is the only external evidence that Blake engraved two of these three plates.
[4] This receipt has not been traced since it was sold at Sotheby's, June 24th, 1903. Most of the Butts receipts below are in the possession of Kerrison Preston. Up to Dec. 7th, 1808 they regularly have stamps: twopence on those of £4–£5, plus June 2nd, 1807, January 14th, July 29th, 1808; fourpence on those for £10 to £16. 7s. 4d.; eightpence on £21 to £28. 6s. 0d.

her mother in Law & Sister 3. The three Maries at the Sepulcher 4 The Death of Joseph 5 The Death of the Virgin Mary 6 St Paul Preaching & 7 The Angel of the Divine Presence clothing Adam & Eve with Coats of Skins[.]' On August 16th Blake sent these '7 Drawings' which he thought 'about balances our account', and said he was 'go[*ing*] on with the Subjects which you gave me commission to Execute for you'. I cannot explain how the one drawing sent on July 6th and the seven on August 16th became eleven drawings when delivered on July 8th and August 20th, 1803, except by supposing that this receipt also covers the miniature of Butts sent September 11th, 1801 and the 'Two Pictures' sent November 22nd, 1802. The extra three guineas (£14. 14s. 0d. for eleven 'one Guinea' pictures) may be accounted for by supposing that they paid for the frame for the miniature and the eight canvases Butts had not bought for Blake before Blake left London, and for which, therefore, Blake had had to advance the money himself.

These facts seem to reveal a very curious accounting practice. Apparently Butts gave Blake advances on work in hand (the August 16th delivery 'balances our account'), which were recognized and accounted for after the fact, as in the above receipt. The receipts should instead perhaps read 'Received of Mr Blake 11 drawings on further account [or for £14. 14s. 0d.] Thomas Butts'. With other receipts we should therefore suspect that the date marks not the payment of cash but the delivery of merchandise.

For the titles of the last ten pictures from the order for fifty Bible pictures, see the Account for March 6th, 1806.

The 'Account of Money Recievd & Work done' which Blake sent to Butts with his letter of November 22nd, 1802 has not been traced.

[*Tuesday*] 22: Janry 1805

Received of Mr· Butts twelve Pounds twelve Shillings on further account
William Blake

£12. 12—

January 22nd, 1805

Since, according to the Longman accounts,[1] the cost of 'Engraving 5 New plates [*for Flaxman's* ILIAD *in April 1805 was*] —— 26 6 ,,', Blake must have received £15. 15s. 0d. for his three plates.

April, 1805

[*Friday*] 5 July 1805

Received of Mr· Butts five Pounds seven Shillings on further account
William Blake[2]

£5 ,, 7 ,, –

July 5th, 1805

[1] Longmans Impression Book No. 3, f. 21. For fuller details, see G. E. Bentley, Jr., *The Early Engravings of Flaxman's Classical Designs*, N.Y., 1964, p. 35.

[2] The items for which this partly paid are specified under March 6th, 1806.

[*Saturday*] 7: Sept.ʳ· 1805

Received of Mʳ· Butts four Pounds four Shillings on further account

WILLIAM BLAKE¹

£4 ,, 4

*March
3rd,
1806*

On Thursday, March 3rd, 1806 Blake straightened out his accounts with Thomas Butts:

Mʳ Butts	Dꝛ		Cʳ
[*Sunday*] May 12 1805 Due on Account——	0. 4. 0	[*Saturday*] Janʸ 12 [*1805*] By Cash———	12. 12. 0
12 Drawings Viz 1 Famine 2 War 3 Moses Striking the Rock 4 Ezekiels Wheels 5 Christ girding himself with Strength 6 Four & twenty Elders 7 Christ Baptizing 8 Samson break ᵍ bonds 9 Samson subdud 10 Noah & Rainbow 11 Wise & foolish Virgins 12 Hell beneath is moved for thee &ᶜ from Isaiah——	12. 12. 0²	[*In the receipt this is Jan 22 1805*]	
[*Friday*] 5 July [*1805*] 4 Prints Viz 1 Good & Evil Angel 2 House of Death 3 God [*Creating del*] Judging Adam 4 Lamech———	4. 4. 0	5 July By dº———	5. 7. 0³
[*Wednesday*] 21 Augˢᵗ [*1805*] 4 Nᵒˢ of Hayleys Ballads⁴———	0. 10. 0		

¹ The items for which this partly paid are specified under March 6th, 1806.

² Numbers 3–12 in this list are the last ten drawings for Butts's order for fifty small pictures from the Bible, which are discussed at greater length under Aug. 20th, 1803. These ten drawings were clearly produced between the summer of 1803 and May 12th, 1805, and were probably delivered at intervals during that time.

³ This entry is also covered by a separate receipt.

⁴ This and all the other 'Ballads' mentioned are clearly the 1802 issue, which sold for 2*s*. 6*d*. apiece. Probably each entry represents one of the four numbers printed. This particular entry is referred to in Blake's letter of Nov. 22nd, 1802: 'I also enclose you some Ballads by Mʳ Hayley'.

[*M*ʳ *Butts* *Dᴿ*]	[*Cᴿ*]

[*Saturday*] 7 Septʳ [*1805*]	7 Septʳ
4 Prints Viz	By dᵒ———— 4. 4. 0[1]
1 Nebuchadnezzar 2	
Newton 3 God Creat-	
ing Adam	
4 Christ appearing——— 4. 4. 0	
[*Thursday*] Decʳ 12 [*1805*]	
Touchˢ up Christ	
Baptizing———— 1. 1. 0	
Should be 22.15 £21. 15. 0	Should be £22.3 £21. 3. 0

[*Verso*]

Dᴿ Mᴿ Butts	Cᴿ
Broᵗ over———— £22. 15. –	Broᵗ over————£22. 3. –
Drawings &c sent	Balance due from me
from Felpham——— 14. 14. –[2]	previous to my going
	to Felpham——— 14. 10. 8[3]
Urizen, Heaven &c &	
Songs of Experience	
for balance[4]———— –,, 10. 6	By Coals[5] to [*Satur-*\ } 12. 19. –
	day] 5: Octoᴿ }
	1805———— }

[1] This entry is also covered by a separate receipt.

[2] This is almost certainly the delivery referred to in the receipt of Aug. 20th, 1803, q.v.

[3] This most curious entry seems to mean that, when *Blake* went to Felpham in Sept., 1800, Butts had advanced him £14. 10s. 8d. beyond moneys already received by Blake for work done. The '7 Drawings' Blake sent on Aug. 16th, 1803 he thought 'about balances our account'. Here, as elsewhere, the system seems to be to enter sums already paid by Butts only after Blake had completed work for them. All the entries in this list seem to be for 1805 or 1806 except the £14. 14s. 0d. and the £14. 10s. 8d. which Butts had paid him previous to his move to Felpham. Apparently on Aug. 16th, 1803 Blake had sent drawings worth 3s. 4d. more than he had been paid (£14. 14s. 0d. minus £14. 10s. 8d.), though this seems to have been converted to 4s. at the head of the list under May 12th, 1805, and to have been ignored in the Aug. 20th receipt.

Admittedly this explanation of this debtor–creditor list neither accords with normal accounting practice nor makes all the items balance precisely.

[4] Since the 1793 cost of the *Marriage* alone was 7s. 6d., the low price suggests that these may have been separate plates such as those (*Urizen*, pls. 1, 4, 25, *Marriage*, pls. 5–6, *Songs*, pls. 30–2, 37, 40, 42, 44, 47, 51) later bound with other Blakeana including the 'Order' of the *Songs*.

[5] According to his Will (proved June 23rd, 1845 and now in Somerset House, London), Butts owned a number of mines, which may help to account for why Blake was paid in coals.

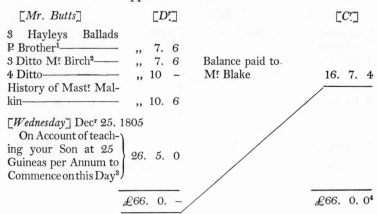

[*Mr. Butts*]

3　Hayleys　Ballads
P. Brother[1]——————　,,　7.　6
3 Ditto M.ʳ Birch[2]——　,,　7.　6
4 Ditto—————————　,,　10　–
History of Mast.ʳ Mal-
kin——————————　,,　10.　6

[*Wednesday*] Dec.ʳ 25. 1805
　On Account of teach-
ing　your　Son　at　25　} 26.　5.　0
Guineas　per　Annum　to
Commence on this Day[3]

£66.　0.　–

[*D.ʳ*]

[*C.ʳ*]

Balance paid to.
M.ʳ Blake　　　　16.　7.　4

£66.　0.　0[4]

Affixed to this long document by a wafer is the receipt which clears
the account:

　　Recievd of M.ʳ Butts, [*Sunday*] March 3. 1806 the Sum of Sixteen
Pounds Seven & Four pence Balance to this day as per Annexed
Account

　　　　　　　　　　　　　　　　　　　William Blake

£16.　7.　4

[*Monday*] 30: June 1806

*June
30th,
1806*

　　Received of M.ʳ Butts twenty one pounds ten Shillings on account for
sundry Drawings

　　　　　　　　　　　　　　　　　　　Will.ᵐ Blake

£21 ,, 10 ,, 0

¹ This lot is referred to in Blake's letter to his brother James of Jan. 30th, 1803:
'I send with this 5 copies of N.4 of the Ballads for M.ʳˢ Flaxman & Five more two of
which you will be so good as to give to M.ʳˢ Chetwynd if she should call or send for
them.' The odd three obviously went to Butts.

² Presumably these are the Ballads referred to in Blake's letter to Butts of
April 25th, 1803: 'I now send the 4 Numbers for M.ʳ Birch'. Evidently Birch kept
one for himself and Butts got the rest.

³ For more details about this relationship, see Winter 1806.

⁴ The original document is in the possession of Kerrison Preston. Each sum has
a check against it. (All the first page appears to be written by Blake, while the
credit side of the second page seems to be in Butts's hand.) The 'History of Mast.ʳ
Malkin' is B. H. Malkin's *A Father's Memoirs of his Child*, which seems to have
been delivered (or paid for?) by Christmas Day 1805, despite the fact that the
preface is dated Jan. 4th, 1806 and Cromek's plate after Blake is dated Feb. 1st,
1806. The date on which the lessons commenced ('this Day') was probably March
3rd, for the next payment is exactly a year later—see March 3rd, 1807.

[*Tuesday*] 9 Sept^r· 1806

Receiv'd of M^r· Butts six Pounds six Shillings for Drawings Songs of Innocence &c¹

William Blake

£6 ,, 6 ,,

[*Wednesday*] 15: Oct^r· 1806

Received of M^r Butts five Pounds 5/. on further account

Will^m Blake

£5 ,, 5 ,, —

In the week ending November 22nd, 1806 Flaxman paid for 'Blake's drawing —— 1 1 [0]'.² This is probably the 'singularly grand drawing of the Last Judgment, by Blake' which was bought at Flaxman's sale at Christie's on July 1st, 1828.

[*Thursday*] 29: Janry 1807

Received of M^r Butts Twenty one Pounds on further account

William Blake³

£21 —

Recievd [*Tuesday*] March 3. 1807 of M^r· Butts the Sum of Twenty Eight Pounds Six Shillings on Account

Will^m Blake

28. 6. 0 [*Below is added in pencil:*]

Tom— 26. 5
Drawings in } 28. 6
full to this 2. 1
 day—

28. 6.
25. 4. 6

3. 1. 6⁴

[*Tuesday*] 2: June 1807

Received of M^r· Butts twelve Pounds 1/6 on further account

William Blake

£12. 1 ,, 6 —

¹ This is probably *Songs of Innocence and of Experience* (E) which Butts owned. This receipt is quoted in *Letters of William Blake*, ed. G. Keynes, London, 1956, from the original in the possession of Ruthven Todd.
² BM Add. MSS. 39784N, f. 25.
³ Reproduced in facsimile in A. E. Briggs, 'Mr. Butts, the Friend and Patron of Blake', *Connoisseur*, xix (1907), 92–96.
⁴ The figures in the lower left itemize the work for which money was due.

July
13th,
1807

[*Monday*] 13, July, 1807—

Received of Mʳ· Butts Fifteen Pounds 15/- on further account

£15 ,, 15 — William Blake

[*Tuesday*] 6: Octoᵗ 1807—

October
6th,
1807

Received of Mʳ· Butts Ten Guineas on further account

£10 ,, 10 — William Blake

London Decʳ 30, 1807

December
30th,
1807

Received of Mʳ Cromek Engraver ten pounds ten shillings which together with the proof prints of Chaucer's Pilgrims and the poem of the Grave designs by Blake is and will be in payment for a Manuscript now delivered.

T Holcroft[1]

January
14th,
1808

[*Thursday*] 14: Janry 1808—

Received of Mꜟ Butts twenty six pounds 5/- on further account

 for Wᵐ Blake
 Catherine
£26 ,, 5 Blake[2]

February
29th,
1808

[*Monday*] 29: Febry 1808—

Received of Mꜟ Butts Ten Pounds on further account

£10 ,, —[3] William Blake

July
29th,
1808

[*Friday*] 29: July 1808—

Received of Mʳ· Butts Ten Pounds on further account

£10— William Blake

November
3rd,
1808

[*Thursday*] 3: Novemᵗ 1808—

Received of Mꜟ Butts five Guineas on further account

£5 ,, 5 ,, Willᵐ Blake

December
7th,
1808

[*Wednesday*] 7: Decᵗ 1808—

Received of Mꜟ Butts five Guineas on further account

£5 ,, 5 ,, – William Blake

April
7th,
1809

[*Friday*] 7: April 1809—

Received of Mʳ Butts Twenty one Pounds on further account

£21—[4] William Blake

[1] The MS. of this receipt, kindly pointed out to me by Mr. Richard Shroyer, is in an extra-illustrated Royal Academy catalogue for 1808 in the Royal Academy Library. Thomas Holcroft appears in the subscription list to the 1808 Blair, but his 'Manuscript' probably has nothing to do with it.

[2] This is the annual fee for tutoring Tommy, though six weeks early.

[3] Not counting the twenty-five-guinea fee for tutoring Tommy, from March 3rd, 1807 to Feb. 29th, 1808 Blake received a total of £50. 7s. 6d., almost a guinea per week.

[4] In 1808–9 Blake received considerably less from Butts, for the total from Feb.

Blake's receipt to Butts for £10. 10s. 0d. 'On further account' is dated Thursday, June 19th, 1809.[1]

[*Monday*] 10: July 1809—

Received of M^r. Butts ten Guineas on further account

William Blake

£10 ,, 10 —

[*Thursday*] 10: August 1809—

Received of M^r. Butts ten Guineas on further account

Will^m Blake

£10 ,, 10 —

[*Wednesday*] 4: Octo^r 1809—

Received of M^r Butts ten Guineas on further account

Will^m Blake

£10 ,, 10 —

[*Saturday*] 25: Nov^r 1809—

Received of M^r Butts, twenty Pounds on further account

William Blake

£20—[2]

[*Tuesday*] 16. Janry 1810—

Received of Mr. T. Butts twenty one Pounds on further account

William Blake

£21—

[*Saturday*] 3: March 1810—

Received of M^r. Butts ten Guineas on further account

William Blake

£10 ,, 10 —

[*Saturday*] 14: April 1810

Received of M^r. Butts twenty one Pounds on further account

William Blake

£21—[3]

29th, 1808 to April 7th, 1809 is only £41. 10s. 0d., and this must include the fee for tutoring Tommy.

[1] Dec. 19th, 1932, Sotheby sale of the property of (among others) Anthony Bacon Drury Butts.

[2] Perhaps because of the failure of his exhibition, Blake was being paid much more than his usual guinea a week by Butts. In the seven months since the April receipt he received £62. One basis for extra money was probably Blake's miniature of Tommy Butts, inscribed on the back 'T. Butts, Junr., Engr / Aetat 20 / 1809' (Sotheby sale of the Butts Collection, Dec. 19th, 1932, Lot 125).

[3] If we calculate that the £125 from Butts since Dec. 7th, 1808 included Tommy's two twenty-five-guinea tutorial fees for 1808 and 1809, the total remaining (£72. 10s. 0d.) is just under a guinea a week for the seventy weeks since Dec. 1808.

April 23rd, 1810 In his Small Diary for April 23rd, 1810 Crabb Robinson noted that he had been to Blake's exhibition and paid for '4 Catalogues Blakes Exhib 10 —'.

June 30th, 1810

<center>[*Saturday*] 30: June 1810—</center>

Received of M͞r Butts five Guineas on further Account

<div align="right">Will͞m Blake</div>

£5 ,, 5 ,, —

July 14th, 1810

<center>[*Saturday*] 14: July 1810—</center>

Received of M͞r Butts fifteen Guineas on further account

<div align="right">William Blake</div>

£15 ,, 15 ,, —

September 20th, 1810

<center>[*Thursday*] 20: Sept͞r· 1810</center>

Received of M͞r Butts ten Pounds ten Shillings on further account

<div align="right">William Blake</div>

£10 ,, 10 —

December 18th, 1810

<center>[*Tuesday*] 18: Dec͞r· 1810</center>

Received of M͞r· Butts ten Pounds ten Shillings on further account

<div align="right">William Blake</div>

£10 ,, 10 —

This is the last receipt from Butts. Gilchrist says that eventually even Butts 'grew cool . . . and during the few remaining years of Blake's life they seldom met.'[1]

In the ten years for which we have records, Butts gave his protégé: 1803–6—£99. 1*s*. 0*d*.; 1807—£87. 12*s*. 6*d*.; 1808—£56. 16*s*. 0*d*.; 1809—£83; 1810—£94. 10*s*. 0*d*; a total of £420. 18*s*. 6*d*.

December 27th, 1810 Two days after Christmas, 1810, Crabb Robinson noted in his Small Diary that he had bought 'Blakes Young's Night Thoughts 1 11 6'.

May 28th, July 9th–30th, 1814 In the weeks ending May 28th and July 9th, 1814 Flaxman paid 'Blake 2 – –', and in the week of July 24th–30th he bought 'Blake's Song's — 1 – –'.[2] Perhaps he was paying Blake in instalments for colouring his copies of *Songs of Innocence* or *Songs of Experience*.

November 11th, 1816 In the Wedgwood files under November 11th, 1816 is a note of payment to 'William Blake Engraver London w ac[?] on acco͟t of engraving [?*ledger no.*] 261 [£]30 C[*onsideratio*]ⁿ',[3] for the plates he had engraved in December 1815.

The contract for Flaxman's *Hesiod*, 1817, with Blake's plates, was

[1] Gilchrist, 1942, p. 287; 1863, p. 282.

[2] BM Add. MSS. 39784U, ff. 2, 5, 6.

[3] Quoted from a photostat of the original in the Wedgwood Museum.

not signed until quite late in its history, on February 24th, 1816.[1] The Longman records for the book begin in 1814.

			Blake's Hesiod	[£	s.	d.]
		[*Blake charges for each of the*] Plates		5.	5.	0
1814		10–10–0— 17/10				
Sep.	22	To M⁺ Blake for 2 plates & 2 Coppers[2]		11	7	10
	24	,, Rylance Reading MS—		—	10	6
Oct	7	,, M⁺ B for 2 plates 10–10– Coppers 17/6		11	7	6
	27	,, M⁺ B for Dᵒ ——10–10– Copper 5/4		10	15	4
Nov.	15[3]	,, Dᵒ —— for 2 Dᵒ —— 10–10— copper 25/10				
				11	15	10
Dec.⁺	3	,, Dᵒ —— 2 Dᵒ—— 10–10— & dᵒ 16/7½		11	6	7½
	30	,, Dᵒ —— 2 Dᵒ—— 10–10— & 2 Copp⁺				
[*1815*]		16/6		11	6	6
Feb	10	,, Dᵒ —— 3 Dᵒ——		15	15	
		,, Dᵒ —— for 4 Coppers——		1	14	4½
Mar	11	,, Dᵒ —— for 2 plates——		10	17	6
June	15	,, dᵒ —— for 1 Plate & Copper——		5	13	6
Dec.	7	,, Dᵒ —— for 2 plates——		10	10	
		,, Dᵒ —— Coppers——			17	6
1816						
Jan'y	4	,, Dᵒ —— for a plate——		5	13	6
Apr.	10	,, Dᵒ —— for plates & Coppers		11	3	–
	18	,, Dᵒ —— for 1 plate & Copper——		5	11	6
May	17	,, Dᵒ —— for 2 plates & Coppers——		11	4	–
June	21	,, Jeffreys Writing to 14 plates[4] @ 7/.——		4	18	–
		,, Cox & B— proof 14 plates[5]——			7	–

[1] BM Add. MSS. 39791, f. 21.

[2] The cost of the copper seems to vary inexplicably, from 2s. 8d. to 12s. 11d. each. Blake was paid once (Feb. 10th, 1815) for one more copperplate than he delivered, perhaps because one plate had been accidentally spoiled.

[3] In the Bodleian Library are proofs before letters of the thirty-seven Hesiod plates, some called 'Blake's Hesiod' (2, 7, 11, 16, 22, 29, 37), and some labelled 'Flaxman's Hesiod' or 'Flaxman' (18, 34, 35). Many are dated in MS., and these dates correspond to the days on which Blake was paid for his engravings, as follows: Plate 7 (15 Nov.), 2 (13 Dec.), 22, 26 (30 Dec. 1814), 14, 37 (11 March), 29 (15 June 1815), 18 (5 Jan.), 34, 35 (10 April), 13 (18 April), 15, 30 (17 May), 16, 33 (29 June), 28, 32 (27 Aug.), 17, 31 (18 Oct. 1816).

[4] Apparently it was at first hoped that the work could be published in June, for the proof of Plate 2 in Bodley is inscribed in MS. 'London, Published by Longman, Hurst, Rees, Orme & Brown Paternoster Row June 1816', but when June came eleven plates were not yet finished. The '14 plates' to which Jeffreys added writing on June 21st, 1816 were probably the fourteen dated Nov. 1st, 1816 (3–11, 22, 23, 25–27). At that time Jeffreys had in hand but did not add the writing to Plates 2, 13–15, 18, 29–30, 34, 35, 37, and two others.

[5] The Cox & Barnett proofs were clearly pulled in order to read the new writing

[*£* *s.* *d.*]

[June] 29 *[To]* M͏ͬ Blake for 2 plates & Coppers——— 10 18 6
Aug͏ͭ 26 ,, do——— do——— 11 1 6
Oct. 18 ——— d͏ᵒ——— 2 pl & co——— 11 3 –

[Carry] to opposite page *[in pencil:]* 185 18
1816 Blake's Hesiod
 From opposite page *[in pencil:]* 185 18
 10–10– 12/6
Dec͏ͬ 10 To M͏ͬ B——— For 2 plates & 2 Coppers 11 2 6
 ,, Jeffreys writing to 20 plates[1]——— 7 ———
 1817 altering writing of 6 plates 1 1 –
Jan 23 M͏ͬ B for 3 plates £15..15..0
 3 Coppers ,, 18 ,, 16 13 ,,
 ,, Cox & B— proofs 6/. Dec 7— 3/. Dec 28 9 –
 28 ,, Jeffreys altering 5 plates——— 5 –
Feb 10 ,, do writing to pl 1. 12. 37[2]——— 1 1 –
 21 ,, do label——— 10 6
Jan 11 ,, C & B 31 proofs 15/6———feb 15———4 proofs 2/- 17 6

 [in pencil:] 224 17 6[3]

August
12th, Recieved. *[Wednesday]* 12 August of M͏ͬ Linnell Two Pounds
1818 W Blake[4]

September
11th, Recievd *[Friday]* 11 Septemb͏ͬ 1818 of M͏ͬ Linnell the Sum of Five
1818 pounds on account of M͏ͬ Uptons Plate
 5. 5. 0 William Blake[5]

added to the plates by Jeffreys. Blake probably pulled the Bodley proofs on his own press.

 [1] At this point Jeffreys had added the writing to all the plates Blake had so far completed. The alterations below may perhaps be accounted for by the MS. corrections on Bodley Plates 2, 7, 11, 15, 16, 20, 22, and 25.

 [2] These three plates (delivered Jan. 23) and the previous twenty are dated Jan. 1st, 1817. Plate '37' is probably the proof of Plate 20 in Bodley, in which the printed number '37' has been corrected in pencil to '20'.

 [3] Longmans Miscellaneous Publication Expenses, ff. 269͏ʳ–268͏ᵛ *[sic]*. Longmans Impression Book No. 6, f. 70, summarizes Blake's part:

 Engraving 37 plates @ 5 guineas, Blake ——— 194 5 –
 Copper for do ——— ——— do 13 13 –

For sales and other records of Hesiod, see G. E. Bentley, Jr., *The Early Engravings of Flaxman's Classical Designs*, N.Y., 1964, pp. 53–56.

 [4] Except for those otherwise specified, all the Linnell receipts are transcribed from photostats of the originals in the Yale University Library and are also recorded in Linnell's account book below. This payment was clearly an advance on the Upton portrait.

 [5] The original, with a threepenny stamp, is in the possession of Sir Geoffrey Keynes.

Mr Linnell Dr

[*Saturday*] 19 Septembr 1818 To Willm Blake
For Laying in the Engraving of Mr Uptons portrait—— 15. 15. 0
 Recievd on this account 7. 0. 0[1]

 8. 15. 0

Recievd [*Monday*] 9 Novr of Mr Linnell The Sum of Five Pounds on Account
 William Blake

5. 0. 0

Recieved [*Thursday*] 31 Decembr 1818 of Mr Linnell the Sum of Three Pounds Fifteen Shillings the Balance of Account of Mr Uptons Plate
 William Blake

3. 15. 0

[*Friday*] August 27. 1819
Recievd One Pound Nineteen & Sixpence of Mr Linnell for Songs of Innocence & Experience One Copy William Blake[2]

1. 19. 6.

Recievd [*Wednesday*] 30 Decembr 1819 of Mr Linnell the sum of Fourteen Shillings for Jerusalem Chap 2[3]
 Willm Blake

0. 14. 0

Recievd [*Monday*] April 30: 1821 of Mr Linnell the Sum of Two Guineas for Heaven & Hell[4]
 Willm Blake

£2. 2 .0

Recievd [*Friday*] 1 March 1822 of Mr Linnell Three Pounds on Acot.
 William Blake

£3. 0. 0

[1] This is, of course, simply a statement of what had changed hands on Aug. 12th and Sept. 11th. The £8. 15s. 0d. was still due, and was paid on Nov. 9th and Dec. 31st, 1808.

[2] On June 9th, 1818 Blake had written that the price of the combined *Songs* was £6. 6s. 0d. A flyleaf watermarked 1824 demonstrates that the white vellum on this copy (R) was put on after Linnell had acquired it, probably at the same time he had his *Jerusalem, Marriage, Europe*, and *America* put into similar bindings.

[3] This is part of Copy C. Blake may have been issuing *Jerusalem* in parts (in the Accounts—p. 585—this is called '2nd No') because the rest was not completed.

Sideways in the corner of this sheet is written Linnell's cryptic note to himself: '2 £. to Father Paid by Mr Varley lent 1/6'. [4] This is copy H.

November 2nd, 1822

According to his account book, in the week ending November 2nd, 1822 Flaxman paid 'M.̠ Blake —— 3 – [0]'.[1]

On the back of the 'Memorandum of Agreement between William Blake and John Linnell [*concerning* JOB] March 25t͟h 1823' (q.v.) is written this note:

March 25th, 1823

1823.

March 25th £

Cash. on acc.̠ of Plates in the foregoing agreement—— 5. 0.—[2]

September 16th, 1825

[*Friday*] September 16. 1825. Received of Mr. Linnell for the Wood-Blocks executed by Mr. Blake two guineas for Mr. Mr. Mr. Harrison R. I. Thornton M.D. [*sic*][3]

January 18th, 1826

John Linnell's father James, a framemaker, noted in his account book the order of 'Mr Varley [*Wednesday*] Jany 18th 1826 21 flatts for M.̠ Blakes Prints'.[4]

March 9th, 1826

London [*Thursday*] March 9 1826

Rec.̠d of Mr Linnell Forty nine pounds nineteen Shillings & 11.̠d for printing Proofs of Job on India Paper—
£49. 19. 11

 J Lahee[5]

July 14th, 1826

London [*Friday*] July 14: 1826

Recievd of M.̠r John Linnell, the Sum of One Hundred & fifty Pounds for the Copy-right & Plates (Twenty-two in number) of the Book of Job. Publishd March 1825 by Me: William Blake Author of the Work.

N.̠o 3 Fountain Court Strand

Witnes: *Edw.̠d Jno Chance*[6]

[1] BM Add. MSS. 39784z, f. 24.

[2] In fact, the money had been paid on March 14th, according to Linnell's Account Book.

[3] *Catalogue of an Exhibition of Drawings, Etchings & Woodcuts by Samuel Palmer and other Disciples of William Blake*, Victoria & Albert Museum, London, 1926, p. 28.

[4] Ivimy MSS., f. 73 of James Linnell's account book. 'Blakes Prints' are probably unfinished proofs for *Job*. Perhaps 'flatts' should be 'Matts'.

[5] Ivimy MSS. There is a 1*s.* stamp on the receipt. Lahee's bill is entered in Linnell's Account Book as £50. N.B. The printer's name has often been transcribed as 'Laker', but it should be 'Lahee', as this signature clearly shows. His address was Castle Street, Oxford Market.

[6] In his letter to Linnell of the same day Blake had written a very similar statement:

To M.̠r John Linnell—July 14: 1826

I hereby Declare, That M.̠r John Linnell has Purchased of Me. The Plates & Copy-right of Job; & the same is his sole Property.
Witness William Blake
 Edw.̠d Jno Chance

Confusion may have arisen because the March 1825 inscription on the plates listed

Recieved [*Saturday*] 29 July 1826 of M^rs Ade^rs by the hands of M^r Linnell the Sum of Five Pounds Five Shillings for the Songs of Innocence.

<div style="text-align: right">July 29th, 1826</div>

<div style="text-align: right">William Blake</div>

£5. 5. 0[1]

George Cumberland wrote in his diary for Wednesday January 16th 1828:

By M^rs Blakes account paid her through Sydney—for the Card—	3. 3. –	*January 16th,*
for the Copy of Job——	2 12 6	*1828*
making a part of his Q^rs rent to Xmas & took his receit——[2]	£5 16. 6	

Cumberland made another undated memorandum to himself of these facts on the end-papers of the same notebook:

Ordered M^rs Blake for the Job—	2 12 6
& for the Plate with name——	3. 3
to be ded. by Sydney from my Xmas [*word illegible*] rent. & took [?] recet.[3]	

Next day Linnell recorded the same facts in his own Diary: '1828 Jan^y Th 17 M^r Cumberland came & paid M^rs Blake for the card plate 3 gs & for the copy of Job 2.12.6'.

<div style="text-align: right">*January 17th, 1828*</div>

Blake as the publisher, while the label of March 1826 (when the work was in fact published) listed both Blake and Linnell as publishers. On April 24th, 1826 Balmanno had implicitly questioned Linnell's rights in *Job*, and the July 14th, 1826 statements were evidently intended to make clear that for £150 Linnell had made *Job* 'his sole Property'.

According to the *Job* accounts (p. 605) Blake had in fact been paid £150. 19s. 3d. by about Oct. 30th, 1825, and this was £50 more than had been specified in the original agreement.

[1] This was for copy AA of *Innocence aud Experience*. On Aug. 8th, 1835, about the time they were selling off their collections of art works, Mrs. Aders wrote to Linnell that she had understood the price of her portrait, which he was painting, was to have been twenty-five guineas; 'when therefore you took Blakes Songs of Innocence &c at 6 G^s I of course concluded I had only 20 £ to pay'. She went on to say that she wouldn't pay more for the portrait, but that a friend might, 'in which case when you receive the money you will send us the 6 G^s for Blakes work' (Ivimy MSS.). Linnell apparently acceded to their proposal, for this copy of the *Songs* is inscribed: 'Given to James Tho^s Linnell by John Linnell sen^r, April 28 1863.'

[2] BM Add. MSS. 36521c, f. 154. George, Sr. must have backdated his diary, for he cannot have heard of the payment so soon—cf. Jan. 15th, 1828. Linnell entered receipt of this sum in his Account Book as Jan. 7th, which is almost certainly over a week too soon.

[3] BM Add. MSS. 36521c, f. 220. The numbers are deleted.

January 28th, 1828

Rec^d Jan^y 28. 1828 of Mr Linnell Ten Pounds eighteen Shillings for the Funeral Expences of the late Mr W^m Blake as ℙ Bill Deliv^d

B Palmer & Sons[1]

£10..18..0

[*Saturday*] May 16th 1829

May 16th, 1829

Receivd of Mr. J. Linnell one pound Eleven shillings & Sixpence for Homers Illiad & Oddisy

for M^rs Blake
Frederick Tatham[2]

March 31st, 1831

An unsigned receipt for Tuesday March 8th, 1831 preserved by Linnell was for 'Set of Job—8..8..0'.[3]

B

LINNELL'S GENERAL ACCOUNT BOOKS, 1818–1836

Up to August 8th, 1821 I quote from a transcript of Linnell's Account Books by A. H. Palmer in an Exercise Book (now with the Ivimy MSS.) headed 'Blake Accounts' (pp. 3–7). These entries are given in very slightly different form (chiefly dates and prices given at greater length) by A. H. Palmer in another Exercise Book with the Ivimy MSS. headed 'Blake Boyd Dante' (p. 38), which adds no new information. These entries are clearly from a 'Cash Account' book which has not survived.

After 1821 the entries are quoted from a little book (5¼ in. by 7¾ in.) headed 'Cash Account' which is also with the Ivimy MSS. This is Linnell's original account book. The pages are not foliated, and the dates range from January 2nd, 1822 to December 31st, 1836, averaging about two or three a week. The list includes all Linnell's expenses and receipts, including prints bought, payments of £1 to Dr. Thornton, colours from Newman, books from Palmer of Broad Street, and so on. The Blake entries are interspersed among these.

1818			[£	s	d]	
August 12	*M^r Blake* on account		2			[*Receipt*][4]
Sept 11	,,	of Plate of M^r Upton	5			[*Receipt*]

[1] Quoted from the MS. in the Huntington Library.

[2] This book is identified by A. T. Story, *The Life of John Linnell*, London, 1892, vol. i, p. 78, as *The Whole Works of Homer; prince of Poetts* In his Iliads, and Odysses. Translated according to the Greeke, by Geo: Chapman. London, [1616]. Blake's copy itself has not been traced.

[3] Ivimy MSS. This does not appear in the *Job* accounts. I cannot account for the high price.

[4] Entries for which Blake's receipt survives are identified thus in brackets, and will be found above entered separately.

[*1818*]			[*£ s. d.*]		
Nov 9		on account	5		[*Receipt*]
[*Dec. 31*	M^r *Blake on account*		5]		[*Receipt*]¹
1819					
Aug 27	For Book of Designs		2		[*Receipt*]²
Dec 31	2nd N° of Jerusalem			14	[*Receipt*]³
1820					
Dec^r 10	For prints		1⁴		
1821					
Feb 4	Balance of Jerusalem			15⁵	
April 30	—A copy of marriage of Heaven & Hell		2	2	[*Receipt*]
August 4	For a design		1	1⁶	
8	On acct of a Book of Europe & America not finished		1⁷		
[*1822*]			Paid		Rec^d
3 [*March*]	to D^r Thornton——		1 –		
	to M^r Blake		2 –	–	[*Receipt*]
.					
5 March	to M^r Blake—— on acct		2 –	–⁸	
.					

¹ This entry does not appear in the transcripts of the Account Book, and is known only from the receipt given above.

² This is identified in the receipt as *Songs of Innocence and of Experience*, and the price as £1. 19*s*. 6*d*. It is revealing that Linnell thought of the book primarily as 'Designs' and not as poetry.

³ The receipt for this is dated Dec. 30th, but both transcripts of the Account Book agree on the 31st.

⁴ Since no receipt exists for this entry, we can only guess at what it represents. Unless it was separate prints, it was probably *All Religions are One* (copy A), *Songs of Innocence* (copy I), or Chapter III of *Jerusalem* (copy C), which Linnell is known to have owned, and for which there are no receipts. The *Jerusalem* chapter seems most likely.

⁵ Since no receipt specifies how many chapters this 'Balance' consists of, we can only guess from the price that it was only the last chapter (see above, Dec. 31st, 1819). Linnell's Journal mentions a visit to Blake on Feb. 3rd.

⁶ Since no receipt identifies this design, it is a mere guess that this may have been Plate 11 of *Europe* (now in the Melbourne Art Gallery).

⁷ Linnell's copies of *Europe* (K) and *America* (O) are now richly finished, so Blake must have tinted them after Linnell's purchase.

⁸ Blake signed a receipt for £3 on March 1st, 1822.

In his Journal for Feb. 19th, 1822 Linnell noted that he had been 'To Bank Sold £950 5 p^r Ct. ƒ 103 3/4 & Bot 1000 4 per Cts at 98 3/4'. ([S. Calvert], *A Memoir of Edward Calvert Artist*, London, 1893, p. 59, asserts that Linnell would never bank his money or accept cheques, and that after his death it took days to count his cash on hand. Clearly if there is any truth in Calvert's story it applied only to the

[*1822*]			[£	s.	d.]			
May 8ᵗʰ	to Mʳ Blake on accᵗ——		5	–	–			
	W Blake¹							
	Dᵒ	Dᵒ ——	2	–	–			
.								
June 19	to Mᵗ Blake on accᵗ——		1	–	–			
.								
[*1823*]								
[*March 14*]	to Mʳ· Blake on accᵗ of							
	Engravings of Job²		5	–	–	[*Receipt*]		
.								
[*May 3*]	to Mʳ Blake on accᵗ of Job³		3	–	–			
[*May*] 5	Dᵒ	Dᵒ——	10	–	–			
.								
[*July 10*]	to. Mᵗ Blake on accᵗ of Job⁴		3	–	–			
.								
[*Aug. 2*	*To Mr Blake on account of Job*⁵		2	–	–]			
[*August*] 17	to Mʳ Blake on accᵗ [*of Job*]⁶		1	–	–			
.								
[*Sept. 3*]	to Mʳ Blake on accᵗ [*of Job*]		2	–				
[*Sept. 14*	*To Mr Blake on account of Job*		1	–	–]			
[*Sept. 25*	*To Mr Blake on account of Job*		2	–	–]			
[*Oct. 12*	*Mr Baily's subscription paid To*							
	Mr Blake on account of Job		1	–	–	1	–	–]
.								
[*Oct.*] 20	to Mʳ Blake on accᵗ of Job——		1	–				
.								
[*Nov. 6*]	to Mʳ Blake on accᵗ [*of Job*]		1	–				
.								

end of Linnell's life.) A. H. Palmer calculated (in an Exercise Book with the Ivimy MSS. headed 'Job Revise (2)', p. 1) that Linnell's income in 1822 was £899.14*s.* 6*d.*

¹ Blake's signature is written very shakily in his own hand.

² In the *Job* 'Memorandum of Agreement' of March 25th, 1823 Blake acknowledges receipt of this sum which, as the above entry makes clear, he had received eleven days previously, but in the *Job* Accounts below it is dated March 20th. This is the earliest mention of *Job*.

³ In the *Job* Accounts this entry is dated May 2nd. Frequently the dates in the two Accounts do not coincide, but I cannot explain the discrepancies. Probably the *Job* Accounts are the more accurate, as I have found no omissions in them, whereas there are numerous omissions in the Account Book.

⁴ This is dated July 11th in the *Job* Accounts.

⁵ In at least sixteen cases Linnell forgot to make an entry related to Blake in his Account Books. I have inserted these entries *in italics* and within square brackets. Many and perhaps all of these omitted entries are for money or coal given to Blake by someone else on Linnell's behalf.

⁶ Hereafter, when entries simply 'on account' have '[*of Job*]' entered in brackets, it means that the purpose of the payment is specified in the *Job* Accounts.

[*1823*] [£ *s.* *d.*]
[*Nov.*] 13 to Mʳ Blake on acctᵗ [*of Job*]—— 1 – –

.
[*Nov. 15* *Mr. Balmanno's subscription paid to*
 Mr Blake on account of Job 1 – – 1 – –]
[*Nov. 16*]¹ to Mʳ Blake on acctᵗ [*of Job*]—— 6 – –

.
[*Dec.*] 15 to Mʳ Blake on acct [*of Job*]—— 5 – –

.
[*1824*]
[*Jan. 10*] to Mʳ Blake on acctᵗ of Job—— 7 – –
 of Mʳ Leigh Bookseller.² Sub. for Job—— 2 – –

.
[*Jan.* *For coal sent to Mr Blake* 3 5 9]
Feb 2 to Mʳ Blake on acctᵗ [*of Job*]—— 5 – –

.
[*Feb.*] 11³ to Mʳ Blake on acctᵗ of Job 10

.
[*March 29*] to Mʳ Blake on acctᵗ of Job 5 – –

.
[*May 4* *Mr Muss's subscription paid to Mr*
 Blake on account of Job 1 – – 1 – –]
[*May 7*]⁴ to Mʳ Blake on acctᵗ of Job 10 – –
[*June 11* *For coal sent to Mr Blake* 1 17 –]

.
[*June 12*]⁵ to Mʳ Blake on acctᵗ of Job 5 – –

.
[*July*] 6 to Mʳ Blake on acctᵗ of Job⁶ 5 5 – [5 5 –]
[*Aug. 18* *To Mr Blake on account of the portrait*
 of Mr Lowry 5 – –]

.
[*Sept. 11*] to Mʳ Blake for Mʳ Stephen⁷ 1 1 –
.

¹ This entry is dated Nov. *18th* in the *Job* Accounts.

² The *Job* Accounts add that the subscription was for Mr. Willowby, and that it was paid directly to Blake.

³ This is entered under Feb. 21st in the *Job* Accounts.

⁴ This is given as May 6th in the *Job* Accounts.

⁵ This is given as June 11th in the *Job* Accounts, and the entry for coals, which succeeds it, has no date and may in fact be for July or August.

⁶ The *Job* Accounts indicate that this was Dr. Thornton's subscription, which was paid to Blake.

⁷ Apparently George Stephen was paying Blake through Linnell for something, but what it was we can only guess. Stephen is not known to have owned any works in Illuminated Printing. This could of course be part of Stephen's subscription to *Job*, but he does not appear in the *Job* Accounts.

[*1824*] [£ s. d.]
Nov^r 10 to M^r Blake on acc^t of the Plate of
 the Portrait of M^{r.} Lowry—— 5 – –

.
[*Dec. 25* *To Mr Blake on account of Lowry* 5 – –]
[*1825*]
[*Jan. 28*]¹ to M^r Blake——D° [*i.e., on
 account*] 10 – –

.
[*March 3*] Proofs at Dixons—— – 14 8
[*March*] 4 Paper——D°——²

.
[*March*] 12 to M^r Blake on account of Job 5 –

.
[*April 8*] to M^r Blake on acc^t of Job—— 3 10 –

.
[*May*] 3 to M^r Blake on acc^t of Job—— 5 –

.
[*May*] 5 to M^r Palmer³ for one chaldron of
 Coals to be sent to M^r Blake.—— 2 13 6

.
[*June*] 6 to M^r Blake on acc^t of Job——⁴ 2 – –

.
[*June*] 28 to Lahee.⁵ Bill to this date—— 7 6 10

.
[*Aug. 21*] to M^r Blake on acc^t of Job—— 3 – –

.
[*Sept. 3* *To Mr Blake on account of Job* 1 – –]
[*Sept. 6*]⁶ to M^r Blake on acc^t of Job—— 10 – –

.
[*Sept.*] 27 to M^r English for Binding—— 2 1 –
[*Sept.*] 30 of M^r Riviere—sub[*scription*]. for
 Job—— 1 –

¹ This is dated Jan. 27th in the *Job* Accounts, where it is also made clear that £5 of this was for the engraving of Lowry and £5 for *Job*. Linnell's Journal, however, records a visit to Blake on the 28th.

² Linnell apparently forgot to enter the cost of the paper on March 4th. In the *Job* Accounts there are two entries under Dixon for proofs, and proofs and paper, at £1 apiece, which imply that the March 4th entry above should be £1. 5s. 4d. On the next day, March 5th, he mentions in his Journal going 'With M^r Blake to Lahee's proving Job', suggesting that the switch from Dixon to Lahee was rather abrupt.

³ This was Thomas Palmer, Linnell's father-in-law, who also sold books.

⁴ Acknowledged in Blake's letter of the 7th.

⁵ Lahee was the printer of *Job*, but whether his 'Bill to this date' included work on it, or whether the bill was exclusively for Linnell's numerous other projects, I cannot say. The accounts with Lahee below (May 20th, 1826) are extremely perplexing. In the *Job* Accounts is an undated bill to Lahee between March and Sept. 1825 for 10s. which may have been for work done by this particular day, June 28th, 1825. ⁶ This is dated Sept. 4th in the *Job* Accounts.

[1825]		[£	s.	d.]			
Oct 1ˢᵗ	to Mʳ Blake on accᵗ of Job——	1	–	–			
[Oct.] 3	to Mʳ English for Bᵈⁱⁿᵍ two Sets of Job¹		6				
.							
[Oct.] 6²	to Mʳ Blake on accᵗ of drawings of Paradise Regained——	5	–	–			
.							
[Oct.] 30	to Mʳ Blake on accᵗ of Job——	5					
	Dᵒ Dᵒ by Mʳ Flaxmans payment³	3	3	–	[3	3	–]
[Nov.?]⁴	*Mr Calvert's subscription*				1	–	–
	paid to Mr Blake on account of Job	1	–	–]			
.							
[Nov.] 19	to Mʳ Blake on accᵗ of Paradise regᵈ	5	–	–			
[Nov.] 26	to Mʳ English Bᵈᵍ Job——		3	–⁵			
.							
[Dec. 21]	to Mʳ Blake on accᵗ of Dante⁶	3	–	–			
.							
[1826]							
[Jan. 6]	*Mr Robinson's subscription to Job*				3	–	–
	*paid to Mr Blake on account*⁷	3	–	–]			
[Jan. 27]	to Mʳ Palmer for 1 chaldron of coals sent to Mʳ Blake——	2	19	6			
[Feb.?]⁸	*Of Mr Harrison for his copy of Job*				2	12	6]
.							
[March] 9	to Mʳ Lahee for Printing & paper of 150 sets of Book of Job—on India paper	50	–	–	[*Receipt*]⁹		

¹ This entry suggests that the previous one for Mr. English was for binding fourteen sets of *Job*. There is no reference to Mr. English in the *Job* Accounts unless that for Nov. 1825 is for his work.

² This entry is dated Oct. 10th in the *Job* Accounts.

³ The *Job* receipts were kept somewhat irregularly in Linnell's general Account Book. It seems odd, for instance, that there is not a corresponding receipt for money *from* Flaxman as well (though there is in the *Job* Accounts proper). Clearly, however, Flaxman gave the money directly to Blake, and Linnell made this entry in his Account Book on the basis of his wife's letter to him of Oct. 18th.

⁴ In the *Job* Accounts, this entry follows the last dated Oct. 30th, and could be any time thereafter, but since it is only a partial subscription (Calvert eventually paid the full £2. 12s. 6d.) it was probably made in advance of publication.

⁵ In the *Job* Accounts for Nov. 1825 is a debit for 'Binding 3 sets—7 6', so Linnell has probably omitted a 4s. 6d. entry for binding.

⁶ This is the first reference to *Dante*. I assume the subsequent payments on account are for *Dante*. ⁷ See below, April 15th, 1826.

⁸ Harrison wrote ordering the *Job* on Jan. 31st, 1826, but the receipt of his subscription in the *Job* Accounts is undated.

⁹ The *Job* receipts are extremely confusing—see below, May 20th, 1826.

[*1826*] [£ s. d.]

.

March 9 to White for Book for Job¹ 2 4 6
[*March 9* *to White for 1 ream of paper* 1 6 –*]

.

[*March 9*] to M^r *Freeman for Printing* the Job 1 –

.

[*March 9*] to M^r Blake on acc^t of Dante 2 – –

.

[*March 22*] to M^r Tickman[?] for 500
 Labels²—— 10 6

.

[*March 28*]³ of T. G. Wainwright Esq for one
 Copy of Job Proof—— 5 5 –

.

[*March 25*] to M^r Blake D^o [*i.e., on account*] 5 –
 to M^r Collins at Hampstead Farm
 one Quarter Rent— 10 10 –

.

April 9 of M^r Stewart for his Copy of Job—— 4 14 6
 of M^r Vine for a copy of Job proofs—— 5 5 –
[*April*] 15 of M^r Taylor C.B.F. prison by
 Hands of F Tatham—for Job
 proofs⁴ 5 5
 of Lady Torrens for Job——⁵ 5 5 –
 of M^r Prosser[?] Charing X for
 Job prints⁶ 3 3 –

.

[*April 15*] of M^r Robinson for 3 copies of
 Prints Job—bal——⁷ 6 9 –

¹ In the *Job* Accounts this is entered 'to Mr White for Boarding', presumably referring to part of the binding process. The reference below to paper for interleaving (cf. Balmanno's letter of April 22nd, 1826) supports this conclusion.

² Linnell was clearly preparing himself for a heavy sale of *Job*, for he printed 500 labels for 315 sets of the work.

³ The letter enclosing this payment was dated the 29th.

⁴ In the *Job* Accounts this is amplified to 'Taylor being [*in*] s[*ai*]^d H[*ouse*]. of C[*orrectio*]^n for swindling'.

⁵ In the *Job* Accounts this is entered under Sir Henry Torrens.

⁶ I read this name with some hesitation; it could be 'Peoper'. The address following his name is Linnell's standard way of indicating a bookseller.

⁷ On Jan. 6th, 1826 Crabb Robinson told Blake: 'I had procured him two Subsc^s for his Job from Geo: Proctor & Bas: Montagu[.] I p^d £1 on each'. In the *Job* Accounts the total Robinson paid is given as £9. 9s. 0d., the normal price for three plain copies of *Job*. Robinson must therefore have given Blake £3 on Jan. 6th (as deposits for his own subscription plus those for Proctor & Montagu), which properly belonged to Linnell, and which Linnell debited to Blake's account without remembering to enter it in his Account Book.

Blake Accounts 591

[April 15, 1826]	[£	s.	d.]	
& for M^r Blakes Songs——		5	5	
to M^r Blake the money for the Songs of Inn——[1]	5	5	–	
[April] 22 to M^r Leighton on acct	5	–		
[April 27?] *Balance of Balmanno's Subscription*		1	12	6
paid to Mr Blake on account[2]	1	12	6]	
[April] 29 to M^r Leighton balance of acc^t for Binding books for Job——[3]	4	2	6	
of M^r Butts for his Copy of Job——[4]		3	3	–
of M^r Riviere bal for D^o——		1	12	6
of M^r Parker of Oxford for D^o[5]		2	12	6
of M^r Leigh (Strand) for D^o——		–	12	6
of M^r Chantrey for copy of Job——		5	5	–
of M^r Westmacott for D^o——		5	5	–
of M^r F. Tatham for his Copy of Job——[6]		2	12	6
of M^r Geo Young—for D^o——		3	3	–
of D^r Ley for—— D^o——		3	3	–
of M^r Bury for Copy of Job——		5	5	
[April 29?] *Of Mr Waters for a copy of Job*		2	12	6]
[April 29?] *Sir T. Lawrence's subscription*		5	5	–
paid to Mr Blake on account[7]	5	5	–]	
[May 20] to M^r Lahee (his Bill) final[8]——	40	–	–	

[1] This was copy Z; cf. Robinson's Diary for Feb. 18th, 1826.

[2] Cf. Balmanno's letter of April 24th, 1826.

[3] In the *Job* Accounts, Leighton's bill for 'Bind^g & Paper &c' is £13. 17s. 0d. so there must be a suppressed payment to him of £9. 14s. 6d. between March 9th, when *Job* was printed, and this date.

[4] The *Job* Accounts specify that this was a special price for a proof copy 'because he lent the Drawing to Copy'.

[5] See E. T. Daniell's letter of April 11th, 1826.

[6] In the *Job* Accounts this is entered as C. H. Tatham, Frederick's father.

[7] These two entries are undated in the *Job* Accounts, and are entered under April 29th simply because more subscriptions are entered under that date than under any other, and because they are unlikely to have been made either before or much after *Job* was actually published. The *Job* Accounts explain the entry above as follows: 'Sir T.L. sent 10 Gs. to Mr Blake', '[£5. 5s. 0d.] for one Copy [*of* JOB *for himself*]'; 'the extra 5 Gs. which Sir T.L. gave [*and which Blake kept*] is not reckoned against Mr Blake [*because*] Sir T.L. perhaps intended it for the copy presented to him [*free*] for the library of the Royal Academy.'

[8] The accounts with Lahee are very confusing. Not only does the entry 'Paid to M^r Lahee for 150 sets of Proofs on India paper' appear as £50 in the Account Book above [March 9th, 1826] and £56. 5s. 0d. in the *Job* Accounts, but the debits, the credits, and the dates rarely correspond. Even assuming that the *Job* Accounts

[*1826*] [*£ s. d.*]

[*May 30*] to M^r Blake on acc^t——¹ 2 12 6
 D°——² 1 12 6
 D°—— 2 – –

.
[*June 29*] of M^r Bohnes for Book of Job—— 2 12 6

.
[*July*] to M^r Blake on acc^t——³ 5 – –

.
[*July 12*] to M^rs Blake——⁴ 3 – –

.
[*July 29*] to M^r Blake for Songs of Inn
 M^rs Aders 5 5 – [*Receipt*]
[*July 29?*] *of Mr Aders for copy of Job*⁵ 5 5 –]

.
[*Aug.*] of M^r Bailey for Job (bal.)—— 1 12 6

.
[*Aug. 17*] to M^r Blake for Aders Cant
 Pilgrims⁶—— 2 2 –

.

under 'Expenses of the Book of Job' are charges and not payments, and that any single payment may comprehend either more or less than a single charge, the entries still do not balance.

JOB *Accounts*			*General Accounts*		
Lahee's Charges			Paid Lahee		
June? 1825 (N.B.)	10.	0	June 28, 1825 (N.B.)	7	6 10
Sept. 1825	2 –	–			
Oct. 1825	2 –	–			
March 1826	56 6	–	March 9, 1826	50	– –
March 1826	16 3	–			
March 1826	10 10	–			
March 1826	10 10	–	May 20, 1826	40	– –
	£97 19	–		£97	6 10

In this accounting, the dates are the difficult factor. Since the last payment to Lahee is '(his Bill) final', the accounts must have been cleared by then. Therefore, unless Linnell had a credit with Lahee after June 1825, there must have been unentered payments to Lahee of about £7. 9*s.* 0*d.* between June 29th, 1825 and May 20th, 1826.

 ¹ It seems likely that this was the undated *Job* subscription of 'Arnould, Bookseller' entered in the *Job* Accounts.

 ² This is probably the unpaid remainder of Calvert's subscription, £1 paid Nov.? 1825 and the whole £2. 12*s.* 6*d.* acknowledged in the *Job* Accounts.

 ³ Acknowledged in Blake's letter of July 5th.

 ⁴ In his letter of July 14th, 1826 Blake spoke of being 'very considerably weakened by the Last severe attacks', and he was probably forced to send Catherine to get the money on July 12th.

 ⁵ It seems likely that the Aders paid for *Job* at the same time that they were giving Linnell money for Blake's *Songs*.

 ⁶ The 'Canterbury Pilgrims' and the *Innocence and Experience* were apparently

[*1826*]		[£ s. d.]	
[*Aug. 29*] to M^r Blake on acc^t——		5 – –	

| [*Oct.*] 31 | of E^d Denny Esq for a Copy of Job proofs 5. 5. & Blair's Grave 2. 12 6——[1] | | 7 17 6 |

| Nov 23 | to Evans balance of exchange for Blairs Grave &c——[2] | | |
| | to Blake on acc^t—— | 2 – | |

| [*Dec. 16*]——to Blake on acct—— | | 3 – | |

| [*1827*] | | | |
| [*Jan. 9*] to M^r Blake on acct | | 5 – | |

| [*Jan.*] 18 | to M^r Blake on acc^t——[3] | 5 – | |

| | to Evans for Prints & bal. of exchange—— | | 15 6 |

[*Feb.*	*to M^r Blake on acc^t*[4]	5 – –]	
[*Feb.*] 21	to M^r Blake——	2 – –	
[*March 13*	*to M^r Blake on acc^t*[5]	2 – –]	

| [*April ?*] | to Lahee acc^t to this date | 27 15 – | |

| | to M^r Blake on acc^t: | 10 – – | |

| [*June 1*] to M^r Blake on acc^t—— | | 1 – | |

| [*June 20*] | of Mess Budd & Calkin, Booksellers for. the Copy of Job sent to the King——[6] | | 10 10 – |

delivered on Dec. 10th, 1825, but on Jan. 3rd, 1826 Mrs. Aders revealed that she was not sure whether they were a sale or a gift. Apparently it took eight more months to settle this rather delicate question satisfactorily.

[1] This entry is dated carelessly, for Denny's letter requesting *Job* and *The Grave* is dated Nov. 4th, 1826. It seems likely that many of these entries were made some time after the fact, as the string of subscriptions for *Job*, all grouped under April 29th, 1826, would suggest. Denny does not appear in the separate *Job* Accounts.

[2] Linnell forgot to enter what the balance was, so we can only guess (with help from the fifth entry below) that Linnell exchanged several copies of *Job* for the Blair and part of his standing bill with Evans. Evans does not, however, appear in the *Job* Accounts. [3] On Jan. 27th Blake said this had arrived on the 16th.

[4] In his letter of February 1827 Blake thanks Linnell 'for the Five Pounds recieved to day'. [5] Acknowledged by Blake March 15th, 1827.

[6] This had been ordered, and presumably delivered, about Feb. 23rd, 1827.

[1827]					[£	s.	d.]
[June 20]	to Mr Blake——1				10	–	–
	1 Do					10	
.							
	to Lahee for proofs——2				8	10	
[July?]	Of Colnaghi & Co for two India & one plain Job]						
[July?]	of Mr Meredith for copy of Job				5	5	–]
[July?]	of Sir G. Pocock for copy of Job3				5	5	–]
.							
[Aug. 3]	to Mr Blake on acct——				2	–	–
.							
	to Lahee for Proofs——				–	11	4
[Aug. 11]	of Mr Ottley for Mrs Blake for a copy of Jerusalem4——				5	5	
.							
	to Mrs Blake money from Mr Ottley	5	5	–			
[Aug. 12	Mrs Blake borrowed and repaid5	5	–	–	5	–	–]
. . . .							
Septr 4	to Lahee for proofs		6	2			
[Sept. 56]	To Mrs Blake for proofs, &c	1	5	–]			
.							
[Sept.] 6	of Saml. Woodburn for a Copy of Job——				5	5	–
.							
[Sept. 10]	of Mr Flowers for a Copy of Job——				3	3	–
.							
[Sept. 29]	of Mr Flowers for a print. Cant Pilgrim's, India——				2	–	–
	to Mrs Blake the same	2	–				
	of Mr Flowers the balance				–	12	6
	pd to Mrs B—		12	6			

1 Acknowledged in Blake's letter of July 3rd.

2 This and the following payments to 'Lahee for proofs' may be for *Dante* proofs.

3 These three undated entries in the *Job* Accounts are associated with others of 1827, but their dating is mere guesswork. Colnaghi appears as three separate entries in the *Job* Accounts, with no prices entered, presumably because Linnell used them for credit on his account there.

4 Perhaps copy A, D, or F, the early histories of which are unknown.

5 This and the next nine hypothetical entries are editorially transferred to Linnell's Account Book from the list of 'Cash paid . . . to Mrs. Blake' below.

6 This entry is dated merely 'Sep' 1827 in Mrs. Blake's account, but it seems possible that it paid for proofs of *Dante* which Catherine pulled from her own press, which was moved to Linnell's house on Aug. 29th (she herself moved in with Linnell on Sept. 11th). The last payment to Lahee for proofs (presumably of *Dante*) is on Sept. 4th, and it would be natural to expect Linnell to begin trying out Catherine's press the next day. Evidently thereafter Linnell had proofs pulled on Catherine's press. Alternatively, however, the 'proofs' above could be for the 'Canterbury Pilgrims', as in the next inserted entry.

⌈*1827*⌉ ⌈*£ s. d.*⌉

⌈*Sept.* To Mrs Blake for proofs of the Canterbury
 Pilgrims[1] *14* –⌉
⌈*Sept.* To Mrs Blake *1 15* –⌉
⌈*Oct.* To Mrs Blake *1 –* –⌉
⌈*Nov.* To Mrs Blake *2 10* –⌉

.

⌈*Nov.*⌉ 2 of M⌈r⌉ Daniel for a Book of Job
 p⌈*rin*⌉t⌈s⌉[2]
 5[s] owing *5* –
⌈*Dec.* To Mrs Blake *1 5* –⌉
⌈*1828*⌉
⌈*Jan.* To Mrs Blake *2 –* –⌉

.

⌈*Jan. 7*⌉ of M⌈r⌉ Cumberland for a Copy of
 Job——[3] *2 12 6*

.

⌈*Jan. 26*⌉ to M⌈rs⌉ Blake for to pay M⌈r⌉ Palmer
 for M⌈r⌉ Blakes funeral[4] *10 18* –
 of M⌈r⌉ Younger for a Copy of Job——[5] *5 5* –
⌈*Feb.* To Mrs Blake *2 15 6*⌉
⌈*March* To Mrs Blake *5 –* –⌉
⌈*April* To Mrs Blake (*furniture sold*)[6] *1 10* –⌉
⌈*April* To Mrs Blake *10* –⌉

.

⌈*July*⌉ 6 to M⌈rs⌉ Blake (by F. Tatham)[7] *10 –* –

.

Sept 8 of M⌈r⌉ Johns by the Hands of
 M⌈r⌉ Calvert—for a Copy of Job——[8] *3 –* –

.

[1] Clearly this entry is connected with those immediately preceding it, but I cannot tell how, unless Linnell gave Catherine 14*s.* before he showed Mr. Flowers the proof, and £1 18*s.* 6*d.* more on the 29th when he found Flowers would pay as much as two-and-a-half guineas for it.

[2] This had been ordered Sept. 4th, 1827.

[3] This date is almost certainly over a week early, for on Jan. 15th, 1828 Cumberland's son reported that his brother 'Syd gave me the money ⌈*for* JOB *and the calling card*⌉ for M⌈rs⌉ *Black* too late in the day for me to attend to it—'. This receipt is not entered in the *Job* Accounts.

[4] The bill itself is dated Aug. 13th, 1827, but it was apparently not paid until Jan. 26th, 1828. In the account below of 'Cash paid . . . to Mrs. Blake' this sum is entered as £10. 15*s.* 0*d.*

[5] W. C. Younge had written enclosing £5. 5*s.* 0*d.* on Jan. 23rd, 1828. In the *Job* Accounts 'M⌈r⌉ Younger' became 'M⌈r⌉ Young of Devonshire'.

[6] I take this to mean that Linnell had bought or sold some of Catherine's furniture.

[7] This sum is entered in the 'Cash paid . . . to Mrs. Blake' account.

[8] For Johns's undated letter arranging this payment, see Sept. 1828.

[*1828*]　　　　　　　　　　　　　　　　　　[£　*s.　d.*]

[*Sept. 16*] to Mʳˢ Blake by F. Tatham¹——　　7　–

[*1829*]

[*Jan. 26*] to Mʳˢ Blake on accᵗ for a
Drawing of Heads by Mʳ B. &
two by Fuseli　　　　　　　　　1　–　–

[*Spring?*]　*Of Mr J Brown for copy of Job²*　　　　　　　　　]

[*Spring*]　*Of W S Davidson for copy of Job*　　　　　　5　5　–]

[*Spring*]　*Of Colnaghi & Co for Job India proofs*　　　　　　]

[*Spring?*]　*Of Mr Woodburn for copy of Job—*
paid for by a Spanish sixpenny set of
Mantuanas and by Michael Angelo]

.

May [*15*] to Mʳˢ Blake by F. Tatham for
Homer's Illiad & Oddessey Trans
by Chapman　　　　　　　1　11　6　[*Receipt*]³

.

[*1830*]

[*July*] 24ᵗʰ of L. Egrement (by Mʳ Callcott)
for a copy of Job proofs——⁴　　　　　　　6　6　–

.

[*July*] 30　of Mʳ Revᵈ Jebb for a set of Blake's
Job bᵈ small——⁵　　　　　　　　3　3

.

[*Dec.*] 27ᵗʰ of Mʳ Bird for a Copy of Job——　　　　2　12　6

.

[*1831*]

[*Aug. 25*] to Mʳˢ Blake for a Catalogue⁶　　　　2　6
　　　　Dᵒ　　　　for Poems——　　　　2　6

.

[*Autumn?*]　*Of Miss (Opie?), friend of Mrs*
Austin, for a copy of Job　　　　　　　　　　]

[*Autumn?*]　*Of Dr King for a copy of Job*　　　　　　　　　]

[*Autumn?*]　*Of Dr— German friend of Mrs*
Austin for a copy of Job⁷　　　　　　　　　　　]

.

¹ This is the last entry in the 'Cash paid . . . to Mrs. Blake' accounts below.

² This and the next three entries are only dated about 1829 in the *Job* Accounts, and I have no other evidence on which to assign them a date. No prices are entered for this and the Colnaghi copy below, perhaps because they were applied against Linnell's standing bills.

³ The Receipt for Chapman's Homer is dated May 16th, 1829.

⁴ The undated letter enclosing this sum is given under April 1831, q.v.

⁵ This is apparently John Jebb, Bishop of Limerick—see March 3rd, 1830.

⁶ The 'Catalogue' is clearly Blake's 1809 *Descriptive Catalogue*, and the 'Poems' are probably the 1783 *Poetical Sketches*.

⁷ These three entries are dated merely 1831 in the *Job* Accounts, and no sums are entered by any of them.

[*1832*] [*£ s. d.*]

[*April*] 30 of M^r Brett[?] for a Copy of
 Job—— 2 12 6

.

Aug^t of M^r Lizars for two proofs of M^r
 Calcott 1. 10. – & Book of Job plain
 2. 10. – 4 –

.

[*1833*]
[*June 14*] to M^r Bayley for Binding Job: – 8 –

.

[*1834*]
[*Feb. 22*] of M^r Richmond for Copy of
 Job——[1] 2 10

.

[*Nov. 8*] of M^r Varley for Book of Job sold
 to M^r Leonard & Princess [?].[2]
 1. 10 – & 5^s 1. 15 –

.

[*1835*]
March 30 of Sam^l Boddington Esq for a plain
 Copy of Job. 1. 10. – and a proof
 of Blake's Canterbury pilgrims—— 4 13 –

.

[*April 8*] of—H Taylor Esq for a book of
 Job.—— 1 10

.

[*1835*]
[*July*] 23 of H. Taylor Esq——for two
 Copies of Job plain.—— 3

.

[*1836*]
[*Jan. 22*] of J Palmer for Job £1. 5 &
 Blakes woodcuts[3]—— 5—— 1 10

.

[*May 26*] to M^r Bohn balance of acc^t in ex-
 change of Book of Job—&c as
 for[?] eight[?] & receipt[?]. 18 –

[1] This is the 'small paper' copy which, according to the *Job* Accounts, Richmond took on Sept. 19th, 1832, 'to be paid for in 6 months'.

[2] According to the *Job* Accounts, this had been given 'to Mr Leonard by Mr Varley to shew . . . to Princess Sophia'. The other entries below do not appear in the *Job* Accounts.

[3] The woodcuts are clearly proofs of the *Virgil* plates. It is remarkable that plain copies of *Job* declined in price from £2. 12s. 6d. (up to April 30th, 1832) to £2. 10s. 0d. (Aug. 1832 to Feb. 1834) to £1. 10s. 0d. from Nov. 1834.

C

LINNELL'S *JOB* ACCOUNTS, 1823–1834

The following accounts appear in a little marbled book in the Yale University Library labelled on the cover 'Subscribers &c to the Book of Job', and on the inside cover 'Subscribers to & Purchasers of the Book of Illustrations of the History of Job Designed & Engraved by William Blake. Begun 1823—& Publish[ed] March, 1826 by the Author & J. Linnell'.[1]

The account book consists of a notebook of eleven leaves (pp. 17–38) into which eight slightly smaller leaves (pp. 1–16) have been pasted. The pasting has covered one endpage and pp. 1, 16, and 17. At one end of the book thus formed (pp. 3–10) Linnell entered the names of 'Subscribers to . . . Job'. He then reversed the book, and at the other end he entered copies 'for Sale or return' (pp. 39 [the end-paper], 38), the 'Account of Expenses of the Book of Job' (pp. 37, 36), copies 'unsettled for' (p. 15), and 'Copies of the Book of Job exchanged' (pp. 14, 12). The anachronistic arrangement of all these entries suggests that they were transferred from another notebook which has not survived.

Associated with the notebook are three separate leaves (pp. A–F) containing Linnell's record of 'Cash Paid to M^r Blake on account of Job' and of 'the Portrait of M^r Lowry', with Blake's initials acknowledging receipt of the sums specified. For convenience in understanding these accounts, I have arranged the pages in this order: 3–7, 9–10, 15, 14, 12, 39, 38, 37, 36, A–E. Pp. 8, 11, 13, 18–35, F are blank.

[*Page 3*]

1823 Plain

Oct^r [*12, 1823 and August 1826*] Ed. Hodges Baily Esq R.A.

S	Sub. for one Copy plain	2. 12	6
S	[*Nov. 15, 1823 & April 27?, 1826*]——[*Robert*] Balman[*n*]o Esq. D°	2 12	6
S	[*Jan. 10, 1824 & April 29, 1826*] [*Samuel*] Leigh, Bookseller for Mr Willowby——	2 12	6
S	[*Oct. 30, 1825*] J Flaxman Esq R.A. one copy plain——	3 3	–
S	[*Sept. 30, 1825 & April 29, 1826*] Mr Riviere D°	2 12	6
S	[*Feb.? 1826*] Mr Harrison, Tower St.	2 12	6

[1] Underneath this second inscription is written: 'This appears to be Blake's autograph'. It does. In the entries that follow, the dates in brackets refer to Linnell's general Account Book given above. The letters preceding the entries appear to refer to individual subscribers (S) and booksellers (P for Publishers?), who are given an address and no title.

S [*April 29, 1826*] M^r Butts, Fitzroy sqr. 1 Copy of 3 3 –
 Proofs—for
 because he lent the Drawing to Copy—
S [*January 6, & April 15, 1826*] H. Robinson Esq of the
 Temple—3– copies—— 9 9 –
 28 17 6

[Page 4]

 Plain

P [*April 15, 1826*, q.v.] Mr. Prosser Charing X one copy
 plain—— 3 3 –
S [*April 29, 1826*, q.v.] C. H Tatham Esqr one copy plain— 2 12 6
S [*April 29, 1826*] D^r H. Ley—1 Copy plain Half Moon S^t
 Piccadilly 2 12 6
P. [*June 29, 1826*, q.v.] Mr Behnes Dean St Soho—1 copy
 Plain. 2 12 6
S [*April 29?, 1826*] M^r Waters—D? 2 12 6
P[?] [*April 29, 1826*] [*Joseph*] Parker—Bookseller Oxford
 1 copy plain—— 2 12 6
S [*Nov.? 1825 & May 30?, 1826*] Mr Calvert, Brixton 1
 copy Plain– 2 12 6
P [*May 30?, 1826*] Arnould, Bookseller, Spring Garden
 1 copy Plain 2 12 6
 21 10 6

[Page 5]

1826 Proofs:—
S [*April 15, 1826*] Sir Henry Torrens, proofs—— 5 5 –
S [*April 29, 1826*] Rev^d Edw^d Bury D? 5 5 –
S [*April 9, 1826*] Anthony Stewart Esq 4 14 6
S [*July 29?, 1826*] Cha^s Aders Esq. D? 5 5 –
S [*March 28, 1826*] T. G. Wainwright Esq D? 5 5 –
S [*April 9, 1826*] James Vine Esq 5 5 –
S [*April 29, 1826*] Sir Tho^s Lawrence one copy of Proofs
 for himself 5 5 –
 [5 del] 36 4 6
one copy given to the Royal Academy—but Sir
T. L. sent 10 Gs. to Mr Blake—5 G^s of which
was given to Mr B—although Sir T. L. might have

[Page 6]

intended it for the copy presented to him for the
Royal Academy
 Proofs

[*June 20, 1827*] The King—1 copy of Proofs
 Sent by the order of Sir W^m Knighton & D^r [*Robert*]
 Gooch—& for which 10 Gs. was ordered to be paid—
 & was pd. by Mess Budd & Calkin Pall Mall.—given
 to Mr Blake 10 10 –

[*April 15, 1826*] Josiah Taylor Esq. 1 copy of Proofs sent to
the House of Correction by F. Tatham— 5 5 –
 [(]*Taylor being* [*in*] *s^d H. of C^n for swindling*)
[*Jan. 26, 1828*] M^r Young of Devonshire by Mr Johns
 1 Copy 5 – –

 20. 15.

[*Page 7*] Plain

S [*Sept. 8, 1828*] M^r Johns of Devonshire 1 copy—— 3 – –
P [*Sept. 10, 1827*] Mr Flower of Islington 1 copy—— 3 3 –
S [*April 29, 1826*] M^r Geo Young, surgeon brother of
 [*Charles Mayne*] Young the actor, 1 copy—— 3 3 –
 [*July 30, 1830*] M^r Rev^d Jebb—— 3 3
P. [*Dec. 27, 1830*] Mr Bird 2 12 6
Aug^t
 1832 H. W. Lizars Edinburgh for a friend—— 2 12 6

 17 14

[*Page 9*]

 Proofs

[*July? 1827*] W[?] Meredith Esq Harley Place 1 Copy of
 Proofs 5 5 –
[*Nov. 2, 1827*] Rev^d T[?] Daniel of Norwich—1 Copy sent
 to Oxford 5 –
[*April 29, 1826*] Westmacott R.A. 1-c. Proof—— 5 5 –
[*April 29, 1826*] Chantry, R.A. 1. c. proofs 5 5
[*Sept. 6, 1827*] M^r S. Woodburn—one copy proofs 5 5
[*July? 1827*] Sir Geo. Pocock B^t 1 c. proofs—— 5 5

 31 5

[*Page 10*]

18 Proofs

[*Spring 1829*] W: S. Davidson Esq 1 c. proofs 5 5
[*July 24*] 1830 the Earl of Egremont[1] 6 6

 11 11
 28 17 6
 21 10 6
 36. 4 - 6 [56 4 6
 del]
 20 15
 17 14
 31 5

 [187 17 6
 del]
 167 17 6

 [1] Perhaps this year should be 1831; see April 1831.

[*October 31, 1826 E. Denny*[1] 5 5 –]
[*Nov. 23, 1826 R. H. Evans* ?]
[*Jan. 7, 1828 George Cumberland* 2 12 6]
[*Nov. 8, 1834 John Varley* 1 10 0]
[*March 30, 1835 S. Boddington* 1 10 –]
[*April 8 & July 23, 1835 H Taylor* 4 10 –]
[*Jan. 22, 1836 J Palmer* 1 5 –]
[*May 26, 1836 Bohn* ?]
[*July 6 1824 Dr Thornton*[2] 5 5 –]
[*May 4 1824 Mr Muss* 1 – –]
[*Corrected total of known receipts for* JOB *to May 1836*: £185 10 0]

[*Page 15*]

[*Spring 1829*] 1 Copy Proofs unsettled for to Mr Woodburn 1829
Paid for by Spanish 6ᵈ set of Mantuanus & M. Angelo

[*Page 14*]

Copies of the Book of Job. exchanged

1 Copy proofs to Rodwell & Martin Booksellers Bond St
which they sold to Mr Phillips R.A. the above to
pay for a Copy of Pompei had before.
1 Copy to Mr Bohn Bookseller Henrietta Street Covent Garden
1 Dᵒ to Dᵒ
1 Copy Plain to Mr Palmer Bookseller Bond St. St Giles.
1 Copy Plain to Mʳ Evans Printseller queen St Lincolns Inn fields
1 Copy to J. Bull in exchange for work.

[*Page 12*]

[*July?*] 1827
1 Set of Proofs, to Colanaghi & co ⎞
1 Copy Plain to Dᵒ ⎟
1 Copy India Proofs to Dᵒ——³ ⎠

1829

[*Spring*] 1 Set of India Proofs to M. Colanaghi in exchange
[*Spring*] 1 Copy Proofs to Mr Brown of Carmarthen Sᵗ returned
[*Spring*] 1 Copy Proofs to Mʳ James Brown of Thornhaugh St.

¹ This and the next seven entries are taken from Linnell's general Account Book
and inserted here for the sake of consistency.
² This and the next entry are taken from the payments to Blake in the *Job*
Accounts themselves.
³ Probably the reason no prices are entered here is that these sets, if sold, were
balanced against Linnell's bill to Colnaghi; see below and Linnell's letter of Dec.
1826.

[*Page 39*]

1832

June 1 copy of India proofs to R. Cooke Esq to look at 2 Abby
 R.ᵈ—Sᵗ Johns Wᵈ
[March 1 copy Plain to J.ˢ Linnell
1830 Feb 1 Copy India proofs to James Linnell, for Sale or return *del*]¹
1834 [Oct one plain Copy to Mr Leonard by Mr Varley to shew *del*.]
 [Octʳ 1834 1 Copy to shew to Mr Denham
 Princess Sophia *del*]²
1831 1 copy [of India proofs to *erased*] Dʳ King
 upon sale or return Brighton
 returned

[*Page 38*]

1 copy plain to Miss:—— friend of Mʳˢ Austin³
1 Copy plain to Dʳ —— German friend of Mʳˢ Austin
[Sept. 19th, 1832—1 small paper to Mr Richmond to be paid for
 in 6 months⁴ *del*]
1 Copy plain to Mr Allen given
1 Copy plain to Mr Lizars Edinbᵍ preserve June 1831

[*Page 37*]⁵

Account of Expenses of the Book of Job—by Mʳ Blake

1823 £ s d

			£	s	d
[*March*]	6 copper Plates for Job—		1.	–	
	6 Dᵒ —	Dᵒ —	1	2	
	6 Dᵒ —	Dᵒ —	1.	3.	7
1825	2 Dᵒ —	Dᵒ —⁶	.	6	
[*March 3*]	proofs——		1	–	–
[*March 4*]	Dᵒ at Dixons & paper		1	——	

¹ These two lines are deleted with a single X.

² For some light on the enigma of these three lines, see the Account for Nov. 8th, 1834.

³ Mrs. Austin, who also had a 'German friend' (see the next entry), is probably Mrs. Sarah Austin (1793–1867), the translator, who lived in Germany after 1827. Her friend in this entry may have been Amelia Opie (1769–1853), the novelist, whom she had known from childhood. A copy of *Job* is inscribed: 'This work, remarkable both for genius and extravagance, is the gift of Amelia Opie to her Friend David, whose own genius will make him prize the former, while his eminent taste makes it impossible for him to imitate the latter—Paris, 14.ᵐᵉ Mo. 22ᵐᵉ [*i.e. Nov. 22nd?*] 1831[.] j'ai achete ce livre à la vente de feu [*de Pierre Jean*] David le Statuaire, H. de T[*riqueti*] 1856[.]' (This information is given in an unidentified cutting from a sale catalogue of about 1925, in a scrapbook now in the possession of Paul Mellon.) This would explain reasonably how Mrs. Opie came into possession of a set of *Job* at such an early period when she does not appear in the *Job* accounts.

⁴ This is deleted with a single X. See the Account for Feb. 22nd, 1834.

⁵ This page is written sideways in two columns.

⁶ Two of the twenty-two plates are not accounted for in this list at all.

[*June?*]	Dᵒ at Lahee &c			. 10	–
Sep	Proofs——			2	– –
Oct	Dᵒ	Dᵒ——		2	–
Nov	Binding 3 sets			–	7 6

$£9. 19. 1$

[*Should be* $£10. 9. 1$]

[*Next column*]

March [*9*]		Bᵗ over		9. 19.	1
1826	Paid to Mʳ Lahee for 150 sets of Proofs on			£	s d
	India paper——			56. 5	
	to Freeman the workman——			1.	
	to Mr White for Boarding			2. 4	6
	1 ream of paper for Dᵒ			1. 6.	
[*April 22 & 29, 1826*]	to Mʳ Leighton for Bindᵍ & paper &c——13			17	–
[*May del*]	to Lahee——			[43	– – *del*]
1826	for 65 Setts of Job on french paper——			16. 3.	
March	to Dᵒ for 50 Sets on Drawing paper——			10. 10.	
	to Dᵒ for Dᵒ——			10. 10	

$£111. 15. 6¹$

[*Page 36*]

1834 Expenses continued

[*June 14 1833*] to Mr Baley for binding in Cloth—Copies
 Dᵒ Dᵒ in paper

[*Page A*]

1823

					£	s –
March 20—To Mʳ Blake—1ˢᵗ payment on account of Job				WB	5	–0
see memorandum of agreement, &c [*March 25, 1823*]						
May 2ᵈ	Cash		Dᵒ		WB	3 –0 –
[*May 5*]	Dᵒ		Dᵒ		WB	10 –0
July 11	Dᵒ		Dᵒ		WB	3 –0
Augᵗ 2 —	Dᵒ		Dᵒ		WB	2. 0.
17	Dᵒ	——	Dᵒ	——	WB	1. 0
Sept 3 —	Dᵒ	——	Dᵒ	——	WB	2 –0
14 —	Dᵒ	——	Dᵒ	——	WB	1 –0
25	Dᵒ	——	Dᵒ	——	WB	2 –0

¹ This total does not include the erroneous $£9. 19s. 1d.$ at the top of the column, $£2. 7s. 0d.$ to Mr. English on Sept. 27th and Oct. 3rd, 1825 for binding, or 10s. to Mr. Tickman, March 22nd, 1826, for labels. The total expenses for *Job* entered here come to $£124. 12s. 1d.$

Oc.ᵗ 12 —	Dᵒ	——	Dᵒ ——	WB 1 –0	
20	Dᵒ	——	Dᵒ ——	WB 1 –0	
Nov.ʳ 6	Dᵒ	——	Dᵒ ——	WB 1 –0	

£32. 0

[*Page B*]

1823

Nov.ʳ	Cash Paid to M.ʳ Blake on account of Job——		£—s —
—	Bro.ᵗ over——		32 –0
13—	Cash——		WB 1 –0
15	D.ᵒ Balmano's Sub.		WB 1 –0
18	Dᵒ——		WB 6 –0
Dec.ʳ 15	Dᵒ——		WB 5 –0
1824	M.ʳ Leigh's Subs.——		WB 2 –0
Jan 10—	Cash——		WB 5 –0. 0
	Coals——		WB 3. 5. 9
Feb. 2.ᵈ	Cash——		WB 5 –0. 0
21	D.ᵒ——		WB10 –0. 0
March 29:	D.ᵒ——		WB 5 –
May 4	Dᵒ M.ʳ Muss's[1] sub——		WB 1 –
6	Dᵒ——		WB10 –
June 11.	Dᵒ——		WB 5 – –
	1 Chaldron of Coals[2]——		WB 1. 17 –
July 6.	Cash by D.ʳ Thornton's order[3]		WB 5. 5.

98: 7. 9

[*Page C*]

Aug.ᵗ 18.ʰ 1824.				£	
Cash on account of the Portrait of M.ʳ Lowery			WB	5 –	
Novembr 10.ᵗʰ	Dᵒ	Dᵒ ——	WB	5 –	
Dec.ʳ 25.	Dᵒ	Dᵒ ——	WB	5 –	
Jany 28	Dᵒ	Dᵒ ——	WB	5 – –	

1825

for Sketches of Subjects from Dante		5

carried to page 5.[4]

Oc.ᵗ 10.ʰ on acc.ᵗ· of Drawings of Paradise regained—	WB	5 – –		
Nov.ʳ 19.ᵗʰ	Dᵒ ——	Dᵒ ——	5 – –	

[1] This is perhaps Charles Muss, who died suddenly in Aug. 1824.
[2] I cannot explain why '1 Chaldron of Coals' cost £1. 17s. 0d. in June 1824, while 'one chaldron of Coals' cost £2. 13s. 6d. in May 1825 and £2. 19s. 6d. in Jan. 1826.
[3] Under Dr. Thornton's order is something which looks like 'pd by M.ʳ Post'.
[4] The page to which this refers has not been traced.

[*Page D*]

acc.ᵗ of Expenses Page 7 [*i.e. page 37?*]
Names at the other End

				£	s	
	[*Page E*]	Broᵗ over		98	7	9
Janʸ 1825				£	s	
27.ʰ	Cash on accᵗ of Job——		WB	5	–	–
March 12	Dᵒ —— Dᵒ ——		WB	5	–	
April 8	Dᵒ Dᵒ ——		WB	3. 10		
May 3ᵈ	Dᵒ —— Dᵒ ——		WB	5.	–	
June 6	Dᵒ —— Dᵒ ——		WB	2	–	–
	By Coals sent in May.		WB	2. 13. 6		
Augᵗ 21	Cash——		WB	3	–	
Sep 3	Dᵒ ——		WB	1	–	
4	Dᵒ ——		WB	10	–	
Oct: 1ˢᵗ	Dᵒ ——		WB	1	–	
		[*136 del*]				
30	Dᵒ ——¹			5	–	
	Dᵒ —— by Mʳ Flaxmans Sub.			3. 3.		
[*Nov?*]	Dᵒ Mʳ Calverts Dᵒ ——			1.	–	
75 [*April 29? 1826*]	by Sir Thos.ˢ Lawrence Dᵒ			5	5	
				150. 19	3	

for one Copy—the extra 5 Gs. which Sir T. L. gave
1826 is not reckoned against Mr Blake. Sir T. L. perhaps
intended it for the copy presented to him for the
library of the Royal Academy.

D

LINNELL'S PAYMENTS TO MRS. BLAKE, 1827–1828

'Cash paid by J. Linnell to Mrs. Blake—Sep. 13ᵗʰ 1827—

to Sep.ʳ 1828'²

Sep [*5?*]—(Proofs, &c) £1.—5/- [*Sept 9?*] (Proofs of Cant.ʸ
Pilgrims) 14/- £1. 15.- Oct. £1.— Nov £2. 10— Dec.ʳ £1. 5. 0—
(1828) Jan. £2.— [*Jan 26*] (Burial of Mr. Blake) £10. 15. 0— Feb.

¹ I cannot explain why this and the next two entries were not initialed by Blake,
except that Blake was intermittently ill in the autumn of 1825 (Nov. 10, 1825: 'I
cannot get Well & and am now in Bed') and perhaps could not come to Linnell.
More probably, Linnell simply forgot.

² The figures so headed were entered by John Linnell, Jr. in the 'List of John
Linnell Senior's Letters and Papers' (p. 42), now with the Ivimy MSS. He does not
identify his source, but it is apparently Linnell's Journal—probably of about March
9th, 1831. It seems likely that Linnell kept his accounts with Catherine on separate
sheets, as he did those with Blake. Certainly only two of these entries got through
to the general Account Book, from which the dates are inserted here.

2. 15. 6, March, £5..— April (Furniture sold) £1. 10.— 10/- July
[6] £10.—
Sep. £7. (total £47. 19. 6[)]
(Mrs. B. borrowed 8/12/27—£5. & repaid it)

SUMMARIES OF ACCOUNTS: PAYMENTS TO BLAKE

1783	from Macklin for engraving 'Fall of Rosamund'	£80. –. –
1795	from Flaxman	14. 6
1796	from Flaxman	£ 5. 5. –
1796	from Cumberland	£16. 16. –
1797	from Flaxman	£ 2. 2. –
1799	from Flaxman	£ 9. –. 8
		£113. 18. 2

1802 £31. 10. 0 for his head of Cowper; presumably the
same for his other two *Cowper* portraits; perhaps
£10. 10. 0 each for his three other small engrav-
ings for *Cowper* (see August 7th, 1803) £126. –. –

1803 for printing the plates for *Cowper*, vols. i and ii
(see Blake's letter of January 30th, 1803)—if the
rate was the standard one of 6s. per hundred pulls
this represents 1,750 copies each of the first four
plates £21. –. –

1803 for plates to Hayley's *Triumphs of Temper* (see
Blake's letter of January 30th, 1803) £63. –. –

1804 for the plates to Fuseli's Shakespeare (see Blake's
letter of June 22nd, 1804) £52. 10. –

1804? for Hayley's *Romney* (see Hayley's letter of August
7th, 1803 and Blake's of October 23rd and Decem-
ber 28th, 1804); this omits possible payment for
'The Shipwreck' £42. –. –

1805 for plates to Flaxman's *Iliad* £15. 15. –

1805 for plates to Hayley's *Ballads*— £42. –. –
and as much again to come if they are successful
(see Blake's letter of April 25th, 1805)

1805? from Cromek for the Blair designs £21. –. –

1805? for *Innocence and Experience* from Revd. Thomas
(see September 1805) £10. 10. –

 394. 16. ——

1803–1806	from Butts, chiefly for designs	£99. 1. –
1806	from Flaxman	1. 1. –
1807	from Butts, ditto	£87. 12. 6
1808	from Butts, ditto	£56. 15. –
1809	from Butts, ditto	£83. –. –
1810	from Butts, ditto	£94. 10. –
		£421. 19. 6

1810	from Crabb Robinson for Catalogue	–. 10. –
1814	from Flaxman	£ 5. –. –
1815	from Wedgwood	£30. –. –
1814–1817	for Flaxman's *Hesiod*	£207. 18. –
		£243. 8. –

1818	from Linnell for Upton engraving	£15. 15. –
1819	from Linnell for *Experience* and *Jerusalem*	£ 2. 13. 6
1820	from Linnell for prints	£ 1. –. –
1821	from Linnell for *Marriage, America, Europe, Jerusalem*, a design, etc.	£ 4. 18. –
1822	from Flaxman	£ 3. –. –
1822	from Linnell	£12. –. –
1823	from Linnell for *Job*	£45. –. –
1824	from Linnell for Lowry engraving	£15. –. –
	for *Job*	£53. 7. 9
1824	from Mr Stephen	£ 1. 1. –
1825	from Linnell for Lowry	£ 5. –. –
	for *Job*	£47. 6. 6
	for *Dante*	£ 3. –. –
	for *Paradise Regained*	£10. –. –
1826	from Crabb Robinson for *Songs*	£ 5. 5. –
1826	from the Aders for *Songs* and print	£ 7. 7. –
1826	from Sir Thomas Lawrence for two drawings[1]	£52. 10. –
1826	from Linnell for *Dante*	£43. 12. –
1827	from Linnell for *Dante*[2]	£42. 10. –
1827	from Ottley for *Jerusalem*	£ 5. 5. –
		£375. 10. 9

1827	from Linnell to Catherine for proof, print, etc.		£10. 11. 6
1827	from Tatham for print[3]		£ 3. 13. 6
1828	from Cumberland for engraved card		£ 3. 3. –
1828	from Linnell		£39. 13. 6
1828	from Crabb Robinson for two prints of 'Canterbury Pilgrims', January 8th		£ 5. 5. –
1828	from Lord Egremont for 'The Faerie Queene'; see January 8th for perhaps £10 to £20 more		£84. –. –
1828	from Miss and Mrs. Smith, March 17th		£ 8. 12. –
1829	from Linnell for *Homer* and drawings		£ 2. 11. 6
1830	from John Jebb for two prints, two drawings and *Songs*, March 3rd		£21. –. –
1831	from Linnell for *Catalogue*, poems		5. –
		£178. 15. –	£1,728. 7. 5

[1] See J. T. Smith, p. 468, n. 3.

[2] It seems likely that the total of these two ought to be £13. 18s. 0d. higher; see March 9th, 1831.

[3] Smith, p. 471 n.

For the period during which our records are most complete, 1802–27, we have evidence that Blake was paid at least £1,531. 15s. 5d. or about £58. 10s. 0d. a year. Naturally there are a great many omissions here, but the missing sums might add no more than about £30 a year. At no time does Blake's yearly income seem to have gone much above £100, and sometimes it was probably not much more than £50.

SECTION IV

ENGRAVINGS BY AND AFTER BLAKE

Date	Book or Separate Print[1]	Publisher	Number	Designer	Engraver
1773	'Joseph of Arimathea' (1773, 1810 ff.)	. .	1	Michael Angelo	Blake
1774?	J. Bryant, *Analysis of Ancient Mythology* (1774–6)	T. Payne, etc.	1?	Blake?	Blake?
1776–9	[R. Gough] *Sepulchral Monuments in Great Britain* i (1786, 1796)	R. Gough	8	Blake	Blake?
1780	[J.] Oliver, *Fencing Familiarized* (1780)	John Bell	1	J. Roberts	Blake
1780	'Glad Day' (1780, 1796)	Blake	1	Blake	Blake
1780 Aug. 1	W. Enfield, *The Speaker* (1780–1820?)	J. Johnson	1	Stothard	Blake
1780 Sept. 16	J. Herries, ed., *Royal Universal Family Bible* (1780–2)	Fielding & Walker	1	Anon.	Blake
1781?	*Protestants Family Bible* (1781?)	Harrison & Co.	5	Raphael (3) Rubens (2)	Blake
1781?	E. Kimpton, *Universal History of the Holy Bible* (1781?); *Works of Flavius Josephus* (1786?–1800?)[2]	J. Cooke	3	C. M. Metz (2) Stothard (1)	Blake
1781 Aug. 18 Oct. 13 Dec. 22	*Royal Universal Family Bible* (1780–2)	J. Fielding	3	Anon.	Blake
1782	J. Bonnycastle, *Introduction to Mensuration* (1782–1791)	Johnson	1	Stothard	Blake

[1] Most of the information about these prints is derived from the Bentley and Nurmi *Blake Bibliography* (1964) and Geoffrey Keynes, *Engravings by William Blake: The Separate Plates* (Dublin, 1956). The date in the left-hand column is ordinarily that on the print itself; that under Books is the date on the title-page of the book. The Publisher is the one mentioned in the imprint of the engraving.

[2] The title-page of Kimpton's *History* specifies that the 'beautiful COPPER-PLATES . . . [were] engraved by the most Capital Performers . . . [including] Blake', though Blake is not mentioned among the engravers for the three editions of *Josephus*.

Date	Book or Separate Print	Publisher	Number	Designer	Engraver
1782	*Poetical Works of John Scott* (1782–95)	J. Buckland	4	Stothard	Blake
1782 Jan. 12	J. Seally and I. Lyons, *Complete Geographical Dictionary* (1784, 1787)	J. Fielding	1	Anon.	Blake
1782 Feb. 23	*Royal Universal Family Bible* (1780–2)	J. Fielding	1	Blake	Blake
1782 Apr. 6, May 4	Seally and Lyons, *Complete Geographical Dictionary*, ii (1784, 1787)	J. Fielding	2	Anon.	Blake
1782 May 4, June 15	*Novelist's Magazine*, viii, Cervantes (1782–92)	Harrison & Co.	2	Stothard	Blake
1782 July 6, Aug. 10	*Novelist's Magazine*, ix, Sterne and S. Fielding (1782–93)	Harrison & Co.	2	Stothard	Blake
1782 Aug. 10, 21	'Morning [*and* Evening] Amusement'	T. Macklin[1]	2	Watteau	Blake
1782 Sept. 21	*Novelist's Magazine*, ix, Richardson (1782–93)	Harrison & Co.	1	Stothard	Blake
1782 Nov. 1	*Lady's Pocket Book* (1782)	Johnson	2	Stothard	Blake
1782 Dec. 7	*Novelist's Magazine*, x, Richardson (1783–93)	Harrison & Co.	1	Stothard	Blake
1783	T. Henry, *Memoirs of Albert de Haller* (1783)	Johnson	1	Dunker	Blake
1783	Ariosto, *Orlando Furioso*, tr. J. Hoole (1783–99)	J. Hoole, etc.	1	Stothard	Blake
1783	[J. Ritson] *Select Collection of English Songs* (1783)	Johnson	9	Stothard	Blake
1783 Jan. 18	*Novelist's Magazine*, x, Richardson (1783–93)	Harrison & Co.	1	Stothard	Blake

[1] In Poetic *Description of Choice and Valuable Prints*, Published by Mr. Macklin, at the Poets' Gallery, Fleet Street (London, 1794), pp. 62, 28, 70, 'The Fall of Rosamond. Painted by T. Stothard, R.A.', 'Robinhood and Clorinda. Painted by J. Meheux', 'Morning [*and* Evening] Amusements. Painted by Watteau', each 'Engraved by W. Blake' ('Size[s] 12 inches, circle', 'eight inches and a half, circle', '12 inches by 10, oval') were offered at 'Price 7s. 6d. Plain, and 15s. in Colours', except for 'Robinhood and Clorinda', which cost '4s. Plain, and 7s. 6d. in Colours'.

Date	Book or Separate Print	Publisher	Number	Designer	Engraver
1783 Mar. 30	'Robin Hood & Clorinda'	J. Macklin	1	J. Meheux	Blake
1783 Apr. 5	*Novelist's Magazine,* x, Richardson (1783–93)	Harrison & Co.	1	Stothard	Blake
1783 May 24	*Poetical Works of Geoff. Chaucer,* xiii (1783?)	John Bell	1	Stothard	Blake
1783 Oct. 1	'The Fall of Rosamond'	T. Macklin	1	Stothard	Blake
1784 Feb. 1 Mar. 1 Apr. 1 May 1 June 1	*The Wit's Magazine,* i (1784) [1]	Harrison & Co.	5	Stothard (1), S. Collings (4)	Blake
1784 June 6	D. Fenning and J. Collyer, *New System of Geography* (1785, 1787)	G. Wilkie	1	Stothard?	Blake?
1784 Dec. 17	'Zephyrus & Flora', 'Callisto'	Blake & Parker	2	Stothard	Blake
1785 Apr. 16	Fenning and Collyer, *New System of Geography* (1785, 1787)	G. & T. Wilkie	1	Stothard	Blake
1786?	'Job' (1786, Aug. 18, 1793)	Blake	1	Blake	Blake
1786 July 1	T. Commins, *Elegy* (1786)	J. Fentum	1	Blake	Blake
1787 Nov. 21	'Venus Dissuades Adonis' (1787, 1823)	G. Hadfield (brother of Maria Cosway)	1	R. Cosway	Blake
1788?	'The Approach of Doom' (1788?)	..	1	W. and R. Blake	Blake
1788?	*There is no Natural Religion* (1788?)	..	21?	Blake	Blake
1788?	*All Religions are One* (1788?)	..	10	Blake	Blake
1788	J. C. Lavater, *Aphorisms on Man,* tr. J. H. Fuseli (1788–94)	Johnson	1	Fuseli?	Blake
1788 May?	J. C. Lavater, *Essays on Physiognomy,* tr. H. Hunter, i (1788)	J. Murray, etc.	1	Rubens	Blake

[1] A puff on the title-page of each issue of *The Wit's Magazine* says that the number was published 'With a Large Quarto Engraving . . . engraved by [Mr. W.] Blake, purposely for this Work.'

Date	Book or Separate Print	Publisher	Number	Designer	Engraver
1788 May 12	'The Idle Laundress', 'The Industrious Cottager' (1788, 1803)	J. R. Smith (father of Mrs. Aders)	2	G. Morland	Blake
1788 Oct. 29	*Works of William Hogarth* (1790–1838?)	J. & J. Boydell	1	Hogarth	Blake
1789	*The Book of Thel* (1789)	Blake	8	Blake	Blake
1789	*Songs of Innocence* (1789)	Blake	31	Blake	Blake
1789 Feb.?	Lavater, *Physiognomy*, i (1789)	Murray, etc.	2	Anon.	Blake
1790?	'Falsa ad Coelum', 'Satan'	..	2	Fuseli	Blake
1790?	'Edmund Pitts'	..	1	J. Earle	Blake
1790?	[Figures in a boat][1]	..	1	Blake?	Blake?
1790–3	*Marriage of Heaven and Hell* (1790–3)	Blake	27	Blake	Blake
1790 July 28	'Timon and Alcibiades'	..	1	Fuseli	Blake
1790 Oct. 1	C. G. Salzmann, *Elements of Morality*, [tr. M. Wollstonecraft], i (1791–9)	Johnson	8?	Chodowiecki	Blake?
1791 Jan. 1	Salzmann, *Morality* ii (1791–9)	Johnson	2?	Chodowiecki	Blake?
1791 Mar. 1	D. Hartley, *Observations on Man* (1791)[2]	Johnson	1	Shackleton	Blake
1791 Mar.15	Salzmann, *Morality*, iii (1791–9)	Johnson	7?	Chodowiecki	Blake?
1791 Sept. 1	M. Wollstonecraft, *Original Stories from Real Life* (1791, 1796)	Johnson	6	Blake	Blake
1791 Dec. 1	E. Darwin, *Botanic Garden* (1791–1806)[3]	Johnson	10	Blake	Blake

[1] Attributed to Blake by Keynes (*Bibliotheca Bibliographici*, London, 1964, no. 553) on the basis of the anonymous inscription on the back of his print: 'By William Blake (Mr. Stothard)'.

[2] The title-page to Hartley's *Observations on Man* made special mention of the engraved 'Head of the Author', and the *St. James Chronicle* (April 5–7 [*sic*], 1791) and Johnson's *Analytical Review* (April 1791) specify that the work was sold both unillustrated and illustrated 'With a Head of the Authour, engraved by Mr. BLAKE . . . the Head may be had alone. Price 2s. 6d.' 'The Bookseller's Advertisement' says: 'For the use of a portrait, from which an engraving has been taken by Mr. Blake . . . the bookseller returns his thanks [*to* the Author's family].'

[3] Five Blake plates appeared in the quarto editions of the *Botanic Garden* (1791–

Date	Book or Separate Print	Publisher	Number	Designer	Engraver
1792 Apr. 3	J. Stuart and N. Revett, *Antiquities of Athens*, iii (1794)	J. Nichols	4	W. Pars	Blake
1792 Nov. 15	J. Hunter, *Historical Journal of the Transactions at Port Jackson* (1793)	Stockdale	1	King	Blake
1792 Dec. 1	J. G. Stedman, *Narrative... to Surinam* (1796–1813)[1]	Johnson	4	Stedman	Blake
1793	*Visions of the Daughters of Albion* (1793)	Blake	11	Blake	Blake
1793	*America* (1793)	Blake	22	Blake	Blake
1793	J. Gay, *Fables* (1793, 1811)	Stockdale	12	Anon.	Blake
1793 May 17	*For Children: The Gates of Paradise* (1793, 1818?)	Blake	18	Blake	Blake
1793 June 5	'War' (1793, 1810?)	Blake	1	Blake	Blake
1793 Aug. 1	*Bellamy's Picturesque Magazine*, i (1793)	T. Bellamy	1	C. R. Ryley	Blake
1793 Aug. 18	'Edward & Elinor'[2] (see also 1786)	Blake	1	Blake	Blake
1793 Oct.10	'To the Public'	Blake	1	Blake	Blake
1793 Dec.2	Stedman, *Narrative* (1796–1813)	Johnson	12	Stedman	Blake
1794	*Songs of Experience* (1794)	Blake	25	Blake	Blake
1794?	'Joseph of Arimathea Preaching'	Blake	1	Blake	Blake

5) and were re-engraved with the same date for the octavo editions of Darwin's *Botanic Garden* (1799) and *Poetical Works* (1806).

[1] Stedman's *Surinam* was announced for publication with eighty plates 'executed by Bartolozzi, Blake, Holloway, Benedetti, &c. &c.' in Johnson's *Analytical Review* (xxiii [Feb. 1796]). The *Analytical Review* remarked: 'The numerous plates . . . are neatly engraved, and are, we have great reason to believe, faithful and correct delineations of objects described in the work' (xxiv [Sept. 1796], 237); *The Critical Review* praised the engravings for being 'in a style of uncommon elegance' (Jan. 1797, 52–60); and *The London Review* singled out Blake's eighth plate as 'a very good print' (Feb. 1797, 118).

[2] Blake's 'Edward & Elinor' of Aug. 18th, 1793 is probably somehow connected with the '397 [*copies of*] Edward and Eleonora, a Tragedy, [*by James Thomson?*], 8vo.' which appeared in the 'Catalogue of Books in Quires being the stock of Mr. John Bell' sold on Aug. 8th, 1793 (S. Morison, *John Bell, 1745–1831* [Cambridge, 1930], at p. 42).

Date	Book or Separate Print	Publisher	Number	Designer	Engraver
1794	*Europe* (1794)	Blake	18	Blake	Blake
1794	*The First Book of Urizen* (1794)	Blake	28	Blake	Blake
1794?	'The Man Sweeping the Interpreter's Parlor' (1794, 1824?)	Blake	1	Blake	Blake
1794?	'The Ancient of Days'	Blake	1	Blake	Blake
1794 Oct. 27	'Ezekiel'	Blake	1	Blake	Blake
1794 Nov. 5	G. Cumberland, *Thoughts on Outline* (1796)[1]	Robinson, Egerton	6	Cumberland	Blake
1795	*The Song of Los* (1795)	Blake	8	Blake	Blake
1795	*The Book of Los* (1795)	Blake	5	Blake	Blake
1795	*The Book of Ahania* (1795)	Blake	6	Blake	Blake
1795 Jan. 1	Cumberland, *Thoughts* (1796)[1]	Wilson, etc.	2	Cumberland	Blake
1795 Mar. 10	*Poems of . . . Catullus* [tr. J. Nott] (1795)	Johnson	2	Della Rosa	Blake
1795 May 1	*Elements of Medicine of John Brown* (1795)	Johnson	1	Donaldson	Blake
1795 Aug. 1	Darwin, *Botanic Garden* (1795)	Johnson	1	Fuseli	Blake
1796	G. A. Burger, *Leonora*, tr. J. T. Stanley (1796)	W. Miller	3	Blake	Perry
1796 June 27	E. Young, *Night Thoughts* (1797)[2]	R. Edwards	22	Blake	Blake
1797	L. Euler, *Elements of Algebra* [tr. F. Horner] (1797)	Johnson	1	Ruchotte	Blake

[1] Four of the eight plates Blake engraved for Cumberland's *Thoughts on Outline* (1796) were reprinted in Cumberland's *Outlines from the Antients* (1829), in the Appendix of which Cumberland wrote: 'The four following plates . . . outlined by *Blake* . . . [*exemplify the principle*] of lines flowing towards lines so as to produce a harmony by confining the eye to the subject.' One of the plates after Cumberland dated Jan. 1st, 1795 was evidently misdated, for as late as Dec. 6th, 1795 Blake apologized for not having 'been able to send a proof of the bath tho I have done the corrections'.

[2] Blake's *Night Thoughts* designs are accompanied by a detailed 'Explanation of the Engravings', perhaps by Fuseli.

Date	Book or Separate Print	Publisher	Number	Designer	Engraver
1797?[1]	'Moore & Co' advertisement	Moore & Co.	1	Blake	Blake
1797 Jan. 1	Young, *Night Thoughts* (1797)	R. Edwards	1	Blake	Blake
1797 Jan. 4	Young, *Night Thoughts* (1797)	R. Edwards	1	Blake	Blake
1797 Mar. 22	Young, *Night Thoughts* (1797)	R. Edwards	2	Blake	Blake
1797 June 1	Young, *Night Thoughts* (1797)	R. Edwards	17?	Blake	Blake
1797 Sept.	*Monthly Magazine* (1797)	R. Phillips	1	Anon.	Blake
1797 Dec. 1	C. Allen, *History of England* (1798)	Johnson	4	Fuseli?	Blake
1797 Dec. 1	C. Allen, *Roman History* (1798)	Johnson	4	Fuseli?	Blake
1799	J. Flaxman, *A Letter to The Committee for Raising The Naval Pillar* (1799)	Cadell & Davies, T. Payne, R. H. Evans	3	Flaxman	Blake
1799 Mar. 25	*Dramatic Works of Shakspeare*, ed. G. Steevens (1803, 1832)	J. & J. Boydell	1	J. Opie	Blake
1800 Feb. 1	C. G. Salzmann, *Gymnastics for Youth* (1800)	Johnson	10	Anon.	Blake?
1800 May 1	'Rev. John Caspar Lavater'	Johnson	1	Anon.	Blake
1800 June 14	W. Hayley, *Essay on Sculpture* (1800)	Cadell & Davies	3	Blake, T. Hayley, Flaxman	Blake
1800 Oct. 5	[W. Hayley] *Little TOM the Sailor* (1800)	The Widow Spicer	1	Blake	Blake
1801	H. Fuseli, *Lectures on Painting* (1801)	Johnson	1	Fuseli	Blake
1802 June 1	W. Hayley, *Designs to A Series of Ballads*, i (1802)[2]	Blake, Evans, Seagrave, Humphry	5	Blake	Blake
1802 July 1	Hayley, *Designs*, ii (1802)	Blake, etc.	3	Blake	Blake

[1] In 'The Suppressed and Altered Passages in Blake's *Jerusalem*', *Studies in Bibliography*, xvii (1964), 36, D. V. Erdman demonstrates that the Moore & Co. advertisement must be dated 1797–8 rather than 1790? as in Keynes.

[2] According to the title-page, the 'Designs . . . [*were*] Drawn, Engraved, and Published, by William Blake.'

Date	Book or Separate Print	Publisher	Number	Designer	Engraver
1802 Aug. 5	Hayley, *Designs*, iii (1802)	Blake, etc.	3	Blake	Blake
1802 Sept. 9	Hayley, *Designs*, iv (1802)	Blake, etc.	3	Blake (2) T. Hay-lay (1)	Blake
1802 Nov. 5	W. Hayley, *Life . . . of William Cowper*, i, ii (1802, 1803)	Johnson	4	Romney, D.Heins, T. Law-rence, Blake	Blake
1803 May 1	W. Hayley, *Triumphs of Temper* (1803, 1807)	Cadell & Davies	6	M. Flax-man	Blake
1804–8?	*Milton* (1804–8?)	Blake	51	Blake	Blake
1804–20?	*Jerusalem* (1804–20?)	Blake	100	Blake	Blake
1804	P. Hoare, *Academic Correspondence* (1804)	Robson, Payne, Barker	1	Flaxman	Blake
1804 Jan. 14	*Plays of William Shakspeare*, ed. A. Chalmers (1804–12)	Rivington	1	Fuseli	Blake
1804 Mar. 25	Hayley, *Life . . . of . . . Cowper*, iii (1804)	Johnson	2	F. Stone, Flaxman	Blake
1804 May 12	*Plays of . . . Shak-speare*, ed. A. Chal-mers (1804–12)	Rivington	1	Fuseli	Blake
1805	'Lucifer & the Pope,' 'Let him look up in-to the Heavens'	. .	2	Blake	Blake
1805?	W. Blair, *The Grave*	. . [1]	1	Blake	Blake
1805	*The Iliad* (1805–70)	Longman	3	Flaxman	Blake
1805 June 18	W. Hayley, *Ballads* (1805)[2]	R. Phillips	5	Blake	Blake

[1] The Blair drawings were made in 1805; the one engraving by Blake was not used; and some proofs (by Schiavonetti) were given early dates which were later altered to May 1st, 1808. The title-page and some of the advertisements did not mention Blake. In 1826 Jose Joaquin de Mora wrote some poems to accompany the designs which were published as *Meditaciones Poeticas*.

In the first four editions of Blair (1808, 1808, 1813, 1813) there is a description, probably by B. H. Malkin, 'Of the Designs'. The account of 'The Last Judgment' with the words 'Satan, wound round with the Serpent' repeated in Blake's letter of Jan. 18th, 1808 ('Satan wound round by the Serpent') may make us suspect that Blake himself supplied notes for the descriptions.

[2] The title-page of Hayley's 1805 *Ballads* says the 'Prints [were] Designed and Engraved by William Blake', and the work was so advertised, for instance, in the



Date	Book or Separate Print	Publisher	Number	Designer	Engraver
1806 Feb. 1	B. H. Malkin, *A Father's Memoirs of His Child* (1806)	Longman	1	Blake	Cromek
1806?	'Christ Trampling upon Urizen' (1903)	..	1	Blake	Blake & Butts
1806 Feb. 1	R. Blair, *The Grave* (1808–1926)	Cromek	1	Blake	Schiavonetti
1806 Feb. 21	P. Hoare, *Inquiry in-to the . . . Arts* (1806)	R. Phillips	1	Reynolds	Blake
1806 June 1	Blair, *Grave* (1808–1926)	Cromek	2	Blake	Schiavonetti
1807?	'Enoch'	..	1	Blake	Blake
1808 May 1	Blair, *Grave* (1808–1926)	Cromek, Ca-dell & Davies, etc.	9	Blake	Schiavonetti
1809 Apr. 14[1]	W. Hayley, *Life of George Romney* (1809)	T. Payne	1	Romney	Blake
1810 Oct. 8	'Canterbury Pil-grims' (1810–1941)	Blake	1	Blake	Blake
1811 Dec. 26	Chaucer, *Prologue* (1812)[2]	Newberry	1	Blake	Blake
1812	'The Chaining of Orc'	..	1	Blake	Blake
1813 Spring?[3]	'Earl Spencer'	..	1	T. Phil-lips	Blake
1815–16	[Wedgwood, *Cata-logue*] (1816–43?)	Wedgwood	18	Blake?	Blake
1815 Oct. 1	A. Rees, *The Cyclo-paedia* (1802–20)	Longman, etc.	1	Blake	Blake
1816?	'Mirth' (1816? 1820?)	..	1	Blake	Blake
1816 Jan. 1 Feb. 1 Mar. 1	Rees, *Cyclopaedia* (1802–20)	Longman, etc.	3	Blake?	Blake

Edinburgh Review, vi (July 1805), 495. These plates are different from those published in 1802 with Hayley's *Ballads*.

[1] Blake's plate for Hayley's *Romney* was probably finished long before the date of the imprint, probably in 1805. Blake also worked long on an engraving of a portrait of Romney, to which he refers in his letters of Oct. 7th, 26th, Dec. 13th, 1803; Jan. 27th, Feb. 23rd, March 16th, May 4th, June 22nd, Sept. 28th, Oct. 23rd, Dec. 18th and 28th, 1804, but no copy of it has been traced.

[2] According to the title-page, this edition of Chaucer was 'intended to illustrate a particular design of Mr. William Blake, which is engraved by himself. And may be seen at Mr. Colnaghi's, Cockspur Street; at Mr. Blake's [*brother's house*], No. 28, Broad Street, Golden Square; and at the Publisher's, Mr. Harris, Bookseller, St. Paul's Church Yard.' [3] See April 12th, 1813; Keynes dates the plate about 1811.

Date	Book or Separate Print	Publisher	Number	Designer	Engraver
1816 Nov. 1	Hesiod, *Works Days and Theogony* (1817–70)[1]	Longman	14	Flaxman	Blake
1817 Jan. 1	Hesiod, *Works* (1817–70)	Longman	23	Flaxman	Blake
1818?	*For the Sexes: The Gates of Paradise* (1818?)	Blake	3	Blake	Blake
1818?	'Laocoon'	Blake?	1	Blake	Blake
1818 Mar.	[Death's Door][2]	..	1	Blake	R. J. Lane
1818 Mar. 2	'The Child of Nature', 'The Child of Art'	C. Borckhardt	2	C. Borckhardt	Blake
1818 Nov.11 Dec.10	Rees, *Cyclopaedia* (1802–20)	Longman, etc.	2	Blake?	Blake
1819	Rees, *Cyclopaedia* (1802–20)	Longman, etc.	1	Blake	Blake & W.Lowry
1819	J. Varley, *Zodiacal Physiognomy* (1828)	Varley	2	Blake	Linnell
1819 June 1	'James Upton'	..	1	Linnell	Blake & Linnell
1820?	'On Homer's Poetry [and] On Virgil'	Blake?	1	Blake	Blake
1820 May 1	'Rev^d Robert Hawker'	A. A. Paris	1	I. Ponsford	Blake
1820 June 1	'Mrs. Q' (1820, 1906)	I. Barrow	1	H. Villiers	Blake
1821	*Pastorals of Virgil*, ed. John Thornton (1821)	J. Thornton	27	Blake	Blake(23) Byfield(1) Anon. (3)
1822	*The Ghost of Abel* (1822)	Blake	2	Blake	Blake
1824 Nov.?	[R. J. Thornton] *Remember Me!* (1824, 1825)	I. Poole	1	Blake	Blake

[1] 'Compositions in Outline, from Hesiod's Theogony, Works and Days, and the Days. Engraved by J. Blake, from Designs by John Flaxman, R.A. Professor of Sculpture to the Royal Academy. Folio Size, to correspond with the Outlines from Homer, &c.' was announced in the *Literary Panorama*, N.S., v (March 1817), col. 953, *Edinburgh Review*, xxviii (March 1817), 261 ('Weeks' is printed for 'Works', and for 'Professor . . . Size' is substituted 'Printed'), *New Monthly Magazine*, vii (April 1, 1817), 246 (after 'R.A.' is only 'fol. 2 1. 12s. 6d.'). The 'and the Days' and 'J. Blake' are simply mistakes.

[2] Keynes does not mention the copy after Blake's 'Death's Door' design by Richard James Lane (1800–72), dated 'March 1818', in the British Museum Print Room (208 c 12). In 1816 Lane was articled to the engraver Charles Heath.

Date	Book or Separate Print	Publisher	Number	Designer	Engraver
1825 Jan. 1	'Wilson Lowry'	Hurst, Robinson	1	J. Linnell	Blake and Linnell
1825 Mar. 8	Illustrations of the Book of Job (1826, 1874)	[Linnell]	22	Blake	Blake
1825–7	Illustrations of Dante (1838–1968)	Linnell	7	Blake	Blake
1827	[Cumberland's Calling Card] (1828 ff.)	..	1	Blake	Blake
1828?	J. Whitaker, The Seraph (1818–28?)	Button, Whitaker & Co.	1	Blake	P. Jones
1828?	Head of Blake, visionary head of Cancer[1]	..	1	Anon and Blake	Linnell?
[1831 Nov. 30]	G. Hamilton, The English School, iii (1832)[2]	C. Tilt (London), G. Hamilton & Audot (Paris)	1 1	Blake	Normand fils
[1832 June 29]	Hamilton, The English School, iv (1832)[3]	Tilt, Hamilton, Audot	1	Blake	Normand fils
			841		

[1] A copy of this print, which was probably made by Linnell for an unpublished number of Varley's *Zodiacal Physiognomy*, is in the collection of Sir Geoffrey Keynes.

[2] This copy of 'Death's Door' for Blair's *Grave* (see Pl. LIX) is said to be 'the work of an artist whose productions, though often disfigured by conceit and extravagance, and sometimes unintelligible, occasionally present much grace, beauty, and originality'.

[3] Normand's copy of the 'Death of the Strong Wicked Man' (see Pl. XXI) from Blair's *Grave* is said to have been described as 'fearful and extravagant: admitting the truth of the observation, it may be remarked, that the first qualification, being derived from the poem, belongs to the subject, the extravagance is characteristic of Blake, and is found more or less in almost all his productions.'

SUMMARY OF ENGRAVINGS

BLAKE DESIGNED OR ENGRAVED PLATES

For		*After*	
Joseph Johnson (1780–1804)	96	William Blake (1773–1827)	606
Harrison & Co. (1781–4)	18	Thomas Stothard (1780–6)	34
Blake & Parker (1784)	2	J. H. Fuseli (1788–1804)	17
William Blake (1784–1822)	391	George Cumberland (1794–5)	8
John Stockdale (1792–3)	13	John Flaxman (1799–1817)	46
R. Edwards (1796–7)	43	Others	130
R. H. Cromek (1805–8)	12		
Longman & Co. (1805–19)	48		
Wedgwood (1816)	18		
John Thornton (1821)	27		
John Linnell (1826–38)	29		
Others	144		
	841		841

	Commercially Published	Published by Blake	Unpublished
1773–9	9	..	1
1780–8	63	4	32
1789–95	87	214	4
1796–1803	87	14	..
1804–14	29	152	7
1815–32	127	7	4
	402	391	48

ADDENDA

Since 1964, when the *Blake Records* went to press, a number of contemporary references to Blake have appeared, some of them generously pointed out to me by Mr. J. H. Macphail, Mr. Richard Shroyer, Mrs. Robert D. Chellis, Professor Mark Reed, Mr. Martin Butlin, Mr. Victor Skretkowicz, Jr., Miss Valerie Rance,[1] and Miss Nancy Bogen.[2] Those references which were too extensive to insert into the body of the page-proof have been assembled below as Addenda.

* * *

The etching representing the scene when Stothard, Blake, and a friend, out on a sailing expedition, were arrested as spies is described by a contemporary as follows:

September, 1780?

This print is curious[;] the following is its history—Stothard, Blake & I believe Parkes [*i.e.* Parker] an Engraver pupil with Blake & Basire—during the late War went upon a sailing Excursion for some days [;] they landed & Encamped as this plate represents[;] they were there found and taken before some authority as spies and narrowly escaped further trouble[,] perhaps danger. *H*aving got their liberty they returned home—
The plate is the production of Blake though I am certain it is designed by Stothard—
This is the account of Frederick Tatham recieved from M^{rs} Blake[.][3]

This description corresponds with that of Mrs. Blake given

1 Miss Valerie Rance, 'The History of William Blake's Reputation from 1806 to 1863', Reading University M.A., 1965.

2 Subsequently published as 'An Early Listing of William Blakes's *Poetical Sketches*', *English Language Notes*, iii (1966), 194–6 (see p. 34 above).

3 The MS. was written in a hand unknown to me (perhaps Robert Balmanno's) and bought in 1849 (the date of the accession-stamp) by the British Museum Print Room, where it is kept with a collection made by Robert Balmanno of MS. materials about Stothard and catalogued as NN. 6.18. This is probably the document in the British Museum Print Room referred to by Mrs. Bray in her *Life of Thomas Stothard*, 1851 (see p. 20 n. 1 above) in which 'The etching is . . . stated to be by Blake'.

above (p. 19 n. 3) in identifying the third man on the expedition as James Parker and the etching as by Blake and seems inherently probable.

* * *

Blake was becoming well enough known by 1789 to be listed in a German dictionary of engravers as: 'W. BLAKE. Graveur en Angleterre.'[1]

* * *

On March 4th, 1800, Flaxman wrote to Hayley at Eartham:

March 4th, 1800 I have wrote no answer to your last because as I had put the Drawings & Engravings in the train You desired I knew that Mr Blake & Mr Howard would give you a better account of their proceedings than I could[2]

* * *

The reviewer of Malkin's *Memoirs of his Child* in the *Literary Journal* for July 1806 said that

July, 1806 upon the whole, we approve of this publication . . . although we cannot extend our approbation to the irrelevant panegyric upon Mr. William Blake, painter and engraver. Of that gentleman, here forced upon our notice as a poet, we shall have occasion to speak . . . at the conclusion of this critique. . . .

To relieve our readers with a lighter subject, with a touch, indeed, of the ridiculous—let us refer to Mr. William Blake. With the professional occupations of painting and engraving, in which this gentleman is engaged, we have nothing to do; except, indeed, to praise his design prefixed to this volume. The portrait of the child is very interesting.—But what can Mr. Malkin mean by introducing his friend to us as a poet? He allows that Mr. Blake's attempts are 'unfinished and irregular'—and he asserts him to have ventured on the 'ancient simplicity'—illa priorum simplicitas—but with due submission to the judgment of our readers, should we not say that Mr. Blake has successfully heightened the 'modern nonsense?' We conclude our critique with an extract:

LAUGHING SONG. . . . [*see p.* 425]³

* * *

¹ [C. H. von Heinecken] *Dictionnaire des Artistes, dont nous avons des Estampes*, avec une Notice Detaillée de leurs Ouvrages Gravés, Leipsig, 1789, vol. iii, p. 3.

² Quoted from a photostat of the MS. kindly sent me by its owner, Mrs. Robert D. Chellis.

³ Anon., 'Art. II. *A Father's Memoirs of his Child. By* Benjamin Heath Malkin . . .', *Literary Journal*, 2 S, ii (July 1806), 28, 34–35. This reference was kindly pointed out to me by Professor Mark Reed.

The reviewer of Malkin's memoir of his son in *The Annual Review* in 1807 was sympathetic to the account of the child but could not

January, 1807

however entirely approve the manner in which the author has executed his task. In the first place, the dedication occupies nearly a third of the whole volume, and includes the life and poems of Mr. Blake the artist. What connection this has with the main object of the work, it is difficult to conjecture, unless indeed it is introduced, because Mr. Blake once approved [*on pp. 33–34 of Malkin's book*] the drawings of Master Malkin. The poems are certainly not devoid of merit, one specimen we shall give our readers.

'SONG. [*"*I love the jocund dance*"*, *see p. 430 above*]'[1]

* * *

A French dictionary of engravers noticed Blake somewhat inaccurately in 1809 by saying that 'BLAKE, (w.) a gravé à Londres en 1784 &c. divers sujets à la manière pointillée, d'après différens artistes Anglais.'[2]

1809

* * *

A letter by 'P.' to *The Gentleman's Magazine* for September 1812 described the surviving Talbot Inn, which had been known to Chaucer's pilgrims as the Tabarde Inn, and mentioned that 'A well-painted Sign by Mr. Blake represents Chaucer and his merry Company setting out [*from it*] on their journey.'[3] 'P.' was probably a friend of Blake's, for few contemporaries seem to have known of his Chaucer design, and no other reference to it in the public journals is known.

September, 1812

* * *

Evidently Varley often brought with him when he called on Blake a Sketchbook of his own in which Blake sometimes dashed

[1] Anon., 'Art XIV. *A Father's Memoirs of his Child*, by Benjamin Heath Malkin . . .', *Annual Review* . . . for 1806, v (1807), 379–81.

[2] P. F. et A. L. Basan, *Dictionnaire des Graveurs Anciens et Modernes*, Seconde Edition [the first edition was in 1767], Paris, 1809, vol. i, p. 70. Blake used the dotted manner in 'Zephyrus & Flora' and 'Callisto' (17 December 1784) for the firm of Parker & Blake, but rarely thereafter.

[3] *Gentleman's Magazine*, lxxxii (Sept. 1812), p. 217. The enigmatic 'Sign' may be a misprint for 'design'.

down the scenes he saw, and occasionally someone, probably
Varley, made notes about the visions as well. On p. 16 of the
Sketchbook, beneath two sketches for chandeliers and what
appears to be a plan of an octagonal room, is the date 'octr 29
Friday 11 P M 1819' and a note:

the Empress Maud said rose water was in the vessel under the table &
said [?] there were closets which contain all the conveniences for the
bed chamber [.]¹

This suggests that the room and chandeliers were the Empress
Maud's. On the first page of the sketchbook is another note
which may also be associated with her:

*October
29th,* Can you think I can endure to be considerd as a vapour arising
1819 from your food? I will leave you if you doubt I am of no [more *del*]
greater importance than a Butterfly[.] Spiritual communication to mr
Blake[.]

Empress Maud not very tall[.]

Further along (p. 75) is sketched an angular, demonic face
with sharply slanted eyes, and under it is written '22ᵈ octr'.
To the right is a separate sketch, rather ill defined, of a knight
fully armed in chain mail. Still later (p. 91), beside a regular
series of linked dots labelled 'Counting for Geomancy', is:

Hotspur said
any[?] & we shou[l]d have had the Battle had it not been for those
cursed Stars[.] Hotspur Said[?] he was indignant to have been killd
by trusting[?] the Stars[?] [*words illeg.*] by such a Person as Prince
Henry who was so much his inferior[.]

* * *

In his *Desultory Exposition of an Anti-British System of
Incendiary Publication, &c.* in 1819, W. P. Carey defended him-
self from an attack upon his book on West's 'Death on the
Pale Horse' by saying that he had

¹ Quoted, like the other Varley–Blake Sketchbook references below, from photo-
graphs of the original generously provided by Mr. Clayton-Stamm, who acquired
the Sketchbook in the spring of 1967 after it had been lost to public sight for
almost a century. The date above is on a separate line between 'table' and '& said'.
Mr. Vanderhoef has a Visionary Head of The Empress Maud.

not only not confined myself to Mr. West and his Death on the Pale
Horse, to the total exclusion of all others, but I have in page 9, in my
preliminary observations, mentioned HAYDON I have introduced
Blake and his imperishable series of designs for the Grave, executed
by the lamented SCHIAVONETTI [*see p. 245 above.*]. . . In page 129, I
also marked my continued sense of this distinction [*that paintings from
Sacred History are* more capable of developing the human genius and
exciting a higher public interest than pictures from *Pagan* fiction], in
BLAKE's 'devotional grandeur of conception,' 'his solemn religious
fervour,' [*p. 246 above.*] . . .¹

1819

* * *

A review of J. T. Smith's book in *The Athenaeum* for November
19th, 1828 commented that

The notices of Flaxman and Blake are very interesting. Of the
latter, Mr Smith is a great admirer. He describes him to have been a
very eccentric being, at times almost a madman. The greater part of
his designs were conceived from the hints given him in his visions by
his brother and others, and amongst them, Apelles seems to have
favoured him with a visit now and then; but, wherever the designs
may have originated, most of this artist's pictures certainly present
the effect of an exceedingly grand imagination; and in proof of his
talent, we will quote the opinion of Flaxman and Fuseli, 'that a time
will come when Blake's finest works will be sought after and treasured
up in the portfolios of men, as much as those of Michael Angelo are at
present [*see p. 467 above*].'²

*November
19th,
1828*

* * *

A few weeks later another review appeared in *The Eclectic
Review*:

The biography of that strange and eccentric being, Blake, has pleased
us most, inasmuch as we were not previously in possession of the facts,
though well acquainted with that artist's works. He was an engraver
by profession, but a poet and designer by preference. Of his poetry,
we cannot speak favourably, and much of his invention in design is
frigidly extravagant. But, amid much out-of-the-way rubbish, there
are gleams of high conception and vigorous expression. He had strong
powers of abstraction, and in his fits of mental absorption, saw

*December,
1828*

¹ William Carey, *Desultory Exposition of an Anti-British System of Incendiary
Publication, &c.*, London, 1819, pp. 22, 32. Carey mentions (p. 9) that his *Pale
Horse* book was published on February 5th, 1818.
² Anon., 'Nollekens and his Times', *Athenaeum*, No. 56 (Nov. 19, 1828), 881–2.

visions, and held supernatural conversations [*Here he quotes Blake's letter to Flaxman about his visions at Felpham; see pp.* 461–2 *above.*]

Blake was, although poor, a singularly happy man. He had an amiable wife, kept clear with the world, and rejoiced in the harmless insanity that gave him communion with the invisible world.[1]

* * *

The reviewer of Cunningham's *Lives* for *The Gentleman's Magazine* in February 1830 was chiefly interested by what Cunningham said of Blake's eccentricity:

February, 1830

Of *Blake*, the visionary, we hardly know how to speak: he appears to have been an amiable enthusiast, on the wrong side of the line of demarcation as it respected his sanity. 'His fancy overmastered him,' says Mr. C. [*p. 503 above*] until he at length confounded 'the mind's eye' with the corporeal organ, and dreamed himself out of the sympathies of actual life. The following absurdity is recorded of him; and his friend, Mr. Varley, has authenticated the story by giving an engraving of the '*Spiritualization*,' in his equally absurd volume on 'Astrological Physiognomy [*pp.* 372–3 *above*].'

'He closed the book, . . . so he drew him [*Cunningham paragraph* 39].'[2]

* * *

According to W. M. Tartt,[3] who had 'met Cromek in 1808, as the guest of Mr. Roscoe at Allerton', 'The best specimen, in this way [*of MS epigrams*], was circulated (and attributed to Blake) in the first decade of the present century

' "Tickle me," said Mr. Hayley,
"Tickle me, Miss Seward, do;
And be sure I will not fail ye,
But in my turn will tickle you."
So to it they fell a-tickling.

"Britain's honour! Britain's glory!
Mr. Hayley that is you."
"The nine muses bow before ye!
Trust me, Lichfield's swan, they do.'

[1] Anon., 'Art. III. *Nollekens and his Times:* . . . by John Thomas Smith . . .', *Eclectic Review*, iii (Dec. 1828), 536–7.

[2] Anon., '*The Lives of the most eminent British Painters, Sculptors, and Architects. By* Allan Cunningham. *Vol. II.* Murray. 1830', *Gentleman's Magazine*, C (Feb. 1830), 141–3.

[3] Anon., ' "Pictor Ignotus;" A Biography [*by Gilchrist*]', *New Monthly Magazine*, cxxx (1864), 312, 316, reprinted without the verses in Tartt's *Essays on Some Modern Works*, London, 1876, pp. 200, 207.

Thus these feeble bardlings squandr'ing
Each on each their lavish rhymes,
Set the foolish reader wond'ring
At the genius of the times!'

Blake almost certainly did not write these lines,[1] but it is interesting that a contemporary had heard he had.

* * *

R. C. Jackson's father told him that George Romney gave Blake the vine and fig-tree which pleased Blake so much in his garden in Lambeth, and that Blake 'never enjoyed any of his etching-painting rooms' as much as he had enjoyed the panelled back room looking on the garden in Lambeth.[2] R. C. Jackson is an extraordinarily unreliable witness, but the information he gives on his father's authority (here and on pp. 235 n. 4, 562 n. 1) seems inherently possible or plausible.

[1] Lines very like the second stanza are attributed to Bishop William Lort Mansell (1753–1820) by W. Partington, ed. *The Private Letter-Books of Sir Walter Scott*, London, 1930, p. 215.

[2] Richard C. Jackson, 'William Blake: An Unlooked for Discovery', *South London Observer*, 22, 29 June 1912.

INDEX

For assistance and distraction during the production of this index, I am grateful to Julia, Sarah, and Beth.

Abbot, painter, 109, 113 and n. 4.
Abbott, C. C., *Life . . . of George Darley* (1928), 222 n. 3, 410 n. 2.
Abershaw, Louis Jeremiah (1773?–95), robber, 49.
Abraham, prophet, 2, 473.
Accounts, 569–608.
Achilles, 323, 362.
Ackermann, Rudolph (1764–1834), bookseller, 333, 334 n. 1.
Adam, progenitor, 46, 95, 102, 438–9, 452, 473, 484.
— (Blake as), 54, 257 n. 1.
— *see* 'The Angel of the Divine Presence Clothing Adam & Eve with Coats of Skins' (1803), 571.
— *see* 'God Creating Adam' (1805), 572–3.
— *see* 'God Judging Adam' (1805), 572.
Adams, R. B., collection, 189 n. 1.
Addison, Joseph (1672–1719), author, 34, 162.
Aders, Charles, collector, 216 n. 3, 267, 286, 301 and n. 2, 308 n. 3, 309, 310 and n. 1, 313, 314 n. 2, 325, 336, 363, 538–9, 542, 592 and n. 5, 599.
Aders, Elizabeth [Ward], wife of Charles, 216 n. 3, 301 and n. 2, 308 n. 3, 309 and n. 2, 310 n. 1, 313, 318 n. 2, 319–20, 333 and n. 2, 336, 338, 538–9, 583 and n. 1, 592 and nn. 5 and 6, 612.
Aeschylus, 138.
Aesop, 48, 172.
'Agnes from the Novel of the Monk' (1800?), 73, 237 n. 2.
'Ah! Sun Flower', *Songs of Experience* (1794), 252 n. 1, 469.
Ahania, see *The Book of Ahania*.
Aikin, C., friend of HCR, 225, 231.
Albion, character, 383 and n. 1, 470, 513 and n. 1.
Alcibiades, *see* 'Timon and Alcibiades' (1790).

Aldridge, A. O., *Man of Reason* (1959), 530 n. 2.
Alfred (849–901), King, 237, 512.
'Alfred and the Danes' (1808?), 214 and n. 3.
All Religions are One (1788?), 585 n. 4, 611.
Allen, 602.
Allen, Charles, *History of England* (1798), 264 n. 4, 615.
— *Roman History* (1798), 615.
Allen, J., painter, 555.
America (1793), 61, 120 n. 1, 176, 211 n. 2, 224 nn. 1 and 3, 244, 259 n. 1, 270 and n. 3, 356, 416, 446 and nn. 1, 6, 447 and n. 1, 454, 460 and n. 3, 470, 500 and n. 1, 501, 503, 561, 581 n. 2, 585 and n. 7, 607; Pl. li.
American Monthly Magazine (1831), 410.
Anacreon, Greek poet, 69.
Analytical Review (1791), 39 n. 1, 41, 612 n. 2.
— (1796), 55 and n. 2, 613 n. 1.
'The Ancient Britons' (1809), 214 n. 3, 217, 220 and n. 2, 222 and n. 1, 226 and n. 3, 436, 438, 450–1, 556 n. 1.
'Ancient of Days' (1794), Frontispiece of *Europe*, 54, 377 n. 2, 463, 470–1, 498 n. 4, 502 and n. 1, 527, 614.
The Ancients, 234 n. 6, 256, 271, 273 n. 1, 295 and n. 1, 300, 409 n. 3, 564.
Anderdon Papers, BMPR., 41 n. 4.
'The Angel', *Songs of Experience* (1794), 252 n. 1, 469.
'The Angel of the Divine Presence Clothing Adam & Eve with Coats of Skins' (1803), 571.
Anglican Church, 440, 452, 458 n. 1, 475–6.
Annals of the Fine Arts (1816), 466 n. 1, 555, 560 n. 1.
— (1816–19), 563 n. 1.

Anne of Bohemia (1366–94), First Queen of Richard II, 422, 511.
Annual Biography and Obituary (1828), 350 n. 1, 361 and n. 2, 362 n. 1.
Annual Register (1828), 350 n. 1, 362 and n. 2.
Annual Review for 1805 (1806), 177 and n. 3.
— for 1806 (1807), 623 n. 1.
Antijacobin (1798), 181 n. 3.
Antijacobin Review (1808), 183, 199–208 and n. 2.
Antiquarian Society, *see* Royal Society of Antiquaries.
Antonio, Mark, *see* Raimondi Marcantonio.
Antony, *see* Mark Antony.
Apelles, Greek painter, 468, 495, 625.
Apollo, 17, 198, 217, 222, 288, 314, 438, 451, 493, 541.
Apollo Belvidere, 493 n. 14.
Apostles, 315.
Apprenticeship, 9 n. 3, 10 and n. 2, 11, 12 n. 1, 13–14, 19 n. 2, 422 and n. 2, 423, 456, 478, 509 and n. 1, 511 and n. 1, 552 n. 3.
'The Approach of Doom' (1788?), 611.
Argyle, Duke and Duchess of, 264 and n. 5.
Ariosto, Lodovico (1474–1533), poet, 69–70.
— *Orlando Furioso* (1783–99), 610.
Aristophanes, 287 n. 2.
Armitage, *see* Harmitage, 551–2 and n. 1.
Army Pay Office, 358–9.
Arnald, Royal Academician, 468.
Arnould, bookseller, 592 n. 1, 599.
Art Gallery, Manchester, *see* Whitworth Art Gallery, Manchester.
Art Institute, Chicago, 112 n. 1, Pl. iii.
Arthur, King, 214 n. 3, 222, 423 n. 1, 512.
Artist (1807), 186 n. 5, 191 n. 5, 219.
Artists' Benevolent Fund, 275 n. 2.
Artists' General Benevolent Association, 466 n. 1.
Astley, Philip (1742–1814), showman, 508, 521 and n. 3, 522, 560 and n. 5.
Astrology, 259, 263, 296–7, 370, 390 n. 2, 402 n. 3, 489 n. 1, 618.
Atheism, 313, 316, 324 and n. 3, 325, 541, 543–5.

Athenaeum (1828), 625 and n. 2.
— (1830), 377 and n. 2, 400.
— (1843), 267 n. 2.
Athenaeum Magazine (1808), 190 n. 2, 191 n. 2.
Athens, 282.
— *see* Stuart and Revett, *Antiquities of Athens* (1794).
Atossa, 138.
Audibert, M., French M.P., 530 n. 2.
Audinet, Philip (1766–1837), engraver, 48.
Augustus (63 B.C.–A.D. 14), emperor, 267 n. 1.
Austen, Jane (1775–1817), novelist, 213 n. 2.
— *Letters* (1952), 96 n. 2.
Austin, Mrs. Sarah (1793–1867), translator, 596, 602 and n. 3.
Australia, 266.

Bacon, Francis (1561–1626), essayist, 106 n. 2, 313, 541.
— *Essays* (1798) annotated by Blake, 356.
Bailey, Edward Hodges (1788–1867), sculptor, 276, 468 and n. 4, 586, 592, 598.
Baines, Henry (fl. 1820–9), Blake's brother-in-law, 318 n. 2, 395, 525, 564 and n. 2.
Baines, Mary (fl. 1820–9), Blake's sister-in-law, 395, 525 n. 3, 564 and n. 2.
Bakers, 508, 509 and n. 1, 568.
Bakers' Hall, 509 n. 1.
Baley (*Job* binder), *see* Bayley.
'Ballads MS', *see* 'Pickering MS'.
Balls, undertaker, 411.
Balmanno, Robert (1780–1860), collector, 329 and n. 2, 377, 582 n. 6, 587, 590 n. 1, 591 and n. 2, 598, 604, 621 n. 3.
Banes, Henry, *see* Baines, Henry.
— Mary, *see* Baines, Mary
Banks, Thomas (1735–1805), sculptor, 55?, 287, 362.
Baptist Church, 7, 8 and n. 2, 257, 440 n. 6.
'The Bard, from Gray' (1785), 30, 179 n. 1.
Barker, J., printer and bookseller, 616.
Barkers Continuation of Egerton's Theatrical Remembrancer (1801), 34 n. 1.

Barkers Complete List of Plays (1803), 34 n. 1.
— *The Drama Recorded* (1814), 34 n. 1.
Barling, Mrs., Linnell's sister, 321 and n. 1.
Barlow, Francis (1626?–1702), animal painter, 48.
Barnes, Thomas (1785–1841), editor of *The Times*, 231.
Barrett, J. A. S., *TLS* (1928), 393 n. 2.
Barrett, Mr. Roger W., collection, 178 n. 3.
Barrow, I., print seller, 618.
Barry, bookseller of Bristol, 219 and n. 2.
Barry, James (1741–1806), painter, 46, 55?, 235, 375, 377.
Bartolozzi, Francesco (1727–1815), engraver, 43, 44, 45 n. 2, 46, 48–49, 87, 112, 121, 173, 554, 613 n. 1.
Barton, Bernard (1784–1849), poet, 284, 370 and n. 3., 394, 396–8 and n. 1, 400–1, 496.
Basan, A. L. & P. F., *Dictionnaire des Graveurs* (1809), 623 n. 2.
Basire, James (1730–1802), engraver, 9 and nn. 3 and 4, 10–13 and n. 1, 14, 18, 25, 29, 58, 155 n. 2, 176 n. 1, 317 n. 1, 349, 354, 356, 361 n. 2, 422 and nn. 2 and 3, 423 and n. 1, 433, 448, 456, 466, 478 and n. 2, 480, 511 and n. 1, 512 n. 1, 556 and n. 3, 621.
Basire, James [Jr.] (1769–1832), son and apprentice of James Basire, 12.
Basire, Richard Woollett (fl. 1787), apprentice to James Basire, 12.
Bassett St. (Kentish Town) Baptists, 8 n. 2.
Bateman, Elizabeth (fl. 1738), wife of James Blake, 553.
Bath, city, 96 and n. 2, 97, 101, 103, 108 n. 2, 111.
Bath Guide, see *New Bath Guide*, 187 and n. 1.
Bathurst, Henry (1714–94), Lord Chancellor, 524 n. 1.
Bathurst, Henry (1762–1834), statesman, 318 n. 2?
Bathurst, Tryphena (d. 1807), widow of the Lord Chancellor, 524 n. 1.
Battersea, 6, 21 and n. 3, 22 and n. 1, 344, 459, 481 n. 4, 564 n. 2.
— see St. Mary's, Battersea.

Battini, William, J.P. at 1803 trial, 131.
'Battle from the Welsh Triads', see 'The Ancient Britons' (1809).
Bayley, binder, 597, 603.
Bayley, William, juror (1804), 140.
Beaumont, Sir George Howland (1753–1827), connoisseur, 546 n. 1.
Becker, friend of Henry Crabb Robinson, 225.
Beckford, William (1759–1844), collector, 280 n. 1, 369 n. 1, 431 n. 1.
Bedlam, 40 n. 2, 299 n. 1.
Beechey, Sir William (1753–1839), painter, 153, 169, 193, 201, 247, 348.
Behmen, Jacob, see Boehme.
Behnes, dealer, 599.
Bell, John (1745–1831), bookseller, 609, 611.
— see Morison, S., *John Bell, 1745–1831* (1930), 613 n. 2.
[T.] *Bellamy's Picturesque Magazine* (1793), 613.
Bellenden, John Ker, see Ker, John Bellenden.
Bellenden, 7th Baron, see Duke of Roxburgh, 227 n. 3.
Belvidere, Torso, 283.
Benedetti, engraver, 613 n. 1.
Bensley, Thomas (d. 1831), printer, 171, 191, 213.
Bentham, Jeremy (1748–1832), writer, 327 n. 2?, 387.
Bentley, G. E., *Shakespeare, A Biographical Handbook* (1961), 428 n. 1.
Bentley, G. E., Jr., collection, 131 n. 2, 134 n. 1, 139 n. 2, 153 n. 2, 199 n. 3, 342 n. 1, Pl. xxxviib.
— *Early Engravings of Flaxman's Classical Designs* (1964), 184 n. 3, 571 n. 1, 580 n. 3.
— *N. & Q.* (1958), 26 n. 1; (1965) 249 n. 1.
— *PMLA* (1956), 67 n. 1, 340 n. 3, 509 n. 3.
— *Review of English Studies* (1956), 71 n. 1, 90 n. 2.
— and M. K. Nurmi, *Blake Bibliography* (1964), 609 n. 1.
Bentley, Richard (1708–82), writer, 512 n. 2.
Berg Collection, New Public Library, 91 n. 2.

Berkeley, George (1685–1753), philosopher, 313 n. 2.

Bermondsey Borough Council, 551 n. 1.

Beulah, 297 n. 1.

Bewick, Thomas (1753–1828), engraver, 119.

— *Memoir* (1887), 119 nn. 1 and 2.

Bible, 36 and n. 1, 42, 59, 90, 106, 189, 283, 311 n. 1, 312, 316, 319, 322 and n. 2, 324 n. 3, 331–2, 337, 349, 352, 354, 388, 423 n. 2, 426, 427 and n. 1, 458, 467, 470, 493, 498 n. 3, 499, 527, 528 and n. 2, 531 and n. 2, 541 n. 1, 543, 545 and n. 1, 547–8, 570–1, 572 and n. 2; *see also* Kimpton, E., *History of the Holy Bible* (1781) and *Protestants Family Bible* (1781?) and *Royal Universal Family Bible* (1780–2).

Bindman, Mr. David, collection, 47 n. 2; Pl. vi.

Biographie Universelle (1814), 211 n. 4.

Birch, John (1745?–1815), surgeon, 73 and n. 1, 116, 574 and n. 2.

Bird, Edward (1772–1819), painter, 563 n. 1.

Bird, Mr., painter, 411, 535, 596?, 600?

Bishoff, John, 233.

Bishop, friend of Cumberland, 55 n. 3.

Black Prince, *see* Edward Prince of Wales, 298.

Black, Mrs.; mistake for the poet's wife, 364, 595 n 3.

Black, Guillermo; mistake for the poet, 334.

Blackburne, Francis, *Memoirs of Thomas Hollis* (1780), 317 n. 1, 543.

Blackheath, Surrey, 234.

Blackwood's Edinburgh Magazine (1820), 265 n. 4.

Blagden, C., *Stationers' Company* (1960), 14 n. 3.

— *Guildhall Miscellany* (1959), 9 n. 2, 10 nn. 1 and 2, 11 nn. 1–4.

Blair, Robert, *The Grave*, prospectus (1805), 168–71, 190–1, 424.

— *The Grave* (1808), drawings, 166–7 and n. 1, 168 and n. 1, 172, 174–5, 184, 186 and n. 3, 200 and n. 2, 367, 464 and nn. 1–2, 606, 616 n. 1, 618 and n. 2; Pls. xviii, xxv.

— *The Grave* (1808), 166–74, 177–9, 182 and n. 1, 183, 190–210, 213 and n. 4, 214 and n. 1, 216, 221 n. 2, 222, 224 n. 3, 225–7 and n. 1, 245–8 and n. 2, 264, 270–1, 284 n. 4, 289, 326, 330, 331 n. 1, 333, 335 and n. 2, 336, 346, 348, 351, 354, 356 n. 5, 357, 362 n. 2, 368, 372, 398, 402 n. 3, 413 n. 1, 424 and n. 1, 433–4, 436, 449–50, 464 and nn. 1 and 2, 490, 491 and n. 1, 538, 576 and n. 1, 593 and nn. 1 and 2, 625; Pls. xx–xxi, xxiv, xxvi–xxxi, xxxiv, xlv–xlvi, liii.

— *The Grave* (1808–1926), 617.

— *The Grave* (1808–13), 616 n. 1.

— *The Grave* (1813), 227 n. 1.

Blair, William, mistake for Robert Blair, 168 n. 1.

Blake & Son, Hosiers and Haberdashers, 28 Broad St., 552 and n. 3.

Blake Buildings, Lambeth, 560 n. 4.

Blake, the poet's aunt, 476 and n. 1.

Blake, Andrew (fl. 1772), Merchant of 12 Fountain Court, 564 n. 2.

Blake, B. (fl. 1807–25), artist, sometime of 37 Broad St., 553.

Blake, Barnabas (fl. 1806), hotel keeper, 554.

Blake, Caesar (b. 1712), son of Francis of Battersea, 22 n. 1.

Blake, Catherine (b. 1719), daughter of Henry of Battersea, 22 n. 1.

Blake, Catherine (fl. 1755), wife of John, the poet's mother?, 3 and n. 2.

Blake, Catherine Elizabeth (b. 1764, d. after 1833), sister of the poet, 7 and n. 2, 8, 29 n. 7, 74, 77, 410, 413, 416–17, 462, 488, 508–10 and n. 2, 558, 562 n. 1.

Blake, Catherine [Harmitage], the poet's mother, 2, 3, 5–7, 29 n. 7, 47 and n. 4, 48, 340 n. 4, 476, 477 and n. 4, 481, 508, 509 and n. 1, 518–19, 551.

Blake, Catherine Sophia [Boucher] (1762–1831), the poet's wife, 5, 6 and n. 1, 19 n. 3, 21–23 and n. 1, 26, 29 and nn. 3 and 7, 30, 32 and n. 3, 33, 35, 41 n. 4, 48, 52, 54, 67, 71, 73 and n. 1, 74–77, 79, 83, 85, 89, 95, 97, 99, 103, 106 and n. 1, 107–8, 110–12 and n. 2, 114, 118–20, 124, 127, 142–3, 146, 148, 164–5, 186, 214–15, 220 n. 3, 221 n. 4, 235–7 and nn. 2 and 3, 238, 241, 245 and n. 2, 250, 256 n. 2,

Blake, Catherine Sophia [Boucher] (*cont.*):
257 n. 1, 258, 276 and n. 1, 278, 288, 291, 293–4, 302, 307, 310 n. 2, 320, 322 and n. 3, 342 and n. 3, 343, 344 and nn. 2–4, 6–8, 345 and n. 5, 346 and n. 2, 348, 350–1, 353 and n. 2, 354 and n. 1, 355–9 and n. 2, 360–2 and n. 2, 363 and n. 2, 364 and n. 2, 365 and n.1, 366–7, 369–74 and nn. 1 and 3, 375, 378 and n. 1, 379 and n. 4, 383 n. 1, 393, 395, 398 and n. 2, 399, 400 n. 1, 401, 403 n. 1, 404, 405 and n. 1, 406, 407 and n. 2, 408–10 and n. 4, 411–13 and n. 1, 414–15 and n. 1, 416–17 and nn. 1 and 2, 459 and nn. 1 and 2, 460–1 and n. 1, 462–3, 465 n. 1, 467, 476 n. 1, 468, 471 and n. 2, 473–5 and n. 4, 476 and n. 1, 481 and nn. 3 and 4, 482, 487–8, 490 n. 1, 498 and 4, 499, 501 and n. 4, 502–5, 507–8, 517–18 and n. 1, 521, 522 and n. 1, 524–5 and n. 3, 526 and n. 1, 527–8 and n. 3, 533–4 and nn. 2–4, 535, 538, 542–3, 547, 549, 562 and n. 1, 564 and n. 2, 565 and n. 4, 567 and n. 3, 568–9, 576, 583–4, 592 and n. 4, 594 and nn. 5 and 6, 595 and nn. 1, 3, 4, 6, 7, 596 and n. 1, 605 and n. 2, 606–7, 626 ; Pl. xxxiii.

Blake, Charles (b. 1758), son of James and Mary, 553.

Blake Charles (fl. 1784–92), hosier, 557 n. 1.

Blake, Charles, rioter, 1804, 146 n. 4.

Blake, Charles (mistake for poet), 146 and n. 4.

Blake, Christopher (b. 1717), son of Henry of Battersea, 22 n. 1.

Blake, Daniel (d. 1741) of Battersea, 22 n. 1.

Blake, Daniel (fl.1774), shoemaker, 554.

Blake, Deborah, buried in Bunhill Fields, 476 n. 1.

Blake, Elizabeth (b. 1712), daughter of Henry of Battersea, 22 n. 1.

Blake, Elizabeth (fl. 1731–51), wife of Thomas of Battersea, 22 n. 1.

Blake, Elizabeth (d. 1740) of Battersea, 22 n. 1.

Blake, Elizabeth (1751–8), daughter of Thomas and Elizabeth of Battersea, 22 n. 1.

Blake, Elizabeth (b. 1769), daughter of John and Margaret, 554.

Blake, Elizabeth buried in Bunhill Fields, 476 n. 1.

Blake, Frances (fl. 1752), mother of Reuben, 553.

Blake, Francis (fl. 1712), father of Caesar of Battersea, 22 n. 1.

Blake, George (b. 1735), son of John and Mary, 1 n. 2.

Blake, George, father of Stephen, haberdasher, 552 n. 3.

Blake, Henry (fl. 1709–46?), of Battersea, 22 n. 1.

Blake, Henry (b. 1714), son of Henry of Battersea, 22 n. 1.

Blake, Hephzibah, buried in Bunhill Fields, 476 n. 1.

Blake, Hester, buried in Bunhill Fields, 476 n. 1.

Blake, James (fl. 1721), husband of Susanna, 1 n. 2.

Blake, James (fl. 1737), of Rotherhithe, the poet's grandfather?, 1, 23.

Blake, James (fl. 1738), husband of Elizabeth, 553.

Blake, James (b. 1721), son of James and Susanna, 1 n. 2.

Blake, James (1722?–84), father of the poet, 1 and n. 2, 2, 5–9 and n. 3, 10, 21 and n. 3, 23–24, 28 and n. 4, 29 and n. 1, 47 and n. 4, 48, 318 n. 2, 340 n. 4, 456–7, 476–7 and n. 4, 482 and n. 2, 508–9 and n. 1, 510 and n. 4, 511 and n. 1, 518, 551–2 and n. 3, 553, 556, 558.

Blake, James (b. 1724), son of John and Mary, 1 n. 2.

Blake, James (fl. 1758), father of Charles, 553.

Blake, James (1753–1827), the poet's brother, 2 and n. 4, 3 and n. 1, 5, 8, 23–24, 29 n. 7, 47 n. 4, 73 and n. 1, 112 n. 2, 113, 115–16, 120, 219, 225, 290 n. 2, 338 n. 3, 340 and n. 4, 461 n. 1, 465, 476, 492, 508 and n. 3, 509 and n. 3, 537, 552 and n. 3, 553, 555, 557–8, 561–2, 564, 572 and n. 1, 617 n. 2.

Blake, Jane (b. 1717), daughter of William of Battersea, 22 n. 1.

Blake, Jane, buried in Bunhill Fields, 476 n. 1.

Blake, John, mistake for the poet's father?, 3 and n. 2.

Blake, John (b. 1715), son of William of Battersea, 22 n. 1.

Blake, John (fl. 1724), husband of Mary, 1 n. 2.

Blake, John (b. 1734), son of Thomas and Elizabeth of Battersea, 22 n. 1.

Blake, John (fl. 1752), father of Reuben, 553.

Blake, John (fl. 1760–80), father of Maria and Elizabeth, 554.

Blake, John (fl. 1767), husband of Sarah, 554.

Blake, John (b.1755), the poet's brother, 3 and n. 2.

Blake, John (1760–1800?), the poet's brother, 3 n. 2, 5 and n. 1, 8, 508 and n. 3, 509 and nn. 1 and 2, 557, 558 and n. 2.

Blake, John (fl. 1780), the poet's uncle?, 28 n. 4, 551, 556–7.

Blake, Joseph (b. 1719), son of William of Battersea, 22 n. 1.

Blake, Juda, buried in Bunhill Fields, 476 n. 1.

Blake, Kitty (fl. 1781–2) of 22 Marshall St., 553.

Blake, Margaret (fl. 1760–9), wife of John, linen draper, 554.

Blake, Maria (b. 1760), daughter of John and Margaret, 554.

Blake, Mary (1687–1770), of Battersea, 22 n. 1.

Blake, Mary (b. 1709), daughter of Henry of Battersea, 22 n. 1.

Blake, Mary (fl. 1724), wife of John, 1 n. 2.

Blake, Mary (fl. 1758), mother of Charles, 553.

Blake, Mary (d. 1770), a child of Battersea, 22 n. 1.

Blake, Mary, buried in Bunhill Fields, 476 n. 1.

Blake, Peter (fl. 1788), baker, 509 n. 1, 554.

Blake, Philip (b. 1711), son of William of Battersea, 22 n. 1.

Blake, Rebecca (b. 1716), daughter of William of Battersea, 22 n. 1.

Blake, Rebecca, buried in Bunhill Fields, 476 n. 1.

Blake, Reuben (b. 1752), son of John and Frances, 553.

Blake, Richard (b. 1723), son of John and Mary, 1 n. 2.

Blake, Richard (b. 1726), son of John and Mary, 1 n. 2.

Blake, Richard (b. 1762), the poet's brother, 6–7 and n. 1.

Blake, Robert, mistake for poet, 284.

Blake, Robert (fl. 1774), baker, 509 n. 1, 554.

Blake, Robert (1767?–1787), brother of the poet, 7 and n. 1, 8, 20, and n. 3, 29 and n. 7, 30–32, 47 and n. 4, 48, 67, 340 n. 4, 457 and n. 3, 459 and n. 2, 460, 476, 482 and n. 3, 486, 508–10 and n. 1, 611, 625.

Blake, Samuel (1743–51), son of Thomas and Elizabeth of Battersea, 22 n. 1.

Blake, Sarah (fl. 1767), wife of John, 554.

Blake, Sarah, buried in Bunhill Fields, 476 n. 1.

Blake, Sarah Phillips (fl. 1723–44), wife of Thomas of Battersea, 22 n. 1.

Blake, Stephen (fl. 1752–83), haberdasher of 28 Broad St., 552 and n. 3.

Blake, Susanah, buried in Bunhill Fields, 476 n. 1.

Blake, Susanna (fl. 1721), wife of James, 1 n. 2.

Blake, T., mistake for the poet, 19 n. 3.

Blake, Thomas (fl. 1723–44), husband of Sarah of Battersea, 22 n. 1.

Blake, Thomas (fl. 1731–51), husband of Elizabeth of Battersea, 22 n. 1.

Blake, Thomas (b. 1731), son of Thomas and Elizabeth of Battersea, 22 n. 1.

Blake, Thomas (d. 1744), a child of Battersea, 22 n. 1.

Blake, Thomas (b. 1744), son of Sarah and Thomas of Battersea, 22 n. 1.

Blake, Thomas (fl. 1788), 'coffeeman', 554.

Blake, Thomas (fl. 1792–1818), tailor, 553.

Blake, Thomas (fl. 1806), hair cutter, 554.

Blake, William (fl. 1711–21) of Battersea, 22 n. 1.

Blake, William (b. 1721), son of William of Battersea, 22 n. 1.

Blake, William (b. 1728), son of John and Mary, 1 n. 2.

Blake, William (fl. 1749–74), poulterer, 553.

Blake, William (1757–1827), *Complete Writings* (1957), 191 n. 1.

— 'Blake's Memorandum' (1803), 124 n. 1, 125–7.

— *Letters* (1956), 66 n. 1, 575 n. 1.

— *Poetical Works* (1905), 332 n. 2.

Blake, William (b. 1767), son of John and Sarah, 554.

Blake, William (fl. 1774–90), gentleman, 554.

Blake, William (fl. 1784–8), carpenter, 554.

Blake, William (fl. 1814–44), not poet, 249 n. 1.

Blake, William Staden (fl. 1770–1817), writing-engraver, 58, 561.

Blessington, Lady, 277 and n. 3.

'Blind-Man's Buff', *Poetical Sketches* (1783), 481 n. 3.

'The Blossom', *Songs of Innocence* (1789), 252.

Blunt, Sir Anthony, collection, 253 n. 1; Pl. xxxv.

Boddington, Samuel, collector, 404, 597, 601.

Bodham, Mrs. Anne, friend of Cowper, 113.

Bodleian Library, Oxford, 79 n. 2, 81 nn. 1 and 4, 84 n. 1, 85 nn. 3 and 6, 86 n. 2, 89 n. 3, 90 n. 1, 95 nn. 3–4, 6, 98 n. 1, 104 n. 1, 107 n. 1, 111 n. 4, 118 n. 2, 131 n. 1, 139 n. 3, 146 n. 3, 148 n. 3, 181 n. 4, 272 n. 2, 423 n. 1, 579 nn. 3–5, 580 nn. 1 and 2; Pl. xlix–l.

Boehme, Jacob (1575–1624), mystic, 41 n. 4, 313 and n. 1, 324, 541.

— *Works* (1764–81), 313 n. 1, 541.

Bogen, Miss N., *English Language Notes* (966), 1621 n. 2.

Bohmen, *see* Boehme, Jacob.

Bohn, Henry George (1796–1884), bookseller, 341 n. 3?, 597, 601.

— *Catalogue* (1847), 275 n. 2.

Bohnes, *Job* buyer, 592, 599.

Bolswert, 397.

Bone, Henry (1755–1834), painter, 276.

Bonnington, K., 280 and n. 2, 288.

Bonnycastle, J., *Introduction to Mensuration* (1782–91), 610.

Book of Ahania (1795), 561, 614.

Book of Job; see *Job*.

The Book of Los (1795), 561, 614.

The Book of Thel (1789), 211 n. 2, 243 n. 2, 275 and n. 2, 289 n. 2, 385 and n. 2, 386 and n. 3, 561, 612.

Book of Urizen; see *The First Book of Urizen*.

Borckhardt, C., designer and print-seller, 618.

Boswell, James [Jr.] (1778–1822), lawyer, 368 and n. 3.

Boucher family, 517.

Boucher, Catherine Sophia, *see* Blake, Catherine Sophia, the poet's wife.

Boucher, 'Charlott' (1759–59), the poet's sister-in-law, 5.

Boucher, Elizabeth (1747–91), the poet's sister-in-law, 5.

Boucher, Hester (b. 1751), the poet's sister-in-law, 5, 564 n. 2.

Boucher, James (b. 1761), the poet's brother-in-law, 5.

Boucher, Jane (b. 1755), the poet's sister-in-law, 5, 564 n. 2.

Boucher, John Hillesdon (b. 1753), the poet's brother-in-law, 5.

Boucher, 'Julett' (1759–59), the poet's sister-in-law, 5.

Boucher, Martha (b. 1745), the poet's sister-in-law, 5, 564 n. 2.

Boucher, Mary, *see* Moody, Mary.

Boucher, Mary, *see* Baines, Mary, the poet's sister-in-law.

Boucher, Mary (d. 1782?), the poet's mother-in-law, 5–6, 517–18, 564 n. 2.

Boucher, Richard (1761–70), the poet's brother-in-law, 5.

Boucher, Sarah (1743–51), the poet's sister-in-law, 5.

Boucher, Sarah (b. 1757), the poet's sister-in-law, 5, 564 n. 2.

Boucher, William (?1714–94), the poet's father-in-law, 5, 6 and n. 1.

Boucher, William [Jr.] (b. 1749), the poet's brother-in-law, 5.

Bouchier, *see* Boucher.

Boult, Mrs. F. H., collection, 399 n. 4.

Bourgeois, Sir Peter Francis (1756–1811), painter, 199.

Boutcher, Catherine, *see* Blake, Catherine Sophia, the poet's wife, 517–18.

Bowles, Caroline Anne (1786–1853), poetess, second wife of Robert Southey, 71 n. 1, 398 and n. 2.

Bowyer, Robert (1758–1834), bookseller, 46, 155.

Bowyer, William (1699–1777), bookseller, 10 n. 1.

Boxall, William, juror in 1803, 134 n. 1.

Boydell, John (1719–1804), bookseller, 46–47, 56 n. 3, 612, 615.

Boydell, Josiah (1752–1817), bookseller, 56 n. 3, 612, 615.

Bradford, Mrs., mother of Thomas, 199 and n. 2.

Bradford, Thomas, *Poetical Pieces* (1808), 199 and n. 2.

Braham, John (1774?–1856), tenor, 272.

Bramble, Matthew, of *Humphry Clinker*, 554.

Bray, Mrs. A. E., *Life of Thomas Stothard* (1851), 19 and n. 3, 20 nn. 1 and 2, 186 n. 5, 187 n. 2, 621 n. 3.

'A Breach in a city, the morning after a battle' (1784), 28, 318 n. 2.

Brereton, William, J.P., at 1803 trial, 131.

Brett?, *Job* buyer, 597.

Brewer, L. A., *My Leigh Hunt Library: The Autograph Letters* (1938), 61 n. 1.

Briggs, A. E., *Connoisseur* (1907), 54 n. 2, 67 n. 1, 176 n. 1, 575 n. 3.

British Critic (1796), 55 n. 1; (1806), 181 and n. 3.

British Gallery, 272.

— Exhibition (1823), 278.

British Institution, 178 n. 1, 179, 215.

British Museum, 275 n. 1, 278 and n. 1, 279, 289 n. 2, 366, 368 n. 2, 370 n. 1, 399 n. 4, 416, 552.

— Add. MSS, 17 n. 3, 18 n. 1, 19 n. 1, 24 n. 3, 25 n. 1, 40 n. 3, 45 n. 1, 48 n. 3, 50 n. 1, 55 n. 3, 56 n. 1, 60 n. 1, 71 n. 2, 73 n. 5, 78 n. 2, 79 nn. 1 and 3, 80 n. 1, 85 n. 5, 86 n. 3, 87 nn. 3 and 4, 90 n. 2, 91 n. 3, 92 n. 1, 94 n. 2, 96 nn. 1 and 3, 97 n. 3, 98 n. 2, 99 n. 2, 102 n. 2, 103 n. 2, 105 n. 1, 106 n. 2, 108 nn. 1 and 2, 111 nn. 1 and 2, 112 nn. 3 and 4, 113 nn. 1–3, 114 n. 3, 118 nn. 1 and 4, 121 n. 1, 135 n. 2, 139 n. 1, 152 nn. 1 and 3, 154 n. 2, 166 n. 2, 171 n. 4, 172 n. 2, 173 n. 4, 187 n. 5, 189 n. 4, 190 nn. 3 and 4, 192 n. 2, 197 n. 1, 198 n. 1, 209 nn. 2 and 3, 210 n. 3, 211 nn. 1 and 3, 212 n. 3, 213 n. 1, 214 n. 2, 219 nn. 2–4, 220 n. 1, 227 n. 2, 228 nn. 1, 3, 4, 232 nn. 1, 3, 4, 236 nn. 1 and 4, 242 n. 1, 256 n. 1, 261 n. 2, 265 n. 2, 278 n. 1, 279 n. 2, 284, nn. 1 and 2, 286 nn. 3 and 4, 287 n. 3, 288 n. 1, 295 n. 5, 300 n. 3, 304 n. 2, 340 n. 5, 356 n. 2, 357 n. 3, 358 nn. 1–3, 359 n. 2, 360 n. 1, 361 n. 1, 364 n. 3, 365 nn. 3 and 4, 366 nn. 1 and 3, 367 n. 1, 371 nn. 3 and 4, 562 nn. 4, 6–9, 563 n. 1, 568 n. 2, 569 nn. 2, 3, 5, 570 nn. 1 and 2, 575 n. 2, 578 n. 2, 579 n. 1, 582 n. 1, 583 nn. 2 and 3.

— Print Room, 17 n. 2, 20 n. 1, 41 n. 4, 166, 192 n. 1, 221 n. 1, 238, 299 n. 3, 359, 369 n. 1, 377 n. 1, 495 n. 5, 524 n. 2, 526 n. 3, 618 n. 2, 621 n. 3; Pls. vii–ix, x*b*, xi, xiii, xv–xvii, xxii–xxiii, xxv, xl–xli, xliv, xlvii–xlviii, lviii*b*.

Brixton, 333 and n. 4, 345 and n. 4.

Broad St., Westminster, 2, 9 and n. 3, 29 and n. 7, 30 and n. 4, 215, 219, 456, 457 and n. 2, 465, 477, 482, 492, 508, 509 nn. 1 and 2, 537, 557 and n. 3, 558 and nn. 1 and 2, 559, 560 n. 1, 561–2, 563 n. 2, 564, 617 n. 2; Pl. lv.

Broadwick St., 555.

Brockedon, William (1787–1854), painter, 560 n. 1.

Bromley, William (1769–1842), engraver, 464 n. 1, 465.

Brothers, Richard (1757–1824), prophet, 235 and n. 2, 520.

Brown of Carmarthen St., 601.

Brown, Allan R., collection, *see* Trinity College, Hartford, Connecticut, 462 n. 1.

Brown, James, of Thornhaugh St., 596, 601.

Brown, John, *Elements of Medicine* (1795), 614.

Bruce, Robert de, VIII (1274–1329), King of Scotland, 298.

Bryant, J., *Ancient Mythology* (1774–6), 609.

Buchan, friend of Cumberland, 55 n. 3.

Buchan, Earl of, *see* Erskine, David Steuart.

Buckland, J. (fl. 1782–6), bookseller, 610.
Budd & Calkin, booksellers, 339, 340
and n. 2, 593, 599.
Bull, J., *Job* buyer, 601.
Buller [? Sir George (1802–84),
General], 300.
Bulwer Lytton, Edward, Lord Lytton
(1803–73), writer, 59.
— *All the Year Round* (1862), 402 n. 3.
— *New Monthly Magazine* (1830), 401,
402 and n. 3.
— *A Strange Story* (1862), 402 n. 3.
— *The Student* (1835), *L'Etudiant*
(1835), 402 n. 3.
Bunhill Fields Burying Ground, 3 n. 2,
5 n. 1, 8, 28, 32, 47 and n. 4, 340 and
n. 4, 343 and n. 1, 347 and n. 2, 371,
410 and n. 3, 411 and n. 2, 412, 476,
510 n. 2, 528, 535, 557, 564, 567.
Bunyan, John (1628–88), author, 295
and n. 3, 370, 495 n. 5.
— *Pilgrim's Progress* designs (1824?),
295 and n. 4.
Buonarroti, *see* Michael Angelo.
Burger, G. A., *Leonora* (1796), 54–55
and nn. 1 and 2, 614; Pl. viii.
Burke, Haviland (fl. 1830), 379.
Burlington Fine Arts Club, 37 n. 3.
Burlington House, 423 n. 1.
Burney, Dr. Charles (1726–1814),
musicologist, 560 n. 1.
Burns, Robert (1759–96), poet, 193, 389.
— *Reliques* (1808), 213 and nn. 3 and 4.
Burton, Robert (1577–1640), author,
392.
Bury, Lady Charlotte Susan Maria
(1775–1861), novelist, 248–9 and
n. 1, 250.
— *The Court of England under
George IV* (1896), 250 n. 1.
— *Diary* (1839, 1908), 249–50 and n. 1.
Bury, Revd. Edward (d. 1832), hus-
band of novelist, 591, 599.
Butcher, *see* Boucher.
Butcher, Ann (1766–70), daughter of
John and Ann, 6 n. 1.
Butcher, Ann Marshall (fl. 1765-9),
wife of John, 6 n. 1.
Butcher, Elizabeth (d. 1758), wife of
John, 6 n. 1.
Butcher, John (d. 1783), husband of
Elizabeth and Margaret and Ann
Marshall, 6 n. 1.

Butcher, Margaret (1695–1765), wife
of John, 6 n. 1.
Butcher, Mary (1769–71), daughter of
John and Ann, 6 n. 1.
Butcher, William (fl. 1764), the poet's
father-in-law?, 6 and n. 1.
Bute, Marquis of, 120 n. 1.
Bute [John Stuart (1713–92)], third
earl of, 120 n. 1.
Butlin, M., 621.
— *Burlington Magazine*(1958), 353 n. 2.
Button, Whitaker & Co., booksellers,
619.
Butts, Mrs., wife of Blake's patron, 67,
73–75, 77, 176, 214, 237 n. 2,
524 n. 2.
Butts, Anthony Bacon Drury, great-
grandson of Blake's Patron, 73 n. 3,
176 n. 1, 577 nn. 1 and 2.
Butts, Captain Frederick, grandson of
Blake's patron, 54, 67 n. 1, 215 n. 1.
Butts?, George, 214.
Butts, Thomas (1757–1845), the poet's
patron, 13 n. 4, 53, 54 and n. 2, 67
and n. 1, 70, 72, 73 n. 3, 74–77, 80,
104 n. 1, 116, 120 and n. 1, 122, 123
and n. 1, 125 n. 3, 128, 175 and n. 2,
176 and nn. 1 and 2, 179 n. 1, 181,
186 n. 1, 214, 220 and n. 2, 222–3,
230, 237 n. 2, 257 n. 1, 268, 273–5,
278, 300, 318 n. 2, 339, 340 and n. 3,
344 and n. 4, 465, 509 n. 3, 515 and
n. 2, 517, 560 and n. 1, 562, 570 and
n. 4, 571–2 and n. 2, 573 and nn. 3–5,
574 and nn. 1, 2, 4, 575 and nn. 1 and
3, 576 and n. 4, 577 and nn. 2 and 3,
578, 591, 599, 606, 617; Pl. ix.
Butts, Thomas [Jr.] (1788–1862),
Blake's pupil, 67 and n. 1, 73–74,
175 and n. 2, 214–15, 220 and n. 2,
222, 524 n. 1, 574 and n. 4, 575,
576 nn. 2–4, 577 nn. 2 and 3.
Butts, William, mistake for Thomas
Butts, 515.
Byfield, John (fl. 1820–30), engraver, 618.
Byron, George Gordon, Lord (1788–
1824), poet, 229 n. 3, 231, 248,
296 n. 2, 387, 536.

Cadell [Thomas (1773–1836)] & Davies
[William (d. 1820)], booksellers,
152 and n. 1, 171, 191, 209 n. 1, 213
and n. 4, 615–17.

'Cain & Abel' (1821?), 274.

Calkin, bookseller, *see* Budd & Calkin, booksellers.

Callcott, Sir Augustus Wall (1779–1844), painter, 409, 596–7.

'Callisto' (1784), 611, 623 n. 2.

Calvert, Edward (1799–1883), artist, 268, 271, 290 n. 3, 292 and n. 3, 294, 295 and n. 2, 302, 326 and n. 1, 333 and n. 4, 345 n. 4, 360, 369 and nn. 3 and 4, 409 n. 3, 417 n. 3, 476, 528, 589 and n. 4, 592 n. 2, 595, 599, 605.

Calvert, Mrs. Edward, 302, 333 and n. 4.

Calvert, Samuel, *Memoir of Edward Calvert* (1893), 271 n. 2, 290 n. 3, 294 nn. 1 and 5, 295 nn. 1 and 2, 302, 303 and n. 1, 326 and n. 1, 333 and n. 4, 417 n. 3, 585 n. 8.

Calvin, John (1509–64), reformer, 312–13, 541, 548.

Cambridge, 104.

Cambridge, King's College Library, 379 n. 4.

Cambridge University, 476 n. 2, 528 n. 3.

Camoens, Luis Vaza de (1524–80), Portuguese poet, 69.

Campbell, Thomas (1777–1844), poet, 161, 231, 387.

Canaletto, Antonio (1697–1768), painter, 24 n. 3, 554.

'Cancer' (1818?), Visionary Head, 370 n. 1, 619.

'Candid' (i.e. George Cumberland), 17 and n. 3, 30 n. 4.

Canterbury, Archbishop of, 22–23, 76 and n. 1, 561.

Canterbury, Prerogative Court of, 29 n. 1, 374 n. 3.

'Canterbury Pilgrims' engraving (1810), 3 n. 1, 179 and n. 3, 180, 182 n. 1, 216, 217 and n. 1, 219–20, 244, 285, 292 n. 2, 310, 346, 357, 362, 368, 404, 439, 465–6, 538–9, 549, 592 and n. 6, 594 and n. 6, 595, 597, 605, 607, 623 and n. 3; Pl. xxxiib, *see also* 'Chaucer (Sir Jeffery) . . .'.

— (1810–1941), 617.

— drawing, *see* 'Chaucer (Sir Jeffery)...'.

Cappe, J. (fl. 1779), 16.

Caputi, cameo cutter, 250 n. 4.

Caracci, Agostino (1557–1602), Annibale (1560–1609), Lodovico (1555–1619), painters, 200.

Caractacus (fl. 48–51), British chief, 362.

Carey, William Paulet (1759–1839), art critic, 269 and n. 1, 350 n. 1, 370 n. 2, 373 n. 1.

— *Critical Description of . . . Chaucer's Pilgrims* (1808, 1818), 192 n. 2, 209 and n. 1.

— '*Death on the Pale Horse*' (1817, 1836), 245–8 and n. 2, 625 n. 2.

— *Desultory Exposition* (1819), 624–5 and n. 1.

— *Variae* (1822), 269 n. 1.

Carfax Conduit, Oxford, *see* 'View of Carfax Conduit, Oxford'.

Carlyle, Thomas (1795–1881), essayist, 388 n. 2, 393 n. 2, 418.

Caroline Amelia Elizabeth (1768–1821), Queen of George IV, 248 n. 3, 265.

Carpenter, William Hookham (1792–1866), keeper of BMPR, 259.

Carr, Sir John (1772–1832), travel writer, 81 and n. 3, 82, 95, 110–11, 113–14, 149, 160–1.

— *Stranger in France* (1803), 110 and n. 1.

Carthew, Miss A. G. E., collection, 400 n. 2.

Cary, Henry Francis (1772–1844), translator, 232, 233 n. 1, 251, 315, 363 and n. 2; *see* Dante, *The Vision*, tr. H. F. Cary (1819, 1822).

Cary, J., *English Atlas* (1793), 103 n. 2.

Casket (1830), 398 and n. 3.

Catullus, *Poems* (1795), 614.

Ceninni, C., *Trattato* (1821), 33 n. 3.

Ceres, 136.

Cervantes Saavedra, Miguel de (1547–1616), novelist, 344 and n. 1, 610.

'The Chaining of Orc' (1812), 617.

Challen, Benjamin, juror in 1803 trial, 134 n. 1.

Chalmers, Alexander, ed., *Plays of William Shakspeare* (1801–12), 616.

Chambers, Sir William (1726–96), architect, 560 n. 1.

Chance, Mrs., Linnell's sister, 321 n. 1.

Chance, Edward John, Linnell's nephew, 320, 321 n. 1, 344 and n. 7, 364, 401, 582 and n. 6.

Chandler, J. E., *see* Cox, H. and, Chandler, J. E., *House of Longman* (1925), 376 n. 2.

Chandos, John, of *Poetical Sketches* (1783), 479.
Chantrey, Sir Francis Legatt (1781–1841), sculptor 339 and n. 1, 468 and n. 4, 591, 600.
Chapman, George, see *Homer, The Whole Works of*, tr. Geo Chapman (1616), 584 and n. 2.
'The Characters of Spenser's Faerie Queen', 363 and n. 1, 607.
Charles, King, 118–19.
Charlotte Sophia (1744–1818), Queen of George III, 178–9, 184 and n. 1, 192, 208; see 'To the Queen' (1807).
Charlotte St., see Charlton St., 534 n. 4, 567–8.
Charlton St., No. 17, 411, 534 n. 4, 567–8.
Chatterton, Thomas (1752–70), poet, 546.
Chaucer, Geoffrey (1340?–1400), poet, 69, 180 and n. 2, 186 and n. 4, 190, 192 n. 2, 209, 230 and n. 1, 254–5, 285, 439, 492, 494, 538, 623.
— *Poetical Works* (1783), 611.
— *Prologue and Characters* (1812), 230 and n. 1, 617 and n. 2.
'Chaucer (Sir Jeffery) and the nine and twenty Pilgrims on their journey to Canterbury' (1809), drawing, 216–17, 230, 231 n. 1, 357, 363, 439, 452, 464 and n. 1, 465–6, 491–2, 500.
— see 'Canterbury Pilgrims' (1810–1941).
Cheetham, J., *Life of Thomas Paine* (1817), 530 n. 2.
Chellis, Mrs. Robert D., collection, 239 n. 3, 621, 622 n. 2.
Chetwynd, Mr. (fl. 1801), 82.
Chetwynd, Mrs. (fl. 1801), 116, 574 n. 1.
Chevalier, Ellen M., great-granddaughter of Thomas Chevalier (1767–1824), 288 n. 3.
Chevalier, Thomas (1767–1824), surgeon, 8 n. 2, 288 n. 3.
Chicago Art Institute, see Art Institute, Chicago.
'The Child of Art' (1818), 618.
'The Child of Nature' (1818), 618.
'Chimney Sweeper', *Songs of Experience* (1794), 229, 253, 289, 469.
— *Songs of Innocence* (1789), 224 n. 3, 229, 252, 284–5, 289, 483–4, 496.

Chitty, J., *The Law Relative to Apprentices* (1812), 10 n. 2.
Chitty, John, juror, 1804, 140.
Chodowiecki, Daniel Nicolas (1726–1801), painter, 612.
Christ and Christianity, 13, 35, 42–43, 139, 176, 203, 207, 213, 281 n. 1, 291, 297 n. 1, 310–11, 316, 319, 321, 322 and n. 2, 331–2, 337, 347, 439–40, 452, 473–5, 491, 502, 531, 533–4, 539–40, 541 n. 1, 547–8.
'Christ Appearing' (1805), 573.
'Christ Baptizing' (1805), 572–3.
'Christ Girding Himself with Strength' (1805), 572.
'Christ in the sepulchre, guarded by angels' (1808), 189.
'Christ Trampling upon Urizen' (1903), 176, 617.
Christie, James (1730–1803), auctioneer, 421.
Christie, Jonathan Henry, assassin, 265 n. 4.
Christie sales (1814 July 22–23), 227 n. 1.
— (1827 May 28), 222 n. 3.
— (1828 June 12), 369 n. 1.
— (1828 July 1), 368, 575.
— (1830 May 21), 400.
— (1835 May 6), 366 n. 1.
— (1876 April 26), 165 n. 3, 369 n. 1.
— (1883 Feb. 26–27), 369 n. 1.
— (1893 Feb. 7), 119 n. 3.
— (1918 March 15), 275 n. 3.
Christus, Petrus, 310 n. 1.
Church of England, see Anglican Church.
Cicero, 69.
Cipriani, Giovanni Battista (1727–85), painter, 317 n. 1.
Cirencester Place, residence of John Linnell, 321 and n. 2, 327, 338 and n. 3, 350 n. 2, 351, 354 and n. 1, 359 n. 2, 364, 405, 567.
— residence of the poet's brother James, 3, 340 and n. 4, 564.
Cirencester Street, later name of Cirencester Place, 3, 564.
Clare, John (1793–1864), poet, 389.
Clarke, James Stanier (1765?–1834), author, 213 n. 2.
Clarke, Robert Hayley, son of J. S., 213 n. 2.

Clarke, William, bookseller of New Bond St., 368?, 369 n. 1.

Clarkson, Catherine, wife of Thomas, 225 and n. 3.

Clarkson, Thomas (1760–1846), anti-slavery agitator, 225 n. 3.

Claude Gelée [Claude of Lorraine] (1600–82), painter, 315.

Claudius (10 B.C.–A.D.54), Emperor, 362.

Clayton-Stamm, Mr., collection, 624.

Cleopatra, 297–8.

Clinton, Lord, 553.

'The Clod and the Pebble', *Songs of Experience* (1794), 252, 469.

Coal, paid to Blake, 573 and n. 5, 587–9, 604 and n. 2.

Cochran, Linnell's friend, 341.

Cock Lane Ghost Story, 519.

Cock (fl. 1726), auctioneer, 554.

Cock, John (fl. 1803–4), private, 122–3, 125 and nn. 2–3, 126–9, 131 n. 2, 134 n. 1, 143–4, 146, 149, 164.

Coke, David Parker (fl. 1801), 80.

Cole, Henry, *Athenaeum* (1843), 267 n. 2.

Colebrook, John, juror at 1803 trial, 134 n. 1.

Coleridge, Samuel Taylor (1772–1834), poet, 73 n. 6, 109 and n. 3, 223, 229, 231, 242, 250–1, 252 and n. 1, 253, 272, 301 and n. 2, 312 n. 3, 325, 381, 386–7, 536.

— *Collected Letters* (1956, 1959), 73 n. 6, 109 n. 3, 251 and n. 1.

Collings, *see* Collins, Richard.

Collings, Samuel (fl. 1780–90), painter, 611.

Collins, Mrs., of Hampstead Farm, 333.

Collins, Charlotte (fl. 1804), engraver, 99–100, 114 n. 3, 116.

Collins, George, juror, 1804, 140.

Collins, of Hampstead farm, 354 n. 1, 590.

Collins, Richard (1755–1831), minia-turist, 55 n. 3.

Collins, William (1788–1847), painter, 17 n. 3, 276 and n. 3, 307, 395, 468.

Collyer, J., *Parent's and Guardian's Directory* (1761), 29 nn. 2, 4–5, 186 n. 1, 509 n. 1.

— *see* Fenning, D., and Collyer, J., *New System of Geography* (1785, 1787), 611.

Colnaghi, firm of print-sellers, 258, 276, 288 n. 3, 337 and n. 3, 366, 376 and n. 2, 395 and n. 2, 594 and n. 3, 596 and n. 2, 601 and n. 3, 617 n. 2.

Colour, 368, 399, 468, 470 and n. 2, 471 and n. 2, 472–3, 482, 486, 492, 503–4, 515–17, 527, 534, 538, 578, 584.

Colour printing, 33–34 and n. 1.

Colville-Hyde, Mrs., widow of Captain Frederick Butts, 67 n. 1, 215 n. 1.

Combes, George, juror in 1803, 134 n. 1.

Commins, T., *Elegy* (1786), 611.

Commissary General of Musters, office of, 340, 509 n. 3.

Compton, Theodore, 250 n. 4.

Conder, Josiah (d. 1831), bookseller, 110.

Conder, Josiah (1789–1855), book-seller, 226.

Constable & Co., booksellers, 171 n. 3.

Constable, John (1776–1837), painter, 258, 269, 272, 343 and n. 2, 345–6.

— *see* Leslie, C. R., *Memoirs of . . . John Constable* (1843).

'Contemplation', *Poetical Sketches* (1783), 480 n. 6, 514 and nn. 2 and 11.

Cooke, John (1731–1810), bookseller, 609.

Cooke, R., *Job* subscriber?, 602.

Cooper, Abraham (1787–1868), painter, 276, 378–9.

Copley, John Singleton (1735–1815), painter, 199.

Corinna, visionary head, 497.

Cornell University Library, 68 n. 2, 83 n. 3, 87 n. 1.

Corner, John (fl. 1788–1825), engraver, 48.

Correggio [i.e. Antonio Allegri] (1494–1534), painter, 200, 216, 218, 435–6, 450, 492 and n. 4, 495, 516, 538.

Cosens, owner of mill at Felpham, 123, 126.

Cosway, Maria Cecilia Louisa (Had-field] (fl. 1780–1820), wife of Richard, 49, 611.

Cosway, Richard (1740–1821), minia-turist, 46, 49–50, 55, 169, 193, 201, 209, 232, 247, 332, 348, 562 n. 6, 611.

'The Couch of Death', *Poetical Sketches* (1783), 480 n. 6.

Courier (1820), 265.

Courteney (fl. 1802), of Newport Pagnell, 110.

Cowdray Park, 100 and n. 1.

Cowley, Abraham (1618–67), poet, 69.

Cowper, Anne (d. 1737), mother of William, 78, 79 n. 1, 81, 86, 95, 113.

Cowper, Earl, 71, 110, 113.

Cowper, Theodora (d. 1824), William's cousin, 78, 111, 113, 150 and n. 1.

Cowper, William (1731–1800), poet, 44, 47, 63 n. 1, 69, 71, 73, 78–83, 85–86, 88–90, 93–94, 96, 98, 105–106 and n. 2, 107–9, 112 and n. 4, 113–14, 121, 137, 147–50 and n. 1, 151, 156, 161–2, 164, 172, 213 n. 2, 455, 606.

— *Works* (1836), 148 n. 2.

— *see* Hayley, *Life of . . . William Cowper* (1802-3).

— *see* Homer, *Iliad* (1792, 1802), *Odyssey* (1792, 1802), tr. Cowper.

— *see* Milton, *Latin and Italian Poems*, tr. Cowper (1808).

Cowper family, 101, 110.

Cowper Museum, Olney, Bucks, 149 n. 2, 156 n. 3, 162 n. 2, 163 n. 1, 165 nn. 1 and 5.

Cox & Barnett, copperplate printers, 579 and n. 5, 580.

Cox, H., and Chandler, J. E., *House of Longman* (1925), 376 n. 2.

Crabbe, George (1754–1832), poet, 119.

'Cradle Song', *Songs of Innocence* (1789), 252, 384 and n. 1, 385, 532 and n. 6.

Craig, William Marshall (fl. 1788–1828), painter, 199.

Cranfield, John Smyth (b. 1758), sculptor, 16.

Crawfurd, O., *New Quarterly Magazine* (1874), 13 n. 4.

Cregan, Martin (1788–1870), artist, 214 and n. 3.

Critical Review (1797), 613 n. 1.

Croft-Murray, Mr. Edward, Collection, Pl. v.

Cromak, *see* Cromek.

Cromek, Robert Hartley (1770–1812), book speculator, 48, 154 and nn. 1 and 2, 155, 166–8 and n. 1, 169, 171–2, 174–5, 179, 180 and n, 2, 183–4 and nn. 1 and 2, 185 and n. 2, 186 and nn. 2, 3, 5, 187 and nn. 1 and 2, 190 and n. 4, 191 n. 1, 192 and n. 1, 200 and nn. 1 and 2, 201–2, 208 and nn. 1 and 2, 209 and nn. 1 and 2, 213 and n. 3, 226–7, 244 and n. 1, 245, 247, 248 and n. 1, 318 n. 2, 375 n. 1, 418, 464 and n. 1, 465 and n. 1, 490 and n. 5, 491, 523 n. 1, 548, 574 n. 4, 576, 606, 617, 619, 626; Pls. xix, xxiii, *see* Blair, Robert.

— *Examiner* (1810), 227 n. 1.

— *Gentleman's Magazine* (1810), 227 n. 1.

Cromek, Mrs. R. H., 209 and n. 2.

Croyden, Surrey, 234.

Cumberland, Allan; mistake for Allan Cunningham, 538.

Cumberland, George (1754–184?), dilettante, 17 and n. 3, 18–19 and n. 1, 20 n. 1, 30 n. 4, 32 and n. 2, 40 n. 3, 44 n. 3, 49–50 and n. 1, 55 and n. 3, 56, 60 and nn. 1 and 3, 61, 118 and n. 4, 119 n. 3, 177 n. 2, 187 and n. 4, 188–9 and n. 4, 190, 198 and n. 1, 209 and n. 2, 210–11 and n. 2, 212 and nn. 1–3, 213 n. 1, 214, 216 n. 3, 219 and nn. 2 and 4, 227–8, 231–2 and nn. 1, 4, 5, 235, 236 and n. 4, 256 and n. 1, 265, 276, 279, 283–4 and n. 2, 287 and n. 1, 295, 300, 304, 323 n. 1, 340, 344 n. 4, 345, 356–9 and n. 2, 360–2, 364 and n. 2, 365 and nn. 3 and 4, 366 and n. 1, 367, 371, 390 n. 1, 490 n. 4, 562 and nn. 6, 7, 9, 563 and nn. 1 and 3, 568–70, 583 and n. 2, 595 and n. 3, 601, 607, 614, 619.

— *Essay on . . . Ancient Engravers* (1827), 279.

— *Journal of Natural Philosophy* (1811), 212 n. 1.

— Message Card, 347, 357–61, 365 and n. 4, 366–7, 371, 583, 595 n. 3, 607, 619.

— *Original Tales* (1810), 55 n. 3.

— *Outlines from the Antients* (1829), 284 and nn. 1–2, 286, 300, 614 and n. 1.

— *Thoughts on Outline* (1796), 40 n. 3, 55 and n. 3, 56 and nn. 1 and 2, 172, 236 n. 4, 283–4, 287 n. 1, 569, 614 and n. 1.

Cumberland, George [Jr.] (fl. 1808–30), 209 and n. 2, 210–12 and n. 3, 213 n. 1, 214, 219–20, 235–6 and

n. 4, 256 and n. 1, 257, 283, 286–7, 295, 357–60, 364 and n. 2, 365 and nn. 3 and 4, 366–7, 562 n. 6, 563 n. 3, 595 n. 3.

Cumberland, Georgiana (fl. 1808), daughter of George, 209.

Cumberland, Sydney (fl. 1808–30), son of George, 209, 235, 358, 361, 364, 366–7, 583, 595 n. 3.

Cunningham, Allan (1784–1842), author, 187 n. 2, 375 and n. 1, 395, 410.

— *Cabinet Gallery of Pictures* (1833), 183 n. 2.

— *Life of Sir David Wilkie* (1843), 559 n. 3.

— *Lives* (1830), 24 n. 1, 225 n. 2, 226, 243 and n. 1, 260 n. 2, 349 n. 5, 375 and n. 1, 377 and n. 2, 378 and n. 2, 379–80 and nn. 1 and 2, 387 n. 1, 388–90, 392–5, 398 and nn. 2 and 3, 400, 410, 476–507, 517 n. 1, 532 n. 5, 537–8, 549, 626 and n. 2.

— *Lives* (1831, 1837, 1839, 1842, 1844, 1846, 1907), 477 and n. 2.

— *Lives* (1880, 1886, 1893), 477 n. 3.

— see Hogg, D., *Life of Allan Cunningham* (1875), 477 n. 3.

Cunningham, Peter, collection, 187 n. 2.

— *Builder* (1863), 136 n. 1.

Cupid, 284, 287 n. 2, 428–9.

Currie, Dr. James (1756–1805), physician, 192 n. 1.

Curry, Prof. Kenneth, 399 n. 4.

Dacre, Tom, of 'The Chimney Sweeper', *Songs of Innocence* (1789), 292 n. 2, 484.

Dagworth, Sir Thomas of *Poetical Sketches* (1783), 479.

Dally, R., Blake's solicitor, 131 n. 2, 136–7.

Daniel, prophet, 196.

Daniell, Revd. Edward Thomas (1804–43), traveller, 301, 328 and n. 2, 353 and n. 2, 354, 591 n. 5, 595, 600.

Daniell, Thomas (1749–1840), painter, 168 n. 1.

Danniels, E., see Daniell, E. T., 353 n. 2.

Dante, 69, 232, 233 n. 1, 290 nn. 2 and 3, 311–13, 316–17, 324–5, 350, 355, 488, 527, 540–1 and n. 1, 543.

— drawings, 290–1 and n. 1, 292 n. 2, 315 and n. 2, 333, 336, 338–9, 345 and n. 2, 349, 355, 395, 403–5 and n. 1, 406 and n. 2, 407 and n. 2, 408 and n. 2, 409, 414–15, 417, 475 and n. 3, 495 n. 5, 501, 527, 543, 589 and n. 6, 590, 604, 607; Pl. xliii.

— tracings, 403, 405 and n. 1, 406 and n. 2.

— engravings, 345 and nn. 2 and 4, 373 and n. 3, 396, 400, 403–8, 475 and n. 3, 543, 594 nn. 2 and 6.

— *Illustrations of* (1838–1955), 619.

— *Dante*, ed. C. Landino & A. Vellutello (1551–96), 349 and n. 1, 354.

— *The Vision* (1819, 1822), 315 n. 2, 347 and n. 2, 354, 363, 475, 543.

— *Inferno* (1785), Blake's annotations, 355.

'Dante wood', 333.

Darius, Persian king, 138.

Darley, George (1795–1846), poet, 410 and n. 2.

— *Athenaeum* (1843), 222 and n. 3.

Darwin, Erasmus (1731–1802), scientific poet, 43, 181 n. 3, 506.

— *Botanic Garden* (1791–1806), 43, 612 and n. 3, 614.

— *Poetical Works* (1806), 612 n. 3.

David, King, 263.

David, visionary head, 352.

David, Pierre Jean, sculptor, 602 n. 3.

Davidson, W. S., *Job* subscriber, 596, 600.

Davies, Edward (1756–1830), Welsh antiquary, 63? and n. 5.

Davies, William (d. 1802), bookseller, 63? and n. 5; see Cadell & Davies.

Da Vinci, Leonardo, 49–50 and n. 1, 281, 283.

Davis, see Cadell & Davies.

Davis, attorney of C. H. B. Ker, 228.

Dawe, George (1781–1829), painter, 555.

Dawe, Philip, father of George, 555.

Dayley, friend of Cumberland, 232 and n. 4.

'The Death of Earl Goodwin' (1780), 17.

'The Death of Joseph' (1803), 571.

'The Death of the Virgin Mary' (1803), 571.

Defence of Literature (1804), 156.

Della Rosa, Xavier, Veronese painter, 614.

De Morgan, Sophia Elizabeth [Frend], *Threescore Years and Ten* (1895), 273 and nn. 2 and 3.

Demosthenes (384–322 B.C.), orator, 62, 63 and n. 4, 69.

Dendy, Walter Cooper, *Philosophy of Mystery* (1841), 489 n. 1.

Denham (fl. 1831), sculptor, 411, 535, 602?

Denman, Maria, Flaxman's sister-in-law, 24 n. 2, 233 n. 1, 250 n. 4, 288 n. 3, 309, 478 n. 6, 521 n. 1.

Denman, R. D., *see* Dunlop, O. J., *English Apprenticeship & Child Labour* (1912), 14 n. 2.

Denny, Edward (fl. 1818–27), collector, 259, 265, 335 and n. 2, 336, 593 and n. 1, 601.

De Quincey, Thomas (1785–1859), author, 387.

Descriptive Catalogue (1809), 179 n. 1, 185 n. 1, 186 n. 4, 191 n. 1, 197–8, 216 and nn. 2 and 8, 217 and n. 2, 218 and nn. 1–4, 219, 222 n. 1, 224 nn. 2–3, 225, 226 and n. 2, 229, 230 n. 1, 231 n. 1, 235 n. 4, 244, 255, 259 n. 1, 285 and n. 1, 286, 357, 363 n. 1, 392, 423 n. 2, 435 nn. 2 and 3, 436 nn. 1 and 2, 438 nn. 1–3, 439 nn. 2, 3, 5, 440 nn. 1 and 2, 441 nn. 1 and 2, 449, 451, 465, 492 and n. 3, 515 n. 1, 516 n. 1, 537–8, 578, 596 and n. 6, 607.

Devil, 260, 316, 318, 321, 323, 353, 435, 466 n. 1, 497 n. 2, 498, 538; *see also* Satan.

Deville, James S. (1776–1846), life-mask maker, 278 and n. 3, 279; Pl. xlii.

Devonshire, Duke and Duchess of, 27 nn. 3, 5, 34.

Dictionnaire des Artistes (1789), 622 n. 1.

Dibdin, Thomas Frognall (1776–1847), bibliographer, 242 and n. 2, 243 and n. 1, 289 and n. 2.

— *Library Companion* (1824), 289 and n. 2.

— *Reminiscences* (1836), 244 nn. 3 and 4.

Dickens, C., *Nicholas Nickleby* (1839), 555 and n. 3.

Digby, Lord (fl. 1810), 228.

Dilke, Charles Wentworth (1789–1864), critic, 327 n. 1.

Dictionary of National Biography, 13 n. 1, 259 n. 1.

Directories, 340, 552, 555 n. 2, 557 n. 1, 561, 564 n. 2.

Dirkson (fl. 1828), of Great Portland St., 337.

D'Israeli, Isaac (1766–1848), author, 243–4 and n. 3, 289 and n. 1.

Dissenters, 8 and n. 2, 440 and n. 4, 452, 458 n. 1, 475.

'The Divine Image', *Songs of Innocence* (1789), 224 n. 3, 252, 385 n. 1, 425 n. 3, 427–8.

Dixon (fl. 1824), printer, 588 and n. 2, 602.

Dixon, William (fl. 1824), painter, 280 and n. 2, 288, 330.

Dobinson, Mrs. William (*née* Ellen M. Chevalier), collection, 288 n. 3.

Dodd, Thomas (1771–1850), print-seller, 56 n. 1, 171 n. 4, 192 n. 2.

Donaldson, painter, 614.

Douce, Francis (1757–1834), antiquary, 209, 272 and n. 2, 562 n. 6.

Dove Cottage, Grasmere, 430 n. 1.

Drapers' Company, 1 and n. 3.

'A Dream', *Songs of Innocence* (1789), 252.

'The Dream of Queen Catherine', *see* 'Queen Catherine's Dream'.

Dress, 3, 40, 273, 275, 280 and n. 5, 281, 542; *see also* Nudity.

Druid, 439, 452, 512–13, 559.

Drury Lane Theatre, 272–3.

Dryden, John (1631–1700), poet, 69, 76 n. 2, 297.

Ducaret, Coltee (fl. 1782), surrogate, 21.

Ducros, Pierre (1745–1810), painter and engraver, 211 and n. 4.

Dudman (d. 1803), painter, 118 n. 1.

Dulwich, Surrey, 234.

Dulwich Hill, 7.

Dumaresq, H., friend of Linnell, 367.

Dundas, Henry (1742–1811), Viscount Melville, 178 and n. 2.

Dunker, painter, 610.

Dunlop, O. J., and Denman, R. D., *English Apprenticeship & Child Labour* (1912), 14 n. 2.

Durer, Albrecht (1471–1528), painter and engraver, 216, 282, 315, 397, 422, 433, 435–6, 448, 458, 492, 510, 565 n. 3.

Dyer, George (1755–1841), author, 272 and n. 2.

Eagles [? John Eagles (1783–1855), artist], 232 and n. 4.
Earle, James (d. 1796), painter, 612.
'Earth's Answer', *Songs of Experience* (1794), 224 n. 3, 252, 469.
Eastgate (fl. 1793), engraver, 48.
Ebert, Friedrich Adolph, *General Bibliographical Dictionary* (1837), 270 n. 3.
— *Allgemeines Bibliographisches Lexikon* (1821, 1830), 270 n. 2, 375, 376 and n. 1.
'The Echoing Green', *Songs of Innocence* (1789), 252.
Eclectic Review (1805), 172, 173 n. 1.
— (1828), 625–6 and n. 1.
Edinburgh Philosophical Magazine (1820), 214 n. 2.
Edinburgh Review (1805), 616 n. 2.
— (1809), 191 n. 2.
— (1819), 259 n. 1.
— (1824), 279 n. 3.
— (1834), 380 and n. 2.
Edgerton, *see* Egerton, Daniel, 562 and n. 7.
Edward the Confessor (d. 1066), 422, 511.
Edward I (1239–1307), 157, 165 and n. 2, 261 and n. 2, 262–3, 298 n. 1; Pl. xxxix; *see* 'Wallace & Edward I' (1819).
'Edward I' visionary head, 370, 489 n. 1, 496–7; Pl. xxxviii.
'Edward & Elinor' (1793), 423 n. 2, 613 and n. 2.
Edward III (1312–77), 298–9, 422, 511; Pl. xlix; *see* 'King Edward the Third', *Poetical Sketches* (1783).
Edward VI (1537–53), 297.
Edward (1330–76), Prince of Wales (the Black Prince), 298.
Edwards, James (1757–1816), bookseller, brother of Richard, 46 n. 2, 50 and n. 3, 59 and n. 1.
Edwards, Richard (1768–1827), publisher of *Night Thoughts* (1797), 44, 50, 52, 56–57, 59 and n. 1, 269, 270 n. 1, 318 n. 2, 432, 442 n. 1, 487, 614–15, 619.
Edwards, Thomas (1762–1834), bookseller, brother of Richard, 269, 270 n. 1, 280 n. 1, 330–1 and n. 3, 368 and n. 3.
Edwards, Prof. Walter M., 50 n. 3.
Edy, John William (b. 1760), painter, 16.
Egerton, Daniel (1772–1835), actor, 562 and n. 7.
Egerton, John, *Theatrical Remembrance* (1788), 34 n. 1.
Egerton, T., bookseller, 614.
Egremont, wife of the Earl, 179 n. 1, 188, 236, 363 n. 1, 441 n. 2, 473.
Egremont, Third Earl of (Sir George O'Brien Wyndham [1751–1837]), patron, 131, 179 n. 1, 216 n. 3, 318 n. 2, 339, 363 and n. 1, 408 and n. 2, 409 and n. 3, 575, 596, 600, 607.
Egypt, 217, 437, 439, 443, 451, 453, 493, 497.
Eldon, First Earl of (John Scott [1751–1838]), Lord Chancellor, 227 n. 3.
Elgin marbles, 283.
Elijah, prophet, 205.
Elinor (d. 1291), Queen of Henry III, 422, 511; *see* 'Edward & Elinor' (1793).
Elizabeth, Princess (1770–1840), daughter of George III, 101 n. 3, 102, 162 and n. 2.
Ellis, E. J., *The Real Blake* (1907), 304 n. 3, 333 n. 1.
Ellis, William, Clerk of the Peace, 128, 131, 134, 136, 140.
Elmes, J., see *Annals of the Fine Arts* (1816–20), 17 n. 1.
Elohim, 545 and n. 1.
Elwell, friend of Garth Wilkinson, 416.
Enfield, W., *The Speaker* (1780–1820), 609.
English, *Job* binder, 588, 589 and n. 1, 603 n. 1.
English Connoisseur (1766), 421 n. 1.
Engravers, Rules, Orders, and Regulations of Society of, 344 n. 7.
Engraving, 9 and n. 3, 10–13, 15, 16 and n. 1, 20, 32, 38–39, 44–46, 48–50, 55, 56 n. 1, 58, 61, 65–67, 71–74, 78–81, 82 n. 2, 84–89 and n. 2, 91, 92 n. 2, 93, 95–96, 99–101, 104–9, 112–14, 115 n. 4, 117, 118 n. 4, 120–1, 130, 134 and n. 1, 136, 138–40, 142, 146–50, 152–5, 160–1, 163,

Engraving (*cont.*):
166–8 and n. 1, 172–3 and n. 3, 174–7, 179 and n. 2, 180, 184–5, 186 nn. 1 and 4, 187, 189, 190 and n. 1, 192–5, 200–1, 209 and n. 1, 210–11 and n. 3, 212 n. 1, 216, 222, 230, 233–4 and nn. 1 and 5, 235–6, 239–41, 244, 247, 256–7, 276–7, 282–4, 286–8, 300, 324, 333–4, 344 n. 7, 346, 349–50 and n. 2, 354–5, 357, 359–62, 365, 376 and n. 1, 377 n. 2, 396–7, 401–2, 413, 422, 424, 449, 453, 456, 548, 461 and n. 1, 464 and n. 1, 465–7, 474, 477–8, 481–2, 484–91, 499–501, 503–4, 511 and n. 1, 513, 525–6, 533, 537, 542–3, 561, 563 n. 1, 565 and n. 3, 566, 569 and n. 1, 570–2, 578–80 and n. 3, 581, 586, 598, 609–19; Pls. viii–xi, xiii, xv–xvii, xx, xxiv, xxvi–xxxi, xxxii*b*, xxxiv–xxxvi, xl–xli, xliv–xlviii, li–liv.
Enitharmon, 471.
'Enoch' (1807?), 563, 617.
Enoch, Mrs., Blake's fellow lodger (1804), 563.
Ensom, William (1796–1832), engraver, 238, 239 and nn. 1 and 2.
Ercilla y Zúniga, Alonso de (1533–95), poet, 69–70.
Erdman, D. V., *Blake: Prophet Against Empire* (1954), 523 n. 2, 530 n. 2.
— *Journal of the Warburg and Courtauld Institutes* (1952), 46 n. 1.
— *N & Q* (1953), 41 n. 2.
— *Studies in Bibliography* (1964), 615 n. 1.
Erskine, David Steuart (1742–1829), 11th Earl of Buchan, 188 and n. 3, 189 n. 1.
Erskine, Henry (1746–1817), Lord Advocate, 188 n. 3.
Erskine, Thomas (1750–1823), Lord Chancellor, 188 n. 3.
Esdaile, K. A., *The Library* (1914), 432.
Etching, *see* Engraving.
Etruscans, 437.
Euler, L., *Elements of Algebra* (1797), 152 and n. 2, 614.
Euripides, 69.
Europe (1794), 60, 211 n. 2, 224 nn. 1 and 3, 243 n. 2, 244, 259 n. 1, 270 and n. 3, 356, 416, 446 and n. 1, 447 and n. 1, 454, 460 and n. 3, 463, 470

and n. 2, 471 and n. 1, 472 and n. 1, 500 and n. 1, 501, 503, 561, 581 n. 2, 585 and n. 7, 607, 614; Pls. x*b*, lii; *see* 'Ancient of Days'.
European Magazine (1823), 278 n. 3.
Evans, Robert Harding (1778–1857), bookseller, 101, 105, 114–17, 121, 335 n. 2, 593 and n. 2, 601, 615.
— Auction (1821 Feb. 13–27), 27 n. 5, 116 n. 2.
— (1828 March 22–29), 177 n. 2, 349 n. 1.
Eve, 46, 473.
— (Catherine as), 54, 257 n. 1, 543.
— *see* 'The Angel of the Divine Presence Clothing Adam & Eve with Coats of Skins' (1803), 571.
'Evening' (1801?), 88.
'Evening Amusement' (1782), 610.
Everett, J., *see* Holland, J.
Examiner (1808), 195–9, and n. 1.
— (1809), 215–18 and n. 4, 219 n. 1.
— (1810), 227 n. 1.
Exeter, Marquis of, 180 n. 2.
Exhibition (1809), 180, 214 n. 3, 215 and n. 2, 216, 218 n. 4, 219 and n. 2, 224 n. 1, 225–6, 363 n. 1, 399, 435 n. 1, 438 n. 2, 449, 465, 491–2, 500, 537, 555, 577 n. 2, 578.
'Exhibition of Paintings in Fresco' (1809), 435 n. 1, 438 n. 2.
Ezekiel, prophet, 519.
'Ezekiel' (1794), 379 and n. 3, 614.
'Ezekiels Wheels' (1805), 572.

'Face in the Fire', 459 n. 1, 567.
Fairholt, F. W., *Art Journal* (1858), 565 n. 1.
Fairy Funeral, 410, 489 and n. 1.
'The Fall of Rosamund' (1783), 569, 606, 611.
'Falsa ad coelum' (1790?), 612.
Family Library, *see* Cunningham, A., *Lives* (1830).
'Famine' (1805), 572.
Farington, Joseph, Diary, 50 and n. 2, 51–52, 57–58, 172.
Farr, Dr. William, father-in-law of Samuel Rose, 152.
Farringdon Works & H. Pontifex & Sons Ltd., successor of Jones & Pontifex, 277 n. 4.

Fawkes, Guy (1570–1606), incendiary, 401.

Felpham, Sussex, 65 n. 1, 68–130 *passim*, 139, 142, 144, 146, 244, 363, 461 and n. 2, 462, 463 and n. 1, 487, 489, 523 n. 1, 524 nn. 1 and 2, 525, 534 n. 2, 550, 561–2, 570, 573 and n. 3; Pl. lvii *a–b*.

Fenning, D., and Collyer, J., *New System of Geography* (1785, 1787), 611.

Fentum, J. (fl. 1786), bookseller, 611.

Ferguson, James (fl. 1830), artist, 363 and n. 2.

Field, Barron (1786–1846), lawyer and author, 231, 362, 365 and n. 1, 549.

Fielding & Walker, booksellers, 609.

Fielding, J. (fl. 1780–87), bookseller, 609–10.

Fielding, Sarah (1710–68), novelist, 610.

Finch, Francis Oliver (1802–62), artist, 268, 288, 294.

The First Book of Urizen (1794), 243 n. 2, 353 n. 2, 417 n. 3, 486 and n. 3, 487, 501 and n. 3, 503, 507, 561, 573 and n. 4, 585 n. 6, 614.

Fittler, James (1758–1835), engraver, 46.

Fitzwilliam Museum, 62 n. 1, 63 nn. 1–5, 64 nn. 1 and 2, 65 n. 1, 70 n. 3, 72 n. 3, 78 n. 1, 81 nn. 2 and 5, 82 n. 3, 83 n. 1, 85 nn. 1, 2, 4, 86 n. 1, 87 nn. 1 and 2, 88 n. 4, 89 nn. 1, 4, 5, 90 n. 3, 91 nn. 1 and 4, 94 n. 4, 95 nn. 1 and 5, 99 n. 1, 100 n. 2, 101 n. 1, 109 nn. 1 and 4, 110 nn. 2 and 4, 112 n. 2, 137 n. 2, 147 n. 1, 148 n. 1, 149 nn. 1, 3, 151 n. 4, 154 n. 1, 155 n. 1, 156 n. 4, 159 n. 1, 163 n. 3, 165 n. 3, 167 n. 3, 189 n. 2, 190 n. 1, 274 n. 3, 278 n. 3, 281 n. 2, 371, 379 n. 3; Pls. i–ii, x*b*, xix, li–lii, liv.

Flaxman, Ann (Nancy) (1760?–1820), wife of the sculptor, 24 and n. 3, 25 and n. 1, 27 n. 3, 28, 45, 48, 68, 70, 83, 85, 88–89, 91, 94, 99 and n. 1, 110, 112 and n. 1, 130, 165 and n. 3, 166, 188 and n. 2, 241–2, 245 and n. 1, 331 and n. 5, 336, 488, 521 and n. 1, 574 n. 1.

Flaxman, Elizabeth (d. 1793), the sculptor's step-mother, 48 n. 3.

Flaxman, John, father of the sculptor, 24.

Flaxman, John [Jr.] (1756–1826), sculptor, 17 n. 3, 19, 24 and nn. 2 and 3, 25 and n. 1, 26–27 and nn. 2–5, 28, 39 and n. 4, 46 n. 3, 47, 51 and n. 1, 52–53, 58, 62 and n. 1, 63 and nn. 2 and 4, 64 and n. 2, 65–66, 68, 70, 72 and n. 3, 74, 78, 82–83 and n. 1, 84–85, 88–89 and nn. 1 and 2, 91 and n. 3, 94, 99 and n. 1, 100–1, 105 n. 2, 110 and n. 2, 111, 112 n. 1, 114, 116, 120–1, 130, 136 and n. 1, 137–9 and n. 4, 147 and n. 1, 148 and n. 2, 151–4 and nn. 1 and 2, 155 and nn. 1 and 2, 156, 165 and n. 3, 166–9, 172–3 and n. 3, 174–5, 177 n. 1, 179–80, 187 and n. 3, 189 and n. 2, 190 and n. 1, 193, 197 n. 1, 201, 220 and nn. 2 and 3, 223, 224 n. 4, 232–3 and n. 1, 235 and nn. 2 and 3, 239, 242, 245, 247, 250 and n. 4, 261 n. 2, 267 n. 3, 283, 287 and n. 1, 288 n. 3, 300–1, 305–6 and n. 1, 311, 312 n. 3, 331 and n. 5, 332, 336–7 and n. 2, 338, 348, 354, 357, 361–2 and n. 1, 368–9 and n. 1, 371, 380–1, 383, 390 n. 1, 410, 440 n. 6, 455–6 and n. 3, 461 and n. 2, 462, 467 and n. 2, 468, 475, 478 and n. 6, 480 and n. 10, 487 and n. 1, 488, 503, 513, 519 and n. 2, 520–1 and nn. 1 and 2, 525, 531, 536–8, 540, 548, 555, 558 n. 1, 569 and n. 5, 570, 575, 578, 579 n. 3, 582, 589 and n. 3, 598, 605–7, 615–16, 618, 619, 622, 625–6; Pls. i–vi, xi, xix.

— 'Basso Relievo', A. Rees, *Cyclopaedia* (1802–20), 138, 139.

— *Hesiod, Works, Days and Theogony* (1817), 184 n. 3, 233 and n. 2, 236 n. 1, 241, 578–80, 607.

— *Hesiod, Works, Days and Theogony* (1817–70), 618.

— *Iliad* (1805), 152–3, 184 n. 3, 186 n. 1, 189, 233, 287 and n. 1, 571, 606.

— *Iliad* (1805–70), 616.

— *A Letter to The Committee for Raising The Naval Pillar* (1799), 570, 615.

— *Odyssey* (1805), 152–3, 233, 287 and n. 1.

— 'Sculpture', A. Rees, *Cyclopaedia* (1802–20), 238.

Flaxman, John, *see* Bentley, G. E., Jr., *Early Engravings of Flaxman's Classical Designs* (1964).
— *See* P. Cunningham, *The Builder* (1863), 136 n. 1.
Flaxman, Maria Ann (1768–1833), the sculptor's half-sister, 45, 48, 121, 130, 154 n. 2, 309, 616.
Flea, *see* 'Ghost of a Flea'.
Fleming, R. B., and Co. Ltd., Pl. viiia.
Flower(s), Mr., of Islington, 594, 595 n. 1, 600.
'The Fly', *Songs of Experience* (1794), 252, 469.
Fogden, Alexander, juror, 1804, 140.
Fogg Museum, 339 n. 2.
For Children: The Gates of Paradise (1793), 182, 213 n. 2, 244, 259 n. 1, 356 and n. 4, 433 n. 2, 486 n. 2, 561, 568, 613.
For the Sexes: The Gates of Paradise (1818?), 411, 412 n. 1, 486 n. 2, 527 n. 1, 613; 618, *see also Gates of Paradise.*
Forbes, Miss, friend of HCR, 331 and n. 5.
Ford, Lady (fl. 1820), 264.
Fordyce, Dr. James (1720–96), minister and poet, 27 and n. 3.
Forgery, 58.
Forster, Revd. Charles, chaplain to John Jebb, 379 nn. 3 and 4.
Forster, E. M., nephew of Laura, 379 nn. 3 and 4.
Forster, J., *Walter Savage Landor* (1869), 229 n. 3.
Forster, Miss Laura, daughter of Charles, 379 nn. 3 and 4.
Fortescue, J. B., *Manuscripts* (1894), 530 n. 2.
Fountain Court, No. 3, 237, 272 n. 1, 273 n. 2, 300, 315, 318 n. 2, 327, 341 n. 1, 342, 347, 354 n. 1, 371, 380, 395 and n. 2, 404 and n. 2, 475 n. 1, 476, 501, 525 and n. 3, 542, 563–6, 582; pl. lviiib.
Fouqué, Frederic, Baron de la Motte, *Sintram and his Companions* (1820), 337 and n. 1.
'Four & Twenty Elders' (1805), 572.
The Four Zoas; see *Vala.*
Fox Inn, Felpham, 122 and nn. 1 and 2, 123, 126 n. 1, 127, 144, 561.

Fox, Charles James (1749–1806), Whig, 55, 553, 558 and n. 1.
Fra Angelico (1387–1455), painter, 42 n. 1, 283.
France and French, 19 and n. 2, 20, 32, 41, 85, 112 and n. 1, 124, 236, 290 and n. 2, 322, 326 n. 2, 395, 402 n. 3, 467, 471, 479, 526 n. 3, 530 n. 2, 547, 563.
Fraser's Magazine (1830), 386–93 and n. 2.
— *see* Thrall, T. M. H., *Rebellious Fraser's* (1934), 393 n. 2.
Free Mason's Tavern, 239, 466 n. 1, 556.
Freeman, printer of *Job*, 321 and n. 3, 590, 603.
Freher, Dionysius A. (1649–1728), Boehme scholar, 313 n. 1.
French Revolution, 149, 355.
French Revolution (1791), 41, 213 n. 2, 355.
Frend, Sophia Elizabeth (b. 1809), 273 and n. 2; *see also* De Morgan, Sophia Elizabeth, *Threescore Years and Ten* (1895).
Frend, William (1757–1841), radical, 273.
Frere, John Hookham (1769–1846), author, 181 n. 3.
Fresco, 31, 33 n. 3, 181, 215, 357, 413, 449, 464 and n. 1, 465 and n. 2, 467, 470, 472, 493, 504, 565.
Fuseli, John Henry (1741–1825), painter, 39–40, 44 and n. 2, 46–47, 51–53, 58, 72, 139, 169 and n. 2, 170–1, 177 n. 1, 179 and n. 2, 182 and n. 1, 191–2, 193 and n. 1, 195 and n. 2, 197, 201 and nn. 1 and 3, 202, 204, 206, 210, 213, 215 and n. 3, 220 and nn. 2 and 3, 221 n. 1, 222 n. 3, 232, 238, 242–3, 245, 247, 254, 264 n. 4, 269, 281–2 and n. 1, 283, 307–8 and n. 1, 318 n. 2, 330, 331 and n. 1, 348 and n. 2, 354, 356 n. 5, 357, 368 n. 2, 375, 377, 380, 390 n. 1, 424, 434 and n. 1, 449, 455, 467 and n. 2, 468, 475, 480 and n. 10, 489 n. 1, 490, 503, 516–17, 522 n. 1, 530 n. 2, 531, 536, 538, 554, 559, 596, 606, 611–12, 614 and n. 2, 615–16, 619, 625; *see also* Knowles, J., *Life and Writings of . . . Fuseli*

(1831); Lavater, J. C., *Aphorisms on Man* (1788–94), tr. Fuseli.
— Milton Gallery, 47, 110, 177 n. 1.
— *Lectures on Painting* (1801), 615.
Fuseli, Sophia [Rawlins], wife of John, 53.

Gabriel, angel, 183, 441, 452.
Gaelic, 526 n. 3.
Gainsborough, Thomas (1727–88), painter, 24 n. 3.
Galt, Mrs. George, collection, 58 n. 1.
'The Garden of Love', *Songs of Experience* (1794), 224 n. 3, 252, 385 and n. 1, 445–6, 454, 469 n. 1.
Gardner, J. (fl. 1782), vicar of St. Mary, Battersea, 23.
Garnerin, Jacques (1769–1826), balloonist, 104 and n. 1.
Garnett, Richard, *William Blake* (1895), 417 n. 3.
Gates of Paradise, 211 n. 2, 460 and n. 4, 486, 503; see also *For Children: The Gates of Paradise* (1793) and *For the Sexes: The Gates of Paradise* (1818?).
Gawler, John, *see* Ker, John Bellenden.
Gay, John, *Fables* (1793, 1811), 48 n. 2, 613.
General Description of All Trades (1747), 509 n. 1.
'Genesis, Version of', 322, 547.
Gentleman's Magazine (1810), 227 n. 1.
— (1812), 623 and n. 3.
— (1827), 350 n. 1, 356–7 and n. 2, 359, 361 n. 2, 362 n. 2.
— (1830), 626 n. 2.
— (1852), 187 n. 2, 548.
Geomancy, 624.
George III (1738–1820), 10, 20, 22, 73, 123–5 and n. 3, 126, 128–9, 131–4, 141, 143, 146, 188 n. 3, 236, 463 n. 1, 511 n. 1, 523, 524 n. 1.
George IV (1762–1830), 51, 339, 340 and n. 2, 344 n. 6, 345, 593, 599.
George Inn, Glastonbury, 423 n. 1.
German, 95, 270, 310 n. 1, 311, 338, 375–6, 377 n. 2, 382, 432–47, 536–7, 539.
Ghost, 54, 303, 489 n. 1, 519–20.
'Ghost of a Flea' (1819), 226 n. 3, 264, 298, 299 n. 1, 352, 370 n. 1, 372–3 and n. 1, 467, 472, 497 n. 1, 498; Pl. xlviii.

The Ghost of Abel (1822), 618.
Gibbon, Edward (1737–94), historian, 69.
Gibson, John (1790–1866), sculptor, 245 and n. 2.
— [auto]*Biography* (1911), 425 n. 2.
— *Life* (1870), 245 n. 2.
Gilchrist, Alexander (1828–61), biographer, 318 n. 2, 375 n. 1, 417, 459 n. 1, 466 n. 1.
— *Life of William Blake* (1863), 2 n. 4, 3 and n. 1, 7 nn. 3 and 4, 12 n. 1, 13 and nn. 2 and 5, 14 n. 1, 18 n. 2, 21 and nn. 1 and 3, 24 nn. 1 and 2, 29 nn. 6 and 7, 30 n. 1, 31 nn. 1 and 2, 32 n. 1, 33 and nn. 2 and 3, 39 nn. 3–5, 40 n. 3, 41 and n. 1, 42 n. 1, 43 nn. 1–3, 48 n. 1, 53 and nn. 2 and 3, 54 nn. 1–3, 71 n. 3, 120 n. 3, 145 n. 3, 146 nn. 1 and 2, 166 and n. 1, 180 n. 1, 181 nn. 1 and 2, 194 n. 1, 213 and n. 2, 216 n. 3, 221 n. 2, 233 and nn. 1, 3, 5, 234 nn. 1–3, 6, 235 nn. 1 and 4, 236 and n. 3, 237 nn. 2–4, 238 and nn. 1 and 3, 250 n. 2, 257 n. 1, 259 n. 2, 260 nn. 1 and 2, 267 n. 2, 268 and nn. 1–3, 274 n. 1, 275 n. 1, 276 n. 1, 279 n. 1, 280 and nn. 4 and 5, 281 n. 2, 282 and nn. 1 and 2, 283 n. 1, 290 nn. 1 and 2, 291 n. 2, 294 nn. 1 and 4, 295 n. 2, 301 nn. 2 and 3, 302 n. 1, 306 and nn. 4 and 6, 307 n. 1, 308 n. 2, 309 nn. 1 and 2, 310 n. 2, 312 n. 2, 313 n. 2, 314, 315 n. 1, 316 n. 1, 321 n. 5, 322 n. 2, 326 n. 1, 333 n. 3, 338 n. 2, 339 nn. 1 and 3, 341 n. 4, 342 n. 1, 363 nn. 1 and 2, 364 n. 1, 379 n. 4, 400 n. 2, 410 nn. 3 and 6, 415 nn. 1 and 2, 458 n. 1, 462 n. 1, 466 n. 1, 468 n. 1, 475 n. 4, 511 n. 1, 517 n. 1, 521 n. 1, 524 n. 1, 526 n. 1, 530 n. 2, 534 n. 4, 556 n. 2, 561 n. 3, 562 nn. 1 and 5, 563 n. 3, 564–5 and nn. 1, 3–4, 566 and nn. 1–4, 567 and n. 1, 578 and n. 1.
— (1880), 120 n. 3, 145 n. 3, 274 n. 1, 307 n. 2, 524 n. 1.
— (1907), 53 n. 3.
— (1942), 2 n. 4, 3 and n. 1, 7 nn. 3 and 4, 12 n. 1, 13 and nn. 2 and 5, 14 n. 1, 18 n. 2, 21 and nn. 1 and 3, 24 nn. 1

Gilchrist, Alexander (*cont.*):
and 2, 29 nn. 6 and 7, 30 n. 1,
31 nn. 1 and 2, 32 n. 1, 33 and nn. 2
and 3, 34 n. 1, 39 nn. 1, 3–5, 41 and
n. 1, 42 and n. 1, 43 nn. 1–3, 48 n. 1,
53 and nn. 2 and 3, 54 nn. 1 and 3,
71 n. 3, 88 n. 2, 120 n. 3, 145 n. 3,
146 nn. 1 and 2, 166 and n. 1, 180 n. 1,
181 nn. 1 and 2, 194 n. 1, 213 and
n. 2, 216 n. 3, 233 and nn. 1, 3, 5,
234 nn. 2 and 6, 235 n. 1, 236 and
n. 3, 237 nn. 3 and 4, 238 and nn. 1
and 3, 250 n. 2, 259 n. 2, 260 nn. 1
and 2, 267 n. 2, 268 and nn. 1–3,
274 n. 1, 275 n. 1, 276 n. 1, 279 n. 1,
280 and n. 5, 281 n. 2, 282 nn. 1 and
2, 283 n. 1, 290 nn. 1 and 2, 291 n. 2,
292 n. 2, 294 nn. 1 and 4, 295 n. 2,
301 nn. 2 and 3, 302 n. 1, 305 n.
2, 306 n. 6, 307 nn. 1 and 2, 308 n. 2,
309 nn. 1 and 2, 310 n. 2, 312 n.
2, 313 n. 2, 315 n. 1, 316 n. 1, 322 n.
2, 326 n. 1, 333 n. 3, 338 n. 2, 339
nn. 1 and 3, 341 n. 4, 342 n. 1, 363
n. 1, 364 n. 1, 379 n. 4, 410 nn. 3 and
6, 415 n. 2, 462 n. 1, 466 n. 1, 468 n.
1, 475 n. 4, 511 n. 1, 517 n. 1, 521
n. 1, 524 n. 1, 526 n. 1, 530 n. 2, 534
n. 4, 556 n. 2, 561 n. 3, 562 nn. 1 and
5, 563 n. 3, 564–5 and nn. 1, 3, 4,
566 and nn. 1–4, 567 and n. 1, 578
and n. 1.
Gilchrist, Anne (1828–85), wife of
Alexander, 34 n. 1, 274 n. 1, 302 n. 1,
307 n. 2, 319, 321 n. 5, 416–17 and
n. 3.
Anne Gilchrist: Her Life and Writings
(1887), 14 n. 1, 34 n. 1, 40 n. 1,
53 n. 2, 278 n. 3, 293 n. 1, 315 n. 1,
342 n. 2, 418 n. 1, 566 n. 5.
Giles, John, cousin of Samuel Palmer,
294.
'Glad Day' (1780, 1796), 609.
Glasshouse St., No. 5, 2, 6, 8 n. 2, 551,
557.
Glasses, 281 and n. 2.
Glenbervie, Douglas Sylvester, Lord
(1743–1823), politician, 149 and n. 3.
Glynn (fl. 1830), 377.
Gnostics, 545.
Gobbe, J. H., magistrate at 1804 trial,
140.
God, 310–11, 567.

'God Creating Adam' (1805), 572–3.
'God Judging Adam' (1805), 572.
Godfrey, Charles, Hayley's cousin, 151.
Godwin, William (1756–1836), radical,
40–41 and nn. 2 and 3, 81 n. 2,
177 n. 1, 318 n. 2, 523 n. 1.
Godwin, Mrs. William, 523 n. 1.
Goethe, Johann Wolfgang von (1749–
1832), author, 387, 434 and n. 3,
446 n. 2, 449.
Golden Square, *see* Broad St.
Goldring, James, juror in 1803, 134 n.
1.
Goldoni, Carlo (1707–93), dramatist,
105, 108.
Goldsmith, Oliver (1728–74), author,
13, 119, 267 n. 2.
Golgonooza, 266.
Gooch, Dr. Robert (1784–1830), physi-
cian, 340, 599.
'Good and Evil Angels' (1805), 353 n. 2,
572.
Goodwin, Earl, *see* 'The death of Earl
Goodwin', 17.
Gordon riots, 17–18, 554.
Gordon, Caroline, *see* Mrs. Charles
Harrison, 250 n. 4.
Gordon, Mrs. John, daughter of C. A.
Tulk, 250 and n. 4.
Goss, Thomas (b. 1765), painter, 16.
Gothic, 26, 170, 217, 316 n. 1, 321 n. 5,
422–4, 428, 433, 439, 448, 490, 498,
512.
Götzenberger, Jacob (fl. 1826), artist,
338 and n. 1, 363, 536, 543, 549.
Gough, Richard (1735–1809), anti-
quary, 13, 423 n. 1.
— *Sepulchral Monuments* (1786, 1796),
422 n. 3, 466, 512 n. 1, 609;
Pls. xlix–1.
Grafton St. Baptist Church, 7–8 and n. 2.
Grainger (fl. 1793), engraver, 48.
Grape vine, 521 and n. 1.
Gray, Thomas (1716–71), poet, 30,
100, 101 n. 1, 104.
— *Poems* (1790) drawings, 166,
187 n. 3, 369 and n 1.
Great Queen St., No. 31, 9 and n. 3, 11,
18, 478 n. 2, 556.
Greatheed, Samuel, friend of Cowper,
108–9 and n. 1, 110, 116, 118, 148–9
and n. 1, 151, 167, 172–3 and n. 1.
— *Eclectic Review* (1805), 173 n. 1.

Greek, 12, 41 n. 4, 63 and n. 2, 86, 89 and n. 5, 198, 217, 290 and n. 2, 310, 314, 437, 439, 451, 493, 526 n. 3, 541.

Green St., No. 23, 28 n. 2, 457 n. 3, 482, 518, 557.

Grignion, Charles (1717–1810), engraver, 212 and n. 2.

Grignion [Thomas, watchmaker], brother of Charles, 212.

Grinder, Mr., owner of the Fox Inn, and Blake's landlord in Felpham, 122–3, 125 n. 3, 126–7, 561.

Grinder, Mrs., 122–3, 125 n. 3, 126–7, 143–4.

Grinder, Miss, 122–3, 125 n. 3, 126.

Grove, John, juror, 1804, 140.

Guantock, 129 n. 1; *see also* Quantock, John.

Guildhall Library, 47 n. 4, 347 n. 2, 374 n. 3, 411 n. 2, 509 n. 1, 552 n. 3.

Gunnis, R., *Dictionary of British Sculptors 1660–1851* (1953), 278 n. 3.

Guy, James, juror, 1804, 140.

Guy, Dr. William, physician, 94, 144.

Gwantock, 129 n. 1; *see also* Quantock, John.

Gwantok, 129 n. 1; *see also* Quantock, John.

Gwantoke, 129 n. 1; *see also* Quantock, John.

'Gwin, King of Norway', *Poetical Sketches* (1783), 505–6.

Hades, 285.

Hadfield, George (d. 1826), architect, 611.

Haley, *see* Hayley, William.

Hall, John (1739–97), engraver, 48.

Halladay, Matthew, juror in 1803, 134 n. 1.

Haller, Albert de, *see* Henry, T., *Memoirs of Albert de Haller* (1783), 610.

Hamilton, Emma, Lady (1761?–1815), wife of Sir William, 78 n. 1.

Hamilton, Sir William (1730–1803), archaeologist, 43.

Hampstead, 234, 272, 286, 288, 292 and n. 2, 304 and n. 3, 305–7, 333, 338, 354 n. 1, 358, 590.

Hampstead Heath, 231, 258.

Hamwood Papers (1930), 224 n. 4.

'Hand', character, 219 n. 1.

Hannay, Neilson, C, collection, 81 n. 3.

Hansard, Luke (1752–1828), printer, 50–51.

Hanson, Mr. T. W., collection, 270 n. 1, 331 n. 4.

—*Halifax Guardian* (1912), 270 n. 1.

Har, character, 385–6.

Harcourt, Lord William (1743–1830), and Mary (d. 1833), 98.

Hardie, M., *Samuel Palmer* (1928), 291 n. 1.

Harding, George, juror, 1804, 140.

Hare-Naylor, Francis (1753–1815), author, 224 n. 4.

Hare-Naylor, Georgiana [Shipley] (d. 1806), wife of Francis, 224 and n. 4.

Harlow, George Henry (1787–1819), painter, 222 n. 3, 259.

Harmitage, poet's mother's family, 552 and n. 1.

Harmitage, Catherine, *see* Blake, Catherine, the poet's mother, 552.

Harold (1022?–66), King, 297.

Harrington, James, 42.

Harris, G. F., printer, 192.

Harris, John (1756–1846), bookseller, 617 n. 2.

Harrison & Co., booksellers, 609–11, 619.

Harrison, Mrs. Charles, granddaughter of C. A. Tulk, 250 n. 4.

Harrison, George (1790–1859), 250 n. 4.

Harrison, William (fl. 1821–6), bookseller, 271, 320 and n. 3, 582, 589 and n. 8, 598.

Hartley, David, *Observations on Man* (1791), 555, 612 and n. 2.

Hartley, David [Jr.] (1732–1813), statesman, 555.

Harvard Library, 90 n. 2, 111 n. 3, 115 n. 2, 274 n. 1.

Harvey, Francis, catalogue (1865?), 41 n. 4.

Hastings [?Warren (1732–1818), governor-general of India], 55.

Hatton Garden New Jerusalem Church, 440 n. 6.

Haughton, Moses (1772?–1848?), engraver, 330.

Haverford College Library, 570 n. 3.

'Hawker, Revd Robert' (1820), 288 and n. 4, 618.

Hawkins, John (1758?–1841), dilettante, 24 and n. 3, 25, 27 and n. 3, 28, 68, 70–72 and n. 1, 99.

— *I am, my dear Sir* (1959), 100 n. 1.

Haydon, Benjamin Robert (1786–1846), painter, 560 n. 1, 625.

— *Life* (1853), 399 n. 3.

Hayley, Elizabeth (d. 1800), wife of William, 28, 80, 84, 556 n. 3.

Hayley, Thomas Alphonso (1780–1800), illegitimate son of William, 51 and n. 1, 62–65 and n. 1, 66–68 and n. 2, 69–70 and n. 1, 71, 73 and n. 5, 78, 80, 83, 106, 112, 121, 130, 462 n. 1, 463, 555, 615–16; Pls. xi–xii.

Hayley, William (1745–1820), biographer, 27 and nn. 2, 5, 28, 51, 62 and n. 1, 63 and nn. 1–5, 64 and n. 1, 65 and n. 1, 66 and n. 1, 67, 68 and n. 2, 69 and n. 1, 70 and nn. 1 and 3, 71 and n. 1, 72 and n. 3, 73 and n. 5, 74, 77–78 and nn. 1–3, 79 and nn. 1 and 2, 80–81 and nn. 2, 3, 5, 82 and nn. 1–3, 83 and nn. 1, 3, 84–85 and nn. 2, 4, 86 and n. 1, 87 and nn. 1 and 2, 88 and n. 4, 89 and nn. 1, 4, 5, 90 and nn. 2 and 3, 91 n. 1, 92–94 and n. 4, 95 and nn. 1, 2, 5, 96–97 and n. 1, 98 and n. 1, 99 and n. 1, 100 and n. 2, 101 and nn. 1 and 2, 103 and n. 2, 105 and n. 1, 106 and nn. 1 and 2, 107–9 and nn. 1, 2, 4, 110 and nn. 2 and 4, 111–12 and nn. 2 and 4, 113–14 and n. 3, 115 and nn. 2 and 4, 116 and n. 2, 117 and n. 1, 118 and n. 1, 119–24 and n. 1, 126–8, 130–1, 134–5 and nn. 1 and 2, 137 and n. 2, 138–9 and n. 4, 142, 144–5 and n. 2, 146–7 and n. 1, 148 and nn. 1–3, 149 and nn. 1 and 3, 150 and n. 1, 151 and n. 4, 152 and n. 1, 153–4 and nn. 1 and 2, 155–6 and n. 4, 157–8 and n. 1, 159 and n. 1, 160–1 and n. 1, 162 and n. 2, 163 and n. 3, 164–5 and nn. 2, 3, 5, 166–7 and n. 3, 168, 171–3 and nn. 1–3, 174–5, 177 and n. 3, 189, 190 and n. 1, 199 and n. 2, 245, 290 n. 2, 318 n. 2, 322 n. 2, 345 and n. 1, 362 n. 2, 390 n. 1, 461 and n. 2, 462 n. 1, 463, 487–8, 490, 506, 524–5 and n. 2, 526 n. 3, 556 and n. 3, 562 and n. 3, 606, 622, 626–7.

— *Ballads* (1805), 92 and n. 2, 115 n. 1, 157–62 and n. 1, 163 and n. 3, 165 and n. 3, 167, 172, 173 and n. 1, 177 and n. 3, 186 n. 1, 245, 355, 356 and n. 6, 433 n. 2, 606, 616 and n. 2; Pl. xvii, xxii.

— MS 'Collection of brief devotional Poems', 83 n. 3, 87 n. 1.

— *Designs to A Series of Ballads* (1802), 88, 92–99 and n. 1, 100–2 and n. 1, 103–5 and n. 1, 107–8 and n. 2, 109 and nn. 1, 2, 4, 110 and n. 4, 111, 114 and n. 2, 115 and nn. 1 and 4, 116 and n. 1, 117 and n. 1, 118, 157, 173, 177 and n. 3, 355, 356 and n. 6, 433 n. 2, 572 and n. 4, 574 and nn. 1 and 2, 615–16 and n. 2; Pls. xv–xvi.

— 'Edward 1st', 157, 165 and n. 2.

— *Essay on Sculpture* (1800), 62–66 and n. 1, 67, 68, 73, 615; Pl. xi.

— *Life of George Romney* (1809), 112 n. 4, 115 n. 4, 121, 130, 138–9, 147 and n. 1, 152–4 and n. 1, 155, 174, 190 and n. 1, 606, 617 and n. 1.

— *Life . . . of William Cowper* (1802–3), 73, 74, 78–79 and n. 1, 81–82, 85–89, 91 n. 1, 92–93, 95–96, 98, 103, 105, 107–9 and n. 3, 112–14, 115 nn. 3 and 4, 121, 137–8, 148 and n. 2, 149–51 and n. 1, 160–2, 167, 172–4, 456 n. 1, 461 and nn. 1 and 2, 487–8, 525, 606, 616.

— (1806), 145 n. 2.

— *Little Tom the Sailor* (1800), 29 n. 3, 74, 77, 615; Pl. xiii.

— *Memoirs* (1824), 27 n. 2, 51 n. 1, 70 n. 1, 73 n. 5, 74 n. 2, 82 n. 3, 88 and n. 1, 91 n. 4, 92 and n. 2, 95 n. 2, 109 n. 4, 144–5 and n. 2, 162 n. 2, 278 and n. 2.

— *Plays of Three Acts* (1784), 27 n. 3.

— *The Triumph of Music* (1804), 157, 161 n. 1.

— *Triumphs of Temper*, 468.

— (1799), 345 and n. 1, 462 and n. 1.

— (1803), 115 and nn. 1 and 4, 120–1, 130, 158, 606, 616.

— (1807), 616.

— tr. Musaeus, 'Hero & Leander', 173 and n. 3.

Hayley's Library decorations, 69–71, 525 and n. 2.

Haynes, Mrs., wife of miller's servant at Felpham, 123, 125–6, 164.

Haynes, Miss, 123, 126.

Hazlitt, William (1778–1830), critic, 223, 229, 254–5.

— see Holcroft, T., and Hazlitt, W., *Life of Thomas Holcroft* (1925).

— *Lectures on the English Poets* (1818), 254 n. 3.

— *Plain Speaker* (1826), 332 and n. 1.

Healey, Prof. George H., 546 n. 1.

Heath, Charles (1785–1848), engraver, 618 n. 2.

Heath, James (1757–1834), engraver, 191 n. 1, 554–5 and n. 1.

Heather, Henry, landlord of 17 Charlton St., 567.

Heber, Dear Miss (1930), 224 n. 4, 225 n. 1.

Heber, Reginald (1783–1826), bishop, 226.

Hebrew, 41 n. 4, 290 n. 2, 526 n. 3.

'Hecate', 153.

Heemskerk, Martin Jacobsz (1498–1574), painter, 422, 433, 448.

Heinecken, C. H. von, *Dictionnaire des Artistes* (1809), 622 n. 1.

Heinz, D. [? i.e. John Theodore (1732–71)], painter, 79 n. 1, 616.

Helen of Troy, 68.

'Hell Beneath Is Moved for Thee &c' (1805), 572.

Hemans, Felicia (1793–1835), poet, 370 n. 3.

Hendon, Middlesex, 273.

Henry III (1207–72), 422, 511.

Henry V (1387–1422), 624.

Henry, T., *Memoirs of Albert de Haller* (1783), 610.

Heraud, John Abraham (1799–1887), poet, 393 n. 2.

Hercules, 170, 217, 222, 246, 422, 438–9, 493 and n. 14.

Hercules Buildings, No. 13, 52, 54, 59 n. 4, 64, 75 and n. 2, 244, 318 n. 2, 341 n. 1, 356, 475 n. 1, 487, 520, 521 nn. 1 and 3, 522, 560–1; Pl. lvi; *see also* Lambeth.

Hercules Farnese, 493 n. 14.

Hero, *see* Musaeus, 'Hero & Leander'.

Herod, visionary head, 497.

Herries, J.; see *Royal Universal Family Bible* (1780–2).

Hesiod, *see* Flaxman, *Hesiod* (1817).

Hesketh, Harriet, Lady (1733–1807), Cowper's cousin, 71 and n. 1, 73, 78–79 and n. 1, 80, 82 n. 2, 85–88, 90 and n. 2, 91, 94–98, 100–8 and n. 2, 111–13, 116–18 and n. 3, 121, 135 and n. 2, 146, 148 and n. 2, 149, 150 and n. 1, 156, 162 and n. 2, 163–5 and nn. 4 and 5, 455.

Hews, Thomas, juror, 1803, 134 n. 1.

Heyne, Christian Gottlob (1729–1812), author, 389.

Hezekiah, visionary head, 352.

Hidalgo, Hayley's horse, 148, 149 n. 1.

Highgate, 234.

Hill, Dr. John (d. 1775), quack, 554.

Hindmarsh, Robert (1759–1835), Swedenborgian, 35 n. 1, 38 n. 2.

Hindu, 217, 451, 493.

Historical Society of Pennsylvania, 60 n. 1, 68 n. 1, 233 n. 4.

'History of England', 423 and n. 2.

Hoare, Prince (1755–1834), painter, 136, 139, 177 n. 1, 190–1 and n. 1, 218–19.

— *Academic Correspondence* (1804), 136, 139, 616.

— *Inquiry into the Arts* (1806), 16 n. 3, 136, 617.

Hofer, Mr. Philip, collection, 400 n. 2.

Hoffley, William, juror in 1803, 134 n. 1.

Hoffman, Ernst Theodor Wilhelm (1776–1822), poet, 388.

Hoffman, Franz Joseph Ignaz (fl. 1780), stereotype inventor, 32.

Hog Lane, London, 28 n. 4, 556–7.

Hogarth, Elizabeth, 374 n. 2.

Hogarth, Joseph (fl. 1878), printseller, 374 and n. 2, 467 n. 2, 468 n. 3, 476 n. 5.

Hogarth, William (1697–1764), painter, 24 n. 3, 107, 410, 455, 557 n. 2.

— *Works* (1790–1838?), 612.

Hogg, D., *Life of Allan Cunningham* (1875), 477 n. 1.

Hogg, James (1770–1835), poet, 389.

Holcroft, Thomas (1745–1809), author, 40, 235 n. 2, 576 and n. 1.

Holcroft, T., and Hazlitt, W., *Life of Thomas Holcroft* (1925), 235 n. 2.

[W.] *Holden's Triennial Directory* (1799), 561.

— (1799–1811), 552.

— (1802–17), 264 n. 3.

Holland, J., and Everett, J., *Memoirs of . . . James Montgomery* (1854), 194 n. 3.

Holland, Mr. Joseph, Jr., collection, 259 n. 2, 347 n. 1.

Holland, Peter (b. 1757), painter, 16.

Hollis, Thomas, *see* Blackburne, Francis, *Memoirs of Thomas Hollis* (1780).

Hollist, Richard, J.P. in 1803, 131.

Holloway, Thomas (1748–1827), engraver, 44, 613 n. 1.

Holmes, James (1777–1860), painter, 259, 292; *see also* Story, A. T., *James Holmes and John Varley* (1894), 402 n.3.

'Holy Family' (1808?), 210 and n. 3, 211.

Holy Ghost, 322.

'Holy Thursday', *Songs of Experience* (1794), 252, 469.

— *Songs of Innocence* (1789), 224 n. 3, 252–4 and n. 1, 425 n. 3, 426, 430 n. 1, 444, 454, 504 and n. 2; Pls. xxxv–xxxvi.

'Home Philosophical Journal' (1808), non-existent periodical, 214 and n. 2.

Homer, 69–70, 138, 189, 229 n. 3, 287, 322–3, 417 n. 3, 488, 507 n. 1, 547.

— *Iliad*, tr. William Cowper (1791), 44 n. 2; (1802), 81, 86.

— *Odyssey*, tr. William Cowper (1791), 44 n. 2; (1802), 81, 86, 89 and n. 5, 90.

— *Whole Works*, tr. George Chapman (1616), 584 and n. 2, 596 and n. 3, 607.

— *see* Flaxman, *Iliad* (1805); *Odyssey* (1805).

Hood, Samuel (1724–1816), admiral, 558.

Hoole, J., *see* his tr. of Ariosto, *Orlando Furioso* (1783–99), 610.

Hope, Miss, sister of Thomas, 224.

Hope, Thomas (1770?–1831), author, 169 and n. 1, 193 n. 1, 224 and n. 4, 424.

Hoppner, John (1758–1810), painter, 57–58, 168 n. 1, 186 n. 5, 190, 191 and n. 1, 348.

Horace, 69.

Horn, Charles Edward (1786–1849), musician, 273.

Horner, F., tr. L. Euler, *Elements of Algebra* (1797), 614.

Hornsea, 234.

Horsham, Sussex, 136.

Horwood, R., *Plan of . . . London and Westminster* (1792–9), 550, 556; Pls. lix–lx.

Hosier, William, Hayley's gardener, 123, 125–7.

'Hotspur', *see* Percy, Sir Henry, 621.

Houghton, Lord, *see* Milnes, Richard Monckton.

'House of Death' (1805), 572.

'How sweet I roam'd', *Poetical Sketches* (1783), 224 n. 3, 428–9, 457, 513 and n. 3.

Howard, Henry (1769–1847), artist, 62 and n.1, 63–64, 65 n.1, 71, 232, 276, 622.

Howe, E., *List of London Bookbinders 1648–1815* (1950), 9 n. 2, 14 n. 3.

— ed., *London Compositor* (1947), 10 n. 2, 11 n. 1, 160 n. 1, 186 n. 1.

Hudson, Thomas (1701–79), painter, 556.

Hulton, George, Lt. in First Regiment of Dragoons, 124, 127–9 and n. 1, 130 n. 1.

'The Human Abstract', *Songs of Experience* (1794), 224 n. 3, 252 n. 1, 469.

Hume, David (1711–76), philosopher, 311, 540.

— *History of England* (1800?), 46 and n. 2, 155.

Hume, M. C., *Life . . . of Charles Augustus Tulk* (1850, 1890), 250 n. 4.

Humphry, Ozias (1742–1810), painter, 50, 168 n. 1, 178–9 and n. 1, 188–9 and n. 1, 224 n. 1, 363 n. 1, 468 n. 5, 472 n. 2, 473 and n. 1.

Humphry, P. (fl. 1802), bookseller, 615.

Hundleby, George, friend of HCR, 317.

Hunt, James Henry Leigh (1784–1859), author, 53, 61 and n. 1, 194–5, 197 n. 1, 198, 199 n. 1, 215 n. 3, 218, 219 n. 1, 272.

— *Examiner* (1808), 199 n. 1.

Hunt, John, brother of Leigh, 219 n. 1.

Hunt, Mary, mother of Leigh, 61.

Hunt, Robert, brother of Leigh, 61, 194–5 and nn. 1 and 2, 196–7 and n. 1, 200 n. 2, 215–18 and n. 4, 219 n. 1.

— *Examiner* (1808), 195–7 and n. 1.
— (1809), 215–18 and n. 4.
Hunter, bookseller, successor to Joseph
Johnson, 213 n. 2.
Hunter, H., tr. J. C. Lavater, *Essays on
Physiognomy* (1788), 611.
Hunter, John (1728–93), surgeon, 26
and n. 1, 554, 557.
Hunter, J., *Historical Journal of the
Transactions at Port Jackson* (1793),
613.
Huntington Library, 27 n. 5, 34, 44
n. 3, 265 n. 3, 286 n. 1, 322 n. 2, 343
n. 1, 412 n. 1, 584 n. 1; Pls. xx–xxi,
xxiv, xxvi–xxxi, xxxiv, xlv, liii.
Hurd, Richard (1720–1808), Bishop of
Worcester, 101 and n. 3, 102, 105.
Hurst, Robinson, booksellers, 618.
Hutchison, S. C., *Walpole Society*
(1962), 15 n. 1, 16 n. 2.
Hut'n, Huttn, Hutton, *see* Hulton,
George, Lt.
Hyde, Justice, 18.
Hyde, Mrs. Donald F., collection,
189 n. 1.

'The Idle Laundress' (1788, 1803), 612.
'I give you the end of a golden string',
Jerusalem (1804–20), 1, 458.
'I Love the Jocund Dance', *Poetical
Sketches* (1783), 429–30 and n. 1, 505
n. 3, 623.
Imperial Calendar (1814–16), 340.
India, 385; *see also* Hindu.
'The Industrious Cottager' (1788,
1803), 612.
'Infant Joy', *Songs of Innocence* (1789),
252.
'Infant Sorrow', *Songs of Experience*
(1794), 252, 469 n. 1.
Inns of Court, 12.
'Introduction', *Songs of Experience*
(1794), 224 n. 3, 252, 381 and n. 1,
469, 484 n. 9.
— *Songs of Innocence* (1789), 224 n. 3,
243 n. 1, 443–4, 454, 483.
Iremonger, Elizabeth (fl. 1789–1813),
224 and n. 4, 225 and n. 1, 226 and
n. 1, 232, 443 n. 1.
Iremonger, Joshua, father of Elizabeth,
224 n. 4.
Iremonger, Joshua, brother of Eliza-
beth, 224 n. 4.

Iremonger, Lascelles, brother of Eliza-
beth, 224 n. 4.
Irvine, Charles, friend of Cumberland,
55 n. 3.
Irving, Edward (1792–1834), prophet,
313, 418, 530 n. 1, 541.
Isaiah, Prophet, 293 and n. 2, 310 n. 2.
Islington, 234.
Italian and Italy, 24 n. 2, 28, 41 n. 4,
47, 290, 350, 355, 475 and n. 3,
526 n. 3, 527.
Ivimy, Mrs., Linnell's granddaughter,
406 n. 2.
Ivimy MSS. 8 n. 1, 33 n. 3, 234 n. 1, 256
nn. 1 and 2, 264 n. 5, 267 n. 1, 275
n. 2, 280 n. 2, 288 nn. 2 and 3, 290
n. 3, 292 n. 2, 301 nn. 1 and 2, 304
n. 1, 306 nn. 1 and 2, 308 and n. 3,
310 n. 1, 318 n. 2, 320 nn. 1 and 3,
321 n. 3, 327 nn. 2–4, 328 nn. 1 and
2, 329 nn. 1 and 2, 330 nn. 1 and 2,
333 n. 2, 335 nn. 1 and 2, 336 n. 1,
337 n. 4, 339 n. 4, 340 n. 1, 342 n. 3,
343 n. 2, 344 n. 3, 345 n. 5, 346 nn. 2
and 3, 350 n. 2, 353 n. 2, 354 n. 1,
355 n. 2, 358 n. 4, 359 n. 2, 364 n. 2,
365 n. 1, 366 nn. 2 and 4, 367 n. 2,
369 nn. 2 and 3, 371 n. 1, 373 n. 2,
375 n. 1, 376 n. 2, 378 nn. 3 and 4,
379 nn. 1 and 2, 393 n. 3, 403 nn. 1
and 2, 405 nn. 1 and 2, 406 nn. 1 and
2, 409 nn. 1–3, 410 n. 1, 411 n. 1,
414 nn. 1–3, 415 nn. 1 and 3, 459 n. 1,
582 nn. 4 and 5, 583 n. 1, 584 and
n. 3, 585 n. 8, 605 n. 2.

'Jacob's Dream' (1808), 189.
Jackson, R. C., *South London Observer*
(1912), 627 n. 1.
Jebb, John (1775–1833), Bishop of
Limerick, 379 and nn. 3 and 4, 596
and n. 5, 600, 607.
Jeffreys, writing engraver, 579 and
nn. 4 and 5, 590.
Jehovah, 312 and n. 3, 321, 325,
541 n. 1, 545.
Jelliff, Joshua, juror, 1804, 140.
Jenkins, Herbert, *Nineteenth Century*
(1910), 131 n. 2, 140 n. 2.
— *William Blake* (1925), 131 n. 2,
140 n. 2.
'Jephthah sacrificing his Daughter'
(1803), 570.

Jerdan, William, *Autobiography* (1852), 350 n. 1.

Jerusalem, character, 229 n. 2, 513; city, 229 and n. 2.

Jerusalem (1804–20?), 1 and n. 1, 36 n. 1, 129 n. 1, 130 n. 1, 140, 187 n. 4, 219 n. 1, 229 and n. 2, 231 and n. 2, 236 n. 1, 266, 297 n. 1, 341 and n. 3, 344 nn. 4 and 8, 347, 383 n. 1, 398 n. 4, 416, 458 and n. 3, 460 and nn. 1 and 2, 463, 489, 490 and n. 1, 501 and n. 4, 503, 507, 513 n. 1, 520 and n. 1, 532 and nn. 2 and 4, 560, 581 and nn. 2 and 3, 585 and n. 4, 594, 607, 615 n. 1, 616; Pl. liv.

Jesus, *see* Christ.

Jews, 440, 452.

'Job' (1786, 1793), 379 and n. 3, 611.

Job drawings, 598.

— *Illustrations of the Book of* (1826), 14, 211 n. 2, 234 n. 1, 237, 256 n. 2, 257 n. 1, 264, 273–5, 277 and n. 5, 278, 281–2, 290 and n. 1, 291 n. 1, 297 and n. 2, 298, 300, 305, 320 and nn. 2 and 3, 321 and nn. 2 and 3, 326–7 and nn. 2–4, 328 and nn. 1 and 2, 329 and nn. 1 and 2, 330 and n. 2, 332–3, 335 and n. 2, 336–7 and n. 3, 339–40 and n. 2, 341, 344 n. 6, 345 n. 2, 346, 350, 353 and n. 2, 356–62, 364–6 and n. 2, 367, 369 and nn. 1, 3, 4, 371, 373, 375, 376 and n. 2, 393–4 and n. 1, 395–7, 401 and n. 3, 403, 406 n. 2, 408 and nn. 1 and 3, 409–10 and n. 1, 415 n. 3, 468 and nn. 2 and 4, 499 and n. 1, 500 and n. 1, 503, 538, 549, 566, 569, 582 and nn. 4 and 6, 583, 584 and n. 3, 585 n. 8, 586–607; Pl. xliv.

— (1826, 1874), 619.

— (1937), 327 n. 1.

John (1167?–1216), King, 480, 512; *see* 'Prologue to King John'.

Johnes, Thomas (1748–1816), author, 177, 181, 421, 424 n. 1, 562 n. 9.

Johns, Ambrose Bowden (1776–1858), painter, 360 and n. 2, 364, 366 and n. 2, 369 and nn. 3 and 4, 595 and n. 8, 600.

Johnson, Miss Ann Cox, 564 n. 1.

Johnson, Ben, *see* Jonson, Ben.

Johnson, Catherine, Johnny's sister, 103.

Johnson, Dr. John (d. 1838), Cowper's cousin, 'Johnny of Norfolk', 79–81 and n. 5, 82 and n. 3, 84–85 and nn. 2 and 4, 86 and n. 1, 87 and nn. 1–2, 88 and n. 1, 89 and n. 5, 90 and n. 3, 91, 94–95 and n. 5, 96–97 and n. 2, 98 and n. 1, 100, 101 n. 1, 103–4, 107, 109 and n. 4, 110–11, 116, 118, 131, 137 and n. 2, 139, 146–8 and nn. 1 and 3, 163; Pl. xiv; *see also* Hayley, William, *Memoirs*, ed. J. Johnson (1823).

Johnson, John (1777–1848), *Typographia* (1824), 160 n. 1, 350 n. 2.

Johnson (John) Collection, 44 n. 2, 46 n. 2, 59 n. 1, 296 n. 1.

Johnson, Joseph (1738–1809), bookseller, 39 and n. 1, 40–41 and n. 1, 43–44, 48–50, 55, 72, 81 and n. 4, 86, 89 n. 5, 110 n. 1, 115 n. 3, 150 n. 1, 151, 171, 177 n. 1, 213 n. 2, 530 and n. 2, 609–12 and n. 2, 613 and n. 1, 614–16, 619.

Johnson, Miss Mary Barham, collection, 88 nn. 1 and 3, 97 n. 2, 110 n. 3, 163 n. 2; Pl. xiv.

Johnson, Dr. Samuel (1709–84), author, 189 n. 1, 392, 427 and n. 2, 456.

Johnstone, Miss, collection, 72 n. 2.

Jones, Mr., of Felpham, 123, 127.

Jones & Pontifex, copperplate makers, 277 n. 4.

Jones, P. (fl. 1828?), engraver, 619.

Jones, T. [? Thomas (1743–1803), painter, or Thomas (1768–1828), Welsh poet], friend of Butts, 67.

Jonson, Benjamin (1573–1637), dramatist, 425 and n. 4, 426 and n. 1, 428–9, 513.

Joseph, husband of Mary, 13.

Joseph, *see* 'The Death of Joseph' (1803), 571.

Joseph, Israelite, 296.

'Joseph making himself known to his brethren' (1785), 30.

'Joseph ordering Simeon to be bound' (1785), 30.

'Joseph's brethren bowing before him' (1785), 30.

'Joseph of Arimathea' (1773, 1810 ff.), 609.

'Joseph of Arimathea Preaching' (1794?), 613.

Josephus, Flavius, *Works* (1786?–1800?), 609 and n. 2.
Journal of Natural Philosophy, Chemistry, and the Arts, 188.
— (1811), 212 and n. 1.
Jowatt, Revd. Mr., 140.
Judas, 281.
Julius, Dr. Nikolaus Heinrich, tr. of HCR, 223, 432, 537.
Jupiter, 198.

Kauffmann, Angelica (1741–1807), painter, 554.
Kean, Edmund (1787–1833), actor, 344 and n. 5.
Keats, John (1795–1821), poet, 272.
Keen, *see* Kean, Edmund, 344.
Kennedy (fl. 1830), 400.
Kenney, Louisa (d. 1853), wife of James, widow of Thomas Holcroft, 231.
Kent [?William], friend of HCR, 226.
Kent's Directory (1793–1814), 552.
Keppell Street Baptists, 8 n. 2.
Ker, Charles Henry Bellenden (1785?–1871), legal reformer, 227 and n. 3, 228 and n. 2.
Ker, John Bellenden (1765?–1842), born John Gawler, took the name of John Ker Bellenden, known as J. B. Ker, 227 n. 3.
Kew, 517.
Keynes, Sir Geoffrey, collection, 20 n. 1, 63 n. 2, 66 n. 1, 80 n. 2, 121 n. 2, 154 n. 2, 181 n. 3, 237 n. 2, 327 n. 1, 353 n. 2, 356 n. 1, 459 n. 1, 580 n. 5, 619 n. 1.
— *Bibliotheca Bibliographici* (1964), 73 n. 2, 176 n. 1, 567 n. 2, 612 n. 1.
— *Blake Studies* (1949), 9 n. 3, 44 n. 1, 241 n. 1.
— *Blake's Pencil Drawings* (1956), 238 n. 2.
— *Engravings by William Blake: The Separate Plates* (1956), 232 n. 1, 295 n. 4, 609 n. 1, 615 n. 1, 618 n. 2.
— *Library* (1945), 213 n. 2.
— *TLS* (1942), 416 n. 3.
— *TLS* (1958), 256 n. 2, 273 n. 1, 274 n. 2, 403 n. 1.
— and Edwin Wolf 2nd, *William Blake's Illuminated Books: A Census* (1953), 339 n. 1, 468 n. 5, 472 n. 2.

Kimpton, Edward, *History of the Holy Bible* (1781?), 555 n. 1, 609 and n. 2.
King, Dr., of Clifton, 359, 596, 602.
King, Philip Gidley (1758–1808), governor in Australia, 613.
King & Lochee auction (1807 Dec. 5), 188 and n. 2.
— (1813 April 26), 232.
'King Edward the Fourth', *Poetical Sketches* (1783), 431 n. 2.
'King Edward the Third', *Poetical Sketches* (1783), 34 and n. 1, 245, 431 n. 2, 479.
King's Arms Tavern, 559.
Kirkup, Seymour Stocker (1788–1880), artist, 220 and nn. 2 and 3, 221 and nn. 1–4, 222 and nn. 1 and 2, 345 n. 6.
Klopstock, Gottlieb Friedrich (1724–1803), poet, 69, 71, 95.
Kneller, Sir Godfrey (1646–1723), painter, 556 and n. 3.
Knighton, Sir William (1776–1838), Keeper of the Privy Purse, 344 and n. 6, 599.
Knowles, J., *Life and Writings of Henry Fuseli* (1831), 44 n. 2, 168 n. 1.
Kotzebue, August Friedrich Ferdinand von (1761–1819), dramatist, 272.
Kwantok, *see* Quantock, John, 129 n. 1.

Lady's Pocket Book (1782), 466 n. 2, 610.
Lady's Poetical Magazine (1782–4), 466 n. 2.
Lahee, J. (fl. 1826), printer, 300, 321 and n. 2, 350–1, 582 and n. 5, 588 and nn. 2 and 5, 589, 591 and n. 8, 593, 594 and nn. 2 and 6, 603.
Lais the courtesan, visionary head, 497.
Laker, *see* Lahee, J., 582 n. 5.
'The Lamb', *Songs of Innocence* (1789), 252, 292 n. 2, 356 n. 1, 504–5, 532 and n. 5.
Lamb, Lady Caroline (1785–1828), novelist, 248 and n. 3, 249 and n. 1, 318 n. 2.
Lamb, Charles (1775–1834), essayist, 94, 223, 226, 229, 232, 247 n. 1, 266, 272 and n. 2, 284 and nn. 3 and 4, 286, 313, 362, 367, 370 and n. 3, 496 and n. 1, 537–8, 549.
Lamb, Charles and Mary, *Letters* (1935), 94 n. 1, 266 n. 2, 284 n. 4, 370 n. 3.

Lamb, Mary Ann (1764–1847), sister of Charles, 226.

Lambert, Mrs., friend of Hayley, 81.

Lambeth, 49, 54, 341 n. 1, 470, 472, 487, 520, 521 n. 3, 550, 560–1, 627; *see also* Hercules Buildings.

Lambeth Palace Library, 2 n. 1, 21 n. 2, 23 n. 1, 374 n. 3.

'Lamech' (1805), 572.

Landor, Walter Savage (1775–1864), poet, 229 and n. 3.

Lane, bookseller of Clifton, 359.

Lane, Richard James (1800–72), engraver, 618 and n. 2.

Langford, Abraham (1711–74), auctioneer, 421–2, 510 and n. 4.

Language, 41 n. 4, 290 and n. 2, 467, 526 and n. 3, 527, 547; *see also* French, Gaelic, German, Greek, Hebrew, Italian, Latin, Spanish.

Laocoon, 238.

'Laocoon' (1818?), 618.

'A Large Book of Designs', 472 n. 1.

'The Last Judgment' (1806?), 369, 575.

— (1808), 179 n. 1, 188–9, 363 n. 1, 473–4.

— (1815?), 235 and n. 4, 236, 563 and n. 3.

— (1827?), 467–8 and n. 1, 472.

Last Judgment, *see* Blair, *The Grave*, designs and engravings.

'The Last Supper' (1799), 59, 560.

Latin, 41 n. 4, 290 n. 2, 526 n. 3.

'Laughing Song', *Songs of Innocence* (1789), 252, 425 and n. 3, 504 and n. 3, 622.

Lautenschlager, Philip (fl. 1785), Basire apprentice, 12.

Lavant, Lady of, *see* Poole, Harriet.

'Lavater, Rev. John Caspar' (1800), 526 and n. 2, 615.

Lavater, J. C., *Aphorisms on Man* (1788) Blake's annotations, 39, 356.

— *Aphorisms on Man* (1788–94), 39, 288 n. 4, 611.

— *Essays on Physiognomy* (1788–9), 611–12.

Lavington, Wiltshire, 100.

Law, William (1686–1761), religious writer, 313 and n. 1, 541.

Lawrence, Sir Thomas (1769–1830), painter, 79, 85–87, 95, 112, 121, 169, 172–3, 193, 201, 247, 248 n. 3, 249–

50, 257 n. 1, 267, 277 and n. 2, 301, 318 n. 2, 338, 339 and nn. 1 and 2, 346, 348–9, 354, 357, 395, 400, 468 and nn. 3 and 4, 591 and n. 7, 599, 607, 616.

Leach, John, J.P. at 1803 trial, 131.

Leander, *see* Musaeus, 'Hero & Leander'.

'Lear & Cordelia', 367.

Le Brun, Charles (1619–90), painter, 17.

Leigh & Sotheby, *see* Sotheby.

Leigh, James Mathews (1808–1860), painter, 264 and n. 3, 326 n. 1.

Leigh, Mrs. John Gordon, *see* Gordon, Mrs. John.

Leigh, Samuel, bookseller, father of J. M. Leigh, 264 n. 3, 587?, 591?, 598?, 604?

Leighton (fl. 1826), binder, 591 and n. 3, 603.

Lely, Sir Peter (1618–80), painter, 24 n. 3.

Leney (fl. 1793), engraver, 48.

Leonard (fl. 1834), 597 and n. 2, 602.

Leonardo Da Vinci, *see* Da Vinci, Leonardo.

Leslie, C. R., *Autobiographical Recollections* (1860), 19 n. 1.

— *Memoirs of . . . John Constable* (1843), 258 n. 2.

'Let him look up into the Heavens' (1805), 616.

Lewis, Charles (1786–1836), binder, 280, 368.

Lewis, Frederick Christian (1779–1856), engraver, 300 n. 3.

Lewis, Matthew Gregory (1775–1818), author, 73, 237 n. 2.

Ley, Mrs., *see* Gordon, Mrs. John, 250 and n. 4.

Ley, Dr. Hugh (1790–1837), physician, 591, 599.

Library of Congress, 153 n. 1, 194 n. 1, 275 n. 1; *see also* Rosenwald Collection.

Library of the Fine Arts (1832), 15 n. 1, 16 n. 2.

Life mask, 278 and n. 3, 279; Pl. xlii.

'The Lilly', *Songs of Experience* (1794), 252 n. 1, 469.

Limerick, Bishop of, *see* Jebb, John.

Lincoln's Inn, 12.

Linnaeus (Carl von Linné [1707–78]),
botanist, 254–5, 494.

Linnell, mother of Blake's patron, 271.

Linnell, Elizabeth (b. 1819), daughter
of Blake's patron, 406 n. 2.

Linnell, Hannah (b. 1818), daughter of
John, wife of Samuel Palmer, 257,
292 n. 2, 304 and n. 1, 305 and n. 1,
406 n. 2, 566 n. 2.

Linnell, James, father of Blake's patron,
275 n. 2, 332, 393 and n. 3, 394, 401
and n. 3, 581 n. 3, 582 and n. 4, 602.

Linnell, James Thomas (b. 1822), son
of Blake's patron, 406 n. 2, 583 n 1.

Linnell, John (1792–1882), painter,
Blake's patron, 3 and n. 1, 8 n. 2,
29 n. 5, 32 n. 1, 34 n. 1, 43 and n. 2,
53–54, 234 and n. 1, 237 n. 2, 256
and nn. 1 and 2, 257 and n. 1, 258
and n. 1, 259 and n. 2, 260, 263 n. 2,
264 and n. 5, 265–7 and nn. 1 and 2,
271–4 and n. 2, 275 and nn. 2 and 3,
276 and n. 3, 277 and n. 2, 278,
280 and n. 2, 282, 286, 288 and n. 3,
290 and n. 1, 291 and nn. 1–3, 292,
295 and nn. 1 and 5, 296, 297 n. 2,
298 n. 1, 299–301 and n. 2, 303–5
and n. 1, 308 and n. 3, 309, 310 n. 1,
314 and n. 2, 318 and n. 2, 319 and
n. 1, 320, 321 nn. 1 and 2, 322 n. 2,
327 and nn. 1–4, 328 and n. 1, 329–
30, 332–3, 335 and nn. 1 and 2, 336–
7 and nn. 3 and 4, 338 and n. 3, 339
and n. 4, 340 and n. 2, 341 and n. 2,
342 and n. 3, 343 n. 2, 344 and nn. 2–
4, 345 and nn. 2 and 5, 346 and nn. 1
and 2, 347, 350 and n. 2, 351, 353
and n. 2, 354 and n. 1, 355, 357–9
and n. 2, 360–3 and n. 1, 364 and
n. 2, 365 and nn. 1 and 2, 366 and
n. 2, 367 and n. 2, 369 and nn. 2 and
3, 370–3 and nn. 2 and 3, 374,
375 n. 1, 376 and n. 2, 378 and n. 3,
379 and n. 2, 383 n. 1, 393 n. 3, 394–
8 and n. 1, 400–1 and n. 4, 403–4 and
nn. 1 and 2, 405 and n. 1, 406 and
nn. 1 and 2, 407 and nn. 1 and 2, 408
and nn. 1 and 2, 409 and nn. 1–3,
410 n. 5, 411, 413–14 and n. 2, 415
and nn. 1 and 3, 416–17 and n. 1,
459 nn. 1 and 2, 460 nn. 1 and 4,
461 n. 1, 463 n. 1, 464 n. 1, 466 n. 1,
468 and n. 4, 497 n. 1, 500, 525 n. 3,

534 nn. 3 and 4, 538, 543, 549, 555,
563–4, 566 n. 2, 567 and n. 3, 569,
580 and n. 4, 581 and nn. 2 and 3,
582 and nn. 2, 5, 6, 583 and nn. 1 and
2, 584–607, 618, 619 and n. 1, 620;
see also Story, A. T., *The Life of
John Linnell* (1892).

— MS Autobiography, 8 n. 2, 17 n. 1,
53, 256–7 and n. 1, 263, 264 and n. 1,
277 n. 2, 280 n. 2, 292 n. 3, 328 n. 1,
343 n. 2, 510 n. 5.

Linnell, John, Jr. (b. 1820), son of
Blake's patron, 256 n. 2, 318 n. 2,
327 n. 4, 337 n. 4, 339 n. 4, 342 n. 3,
346 n. 2, 354 n. 1, 364 n. 2, 379 n. 2,
401 n. 4, 406 n. 2, 409 n. 3, 414 and
n. 2, 415, 605 n. 2.

Linnell, Mr. John S., collection, 8 n. 2,
257 n. 1.

Linnell, Mary Ann [Palmer], wife of
Blake's patron, 280, 288, 292, 303–6
and n. 1, 320–1 and n. 3, 343 n. 1, 415.

Linnell, William, son of Blake's patron,
304 n. 3.

Linton, Miss Marion, 214 n. 2.

Liotard, Jean Etienne (1702–89),
painter, 554.

Lisson Grove, No. 20, 405, 413–14,
416, 535, 567 and n. 2.

Literary Chronicle (1827), 351–3 and
n. 1.

Literary Gazette (1823), 278 n. 2.

— (1824), 289 n. 2.

— (1827), 168 n. 1, 348–50 and n. 1,
354, 356, 357 nn. 1 and 2, 361 n. 2.

— (1828), 370 and nn. 2 and 4, 372,
373 and n. 1.

Literary Journal (1806), 622 and n. 3.

Literary Port Folio (1830), 400 and n. 1.

'The Little Black Boy', *Songs of Inno-
cence* (1789), 224 n. 3, 252.

'The Little Boy Found', *Songs of Inno-
cence* (1789), 252.

'A Little Boy Lost, *Songs of Experience*
(1794), 224 n. 3, 252, 469.

'The Little Boy Lost', *Songs of Inno-
cence* (1789), 252.

'The Little Girl Found', *Songs* (1789–
94), 252 n. 1, 253, 469 n. 1.

'A Little Girl Lost', *Songs of Experi-
ence* (1794), 253, 470.

'The Little Girl Lost', *Songs* (1789–94),
252 n. 1, 253, 469 n. 1.

'The Little Vagabond', *Songs of Experience* (1794), 253, 469 n. 1.

Liverpool Public Library, 47 n. 1, 94 n. 3, 179 n. 2.

Livy (Titus Livius [59 B.C.–A.D. 17]), historian, 69.

Lizars, William Home (1788–1859), painter, 214 n. 2, 597, 600, 602.

'The loaves and fishes' (1800), *66*.

Locke, John (1632–1704), philosopher, 106 n. 2, 313, 316, 541, 543.

Locke, William Jr., (1767–1847), art amateur, 169 and n. 2, 193 n. 1, 424.

'London', *Songs of Experience* (1794), 253, 469, 531–2.

London Commissary Court, London Division, 374 n. 3.

London County Council, 551 n. 1.

London Institution, 224, 353.

London Library, 214 n. 3.

London Literary Gazette (1830), 378 and n. 2.

London Magazine (1820), 265–6 and n. 1.

London Review (1797), 613 n. 1.

London University Magazine (1830), 380–6 and n. 6.

Long, Charles, friend of Cumberland, 55 n. 3.

Long, William (1747–1818), surgeon, 27 and n. 4, 99.

Longman, publishing firm, 181 n. 3, 189, 569 n. 3, 571 and n. 1, 579, 580 n. 3, 616–19.

Longman & Co, *see* Cox, H., and Chandler, J. D., *House of Longman* (1925), 376 n. 2.

Longman & Rees, 152, 569 n. 3.

Longman, Brown, Green, and Longmans, 376 n. 2.

Longman, Hurst, Rees, & Orme, 171.

Longman, Hurst, Rees, Orme, & Brown, 579 n. 4.

Longmans, Green & Co., 376 n. 2, 569 n. 3.

Lords, House of, 227 n. 3.

Los, 266.

Lot, visionary head, 499.

Loutherbourg, Philip James (1740–1812), painter, 26, 332.

Lovah; mistake for Luvah, 385 and n. 3.

'Love and Harmony Combine', *Poetical Sketches* (1783), 513–14.

Lovegrove (fl. 1793), engraver, 48.

Lowell, James Russell (1819–91), author, 221 n. 4.

Lowery, M. R., *Windows of the Morning* (1940), 425 n. 1.

[Lowndes] *London Directory* (1792), 557 n. 1.

Lowndes's London Directory (1784), 552.

Lowry, Wilson (1762–1824), engraver, 587, 588 and n. 1, 598, 604, 607, 618.

'Lowry, Wilson' (1825), 407 n. 2, 618.

Lucas, Charles, friend of Cumberland, 55 and n. 3.

'Lucifer and the Pope' (1805), 616.

Luini, Bernardino (?1465–?1540), painter, 50 n. 1.

Luther, Martin (1483–1546), reformer, 312–13, 541.

Luvah, 385 n. 3.

Lyons, I., *see* Seally, J., and Lyons, I., *Geographical Dictionary* (1784, 1787), 610.

Lytton, Edward Bulwer, *see* Bulwer Lytton, Edward.

Macklin, J. (fl. 1783), printseller, 610.

Macklin, Thomas (fl. 1783), printseller, 46, 569 and n. 1, 606, 610–11.

Macmillan, publisher, 321 n. 5, 327 n. 2.

Macphail, Mr. J. H., 621.

Macpherson, James (1736–96), poet, 546.

'Mad Song', *Poetical Sketches* (1783), 226 n. 2.

Madness, 2, 7, 19, 39 n. 4, 42, 52–54, 57–58, 80, 105–6 and n. 2, 107–8, 138, 164–5, 171, 173–4, 180, 195, 208, 215–16 and n. 1, 217–20 and n. 2, 221 and nn. 2 and 4, 223, 226 and n. 2, 229 and n. 3, 232–3 and n. 1, 235–6, 244, 263, 268, 285, 299 n. 1, 309, 321, 326, 352, 363, 367, 370, 372, 379–80, 387, 391 and n. 1, 396, 398–9, 401, 402 and n. 3, 424, 431 n. 1, 432, 448–9, 455–6, 466 n. 1, 477, 480 and n. 10, 489 n. 1, 493–4, 499, 517, 519–20, 536–7, 539, 625–6.

Magdalene College, Cambridge, 528 n. 3.

Maggs Bros, London, book dealers, 178 n. 3.

Maginn, William (1793–1842), writer, 393 n. 2.

'Malevolence' (1799), 60; Pl. x*a*.

Malkin, Benjamin Heath (1769–1842), author, 169, 174–7 and nn. 1 and 2, 192, 225, 230, 349 n. 1, 562 and n. 9, 563, 616 n. 1.

— *A Father's Memoir of his Child* (1806), 13 n. 3, 174, 177, 181 and nn. 3 and 4, 182, 223, 254 n. 2, 318 n. 2, 385 n. 1, 421–31, 433 n. 1, 444 n. 1, 479 n. 1, 504 nn. 2 and 3, 510 and nn. 3 and 4, 511 and n. 2, 513 n. 3, 537, 574 and n. 4, 617, 622–3; Pl. xxiii.

Malkin, Thomas William (1795–1802), son of B. H., 177, 421.

Mallet (fl. 1810), friend of HCR, 226.

Malone, Mary E., collection, 231 n. 2.

'The Man Flea', *see* 'The Ghost of a Flea', 352.

'The Man who built the Pyramids' (1819), 259, 263.

'The Man Sweeping the Interpreter's Parlor' (1794, 1824?), 295 and n. 4, 614.

Manichean, 316, 543.

Manny, Sir Walter, of *Poetical Sketches* (1783), 479.

Marcantonio, Raimondi (1488?–1534?), engraver, 345, 458.

Marchant, Nathaniel (1739–1816), gem-engraver, 53.

Margoliouth, H. M., *N & Q* (1948), 1 n. 2.

Mark Antony, 298.

Marriage, 21–23 and n. 1, 24, 332, 377, 459, 482, 548.

Marriage of Heaven and Hell (1790–3), 38 and n. 1, 234 n. 2, 243 n. 2, 272, 319 n. 1, 321 n. 5, 339, 417 n. 3, 458 n. 1, 460, 561, 573 and n. 4, 581 and n. 2, 585, 607, 612.

Marsh, Edward Garrard (1783–1862), priest, 100 n. 2, 111 and n. 3.

Marshall St., 552 n. 2, 553, 556, 558.

Marshall, Ann, *see* Butcher, Ann [Marshall].

Marshall, Miss Ruth, collection, 250 n. 4.

Martin, Mr. H. Bradley, collection, 27 n. 4.

Martin, John (1741–1820), Baptist minister, 8 n. 2.

Martin, Jonathan (1782–1838), incen-

diary; see *Monthly Magazine* (1833), 299 n. 1, 374 n. 1.

Martin, Mark, Blake's landlord in South Molton St., 395, 563 and n. 2.

Marvell, Andrew (1621–78), poet, 42.

Mary, Virgin, 480 n. 10.

— *see* 'The Death of the Virgin Mary' (1803), 571.

— *see* 'The Three Maries at the Sepulchre', 570–1.

Mason, J. (fl. 1791), 530 n. 2.

Mason, W. (fl. 1808), printer, 199 and n. 2.

Mason, William (1724–97), poet, 161–2.

Masquerier, John James (1778–1855), painter, 243, 331 and n. 5, 336, 549.

Masquerier, Rachel (d. 1850), wife of John James, 331 and n. 5, 549.

Mathew, Revd. A. S. (1733–1824), patron, 25, 26 and n. 1, 455, 456 and n. 4, 478 and nn. 5 and 6; Pl. iv.

Mathew, Harriet, wife of A. S., 25–26, 30, 455–7 and n. 2, 513 and n. 2; Pl. v.

Mathew, Revd. Henry; mistake for A. S. Mathew, 26 and n. 1, 456.

Mathew, William Henry (b. 1769), son of A. S., 26 and n. 1.

Mathews, Mrs. E., widow of James, 264 n. 3.

Mathews, James (d. 1803?), bookseller, 264 n. 3.

Mathews, Lucia Elizabeth (1797–1856), actress, 273.

Matthews; mistake for A. S. Mathew, 478.

Matthews, Mrs., *see* Mathew, Harriet, 513 and n. 2.

Matthews, Mrs. E., *see* Mathews, Mrs. E., 264 n. 3.

Matthews, Mary J., daughter of Garth Wilkinson, 213 n. 2.

Maud, Empress (1102–67), daughter of Henry I, mother of Henry II, 624 and n. 1.

Mazell (fl. 1793), engraver, 48.

Mechanic's Magazine (1823), 279 and n. 1.

Medland, Thomas (d. 1833), engraver, 48.

Medway, river, 19.

Mee, Anne (1775?–1851), miniaturist, 249, 250 n. 1.

Meheux, J., painter, 610.
Melbourne Art Gallery, 585 n. 6.
Melchett, Gwen Lady, collection, Pl. xviii.
Mellon, Mr. Paul, collection, 182 n. 1, 239 n. 2, 356 n. 1, 507, 602 n. 3.
Melville, Lord, *see* Dundas, Henry.
Memling, Hans (1430–94), painter, 310 n. 1.
Merchant, *see* Marchant, 53.
Meredith, of Harley Place, 304 n. 2, 594, 600.
Meres, F., *Palladis Tamia* (1598), 428 n. 1.
Merlin, magician, 512, 518.
Metastasio (Pietro Trapassi [1698–1782]), poet, 273.
Metcalfe, William (d. 1801), servant of Hayley, 87 and n. 1, 89.
Methodism, 197.
Metz, C. M., painter, 609.
Meyer, Miss, daughter of Jeremiah, 100 n. 2.
Meyer, Barbara Marsden, wife of Jeremiah, 100 n. 2.
Meyer, Jeremiah (1735–89), miniaturist, 70 n. 1, 100 n. 2, 147.
Meyer, William, son of Jeremiah, 100 and n. 2.
Meyer family, 111.
Michael Angelo Buonarroti (1475–1564), painter, 16–17, 27, 39, 147, 182–3, 185, 189, 200, 216–18, 244, 283, 285, 287–8, 290 and n. 3, 291, 297–8, 299 n. 1, 306, 311, 313, 330, 422, 433–6, 439, 448–50, 463, 467, 470, 490, 492, 510 and n. 5, 515–17, 520, 524, 527, 538, 540–1, 546, 596, 601, 609, 625.
Middlesex County Record Office, 374 n. 3, 551 n. 4, 563 n. 2.
Middlesex Court of the Archdeaconry, 374 n. 3.
Midhurst, 100 and n. 1, 114 n. 3, 148 n. 1, *see also* Collins, Charlotte, *and* Spilsbury.
Military Painter, 126.
Miller, William (1769–1844), bookseller, 55 n. 2, 171, 614.
Millyard, Thomas, juror, 1804, 140.
Milnes, Richard Monckton (1809–85), Baron Houghton, 220, 221 n. 2, 222 n. 2, 229 n. 3, 549; *see* Reid,

T. W., *Life of . . . Lord Houghton* (1903), 222 n. 2.
Milton (1804–8?), 129 n. 1, 187 n. 4, 219 n. 1, 275 and n. 2, 297 n. 1, 327 and n. 3, 413, 560, 616; Pl. lviib.
Milton, John (1608–74), poet, 42, 47, 54, 56 and n. 3, 60, 69–71, 109–10, 113, 115 n. 4, 138, 195–6, 210 and n. 1, 217, 242, 297 and n. 1, 316 and n. 1, 317 and n. 1, 320, 324–5, 399, 426–7, 439, 471, 488, 536, 543, 544 and n. 1, 565 n. 3.
— *L'Allegro*, drawings, 236 n. 1, 242 n. 3.
— *Comus*, drawings, 120 n. 1, 166 and n. 1, 236 n. 1.
— *Latin and Italian Poems* (1808), 44, 109–10, 113 and n. 4, 115 n. 4, 174, 189, 233.
— 'Nativity Ode', 166 n. 1.
— *Paradise Lost*, drawings, 166 n. 1, 236 n. 1, 275.
— *Paradise Regained*, drawings, 236 n. 1, 338–9, 589, 604, 607.
— *Il Penseroso*, drawings, 236 n. 1, 242 n. 3.
— *Poetical Works* (1794–7), 56 and n. 3.
Miner, P., *Bulletin of the New York Public Library* (1958), 6 n. 2, 23 n. 2.
Minerva, 121, 198.
Miniature, 78–80, 88, 100 n. 2, 113, 124, 126, 166, 443, 453, 461, 525 and n. 2, 571, 577 n. 2; Pl. xiv.
Minutes of a General Conference of the New [Jerusalem] Church (1789), 35 n. 1, 37 n. 2.
'Mirth' (1816?, 1820?), 617.
Mitford, William, J.P. at 1803 trial, 131.
Mohammedan, 314, 541.
Moloch, Muley, 324 and n. 3.
Money, 275, 276 and n. 1, 339, 342, 345, 361–3, 372, 403–4, 406–7 and n. 2, 408 and n. 1, 409, 460, 481, 485, 499–500, 503, 508, 509 n. 1, 522, 525, 558, 569–608.
Money, Mr. (fl. 1830), 400 and n. 2.
Mongan, E., *see* Wolf, E., 2nd and Mongan, E., *William Blake 1757–1827* (1939).
Monger, Thomas (fl. 1782), witness at Blake's marriage, 23 and n. 2.
Montagu, Basil (1770–1851), writer, 320, 590 n. 7.

Montgomery, James (1771–1854), poet, 194 and nn. 2 and 3, 286 and n. 1.

— *Chimney-Sweeper's Friend* (1824, 1825), 284 and n. 3, 285, 286 n. 1, 496.

Monthly Literary Advertiser (1808), 191 and n. 2.

— (1818), 254 n. 3.

Monthly Magazine (1797), 615.

— (1801), 569 n. 1.

— (1807), 182 and n. 2.

— (1808), 190 and n. 2, 210 and n. 2, 213 n. 3.

— (1809), 212 and n. 2.

— (1827), 350 n. 1, 351 and n. 2, 354–5 and n. 1, 356.

— (1833), 299 n. 1, 374 n. 1.

Monthly Review (1806), 181 and n. 4.

— (1808), 209–10.

— (1830), 379–80 and n. 1.

Moody, Christopher Lake, *Monthly Review* (1806), 181 n. 4.

Moody, Jane (fl. 1805), 163 n. 3.

Moody, Mary [Boucher] (fl. 1764), wife of Robert, 6 n. 1.

Moody, Robert (fl. 1764), husband of Mary Boucher, 6 n. 1.

'Moore & Co' advertisement (1797?), 615 and n. 1.

Moore, Col. (fl. 1828), friend of Linnell, 365 and n 1.

Moore, Harriet Jane (b. 1801), 182 and n. 1.

Moore, John (1730–1805), Archbishop of Canterbury, 76 n. 1.

Moore, Sir John (1761–1809), lieutenant-general, 182 n. 1.

Moorman, M., *N & Q* (1957), 430 n. 1.

Mora, José Joaquin de, *Meditaciones Poeticas* (1826), 333–4 and n. 1, 335, 616 n. 1; Pl. xlvi.

Morgan Library (Pierpont), 27 n. 2, 28 n. 1, 130 n. 2, 138 n. 1, 156 n. 1, 167 nn. 1 and 2, 337 n. 3, 396 n. 1.

Morison, S., *John Bell, 1745–1831* (1930), 613 n. 2.

Morland, George (1763–1804), painter, 274, 377, 612.

'Morning Amusement' (1782), 610.

Morning Chronicle (1780), 17.

— (1785), 30 and n. 4.

— (1792), 530 n. 2.

Moser, George Michael (1704–83), painter, 15, 17 and n. 2, 423 and n. 3.

Moses, 2, 290, 296, 298, 299 n. 1, 310 n. 2, 332, 473, 488, 497, 529.

'Moses Striking the Rock' (1805), 572.

Moses, Henry (1782?–1870), engraver, 300.

Moss, Mr. W. E., collection, 176 n. 1.

Mowbray (fl. 1815), Wedgwood agent, 240 and n. 1.

Mozart, Wolfgang Amadeus (1756–91), composer, 273.

Mozley, G., *Blakes of Rotherhithe* (1935), 551 n. 1.

Muley, Ishmael (1646–1727), emperor of Morocco, 324 and n. 3.

Mulready, William (1786–1863), painter, 267 n. 2, 555; *see* Stephens, F. G., *Memorials of William Mulready* (1867), 277 n. 3.

Munby, A. N. L., *Connoisseur* (1946), 83 n. 1.

Munday, Robert (fl. 1782), parish clerk, 23.

Munro, Alexander (1825–71), sculptor, 274 n. 1.

Murray, John (1778–1843), bookseller, 46 n. 2, 171 n. 3, 393 n. 1, 611–12.

Musaeus, 'Hero & Leander', 173 and n. 3.

Muses, C. A., *Illumination on Jacob Boehme* (1951), 313 n. 1.

Music, 26, 305, 383, 457, 482, 502, 521 and n. 3, 528, 547.

Muss, Charles (1779–1824), painter, 587, 601, 604 and n. 1.

Muster Master General, 120 n. 1; *see* Butts, Thomas *and* Commissary General of Masters.

Muswell Hill, 234.

'My Pretty Rose Tree', *Songs of Experience* (1794), 252 n. 1, 469.

Mysticism, 41 n. 4, 251, 297 and n. 2, 309, 319 n. 1, 332, 334, 387, 390, 424, 432, 448, 454, 480, 484, 489, 503, 507, 513, 537.

Nangle, B. C., *Monthly Review Second Series 1790–1815* (1955), 181 n. 4.

Napoleon, 42, 124, 132, 146, 236, 352, 477.

Napper, John, J.P. at trials, 131, 140.

National Buildings Record, Pl. lv.
National Gallery, London, 314, 400 n. 2.
National Gallery of Victoria, Melbourne,
Australia, Pl. xliii.
National Library of Scotland, 478 n. 6.
National Portrait Gallery, London, 183,
278 n. 3, 279; Pl. xlii.
Nativity, 296–7 and n. 2.
Naylor, *see* Hare-Naylor.
Neale (fl. 1825), 300.
'Nebuchadnezzar' (1805), 573.
Nebuchadnezzar, visionary head, 370.
'Nebuchadnezzar, Coin of', 370 n. 1.
Negroes, 45.
Nelson, *see* 'The Spiritual Form of
Nelson Guiding Leviathan' (1809).
Neptune, 62–63, 74–75 and n. 2, 77,
462, 488, 562 n. 1.
New Annual Directory (1800–13), 552.
New Bath Guide (1766 ff.), 187 and n. 1.
New Church College, Woodford Green,
Essex, 35 n. 2, 440 n. 6.
New Complete Guide (1772), 564 n. 2.
— (1783), 552.
New-England Weekly Review (1830),
398 and n. 3.
New Jerusalem Church, 34–35 and nn.
1 and 2, 36 and n. 1, 37 and nn. 1 and
2, 38 and nn. 1 and 2, 440 n. 6, 519
n. 2.
New Monthly Magazine (1827), 350
n. 1, 359 and n. 3.
— (1830), 401–2 and n. 3.
New Statesman, 267 n. 2.
New York Mirror (1831), 410.
New York Public Library, 91 n. 2.
New Zealand, *see* Turnbull Library,
Wellington, New Zealand.
Newberry, Francis (1743–1818), book-
seller, 617.
Newgate Prison, 18.
Newland, Charles, juror, 1804, 140.
Newman (fl. 1825), paintseller, 584.
Newport Pagnell, 108.
Newton, Francis Milner (1720–94),
painter, 16.
Newton, Isaac (1642–1727), scientist,
106 n. 2, 255, 313, 494 n. 10, 541.
'Newton' (1805), 573.
Nichols, John (1745–1826), printer,
613.
Nicholson, William (1753–1815),
scientist, 188, 212 and n. 1.

— *British Encyclopedia* (1809), 282 n. 2.
'Night', *Songs of Innocence* (1789),
224 n. 3, 252.
Nightingale, Florence, 367 n. 4.
Nineveh, 311 and n. 1, 540.
Noah, 439, 452.
'Noah & Rainbow' (1805), 572.
Noble, R. (fl. 1797), printer, 375.
Noble, Samuel (1779–1853), minister,
38 n. 2.
Nollekens, Joseph (1737–1823), sculp-
tor, 53, 169, 193, 201, 247, 278 n. 3,
348, 410; *see* Smith, J. T., *Nollekens
and his Times* (1828).
Northcote, James (1746–1831), painter,
169 and nn. 1 and 2, 193 n. 1, 242,
557.
Norton, Mrs., of *Humphry Clinker*, 554.
Norton, C. E., *Letters* (1913), 221 n. 4.
Norwood, Surrey, 234.
Notebook (1793?–1818?), 47 n. 3, 106
n. 1, 119 n. 3, 121 n. 2, 171 n. 5,
215 n. 3, 216 n. 1, 219 n. 1, 232, 234
n. 1, 236 n. 2, 281 n. 1, 561 n. 1.
Nott, J., tr., *Poems of . . . Catullus*
(1795), 614.
Novalis [Friedrich Leopold, Freiherr
von Hardenberg] (1772–1801), poet,
383.
Novelist's Magazine (1782–93), 344 n. 1,
356, 466, 610–11.
Nudity, 54 and n. 1, 194, 206, 257 n. 1,
487.
Nurmi, M. K., *see* Bentley, G. E., Jr.
and M. K. Nurmi, *Blake Bibliography*
(1964), 609 n. 1.
'Nurse's Song', *Songs of Experience*
(1794), 252, 469.
'Nurse's Song', *Songs of Innocence*
(1789), 252.

'Oberon and Titania', 363.
Ogilvy, J. S., *Relics & Memorials of
London Town* (1911), 556 n. 1.
Ogle, George (1704–46), translator,
230.
Ogleby (fl. 1780), friend of Stothard,
19 and n. 3, 20.
Old Water-Colour Society, 264 n. 5.
— exhibition (1812), 230, 231 n. 2.
Oliver [J.], *Fencing Familiarized*
(1780), 609.
'Olney Bridge' (1801?), 88.

Olney, Bucks, *see* Cowper Museum, Olney, Bucks.

Ololon, Pl. lviii*b*.

'On Another's Sorrow', *Songs of Innocence* (1789), 252.

'On Homer's Poetry [*and*] On Virgil' (1820?), 618.

Opie, Amelia (1769–1853), novelist, wife of John, 596, 602 n. 3.

Opie, John (1761–1807), painter, 57, 169 and n. 2, 193 n. 1, 348, 375, 615.

Oram, Edward (fl. 1770–1800), painter, 26.

Orc, 470–1; *see* 'The Chaining of Orc' (1812), 617.

Osborn, Mr. James Marshall, collection, 68 n. 2, 69 n. 1, 159 n. 2, 376 n. 2, 556 n. 3.

Ossian, *see* Macpherson, 546.

Ottley, William Young (1771–1836), art amateur, 341 and n. 3, 344 and nn. 4 and 8, 347, 383 n. 1, 594, 607.

Ottly, *see* Ottley, W. Y.

Otway, Thomas (1652–85), dramatist, 69.

Oulton, W. C., 34 n. 1.

Outhoun, an otherwise unknown work by Blake, 363 n. 2.

Ovid, 428, 527, 565 n. 3.

Owen, William [later William Owen Pugh] (1759–1835), Druidist, 226, 399 and n. 1, 400, 438, 451.

Owen, William (1769–1825), painter, 169 n. 2, 193 and n. 1, 201, 247, 348.

Oxford, 111 n. 3.

Oxford St., 229 and n. 2.

Oxford University, 328, 353.

P., *Gentleman's Magazine* (1812), 623, and n. 3.

Paine, Thomas (1737–1809), revolutionary, 40–41 and n. 1, 46 and n. 3, 70 n. 2, 146, 318 n. 2, 530 and n. 2; *see* Aldridge, A. O., *Man of Reason* (1959), 530 n. 2, *and* Cheetham, J., *Life of Thomas Paine* (1817), 530 n. 2.

Palmer, bookseller, Bond St., 601.

Palmer [? Samuel, Sr.]; father of Samuel, 302–3, 369.

Palmer & Son, 342, 347, 584, 595; *see* Palmer, Benjamin.

Palmer, A. H., son of Samuel, 256 nn. 1 and 2, 264 n. 5, 265 n. 1, 267 n. 1, 274 n. 2, 280 n. 4, 291 nn. 1 and 3, 292 nn. 1 and 2, 306 nn. 1 and 2, 321 n. 3, 327 n. 2, 329 n. 1, 335 nn. 1 and 2, 336 n. 1, 344 nn. 3 and 5, 345 nn. 4 and 5, 346 n. 1, 351 n. 1, 367 n. 2, 406 n. 2, 409 nn. 1–3, 415 n. 3, 584, 585 n. 8.

— *Catalogue of . . . Samuel Palmer* (1926), 272 n. 1, 280 n. 4, 292 n. 4, 300 n. 1, 372 n. 1, 582 n. 2.

— *Life . . . of Samuel Palmer* (1892), 53 n. 1, 256 n. 2, 272 n. 1, 290 n. 3, 291 n. 3, 292 and nn. 1 and 2, 294 n. 2, 299 n. 2, 302 n. 1, 312 n. 1, 319 n. 1, 321 n. 5.

Palmer, Benjamin, Mary Anne Linnell's uncle, undertaker, 342, 343 n. 1; *see also* Palmer & Son.

Palmer, J. (fl. 1836), 597, 601.

Palmer, Robert, juror at 1803 trial, 134 n. 1.

Palmer, Samuel (1805–81), painter, 3 n. 1, 13–14, 39 n. 4, 41 and n. 1, 42 and n. 1, 54, 216 n. 3, 233 n. 5, 267 n. 3, 271–2 and n. 1, 275–6, 280 and nn. 1 and 4, 281–2 and n. 3, 290 and nn. 1 and 3, 291 and nn. 1–3, 292 and nn. 2 and 4, 293–4, 299 and n. 3, 300–2 and n. 2, 303, 306 n. 6, 309, 312 nn. 1 and 2, 314–15 and n. 1, 316 n. 1, 319 and n. 1, 321 n. 5, 330 and n. 2, 346–7, 355, 356 n. 1, 363, 369, 372 and n. 1, 409 n. 3, 458 n. 1, 495 n. 5, 565 nn. 1, 3, 4, 566 and n. 4; *see* Hardie, M., *Samuel Palmer* (1928), 291 n. 1, Palmer, A. H., *Catalogue of . . . Samuel Palmer* (1926), and Palmer, A. H., *Life . . . of Samuel Palmer* (1892).

Palmer, Thomas, Linnell's father-in-law, 8 n. 2, 306 and n. 1, 584, 588 and n. 3, 589.

Palmer, Thomas (fl. 1795), 49.

Palmer, William (fl. 1795), 49.

Palmer, William (fl. 1833), brother of Samuel, 414–15.

Pan, 222.

Paris, Helen's abductor, 68.

Paris, France, 110 and n. 1.

Paris, A. A. (fl. 1820), printseller, 618.

Parke-Bernet auction (1961 Nov. 29), 398 n. 2.

Parker, bookseller of Oxford, 328 and
n. 2, 353, 591, 599.
Parker, James (1750–1805), engraver,
12, 14, 19 n. 3, 29 and n. 3, 30,
116 n. 1, 138, 155 and n. 2, 189,
422 n. 2, 457 and n. 2, 482 and n. 3,
553, 557 and n. 3, 558 and n. 1, 611,
619, 621–2, 623 n. 2; Pl. ii.
Parker, Mrs. James, 29 n. 7, 30, 558.
Parkes; mistake for James Parker?,
19 n. 3, 621.
Parnell, Thomas (1679–1718), poet,
314 and n. 1, 541.
— *Poetical Works* (1796?), 314 n. 1.
'Parr (Old) When Young' (1820), 265.
Parrish, Prof. Stephen M., 430 n. 1.
Parrs [?Henry Pars (1734–1806),
draughtsman], 55.
Pars, William (1742–82), painter, 44,
613.
Pars's (Henry) drawing school, 422,
448, 510 and n. 3.
Partington, W., *TLS* (1939), 374 n. 2,
467 n. 2, 468 n. 3.
Passavant, M., *Tour of a German Artist
in England* (1836), 310 n. 1.
Patriotische Annalen; mistake for *Vater-
ländische Museum*, 537.
Paul, Apostle, 53.
Paulina, *see* Poole, Harriet.
Payne, J. H., *Thérèse*, 272.
Payne, Thomas (1719–99), bookseller,
609, 615.
Payne, Thomas [Jr.] (1752–1831),
bookseller, 171, 616–17.
Peachey, John, J.P. at trials, 131, 140.
Peckham Rye, 7.
Pegasus, 302.
Pellet, John, great-great-grandfather of
Cowper, 86.
'The Penance of Jane Shore', 423 n. 2.
Pencil Drawings (1927), 259 n. 3.
Pennsylvania Historical Society, *see*
Historical Society of Pennsylvania.
Peoper (? fl. 1826), 590 n. 6.
Pepper (fl. 1820), 265.
Percy Chapel, Charlotte St., *see* Mathew,
A. S., 26.
Percy, Earl, 553.
Percy, Sir Henry (1364–1403), 'Hot-
spur', 624.
Pericles, 64, 67.
Perry (fl. 1796), engraver, 614; Pl. viii.

Persian, 451, 493.
Perthes, Friedrich Christoff (fl. 1810),
editor, 223, 225, 229, 537.
Peters, Lord (fl. 1780), 18.
Petworth, Sussex, 131, 136, 363 n. 1;
see also Egremont, third Earl of.
Pewter engraving, 119 n. 3, 232.
Pforzheimer (Carl H.) Library, N.Y.,
114 n. 2.
Phidias (*c.* 500–432 B.C.), painter and
sculptor, 221.
Philippa (1314?–69), Queen, 422, 466,
511.
Philips, Ambrose (1675?–1749), poet,
271.
Philips, Sarah, *see* Blake, Sarah [Philips].
Phillips, George (fl. 1783), Basire ap-
prentice, 12.
Phillips, Sir Richard (1767–1840),
bookseller, 92 n. 2, 156 and n. 4,
157–8 and n. 1, 159 and n. 1, 160–1
and n. 1, 173 n. 1, 186 n. 1, 209, 212
and n. 3, 562 n. 6, 615–17.
Phillips, Thomas (1770–1845), painter,
168 n. 1, 182–3, 193, 195 and n. 1,
200 n. 1, 208 and n. 1, 210, 226, 242–
3, 247, 248 and n. 1, 278, 289, 348,
357, 362 n. 2, 378, 449, 468, 601,
617; Pl. xxiv.
'Pickering MS', 41 n. 4, 322 n. 3.
Piercey, Richard, juror, 1804, 140.
Pierpont Morgan Library, *see* Morgan
Library.
Pimlico, 416.
Pindar (*c.* 522–443 B.C.), poet, 428, 488.
Pindar, visionary head, 497.
Pitt, *see* 'The spiritual form of Pitt' (1809).
'Pitts, Edmund' (1790?), 612.
Plato, 42 n. 1, 304, 310–12, 324, 363,
539–40, 541 n. 1.
Pliny the Elder (*c.* A.D. 23–79) or
Younger (*c.* A.D. 61–113), author,
138, 147, 153.
Pocock, Sir George (1765–1840), 594,
600.
Pocock, Isaac (1782–1835), sculptor,
555.
Poetical Magazine, 466 and n. 2.
Poetical Register for 1802 (1803),
109 n. 2.
— *for 1805* (1807), 177 n. 3.
Poetical Sketches (1783), 12, 20, 25,
26 and n. 2, 27–28, 34 and n. 2, 188,

191 n. 1, 224 n. 3, 226 n. 3, 242, 245, 428–9 and n. 1, 430 and n. 1, 431 n. 2, 442, 453, 456–7 and n. 2, 478 and nn. 3, 6, 7, 479–80 and n. 6, 481 n. 3, 482 n. 4, 505 and n. 3, 506 and n. 7, 513 and n. 2, 514 and n. 11, 538, 569 n. 5, 596 and n. 6.

'A Poison Tree', *Songs of Experience* (1794), 224 n. 3, 253, 382 and n. 1, 469.

Poland St., No. 28, 30, 457 n. 2, 482 and n. 3, 487, 520, 557 n. 3, 558–60 and n. 1, 561; Pl. lvi.

Polidore, 315.

Ponsford, I. (*c.* 1790–1870), painter, 618.

Poole, Harriet (d. 1827), the Lady of Lavant, 79 and n. 2, 85–87, 89–90, 94, 103 and n. 2, 118, 145, 148, 150 and n. 1, 173 n. 2.

Poole, I. (fl. 1825), bookseller, 618.

Poole, William (fl. 1792), Basire apprentice, 12.

Pope, the, 42, 104.

Pope, Alexander (1688–1744), poet, 69, 434 n. 2.

Portarlington, Countess of (d. 1813), 119, 120 n. 1.

Porter, Jane, *Scottish Chiefs* (1810–41), 261 and n. 2, 262–3 and nn. 1 and 2.

Portland Vase, 43.

Post (fl. 1824), 604 n. 3.

Potter, Paul (1625–54), painter, 24 n. 3.

Povey, Mr. Kenneth, collection, 151 n. 3.

— *N & Q* (1926), 69 n. 2.

Poynder, John (1779–1849), collection, 400 n. 2.

Poyntz, William Stephen (1770–1840), M.P., J.P. at Blake's trials, 100 n. 1, 131, 140, 173 n. 2.

Poyntz, Mrs. William Stephen, 100.

Praed (fl. 1814), banker and friend of Cumberland, 232 and n. 5.

Prag, Mr. A., 512 n. 3.

Pratt, George, juror at 1803 trial, 134 n. 1.

Press, rolling copperplate, 29 and n. 3, 114, 272 n. 1, 350 and n. 2, 351, 482, 594 n. 6.

Preston, Mr. Kerrison, collection, 77 n. 1, 231 n. 2, 570 n. 4, 574 n. 4.

Priam, 439.

Price, Richard (1723–91), radical minister, 40.

Price, T. (fl. 1804), friend of Cumberland, 55 n. 3.

Priestley, Joseph (1733–1804), radical minister, 40, 41 n. 1.

Primrose Hill, 314, 541.

Princeton University Library, 78 n. 3, 81 n. 3, 82 nn. 1 and 2, 89 n. 2, 113 n. 4, 118 n. 3.

Print collection, the poet's, 276, 421–2.

Printing, 77, 97, 117, 150, 151 n. 1, 213, 322, 341 and n. 1, 365, 367, 376 n. 2, 459–60, 461 n. 1, 522, 547, 579 and n. 5, 590, 606.

Printselling, 29 and n. 3, 30, 374, 422, 457 and n. 2, 482 and n. 3, 511 n. 1, 582 n. 6, 609–19.

Proctor, George (fl. 1826), friend of HCR, 320, 590 n. 7.

'Prologue to King John', *Poetical Sketches* (1783), 34, 480 n. 6.

'Prospectus' (1793), 423 n. 2.

Prosser (fl. 1826), bookseller, 590, 599.

Protestants Family Bible (1781?), 609.

Protogenes (fourth century B.C.), painter, 495.

Proud, Joseph (1745–1826), Swedenborgian minister, 432, 440 and n. 6, 452.

Prowett, Septimus (fl. 1824–8), bookseller, 283–4, 286–7, 300.

Psyche, 284.

'Public Address', 230 n. 1.

Public Record Office, London, 9 n. 3, 144 n. 1, 228 n. 2, 340, 509 n. 1, 552 n. 3.

Puget & Banbridge, bankers?, 336.

Pugh, William Owen, *see* Owen, William, 399–400.

Pye [?John (1782–1874), engraver], 365.

Pye, J., *Patronage of British Art* (1845), 275 n. 2.

Pyramids, *see* 'The Man Who Built the Pyramids' (1819).

Pythagoras (sixth century B.C.), philosopher, 428.

'Q, Mrs.' (1820, 1906), 618.

Quantock, John (1740–1820), J.P. at Blake's trials, 124 and n. 1, 125, 128–9 and n. 1, 130, 140.

Quarterly Review (1826), 326 n. 2.
Queen, *see* 'To the Queen' (1807).
'Queen Catherine's Dream', 339, 400.
Queen St., *see* Great Queen St.

Raimbach, Abraham (1776–1843), engraver, 189–90.
— *Memoirs* (1843), 59 n. 2, 66 n. 2, 190 n. 1.
Rance, Miss V. W., 'Blake's Reputation from 1806 to 1863' (1965), 621 n. 1.
Randolph, Dr. (fl. 1802), 98, 102.
Raphael Sanzio (1483–1520), painter, 17, 182, 185, 200, 209, 211, 216–18, 244, 285, 287, 297, 311, 315, 422, 433–6, 439, 448–50, 470, 477, 492, 510, 516, 538, 540, 609.
Read (fl. 1821–5), friend of Linnell, 274, 300.
Read, David Charles (1790–1851), painter and engraver, 274 n. 2.
Redgrave, R. and S., *A Century of Painters of the English School* (1866), 214 n. 3.
Reed, Isaac (1742–1807), editor, 188 and n. 2.
Reed, Prof. Mark, 620, 622 n. 3.
Rees, *see* Longman.
Rees, A., *Cyclopaedia* (1802–1820), 138–9, 236 n. 1, 238, 617–18.
Rees, T., *Reminiscences* (1896), 115 n. 3.
Reid (fl. 1821), engraver, 274 n. 2.
Reid, T. W., *Life of . . . Lord Houghton* (1890), 222 n. 2.
Rembrandt, Harmens van Rijn (1606–69), painter, 216, 435–6, 492 and n. 4.
Remember Me! (1824, 1825), 295–6 and n. 2, 618.
Rennie (fl 1821), friend of Linnell, 300.
Repository of Arts, Literature, Fashions, Manufactures, &c. (1810), 284 n. 1.
— (1818), 248 n. 2.
Residences, 550–68.
'Resurrection', 339 n. 2.
Reuss, J. D., *Alphabetical Register* (1791), 34 n. 1.
Reveley, Willey (d. 1799), architect, 44.
Revett, N., *see* Stuart and Revett, *Antiquities of Athens* (1794).
Revue Britannique (1833), 40 n. 299 n. 1.

Reynolds, Sir Joshua (1723–92), painter, 16, 31, 242, 455, 463, 477, 515–16, 556–7, 617.
— *Works* (1798), Blake annotations, 17 and n. 2, 102–3 and n. 1, 185 n. 4, 290 n. 2, 345 n. 2, 526 n. 3.
Rhodes, 282.
Richard I (1157–99), Coeur-de-Lion, 259 and n. 2.
'Richard I' (1819), 259 and n. 2; Pl. xxxviia.
Richard II (1367–1400), 422, 511; Pl. l.
Richard III (1452–85), 299 n. 1.
Richardson, Samuel (1689–1761), novelist, 610–11.
Richmond, Charles Lennox (1735–1806), third Duke of, J.P. at Blake's trials, 18, 131, 140, 145 and n. 1, 147, 152.
Richmond, George (1809–96), painter, 39, 53, 278 and n. 3, 292–3 and nn. 1 and 2, 342 and nn. 1 and 2, 346–7, 372 and n. 1, 379 n. 4, 411, 476, 528, 535, 566, 597 and n. 1, 602.
Richmond, G. and W. B., *Richmond Papers* (1926), 53 n. 1, 292 n. 4, 293 n. 2, 294 nn. 2 and 3.
Richmond, Julia [Tatham], wife of George, 411, 535.
Richmond, William Blake, son of George, 293 n. 2.
Richter, Henry [Jr.], 465 n. 1.
Richter, Henry James (1772–1857), painter, 269, 292 and n. 3, 465 n. 1.
Rigaud, John Francis (1742–1810), painter, 49, 57.
Riot, *see* Gordon Riots.
'Riposo' (1803), 570.
Rippengale [?Edward Villiers Rippingillie (1798?–1859), painter], 359.
[Ritson, J.], *Select Collection of English Songs* (1783), 610.
Riviere [?Daniel Valentine (1780–1854), drawing-master], 588, 591, 598.
Rivington, Francis (1745–1822) & Charles [Jr.] (1754–1831), booksellers, 328, 355, 616.
Rivington, Francis, Charles & John (1779–1841), booksellers, 271.
Rivington and Cochran, *Catalogue* (1824), 279 and n. 3, 280 and n. 1.

Robbery of Blake, 49, 522.
Roberts, J[ames? (fl. 1775–1800)],
painter, 609.
Robertson, W. Graham, *Blake Collection* (1952), 323 n. 2, 353 n. 2.
Robertson, Will (fl. 1796), friend of
Cumberland, 51.
'Robin Hood and Clorinda' (1783), 610.
Robinson, George (1737–1801), George
[Jr.] (d. 1811), John (1753–1813),
booksellers, 614.
Robinson, Henry Crabb (1775–1867),
diarist, 39 n. 4, 223 and n. 1, 224 and
nn. 2–4, 225 and nn. 2 and 3, 226 and
n. 1, 228–9 and n. 3, 231–2, 235 and
nn. 2 and 3, 255, 261 n. 2, 284 n. 4,
286, 309–26, 331 and nn. 6 and 7,
333, 336–7 and n. 1, 338, 362–3,
367–8 and n. 1, 371, 398 n. 4, 400,
417 n. 3, 507 n. 1, 535–7, 564, 589–90
and n. 7, 591 and n. 1, 599, 607.
— 'Reminiscences', 223 and n. 1,
224 n. 4, 225 and n. 2, 232 n. 2,
317 n. 1, 332, 535–49.
— *Diary, Reminiscences, and Correspondence* (1869), 235 n. 2.
— *On Books and their Writers* (1938),
261 n. 2, 312 n. 3, 368 n. 1.
— Small Diary, 223 n. 1, 224 and n. 2,
225 and n. 2, 226, 228–9 and n. 1, 317
n. 2, 320 n. 2, 331 n. 5, 332, 337 n. 2,
338 n. 1, 578.
— *Vaterländische Museum* (1811), 270,
356 n. 5, 385 n. 1, 432–55, 478 n. 7.
Robson, James (1733–1806), bookseller, 616.
Rodd, John (fl. 1782), clerk?, 23 and n.
1.
Rodwell & Martin, booksellers, 601.
Roffe, John (fl. 1785), Basire apprentice, 12.
Rogers, Samuel (1763–1855), poet,
99?, 161, 209, 562 n. 6.
Rome and Romans, 28, 285, 298, 438,
451.
Roman Catholics, 17–18, 42, 312,
321 n. 5, 440, 452, 458 n. 1.
Romano, Giulio [Giulio Pippi] (1492–
1546), painter, 216, 314–15, 422,
435, 492, 510, 520, 565 n. 3.
Romney, George (1734–1802), painter,
27 and n. 2, 46, 51 n. 1, 65, 70 and
nn. 1 and 2, 71, 77–78 and n. 3, 79–

80, 95, 112 and nn. 1 and 4, 113, 121,
130, 138–9, 147 and n. 1, 152–4
and n. 1, 154 and nn. 1 and 2, 155, 190
n. 1, 616–17, 627; *see also* Hayley,
W., *Life of George Romney* (1809).
Romney, John (1758–1832), son of
George, 147, 153–4.
Roper (fl. 1827), secretary of the Royal
Academy, 343.
Roscoe, E. S., *Magazine of Art* (1881),
267 n. 3, 521 n. 3.
Roscoe, William (1753–1831), biographer, 46, 179, 192 n. 1, 626.
Rose, Samuel (1767–1804), barrister,
62 and n. 1, 63 and nn. 1 and 4, 64,
85, 97 and n. 1, 109, 111, 124 n. 1,
126 n. 2, 135 n. 2, 137, 139, 141–5
and n. 2, 149–51 and n. 2, 152, 155,
156 and n. 2, 164–5.
Rose, Sarah, wife of Samuel, 74, 152.
Rose Tavern, near Temple Bar, London, 423 n. 1.
Rosebery, F., *Book Collector* (1965),
431 n. 1.
Rosenwald Collection, Library of Congress, 19 n. 3, 116 n. 1, 176 n. 1,
227 n. 1, 261 n. 1, 288 nn. 3 and 4,
304 n. 3; Pls. xxxiib, xxxviii.
Rossetti, Dante Gabriel (1828–82),
painter and poet, 275 n. 1, 307 n. 2.
— *Letters . . . to William Allingham*
(1897), 162 n. 1.
— MS; see *Notebook*.
— *Papers 1862 to 1870* (1903), 34 n. 1,
220 n. 2, 221 n. 2, 222 n. 1, 471 n. 2.
Rossetti, William, Michael, brother of
D. G., 194 n. 1, 220 n. 2, 221 n. 2,
274 n. 1, 416, 471 n. 2.
— *Letters* (1934), 243 n. 2.
Rossi, John Charles Felix (1762–1839),
sculptor, 168 n. 1, 348.
Rossini, Gioachino Antonio (1792–
1868), composer, 273.
Rotherhithe, 1 and n. 2, 551 and n. 1.
Roubiliac, Louis Francois (1695–1762),
sculptor, 455.
Rough, William (d. 1838), lawyer,
229.
Rouquet, M., *Arts in England* (1755),
553 n. 1.
Rousseau, Jean-Jacques (1712–78),
philosopher, 322, 417 n. 3, 507 n. 1,
547.

Rowley, pseudonym of Chatterton, Thomas, 546.
Roxborough, fourth Duke of and seventh Baron Bellenden, 227 n. 3.
'Roxburgh Cause', 227 and n. 3.
Royal Academy (1769 ff.), 15 and n. 1, 16 and nn. 1 and 2, 17 and n. 2, 19 n. 2, 20, 31 and n. 2, 57, 66 n. 2, 121, 136, 166, 168 and n. 1, 169, 172, 178 n. 1, 182, 192–3, 195 n. 1, 200 and n. 2, 201 and n. 3, 210, 213, 215 and n. 3, 220 n. 3, 221, 238, 247–8, 266, 269, 276 and n. 3, 277 n. 1, 279, 280 and n. 5, 308 n. 1, 341, 343, 344 n. 7, 346 and n. 2, 395 and n. 2, 423 and n. 3, 433, 448, 468 and n. 4, 591 n. 7, 599, 605.
— Council Minutes, 15–16 and n. 1, 276 and n. 3.
— Exhibition (1777), 554 n. 3.
— (1780), 17, 554 and n. 3.
— (1781), 554 n. 3.
— (1782), 554 n. 3.
— (1784), 28 and n. 2, 557.
— (1785), 30 and n. 4, 558.
— (1799), 59 and n. 4, 560.
— (1800), 66 and n. 2.
— (1807), 183, 553.
— (1808), 189 and n. 3, 553, 562 n. 6, 576 n. 1.
— (1811), 553.
— (1812), 553.
— (1816), 553.
— (1817), 553.
— (1821), 272, 553.
— (1823), 278, 280.
— (1824), 280 and nn. 2–4, 281, 288.
— (1825), 301, 553.
— (1828), 467.
— Library, 576 n. 1.
Royal College of St. Peter's at Westminster; *see* Westminster School, 512 and nn. 2 and 3.
Royal Hibernian Society, 214 n. 3.
Royal Masonic Institution for Girls, 556 n. 2.
Royal Society, 58.
Royal Society of Antiquaries, 423 n. 1, 456, 511.
— Minute Book, 423 n. 1.
Royal Universal Family Bible (1780–2), 609–10.
Rubens, Peter Paul (1577–1640), painter, 17, 216, 218, 435–6, 450, 492 and n. 4, 493, 495, 516, 538, 609, 611.
Ruchotte, painter, 614.
Ruddicombe, Dr Tobias; pseudonym for Blake, 265 and n. 5.
Rules, Orders, and Regulations of the Society of Engravers (1804), 344 n. 7.
Ruskin, John (1819–1900), author, 162 n. 1.
Russell, apothecary, of 28 Broad St., 508.
Russell, A. G. B., *Catalogue of Loan Exhibition of Works by William Blake*, National Gallery (1913), 400 n. 2.
'Ruth & her Mother-in-Law & Sister' (1803), 570–1.
Rutt, John Towill (1760–1841), politician, and Rachel his wife, 367.
Ruysdael, Jacob van (*c.* 1628–82), painter, 24 n. 3, 290.
Ryder, Thomas (1746–1810), Basire apprentice, 12.
Rylance, Longman's proofreader, 579.
Ryland, William Wynne (1732–83), engraver and forger, 511 n. 1.
Ryley, Charles Reuben (1752?–98), painter, 613.
Ryskamp, Prof. Charles, 114 n. 2.

Sadleir, Richard Vernon (fl. 1805), friend of Hayley, 163 n. 3, 173 n. 2.
St. George's, Hanover Sq., 2 n. 1.
St. George's Chapel, 2.
St. James's, Picadilly, 1 n. 2, 2 and n. 3, 3 and n. 2, 5, 7, 553–4.
St. James's Chronicle (1791), 612 n. 2.
St. Jerome, 176.
St. Martin's-in-the-Fields, 26.
St. Mary's, Battersea, 5, 6 and n. 1, 21, 22 n. 1, 23 and n. 3.
St. Marylebone Public Library, 564 n. 1, 568 n. 1.
St. Peter's, Rome, 283.
'St Paul Preaching' (1803), 571.
St. Paul's Cathedral, 253, 254 and n. 1, 374 n. 3, 444, 454.
— Peculiar Court of the Dean and Chapter, 374 n. 3.
St. Theresa (1515–82), nun, 41, 321 n. 5.
Sakontola, 385.

Salzmann, C. G., *Elements of Morality* (1791–9), 38–39 and n. 1, 612.
— *Gymnastics for Youth* (1800), 615.
'Samson', *Poetical Sketches* (1783), 480 n. 6.
'Samson Breaking Bonds' (1805), 572.
'Samson Subdued' (1805), 572.
Sandby Paul (1725–1809), painter, 560 n. 1.
Sappho (seventh–sixth centuries B.C.), poet, 69.
Sargeaunt, J., *Annals of Westminster School* (1898), 512 n. 2.
Sargent, John [? d. 1831], J.P. at 1803 trial, 131.
Sartain, John (1808–97), 260–1.
— *Reminiscences* (1899), 260 n. 3, 465 n. 1.
Satan, 46–47, 313–14, 321, 418, 438, 467, 498–9, 541, 543, 545, 616 n. 1; Pl. xliv; *see also* Devil.
'Satan' (1790?), 612.
'Satan calling up his Legions' (1809?), 179 n. 1, 363 n. 1, 441 n. 2.
'Saul, King' (1819?), 260, 352.
Saunders, William (fl. 1804), picture dealer, 139 and n. 2, 147, 153–4.
Savile, Sir George (1726–84), politician, 18.
Savonarola, Girolamo (1452–98), reformer, 42 n. 1.
Schiavonetti, Louis (1765–1810), engraver, 167–8 and n. 1, 169, 171, 172 and n. 1, 174, 182 and n. 1, 184–5, 190–1 and n. 2, 192–5, 197, 201, 208 and n. 2, 209 n. 1, 210 and n. 2, 213, 216, 220, 222, 226–7 and n. 1, 243, 245, 247, 270, 286, 289, 334, 357, 434, 449, 464 and n. 1, 465, 491, 538, 616 n. 1, 617, 625; *see* Blair engravings.
Schiavonetti, Nicholas (1771–1813), brother of Louis, 227 n. 1.
Schiller, Johann Christoph Friedrich von (1759–1805), author, 392.
Schofield, *see* Scolfield, 129 n. 1.
Scholfield, J., *see* Scolfield, John.
'The School Boy', *Songs* (1789–94), 252, 469 n. 1.
Schorer, M., *William Blake* (1946), 523 n. 1.
Schrovenetti, *see* Schiavonetti, Louis.
Scofeld, *see* Scolfield, 129 n. 1.

Scolfield, John (d. 1812), soldier, 122–3 and n. 1, 124 and n. 1, 125 and n. 1, 126 and n. 2, 127–9 and n. 1, 131 and n. 2, 134 and n. 1, 138, 141–4, 145 n. 1, 146, 148, 164–5, 463 n. 1.
Scotland, National Library, *see* National Library of Scotland, 478 n. 6.
Scott, David (1806–49), painter, 194 n. 1; *see* Scott, W. B., *Memoirs of David Scott* (1850).
Scott, John, *Poetical Works* (1782, 1786), 610.
Scott, John (1783–1821), editor, 265 n.4.
Scott, John (fl. 1783), 12.
Scott, Robert (1777–1841), engraver, 193, 194 n. 1.
Scott, Sir Walter (1771–1832), poet, 199, 229 n. 3, 231, 536.
Scott, William Bell (1811–90), poet and painter, 193, 194 n. 1.
—*Autobiographical Notes* (1892), 194 n.1.
— *Memoirs of David Scott* (1850), 194 n. 1.
Seagrave, Joseph (d. 1808), printer, 94, 97, 99, 117 and n. 1, 128, 134, 135 n. 1, 150 and n. 1, 151, 157–9 and n. 1, 160–2, 173 n. 2, 615.
Seally, J., and Lyons, I., *Geographical Dictionary* (1784, 1787), 610.
'The Seasons' (1827), Cumberland's message card, q.v., 365.
Sedition, *see* Trial.
Seguier, William (1771–1843), painter, 222 and n. 3, 524 n. 1.
Select Collection of English Songs (1783), *see* its editor, Ritson, J., 610.
Semiramis (*c.* 800 B.C.), Assyrian princess, 298, 299 n. 1.
Sepulchral Monuments (1786, 1796), *see* Gough, Richard.
Seth, mistake for Pitt, 492 n. 2.
Severn, Mrs. Arthur, daughter-in-law of Joseph, 294 n. 3.
Seward, Anna (1747–1809), author, 114, 626–7.
Shackleton, John (d. 1767), painter, 612.
'Shadrach and his Companions Coming from the Fiery Furnace', 468 n. 3.
Shakespeare, William (1564–1616), dramatist, 56 and n. 3, 69, 195–6, 217, 322 and n. 1, 324, 367 n. 3, 383, 400, 417 n. 3, 428, 432, 439, 448, 489 n. 1, 507 n. 1, 529, 547.

Shakespeare, William, *Comedies, Histories, and Tragedies* (1632), 166 and n. 1.
— *Dramatic Works* (1803, 1832), 56 and n. 3, 615.
— *Plays* (1804–12), 139 and n. 4, 606, 616.
— *see* 'Lear and Cordelia', 367.
Sharp, William (1749–1824), engraver, 13 n. 1, 44, 46 and n. 3, 47, 58, 151, 155, 235 and n. 2, 332, 362, 530 n. 2.
Sharpe, Sutton (fl. 1826), friend of HCR, 331 and n. 5.
Sharpe, William, *see* Sharp, William.
Shee, Martin Archer (1769–1850), painter, 169, 193, 201, 247, 348.
Shelburne, Lord [Sir William Petty (1737–1805)], 18.
Shelley, Percy Bysshe (1792–1822), poet, 272, 388 n. 1.
Shelley, Samuel (1750–1808), miniaturist, 17 n. 3, 55 n. 3.
'The Shepherd', *Songs of Innocence* (1789), 252.
Sheridan, Richard Brinsley (1751–1816), dramatist, 55, 272.
Sherrif (fl. 1821), actor, 273.
Shields, Frederick J., artist, 565 n. 1.
Shipley, Catherine Louisa, daughter of William Davies, 224 and n. 4, 443 n. 1.
Shirley (fl. 1825), 182 n. 1.
Shoberl, F., *see* Watkins, J., and Shoberl, F., *Biographical Dictionary* (1816).
Shore, Jane, *see* 'The Penance of Jane Shore', 423 n. 2.
Shoreham, Kent, 302–3, 369, 372.
Short, Augustus (1802–83), bishop of Adelaide, 512 n. 2.
'Shorto, H. H.' (fl. 1827), 337 n. 4.
Shorts, H. S. C. (fl. 1827), 337 and n. 4.
Shroyer, Mr. Richard, 576 n. 1, 620.
Shute, Revd. R. A., 1 n. 2.
Sibly, Manoah (1757–1840), Swedenborgian, 38 n. 2.
'The Sick Rose', *Songs of Experience* (1794), 224 n. 3, 253, 469 n. 1.
Sievwright, *see* Sivewright.
Simpkins (fl. 1796), engraver, 51.
Sister Nativity, 326 and n. 2.
Sistine Chapel, 517.
Sivewright [? John (fl. 1805–15), engraver, musician, inventor], 214 and n. 2.
Skelton, William (1763–1848), Basire apprentice, 13 n. 1, 48.
Skofeld, 129 n. 1, *see* Scolfield.
Skofield, 129 n. 1, *see* Scolfield.
Skretkowicz, Mr. Victor, Jr., 621.
'A Small Book of Designs', 468 n. 5, 472 n. 2.
Smirke, Robert (1752–1845), painter, 50.
Smirke, Robert [Jr.] (1781–1867), architect, 276.
Smith, Francis (fl. 1737), draper, 1.
Smith, John Raphael (1752–1812), painter, printseller and engraver, 612.
Smith, John Thomas (1766–1833), biographer, 177 n. 1, 370–1.
— *A Book for a Rainy Day* (1845), 26–27 and n. 1, 457 n. 2.
— *Nollekens and his Times* (1828), 24 n. 1, 25 n. 2, 29 n. 5, 30 n. 2, 32 n. 1, 33 n. 3, 38 n. 3, 52 and n. 1, 54, 326 n. 1, 341 n. 4, 354 n. 1, 370 and n. 4, 371–2, 374, 375 n. 1, 380, 440 n. 5, 455–76, 477 n. 4, 478 nn. 5 and 6, 481 n. 4, 486 n. 1, 487 n. 1, 490 nn. 1 and 3, 491 nn. 1 and 3, 498 n. 4, 500 n. 2, 501 n. 1, 502 n. 1, 503 and n. 1, 504, 513 n. 2, 517 n. 1, 521 n. 2, 528 n. 3, 531 n. 1, 561 n. 3, 607 nn. 1 and 3, 625–6 and n. 1.
— (1920), 564 n. 2.
Smith, Julia (fl. 1828), 367, 607.
Smith, R. C. (fl. 1833), 374 n. 1.
Smith, Mrs. Samuel (fl. 1828), 367, 607.
Smith, Thomas, juror, 1804, 140.
Smollett, T., *Humphry Clinker*, 554.
Sneyd (fl. 1820), Blake acquaintance, 265.
Snowdon, Wales, 285.
Soane, Sir John (1753–1837), architect, 168 n. 1, 336?, 348, 413 and n. 1.
— *Portrait* (1927), 413 n. 1.
— *Museum*, 413 n. 1.
Society for the Encouragement of Arts, Manufactures, and Commerce, 238–9 and n. 1.
Society of Antiquaries, 13, 58.
Society of Artists in Water Colours, 467.
Society of Engravers, *see* Rules, Orders, and Regulations of the Society of Engravers (1804), 344 n. 7.

Society of Painters in Oil and Water-Colours, *see* Old Water-Colour Society, 230, 264 n. 5.

Sockett (fl. 1804), friend of Hayley, 114.

Socrates (*c.* 470–399 B.C.), philosopher, 309, 310 and n. 2, 539.

Solomon, 196, 263, 321, 325, 545.

Somerset House, London, 8 n. 2, 28 n. 4, 38 n. 2, 47 n. 4, 238, 272, 278, 340 n. 4, 341, 347 n. 2, 411 n. 2, 467, 573 n. 5.

The Song of Los (1795), 211 n. 2, 243 n. 2, 561, 614.

Songs of Experience (1794), 224 nn. 1 and 3, 244, 245 n. 1, 252 n. 1, 253, 259 n. 1, 292 n. 2, 356, 380 n. 3, 381 and n. 1, 382 and n. 1, 385 and n. 1, 429–30 and n. 1, 431 and n. 1, 444–6, 454, 468 n. 5, 469 and n. 1, 470 and n. 2, 479 and n. 1, 482 n. 4, 483, 484 n. 9, 531 and n. 4, 532, 537, 561, 573 and n. 4, 607, 613.

Songs of Innocence (1789), 39 n. 4, 40, 120 n. 1, 165 n. 3, 177, 213 n. 2, 224 n. 3, 229, 243 and n. 1, 245 n. 1, 253, 284 and n. 3, 292 and n. 2, 333, 339, 355, 356 nn. 1 and 5, 368 and n. 3, 369 n. 1, 377 n. 1, 384 and n. 1, 385 and n. 1, 425 and nn. 2 and 3, 426–8, 430 n. 1, 443–4, 454, 460 n. 1, 482 n. 4, 483, 485 and n. 3, 486, 500, 501 and n. 3, 504 and nn. 2 and 3, 505, 507, 532 and nn. 5 and 6, 561, 569 n. 5, 575 n. 1, 583, 584 n. 4, 592, 612; Pls. xxxv–xxxvi.

Songs of Innocence and of Experience (1794), 165 and n.3, 166 and n.2, 211 n. 2, 224 n. 4, 225 n. 1, 232 and n. 2, 242, 243 n. 2, 245 and n. 1, 251–2 and n. 1, 266, 270, 279–80 and n. 1, 319, 320 n. 1, 323 and n. 1, 333, 339 and n. 1, 341 and n. 2, 355, 369 n. 1, 377 and n. 1, 379 and n. 4, 380, 416 and n. 3, 443 and n. 1, 453, 460, 482, 485 n. 3, 503, 533, 536, 548–9, 569 n. 5, 573 n. 4, 575 and n. 1, 578, 581 and n. 2, 583 and n. 1, 585 n. 2, 591, 592 and nn. 5 and 6, 606–7.

— (1839), 194 n. 1, 538.

Sonsby, Samuel (fl. 1772), engraver?, 12.

Sophia (1777–1848), Princess, 220 n. 3, 345 and n. 5, 597 and n. 2, 602.

Sotheby Auction (1805 May 1–3), 156 n. 2.

— (1817 July 28–30), 224 n. 4.

— (1825 May 24–June 3), 368 n. 3.

— (1825 July 25), 182 n. 1.

— (1830 Jan. 13), 377 and n. 1.

— (1830 May 4–12), 329 n. 2.

— (1832 Dec. 12), 239 n. 1.

— (1836 June 18), 41 n. 3.

— (1837 July 21), 341 n. 3.

— (1878 May 20–22), 124 n. 1, 165 n. 2, 173 n. 3.

— (1903 June 24), 570 n. 4.

— (1925 July 29), 222 n. 3.

— (1932 Dec. 19), 176 n. 1.

— (1934 March 6), 367 n. 4.

— (1937 March 2–9), 176 nn. 1 and 2.

— (1949 April 14), 182 n. 1.

— (1966 June 28), 263 n. 2.

South Molton St., No. 17, 136, 153, 189 n. 3, 209, 214, 215 n. 1, 232, 240, 257, 341 n. 1, 380, 395, 489, 501, 525 n. 3, 562–3 and nn. 1–3; Pl. lviii*a*.

Southcott, Joanna (1750–1814), prophet, 235, 399–400.

Southey, Robert (1774–1843), poet, 53 and n. 3, 71 n. 1, 94, 109, 226 and n. 2, 229 and n. 2, 398 and nn. 2 and 4, 399 and n. 3, 400.

— *Annual Review* for 1805 (1806), 177 and n. 3.

— *Correspondence . . . with Caroline Bowles* (1881), 71 n. 1, 398 n. 2, 399 n. 4.

— *Doctor, &c.* (1847), 226 n. 2.

Southgate & Barrett auction (1854 July 7–30), 374 n. 2.

Spanish, 333–4.

Speght, Thomas (fl. 1600), editor of Chaucer, 230.

'Earl Spencer' (1813), 232 and n. 1, 617 and n. 3.

Spencer [? Elizabeth] Lady, 224 n. 4.

Spencer [George John Spencer (1758–1834)], second Earl of, 98.

Spencer, Lady Lavinia (d. 1831), wife of George John, 98.

Spenser, Edmund (1552?–99), poet, 69, 363 and n. 1.

Spicer, Mrs. (fl. 1800), vendor of Hayley's *Little Tom the Sailor* (1800), 74, 615.

Spicer, Thomas (fl. 1800), hero of Hayley, *LittleTom the Sailor* (1800), 74.

Spilling, J., *New Church Magazine* (1887), 38 n. 1.

Spilsbury (fl. 1802–3), of Midhurst, 100, 114 and n. 3.

Spilsbury, Jonathan (fl. 1760–90), engraver and painter, 114 n. 3.

Spinoza, Baruch (1632–77), philosopher, 311, 324, 540.

'The spiritual form of Nelson guiding Leviathan . . .' (1809), 231, 451, 492–4.

'The spiritual form of Pitt, guiding Behemoth . . .' (1809), 231, 451, 492 and n. 2, 493–4.

Spurzheim, J. G., *Observations on . . . Insanity* (1817), Blake's annotations, 106 n. 2, 175 n. 1.

Stael, Anne Louise Germaine Necker, Baronne de Stael-Holstein (1766–1817), author, 381.

Stanley, J. T., tr. G. A. Burger, *Leonora* (1796), 54, 614.

Stationers' Hall, 9 and nn. 2–4, 10 nn. 1 and 2, 11 and n. 3, 14, 27 n. 3, 41, 55, 271, 511 n. 1.

Stedman, Adriana, wife of J. G., 48.

Stedman, John Gabriel (1744–97), soldier, 45, 48–49, 613.

— *Journal, 1744–1797* (1962), 45 n. 2.

— MS Journal, 45 and n. 2, 48–51.

— *Narrative, of a five years' expedition . . . [to] Surinam* (1796), 45, 48–49, 613 and nl 1.

Steel, Mrs., collection, 119 n. 3.

Steele, Richard, 34.

Steer, Mr. Francis W., 561 n. 3.

Steevens, G., ed., Shakespeare, *Dramatic Works* (1803, 1832), 615.

Stephen, George (fl. 1824–9), 373 and n. 2, 415 and n. 3, 587 and n. 7, 607.

Stephen, Sir George (1794–1879), author, 373 n. 2.

Stephens, F. G., *Memorials of William Mulready* (1867), 277 n. 3.

— *Portfolio* (1872), 291 n. 2.

Stephens, George (fl. 1833), 415 and n. 3.

Stereotype, 32 and n. 2, 460 and n. 1, 473, 486, 504.

Sterne, Laurence (1713–68), novelist, 610.

Stevens, Richard John Samuel (1757–1837), composer, 425 and n. 4.

Stewart, Anthony (1773–1846), miniaturist, 259, 590, 599.

Stewart, Wheatley, & Adlard, auction (1828 May 24), 368 and n. 3.

Stockdale, John (1749?–1814), bookseller, 48, 613, 619.

Stod[d]art; mistake for Thomas Stothard, 538.

Stone, F. (fl. 1802), draughtsman, 616.

Stonebridge, Mr. A. J. D., 568 n. 1.

Story, A. T., *James Holmes and John Varley* (1894), 402 n. 3.

— *Life of John Linnell* (1892), 256 n. 2, 257 n. 1, 258 n. 1, 265 n. 1, 275 n. 2, 277 n. 5, 286 n. 2, 291 n. 1, 292 n. 3, 305 n. 1, 306 n. 5, 318 n. 2, 379 n. 4, 394 n. 2, 397 n. 1, 398 n. 1, 401 nn. 1 and 2, 405 n. 1, 409 nn. 1 and 3, 415 n. 1, 584 n. 2.

— *Life of William Blake* (1892), 332 n. 2.

Stothard, Alfred Joseph (1793–1864), medallist, son of Thomas, 20 n. 1.

Stothard, Robert T. (fl. 1863), son of Thomas, 284, 287, 300.

— *Athenaeum* (1863), 172 and n. 1, 180 and n. 2, 326 n. 1, 466 n. 1.

Stothard, Thomas (1755–1834), painter, 19 and nn. 1–3, 20 n. 1, 26, 39, 46, 48, 52, 55 and n. 3, 57–58, 169, 172 and n. 1, 179 and n. 3, 180 and nn. 1 and 2, 181, 182 n. 1, 186 and nn. 4 and 5, 190, 191 n. 1, 192 n. 2, 193, 201, 209 and n. 1, 216, 219, 220 and n. 2, 226–8, 232, 244 and n. 1, 247, 269, 283, 287, 292 n. 3, 318 n. 2, 348, 362, 366, 456, 462, 464 n. 1, 465 and n. 1, 466 and nn. 1 and 2, 467, 480 n. 10, 491 and nn. 2 and 3, 538, 569, 609–10 and n. 1, 611, 619, 621 and n. 3; Pl. xxxiia; *see also* Bray, Mrs. A. E., *Life of Thomas Stothard* (1851).

Stothart, *see* Stothard, Thomas, 569.

Stover, Linnell's governess, 344 and n. 3.

Strutt, Joseph (1749–1802), engraver, 511 n. 1.

Stuart, Lady Caroline, *see* Portarlington, Countess of, 120 n. 1.

Stuart, J., and Revett, N., *Antiquities*

of *Athens* (1794), 44, 136, 189 and n. 4, 422, 433, 448, 613.

Suffolk, Lord (fl. 1818), 257.

Surrey Institution, 254.

Sussex, Augustus Frederick (1773–1843), Duke of, 304.

Sussex County Council, 561 n. 3.

Sussex County Record Office, 51 n. 1, 72 n. 2, 125 n. 1, 128 n. 1, 129 n. 1, 130 n. 1, 131 n. 1, 134 n. 1, 137 n. 1, 140 nn. 1 and 2, 146 n. 4.

Sussex Weekly Advertiser (1803), 135.
— (1804), 146.

Swedenborg, Emanuel (1688–1772), prophet, 2 and n. 4, 34, 35 and n. 1, 36–37 and n. 3, 38 and n. 1, 41 n. 4, 53, 250 and n. 4, 251, 253, 312–13, 324, 377 n. 2, 432, 438, 440 and n. 6, 441, 451–2, 519 and n. 1, 520, 536, 540; *see also* New Jerusalem Church.
— *Divine Love and Divine Wisdom* (1788), 35, 37 and n. 1, 416.
— *Divine Providence* (1790), 38.
— *Heaven & Hell* (1784), 34.
— *Worship and Love of God,* 37 n. 3.

Swedenborg Society Inc., 250 n. 4.

Swinburne, Algernon Charles (1837–1909), poet, 220 and nn. 2 and 3, 221 n. 3, 222.
— *William Blake* (1868), 31 n. 3, 221 n. 3, 345 n. 6.

Sylvester, Douglas, *see* Glenbervie, Lord.

Symons, A., *William Blake* (1907), 1 n. 2, 417 n. 3.

Tabarde Inn, 623.

Talbot Inn, 623.

Talfourd, Thomas Noon (1794–1854), lawyer, 229 n. 3, 313, 314 n. 2.

Tanner (fl. 1824), friend of Linnell, 286.

Tartt, W. M., *New Monthly Magazine* (1830), *Essays* (1876), 626 n.3.

Tasso, Torquato (1544–95), poet, 69, 322 n. 2.

Tate Central Library, London, 550.

Tate Gallery, 264, 367 n. 3; Pls. xxxii*a,* xxxiii.

Tate, Nahum (1652–1715), dramatist, 367 n. 3.

Tatham, Arthur (1809–74), brother of Frederick, 288 n. 3, 476 and n. 2, 528 and n. 3.

Tatham, Charles Heathcote (1772–1842), architect, 8 n. 2, 61, 273 and n. 1, 288 and nn. 3 and 4, 293, 591 n. 6, 599.
— *Etchings . . . of Ancient Ornamental Architecture* (1799), 61.

Tatham, Frederick (1805–78), 2 n. 4, 3 n. 1, 30 n. 1, 33, 34 n. 1, 41 n. 4, 66 n. 1, 235 n. 4, 238, 239 n. 3, 268, 273 n. 1, 286, 288 and n. 3, 292 and n. 3, 322 n. 3, 339, 351, 364, 370, 374 and n. 2, 375, 383 n. 1, 403–5 and n. 1, 406 and n. 1, 407–8 and n. 2, 410 and n. 6, 411, 413 and n. 1, 414–15 and n. 1, 416–17 and nn. 1 and 3, 465 n. 1, 471 and n. 2, 475 n. 4, 476 and n. 3, 477 n. 4, 498 n. 4, 501 n. 4, 502 n. 1, 507–8, 567 and n. 3, 584, 590–1 and n. 6, 595–6, 600, 607, 621.
— MS 'Life of Blake' (*c.* 1832), 6, 7 n. 3, 9 n. 1, 21 and n. 1, 24 n. 1, 32 n. 3, 49, 52, 70 n. 2, 265 n. 5, 276 n. 1, 290 n. 2, 318 n. 2, 349 n. 5, 354 n. 1, 374–5, 410 n. 6, 411 n. 2, 412 n. 1, 456 n. 3, 467 n. 1, 471 n. 2, 475 n. 1, 476 n. 3, 477 n. 4, 478 n. 1, 502 n. 1, 507–35, 558, 560 and n. 5, 561, 565 n. 2, 567.

Tatham, Mrs. Frederick, 410–11, 507, 535, 567.

Taylor, Ann (1782–1866), author, 254.

Taylor, H. (fl. 1834), 597, 601.

Taylor, Sir Henry (1800–86), author, 53 and n. 3.

Taylor, Isaac (1730–1807), engraver, 254.

Taylor, Jane (1783–1824), author, 226, 254.

Taylor, Jane & Ann, *City Scenes* (1809–28), 253–4 and n. 2; Pl. xxxvi.

Taylor, Jeremy (1613–67), bishop, 349 and n. 3.

Taylor, Josiah (fl. 1826), swindler, 590 and n. 4, 600.

Taylor (?Mary [d. 1809]), wife of the Platonist, 399.

Taylor, Thomas (fl. 1782), of 23 Green St. (not the Platonist), 557.

Taylor, Thomas (1758–1835), Platonist, 60 n. 1, 304 and n. 2, 399.

Teaching, 175–6, 220–2, 523, 524 and n. 1, 574 and n. 4, 575, 576 nn. 2–4, 577 n. 3.

Teniers, David (1582–1649), or more probably his son David (1610–90), painters, 24 n. 3.

Thane, William (fl. 1807–36), picture restorer, 227 n. 1.

Thel, character, 385.

Thel, see The Book of Thel (1789).

There is No Natural Religion (1788?), 242, 611.

Theresa, St., *see* St. Theresa.

Theseus, 283.

Thetis, 362.

Thomas, Sir George White, J.P. at trials, 131, 140.

Thomas, John (fl. 1782), bondsman?, 22–23.

Thomas, Revd. Joseph (d. 1811), Rector of Epsom, 120 n. 1, 165, 166 and nn. 1 and 2.

Thompson, Mr. Stanbury, Collection, 45 n. 2.

Thomson, Henry (1773–1843), painter, 169, 193, 201, 247, 348.

Thomson, James (1700–48), poet, 613 n. 2.

Thomson, Richard (1794–1865), antiquary, 469.

Thorn, W. [? William (1781–1843), soldier], 401 and n. 3.

Thornbury, Walter, *British Artists from Hogarth to Turner* (1861), 264 and n. 2, 326 n. 1.

Thorne, Mrs. L. K., collection, 163 n. 4, 307 n. 2.

Thornton, Dr. Robert John (1768?–1837), author, 258, 266–7, 271 and n. 1, 272–3, 296 n. 2, 304, 320 and n. 3, 365, 582, 584–5, 587 n. 6, 601, 604 and n. 3, 618–19; *see Remember Me!* (1824–5) *and* Virgil, *Pastorals* (1821).

— *New Translation of the Lord's Prayer* (1827), 271, 369 and n. 2.

Thornton, Sylvia, daughter of R. J., 296 n. 2.

Thrall, T. M. H., *Rebellious Fraser's* (1934), 393 n. 2.

'Three Heros of Camlan', *see* 'The Ancient Britons' (1809).

'The Three Maries at the Sepulcher' (1803), 570–1.

Throckmorton, Mrs. (fl. 1802), 110.

Tickman (fl. 1826), printer, 590, 603 n. 1.

Tilloch, Alexander (1759–1825), inventor, 32, 58 and n. 1.

Timbril (fl. 1804), friend of Cumberland, 55 n. 3.

'Timon and Alcibiades' (1790), 559, 1612.

Tiriel (1789?), 561.

Titian [Tiziano Vecelli (*c.* 1477–1576)], painter, 57, 200, 216 and n. 3, 218, 221, 285, 435–6, 450, 492 and n. 4, 495, 516, 538.

'To the Muses', *Poetical Sketches* (1783), 224 n. 3, 442, 453, 478 and n. 7.

'To the Public' (1793), 613.

'To the Queen', R. Blair, *The Grave* (1808), 192, 208, 224 n. 3.

'To Tirzah', *Songs of Experience* (1794), 253, 469 n. 1.

Todd, Mr. Ruthven, collection, 575 n. 1.

Tomlin, R. E., *Law Dictionary* (1810), 134 n. 1.

Tonner, Mrs. William Y., collection, Pl. x*a*.

Tooke, John Horne (1736–1812), radical, 177 n. 1, 318 n. 2.

Toomer, Jos. (b. 1760), painter, 16.

Toronto Public Library, Pl. xxxvi.

Torrens, Sir Henry (1779–1828), soldier, 327, 590 n. 5, 599.

Torrens, Sarah, Lady, wife of Sir Henry, 327, 328 and n. 1, 590.

Townley, Charles [?(1737–1805), collector], 55 n. 3, 68, 70.

Townly (fl. 1813), of South Molton St., friend of Cumberland, 232 n. 4, 563.

Townshend, Charles (1728–1810), politician, 558 n. 1.

Transactions of the Society . . . for the Encouragement of Arts (1815), 239 n. 1.

Treason, *see* Trial, 463 n. 1.

Trederoft, Nathaniel, J.P. at 1803 trial, 131.

Tresham, Henry (1749?–1814), painter, 169, 193, 201, 247, 348.

Triads, 222, 226, 438, 451.

Trial, 1803, 122–37.

Trial, 1804, 137–48, 152, 164, 318 n. 2, 463 n. 1, 563.

Trimlet (fl. 1827), printseller, of Bristol, 359.

Trinity College Library, Hartford, Con-

necticut, 124 n. 1, 127 n. 1, 144 n. 1, 220 n. 3, 462 n. 1.

Triqueti, H. de (fl. 1856), 602 n. 3.

Trotter, engraver, 466.

Trowbridge, G., *Morning Light* (1903), 37 n. 3.

Trusler, Dr. John (1735–1820), author, 60 and nn. 1 and 3, 61, 210 n. 1.

Tulk, Caroline, *see* Gordon, Mrs. John.

Tulk, Charles Augustus (1786–1849), Swedenborgian, 38, 213 n. 2, 242, 250 and n. 4, 251, 252 n. 1, 353 n. 2; *see also* Hume, M. C., *Life . . . of Charles Augustus Tulk* (1850, 1890), 250 n. 4.

Tulk, Susannah, wife of C. A., 242.

Turnbull Library, Wellington, New Zealand, 28 n. 3.

Turner, Joseph Mallord William (1775–1851), painter, 257, 360 n. 2.

Turner [?Sharon (1767–1847), historian], 229.

Tuscany, 283.

'Twelve Good Rules' (1803?), 118 and n. 4, 119 and nn. 2 and 3.

'The Tyger', *Songs of Experience* (1794), 224 n. 3, 252, 285 and n. 2, 286, 292 n. 2, 429–30 and n. 1, 431 and n. 1, 444–5, 454, 469, 479 and n. 1, 482 n. 4, 532, 537.

Tyler, Wat (d. 1381), rebel, 264 n. 4.

'Tyler, Wat' (1819), 264.

Tynan, Katharine, correspondent of Yeats, 319 n. 1.

Tyson (fl. 1827), printseller, of Bristol, 359.

United States, 42, 156, 321 n. 5, 398, 400, 410, 470.

Universal British Directory (1790), 552, 555 n. 2.

University College, London, 250 n. 4.

University of Chicago Library, 136 n. 2.

Unwin, Mary (1724–96), friend of Cowper, 85–86, 89.

Upcott, William (1779–1845), collector, 224 and nn. 1 and 3, 264 n. 3, 342 n. 1, 353 n. 1, 447 n. 1, 468 and n. 5, 469 n. 1, 473 and n. 1.

Upper Charlotte St., *see* Charlton St., 567.

Upper Charlton St., *see* Charlton St., 411.

Upperton, Robert, juror in 1803 trial, 134 n. 1.

'Upton, James' (1819), 256–8 and n. 1, 407 nn. 1 and 2, 580 and n. 4, 581, 584, 607, 618.

Urania (1825), 296 and n. 3, 297 and n. 2.

Urizen, character, 487; *see* 'Christ Triumphing over Urizen' (1806?), 176, 617.

Urizen, see The First Book of Urizen (1794).

Vala or *The Four Zoas* (1797?–1808?), 234 n. 1, 332, 406 n. 2, 495 n. 5, 561.

Valence, Aymer de (d. 1260), bishop, 423.

Valuable Secrets concerning Arts (1758–1810), 32 n. 2.

Van Dyke, Sir Anthony (1599–1641), painter, 227.

Van Eycke, Hubert (?1366–1426), or Jan (?1385–1440), painters, 310 n. 1.

Van Leyden, 310 n. 1.

Vanderhoef, Mr. F. Bailey, Jr., collection, 259 n. 2, 624 n. 1; Pls. xxxvii*a*, xxxix.

Varley, Cornelius (1781–1873), painter, 268, 393.

Varley, H. [? son of John], 394.

Varley, J. [? son of John], 393.

Varley, John (1778–1842), painter, 237, 257–8 and n. 1, 259–60 and n. 3, 261 n. 2, 263 and n. 1, 264–5, 269, 277, 280, 288, 292, 294, 323, 332, 355, 370, 375, 390 n. 2, 393, 401 and n. 4, 402 n. 3, 467, 489 n. 1, 496 n. 3, 497 n. 1, 555, 581 n. 3, 582, 597 and n. 2, 601, 602, 618, 623; *see also* Story, A. T., *James Holmes and John Varley* (1894), 402 n. 3.

— *Zodiacal Physiognomy* (1828), 226 n. 2, 370 and n. 1, 372, 373 n. 1, 618, 619 n. 1, 626; Pl. xlviii; prospectus, 370 and n. 1.

Varley-Blake Sketchbook (1819?), 623–4 and n. 1.

Vasari, Giorgio (1511–71), painter and author, *Lives of the Artists*, 345 and n. 2.

Vaterländische Annalen, *see Vaterländische Museum.*

Vaterländische Museum (1811), 223, 224 n. 3, 229 and n. 1, 270 and n. 3, 356 n. 5, 432–55, 537.

Vatican, 315, 517, *see also* Sistine Chapel.

Venn, A., *Alumni Cantabrigienses* (1954), 166 n. 1.

Venus, 198, 284, 287 n. 2, 493 and n. 14, 516.

Venus Anadyomene, 176; Pl. ix.

'Venus and Adonis' (1787), 192 n. 2.

Venus de Medicis, 290, 422, 493 n. 14.

'Venus Dissuades Adonis' (1787, 1823), 611.

'Version of Genesis', 547.

Vestris, Mme, *see* Mathews, Lucia Elizabeth, 273.

Victoria and Albert Museum, 231 n. 2, 299 n. 3.

'View of Carfax Conduit, Oxford', attributed to Blake, 192 n. 2.

Villiers, Huet (fl. 1820), painter, 618.

Vincent, George (1796–1836?), painter, 265 and n. 3.

Vinci Leonardo Da, *see* Da Vinci, Leonardo.

Vine[s], James (fl. 1817–26), patron, 275 and n. 2, 286, 590, 599.

Virgil [Publius Vergilius Maro (70–19 B.C.)], poet, 138, 267 and n. 1, 488.

— *Pastorals* (1821), 266, 267 and nn. 1–3, 271 and n. 1, 272 and n. 1, 273, 320 n. 3, 356, 369, 582, 597 and n. 3, 618; Pls. xl–xli.

Virgin Mary, *see* Mary.

Vision, 2–3, 7, 13 and n. 4, 32–33, 40 n. 2, 41 n. 4, 53–54, 58 n. 1, 60–61, 67, 120, 146, 183, 195, 198, 200, 221 and n. 2, 234, 235, 237, 257, 260, 285, 290, 294, 295 n. 2, 297–9, 301, 303, 310, 312, 316–17, 322 and n. 2, 323–4, 338, 351–2, 370, 372–4 and n. 1, 377 and n. 2, 379, 398 n. 3, 402 n. 3, 424, 448, 451, 459–60, 462 n. 1, 463, 482, 484–9 and n. 1, 490–9, 501, 503, 518–20, 524 n. 2, 537–44, 547.

'Vision of Genesis', 547.

'Vision of the Last Judgment' picture, *see* 'Last Judgment'.

Visionary Heads, 182, 237, 259 and n. 2, 260 and n. 2, 261–4, 289 n. 1,

297–8 and n. 1, 299 and n. 1, 323, 352, 372–3, 401, 467, 489 n. 1, 496–7 and n. 1, 498–9, 518–19, 547, 619, 629 and n. 1; Pls. xxxvii–xxxix.

Visions of the Daughters of Albion (1793), 46, 211 n. 2, 243 n. 2, 288 n. 3, 320 n. 1, 417 n. 3, 561.

Vitalis, 389–90, 393 n. 2.

'The Voice of the Ancient Bard', *Songs of Innocence* (1789), 252, 380 and n. 3, 469 n. 1.

Voltaire, Francois Marie Arouet de (1694–1778), author, 69, 322–4, 417 n. 3, 507 n. 1, 526 n. 3, 539, 547.

Voting, 551, 553–4, 558 and n. 1.

Wackenroder, W. H., 440 n. 3.

Wadham College, Oxford, 111 n. 3.

Wainewright, E. F. [Frances], wife of T. G., 346.

Wainewright, Thomas Griffiths (1794–1852), author, painter, poisoner, 182 n. 1, 265–6, 280 and n. 3, 327 and nn. 3 and 4, 339 and n. 4, 341 n. 2, 344 n. 4, 345–6, 590, 599.

— *London Magazine* (1820), 265–6 and n. 1.

Wait, John, juror in 1803 trial, 134 n.1.

Wakefield, G. [?Gilbert (1756–1801), controversialist], 55.

Walker, Joseph Cooper (1761–1810), antiquary, 81 and n. 2, 94–95, 163.

Walker, W. (fl. 1808), 199 and n. 2.

Wallace, Sir William (1272?–1305), Scottish patriot, 260–1 and 2, 262–3 and n. 2, 264, 297, 489 n. 1.

— Visionary head, 496–7.

'Wallace & Edward I' (1819), 260–1 and n. 2; Pl. xxxix.

Waller, Edmund (1606–87), poet, 427 and n. 2.

Walpole, Horace, *Letters* (1903–5), 324 n. 3, 512 n. 2.

Walter, Henry (fl. 1825), 294.

Walton, Izaak (1593–1683), author, 280 and n. 3.

Walton-upon-Thames, 234.

'War' (1793, 1810?), engraving, 613.

'War' (1805), drawing, 572.

'War unchained by an angel, Fire, Pestilence, and Famine Following' (1784), 28.

Ward, George Raphael (1798–1878), engraver, son of James, 268.

Ward, James (1769–1859), engraver and painter, 267–9, 468.

Ward, John (fl. 1770), Basire apprentice, 12.

Washington, George (1732–99), President of U.S., 470.

Water Colour Society, *see* Old Water-Colour Society (1812), 230.

Watercolour, 215.

Watercolour mixing, 33.

Waters (fl. 1826), 591, 599.

Watkins, J., and Shoberl, F., *Biographical Dictionary* (1816), 244 and n. 2, 259, 342 n. 1, 356 n. 5.

Watson, Caroline (1761?–1814), engraver, 70 n. 1, 152–6, 160–1, 167.

Watson [? George (1767–1837), painter], 178 and n. 1.

Watt, R., *Bibliotheca Britannica* (1819–24), 258–9 and n. 1, 356 n. 5.

Watteau, Antoine (1684–1721), painter, 610.

Watts, Isaac (1674–1748), hymnwriter, 181 and n. 4, 427.

Weale, James (1791–1862), bookseller, 266.

Weathercock, Janus; pseudonym for T. G. Wainewright, 266 n. 1.

Wedd, Joseph (fl. 1826), friend of HCR, 321.

Wedgwood, Josiah (1730–95), potter, 19, 44.

Wedgwood, Josiah [Jr.], potter, 239–40 and nn. 1 and 2, 241.

[Wedgwood *Catalogue*] (1816–43?), 236 n. 1, 239 n. 3, 617.

Wedgwood firm, 578 and n. 3, 607, 617.

Wedgwood Museum, 240 n. 1, 241 n. 1, 578 n. 3.

Weller (fl. 1805), carver, 94, 163.

Welsh, 222, 226, 399, 438, 451, 538.

West, Benjamin (1738–1820), painter, 46, 50, 169, 193, 201, 245, 247, 248 n. 2, 348, 375, 422 and n. 1, 433, 448, 529, 624–5.

West Sussex County Council, *see* Sussex County Council, 561 n. 3.

Westmacott, Sir Richard (1775–1856), sculptor, 168 n. 1, 276, 348, 468 and n. 4, 591, 600.

Westminster Abbey, 13–14, 318 n. 2, 422–3, 433, 448, 466, 511–12 and nn. 2 and 3; Pls. xlix–l.

Westminster Hall, 189.

Westminster Public Library, London, 550, 553 n. 1.

Westminster School, 512 and nn. 2 and 3.

Whatman, J., watermark, 507.

Wheatley, Francis (1747–1801), painter, 554.

Whitaker, J., *The Seraph* (1819–1828?), 619.

Whitaker, Dr. T. H., *Loides and Elmete* (1816), 233 and n. 4.

White (fl. 1826), binder, 590 and n. 1, 603.

White, J. (fl. 1805–13), bookseller, 171, 236 n. 4.

White, W. A., collection, 176 n. 1.

Whitley, W. T., *Artists and their Friends in England, 1700–1799* (1928), 421 n. 1, 554 n. 1, 557 n. 2.

Whitworth Art Gallery, Manchester, 525 n. 2; Pl. xii.

Whyte, John, Lt.-General, J.P. at 1803 trial, 131.

Wilberforce, William (1759–1833), philanthropist, 344 and n. 2.

Wilkie, Sir David (1785–1841), painter, 559 and n. 3; *see* Cunningham, A., *Life of Sir David Wilkie* (1843).

Wilkie, G. (fl. 1785–7), bookseller, 611.

Wilkie, G. and T. (fl. 1785–7), booksellers, 611.

Wilkinson, C. J., *James John Garth Wilkinson* (1911), 416 n. 2.

Wilkinson, James John Garth (1812–99), Swedenborgian, 38 n. 1, 194 n. 1, 213 n. 2, 416, 536, 538, 549.

Will, 41 n. 4, 374 and n. 3, 410 and n. 5, 413, 415 n. 1, 417 n. 1.

William, Blake's gardener, 122–3, 125 n. 3, 126 and n. 1, 127, 143.

Dr. Williams's Library, London, 223 n. 1, 224 nn. 2 and 3, 314 n. 2, 321 n. 4, 323 n. 3, 336 n. 2.

Williams, David (1738–1816), radical, 46 and n. 2.

Williams, Mrs. I. A., collection, Pl. iv.

Willowby (fl. 1826), 587 n. 2, 598.

Wilson, Miss (fl. 1821), singer, 272.

Wilson (fl. 1793), engraver, 48.

Wilson, Prof. John (1785–1854), author, 387.
Wilson, M., *Life of William Blake* (1948), 67 n. 1, 175 n. 2, 215 n. 1, 294 n. 3.
Wilson, W. (fl. 1794), bookseller, 614.
Wilson, W., *Dissenting Churches* (1814), 8 n. 2.
Winckelmann, Abbé J. J., *Reflections on the Art and Sculpture of the Greeks* (1765), 12.
Windsor Castle Library, 50 n. 2.
Wine, 308.
Winstanley, Thomas & Co, auction (1826 May 10), 330, 331 nn. 3 and 4, 368 and n. 2.
'Winter' (1801?), 88.
'The Wise & Foolish Virgins' (1805, &c.), 339, 400 and n. 2, 468 n. 3, 572.
Wit's Magazine (1784), 466, 611 and n. 1.
Wolf, Mr. Edwin 2nd, 32 n. 2; *see also* Keynes and Wolf, *Census* (1953).
Wolf, E., 2nd and Mongan, E., *William Blake 1757–1827* (1939), 264 n. 4.
Wollstonecraft, Mary (1759–97), author, 40; *see also* Salzmann, C. G., *Elements of Morality* (1791–9).
— *Original Stories from Real Life* (1791, 1796), 433 n. 2, 612.
Wood, Polly, whom Blake courted, 517.
Woodburn, Samuel (fl. 1821–9), picture dealer, 273, 344 n. 4, 345, 594, 596, 600–1.
Woollett, William (1735–85), engraver, 557.
Woolner, Thomas (1825–92), sculptor, 275 n. 1.
Wordsworth, Dorothy (1771–1855), sister of William, 323–6, 430 n. 1.
Wordsworth, William (1770–1850), poet, 39 n. 4, 199, 223, 226, 229 n. 3, 231, 311–12 and n. 3, 313, 317–18, 320–1, 323–4 and nn. 1 and 3, 325 and n. 3, 331 and n. 7, 387, 430 n. 1, 536, 541 n. 1, 544–6.
— *Excursion* (1814), 312 and n. 3, 321 and n. 4, 325 and n. 2, 541 n. 1, 545.

— *Poems* (1815), 544–6.
Wright, printer, 51.
Wright, T., *Life of William Blake* (1929), 83 n. 1, 122 n. 2, 556 n. 1, 559 n. 2, 560 n. 3, 562 n. 5, 565 n. 1; Pl. lxb.
Wright, Waller Rodwell (d. 1826), author, 225, 226 n. 1.
Wright's Coffee House, 57.
Wyatt, Henry (1794–1840), painter, 264, 265 n. 1.

Yale University Library, 74 n. 2, 92 n. 2, 95 n. 2, 120 nn. 1 and 2, 145 n. 2, 277 n. 5, 315 n. 1, 328 n. 2, 329 n. 2, 366 n. 2, 406 n. 2, 580 n. 4, 598.
Yeats, W. B., *Letters to Katharine Tynan* (1953), 319 n. 1.
Young, *see* Younge, W. C., 366 n. 2.
Young, Charles Mayne (1777–1856), actor, 409, 600.
Young, Edward (1683–1765), poet, 270 n. 1.
— *Night Thoughts*, 183 and n. 1.
— (1797), 41 n. 3, 52, 56–57 and n. 1, 58, 59 and n. 1, 60, 166, 176, 193, 227 n. 1, 229, 231, 243, 270 n. 2, 271, 284 and n. 4, 289, 331 nn. 1 and 2, 346, 356 and n. 5, 375–6 and n. 1, 398 n. 2, 401–2 and nn. 2 and 3, 441 and n. 3, 453, 461 and n. 2, 487, 538, 561, 578, 614 and n. 2, 615; Pls. ix, xb.
— (1797), engravings coloured, 239, 413 n. 1.
— (1797), drawings, 50, 52, 183 n. 1, 269 and n. 2, 330–1 and n. 2, 368 and nn. 2 and 3, 432, 442 and n. 1, 453, 495 n. 5, 526 n. 3, 561; Pl. vii.
Young, George (fl. 1827), surgeon, brother of C. M., 409–10 and n. 1, 591, 600.
Younge, Miss (fl. 1783), 25 n. 1.
Younge, W. C. (fl. 1827), 366 and n. 2, 595 and n. 5, 600.
Younger, *see* Younge, W. C., 366 n. 2, 595 and n. 5.

Zeitgenossen (1830), 377 n. 2.
'Zephyrus & Flora' (1784), 611, 623 n. 2.

PRINTED IN GREAT BRITAIN
AT THE UNIVERSITY PRESS, OXFORD
BY VIVIAN RIDLER
PRINTER TO THE UNIVERSITY